THE DRAWINGS
OF THE VENETIAN PAINTERS

THE DRAWINGS
OF THE VENETIAN PAINTERS

IN THE 15TH AND 16TH CENTURIES

by HANS TIETZE and E. TIETZE-CONRAT

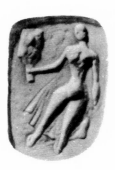

HACKER ART BOOKS, NEW YORK, 1979

To

FISKE KIMBALL

our oldest friend in our new country

© 1944 by Hans Tietze
First published in New York, 1944
Reissued by Hacker Art Books, Inc. New York 1979

Library of Congress Catalogue Card number 79-84535
International Standard Book Number 0-87817-254-8

Printed in the United States of America

TABLE OF CONTENTS

PREFACE

In the case of two students who were first introduced to the history of art by Franz Wickhoff, that great lover and connoisseur of Venetian art, a special interest in Venice scarcely needs an explanation. As a matter of fact, our first clumsy efforts in research led us to Venetian art. E. Tietze-Conrat's thesis on the Austrian sculptor G. R. Donner involved an investigation of Venetian sculpture of the late 17th century, quite unknown around 1900, while Hans Tietze's early study on the Baroque painter J. M. Rottmayr necessitated some knowledge of his background, Venetian painting of approximately the same period. Later on our interests gradually centered on the Renaissance. Our common studies on Albrecht Dürer stretching over many years deepened our interest in a school in which Italian and Northern art met and blended, while on the other hand a preoccupation with Titian increasingly anchored our chief interests in Venetian drawings of the 15th and 16th centuries.

After having made preliminary studies in earlier years we started in 1935 a systematic investigation of the drawings in European collections and continued with those in American collections after having moved to the United States in 1939. By this time the gathering of the European material had virtually been completed, although the crisis which had been preparing for many years prevented us from achieving that thoroughness which under normal conditions would indubitably have been an essential obligation. Mounting difficulties made it impossible to see and check certain drawings. Those in the Bibliothèque Nationale in Paris, for instance, had been packed away for evacuation during the Munich crisis and were never unpacked during our stay in Paris in the winter of 1938 to 1939. A visit to Scandinavian and Russian collections scheduled for 1939 proved impossible, so that we had to limit ourselves to the published material and to supplement it by notes and photographs graciously and abundantly supplied by the curators of the collections in question or by friends who took notes on the spot in our behalf. For the collections in Germany we were forced to depend on our earlier studies and on information received from German colleagues. They sometimes had to gather it surreptitiously since the German authorities did what they could to frustrate our efforts. Information and photographs for which we asked were refused to us and sometimes even to our agents when their principals were guessed. Nevertheless we succeeded in securing most of the photographs of drawings ascribed to the Venetian School or Schools in these collections, but were unable to check the drawings which may be listed under other names. This makes our material incomplete, but only relatively so since even in collections where we have studied the originals for many months—in the Uffizi, the Louvre, the British Museum, the Albertina, and others—complete knowledge of everything in existence is a practical impossibility, and even in these collections Venetian drawings consigned to other schools may have escaped our attention.

Since, in our opinion, for drawings no less than for other works of art a study of the originals is indispensable and cannot be replaced by that of reproductions, we have made explicitly a note in our lists of drawings which we have not seen in the original. This should put the student on guard against possible misjudgments. Our descriptions and lists refer to the situation in Europe in 1935–39. Later changes could not be taken into consideration. We list for instance the collection of Mr. Koenigs as in Haarlem, Holland, though it was already temporarily deposited in the Boymans Museum in Rotterdam when we saw it for the last time. Since then according to unverifiable reports the collection, or essential parts of it, has passed into the ownership of Mr. Van Beuningen in Rotterdam. It is impossible to know and hard to estimate what other changes and destructions have taken place within these last five years. The survey which we have tried to make as complete as possible refers, as far as Euro-

pean collections are concerned, to the pre-war era. The manuscript was practically completed by the end of 1941. Completeness, however, though admittedly the ultimate scope of a catalogue like ours, remains an ideal postulate. The essential claim we make for this book is that, for the first time in this field, the whole actually available material has been brought together and submitted to critical examination from a uniform point of view. The small minority of drawings we were unable to reach—we estimate it at hardly more than five percent—can easily be fitted later on into the firmly established system.

On the whole absolute completeness was not our aim. In older collections numerous drawings have been freely attributed to certain favorite Venetian artists (Giorgione, Titian, Campagnola, Tintoretto, Paolo Veronese) and newer sales catalogues and private collectors were no less generous with such baptisms. After having carefully examined this sort of material we consider it a useless burden to carry along all these gratuitous attributions. Accordingly, in selecting the material to be included in our corpus we adhere to the following principles:

1. In public collections we list drawings which in our opinion were made by individually known Venetian painters of the Renaissance, or which have been attributed to such artists by experts of the last generation, are supposed to be Venetian and which we are able to identify once and for all by ascribing them to other masters.

2. In private collections we list the drawings in much the same way, omitting however mention of them in cases where our opinion differs too widely from that of the owner, or where the owner wishes to keep the right of publication for himself. If, however, the drawing has been published previously we feel authorized to discuss its attribution and to dispute it.

3. In the art market we list only drawings which are discussed in recent publications, and those which promise a valuable contribution to our knowledge of their authors. Accordingly the omission of drawings mentioned in sales catalogues, or seen at artdealers, need not mean that we question the attribution.

Our intention, generally speaking, was to avoid dead freight. We do not see any profit in discussing or even mentioning hundreds of drawings handed down under the names of Giorgione or Titian in the Uffizi and elsewhere, attributions which in actual fact long since have been dropped by the curators of these collections. In the National Museum in Stockholm, to offer an example, numerous drawings are listed under the name of Paolo Veronese, most of which are fairly remote from his style and indeed have already been rejected by Sirén in his catalogues. Why should we continue to carry them along? Another instance from private collections: in the catalogue of the exhibition of Venetian paintings and drawings in the Matthiesen Gallery, London, 1939, two privately owned drawings were listed under the names of Paris Bordone and Jacopo Bassano respectively, without naming the collector and without illustration. The first has no connection whatsoever with Venetian art at any time, the second is a typical copy (from a painting by Jacopo Bassano in the National Gallery in London). It seemed useless to list such drawings, the photographs of which incidentally are among those we have deposited in the Metropolitan Museum (MM). On the other hand, other drawings in the same exhibition were included in our book, e.g., the so-called Giorgione in Chatsworth (No. **A 704**), repeatedly published under this name, and M. André de Hevesy's Ganymed (No. **A 320**) which we discussed ourselves as possibly by Mantegna in an article in Print Collectors Quarterly.

To sum up we have felt obliged to take a stand where the drawing had already been the subject of scholarly discussion, and felt justified in omitting it where its mention promised no enlightenment, especially when we could not illustrate the drawing, or at least point out a reproduction in an easily available book, catalogue or periodical.

The selection of our own illustrations demanded careful consideration since a discussion of drawings for students unable to check them seemed useless and, on the other hand, the reproduction of all the drawings listed in our corpus was impossible. The choice we made was determined by two considerations: the one to bring in as much unpublished material as possible, the other not to exclude especially important drawings even if more or less well known from previous publications. In many cases the student will be in a position to supplement our illustrations by those in other books. First of all he should have at hand Detlev von Hadeln's five albums and, for Jacopo Bellini, one of the complete editions of his two sketchbooks, preferably that of V. Goloubew.

In order to supplement our illustrations and to enable the student to check our material even if not reproduced in our corpus, or elsewhere, we have made with the Metropolitan Museum in New York an arrangement by which all our photographs of Venetian drawings listed in the book will be deposited in the Photograph Collection of the Library where they may be consulted. Each item of which a photograph has been deposited in the museum is marked with MM in our lists and can easily be identified by the number in our catalogue. Moreover, to make this photographic material still more helpful for students specializing in this field, we have added several hundred more photographs of drawings ascribed to Venetian masters in public or private collections with so little foundation that we do not list them, or which we omit because they are in the art market. We are confident that specialists will glean with profit through this material and find it useful for amplification or correction of our results.

For, of course, we do not believe that our catalogue solves all the problems. It is the limitation, and the privilege, of scholarship never to reach the final truth, but to push knowledge forward in that direction. In our special field of drawing, and, what is more, of Venetian drawing, for reasons explained in our introductory chapter certainty is perhaps still more unattainable than elsewhere, and our aim was less to make final attributions than to determine the part of drawing within the production of the great masters of the Venetian Renaissance.

Even this limited goal could be reached only by assistance of many helpers. Besides our literary predecessors whose opinions we conscientiously weighed even when disagreeing with them, many other colleagues have facilitated our studies: the curators of public collections, those anonymous assistants who helped us to overcome the obstacles deliberately put in our way by German authorities, the owners of private collections, the friends with whom we discussed the problems involved. In view of the broad range of our studies they are too many for all of them to be enumerated. Still we are happy to convey our thanks to Sir Sidney Cockerell, Paul Oppé, K. T. Parker, A. B. G. Russell, A. E. Popham, A. Scharf, E. Schilling in England; André de Hevesy, Gabriel Rouchès, André Linzeler, G. Lebrun in Paris; Commendatore Odoardo Giglioli and his priceless assistant Ristori in Florence, Giuseppe Ortolani in Naples, Vittore Moschetti and Rodolfo Pallucchini in Venice; Mrs. Lili Fröhlich-Bum who for many years worked side by side with us in the Albertina and is now living in London; Frits Lugt and J. Q. van Regteren Altena in Holland; Dr. Rudolf Berliner, H. C. Francis, Frederick Hartt, Frank J. Mather Junior, Ulrich Middeldorf, Miss Agnes Mongan in this country. Our thanks are also directed to those who either granted us unlimited authorization to make photographs in their collections or provided us with their own photographs. In this connection we wish to thank the directors and assistants of the printrooms in Cambridge, England, Cambridge, Mass., Chicago, Cleveland, Copenhagen, London (the British Museum and the Victoria and Albert Museum), Milan, Naples, Oxford, Paris, Rotterdam, Sacramento, Stockholm, Upsala; furthermore, André de Hevesy, Robert von Hirsch, Victor Koch, Franz Koenigs, Robert Lehman, Frits Lugt, Maurice Marignane, Frank J. Mather Junior, Paul Oppé, A. B. G. Russell and Janos Scholz, who generously gave

us photographs from their own collections for our studies; Otto Kurz, K. T. Parker and William Suida who lent us important photographs, and finally Major Theodore Sizer who in the middle of his task in occupied Italy took time to procure us the badly needed photograph of No. **1724.**

We also gratefully acknowledge our indebtedness to those institutions whose hospitality we enjoyed in the course of these long studies: the Albertina in Vienna, the Sir Robert Witt Library in London, the Toledo Museum of Art in Toledo, O., the Frick Art Reference Library in New York. We owe special thanks to the governing boards of the institutions whose financial support facilitated our work and made the publication of this book possible: The Philosophical Society of America which granted us a subsidy for traveling through the United States and studying the material in Western collections; the Karl Schurz Memorial Foundation which accorded a grant for the publication of our book; the Metropolitan Museum of Art which by purchasing our photographs put us in a position to use most of this amount for the publication.

Two more acknowledgments equally obligatory and gratifying are due to Miss Daphne Hoffman of the Frick Art Reference Library and to our publisher. Miss Hoffman revised our English and helped us immensely not only by her unusual linguistic gifts, and her skill in saving in the revised text as much as possible of our struggles with the complicated matter and of our personal rhythm, but also by her subtle and sympathetic understanding of the problems involved. She played for us the part of the ideal reader — avant le livre. J. J. Augustin accepted the difficult task of publishing this book in spite of the risks and uncertainties caused by war conditions, mindful of the fact that making money should not be the only goal of a publisher, but that helping scholars to reach their public is his true privilege. The last word of this preface should be devoted to ourselves since our way of collaboration now continued through many years and on various subjects is indeed rather unusual. A friend in England, after the publication of our *Dürer* asked us: How is it possible that for thousands of separate questions in such a critical catalogue two authors always agree? Our answer was, and is, that, on the contrary, we very often do not agree, but that many statements we make are the result of long and hard fights in which at the end one opinion wins. These dissensions within a team, however, are no different from those within the mind of one individual author who too at different times looks differently at the same problem. Our conflicts are only more articulate and, consequently, more thoroughly threshed out. Otherwise we feel solidly united. In many cases we ourselves do not know after a while which of us is to be given credit for this or that idea, objection, discovery. We also honestly do not know who conceived or wrote specific passages, paragraphs, and even chapters. We wonder whether there is a merit to be shared in this book, but we are certainly ready to share the responsibility up to the last word.

HANS TIETZE and E. TIETZE-CONRAT

VENETIAN DRAWINGS IN THE HERMITAGE

HANS TIETZE AND E. TIETZE-CONRAT

In pointing out the deficiencies of our lists, in the preface of our *Drawings of the Venetian Painters*,[1] we expressly mentioned one difficulty. The rising threat of war made it impossible to check the drawings in Scandinavian and Russian collections. The most important of the collections thus neglected is the department of drawings in the Hermitage. We are now very much pleased to be in a position to supplement our scanty remarks, limited to previously published material and notes received from Frederick Hartt, by the help of a book with which we recently became acquainted. It is M. B. Dobroklonsky, *Italian Drawings of the XVth and XVIth Centuries in the Hermitage*, Leningrad, 1940. It is written in Russian and contains a short history of the collection, as well as a careful and well documented description of its Italian drawings. Quite a few of the unknown ones are illustrated in unassuming halftones. This enables us to supplement our previous references to these drawings, or to offer comments upon others unknown to us, while limiting ourselves to the Venetian School as defined in our book. We regret that so many which are not illustrated still remain withheld from us and that the numerous drawings listed as anonymous continue to be an inaccessible hunting ground.

Our remarks follow the sequence of the catalogue.

1) Antonello da Messina, *Bust of a Young Man*. Originally listed among the anonymous items, later ascribed to Hans Holbein the Elder, and by Dobroklonsky attributed to Antonello da Messina on the ground of a certain resemblance to painted portraits by this artist. The classification of the drawing shows a marked analogy to that of the drawing in the British Museum 1895–9–15–789, which has gone through the same stages, only substituting the younger Hans Holbein for the elder, and which we consider (Tietze No. A 50) as a copy from a painting by, or in the manner of, Antonello. The drawing in Leningrad also offers his favorite arrangement of a bust in three quarter profile, but is a typical copy, the Venetian origin of which is by no means certain.

3) Giovanni Bellini, *Christ, Study for a Baptism*. Tietze No. A 306.

4) Giovanni Buonconsiglio, *Design for an Altarpiece*. Tietze No. A 411.

7) V. Carpaccio, *Torso of a Crucified Man*. Tietze No. 611.

8) V. Carpaccio, Two sketches. Tietze No. 610.

73) Leandro Bassano, *Saint Martin and the Beggar*. Tietze No. 220, where we did not take a stand, not having seen either the drawing itself or its reproduction. Dobroklonsky's reference to the drawing in Dresden published as by Leandro Bassano by Ludwig Zottmann, *Zur Kunst der Bassani*, Strasbourg, 1908, pl. x, 22, is particularly unfortunate because this drawing is not by Bassano. It is a copy either from Pordenone's painting in San Rocco, Venice, illustrated in Adolfo Venturi, *Storia dell'arte italiana*, IX, 3, p. 696, fig. 476, or from the design for the painting Tietze No. 1298. Jacopo's painting in the Museo Civico at Bassano, illustrated in Walt Arslan, *I Bassano*, Bologna, 1931, pl. LVI, to which Dobroklonsky further refers, has nothing in common with the drawing but the subject matter. The drawing in Leningrad is a typical copy from a Bassanesque painting. (We were unable to check another *Saint Martin* by Bassano in San Sisto, Piacenza, mentioned, but not illustrated in *Rassegna d'Arte*, 1916, p. 24.)

76) Jacopo Bassano, *Saint Jerome*. The attribution is not supported by any argument. It is indeed erroneous, the figure lacking Jacopo's very typical rhythm and the technique being far advanced in the pictorial tendencies of the seventeenth century.

82) Paris Bordone, *Adoration of the Shepherds*. Dobroklonsky's reference to two drawings in Budapest and Vienna respectively, Tietze No. A 387 and A 409, makes clear what misled him. Both are, in our opinion, not by Bordone, but much closer to Romanino's loose way of drawing. The drawing in Leningrad, however, is still farther advanced beyond them in its style.

115) Paolo Veronese, *Saint John the Evangelist*, belonging together with 112 to 114, representing the three other evangelists, and with 116, *Saint George*. Only 115 and 116 are illustrated. In our opinion, these are copies in the style of the Veronese shop.

119) Paolo Veronese, *Saint Margaret*. Tietze No. 2089.

145) Domenico Campagnola, *Wide Landscape with a Recumbent Female Nude and Two Cupids*. Convincing attribution, middle of sixteenth century.

159) Leonardo Corona? *Tobit and the Angel*, allegedly belonging together with 160, 161, not illustrated. We appreciate the question mark. The drawing belongs to a group of heretofore unidentified drawings reaching far into the seventeenth century. See Tietze Nos. A 1751 and A 1757.

169) Bernardo Licinio, *Portrait of Jacopo Sannazaro*. Formerly ascribed to Campagnola. Dobroklonsky's reference to the drawing in Berlin, 5066, which we (A 751) identify as by Callisto da Lodi, discloses only the identities of technique (red chalk) and of the posture in pure profile, typical of designs preparing or copying medals. The interesting drawing in Leningrad might indeed be connected with the medal of Sannazaro attributed to Girolamo Santacroce.[2] The history of this medal is not wholly clarified; it might be the one ordered by Isabella d'Este and apparently in the making in 1519.[3] At any rate the drawing represents Sannazaro in his advanced age, around 1520, when he permanently lived in Naples. Its author should be sought for among the local artists there. Whether Girolamo Santacroce, the presumed maker of the mentioned medal, and Montorsoli, the sculptor of Sannazaro's bust for his funeral monument, should be taken into consideration remains doubtful in view of the obscurity covering both works. In the bust and in the medal Sannazaro appears in idealized costume, while the otherwise very similar drawing presents him in modern dress and is apparently made from nature. Nothing points to the elusive Licinio.

170) Lorenzo Lotto? *Portrait of a Man*. Dobroklonsky is quite right not to be satisfied by the attribution to Lotto — entirely devious in our opinion — for which credit is given to Sir Kenneth Clark. The reference to the drawing 85 in the Albertina (Tietze A 778) offers no help, this drawing being of Lombard, not Venetian origin, as already recognized by Suida. Dobroklonsky's further reference to a drawing in the Uffizi confuses Lodovico Mazzolino and Filippo Mazzola.

176) Marco Angolo dal Moro, *Christ and the Woman Taken in Adultery*. Dobroklonsky's reattribution of this drawing, formerly ascribed to Tintoretto, rests on its close resemblance to, and almost exact conformity with, an engraving by Gasparo delli Oselli, bearing an additional monogram usually deciphered as Marco dal Moro's. The identification of that monogram has hardly been examined since Zani suggested it in 1820; the only expert who looked into this unattractive dark corner, Mary Pittaluga,[4] for reasons of style bluntly rejected the identifica-

1. Hans Tietze and E. Tietze-Conrat, *The Drawings of the Venetian Painters of the XVth and XVIth Centuries*, New York, 1944.

2. G. F. Hill, *A Corpus of Italian Medals of the Renaissance*, London, 1930, No. 350, p. 87, pl. 57.

3. *Giornale storico della letteratura italiana*, XL, 1902, p. 306, note.

4. Mary Pittaluga, *L'incisione italiana nel cinquecento*, Milan, n.d., pp. 286 and 333.

tion and differentiated between Marco dal Moro and the un-
identified monogrammist M V. At any rate the style of this
group of engravings and of the drawing is definitely not Marco
dal Moro's. Moreover, the drawing is neither a sketch nor a de-
sign for an engraving; it is too little settled for the latter and
too much for the former. It is a free copy from an already ex-
isting composition, perhaps the same to which Dobroklonsky
refers, a painting in the Royal Palace in Genoa, formerly listed
as by Moretto, but published by W. Suida[5] as Genoese School,
sixteenth century. It remains unknown who drew the copy that
modernizes the overcrowded and old-fashioned composition.
Certainly it was not Marco Angolo dal Moro.

241) Palma Vecchio, *Madonna.* Tietze No. A 1261. Do-
broklonsky's mistake is caused by his relying on two drawings
published as Palma Vecchio's by Hadeln. In our opinion, these
are copies by Palma Giovine from paintings of his uncle. See
Tietze Nos. 968, 983.

246) Palma Giovine, *Holy Family.* Good attribution.

248) Palma Giovine, *Unknown Saint Carried towards
Heaven,* sketch for a ceiling. We agree with this attribution,
correcting an older one to Odoardo Fialetti. The drawing fits
into our conception of Palma's style in sketches as discussed by
us under No. 1143. May the hasty sketch be related to Palma's
ceiling in San Giuliano, Venice, Julian raised to heaven and re-
ceived by the Holy Trinity surrounded by numerous saints?[6]

252) Palma Giovine, *S. Zachariah Carried toward Heaven.*
Tietze No. 980.

253) Palma Giovine, *S. Jerome Kneeling.* Tietze No. 979.

258) Palma Giovine, *Presentation of the Bride.* Tietze No.
978. The correct attribution of this drawing previously as-
cribed to Jacopo and Domenico Tintoretto was first made by
Jaremitch. We wonder who recognized the subject. The scene
is indeed the presentation of the bride (*novizza*), who, con-
forming to Venetian customs, has to meet and greet her visitors
accompanied by an old gentleman called "*Il Ballerino.*" The
drawing was made for Giacomo Franco's engraving in his book
Habiti delle donne veneziane.[7]

334) Giuseppe Salviati, *Flagellation of Christ.* Not entirely
satisfactory, for the Netherlandish elements in the drawing are
hardly compatible with Salviati.

346) Andrea Schiavone, *Entombment of Christ.* Though
Schiavonesque in the types and in its technique, it is too poor of
quality to be by Schiavone himself.

359) Jacopo Tintoretto, *Male Nude.* Tietze No. 1682.

360) Jacopo Tintoretto, Design for the angel in *Elija in
the Wilderness* in the Scuola di San Rocco. Tietze No. 1680.
The photograph from which our reproduction has been made
was apparently slightly cut at top and bottom.

361) Jacopo Tintoretto, *Nude.* Tietze No. 1681.

362) Jacopo Tintoretto, *Male Figure.* Tietze No. 1683.

365) Titian, *Study for a Christ Rising.* (See 366.)

366) Titian, *Cupid.* Tietze No. A 1922. These two attribu-
tions to Titian, in our opinion, are Dobroklonsky's worst blun-
ders. The resemblance to Titian's pen drawings is quite super-
ficial; the unification of forms by parallel hatching points to a
far later period. Every drawing we know sharing the character-
istics of those two belongs to the very late sixteenth or even the
seventeenth century. Even the origin in Venice seems by no
means beyond doubt.

In spite of such criticism we consider Dobroklonsky's cata-
logue a most valuable contribution to our knowledge of Vene-
tian drawing, and regret that we did not know his book in time.

It was published in 1940 by the Soviet Academy of Science,
and the only copy we happened to come upon in this country
is one that did not enter the Metropolitan Museum regularly,
but was bought from a second hand art book dealer in 1944.
This illustrates how disrupted the world of studies, the "Repub-
lic of the literati," has become in recent years. The catalogue it-
self is another illustration of the same phenomenon. Although
it is the work of a conscientious and industrious scholar, the
bibliographic list is lamentably incomplete and deficient in
modern literature. Still worse, the author's judgment is appar-
ently blunted by having been denied access for many years to
the great collections of drawings; or perhaps he was never ac-
quainted with them, and had to rely on reproductions. No one
can develop genuine critical acumen without frequent return to
the originals. A knowledge of drawings almost entirely depend-
ing on misleading reproductions must necessarily become dis-
torted. We wish to stress the statement, because we here in
America begin to suffer from the same strain. Those of us who
try to maintain our contacts with European art of the past have
the feeling that the roots begin to wither. Instead of communi-
cating with the most genuine manifestations of great art we
live in an artificial world of photographs and other reproduc-
tions. How much more would the reviewers have learned from
the drawings in Leningrad if they had been able to bend over
the originals for a while!

NEW YORK CITY

5. Wilhelm Suida, *Genua* (*Berühmte Kunststätten,* vol. 33), Leipzig,
1906, fig. 97.

6. C. Ridolfi, *Le maraviglie dell'arte,* ed. Hadeln, Berlin, 1924, II,
p. 175.

7. *Habiti delle donne veneziane intagliati in rame da Giacomo Franco,*
Venice, n.d. (ca. 1600). Also reproduced in Pompeo Molmenti, *La storia
di Venezia nella vita privata,* Bergamo, 1911, II, p. 511.

SIGNS AND ABBREVIATIONS

(Measurements are given in millimeters.)

A

A (with a number following) indicates that we reject the attribution of the drawing to the artist under whose name it is listed.

A (without a number following) indicates that the drawing is not described here, but shifted to another artist.

A. in A. — Art in America.

Albertina Cat. I (Wickhoff) — Franz Wickhoff, Die italienischen Handzeichnungen der Albertina I, Die venezianische Schule. In Jahrb. K. H. Samml., XI, Vienna 1891 to 92.

Albertina Cat. II (Stix-Fröhlich) — Alfred Stix und L. Fröhlich-Bum, Beschreibender Katalog der Handzeichnungen in der Albertina. I Zeichnungen der venezianischen Schule, Vienna 1926.

Albertina N. S. I — Joseph Meder, Handzeichnungen alter Meister aus der Albertina und aus Privatbesitz. N. F. I, Vienna 1922.

Albertina N. S. II — Alfred Stix, Handzeichnungen alter Meister aus der Albertina N. F. II. Italienische Meister des 14. bis 16. Jahrhunderts, Vienna 1925.

Amsterdam Exh. Cat. — Italiaansche Kunst in Nederlandsch Bezit, Amsterdam Staedelijk Museum 1934.

Amtl. Ber. — Amtliche Berichte aus den Königlichen Kunstsammlungen. Berlin 1890 ff.

Anonimo — The Anonimo. Notes on pictures and works of art in Italy. Edited by George C. Williamson, London 1903.

Arch. Ph. — Archives Photographiques d'art et d'histoire, Paris.

Archivio Storico — Archivio storico dell'arte, Rome 1889–97.

Arslan — Wart Arslan, I Bassano, Bologna 1931.

Art Bulletin — The Art Bulletin. An illustrated quarterly published by the College Art Association of America. Chicago 1913 ff.

L'Arte — L'Arte. Rivista di Storia dell'Arte medioevale e moderna, Rome and Turin 1898 ff.

ascr. — ascribed.

attr. — attributed, attribution.

B

B.M. — British Museum, London.

Bailo-Biscaro — Bailo e Biscaro, Della vita e delle opere di . . . Bordone, Treviso 1900.

Bardi — Girolamo Bardi, Dichiarazione di tutte le istorie che si contengono nei quadri posti novamente nelle sale dello Scrutinio e del Gran Consiglio del Palagio Ducale della S. Republica di Vinegia. Venice 1587.

Bell — C. F. Bell, Drawings of the old masters in the Library of Christ Church, Oxford. Oxford 1914.

Belvedere — Belvedere, Monatsschrift für Sammler und Kunstfreunde, Vienna 1922–1938.

Bercken-Mayer — Erich von der Bercken und A. L. Mayer, Tintoretto, Munich 1923.

Berenson — B. Berenson, Italian pictures of the Renaissance, Oxford 1932.

Berenson, *Drawings* — B. Berenson, Drawings of the Florentine painters. Amplified edition, Chicago 1938.

Berenson, *Lotto* — B. Berenson, Lorenzo Lotto. An essay in constructive art criticism, London 1901.

Berenson, *Venetian painting* — B. Berenson, Venetian painting in America, New York 1916.

Berlin Publ. — Zeichnungen alter Meister im Kupferstichkabinett der K. Museen zu Berlin, Berlin 1910 (Text by Elfried Bock).

bl. — black.

Bock — Elfried Bock, Die Zeichnungen in der Universitätsbibliothek Erlangen, Frankfort 1927.

Boll. d'A. — Bolletino d'Arte del Ministero della Publica Istruzione, Rome 1907 ff.

Bonnat Publ. — Les Dessins de la Collection Léon Bonnat au Musée de Bayonne, 1924–26.

Borghini — Raffaele Borghini, Il Riposo, Florence 1584.

Boschini, *Carta* — Marco Boschini, La Carta del Navegar pittoresco, Venice 1660.

Boschini, *Minere* — Marco Boschini, Le ricche Minere della Pittura Veneziana, Venice 1674.

Boschini-Zanetti, *Descrizione* — Descrizione di tutte le pubbliche pitture della città di Venezia, o sia Rinnovazione delle ricche Minere di Marco Boschini, Venice 1733.

Both de Tauzia — Both de la Tauzia, Notices des dessins de la collection His de la Salle, Paris 1881.

br. — brown.

Budapest Yearbook — Az országos Magyar szépmüvészeti muzeum évkönyve, Budapest IV, 1924–26.

Buffalo Exh. Cat. — Master drawings selected from the museums and private collections of America, 1935.

Burl. Mag. — The Burlington Magazine, London 1903 ff.

C

Cat. — Catalogue.

Cavalcaselle — Crowe and Cavalcaselle, A history of painting in North Italy ed. Tancred Borenius, New York 1912.

ch. — chalk.

Chatsworth Dr. — S. A. Strong, Reproductions of drawings by old masters in the collection of the Duke of Devonshire at Chatsworth, London 1902.

coll. — collection.

Colvin — Sidney Colvin, Drawings of the old masters in the University Galleries and in the Library of Christ Church, Oxford, Oxford 1903–7.

Critica d'A. — La Critica d'Arte, Florence 1935–38.

D

Davies — H. W. Davies, Bernhard von Breydenbach and his journey to the Holy Land, London 1911.

Dedalo — Dedalo, Rassegna d'Arte, Milan and Rome 1920–33.

Degenhart — Bernhard Degenhart, Zur Graphologie der Handzeichnung, in Kunstgeschichtliches Jahrbuch der Biblioteca Hertziana. I, Leipzig 1937, p. 223 ff.

Düsseldorf Cat. — Illa Budde, Beschreibender Katalog der Handzeichnungen in der staatlichen Kunstakademie in Düsseldorf, Düsseldorf 1930.

Dussler — Luitpold Dussler, Giovanni Bellini, Frankfort/M. 1935.

E

É. d. B. A., Exh. Cat. — Paul Lavallé, École des Beaux Arts, Exposition d'Art Italien des XVe et XVIe siècles, Paris 1935.

exh. — exhibited, exhibition.

F

Fenwick Cat.—A. E. Popham, Catalogue of drawings in the collection formed by Sir Thomas Phillipps . . . now in the possession of . . . T. Fitzroy Phillipps Fenwick, London 1935.

Fiocco, *L'Arte di Mantegna* — Giuseppe Fiocco, L'Arte di Andrea Mantegna, Bologna 1927.

Fiocco, *Carpaccio* — Giuseppe Fiocco, Carpaccio, Rome s.a.

Fiocco, *Mantegna* — Giuseppe Fiocco, Mantegna, Milan 1937.

Fiocco, *Pordenone* — Giuseppe Fiocco, G. A. Pordenone, Udine 1939.

Fiocco, *Veronese I* — Giuseppe Fiocco, Paolo Veronese, Bologna 1928.

Fiocco, *Veronese II* — Giuseppe Fiocco, Paolo Veronese, Rome 1934.

Fogolari — Gino Fogolari, I Disegni della R. Galleria dell'Accademia Venezia, Milan 1913.

Fröhlich-Bum *N. S. II* — L. Fröhlich-Bum, Studien zu Handzeichnungen der Italienischen Renaissance, in Jahrbuch der K. H. Samml., N. S. vol. II, p. 163 ff.

Fröhlich-Bum, *Schiavone I* — L. Fröhlich-Bum, Andrea Meldolla, genannt Schiavone, Jahrb. K. H. Samml. vol. XXXI, p. 137 ff.

Fröhlich-Bum, *Schiavone II* — Supplement to Schiavone I, in Jahrb. K. H. Samml. vol. XXXIII, p. 367 ff.

G

Gamba, *Bellini* — Carlo Gamba, Giovanni Bellini, Milan s.a. (1938).

Gaz. d. B. A. — Gazette des Beaux Arts, Paris, 1859 ff.

Goloubew — Victor Goloubew, Les dessins de Jacopo Bellini au Louvre et au British Museum, Brussels 1912.

Graph. Künste — Die Graphischen Künste, mit Beiblatt: Chronik der Gesellschaft für Vervielfältigende Kunst, Wien, 1879 ff.

Gronau, *Spätwerke* — Georg Gronau, Spätwerke des Giovanni Bellini, Strassburg 1928.

Gronau, *Künstlerfamilie* — Georg Gronau, Die Künstlerfamilie Bellini, Bielefeld and Leipzig 1909.

H

Hadeln, *Hochren.* — Detlev Freiherr von Hadeln, Venezianische Zeichnungen der Hochrenaissance, Berlin 1925.

Hadeln, *Koenigszeichnungen* — Detlev Freiherr von Hadeln, Meisterzeichnungen aus der Sammlung F. Koenigs, Haarlem. Venezianische Meister. Frankfort 1933.

Hadeln, *Quattrocento* — Detlev Freiherr von Hadeln, Venezianische Zeichnungen des Quattrocento, Berlin 1925.

Hadeln, *Spätren.* — Detlev Freiherr von Hadeln, Venezianische Zeichnungen der Spätrenaissance, Berlin 1926.

Hadeln, *Tintoretto* — Detlev Freiherr von Hadeln, Zeichnungen des Giacomo Tintoretto, Berlin 1922.

Hadeln, *Tizianzeichnungen* — Detlev Freiherr von Hadeln, Zeichnungen des Tizian, Berlin 1924.

Hadeln, *Titian drawings* — Detlev Freiherr von Hadeln, Titian's drawings, London 1929.

height. w. wh. — heightened with white.

Heil — Walter Heil, Palma Giovine als Zeichner, in Jahrb. Pr. K. S. vol. XLVII, p. 60 ff.

Hevesy, *Barbari* — André de Hevesy, Jacopo de' Barbari, Paris 1925.

I

ill. — illustrated, illustration.

J

Jahrb. Hertziana — Kunstgeschichtliches Jahrbuch der Biblioteca Hertziana in Rome, 1937 ff.

Jahrb. K. H. Samml. — Jahrbuch der Kunsthistorischen Sammlungen in Wien, Jänner 1883 ff.

Jahrb. Pr. K. S. — Jahrbuch der Preussischen Kunstsammlungen, Berlin 1880 ff.

Justi, *Giorgione* — Ludwig Justi, Giorgione, second edition, Berlin 1926.

K

Klassiker, Bellini — Georg Gronau, Giovanni Bellini, Klassiker der Kunst, vol. XXXVI, Stuttgart-Berlin, 1936.

Klassiker, Correggio — Georg Gronau, Correggio, Klassiker der Kunst, vol. X, Stuttgart-Berlin 1910.

Klassiker, Donatello — F. Schubring, Donatello, Klassiker der Kunst, vol. XI, Stuttgart-Berlin 1907.

Klassiker, Dürer — Friedrich Winkler, Albrecht Dürer, Klassiker der Kunst, vol. IV, Fifth edition, Stuttgart-Berlin (1928).

Klassiker, Mantegna — Fritz Knapp, Andrea Mantegna, Klassiker der Kunst, vol. XVI, Second edition, Stuttgart-Berlin 1925.

Klassiker, Palma Vecchio — G. Gombosi, Palma Vecchio, Klassiker der Kunst, vol. XXXVIII, Stuttgart-Berlin 1937.

Klassiker, Tizian — Oskar Fischel, Tizian, Klassiker der Kunst, vol. III, Third edition, Stuttgart-Berlin 1907.

Kr. — Kristeller.

Kristeller, *Barbari* — Paul Kristeller, Engravings and woodcuts by Jacopo de' Barbari, International Chalcographical Society, London 1896.

Kristeller, *Campagnola* — Paul Kristeller, Giulio Campagnola, Graphische Gesellschaft, Berlin 1907.

Kristeller, *Mantegna* — Paul Kristeller, Andrea Mantegna, London 1901.

L

l. — left.

Lees — F. Lees, The art of the great masters, as exemplified by drawings in the collection of Emile Wauters, London 1913.

Lorenzetti — Giulio Lorenzetti, Venezia e il suo estuario, Venice 1926.

Ludwig, *Archivalische Beiträge* — Archivalische Beiträge zur Geschichte der venetianischen Kunst. Aus dem Nachlass Gustav Ludwigs herausgegeben von W. Bode, G. Gronau and D. Freiherr von Hadeln. Fourth volume of Italienische Forschungen, ed. Kunsthistorisches Institut in Florenz, Berlin 1911.

M

MM — Photograph available in the Metropolitan Museum, New York.

Malcolm Cat. — J. C. Robinson, Descriptive catalogue of drawings by the old masters, forming the collection of John Malcolm of Poltalloch, Esq., London 1876.

Malaguzzi-Valeri, *Brera* — Francesco Conte Malaguzzi-Valeri, I disegni della R. Pinacoteca di Brera, Milan 1906.

Meder, *Handz. or Handzeichnung* — Joseph Meder, Die Handzeichnung, ihre Technik und Entwicklung, Vienna 1919.

Meder, *Facsimile* — Handzeichnungen italienischer Meister des 15.- 18. Jahrhunderts, Vienna 1923.

Meissner — Franz Meissner, Paolo Veronese, Bielefeld 1897.

Metropolitan Museum Dr. — European Drawings from the collections of the Metropolitan Museum of Art. I, Italian Drawings. New York 1943.

Molmenti-Ludwig — P. Molmenti and G. Ludwig, The life and works of Vittore Carpaccio, translated by R. H. H. Cust, London, 1907.

Mond Cat. — Tancred Borenius and Rudolph Wittkower, Catalogue of the collection of drawings by the old masters formed by Sir Robert Mond, London 1937.

Monatshefte — Monatshefte für Kunstwissenschaft, Leipzig 1908–22.

Mongan-Sachs — Drawings in the Fogg Museum of Art by Agnes Mongan and Paul J. Sachs, Cambridge, Mass. 1940.

Morassi-*Rasini* — Antonio Morassi, Disegni antichi dalla collezione Rasini in Milano, Milan 1937.

Morelli — Giovanni Morelli, Critical studies of Italian painters, London 1907.

Morelli, *Berlin* — Giovanni Morelli, Kunstkritische Studien über italienische Malerei, Die Gallerie zu Berlin. Leipzig 1893.

Morgan Dr. — A selection from the collection of drawings by the old masters formed by C. Fairfax Murray, London 1905.

Moschini — Giannantonio Moschini, Guida per la città di Venezia, Venice 1815.

Mostra Tintoretto — La Mostra del Tintoretto, Venice 1937.

Mostra Tiziano — Mostra di Tiziano, Venezia MCMXXXV (Venice 1935).

Mostra Veronese — Mostra di Paolo Veronese, Venice 1939.

Münchn. Jahrb. — Münchner Jahrbuch der bildenden Kunst, Munich 1924 ff.

N

n. — note.

N. G. — National Gallery.

Nicodemi, *Romanino* — Giorgio Nicodemi, Girolamo Romanino, Brescia 1925.

O

O. M. D. — Old Master Drawings. A quarterly magazine for students and collectors, London 1926 ff.

Oppenheimer Cat. — Catalogue of old master drawings collected by the late Henry Oppenheimer, Sale Christie, July 10 to 14, 1936.

Osmaston — Francis Plumptree Beresford Osmaston, The art and genius of Tintoretto, London 1915.

Osmond — Osmond, Paolo Veronese, his career and work, London 1927.

P

P. C. Q. — The Print Collectors Quarterly, Kansas City.

Parker — K. T. Parker, North Italian drawings of the Quattrocento, London 1927.

Pembroke Dr. — S. A. Strong, Drawings by the old masters in the collection of the Earl of Pembroke and Montgomery at Wilton House, London 1900.

Pittaluga — Mary Pittaluga, L'Incisione Italiana nel Cinquecento, Milan 1930.

Pittaluga, *Tintoretto* — Mary Pittaluga, Il Tintoretto, Bologna 1925.

pl. — plate.

Planiscig — Leo Planiscig, Venezianische Bildhauer der Renaissance, Vienna 1921.

Planiscig-Voss — Drawings of old masters from the collection of Dr. Benno Geiger, Vienna s.a.

Popham, *Cat.* — A. E. Popham, Italian drawings exhibited at the Royal Academy, Burlington House, London 1930, Oxford 1931.

Popham, *Handbook* — A. E. Popham, A handbook to the drawings . . . in the British Museum, London 1939.

publ. — published, publication.

R

r. — right.

R. L. — Royal Library, Windsor.

Rass. d'A. — Rassegna d'Arte, Milan and Rome 1901–1922.

Rep. f. K. W. — Repertorium für Kunstwissenschaft, Berlin and Leipzig 1875–1921.

Ricci — Corrado Ricci, Jacopo Bellini e i suoi libri di disegni, Florence 1908.

Richter — G. M. Richter, Giorgio di Castelfranco, Chicago 1937.

Ridolfi — Carlo Ridolfi, Le maraviglie dell'arte, Venice 1648. Ed. Detlev Freiherr von Hadeln, Berlin 1914 and 1924.

Riv. d'A. — Rivista d'arte, Florence 1904 ff.

Robinson, see *Malcolm Cat.*

S

Schönbrunner-Meder — Joseph Schönbrunner und Joseph Meder, Handzeichnungen alter Meister aus der Albertina und anderen Sammlungen, Vienna 1896–1908.

Schubring, *Cassoni* — Paul Schubring, Cassoni, Truhen und Truhenbilder der italienischen Frührenaissance, Leipzig 1923.

Schwarzweller — K. Schwarzweller, G. A. da Pordenone, Ph.D. thesis, Göttingen 1935.

Simon — Hertha Simon, Die Chronologie der Architektur und Landschaftszeichnungen in den Skizzenbüchern des Jacopo Bellini, Ph.D. thesis, Munich 1936.

Sirén *Cat. 1917* — Oswald Sirén, Italienska handteckningar fran 1400 och 1500 talen i Nationalmuseum, Stockholm 1917.

Sirén, *Dessins* — Oswald Sirén, Dessins et tableaux de la Renaissance Italienne dans les collections de Suède, Stockholm 1902.

Sirén *1933* — Oswald Sirén, Italienska tevlor ooch teckningar i Nationalmuseum och andrea svenska och finska samlingar, Stockholm 1933.

Staedel Dr. — Handzeichnungen alter Meister im Staedelschen Kunstinstitut, Frankfort on the Main 1908 to 14.

Sterling *Cat.* — Exposition de l'art Italien, Paris, Palais des Beaux Arts 1935. Dessins, note rédigée par Ch. Sterling.

Stift und Feder — Stift und Feder, Zeichnungen aller Zeiten und Länder in Nachbildungen, herausgegeben von Rudolf Schrey, Frankfort on the Main 1926–30.

Suida, *Tizian* — Wilhelm Suida, Tizian, Zürich, Leipzig (1933).

Swarzenski-Schilling — Ausstellung von Handzeichnungen alter Meister aus deutschem Privatbesitz, Frankfort on the Main.

T

Testi — Laudadeo Testi, La storia della pittura Veneziana, Bergamo 1909, 1915.

Thieme-Becker — Allgemeines Lexikon der bildenden Künstler, herausgegeben von U. Thieme und F. Becker, Leipzig 1907 ff.

Thode — Henry Thode, Tintoretto, Bielefeld and Leipzig 1901.

Tietze, *Dürer* — H. Tietze und E. Tietze-Conrat, Kritisches Verzeichnis der Werke Albrecht Dürers, Augsburg 1928, Basel 1937, 1938.

Tietze, *Tizian* — Hans Tietze, Tizian, Leben und Werk, Vienna 1936 (later London 1939).

Tizian-Studien — Hans Tietze und E. Tietze-Conrat, Tizian-Studien, in Jahrb. K. H. Samml. N. S. X, p. 137 ff.

U

Uffizi Publ. — I disegni della R. Galleria degli Uffizi in Firenze, Florence 1912 to 21.

V

Van Marle — Raimond van Marle, The development of the Italian Schools of painting, The Hague 1923 to 37.

Vasari — Giorgio Vasari, Le vite de' più eccellenti pittori etc., ed. Milanesi, Florence 1878 to 1885.

Vasari Soc. — The Vasari Society for the reproduction of drawings by old masters, Oxford, first series 1905–15; second series 1930–35.

Venturi — Adolfo Venturi, Storia dell'arte Italiana, Milan 1901 ff.

Venturi, *Studi* — Adolfo Venturi, Studi del vero, Milan 1927.

Venturi, *Giorgione* — Lionello Venturi, Giorgione e il Giorgionismo, Milan 1913.

Venturi, *Origini* — Lionello Venturi, Le origini della pittura Veneziana, Venice 1907.

Verci — G. B. Verci, Notizie intorno alle vite ed alle opere dei pittori di Bassano, Venice 1775.

W

Westphal — Dorothea Westphal, Bonafazio Veronese, Munich 1931.

wh. — white.

Willumsen — Jens Ferdinand Willumsen, La jeunesse du peintre El Greco, Paris 1927.

Woermann, *Dresden* — Karl Woermann, Handzeichnungen des Dresdner Kupferstichkabinetts, Munich 1896–98.

Y

Yearbook of Budapest Museum, see *Budapest Yearbook.*

Z

Zeitschr. f. B. K. — Zeitschrift für bildende Kunst, N. S., Leipzig 1890–1932.

Zottmann — Ludwig Zottmann, Zur Kunst der Bassani, Strasbourg 1908.

INTRODUCTION

THE ROLE OF DRAWING IN VENETIAN ART

In compiling this book we have aimed to provide a companion-piece to Bernard Berenson's book on the drawings of the Florentine painters. And this is the purpose we hope to accomplish in spite of basic differences in the material studied and the different approach of the respective authors. When Mr. Berenson published his "Florentine Drawings" in 1938—the first edition of which had been an audacious pioneer undertaking in 1903—he could look back on a successful life-long occupation with his subject. Although we have devoted a considerable amount of research to Venetian art, we feel less qualified than he to pronounce authoritative judgments. Hence, we feel more obligated to include ample—undoubtedly at times even rather tedious—discussion of controversial problems. The essential difference in the character of our respective materials works in the same direction. Mr. Berenson was dealing with Florentine drawings, many of which (*vide* Leonardo da Vinci and Michelangelo!) had previously been the subject of extremely thorough investigation; up to a certain point at least, definite knowledge had been reached. Venetian drawings, on the contrary, have received much less attention: Hadeln's thorough knowledge of the field has not been matched by later scholars. In spite of partial successes scored by Borenius, Fiocco, Fröhlich-Bum, Parker, Byam Shaw and others, the general sketch left by Hadeln in the introductions to his five albums of Venetian drawings of the Renaissance has hardly been clarified to any extent. Even Hadeln's work, moreover, offers merely a selection of outstanding examples, with no attempt at making an exhaustive survey of the subject. The foundation upon which we have to build our structure is thus much less solid and reliable than Mr. Berenson's. For this reason again, we are forced to take a more cautious attitude—to weigh objectively and impartially the conflicting opinions, and even then more than once to leave the decision in abeyance. All the more is this true because we derive from the standard work of Mr. Berenson not only a vast store of detailed information and cogent instruction in questions of method, but the predominant skepticism of our general attitude as well. Unlike the pompous self-assurance of earlier connoisseurship which had a name ready for every drawing, we share Mr. Berenson's conviction that in this field "our knowledge is never strictly scientific, that is to say measurable, reversible, and demonstrable, but at best only plausible."

The reasons for this deficiency have been systematically enumerated and discussed by Mr. Berenson, to whose conclusions it would hardly be possible to add. We should, however, like to call attention to an intrinsic difficulty: the contrast between the modern effort to comprehend the artist as an individual, and the attitude of the older connoisseurship which was satisfied at reaching his generic character.

This decisive difference in the basic concept of originality in drawings was rightfully stressed by our teacher, Franz Wickhoff, in the introduction to his *Catalogue of the Italian Drawings in the Albertina (Jahrb. K.H.S. 1891/92)*—a work which may justly be called the first attempt at a scientific catalogue of an outstanding collection of drawings. In his opinion, when older connoisseurs spoke of original drawings, they did not mean to insist on their attributions to individual authors. To substantiate his assertion Wickhoff quoted a passage from a letter written by Goethe in 1815. "In paintings—and still more so in drawings—originality is all-important. By originality I do not mean that the work in question could have been done only by the master to whom it is attributed, but that it is sufficiently ingenious to deserve at any rate the distinction of a famous name." This concept—that the principal merit of a drawing consists in being worthy of a great artist and of suggesting a specific artist to the spectator—was inherited from the 18th century connoisseurs who had laid down both the foundations of

I

our knowledge in this field and that of the famous old collections of drawings. Comte Caylus, in a lecture delivered in the Royal Academy of Painting and Sculpture at Paris in 1732, eulogized this special branch of art in language both eloquent and elegant. After having emphasized the enormous advantage and enjoyment which he derived from observing in his drawings the growth of an artist's conception, he concluded: "Une copie qui aura été determinée originale par des gens sages ou connoisseurs est, à mon sens, un original; elle est encore plus authentique quand elle aura été jugée telle par les peintres." (Jouin, *Conferences de l'Academie Royale de Peinture et de Sculpture,* Paris, 1883, p. 369). This difference of attitude explains on one hand the enormous number of drawings attributed to individual great masters in the older collections, and on the other hand, the modern efforts at discriminating between authentic works—originals in our sense—and those previously considered such. For illustration of this point we may well consider the name of an artist especially favored by older attributionists: Giorgione. Older connoisseurs were satisfied to comprehend the *ideal* type of Giorgione; we strive to fix on the *real* man. This addition of reality to a concept which by the very nature of historical cognition must remain an ideal construction leads to a desperate strain on our critical connoisseurship, while our predecessors, uncritical as they may appear to us, nevertheless felt successful and happy in their task. These first connoisseurs were evidently satisfied to measure the shadow of the man whom we try to dissect according to scientific rules. But paradoxically enough, here the shadow is clearer than the real thing. Obscure and disconcerting as the artistic figure of Giorgione is, the notion of the Giorgionesque is clear and comforting. It gave the older students a most salutary certainty, while after all our investigation we have nought but an assortment of incoherent wreckage on our hands.

This depressing insight into the somewhat sterile results of our endeavors must not prevent us from pursuing them. Science, at each stage of its evolution, has its specific means and aims, and we have to go on in pursuit of the individual in spite of our skeptical attitude toward the results.

Our efforts, we are afraid, will appear still more doubtful and futile than Mr. Berenson's, whose Florentine material may boast of the backing of sounder tradition than the Venetian with which we have to deal.

Even the delimitation of this material may cause some difficulty in itself. In a basic article published in the *Kunstgeschichtliches Jahrbuch der Biblioteca Hertziana* 1937, I, p. 233 ff. (*Zur Graphologie der Handzeichnung*), Bernhard Degenhart tried to determine the essential characteristics of the various local schools of drawing in Italy. Easily recognizable in its conformity to powerful currents of our times, his theory rests exclusively on racial connection; namely, on the premise that the specific character of an artistic school is determined by the racial inheritance of the artist. Since Degenhart himself candidly admits that his approach to drawings is only one of many possible approaches, we need not criticize it in detail here; in discussing individual artists we shall repeatedly have opportunity of pointing to the one-sided and contradictory results of his system. The part of it that we accept is limited almost to a truism—a fact which Degenhart himself admits to a certain degree. The artist's blood—his racial inheritance—provides the fundamental strata of his creative essence, comprises the preconceived loom within which he remains bound. This bond is so much a matter of course that it loses by the rationalization to which it has been subjected; a mysterious vital force dwindles away by being channeled in countless individual genealogies. The numerous exceptions invalidate the rule.

Our conception of the Venetian School is based on the conviction that if, as the saying goes, blood is thicker than water, then spirit is surely stronger than blood. For us the Venetian School neither consists exclusively of artists of Venetian descent nor does it even include all such artists; rather it forms a historic concept and artistic unit that are very distinctly felt by everyone who has ever been engaged in studies of Italian art. It is the art of the

city of Venice which became an empire and radiated its influence through the territories acquired on the Italian mainland, chiefly during the period with which we deal in this book. The period begins with the decisive new orientation of Venice toward the Occident. In politics this was expressed in the Republic's realization that its natural impulse toward the East needed a counterbalance on the Italian mainland; in the history of civilization it marked the transformation of a Byzantine province into an integral part of the Italian nation just then in the making. This process, politically and culturally, stretches over the best part of the 15th century, is completed in the 16th century (when, we may say, Venice took the lead within the nation) and declined when the Baroque age led to new political organizations on a European scale and to a new system of civilization.

The school which we propose to study in one limited field of its activities is a genuine manifestation of the European and Italian Renaissance. Its specific Venetian form, growing out of the unique conditions of the city, penetrates the local schools of the *Terraferma* with varying intensity. It absorbs some of their artists and fails to absorb others who remain attached to their home provinces; on the other hand, it does not always succeed in holding artists born and trained in Venice, but who for various reasons and conditions were more attracted by other art centers.

The Venetian School, as we see it, is not a natural product, but a spiritual power. Theoretically, it is the artistic expression that widened its Byzantine tradition by Central and North Italian influences to become an independent section of Italian Renaissance art, and later was to exhaust its vitality in the beginning of the 17th century. Practically, it includes those artists within the period extending from Jacopo Bellini up to Domenico Tintoretto and Palma Giovine, who worked in and for Venice in artistic connection with the school dominant there. We therefore exclude drawings antedating our period, such as the illustrations of Titus Livius given to Semitecolo (see p. 9), or the group of drawings in the British Museum, which were published in *Vasari Society,* III, pls. 7, 8, 9, as Veronese School (?), but which in view of their subjects seem likely to have been Venetian, perhaps connected with the first decoration of the Sala del Maggior Consiglio (Antonio Veneziano, see Ridolfi, I, p. 40). Furthermore, we omit artists who, even though they worked in Venice, were only casual visitors—as for example Gentile da Fabriano or Pisanello, Mantegna, Francesco Salviati or Vasari—as well as those like Giovanni Battista Franco who in spite of their Venetian origin or training were absorbed by another school. But we do include artists coming from abroad who grew to be integral parts of the artistic culture of Venice, such as Antonello da Messina, Palma Vecchio, Bonifazio, Titian, Schiavone, or Paolo Veronese. The boundary line sometimes cuts through an individual artist; Sebastiano del Piombo or El Greco for us are Venetians in their beginnings though not in their later evolutions, while Domenico Campagnola, after having started almost as Titian's double, became a local painter of Padua without interest for Venice or the rest of the world. We are fully aware of a certain arbitrariness in this demarcation; however, it does justice to the predominant universal idea of the "School of Venice."

Finally, we must add that, conforming to the plan of Mr. Berenson's book, ours also limits itself to individual painters. The inclusion of "anonymous Venetians" would have loaded us with an enormous weight without furthering our task of contributing to the store of knowledge on the Venetian painters. And the admission of sculptors, such as Jacopo Sansovino or Alessandro Vittoria, whose activities border on those of architects and decorators, would have forced us to face numerous new problems that are hardly ripe for solution.

Even with all these restrictions our book still abounds in puzzling questions. For in spite of the sharp demarcation of local borderlines in painting, as far as drawings of the Venetian School are concerned, tradition (as mentioned above) is much poorer than it is in Florence. Here from Vasari's time onward, drawings were considered

important enough to be collected like paintings, and consequently a certain connoisseurship developed which safeguarded attributions. As early as the middle of the 17th century Baldinucci laid the ground work for the famous collection of drawings in the Uffizi. In Venice, on the contrary, such a material and moral center for collecting drawings never existed—and, we may add, even now does not exist, the collection in the Academy in Venice being merely a chance deposit of drawings which for the most part are of Lombard origin. The richest treasure houses of Venetian drawings lie outside Venice: in the Uffizi and in the Louvre. Apparently Venetian amateurs with few exceptions were not interested in drawings; under such conditions, it is easily understood that traditional attributions were lost. Attributions were in fact entirely arbitrary. In the second half of the 19th century when critics began to study drawings, the oeuvres of the Venetian artists had to be radically reconstructed. That is what Morelli did for Giovanni Bellini and later on Hadeln did for Titian and Tintoretto, but the foundations were too weak to permit a solid and convincing structure. Thus we may say that our knowledge of the Venetian drawing of the Renaissance is almost entirely devoid of sound tradition.

Does the attitude of Venetian collectors reflect a lack of interest in drawing typical of the Venetian artists of the Renaissance? The later conscious contrast of "Florentine design" and "Venetian coloring"—mainly developed in the circle of Florentine academicians who were so influential in all subsequent theories of art—produced the idea that Venetian artists did not draw at all. Vasari, who may be considered the authoritative spokesman of this creed, in his *Life of Giorgione* expressly states that Giorgione worked without making drawings. "He believed painting exclusively with colors, without any preparatory drawing on paper, to be the best procedure." Whatever Giorgione's standpoint may have been in this matter, there is no doubt that a wholesale generalization would be wrong and that Venetian painters drew much more than the existing stock of their drawings might lead us to believe. The scarcity of preserved drawings may be accidental. In his introduction to his "*Quattrocento*," Hadeln correctly inferred from the existence of one drawing (No. **686**) connected with a single relatively unimportant figure in an altar-piece by Crivelli, and from the existence of another single "*simile*" by Giovanni Bellini for a similar practical purpose (No. **299**), that many drawings of this kind must have existed, the part preserved representing only an insignificant percentage of the original abundance. The same conclusion may be drawn from casually preserved drawings made by Pordenone or Titian in preparation of secondary details for their paintings; countless similarly prepared drawings have undoubtedly been lost. There is good reason to believe that some Venetian artists drew as much as those of other schools.

Nevertheless, the lesser importance of drawing within Venetian art remains a fact. In *Critica d'Arte,* VIII, p. 77 ff., in which we discussed problems of principle referring to these drawings, we concluded that this difference—this apparent deficiency—resulted from the greater difficulty inherent in according drawing its proper place within the field of Venetian art as a whole. In Florence drawing and painting are clear manifestations of the same formative will and thus may be said to be on the same stylistic plane; in Venice there is a fundamental contrast between drawing style and painting style which is adjusted only at the end of our period—and then only in part.

Other critics reached similar conclusions: Degenhart saw the essential difference between Central and North Italian (including Venetian) drawing in the close connection of the former to another artistic aim, and the independence and autonomy of the latter. According to him, in Central Italy drawing had a function within the general process of artistic production, while the North Italian drawing was without such function but was produced merely for its own sake. This bestows on it the detached spontaneity and calligraphic liberty that form its

charm. With some modifications Degenhart's theory has been accepted by Oertel in his excellent and instructive article *"Wandmalerei und Zeichnung in Italien,"* in *Mitteilungen des Kunsthistorischen Instituts in Florenz,* V–VI (1939/40), p. 256. However, other important objections have to be made to it since the place of the Venetian drawing was also firmly determined by its function within the total working process leading to a painting or other work of art. We even believe that the puzzling disproportion noticed in the number of drawings preserved from among various other Venetian artists may partly be explained by the unequal use made of them in the respective workshops; the relative frequency of drawings by Jacopo Bellini, Carpaccio, Tintoretto, Palma Giovine, is the result of differences in the functional task.

To justify our assertions we must emphasize the fact that art production was much more a collective task in Venice than in Florence. The art of Florence was produced primarily by individuals, while in Venice it was carried on by families who ran workshops. This practice, which may have rested on the traditionalism of the city's Byzantine foundations and on the well-known prevalent conservatism of all its social and cultural institutions, can be traced throughout the whole history of art in Venice. In the centuries preceding the Renaissance and in those succeeding it, as well as in the Renaissance itself, artists hardly ever appear except as members of families working more or less as units.

These working conditions (which, as we said, were an outgrowth of the total organization of life in Venice) have been described in an article in *Parnassus,* 1940 (Hans Tietze, *Master and Workshop in the Venetian Renaissance*). We may add that they prevail no less in the pre- and post-Renaissance periods. The earliest sources that offer some insight into the private conditions of Venetian artists—as for instance the last wills of painters, first published by R. Fulin, in *Archivio Veneto,* XII, p. 130 ff., and newly discussed in detail by L. Testi, II, p. 131—disclose not only that father and sons or several brothers had embraced the artistic career, but that the various members of one family collaborated and thus the activity on an important commission sometimes stretched over more than one generation. To mention only one instance: Angelo Tebaldi in his last will of 1324 recalls certain accounts received from a customer "for designs made for him by myself and my sons," and pledges his son Gioachimo to take care of the completion of these paintings in San Canciano. It is well-known that the same conditions continued up to the fall of the Venetian Republic, and that the confusion between Tiepolo father and son or between the various Guardi is due to the closeness of their connection and collaboration. As for the Renaissance proper, it is sufficient to refer to the article in *Parnassus.* The leading painters of the period are the Vivarini, the Bellini, the Vecelli, Campagnola, Palma, Pitati, Robusti, da Ponte, Caliari. Concerning the last name we recall the fact, unique in the history of art, that after Paolo Veronese's death his brother and sons continued their common activity under the signature "Haeredes Paoli," heirs of Paolo Veronese. There are very few exceptions—artists whose activity is not taken up by sons, brothers, or nephews: Giorgione who died as a youth, and Sebastiano del Piombo who became a cleric and had long before transferred from the Venetian to the Roman School.

Having emphasized elsewhere the importance of these conditions for the perception of the artistic structure of Venice as a whole, we may now limit ourselves to one point: the part played by drawings within a workshop-production stretching over several generations. The drawings, the use of which within the working process varied as we will later discuss more fully, were and remained the backbone of collective activities which united the various members of the shop into one productive order. By this means the shop tradition was maintained and the common style produced which allows us to speak—as contemporaries also did—of the Tintoretto, the Bassano, the Veronese, and so forth, as artistic units. Again the last wills prove the most instructive documents: few among

the many published by Fulin, Mas Lastrie, Paoletti, G. Ludwig, and others, do not contain arrangements concerning the drawings owned by the testator. As a rule—and with a formula that remains almost unchanged through several centuries—they are left to a son or some other relative destined to head the orphaned shop and to direct its further activity. If the relatives in question were minors, the bequest is often made contingent on the condition that they choose an artistic career; if no relatives are available some assistant or favorite pupil takes their place. In any case the artist tries to keep up the shop beyond his own lifetime.

Such tendencies are, of course, closely connected with the medieval conception of the artistic profession, and similar arrangements occur in the last wills of Florentine (see M. Wackernagel, *Der Lebensraum des Künstlers in der Florentinischen Renaissance,* Leipzig 1938) or German artists. The essential point, however, is first that, thanks to the predominant conservatism of all institutions in Venice, they continue there throughout and beyond the Renaissance period; and second, they contradict the above-mentioned thesis to the effect that in Venice, contrary to Florence, drawing was exercised for its own sake. Not only just as elsewhere, but *more* than elsewhere, drawing has its function within the artistic production.

With the proviso that they continue the painter's profession, Niccolò fu Michele di San Lio bequeathes to his assistants Andrea and Niccolao "omnia mea designia quae habeo per apothecam" (all my designs I have in my shop). Jacobello del Fiore makes his stepson Ercole the heir of the designs, colors, and everything belonging to the profession if he chooses to remain; otherwise they are to be sold. Francesco Rizzo da Santa Croce, pupil of Francesco di Simone, inherits the latter's brushes, colors, designs, and every other tool needed for painting, in order to allow him to continue this art and become Francesco's successor.

It remains doubtful, however, whether "designia" or designs in these references to be understood in the sense of drawings; it is even more likely that painted models preserving the typical compositions are meant. But certainly we are concerned with drawings in Jacopo Bellini's so-called sketchbooks in Paris and London. To them refer passages in Anna Rinversi's (Jacopo's widow) and in Gentile Bellini's last wills. By the former's will of November 25th, 1471, not only all casts, marbles and paintings, but all albums of designs go to Gentile Bellini. When the latter made his last will in 1507, he in turn bequeathed to his brother Giovanni "the book with drawings having been the property of our father," and to his pupils Ventura and Hieronimo all his drawings made in Rome. Referring to our fuller expositions on p. 102, we may merely sum them up here by stating that in receiving the whole working material Gentile was installed as head of his late father's workshop, including the obligation to complete works left behind unfinished; by his testament he turned over this leadership and responsibility to his brother Giovanni. About one hundred years later the part given to the drawings in the last wills of Jacopo and of Domenico Tintoretto is almost the same (for details see p. 258): Domenico is the heir of Jacopo's drawings and becomes the head of the workshop, and by Domenico's last will this dignity reverts to his brother Marco Robusti, while apparently their brother-in-law, Sebastiano Casser, is considered next in line of succession.

In all these numerous documents the drawings mentioned are quite naturally treated as material property of the testators. The question of artistic property is not even raised. It is not expressly stated that the drawings left behind by Jacopo Bellini or Jacopo Tintoretto had been executed by these artists. Drawings were material which they owned and on which the workshop throve. General considerations lead to the assumption that besides drawings of the artists responsible those by other members of the shop were included as well.

We do not possess sufficient documentary evidence concerning the internal organization of such shops in the Middle Ages or in the Renaissance, but an analogy may be offered by the building artisans about whose organi-

zations quite a wealth of literature exists. Their regulations expressly stipulate that any design made by an assistant remained with the workshop for the duration of his employment therein. (H. Tietze, *Aus der Bauhütte von St. Stephan,* in *Jahrbuch der Kunsthistorischen Sammlungen,* N. S., IV, p. 7). And as far as the material of such shops has been preserved—for instance, that of St. Stephen's Cathedral in Vienna (see above)—it consists of the production of very diverse hands. In the numerous existing regulations of painters' guilds nothing analogous is ever stipulated; and more specifically, nothing in the statutes of the Venetian guild as far back as 1271 (published by G. Monticolo, in *Nuovo Archivio Veneto,* I/II, p. 321 ff.; see also L. Testi, I, p. 137).

For want of confirmation or refutation by these statutes we may refer to some documents offering interesting insight into the working organization of a famous shop—not in Venice itself but in its immediate neighborhood. In a contract dated October 17, 1466, the painter Pietro Calzetta assumes the obligation to make a painting for San Antonio at Padua, conforming to the sketch still preserved in the archives, and copied from a design of Master Francesco Squarcione executed by Niccolò Pizolo (ritrato da un desegno de Maistro Franc^co Squarzon el qual fo de man de Nicolo Pizolo; *L'Arte,* 1906, p. 55). Here a sharp contrast between material and artistic property is made. The drawing belonged to Francesco Squarcione as head of the shop (which he had the reputation of exploiting systematically!) although it was done by the hand of Niccolò Pizolo who in the middle of the century had been Squarcione's chief assistant together with Andrea Mantegna and the latter's collaborator and competitor in the Eremitani Chapel (see Hans Tietze, *Mantegna and his companions in Squarcione's shop,* in *Art in America,* 1942, January, p. 54).

Of approximately the same period there also exists outstanding material which we regard as the working material of another important shop. After the enlightenment thrown by Mrs. L. Fröhlich-Bum and Miss H. Simon on Jacopo Bellini's so-called sketchbooks in London and Paris, we believe them to be (as we shall endeavor to prove in detail on p. 109) not the production of Jacopo Bellini as an individual artist, but the working material of his shop—an accumulation of drawings by various hands. We may suppose that similar conditions prevailed in other Venetian shops. In his last will Domenico Tintoretto selected from the enormous stock of drawings compiled in the studio those that apparently were done by himself and by his chief assistant Bastiano Casser (see again the fuller statements on p. 258). This explains the general conformity and at the same time the enormous diversity in quality and even style of the drawings which have been handed down to posterity under the generic name of Tintoretto.

For a better understanding of the heterogeneous character of such working stocks we must keep in mind the double function of a medieval workshop—a function which survived through the best part of the Renaissance. The workshop served both as a place for production and a place for instruction. The young apprentice learned by co-operating in common tasks and by copying the works of his master or of senior assistants. For these efforts drawings—easier to copy than paintings—were very acceptable. Most of the biographies of Venetian painters start with the statement that they copied drawings; how many of these may have crept into the common stock with which the shop worked?

Again we recall that this custom is not specifically Venetian. Everywhere in Italy, and most likely outside too, the first step in artistic training consisted of drawing from well-chosen models. Cennini, the spokesman of the belated Trecento tradition in Tuscany, recommends this procedure. In another paragraph, he adds a piece of advice which again we feel tempted to generalize: in order to obtain a harmonious and homogeneous style, he counsels the young artists to stick to one model, and not to copy any drawings by various masters. Since the closest

possible approach to one's master's style was considered the goal, the drawings thus produced must have been very similar to their models; and, indeed, the biographers tell us repeatedly that such and such an artist succeeded in making drawings so like the copied models as to be mistaken for them. The workshop as a whole formed a kind of unit; when Palma Giovine used his young pupil Gambarato as a model for his studies from the nude, the young painter was allowed to copy each drawing the master made, and to keep it. There is but little doubt that we too are frequently deceived by such repetitions of drawings made under the eyes of the master who approved them (or not!) and certainly sometimes added them to his own stock. (From a later period Mannlich, a pupil of François Boucher, tells us that his master's teaching method still consisted of making his pupils copy his own drawings. He used to look over these copies at the breakfast table; if one seemed exceptionally well done, he honored it by adding his own signature.)

Even if the master did not usurp the drawings made by his assistants, later connoisseurs confused them. About twenty or thirty years ago somebody began to connect a number of charcoal or black chalk studies after classic sculptures or the like by Michelangelo — some drawings which as a rule had previously been ascribed to Titian — with the reports in the literature of Tintoretto's studies after such models. Since then, all studies of this kind have indiscriminately been attributed to Jacopo, although the very noticeable differences in quality and the existence of dozens of virtually identical copies from the same bust should have aroused suspicion. These endlessly repeated heads of Vitellius, figures of an Atlas, and copies from Michelangelo, are evidently the output of a kind of family academy. Exercises which Jacopo had found useful for himself were apparently also demanded by him from his children and other pupils. Some day intensive connoisseurship may be able to distinguish among the various hands involved. Following a hint of Morassi we have succeeded at least in differentiating Marietta and have tried to clarify the figures of Domenico and Marco Robusti. A few more personalities, though still anonymous, begin to unveil their features. Their shares, of course, are not limited to the studies after sculpture. Within the enormous mass of figure studies a division of hands is no less indispensable. Originals and copies, works of the master and those by members of the shop, run into one another.

The resultant confusion, certainly due in part to the bluntness of our tools of investigation, is also founded on the complex origin of drawing. Contrary to the modern conception in which drawing is the most spontaneous utterance of an artist's creative urge, we must resign ourselves to recognizing it in its original form as a link between an existing and a presumptive work of art — as a reproductive rather than a productive expression. Much of this original character still survives even in the late Renaissance.

This problem, hitherto treated with a certain aloofness and on the basis of modern prejudices, has been dealt with more thoroughly and profoundly than by any previous writer by Robert Oertel in his article on "Mural painting and drawing in Italy." His results, though primarily based on Tuscan material, are also applicable to Venice and, incidentally, to other parts of Europe. In view of their radical departure from older theories, we shall need to repeat and amplify them here.

Drawing seems to be such a natural artistic expression that it was supposed to have existed at all times. As a matter of fact, its technical means and modes of expression are largely prepared by the illustration of medieval manuscripts. A detached page from an illustrated manuscript of the late Middle Ages, particularly one executed in pen on paper or in silverpoint on vellum, is scarcely distinguishable from a drawing. For other professional purposes, too, people in the Middle Ages were doubtless able to handle chalks and metal points and the pen.

This command of the technical means, however, does not yet make miniatures the immediate preparatory step

to drawing; the ethical difference, and thereby the aesthetic one as well, remains fundamental. The miniature is illustrative, bound to a literary text, even when this text is omitted as being universally known or in order to produce a pictorial compendium. A Biblia Pauperum, to cite one of the best known instances of such medieval picture books, still illustrates the Bible, the knowledge of its subjects being presupposed.

Thus, medieval illustrations are predecessors of drawing, technically but not artistically. In our opinion, Degenhart is mistaken in making the illuminated manuscript 214 in the Ambrosiana in Milan (the "Deca di Tito Livio in volgar" of 1373) an incunabulum of Venetian drawing — and even in connecting it on stylistic grounds with a painter like Semitecolo. Even admitting a stylistic relationship between the paintings attributed to Semitecolo and the miniatures in Milan, we cannot accept the latter as drawings. Nor can we agree to the identification of an individual style expressed by and exclusively known to us through murals in such a completely different medium as that of miniatures. It is simply the style of the period expressed in each case; Degenhart's stylistic arguments only confirm the localization of this manuscript in Venice — which Fogolari already proposed for entirely different reasons many years ago (*L'Arte* X, 1907, p. 330).

The connection of Venetian drawings with local miniatures is all the more difficult since the production of the latter is surprisingly meager for a city of such extraordinary wealth and ambition. Many critics, as for instance Adolfo Venturi, *Storia 5,* p. 1049, have emphasized the sterility of this special field and have tried to explain it (R. Bratti, *Miniatori veneziani,* in *Nuovo Archivio Veneto,* N. S. II, I, p. 73) as the result of the specific social and cultural structure of Venice. Perhaps there is some foundation to the idea expressed as early as 1857 by Foucard (*Atti dell'Imp. Reg. Acc. de Belle Arti in Venice,* reprint, p. 36, 68) that the supremacy of mosaic painting in Venice had handicapped the development of other branches of painting. However the case may be, miniature painting is quite unimportant in Venice. It is hardly more than a degenerate branch living on foreign influence and limiting its activity almost entirely to the decoration of documents of the State and of the Guilds and Brotherhoods.

Since, as we stated above, illustrations of manuscripts may be the technical though not artistic predecessors of drawing, this deficiency is not a serious shortcoming. Only one specific group of illuminated manuscripts forms a kind of link between the two branches: the modelbooks, especially studied by Schlosser (*Zur Kenntnis der künstlerischen Überlieferung im späten Mittelalter, Jahrb. K. H.S.* XXIII, p. 279ss.) and his pupils (H. R. Hahnloser and F. Rücker, *Das Musterbuch von Wolffenbüttel, Graphische Künste* 1929; H. R. Hahnloser, *Villard de Honnecourt,* Vienna, 1935). There is a distinctive feature to this category of books: no longer books in the sense of placing the main stress on a specific text, they nevertheless offer a stock of models to be used for illustrations or other paintings. These books, a limited number of which still exist, were part of the typical equipment of a late medieval painter's shop. The artist was thus enabled to have ready in systematic order all the types which may occur in the course of his professional career. Since these models, here arranged for further use, were copied from older works, the modelbook thus forms a link between already existing and planned works of art — a task so closely conforming to medieval traditionalism that these books appear as the most typical documents of the artistic tradition in the late Middle Ages. In them the pictures have become independent of the word and are an autonomous formal expression. They are not, however, individual works of art; on the contrary, they still represent only a provision ready to be drawn upon for any purpose that may arise.

The intention of individualization, however, is an essential feature in the definition of a drawing.

This step is undertaken, though perhaps not consummated, in Jacopo Bellini's so-called sketchbooks. They

not only comprise the most important contribution of Venice to the history of early Italian drawing, but are themselves distinguished by uniqueness in more than one sense. Referring to our extensive explanations in the general introduction to Jacopo Bellini (p. 95 f.) and in the description of the albums and especially the one in the Louvre (p. 106 ff.), we limit ourselves here to establishing their place within the evolution of drawing. Though the books are no longer modelbooks in the medieval sense, a substantial portion of the drawings are not meant to serve as individual works of art, but to offer sample solutions of problems just as the modelbooks had done. Jacopo's complicated figure compositions placed in no less elaborate architecture—forming the most conspicuous share in the "sketchbooks"—are not intended as designs for murals or panels. Consequently, the search for their analogies in works actually executed has had to remain a vain one. They present, on the contrary, what Mrs. Fröhlich-Bum in a felicitous expression calls "a counterpart to the trattato della pittura," the literary theory of painting, in Tuscany. A younger artist studying these books would find in them not direct models suitable for copying but instructive illustrations of current art problems. (A kind of parallel exists in the German ornamental engravings of the 15th century which present ideal rather than practical models.)

Besides these ideal solutions of theoretical problems, the "sketchbooks" contain drawings belonging to various other categories: studies from nature or from antiquity, and studies for individual works of art. The first group contains genre drawings made from nature—comparable to similar studies by Pisanello; the second presents the results of Jacopo's efforts on behalf of an equestrian monument or other works done or planned for the Court of Ferrara. It is no mere coincidence that these categories, seemingly so different, made their appearance hand in hand: all of them express the same tendency toward autonomy which is part of the general Renaissance current.

This trend toward autonomy has been considered by Oertel as an inherent quality of drawing in Northern Italy. Although, indeed, some preliminary conditions exist here, in our opinion the decisive instigation came from Central Italy. Jacopo's attitude reflects the theories of Alberti with whom he must have been in contact at Ferrara and perhaps also during Alberti's stay at Venice. In Alberti's *Trattato della Pittura* compiled in 1435, for the first time "designs and models of the whole composition and of each part of it" are recommended; Oertel states very judiciously that the passage gives more the impression of a theoretical demand than of a current usage. In Jacopo's "sketchbooks" the same order of thought is reflected and prepares the subsequent division into invention and execution—a well-known favorite idea of the amateurish Alberti, and one which leads to complete independence and autonomy of drawing.

It takes, of course, more than one step to reach this stage. Not until the end of the 15th century do art patrons begin to lay greater stress on the design—as representing the essential contribution of the creative artist—than on the execution which in increasing degree is left to assistants. The second half of the century is a period of transition, as Oertel has carefully demonstrated with the aid of Tuscan material.

In Venice, too, drawing does not change its meaning all at once. Some of its medieval characteristics survive up to the end of the Quattrocento and even later.

In their didactic and practical purposes Jacopo's "sketchbooks" still resemble the medieval modelbooks. The main stress, however, has been shifted from a stock of principal types of current subjects to a supply of compositional patterns and a choice of secondary figures. This difference is very important. In the Middle Ages proper nobody objected to the repetition of traditional types—for Christ, the Holy Virgin, or the Apostles and other favorite Saints—collected in the modelbooks for this purpose; for the compositions models were less necessary, the compositions being firmly entrenched in an almost rigid iconographic tradition. Besides an original arrange-

ment of the composition, the rising individualism of the 15th century demanded a more personal interpretation of the principal actors, although for filling-in figures in the middle and backgrounds the use of conventional types continued and even increased. It has never been sufficiently emphasized that most of the later *"simile"* drawings are meant and used for such accessories. Not among the main figures, but in the subordinate parts of Gentile Bellini's or Carpaccio's compositions, we find an abundance of repetitions which are to be explained by the use of *"simile"* drawings.

There is another point which should be stressed. The older *similes* were based on existing works of art which themselves may have had a similar origin. They are interwoven in one of those numberless chains that crossed the medieval tradition in every direction. The original experience of form is, so to speak, entirely dried up in them; they have become mere formulas. The new *similes* are less degenerate heirs than presumptive ancestors. They are based on the personal experience of an individual artist and draw their decisive power for the future not from a venerable tradition backing them, but from the penetrating vision of a creative artist.

In Jacopo Bellini's genre figures this faculty of perpetuating types is still faint—certainly much more so than in Pisanello's corresponding studies that may have influenced them. Gentile Bellini's drawings of this kind, on the contrary, with their gift of sharp observation and convincing realization, had an enormous following. Carpaccio and Dürer were the most eager utilizers of his *similes* (see p. 66). The reader of our introductory notes to Carpaccio may be amazed by the frequency and faithfulness of this imitation; the overrating of artistic originality from the 18th century on may make him forget that throughout the Renaissance the direct imitation of suitable models was still not only a means of artistic education, but a legitimate working process as well. Even for Leonardo, the harbinger of artistic originality, copying from famous models is still the best initiation for the beginner; and drawings by Michelangelo—as by Dürer in the North—still exist bearing testimony to the juvenile efforts of these artists. In his biography of Beccafumi Vasari speaks of his hero's inadequate teacher: but he made Beccafumi learn from drawings of excellent painters "which he had in his shop and which he used for his needs as is the habit of those painters who are poor designers." On the whole the trend toward originality had not yet reached its later predominance; minor artists saw no harm in plastering their compositions with the most heterogeneous borrowings (for instance, the Santacroce, see p. 245) and in changing studies from nature into a formula. One of the most pertinent instances is the landscape in the Ambrosiana, No. **347**, used at least half a dozen times in the backgrounds of paintings and thereby causing quite a confusion in their attribution. A *simile* was accessible to more than one artist and wandered from workshop to workshop. In a period in which the use of such an expedient was no longer part of a strict system but a voluntary choice, the adoption and repetition of another artist's especially well executed pieces is comparable to the use or abuse of quotations which was very typical of the same period. Minor artists took pride in inserting such conspicuous ornaments in their products. The transformation from the appeal to reliable witnesses to the arbitrary reference to renowned predecessors is a common feature of both literature and art.

From the late 15th century on, drawing in this respect was partly displaced by graphic art. The latter's enormous circulation and easy accessibility made engravings and woodcuts the usual cribs for poor inventors. But even then drawing did not completely lose this function. Throughout the whole period with which this Catalogue deals we may observe a continuous trickle of *simile* drawings. We may even say that the formation of the great workshops of the 16th century gave this class of drawing a kind of revival.

Before pointing to such belated specimens we must emphasize the use of *similes* in Giovanni Bellini's work-

shop. It is no mere coincidence that the drawings belonging to this group all originate from the later years of the master when he apparently made ample use of the help of assistants (see p. 81). While some of these drawings despite their late origin cling to the style of the 15th century, there are others which repeat older inventions but are already executed in the advanced style of the following generation (see No. 719). In Giorgione's and Titian's studios the use of drawings for the preparation of stock productions is not unknown. The marked predilection of both for the pictorial, however, seems on the whole to have put the system of multiplication and modification of the respective master's ideas on a somewhat different basis. For Titian at least it is established that the modified shop version grew on the canvas itself. The real revival of the *simile* took place in the large shop of Tintoretto and of the Bassano. A considerable stock of drawings, especially of the former, acquaints us with interesting methods of multiplication of the master's inventions by the assistants. Drawings were copied, inverted by tracing, changed from a front view to a back view by filling in the outlines with altered modeling. Tintoretto's figures, accessible through the enormous stock of drawings — originals, copies, and modified versions done by pupils and assistants — are pushed through the compositions like pawns on a chessboard.

We have pursued this specific class of drawings through its later vicissitudes in order to call attention to the fact that spiritual qualities are never entirely lost. The function by which drawing separated itself from earlier technically kindred activities (namely, that of mediating between an existing and an intended work of art) proves inherent; it survives alongside of or beneath other functions which in part may also be traced back to the earliest stages of drawing.

In general, we may say that the primary purpose of drawing as described above is essentially divided into two parts: drawings either derive from or prepare for another work of art. They are copies made for the most varied purposes, sketches to fix a general arrangement, cartoons to allow assistants to execute the idea of the designer, *modelli* to give the customer an approximate idea of the work he plans to order; they are studies intended to clarify some detail; or, finally, they are made for exercise and to perfect the artist's ability. The latter purpose, as already mentioned, is often aimed at by copying from works considered to be exemplary models. So closes the circle whose parts are connected by manifold interrelations.

Most of these various drawings connected with another work of art involve a transformation in size which demands an abstraction unknown to the Middle Ages and contrasting with its essential attitude toward art. The importance of this fact can hardly be sufficiently grasped by us whom use and abuse of all kinds of reproductions, including photographs, have bereaved of this close link. For the medieval artist or spectator size was an essential part of an artistic conception; its enlargement or reduction seemed hardly conceivable. That is why there was no place left for drawing in this system. The *simile* is a note made to record approved types rather than an artistic interpretation. The normal preparation of a medieval mural or other painting, therefore, was done in its natural size on the actual site of the work-to-be. Oertel made a special point of backing this fundamental fact with abundant demonstrative material; he also rightly referred to the analogy in medieval architecture, wherein the details of Gothic cathedrals were not prepared by drawings on paper or vellum but by life-sized models or designs. The huge sizes of late Gothic architectural designs still testify to the difficulty of abstracting from the original dimensions.

In drawing proper, an impetus for overcoming this deeply rooted obstacle may have been the drawing made for legal purposes. Once more we agree with Oertel's thesis that drawings made to accompany and illustrate contracts represent an important intermediary step in the formation of drawing proper. Such a design was meant

to clarify the obligations assumed by artist and art patron; the reduction of the planned composition to a more convenient size follows naturally from the whole situation. In Venice, as elsewhere, documents mention such drawings—for instance, in 1452 Jacopo Bellini had to paint a church banner for the Scuola della Carità "secundum formam et designum datum." But the material of drawings themselves is scarce; among the earlier drawings there is hardly one the original destination of which as an annex to a contract can be assumed with certainty. This gap may be filled to a certain extent, however, by a reference to two well-authenticated drawings from neighboring Padua where they are still kept in the respective archives. One is the already mentioned design, copied from a drawing by Pizolo which was to serve as the basis for a painting in the Santo: Pietro Calzetta engaged himself to paint a composition conforming to the sketch on the attached sheet (una historia simile al squizzo che e suso questo foglio, *L'Arte*, 1906, p. 55). Here the connection of the contract design and the *simile* is evident. In this instance in 1466 the patron ordered a painting on the basis of an older invention. On the other hand, in a drawing appended to a contract between the physician Christoforo da Reccanati and the sculptor Giovanni Minelli, dated 1483 and concerning a funeral monument to be erected in San Bernardino at Padua, stress is laid on the originality of the invention. The carefully executed design which the sculptor is obliged to follow (ad ipsius disigni similitudinem) constitutes an individual work of art. The exactness with which the artist fulfilled his obligation may be verified by comparison of the design with the lower part of the otherwise destroyed monument, preserved in the Museo Civico at Padua (compare Piera Carpi, *Nuove notizie e documenti intorno a Giovanni Minello,* in *Boll. del Mus. Civ. di Padua* 1930, N.S. VI/VIII). The judicial rather than artistic character of the drawing manifest even by its dryness is evident. Oertel, whose Tuscan material shows a close analogy to ours, states that in 1485, in the contract of Giovanni Tuornabuoni with Domenico Ghirlandajo for the murals in the choir of Santa Maria Novella, the commissioner for the first time reserves for himself the right to pass on the designs of the artist; and thus for the first time designs are recognized as an essential preparatory step in the formation of the final work of art. Our earliest analogous Venetian example is a contract with Bastiani on April 28, 1473, whereby the patron reserves the same right for himself to see the design before the work itself is begun (Molmenti-Ludwig, p. 229).

A similar predominantly judicial character is indicated for Aliense's models in London and Paris (Nos. **9** and **16**) by the long inscriptions on their back (though the reference of both versions to the same planned altarpiece is somewhat confusing). Another example would be Montemezzano's design for an altar-piece (No. **805**). In both cases the style is typical of the legal purpose of the drawings. There are a few more drawings, now separated from the documents which they may originally have accompanied, in which a marked tendency toward completeness and the dry minuteness of style stamp them as intended for laymen rather than for artists. They were meant to give the patrons a general idea of how a work of art would look even prior to execution.

Such a *modello* is the large drawing of the Presentation of the Virgin, in Florence, No. **284**, whose stylistic character led Molmenti-Ludwig to connect it with a competition for a painting arranged by the Scuola della Carità in 1504; another representation of the same subject, in Windsor, No. **641**, may just as well, and just as hypothetically, be related to the same object. The similarity of the architectural detail supports such a theory. The proposed attribution to Carpaccio of both drawings is discussed and rejected in its due place (see p. 140); at this point we shall only mention the *modello* character of the drawings, to which the abundant use of older types taken from Gentile Bellini adds an archaic element. More typical models from Carpaccio and Carpaccio's workshop are in Upsala, for the Death of St. Jerome of 1502 (No. **636**); in the British Museum for St. Jerome in his Cell

(No. 617); in Dresden, for an altar-piece lost at sea on its way to England in 1869 (No. 596); in Copenhagen, for a painting executed in 1538 by Benedetto Carpaccio for Capodistria (No. 644). For later *modelli* by Pordenone (No. 1311), Schiavone (No. 1426), Giuseppe Salviati (No. 1383), Paolo Veronese (Nos. 2045, 2056), and others (and one attributed to Bordone, No. A 385), see the respective items in the catalogue. In some other drawings by Carpaccio representing total compositions, No. 597 and No. 604, the intimate touch might suggest a study originally made by the artist for his own purposes. We should, however, note that on No. 597 the Greek inscription and the indication of the scale seem to indicate that the drawing was intended for the commissioners, the Greek brotherhood of St. George. It might be that Carpaccio presented a sketch he had originally made for himself in order to give a general idea of the future arrangement of the painting.

In this case a sketch would have been used as a *modello*. As a rule, the latter may be distinguished by its stress on the definitive nature of the conception (compare the examples by Bordone and Schiavone mentioned above). Even if it is eventually modified, it must look finished at the time of contract or competition. In two versions of Pordenone's "Death of St. Peter Martyr" the difference of style between model and sketch is extremely striking and instructive (Nos. 1301 and 1311).

A similar stiffness is also typical of models intended not for the art patron but for the person who would ultimately execute the master's definitive design. This is equally true of models to be used by assistants as well as those destined for graphic reproduction. The former group gains importance from the end of the 15th century on, marking the beginning of the division between invention and execution which later culminated in the regular use of the cartoon. This important innovation makes its appearance in Central Italy almost simultaneously with Domenico Veneziano, Piero degli Franceschi, Castagno. By about 1500—in the case of Pinturicchio's murals in the Libreria in Siena—it has already reached the point where the contract lays greater stress on the cartoons than on the paintings to be executed by assistants. The abundant use made of the cartoon in the School of Raphael established it firmly within the academic routine.

In the Venetian School, by reason of its pictorial tendencies, the cartoon never attained a corresponding predominance. But here, too, drawings exist that were meant to be used by assistants for transfer of the design to its final location. Among Pordenone's drawings this category is well represented, as may be seen in No. 1313 for Santa Maria della Campagna in Piacenza. In some cases, design and model are scarcely distinguishable from each other, as for instance Francesco Bassano's drawing for the ceiling in Santa Maria Maggiore in Bergamo (No. 82) or Titian's Sacrifice of Abraham (No. 1962). Sometimes the participation of the inventing artist may have been limited to very precise designs for use by assistants who carried out the final execution.

Models for engravings are the other group of drawings deprived of immediate spontaneity by their close connection with a plan for execution in another medium. As fair instances of the ambiguous character of this category we may cite Giulio Campagnola's drawing for his landscape with two seated philosophers, subsequently modified by Domenico Campagnola; the design for Domenico's engraved Venus; Barbari's design for the female nude, traditionally called, or miscalled, Cleopatra. (For the advanced 16th century, see Schiavone's No. 1429 and Battista Angolo dal Moro's No. 38). On the one hand by their close and immediate connection to such well-authenticated works they seem to possess an unusually close link to their respective masters; on the other, the lack of spontaneity resulting from their technical purpose distorts individual expression to such a degree that these drawings, though well-authenticated, offer no help in identifying drawings of a different character.

In judging drawings connected with engravings we must bear in mind that in Italy engraving with few

exceptions is predominantly reproductive. This means that we must in each case ask: is the invention that of the engraver himself or of some other artist who contributed the design, and further, is the drawing which we have before us this original design or its adaptation by the engraver himself or some intermediate hand in the specific technical operations. Giulio Campagnola, for instance, borrowed from every direction; in one case the drawing existing for the engraved Ganymede is obviously far superior to the engraved version. We find it nearer to Mantegna who had been credited with the invention long before the drawing was discovered.

Similar problems appear one or two generations later in Titian's drawing of a romantic scene reproduced by C. Cort in a well-known engraving. The problem, more fully discussed on p. 306, is once more: is this an older drawing by Titian himself, later chosen for reproduction, or a drawing made by him especially for the engraving; or is it a drawing made by some assistant in the shop or by Cort himself for graphic adaptation of Titian's invention existing in a painting or in a hasty sketch? The problem is all the more urgent since another drawing, No. **1999**, is also connected with one of Cort's engravings after Titian (we insist it is closer to the engraving than to the corresponding painting in Madrid, see p. 330) although evidently its character is entirely different from No. **1872**. Is the drawing in question, No. **1999**, a hasty sketch by Titian, or is it an abbreviated copy made by the member of the shop responsible for preparing the engraving? At any rate, the drawing represents a hitherto disregarded step within the working process.

Some of these uncertainties reappear in modified form in the relation between design, model and elaborate version made for the special needs of art collectors. With the increasing autonomy of art, paintings and drawings were freed from their earlier dependence; finished drawings were produced to serve as less expensive substitutes for paintings in demand by the fast-growing guild of collectors. A group of very carefully finished drawings by Paolo Veronese stands precisely on the borderline between the two categories mentioned. They have been considered by the last biographer of the artist as models for reproduction in chiaroscuro. The way in which they are described in early collections, however, makes us prefer the conjecture that they were from the very beginning produced for their own sake—or what is almost the same—for the sake of amateurs. Here strict subordination to a definite aim and complete aimlessness border closely on each other.

In this group of carefully executed drawings by Paolo Veronese one was inscribed by the artist as a composition "he had once painted for himself." This reminds us that many presumed sketches are not planned preparations but rather derivates from existing paintings. Many a reason may have induced an artist to keep a record of a work with which he had to part: for instance, the wish to repeat the composition in a second work or the wish to have a sort of "liber veritatis," an intention we surmised for Tintoretto (see p. 277). The poorly executed "Lamentation of Christ" in the Louvre (No. **1737**), formerly in Vasari's album, might be such a memento. Pupils and assistants had other reasons for copying their masters' compositions; and many copies of this description have later been taken for sketches or models. Old and new collections abound in them, and an interesting study would be an investigation of copies after Tintoretto—by Corona, Palma Giovine, Rottenhammer, Bassetti, Mera, and others—some of which are occasionally mentioned in our catalogue and many more contained in the photographic material deposited in the Metropolitan Museum.

In the case of contemporary copies (e.g., those used in the Bassano studio or the repetition of Lotto's Legend of St. Lucy in Malvern No. **767**) the stylistic approach to the master himself is sometimes so close that differentiation between preparation and subsequent repetition proves difficult. It is easier in cases where the copyist belongs to a later generation and consequently adds an element of his own to the imitation of older art. Instances are Nos.

970 and **983**—in our opinion not originals by Palma Vecchio, but copies of his uncle's compositions made by Palma Giovine.

A special case is that of copies made for collectors: hastily, as in the illustrated catalogue of the Vendramin Coll. (T. Borenius, *The picture gallery of Andrea Vendramin,* 1923); or carefully, as in **No. 1947** after Titian or in a copy from Jacopo Bassano perhaps by the same hand (which we saw at Colnaghi's in 1938, but did not include in our catalogue because it had never been published before). A clue to the scope of such copies is given in a manuscript of the Marciana quoted by Anna Tositti, *Marco Boschini critico dell'arte Veneta,* in *Convivium,* 1934, p. 712: The painter V. Cassana, agent of the grand duke of Tuscany, sent his patron to acquaint him with the merits of paintings offered for purchase, a model of the painting in question, "sometimes a drawing, sometimes a painted sketch."

The design proper (that is, the drawing by which the artist prepares or sets down the general arrangement of a prospective work of art) develops in a somewhat parallel direction though certainly in a different manner. It is not easy to determine the point where this kind of drawing—one which more closely conforms to the modern conception of drawing in general than any of the previously discussed categories—branches off from the *"simile,"* that primary cell of drawing. It is partly a question of interpretation. Corrado Ricci and other authorities considered the great compositions in Jacopo Bellini's books as designs for no longer existent murals and paintings. As stated above, we do not now adhere to this theory. Moreover, we find drawings more restricted in their ambition; by subject and treatment they are apparently so closely bound to a definite commission or project that we can hardly doubt their original function as designs. Gentile Bellini's sketches for the Procession of the Holy Cross in St. Mark's Square (**No. 270**) and for some other historical subject, perhaps the Recognizance of Pope Alexander III at the Carità (**No. 263**), bear the signs of a spontaneous artistic expression at the moment when the ideas are still in a state of flux. We do not agree with critics who on the grounds of technique attribute these drawings to Carpaccio. For us they testify to Gentile Bellini's scientific mind—to his keenness of observation which is also revealed by his sketches in Munich, by the fidelity of his portraits, and by the minuteness of his studies from nature. Carpaccio, so thoroughly indebted to Gentile, might easily have borrowed along with types and other elements the latter's technique of drawing as well. His own sketches to which we have already referred above make an ampler use of foreign elements than the apparent spontaneity of their linework might lead us to expect. In Giovanni Bellini's oeuvre, sketches of total compositions are almost entirely lacking. The Healing of Ananias, in Berlin, **No. 289**, might better be called a working design for a sculptor; the late Pietà in Paris, **No. 319**, if rightly attributed to Giovanni Bellini, would be the only one of these drawings in which we find the artist groping for his form and in which we can see the invention apparently taking shape before our eyes.

A few Venetian paintings still existing, but left unfinished, provide clues to the working process. A small painting attributed to Cima in the N. G. in Edinburgh—to which Borenius first drew attention (*Burl. Mag.* 1916, p. 164)—shows in its unfinished parts a design made with a pointed brush on the white ground; in the finished parts this preparation is entirely covered by the colors. Mansueti's Entombment of Christ, in the Careggiani Collection at Venice, published and illustrated in *Art in America* (Vol. 28, no. 2; April 1940, p. 54 ff.), is apparently a version not finished for customers but kept in the shop as a model for later fully colored repetitions. Extremely careful chiaroscuro execution gives the painting the character of a cartoon intended as a preparation for the final painting.

The new generation renounced this procedure for another almost entirely devoid of drawings. Giorgione is

described by Vasari (see above p. 4) as definitely opposed to preparing paintings by drawings; the study of literary sources and of the paintings themselves confirms the fact that Titian's compositions also were developed on the canvas as directed by the given color scheme.

Marco Boschini, the leading theoretician of Venetian art in the 17th century, emphasizes the all-important part of design in painting but demands that it vanish in the executed work much as the ruled paper is discarded when the letter is written. There are, however, exceptions in Giorgione, if the attribution to him of the drawing in Darmstadt No. 706 is correct; and exceptions in Titian, if the "Jealous Husband slaying his Wife," No. 1961, is allowed to remain the cornerstone of our knowledge of Titian's drawing style even in the face of serious doubts. The only sketches in which we catch Titian struggling with the general arrangements of compositions are two relatively early works: very hasty pen drawings connected with his altar-pieces in Brescia and the St. Peter Martyr for San Giovanni e Paolo. The doubtful No. 1999 and reflections in the production of followers (see No. 1977 and Verdizotti's drawing in Brunswick, No. 2021) might give us some idea of Titian's sketching style in later years.

Studying this very sparse material, we notice that the artist's interest is limited solely to the grouping of the figures without regard to their location in space. He is a real Cinquecento artist, compared to whom Gentile Bellini's or Carpaccio's efforts seem almost Gothic. Tintoretto followed Titian's example; while hundreds of studies of single figures still exist, the sketch for Vulcan and Venus, in Berlin, No. 1561, thus far remains an almost unique exception. In view of Tintoretto's huge compositions to a notable degree certainly executed with the help of assistants, it seems incredible that he could have used no other expedient than the one circumstantially described by Boschini. This consisted in building up the whole composition by means of small clay figures on a miniature stage, thereby making a drawing sketch of the whole arrangement unnecessary.

Another well-known story tends to confirm his antipathy to sketches: in the competition for the ceiling of the "Albergo" in San Rocco he refused to present drawn sketches as the other competitors did, but smuggled in the finished canvas. Yet, on the other hand, something like sketches must have been indispensable in certain cases. In the big order from the Court of Mantua, for example, the patron insisted on first examining the sketches in view of corrections eventually to be made. The sketch in Naples, No. 1724, gives a very summary idea of the composition, understandable only to the assistants for whom it may have been meant. It can hardly be what the literary advisors of the Court wanted to see and were supplied; in such a sketch they could never have noticed mistakes in the disposition of troops or in heraldry.

Admitting the possibility and even probability of general sketches by Tintoretto which offer a certain amount of detail, we must still emphasize that up to now all efforts to find them have failed. This statement applies to newer attributions of pen sketches made by Meder and by Stix-Fröhlich as well as to the typical older attributions of wash sketches aiming at painter-like effects formerly claimed for Jacopo Tintoretto. In our theoretical discussion in *Critica d'Arte* VIII, we pointed out that this mistake is one of principle; this kind of drawing was not preparatory to, but emanating from the finished paintings by Tintoretto. Tintoretto himself, who did not spare strong expressions in extolling drawing as the foundation of art, certainly meant by such statements something very distinct and very different from the Central Italian concept of design. To him, it was a complete penetration of an individual form and not a substitute for the creative idea that would be expressed in — and according to the genuine Venetian concept produced by — painting. It may be a sign of the dissolution of that great local tradition, coincident with the end of a great School there, that from the end of the 16th century on drawing assumed a somewhat different character.

The transformation occurs at various places—one of which is Tintoretto's own studio. His son Domenico is one of the emancipators of drawing. In an abundant stock of designs, ranging from charcoal drawings to oil sketches (many of which are preserved in the British Museum), he indulges in the pleasure of pouring out half-formed ideas. This procedure and the spiritual conditions behind it are fundamentally different from Jacopo's. Yet, for their brilliance and their extreme condensation of Tintorettesque elements, these sketches were formerly attributed to Jacopo—disregarding the approved rule of thumb that an exaggeration of an artist's characteristics in a work may be an argument *against* its attribution to him. The ascription of the London sketchbook to Jacopo—quite aside from a dozen good reasons, most of them already presented by Hadeln and Tozzi—is all the more inexcusable since this material resembles an illustration of the literary portrait of Domenico Tintoretto as drawn by Ridolfi (II. 262). In distinct contrast to his father, Domenico was fond of literary refinement, interested in ingenious and subtle subjects—in a word, thoroughly infected with the spirit of Baroque in formation. We might charge Domenico—but never Jacopo—with so loose a connection to a pictorial idea as to produce ten or twenty different versions of one composition, and thus to disclose its conception as a purely literary act. As a matter of fact, the numerous points of conformity to paintings by Domenico—not Jacopo—do not go much further than identity of the subject and general resemblances. The conception as laid down in the drawing is independent of the conception on which the painting itself is based. Drawing is severed from its former background, has grown into an autonomous expression of a formative urge, is about to be dissolved into a kind of play-drawing for the sake of drawing.

In the case of Domenico this trend is vigorously counterbalanced by his deep indebtedness to the tradition of the paternal workshop, in which for two decades he had played a prominent part. His luxuriating in expression by drawing is only a byroad; in the greater part of his drawings he carries on the inherited routine. The important point, however, is that although Domenico is a faithful Tintorettesque, he occasionally yields to the new current which some of his contemporaries evidence even more distinctly.

Besides those very elaborate drawings mentioned above, Paolo Veronese—Jacopo's and not Domenico's contemporary, it is true—produced a considerable number of hasty sketches to which Borenius, Russell and Hadeln drew well-deserved attention. Their most striking feature is their apparent self-sufficiency and lack of restraint. This master of great representational compositions whose harmonious balance made them the models for several generations to come seems to have become a playful child in his drawing. These drawings are sketches, numerous connections with painted versions of the same subject have been pointed out, and we ourselves have had occasion to increase their number. But the relation is not so much that the drawings contain the future composition in embryonic form as that they prepare it by loosening and fecundating the artist's imagination. He toys with an idea, tastes its various possibilities, until the final solution presents itself, perhaps entirely different from any of the ideas appearing in the preparatory sketch.

A third type in this process of dissolution is Palma Giovine—he, too, the heir of a proud family tradition and by the circumstances of his life the residuary legatee of the whole Venetian School. We hear from Ridolfi that he was a passionate draftsman who devoted every leisure moment to drawing; even at his meals drawing materials lay next to his eating utensils. The results of his prolific production lie before us in hundreds and hundreds of drawings, a good number of which were collected in the books—more correctly scrapbooks than sketchbooks—in Munich and London. Again what strikes us most is the luxuriant, almost purposeless character of the drawings. Though occasionally referring to compositions also existing in paintings, they are entirely without roots—output

of a permanent and unconcentrated creative urge, fulfilling more an uncontrollable drive rather than a need of the artist—mere finger-exercises to loosen the hand. They are in fact just drawings, which by their detached character recommend themselves as valuable teaching material. Indeed, some of these drawings, floating around unconnected, were compiled and published as "Palma's Academy" in Giovanni Battista Franco's etchings. The contrast with Jacopo Bellini's sketchbooks, the educational aim of which we have stressed, is very striking and instructive. In these books Venetian drawing started in the shadow of monumental painting, a modest cog within the unit of artistic production; in the later Jacopo's production, drawing has become a pastime for children and adults, an entirely autonomous activity, upheld by only a very slender educational purpose.

After surveying the evolution of the sketch or design, we now glance at the development of the single study which prepares only a portion of the total composition. Here again the derivation from the medieval *simile* is evident—even more evident than for the sketch since, as we remarked before, the *simile* presents one typical figure or some other detail, not a complete composition. Jacopo Bellini's sketchbooks are the place where we can study its start as an independent activity. We have pointed out that Jacopo's single figures, even when studies from nature, remain typical—and Pisanello's too, in this respect. Only with Gentile's studies do we have to deal with direct analysis of reality in individual manifestations. And it is just that sharpness and freshness of observation and rendering that turned these studies from nature into much-imitated models for the next generation. Gentile's Oriental studies, drawn from a world both alluring and inaccessible, were an especially welcome hunting-ground for later artists both inside and outside of Venice. Through their graphic copies, among which we must first cite Reeuwich's illustrations and Dürer's woodcuts and engravings, they became common property of all European art.

Gentile Bellini may be called the ancestor of Venetian drawing in another sense than his father. While the latter's sketchbooks represent a kind of protoplasm containing the germs of all further development, Gentile's drawings offer the real prototypes for most specific efforts in this field. His above-mentioned Turkish types, whether preserved in originals or in copies, proved their convincing power of observation by the very fact that they were so frequently imitated. Gentile's rendering of a definite site—for instance the place in front of the Carità or Campo San Lio—bears witness to a cool and objective study of a given situation. The current which starts here culminates in Canaletto's city views.

Gentile also provides us with the first Venetian portrait of an individual model, though there is one example among Jacopo's drawings (No. **364**, pl. XX) that may formerly have had companions. In the study in Berlin for one of the portraits in Gentile's Procession of the Holy Cross—incidentally permitting the conclusion that similar studies of the numerous other heads also existed—we note the effort to grasp the oneness of an individual artist. Its deliberate subjectivity in rendering the model leads us to doubt Gentile's authorship in the second portrait-drawing in Berlin in spite of its time-honored companionship to the former. We claim it for Giovanni Bellini—with the reservation, however, that our knowledge of his portrait style is hardly sufficient to put forward such a claim with certainty. With few exceptions, the attributions of painted portraits to Giovanni Bellini are gratuitous; so, too, are most other attempts made in the field of drawing. Unless the prevalent confusion regarding portrait painting in Venice is cleared up, there is hardly any hope of bringing the attribution of portrait-drawings above the level of conjecture. We cannot feel that we have resolved this problem in such famous cases as the so-called Antonello in the Albertina (No. **51**) or the portrait of a youth (No. **326**) in the same collection; in a series of heads, certainly by the same hand, in Frankfort, Leipzig, and the Liechtenstein Collection; in several others more or less arbitrarily distributed among Basaiti, Previtali, Licinio, Pordenone, and Lorenzo Lotto. (For

the last named, the discovery of a portrait authenticated by the study on its *verso* has offered unexpected help.) Regarding the leading masters of the Cinquecento, the material of drawn portraits on the whole is extremely uneven.

A few of the portrait-drawings claimed for Paolo Veronese may be accepted, but the only one attributed to Jacopo Tintoretto has to be eliminated (No. 824). What we have by Titian—with the exception of No. 1878 which we are the first to attribute to him—is secondary material: the Duke of Urbino, No. 1911, a study for the general arrangement rather than a portrait proper; a working design (No. 1964) intended to adapt an older type to a second use; a study of a Moor, in our opinion similar to one in the Pesaro Madonna (No. 1908v). The most interesting feature of the last-mentioned drawing, if its attribution to Titian is accepted, would be its conformity with Titian's procedure in painting heads as revealed by the X-ray photographs of his portraits.

We have stressed that the various genres into which painting and drawing split in later centuries may be traced back to Gentile Bellini. This, of course, does not imply his superiority to Giovanni Bellini who fore-shadows the leaders of Venetian painting by his reluctance to admit drawing as a specialized activity. It might be said that in this regard both he and these later masters maintain the tradition of the city abandoned or mitigated by others. In the special field of drawing Gentile's immediate successor is Carpaccio; at least he is the one artist in the late 15th century whose figure as a draftsman is most tangible. Though he follows Gentile, he hardly ever comes up to him. A comparison of their single studies, heads or landscape motives discloses that even as a drafts-man his adroit imitation of Gentile's technique is superficial. Endowed with charming zest as a storyteller, Carpaccio nevertheless lacks a deeper interest in the individual phenomenon. On closer examination his figures appear mere puppets; his portraits are typical masks, and his landscape, No. 615, at first sight so fascinating, reveals itself as a mere compilation of heterogeneous models.

To a higher degree than their engaging charm might lead us to believe, many of Carpaccio's compositions too are such compilations, or at least contain ingeniously inserted elements taken from elsewhere without much modification. Ample evidence in this point is given in the general paragraph on Carpaccio and in the description of his individual drawings. In this latter consideration, we have had to emphasize something mechanical in Carpaccio's way of proceeding to build up his compositions with the help of models by other artists or of careful drawings, almost cartoons, prepared by himself. The two maiden's heads in Donnington Priory, twice appearing in paintings, resemble in their technique and in their minuteness the drawn heads and hands and other details which serve Dürer for similar purposes. (It should be remembered that Dürer was in Venice in 1505–7 and may have been in contact with Carpaccio or other Venetians working along the same principles.) The difference, however, remains that although Dürer had no objection to going back to old drawings as yet unused, he did not, as far as we know, repeat himself; Carpaccio, on the other hand, had no scruples about so doing. For him details set down in a drawing are movable elements, applicable to any newly arising need. When his imagination grew sterile with increasing age, this way of working became more and more frequent; in his later years he, and after his death his workshop, meeting the artistic needs of provincial places far from Venice, throve on such old studies.

As to other survivors of Quattrocento art—Cima, Previtali, or the Santacroce—the stock of drawings that may be connected with them is hardly sufficient to justify conclusions. Single figures and heads by Palma Vecchio, Lotto, and Savoldo have been preserved which were used in painted compositions; for example, a number of heads by Savoldo executed with extreme minuteness prepare parts of the pictures in the way of cartoons.

It may be that our knowledge of Giorgione's drawings is too fragmentary to venture any conclusions. In

Titian's work, with which we are a little better acquainted, all kinds of drawings appear, but all are more or less casual — proving rather than disproving the negligible share which they may claim within this activity. The few of them which prepare figures in paintings have increased importance because of this confirmation of authenticity, although in some cases the connection has been questioned or interpreted as a dependence of the drawing on the painting. The Horseman or the St. Bernard in the Uffizi, for instance, have been declared to be copies from, not designs for, the corresponding painted figures — a crucial alternative in every criticism of drawings. In our opinion, the question is definitively settled for the Study of Trees (No. 1943) and for the Legs of the Executioner of St. Lawrence (No. 1906). The Horsemen at Oxford and Munich (Nos. 1941, 1949) might have been drawn for a battle-piece, painted by Orazio Vecelli and only known from literary sources; the Jupiter and Io at Cambridge (No. 1886) for an erotic series to which, by reason of the delicate character of such a subject, only insignificant traces exist in the literature. Any one of these master drawings might satisfy our doubts concerning Titian's abilities in this special field. These studies, as well as a few more not similarly authenticated by paintings and literary sources, reveal that intensity of approach which is the exclusive mark of superior mastership: the complete concentration which puts the total of a master's creative power into this limited task, regardless of an eventual future use of the study. In this boundless devotion we feel Titian's spiritual relationship to Dürer, from whom he undoubtedly received more than he gave. The German, first of all a graphic artist and a draftsman by profession, and the Italian, primarily a painter who drew only occasionally, meet as equals on a level not accessible to artists who lack this complete devotion to the momentary task. The latter may be excellent draftsmen; yet their drawings are not filled with a life of their own, always retaining something of improvisation, something provisional, as is the case with Carpaccio or Tintoretto.

A comparison of Tintoretto's and Titian's drawings is extremely instructive. The former, as we know by his own testimony — and that of so many preserved examples — made numerous drawings from nature in his preparation of large compositions; and such an intensive study of the single figures seems indeed to have been an indispensable step within the working system of the master. These hastily sketched figures, with no pretence at inner modeling, by no means strive to grasp the total vitality of the human bodies represented. They reduce their abundance to a formula, jot down the relationships of their parts, are notations of movements and not symbols of living beings as are Titian's figure-drawings. Such studies are drawn from nature, but with a view toward a planned composition to which they remain inextricably bound. Added to the working stock of the shop, they were later used by the sons and other assistants or pupils for other compositions — sometimes, as said before, in reverse or shown from the opposite side. They remain extraneous and at the same time spread a net of Tintorettesque character over the composition, thus giving it that family likeness so often interpreted by modern attributionists as a sign of authenticity.

Of the other leading workshops of the late Renaissance, Veronese's can hardly be discussed here. Studies from single figures by him are almost entirely lacking, and some of the few we have are doubtful. With the Bassano drawing was never popular; in a letter concerning drawings of his father, Francesco expressly states that their family had always considered painting, not drawing, their job. This recalls Titian's attitude. Another relationship lies in the fact that Jacopo Bassano, as soon as he sat in front of an interesting subject, forgot his dislike of drawing and threw himself into the task with the same intensity and directness as Titian himself. His studies have the earthy smell of immediate experience. Jacopo's sons, Francesco and Leandro, by reason of their long stay in Venice in closer touch with metropolitan currents as well as being part of a younger generation probably more attracted

by Tintoretto than by Titian, lack this depth; their studies owe more to routine than to effort. A series of heads which has emerged in these last few years, all from the same source, gives the impression of being a direct preparation for painted portraits. We claim them for Leandro, the specialist in this branch within the family workshop, and must emphasize their auxiliary task and their consequent lack of balance. They are merely working material to be evaluated from the final result.

Palma's portraits (incidentally, almost all of close relatives) are on the contrary improvised plays of the pen, except for No. **824**, in which he seems to have aimed at the effects of Tintoretto's painted portraits. Like the rest of his studies, the others sacrifice the essence of their objects to their author's instinct of play which dissolves their substance in graphic linework. The books in Munich abound in hasty notes from a real and from an imaginary world, the borderlines between the two no longer traceable. The academic tendency—which we noted in Palma before—transposes reality into a purely aesthetic essence. Looking back over a century and a half we discover the first intimations of this momentous evolution in Jacopo Bellini's sketchbooks. Let art—or for that matter any other spiritual power—take its first independent steps, and it will not rest until it reaches full autonomy according to a natural law.

In the foregoing survey in which we have tried to assign each category of drawings to its place within the whole scheme, we have treated the latter as a vacuum independent of historic conditions. We must now add an outline of the evolution of Venetian drawing as it took place under the specific conditions offered by the period and the territory, and by the artistic individualities dependent on both.

Again we have to start from Jacopo's sketchbooks. In trying to circumscribe the range of our studies (p. 9 f.) we explained why from our point of view all earlier art production in Venice is prehistoric: there is nothing that falls within our definition of drawing and nothing that falls within our definition of Venetian. Productions like the manuscript of Titus Livius in the Ambrosiana or the group of historical representations mentioned on p. 3 illustrate the raw material transformed into Venetian drawing by Jacopo Bellini. He succeeded in doing so by the help of foreign stimuli—a process analogous to the general picture of how Venetian art overcame its stagnating local tradition by accepting outside influences.

Jacopo's merit is to have transformed the art of Gentile da Fabriano and Pisanello (invited to Venice by official commissions) into a living power within Venetian art, adding to their influence that of Florentine art just entering upon the decisive stage of its ascent. In our analysis of the sketchbooks we point to numerous contacts and conformities with Pisanello and Gentile. Both there and in the introduction to Jacopo Bellini, p. 97 f, we emphasize the part played by Alberti in Bellini's formation and especially in the origin of his interests in perspective and composition. How far the same or other influences also determined the style and technique of Jacopo's drawing is difficult to judge, since the drawings were handed down to us under the confusing veil of heavy overworking. The original linework can hardly be more than guessed from a few portions that have escaped destruction. Mostly executed in silverpoint, it displays the delicacy typical of the modelbooks endeavoring to evoke in a different medium the impression of mural paintings. Besides this less graphic technique used in drawings, many others appear here: pen and ink, brush, black and red chalk, watercolor. It seems natural that in this primer of Venetian drawing the various techniques should lie close together. On the whole, the techniques used in drawing had existed before drawing proper started. They were not invented to satisfy changing specific needs of drawing, but were selected from already existing practices whenever new needs emerged.

(For this reason we consider it unnecessary to discuss the various techniques again at length. Hadeln and

Meder made valuable contributions to their history; Degenhart in his analysis gave the reasons why certain drawing materials—brush and chalk, and especially oilchalk—and the blue "Venetian" paper were so much favored by this school. Degenhart's explanations are most convincing: the chosen materials were meant to dissolve the outline and, generally speaking, to attenuate the linear character of the strokes and to augment the pictorial aspect. He emphasized the right point; the choice of technique and material is less important than the use made of them. The technical means in themselves are more or less common property, and it is dangerous to connect them too closely with individuals or schools. In principle there is no reason why an artist should have limited himself to one single technique or should have shunned another. Hadeln, who first had denied the use of red chalk by Titian for his drawings, later admitted it; and the thesis that Tintoretto never drew in pen must be rejected, although none of his pen drawings have thus far been identified. The preference for blue paper in the Venetian School is certainly well established, but the same paper has been used by artists of other schools often enough to veto its application as a decisive argument for an attribution to this school.)

In Jacopo's sketchbooks, he and the others who have a share in them used various techniques, developed in the illumination of manuscripts and in other kindred activities. A stylistic dependence on the drawings of those masters who exercised a general influence on him can hardly be proved or disproved: no drawings by Gentile da Fabriano are universally recognized, and to the many existing by Pisanello no connecting line is traceable from Jacopo's—at least as they present themselves now.

The next important step in the development of Venetian art is, according to traditional opinions, the contact of the Bellini family and the Bellini workshop with Mantegna. If Gentile and Giovanni were the latter's companions in the paternal workshop, it is very likely that their way of drawing should also reflect these contacts. Unfortunately there are difficulties on both sides. Gentile as well as Giovanni are most indistinct figures as draftsmen; and Mantegna's drawings, especially in the earlier period important for our problem, are in utmost confusion. Nothing makes this clearer than the treatment of a group of outstanding drawings: originally listed for the most part as by Mantegna, later claimed for Giovanni, they were finally in part revindicated for Mantegna by Sir Kenneth Clark, while Fiocco defended the opposite theory so consistently as to attribute to Bellini even the famous sketch of Mantegna's early masterpiece, Saint James Led to His Execution.

On p. 84 we advanced our reasons why in this case we maintain the attribution to Mantegna and why on the basis of this attribution we return to him some, though not all, of the drawings given to Giovanni Bellini by Hadeln and others. At this point we shall bring out only one feature: namely, that the linework of the drawing in Donnington Priory grows out of a tradition which we may consider a local Paduan School. The veiling of the outlines by drawing over with parallel hatchings, the use of the latter also in making lighted and shaded parts alternate, are Mantegna's contribution. By his influence on his brothers-in-law, this became part of the Venetian style in drawing. Some of this quasi-impressionistic expression comes out in Gentile's crowds, while Giovanni's studies of single figures are the almost direct continuation of Mantegna's. The borderline is hardly perceptible. We certainly do not claim peremptorily to have fixed it at exactly the right place, when interpreting Giovanni Bellini in his drawings as a softened Andrea Mantegna, and Andrea Mantegna—again in his drawings—as gradually developing toward graphic sharpness and plastic roundness. There is no reason to suppose that Giovanni Bellini in the years of his mature mastership followed Mantegna in this direction. On the contrary, in view of his evolution as a painter, we may surmise that in his drawings too he grew more pictorial, preparing or anticipating the current of the early Cinquecento.

In this connection we must keep in mind that within a school of art drawing does not evolve independently, but that, while following its intrinsic trends, it also reflects more general currents. In a place like Venice where artistic interests culminated so positively in painting, an approach to it by drawing seems a most natural course. In Carpaccio who had started from Gentile Bellini, this tendency is evident. Even in relatively early drawings his modeling had not produced the impression of plastic forms; later, it is wholly replaced by a play of dark and light parallels spread over the figures and heads to create the illusion of an animated surface. A comparison of No. 589v with No. 629 or of No. 618 with No. 589 is very instructive.

The connection with painting explains the motley picture and lack of unity presented by Venetian drawing, fed from so many different sources. One of the most influential, about 1500, is the art of Albrecht Dürer who visited Venice twice, in 1494/5 and 1505/7. How eagerly the painters snatched at his graphic works and imitated them "in all the churches," he himself bewailed in one of his letters home. He is, moreover, no less important for the evolution of drawing in Venice. In the introduction to his *Titian Drawings,* Hadeln stressed this point very expressly; in our *Tizian-Studien* we have supplemented and in part contradicted his statements. According to our investigations Titian was most of all stimulated by Dürer's general attitude toward nature. Perhaps with the exception of Lotto whose contact with Dürer must have been very intimate, most of the other Venetians are satisfied with looting Dürer's rich store and borrowing single elements. Only Titian accepts his initiation to a deeper penetration of natural life in all its manifestations. This devotion to nature permeates the linework of Titian's early drawings and endows them with a sensitiveness and emotion new to Venice and distinctly recalling Dürer's own personal touch. The spiritual relationship governs the technical resemblance which, in our opinion, Hadeln made too narrow in explaining it as an imitation of the style of Dürer's woodcuts. It is less an imitation than an affinity of genius.

Hadeln, on the other hand, is right in connecting the style of Titian's early drawings—and perhaps also his predilection toward pen and ink for their execution—to woodcuts. In these years Titian produced his gigantic Triumph of Faith, supervised the execution of the also unusually large Sacrifice of Abraham and a few more designs for woodcuts. Some of the latter attracted attention in the last few years (for further particulars see our two articles on Titian's graphic art in *Graphische Künste* and *Print Collectors' Quarterly*) and have helped to clarify Titian's early activity as a draftsman.

The drawing technique in most of these early specimens of Titian's draftsmanship is one of dissolving outlines and deliberately destroying plastic values—a method inherited from Giovanni Bellini and, incidentally, described by Degenhart as typical of Venice in general. It is also used in the few chalk drawings where the effect has naturally been softened. Without renouncing a graphic treatment, the study for Peter of the Assunta in the Frari, No. 1929, achieves luster by its broad use of black chalk and the addition of heightening in white. This mode of expression, a mixture of graphic and pictorial media, became typical of an artist who had been staying with Titian at the time when the latter developed this technique: Paris Bordone. Because of their close proximity to one stage in Titian's development, his drawings must be picked out in part from Titian's. As is usual with minor artists, Paris Bordone retained the overwhelming influence of his master which he had experienced in his early and formative years. Titian himself outgrew this phase. In his late drawings, such as the Horsemen in Oxford and Munich, the Angel in Florence, the Kneeling Apostle in the Earl of Harewood's Collection (Nos. 1941, 1949, 1905, 1935), he had reached a visionary power far surpassing not only Bordone's efforts but also his own previous production. Thus the notions of plastic or pictorial style lose their outworn meaning. As in Titian's late painted

masterpieces, reality is replaced by an unreality that nevertheless aspires to a higher and more intense reality. The word surrealism would force itself upon us if it had not taken on another meaning in current art terminology.

This synthesis, a peak in Titian's personal development, represents at the same time one of the purest manifestations of the specifically Venetian spirit in art. One might call it a resuscitation of the ancient mosaic style by a modern who had felt the touch of Michelangelo. In spite of Titian's approach to Central Italian art, noticeable in his paintings executed during his stay in Rome and immediately before (for it is the mysterious gift of the genius to anticipate external experiences), his late works, paintings and drawings, show that this contact has been overcome or absorbed. In other artists contemporary with Titian analogous conditions are resolved in another way.

We may disregard Sebastiano del Piombo, who surrendered almost entirely to the art of his new surroundings. Among those Venetians who clung to the tradition of their city, Pordenone was the pioneer of Central Italy in the first generation — more so than Titian and antedating him. His drawings reveal a greater interest in plastic form — an impression heightened by the fact that quite a few of them border on working designs made for a workshop very productive in provincial areas. The minor artists who assisted him were apparently accustomed to working with the help of drawings in which careful and clear execution was a presupposition; the same method was used by Pordenone's follower Pomponio Amalteo and probably in other workshops as well. In one case the use of a model head from a Central Italian School, perhaps Signorelli's, must be surmised for Pellegrino da San Daniele, a local artist in the Friuli; it seems impossible that the producer of such poor murals could himself have made this master drawing. Pordenone, to whom Professor Fiocco in his new monograph accords equal merit with Titian, certainly has moments in which he rises far above the routine of his average production. Nowhere does he appear more ambitious than in his early frescoes for Cremona and in their preparatory drawings; their greater number alone testifies to the special care used by Pordenone in preparing this amazing creation. No less than five spirited drawings refer to it. Pordenone's sketches for Cremona, in spite of their precision, reveal a pictorial softness enhanced by the choice of red chalk as material that reminds us of similar aspirations and achievements in contemporary Florentines (Andrea del Sarto). The fusion of the various sectional schools of Italian art into a genuine national expression — in our opinion the decisive achievement of the High Renaissance — is under way. It takes place under very different guises: Girolamo da Treviso's uninspiring eclecticism; Schiavone's mixture of elegance and grand style (as far as we may succeed in grasping him at all); Giuseppe Salviati's resolute effort to mix his Florentine patrimony with the art of his country of adoption.

The most effective synthesis of Central Italian (more precisely Michelangelesque) influence and Venetian tradition is commonly sought and found in Tintoretto; in his drawings, too, he is supposed to combine Michelangelo and Titian. This, however, is correct only with certain reservations; his interests in this field run along two different tracks. Tintoretto's drawings after classical and contemporary sculpture are connected with his efforts to master the classic form in all its aspects. Earlier we had occasion to state that he made this sort of study part of the training system his pupils had to undergo. He craved absolute mastery in this regard and did not limit his approach to those views the sculptors themselves would have considered the essential ones; he was forever in search of unusual, daring, and generally unsculptural views. The linework in itself has no connection with or resemblance to Michelangelo's; it is rather his modeling in stone or clay that is reflected in Tintoretto's drawing style.

But as integral a part in Tintoretto's art as this group of drawings may play, its importance is hardly to be com-

pared to that of the single studies from nature. These formed the main bulk of his drawings and chiefly determine his aspect as a draftsman. In these drawings any effort to evoke an illusion of the surface is dropped. That remnant of reality still lingering in Titian's most unreal visions is deliberately reduced to an extract of action and motion —a substitute for vitality. These vibrant figures live not with the abundance of natural existence, but with the concentrated dynamics of an engine or the logic of an abstract formula. The lack of material substance makes these figures even more suitable for their purpose in the realm of art. They are the notes that determine the specific rhythm of Tintoretto's compositions—the elements of his artistic essence which even isolated retain his characteristics and express his individual handwriting. It is instructive to observe how in the production of the workshop this personal language is transformed by modification and transmutation into a kind of family code or trademark. It is, however, still more attractive to observe how inimitable it remains in its very essence, the emanation of a unique artistic personality.

This peculiar use of specific motives—serving as a key for a whole composition over which, inflected and modulated, they are distributed—has been studied in detail with respect to Tintoretto's drawings by E. Tietze-Conrat in *Graphische Künste*, N. S. I. Like others who have endeavored to clarify Tintoretto's principles of composition, she found it necessary to have recourse to a terminology taken over in part from music. In spite of the tremendous amount of imitation by Venetian artists of the late Renaissance, Tintoretto's studies of single figures are the most personal expression of an individual rhythmic urge.

Their uniqueness is thrown into relief when Tintoretto as a draftsman is compared with contemporaries bordering upon him: especially Vicentino, Paolo Veronese, and Palma Giovine. There are positive contacts between them and Tintoretto. In the case of Paolo Veronese these rest on the derivation of both from Titian's late style; in the case of Vicentino, on the efforts of a competitor to catch up with a superior model; in the case of Palma, on the versatility of a talent to whose lot had fallen the complete legacy of the classic school of Venetian painting. Tintoretto is one of those to whom he is definitely indebted, and even in his last will Palma admitted his obligations to the House of Tintoretto. The confusion in the attributions to these artists, therefore, is easily understood. They have in part a common technique; they strive for the same effects; they imitate each other, at times even deliberately. But the rhythm of their style of drawing is fundamentally different. A thorough investigation of Jacopo Tintoretto's and Paolo Veronese's drawings—something, it is true, that cannot be accomplished by casual examination—makes the critic wonder how one could be mistaken for the other. In Veronese's sketches, the playlike character of which we have emphasized previously, the additional touch of mannerism resulting from his early education is never entirely abandoned. The separate elements always remain to a certain extent self-contained, vertical, isolated, lacking the flowing swing typical of Tintoretto's figures even when isolated. Veronese's drawings are distributed over a sheet, Tintoretto's overflow it. According to their contrasting purposes the latter favors the supple material of chalk, while the former chooses the brittleness of pen and ink softened by occasional touches of gray wash. Admitting the difficulty of grasping such subtle shades by verbal description, we must still insist that the difference is very positive and easily perceptible in an intensive study of the drawings themselves.

It is nonetheless possible to find the specific Vicentinesque or Perandesque touch in the drawings of these artists, though in them—as still more so in Palma Giovine's—the enormous adaptability and facility of these later artists cause some confusion. Art was by this time predominantly a means of personal expression. The style of an individual artist had become personal property and thereby invited imitation. It is no coincidence that

a minor artist, Lorenzo Stampa, bequeathes a painting of his to Jacopo Tintoretto "not as a work of much importance but to remind him of me" (*Jahrb. Pr. K. S.* XXVI, p. 154); and that to secure an order Jacopo Tintoretto himself promises to paint an altar-piece in the manner of Paolo Veronese—which indeed he did, in the Assumption of the Gesuiti Church.

Drawing were even more extensively borrowed upon than paintings. Aliense was praised for his ability to imitate the drawings of other artists and made a speciality of counterfeiting Cambiaso's. The age of Picart's "impostures innocentes" is ahead. Mark the difference from the beginning of the period we have studied: Cennini had counseled young artists to imitate one chosen model consistently in order to gain a personal style, an artistic expression for their lifetime. Now from almost unlimited opportunities he may select what he likes. When Aliense, first a pupil of Paolo Veronese, broke with his master, he sold all the drawings made in his style and went over to Tintoretto whom henceforth he followed. Any sort of eclecticism has now become possible.

Palma Giovine, rounding out and thinning out Venetian art, is a fair specimen of the prevailing eclecticism —in two directions. First, he imitated Titian or Tintoretto up to the point of having some of his best drawings absorbed into their more highly valued oeuvres. Second, his own style in drawing became the grammar and vocabulary of his numerous followers. Among the huge quantity of drawings handed down under his name and in his style, there are apparently a good many executed by other hands. Not sufficiently marked by their own personal characteristics to be differentiated and individually recognized, they thus vanish in the current style of the Palma Giovine shop.

In the Jacopo Bellini shop, where our investigation started, similar difficulties were caused by the closeness of spiritual ties in the Middle Ages and the resulting sublimation of the individual. By the early 17th century, individualities have so far evaporated that they again become intangible. This is most conclusively confirmed by a group of drawings which, after many vain efforts to locate them elsewhere, we are now inclined to regard as the anonymous sediment of the golden age of Venetian painting. Most of these drawings, now in the Koenigs Coll., in the Lugt Coll., in the Albertina and in the Robert Lehman Coll., have a common source: the Grassi Collection, thereby seeming to have formed a unit from the beginning. They are by no means negligible; some are even especially attractive, outstanding in their quality and interesting in their ambitious and unusual subjects. In spite of these qualities they have resisted all our efforts over a period of years to relate them to existing paintings, to literary sources, to individual artists. They are given at random to Tintoretto or Veronese, or to various contemporaries; in the Koenigs Coll. a daring attempt is made to cut the Gordian knot by attributing the whole lot to El Greco. This suggestion, although hardly tenable, has the merit of an instinctive sensing of the distinctly Baroque element within this group. The drawings are advanced in spirit beyond the stylistic characteristics of an older generation to which in an epigonic fashion they adhere stylistically.

Noticing the close connection between one of the most typical of these drawings, No. **1757**, and a drawing in the Uffizi (no. 12862) claimed for Alessandro Maganza by an old inscription, for a moment we believed that we had at last found a clue to the solution of our puzzle. But the numerous paintings of this prolific local artist of Vicenza offered no corroboration, and he seems too poor an inventor to be credited with these imposing compositions. Nevertheless, this clue may not lead us completely astray; it may be that one or more of the drawings are Alessandro Maganza's, but not all of them. The seeming homogeneity of the group may be deceptive, stemming from our inability to differentiate individuals when we are too little acquainted with the species as a whole. We cannot recognize separate artists where a whole school is still a dark continent for us.

After the dissolution of its first great school in Domenico Tintoretto and Palma Giovine and before its renaissance in a second great school in the 18th century, Venetian painting is *terra incognita,* unexplored, in spite of the short distance separating us from it and in spite of the many names and works of artists handed down to us. As pointed out on p. 292, the paintings of Pietro Negri or Antonio Zanchi offer a similar phenomenon, wedged between the Tintorettesque and Palmesque followers at the beginning, and the Sebastiano Ricci and Piazzetta at the end of the century. It is the same with these drawings. They live on the inheritance of Domenico Tintoretto and Palma Giovine and, through them, even on that of Titian and Jacopo Tintoretto. Their style is continued in that of Diziani and Ricci, and in a certain sense even in that of Tiepolo and Francesco Guardi. They have their ghostlike being between the two periods in which Venetian painting rose to exuberant vitality. For these forgotten men, too, a day of resurrection may come.

CATALOGUE
[IN ALPHABETICAL ORDER]

ANTONIO VASSILLACCHI, CALLED ALIENSE

[1556–1629]

Ridolfi's biography of the Greek-born Aliense (II, p. 207–222) is worthy of special credence and attention. The biographer had been Aliense's pupil for five years and continued to be "his faithful and loving friend" until his death. Ridolfi tells us explicitly (II, p. 220) that he even took care of Aliense's funeral in San Vitale. Consequently, we may accept Ridolfi's testimony as especially trustworthy and acknowledge his evident efforts to give a well-rounded and well-authenticated biography of his friend and teacher. Even in speaking of the side of Aliense's activities that concerns us most—his drawing—Ridolfi tells us more about him than about others; and we learn that he was particularly devoted to drawing. Hardly any use, however, has been made of this hint. Hadeln did not include Aliense in his *Spätrenaissance drawings;* Odoardo Giglioli even deprived him of a drawing in the Uffizi supported by an old tradition. The attribution to him of a drawing in the Albertina (No. 20) rests on a confusion with Vicentino. In *Critica d'Arte* VIII we also limited ourselves to a special case: a *"modello"* for an altarpiece of 1583 existing in two versions (No. 9 and No. 16).

Ridolfi is important not only as a literary source, but also as direct evidence for one drawing that had been his property and passed to Christchurch Library in Oxford with the rest of his collection. The inscription, Antonio Vassillacchi, probably in Ridolfi's own handwriting, on No. 14, confirms a statement made in his biography of Aliense: namely, that the latter had started as a pupil and follower of Paolo Veronese. Together with his companions, Montemezzano and Pietro dei Lunghi (alias Longo), Aliense copied Paolo's drawings and paintings with great facility. His break with Paolo, according to Boschini (Boschini-Zanetti, *Descrizione,* 1733, p. 51), was caused by an assertion made by Paolo in connection with these copies. As long as Aliense had them to support him—said Paolo—he would maintain the reputation of a great painter. Thereupon Aliense "spurred by Greek pride" sold all the drawings he had made during his stay in Paolo's house to the art dealer, Antonio dalle Anticaglie, and thenceforth adopted the style of Tintoretto. Therefore drawings by Aliense closely paralleling the style of Paolo Veronese must have existed. On the basis of its resemblance to No. 14 we claim for him No. 5. A resolute inroad into the stock of drawings attributed to Paolo on the ground of their general Paolesque character alone, however, might probably lead to an enlarging of Aliense's share.

The fact that after this episode he followed Tintoretto's style and studied casts of classic works is still not indisputable evidence that he worked in Tintoretto's shop. But intimate contact between the two artists must certainly have existed, since we are told that Aliense followed Tintoretto's method of preparing his compositions with the help of small modeled figures. Again, as in the case of Veronese, we feel justified in searching among the enormous number of Tintoretto and Tintorettesque drawings for those that may be by Aliense.

A good point of departure for the study of Aliense's drawing is offered by No. 12 in the Rasini Collection, Milan—hesitatingly placed near Titian by Morassi, and more apodictically given to Palma Giovine by Ragghianti—which we recognized as the design for one of Aliense's paintings in the ceiling of the Sala del Maggior Consiglio in the Ducal Palace. Here we have Aliense's sketching style in his ripe period. Once recognized, it is quite a personal expression—distinctly different from what we might expect from Tintoretto in this technique, and less fluid than Palma Giovine's somewhat similar manner. Aliense's sketching style is stiffer, less casual and easy-going. There is scant relationship between it and the style of the equally well-authenticated *"modelli"* Nos. 9 and 16. Let us stress this point—which incidentally has its complete analogy in Paolo Veronese's drawings. The purpose of a

drawing has a decisive influence on its mode of expression. To recognize an artist's total range, it is indispensable to have at one's disposal specimens of his expression of various artistic purposes.

Between the two extremes—the sketch and the model—another category, apparently especially favored by Aliense, may find its place. Ridolfi mentions repeatedly outstanding drawings, *"singolari disegni,"* which he made in the preparation of important compositions. The large drawing in the B.M., No. **10**, representing Christ surrounded by the Patriarchs, may be one of these careful preparations. It is ascribed in the B.M. to Jacopo Tintoretto, but was never published as his; in our opinion, it is probably the *"singolare disegno"* made by Aliense for the ceiling of the nuns' church of St. Justina. Ridolfi gives an exact description of the composition. Another drawing, equally imposing in size and this time ascribed to Domenico Tintoretto (No. **6** in the Koenigs Collection) may be the *"gran disegno a chiaroscuro"* made by Aliense for the Sacrament chapel in San Marciliano—a drawing with which Cavalier Passignano was so much taken that Aliense offered it to him as a present (Ridolfi II, p. 211).

Three more drawings may be added here: Nos. **17, 1, 3**. For the second we may even recall that the subject "The Rape of Helena" had been represented by Aliense in a large painting sent to Augsburg (Ridolfi II, p. 216); for the others we rely only on stylistic clues, on general character, and on the relationship to other well-authenticated drawings, for instance, Nos. **10, 12**. The compositions, though rather hasty in their linework, seem to be complete in themselves. As Domenico Tintoretto also did, Aliense began to draw compositions just out of pure interest in drawing or possibly with an eye toward prospective art-lovers who were beginning to appreciate an artistic idea for its own sake.

This is a point the importance of which we wish to emphasize strongly. For it indicates a loosening of the hitherto close connection between preparation and execution. When Aliense had to paint "The Coronation of King Balduin" in the Sala del Maggior Consiglio, he made a *"singolare modello"* which was later carried to Augsburg by his pupil, Hendrik van Falkenburg. The model was made by Aliense, but—following the custom in his shop, as Ridolfi explains (II, p. 216)—the mural was executed by his son Stefano who deviated widely from the model. We note not only the distinction made by Ridolfi between the painted *"modello"* and the *"disegno,"* but also the relative independence of the final work from the preparatory stage. A new approach to art is in the making.

The new appreciation of drawings as independent works of art is one of the symptoms of the impending change. Aliense, we are told, was a great collector of old master drawings. One of the prizes of his collection, which foreign princes, ambassadors and famous artists came to visit, was a series of drawings by Paolo Veronese made on prepared paper. Aliense seems to have drawn some of his inspiration from his collection. An excellent draftsman himself, he enjoyed making drawings in imitation of other artists' styles—especially in imitation of Luca Cambiaso. According to Ridolfi (II, p. 219) Aliense made some drawings that were taken for works of Cambiaso. Apparently Giglioli had overlooked this passage when he replaced the traditional attribution to Aliense of No. **4** in the Uffizi by one of Cambiaso with whose style the drawing certainly has much in common. Other drawings which similarly combine Venetian elements with a resemblance to Cambiaso are Nos. **10, 13, 19**. In the Catalogue of the Albertina, the last-mentioned is ascribed to the School of Tintoretto. Years ago, E. Tietze-Conrat, impressed by its Cambiasesque character, fell into the same error as Giglioli with regard to No. **4**; now we believe the solution is: Aliense deliberately imitating Cambiaso. (We wonder whether Jacopo Tintoretto's warning, quoted by Ridolfi II, p. 68, to young artists not to indulge too much in the imitation of Cambiaso's drawings, was not actually directed against Aliense.)

1 BAYONNE, MUSÉE BONNAT. Rape of Helena. Pen. Probably cut at both sides. Ascr. to Jacopo Tintoretto.

Our attribution rests on stylistic reasons. A painting of this subject by Aliense is mentioned by Ridolfi II, p. 216.

2 BERLIN, KUPFERSTICHKABINETT, 5085. Groups of fighting men. Pen, br., wash. 264 x 188. — *On verso:* Similar motives. Coll. von Beckerath. Ascr. to Jacopo Tintoretto.

[*Pl. CXXXVI*, 1. Both sides **MM**]

Not acknowledged by Hadeln; in our opinion nearer in style to Aliense on the basis of No. **12** and No. **14**.

3 FLORENCE, UFFIZI, 1830. Pluto enthroned and surrounded by his Court. Pen and bistre, height. w. wh., on yellowish. 370 x 280. Publ. by Charles Loeser, in *Uffizi Publ.* I, p. 2, no. 10, as by Jacopo Tintoretto, and "more likely an unfinished drawing to be later on more thoroughly completed than a sketch for a painting."

The combination of elements recalling Tintoretto and those resembling Cambiaso makes us attribute the drawing to Aliense to whose predilection for drawing-for-its-own-sake the general style corresponds. The Bolognese Odoardo Fialetti (1573–1638) should, however, also be taken into consideration. He moved to Venice as an admirer of Tintoretto and, according to the testimony of his pupil Marco Boschini, (recorded in Malvasia, *Felsina Pittrice*, ed. of 1841, p. 233 ff.) specialized in broad pen drawings executed in huge sizes.

4 ————, 1875F. Venus and Adonis. Pen. 252 x 351. O. Giglioli, in *Boll. d'A.* 1937, p. 542, attr. the drawing to Luca Cambiaso.

[*Pl. CXXXVII*, 2. **MM**]

We believe the traditional attribution to Aliense to be correct because of Ridolfi's statement (II, p. 219) concerning Aliense's successful imitation of Cambiaso's drawings. The relationship of the drawing style to that of No. **12** confirms the attribution.

5 ————, 12894. Moses and David seated on clouds. Pen, gray, wash, on blue prepared paper. 195 x 255. — *On verso:* Saints, Madonna and Child, the Virgin from an Annunciation. Pen, on yellowish wh. Inscription: de Mg. Paolo Veronese.

While the *recto* displays the characteristics of a copy, the sketches on the back are closer to Veronese's style about 1565, but might be by a close follower rather than by himself. We attribute the drawing (ascr. to Paolo Veronese in the Uffizi) to Aliense, with whose well-authenticated drawing in Christchurch, No. **14**, the resemblance seems convincing. The drawing might be one of those that in the youthful Aliense sold to Antonio dalle Anticaglie when he left Veronese's studio.

6 HAARLEM, COLL. KOENIGS, I 394. Resurrection of Christ. Bl. ch., slightly washed with br., height. w. wh. 412 x 276. Squared, the squares inscribed in part with numbers. At the bottom, inscription and no. 179, both cut. — *On verso:* hasty sketch, a woman rushing forward. Coll. Julius Boehler, Ascr. to Domenico Tintoretto. — [**MM**]

In our opinion, by Aliense, and the large drawing *"in chiaroscuro"* — or its preparation — made by him for the painting of the subject in San Marceliano, Venice, signed and dated 1586; according to Ridolfi II, p. 211, Aliense presented the drawing to Passignano who painted the Crucifixion on the opposite wall. Ridolfi's description of the painting runs: "Christ rising from the dead surrounded by flying angels who hold the tools of his passion in their hands, while the

guardians below awakened by rays from heaven are shown in lively postures."

7 LONDON, BRITISH MUSEUM, 1895–9–15 — 842. Design for an altar-piece: four Saints seated; above in clouds, God the Father. Over bl. ch., pen, br., wash. Semicircular top. Ascr. to Paolo Veronese.

In our opinion the design, another version of which is No. **8**, shows some affinity with Veronese for the invention — compare his painting in San Giuliano, anterior to 1584, ill. *Mostra Veronese* 1939, no. 88 — while the style of drawing is different and perhaps closer to Aliense.

8 ————, 1895–9–15 — 843. Design for an altarpiece, Bishop Saint between St. Mark and St. George; God the Father above. Pen, br., wash; semicircular top. 301 x 139. [**MM**]

Deviating version of No. 7.

9 ————, 1895–9–15 — 850. The Virgin and Child enthroned between two Saints. Ornamental border. Pen, br., wash. 415 x 306. The architectural lines were drawn with a ruler. — On the back, long contract of December 13, 1583, signed by the painter and the commissioner Zan Bata di Bugati (. . fu acetado questo oltra schrito disegno per precio de duchati cinquanta da lire sei e soldi quattro per duchato a tute sue spese si de tela chome de cholori de azuri oltra (marini) et altri cholori finissimi). [*Pl. CXXXVI*, 4. **MM**]

Simplified version of the drawing No. **16**. Important as an early work. Perhaps for a church banner.

10 ————, 1895–9–15 — 852. Christ and the patriarchs, at l. a female Saint; angels flying and carrying the tools of the Passion of Christ. Broad pen, br. 244 x 365. Coll. Malcolm (Robinson 403). Ascr. to Jacopo Tintoretto. [*Pl. CXXXVIII*, 1. **MM**]

The drawing seems to be a study for a ceiling in oval shape. In our opinion it might be a design for Aliense's planned painting for the choir of the church of S. Justina, Venice, never executed. Ridolfi II, p. 215: Aliense made an outstanding drawing of Christ rising toward Heaven accompanied by a number of patriarchs and angels carrying in triumph the symbols of the Passion of Christ.

11 ————, P.p. 3/191. The Massacre of the Innocents; three senators on both sides. Brush, br., wash, on yellow. Squared in ch. 253 x 371. Ascr. to Jacopo Tintoretto.

Attr. for reasons of style. [**MM**]

12 MILAN, COLL. RASINI. Men wrestling in a boat. Pen. 160 x 200. Damaged in upper r. corner. Coll. Guidini. Publ. by Morassi, Rasini, pl. XXI, p. 30 f. as Titian (?), with reference to the drawings No. **901** and to Titian's ceilings in the sacristy of Santa Maria della Salute, Venice. Morassi finds, moreover, evident connections with Palma Giovine's style. Ragghianti, in *Crit. d'A.* XI/XII, p. XXXVII, rejects the attribution to Titian and gives the drawing to Palma Giovine.

[*Pl. CXXXVII*, 1. **MM**]

The drawing is a sketch for the group in the foreground of Aliense's painting in the ceiling of the Sala del Maggior Consiglio in the Ducal Palace, representing Carlo Zeno routing the enemy (see Bardi, p. 56, Ridolfi II, p. 209, Moschini I, p. 466). The decoration was executed between 1578 and 1585. The figure of the tumbling man repeats in reverse the figure of St. Lawrence in Titian's Martyrdom of this saint in the Gesuiti in Venice (ill. Tietze, *Titian*, 218).

13 MODENA, PINACOTECA ESTENSE, 1175. Conversion of St. Paul. Broad pen and wash, br., on buff. 382 x 270. Lower l. corner torn off. Design for a ceiling. Ascr. to Palma Giovine. (on the mount). **[MM]**

Our tentative attribution to Aliense is based on the combination of a Venetian character with Cambiaso's style. See No. **4**. Ridolfi reports (II, p. 89 f.) that Dario Varotari painted this subject on the ceiling of SS. Apostoli in Venice. His paintings formed part of a greater decoration commissioned of Aliense, who may have made the designs for his helpers. The circumstances mentioned also make possible Varotari's authorship, by whom no material is available for comparison.

14 OXFORD, CHRISTCHURCH LIBRARY, L 25. Sheet with sketches for an Annunciation. Pen, br., on yellow. 278 x 207. — *On verso:* in Carlo Ridolfi's handwriting: Antonio Vasilacchi. Coll. Carlo Ridolfi. *[Pl. CXXXVI, 2.* **MM]**

The drawing style is influenced by Veronese in whose shop Aliense was trained (Ridolfi II, p. 207 s.).

15 OXFORD, ASHMOLEAN MUSEUM. Christ bearing the cross. Broad pen over ch. sketch, br., wash. — *On verso:* Studies of single limbs. Ascr. to L. Cambiaso. **[MM]**

Dr. Parker pointed out orally the Venetian character of the drawing. This combination is our argument in favor of Aliense, see No. **4**.

16 PARIS, LOUVRE, 5505. Virgin and Child enthroned between two Saints, in an architectural frame containing the four Evangelists; in the predella five other saints. — On the back, a long contract dated December 13, 1583, signed by Aliense and the commissioners and fixing the price at 80 ducats. Publ. by us *in Crit. d'A.* VIII, 1937, p 79, fig. 3. *[Pl. CXXXVI, 3.* **MM]**

The design is a richer version of No. **9**.

17 ⸺, 5737. Adoration of the shepherds. Pen, br., on paper turned yellow. 170 x 132. At the top an added strip on which the composition continues. In the collection anonymous. **[MM]**

Our tentative attribution rests on the stylistic resemblance to drawings authenticated for Aliense, as for instance No. **12** and No. **10**. Note also reminiscences of Paolo Veronese.

18 ⸺, 5760. Flagellation of Christ. Brush, br., wash, height. w. wh., on yellow. 300 x 283. Inscription (18th century): Antonio Vasilacco Aliense. **[MM]**

19 VIENNA, ALBERTINA, 103. Saints appearing in the clouds during a battle. Pen, br., wash. 231 x 346. The former attribution to Jacopo Tintoretto was rejected in *Albertina Cat.* I (Wickhoff), 128. *Albertina Cat.* II (Stix-Fröhlich) 103 lists the drawing under School of Tintoretto. E. Tietze-Conrat, in *Graph. Künste* N.S.I., p. 100, fig. 9, proposed Luca Cambiaso. **[MM]**

The predominance of a general Venetian character makes us believe that the drawing is one of those that Aliense made in imitation of Cambiaso. A drawing somewhat different in style and subject, but definitely related to the Albertina drawing with which several figures correspond exactly, was signed Giulio Benso in Sale Sotheby December 9/10, 1920, No. 29. (Not ill., Photo Witt). Since Giulio Benson (1609–68) was a Genoese, his drawing might go back to the same composition by Cambiaso as Aliense's drawing.

A ⸺, 124. See No. **2240**.

A 20 ⸺, 125. The plague in Venice. Pen, wash. 223 x 190. Later inscription: Swart Jan. 1526. The former attribution to the Flemish School is changed to one to Aliense in *Albertina Cat. II,* (Stix-Fröhlich), probably on the basis of No. **2240**. **[MM]**

In spite of some resemblance to this drawing, in our opinion by Vicentino, the northern character is predominant. In this context we point to the information found in Boschini-Zanetti (1733, p. 148) according to which a painting, "The Scourge of the Plague" by the French painter Pierre Vanei (whom we are unable to identify) existed in an annex of the Ducal Palace.

POMPONIO AMALTEO
[1505–1588]

An explanation is scarcely necessary as to why a secondary and provincial artist like Pomponio Amalteo — although considered worthy of a monograph (Ruggiero Zotti, *P. Amalteo,* Udine, 1905) — cannot be defined as a draftsman. It would perhaps be more necessary to explain why such a man, who spent all his life in the province of Friuli — the least Venetian in spirit of the possessions of the Republic on the mainland — has been included at all in this Catalogue of Venetian Drawings. We have done so because of his close approximation to Pordenone, whose figure in spite of his Friulan origin and predominantly provincial career looms so large in the history of Venetian painting in the High Renaissance. The little we have to say about Amalteo's drawings is to be understood as a corollary to our remarks about those of Pordenone. Like Fiocco, we suggest the name of Amalteo for some drawings which seem to turn Pordenone's style into a coarser expression. A means for a more objective distinction is offered by No. 23 in New York, in which an old inscription corroborates the conclusions of art criticism. In another case, No. 27, auxiliary evidence is offered by the resemblance to a Pordenonesque mural, claimed for Pomponio Amalteo by more recent studies.

21 BERLIN, KUPFERSTICHKABINETT, 5176. Scene from Roman history (?). Pen, wash, height. with wh., on blue, here and there dark gray touches, white lead oxidized. 238 x 278. Ascr. to Pordenone, but apparently not accepted by Hadeln. [**MM**]

The draftsmanship has no analogy in any known drawing by Pordenone, while the composition and the poses reflect his style. Our attribution to Amalteo, based on a certain relationship to No. **23**, is merely hypothetical.

22 LONDON, BRITISH MUSEUM, 1895–9–15 — 822. Sketch for martyrdom of St. Peter the Martyr. Pen, bl. wash. 137 x 146. Coll. T. Lawrence, Reynolds, Esdaile, Malcolm. Exh. in École des Beaux Arts, Paris, 1879, No. 200, as Titian; again attr. to him by L. Fröhlich-Bum in *Burl. Mag.* 1927 p. 228 as one of his sketches for his painting in S. Giovanni e Paolo. [**MM**]

We rejected this attribution in our *Tizian-Studien* (p. 154) without suggesting another author. The relationship to the fairly well-authenticated No. **23** justifies the attribution to P. Amalteo.

23 NEW YORK, PIERPONT MORGAN LIBRARY, IV/70. Flight to Egypt. Pen, br. wash, height. with wh., on blue. 205 x 240. Inscription: del Amaleo. — Back: Draperies for the Virgin and the Child on the principal side; kneeling nude. Coll. Esdaile, Thane, Cosway, Richardson, Robinson. The spontaneity of the sketch is well-illustrated by the numerous "pentimenti" in the figure of St. Joseph.

[*Pl. XCV*, 1. **MM**]

The general character corresponds to the style of Amalteo's paintings, thus corroborating the old inscription.

24 PARIS, LOUVRE, 5425. Judgment of Daniel. Brush, wash, height. w. wh., on blue. 237 x 422. Damaged, at l. a strip is added. Later inscription: manu propria del Pordenone. In the Louvre anonymous.

[*Pl. XCV*, 3. **MM**]

Exactly conforming to Ridolfi's description (I, 116) of a mural in the Loggia in Ceneda, attr. by him — and before him by Lomazzo (Trattato II, p. 45) — to Pordenone, but painted by Pompeo Amalteo 1534–36, as established by Girolamo de' Renaldis (*Della Pittura Friulana*, Udine 1798, p. 51). Compare Zotti (*Amalteo*, p. 138) and Fiocco (*Pordenone*, p. 140). The fresco still exists, but we had no opportunity of checking it. A copy showing very slight deviations from the Louvre drawing appeared in the Sale at Sotheby's May 22, 1928, No. 77 (Photo Witt).

25 TURIN, BIBLIOTECA REALE, 15915. Christ nailed to the cross. Pen, reddish br. wash, on faded blue. Squared in ch. 205 x 411. A few stains from mold. Two top corners restored. [**MM**]

Attr. to Pordenone, whose characteristics appear somewhat modified, so that an attribution to a follower like Amalteo seems safer. Moreover, the style of the drawing approaches Amalteo's more closely than Pordenone's, in whose authentic work this technique is not traceable.

26 VIENNA, ALBERTINA, Reserve. Scene from Roman history (?). Pen, br. wash, on faded blue. Squared. 249 x 195. Old inscription: Pomponio Amalteo.

The ascription to Amalteo was accepted by *Albertina Cat. I* (Wickhoff) 203, but the drawing is not listed in *Albertina Cat. II* (Stix-Fröhlich) and is kept in the reserve.

27 ——, Reserve. Two biblical figures fallen on the ground. Pen and brush, height. w. wh., on blue. 202 x 361. Inscription: Paris Bordone. *Albertina Cat.* I (Wickhoff) 141: Copy after a study by Titian for his St. Peter the Martyr. Hadeln, *Hochren.*, pl. 50: Pordenone, study for a Conversion of St. Paul. *Albertina Cat.* II (Stix-Fröhlich) p. IX, note: copy from a drawing by Pordenone. Fiocco (*Pordenone*, pl. 181, p. 155): original by Pordenone, study for a Transfiguration, utilized by Pomponio Amalteo in a painting in the Cathedral of Oderzo (ill. in Zotti, *Pomponio Amalteo*, p. 80).

The solution of these uncertainties seems to be that the drawing, which by its coarse linework resembles No. **29**, is by Amalteo himself.

28 WINDSOR, ROYAL LIBRARY, 4775. Adoration of the Magi. Over ch. sketch, pen, br., on yellow. 258 x 305. [**MM**]

In the collection attr. to Pordenone, but from a certain resemblance with the fresco of the same subject by Amalteo in S. Vito, Chiesa dei Battuti (reproduced in Rug. Zotti, *Pomponio Amalteo*, 1905, p. 12) perhaps a working drawing from the shop of Amalteo.

29 ——, 6660. Two evangelists. Design for the ceiling in the parish church in Lestans (ill. Fiocco, *Pordenone*, pl. 203). Red ch., height. w. wh. 240 x 166. Upper corners cut.

Publ. by Hadeln, *Hochren.*, pl. 31, as by Pordenone, but rightly revindicated for Pomponio Amalteo by Fiocco, pl. 204, p. 152, who recognized the use of the drawing for the ceiling in Lestans.

30 ——, 6661. Angels playing music. Design as No. **29**. Red ch., height. w. wh., on blue. 247 x 185. Later inscription: de man del Pordenō. Hadeln, *Hochren.*, pl. 32: Pordenone. Fiocco, *Pordenone*, pl. 206, p. 152: Pomp. Amalteo, see No. **29**.

31 ——, 6662. Saint Lucas and another evangelist. Design as No. **29**. Red ch., height. w. wh. 213 x 183. Late inscription: de man del Pordenone. Hadeln, *Hochren.*, pl. 30: Pordenone. Fiocco, *Pordenone*, pl. 205, p. 152: Pomp. Amalteo, see No. **29**.

ANDREA DA MURANO
[*Mentioned 1462 to 1507*]

The name of Andrea da Murano has been written by a later hand on the drawing No. **32**. This artist is erroneously called the teacher of Alvise Vivarini by Ridolfi (I, p. 36), who, as van Marle (XVIII, p. 524) points out, overrated his importance. This bit of literary reputation may have induced some owner of the drawing to write the name Andrea Murano upon it in spite of the evident difference in style. Andrea da Murano is revealed by his authentic works as a close and poor follower of Bartolomeo Vivarini, with whom he collaborated on a painting in

the Scuola di San Marco in 1467 (L. Venturi, *Origini,* p. 185). A drawing in Chantilly, attr. to Bartolomeo Vivarini by Byam Shaw (see No. **2251**), may more probably be by Andrea: it shows a marked resemblance to his principal work, the altar-piece of Mussolente.

32 BAYONNE, MUSÉE BONNAT, 688. Design for a triptych, with the Virgin and Child in the center, and the Saints Sebastian and Peter in the wings; the body of Christ, supported by a bearded man in the top. Pen and brush, red (for the architecture) and blue (for the figures), on paper turned yellow. 340 x 246. Inscription in br. ink: Andrea Murano f^t. **[MM]**

The style of the drawing can hardly be reconciled with the paintings by Andrea; the draftsman is one of the minor masters of the Bellinesque tradition, typical of the early 16th century. The drawing is too poor to venture attribution to an individual artist.

BATTISTA ANGOLO, CALLED DAL MORO
[Born about 1514, died about 1574]

Battista's date of birth can be reconstructed only from the fact that as early as 1568 Vasari mentions his son Marco as his collaborator in Murano, where Battista's activity started about 1557. As for the date of his death, in 1573 Battista made his last will (Ludwig, *Archivalische Beiträge,* p. 117 ff.) and in 1574 is already mentioned as being dead. Vasari praises him as a miniaturist and engraver. The engravings in question, confused by their very different signatures, up to now have not been sifted and thus can hardly offer a clue to Battista's activity as a draftsman. (Compare No. **38** with the corresponding engraving ill. Pittaluga, fig. 236).

The best-authenticated drawings are the two that belonged to Vasari, No. **39**; a copy of one of them, in Dresden, had erroneously been published as by Paolo Veronese. Almost as reliable is the attribution to Battista of No. **37** in Oxford, supported by Ridolfi's authority; only a little less trustworthy is that of No. **36**, going back to Padre Resta. Adding to all these a drawing in London, supported only by an old inscription (No. **34**) and another drawing there, No. **35**, stylistically closely related, we gain a general idea of Battista's drawing style which is easier to describe in a negative than in a positive manner. We feel the non-Venetian element so predominant that we are tempted to drop Battista altogether, although he is closely linked to Venetian art. There are contacts with Paolo Veronese in the compositions, possibly to be explained by the common origin and early collaboration of the two artists, contacts with Schiavone that may be explained by a similar acceptance of Parmegianino's influence. Battista's own influence in Venice — which, to be sure, can only insufficiently be judged since most of the external murals there have been lost — is limited to his sons, who carry on a kind of family style.

A 33 CHELTENHAM, FENWICK COLL., Cat. p. 67, 1. Christ carrying the cross. Brush, pink and violet, height. w. wh. oil color, on pink. 267 x 180. Arched top. Coll. T. Hudson, C. Rogers. Formerly ascr. to Palma Giovine or to Luis Morales. Attr. to Batt. dal Moro by Popham in *Fenwick Cat.* with reference to the peculiar technique and style typical of him. **[MM]**
We cannot agree with Popham and recognize hardly any Venetian features in the drawing.

34 LONDON, BRITISH MUSEUM, 1920-11-16 — 2. Design for the decoration of an apsis, with Resurrection of Christ in the center and writing prophets in the architectural frame. Over ch. sketch, brush, red, height. w. wh., on yellowish. 198 x 261. Later inscription: Baptista del Moro. Publ. by Hadeln, *Spätren.,* pl. 17.
The attribution is mainly based on the inscription.

35 ————, 1920-11-16 — 3. Lamentation over the body of Christ

between the standing figures of St. Nicholas and St. Catherine. Over ch. sketch, brush, red, height. w. wh., on yellow. 176 x 262. Cut. Publ. by Hadeln, *Spätren.,* pl. 16.
The attribution rests on the technical resemblance to No. **34** and the stylistic resemblance to the drawing No. **37** authenticated by Ridolfi.

36 MILAN, AMBROSIANA, Resta Coll. Exhibited. Design for an altarpiece: Virgin and Child in clouds between two angels, beneath John the Baptist, Anthony Abbot and two other saints. Pen, bl., height. w. wh., on yellowish-brown tinted paper. About 370 x 220.
The attribution to Batt. dal Moro goes back to Padre Resta and may be trustworthy.

37 OXFORD, CHRISTCHURCH LIBRARY I 9. Saint Agnes in glory surrounded by saints and worshipped by a kneeling crowd. Pen, bl.,

wash, height. w. wh., on faded blue. 350 x 263. Semicircular top. — *On verso:* other version of the same subject. Pen. Ridolfi Coll.

[*Pl. CXXXII, 2.* **MM**]

The attribution to Batt. dal Moro goes back to Ridolfi and may be trustworthy.

38 PARIS, LOUVRE, 5081. Bearded saint standing in adoration. Pen, br. 330 x 165. Cut in oval. — *On verso:* inscription in a handwriting of the 16th century: de mã di m. Batista del moro. [**MM**]

Design for Moro's engraving (*in reverse*) St. Roch, ill. Pittaluga (p. 296, fig. 236). The engraving is enriched by a tree and a dog.

39 ————, 5080. Flagellation of Christ in a lunette and Pietà, both drawings mounted in the fashion typical of Vasari. Pen, br., wash, on yellowish. 250 x 380, 191 x 117, resp. Inscription in pen: Battista del Moro. A former inscription "Paolino Pitt. Veronese" is cancelled. A copy of the Pietà is in Dresden and has been published as Paolo Veronese in Meissner, fig. 38, see No. 2058. Publ. by Otto Kurz, *O. M. D.* XLV, pl. 14. [**MM**]

GIULIO ANGOLO, CALLED DAL MORO
[*First mentioned 1573, last 1615*]

Giulio worked as a sculptor, an architect, and a painter. Thieme-Becker, v. I, p. 520, following Zanetti, erroneously calls him a brother of Battista (corrected by Ludwig, *Archivalische Beiträge*, p. 116). Vasari, who was already dead in 1578, owned a drawing, No. **41**, by him, too, which offers us a point of departure for the study of his style. The most important drawing from Giulio's later period is the sketch No. **40** for the mural painted by Giulio in the Ducal Palace to replace a painting by Francesco Bassano which rain had destroyed. The composition of Bassano still shows through the right half of the picture in contrast with the greater looseness of the other half. In the finished painting, a powerful female figure is added in the foreground to counterbalance the youth on the right. The drawing used to be ascribed to Jacopo Tintoretto before we published it in *Critica d'Arte* VIII. This fact reminds us how forcibly Tintoretto's "Ducal Palace style" influenced all decorative painting in Venice.

40 FLORENCE, UFFIZI, 1831. Design for Giulio dal Moro's mural: Doge Ziani receiving eight white banners from Pope Alexander III, in the Sala del Maggior Consiglio in the Ducal Palace. Over ch. sketch, pen, bl., wash, on greenish paper. 370 x 300. Formerly ascr. to Jacopo Tintoretto, identified and publ. in H. Tietze — E. Tietze-Conrat, *Critica d'A.* VIII, p. 78, pl. 60. [*Pl. CXXXIII, 1.* **MM**]

The painting deviates in many points from the design.

41 PARIS, LOUVRE, 5083. Venus lamenting over the dead Adonis. Brush, blue and wh., on greenish-blue. 370 x 361. Coll. Vasari. Mounted in the frame typical of this collection. Otto Kurz in *O. M. D.* XLVII, p. 43. [*Pl. CXXXII, 3.* **MM**]

The drawing must be a very early production by Giulio, since he was born only in 1555 and Vasari died in 1578.

MARCO ANGOLO, CALLED DAL MORO
[*Born about 1537, died after 1586*]

A drawing by Marco from Vasari's Album (No. **47**) showing an especially child-like awkwardness and a marked dependence on Dürer, as well as his collaboration in his father's murals in the Palazzo Trevisani, Murano (mentioned by Vasari) allow a conjecture as to his date of birth. Like his father, Marco was also a miniaturist and engraver. His dependence on Battista is well demonstrated by No. **42** (compare No. **39**) and No. **43** (compare No. **37**). His importance for Venice is negligible.

42 CHATSWORTH, DUKE OF DEVONSHIRE, 231. Resurrection of Christ. Pen, br., wash, height. w. wh. 431 x 335. Inscription on the shield in lower l. corner: Mar^co Angolo IV. F. MDLXX. [*Pl. CXXXII, 1.* **MM**]

On verso: Studies including one for the r. arm of the Virgin. Bl. ch. Lawrence-Woodburn Sale, lot 885. [**MM**]

The old attribution accepted by Popham in Fenwick Cat. seems convincing.

43 CHELTENHAM, FENWICK COLL. Cat. p. 67, 1. Virgin and Child surrounded by female saints and a donor. Three-quarter length. Pen, br., wash, on green. 149 x 201. Old inscription: Marco del Moro —

44 ————, Cat. p. 68, 2. Design for an altar-piece: Coronation of the Virgin with saints. Pen, br., wash. 252 x 182. Arched top. Coll. Lord Spencer. E. Coxe, W. Esdaile, Lawrence-Woodburn Sale, lot

662. Formerly ascr. to Federigo Zuccaro, tentatively attr. to Marco del Moro by Popham. **[MM]**

45 London, British Museum, 1895-9-15 — 796. Esther kneeling before Ahassuerus. Pen, br., blue wash, height. w. wh., on blue. 360 x 258. Old inscription: Marci Battiste del moro Veron. Formerly ascr. to Battista dal Moro, publ. as Marco dal Moro by Hadeln, *Spätren.*, pl. 18.

A 46 London, Coll. Sir Robert Mond, No. 170. Women playing musical instruments. Pen, wash in gray. 133 x 168. Old inscription:

Marco del Moro. Publ. as "Four Muses" and ill. in Borenius-Witkower, pl. XXV.

In our opinion bears no connection with Marco dal Moro.

47 Paris, Louvre, 5084. Christ carrying the cross. Bl. ch. and pen, br. 290 x 290. Coll. Vasari, mounted in the frame typical of this collection. Mentioned by O. Kurz in O. M. D. 1937, Dec., p. 43. **[MM]**

The composition, very much influenced by Dürer, shows a style somewhat different from the other drawings by Marco. The drawing already owned by Vasari may be an especially early production.

BALDASSARE D'ANNA
[Born c.1560, died 1639]

Pupil of Lionardo Corona, with whom he apparently remained in touch until the latter's death in 1605; on the other hand, already mentioned as an independent artist in 1593. Resta's attribution to Baldassare of No. **48** which in style resembles pen drawings by Peranda — incidentally another pupil of Corona — seems convincing. There exists a certain relationship between this "Adoration of the Shepherds" and the painting of the same subject in the Academy in Venice, publ. under the name of Matteo Ponzone in Venturi 9, VII, fig. 164. Ponzone was also a pupil of Peranda. Evidently all these artists knew and influenced one another.

48 Milan, Ambrosiana, Resta 105. Adoration of the shepherds. Pen, br., wash in violet, on paper turned slightly yellow. 299 x 187. Semicircular top. Inscription on the mount in Resta's handwriting: Baldissera de Ana Venetiano pittore.

The figures in the foreground seen from behind, very much in

L. Corona's style of composition, remind us of corresponding figures in the painting Ecce Homo (Ateneo Veneto, Venice) which is ascr. to d'Anna by Boschini, Minere, S. Marco, p. 98, and to Corona, only finished by d'Anna (resp. by Corona's pupils) by Ridolfi II, 107 (ill. Venturi 9, VII, p. 258 fig. 157). **[MM]**

ANTONELLO DA MESSINA
[Born about 1430, died 1479, active in Venice 1475–76]

Numerous attributions have been made to Antonello whose artistic figure, subject, or supposedly subject to heterogeneous influences, attracted such suggestions. None, however, has withstood a thorough critical investigation. Neither Lauts, in his monograph in *Jahrb. K. H. Samml.*, N. S. VII, p. 79, nor van Marle (XV, p. 538) acknowledges the authenticity of any. In accordance with this wide range of Antonello's artistic personality, the erroneous attributions stretch from a representative of the "soft" international style of the middle of the 15th century to Antonello's followers in Venice. No. **51** in the Albertina contains a remnant of Antonello's spirit transformed into a more realistic attitude by his legitimate heir, Alvise Vivarini. We may, by the way, speculate as to whether Antonello's style of drawing, formed under quite different conditions, was after all so close to the Venetian tradition as is at times taken for granted.

A 48 bis Berlin, Kupferstichkabinett, 1552. Bust of a beardless man in profile. Metalpoint (according to Lauts, brush) on brownish tinted paper. 170 x 123. Coll. Robinson. Charles Loeser in *Rep.f.K.W.* XXV, p. 355 rejected the traditional ascr. to Antonello da Messina and suggested as the author a minor Venetian painter of the late 15th century. Publ. in *Berlin Publ.* I, pl. 71 as Antonello(?) Lauts, in *Jahrb. K. H. Samml.* N. S. VII, p. 79 accepted Loeser's suggestion in view of the dry brushwork and of the pure profile incompatible with Antonello. **[MM]**

A 49 Frankfort/M., Staedelsches Kunstinstitut. The thief on the cross. Silverpoint, on prepared wh. paper. 128 x 183. Publ. in *Staedel Dr.* VIII, pl. 5 as anonymous Italian, first half of 15th century. Attr. by Frizzoni, *L'Arte* 1913, p. 167, to a predecessor of Antonello da Messina, by Meder, *Handz.* p. 390, to a Netherlands artist of the second half of the 15th century, by G. Glück, *Burl. Mag.* XLI, p. 270, (and again in *Aus drei Jahrhunderten europäischer Malerei*, Vienna, 1933, p. 263–267) to Antonello himself, with reference to Antonello's Crucifixions in Antwerp and in London. G. Swarzenski, *Vorträge*

der Bibliothek Warburg 1926–1927, p. 22 ff., attr. the drawing to an artist from the circle of the "Master of Rimini," without deciding whether he was German or Italian. This suggestion was accepted by Lauts in *Jahr. K. H. Samml.*, N. S. VII, p. 79, while van Marle XV, p. 538, limits himself to rejecting the attribution to Antonello.

A 50 LONDON, BRITISH MUSEUM, 1895-9-15 — 789. Portrait of a beardless man, turned three quarters to left. Over ch. sketch, pen, bl., height. with wh., oxidized, on blue. 346 x 250. Stained by mold. Inscriptions: H. Holbein, and below: venti (?) Malcolm Coll. (Robinson *Cat.* no. 342: anonymous). Ascr. to Antonello by Morelli, II, p. 194, note (ill.), an attribution rejected by Lionello Venturi, *Origini*, p. 234, who gives the drawing to a poor imitator of A. Solario, and by Hadeln, *Quattrocento*, p. 17, note, who considers the drawing a copy. The attribution is also rejected by van Marle XV, p. 438, note, and by Lauts, in *Jahrb. K. H. Samml.*, N. S. VII, p. 79, who joins in the opinion of L. Venturi. [MM]

A 51 VIENNA, ALBERTINA, 30. Portrait of a boy. Bl. ch., on br. 337 x 276. Formerly ascr. to Gentile Bellini by *Albertina Cat. I* (Wickhoff) and by Schönbrunner-Meder, 594 to Francesco Bonsignori. First publ. as Antonello da Messina by A. Venturi, *L'Arte* XXIV, p. 71, followed by Parker, 35, and *Albertina Cat. II* (Stix-Fröhlich) with reference to the portraits in the Kaiser-Friedrich-Museum in Berlin (No. 18, ill. van Marle XV, fig. 325), in Milan, Museo Civico (ill. van Marle fig. 326), and the Madonna, formerly in the Benson Coll., London (ill. van Marle fig. 322). The attribution was rejected by van Marle (XV, p. 538, note) and Lauts, (*Jahrb. K. H. Samml.*, N. S. VII, p. 79), who attributes the drawing to a Venetian painter under the influence of Antonello, in the direction of Alvise Vivarini.
 [*Pl. XXVI*, 1. **MM**]

In our opinion, too, the drawing is advanced over Antonello's period and is nearer to Alvise Vivarini, with whose portraits (N. G. no. 2509, ill. Venturi 7, IV, fig. 251 and Bergamo, ibidem fig. 243) we find a marked resemblance. It is true that the mode of drawing of No. **2245** offers no confirmation.

STEFANO DALL' ARZERE

[Active in the middle of 16th century]

Local painter of Padua, called a pupil of Titian by Michiel, and stylistically related to Domenico Campagnola. From our point of view, his main interest rests on his being an example of the disintegration of Titian's style in provincial activity.

52 MALVERN, ENGLAND, MRS. JULIA RAYNER WOOD (SKIPPES COLL.). Sketch of an altar-piece, St. Barbara standing between St. Anthony and St. John the Baptist, in clouds Madonna and Child surrounded by angels. Pen, br., wash, on greenish blue. 249 x 185. Anonymous. [*Pl. LXXXII*, 1. **MM**]

Design for Stefano dall'Arzere's altarpiece, now in the Museo Civico in Padua, ill. Venturi 9, VII, fig. 11, p. 26. Note the striking difference in proportion in the figures of both versions.

CAMILLO BALLINI

[Active in the second half of the 16th century]

According to Thieme-Becker II, p. 420, a pupil of Palma Giovine, although he calls himself a pupil of Titian in two signatures of 1574 and 1578. One drawing is well-authenticated for Ballini, No. **53**, an academic study which offers no further help. The attribution of No. **54** to him by Resta may be correct as the drawing recalls the theatrical showiness of Ballini's Victory of Trapani in the Ducal Palace (Photo Boehm 495).

53 BESANÇON, MUSÉE, 1008. Lower part of an écorché; one leg only outlined. Pen, reddish br. 301 x 178. Signed with the same ink: Camillo Ballino.
Academic study.

54 MILAN, AMBROSIANA, Resta 140. Christ carrying the cross, design for a tympanum, in ornamental frame. Pen, br., wash, on paper turned yellow. 268 x 378. In lower l. corner inscription in Padre Resta's handwriting: *Camillo Ballini*. [*Pl. CLXXXIV*, 1. **MM**]

55 STOCKHOLM, NATIONAL MUSEUM, 1399. Allegorical composition, design for a ceiling. Pen, br., wash. 225 x 354. Late inscriptions: *Cabinet Crozat* — and — *Tintoret*. Sirén, Cat. 1917, 465: School of Tintoretto. [MM]

The drawing represents the same subject as Ballini's ceiling in the Ducal Palace, ill. Venturi 9, VII, fig. 86, p. 149: The Lord — in the painting God the Father, in the drawing, Jesus — in glory with Saint Mark and S. Justina in small figures; Venezia enthroned, crowned by a female genius, fettered Turks on the steps of the throne. The two compositions are different, the one in the drawing enriched, moreover, by the group of the donors. We list the drawing, nevertheless, among Ballini's, since the style of drawing seems somewhat similar to No. **54**. The drawing is to be dated soon after 1572, the battle of Lepanto.

56 VIENNA, ALBERTINA, Reserve, 119. Portrait of a beardless man, to the r. Red ch. 110 x 83. Traditionally ascr. to Camillo Ballini. *Albertina Cat. I* (Wickhoff 292).

JACOPO DE' BARBARI

[Circa 1440–50 to circa 1515]

Although there are two lines of approach to Jacopo de' Barbari as a draftsman, from his engravings and from his relation to Dürer, his figure as such has not been sufficiently clarified. Well-known as a result of his connection with Albrecht Dürer, he had become a generic name used for all kinds of drawings on the borderline between Italian and Northern art; Hevesy's cautious criticism in his monograph and in several articles was mostly limited to a clearing of the ground. What remained is little enough: No. **62**, the design for Barbari's engraving, Kristeller 28, oddly misnamed Cleopatra, is very useful as it is well-authenticated by its connection with the engraving, but rather useless for our purposes because of its character as a final preparation of an engraving. Also, two drawings in the Uffizi, Nos. **60, 61**, so strikingly graphic in their rendering that Hevesy suggested they might both be copied from lost engravings by Barbari. This suggestion does not seem convincing to us. In our opinion, the drawings might well be originals. Finally, the "Dead Partridge" in the B. M., No. **64**, the attribution of which rests on its belonging in a category of still life, which we have become accustomed to giving to Barbari (painting in Munich, signed and dated 1504).

To these rather unsatisfactory gleanings we add two drawings (No. **68** and No. **71**) which at least have the merit of offering fascinating puzzles.

A 57 AMSTERDAM, COLL. VAN REGTEREN ALTENA. Female maritime deity, riding on a dolphin. Penn, light-br. cut into an oval. 199 x 149. Exh. Amsterdam 1934, *Cat.* No. 649 as Barbari.

In our opinion, the resemblance to Barbari is only superficial and rests on a general resemblance of types. The drawing shows a routine which does not correspond to Barbari's graphic style. **[MM]**

A 58 DRESDEN, KUPFERSTICHSAMMLUNG. Maritime centaur making love. Pen. 116 x 182. Collections Mariette, Lawrence, Woodburn. Formerly ascr. to Lorenzo di Credi, then attr. to Barbari by Thausing, *Dürer*, I, p. 299, and Morelli, *Italian Paintings,* p. 224. Publ. by Woermann, *Dresden,* I, pl. 25, No. 34, who mentions that Kristeller, A. Venturi, F. Lippmann question the attribution to Barbari, with whose doubts he agrees. Kristeller and Fabriczy in *L'Arte* VIII, p. 410, C. Ricci, in *L'Arte* XVIII, p. 112, and M. J. Friedländer, *Repertorium* XX, p. 73, suggest Aspertini. Hevesy, *Barbari,* p. 42, and van Marle XVIII, p. 478, give the drawing more generally to a follower of Mantegna. **[MM]**

We believe the attribution to Aspertini more correct than any other although it is not completely convincing.

A 59 FLORENCE, UFFIZI, 1341. Saint Sebastian, tied to the tree by a naked man (?). Pen, dark br. 144 x 123. Cut. The wand of Mercury added later in another ink. — *On verso:* Sketch of a standing woman holding a shield (?). Inscription: Brandonelli (?). (Photo Braun 764, Cipriani 6134.) Ascr. to Barbari. Listed by Hevesy, p. 42, and van Marle XVIII, p. 478, as by an imitator of Mantegna. [Both sides **MM**]

We agree as far as the rejection of the attribution to Barbari goes.

60 ————, 1476. Seated man, holding a horn of plenty. Pen. 190 x 262. Watermark: A hunting horn. Ascr. to Barbari. Publ. by Hevesy, in *Burl. Mag.* LV, p. 143, and in his book on Barbari, p. 42, as contemporary copy after a drawing or lost engraving by Barbari. Van Marle XVIII, p. 477, follows Hevesy.

The resemblance of the type to the corresponding figure in Bar-

bari's engraving, Kristeller 25, makes the attribution to him convincing, the resemblance of the drawing style to No. **62** makes us consider the drawing an original.

61 ————, 1477. A nymph reclining. Pen. 160 x 254. (Photo Cipriani 3792.) Ascr. to Barbari. Publ. by A. Hevesy, in *Burl. Mag.* LV, p. 145, and in his book on Barbari, pl. 4, p. 42, as contemporary copy after Barbari, as No. **60**.

In our opinion it is an original, companion-piece to No. **60**.

62 LONDON, BRITISH MUSEUM, 1883–8–11 — 35. So-called Cleopatra, design for the (inverted) engraving Kristeller 28. Pen, lightbr. 205 x 173. Squared. Stained by mold. Collection Firmin Didot, *Cat.* 1877, No. 100. Morelli, II, p. 198, note, Kristeller, *Barbari,* pl. 3, Hadeln, *Quattrocento,* pl. 88, Hevesy, *Burl. Mag.* XLIV, p. 76 f., pl. I a, Parker, pl. 48, Hevesy, *Barbari,* pl. I, van Marle XVIII, p. 479, fig. 262. *[Pl. XLV,* 1. **MM**]

The identification of the nude woman as Cleopatra is apparently not justified (the supposed snake is a root). The importance of the drawing, the authenticity of which is established by the engraving, has rightly been emphasized. On the other hand, its character as the last stage preceding an engraving makes it less useful for the identification of other more sketchy drawings. We date the drawing about 1500.

A 63 ————, 1895–9–15 — 794. Sheet with studies. At l. a nude youth recumbent, seen from back; at r. four draped men behind a kind of arch. Pen, gray wash (l.); red ch. (r.). Malcolm Coll. (Robinson 347: North Italian). Attr. to Barbari by Morelli, II, 198, note. In London called Venetian about 1500. **[MM]**

The attribution to Barbari seems to rest on a superficial resemblance of the nude to No. **61**. But even here we feel the Florentine character to be predominant. This is even more apparent with the figures at r., which are closer in style to early works by Fra Bartolomeo or to Davide Ghirlandajo.

64 ————, 1928-3-10 — 103. Dead partridge. Pen, brush, br. and gray watercolors. 257 x 152. In upper l. corner monogram of Albrecht Dürer and — rather old — the date 1511. Modern inscription: Gray Partridge. Sloane Coll. Publ. by Popham, *Vasari Soc.,* N. S. IX 2, with reference to Barbari's painting of 1504 in Munich, ill. Hevesy, *Barbari,* pl. XXXVI, further, to a miniature on parchment, representing a dead bird, and under the name of Barbari at the Max Reinhart Galleries in 1927, finally, to the predilection of Barbari's pupil, Lucas Cranach, for still lives of this description.

65 MILAN, AMBROSIANA. Seated female figure. Pen, on white turned yellow. 80 x 120. Publ. by Hevesy, in *Zeitschr. f. B. K.* 1925-26, p. 287, as a study by Barbari for a Holy Family.

In our opinion, the figure goes back to an antique model, see for instance, the coin "Germania Capta," also copied by Jacopo Bellini (*Goloubew* II, pl. XLIII). The antique type appears also as representation of the Milky Way in the illustrations of constellations in medieval miniatures. The attribution to Barbari, although not completely convincing, nevertheless seems attractive.

A 66 OXFORD, CHRISTCHURCH LIBRARY H 24. Nereid and Triton, copy from an antique relief. Brush, on bluish gray. 117 x 160. Mentioned as Barbari by Morelli, II, p. 198, note. Publ. by C. F. Bell, pl. IV, as "attr. to Bellini." Hevesy, *Barbari,* p. 42, rejects the attribution in favor of "Imitator of Mantegna." Exh. Burl. House 1930, 635. Popham *Cat.* 166: Attr. to Barbari. The drawing copies a portion of a lost antique sarcophagus, preserved in a drawing in the *Codex Escurialensis,* see edition by H. Egger, Vienna 1906, fol. 34 *recto.* Van Marle XVIII, p. 478: "Follower of Mantegna."

Another copy exists in the Ambrosiana, showing on the r. another Triton seen from back and further figures.

A 67 ————, I 5. Triumphal procession. Red ch. 230 x 344. Attr. to School of Lorenzo Costa, ill. C. F. Bell, pl. XXVII. Attr. to Barbari by Hevesy, *Burl. Mag.* XLIV, p. 83, pl. III F and *Barbari,* p. 41, pl. IX. Van Marle XVIII, p. 479, accepts with reservations, and with regard to the very Mantegnesque, or at least Paduan, style dates the drawing prior to Barbari's departure from Venice (about 1500).

In our opinion, the drawing is not Venetian at all.

A 68 PARIS, LOUVRE, R. F. 1870, 4249. Couple of sea centaurs embracing. Pen, light br., on paper turned yellow. 203 x 238. The paper is torn below and in upper l. corner. Inscription G. G. V., according to Dr. Parker's oral information typical of the Antaldi collection and meaning Girolamo Genga Urbinas. Later inscription G. R. In the Louvre ascr. to Giulio Romano. On the mount modern inscription calling the drawing the only one preserved of Giulio Romano's oftenmentioned series of forty drawings of this character made for Pietro Aretino and engraved by Marcantonio. Coll. Marquis Mario de Candia, Conte Matteo d'Ancona. Publ. by us in *P. C. Qu.* 1941, p. 111 ff. [**MM**]

The attributions, both to Genga and to Giulio Romano, are out of the question. Instead, we advanced the following alternative in our publication: either Dürer tried to surpass Barbari's awkward and stiff composition, in his engraving Kristeller 23, by a more temperamental and passionate invention, or Barbari himself tried to improve his conception under the influence of his younger friend. Our growing partiality for the first theory has been strengthened by Panofsky's acceptance of the drawing as a work of Dürer, though considering it a copy after a Dürer drawing of about 1495 rather than an original,

in view of its graphic weaknesses (E. Panofsky, *Dürer,* II, p. 93, No. 907). To our mind, the latter criticism is caused solely by the poor reproduction in our article, considerably reducing the size. The original, because of its vitality, is overwhelming and contradicts the idea of a copy.

A 69 ————, 4646. Virgin making the Child Jesus ride on a lamb. Pen. 96 x 70. Upper r. corner patched. In the Louvre under Giorgione. Publ. by Bernh. Degenhart, in *Burl. Mag.* 1932, vol. 61, p. 132, as Jacopo Barbari, with reference to his engravings and the drawing No. **62**. [**MM**]

In our opinion the composition is advanced far beyond Barbari and shows a marked influence of Palma Vecchio with whose early drawing style there even exists a certain resemblance. Compare No. **1261.**

A 70 ————, 5614. Allegory, group of four nude figures, two men and two women. Pen, reddish br., on wh. turned yellow. 247 x 145. Modern inscription: Leonardo da Vinci. Publ. by Hevesy, *Burl. Mag.* XLIV, p. 82, and *Barbari,* p. 41, pl. VI as Barbari and accepted as such with reservations by van Marle XVIII, p. 479. [**MM**]

In our opinion, these reservations are very understandable. While the linework and the types are very close to Barbari's, we have no other instance in his work of postures so far advanced in style.

A 71 ————, Copy from an antique statue of Venus, without head and arms, draped, the l. breast nude. Red ch. Coll. His de la Salle as Leonardo da Vinci. Publ. as Jacopo de' Barbari by S. Reinach, in *Gaz. d. B. A.* 1896 (3rd series, vol. XVI, p. 326), who refers to a circumstantial piece of information received from Mr. Berenson, and connects the drawing with Barbari's early engraving Kr. 25. The statue, which the drawing reproduces, must have been famous in Venice around the end of the 15th century and appears in various Venetian paintings of the period. — A better illustration than in *Gaz. d. B. A.* is to be found in Tietze, *Dürer,* p. 403, fig. 401. Franz Kieslinger, *Belvedere,* 1934-1936, p. 171, attr. the drawing to Titian, not on the basis of the style of the drawing, but merely because of its quality — ("Who else could have done it!") — and of its alleged use, first in the Fondaco frescos, later on in the painting "Sacred and Profane Love": "Titian first changed the motive into its reverse and then, with a few daring knacks, from a standing into a seated figure."

We did not succeed in locating the drawing in the Louvre again. As far as our reproduction allows a judgment, the drawing does not show any connection with Titian's mode of drawing, nor can we find any relationship between the statue and the seated nude in Titian's painting. The attribution to Barbari, too, does not seem convincing since the rendering of the drapery differs from his; his draperies are softer and more silky. — In our opinion, the statue shown in the drawing might be one mentioned by M. A. Michiel, in 1532, in the house of Andrea Odoni at Venice: "La figura marmorea de donna vestita intiera, senza la testa e mani, è antica; e solea essere in bottega di Tullio Lombardo, ritratta da lui più volte in più sue opere." (See L. Planiscig, p. 227, who stresses the classic influences in the female figures forming part of the monument of Andrea Vendramin in San Giovanni e Paolo). In view of the somewhat dry rendering of the draperies the drawing may be attributed to Tullio Lombardo himself or to another sculptor. A related graphic treatment can be found in one of the rare drawings authenticated for a Renaissance sculptor, Angelo de Marini's "St. Helen" (also red ch.) in the Louvre, publ. in *O. M. D.* 1939, June, p. 6, pl. 5.

BARTOLOMMEO VENETO

[Mentioned between 1502 and 1530]

Bartolommeo is one of the adopted sons of Venetian art: in a signature of 1502 he calls himself *"mezo Venizian e mezo Cremonese"* (half Venetian and half Cremonese), later on he simply signs Bart. Venetus. As the only drawing which can be connected with one of his paintings is No. **347** which we identify as a production from Giovanni Bellini's workshop, the idea of his style in drawing is merely based on his general portrait style. We need hardly point out how unreliable such a basis is.

A MILAN, AMBROSIANA. Landscape with Saint Mary and Saint John, see No. **347**.

72 MODENA, PINACOTECA ESTENSE, 861. Portrait of a bearded young man, three quarter turned to l. Bl. ch., on yellow. 256 x 221. Very much damaged. The attribution to Bartolommeo is due to Dr. Rodolfo Pallucchini. [*Pl. XLIV*, 4. **MM**]

73 VIENNA, ALBERTINA, 35. Portrait of a young man turned to l. Bl. ch., height. w. wh. 380 x 286. Formerly called Gentile Bellini. *Albertina Cat. I* (Wickhoff), 9: Francesco Bonsignori. A. Venturi,

L'Arte 1899, p. 452, and idem, *La Galleria Crespi*, p. 98: Bartol. Veneto. Schönbrunner-Meder 274: Veronese, early 16th century. Mentioned and ill. by A. L. Mayer in *Pantheon*, 1928, 2, p. 574 and 579 as possibly a study for Bartolommeo's painted portrait of a young man, in the Th. M. Davis coll., Newport (now Metropolitan Museum, New York, no. 30. 95. 296), a hardly tenable suggestion. Meder, *Facsimile* No. 31: Veronese School. *Albertina Cat. II* (Stix-Fröhlich) follows A. Venturi. [*Pl. XLIV*, 3. **MM**]

There is no evidence for this attribution which, however, accords with the portraits painted by Bartolommeo.

MARCO BASAITI

[Mentioned between 1500 and 1521]

The difficulty in dealing with Marco Basaiti's drawings is caused not only by the inconsistencies or obscurities of his figure as a painter, but most of all by our insufficient knowledge of his position between Alvise Vivarini and Giovanni Bellini. The fact that his first appearance in Venetian art is his finishing of Alvise's altar-piece in the Frari, after Alvise's death in 1503, leads to the logical conclusion that he was a member of the Vivarini shop and, according to the habits of the period, a pupil of one of the partners, probably Bartolommeo. Later on, Basaiti came closer to the competing shop of the Bellini, and van Marle seems right in placing the climax of Giovanni Bellini's influence between 1509 and 1515. Connoisseurs of these involved problems know that here the question of Pseudo-Basaiti crops up, which, although greatly discussed in former years, has now been reduced to a side issue of the general problem of Giovanni Bellini's late production. Dropping former opinions, Gronau toward the end of his life was willing to accept the whole questionable group as part of Giovanni's late work. This group includes certain drawings which we consequently discuss as Giovanni Bellini's shop productions as we are not authorized to decide a question which the criticism of painting has proved unable to solve although provided with a far richer material. These drawings, Nos. **333, 338, 345, 348, 349, 352**, to our mind are shop productions or working material belonging to Giovanni Bellini. However, we do not absolutely exclude the authorship of Basaiti whom we believe to have contributed considerably to Giovanni's late production. The paintings discussed many years ago by Mr. Berenson, in his *Venetian Painting in America,* including the Saint Francis of the Frick Collection and other principal works from Giovanni's old age, demand a re-examination. From the standpoint of drawings this claim is made urgent by No. **353**, formerly given to Marco Basaiti by reason of its relationship to Basaiti's masterpiece in the Academy. It was rejected as Basaiti by Hadeln, who correctly noted the rendering of space as completely different from Basaiti's and closer to Giovanni Bellini as well as to Giorgione. The catalogue of the Albertina returned it again to Basaiti. There is little hope of solving this and similar questions unless we realize

that Marco Basaiti, or another first assistant, to a higher degree than our current prejudices are willing to admit, may have been absorbed by his master. When Basaiti became a master himself, the tables may have been turned, and No. 75, on very superficial grounds attributed also to Carpaccio, may be his, although Francesco da Milano is supposed to have had a share in the execution of the painting to which it belongs.

The question of portraits, as usual, occupies a place of its own. The excellent example in Berlin, No. 74, cannot plead a striking resemblance to any established portrait by Basaiti. Nevertheless, the attribution is rather convincing: the drawing is certainly superior to the average school production and is advanced beyond Giovanni Bellini, but, at the same time, not advanced in the direction of the leaders of the new generation. The drawing is a masterpiece of a backward artist. This characterization marks the locus where we might expect to find Basaiti.

Another landscape, No. 76, leads to a problem no less exasperating than that of the point where two generations part or merge, the one of the meeting and merging of North and South in Venetian Art, dramatized by the two influential visits of Dürer in Venice—in 1494–95 and 1505–7. The landscape in question, ascribed to Basaiti, in our opinion, might belong to Dürer in the first of these periods; Degenhart considers the watercolor a reflection of Dürer's influence on Basaiti's adaptable art. His point of view has recently been accepted by Panofsky.

74 BERLIN, KUPFERSTICHKABINETT, 5077. Portrait of a bearded man. Bl. and red ch. 411 x 295. Watermark: Cardinal's Head, resembling Briquet 3408. Collections Guggenheim, von Beckerath. Publ. in *Berlin-Publ.* I, 77, and by Hadeln, *Quattrocento,* pl. 82. Van Marle XVII, p. 513, refers in this connection to a painting owned by Mrs. Stuyvesant, New York, ill. Berenson, *Venetian Painting in America,* fig. 100.

We are unable to find any special resemblance to the last-mentioned painting, but notice a very general conformity in style and also a certain affinity to two other portraits attr. to Basaiti in the Johnson Coll. in Philadelphia, ill. Berenson, *Johnson Collection,* pl. 179 and 181.

75 FLORENCE, UFFIZI, 156. Study of a dead Christ, connected with the painting in the Academy in Venice, ill. van Marle XVII, fig. 303. Pen, 106 x 245. Publ. by Ferri, *Boll. d'Arte* III, 1909, 373, and by Gamba, in *Uffizi-Publ.* III, p. I, 11, as Basaiti, in spite of the fact that the painting in Venice has also been attr. to Francesco da Milano; in his opinion the drawing is far superior to the painting in quality and expression. The attribution is accepted by Hadeln, *Quattrocento,* pl. 81, and Popham, *Cat.* 175, while Fiocco, *Carpaccio,* pl. CXCII, p. 83 f. attr. the drawing to Carpaccio because of the softness of the linework and the poetical expression of the face. Van Marle XVII, p. 513, returns to Basaiti with reference to the painting in Venice, which he considers to be by Basaiti, with the exception of the angels which might be the addition of an imitator. [*Pl. XLV, 2.* **MM**]

Fiocco's opinion seems to be influenced by a slight resemblance of the drawing to the "Mystical Vision of the Dead Savior" in Berlin

(ill. Fiocco, *Carpaccio,* pl. CXC 17) attr. to Carpaccio. In our opinion, however, its connection with the painting in Venice, which Fiocco does not mention, is certainly far closer. There is no reason to give the drawing to Carpaccio, especially as its mode of drawing is different from that of all authentic works by Carpaccio. There is only a certain approach to No. **A 588,** attr. by Fiocco to Carpaccio, but not accepted by us.

A 76 ——, 1700 F. Landscape. Watercolor. 203 x 273. Repaired in several places. Unfinished. Inscription (in 17th century hand): Marco Basaiti. Listed under his name in the Uffizi. Publ. by Hans Tietze and E. Tietze-Conrat in *O. M. D.* 1936, p. 34, pl. 29, and tentatively attr. to Albrecht Dürer, emphasizing, however, the close relationship to Basaiti. In *Mitteilungen des Kunsthist. Institutes in Florenz,* 1940, July, p. 423ff., Bernh. Degenhart interceded in favor of the older tradition, presenting substantial reasons for Basaiti's authorship and, on the other hand, considering this watercolor — which would be the earliest work of this technique in Venice — a close imitation of Dürer. Degenhart's point of view has been accepted by Panofsky, *Dürer* II, p. 136, no. 1418.

Degenhart's reference to Venetian elements in the artistic interpretation and to a lack of German elements convinces us as little as our argument of principle apparently convinced Degenhart, namely, that Basaiti never showed the originality needed to become a pioneer in any field.

A VIENNA, ALBERTINA, 22, see No. **353.**

FRANCESCO DA PONTE, CALLED BASSANO

[1549–1592]

(See also the introduction to Jacopo Bassano, p. 47 ff.)

No paintings by Francesco exist posterior to Jacopo's death. Like Orazio Vecelli's, his *oeuvre,* too, might have been absorbed by that of his father, had he not lived in another town than the latter. As a consequence of this separate residence, we know of a number of paintings, well-authenticated for Francesco alone, by documents or

literary sources, and are able to distinguish the two artists positively. The designs and studies to be connected with some of these paintings differ from Jacopo's by their coarser expression, their heavier proportions and their closer adherence to details. The result of this differentiation is that Jacopo's *oeuvre* appears very substantial and, compared with it, Francesco's is very unimportant. If we could not distinguish them from one another by these exterior reasons, Jacopo's artistic personality would simply have been watered down to include Francesco's output as well. Nos. 78, 82, already recognized by Hadeln as Francesco's designs for S. Maria Maggiore in Bergamo, offer the best evidence to Francesco's poorer talent when compared with Jacopo's drawings of an analogous character. This talent is at its best in studies for single figures as, for instance, No. 83. Hadeln had published it as Jacopo's, but Arslan already recognized Francesco's hand. We are in a position to add that it prepares the principal figure in Francesco's Rape of the Sabine Women in Turin, a signed work, already mentioned by Borghini (c. 1580) and Lomazzo (c. 1590). Another drawing published by Hadeln as by Jacopo, No. 84, is dated December 1587. Since it differs from Jacopo's style, so careless of details, and is connected with the painting Hercules and Omphale, in Vienna, signed by Francesco, an attribution to Francesco seems justified. No. 85 is the nearest in style. The drawings (Nos. 91, 92) connected with the ceilings in the Sala del Gran Consiglio may belong to Francesco and his shop although we are informed by Ridolfi that in the execution of these decorative paintings Francesco was helped by his father's advice. The situation is more complicated where the drawings are connected with paintings ordered from Francesco, but only begun by him and completed by his brother Leandro. No. 94 connected with the painting "The Doge Ziani taking leave of Pope Alexander III," in the Ducal Palace, has been ascribed to Leandro by A. G. B. Russell and others, but in our opinion, for stylistic reasons is more probably by Francesco. On the other hand, some drawings (Nos. 213, 214) that are connected with the paintings in Montecassino ordered from Francesco might better be attributed to Leandro, who did most of the execution; the difference from Francesco's style is striking. (The drawing representing a view of Bassano, begun by Francesco and completed by Leandro in 1610 [mentioned by Arslan, p. 262], is no longer traceable.)

77 BERLIN, KUPFERSTICHKABINETT, 15790. Table servant. Charcoal, height. with wh. (rubbed). 170 x 158. Publ. as Jacopo Bassano by L. Fröhlich-Bum in *Zeitschr. f. B. K.,* fig. 65, p. 125, with reference to a version of "Christ and the Disciples at Emaus" in the Palazzo Doria in Rome, probably executed by Francesco.

[*Pl. CXLVII,* 1. **MM**]

The type and pose of the boy certainly originate from Jacopo, but the style of drawing in our opinion is Francesco's, see No. 94.

78 ———, 4539. The birth of the Virgin. Charcoal, on gray green, slightly height. with wh., oval. 408 x 520. Formerly ascr. to Jacopo, but recognized by Hadeln (*Spätren.* pl. 84) as a design for Francesco's ceiling in S. Maria Maggiore in Bergamo. Arslan p. 228. See No. **82**.

79 CHATSWORTH, DUKE OF DEVONSHIRE, 270. Head of an old bearded man. Many-colored ch., on faded blue. 162 x 141. Ascr. to Jacopo Bassano. [**MM**]

Attr. by us to Francesco with reference to the figure left of Moses in Francesco's Paradise in the Church of Gesù in Rome (ill. *Rivista del R. Ist. d'Arch.* 1935 v. I, II, p. 180). We admit, however, that Francesco could have used a drawing by his father, with whose technique it corresponds, but the finished modeling points rather to Francesco.

80 CHELTENHAM, FENWICK COLL. Crucifixion. Pen, wash, height. w. wh., on green. 395 x 242. The corners cut. Coll. R. Cosway, Lawrence-Woodburn Sale. Popham in *Fenwick Cat.,* p. 31, 1, attr. to Francesco on the basis of No. **82**.

In our opinion, working material of the shop.

81 CREMONA, MUSEO CIVICO, 181. Mother with a child and a peasant (fragment of a larger composition). Bl. ch., on faded blue, the upper corners cut. 207 x 183. Modern inscription: *Giacomo Bassano.* Coll. Ponzone. Ascr. to Jacopo Bassano.

In our opinion, a working design from Francesco's shop.

82 FLORENCE, UFFIZI, 1888. The Presentation of the Virgin in the temple, design for the ceiling in S. Maria Maggiore at Bergamo. Charcoal, height. with wh., on blue. Oval 435 x 530. — *Verso:* The Birth of the Virgin. *Recto* publ. by Hadeln, *Spätren.,* pl. 83, the *verso* a modified version of the somewhat smaller and more finished No. **78**. [*Pl. CXLVI,* 3 *and* 4. Both sides **MM**]

83 ———, 1890 F. Woman, half-length. Charcoal, somewhat blurred, height. with wh., on brownish gray. 156 x 191. Hadeln, *Spätren.,* pl. 75, p. 16: Jacopo Bassano. Arslan, p. 229: Francesco Bassano. [*Pl. CXLVII,* 3. **MM**]

We agree with Arslan since we could identify the drawing as a study for the principal figure in Francesco's Rape of the Sabines paint-

ing in the Gallery in Turin (ill. Venturi 9, IV, fig. 883). The painting, probably identical with one in the property of the Duke of Savoy, already mentioned by Borghini, *Riposo*, 564, is to be dated 1580 or shortly before.

84 ————, 1892. Two women seated and a child. Ch. and brush, brown and wh., on blue. 276 x 379. — *Verso:* Study of a drapery in bl. ch. Dated in brush: *X^bo 1587*. Hadeln, *Spätren.*, pl. 89, p. 18: ascr. to Jacopo, but probably by his son Leandro. [*Pl. CXLVI, 1.* **MM**]

Since the drawing is a study for the signed painting by Francesco "Hercules and Omphale" in the Gallery in Vienna (no. 280), Hadeln's ascription to Leandro must be dropped.

85 ————, 1894 F. Couple of lovers. Charcoal on br. 270 x 331. Hadeln, *Spätren*. pl. 87, p. 15, ascr. the drawing, attr. to Jacopo, "to one of his sons, probably to Francesco." Arslan p. 278: Leandro. [**MM**]

We agree with Hadeln on the basis of No. **83** and No. **84**.

86 ————, 12812. The Magdalene kneeling at the cross. Bl. ch., height. with wh. (rubbed), on faded blue. 339 x 193. — *Verso:* later inscription: Bassan. The drawing, still listed as G. Muziano, but ascr. to Francesco Bassano (on the mount).

A 87 ————, 12815. Orpheus and the animals. Brush, br., wash, height. with wh., on faded blue. 600 x 460. A strip of blue paper about 5 cm high is added at the top. Publ. as Francesco Bassano by Gamba in *Uffizi Publ.* III, I 25. Rejected by Arslan, p. 344.

The composition exists in various painted versions, one of which, engraved by Ossenbeeck, in the Gallery of Archduke Leopold Wilhelm, was ascr. to Leandro (Bartsch V. 308, 10). The brilliant drawing is, in our opinion, a later copy of one of the versions, some of which are illustrated in W. Suida's article *"Studien zu Bassano"* in *Belvedere* XII (1934–36), fig. 215 and 216.

88 ————, 13049. Study for an old man and a child. Bl. ch., height. with wh., on gray. 282 x 334. In very bad condition. On *verso* later inscription: di mano Fran^co Bassano. Arslan, p. 299: Study for the painting "Moses and the Israelites," Vienna no. 285.

89 ————, 13050. Sketch of a boy. Charcoal, height. with wh., on gray. 283 x 166. Arslan, p. 299: Probably study for one of the boys on a tree in "St. John Preaching," Venice, S. Giacomo dell'Orio.

90 ————, 13054. Girl bending to the right, drinking, half-length. Bl. ch., height. with wh., on dark br. prepared paper. 200 x 250.

The pose is typical of the Bassano, the style in particular of Francesco.

91 ————, 13059. Battle. Brush. 490 x 633. Arslan 229: Design for the "Battle of Casal Maggiore" in the Sala del Maggior Consiglio (Lorenzetti, p. 26, no. 7; already mentioned by Borghini, *Riposo*, p. 564. Therefore earlier than 1580).

Working design.

92 ————, 13062. Battle. Black and many-colored ch., executed with much care. Oval. 766 x 1050. Damaged and patched.

"Modello" for the painting on the ceiling in the Sala del Maggior Consiglio in the Ducal Palace, (ill. Venturi 9, IV, p. 1298, fig. 886; already mentioned by Borghini, *Riposo*, p. 564. Therefore earlier than 1580).

93 ————, 13073. Juda and Tamar. Brush, br., on grayish green. 300 x 427. Arslan, p. 230: perhaps Francesco Bassano.
Working material of the shop.

94 LONDON, VICTORIA & ALBERT MUSEUM, Dyce 1017–1900. Study for the page in the painting: The Doge Ziani taking leave of Pope Alexander III. Bl. ch., height. with wh., on br. 276 x 178. Formerly ascr. to "School of Titian" (as such in H. S. Reitlinger *"A Selection of Drawings by Old Masters,"* London, 1921, pl. VIII), but already recognized as the study for the painting in the Sala del Consiglio dei Dieci by A. G. B. Russel (*Burl. Mag.* XLV, p. 121). Since this painting, begun by Francesco, was finished after his death by Leandro, Russel ascr. the drawing to Leandro. Hadeln, *Spätren.*, pl. 88, and Arslan, p. 279, follow Russel. [*Pl. CXLVII, 2.* **MM**]

In our opinion, the drawing from its style is to be placed between No. **83** and No. **84**, both ascertained for Francesco. It corresponds also to Francesco's style as described by Hadeln, influenced to a higher extent by Tintoretto than by his father or his brother Leandro. In our opinion, the drawing in the Koenigs Coll. I 60, [**MM**] believed to be another study for this figure together with the second page behind the Doge is a note after the painting, made only slightly later.

95 LONDON, COLL. OPPÉ. Battle. Bl. ch., height. with wh., wash, on greenish blue. 490 x 604. Upper l. corner added. [**MM**]

Connected with the "Battle at Polesella" in the Sala del Maggior Consiglio, Ducal Palace, (Lorenzetti, p. 216, 6); working material.

96 MODENA, PINACOTECA ESTENSE, 1176. Shepherd with a vessel in his hands, bending down, surrounded by sheep and a dog. Bl. ch., slightly height. with wh., on buff. 201 x 300. Inscription: Bassano. Ascr. by Bariola to Jacopo, by Brandi to Leandro, by Pallucchini to Leandro or Francesco. [**MM**]

The whole group appears in a painting "Moses bringing forth Water from the Rock" in Munich, ascr. to Francesco Bassano, whose drawing style the study resembles.

97 MUNICH, GRAPHISCHE SAMMLUNG, Mannheim Coll., 2972. St. Francis kneeling. Brush. 268 x 212. Inscription: Bassano. Zottmann 52, pl. 10. *Monatshefte* II, p. 6. Arslan 347. Degenhart, p. 270.

In our opinion, not a drawing from the 16th century, but by an artist of the next generation and dependent on the composition (in reverse) of the same subject ascr. to Francesco Bassano (ill. Arslan, pl. LXX), but in our opinion definitely later.

98 NEW YORK, PIERPONT MORGAN LIBRARY. Kneeling woman with tools in her hands (perhaps grill for roasting quails). Bl. and wh. ch., wash, on gray. 281 x 373. Ascr. to Jacopo. [*Pl. CXLVI, 2.* **MM**]
In our opinion by Francesco, close to No. **94**.

99 PARIS, LOUVRE, 5288. Tinker seated. Charcoal, on blue. 303 x 210. Inscription: Bassan. Hadeln, *Spätren.*, pl. 86, p. 15: Study for the painting "Forge of Vulcan," the best (though cut) version in the Museum in Vienna shows Francesco's hand. Arslan, p. 231.

We agree with Hadeln on the basis of the affinity to Nos. **94, 84**.

100 ————, 5297. Girl seated, seen from behind. Bl. ch., on gray. 249 x 203.

The drawing, ascr. to Jacopo, is in our opinion closer to Francesco.

101 ————, 5306. Annunciation to the shepherds. Brush, wash in two colors, height. with wh.

102 Vienna, Albertina, 78. Old man and a youth. Ch., pen, wash, height. with wh., on greenish paper. *Albertina Cat. I* (Wickhoff) 286: autograph by Leandro Bassano. *Albertina Cat. II* (Stix-Fröhlich): Francesco. Arslan, p. 233.

We agree with Stix-Fröhlich, the drawing being a study for the two figures at the left in Francesco's signed "Last Supper" in Madrid (ill. Venturi 9, IV, fig. 866, p. 1273).

A ——————, 79, see No. **1974**.

A 103 ——————, 79a (Inv. 25294) Studies of a calf. Bl. ch., height. with wh., on blue. Contemporary (illegible) inscription of colors (?). 303 x 198. — *Verso:* Calf's head.

Not listed in the cat. since the drawing was bought only in 1927. It belongs to a group of unpublished drawings, most of which are in the Rayner Wood Coll. in Malvern [**MM**], two in Berlin (15668–9 **MM**) and one (I 54) in Haarlem, Koenigs Coll., containing studies of the nude and of cows. All of them show the same neat technique and the same realism. Many of the drawings bear later (18th century) inscriptions "Bassan"; nevertheless, for many of those in Malvern, Baroccio's authorship was suggested by Mr. Berenson. It is indeed not Bassano's habit to study the individual model to the extent of describing every muscle and cavity so thoroughly. The poses, moreover, do not have the simplified flow of Bassano or any other Venetian artist. In the drawing, Uffizi No. 9143 by Passignano, we found a certain resemblance to our group and propose him, most cautiously, how-

ever, as its author. We could not connect one of the studies with a painting by Passignano, but refer to his well-known sojourn in Venice and its influence on his work executed immediately afterward in Florence. The nudes in the foreground of the frescos in S. Marco, Florence (Venturi 9, VII, fig. 349 f., p. 641, or the figures in the right corner, Venturi, fig. 352, p. 645) might have been based on similar studies.

104 Vienna, Private Collection. Head of an old man turned to the right. Brush. 162 x 160. The paper is composed of two patched pieces. Publ. by L. Fröhlich-Bum in *Zeitschr. f. B. K.* 65, p. 124, fig. 122: Jacopo Bassano, with reference to the painting of St. John in the Museo Civico, Bassano.

We find the type and posture of the head closer to Francesco. Compare his St. Joseph, on the design for Bergamo in Florence, No. **82**. We have not seen the original.

105 Windsor, Royal Library, 6671. Study of a Christ for a Baptism. Bl. ch., on blue. 254 x 172. Later inscription: Bassano. Hadeln, *Spätren.,* pl. 85, p. 15, ascr. it to Francesco, who was more influenced by Tintoretto than the other artists of the family. Arslan, 234.

A 106 Würzburg, Kunstgeschichtliches Museum der Universität. The Presentation of the Virgin in the temple. Pen. Publ. by Zottmann, pl. XVII. Arslan, p. 356: 17th century, without any connection with the Bassano School.

GIROLAMO DA PONTE, CALLED BASSANO

[Born 1566, died 1621]

The original family plan for Girolamo had not been to make him a painter. He studied medicine in Padua, but when his father and his eldest brother died, he seems to have been induced to enter the paternal shop. He lived as a painter in Venice, and in his last will, of October 27, 1621, bequeathed the paintings and drawings in his property, i. e., those done by himself, to relatives and friends and to his assistant, Marcantonio. It is hardly possible to verify occasional attributions of drawings to him. Some we have had to reject outright, but we have made a tentative attribution ourselves, No. **107**, based solely on stylistic resemblance to a well-authenticated picture.

107 Berlin, Kupferstichkabinett, 5117. Two bishops. Charcoal and red ch., on blue. 282 x 168. Coll. Beckerath.

The drawing which is listed as anonymous shows, in our opinion, a Bassanesque style which, combined with the stiff poses, induces us to ascribe the drawing with reservations to Girolamo Bassano; see his altar-piece in Bassano, Pinacoteca, ill. Venturi 9, IV, fig. 910.

 [*Pl. CL/*1. **MM**]

108 Florence, Uffizi, 19107. Bozzetti, no. 607. Christ driving the merchants out of the temple. Brush, wash. Arslan, 304: perhaps by Girolamo.

We have not seen the drawing.

109 Montpellier, Musée. The Virgin with the Infant. Brush, wash. Arslan, p. 304.

We have not seen the drawing.

109 bis Princeton, N. J., Museum of Historic Art. Deacon standing carrying a censer and a staff. Bl. ch. 270 x 150. On *verso* in

brush four poor sketches (oarsman, monk, figure of Fortuna) and in print the words: Provisores Salutis Bassani Concedemo licentia a . . . and: Bassano die . . . 159(4, added in ink). Coll. Platt.

 [*Pl. CL/*2. **MM**]

The figure of the deacon develops an older type, see No. **373**. Our tentative attribution to Girolamo rests on the resemblance of the linework with No. **107**. The use of a blank apparently connected with the health service in Bassano might add an argument in favor of an artist who, as said above, came from the medical profession.

A 110 Vienna, Albertina, 77. Study of a man from behind, half-length. Charcoal, height. with wh., on gray. 295 x 210. Late inscription: Bassano. Coll. Kutschera-Woborsky. *Albertina Cat. II* (Stix-Fröhlich) ascr. the drawing to Girolamo on the basis of a similar figure in the signed Nativity in the Gallery in Vienna, 325A. [**MM**]

In our opinion, neither the pose nor the style of the drawing is Bassanesque.

JACOPO DA PONTE, CALLED BASSANO
[Born about 1510–15, died 1592]

Jacopo da Ponte, the leading master in the neighboring mountain town of Bassano, worked in Venice only occasionally. Some churches secured works by him for themselves, and the State ordered a portrait from him of Doge Sebastiano Venier (1577–78). None of these paintings exists any longer in Venice. If, nevertheless, we include in our Catalogue the head of such a local school, extending its activity far into the late 17th century, we do so because his art gained the right of citizenship in Venice through his son Francesco. The connection between the latter and Jacopo is to be understood as follows: the shop in Venice was a branch of the one in Bassano. In some cases the son collaborated in his father's commissions, and in others Jacopo's greater experience was consulted for works executed in Venice by Francesco. We may, accordingly, take it for granted that under such circumstances Jacopo's drawings were at Francesco's disposal. Evidence of this is offered by a letter written in 1581 by Francesco Bassano to the art collector Niccolò Gaddi in Florence: "the worries and bad health of my father prevented me from sending you the drawings before now. I have not succeeded in obtaining any by my father, who does not draw any longer, nor can he do very much with the brush, being very old and suffering from poor eyesight. So I can only send those which happen to be in my house, together with my own. . . ." (Bottari, *Lettere* III, 265 ff.). As in the cases of the Bellini, the Carpaccio, the Vecelli, the Robusti, or Caliari, the da Ponte had a family workshop, differing from the others by its topographical extension. Small as the distance between Venice and Bassano looks today, the fact of the separation meant a greater independence for the junior partner. On the other hand, since Francesco has his personal features, too, those of his father are thrown into sharper relief. Jacopo's personality is incomparably greater than Francesco's, and the former has, also, undergone a far richer evolution that did not touch Francesco. Francesco's youth falls in the years when Jacopo had overcome his Quattrocento training and absorbed Bonifazio's influence. The acquaintance with Parmigianino had modified his rustic elements and prepared him to accept those influences of the late Titian and of Tintoretto that are decisive for his later production. This is Francesco's point of departure. He inherited Jacopo's keynote and concentrated on it, though lacking the dynamic versatility of his father. The Venetian Francesco is more Bassanesque than Jacopo himself. Jacopo, having the far greater talent, is more than a mere local artist, while Francesco allows his native idiom to grow stereotyped in the refined atmosphere of Venice.

We have considerable drawing material from Jacopo; that which may be Francesco's within the total production of the shop, is relatively small. What we stated as the essential directions of either's development as a painter is also reflected in their drawings. As for the date of origin, there is hardly much difference since there are no drawings to be ascribed with certainty to Jacopo's youth; the vast majority certainly belongs to his later period. But Jacopo's style has potentialities contradicting Francesco's uniformity. In technique, linework, and in their rhythm of black and white, they are quite homogeneous, and it is easily understood that all of them were handed down to us as by "Bassano," namely, Jacopo Bassano.

As the only drawing that might belong to Jacopo's early years we shall discuss No. **192**, dated 1538 and published by Hadeln as Bernardo Licinio. The attribution to Jacopo Bassano was made by our friend André Linzeler, who intended to publish the drawing in the *Catalogue* of the Louvre drawings as a study for one of the portraits in Jacopo's "Adoration of the Magi" in Edinburgh. In our opinion, the attribution seems reasonable, and we accept it, but with some reservations. The best argument in favor of Jacopo is the combination of simplicity of form and

spiritual restraint that we also meet in other painted portraits contained in Jacopo Bassano's early religious compositions. If the attribution were to be taken as certain, it might throw some light on Bonifazio's style of drawing of which, unfortunately, we know so little. For the time being, however, such conclusions *a posteriori,* from the pupil to the teacher, would be precipitate. (For another drawing attributed to the early Jacopo, but in our opinion from Bonifazio's school, see No. **378**).

The next best established drawings after this tentative foray into the mystery land of Jacopo's youth are, in our opinion, a whole generation later, since we reject Mrs. Fröhlich-Bum's early dating of No. **116.** No. **163** is dated 1568, No. **146** and No. **177,** 1569. For the studies expressly made for the Pentecost in Bassano (Nos. **166, 200**) we may assume the date of about 1570, based on the style of the painting and of the drawings as well. As for the other numerous drawings connected with paintings, the specific management in the Bassano shop prevents us from arriving at conclusions for the dates. The demand for these paintings was so great and lasted so far beyond Jacopo's death that many compositions exist exclusively in later versions. Consequently we are not entitled to draw inferences from the dates of the paintings to those of the drawings unless we are absolutely certain that we have before us the very first use of a specific drawing. We are, moreover, not allowed to conclude from the use of a drawing, in an approximately contemporary painting by Francesco or Leandro, that the drawing in question must be by either. In view of the close collaboration in the shops, we list the working material under the names of Jacopo and his sons, respectively.

Once more we refer to Francesco Bassano's letter to Niccolò Gaddi, mentioned above (p. 47), from which we learned the important facts that Jacopo hardly drew any longer (1581), that drawings of his were in use in Francesco's shop in Venice, and, finally, that the drawings were not of the kind collectors were accustomed to acquire, since the Bassano made no profession of drawing. (". . . perchè noi non avemo disegnato molto, nè avemo mai fatto professione mai tale, ma be avemo messo ogni studio in cercar di farle opere che abbiamo a riuscer al meglio che sia possibile." Bottari, l.c. p. 266). We, therefore, have to refrain from ascribing drawings to the last decade from his life. It may also be that Jacopo refused to part with his drawings which he apparently kept together. The inventory of his estate of April 27, 1592, published by Verci, *Notizie,* p. 99, no. 183, contains: *"due cartoni di diversi disegni e tredici rodoli di diversi disegni* (two portfolios and 13 rolls containing various drawings). As a matter of fact, among the known Jacopo Bassano drawings, finished ones are entirely missing. The bulk of them are hasty studies executed in soft succulent chalks—black, red, or many-colored—aiming at picturesque effects, but dropping all details of heads or hands or draperies. It may be more than a mere coincidence that the only study of Bassano which renders objective form most carefully is that of a child (No. **168**); the exceptional and most difficult model demanded the most objective devotion. Even the designs for total compositions which we have by Jacopo Bassano are different from the usual "modelli" and have more of the character of paintings, though done in chalk. This lack of interest in details makes Jacopo shun the pen. The only pen drawing connected with one of his paintings is No. **A 188,** publ. by Hadeln, pl. 78, and accepted by Arslan; his reference to the approach to Veronese and Palma Giovine is a reluctant admission of its striking difference from other Bassano drawings. (On this drawing Mrs. Fröhlich-Bum based the attribution of two others to Jacopo, Nos. **A 137** and **A 174,** different from him not only in their penwork but also in their compositions.) Having succeeded in pointing out the painted composition in which all the elements of the drawing appear, we are in a position to eliminate this spurious work as notes gathered by a later artist from a painting by Jacopo.

The style of Jacopo's drawings which became the property of the Bassano shop in the widest meaning of the

word is, at least in principle, different from Francesco's by the more striking abbreviations, the more ingenuous invention (subjective criterions) and still more by the slenderer proportions, the small heads, the mannered Parmigianinesque elements (all objective criterions). Jacopo's pathos is of a different nature than his son's. Francesco was considered by Hadeln the one Bassano, relatively, most influenced by Jacopo Tintoretto. His pathos is superficial, his gestures are overdone. Jacopo's pathos is simple and untheatrical. A lost profile of a woman's or a boy's head (compare Nos. **151, 152** for the painting in Rennes) showing hardly more than the outline of a cheek is sufficient for him to seize the very essence of a human being. That he made no profession of drawing (as we have heard) resulted in his not being completely absorbed by contemporaries and immediate followers as far as drawing is concerned; for this side of his activity a renaissance was kept in reserve. His hastiness, which is a direct approach to pictorial values, invests him with a peculiar modernity appreciated by the impressionistic currents of the late 19th century.

111 BERLIN, KUPFERSTICHKABINETT, 5109. Adam and Eve. Red ch., on yellow. 298 x 244. Squared. Coll. Beckerath. Hadeln, *Spätren.*, pl. 69. Arslan, 187. Arslan in *Boll. d'A.* N. S. VIII (1929), p. 412, first noticed the relation of the study to the painting of the Paradise in the Palazzo Doria in Rome, correcting thereby its former description as Hercules and Nymph. Fröhlich-Bum in *Burl. Mag.*, vol. 61, 1932, p. 114, note, considered the drawing a copy done in the shop after the painting in the Doria Coll.

Probably working material, final stage before transfer on canvas. The figure of the woman, in reverse, is also used in the background of Leandro Bassano's portrait of a man, Philadelphia, Johnson Coll., No. 212.

112 ————, 5121. Kneeling woman seen from behind. Red and yellow ch., height. w. wh., on blue. 374 x 246. Coll. Beckerath. Hadeln, *Spätren.* pl. 71. Arslan, p. 187.

113 ————, 15660. Sleeping shepherd with lambs and a goat. Bl., red and yellow ch., on gray. 199 x 297. Coll. Pacetti. The figures appear in reverse and somewhat modified in the "Annunciation to the Shepherds" in the Museum of Douai. **[MM]**
Workshop product.

114 ————, 15262. Bearded man (half-length). Charcoal, height. with wh., on grayish blue, in some places turned br. 257 x 176. Coll. Pacetti. **[MM]**

The figure resembles very closely the apostle on the l. in Jacopo's Pentecost in Bassano. A comparison with No. **200** discloses the difference from an original study by Jacopo. The whole posture is weakened, the head looks academic. The drawing may have been done in the shop as was also the poorer version of the Pentecost painting in the Brussels Gallery, no. 24.

115 ————, 15664. Animals entering Noah's Ark. Charcoal, on blue. 294 x 418. Coll. Pacetti. **[MM]**
Various painted versions of the subject exist (for instance Bologna, Dijon). The drawing may be a working design done in the shop.

A ————, 15668, see No. **A 103.**

A ————, 15669, see No. **A 103.**

A ————, 15790, see No. **77.**

116 ————, 15791. Flight into Egypt. Bl. ch., height. with wh., on brownish paper. 258 x 364. Worn by rubbing. Coll. Pacetti. L. Fröhlich-Bum, in *Zeitschr. f. B.K.* 65, 1931-32, p. 121, publ. the drawing and dated it, before Jacopo's early painting of the same subject in the Museum in Bassano (ill. Venturi 9, IV, fig. 799, p. 1121). **[MM]**

In our opinion, the drawing must be later than the painting as it already shows Jacopo's well-developed manneristic style. The state of preservation makes it difficult to determine whether the drawing — which we have not re-examined in original — is authentic or not.

117 BESANÇON, MUSÉE, 1007. Left half of the composition representing "Winter" (or a winter month). Brush, br., height. with wh., on blue. 538 x 417.
Working design of the shop.

A BREMEN, KUNSTHALLE. The Man of Sorrow. See No. **386.**

118 CAMBRIDGE (ENGLAND), FITZWILLIAM MUSEUM. Sheet with studies of legs and arms. Bl. ch., height. with wh., on blue. Irregularly cut. 201 x 155. Coll. Ricketts and Shannon. Arslan, p. 190. **[MM]**

119 ————, Christ in the house of Simon. Bl. and red ch., height. with wh., on greenish gray. 321 x 435. Inscription: Bassan I.
[*Pl. CXLIV*, 4. **MM**]
Design for a composition preserved in a later version, ascr. to Leandro Bassano and formerly in the Ehrich Galleries, New York (Photo Witt) where a second figure appears at the door.

120 ————, 1980. Man servant seen from behind. Bl. ch., height. with wh., on blue. 190 x 160. Late inscription: Bassano. Coll. Ricketts and Shannon. [*Pl. CXLII/3.* **MM**]
Study for a figure at r. in the Return of the Prodigal Son, Arslan, p. 171, fig. 38.

121 CAMERTON NEAR BATH, SOMERSET, *Coll. Mrs. Maconachie.* Sheet with an executioner above and the head of Christ below. Bl., wh. and red ch., on blue. **[MM]**

A "Crowning with Thorns" ascr. to Jacopo Bassano belonging to a private coll. in Rome and exh. in 1936 in Cleveland (no. 151, Cat. pl. XXV) contains both figures somewhat modified. We have not seen the drawing, but from a study of the photograph we are rather inclined to ascribe it to a follower of Jacopo.

122 CHELTENHAM, FENWICK COLL. The Gathering of Manna. Charcoal, green wash, on green. 525 x 750. Later touches on the con-

tours. Coll. Lawrence, Woodburn Sale. Fenwick Cat. p. 31, 1.
Working design of the shop.

123 ————, Piping shepherd recumbent. Bl. and wh. ch., on green. Irregularly cut, 187 x 285. Old inscription: Bassano. Woodburn Sale.

According to Popham in Fenwick Cat., p. 31, 2, the figure corresponds closely in reverse to one in Aeg. Sadeler's engraving after Jacopo's Annunciation to the Shepherds; Popham believes the drawing a study for this painting. In our opinion, it is a workshop product.

124 CHICAGO, ART INSTITUTE. Gurley 22. 5387. Carrying of the Cross. Bl. ch., on buff. 422 x 309. Rubbed. Coll. Richardson, Barnard. [MM]

125 CREMONA, MUSEO CIVICO, 183. Kneeling shepherd (from behind), peasant boy. Bl. ch., on faded blue. 270 x 195. Modern inscription: Originale di Giacomo Bassano. Coll. Ponzone.
Rather weak, probably done in the shop.

126 DARMSTADT, KUPFERSTICHKABINETT. Head of a youth turned to the r. Bl. and red ch., on buff. 215 x 154. Later inscription: Bassano. Very much rubbed and damaged. Vente Crozat 649, Coll. Dalberg. *Stift und Feder,* 1929, pl. 84: Jacopo Bassano.
Badly preserved and therefore difficult to judge. We have not re-examined the originals of this and the following Nos.

127 ————, Study for a shepherd's head. Charcoal, height. with wh., on buff. The top corners cut. 148 x 159. Later inscription: Bassano. Vente Crozat 642, Dalberg Coll.
Hasty drawing, but typical of Jacopo.

128 ————, Lamentation for Christ. Many-colored ch., on blue. 424 x 315. Dalberg Coll. *Stift und Feder,* 1930, 58 x 59.

129 ————, Ecce homo. Bl. and red ch., on blue. 375 x 270. Later inscription: Ja. Bassan. Dalberg Coll. Zottmann, pl. X, 23 and 38: Middle period. *Stift und Feder,* 1930, 80–81.
No painting of this composition is preserved. The r. side of Jacopo's painting in the Pinacoteca in Vicenza "The Vicentine Rectors kneeling before the Madonna" shows some affinity with the composition, but also striking differences, especially in the manneristic juxtaposition of the acting figures in unequal sizes. Perhaps the influence of Parmigianino, to which Ridolfi refers, may be noticed here.

130 ————, 1432. A man recumbent. Charcoal and many-colored ch., on gray. 260 x 354. Hadeln, *Spätren.,* 77. Arslan, 189.
Sketch for a figure in the foreground of the painting "St. Eleutherius blessing the people," in Venice, Academy (ill. Arslan, pl. LXII). Latest manner.

131 ————, 1435. Kneeling soldier loading his rifle. Charcoal, height. with wh., on blue. 275 x 317. Very much rubbed. Vente Crozat 631 and Coll. Dalberg. Hadeln, *Spätren.,* p. 16. *Stift und Feder,* 1930, 35. [MM]
The study is used in a painting "Caccia in Valle," Coll. Pasquinelli, Milan (Photo Witt), ascr. to Jacopo Bassano.

A 132 DÜSSELDORF, AKADEMIE DER BILDENDEN KÜNSTE. None of the four drawings which are ascr. to Ja. Bassano in the Düsseldorf Cat. — St. Francis, 581, St. Jacob 582, a Monk 583, Mourning Virgin 584, ill. pl. 87 — has any connection with him or with Venetian Art. We have not re-examined the originals. [MM]

133 EDINBURGH, NATIONAL GALLERY, 2232. Adoration of the shepherds. Bl. and red ch., on faded blue. 224 x 326. L. and r. slip added. Hadeln, *Spätren.,* p. 16. Arslan, p. 189. [*Pl. CXLIV,* 3. **MM**]
The composition is used in a painting in vertical shape, existing in various places, e.g., in the Museum in Bassano.

A 134 FLORENCE, UFFIZI, 1825 E. Head of a man with a cap. Bl. ch., height. with wh., on blue. 229 x 267. The corners are added. O. H. Giglioli, in *Boll. d'A.,* 1937, p. 540, fig. 8, attr. the drawing which was previously ascr. to Tintoretto, to Jacopo Bassano (?).
We cannot find Jacopo's or any Bassano's style in this drawing. The graphic character and the intellectual and naturalistic interpretation of the face, in our opinion, are incompatible with Venetian Art in the 16th century.

A ————, 1890 F, see No. **83.**

135 ————, 1893. Kneeling and standing man (for an "Adoration of the shepherds"). — *Verso:* Head of an old man. Charcoal, some wash, on blue. 283 x 196. Damaged by mold. Hadeln *Spätren.,* pl. 72 and 73. Arslan, p. 190.
While the study on the back — used for St. Joseph in the Adoration no. 272 in Vienna — seems very convincing for Jacopo, the other side of the drawing is somewhat different from his style and could be by one of his assistants. Compare, for instance, the corresponding figures in Jacopo's authentic drawing No. **159.**

A ————, 5287, see No. **186.**

136 ————, 12813. Crucifixion. Bl. ch., on faded blue. Damaged by mold. 410 x 303. Ascr. to Gir. Muziano, but already recognized in the collection as belonging to the Bassano School. [MM]
Most of the figures correspond to those in a painted "Crucifixion" belonging to the King of Rumania (where St. John the Evangelist standing and raising his arms is the only important modification). The painting is a late and weak version of the composition made in the shop, on the basis of Jacopo's invention, also preserved in this drawing.

A ————, 12814, see No. **213.**

A 137 ————, 13051. Vintage. Pen. 125 x 188. Publ. by L. Fröhlich-Bum in *Zeitschr. f. B. K.,* 65, p. 125.
No connection with Jacopo Bassano's way of composing.

138 ————, 13052. Peasant walking, bending to the right. Bl. ch., height. with wh., on faded blue. 206 x 193. Stained.
The pose is typical of Jacopo, but the drawing may have been done in the shop.

139 ————, 13053. Page seen from back. Bl. and red ch., on blue. 283 x 198. [*Pl. CXLI,* 4. **MM**]

140 ————, 13063. St. Roch and sick people. Ch., brush, wash, on grayish green. 700 x 712. Damaged. On back old inscription: *Palla di S. Rocco.*
Working material of the shop for the lower part of Jacopo's painting in the Brera (Venturi 9, IV, fig. 834, p. 1199).

141 ————, 13064. Altar-piece: Bishop at an altar; below, the healing of sick people. Ch. 940 x 534. Very much damaged.
Working material of the shop.

142 ———, 13065. Martyrdom of St. Lawrence. Bl. ch., wash, on bluish green. 920 x 630.

A painting by Jacopo of this subject is in the cathedral of Belluno; according to Verci (p. 113) it was painted in 1572. We have not found out whether the working drawing, done in the shop, shows the same composition.

A ———, 13067 see No. **214**.

143 ———, 13068. Female head. Red and bl. ch., on buff. 307 x 205. Lower l. corner torn off. **[MM]**

The face is typical of Jacopo and was used by Girolamo in his altarpiece in St. Giovanni, Bassano, for the saint in the middle.

144 ———, 13072 F. Kneeling milkmaid. Bl. ch., on buff. 298 x 210. Arslan, p. 190: the motive appears in reverse in the painting in the Gallery of S. Luca in Rome.

145 ———, 13952. Noli me tangere. Bl. and red ch., height. with wh., on blue. 257 x 418. Hadeln, *Spätren.*, 81. **[MM]**

Design for a composition existing in a repetition by the shop in Dresden, Gallery 263.

146 ———, 13953. Visitation. Bl. ch., wash, height. with wh., on green. 528 x 398. Inscribed in brush: Nil mihi place(t). And below: Del 1569. Damaged by dampness. Attr. to El Greco by Willumsen, *La jeunesse du Greco* (1927, II, 537), by L. Fröhlich-Bum in *Zeitschr. f. B. K.*, v. 65, p. 124, to Ja. Bassano (with ill.). Willumsen reads dsI, meaning December (instead of del). [*Pl. CXLV*, 1. **MM**]

147 FLORENCE, HORNE FOUNDATION, 5663. Shepherd leaning on a staff, a whip in his hand. Bl. oily ch., height. with wh., on blue. 197 x 135. **[MM]**

The figure is found at r. in the background in a genre picture ascr. to Jacopo in the Museum in Cologne, and in another version of the same composition in the Sale of the Museum in Leningrad, Berlin, Lepke 4./5, VI, 1929, no. 56, ascr. to Francesco.

148 FRANKFORT/M., STAEDEL'SCHES INSTITUT, 15216. Recumbent figure. Many-colored ch., on buff. 269 x 328, irregularly cut. **[MM]**
Hasty sketch. See Nos. **130** and **149**.

149 HAARLEM, COLL. KOENIGS, I 52. Recumbent figure. Bl. ch., height. with wh., on br. 195 x 373. The corners are cut and patched. — On *verso*: B.B. No. 24. (Borghese Coll.) **[MM]**
Hasty sketch belonging together with Nos. **130** and **148**.

150 ———, I 53. Study of Christ for an Ascension. Bl. oily ch., height. with wh., on gray, two corners patched. 386 x 280. Exh. Amsterdam 486. **[MM]**

The figure is used, somewhat modified, in a painting of the Ascension, etched by Teniers in his *"Theatrum Pict."* 148, there ascr. to "Bassano Junior."

151 ———, I 55. Woman sitting with her sleeping child in her lap. Many-colored ch., on gray. 238 x 155. Inscription in pen: Bassan. Damaged in some places. *Verso*: B.B. no. 5. Borghese Coll., Coll. Marignane. [*Pl. CXLII*, 1. **MM**]
This drawing agrees in style with Nos. **130**, **148**, **149**. Together with the latter it is used in a composition of the "Circumcision" of which the Museum in Rennes possesses a version.

152 ———, I 56. A choir boy. Many-colored ch., on gray. 273 x 150. — *Verso*: B.B. no. 3 (?) Coll. Marignane. Exh. Paris 1935: No. 512. Exh. Amsterdam: 485. [*Pl. CXLII*, 2. **MM**]
Correctly identified as used in a composition of the Circumcision, see No. **151**.

153 ———, I 516. Turbaned bearded head in profile turned to r. Bl. and many-colored ch., on faded blue. 174 x 143. — *Verso*: B.B. no. 45 (Coll. Borghese). Ascr. to Francesco Bassano.
Closer to Jacopo with reference to No. **200**, superior in quality.

154 LAUSANNE, COLL. STROELIN. Woman with child. Half-length. Bl. ch., height. with wh., on reddish br. 183 x 162.
[*Pl. CXLII*, 4. **MM**]
Hasty sketch, probably from the same sketchbook as No. **155** and No. **156**.

155 ———, Still life: Chains and instruments of torture (?) on a table. Bl. ch., height. with wh., on reddish br. 125 x 190.
[*Pl. CXLIV*, 2. **MM**]
Probably from the same sketchbook as No. **154** and No. **156**.

156 ———, Two kneeling dignitaries. Bl. ch., height. with wh., on yellow-br. 215 x 157.
Probably from the same sketchbook as Nos. **154** and **155**.

157 LIVERPOOL, WALKER ART GALLERY, Roscoe Coll. 7. Man recumbent. Bl. ch., and some gray wash, on faded blue. 202 x 324. **[MM]**
Workshop drawing taken from the sick man in the lower l. corner of the painting by Jacopo in the Brera, St. Roch visiting the plague-stricken (ill. Venturi 9, IV, fig. 834, p. 1199).

A 157 bis ———, 6. Four warriors in 16th century costumes and a senator standing. Bl. ch., height. w. wh., on faded blue. 418 x 286. Ascr. to Jacopo Bassano. [*Pl. CXCVII*, 2. **MM**]
Copied from the middle group in the mural "The return of Doge Andrea Contarini to Venice after his victory at Chioggia," by Paolo Veronese in the Sala del Maggior Consiglio (Photo Böhm 466). The mode of drawing suggests an origin in the shop of the Bassano.

158 ———, 8. A dog. Bl. and br. ch., on faded blue. Two upper corners added. 207 x 289. **[MM]**
Autograph study from nature, as shown by the corrections. This dog appears frequently in compositions by the Bassano, e.g., in "Noah's Ark" in the Galleria Doria in Rome (Photo Anderson 5368).

159 LONDON, BRITISH MUSEUM, 1895-9-15 — 858 (Malcolm). Adoration of the shepherds. Bl. ch., on buff. 277 x 385. Hadeln, *Spätren.*, pl. 80. Arslan, p. 191.
The drawing in Edinburgh (No. **133**) to which Hadeln points is identical only in its subject.

160 ———, 1920-11-16 — 1. Lazarus and the rich man. Bl. ch., on gray. 327 x 471. Hadeln, *Spätren.*, pl. 82, p. 16. Arslan, p. 191.

A ———, Cracherode F. 7. 1. 72 see No. **222**.

A 161 ———, Cracherode 1-66. Rest on the flight into Egypt. Pen. 148 x 188. Coll. Hone and Reynolds. Engraved under Titian's name by Gius. Toschi. Publ. by L. Fröhlich-Bum in *Zeitschr. f. B. K.* 65, 124, fig. p. 123, as Jacopo Bassano with reference to the painting in the Ambrosiana.
In our opinion, the drawing is not Venetian.

162 London, Victoria and Albert Museum. Dyce 232. Lamentation. Brush, br. and gray, height. with wh., on yellow. Later inscription: Bassano. Cut into oval and mounted. 167 x 249. Damaged by mold. Ascr. to Jacopo. **[MM]**

The corresponding painting in the Louvre was ascr. by Arslan, p. 240, fig. 47, to Luca Martinelli (?), a collaborator of Giambattista da Ponte. Other modified copies exist in paintings and drawings (British Museum: Doubtful, 16th century, 109). This drawing, also, is a product of the Bassano shop in the 17th century.

163 London, Calman Gallery. The mocking of Christ. Many-colored ch. About 400 x 520. Rubbed and damaged by water. Inscription: 1568 da agosti (?). Coll. Marignane, Paris. **[MM]**

Hasty sketch, see No. **177**.

164 London, Geiger Sale. Mystic wedding of St. Catherine. Bl. ch. 535 x 395. Planiscig-Voss, *Drawings of Old Masters from the Coll. of Dr. Benno Geiger*, n.d., Appendix 15. Sale Sotheby December 7–10, 1920, both under the name of Jacopo.

More likely a shop production.

165 ————, Study for a sowing man (without feet). Bl. ch., height. with wh., on bluish paper. 248 x 205. Planiscig-Voss no. 23. Daniell bought the drawing in the Geiger Sale, Sotheby December 12, 1920, no. 24 (Witt). We could not trace it.

Study for a figure in the painting "Autumn" (engraved by R. Sadeler).

166 London, Formerly Mr. Archibald G. B. Russell. St. Peter kneeling, study for the Pentecost in the Museo Civico in Bassano. Bl. ch., height. with wh., on blue. 351 x 263. Hadeln, *Spätren.*, pl. 74. Arslan, p. 191. **[Pl. CXLV, 2. MM]**

The drawing is dated about 1570 by the painting. Its present location is unknown.

167 London, Coll. A. Scharf. A clergyman seated and reading. In the upper corner another smaller figure. Bl. ch., worked over with red color. 300 x 255. **[MM]**

Hasty authentic sketch; in the general character, the figure resembles the one in the lower r. corner of Bassano's Paradise in the Museo Civico in Bassano (Venturi 9, IV, fig. 851, p. 1232).

168 Malvern, Mrs. Julia Rayner Wood (Skippes Coll.). Study of an infant lying on his back. Bl. ch., on faded blue. 185 x 298. Exh. Birmingham 1934. **[Pl. CXLIV, 1. MM]**

The study was used for an infant lying in the lap of his mother in the composition of the "Deluge," a version of which exists in Hampton Court.

169 ————, St. John the Baptist seated. Bl. and red ch. 174 x 240. **[MM]**

Copy after Jacopo's painting in the Museum in Bassano, but in the mode of drawing so close to Bassano that the copy may have been done in the shop.

170 Milan, Formerly Coll. Frizzoni. Head of a woman. Ch., wash, on greenish paper. 90 x 90. Reproduced in Malaguzzi-Valeri, *I Disegni della Pinacoteca di Brera* No. 4.

We could not trace the present location of this drawing. In the reproduction it looks typical of Jacopo, resembling somewhat a woman's head in "Departure for Canaan," ill. Arslan, pl. LII.

171 Modena, Pinacoteca Estense, 1161. Bearded shepherd (?) bending forward, half-length. Many-colored ch., on faded blue. 161 x 187. Ascr. to Jacopo Bassano, publ. as such by Rodolfo Pallucchini, in *Le Arti*, I, 1938, p. 81, with reference to No. **200** and **130**. **[MM]**

A Munich, Graphische Sammlung. 2963, see No. **1038**.

172 ————, Mannheim 2964. Moses bringing forth the water from the rock. Bl. ch. 275 x 407. Zottmann, pl. XI, p. 43. *Monatshefte* II, 1909, p. 6. Hadeln, *Spätren.*, p. 16: Completely ruined by reworking. Arslan, p. 193.

The photograph (Witt) corroborated Hadeln's description of the drawing which was recognized as a free design for the painting in Dresden (Posse, *Catalogue* p. 110 ad 256).

173 ————, Mannheim 2965. Jacob's return. Bl. ch., wash, on yellow. 281 x 375. Zottmann, p. 43. *Monatshefte* II, 16. Hadeln, *Spätren.*, p. 16: Completely ruined by reworking. Arslan, p. 193.

Design for the painting in the Ducal Palace in Venice (Photo Alinari 18624).

A 174 ————, 32456. Flight into Egypt. Pen. 252 x 177. L. Fröhlich-Bum publ. the drawing, formerly ascr. to Titian, as Jacopo Bassano in *Zeitschr. f. B. K.* 65, p. 122 f, dating it between 1542 and 1562.

In our opinion, not Venetian.

A New York, Pierpont Morgan Library 75, see No. **403**.

A 175 New York, Coll. S. Schwarz. Milkmaid. Chalk. 200 x 85. Publ. by L. Fröhlich-Bum in *Zeitschr. f. B. K.* 65, fig. 124, with reference to an "Annunciation to the shepherds" in the Galleria San Luca in Rome.

In our opinion, not Venetian.

176 New York, Coll. J. Scholz. Study of a soldier. Bl. ch., on blue. 287 x 179. Coll. Vallardi. **[MM]**

177 Ottawa, National Gallery of Canada. Scene in the temple (probably the "Presentation of the Virgin" in the temple). Many-colored ch. 514 x 384. Dated: De lano 1569 — and a second time: del 1569. Coll. Borghese. Marignane, Paris. **[Pl. CXLIII. MM]**

Hasty sketch in the style of No. **163**. The composition is very close to the "Circumcision" in the Museum in Bassano which was executed in 1577 by Jacopo and his son Francesco. The fact that the drawing is dated 1569, when Francesco was only twenty years old, shows that in the painting the invention was Jacopo's, and that Francesco had a share only in the execution.

178 Oxford, Christchurch Library, K 26. Study for an infant angel. Bl. and red ch., height. with wh., on br. 266 x 166. Coll. Guise. Bell attr. to Jacopo Bassano. Hadeln, *Spätren.*, pl. 70. Arslan, p. 193. Popham, *Cat.* 288.

Leandro used a drawing of this type (in reverse) for the angel in his "Christ on the Cross" in the Museum in Bassano (Venturi 9, IV, p. 1311, fig. 893).

A 179 ————, K 25. Two men in contemporary costume, one washing his hands. Bell attr. the drawing to Ja. Bassano. Arslan, p. 347, rejects it.

We share Arslan's opinion.

180 Paris, Louvre, 5278. Shepherds (of an Annunciation). Brush, gray-br., height. with wh., on greenish yellow. Damaged by mold. 305 x 522.

Working material of the shop.

181 ———, 5279. Left half of a composition: Adoration of the Child. Brush, gray-br., height. with wh., on greenish blue. 565 x 412.

Working material in connection with the painting of the same subject (Arslan, pl. XXXVI).

182 ———, 5280. Christ driving the merchants from the temple. Pen, br., partly wash, height. with wh., on greenish blue. 525 x 430. Inscription (18th century): bassano, and, below, old inscription: 1570 Casato Martino (?) dni Giac (?) Sacali (?).

Working material of the shop see No. **183**.

183 ———, 5282. St. Jerome in penitence. Pen, br., wash, on blue. 542 x 380. Old inscription: 1587 zugno.

Working material of the shop. Probably by the same hand as No. **182**.

184 ———, 5283. Soldiers leading a woman. Red ch., height. with wh. (partly oxidized). Top semicircular. 520 x 504. **[MM]**

The drawing is the right half of a composition representing the "Execution of Tamar," a version of which, almost the same size, exists in the Gallery in Vienna (269), ill. Arslan, pl. LX. Working material of the shop.

185 ———, 5286. Head of an old woman. Charcoal and many-colored ch., on grayish blue. 367 x 305. Cut to oval shape. Hadeln, *Spätren.*, pl. 68. Arslan, p. 193.

Probably identical with the drawing 609 in the Mariette-Coll.: "Etude d'une tête de Vieille, de forme ovale, faite au pastel, pour un tableau de pastorale qui est connue à Florence dans la gallerie du Grand-Duc." This painting is today attr. to Francesco Bassano, not to Jacopo, but a version by the latter may have existed. At any rate, the drawing is nearer to Jacopo who might have invented this pathetic head for a mourning Virgin.

186 ———, 5287. Woman carrying a child, half-length. Many-colored ch., wash, on yellow. 337 x 245. Willumsen II, 579, pl. 80: Francesco Bassano with reference to a (somewhat similar) figure in the painting in Vienna (Venturi 9, IV, fig. 867, p. 1275).

[*Pl. CXLI*, 3. **MM**]

Willumsen suggests that Francesco might have copied the drawing after El Greco. That proves that Willumsen, also, did not notice Francesco's style in the drawing. As a matter of fact, it belongs to Jacopo Bassano (compare with Nos. **151**, **152**) and the above-mentioned painting by Francesco in Vienna is only a later version of a composition by Jacopo, see Dresden, Gallery, no. 253.

187 ———, 5291. Adoration of the Child. Brush, gray-br., height. with wh., on bluish-green. 537 x 400.

Working material of the shop.

A 188 ———, 5295. Three women in a kitchen, and various animals. Pen, dark br. 130 x 187. Modern French inscription: Bassan, and Jacques Stella. Mounted. Hadeln, *Spätren.*, pl. 78. Arslan, p. 193: Approaching by its technique the pen drawings by Paolo Veronese and Palma Giovine.

The technique, quite unique in Bassano's authentic work, arouses suspicion. Moreover, each element in this drawing exists in another distribution in a painting by Jacopo reproduced as "Hyems" (winter) by Aeg. Sadeler. The drawing cannot, therefore, be a sketch for this painting, nor is it a sheet with separate studies for it, its quality being too poor. It is, in our opinion, a sheet with copies by an unknown artist after Jacopo's painting.

189 ———, 5298. Sleeping shepherd (or Oriental?). — *Verso:* Two female heads. Bl. ch., on blue. 233 x 173.

Working material of the shop. See No. **190**.

190 ———, 5299. Sleeping shepherd. Bl. ch., on gray. 232 x 199. Companion to No. **189** and also from the shop.

A 191 ———, 5300. Group of two men, one standing, one kneeling over a basket. Over ch. sketch, brush, wash br. and bl. 373 x 238. Ascr. to Jacopo and acknowledged by Arslan, p. 193. **[MM]**

Probably Venetian, but later 17th century, and without connection with the Bassano shop.

192 ———, 5679. Portrait of a young man in profile wearing a cap, turned to the left. Half-length. Bl. ch., on gray, somewhat damaged by mold. 340 x 244. Inscription in pen: 1538 21 anni. Attr. to Bernardo Licinio and publ. as such by Hadeln, *Hochren.*, pl. 15.

[*Pl. CLXI*, 1. **MM**]

The attribution to Jacopo Bassano was orally suggested by M. André Linzeler, who based it on the resemblance to a figure in Jacopo's "Adoration of the Magi" in Edinburgh (ill. Arslan, pl. XXII), dated in his early period (p. 74). The resemblance is not absolutely convincing, but the attribution is confirmed by other early portraits by Jacopo, for instance, the one of Soranzo in the large votive painting in the Museum in Bassano (Arslan, pl. XI) and by the character of the drawing. At any rate, we prefer this attribution to the one to Licinio, in favor of which we see no argument at all.

A Paris, École des Beaux Arts, 24–290, see No. **2140**.

193 Paris, Coll. Marignane. Kneeling woman (to the left), boy and sheep. Bl. ch., on yellowish-br. 290 x 200. Later inscription: Bassan. — On back: B.B. no. 16 (Borghese Coll.).

Typical group, appearing in Jacopo's composition of the "Exodus of the Israelites," see Photo Witt, execution ascr. to Leandro, Sale Helbig, Rassi, IX. 29., 1917.

194 ———, Head of a young woman with a chain of pearls around her neck. Many-colored ch., on faded blue. 295 x 195. **[MM]**

Corresponding to Jacopo's late female type. See "The Chaste Susanna" in the Museum of Nîmes (1571, ill. Arslan, Pl. XLVIII).

195 Sacramento, Cal., E. B. Crocker Art Gallery. A woman on horseback. Brush, height. w. wh., on blue. 360 x 265. Later inscription on mount: J. Bassano. Dargenville Coll., (sold 1779), Destouches Coll. (sold 1794). Purchased in Paris 1873. Publ. by A. Neumeyer, in *O. M. D.* 1939, pl. 59, as a preliminary study by Jacopo Bassano for his painting in Dresden, no 253, "The Israelites in the wilderness."

Neumeyer is mistaken in connecting the drawing with the painting, in Dresden, where the woman has a child seated behind her. It is, on the contrary, connected with another version of the same subject where the woman appears alone. The painting in Vienna ascr. to Francesco Bassano and ill. Arslan, pl. LXVI, according to Arslan, is a repetition of a lost original by Jacopo, formerly in the house of the Savorgnan at San Geremia in Venice and engraved in 1763. The style of the drawing is not Jacopo's, but points to the shop, probably at a later period, (see No. **231**).

196 Salzburg, Studienbibliothek, H. 857 (new no. 197). Head of a shepherd looking to the right. Many-colored ch., on buff. 205 x

175. Somewhat rubbed, three corners added. Publ. by J. Meder in *Graph. Künste* 1933, 31, who refers to similar heads, for instance, in the painting Arslan, pl. 25. [MM]

A 197 ――――, H. 93 (new No. 479). Nude from behind. Ch., worked over with fixing brush, on buff. Watermark: crossbow in circle. 205 x 300. Meder, who publ. the drawing in *Graph. Künste* 1933, 31, cannot indicate any use of it in a Bassano painting, but finds the pose similar to Tintoretto's style. [MM]

In our opinion, neither the pose nor the style of drawing corresponds to the 16th century, in general, and Jacopo Bassano, in particular. We believe the author of this drawing to be a follower of Palma Giov. in the 17th century. The same applies to the following drawings in the same collection: H. 829 (new 481 MM); H. 796 (new 480), H. 198/1, H. 210/211 [MM], all attr. by Meder loc. cit. to Jacopo Bassano, and 836 (new 482), attr. by Meder loc. cit. to Francesco Bassano.

198 STOCKHOLM, PRIVATE COLLECTION. A woman (?) seated, turned to the left. Many-colored ch. 300 x 278. Irregularly cut. Later inscription: J. Bassan. Slightly damaged. The naked arm first begun in violet ch., then corrected in bl. — On back: B.B. No. 80 (Borghese Coll., Venice). Marignane Coll., Paris. [MM]

Hasty sketch like No. 154.

A STUTTGART, COLL. FLEISCHHAUER, Study of four figures, see No. 1162.

A 199 VIENNA, ALBERTINA, 71. Portrait of an old lady. Brush, bl., br., red and wh. oil color, on brownish paper. 354 x 250. Old inscription (17th century): La matre di M. Galiasso ... fu lasciato nelle Rei di D^to Galasso et Anibal fratelli et figli di D^tta Madona. Coll. Prince de Ligne. Schönbrunner-Meder, 651, and *Albertina Cat I* (Wickhoff), 137: Jacopo Bassano. Not mentioned by Arslan.

[*Pl. CXCVIII, 3*. MM]

The fact that the technique is unique with Bassano makes caution advisable. The costume points to a later date, still more the psychological spontaneity of the interpretation. We find the next stylistic affinity to Fetti. Compare, for instance, the old woman in his "Miracle of the Loaves," in Mantua, (ill. *Dedalo,* April 1923), or the one in the Campori Coll. at Modena (*Cronache d'Arte* 1924, p. 240).

200 ――――, 72. Head of an apostle used (on the left) in the Pentecost in the Museo Civico, Bassano. Many-colored ch., on blue. 140 x 135. Inscription (18th century): Bassano. Hadeln, *Spätren.,* pl. 76. Arslan, p. 196: magnificent work of Bassano's late age.

[*Pl. CXLI, 2*. MM]

The identification of this drawing as a study for the above-mentioned painting is due to Mrs. Fröhlich-Bum, in *Zeitschr. f. B. K.* 65, 1925.

A 201 ――――, 73. Half-figure of a youth turned to the left and looking upwards. Bl. and wh. ch., on grayish blue. 269 x 218. Coll. Kutschera-Woborsky. Stix-Fröhlich's attribution is questioned by Arslan, p. 286, who suggests Leandro.

In our opinion, the drawing is not Venetian, but Spanish. Compare the types in Juan de Ruelas' Martyrdom of St. Andrew, in Seville, Museum (ill. *Monatshefte* 1911, pl. 14). [MM]

A 202 ――――, 74. The idolatry of Solomon. Red ch. 177 x 181. Bought 1923 from the Grassi Coll. First publ. as Jacopo Bassano by Stix, *Albertina N.S.* II 26 with reference to the painting "Adoration of the Magi" in the Vienna Gallery, no. 272, dated about 1560 by

Hadeln (Ridolfi I, p. 394, note 5). In his review of Stix' publication (*Zeitschr. f. B. K.* 1927 I) Hadeln calls this hypothesis, which places the drawing in Jacopo's manneristic transition period, interesting; adding, however, that no drawings from this period are authenticated. Arslan does not mention the drawing. [*Pl. CXXXI, 1.* MM]

As far as the manneristic style of the figures goes, we too recognize a certain affinity to Bassano's painting in Vienna which has at times even been given to El Greco, but we insist on the complete difference in the interpretation of space. There is no painting by Bassano with an interior corresponding to the one in the drawing. The latter is very closely related to a drawing in the Oppé Coll. in London which from external evidence must be dated shortly before 1577 (No. **747**). We are inclined to attribute this drawing, with every precaution, to El Greco immediately before he left Venice for Spain; the drawing in the Albertina might be its companion. The above-mentioned approach to Jacopo's painting must corroborate the whole (very hypothetical) theory (compare E. Tietze-Conrat in *Art Quarterly,* Winter 1940, p. 22 ff.

A 203 ――――, 75. Presentation in the temple. Bl. ch., pen and bister, wash. 385 x 273. Inscription of the 18th century: Bassan. *Albertina Cat. I* (Wickhoff), 135: Autograph by Jac. Bassano. Accepted by Stix-Fröhlich in *Albertina Cat. II.* [*Pl. CXCIII, 3.* MM]

A drawing, unique in Jacopo Bassano's work for its technique, should not be attributed to him without decisive arguments, for instance, the similarity of composition which, however, has no connection with Bassano's style. In our opinion, the drawing, most probably Venetian, belongs to the early 17th century and is close to Girolamo Pilotti's style, compare, for instance, his drawing in the Louvre, 5785 [MM].

204 ――――, 76. Two young peasants. Ch., wash, height. with wh., on green. 285 x 370. — *Verso:* The left figure of the other side repeated. Bought in 1924. Listed in *Albertina Cat. II* (Stix-Fröhlich) as studies for two figures in Jacopo's "Annunciation to the shepherds" in Dresden (No. 259). Rejected by Arslan.

In our opinion, copy drawn in the shop.

A 205 VIENNA, COLL. PRINCE LIECHTENSTEIN. Annunciation to the shepherds. Brush, wash. Semicircular top. 204 x 314. Schönbrunner-Meder, 1331, Meder, *Handz.,* p. 632, fig. 313: Jac. Bassano.

Late copy.

A VIENNA, PRIVATE COLL. Head of an old man turned to the right, see No. **104**.

A 206 ――――― Seated woman and child, seen from behind. Ch., on gray. 280 x 200. Publ. as Jacopo Bassano by L. Fröhlich-Bum in *Zeitschr. f. B. K.* 65, 125 f., fig 124, with reference to the drawing No. **188**.

This reference is right only as to the subject, the pose is more manneristic. In our opinion, the drawing, which we have not seen, is not Venetian.

A 207 ――――― Adoration of the magi. Charcoal, height. with wh. (rubbed), on gray. 278 x 378. Publ. by L. Fröhlich-Bum in *Zeitschr. f. B. K.* 65, 127 (with ill.) as Jac. Bassano in his last period.

In our opinion, not a drawing from the 16th century. We have not seen the original.

208 WASHINGTON CROSSING, COLL. FRANK J. MATHER, JR. Head of a bearded monk turned to the l. Ch. on buff. 172 x 165.

LEANDRO DA PONTE, CALLED BASSANO

[1557–1622]

(See also the introduction to Jacopo Bassano, p. 47 ff.)

Leandro, Jacopo's younger son, seems to have moved to Venice when Francesco, eight years his senior, was still living. After the latter's suicide he completed the works Francesco left unfinished. Speaking of Francesco (p. 44) we expressed the opinion that the mural in the Ducal Palace, "the Doge Ziani taking leave of Pope Alexander III," was already so well under way at the time of his death that the general composition and the principal figures were fixed; only the drawing for a man carrying a load (No. 243) differing from Francesco's style, may be by Leandro. As we said, the problem of the painting in Montecassino is more difficult. It had been commissioned of Francesco half a year before his death, and the center of the composition seems to have been well advanced when he died. When Leandro took over the completion of the painting, a new contract was made which also provided for an enlargement of the original composition; supposedly the genre figures at the margins of the composition were added only then. There are drawings in the Uffizi (Nos. 213, 214) for a group of these and one separate figure, all ascr. to Jacopo and one of them publ. under his name by Mrs. Fröhlich-Bum. For this specific number (214) we do not doubt for a moment Leandro's authorship, the types being much coarser than Jacopo's usually are. In the other drawing, which is rather similar in style, the types seem to be less coarse, and we may, incidentally, recall that the upper part of one of the figures very closely resembles one in the painting of 1574 in Marostica — according to the signature, a joint work by Jacopo and Francesco. Is this an old study partly used in the painting at Marostica, and again (and this time more completely) in Montecassino, or did Leandro draw the group in question under the influence of the paternal sketches? We have to leave this question unsolved which again leads us into the maze of these family shops.

By a rare chance, a well-authenticated design for an altar-piece by Leandro has been preserved (No. 222), closer in its style to Jacopo than to Francesco, in fact so close that a connoisseur like Hadeln could publish the drawing under the name of Jacopo (Spätren., pl. 79). Mrs. Fröhlich-Bum rejected the attribution and thought of Leandro. As a matter of fact, the composition corresponds very well to that of an altar-piece in the demolished church of Santa Lucia in Venice, mentioned by Ridolfi II, p. 167, and described more fully by Moschini II, p. 81. A second design for an altar-piece, No. 224, already ascr. to Leandro by a former owner, might indeed be his, its resemblance to an altar-piece signed by Leandro (art market London 1937) being indeed striking.

Most of all, however, Leandro was the portraitist in the Bassano family. While Ridolfi mentions only a few portraits by Jacopo and none by Francesco, his list of Leandro's portraits is most impressive. A stock of preparations for portraits that seem to have been kept together in the Borghese collection in Venice, emerging one at a time during these last years, in our opinion, might most likely be by Leandro and his assistants. The material is very uneven. Never does it reach the extraordinary quality of No. 212. This drawing is definitely indicated as a self-portrait by an inscription which must be posterior to 1596, since Leandro is already named Cavaliere, but is apparently the study for the portrait in Vicenza, painted in 1593, and indeed most probably represents the artist when he was 36 years old. Here the contrast to Francesco is evident, as there is nothing of his poise or of his endeavor to give volume. The witty and pointed expression is closer to Jacopo's visionary drawing style that may be said to anticipate El Greco's to a certain extent.

In spite of the complete contrast of the Bassano style to the bulk of Venetian drawings, there are contacts apt to mislead the connoisseur. Popham lists No. **210**, representing Paolo Paruto (d. 1596) and ascribed by tradition to Carletto, under the latter's name; and K. T. Parker, on the basis of this attribution, ascribed to Carletto No. **230**, traditionally called Paolo Veronese, "although his first impression had been Leandro." In our opinion, the style of the two drawings is scarcely to be reconciled with that of No. **2207**, the attribution of which to Carletto we consider as well-authenticated. In spite of the influences accepted by Carletto from the Bassano, we should prefer to leave the drawings with Leandro.

A 209 BASSANO, MUSEO CIVICO, 510. Portrait of a bearded man seen full-face. Bl. and red ch., on buff. 328 x 287. Upper l. corner torn. Pen inscription (later): Leandro da Ponte. Coll. Riva. Listed by P. M. Tua, *Inventario dei Monumenti Iconografici d'Italia I, Bassano,* p. 36, no. 74, as portrait of Leandro, drawn by himself. **[MM]**

We cannot find any resemblance to the drawing in Darmstadt, No. **212**, nor to the style of the Bassano drawings. The resemblance to the portrait of Baroccio in the Morgan Library, attr. to Leone Leoni (Murray p. 25) points to another school.

210 CHELTENHAM, FENWICK COLL. Portrait of Paolo Paruta (d. 1596). Bl., red and wh. ch., on gray-blue. 296 x 198. Old inscription in lower r. corner: Carleto. On back, long notation by Richardson Junior, discussing the origin of the drawing from the Sagredo Coll. in Venice and the person represented. Coll. Sagredo, Richardson, Woodburn. Popham-Fenwick, p. 39, pl. 26, attr. to Carletto Caliari on the basis of the inscribed name. [*Pl. CXLIX,* 3. **MM**]

In our opinion, the style of the drawing conforms so closely to the group of preparatory studies, Nos. **233–242**, that we attr. the drawing to Leandro Bassano. The old inscription is at any rate not an autograph, and no other arguments for Carletto have been given. One should, however, keep in mind that Carletto in his early age was greatly influenced by Jacopo Bassano (Ridolfi I 353).

211 COPENHAGEN, DEN KONGELIGE KOBBERSTIKSAMLING. Group of traveling and resting persons. Bl. ch., height. with wh. 246 x 549. The composition in Copenhagen, supposed to represent an Adoration of the shepherds, was intended for a genre group in the foreground of a painting. See *Burl. Mag.* LXV, 215, pl. I A, from the Caspari Coll., Munich. **[MM]**

We ascribe the drawing to Leandro on the basis of the stylistic resemblance to the somewhat better-established No. **232**, but we have not seen the original.

212 DARMSTADT, KUPFERSTICHKABINETT, A E, 1428. Portrait of the artist. Ch., height. with wh., in face and hand a few touches of red ch., on br. 225 x 180. On a scrap of paper attached to the drawing inscription in ink: Ritratto del Cavalier Bassan fatto di sua mano. Coll. Crozat (?). First publ. by Zottmann, p. 66. Hadeln, *Spätren.,* pl. 90. Arslan, p. 277. Popham Cat. No. 289. [*Pl. CXLIX,* 1, **MM**]

In our opinion, study for the portrait No. 28 in the Museum in Vicenza, ill. W. Arslan, *La Pinacoteca di Vicenza,* p. 38, fig. 23, dated 1593, and named there by Arslan, p. 286: Portrait of a nobleman. If the inscription of the drawing in Darmstadt is reliable — as it seems to be by reference to the self-portrait of Leandro in the Uffizi, Arslan, fig. 55 — the work in Vicenza might be another self-portrait from an earlier period. At any rate, it helps to date the drawing in Darmstadt.

A FLORENCE, UFFIZI, 1893, see No. **84**.

213 ———, 12814. A seated and a standing man. Many-colored ch., on buff. 366 x 246. Formerly ascr. to Girolamo Muziano, now to the school of Jacopo Bassano. [*Pl. CXLVIII,* 2. **MM**]

Study for the "Multiplication of the Loaves" by Francesco and Leandro Bassano in the Badia of Montecassino (ill. *Boll. d'A.,* 1938, XXXII, July, p. 20, fig. 14). For our attribution to Leandro see No. **214**.

214 ———, 13067. Peasant girl carrying a basket. Bl. and red ch., height. with wh. (partly oxidized). 340 x 224. (Fototeca Ital. 9845). Publ. as Jacopo Bassano by L. Fröhlich-Bum, in *Zeitschr. f. B. K.* 65, fig. 125, with reference to a similar genre figure in Francesco's "St. John the Baptist preaching," in S. Giacomo dell' Orio in Venice (ill. Arslan, pl. LXV). [*Pl. CXLVIII,* 3. **MM**]

While this is only a general resemblance, a figure in the "Multiplication of the Loaves" by Francesco and Leandro Bassano in the Badia in Montecassino (ill. *Boll. d'A.* 1938, XXXII, July, p. 20, fig. 14, detail) corresponds exactly to the drawing. Its tendency to a coarse realism leads away from Jacopo's more delicate types and points to the next generation and to Leandro. See the other study for the same painting, No. **213**.

The painting was only ordered on October 28, 1591, and Francesco died on July 3, 1592, leaving the painting unfinished; this is confirmed by the fact that a new contract was made with Leandro obligating him not only to finish the painting but to enlarge it. Since the genre figures are on the border of the composition, they may reasonably be thrown in with Leandro's share, which adds a historical argument in his favor.

215 ———, 13060. The sibyl and the Emperor Augustus. Brush, br., on blue-gray. 515 x 403. Damaged. Ascr. to Jacopo Bassano.

A small picture of this subject by Leandro is mentioned by Ridolfi (II, 169) in the house of Jacopo da Ponte, a son of Leandro. This working design from the shop may have been connected with this painting.

216 ———, 13061. The Virgin (of an Annunciation). Brush, br. and bl. ch., height. with wh., on bluish gray. 537 x 377. Arslan, p. 278.

In our opinion, done in the shop.

217 ———, Santarelli, 7602. Altar-piece: The Virgin enthroned, S. Mark on the left and a group of S. Lucia and S. Lawrence on the right. Bl. ch., on faded blue. 310 x 210.

In our opinion, done in the shop.

218 FLORENCE, HORNE FOUNDATION, 5664. Bearded shepherd from behind, bending to the left. Bl. ch., height. with wh., on blue. Damaged by mold, rubbed. 380 x 296. Ascr. to Jacopo Bassano. **[MM]**

In our opinion, the pose is typical of Jacopo and his school (compare the very similar figure on the painting ascr. to Leandro, Photo Alinari Pc2a 175). We find the style near to No. **213** fairly well-established for Leandro.

219 HAARLEM, COLL. KOENIGS, I 62. Christ supported by two Angels. Bl. and wh. ch., on green. Squared. 268 x 244. On *verso* inscription in pen: B.B. no. 10 (Borghese Coll., Venice). The lower r. corner patched. Ascr. to Francesco Bassano. **[MM]**

In our opinion, nearer to Leandro with reference to the angels in No. **222**. A painted version of the same subject, attr. to Leandro, exists in the Museum in Cleveland but shows a different composition.

220 LENINGRAD, HERMITAGE, Cobenzl Coll. no. 136. S. Martin and a donor. Pen, wash, height. with wh., on bluish gray. 525 x 470. Publ. by Dobroklonsky, *Dessins des Maîtres Anciens*, Expos. 1926, Leningrad, 1927, No. 3: the drawing may be a study for the composition Zottmann p. 10, No. 22.

We have not seen the drawing.

221 LIVERPOOL, WALKER ART GALLERY, Roscoe no. 5. Kneeling man from behind. Brush, grayish-br., on faded blue. 204 x 226. Ascr. to Jacopo Bassano. **[MM]**

Our attribution to Leandro's shop is based on a certain resemblance to No. **231**.

222 LONDON, BRITISH MUSEUM, Cracherode, F. 7. 1–72. Design for an altar-piece: Bishop Saint enthroned, surrounded by angels, four other Saints on the ground. Charcoal, height. with wh., on greenish-gray. Semicircular top. 545 x 327. Hadeln, *Spätren.*, 79: Jacopo Bassano. L. Fröhlich-Bum in *Zeitschr. f. B. K.* 65, p. 127: possibly by Leandro, but certainly not by Jacopo. *[Pl. CXLVIII, 1.* **MM]**

We agree with Fröhlich-Bum and recognize in this drawing the design for Leandro's lost painting in S. Lucia in Venice, described by Ridolfi II, 167: "il Santo Agostino con molti Santi" and more in detail by Moschini II, p. 81: "Nell'altare che si offre grandioso Leandro Bassano dipinse la pala con santo Agostino in gloria, e al piano i santi Nicolò vescovo, Antonio di Padova, santa Monica e s. Giorgio." The latter seems too old in the drawing for a St. George; in any case, he also is a knight saint, and a modification by the painter or a misunderstanding by Moschini may have occurred.

223 LONDON, GEIGER SALE. Doge kneeling before the Pope who presents him with a document: "E . . . B . . . tertiae part(is) Imperij CX° dimidiae." Pen and brush, wash, height. with wh., on blue. 212 x 399. Geiger Sale, Sothebey, December 7, 1920, no. 359. Again Sothebey, May 22, 1928. Later whereabouts unknown. Ascr. to Leandro Bassano (?). **[MM]**

The composition shows a certain resemblance to the main part in Leandro's painting in the Sala del Maggior Consiglio "Alexander III presenting the Doge with a candle." The attribution of this remarkable *"modello"* to Leandro is nevertheless very doubtful, since it does not present either his types or his mode of drawing. We have not seen the original.

224 LONDON, THE SPANISH GALLERY. Preparation for the Martyrdom of St. Lawrence. Bl. ch., height. with wh., on blue. Semicircular top (cut). 410 x 280. On the mount later inscription: L. Bassano. **[MM]**

Jacopo Bassano painted a Martyrdom of S. Lawrence which still exists in the Cathedral in Belluno, and Francesco painted the same subject for Pogiana (Ridolfi I, 407). We were not in a position to compare the drawing in the Spanish Gallery with these two compositions. Anyhow its composition corresponds in style to an altar-piece "Ecce homo" signed by Leandro which we saw in London at the Botenwieser Gallery in 1937. The style of drawing is nearer to Leandro's than to Francesco's manner of modelling.

225 LONDON, COLL. E. SCHILLING, Portrait of a bearded man in white ecclesiastical garment. Many-colored ch., on blue. 300 x 263. Coll. Marignane. Ascr. to Leandro Bassano. **[MM]**

The very stiff portraits in Leandro's (signed) painting "S. Dominicus with his monks at table served by angels" (now in the Museo Correr in Venice) shows some stylistic resemblance with the style of this portrait.

226 MODENA, PINACOTECA ESTENSE, 991. Various sketches: Two women with a candle and with a plate, above; boy with duck, below. All half-length. Over ch. sketch, brush, grayish-br., on faded blue. 313 x 172. Late inscription: Bassano. Attr. by Brandi to Leandro.

In our opinion, drawn in Leandro's shop.

227 MUNICH, GRAPHISCHE SAMMLUNG, 2967. Entombment of Christ. Brush, bl., on yellowish paper. 258 x 147. Zottmann, p. 39: Jacopo Bassano. Muchall-Viebrock suggests Leandro on the basis of Arslan, pl. 80.

We have not seen the drawing.

A 228 NEW YORK, METROPOLITAN MUSEUM, 19.76.16. Head of a beardless youth, in profile to l., and two hands. Bl. ch., height. w. wh. 417 x 275. Coll. Lagoy, Earls of Pembroke. Publ. by A. Strong, *Pembroke Dr.*, II, No. 13, as Venetian School; Strong suggested as author "Jacopo Tintoretto or his imitator Leandro Bassano." In the museum attr. to C. F. Nuvolone (?), following our suggestion. **[MM]**

Certainly by Carlo Francesco Nuvolone (1608–1661). The model seems to be a member of his family, since the young man appears at the l. in Nuvolone's family portrait in the Brera, ill. *Il Ritratto Italiano*, Florence, Palazzo Vecchio, 1911, pl. 7. The same head appears also in Nuvolone's Assumption of the Virgin in the Brera, ill. *Zeitschr. f. B. K.*, vol. 47, p. 73, at r. In a portrait of a musician by Nuvolone, sold at the Wahliss Sale, Feb. 19, 1921 (reprod. Witt) a similar study of hands handling a violin has been used.

A 229 ———, 08.227.33. Head of a young man. Below, Queen of Sheba before Solomon. Bl. and red ch., on blue-gray. 294 x 196. Inscription in pen (contemporary): La Regina Sabea ascholta la sapientia de Salamo. Later inscription: Basan. Ascr. to Leandro Bassano. Publ. under his name in *Metropolitan Museum Dr.*, pl. 26. *[Pl. CXCVIII, 4.* **MM]**

Neither in the types nor in the linework is a distinct relation to Leandro Bassano to be found. In both respects, the drawing reminds us of No. **664** attr. to Giovanni Contarini by Resta. Since the head seems rather advanced in style for a follower of Titian, as Contarini should have been as a portraitist, his close pupil Tiberio Tinelli, excellent as a portrait painter, might also be taken into consideration. He sometimes also followed Leandro Bassano in his portraits (Ridolfi II, p. 278.).

230 OXFORD, ASHMOLEAN MUSEUM. Head of a bearded man in a fur coat. Bl. and red ch., with faint traces of white ch., on faded gray-blue. The letter A next to the eye may indicate the color "azurro." 288 x 179. Warwick Coll. as Paolo Veronese. Publ. by K. T. Parker in

O. M. D. Sept. 1936, pl. 22, as Carletto Carliari, with reference to No. 210, although he admits Jacopo or Leandro Bassano to have been his first impression. [MM]

Giving No. 210 also to Leandro Bassano, we attr. this drawing to him, too, since the only fairly well-authenticated portrait drawing by Carletto — No. 2207 — is fundamentally different. Again we have to remember the close approach of Carletto to the style of the Bassano, reported by Ridolfi for Carletto's youth.

231 PARIS, LOUVRE, 5284. Martyrdom of S. Lucy. Brush, grayish-br., on blue. 584 x 403. At the right, originally dated: 1596. Below, later inscription (18th century): Giacomo da Ponte da Bassano.
 [MM]

Working drawing for the main part of Leandro's painting in S. Giorgio Maggiore, in Venice (ill. Venturi 9, IV., p. 1305, fig. 889), ordered and executed in 1596.

232 ———, 5285. Cavalry fight. Brush, gray, height. with wh., on blue. 420 x 565. Inscription: Di mano del Cavalier bassano. [MM]
Working drawing.

233 PARIS, COLL. MARIGNANE. Head of an elderly, bearded man (to the right). Many-colored ch., on faded blue. 245 x 180. Ascr. to Jacopo. The drawing belongs to a group of portraits similar in style and technique and of the same size, approximately, which are preserved in the Marignane Coll. (or have recently left this collection) and seem to have all come from the same source. They are not portrait drawings ordered by the patron, but "préparations" for painted portraits which were drawn as working material and kept in the shop. This explains their coloristic coarseness and their lack of finishing. In a general way, any member of the Bassano shop might have had his share in this stock. And, as a matter of fact, the owner distributed them among the various members of the family. [MM]

In our opinion, on the contrary, the stylistic differences are too slight and their uniformity is an important argument for attributing all of them to a single member of the shop, preferably to Leandro, since he was the specialist of the family in portraiture. Our attribution to Leandro is, moreover, supported by the close resemblance of this drawing (No. 233) to the donor kneeling at r. in Leandro's painting in the Ducal Palace, Sale dell'Avogaria, ill. *Emporium,* vol. 85, 1937, I, p. 223. Perhaps another still closer resemblance exists to a portrait of Andrea Frizier, in the Museo Civico at Padua, tentatively attr. to Leandro Bassano, see Giglioli, in *L'Arte* XV, 1912, p. 195, fig. 3.

234 ——— Head of a bearded man to the left. Bl., wh., and red ch. 282 x 195. In the coll. ascr. to Francesco. See No. 233.
 [*Pl. CXLIX,* 4. MM]

235 ——— Head of a bearded man with ruff around his neck, looking at the onlooker. Many-colored and bl. 300 x 205. Ascr. to Francesco. See No. 233. [MM]

236 ——— Head of an old clergyman with short beard, looking at the onlooker. Ascr. to Francesco. See No. 233. [MM]

237 ——— Man in an ecclesiastical garment with short beard. Ascr. to Leandro. See No. 233. [MM]

238 ——— Head of a bearded, bald, old man en face. Many-colored ch., on faded blue. 260 x 190. Ascr. to Leandro. See No. 233.
 [*Pl. CXLIX,* 2. MM]

The very good drawing corresponds in style to painted portraits ascr. to Jacopo. See No. 233.

239 ——— Portrait of a boy. Many-colored ch., on blue. 285 x 205. Ascr. to Jacopo. See No. 233. [MM]

240 ——— Portrait of a young woman, nearly en face (to r.). Many-colored ch., on faded blue. 300 x 205. Ascr. to Francesco. See No. 233. [MM]

241 ——— Portrait of a boy with a ruff around his neck and short curled hair. Ascr. to Girolamo Bassano. See No. 233. [MM]

242 ——— Study of a head of the Virgin. Ascr. to Girolamo. See No. 233. [MM]

243 PARIS, COLL. MME. PATISSOU. Study for a bearded man carrying bags. Bl., red, and brown ch., on faded blue. 349 x 257. Later inscription in pen: da Bassan. — *Verso:* Ornamental design, probably for a woodcarving. Ascr. to Jacopo Bassano. [*Pl. CXLVIII,* 4. MM]

Study for a figure in Francesco and Leandro Bassano's painting in the Sala del Consiglio dei Dieci "Meeting of the Doge Ziani with the Pope Alexander III" (ill. Venturi 9, IV, p. 1327, fig. 907). Since the painting was begun by Francesco and finished by Leandro after Francesco's death, there are only stylistic arguments for the ascription of the study. Its contrast to the other study for the same painting, No. **94**, which corresponds very well to other authentic drawings by Francesco, justifies our attribution to Leandro.

244 PARIS, WAUTERS COLL. FORMERLY. Study for the robe of a Venetian senator, standing (the head apparently cut). Bl. ch., fixed with brush, on grayish-blue. Publ. by Frederick Lees, *The Art of the Great Masters,* p. 47, fig. 61, as Jacopo Tintoretto, with reference to the St. Justina with the three Treasurers in the Academy in Venice, ill. Bercken-Mayer, 146.

We have not seen the drawing (the present whereabouts of which we do not know) but are unable to find in it the style of Ja. Tintoretto and are reminded rather of Leandro Bassano.

245 RENNES, MUSÉE. Bust of a young girl, slightly bending to the r. Bl. ch. Late inscription: Pordenone. Publ. as Leandro Bassano by L. C. Ragghianti, in *Critica d'A.* XVI/XVIII, p. XXVI, fig. 6. [MM]
We agree, with reservations.

SHOP OF THE BASSANO

In view of the special character of the shop of the Bassano, most drawings which, in our opinion, are shop productions are discussed under the names of individual members of the family, and only those which have previously been published under the name of "Shop of the Bassano" are here.

246 CAMBRIDGE, MASS., FOGG ART MUSEUM, 64. Study for a kneeling king in an Adoration. Bl. ch., height. w. wh., with touches of red and yellow, on faded blue. 347 x 195. Charles Loeser Bequest 1932: 225. Mongan-Sachs, p. 52.

A 247 VIENNA, ALBERTINA, 80. Christ carrying the cross. Pen, wash, height. w. wh., on blue. 172 x 136. Formerly ascr. to Moretto, an attribution rejected by *Albertina Cat. I* (Wickhoff). *Albertina Cat. II* (Stix-Fröhlich) lists the drawing as Workshop of the Bassano, 2nd half of the 16th century. **[MM]**

We cannot find any connection with the types, the composition or the style of drawing typical of the Bassano. A workshop drawing should exaggerate the characteristics of the master. We propose Ligozzi on the basis of the drawing Albertina 215.

LAZZARO BASTIANI
[Mentioned 1449 to 1512]

Lazzaro Bastiani is one of the dark horses of Venetian Quattrocento painting. His biography, utterly confused by Vasari, was straightened out by discoveries of Paoletti, Ludwig and Molmenti in Venetian archives. Their results, on the other hand, by extending his activity far beyond its previous time limits, opened an arena for eager attributionists who succeeded in producing a muddle compared with which the confusion caused by Vasari appears relatively innocent. We need not discuss the whole matter again, but shall content ourselves with pointing to the paragraph devoted to Bastiani's drawings by Licia Collobi in her comprehensive study on him in *Critica d'A.* XX–XXII, p. 50. She may, however, claim the merit of a discriminative disposal of most older attributions to Bastiani. All attributions to Bastiani, old and new, in default of any authentic document of his style, must rest on general stylistic considerations. Drawings are claimed for him on the basis of their relative nearness to, or remoteness from, Carpaccio and the Bellini whose paths his own evolution seems to have approached or crossed at various occasions. This argument, which could hardly be replaced by a more methodical one, seems especially attractive in the case of No. 253, first claimed for Bastiani by K. T. Parker, and less so in that of No. 248. We feel tempted to add on the same uncertain foundation, the sheet with two female Saints in Turin, No. 258, and the doublesided study for a painting whose place between Carpaccio and the Giovanni Bellini shop is not yet conclusively established (No. 249). The relationship to Bastiani's rendering of space and the resemblance of the Infant Jesus to the child in a painting by Bastiani in the Musée Jacquemart-Andrée gives us some confidence.

But obviously we do not gain very much insight in Bastiani's art by such attributions, right or wrong as they may be, since they rest exclusively on an already extant idea of his art. We should profit more by being able to discover drawings from the borderlands of his art—from his youth in order to see from where he came, and from his old age in order to recognize how far he advanced. Unfortunately, nothing of this kind exists. We can weigh the various possibilities only with the help of two problematic drawings. One of them is among the anonymous in the Louvre, No. 257, for which M. Linzeler (verbally) suggested Bastiani's authorship. It is a very finished drawing, of the kind an artist might have presented to his prospective patrons. Certainly, Bastiani made drawings of such a description (for that matter everyone did). It is, moreover, specifically certified for Bastiani, from whom in 1470 the Scuola di San Marco commissioned a "Story of David" in two compartments, under the express condition of first submitting his design, in order to permit modifications in his compositions (Molmenti-Ludwig, p. 229). The most striking feature in the drawing in the Louvre is a certain contrast between the archaic setting and the figures whose slender proportions and dry draperies recall the style of Bastiani. The arrangement is based on schemes contained in Jacopo Bellini's Sketchbooks (compare the Presentation of the Virgin, Goloubew I, pl. LXVII and II, pl. XXII). May this drawing be an early design by Bastiani, perhaps preserved in a later copy, in view of the dryness of execution?

The other drawing, far superior in quality, is still more puzzling. In the good old days when everything looked so simple, "The Head of an Oriental in Dresden," No. 250, was considered the portrait of Mahomet II by Gen-

tile Bellini. Later on it was attributed to Bastiani because of a slight resemblance to an Oriental in his "Last Communion of St. Jerome." This reference is erroneous and the whole rich and complicated motive — a head looking back over a shoulder turned away — far too advanced for Bastiani. Miss Collobi calls it "Titianesque"; at any rate it is so fully cinquecentesque that Bastiani is out of the question. Another connection with a well established composition of Lazzaro Bastiani makes us seriously consider a sketch in the Earl of Harewood's Collection, No. 254 as his; at any rate the attribution to Carpaccio cannot be upheld — the negative criticism, we are sorry to say, as in most Bastiani problems being easier to apply than the positive.

248 BERLIN, KUPFERSTICHKABINETT, no. 468. Two Venetian patricians standing. Brush, grayish blue, height. w. wh., on faded blue. 196 x 207. Late inscription: Sandro Botticelli. Formerly ascr. to Carpaccio and publ. as his in *Berlin Publ.* I, 75. Attr. to Bastiani(?) by Hadeln, *Quattrocento*, pl. 10, p. 44, by reason of the dryness which excludes Carpaccio. Licia Collobi, *Critica d'A.* XX–XXII, p. 51 (erroneously asserting that Hadeln had attr. the drawing to Carpaccio): Bastiani.

The attribution to Bastiani, not supported by any connection with a painting, rests solely on the use of Carpaccio's technique by a weaker and dryer artist — such as Bastiani has been characterized. The general style of the drawing does not contradict the attribution, which we accept with reservations.

249 CHELTENHAM, FENWICK COLL., Cat. 4, 2. The Virgin, accompanied by the infant St. John adoring the Christ Child, study for a composition, preserved in a painting in the Staedel'sches Kunst-Institut, Frankfort (ill. Fiocco, *Carpaccio,* pl. XXIX) and in another in the Museo Correr in Venice (ill. l. c. pl. XXX). Over red ch. sketch pen, br. 131 x 95. Cut at l. Inscription in pencil: Benozzo. On the back: a somewhat similar study. Mentioned by S. Colvin in *Jahrb. Pr. K. S. XVIII*, p. 201, as by Carpaccio, publ. as his in *Fenwick Cat.*
[*Pl. XIII*, 4. **MM**]

The drawing is certainly a sketch, since the painted composition, chiefly based on the principal side, is modified in its spatial construction on the basis of the drawing on the back. The halos which are seen in the drawing are missing in the paintings. Moreover, the headdress of the Madonna in the drawing, in both paintings, is replaced by others typical of Giovanni Bellini and his school (compare Bellini's "Circumcision" in the N. G., *Klassiker, Bellini,* 150, and Marziale's "Circumcision" in the N. G., ill. Venturi 7, IV, fig. 436, p. 690; see also van Marle XVIII, p. 280). The manner of drawing is similar to that of Carpaccio about 1500, but the analogy is not entirely convincing. The rendering of space — different from Carpaccio's — recalls Lazzaro Bastiani's "Communion of St. Jerome" in Venice, ill. Molmenti-Ludwig, fig. 17. Another argument in favor of Bastiani may be the resemblance of the Infant to the child in the Legend in the Musée Jacquemart Andrée in Paris, ill. in *Critica d'A.* XX–XXII, fig. 36. An attribution to Bastiani may deserve serious consideration, but the available material is not sufficient for a final decision.

A 250 DRESDEN, KUPFERSTICHKABINETT, Head of an Oriental. Bl. 203 x 319. Acquired in London, 1862, at that time ascr. to Gentile Bellini and supposed to be a portrait of Sultan Mahomet II. First attr. to Bastiani by Morelli (verbally) and publ. as his with reservations by Woermann, *Dresden* I, 33, pl. 24. and by Molmenti-Ludwig, *Carpaccio,* p. 10, fig. 19, who take the drawing for a study for the Oriental personage conversing with two monks in the "Last Communion of S. Jerome," Venice Academy, ill. Venturi 7, IV, fig. 225, p. 385. Fiocco,

Carpaccio, p. 93: copy after a study of Carpaccio. Licia Collobi, p. 51, rejects the attribution to Bastiani, because of the "Titianesque" elements, which make the style of the drawing look much too advanced for Bastiani.

We agree with her and specifically contradict the reference to the "Communion of St. Jerome." While here, the personage in question is placed in a pure profile, the study in Dresden displays a richness of movement typical of the generation working in the first quarter of the 16th century. Even for Carpaccio, the motive is by far too advanced.

A 251 DÜSSELDORF, AKADEMIE DER BILDENDEN KÜNSTE, No. 572. St. Mary seated with the dead Christ in her lap between the kneeling Saints St. John and Magdalene. Pen, br. 194 x 190. Formerly attr. to Carlo Crivelli, placed by B. Berenson (verbally) in the neighborhood of Boccaccio Boccaccini or Galeazzo Campi, publ. in *Düsseldorf Cat.* as Venetian-Cremonese School. Licia Collobi, p. 50: If not a design — for the drawing looks later in style —, at any rate a variation of the painting representing the same subject in the Poldi Pezzuoli Museum in Milan.

There is no connection whatever with the miniature in the Poldi Pezzuoli, the attribution of which to Bastiani, moreover, is completely in the air. The stylistic resemblance to the "Lamentation over the Body of Christ" in Dresden, publ. as Ferrarese School 1500–05 by R. Longhi, *Officina Ferrarese,* Rome, 1934, pl. 154 might place the drawing in the same neighborhood.

252 HAGUE, THE, COLL. FRITS LUGT. Four men in Venetian costumes, standing. Brush, gray and wh., on blue. 168 x 254. — On the back: Two groups of Venetians. Coll. Lodovico Mostardo, Calceolari, Grassi. Ascr. to Carpaccio and exh. as his Amsterdam 1934, *Cat.* 513 (ill.), and in Paris 1934/5, *Cat. Sterling.* No. 535. Accepted as his by van Marle XVIII, p. 350, note. [*Pl. XIV*, 1. **MM**]

The material available for Carpaccio is sufficient to reject the attribution to him with certainty. The possibilities for another attribution are less favorable, nevertheless we propose with reservations Lazzaro Bastiani, with reference to No. **248** and to Bastiani's "Miracle of the Holy Cross," in the Academy in Venice, ill. Venturi 9, IV, fig. 232, p. 392, where similarly bodiless figures with rigid folds appear. Very similar types, however, encounter also in the background of Carlo Crivelli's "Annunciation" of 1486 in the N. G. (compare the detail in *Burl. Mag.* LVI, 1930, p. 63, pl. IV, A), but the style of the drawing is, in our opinion, too pictorial to allow an attribution to Crivelli. The manner of drawing may have been common to various artists deriving from Jacopo Bellini.

253 LONDON, BRITISH MUSEUM, 1895-9-15 — 804. Madonna della Misericordia. Pen and brush, height. w. wh., on bluish. 160 x 90. Malcolm Coll. Publ. by K. T. Parker, pl. 49 as L. Bastiani (?) and possibly the design for a pax. Accepted by L. Collobi, p. 50 f., who

dates the drawing about 1490, in the time of the "Coronation of the Virgin" in Bergamo, ill. van Marle XVIII, fig. 111.

For the iconography see the panel in the Scalzi, ill. *Boll. d'A.* XXV, p. 25 and another one in the Academy in Venice, ill. Testi I, p. 183, 184, pl. 180. [*Pl. XIII, 3.* **MM**]

254 LONDON, EARL OF HAREWOOD. Two Groups of clergymen facing one another. Over hasty sketch in red ch. pen. 260 x 280. Coll. Resta-Somers, Thom. Hudson, Reynolds, Thom. Banks, Poynter. Tancred Borenius, in *Burl. Mag.* XXIX, p. 271, pl. A, was the first to propose the attribution to Carpaccio and a connection to his "Death of St. Jerome," ill. Fiocco, *Carpaccio,* pl. XCVI. *Vasari Soc.* 2nd series, VII, No. 2, Hadeln, *Quattrocento,* pl. 18, p. 57, and Fiocco, pl. C, p. 72, follow Borenius. Popham in *O. M. D.* 1935, X, p. 11 expresses his doubts about the connection with the painting. Van Marle XVIII, p. 344 states that the drawing might be the rough sketch of a funeral service by Carpaccio, but certainly not for that of S. Jerome in the Scuola di San Giorgio. [*Pl. XIV, 2.* **MM**]

We agree with van Marle, but go farther, noticing a slight difference in style from Carpaccio's. The tight grouping of all the figures is in contrast to his habit of loose grouping. Moreover, since one of the monks — the bearded one, fourth from l., holding a holy water basin in his outstretched r. hand — appears in Lazzaro Bastiani's "Last Communion of St. Jerome" (ill. Molmenti-Ludwig, fig. 17) we have the feeling that this artist ought to be taken in consideration for this drawing. His principles of composition are rather closely consonant with that of the drawing.

A 255 LONDON, COLL. HUNGERFORD-POLLEN, formerly. St. Francis standing under an arch. Brush, blue, height. w. pink, on grayish blue. 145 x 88. Coll. Henry Oppenheimer (*Cat.* of Oppenheimer Sale No. 8: Anonymous). Exh. Burl. Fine Art Club 1936-7 as Alvise Vivarini. Sale Christie 1937, December 10, No. 88: Anonymous Venetian 15th century. Licia Collobi, p. 51: Bastiani about 1500. [**MM**]

We have not seen the drawing which in the reproduction shows a character of a miniature and deservedly remains among the anonymous.

A 256 NEW YORK, PIERPONT MORGAN LIBRARY, IV, 54. Christ enthroned on a kind of cupola, blessing with His r. hand and holding a globe in His l. Over ch. sketch, pen, brownish gray. 380 x 264. Not completed. On the back inscription (cut): nihil deficit. Publ. by Romolo Artioli in *La Bibliofilia,* 1899, p. 133 ff., when the drawing with five others in the same style were bound with a Bible printed in Rome 1471 and were for sale at Olschi's, Milan. The question of the authorship is left open after a discussion of Mantegna and his school. Attr. to Lazzaro Bastiani by Licia Collobi in *Critica d'A.* XX–XXII, p. 51 without giving substantial reasons.

We find no connection to Bastiani and hardly any striking resemblance to the style of Venice.

257 PARIS, LOUVRE, 5600. In a rich architectural setting two scenes from the Life of the Virgin, at r. her Presentation in the Temple, at l. her Wedding. Pen, br., wash, the sky tinted blue. 212 x 356. Here anonymous. Tentatively ascr. to Bastiani by Linzeler (verbally), in whose opinion we join. [**MM**]

There is a certain contrast between the archaic setting and the figures whose style points to a period around 1500. It may be that the composition rests on an older scheme. The dryness of the linework suggests an old copy.

258 TURIN, BIBLIOTECA REALE, 15906. Two female Saints standing. Brush, height. w. wh. 175 x 201. Formerly ascr. to Mantegna, now to school of Carpaccio. [**MM**]

The expression "School of Carpaccio" might be misleading pointing to a later period, while the drawing is rather archaic and in some features different from Carpaccio.

A 259 VIENNA, *Albertina,* no. 17. Composition sketch for the scene of a ceremony. Pen and bistre. 199 x 257. Badly damaged. Acquired 1924. Attr. to Bastiani by *Albertina Cat. II* (Stix-Fröhlich) 17, rejected by Licia Collobi, p. 51, who proposes Lorenzo Costa as the author. [**MM**]

This attribution to Costa seems convincing to us.

GENTILE BELLINI

[Born c. 1429, died 1507]

No explicit information about Gentile Bellini's artistic education has been handed down to us. It has always been assumed, however, that he got his training from his father Jacopo. Gentile's close collaboration with the latter makes his own activities disappear up to 1465. It is only at the age of 46 that Gentile emerges as an artist; and even later he still worked occasionally with his father (1466, Gattamelata Chapel at Padua). Under these circumstances, it seems reasonable to presume that he stemmed from Jacopo as a draftsman as well. In our analysis of Jacopo's working material (preserved in the British Museum and in the Louvre), we have tried to establish Gentile's authorship for a few of these drawings (No. 364, pl. I, II, XIV, XXIV, XXIX, LVIII, LXIX). We tentatively place others (No. 363, pl. XLV, LIII, LIV, LXII, LXVII, LXIX, LXXXIII, LXXXIV, LXXXIX, XC, XCI–XCIV, XCVII, CXXI, CXXIII, CXXV, CXXXIII; No. 364, pl. III, X, XI, XII, XIII, XV, XXI, XXVI, XXVII, XXVIII, XXXI, XXXIV, XL, XLI, XLVIII, LXVII, LXXII, XCII) on the borderline between father and son without pronouncing on the authorship in each separate case (see p. 109 f.).

One of our arguments for this division is based on the consideration that some of the drawings foreshadow

characteristics typical of Gentile's mature style. This holds good especially for those in which the artist concentrated on spatial depth and architectural preciseness. Moreover, we have added several documentary evidences revealing Gentile Bellini's reputation in the field of theoretical art studies (see p. 99 f.). We do not wish to repeat here the statements made further on, but we should like to emphasize their hypothetical character. If they are correct, they might indicate Gentile's specific reaction to the art of his brother-in-law Andrea Mantegna—a reaction apparently rather different from his brother Giovanni's to the same influence (see p. 73 ff.). This difference is consistent with the dissimilarity of their individual natures which was never completely effaced despite their mutual artistic interrelations which continued until Gentile's death. These interrelations result not only from the attraction and repulsion of kindred natures, but from the social conditions governing their lives. Gentile, and Gentile alone, was the heir of the workshop where long before he had been the first assistant and Jacopo's right-hand man. This is clearly proved by the fact that the drawings which had been Jacopo's working material were bequeathed to Gentile by the last will of his mother Anna (see p. 102). Giovanni may have collaborated in this shop. In a letter of 1471 (quoted p. 100) the two brothers are both equally mentioned, but undoubtedly Gentile was the official head. In 1469 he was awarded the title of Comes Palatinus by the Emperor and in 1474 was appointed to execute the new paintings in the Sala del Maggior Consiglio in the Ducal Palace, thereby becoming the official painter of the Republic. Five years later the Turkish Sultan asked the Venetian Government to send a portraitist to his court. Gentile was selected for this half-artistic, half-diplomatic task, and for the period of his absence his brother Giovanni was appointed his substitute in the Ducal Palace. After his return from Constantinople, Gentile again took up his job for the Venetian Government and headed the artistic activities in the Ducal Palace, assisted by Giovanni and other artists. As for the decorations painted for the Scuole of San Marco and San Giovanni Evangelista, Gentile acted as the head of the family. In 1492, for example, he offered in his own and Giovanni's name to replace the paintings in San Marco which had previously been executed by Jacopo and his sons and later destroyed by fire in 1485. In his last will of February 18, 1507 Gentile appointed Giovanni his successor much in the same way he himself had succeeded their father: Giovanni was to receive the drawings that had belonged to Jacopo (that is, the working material of the shop) with the proviso that the paintings in progress at the time be completed.

Considering the conditions of Gentile's life we might also have expected him to have continued his father's activities in the field of drawing. And in wideness of range Gentile was hardly inferior to Jacopo; he busied himself in most of the branches of drawing that had interested his father. Just as the latter in 1456 had made a model for the figure of Lorenzo Giustiniani in his funeral monument in San Pietro di Castello (see p. 106), so Gentile supervised the sculptor Antonio Rizzo in decorating the façade of the Scuola di San Marco in 1474 (see p. 83). He also redecorated this façade after its destruction by fire in 1485. Jacopo drew from classic monuments (see p. 97) and Gentile allegedly made drawings after the column of Theodosius in Constantinople. This tradition, it is true, rests only on a late copy from these reliefs in the École des Beaux Arts in Paris, formerly attributed to Gentile and engraved in the 18th century from a reduction. (P. Menestrier, Columnia Theodosiana, Paris 1702). Doubts as to Gentile's authorship in a presumed older version, already expressed by Müntz, were again voiced by C. Ricci (*Gentile Bellini a Constantinopoli,* in *Nuova Antologia,* vol. CLXII, 1912, p. 177 ff.). That Gentile owned drawings from Roman antiquities is explicitly stated in his last will in which he bequeathed "mea omnia designia retracta de Roma" to two of his assistants. On p. 97 we have stated that the drawings may have been made by some other artist than Gentile.

Gentile seems also to have followed Jacopo's example in drawing city views, an activity, which in this period of a new approach to reality, had just begun to combine artistic and scientific aims. Various sources agree as to the special ability or interest of Gentile in this field. Angiolello, a contemporary writer, writes in his *Historia Turchesca dal 1429 a 1513* that the Sultan Mahomet II ordered him "che facesse Venezia in disegno e ritraesse molte persone" (to make a drawing of Venice and portraits of many persons). A few years later, in 1493, Gentile was approached by Francesco Gonzaga through his agent, Andrea Salimbene, minister of Mantua in Venice, in order to obtain from him a view of Venice and another of Cairo. Views of Genoa and Paris are later on mentioned in the same correspondence. From one of these letters, written by Salimbene to Francesco Gonzaga on December 23, 1493 (*Archivio Storico*, 1888, I, p. 277) we learn that Gentile when asked for a view of Venice, pointed to one by Jacopo which he owned, and offered to overwork the old, almost faded linework (compare the wording of the whole passage on p. 107). The offer was not accepted, but the drawing was sent to Mantua where the court painter copied it. This old view may have been copied or modernized by Gentile, and we feel tempted to reconstruct it, or at least guess at his lost design whose importance—although merely hypothetical—might justify a digression. In 1486 the first view of Venice worthy of this designation appeared in Bernard von Breydenbach's well known and, in its time, enormously popular book *"Peregrinationes in Terram Sanctam."* In the preface of the book we are told that the noble pilgrim had provided for the illustration of this future book of travels by taking a painter with him to make drawings on the spot. The painter was Erhard Reeuwich from Utrecht. While some critics consider him a Dutch artist, others have long since advanced the opinion that these illustrations show no resemblance to any Dutch woodcuts of the period (Thieme-Becker XXVIII, p. 80). Recently this negative statement has been modified by Count Solms' careful demonstration showing that Reeuwich was Dutch by birth and artistic descent and is to be identified with the so-called "Master of the Housebook" (*Staedel Jahrbuch,* 1935–36, p. 13 to 95). We have had to recall these facts before drawing attention to a problem which strangely enough, had never been pointed out before we discussed it in *Gaz. d. B. A.* 1943, p. 83. Is it possible that this large and splendid view, combining a complete understanding of the unique site of the town with a careful rendering of numberless details, was drawn by a passerby—a tourist who according to the circumstantial diary of the pilgrimage had only spent three weeks at Venice? In our opinion these circumstances show the absurdity of this presumption. The task, new at that time and fulfilled with superior mastership, demanded a more intimate knowledge of the town than could have been gained through a short visit. A few years later Jacopo de' Barbari took years to make his enormous woodcut of Venice. Our theory that the view of Venice was not designed by Reeuwich contradicts the express statement in Breydenbach's preface that Reeuwich had been taken along for the special task of drawing the sites. We moderns are inclined to overvalue such a statement. In the 15th century it was not meant as literally as we are inclined to accept it. In the manuscript of another pilgrimage to the Holy Land, undertaken three years after Breydenbach's, the author boasted of having drawn his (by the way, very lively) illustrations directly from nature and on the spot. They are, however, exact copies of Reeuwich's woodcuts, published three years before the second party left (*Ritter Grünemberg's Pilgerfahrt ins Heilige Land,* 1486, ed. Johann Goldfriederich. As to the relationship of the miniatures of the two existing manuscripts in Gotha and Karlsruhe to Breydenbach's book, see Hellmut Lehmann-Haupt, *Die Holzschnitte der Breydenbachschen Pilgerfahrt als Vorbilder gezeichneter Handschriftenillustration,* in *Gutenberg-Jahrbuch* 1929). Reeuwich's task evidently was to procure the material for the illustrations, either by making the drawings himself or by acquiring suitable models from other artists.

That he did the latter in the case of Venice is further evidenced by the stylistic difference of the view of Venice from others in the book. Especially that of Jerusalem, which as the goal of the pilgrimage, should certainly have demanded the most careful representation. The difference between the two woodcuts is striking. The view of Jerusalem is composed of conventional patterns for which a good draftsman could have made his notes in a few days and which are arranged without any convincing ability. Even details, such as trees or human figures, are conceived in an utterly different manner. Regardless as to whether Reeuwich may have used some other already existing illustration for his view of Jerusalem, we may, from the mere difference between the two views, infer that the original models were by different hands and that Reeuwich did not make the design for the view of Venice. Incidentally, he did not make the designs for some other views which we discuss in connection with Vittore Carpaccio on p. 141 f. If Reeuwich is identical with the "Master of the Housebook," as we think Count Solm has satisfactorily proved, we may add that no characteristic of this very well known and original artist allows us to believe that he ever concentrated on such a task. His best qualities exclude the painstaking patience it must have demanded.

As soon as we surmise that part of Reeuwich's task as official illustrator of Breydenbach's Cruise to the Holy Land consisted in procuring models for his woodcuts, we shall have to suppose that a drawing by a Venetian artist served for the view of Venice. The number of artists to be taken into consideration is extremely limited. Once more we wish to emphasize the great difficulties of such a task which combined theoretical knowledge and practical ability. Considering the date (1486) our first idea cannot but suggest Gentile Bellini, certainly the best prepared to fulfill it, and, as we have heard before, considered a specialist in this field. It is difficult to guess how much he made use of Jacopo Bellini's view of Venice (still available in 1493, see above) in making this design. Certainly, he modernized the view (the conformity of the woodcut with the state about 1480 is emphasized by Davies, p. XXII) and added the staffage in the foreground, which is advanced beyond Jacopo in style and, on the other hand, different from the figures in some other views in Breydenbach's book. The figures in the foreground on that of Venice, as well as the boats of which we shall have a word to say in a minute, are Venetian in subject and style. In our opinion, the drawing for one of them (the lady on high pattens stepping down into a boat, Davies pl. 7 and 10) must have been very similar in style to No. 262 which is rather close to Gentile in its general aspect; another example would be No. 264. We still have a word to say about the boats in this and several of the other woodcuts. It is well known that these boats had become a regular pattern for representations of this subject; especially the proud sail boat on Davies pl. 16 which had been copied innumerably, so minute is its rendering of the complicated organism. And again we wonder how this typical boat, the "boat in itself" for more than one generation, could have been created by an inlander who had spent his life in Central Germany and who discovered the sea on a casual trip of a few weeks? The company remained a day or two at Corfù, at Modane, at Crete, and this short interval between two painstaking voyages is supposed to have been sufficient time for a layman in naval affairs to produce this ideal and irretrievable vision! The authors of this book have sometimes for their own amusement tried to draw one of these old fashioned and fascinating boats in the Mediterranean. They do not believe in the likelihood of such an improvisation, and are inclined to look in the working material of the Bellini shop for the models used by Reeuwich for his woodcuts. Among the drawings, listed in the index of the Paris Sketchbook, but now missing, one, folio 33, represented "algune nave in diversi muodi." Of course, we do not know whether it was by Jacopo or one of his sons, but we recall the fact that Jacopo's teacher, Gentile da Fabriano, had painted the original painting of the sea battle of Doge Ziani, in the Ducal Palace. In the second version, replacing the first,

which was begun by Gentile Bellini and finished by Giovanni, Vasari explicitly praises the rendering of the numerous boats taking part in the battle. We cannot resist the temptation of imagining that for such an occasion, the younger Bellini drew from the material of drawings assembled in the paternal workshop. We are then attracted by the idea that the same material, perhaps in copies, was also available to the visitor from the North whose connections with Venetian art have been discussed for many years. In dealing with Carpaccio we shall try to prove that he used the same models as Reeuwich did, which were probably Gentile's drawings.

Returning from this digression to the more normal drawing activity, we find that, just as Jacopo Bellini, Gentile Bellini's drawing too is devoted to sketches of entire compositions and to studies from separate figures. The fact that both categories are so much less numerous with Gentile is, in our opinion, not merely accidental, but due in part to the further evolution of drawing in Venice. He is the legitimate successor of Jacopo, not only by continuing, but also by superseding him. We have duly, or perhaps even unduly, stressed the fact that Jacopo's drawings were the working material needed and used by his shop (see p. 95). We also suggested that his sons, and especially Gentile, contributed their own work to the common stock. The usefulness of this stock was still acknowledged in Gentile's last will. But if, as we presume, he presented one-half of the collected material to the Sultan in 1480, it would mean that it had lost part of its actuality (p. 108). At any rate, after this date, Gentile did not seem to have added extensively to the material. Otherwise, he would have disposed of it in his will, as he did of Jacopo's and of the special class of archeological drawings. Apparently, this specific type of drawing material, such as that contained in Jacopo's sketchbooks, was no longer as important as it had been before. The transformation of the drawing as an objective "simile" to a means of subjective expression, started by Jacopo, is logically carried on by the new generation. Consequently, mass-production lost its meaning. The progress is less conspicuous as far as single figures are concerned. As a matter of fact, the use of models for such figures continues through centuries, gradually replacing drawn models by engraved ones. Nevertheless, there is a difference that may rest on the new approach to reality. The trend toward a sharper individualization, typical of the second half of the 15th century, was apt to restrict the possible use of such single figures. They had been types suitable to many uses; they were still types, but with a far more limited range of possibilities for general use, while their heightened individuality made them still more suitable for specific cases. Like pieces of movable scenery they make their appearance in many different compositions. For this purpose they were copied and repeated, and this popularity makes it difficult to distinguish original and copy, or to fix the date of origin, which may be distant from the period of execution. Typical specimens of this species are the drawings No. 282 in Turin and No. 285 in Washington, D. C., both published and discussed by Degenhart. For the former, which appears with slight modifications in Gentile's Procession of the Holy Cross of 1496, he suggests an origin about thirty years earlier. The other, which has also been used in the background of Carpaccio's "Return of the Ambassadors," he attributes to a follower of Gentile because of its poorer quality. In spite of this emergence in the production of another artist, even because of the fact that this artist is Carpaccio, we accept the connection of the drawing with Gentile Bellini. It may copy a lost original by him. The common trait in both cases is that studies of characteristic figures were kept ready for use, either by their authors in a much later period, or by some other artist to whom they were accessible. Two more drawings may belong to the same group, although, it is true, they are not verified for Gentile: No. 264 in Donnington Priory, and No. 262 in the Fogg Art Museum, which resembles one in the view of Venice in Breydenbach's book. Mr. Loeser, who had owned the drawing, was not entirely mistaken in recognizing the figure in one of the illustrations of Cesare Vecelli's *Habiti*. Not that the drawing in question served as a model;

but as several other of Vecelli's costume figures go back to Quattrocento drawings, the one of the "Courtesan" may be based on a design akin to our drawing.

All these figures are distinguished by their sharply stressed characteristics akin to characters on a stage. It is evident that drawings of this kind will prove especially impressive when drawn from a sphere, to which access is difficult. Gentile's visit to the court of Mahomet II led him into an artistically unknown world. Ridolfi states explicitly that over an order of the Sultan, Gentile had to draw "gli abiti de popoli orientali." It is easily understood that his priceless studies from nature were not only a store for his own later use, but were also plundered by direct and indirect followers. For instance, Girolamo da Santacroce, at Gentile's death one of his assistants and heirs, eagerly snatched at Gentile's models for the Oriental figures in the background of his paintings (Gombosi, in Thieme-Becker, vol. 29, p. 422). Another collector and preserver of Gentile Bellini's Turkish studies was Albrecht Dürer, who copied a drawing which Gentile himself used in his Procession in S. Marks' Square. Inasmuch as the painting was not completed in 1494–5 when Dürer was in Venice, Gentile's preparatory material may have been accessible to the young German. Judging from his drawing L. 93 in London (or its original, if we were right in considering the drawing a copy after Dürer in our *Dürer-Catalogue* I, p. 87, no. W7) Dürer carried a record of these studies away with his notes. It is well known that many years later Dürer introduced one of these Turks into his etching B. 99. Probably it is not the only one of Gentile's Turkish costume studies which were preserved by Dürer. His drawings L. 630 and 631, in the Albertina and in the Ambrosiana, may go back to such models (Tietze, *Dürer*, I, p. 88, no. W8, W9). The same may be true of the Oriental types which frequently appeared in Italian and Northern productions during the transition period from the 15th to the 16th century, when Turkey held the centre of the international stage.

It is in our opinion difficult to realize how important a part such studies played in the average production of Venetian workshops. When studying Carpaccio we shall be amazed by the number of figures he borrowed from Gentile. A painting like the latter's "Adoration of the Magi" in the N. G., for which Gamba presumed Carpaccio's collaboration, seems to have been a favorite hunting-ground (see No. 606 and others). Carpaccio who could hardly have had the painting under his eyes when he painted, may have copied individual figures for his own use; or he might have had access to Gentile's own studies, to the *simile* drawings that were a current article among the artists. (See No. 640). Identical figures appear in paintings by Carpaccio and in those by Mansueti; we may suppose that both used the same *similes* for models.

An especially interesting group of Oriental figures appearing in Pinturicchio's murals in the Appartamento Borgia in Rome, and later in the Piccolomini Library in the Cathedral of Siena, has been connected with Gentile's Turkish studies. Referring to our conclusions concerning these drawings (see No. 271) we should like to emphasize the difference between the two drawings in the British Museum and the others in Frankfort and Paris. The former are, in our opinion, copies executed before 1500 from models by Gentile Bellini of which the "Turkish Painter" in the Isabella Stewart Museum in Boston might offer an example. The exceptional technique and perhaps even a certain approach to Oriental miniatures may explain that "lack of simplicity" put forward by Lionello Venturi as an argument against the attribution to Gentile. The other five drawings, much poorer in quality, might go back to drawings of Bellini made for a special purpose (see p. 71), but they were executed much later than Pinturicchio's murals. Probably they are late copies from the drawings Pinturicchio had used in his paintings. It is hard to guess how these drawings and also copies from the miniatures (for No. 271 is also used, though inverted, in the Appartamento Borgia) became available to him. May we, merely to indicate one possible

channel, recall the fact that Morto da Feltre (if we are allowed to identify him with Lorenzo Luzzo) worked with Pinturicchio in Rome from 1492 to 94, and that he or some other artist of a similar type may have carried with him such Venetian drawings? Other threads leading from various paintings by Pinturicchio to Bellinesque inventions might suggest that Pinturicchio experienced stronger influences from Venice than are usually admitted. Traces of other drawings of the same category are to be discovered in Reeuwich's woodcuts. We have pointed out one or two, still existing, which are similar to those used in the view of Venice. We suspect that others of the staffage figures in this, and other views, go back to a similar source; even Reeuwich's woodcuts of single figures— so much discussed as supposed models for Carpaccio—are based on such drawings. One of these types (the young lady gathering up her dress, Davies, pl. 34 top) appearing in Carpaccio's drawings Nos. **597** and **640** and the corresponding painting in San Giorgio degli Schiavoni, is to be found in No. **284** which, for reasons presented later on, we consider a compilation from Gentile Bellini's types. Reeuwich's woodcut and Carpaccio's drawing rest on the same invention by Gentile Bellini.

It remains perplexing that all these alleged *similes* are used by Pinturicchio and none of them in a painting by Gentile or his pupils to whom they must have been most readily available. Were the originals carried away from Venice by the supposed mediator who went to Rome? Although they were originally drawn to keep a record of typical Oriental figures, were they later on so closely connected with individual portraits (see our hypothesis on p. 71) that they lost their easy adaptability to changing tasks? The increasing trend toward individuality at the end of the 15th century accounts for the replacing of *similes* by studies made especially for a specific painting. Two excellent examples of this type are the two heads in Berlin, Nos. **260, 261**, preparing two of the innumerable individual portraits in Gentile's "Procession of the Holy Cross." Here the solitary character is evident. They were studies from nature made for the specific purpose of adding to the realism of the whole composition. The outstanding quality of the two drawings is universally admitted. But we disagree with all other critics since we do not recognize the same hand in both. On the contrary we find such decisive contrasts between them (see p. 68) as may be expected in the works of two fellow countrymen, contemporaries or perhaps brothers. No. **260** displays the plainness and solidity typical of Gentile while the interpretation of the other head, No. **261**, is much softer and more picturesque. The identification of the model as Gentile Bellini is convincing, and this fact adds another argument against his authorship: the drawing does not have the character of a self-portrait. In order to put his own likeness into the illustrious assembly gathered to worship the Holy Relic, he used an existing portrait drawing of himself or had it made for this specific purpose; nothing seems more plausible than to suppose that it was done by Giovanni Bellini whose general stylistic characteristics are recognizable here.

Not only the study of characteristic details, but also the recording of whole compositions had become an important task. As long as the range of subjects to be represented had been narrow and bound by a venerable tradition, a number of suitable patterns had been solidly established. But for entirely new subjects, new compositions had to be invented. Preparatory drawings could no longer respect time-honored or slowly evolving schemes, but became experiments to balance out unheard of arrangements. Hence, the tendency in Jacopo Bellini's drawings of whole compositions to be ideal constructions and in Gentile's to be subjective interpretations of reality. Fortunate discoveries in these last years have consistently enriched the number of drawings in this category. The sketches in Munich, Nos. **273** to **278**, and the one recently acquired by the British Museum, No. **270**, connected with paintings by Gentile, offer their support to one longer known, for which the authorship of Gentile has wrongly been questioned. To attribute the sketch in Chatsworth No. **263** to Carpaccio seems a serious, if pardon-

able, mistake; Hadeln had already pointed out the basic difference in the approach of the two artists to the problems of space. The argument that the technique is known only by Carpaccio (incidentally, always a poor argument as no artist has the absolute monopoly of a technique) is now effectively refuted by the appearance of those other examples by Gentile. They establish the stylistic difference so solidly that, on the other hand, a re-examination of Carpaccio's own state of possession seems inevitable. In the "Raising of the Cross' in Oxford (No. **A 628**) the approach to Gentile's early productions, still connected with Jacopo's shop, seems much closer than to Carpaccio. No. **284**, on the contrary, if our arguments for placing it in Gentile Bellini's circle prove convincing, must belong to his latest period. The character of the spatial arrangement is in our opinion decisive: the figures tread on solid ground and the buildings are really built, not merely fantastic inventions serving as side scenes and decorations. Their approach to reality is our chief argument for seeing here (as in No. **265** whoever the artist may be) Gentile's share as the essential feature.

Considering the disconcerting incompleteness of our material, any assistance in reconstructing Gentile Bellini's figure as a draftsman is extremely welcome. We add, therefore, two further large compositions which at least, in part, may testify to his ability in this special field. No. **269**, important, at any rate, as a document on one of Gentile's lost murals in the Ducal Palace is by most authorities taken as a late copy after Gentile, but in our opinion only so heavily reworked, that, as in most drawings in Jacopo Bellini's sketchbooks, the original character seems obliterated. Under this veil we believe we may guess at something of Gentile's touch in his late period. The other drawing in question is No. **283** in Berlin. The composition has the archaic character and clear simplicity of Gentile's early paintings. It may, moreover, as pointed out in the discussion of the drawing, refer to an event that took place about 1470. On the other hand, the linework is definitely not his, nor is the drawing likely to be a design. We reach the conclusion that one of his pupils may have copied a painted composition of Gentile Bellini.

260 BERLIN, KUPFERSTICHKABINETT, 5136. Portrait of a youth, bust turned to left. Used in the "Procession of the Cross," of 1496 (ill. van Marle XVII, fig. 91, p. 165). Bl. ch., on yellowish gray. 227 x 195. Coll. von Beckerath. *Berlin Publ.* I, 74. L. Venturi, *Origini*, p. 345. Hadeln, *Quattrocento*, pl. 7 and others. [*Pl. XII, 1.* **MM**]

A 261 ————, 5170. Portrait of a man, supposed to be Gentile Bellini himself. Used in the "Procession of the Cross," of 1496 (ill. van Marle XVII, fig. 91, p. 165). Bl. ch., on yellowish gray. 230 x 195. Pricked for transfer. In *Berlin Publ.* I, 73 as Gentile Bellini's self-portrait. So Hadeln, *Quattrocento*, pl. 6, Parker, pl. 37, Popham, *Cat.* 158 and others. [*Pl. XXXII, 2.* **MM**]

While we accept the identification of the sitter as Gentile Bellini on the basis of the resemblance to several portraits of him, we cannot believe that the drawing is a self-portrait. The pose and the direction of the gaze contradict this theory. Moreover, the drawing style is noticeably different from No. **260**: compare the modeling of the face there by parallel hatchings, in our drawing by hatchings following the forms. Also the different rendering of the cloth. These predominantly negative arguments are supported by the stylistic resemblance to Gio. Bellini's only authenticated portrait, of the Doge Leonardo Loredano, in the N. G. in London (*Klassiker* 144), whose presumable date, about 1501, is not far from the presumable date of the drawing in Berlin (1496). It shows the same careful way of modeling and the same psychological subtlety. It would be most tempting to suppose

that Gentile's portrait was done by the artist nearest at hand, Giovanni Bellini, who might be credited with the outstanding quality of this drawing and who is reported to have portrayed his brother in one of his murals in the Ducal Palace (Ridolfi I, p. 68). In view of our present state of knowledge such a suggestion should be advanced as cautiously as possible; that is why we list the drawing here and not under Giovanni Bellini.

262 CAMBRIDGE, MASS., FOGG ART MUSEUM. Woman standing on pattens and lifting a transparent veil. Pen, wash, 180 x 102. — On *verso*: Oriental figures standing and sitting under a tent(?). Bl. ch. and pen-and-ink. Coll. Rodrigues, Loeser Bequest 1932 — 314. Loeser's theory that the drawing might be a preliminary study for Cesare Vecelli's *Degli habiti antichi e moderni*, Venice, 1590, is rightly rejected by Mongan-Sachs, p. 38, who point out that the figure is of the late 15th, rather than 16th century origin and style.

[*Pl. X, 1 and 2.* **MM**]

Cesare Vecelli informs us that he used figures taken from old drawings and paintings as models for some of his illustrations. The figure of the courtesan, although not agreeing in its motive with the drawing in the Fogg Art Museum, displays the same general feeling and may go back to a similar drawing.

The freshness and informality of the pose, well emphasized by Mongan-Sachs, are characteristics of a study from nature by an original master whom we are inclined to identify with Gentile Bellini.

More than anyone else he might have had the opportunity of making such studies of an Oriental scene (on *verso,* compare for a similar informality Gentile's "Adoration" in the N. G., ill. van Marle XVII, fig. 88, p. 156), and be interested in sketching the piquant figure of a courtesan. Moreover, a figure rather similar in general spirit and posture appears in the foreground of Reeuwich's View of Venice of 1486 (Davies, pl. 7 and 10) which we suppose to have been copied from a model by Jacopo or Gentile Bellini (s. p. 63 f.). The pen-work does not contradict a tentative attribution to Gentile. (Compare our article in *Gaz. d. B.A.,* 1943, p. 87).

263 CHATSWORTH, COLL. DUKE OF DEVONSHIRE. Procession. Pen, br., over sketch in red ch. 145 x 209. Coll. Resta (G 32 as Giovanni Bellini) Lord Somers. Hadeln, *Quattrocento,* pl. 8. A. Venturi, in *L'Arte* 1926, p. 1 ss.: Gentile Bellini. Exh. London 1930, 694, and attr. by Popham (*Cat.* 169) to Carpaccio, with regard to its (alleged) resemblance to No. **592**. The attribution is accepted by van Marle XVII, p. 175s. and XVIII, p. 332, but not by Borenius, *Pantheon,* 1933, p. 296, Baumeister, *Münch. Jahrb.* N. S. XI, p. 36, and Fiocco, *Carpaccio.* [*Pl. IX, 1.* **MM**]

The essential argument in favor of Carpaccio was, in Popham's view, the technical analogy with well-authenticated drawings by him; see Nos. **591, 592, 623**. Hadeln had already noticed this analogy, but correctly added, that the same technique might have been used by many artists. He emphasized the fact that the general approach to the problem of rendering space is essentially different from Carpaccio's and in accord with Gentile's urge toward architectural clearness and order. Since the time when Popham expressed his opinion, No. **270** and Nos. **273–278** came to light, adding in our opinion decisive arguments in favor of Gentile.

Padre Resta in his catalogue added the following commentary (Popham in *O. M. D.* 1936, June, p. 18): "g 32 Disegno di Gio. Bellini. Dipinte in Venetia per l'istorie d'Alessandro terzo nella Sala del Gran Consiglio, mi vien detto ma (= da) Pittori, ma bisogna, che la loro memoria sbagli il luogo dove stanno Aless⁰ 3⁰ riconosiuta nella Carita, e condotto processionalmente in San Marco." (Design by Giovanni Bellini. Painted in Venice for the series from the Life of Pope Alexander III, in the Sala del Gran Consiglio, as I was told by painters who, however, must have been misled by their memory. The place where Alexander was recognized was in the Carità from where he was conducted in procession to San Marco.) The sketch may indeed represent the recognition of the Pope, the locality being rather similar to the Carità. The main scene would be at r. on the staircase landing; No. **337** might be a copy from a detail of the same composition. The information which Resta received may therefore be correct, and the drawing be a sketch of the composition of this subject, formerly in the Sala del Maggior Consiglio, attr. to Giovanni Bellini (Ridolfi I., p. 67). In view of the cooperation of the Bellini brothers, Giovanni's mural may have gone back to a sketch by Gentile.

264 DONNINGTON PRIORY, COLL. GATHORNE-HARDY. Figure of a youth, seen from behind. Pen-and-bistre, wash. 260 x 90. Damaged, patched on to an old piece of paper by some early collector, who inscribed it Pietro Perugino. *Descriptive Cat. of the Hon. A. E. Gathorne-Hardy,* coll. no. 18: Mr. B. Berenson thinks this drawing is Venetian, perhaps by Gentile Bellini. Publ. in *Vas. Soc.* III, 10, as Anonymous Venetian, last quarter of the 15th century. Attr. to Gentile Bellini in our article in *Gaz. d. B.A.,* 1943, p. 87. [**MM**]

The posture speaks in favor of Venice, the style resembles somewhat the drawing in Jacopo Bellini's sketchbook in Paris, Goloubew

II, pl. XXIX, which we are inclined to attribute to Gentile Bellini's early years. Furthermore, a very similar page is found in the view of Venice in Breydenbach's book, in the design of which Gentile may have had a share (see p. 63 f.).

265 FLORENCE, UFFIZI, 1293. Procession. Pen. 442 x 591. Ascr. to Gentile Bellini, but publ. by P. Molmenti, *Storia di Venezia nella Vita Privata,* II, p. 89, as Giovanni Mansueti, with reference to his painting of a "Miracle of the Holy Cross" (ill. van Marle, XVII, fig. 105, p. 186). Hadeln, *Quattrocento,* pl. 9, p. 45, returned to Gentile Bellini: "The place represented resembles very much the Campo San Lio, as shown in Mansueti's painting, but the drawing is more realistic in its approach to the topographic situation than Mansueti's somewhat childish painting." These arguments did not convince Parker, pl. 38, who ascr. the drawing to Mansueti, because of its connection with the painting. Van Marle, XVII, p. 177 and others, adhere to the attribution to Gentile and date the drawing in his last period.

 [*Pl. VIII,* 2. **MM**]

The exact conformity of the r. half of the drawing to Mansueti's composition is not yet an evidence of Mansueti's authorship, since he might have used a drawing by his master Gentile Bellini for his painting which is signed "Joaniis de Mansuetis Veneti recte sentientium (? corrupted from Gentile?) Bellini discipli," perhaps intentionally indicating a dependence on his master who may have been ordered the whole series of paintings. The drawing which does not represent any actual scene may have been planned for the background of a composition, the main part of which would have been placed in the foreground (compare for instance Gentile's Procession in St. Mark's Square, ill. Van Marle XVII, fig. 81, p. 161). The dryness of the line-work may be caused by an intensive reworking, corresponding to that of the drawings in Jacopo Bellini's Paris sketchbook (No. **364**) by which the original character has suffered. The greater originality of the invention and the architectural clearness as already stressed by Hadeln, appear as the strongest arguments in favor of Gentile.

A ——, 584 E, see No. **334**.

A 266 FRANKFORT/M., STAEDELSCHES KUNSTINSTITUT, 3956. Oriental figure standing, turned to the r. Pen. 258 x 180. Coll. D'Argenville, Joubert. Publ. by A. Venturi, in *L'Arte* I pl. 2a, together with the corresponding figure No. **A 267** as used in Pinturicchio's "Disputation of St. Catherine" in the Appartamento Borgia in the Vatican Palace and considered a copy from Gentile Bellini. Hadeln, *Quattrocento,* p. 46: copy. See No. **271**. [**MM**]

267 ——, 3957. Oriental figure standing, turned to the l. Pen. 260 x 180. Companion piece of No. **A 266**, same origin and same publications. See No. **A 271**. [**MM**]

A 268 HAARLEM, COLL. KOENIGS. Head of a man wearing a cap and turned to the r. Bl. ch. 127 x 100. Coll. Archduke Frederick of Hapsburg. Publ. by Meder, *Albertina* N. S. I, No. 3 as North Italian about 1510. Exh. Haarlem 1926–27, No. 38 as Antonello da Messina. Exh. Amsterdam 1934, No. 489 and Paris 1935 (*Cat.* Sterling No. 513) as Gentile Bellini (?). In our opinion, it is not Venetian because of its style.

269 LONDON, BRITISH MUSEUM, 1891–6–17 — 23. Pope Alexander III presenting the sword to Doge Ziani. Brush, ink, outlines in pen, on parchment, in part yellowed. 350 x 235. — On the back inscription

by a hand of the 16th century: "Schizzo de ma di Za .. Be .. quando fece li quadri nel grã co ... quando Papa Alesando ... Ziani che ando .. Ba rossa." Coll. Marquis of Normanby. Publ. by S. Colvin in *Jahrb. Pr. K. S.* XIII, p. 23 ff as Gentile's sketch for his painting in the Ducal Palace (Ridolfi, I, 58), with reference to a copy of the drawing in the Albertina, then ascr. to Rembrandt, ill. in Wickhoff, *Rep. f. K. W.* 1883. Gronau, *Künstlerfamilie*, p. 34 accepted the attribution to Gentile with reservations, while Lionello Venturi, *Origini*, p. 344, considered the drawing a 16th century copy after Gentile's painting. In Thieme-Becker III, p. 257 Gronau calls the drawing an original, or a good early copy. Most other authors follow Lionello Venturi, for instance, van Marle XVII, p. 176, note, who dates it considerably later. Popham, *Handbook*, p. 25s: possibly copy.
[*Pl. VIII*, 1. **MM**]

An attentive examination of the drawing reveals the fact that those parts of it which are executed only in brush, look much more like drawings of the 15th century and offer considerable resemblance in the technique of sketching to No. **634**. The disturbing impression of other portions, is due, in our opinion, to the reworking with the pen, perhaps as early as in the early 16th century (see the retouches in Jacopo Bellini's sketchbooks, and especially Goloubew II pl. 1). Nothing in the drawing allows us to suppose that it is a 16th century copy. On the other hand, 1577, the year of the destruction of Gentile's painting would be the limit. Also the use of parchment is an argument in favor of an original.

270 ————, 1933–8–3 — 12. A procession on St. Mark's square in Venice, first idea for Gentile Bellini's painting of 1496 in the Academy, ill. van Marle XVII, fig. 91 p. 161. Red ch., pen and ink. 131 x 194. Framed by borderline. Coll. Resta (g 34), Somers, Richardson, Sale Sotheby 1933 August 2nd, lot 58. Ascr., by Resta, to Giov. Bellini, later to Gentile Bellini on the basis of its resemblance to No. **263** and publ. as his by Borenius in *Pantheon* 1933, p. 296, ill. p. 328. Accepted as his by Baumeister, *Münch. Jahrb.* N. S. XI, p. XXXVI, while Popham, *British Museum Quarterly* VIII, 63, and *Handbook* p. 25, is inclined to see in it a reminiscence of Gentile's painting, by Carpaccio. The same attribution in van Marle XVIII, p. 332. [*Pl. IX*, 2. **MM**]

The convincing connection of the drawing with Gentile's famous painting and its stylistic conformity to No. **273** on one hand, and the essential difference in the general approach from Carpaccio's (see No. **263**) on the other hand, support the attribution to Gentile. The church in the background resembling San Marco has the exact shape of the building in the background of Gentile Bellini's "Sermon of St. Mark" in the Brera (ill. van Marle XVII, fig. 96, p. 167.).

A 271 ————, Payne Knight P. P. 1–19. An Oriental seated. Pen. 214 x 175. Companion piece of No. **272**. Both drawings were first attr. to Gentile Bellini by Morelli, but publ. as Pinturicchio by Ad. Venturi, *L'Arte* I, p. 32, 8a, who noticed the use of No. **A 271** and of Nos. **266**, **267**, **279–281**, put by Venturi in the same category, in Pinturicchio's murals in the Appartamento Borgia in the Vatican Palace. G. Frizzoni, in *Rep. f. K. W.* XXI, p. 284, who considered only the two drawings in London as originals and all the others as copies, reclaimed the whole group for Gentile Bellini, adducing besides stylistical arguments, the fact that the words written on No. **272** were in Venetian dialect. He was followed by C. Ricci, *Pinturicchio*, p. 117, and Ludwig, in *Jahrb. Pr. K. S.* 1903, appendix p. 14, while Lionello Venturi, *Origini*, p. 343 ss. nevertheless, declared the drawings not Venetian at all. G. Gronau, *Künstlerfamilie*, p. 30, Martin, in *Burl. Mag.* IX, p. 148, Hadeln, *Quattrocento*, pl. 4, p. 46, Parker,

pl. 36, van Marle XVII, p. 173, Degenhart, in *Jahrb. Pr. K. S.* 1940, p. 43, and others accept the theory that the drawings were made by Gentile Bellini during his stay in Constantinople in 1479 and 1480, and that Nos. **266**, **267**, **279**, **280**, **281** are copies from originals made by him at that time. In spite of all this opposition Adolfo Venturi, in *Storia* 7, II, p. 626, reiterated his arguments against an attribution to Gentile. O. Fischel, *Zeichnungen der Umbrier*, Berlin, 1917, p. 82, explains the difficulty in solving this apparently simple question by pointing out that both the Venetian and the Umbrian School in the second half of the 15th century still clung to the Gothic tradition of using short and parallel hatchings. [*Pl. XI*, 1. **MM**]

The temptation to attribute the whole group of drawings to Gentile is certainly great. Very few European artists of the 15th century had an opportunity of getting first hand information on the Orient. Moreover, Gentile's interest in Oriental figures of a similar character is confirmed by their appearance in several of his paintings and by the well-known and well-authenticated miniature of a "Turkish painter" in the Isabella S. Gardner Museum (ill. van Marle XVII, fig. 184; see Martin, l. c.). Despite Fischel's remarks on the homogeneity of late Gothic drawing style, we must emphasize the decidedly Venetian character of the figures in question which look like foreign elements within Pinturicchio's compositions. The Venetian dialect of the inscriptions on No. **272** is a further support of the theory of a Venetian origin. One objection, however, forces itself immediately into one's mind: If the drawings used in the murals in Rome and Siena are by Gentile Bellini, why do we not find any trace of them in Venice? None of these figures appears in the preserved works of Gentile Bellini or of his followers, who in other cases made abundant use of Gentile's studies which he brought home from the Orient. The only exception would be the drawing of a camel in Windsor, attr. by S. A. Strong (*Chatsworth Dr.*, p. 11, note 6) to Gentile Bellini and connected by C. Ricci (*Pinturicchio*, p. 118) with Nos. **266** and **281** and supposed by him to be used in Gentile Bellini's "St. Mark's Preaching" in the Brera. Neither statement is valid: the camel has no connection with Gentile Bellini, but has correctly been identified as Pisanello's by A. Venturi in *The Connoisseur*, vol. 71, 1925, pl. opp. p. 203; and the camel in the drawing looks different from the one in the Brera painting. It remains a fact, therefore, that the group in question left no trace within the Bellini school, or Venetian art in general.

A further argument advanced by L. Venturi against Gentile Bellini's alleged authorship is the stylistic difference of these figures from Gentile's usual simplicity. Even the two drawings in the B. M., although they are without doubt far superior in quality to the rest of the group, show a dryness in their linework that makes them look more like copies than original studies. Comparing them in detail with the "Painter" in Boston (as Martin did, in order to prove the authenticity of the latter by its resemblance to the drawings in London) we reach the conclusion that their models may have been miniatures of a similar type. Compare the emphasis on corporeality in both and that greater richness with which L. Venturi found fault. For details compare the rendering of the sleeves or the hands. In considering their character as possible copies we should note the extreme hardness of outline and not overlook misconstructions like the shoulder of the man in No. **271**. These copies, as confirmed by the handwriting on No. **272**, were probably done in the 15th century, in Gentile's studio, by an assistant like the one who retouched Jacopo's drawings in Paris (see No. **364** and p. 107) rather than by the master himself.

As for the drawings in Frankfort and in the Louvre, Nos. **266–67**, **279–281**, the connection with the two in London is less close than is as a rule supposed, even by those who admit the considerable dif-

ference in quality. The drawings in London are different, partly because of their earlier date, and partly because of the fact of their being based on miniatures. The others are apparently much later than Pinturicchio's paintings; they may be copies from drawings which he had at his disposal. The two figures in Pinturicchio's mural corresponding to No. 266 and No. 281 do not appear as supernumeraries, but as important actors, philosophers in the "Disputation of St. Catherine" and one as a participant in a solemn *cortège* in Ancona. Their appearance is so striking that efforts have long since been made to identify them as outstanding personalities of the period. (Andreas Paleologos and Prince Djem, both refugees from Turkish oppression, living in Italy, have been suggested). The costumes in Nos. 266 and 268, though to a certain extent Oriental, are not Turkish, but Albanian, which were the costumes of the Christians in the Turkish Empire. The corresponding figure in Pinturicchio's mural, as a matter of fact, is usually designated as Albanian in literature. A group of Christian dignitaries from the Orient is described as existing in one of the compositions in the Sala del Maggior Consiglio in Venice, the "Historia di Ancona" commissioned of Gentile Bellini. It is true, the Storia d'Ancona does not seem to have been executed before 1507 (see No. 635), which means that it was executed at a far later date than Pinturicchio's two cycles in Rome and Siena. But Gentile Bellini may have started to prepare the composition much earlier and may have adapted some of his studies brought from the Orient to represent ideal portraits of the Greek scholars listed by F. Sansovino in his description of the painting ("vestiti ugualmente alla Greca con capelli in capo quasi in sfoggia Albanese," Sansovino 1663, p. 335). This preparatory material which in some way became available to Pinturicchio (see p. 67) must originally have consisted of more drawings than those copies which happened to have escaped destruction. There is at least one other figure in Pinturicchio's murals in Siena, (see Ricci, *Pinturicchio*, p. 187) that also looks extraneous and inserted, and therefore may go back to the same source as the figures corresponding to Nos. 266, 268.

The identity of the seated Oriental in No. 271 with the crouching figure in Pinturicchio's Martyrdom of St. Sebastian, which is sometimes questioned because the figures appear in reverse, is in our opinion certain. The presence of such an Oriental within this representation of a purely Roman legend confirms the theory that Pinturicchio had at his disposal drawings made originally for some other purpose. (An interesting evidence of the longevity of such *"similes"* is the fact that the Turk with the turban of No. A 281 appears slightly modernized in Rubens' painting "Adoration of the Magi," in Lyons (ill. *Klassiker, Rubens,* 164), and still further emancipated from the model in a later "Adoration of the Magi," in Antwerp, and in the "Portrait of an Oriental," in Cassel (ill. ibidem 263 and 268).

A 272 ————, P.P. 1–20. Oriental woman, seated. Pen. 214 x 176. Inscription of the period (late 15th century) indicating colors: orlo rosso; oro; arzento; azurro — in Venetian dialect. Companion of No. 271, q.v. [*Pl. XI,* 2. **MM**]

273 MUNICH, GRAPHISCHE SAMMLUNG, 12552. Interior of a church in which a religious ceremony is taking place in front of an altar. Pen.

96 x 72. — On back: Architectural design. Publ. by E. Baumeister, in *Münch. Jahrb.* N.S. XI, p. XXXVIII, fig. 2, as a study for Gentile Bellini's painting "Miracle of the Holy Cross" (ill. Venturi 7, IV, fig. 140, p. 249.) Compare the following Nos.

274 ————, 12553. Interior of a church with a cross-shaped vault. Pen. 70 x 101. — On back: Circular building with a dome. See No. 273. The *recto* ill. there p. XXXIX, fig. 4. [*Pl. IX,* 3.]

275 ————, 12554. Circular building with arches and vaults. Pen. 72 x 62. — On back: Part of a hall with vaulted arches. See no. 273.

276 ————, 14644. Building with arcades. Pen 153 x 184. Watermark resembling Briquet 3738. — On back: Study for a r. leg. Bl. ch. See No. 273.

277 ————, 14647. Octagonal chapel. Pen 94 x 62. — On back: Tabernacle. See No. 273, the *recto* ill. Pp. XXXVIII, fig. 3.

278 ————, 14648. Interior of a basilica, with three naves and with figures in the choir. Pen. 70 x 110. — On back: Interior of a church. See No. 273, the *recto* ill. on p. XXXIX, fig. 5. [*Pl. IX,* 4.]

A 279 PARIS, LOUVRE 4653. Young Turk standing. Pen, lightbr. wash. 207 x 114. Coll. Crozat. Publ. in *L'Arte* I, pl. 5a. For the attribution see No. 271.

A 280 ————, 4654. A Turkish woman, unveiled, standing. Pen. br., on paper turned yellow. 252 x 171. Inscriptions: *velo, filo bianco*. Publ. in *L'Arte* I, pl. 7a. For the attribution see No. 271.

A 281 ————, 4655. A man with a turban, standing. Pen, br. 301 x 204. Later inscription: Giovan Bellini Venetus. Publ. in *L'Arte* I, pl. 4a, together with the corresponding figure from Pinturicchio's "Disputation of St. Catherine" in the Appartamento Borgia in the Vatican Palace (1493/94). The same figure reappears, in a form much closer to the drawing, in one of Pinturicchio's murals in the Libreria Piccolomini in Siena (1505/07). Piero Misciatelli, *La Libreria Piccolomini*, Siena, 1922, p. 33, and Corr. Ricci, in *Nuova Antologia*, November 16, 1912. For the attribution see No. 271. [**MM**]

282 TURIN, BIBLIOTECA REALE 15905. Group of three men standing, corresponding with slight variations to a group in Gentile Bellini's Procession of the Holy Cross, in the Academy in Venice. Brush, bistre and wh., on blue. 212 x 268. Publ. by Degenhart, in *Jahrb. Pr. K. S.* 1940, p. 37, fig. 1, adding a good detail of the painting in fig. 3. Degenhart dates the drawing in the 1460's and presumes that it was later used in the painting of 1496.

We disagree with Degenhart's dating it in the 1460's, the drawing corresponds neither to the general style of this period, nor does it resemble supposedly early works of Gentile. The character of the drawing with its unaffected realism seems closer to No. 801 from Gentile's late shop; the drawing may not have been done much earlier than the painting.

SHOP OF GENTILE BELLINI

283 BERLIN, KUPFERSTICHSAMMLUNG, 2213. Historical subject. A Doge accompanied by many attendants and kneeling in front of a priest who offers him an object to kiss. Pen, dark gray, wash, some-

what height. w. wh., on yellowish gray. 530 x 402. In Berlin as anonymous. [*Pl. XIII,* 1. **MM**]

The clearness of the construction and the types of the figures point

to Gentile Bellini's early style. The closest analogy for the latter are the priests in the painting "The blessed Lorenzo Giustiniani" in the Academy in Venice (ill. van Marle XVII, fig. 79, p. 142) and the brethren in the Bessarion painting (ill. *Jahrb. K. H. Samml.*, N. S. II, pl. V), of 1465 and 1472 respectively. The kneeling Doge might be Nicolò Tron (1471–73) on the basis of the resemblance to the portrait figure on his tomb (ill. L. Planiscig, fig. 55).

It is tempting to connect the scene with the worship of the holy relic donated by Cardinal Bessarion to the government of Venice in 1472 and carried from San Marco to the Scuola della Carità in the presence of the Doge. No such event, however, is described by the local literature on the relic (J. B. Schioppalba, quoted by L. Planiscig, *Jahrb. K. H. Samml.* N.S. I, p. 53), nor is a painting of this description mentioned in any of the guides of Venice. Maybe such a painting was planned, but was never executed. The exqution of the drawing which we know only from a photograph, scarcely has the character of a design. It is softer and dryer and more in Mansueti's style than in Gentile Bellini's. It may be that one of his pupils copied a painted composition of the latter.

284 FLORENCE, UFFIZI — 1292. Presentation of the Virgin. Brush, pen, on gray. 340 x 557. First publ. as Carpaccio by Molmenti-Ludwig p. 173 and, according to them, not a study for the painting of the same subject in the Brera in spite of its utilization there (ill. Fiocco, *Carpaccio*, pl. CXLIII). They offer the theory that in 1504 Carpaccio may have taken part in a competition arranged by the Scuola della Carità in Venice for a painting of this subject, and that this drawing may be the *"modello"* presented by him on this occasion. Pasqualino Veneto obtained the commission instead of Carpaccio but he did not execute the painting because of his premature death. Hadeln, *Quattrocento*, pl. 23, p. 55 accepted Molmenti-Ludwig's theory with reservations. *Uffizi Publ.* III, p. 1, no. 14: Carpaccio. Fiocco, *Carpaccio*, pl. CXCVIII, p. 84 dates explicitly in Carpaccio's late period, contradicting Molmenti-Ludwig's reference, referring to the organ shutters in the Cathedral of Capodistria, of 1523 (ill. pl. CXCIV). Van Marle XVIII, fig. 201, p. 338 calls it one of the most important and finished drawings that we have by Carpaccio and emphasizes its superiority over the painting in the Brera. [*Pl. XI, 3.* **MM**]

Fiocco's reference to the painting in Capodistria is not persuasive, the resemblance being limited to that of the youth seen from behind, a figure appearing both in No. **602** and in the painting "Calling of St. Matthew," (ill. Fiocco pl. XCII). It is typical of Carpaccio's late work, like the one in Capodistria, to abound with reminiscences of earlier works. (For instance the main group is taken from the painting of 1510, ill. Fiocco pl. CLIII) and for borrowings from other artists (see the shepherd at r. in the background, taken from Dürer's woodcut B. 78).

As for Molmenti-Ludwig's theory, we agree that the character of the drawing, as already pointed out by Hadeln, is indeed that of a *"modello"* suitable for presentation in a competition. Moreover, the existence of No. **641** is a further argument for such a competition: the main features of the complicated architecture are the same so that these details seem to have been recommended to the competitors. (For our attribution, see No. **641**). Among the competitors the name of Carpaccio is not expressly mentioned. The conjecture that he participated rests only on the drawing in the Uffizi in which the presence of many figures typical of Carpaccio is conspicuous, as already noticed by Molmenti-Ludwig. First of all the leading figures appear in the Brera painting (see above), where the woman standing behind St. Joachim in the drawing has been pushed into the middle

ground. Other similarities are: the man in lower l. corner appears again in the "Sposalizio," Brera (ill. Fiocco pl. CXLIX); the Turk next to him in the "Consecration of St. Stephen" in Berlin (Fiocco pl. CLX), on the l. in the "Triumph of St. George," (Fiocco pl. CX) and in "St. George Baptizing" (Fiocco, pl. CXXX); the youth leading this group in the "Visitation," Museo Correr, in the background (Fiocco pl. CXLV); the youth seen from front with his l. arm akimbo in drawing No. **596**; the young woman turned to the r. (almost in the middle) in the drawing No. **640** and in No. **597** where its resemblance to a woodcut by Reeuwich has frequently been observed. The young lady just mentioned, together with the woman behind her, appears in the middle of the "Consecration of the Seven Deacons" (Fiocco pl. CLX). The youth seen from behind, just beneath the High Priest, is the one whose repeated use in Carpaccio's compositions we have mentioned before. Despite all this we are not convinced of Carpaccio's authorship: 1) The figures enumerated above and others look very different from the corresponding ones in Carpaccio's compositions; here they move swifter, are looser, more agile, perhaps more mannered, at any rate different from those in the drawing which are more momentous, static and solemn. They seem to belong to, or derive from, an earlier generation. 2) The drawing style is not Carpaccio's of whom we possess a number of drawings of similar character suitable for comparison (see Nos. **617, 636**). 3) The composition is different from Carpaccio's. He groups his figures loosely on a stage in compositions of this character and uses the buildings only as stage sets and for decorative purposes. In the drawing the figures are packed close together and placed on the same level and the buildings serve to produce spatial depth and clearness. Moreover, they clarify a topographical situation. In spite of the ideal character of the central building, the reminiscence of St. Mark's square, with the long façade of the Procuratie Vecchie at the r., is distinct. Carpaccio's buildings never have this rational soundness, almost corresponding to an architect's approach.

Summing up, we observe in this drawing a number of elements not typical of Carpaccio, but pointing instead in the direction of Gentile Bellini. However, there is no material of his available which is suitable for comparison. We possess only sketches by him, no *"modello"*; besides, if the drawing was connected with the competition of 1504 it would have belonged to Gentile's last years. Of earlier drawings, the most suitable for comparison is No. **269**. Here we find, in spite of the different technique and heavy reworking, considerable points of conformity, especially when we compare reproductions in original size. Taking into account that this drawing was supposedly intended for a competition and therefore is extremely finished, we suggest the execution of a general sketch from Gentile's hand by one of his assistants who had to make use of his master's drawing material. Considering the evident success Pasqualino had with his *"modello"* and, on the other hand, the fact that he seems to have been influenced by Gentile Bellini in his production and to have used his types, we wonder whether this extremely finished and pretentious drawing may be the one Pasqualino presented. The same material, or more probably the drawing under discussion, may have been available to Carpaccio for his later compositions. A similar extensive utilization of a model of Gentile Bellini by Carpaccio occurred in the case of the "Adoration of the Magi" in the N. G. (see e.g. No. **606**).

285 WASHINGTON, D. C., CORCORAN GALLERY, Clark coll. 2185. Group of three figures of standing men, one in a cloak and a wide brimmed hat, the others Oriental warriors. Brush, br., height. w. wh.,

on faded blue. 212 x 253. In the collection as "Jacopo Bellini." Publ. by Degenhart in *Jahrb. Pr. K. S.* 1940, p. 40 f. fig. 5, who points out a slight resemblance of the figures to those in Burgkmair's woodcut "The Triumph of Emperor Maximilian" (ill. *Jahrb. K. H. S.* I, Appendix, p. 161 and 174) and believes the drawing to be a shop production close to Gentile Bellini, possibly by some artist between Bastiani and Mansueti. [*Pl. X, 3.* **MM**]

Although the resemblance to the corresponding figures in Burgkmair's woodcut is too slight to permit any conclusions we agree with Degenhart's further statements. The drawing is an anonymous copy from a model by Gentile Bellini, used as a *"simile"* in Venetian studios. The man at l. appears with slight modifications in Carpaccio's painting "The Return of the Ambassadors" in the Ursula Legend (ill. Fiocco, Carpaccio, p. LXXII).

GIOVANNI BELLINI
[*Born c.1431, died 1516*]

Listening attentively to the voices of Giovanni Bellini's contemporaries, we catch at once a note of warmer admiration for him than for his brother. Gentile, as the head of the workshop, bore official distinctions and commissions, and in this regard Giovanni remained the substitute for his brother and the junior partner of the firm. On the other hand, he is hardly ever mentioned without a laudatory epithet. As far back as 1480, when he got his first official appointment, he is called "pictor egregius," and has retained this ascendency until November 29, 1516 when Marino Sanudo, the official chronicler of the Republic, in his diary (vol. 23, p. 256) wrote his obituary: ". . . whose fame is noted throughout the world, and despite of his old age he still painted excellently." Posterity has ratified this judgment of his contemporaries. More than any other Giovanni Bellini is the representative of the half-century that he covered with his activity, outshining both his brother and father.

Considering the supremacy conceded to Giovanni Bellini from the standpoint of our special studies we may be astonished that his drawings remain in the dark. But on second thought we understand that this very deficiency is another index of his representative character. It is very Venetian that the draftsman should disappear behind the painter. As a matter of fact, Giovanni Bellini's activity in this field has been entirely forgotten. It is no coincidence that modern efforts to reconstruct his drawing production are concentrated almost completely on the two border lines of his activity, his early connection with Andrea Mantegna, and his late period, when his style had become the common property of a multitude of pupils and followers. This means that in the period when he is most himself he disappears as a draftsman. The drawings found on the backs of the polyptych in San Giovanni e Paolo and the triptychs of the old Carità Church, now in the Academy in Venice (published by Fogolari in *Dedalo* XII, p. 360 ff.), might modify this impression by revealing unthought of and perhaps subconscious reactions of the artist. However, the spurious authenticity of these scrawls, as doubtful as that of the panels on which they appear, must put us on our guard against too hazardous an indulgence toward these unexpected accessions.

In view of the considerable number of drawings attributed to Giovanni Bellini in these last few years, even when one puts aside such trifles, the assertion that we do not know anything about his drawings may sound exaggerated. This assertion, however, is true, and we must emphasize the fact that these attributions are almost, without exception, entirely in the air (as also recognized by A. E. Popham in his *Handbook*, p. 26). Absolutely no tradition concerning Giovanni's drawings has survived, and when in the second half of the 19th century Giovanni Morelli started grouping them, he listed only five as authentic (Nos. **323, A 325, A 291, 319, A 295**). This number in Hadeln's *Quattrocento* (who rejected **A 295** and **A 325**) is increased to nineteen, and since then it has been doubled by various attributions, encouraged by the heterogeneous nature of the material gathered by Hadeln. Van Marle (XVII, p. 344 ss. 1) takes a step beyond Hadeln and tries to put this motley mass into chronological order. The understandable desire to gather together a drawing oeuvre for Giovanni Bellini, corresponding to his rich output as a painter, found an unexpected ally in the authors on Mantegna to get rid of most of the

drawings formerly ascribed to their hero, and to acknowledge only those which show a relationship to his engravings. The result, as stated by Berenson (in his *Study and Criticism of Italian Art,* second series, 1920, p. 49) is that all drawings by Mantegna seem to originate from his latest period. In fact, Mr. Berenson's own list best illustrates how the choice of drawings left to Mantegna became very one-sided. It would lead us too far astray to attempt a wholesale revision of the question of Mantegna's drawings. However, as most of the drawings brought together to enrich Giovanni Bellini's early years were formerly called "Mantegna," we have to make it our starting point. Roberto Longhi (in *Vita Artistica* 1927, p. 137, note) voiced his doubts about this wholesale attribution of Mantegna drawings to Bellini, and a little later Sir Kenneth Clark discovered that this problem was not solved (*Burl. Mag.* 1930, p. 87). It is not even solved today, in spite of Clark's withdrawal of his suggestion to return the group in question to Mantegna (*Burl. Mag.* 1932, p. 232). Nevertheless, the controversy, had a positive result: the students of Bellini's drawings had to recognize their close relationship with Mantegna. It was therefore consistent on the part of Fiocco, who apparently did not wish to stir up a dispute so recently settled, to attribute the sketch of the Martyrdom of St. James in Donnington Priory, **A 296**, to Giovanni Bellini which has passed for the most authentic piece of Mantegna's early draftsmanship since Kristeller.

In reopening the discussion we may as well start with this drawing which in spite of our appreciation of Fiocco's logical consistency we still consider as the cornerstone for our knowledge of Mantegna's early drawing style. Our reasons (see No. **A 296**) are founded on the character of the drawing as a design, preceeding the mural in Padua and not derived from it. On the ground of its penmanship we feel entitled to locate it in the Squarcione shop from whence Mantegna took his origin (see No. **750**); and the general stylistic characteristics, to the same extent typical of Mantegna and different from Giovanni Bellini, confirm our judgment. The drawing in Donnington Priory is not the only one claimed for Bellini despite a definite connection with a painting by Mantegna. No. **A 295** in Chatsworth, according to J. P. Richter, is a design supplied by Giovanni Bellini to Mantegna for the wing of his altar-piece in San Zeno, Verona. This theory was first rejected, but later on, as far as we understand, accepted by Adolfo Venturi. Thus Mantegna whose precocious genius already had the murals of the Ovetari chapel in Padua to his credit, would have received the design for one of his masterpieces from Giovanni who, although hardly his junior, was in or about 1456 probably only a beginner. The inversion of the natural order is in this case the more amazing, as the drawing style shows all the characteristics of Mantegna's style in that degree of concentration which usually is an argument against the authenticity of a work of art. The drawing is too exaggeratedly Mantegnesque to be by Mantegna himself; more likely it is a copy from his design, done in his shop.

This theory is confirmed by comparison with another drawing from this controversial group, No. **A 305** in the Koenigs collection, which was possibly Mantegna's first idea for the other wing of the San Zeno altar-piece. The St. John here is less Mantegnesque than the preceding drawing, but is much more Mantegna by reason of the close stylistic relationship to the sketch in Donnington Priory. The four figures on the sheet patched together with the St. John's are more in conformity with the Mantegnesque school style. We do not think we need expatiate here on the essential features of this style as compared with Giovanni Bellini's characteristics. Mantegna's interest in the human body and its functions is well known, as well as the plasticity of his draperies and the dryness of his linework, at least in his early days. All these traits, further accentuated by a marked sculptural trend, are found in drawings like Nos. **A 307, A 325**. The former was claimed for Bellano in an old inscription, the other is stylistically related to Giovanni Minello by whom an absolutely authentic and precisely dated drawing (1483) exists in Padua (ill. *Boll. del Museo Civico di Padua,* 1930, n. s. VI–VIII). Both sculptors are Paduans and thus influenced by

Mantegna. The fact that the two drawings in question, to a greater or lesser degree, recall them, confirms their predominantly Mantegnesque character, in contrast to the kind of imitation we might expect in a Venetian like Giovanni Bellini.

We must not forget, of course, that Giovanni Bellini was also one of the artists who experienced the irresistible attraction of Mantegna whose figure style he followed in his early productions; some of them directly copy a model offered by Mantegna, others follow him more loosely. Giovanni Bellini never lost his admiration for Mantegna. In 1501–06, almost at the end of his life, when he had been commissioned to paint a composition for Isabella d'Este's famous studio in Mantua, he gave as one of the reasons why he had delayed the fulfillment of his promise the fact that he was intimidated by the presence of an important work of Mantegna in this very place. He still admired him, although he no longer imitated him as he had done many years ago.

We are therefore entitled to expect drawings by Giovanni Bellini to approach Mantegna very closely, perhaps no less closely than he did in certain paintings. But at the same time we would expect some foreshadowing of his later artistic appearance in such drawings. How could we otherwise recognize him in drawings overwhelmingly Mantegnesque in style in the absence of any documentary evidence. The drawing which might best fit this description is No. 308, the St. Sebastian in the B.M., published by Hadeln as an early Giovanni Bellini, and related to a supposed painting of 1471. Without believing in the correctness of this reference we do believe in the early date and find in this figure a softened transformation of Mantegna's St. Sebastian in Vienna (ill. *Klassiker, Mantegna,* 92). A further support for the attribution to Giovanni Bellini is its resemblance to a few drawings in Jacopo Bellini's Paris sketchbook which we claim for Giovanni for reasons set forth on p. 100. Incidentally we have no illusions as to the hypothetical character of this and other attributions. Two arguments, originating in very different quarters, converge to support this suggestion: one, that the man who drew the St. Christopher (Goloubew I, pl. XXXIII) or the St. George (Goloubew I, pl. XIV) could hardly be capable of also drawing the same saints (Goloubew II, pl. XVIII or VIII); the other, that in view of the conditions of Giovanni Bellini's artistic formation there is no reason for his early productions to merely reflect Mantegna's style. We surmise in the artistic personality of Giovanni Bellini who met Mantegna when they were both in their early twenties, an older stratum due to the influence of his father and first teacher Jacopo Bellini. We venture the attribution to Giovanni Bellini, because the drawings in question are advanced beyond Jacopo and foreshadow Giovanni's later pictorial style. Herein, in our opinion, they coincide with the St. Sebastian in the B.M. (No. 308). A kind of analogy, though in an entirely different field, is offered by the drawing No. 309, almost unanimously accepted as by Cima da Conegliano, but in our opinion not by him, but by Giovanni Bellini. Rudolf Burckhardt, in his monograph on Cima failed to recognize in it the style of the artist of whom he had made particular study, but felt vaguely reminded of Giovanni Bellini. Strangely enough, however, he pointed to such a late production as No. 353 (if it is by Giovanni Bellini). We, on the contrary, consider both drawings on the sheet in London as early studies in which the influence of Mantegna is still felt, as it is in Giovanni Bellini's early paintings, and in some pages in Jacopo's sketchbook in Paris (Goloubew II, pl. IX, XVIII). Cima's approach to landscape is very different: he loves and depicts its lovely surface which he crowds with details, while here its essential structure is concentrated upon with almost the intensity of a geological interest.

Another example of the fusion of Mantegna's and Jacopo Bellini's influences into a style that we feel as predominantly Giovanni's is No. 312. Its connection with Mantegna's "Crucifixion" in the predella of the San Zeno altar-piece has long been recognized; the situation was later confused by references adduced by newer authors to

Jacopo's lost composition of 1436 in Verona (of which we know only that it must have looked otherwise) and to his murals in the Gattamelata chapel of 1459–60 (of which we do not even know whether they included a Crucifixion). The composition of our drawing, however, certainly has its counterpart in Jacopo Bellini's sketch-book, Goloubew I, pl. XCVII, and is in many points related to Mantegna's predella of San Zeno. This combination again makes the attribution to Giovanni Bellini attractive, although we do not claim for a moment to have pre-sented direct evidence in its favor. It is needless to explain the obvious difficulties which we are facing here because of the lack of a reliable point of departure, and which keep our decision in suspense for a number of drawings. In a few of them, for instance, Nos. **286, 287, 317,** the Mantegnesque essence is so definitely softened and presented with such a Venetian melody, that we feel pretty safe in agreeing to the attribution, proposed in recent years, to Giovanni Bellini. We feel much less certain about No. **323** although the drawing belongs to the nucleus of drawings claimed for Giovanni Bellini by Morelli, long before the days of reckless attributing. Perhaps the draw-ing does not quite have the energy of an authentic Mantegna, at any rate it is disturbingly close to him. In some others the almost indistinguishable similarity of the manner of drawing can be disentangled in part by a difference in the general conception. For instance, No. **A 291** at Brescia, the "Entombment of Christ," formerly ascribed to Mantegna, but almost unanimously acknowledged as Giovanni Bellini from Morelli on, belongs to the group. Sir Kenneth Clark opened a debate on this from which, we are sorry to say, he was too rash to withdraw. Only A. E. Popham, the most cautious of the modern critics, reserved to himself the benefit of the doubt and stuck to "Giovanni Bellini or Andrea Mantegna." In our opinion, the examination of the line-work alone leads nowhere. But the composition with the two men standing in the sarcophagus and supporting the body from beneath — something without analogy within the iconography of the scene — is so audacious and complicated that it hardly fits into the Venetian simplicity of Giovanni Bellini's style. He was neither in search of originality, nor especially interested in problems of foreshortening, both evidently things in which Andrea Mantegna excelled. Similar con-siderations lead us to believe in Mantegna's authorship for No. **A 311** which is evidently a close companion to the drawing in Brescia. Again the general invention (the foreshortened nude studied three times, the women whose draperies spread flat on the ground, varying a motive in Mantegna's engraving B. 3) offers arguments to be thrown into the balance against Giovanni and in favor of Mantegna.

In stating this we may be accused of weighing the imponderable. Although we are in thorough sympathy with Popham's indecision mentioned above, we have to take a stand when making a catalogue of Venetian drawings. However, while doing so, we wish to again emphasize the difficulties of analyzing an extensive oeuvre in which literally not one single piece is really authenticated. In the special case of Bellini's Mantegnesque period we divide the heterogeneous material between two artists both of whom are unknown as draftsmen. This is not the lame guiding the blind, but two blind men co-operating in one task!

Giovanni Bellini, apparently the slower to develop of two outstanding artists, notably fell under the spell of Mantegna in his youth; and as we mentioned before looked up to his early ideal to the end of his life. This, how-ever, did not encroach on his independence. It seems a mistake to attribute drawings to Giovanni Bellini's later period on the basis of a larger or lesser admixture of Mantegnesque elements. In No. **A 292** this admixture is so considerable that, according to Kenneth Clark, "we cannot see how it was ever dissociated from Mantegna's Virgin and Angel in the B. M. and his Battle of Seamonsters in Chatsworth." Hadeln's attribution of the drawing to Bellini, contradicting others that had been proposed before, has rightly been replaced by the caption "Paduan School of Mantegna" by the authors of the Catalogue of the Fogg Art Museum. In its classical coldness we dis-

cover a certain affinity to Andrea Riccio, confirming the Paduan origin, and at any rate a ripeness hardly to be expected before 1500. Why should Giovanni Bellini show any connection to Mantegna at such a late date? A somewhat similar case is presented by No. **A 320**, the design for Giulio Campagnola's engraving, the "Rape of Ganymed." It has been ascribed to Giovanni Bellini, probably on the basis of its general Mantegnesque character and of a slight resemblance of the landscape to that of Bellini's "Allegories" in the Academy in Venice. Referring to our argumentation on p. 89 for an attribution to Mantegna and taking pleasure in citing Adolfo Venturi's statement (made without knowing of the drawing) that Giulio Campagnola's engraving rests on a model by Mantegna, we again raise the question: Why should Giovanni Bellini in his maturity be charged with such outspokenly Mantegnesque productions?

Leaving aside a few minor Mantegnana, Nos. **A 300, A 301, A 333, A 306,** we should like to dwell for a moment on a group of Virgins and Child in half-length, all of which have come to light within the last few years. They are linked together by a slight similarity of their motives and strikingly illustrate the rapid spread of such attributions, connecting uncertain productions to no less doubtful pieces. The three drawings in question, No. **A 313** (in the B. M.), No. **A 315** (in the Borenius Coll.), No. **A 303** (in the Koenigs Coll. in Haarlem), are duly analyzed in their proper places in the catalogue. The common type is their vague "Paduan" character, a quality which by the indiscriminate attribution of such drawings to Giovanni Bellini has become a distinguishing mark of his alleged style. The greatest painter of the Venetian Quattrocento is characterized by a vague resemblance to Mantegna's beginnings, surviving in Padua up to the 16th century!

The task of a catalogue like ours which deals with material devoid of any sound tradition has the scope to raise questions rather than to solve them. Having dwelt for some time on the mystery of Giovanni Bellini's Mantegnesque period, we now turn to a problem, no less puzzling: that of his portraits. Everyone acquainted with Venetian painting will understand the difficulty at once. The Venetian portraits of the late 15th and early 16th centuries were distributed very eagerly among the artists of the period, but with very little foundation. Only a perplexingly small portion of them is really authenticated, certainly far too few to base reliable attributions upon them. That none of the existing drawings of this category is fully established, is to be expected; that the paintings offer so little help makes the attribution to individual masters run into wild confusion.

The situation regarding Giovanni Bellini's share in this group is particularly difficult because of the noticeably increased tendency to attribute all kinds of heads to him. However, there are one or two trustworthy points of departure. One is No. **299**, to which we will return a little later since it is not a portrait proper. Another is Gentile Bellini's portrait of a young man in Berlin (No. **260**) which in our opinion because of its use in Gentile's "Procession of the Holy Cross" of 1496 is as well-authenticated as a drawing can be. While it is true that Mr. Berenson has repeatedly (and again in the Introduction of his *Corpus of the Florentine Drawings*) warned against taking the use of a drawing in a painting as evidence that both are by the same hand, in this particular case the drawing fits well into the supposed working process. Gentile, wishing to introduce a number of portraits in his painting, evidently had to make studies from his models. Moreover, its style is consistent with that of the presumed author. We remember Mr. Berenson's warning, however, when turning over to the other portrait drawing in Berlin which has always been taken for granted to be its companion piece (No. **A 261**). Here the conditions are different. While studying Gentile's drawings (p. 67), we doubted his authorship, emphasizing that the drawing lacks all the characteristics of a self-portrait. Now studying it again in connection with Giovanni Bellini, whom on p. 68 we called the artist most easily available for this task, we have occasion to stress its stylistic

resemblance with the portrait of Lorenzo Loredan, which is, after all, the result of Giovanni's official activity as a state artist and the best authenticated of his portraits. The period of origin must be much the same: the Loredan portrait was painted shortly after 1500, the portrait of Gentile, in view of its use in the painting of 1496 and the age of the model may date from the middle of the 1490's. In the painting and in the drawing, the soft modeling, the veiled glance and the subtle psychological approach are noteworthy. In this respect, among all the drawings belonging in this category and ascribed to Giovanni Bellini, only one seems to a certain degree related—the fascinating young lady in Venice, No. 324. This sweet mystery seems to stand and fall with the St. Justina of the Bagatti-Valsecchi collection which in itself is not a very solid support. An origin in an earlier period may explain a certain reminiscence of Mantegna which is stronger, in our opinion, than the one of Melozzo, recently suggested by Coletti. Again, we are tempted to adopt the skepticism, expressed by Mr. Popham, who denies the possibility of an individual attribution. However, if we were obliged to cast our vote for the stronger candidate, we prefer Giovanni Bellini.

Considering the doubtful results of our examination of these two drawings, we are rather embarrassed remembering that they are in a relatively better situation than the others belonging to the same group, since they, at least, offer some basis for a discussion of Giovanni Bellini's claims. In the other cases it is hard to guess why his name was advanced at all. In this regard a distinction is to be made between two groups, the "Bellinesque" and the "Unbellinesque." In one group we place the drawings which though evidently in the style of the master, lack his personal touch, and, consequently, are as likely to be by some follower as by himself. The other group of drawings, some of them outstanding in quality, are by artists of entirely different gifts and temperaments. In this second group, besides the ambiguous No. A 293, we place three heads (Nos. A 318, A 297, A 326) already grouped together as works of Giovanni Bellini by Byam Shaw, but in our opinion belonging together only by being equally distant from him. The last one was the first to be attributed to Giovanni Bellini; Hadeln did so, with great caution, however, and probably would have disapproved its later use as evidence for further attributions. Nevertheless, the fault remains with Hadeln's mistake, for it is the dissolution or undue expansion of an artist's individuality that throws the door open for arbitrary attributions. The splendid portrait of a youth, for which, by the way, the catalogue of the Albertina sticks to Lotto, is indeed so fundamentally different from Bellini's general conception, that its admission threatens to destroy any homogeneity of his artistic figure. Once this is accomplished, the two other drawings may find their place within his diluted personality. They are much nearer to Mantegna, particularly No. A 318 in Christchurch, which might fill a gap in our knowledge of this master, illustrating his late portrait style.

The drawings of the other group lack the power of conviction, not because they are remote from Giovanni Bellini and independent, but because of their poor quality despite their closeness to him. Common to all of them is their style which points to a late date, 1500 or later, a period when Bellini was the head of a flourishing shop and exercising at the same time a great influence on almost all other artists working in Venice and in the Veneto. While in Nos. 329, A 290, 355 the relationship to Giovanni Bellini is rather vague (in fact, various other names, chiefly that of Alvise Vivarini, have been suggested) two other heads in Berlin, Nos. 330, 331, are closely connected with a large painting which is a typical workshop production. Here again, we must be aware of the dangers involved in such a comparison. Just the donor-portraits, with the individual features changed in every new version, might have been introduced into a typical pattern left for execution to assistants, on the basis of a special portrait study made by the master himself. But the task may as well have been left to an artist who either specialized in

portraits within the shop or was merely a senior assistant. The traditional name given to the drawing in Berlin was Catena; this may be a sound tradition, but not necessarily so, since Catena hardly stands out in the workshop more than the others. And, furthermore, are we allowed to attribute the drawing in Frankfort, No. **A 302**, to Pietro da Feltre, on the basis of its resemblance to his signed portrait, formerly in the Figdor Coll. in Vienna? The problem of Giovanni Bellini's workshop, especially in his later years, has repeatedly been touched on from Morelli on, but scarcely ever thoroughly discussed. We may reasonably surmise that it was a well organized unit, capable of meeting the needs of the master overloaded with commissions. After 1500, Bellini was a very old man and a highly esteemed artist. After reading the correspondence of Michele Vianello with Isabella d'Este (quoted in L. Venturi, *Origini,* p. 350 s.), concerning the painting ordered from Giovanni Bellini for the studio of the princess, which is the most interesting documentary source we have for the artist, we have the feeling that at that time he began to pick out very carefully the sort of work he wished to limit his personal efforts to. We also learn that some people, probably members of the young generation, began to see the master as virtually senile and on the brink of decay (essendo vego e per pegorare, he is old and about to decline, writes Isabella's agent Lorenzo da Pavia on July 6, 1504). People quick to catch undertones will easily perceive an apologetic and refractory undertone in Albrecht Dürer's well-known and often quoted statement: "Although very old Giovanni Bellini is still the best among the painters here." Younger colleagues, partisans of Giorgione and the young Titian, may have tried to convince him of the contrary. The old master, besides producing some very personal masterpieces in these years (as Titian did when he was at a similar time of life) must have relied largely on the help of his assistants; and he certainly ran his shop on the same lines as his predecessors and successors.

What was his share of drawing in this period? Considering the unreliable chronology of Bellini's works, we wonder whether one of his drawings might with certainty be declared a late production. If we were to select one, we should consider the fascinating "Lamentation," in the Louvre, No. **319**, less because of its vague relationship to his late paintings than because of a mysterious feeling of supreme ripeness emanating from the drawing. In this regard we may perhaps state a certain affinity in No. **299** which, it is true, has been assigned by others to an earlier period and No. **298**, which is a further development of similar coupled standing figures in the wings of Giovanni Bellini's Frari altar-piece, and connected with his late "Assumption of the Virgin" in San Pietro Martire, Murano. To such drawings as No. **319** and No. **298**, disclosing the secret mark and seal of Giovanni Bellini's mastership, we contrast No. **299** which is instructive, and perhaps misleading, because it is connected with a painting, the unfinished "Lamentation of the Dead Christ" in the Uffizi. The dating of the latter fluctuates; we agree with Dussler's placing it at the end of the century, but do not believe in its authenticity. The drawing has the dryness and, may we say, the impersonality, of a piece not meant for a specific and unique use, but rather to be kept in stock for use, if needed. It is a typical "simile" such as we have met at an earlier stage where they had been the natural result of an organic growth and the accepted vehicle of the artistic tradition in the late middle ages, while the study, although having the same purpose, has a slightly different character.

The subtlety of this distinction makes us feel the need of digging a little deeper in our analysis. A simile drawing of the traditional type, No. **334**, in the Uffizi, ascribed to Gentile Bellini but listed by us as in the school of Giovanni may serve as a point of departure. The question of attribution is secondary just now as a more important point is the general character of the simile which preserves a figure from a composition like Giovanni Bellini's "Mount of Olives" in the N.G. It is the kind of figure in which drawings of this type would be interested: a complicated posture, very carefully executed, so that a good repetition, concentrated on the problem of this single figure, might prove a permanent auxiliary means for future compositions (No. **335**, also in the Uffizi, although

poorer in quality, belongs to the same category). The Head of the Turk, No. **299**, is not interested in a difficult motive, but in an individual aspect. This drawing does not record the solution of an artistic problem with a view to a later recurrence, but portrays a fragment of reality, the artist being attracted, perhaps, by its value as a type. The former *simile* produces or preserves—both much the same thing here—a formula; the later produces a realistic model. This difference in the general approach leads to the conclusion that the medieval composition built with the help of such preliminary drawings remained homogeneous, while in the Renaissance these preceding studies, each complete in itself, are felt as heterogeneous and unblended, like elements of a mosaic. Giovanni Bellini's "Lamentation" in Florence from this artificial origin (the Turk's head may not be the only *simile* utilized in it, see p. 85) gains something of the character of a living picture. We feel something analogous in Mansueti's composition of the same subject, the figures of which in various versions appear turned in both directions and differently patched together (see H. Tietze, in Art in America, April, 1940). The best student of this Venetian process, as an outsider so frequently becomes, is Albrecht Dürer, who in his Feast of the Rose Garlands, painted in 1506 at Venice (and not before he went there) introduced into his composition a large number of heads, hands and other details, evidently many more than still exist in drawings which were studied beforehand with the utmost care.

These famous Dürer drawings of 1506 have their counterparts in spirit and aspect in certain drawings by Giovanni Bellini, No. 316, 322, while in No. 336, 346 the intrinsic affinity is still more distinct, the attribution of the latter wavering between the Venetian and the German School. Their character as *similes* renders the differentiation between original and copy difficult. It is best not to penetrate too deeply into this problem which might prove insolvable and at any rate promises but little profit.

A special case among the *simile* drawings is the landscape as the use of fixed formulas here is especially strange to us moderns who have been trained by a century of an almost exclusively objective approach to nature. We know, however, that in this field, too, the medieval tradition had been satisfied with repeating approved patterns. The Renaissance gradually replaced them by direct studies from nature, some of which in the routine of everyday production proved handy for repetition. Thence arose the paradoxical situation, as we noticed in the use of other *similes* in this period of transition: fragments of individual reality recurring in compositions with which they had no organic connection; thus their confusing "movable scenery" character. The classic example is No. 347 in the Ambrosiana, attributed to Giovanni Bellini by Padre Resta and claimed for Bartolomeo Veneto by Adolfo Venturi, on the basis of its occurrence in a number of paintings by this artist or ascribed to him. There are indeed about half a dozen pictures, mostly of a rather provincial character, in which this landscape motive has been used identically, or with slight variation. It is evident that this theory moves in a vicious circle, the attribution of the paintings partly resting on the similarity to the drawing, whose attribution to a figure so enigmatic as Bartolomeo Veneto can have no other grounds but its occurrence in the paintings. The whole argument has no value as the drawing is a *simile* that might have been used by anyone. Originally, it may have been made for or from the "Resurrection" in Berlin, painted between 1475 and 1479 for San Michele in Murano and attributed of old to various Venetian painters. Recently, it was attributed to Giovanni Bellini or his school and, with resolute logical consistency, to Bartolomeo Veneto by Adolfo Venturi. But in this painting—in contrast to all the others mentioned before—not only the landscape, but also the figures in the background conform to the drawing, whose Quattrocento character seems otherwise unquestionable. Its only connection with Bartolomeo is that he might have carried a copy with him or even the original from the shop where he had been an apprentice, using

it unscrupulously and repeatedly, if the pictures gathered round this motive are really all by him. May we, in order to emphasize the widespread and long-continuing use of such *similes,* point out that the figures of the three Marys and St. John appear identical in the background of Alvise Donato's Crucifixion in the Academy, Venice (ill. Molmenti-Ludwig, *Carpaccio,* fig. 127), even though we do not believe in the date after 1534 proposed for this painting.

We wish to insist on the fundamental importance of this category of drawings because a neglect of their specific character leads to false conclusions. Among the drawings placed in the circle of Giovanni Bellini there are quite a few belonging to this category of *similes,* authentic and unauthentic at the same time. Before discussing them we must eliminate one drawing which used to be considered especially well-authenticated and which we, too, for a long time took for one of the few fixed points within this confusion. The study of a draped man No. **A 301**, already attributed to Giovanni Bellini by Resta when he owned it, was again claimed for Bellini by Hadeln on the basis of a very ingenious demonstration: the figure appears in the guise of St. Peter in an engraving by Girolamo Mocetto, believed by Hadeln to reproduce a lost altar-piece of Giovanni Bellini. Other critics were more impressed by the resemblance of the figure to Alvise Vivarini's St. John in the Academy in Venice and suggested Alvise's authorship for the drawing. Two points are to be taken into consideration when judging the drawing. The attribution of the lost altar-piece to Giovanni Bellini rests on very weak foundations; authorities who studied Mocetto's engraving, independently of each other reached other conclusions, pointing in the direction of Alvise Vivarini, of Cima and Montagna. We also find its spatial construction different from Giovanni Bellini's. The moment the latter's share in this invention begins to be called into question, Parker's refusal to recognize Giovanni Bellini's handwriting in the execution regains importance. There is no analogy to be found with him for the soft modeling of the folds; whether it is more like Alvise Vivarini has to remain an open question as long as so little material for comparison is available.

At any rate, the drapery study of the B. M. does not belong to the *simile* drawings, which seem to have had an important part in Giovanni Bellini's late shop where assistants had an increasing share in its production. It might be more than co-incidence that one of these hybird drawings, No. **352**, is connected with a triptych in the Academy in Düsseldorf, and three others, Nos. **345, 348, 349,** with the altar-piece in the Kaiser-Friedrich Museum. These, as a rule, are considered shop productions. For the altar-piece in Berlin, Gronau in his "Alterswerke" had already listed a surprisingly large number of paintings and drawings that repeat and vary isolated figures from this altar. Their frequency is quite a characteristic symptom of the late stage of a great shop or school. The frequent appearance of individual figures or draperies from Giovanni Bellini's works in the production of Venetian followers and provincial imitators is evidence that the number of drawings must have been very much greater. Giovanni Bellini's riches accumulated in a lifetime were in the process of being distributed while the old master was still alive. The drawings also offer some interesting material regarding the knowledge of this insufficiently studied process. First of all comes No. **353** whose singular importance was justly felt and stressed by Hadeln. He claimed the drawing for Giovanni Bellini, admitting however its stylistic nearness to the next generation. Marco Basaiti, one of these younger artists to whom the drawing is attributed by other critics, is expressly rejected by Hadeln who claims that the author of the drawing, while solidly rooted in the Quattrocento, at the same time is already touched by the new Giorgionesque style. Is this conclusion more in accord with Giovanni Bellini who gave astonishing evidence of his vigor as late as 1514, than with a follower, not excluding Basaiti? (See p. 94). Is the drawing still Giovanni Bellini's, or has it already passed him? Whoever does not believe in connoisseurship

by sorcery will have to throw up his hands. At any rate, the style of drawing hardly seems consistent with that of No. 319.

A second example is two companion pieces in the collection of A. de Hevesy in Paris, Nos. 350, 351, representing either a standing saint or, more exactly, the same saint in slightly modified postures. Here again, old and new elements are fused, as expected in the production of a good pupil, and of a good teacher too. A certain exterior resemblance to the organshutters in San Barolomeo di Rialto at Venice might have suggested the idea of Sebastiano del Piombo or even of Giorgione, who has been credited with the designs for them. In our opinion, however, there is a closer connection to the altar-piece in San Giovanni Crisostomo in Venice, in which as late as 1513 Giovanni Bellini gave evidence of unbroken strength and ability to compete with the youngest. No. 703 in Budapest is placed exactly on the same borderline, but here the new prevails so distinctly that it seems better justified to discuss it under Giorgione. As in the last drawing, we observe the inheritance of Bellini in its transition to the Giorgionesque style, while in the "Two Peasants" in the Louvre (No. 1953) it may be seen in its evolution towards the Titianesque. At least, Mrs. Fröhlich-Bum published the drawing (already ascribed to Titian in the Louvre) as a work of his about 1540. For reasons which we explain more fully on p. 323 we reject this suggestion, observing in the drawing much more of the naïveté and intenseness of Bellini's latest style. The two men, whom we suppose to be philosophers, interpreted in Bellini's unbiased idea of the classic world, might well take part in the master's mysterious "Feast of the Gods" in the N. G., Washington. But that is still not sufficient evidence to prove that the drawing in the Louvre is by Giovanni Bellini, for who knows how much use the eighty-four year old master made of the assistance of younger helpers in his painting! From here on there is only a step to the simile drawing of the "Nativity" in Windsor, No. A 719, in which Giovanni Bellini's invention of this subject may survive. We know from his correspondence with Isabella d'Este that such a painting belonged to his stock. We do not know, of course, whether the drawing in Windsor, close as it is to our idea of Bellini's latest style, repeats his own design. However, it may have more than its own insignificant artistic value by being an important link between the master and an artist of the next generation, who built on this legacy in the "Allendale Nativity."

Less important examples of the same transition from Bellini to his followers are the school productions Nos. 341, 342, reminding us of Cristoforo Caselli, Giovanni Bellini's assistant in Venice from 1489 to 1498; No. 343 perhaps to be identified with Giovanni Martini da Udine; No. 354 suggesting similar types in Andrea Previtali's works. Readers who by now are familiar with the basic articles of our creed will understand that by giving such hints we do not mean to attribute, but to describe.

286 BAYONNE, MUSÉE BONNAT, 689. St. Peter standing; the hand holding the key is rendered in two positions. Pen, br. 150 x 90. Cut. Formerly ascr. to Ercole Roberti. First revindicated for Giovanni Bellini's Mantegnesque period by Venturi, *Studi*, fig. 142. Parker, pl. 41 points to the resemblance with No. 287 and van Marle XVII, p. 351 to the period of Bellini's altar-piece in Pesaro (*Klassiker, Bellini*, 48). Dussler, p. 160 questions Bellini's authorship, Gamba, *Bellini*, pl. 46 accepts it. [*Pl. XXIX*, 1. **MM**]

In our opinion, the drawing — and its companion piece, see No. 287 — is based on Mantegna's style about 1450 to 1460, changing it, however, into a softer expression. An attribution of this performance to Giovanni Bellini rather than to some other follower of Mantegna is partly justified by a certain resemblance with the (much later) No. 319 and the affinity to No. 308 supposedly an early work as also the drawings in Bayonne must be. We remain, however, aware of the inadequacy of these supporting assumptions.

287 ————, 1274. Apostle standing, holding a book in both hands. Pen, br. 148 x 89. — On back inscription: Squarcione. In Bayonne ascr. to Ercole Roberti (*Bonnat Publ.* II, pl. 10). Ad. Venturi's attribution in *Studi*, fig. 142, to Gio. Bellini is accepted by Parker in *O. M. D.* 1927, March (ad pl. 58) where a stylistic connection to No. 321 is noticed, and in *North Italian Drawings*, pl. 41, where the resemblance to No. 286 is stressed. While Dussler p. 160 lists the drawing among the doubtful works, van Marle XVII, p. 351 and Gamba, *Bellini*, pl. 46 accept the attribution to Bellini, Gamba comparing the drawing with the "Crucifixion" in the Contini Coll. in Florence (ill. *Klassiker, Bellini*, 25). [*Pl. XXIX*, 2. **MM**]

Companion piece to No. 286, see there. The figure seems to develop a type represented by Jacopo Bellini's drawing, No. 363, CXXII.

A ————, St. Francis receiving the stigmata. See No. **A1876**.

288 BERLIN, KUPFERSTICHKABINETT, 5065. Saint Jerome seated to

the r. Pen, brush, height, w. wh., on faded blue. 138 x 142. Arched top. Lower l. corner patched. Publ. by Hadeln, *Quattrocento,* pl. 24, p. 53, as Vittore Carpaccio, accepted by Fiocco, *Carpaccio,* pl. XVI and van Marle XVIII, p. 338, who refers to a certain resemblance with the figure seated at l. in the "Meditation," Metropolitan Museum, New York, ill. Fiocco, pl. CXV. (Carpaccio's authorship in this painting, in our opinion, needs re-examination in spite of F. Hartt's thorough study in *Art Bull.,* March 1940.)

Neither is this reference correct, nor is the drawing connected with Carpaccio or his circle by its invention or its style of drawing. In our opinion, the invention is by Giovanni Bellini, and the style resembles No. **316**. A certain dryness of the drawing, which we have not been able to re-examine, might point to an origin in the shop. The painting in Oxford, Ashmolean Museum (ill. Cavalcaselle I, p. 272b) to which the drawing is similar in composition, is usually attr. to Basaiti (see Cavalcaselle, p. 273, note), only van Marle XVII, p. 276 ascr. it to Giovanni Bellini himself.

289 ————, 68. Miracle of St. Mark, the healing of Ananias the cobbler. Pen. 184 x 173. Coll. Woodburn, Chennevières. Already attr. to Giovanni Bellini and exh. as his École des Beaux Arts 1879, no. 181 (*Gaz. d. B. A.* 1879 II p. 316), while in *Berlin, Publ.* I, 76 the drawing is publ. merely as Venetian, 15th century. It was returned to Giovanni Bellini by Hadeln, *Quattrocento,* pl. 68, p. 46 f., accepted as his by Dussler, p. 160 ("with greatest probability") and van Marle XVII, p. 351, who dates it in the period of the Pesaro altar-piece.

[*Pl. XXX, 3.*]

The attribution is supported solely by a certain stylistic resemblance to Nos. **286, 287,** which, it is true, are not authenticated either. The format of the composition and its treatment are certainly unusual and seem to exclude the idea of an altar-piece or a painting for a brotherhood; that it should be a panel of a predella also seems unlikely in view of the monumentality of the figures. On the whole, the most attractive hypothesis seems to be to consider it a relief. In this connection, it is interesting to recall that in 1476 Antonio Rizzo was given an order from the Scuola di San Marco to make various reliefs, one of them on the basis of a design given by Gentile Bellini, then dean of the mentioned Scuola (Lionello Venturi, *Origini,* p. 326). The subjects of these reliefs are not mentioned, but since, after the destruction of the Scuola by fire in 1485, the reliefs decorating the new façade represent scenes from the legend of St. Mark and especially the "Healing of Ananias," in view of the conservatism typical of Venice in such restorations we may presume that the earlier reliefs had the same subjects. The redecoration of the Scuola was begun by Pietro Lombardo and his sons in 1489 and, after the dismissal of this group in 1490, continued by Mauro Coducci under the supervision of the brothers Gentile and Giovanni Bellini. They expressly accepted the task, not only of providing new paintings for the interior, but also of taking care of the exterior. Gentile, again a high official of the Scuola, engaged Coducci for this work. (The reliefs decorating the façade today, are attributed to Tullio Lombardi by Sansovino. We leave it to L. Planiscig, p. 229, who accepts this attribution, without discussing the above-mentioned documents, whether the question of the authorship ought not to be re-examined.) The important point for us is the marked stylistic relationship between the present reliefs and the drawing in Berlin. The whole set of circumstances makes it very possible, and even probable, that they, too, were executed after designs by one of the Bellini. For stylistic reasons, we believe that only Giovanni can be taken seriously into consideration, and we further believe that the drawing in Berlin was made for the former relief

destroyed by fire. The date of 1476 fits quite well with respect to the style of the drawing. Giovanni's name, it is true, is not mentioned in the document of that year, but since the brothers seem to have had a common workshop at that time, and since, moreover, the document mentions only Gentile as having given the drawing and not as having made it, our suggestion does not seem too daring.

A 290 BESANÇON, MUSÉE, GIGOUX BEQUEST. Bust of a beardless elderly man, turned to r., the fur lining of his cloak visible on his shoulder, Bl. ch., on gray. 340 x 250. In Gigoux Coll. ascr. to Verrocchio. Exh. Paris, École des Beaux Arts 1879, No. 198: École Vénitienne. Berenson, *Lotto,* p. 91: Alvise Vivarini. Mentioned by Popham, *Cat.* 177, p. 94 as by the same hand as No. **318** which he attr. to Gio. Bellini.

We do not recognize an identity of style, but a certain affinity, which leads us to place the drawing in the school of Mantegna.

A 291 BRESCIA, PINACOTECA. Entombment of Christ. Pen. 130 x 96. The sarcophagus is constructed, the two figures are drawn over its lines. Coll. Frizzoni. Formerly ascr. to Mantegna, first mentioned as Giov. Bellini by G. Morelli II, p. 277. Accepted by L. Venturi, *Origini,* p. 388, Gronau, *Künstlerfamilie,* p. 65, and publ. by A. Venturi, in *L'Arte* XXIV 1921, p. 7; Nicodemi, *I Disegni della Pinacoteca in Brescia,* 1921, No. 147; Hadeln, *Quattrocento,* pl. 59. Exh. London, 1930, No. 709 (Popham, *Cat.* 162: Gio. Bellini or A. Mantegna). Included by K. Clark, *Burl. Mag.* LVI (1930), p. 187 in the group of alleged Bellinis for which he proposed Mantegna's authorship, connecting it with No. **311** and considering it an early study for the engraving of the "Entombment" B. XIII, 317, 2 (ill. *Klassiker, Mantegna,* 144). In *Burl. Mag.* LVII, 1932, p. 229 f. Hadeln rejected Clark's theory as a whole, and particularly its application to the drawing in question, emphasizing that the connection with the engraving was quite fortuitous and by no means close. In *Burl. Mag.* 1932 LVIII, p. 232 Clark yielded to Hadeln's arguments. The drawing was also accepted as Bellini by Dussler p. 160, van Marle XVII, p. 349 and Gamba, *Bellini,* p. 17.

The relation to Mantegna's engravings B. 4 and B. 2 (ill. *Klassiker, Mantegna* 143 and 144) is evident. The composition with the two men standing in the sarcophagus and supporting the body from beneath is so audacious and so complicated that it hardly fits into the Venetian simplicity of Bellini's style. The close resemblance of the linework with No. **A 296** and No. **A 305** induces us to return to the old attribution to Mantegna.

A 292 CAMBRIDGE, MASS., FOGG ART MUSEUM, 25. Sacrificial Scene. Pen. 155 x 180. R. upper corner added. Inscription: Mantegna copiato dall' Antico. Charles Loeser Bequest. Frizzoni, in *Archivio Storico* 1904, p. 177 ff, Schönbrunner-Meder 1077, A Venturi, *L'Arte* XXVIII (1925) p. 95: Ferrara. Publ. by Hadeln, *Quattrocento,* pl. 67 as Giovanni Bellini. Accepted as his by Dussler, p. 160 and van Marle XVII, p. 350. In *Burl. Mag.* LVI (1930), p. 187 Kenneth Clark called the drawing "so full of Mantegna's characteristics that we cannot see how it was ever dissociated from Mantegna's Virgin and Angel in the British Museum (ill. *Klassiker, Mantegna,* p. XLV) and his Battle of Sea Monsters in Chatsworth (ill. ibidem p. XLIX)." Mongan-Sachs p. 19 f: Paduan School of Mantegna.

We do not recognize any striking connection with Mantegna himself, and still less any connection with Bellini and wonder what kind of works those who made the attribution had in mind. The drawing has a general Mantegnesque character and may be given to the school

of Padua. It is so far advanced towards Riccio's classical coldness that it might already be dated in the beginning of the 16th century.

A 293 CASSEL, COLL. HABICH, formerly. Head of a youth with a hat. Red ch. 167 x 170. Cut. O. Eisenmann, *Zeichnungen aus der Sammlung Habich*, pl. 4: Barbari. Morelli, II, p. 198, note and Berenson, *Lotto*, p. 32 accept the attribution to Barbari, while Frizzoni, who lists the drawing as being in the Bonnat Coll., Paris, ascr. it to Antonello da Messina (*L'Arte*, X, 1907, p. 465). Hadeln, *Quattrocento*, pl. 70, p. 47, judging on the basis of the reproduction, recognizes in the drawing Bellini's latest style. Dussler, p. 160 rejects the attribution. Van Marle, XVII, p. 352 takes it into consideration, but is somewhat inclined to question the authenticity of the drawing.

For this drawing, which we were unable to locate either in Paris or in Bayonne, Barbari seems out of the question. As for Gio. Bellini the drawing is neither in conformity with any portrait ascertained for him, nor is there any resemblance to his presumed style of drawing. Hadeln's hint points to the second decade of the 16th century, a date which fits the shape of the hat.

A 294 CHANTILLY, MUSÉE CONDÉ 111 bis. Portrait of a young man, supposed to be Vittore Belliniano. Pen. br., height. w. wh. 110 x 90. Old inscription (according to Ludwig in *Jahrb. Pr. K. S.* XXVI (1905), Appendix p. 73 not authentic): Victorem discipulum suum Bellinus pinxit 1505. Coll. Lenoir. Mentioned in Thieme-Becker III, p. 266 and by Gamba, *Bellini*, pl. 171, p. 156 f. as portrait of Vittore Belliniano.

Companion piece of No. **A 372** supposed to be Bellini's portrait by Belliniano. For both these miniatures there is no other evidence but their inscriptions, the importance of which, however, is heavily compromised by the fact that apparently both portraits are, as already stated in *Jahrb. Pr. K. S.* XXVI (1905), Appendix p. 73, by the same hand, a hand evidently much too weak for Giov. Bellini. On the other side, the attribution to Belliniano remains in the air and seems improbable since his style should have been more advanced (see p. 114 f.).

A 295 CHATSWORTH, DUKE OF DEVONSHIRE. Four saints standing. Pen. Formerly ascr. to Perino del Vaga, attr. to Giovanni Bellini by Morelli, I, p. 271, and by J. P. Richter, *Lectures on the N. G.*, London 1898, who calls the drawing a design supplied by Bellini to Mantegna for the l. wing of his altar-piece in San Zeno. This theory was rejected P. Kristeller, *Mantegna*, Engl. edit., p. 153, note, according to whom the drawing is a poor imitation of Mantegna's painting. Ad. Venturi, 7, III, p. 154, note 1, fig. 103, on the contrary, accepted the drawing as Mantegna's design for the painting. In *L'Arte* v. XXIX, 1926, p. 1, fig. 1, and in *Studi*, p. 226, fig. 41 (erroneously reproduced in both places in reverse direction and, therefore, apparently not recognized by Venturi as identical with the one publ. in his *Storia*) A. Venturi brought the same drawing as by Giovanni Bellini and contemporary with the "Death of the Virgin" in the Prado (ill. *Klassiker, Mantegna*, pl. 91) which he also ascr. to Bellini. (See A. Venturi, *Grandi Artisti Italiani*, p. 24 ff.). He does not mention the relation to Mantegna's painting, but praises J. P. Richter who by his attribution of the drawing laid the foundation for the reconstruction of Giovanni Bellini as a draftsman. Roberto Longhi, in *Vita Artistica* 1927, p. 137, questions the attribution to Bellini.

In our opinion, the drawing is neither a design by Mantegna nor by Giovanni Bellini, the quality, as rightly noticed by Kristeller, being too poor, nor is it a derivation from the painted wing. It might be a copy after a sketch by Mantegna done in his shop. That Bellini has

no part in it seems established by the pure Mantegnesque character of the drawing. Compare the types, the small hands so typical of Mantegna's early period and the plastic rendering of the draperies.

A 296 DONNINGTON PRIORY, COLL. GATHORNE HARDY. Saint Jacob led to execution. Connected with Mantegna's fresco in the Eremitani Church. Pen, br., on paper tinted slightly brownish. 155 x 254. Coll. Spencer, Lawrence, Malcolm. Publ. by P. Kristeller, *Mantegna*, p. 100, fig. 33, as Mantegna's design for the mural, an identification which was accepted by most authorities. Sidney Colvin, in *Vasari-Soc.* I, 26 stressed the difference in style from other drawings by Mantegna and the advanced character of our drawing, already reminding one of the style of the 16th·century. He quoted two theories on the drawing, the one that it might be a derivation from the mural, the other that Donatello might have supplied the drawing to young Mantegna. Colvin himself prefers either one of these theories to Mantegna's authorship. In the subsequent discussion over the respective share of Mantegna and Bellini in a certain group of drawings (see Nos. **A 291, A 305, A 311, 317, A 323**) the one in Donnington Priory, although evidently related, was never questioned as Mantegna's until Fiocco (*L'Arte* N. S. IV, 1933, p. 186 and again in his *Mantegna*, 1937, pl. 171) advanced the theory that the drawing might be a study by Giovanni Bellini after Mantegna's painting. (In his previous book, *L'Arte di Mantegna*, p. 186, the copy of the drawing in Donnington Priory existing in the Louvre [**MM**] later on called by Fiocco "a copy too poor to be by the Master (i.e. Bellini) himself," was called "the first idea of Mantegna's painting?".)

It is meritorious of Fiocco to have carried forward the discussion of the Bellini-Mantegna drawings started by Kenneth Clark, see No. **317**. Rightly observing the homogeneity of the group, but believing in Gio. Bellini's authorship for the bulk of it, he drew an erroneous conclusion in attributing to Gio. Bellini, Mantegna's best-authenticated drawing. We are led to the opposite conclusion, i. e., that of giving a number of the discussed so-called Bellini drawings to Mantegna or his immediate neighborhood, see No. **A 291, A 305, A 311**.

As for the drawing in Donnington Priory, the one reason for doubting Mantegna's authorship was its difference from other Mantegna drawings. This argument is invalidated by the fact that those other drawings are all very elaborate and thus hardly comparable with a sketch; moreover, they all originate from a much later period. The second reason was its advanced style, an argument that, by the way, would also exclude Gio. Bellini's authorship, since evidently he might only in his early years be supposed to have been so close to Mantegna. Another objection is the feeling of other experts that the drawing might be by Donatello, as it is the complete unrestraint of the drawing that seems to exclude Mantegna by whom we do not possess any other drawing of this character. We on the contrary believe the drawing is stylistically far advanced over Donatello (born in 1386) and that Mantegna was able to prepare his famous early murals by himself. And we do not doubt that the drawing is a preparation of the mural and not a derivation from it. The composition has not yet reached the clear balance and the uncompromising contrasts so impressive in the final work. Evidently, the artist is still groping here. See, for instance, the principal group at l.: the man standing behind the kneeling figure is a typical Mantegnesque invention (compare corresponding figures in *Klassiker, Mantegna* XLI, XLII). In the painting this figure is canceled and consequently the posture of the kneeling man is straightened, since he alone has now to counterbalance the standing saint. In the same way, the sharp division between the two groups on the other side, still farther stressed by the build-

ings, is not yet achieved. How could anyone who started from the executed painting have retrogressed into its preparatory stage? In our opinion, the drawing remains the classic representative of Mantegna's sketching style. The roots in the school of Padua are made manifest by No. **A 750** and other drawings from the Squarcione workshop discussed there and in *A. in A.* 1942, January, p. 54. The drawing in Paris is a superficial copy after the drawing in Donnington Priory, limiting itself to the principal lines.

A 297 DUBLIN, NATIONAL GALLERY OF IRELAND, 2019. Portrait of Francesco Gonzaga. Bl. ch. with slight wash, on greenish. 347 x 238. Coll. Cosway. Formerly ascr. to Francesco Bonsignori. Publ. by Byam Shaw in *O. M. D.* 1928, pl. 56, as Gio. Bellini, and dated 1495-96, by reason of the age of the model and with reference to Nos. **A 318**, **A 326**, both supposed to be by the same hand as the drawing in Dublin. Mr. Shaw refers to Hadeln's verbal approval. His attribution was rejected by Dussler, p. 160.

We cannot follow Byam Shaw's circumstantial argumentation, nor recognize in the drawing the "painterlike" qualities of the Venetians. Still less do we accept the attribution to Bellini none of whose authentic works shows the slightest relation to the drawing. As for No. **A 318**, see our remarks there.

298 FLORENCE, UFFIZI, 586. Two saints standing, one holding a crozier, the other holding a sword, perhaps St. Paul. Brush, grayish br. and white, on faded blue. 282 x 181. — On back: accounts in handwriting of the period. Cut at l. Ascr. to Gentile Bellini.

[*Pl. XXXVII*, 4. **MM**]

The style of this very important drawing is closer to Giovanni Bellini's late period. The perspective arrangement of the two figures appears like a further development of the saints on the wing of the Frari triptych (ill. *Klassiker, Bellini*, p. 104). The figures may also have been planned for a group around a middle figure. A connection with Giovanni Bellini is further proved by the identity of the figure of St. Paul to the third saint from the r. in Bellini's "Assumption of the Virgin" in St. Pietro Martire, Murano (ill. *Klassiker, Bellini*, p. 155). The figure there is inferior in quality to the great style of the drawing which might be by the master himself, while the painting is supposed to have been executed with the help of the shop. As for the brushwork, we find some resemblance with details in No. **319** (see for instance the shading of the hand) which, it is true, is difficult to compare because of its different technique. The technique in itself is verified as that of Giovanni's shop by No. **352**. In order to indicate the full stature of this drawing we point to its affinity to Dürer's "Apostles" in Munich.

299 ———— 595. Bearded head with turban. In the lower l. corner head of a child, very indistinct and cut. Brush, br., wash, height. w. wh., on faded blue. 225 x 185. — On *verso* old inscription (17th century): Ritratto di Marco Basaiti di sua mano. First recognized by Gronau, *Künstlerfamilie*, fig. 74 and p. 102 as a study for one of the men in Bellini's unfinished "Lamentation over the dead Christ" in the Uffizi (ill. *Klassiker, Bellini*, 100). Hadeln, *Quattrocento*, pl. 65. Accepted by Dussler, p. 142 and 160, who emphasizes the deviating posture of the head in the painting. Also accepted by van Marle XVII, p. 352, fig. 212, and Gamba, *Bellini*, p. 97. — [*Pl. XXXVIII*, 1. **MM**]

The painting, given by Corrado Ricci to Catena, is dated about 1485 by Berenson, *Venetian Painting*, p. 91, a little later by Gronau, *Klassiker, Bellini*, and about 1495-1500 by Dussler. The drawing style shows the characteristics of a "*simile*" and shares the somewhat

impersonal dryness with No. **316**, which, it is true, is earlier. The whole composition is apparently composed of such "*similes*." The two figures in the middle of the second row, in no way participating in the scene, reappear in a "Presentation of the Child in the Temple," existing in many versions (*Klassiker, Bellini*, 189); the hermit at the right who may have been reading in his original form is seated on a higher level, while the woman at l. is standing. Morelli may have been right in rejecting this picture.

A 300 ———— St. Jerome standing, in a landscape, unfinished. Pen. Publ. by A. Venturi in *L'Arte*, XXIX (1926), p. 1, fig. 2, and in *Studi*, p. 229, fig. 141 as by Giovanni Bellini under the influence of Piero de' Franceschi, referring to his altar-piece in Pesaro (*Klassiker, Bellini*, 48). Van Marle XVII, p. 346 rejects this attribution and ascr. the drawing to Mantegna.

In our opinion, the type of the figure and the landscape is Mantegnesque, but not the cautious and soft style of drawing. We believe the drawing to be the transposition of a Mantegnesque model by an engraver. The drawing marks a stage in the working process corresponding to the technique used by Mantegna in his engravings (ill. *Klassiker, Mantegna*, 145). Compare also the very similar seated St. Jerome in Berlin, publ. as school of Mantegna, in Parker, pl. 17.

A 301 ————, Santarelli 1123. Crucifixion. Pen, wash. Formerly ascr. to Pollajuolo (Alinari Photo 109). L. Venturi's attribution to Jacopo Bellini (*Origini*, p. 153) was rejected by L. Testi (p. 247) who gives the drawing to the school of Mantegna. Publ. by van Marle XVII, p. 347, fig. 208, as Giovanni Bellini?; "it corresponds with a picture of the same subject in the Correr Museum" (ill. *Klassiker, Bellini*, p. 24).

In our opinion there is not the slightest relation, in composition, type, draperies or landscape, to this painting. The style of the drawing is closer to that of drawings attr. to Marco Zoppo, see Fiocco, *Un libro di disegni di Marco Zoppo*, in *Miscellanea di storia dell'Arte in onore di I. B. Supino*, Firenze, 1933, p. 339.

A 302 FRANKFORT/M., STAEDELSCHES KUNSTINSTITUT, 6924. Bust of young man with cap, slightly turned to the l. Bl. ch. 334 x 250. Damaged and patched. Modern inscription: Ritratto di Gio. Bellini designato da lui medesimo. Coll. Festetics and Klinkosch. Publ. *Staedel Dr.* X, 6 as Gio. Bellini. [**MM**]

In our opinion by a minor Venetian master about 1500. We point to the related portrait of a beardless man, formerly in the Figdor Coll. in Vienna, signed P⁰d F. and attr. to Pietro da Feltre for reasons which we consider conclusive (*Zeitschr. f. B. K.*, 1901/2, p. 302 ff).

A 303 HAARLEM, COLL. KOENIGS, I 282. Virgin and Child. Pen. 94 x 77. Upper corners cut. Coll. Kieslinger. Formerly ascr. to school of Padua, late 15th century. Attr. to Gio. Bellini by Fiocco, *L'Arte* N. S. IV, 1933, p. 193, fig. 7, and by Valentiner, *Burl. Mag.* LXV (1934), p. 239, pl. E, with reference to the painting in the Huntington Collection in Pasadena, dated 1480 by Berenson. Both refer to No. **315** and Valentiner emphasizes the Donatellesque character of the drawing and its Mantegnesque style, pointing to an earlier period than the painting. Accepted by Gamba, *Bellini*, pl. 121, who reproduces the Huntington painting on pl. 120, and by van Marle XVII, p. 350. [**MM**]

Valentiner's statements are correct. The type of the Virgin is earlier than the one used in the painting, and the resemblance to the latter is rather general. We add that the hair is never unveiled in this fashion

in Bellini's works. The drawing has the character of a design for a sculpture (cf. Minelli's drawing of 1483, ill. *Boll. del Museo Civico di Padua*, 1930, n.s. VI–VIII) or — still more — a copy after one. In sculpture the type of the Madonna is frequent among the followers of Donatello, compare the relief in Santa Maria Materdomini in Venice, ill. as school of Donatello in Venturi, VI, fig. 305, or the one in the Eremitani, in Padua, ill. as Giovanni da Pisa, ibidem fig. 295. The style of drawing is looser than might be expected of an artist before 1480 and, moreover, not closer to Gio. Bellini than any Paduan artist under the influence of Donatello and Mantegna might be. The general resemblance to the Pasadena painting might be explained by the circumstance that this type of half-length Madonna, so popular in Venice, may go back to models offered by the school of Donatello.

A 304 ———, I 367. Seated man, draped and holding an indistinct round object in his hands. Pen, darkbr., on pink tinted paper. 185 x 139. — On *verso* partly indecipherable inscription by a hand of the 15th century: . . . stoforo in ferrari (?) Coll. Padre Resta, Monsignore Marchetti, Lord Somers, Th. Banks, Poynter, A. G. B. Russell. Publ. as Giov. Bellini by Hadeln, *Quattrocento*, pl. 66. Exh. Amsterdam 1934, Cat. no. 490. Van Marle XVII, p. 345. The attribution to Giovanni Bellini was rejected only by Dussler, p. 160.

[*Pl. CLXXXVI*, 3. **MM**]

Mr. Russell suggested orally Donatello, and there is indeed a certain resemblance to Donatello's late Paduan period, or to works of his followers in that city. Compare the "Entombment of Christ" in the Museum in Vienna, ill. *Klassiker, Donatello*, 176. At any rate, the drawing shows no features typical of Venice. We find a closer resemblance in style and penwork to the group — it is true a little more archaic — claimed for Giovanni di Piamonte by R. Longhi, in *Crit. d'A.* XXIII, part 2, p. 97ss. Some drawings of this group are attr. by Berenson (*Drawings* no. 663, fig. 69) to the school of Castagno or even Castagno himself. A work by another painter of this generation in an inventory of Lorenzo de' Medici is described as follows: "una fighura a sedere in uno tabernacholo mezza nuda, con uno teschio in mano, di mano di maestro Domenico da Vinegia; colirita a olio contrafatta a marmo . . ." (E. Müntz, *Les collections des Medicis*, Paris, 1888, p. 84). This description seems to fit our drawing quite well which might be a study for this painting; the inventory does not say a "nude woman" as interpreted by van Marle (X, p. 331) and in Thieme-Becker (IX 409), but a half-nude figure. We limit ourselves to this hint, since the artistic figure of Domenico Veneziano is rather vague, and no drawing has ever been connected with him. The drawing in our opinion is by some Tuscan artist of the middle of the 15th century.

A 305 ———. At l. two studies for St. John Baptist standing, at right four standing apostles. Pen. The two parts are drawn separately on different paper, later pasted together. On top a strip is added. The left part on reddish br. 170 x 145, the right lighter, 170 x 258; the whole, including the added strip, 200 x 402. Later inscription on the l. side: M¹ Angelo Buonaroti. On the strip: No. 43. The cross of St. Andrew is drawn partly on the added strip. Coll. Böhler, Luzern. Publ. as Giovanni Bellini by Hadeln, *Quattrocento*, pl. 58, 57 and in *Koenigszeichnungen*, no. 1. Parker, pl. 40. Exh. London 1930, 715, Popham, *Cat.* No. 164: Gio. Bellini or A. Mantegna. R. Longhi, in *Vita Artistica* 1927, p. 137: Mantegna. Rejected by Dussler, p. 160.

[*Pl. CLXXXVI*, 4. **MM**]

The drawing belongs to a group collected around Giovanni Bellini by Hadeln and for which a closer connection to Mantegna was advocated by Kenneth Clark, *Burl. Mag.* LVI, 1930, p. 182–187. The drawing patched together on two sheets does not form a unit stylistically

either. The two Saint Johns are somewhat different in style and proportions from the other saints, are superior in quality, and besides show the halo foreshortened, while in the other group St. Peter's halo is circular. For the figure of St. John the nearest analogy is No. **A 296**, the close resemblance of which even to the other figures of the drawing was also stressed by Fiocco, *L'Arte*, N. S. IV, p. 193. Among Mantegna's paintings St. John in the wing of the St. Zeno altar-piece (ill. *Klassiker, Mantegna*, 81) by its tension and a close resemblance in the way of standing and in the rendering of draperies, recalls the left figure in the drawing. Note, also, the overlapping thin staff and the pillar behind the figure, both indicated in the drawing, which may present Mantegna's first idea for his painting. In the drawing, St. John is placed against the sky with a landscape motive behind his feet; in the painting, only the upper part of the sky is seen, while all the rest is covered by the Saint's draperies, much the same way as we find them in the second sketch of St. John. The other four figures are stylistically related, but, as said above, poorer in quality; they show the crudeness and superficiality of a shop production.

A 306 LENINGRAD, HERMITAGE. Christ, study for a Baptism. Pen. Publ. by Liphart, in *Starye Gody*, September 1915, illustration facing p. 12, as by Giovanni Bellini and a sketch for his Christ in Santa Corona, Vicenza, ill. *Klassiker, Bellini*, 145, 146.

The many deviations already noticed by Liphart and excluding the idea of a copy from the painting make it also unlikely that the drawing may be a study for the painting. In our opinion, the composition is much closer to the engraving in reverse by Mocetto, ill. van Marle XVIII, fig. 240, an engraving which according to van Marle, p. 434, is based on Bellini's painting in essential points. The resemblance, however, is limited to the iconological type, the composition being entirely different. The drawing might be by Mocetto, a point we refuse to decide.

A 307 LONDON, BRITISH MUSEUM, 1895-9-15 — 780. Bearded saint reading. Pen, reddish br., on reddish tinted paper. 172 x 70. — On the back inscription: Vellano di Padova. Coll. Lawrence, Malcolm (Robinson in *Malcolm Cat.* No. 333: Mantegna). Publ. by S. Colvin, in *Vasari-Soc.* IV, 6, as Gio. Bellini, an attribution accepted by Hadeln, *Quattrocento*, pl. 56 and van Marle XVII, p. 346, fig. 207, but questioned by R. Longhi, in *Vita Artistica* 1927, p. 137 and by Dussler, p. 160.

The style of drawing resembling that of No. **A 296** makes us prefer the older attribution. The sharpness of the features and the rendering of the folds have their analogies in the Saints of the St. Zeno altar-piece. The statuesque character too, which might have suggested the old attribution to Vellano (i.e., Bellano, as already noticed by Robinson) is an argument in favor of Mantegna. There is no reason to suppose that Bellini ever approached the very essence of Mantegna's style so closely. Moreover, there is no analogy in Bellini's painted production.

308 ——— 1895-9-15 — 800. St. Sebastian. Brush, height. w. wh., on reddish tinted paper. 185 x 59. Coll. Malcolm (*Malcolm Cat.* No. 353: early Venetian, ascr. to Carpaccio). Publ. as Giovanni Bellini by Hadeln, *Quattrocento*, pl. 54, p. 48, with reference to the wing in the San Giovanni e Paolo altar-piece (*ill. Klassiker, Bellini*, 32) and his triptych in the Academy in Venice, of 1471 (ill. *Klassiker, Bellini*, 8 and 9). Accepted by Dussler p. 160, van Marle XVII, p. 350, fig. 210, and Popham, *Handbook*, p. 26.

[*Pl. XXVIII*, 2. **MM**]

The connection with the two paintings mentioned, both of which,

by the way, belong to the doubtful Bellinis, scarcely reinforces the general resemblance due to the subject matter. From this angle we approach no nearer to Bellini. Nevertheless, we feel that the attribution to Giovanni Bellini is better founded than many others, based as it is on essential elements of his artistic character. If this softly modeled transformation of a Mantegnesque type (see Mantegna's "St. Sebastian" in Vienna, ill. *Klassiker, Mantegna*, 92) is an instance of Bellini's dependence on his brother-in-law, it is hard to believe that the other group of drawings, very much closer to Mantegna and interpreting his style so differently, has rightfully been given to Bellini. (Compare the Nos. **A 291, A 296, A 305, A 311**.) On the other hand, we are also aware of the inadequate foundation of the attribution of this drawing to Gio. Bellini.

309 ————, 1900–5–15 — 1. Landscape, br. 262 x 195. — *Verso:* Landscape and an indicated curled head. Somewhat stained by mold. Coll. Earl of Warwick. Publ. as Cima in *Vasari Soc.* V, 5 and 6, an attribution rejected by Burckhardt, *Cima*, p. 124 ff. who, following Ludwig, acknowledged a closer connection to the drawing No. **353**. Hadeln, *Quattrocento*, pl. 76, 77, Parker, pl. 47, van Marle XVII, p. 459 f., fig. 275, Popham, *Handbook*, p. 26, accept the attribution to Cima. [*Pl. XXXVI, 1 and 2*. **MM**]

We question Cima's authorship in this outstanding drawing, which, in our opinion, belongs to an earlier generation. We do not find any connection to Cima's lovely and crowded landscapes, while the stress laid on the essential elements and producing an almost geological clearness recalls much more Gio. Bellini's early approach to landscape under the influence of Mantegna. Compare the landscapes in such early works as the "Mount of Olives" in London, the "Crucifixion" of the Museo Correr or the "Transfiguration" in Naples (ill. *Klassiker, Bellini*, 20, 24, 66). The arrangement of the rock on the *verso* resembles the scenery for a "Baptism of Christ"; a comparison of Bellini's painting in Santa Corona, Vincenza, ill. *Klassiker, Bellini*, 145, with Cima's in San Giovanni in Bragorà (ill. van Marle XVII, fig. 241), is more in favor of Bellini than of Cima.

A 310 ————, 1902–8–33 — 4. Standing draped man, connected with the figure of St. Peter in a lost altar-piece, which is preserved in an engraving by Mocetto. Brush, wh., gray and reddish br. over sketch in reddish ch. 225 x 107. Inscribed: i 28 (Resta). Coll. Resta (Popham, in *O. M. D.* vol. XI, p. 18 Lord Somers. Formerly ascr. to Catena, in B. M. called Giovanni Bellini, publ. as Gio. Bellini by Hadeln, *Jahrb. Pr. K. S.* XLIV, p. 206, and *Quattrocento*, pl. 53, p. 48, on the basis of Mocetto's above-mentioned engraving (ill. *Jahrb. Pr. K. S.* l. c. p. 208 or van Marle XVIII, fig. 241), which Hadeln believes reproduces a lost altar-piece by Giovanni Bellini of about 1480. Parker, in *O. M. D.* 1926, p. 6 and in *North Italian Dr.* pl. 44, p. 31 suggests that the drawing is a study by Alvise Vivarini after Bellini for Vivarini's lost pendant to the St. John the Baptist in the Academy in Venice (ill. and already discussed in this connection by Hadeln, l. c.). In *O. M. D.* 1928, September, Parker modifies his opinion and admits Gio. Bellini's authorship, retaining, however, some doubts. Dussler, p. 160, accepts the attribution to Gio. Bellini, while van Marle XVII, p. 353, note, prefers Parker's attribution to Alvise Vivarini. Popham, *Handbook*, p. 26 calls the drawing the "most certain" among the four attributed to the master in the B. M. — [*Pl. CLXXXVII, 2*. **MM**]

The point of departure for the attribution to Gio. Bellini is the similarity of the drawing to the lost altar-piece, engraved by Mocetto. A. M. Hind, *Early Italian Engraving*, connects one of its figures, the standing St. John, with Alvise's painting in the Academy, and van

Marle XVIII, p. 434, rightly emphasizes that the composition of the engraved altar-piece reminds one of Cima (especially for the architectural parts) and of Montagna (compare his altar-piece in the Museum Vicenza, ill. Venturi 7, IV, fig. 265). There must, however, be a connection with Giovanni Bellini, since the figures of St. John and St. Peter, as already noticed by Hadeln, appear almost identical in his "Madonna with Saints" in the Schlichting Collection in Paris, ill. *Klassiker, Bellini*, p. 116.

We, too, believe that the engraving does not reproduce an altarpiece by Giovanni Bellini, but rather by a follower, who may have used "*similes*" from Bellini's shop. The construction of the space is distinctly different from that of Bellini, who never introduces a ceiling. Also the awkward postures of the putti, and the posture and drapery of the Madonna, differ from him. The drawing in London may be based on the (probably early) drawing which served in the Schlichting painting, but the soft modeling of the folds, very different from that of the figure in the mentioned painting, does not fit into any phase of Bellini's artistic evolution. We do not feel able to suggest a name for the copyist. The attribution to Alvise Vivarini can hardly be discussed, no material for comparison being available.

A 311 ————, 1909–4–6 — 3. Three studies of a nude lying on the ground. Pen. 122 x 88. — *Verso:* Two female saints crouching on the ground. Formerly ascr. to the school of Giovanni Bellini, attr. to Giovanni, himself, by Hadeln, *Quattrocento*, pl. 61, 60, p. 49, with reference to No. **A 291**. Accepted as Bellini by Dussler, p. 160, van Marle XVII, p. 350. Clark's attribution to Mantegna in *Burl. Mag.* LVI, 1930, p. 182–187 is withdrawn in *Burl. Mag.* LXI, 1932, p. 232s.

In our opinion, the drawing cannot be separated from No. **A 291** and hence must be given to Mantegna. The two women with the draperies flat on the ground around them vary the motive in Mantegna's engraving B. 3 (ill. *Klassiker, Mantegna* 139). The interest in a foreshortened figure is much more in accord with Mantegna than with Bellini; the figure at the top resembles the one of the lost mural, "The Turks burn the body of St. Mark," ill. Venturi 7, III, fig. 192, after a copy existing in the Museo Civico in Padua.

312 ————, Payne Knight P. P. 1–22. Crucifixion with many assistants, in landscape. Pen and brush, br., height. w. wh., on grayish blue. 240 x 215. All corners patched. Inscription (16th century) below, patched: Dit is mantegas hant, p. ko. Publ. by Morelli, in *Kunstchronik* III, p. 526 as school of Foppa, by C. Brun, in *Zeitschr. F. B. K.* XVI, p. 119, as Mantegna's sketch for his predella in the S. Zeno altar-piece (ill. *Klassiker, Mantegna* 82). Kristeller, *Mantegna*, p. 429, calls the drawing "similar in composition to the San Zeno Crucifixion," as does L. Testi, II, p. 235 who calls the drawing a variation of the painting. Parker, pl. 15: School of A. Mantegna, believes the lost mural by Jacopo Bellini in the chapel of S. Niccolò in Verona to have been the prototype from which Mantegna's compositions for San Zeno derived (Jacopo's mural was executed in 1460 in collaboration with Gentile and Giovanni. Copy ill. in Cavalcaselle, vol. I, pl. opp. p. 110). Van Marle XVII, p. 348, fig. 209, attr. the drawing to Giovanni Bellini, influenced by Mantegna's S. Zeno "Crucifixion." Gamba, *Bellini*, pl. 8, p. 46: "Giovanni Bellini follows here his father's composition in Verona and is influenced by Mantegna." [*Pl. XXVIII, 1*. **MM**]

In our opinion, the composition is more closely related to Mantegna's panel from S. Zeno than to the lost mural by Jacopo. From the former, it takes many figure elements, from the latter, the upright

form and an arrangement of the landscape typical of Jacopo Bellini and frequently found in his sketchbooks.

We must also emphasize the fact that the date of Mantegna's altarpiece in San Zeno is 1457–59, so that it is prior to the decoration of the Gattamelata Chapel, which was only started in 1459. The combination of "Mantegnesque" elements with others from Jacopo Bellini makes the attribution to Giovanni Bellini attractive, although no direct evidence is to be presented due to lack of verified material. We point to a certain stylistic resemblance to No. **308**.

313 ————, Sloane 5527 — 101. Virgin and Child. Pen, bister, on blue. 127 x 95. Publ. by Ph. Hendy, in *Burl. Mag.* LXI, p. 67, pl. B, as Giovanni Bellini, with reference to No. **A 315** and by reason of the general style of Bellini's Madonnas in his middle period. The attribution is accepted by van Marle XVII, p. 353. [*Pl. XXX*, 2. **MM**]

Hendy's reference to No. **A 315** is not helpful, this drawing being entirely different in style and, besides, in our opinion, not by Bellini. Moreover, the motive of the foreshortened r. arm and hand hanging loosely does not exist in Bellini's work. It is so ambitious and characteristic that we would expect to find it again in one of his many Madonnas if it were his. It occurs in a somewhat similar fashion in Alvise Vivarini's altar-piece in Berlin, ill. van Marle XVIII, fig. 100. But the drawing whose slight resemblance with the back of No. **316** we admit, looks earlier and closer to the generation influenced by Mantegna's first style. Unfortunately, there is no sketch of this group existing with which this excellent production might be compared.

A 314 ————, Fawkner 5211 — 8. Three male saints, nude in draperies, standing in a landscape. Other saints in the background. Pen, bister, on brownish paper; cut into three pieces and patched together. 122 x 189. In upper r. corner: 14 and by Resta's hand: g 56. — On the back: studies after classic and medieval buildings. In upper l. corner illegible inscription in a handwriting of the late 16th century. Coll. Resta, Lord Somers. In B. M. ascr. to Bart. Montagna. According to Schönbrunner-Meder 257 resembling in style to No. **353**, at that time ascr. to Basaiti. Tancred Borenius, in *Painters of Vincenza*, p. 107, lists the drawing among those connected with Montagna, does not see much resemblance to No. **353** and points to the somewhat similar No. **309**. Popham, in *O. M. D.* 1936, June, pl. 11, p. 18, lists the drawing as "attr. to Giovanni Bellini" and quotes Resta's opinion: "early Carpaccio or early Gio. Bellini. Or perhaps, Domenico da Venezia." [**MM**]

In our opinion, the drawing is hardly Venetian at all; it may be by some remote follower of A. Mantegna.

A ————, Payne Knight, O. o. 9. 31, see No. **344**.

A 315 LONDON, COLL. TANCRED BORENIUS. The Virgin and Child. Pen, bister. 127 x 108. Upper corners cut. Publ. by Ph. Hendy in *Burl. Mag.* LXI, 1932, p. 67, pl. A as Giovanni Bellini, with reference to its general resemblance to Bellini's early Madonnas and further to the group of drawings claimed both for Gio. Bellini and for Mantegna. Fiocco, in *L'Arte*, N. S. IV, 1933, fig. 16, p. 193 (independently of Hendy): Gio. Bellini, placing the drawing alongside No. **A 303**.

In our opinion, the drawing is not a sketch, but an old copy after a painting made in order to record its composition. Every detail is rendered without hesitation. There is no striking connection with any of Bellini's Madonnas.

316 LONDON, COLL. MRS. BROUN LINSAY. Study of a Christ Child lying with his head on a cushion; the legs are separately studied.

Brush, br., height. w. wh., on blue. 206 x 286. — *Verso:* Female saint standing, holding a palm branch. Pen, wash, squared. At r. hasty sketch of a head, in bl. ch. Coll. Richardson Jun., Earl of Dalhousie. Publ. by Byam Shaw, in *Vasari Soc.*, N. S. 1935, No. 3, pl. XVI, with reference to No. **313** and to the painting in the G. L. Winthrop Coll., New York, ill. *Klassiker, Bellini*, 57, where the Child is very similar. Exh. Burl. Fine Art Club, 1937/38, no. 79 and London, Matthiesen Gallery 1939, Cat. no. 79. [*Pl. XXXI*, 2. **MM**]
 [*Pl. XXX*, 1. **MM**]

317 MALVERN, MRS. JULIA RAYNER WOOD (Skippes Coll.). Two studies of Christ at the column. Pen, br. 236 x 145. — *Verso:* two indistinct small figures, apparently varying the subject on the *recto*. Exh. London 1930, No. 708, and publ. by A. G. B. Russell, in *Vasari Society* N. S. XI, 3 as Giovanni Bellini. Kenneth Clark in *Burl. Mag.* LVI, 1930, p. 182–187, included the drawing in the group discussed as Mantegna or Bellini. He considered it a study or design by Mantegna for a composition preserved in the engraving B. XIII, 317, 1, ill. *Klassiker, Mantegna*, 141, "the figure in the engraving showing various adaptations of motives in both studies." While Russell held out for Giovanni Bellini for general stylistic reasons and Popham (*Cat. no.* 161) left the question undecided, Hadeln, in his reply to Kenneth Clark, *Burl. Mag.* LXI 1932, II, p. 229, insisted on the dependence of the drawing (which he claims for Gio. Bellini) on Mantegna's engraving. Fiocco, *L'Arte*, N. S. IV, p. 192 and van Marle XVII, p. 349, share Hadeln's opinion, which Kenneth Clark adopted in *Burl. Mag.* LXI 1932, p. 232s. [*Pl. XXIX*, 4. **MM**]

We, too, believe that the drawing cannot precede the engraving, but possibly takes it as a point of departure. We can note more clearly the difference in style by comparing the drawing with Nos. **A 291**, **A 305**, **A 311**, **A 323**. The approach to Mantegna is limited to a general resemblance of linework and types while the whole feeling is softer and lacks the plastic intensity so typical of the other drawings. Positive, as far as the rejection of the Mantegna theory goes, we feel less certain about the attribution to Giovanni Bellini. We accept it with the reservation that the grouping of the sketches of this character around Bellini rests on a hypothetical construction of Bellini's early style. The modifying and mollifying of the Mantegnesque elements seen in this drawing fit into this construction. However, the lack of any influence of Jacopo Bellini, such as we might expect in Giovanni Bellini, is a warning not to be too certain of the attribution to him.

A 318 OXFORD, CHRISTCHURCH LIBRARY, H 9. Bust of a beardless elderly man with a cap, slightly turned to r. Bl. ch. wash, on yellowish. 390 x 278. Damaged and repaired. Formerly attr. to Bonsignori. Publ. in *Oxford Drawings* II, 32, as Gentile Bellini? Berenson, *Lotto*, 1901, p. 92: Alvise Vivarini. Mentioned by Byam Shaw in *O. M. D.*, March 1928, p. 54: possibly Gio. Bellini, with reference to No. **A 297**. Exh. London 1930, Popham, *Cat.* 177, pl. 151: Bonsignori, with reference to the portrait in the Widener Coll. and the drawing in the Albertina No. 28. Popham quotes an attribution of the drawing to Mantegna by Hadeln. [*Pl. CLXXXIX*, 1. **MM**]

We exclude Bonsignori, the less refined character of whose drawing in Vienna did not escape Popham, and among the names proposed prefer that of Andrea Mantegna, citing in this connection besides the portraits in the Camera degli Sposi that of the Cardinal Lodovico Mezzarota in Berlin, ill. *Klassiker, Mantegna* 89.

319 PARIS, LOUVRE, 436. Lamentation over the dead body of Christ,

seated on the sarcophagus. Pen. 131 x 181. Top irregularly cut. Coll. Vallardi, His de la Salle. (Both de Tauzia, 1881, p. 23: Gio. Bellini; on the *verso* ornamental study. Mentioned as Gio. Bellini by Morelli, I, p. 271. Publ. by Hadeln, *Quattrocento*, pl. 69. Exh. Paris 1935, Cat. Sterling No. 416. Accepted by Dussler p. 160 and van Marle XVII, p. 352. [*Pl. XXXV*, 1. **MM**]

Probably a drawing from Bellini's late period; compare the painting in the Academy in Venice, ill. *Klassiker, Bellini* 171 and the draperies in the altar-piece in S. Giovanni Cristostomo, ibidem 170. No authenticated drawings similar in style are available for comparison.

A 320 PARIS, COLL. ANDRÉ DE HEVESY. Ganymede on the eagle over landscape, design for Giulio Campagnola's engraving Kristeller 6. Pen, reddish br. 153 x 115. Coll. Suermondt, Stroganoff. Exh. London, Matthiesen Gallery 1939, Cat. no. 77 as Giovanni Bellini, this attribution, according to information by the owner, having first been made orally by Hadeln. Publ. by us in *Pr. C. Qu.* 1942, April as Andrea Mantegna. [**MM**]

The connection with Giulio Campagnola's reversed engraving is so close, that the first reaction is to attribute the drawing to him. There are, however, the following important objections to this solution: In general, Giulio's lack of invention, so expressly stated by Hourticq (*Problèmes de Giorgione*, p. 87 ff.), in particular the stylistic difference between our drawing and No. **579** authenticated by its use in an engraving and further, the replacing of the landscape in the drawing by a motive copied without alteration from Dürer's engraving B. 42. The landscape in the drawing is purely Italian and the cloudy sky is in contrast to Giulio's typical blank horizon. Certainly the drawing is superior in quality to what we might expect from Giulio; note, for instance, how convincingly the motion of flying upwards is rendered in the drawing, while in the engraving the eagle is standing in the air. (Also emphasized by Hourticq, *Giorgione*, p. 87.) The attribution to Bellini is based — besides the quality in general — on a certain resemblance to the *restello* panels in the Academy in Venice, see especially the two allegories, ill. *Klassiker, Bellini* 92 and 93. But, again, we must emphasize the stylistic difference from any drawing given, even tentatively, to Gio. Bellini. Moreover, the introducing of a step in the foreground of the landscape is not Bellinesque, but typical of Mantegna and his immediate followers. Mantegna uses this device in various paintings, see, for instance, his "Madonna with St. John Baptist and St. Mary Magdalene" in London, or the "Parnassus" in the Louvre (*Klassiker, Mantegna* 114 and 59); we find it also in his engravings B. 2 and B. 4 (*Klassiker* 143, 144). Typical of Mantegna is the treatment of the sky. Once suspicion is aroused in this direction one discovers that the penwork is closely related to the drawing of a "Madonna and Child" in the British Museum (ill. *Klassiker* p. XLV). Without knowing of the drawing, Galichon in *Gaz. B. A.* 1862, p. 337, no. 6 and A. Venturi 9, III, p. 494 had stated that Giulio Campagnola in his engraving had used a model by Mantegna.

321 RENNES, MUSÉE. Pietà. Pen, bister, wash. 130 x 90. Lower r. corner added. Late inscription: André Mantaigne. Publ. as Giovanni Bellini by Roberto Longhi, *Vita artistica* 1927, p. 138, who refers to the curious Paduan Pietà in Budapest (no. 105) and dates it about 1480, and by K. T. Parker in *O. M. D.* 1928, pl. 58, who refers to Nos. **286, 287** and Nos. **A 291, A 305** and **A 311**. Also reproduced by van Marle XVII, p. 350, who points out the painting of the same subject in Lord Rothermeres Coll. (publ. by Borenius, *Pantheon* 1932, December, p. 381, and dated between 1465 and 1470). Gamba, *Bellini*,

pl. 73, calls the drawing a study for a lost composition about 1475 and connects it with the "Dead Christ supported by angels" in Berlin (ill. *Klassiker, Bellini*, 74). [*Pl. XXXV*, 2. **MM**]

The reference to No. **286–7** is not convincing. In our opinion, the drawing is later, and its closest analogy is No. **319** not as far as the linework goes, but in the ripeness of its composition. We must add that the attribution of this drawing, the composition of which has no analogy with any painting attr. to Gio. Bellini, remains hypothetical. Compare for the type of composition No. **343**.

322 ROME, GABINETTO NAZIONALE DELLE STAMPE, 130471. Christ Child sleeping. Silverpoint and pen, bistre, height. w. wh., on dark blue. 156 x 129. Kept in a scrapbook containing Baroque drawings. Discovered and publ. by Degenhart, *Jahrb. Pr. K. S.* 1940, p. 46, fig. 10, with reference to similar children in Bellini's paintings in the Academy in Venice, in the Metropolitan Museum and in Verona, Museo Civico (*Klassiker, Bellini*, 12, 14, 47). Degenhart dates the drawing earlier than any of these paintings and believes it was used by Giovanni Bellini in a composition preserved only in a shop production, which Degenhart illustrates in fig. 13, without knowing its present whereabouts. For the technique he points to No. **299**.

More striking than this reference to a drawing which is apparently from a much later period and difficult to compare because of its very different subject, is a comparison to No. **316**, related in style and purpose. We have not seen the original.

323 VENICE, R. GALLERIA, 47 A. Pietà. Pen. 129 x 98. Formerly attr. to Mantegna, first ascr. to Gio. Bellini about 1460/70 by Morelli, I, p. 271. Followed by Loeser, *Rassegna d'A.* III, p. 180, Gronau, *Künstlerfamilie*, p. 65, Fogolari, pl. 59, Hadeln, *Quattrocento*, pl. 62. Exh. in London, 1930, 707 (Popham *Cat.* 163: Gio. Bellini or A. Mantegna), Dussler p. 160, van Marle XVII, p. 350, Gamba, *Bellini*, p. 43, who connects the drawing with the central panel of the altar-piece in S. Giovanni e Paolo (ill. *Klassiker, Bellini*, 33). The drawing belongs to those which Kenneth Clark claimed for Mantegna in *Burl. Mag.* LVI, 1930, p. 181 f. and later restored to Gio. Bellini, ibidem 1932 II, p. 232. [*Pl. XXIX*, 3. **MM**]

The reference to the doubtful Pietà in San Giovanni e Paolo is quite unsatisfactory, in our opinion. The drawing seems much more akin in spirit to Giovanni Bellini's painting in the Brera, ill. *Klassiker, Bellini*, 27. In the linework, we find it closest to Nos. **A 291, A 311**, but completely different from Nos. **319, 321**. The difference from the latter might be sufficiently explained by the supposedly long interval between the two groups. As for Nos. **A 291, A 311** we attr. them to Andrea Mantegna. Is our drawing absolutely tied with the two latter? The Pietà in the Brera, to which we referred before, marks the utmost approach of Bellini to Mantegna. The drawing in Venice might have a similar significance. Comparing it with Nos. **A 291, A 311**, we believe we may note less tension in the modeling of the body of Christ and less understanding of the function of the limbs — a shortcoming that might justify our accepting Giovanni Bellini's authorship in spite of the marked resemblance to drawings which we give to Mantegna.

324 ————, 48. Head of a young woman. Silverpoint, height. w. wh., on greenish gray prepared paper. 208 x 138. Stained by mold. First attr. to Gio. Bellini by Loeser in *Rass. d'A.* III, p. 180, publ. as his by Fogolari, pl. 50, who remarks that the drawing was supposed to be a portrait of Cassandra Fedele. Hadeln, *Quattrocento*, pl. 64. Dussler, p. 160. Gamba, *Bellini*, p. 127 (who connects the drawing with the Madonna dei Cherubini, ill. *Klassiker, Bellini*, 130). A.

Venturi, in *L'Arte* XXIX (1926), p. 157 and in *Studi*, p. 271, fig. 170, suggests Lorenzo Lotto in his early period, referring to the types used in his Recanati altar-piece. Exh. London, 1930 Popham *Cat.* No. 160, who states that the attribution to Gio. Bellini must be regarded as extremely doubtful, a statement in which van Marle XVII, p. 353, note, also concurs. L. Coletti (in *Le Arti*, I fasc. 4, 1939, p. 351) rejects the attribution to Bellini and suggests a return to Lotto.

[*Pl. XXXIII*, 2. **MM**]

We share Popham's doubts in the possibility of an individual attribution, since practically no material for comparison is available. The only approach to the problem is by the date, which in our opinion is about 1470/80, thus excluding the Lotto theory. Among Gio. Bellini's paintings, the closest for its type — possibly a purely accidental resemblance — is the "St. Justina" in the Bagatti-Valsecchi Coll., Milan (ill. *Klassiker, Bellini*, 35, claimed for Gio. Bellini about 1465/70 by B. Berenson, in *The Study and Criticism of Italian Art*, 3d series, p. 38, but previously considered one of the main works of Alvise Vivarini). Behind the sweet simplicity of the head — which, by the way, is not a saint's, but a portrait in contemporary costume — we still feel something of Mantegna's influence; compare the shop drawing in Rotterdam, ill. *Burl. Mag.* 1911, p. 257. The only female portrait claimed for Bellini and publ. by G. M. Richter in *Burl. Mag.* 1936, II, p. 1 would originate from a period definitely later.

A 325 ————, 162. St. John Evangelist standing. Pen, wash. 205 x 91. Late inscription: Mantegna. Mentioned as Gio. Bellini by Morelli, I 271, publ. as Bellini by Fogolari, No. 48, and Gronau, *Künstlerfamilie Bellini*, p. 66, fig. 66, and placed in Bellini's early years. Exh. Paris 1935 (Sterling *Cat.* no. 515: doubtful). Accepted by van Marle XVII, p. 346, and Gamba, *Bellini*, p. 49, who refers to a painting of St. John Evangelist by Giovanni Bellini, highly praised by Marcantonio Michiel in 1527 and again mentioned by Sansovino (p. 226) in 1580. [**MM**]

Because of the lack of corresponding figures in Giovanni Bellini's work and of the stylistic difference from No. **316ᵛ** which is somewhat similar in its motive, we see no reason for separating this very Mantegnesque drawing from the numerous productions of Mantegna's school. We find a striking resemblance to Giovanni Minelli's "Apostles" in the Museo Civico in Padua, ill. in *Boll. del Museo Civico di Padova* 1930, fig. 12, 13, 14 and 28. Compare Minelli's drawing for a tomb, ill. ibidem.

A 326 Vienna, Albertina 84. Portrait of a young man, beardless, turned slightly left. Bl. ch., on brownish paper. 398 x 315. Part of the hair and the sleeve were afterwards added. Formerly attr. to Gentile Bellini. *Albertina Cat. I* (Wickhoff) 10: Bonsignori. Schönbrunner-Meder 487: Anonymous Venetian. A. Venturi, *L'Arte* 1899, p. 437: Bartol. Veneto; the same, *Studi*, p. 268, fig. 169: Lotto. Hadeln, *Quattrocento*, pl. 71, p. 50, after having discussed and rejected Catena, Bissolo, Basaiti and thoroughly examined Lotto in his youth arrives

at the conclusion: "Gio. Bellini in his latest period." *Albertina Cat. II* (Stix-Fröhlich) accepts Fiocco's verbal attribution to Lotto, also made by Venturi, in *Studi*, p. 270, Dussler, p. 160, flatly rejects the attribution to Bellini, Byam Shaw, in *O. M. D.* 1928, March, p. 54, agrees with Hadeln and bases his attribution of the portrait in Dublin, No. **A 297** on the attribution to Giovanni Bellini of the drawing in Vienna. Van Marle XVII, p. 352, too accepts this attribution, but only with reservations. [*Pl. CLXXXVII*, 4. **MM**]

With Hadeln we reject the attribution to Lotto, seeing in this drawing a much closer connection with the local Venetian tradition, founded by Antonello da Messina. But we disagree for the attribution to Gio. Bellini himself. In our opinion none of his own portraits shows such a secular and conscious approach to life, typical of the generation immediately following. Compare, for instance, Previtali's signed portrait in the Poldi-Pezzuoli Museum in Milan, Cat. 1911, p. 81, no. 60.

A 327 Vienna, Coll. Artaria, formerly. Antique warrior standing, seen from front. Pen. Sale Artaria 1885 as Mantegna, publ. as his in *Graph. Künste* vol. VIII, 1885, p. 59; later Coll. Stroganoff, Rome. Mentioned by P. Kristeller, *Andrea Mantegna*, 1901, p. 461 as belonging to the group of Mantegnesque drawings attr. to Giovanni Bellini.

We have not seen the drawing whose present location is unknown. As far as the reproduction allows us to judge, the drawing shows no connection with Giovanni Bellini, and is certainly much closer to Mantegna.

328 Windsor, Royal Library. Bust of St. Anthony Abbot, full face. Brush, height. with wh., on bluish gray. 260 x 190. Damaged. Originally attr. to Alessandro Baldovinetti. Publ. by Parker, in *O. M. D.* 1928, pl. 21, somewhat hesitatingly, as Giov. Bellini in his Mantegnesque period. For the technique, he refers to Bart. Montagna and Cima No. **656**. Among Bellini's paintings, the wing with St. Anthony of the Carità altar-piece, (ill. *Klassiker, Bellini*, 9) in Parker's opinion, would be the nearest analogy. Exh. London 1930, 691. Popham *Cat.* no. 165 finds the resemblance with the painting mentioned above unmistakable and agrees with Parker, insisting that the head, at any rate, must be a work of Gio. Bellini around 1470. Van Marle XVII, p. 344, accepts the attribution, while Dussler, p. 160, questions it. [*Pl. XXXIII*, 1. **MM**]

Leaving aside the question of the authorship of the Carità altar-piece, attr. to Alvise Vivarini before being claimed for Gio. Bellini or his shop, we deny any really convincing resemblance between the two heads. On the contrary, in our opinion, the contrast between the direction of the gaze and that of the head and the heightened tension, point to a later period for the drawing. If the drawing is by Bellini, as it might be, we should prefer to place it close to No. **299** and other heads in the unfinished shop product in the Uffizi, ill. *Klassiker, Bellini*, 100, thus arriving at a date towards the end of the 15th century.

SCHOOL OF GIOVANNI BELLINI

329 Berlin, Kupferstichkabinett, 4192. Bust of a beardless elderly man with a cap, slightly turned to the r. Bl. ch., on blue. 227 x 178. Coll. Mathey, Paris, Chennevières. Exh. in Paris, École des Beaux Arts, 1879, as "Bellini" (Photo Giraudon 12714). Loeser, in *Rep. f. K. W.* XXV, 355, suggests Pordenone. Publ. in *Berlin Publ.* I, 78 as anonymous around 1500. B. Berenson, *Lotto*, 1901, p. 94: Alvise

Vivarini. This attribution is accepted by van Marle XVIII, p. 168, note, with reference to the portrait in the N. G., no. 97.

[*Pl. XXXII*, 1. **MM**]

We agree with Bock's cautious ascription (in *Berlin Publ.*) and his dating c. 1500, which excludes Pordenone. The whole interpretation more closely resembles that of Giov. Bellini in the first decade of the

16th century, as, for instance, in the portrait of the Doge Loredan, ill. *Klassiker, Bellini*, 144, or the one in Hampton Court (ill. ibidem 163, also attr. to the school of Giov. Bellini).

330 ————, 5067. Portrait of a beardless man, wearing a cap, seen from front, slightly turned to the r. Charcoal, height. w. wh., on blue. 273 x 205. Stained by mold. Coll. F. Murray, von Beckerath. Ascr. to Catena. **[MM]**

Companion piece to No. 331. The man represented is possibly the same as the one who appears as donor in the painting, mentioned at No. 331, although shown in an entirely different pose. This suggestion would not have been made, were the female portrait not identical with the kneeling lady in the painting. For the attribution see No. 331.

331 ————, 5068. Portrait of a middle-aged lady, turned three quarters to l. Charcoal, on blue. 273 x 203. Coll. F. Murray, von Beckerath. Ascr. to Catena. [*Pl. XXXIX*, 1. **MM**]

Companion piece to No. 330. There is a striking resemblance between this drawing and the female donor in a Santa Conversazione at the Ferrario Galleries, Milan (in 1938) publ. as Cima by A. Venturi, in *L'Arte* 1934, November, p. 483 ill. and as Giov. Bellini by Porcella, in *Illustrazione Vaticana* 1935/I, p. 185.

The posture is slightly modified, but there can hardly be a doubt as to the identity of the head. The composition is based on Giov. Bellini's painting in San Francesco della Vigna, ill. *Klassiker, Bellini*, 166, of 1507, but is probably done something like a decade later, since the landscape at l. is an exact copy after Giulio Campagnola's engraving (Kristeller 9), of about 1515. Consequently, the authorship of Catena, who collaborated with Giov. Bellini in his late period, though not to be excluded, is by no means confirmed by the comparison with such of Catena's paintings as were probably executed in the period of collaboration, and with the style of his authentic portraits. See No. 330.

332 CHATSWORTH, DUKE OF DEVONSHIRE. Three figures, a fourth cut; the middle figure a bearded saint writing on a scroll. Pen, br., on yellow. 190 x 165. — On the back: St. John the Baptist? preaching and a youth in the costume of the 15th century. Formerly attr. to Gio. Bellini. Publ. as anonymous Venetian by Strong, in *Chatsworth Dr.*, pl. 33, who in his text seems to be rather attracted by the former attribution. **[MM]**

In our opinion, the style points to Padua and Venice about 1470 and somewhat resembles that of the three predella panels depicting the Life of Saint Drusiana, attr. to Lauro Padovano by Michiel in 1527 and connected with Gio. Bellini himself by Gamba, *Bellini*, pl. 14/16, p. 50.

A 333 DÜSSELDORF, AKADEMIE DER BILDENDEN KÜNSTE, no. 573. St. Sebastian. Pen, br., on yellowish. 189 x 255. Old inscription: A. Mantegna. Publ. by Ille Budde, pl. 83 as Giovanni Bellini's shop, based on B. Berenson's verbal opinion: "Contemporary copy from Mantegna by an artist closely related to Gio. Bellini." **[MM]**

There is no reason for calling the drawing a copy after Mantegna. It is an original work by one of his less independent followers, like Montagnana or Parentino (compare the latter's "The Building of Troy" in the Fitzwilliam Museum in Cambridge, England, ill. Schubring, *Cassoni*, pl. 207).

334 FLORENCE, UFFIZI, no. 584E. Apostle St. John sleeping (from a Mount of Olives). Brush, grayish br., wash, height. w. wh., on faded

blue. 197 x 287. Ascr. to Gentile Bellini, and as such reproduced by Bernard Degenhart, in *Jahrb. d. Hertziana*, vol. I, fig. 222 (detail). [*Pl. XXXI*, 1. **MM**]

In our opinion, early "*simile*" drawing taken from a painting of Gio. Bellini's Mantegnesque period; compare the "Mount of Olives" in London, ill. *Klassiker, Bellini*, 20, or Mantegna's engraving B. 8 (ill. *Klassiker, Mantegna*, 136). The soft treatment of the draperies is definitely Venetian.

335 ————, No. 585. Youth (or woman) seated in a long dress holding one hand to the chest. Brush, grayish br., wash, height. w. wh., on faded blue. 223 x 181.

Resembles No. 334 in character, but notably poorer in quality.

336 ————, 1685. Study of a drapery. Bl. ch., height. w. wh., on blue. 282 x 206. Bl. foil round the drapery. Damaged by mold. — On the back: Head of a young man, turned to l., unfinished and cut. [*Pl. XXXIV*, 4. **MM**]

Both sides, in our opinion, point to a Venetian artist of the early 16th century. The excellent drapery seems to be influenced by Dürer's studies of this type. We know that Dürer, not only influenced most of the artists in Venice, but we are expressly told by Vasari that even Gio. Bellini imitated Dürer's draperies. If the drawing were by Bellini, it could only be from his latest years, and there are indeed general analogies in Bellini's late paintings as, for instance, in the Madonna of 1510 in the Brera, ill. *Klassiker, Bellini*, 169. Similar draperies, however, occur also in works of his followers, for instance, in Catena's "St. Christina in adoration," in S. Maria Materdomini. ill. van Marle XVIII, fig. 221.

337 ————, Doge Ziani kneeling before Pope Alexander III, who is disguised as a monk. Brush, height, w. wh. Recognized and publ. by Gronau, *Künstlerfamilie*, p. 35, fig. 21, as a copy by a Venetian artist of the 16th century from Giovanni Bellini's painting in the Sala del Maggior Consiglio, destroyed by fire in 1577 and described by Ridolfi I, p. 66 and others.

As rightly pointed out by Gronau the drawing does not look like a sketch, but is certainly Venetian. We may add that the author seems to be rather close to the period of origin (last quarter of 15th century) and that Cima's drawing in the Uffizi, No. **656**, shows the same technique. According to Boschini-Zanetti, p. 341, there existed a small painting of the same subject in the Chiesa della Carità "cosa in vero molto gentile di mano di Vicenzo Catena."

A 338 ————, 1697. Hermit saint in rocky landscape. Pen and brush, br., wash. 140 x 179. Late inscription: B. Montagna. Formerly attr. to him, publ. by G. Bernardini in *Boll. d'A.* IV, 1910, p. 147 f., fig. 2, as Catena, with reference to the Saint Jerome in the N. G. The attribution is accepted with reservations by Hadeln, in Thieme-Becker VI, p. 183, and van Marle XVIII, p. 403. **[MM]**

We neither recognize any connection with the painting in London (ill. as Giov. Bellini in Gronau, *Bellini*, 83 and as Basaiti in Illustrations of the Cat. v. 1 (1930), p. 12) and, by the way, not established as Catena's nor do we find the characteristics of his style in the drawing. In our opinion, it belongs to an earlier period or at least an earlier stage of the general evolution than Catena. We find a certain general resemblance to a painting of the same subject attr. to Giovanni Mansueti in the Arthur Hughes' Coll., ill. *Burl. Mag.* 1912, vol. XXI, p. 48, pl. 3, and to another "Saint Jerome" in the Museum of Fine Arts in Boston, sometimes attr. to Jacopo da Valenza, ill. Tietze,

Masterpieces, 68. Both paintings have the dryness of execution combined with an obvious pleasure in abundant landscape detail in common with the drawing. We list it among the anonymous works of the late 15th century.

339 HAGUE, THE, COLL. FRITS LUGT. Two standing Romans? turned to l., one with a wreath in his hair. Brush, gray and wh., monochrom, on brownish and bl. tinted paper. 405 x 250. Ascr. to Basaiti. [*Pl. XXXVII*, 1. **MM**]

The two figures are closely related in style, technique and measurement to No. **340**. They are *"simile"* drawings used in a painting which we know only from a photograph in the Witt Library, attr. there to Cariani (and marked Venezia, S. Alvio, Calle Gappuzzi 616). The subject of this painting is unidentified; it represents Christ, surrounded by Apostles and secular figures. The drawing in the Lugt Collection is taken over in the painting with almost no changes, while of the companion piece in Kremsier only the l. figure is used with a modified head, and the figure at r. is adapted to a woman. The connection with No. **340**, the general impression recalling that of No. **352** and the late use in a probably Venetian painting make us attribute the drawing to the Venetian School, replacing, however, Mr. Lugt's suggestion of Basaiti by the more general classification as "School of Gio. Bellini." We must, however, emphasize the distinct Lombard elements in the drawing. These figures may have formed part of a composition representing Christ preaching, corresponding to the fresco by Francesco Benaglio in the Capella Lavognoli, Verona, S. Anastasia (ill. Venturi, 7, III, fig. 347).

340 KREMSIER, COLLECTION OF THE ARCHBISHOP. 218. Two Men in classic draperies standing, apparently cut out of a longer row of such figures, the adjoining ones being partly outlined. Brush, gray, in two shades, on yellow. 400 x 230. [*Pl. XXXVII*, 2. **MM**]

Companion piece to No. **339**, q.v.

341 LONDON, BRITISH MUSEUM, 1875-6-12 — 9. Holy Virgin nursing the Christ Child. Another nude boy sitting in lower r. corner. Pen, br., on wh., turned yellow. 193 x 142. In B. M. anonymous. Companion piece to No. **342**, q.v. [*Pl. XXXVIII*, 4. **MM**]

342 ———, 1875-6-12 — 10. Nude boy — the same as in No. **341** — seated on a trunk and repeated above in half length. Another nude boy, seated and turned to the r. Pen, br. 190 x 113. Modern inscription: Mantegna. In B. M. anonymous. Companion piece to No. **341**.

Parker (on mount of drawing) refers to Giulio Campagnola's engraving, Kristeller 7, where, it is true, the child has stockier proportions. G. Campagnola's engraving may go back to an invention by Gio. Bellini, to whose wider circle, also, the two drawings in London belong. We note, for the children at least, a certain resemblance to Cristoforo Caselli, who worked with Gio. Bellini in Venice from 1489 to 1498, but at the same time we find the Madonna too different from his to risk a definite attribution to him. [*Pl. XXXVIII*, 3. **MM**]

343 ———, 1895-9-15 — 791. Pietà. The Madonna sitting on the edge of the sarcophagus, or standing behind it, in a cave; vista of a landscape with the Mount of Calvary. Pen, bistre, wash. 130 x 95. Late inscription: Udini. — On *verso*: Studies of nude children in various positions. Publ. by K. T. Parker, pl. 42 as by a follower of Gio. Bellini. For the *recto* Parker points to the Mond Pietà, ill. *Klassiker, Bellini*, 40, which probably inspired the drawing, for the *verso* to the "Dead Christ with angels," by Gio. Martini da Udine?

in the Walters Coll. in Baltimore, ill. B. Berenson, *Venetian Painting in America*, fig. 94, adding that this resemblance might make plausible the attribution of the drawing to Gio. Martini da Udine. [**MM**]

We find no connection whatever with the Mond Pietà, but agree as to the resemblance of the *verso* to Gio. Martini. The similarity to the Christ child in Martini's signed and dated (1498) Madonna with Saints in the Museo Civico Correr (Photo Sansoni FARL 23002) may perhaps be still more striking. The Pietà is dependent on the composition preserved in No. **321** and offers evidence that this important invention existed in a painting.

344 ———, Payne Knight O. o. 9 — 31. The two saints on the r. wing of Gio. Bellini's altar-piece in the Frari, ill. *Klassiker, Bellini*, 104. Brush, gray, height, w. wh., on blue. 279 x 140. All corners patched. Coll. Mariette; on the typical mount inscription: Joan. Bellin delin. P. P. Rubens restituit. Accepted by van Marle XVII, p. 353, note. [*Pl. XXXIV*, 3. **MM**]

In our opinion, a shop production, in the character of No. **352** overworked in the heads, hands, the books and parts of the draperies by a later hand. We do not believe that the drawing was copied from the painting, but more probably from a study, which contained also those parts of the drapery at l., which do not appear in the painting.

345 LONDON, SPANISH GALLERY, St. Francis standing. Red ch., on paper turned yellow. 209 x 87. Patched and damaged. Mentioned in *Klassiker, Bellini*, 214, as a copy from the right wing of the altar-piece in the Kaiser-Friedrich-Museum, ill. *Klassiker, Bellini*, 148. [**MM**]

This painting (then in San Cristoforo, between Venice and Murano) is described as by Cima by Boschini and was later on ascr. to Basaiti. For the attribution to Bellini and the frequent copies after the figure of St. Francis, see Gronau, *Spätwerke*, p. 8. Dussler, p. 145 circumstantially rejects the attribution of the painting in Berlin to Bellini.

Companion piece of the drawing No. **348**. It might be a copy done in the shop.

A 346 LONDON, COLL. E. SCHILLING. Study of a drapery, upper part of a sleeve. Brush, br., height. w. wh., on tinted blue paper. 155 x 120. On the back: Head of a child turned to the l. Bl. ch Coll. von Lanna, Prague. Formerly ascr. to the German School, publ. by Schönbrunner-Meder 1146/1147 as "School of Bellini, in the 1490's," an attribution rejected by van Marle XVII, p. 353, note.

In our opinion, too indifferent to allow an attribution.

347 MILAN, AMBROSIANA. Landscape with a fortified hill in the background and with the three Marys and St. John in the foreground. Brush, gray and wh., on greenish. 280 x 332. Damaged and repaired. Coll. Padre Resta. Attr. by Padre Resta to Gio. Bellini, publ. by Ad. Venturi, in *L'Arte*, 1899, p. 439 f. as a design by Bart. Veneto, used in the background of the "Resurrection of Christ" in the Kaiser-Friedrich-Museum in Berlin, ill. *Klassiker, Bellini*, p. 67, and in other paintings some of which are signed by Bartolomeo Veneto, others attr. to him by Venturi. According to Ludwig-Bode, in *Jahr. Pr. K. S.* XXIV, p. 140, the drawing is a copy from the painting in Berlin.
 [*Pl. XXXVI*, 3. **MM**]

The landscape which, by the way, Ludwig-Bode suggest is a view of Monselice (l. c. p. 137) does indeed appear in a number of paintings as the Madonna and Child in the Accademia Carrara, Bergamo, ill. Venturi 7, IV, fig. 440, another Madonna and Child in the Ducal Palace in Venice, in the Portrait of a Nobleman in the Galleria

Nazionale in Rome, in Sebastiano del Piombo's signed early Pietà in the N. G. (ill. Venturi, 7, IV, fig. 430), and in another Pietà in the parish church of San Pietro in San Giovanni Bianco (ill. *Inventario Bergamo*, p. 393). The last mentioned is signed Antonelus R , a signature not yet identified (see *Emporium*, June 1920, p. 286) within the school of Cima to which the painting is ascr. (The painting is wrongly published as by Bart. Veneto, *Arti* l. c. fig. 10). These paintings, however, repeat only part of the drawing, which seems to have been definitely connected with the "Resurrection," since it contains also the figures in the background.

(These figures, the Marys and St. John the Evangelist are incidentally also repeated in the background of the "Crucifixion" by Alvise Donato in the Academy in Venice, ill. Molmenti-Ludwig, fig. 127. Even this late artist, active 1528–1550, still used those old *similes*. Modified, they appear also in "The Dead Savior" in Berlin, attr. to Carpaccio, ill. Van Marle XVIII, fig. 157).

The "Resurrection" was painted for an altar in San Michele in Murano, probably between 1475 and 1479 (Bode-Ludwig, in *Jahrb. Pr. K. S.* XXIV, p. 131). Ridolfi gives it to Gio. Bellini, Boschini to Cima, later Crowe and Cavalcaselle to Previtali. Gronau, *Klassiker, Bellini*, 67, and van Marle XVII, p. 273, maintain Gio. Bellini's authorship, Dussler, p. 154 s. flatly rejects it, without suggesting another name, and A. Venturi, 7/IV, p. 695, adheres to his older attribution to Bartoloemeo. P. d'Achiardi in Thieme-Becker II, p. 579, follows Venturi. The grouping of the above-mentioned pictures around Bartol. Veneto rests in part on the repetition of the landscape. As far as the "Resurrection" in Berlin is concerned, an attribution to Bartoloemeo seems implausible; by whomever the painting might be, its style points to a time about 1480, a period preceding Bart. Veneto's activity. The drawing in the Ambrosiana may explain the connection. It is a *simile*, already used in the "Resurrection" or copied from it, and later on utilized for other backgrounds by various Venetian painters (see above). The appearance of the motive in these paintings is no argument for the identity of their authors. They cannot all be by Bart. Veneto. It can, moreover, neither be proved nor disproved that the *simile* in Milan is drawn by him. The primitiveness of the style points to an earlier artist.

348 PARIS, LOUVRE, 5603. Sainted monk standing, holding a book and a cross formed of branches. Brush, gray, height. w. wh. 256 x 129. Arched top, cut at bottom. Stained by mold. [*Pl. XXXVIII*, 2. **MM**]

Shop production, *simile*, varying the figure of St. Francis in Bellini's Pesaro altar-piece, ill. *Klassiker, Bellini*, 49 and another St. Francis, in the altar-piece of San Cristoforo, now in the Kaiser-Friedrich-Museum in Berlin, ill. *Klassiker, Bellini*, 148. Companion pieces No. **345** and the *simile* in the same technique No. **349**.

349 ———, 5604. St. Jerome in landscape, repetition of the figure in the altar-piece of San Cristoforo, now in the Kaiser-Friedrich-Museum, ill. *Klassiker, Bellini*, 148. Brush, br. wash, height. with wh. 237 x 118. Later inscription: Lorenzo Lotto. Mentioned by Gronau, *Spätwerke*, p. 8, among other repetitions of this figure. See No. **345** and No. **348**. [**MM**]

350 PARIS, COLL. ANDRÉ DE HEVESY. Bishop standing, holding a book in his left hand and blessing with the other. Pen, lightbr., on faded blue. 98 x 51. Right hand is corrected. Coll. Molinier and Tolentini. [*Pl. XXXIV*, 1. **MM**]

Companion piece to No. **351**, q.v.

351 ———, Bishop standing, holding a staff(?) in his l. hand and blessing with his r. hand. Pen, lightbr., on faded blue. 98 x 44. Collector's mark with swastika in circle. The legs are seen under the drapery. [*Pl. XXXIV*, 2. **MM**]

Companion piece to No. **350**, whose correction of the arm is taken over. In line with information from the owner, Professor Fiocco suggested the name of Sebastiano del Piombo with reference to his early figures in San Bartolomeo di Rialto, Venice, ill. Venturi 9, III, fig. 52, 53.

Sebastiano's organshutters in San Bartolomeo stylistically form two pairs. The one, St. Louis and St. Sinibald, executed 1507/9, is the only one that interests us here, since the second pair might be later or, at any rate, displays or anticipates a Michelangelesque touch (see Johannes Wilde, in *Jahrb. K. H. Samml.*, N. S. VII, p. 116). The Giorgionesque element in the earlier pair is so obvious, that drawings by Giorgione might have been, according to a theory advanced by Justi (*Giorgione*, p. 74, 179), used for it by Sebastiano, while Richter, *Giorgione*, p. 242, admits only a strong influence by Giorgione on Sebastiano. As for the connection with the drawing in the Hevesy Collection we must first state that the resemblance is limited to the subject, both representing bishops. Besides the drawing style of Sebastiano in his Venetian period is entirely unknown, so that an attribution to him seems unfounded. There is also not the slightest resemblance to Giorgione's style. We see a closer approach to Bellini's St. Louis in his altar-piece in San Giovanni Crisostomo, ill. *Klassiker, Bellini*, 170, but consider the drawing to be too petty to allow an attribution to the master himself. (Subsequently we note that Dussler's opinion of the drawing is exactly like ours, *Sebastiano del Piombo*, p. 193.) Note also the resemblance to the saint in the painting of the Johnson coll. no. 184, ascr. by Berenson to Girolamo da Santacroce (ill. Venturi, 7, IV, p. 563, fig. 345).

352 VIENNA, ALBERTINA, no. 33. Two standing saints, used in the r. wing of a triptych in the Gallery of the Academy of Fine Arts, Düsseldorf, ill. *Klassiker, Bellini*, 186, and attr. there to the school of Bellini. Brush, monochrome in gray oil, on prepared paper. 284 x 154. Old inscription: Bramantino Milanese. Formerly attr. to Bramantino, but ascr. later by *Albertina Cat. I* (Wickhoff), Sc. Lomb. 1A, to school of Giovanni Bellini. Schönbrunner-Meder 633: the same.

[*Pl. XXXVII*, 3. **MM**]

The altar-piece, formerly in the chapel of the Holy Cross in San Michele in Murano was begun only after 1495; it is universally considered a shop production around 1500. Gronau, who in his *Künstlerfamilie*, p. 126, had explicitly stated that even the design might not be Bellini's invention, being too poor, later in his *Spätwerke*, p. 25, 33, and in *Klassiker, Bellini*, 186 attr. the invention to Bellini and the execution to the shop. Certainly the drawing of the Albertina was not made for this special purpose since in the painting a kneeling donor overlaps the standing saints. The saint with the open book reappears, transformed into St. Mark by an added lion in a painting by Girolamo di Santacroce in the Academy in Venice (Photo Anderson 11534) mentioned by Fiocco, in *L'Arte* 1916, p. 190, 203, and Berenson, *Italian paintings*, p. 409. Evidently this type was popular in the shop. The invention, however, Bellinesque as it is, seems too mediocre for the master himself and may belong to a member of the shop.

353 ———, 22. Christ speaking to St. Peter, St. James and St. John (following Hadeln "The Call of Nathaniel," following the cat. of the Albertina "Scene in the Garden of Olives," Ev. St. Mark's 14, 33,

Matthew's 26, 3). Pen. 257 x 192. Old inscription: Jean Bellin. *Albertina Cat. I* (Wickhoff) 15: Basaiti, perhaps influenced by Gio. Bellini. Gronau, *Gaz. d. B. A.* 1894, p. 322: Giulio Campagnola with reservations. Schönbrunner-Meder 257 and *Albertina Facsimile* no. 31: Basaiti. Hadeln, *Quattrocento,* pl. 72 expressly rejects the attribution to Basaiti and states that in his painting "The Call of the Sons of Zebedee" in the Academy in Venice, ill. van Marle XVII, pl. opp. p. 498, the character of the landscape is much more primitive. The author of the drawing is still connected with the Quattrocento, but at the same time already influenced by the new Giorgionesque style. Hadeln lists the drawing as doubtful Gio. Bellini, not deciding whether it might be by Gio. Bellini himself or a member of the younger generation as, for instance, the ever mysterious young Lotto. *Albertina Cat. II* (Stix-Fröhlich) 22 returns to Basaiti, followed by van Marle, XVII, p. 353, note, while Dussler, p. 160, rejects Bellini without suggesting another artist. R. Burckhardt, *Cima,* p. 125, sees a stylistic resemblance of this drawing to No. **309.** [*Pl. XL, 3.* **MM**]

We agree with Hadeln, as to the difference from Basaiti's paintings in the handling of the landscape. In our opinion, it is closer to that of Gio. Bellini's "Baptism of Christ" in Vicenza (ill. *Klassiker, Bellini,* 145, 146). In either case we are led to a dating about 1500 to 1510. We hesitate to attribute a drawing to the aged Bellini to which no analogy whatever exists, and wonder whether Basaiti might not in a single case have followed his master's approach to landscape. The placing of the small figures into the middle ground very much resembles Basaiti's quoted painting. When listing the drawing as School of Bellini we do not exclude Basaiti completely. Unfortunately, the whole discussion has to rest on paintings, no drawings being available for comparison.

354 Vienna, Akademie der Bildenden Künste, no. I 2555. Virgin and Child seated. Pen, wash. 240 x 175. Publ. by Schönbrunner-Meder 705 as school of Gio. Bellini. [**MM**]

The style is dependent on Bellini's latest works, under Dürer's influence for the draperies, but the arranging of the figure as a broad pyramid is advanced beyond Bellini. We find partly similar types in Andrea Previtali's work, in whose Madonnas this kind of sitting, and draperies occurs. Compare the Madonna in the National Gallery in London, No. 2500 and the one in the Museo Civico in Padua with the fake Palma signature (Photo Anderson 10357).

355 Washington, D. C., Corcoran Gallery, Clark Coll. 2184. Bust of a young man in sharp profile to the left. Bl. ch., wash, on wh. paper turned yellow, later height. w. wh. 360 x 243. Stained by mold. Coll. C. Donaldson. Exh. New Gallery, London 1895, No. 336 as Gio. Bellini. Ascr. to Gentile Bellini. [**MM**]

The attribution to Gentile Bellini is contradicted by the dissimilarity to No. **260.** The greater softness seems to point to the direction of Gio. Bellini, whose portraits, however, authentic or attributed, as a rule are given in a three-quarter view.

JACOPO BELLINI

[About 1400–1470/71]

It appears paradoxical that the first leading master of the most pictorial artistic school in Italy—almost its founder—should be famous above all as a draftsman. This situation, of course, is partly due to a mere chance which has preserved from his production a secondary portion, as a matter of fact, unknown to his early biographers. They knew Jacopo Bellini best of all for his monumental paintings of which they list many, all of which are now lost. For them he was in such a high degree the producer of works of this description that they seem to have given him credit for everything of its sort that belonged to his period. Ridolfi's description (I, 53) of Jacopo's paintings of the Lives of Christ and the Virgin, in the *Scuola* of San Giovanni Evangelista, is an enumeration of all the scenes suitable for illustration. It has rightly been pointed out by Hadeln (Ridolfi, l.c., note 4) that apparently not all the paintings enumerated by Ridolfi had been executed by Jacopo. We may even wonder whether the series, as described by Ridolfi, ever existed. The representation, for instance, of Jesus, as a boy, smiling and walking between his parents on their return from Egypt, very popular in the period in which Ridolfi wrote, seems to have been unknown to the Quattrocento.

Jacopo's painted works are almost entirely lost. The few we know are more or less recent attributions, claimed for him on the strength of their presumed resemblance to his drawings. The predominance of the latter—although, we repeat, merely accidental—nevertheless, does not lack intrinsic justification. After all, Jacopo's importance for the development of Venetian painting rests on his readiness and ability to overcome the limitations of the local tradition by absorption of Central Italian influences and fusion of these with the Venetian trends, resulting in a new alloy vitally important for the future of the whole school. Designing is an essential part of his approach to Central Italy. Not in the sense that his drawings show a striking stylistic resemblance to those of Tuscan masters. On the contrary, we may say that they are a complete expression of Venetian art and could

scarcely in any specific case be taken for Florentine productions. The essential point is, that Jacopo is the first in Venice to make drawing a means of plastic isolation of figures and of their grouping within space.

In our introduction (p. 8f.) we discussed the technical presuppositions of Jacopo's achievement. Something akin to drawing always existed in Venetian art. But Jacopo was the first to transform a merely technical means into an artistic device with purposes of its own; with him drawing became an independent artistic expression, less in the sense of being appreciated or acquired for its own sake, but of an increasing consciousness of its inherent possibilities. What we mean by the independence of drawing is a spiritual quality that does not interfere with its continuing close connection with the normal activities of the artist's workshop. On the contrary, we wish to emphasize the fact that the use of "similes" as typical of medieval art production was carried on in the Renaissance, and that in this regard the drawing continued to play its part as a link between an existing and a planned composition—an impersonal tie and working material. This impersonal character of the drawing, however, was more and more absorbed by its new ethic foundation, the desire to express the artist's individual creative urge even when copying an older work or faithfully studying a natural model. Not the practical scope, but the ideal task was changed, and by accomplishing this shift Bellini became the forefather of drawing in Venice.

This new approach explains the many-sidedness of the material contained in Jacopo Bellini's two so-called sketchbooks which embrace simultaneously every kind of drawing: compositions, separate figures, decorative designs, costumes, studies from life. Due to the double nature of such material the books contain not only the whole range of objects attracting the new artistic interests, but the entire mass of preparatory stuff needed in a well-provided workshop. These sketchbooks, as is well known, contain the main bulk of Jacopo's artistic relics, especially as almost all the separate drawings outside them are scraps from the same stock. The investigation of the sketchbooks as carried out under No. 364 elucidates Jacopo Bellini's character as a draftsman. We refer to our remarks there which demonstrate how ideas about the meaning and character of these books have changed. We do not wish to repeat our statements, but only to reiterate their results: The two books are not separate units offering a cross-section through Jacopo's artistic evolution at a definite point, but a selection divided into two halves on the basis of their material from Jacopo's whole drawing activity, and the surviving working material of a shop that had been active through two full generations. In our opinion the sketchbooks contain, besides Jacopo's drawings from various periods, drawings by other members of his shop, first of all by his sons when they were still his assistants. (We may also keep in mind that his nephew Leonardo di Paolo stayed with him as pupil and assistant for twelve years, beginning with 1443.) These last statements are conclusions drawn by us from the revolutionary results of Mrs. Fröhlich-Bum's studies. As soon as the books are recognized as separate drawings brought together on the basis of the material on which they were drawn, and kept together less by a system than by being bound as books, we must inevitably consider the possibility of contributions by other artists. May we recall that the book in Paris contains several drawings added after the volume had been brought together and its contents listed in an index? That the whole structure of a workshop in the late middle ages and in the Renaissance involves the notion of a collective activity? The many statutes of the building artisans give us a fuller insight into the working conditions of medieval crafts, and we learn from them that the drawings executed by any member remained the property of the shop. From the contract of Pietro Calzetta concerning his mural in the Santo (discussed extensively on p. 7 and previously in *Art in America* 1942, January) we learn that conditions were similar in the painters' workshops. The anonymity swallowing the junior partners and assistant collaborators of such a shop should not obscure the fact that material, for instance, kept together like that of Tintoretto's studio through the best part of

the 18th century was originally made up of no less heterogeneous elements. At all times the workshops, not the individuals, are the real units that carry art production in Venice. The crucial point, of course, remains the question of artistic unity. How far is it possible to comprehend the widely differing drawings in London and Paris within a single artistic individuality? On p. 109 we compare several representations of identical subjects, in order to justify our doubts. We are unable to believe that the artist who drew the "Crucifixion" on No. 363, pl. XCV, and S. Christopher on No. 364, pl. XVIII, might possibly be the one who drew the same subjects on No. 364, pl. XXXVI and No. 363, pl. XXXIII, even if we assume the evolution of three or four decades separating the two representations.

We reach the conclusion that the drawings whose enormous advance seem to lead beyond the limits of Jacopo's personality might be contributions of Giovanni or Gentile Bellini to the common stock, since the sons and heirs naturally continued the older man's work, and we shall later on return to this problem. In view of the extremely archaic character of the earliest drawings in the sketchbooks, however, we have to weigh also the opposite possibility as to whether they may be productions of Jacopo's predecessors kept by him in his working material—just as we presume that Gentile, when he headed the shop, did with his father's. We have instances in which artists did just that; for example, Albrecht Dürer owned drawings by earlier artists on which he wrote his monogram, in order to mark them as his property.

The very little we know about Jacopo's artistic education is not enough to support such a theory. Gentile da Fabriano was the man whom he claimed with pride as his teacher. The rare distinction of such a training obscured the possibility of a previous apprenticeship in a Venetian studio. Of Gentile da Fabriano's drawings we know next to nothing. O. Fischel, in his study of the drawings of the Umbrian School (*Die Zeichnungen der Umbrer,* 1917, p. 75–82) is not willing to acknowledge any of them. The two given to him by van Marle (VIII, fig. 10, 27) are doubtful. As for the native production, it offers still less help. No drawing can be convincingly linked to any of the painters who might have been Jacopo Bellini's predecessors; those connected, rather vaguely, with Giambono (see p. 167) are contemporary, in spite of their decidedly more archaic character. They belong to a stage, not to an age, prior to Jacopo's.

We discover here a weighty argument in favor of Jacopo's authorship of those early drawings. Their style approaches (as it is pointed out below in each separate case) that of Gentile da Fabriano's paintings or the style of painters like Francesco de' Franceschi, who presumably represent the average character of the Venetian school immediately preceding Jacopo. That means they are rooted in those artistic conditions which may have influenced Jacopo's education as an artist. In spite of their connection with the native soil they contain, however, that mysterious admixture of enhanced self-consciousness which we tried to analyze before. Notwithstanding the primitive character of some of them they differ from their surroundings not in degree, but in essence. We feel therefore entitled to claim them for Jacopo.

If they are his (which, as a matter of fact, has never been doubted, but was brought into our discussion for the sake of completeness) they tell something about Jacopo's development. Evidently, his indebtedness to Gentile da Fabriano is the greatest; he may have taken the very foundation of his art from the Umbrian (who from 1408 on had lived in Venice) and finished his education with him when Gentile moved to Florence. In a well known document of 1424 Jacopo is called "formerly Gentile's assistant" (olim famulus). In some of his drawings we notice a relationship to Gentile da Fabriano's works supposed to be prior to his "Adoration of the Magi" of 1423.

The ten or twelve years after Bellini's conflict with the Florentine authorities in 1423/24 are a complete blank

for us. The next document concerning his professional activities is one about the "Crucifixion" in the San Niccolò chapel in the Cathedral of Verona of 1436. The connection of this lost painting with two existing reproductions is a serious mistake. The general character of the composition, corresponding exactly to the stage reached by Mantegna in his *predella* of San Zeno (1456/59), is unthinkable in 1436. One clue to the aspect of the lost composition is the "Christ" in the Museo Civico in Verona, sometimes considered a remnant of the mural and, more likely, a reminiscence of its style; another may be offered by the drawing, No. 364, pl. XXXVI whose evident connection to Altichiero's style has already been noticed by Goloubew. The acquaintance with the representative of the monumental Trecento style at Padua is very natural when considering Jacopo's extended sojourn there. It did not, however, obliterate those earlier incitations that Jacopo owed to his early stay at Florence and Siena and his apprenticeship with a master so close to this school as Gentile da Fabriano. Discussing the single drawings we shall have to mention many connections with Gentile. The compositions of quite a few drawings are constructed following the principles of Masaccio and his contemporaries, and distinctly different from Mantegna's; again the interpretation of the human figures is positively "Pre-Mantegnesque." For some of these drawings connections with the Court of Ferrara have been established, chiefly by Gronau, following observations of Courajod, Heiss, Gruyer and others. The literary evidence of Jacopo's stay in Ferrara in 1441, the reflections in the drawings of the monument for Niccolò d'Este in Ferrara, designed by Antonio di Cristoforo Baroncelli in 1444 and executed in 1451, and the possible connection of other drawings with events that took place in Ferrara at the same period, are all factors inducing us to place this middle of "Ferrarese" period of Jacopo's evolution in the years around 1440 to 1453. In this year the marriage of his daughter Nicolosia to Andrea Mantegna added a personal tie to his growing artistic connection with the master of Padua.

In this period Jacopo, although for a long time an independent master, apparently completed his artistic education. His sojourns in Padua and Ferrara, both cities especially opened to the most varied influences from abroad, must have broadened his views. Here his interest in the remnants of antiquity has already become discernible. Some drawings in Paris (No. 364, pl. XLIII and XLIV) have a predominantly archeological character; in others classic models are freely used. The triumphal arch of Titus, also dear to Andrea Mantegna and many other artists of the Quattrocento, serves as a model for the architecture in No. 364, pl. III and XXXIV.

It is unnecessary to infer from Jacopo's intimate knowledge of this monument, that he had visited Rome; drawings of it circulated freely in the studios of his time. A collection of such archeological drawings evidently formed part of a studio's outfit. Gentile Bellini in his last will disposed of "mea omnia designia retracta de Roma." This passage has been misinterpreted to mean that Gentile Bellini had visited Rome; it has also, still worse, been suggested that these words in Gentile's will mean drawings withdrawn from Rome and refer to Gentile's Oriental studies lent to Pinturicchio, an artificial and far-fetched interpretation which we expressly reject (as was already done vigorously, but in vain, by L. Venturi, *Origini* p. 344) by reasons of logic and grammar. It is not even ascertained that these drawings were done by Gentile himself. They were merely a regular part of his working material and might even be identified with those drawings of the same description already used by Jacopo, were they not expressly distinguished in Gentile's last will from those that had been *"patris nostri."*

The interest in classic art may in part be due to the influence of an artist who in this "Ferrarese" period of Jacopo seems to have gained a considerable and probably lasting ascendancy over him, Leone B. Alberti, whom he might already have met when the latter paid a short visit to Venice in 1437, but with whom he must have become better acquainted in Ferrara, where, in the 1440's, Alberti ruled over artistic life. In 1442, as we learn from his

preface of the treatise on the "Horse in Movement" (*De equo animante,* first printed in Basel 1556 and reprinted in G. Mancini's edition of Alberti's rarer works, Florence, 1890) he was appointed the arbiter over the projects for the equestrian monument of Niccolò d'Este; the best artists had competed among whom we certainly may include Jacopo Bellini. The traces of Alberti in Jacopo's drawings are numerous, as might be expected from the versatile personality of the great Florentine. They consist in the acceptance of his rules on painting, in architectural influences and in a resemblance to his general attitude toward art.

Alberti's treatises were printed and thus made generally known only much later. It has been concluded, for instance, by Julius von Schlosser, *Kunstliteratur,* p. 106, that the authors of the Quattrocento who refer to them apparently knew them from hearsay rather than from actual study. Even this channel may have sufficed to instruct Jacopo about the ideas on painting which Alberti as early as 1435 had gathered in his treatise *"De pictura."* Here we find the advice (ed. Janitschek, in *Quellenschriften* XI, p. 110) that a human figure is drawn first as a nude and only later on covered with clothes (see vol. I, pl. II and II, pl. LVIII); the recommendation to give a composition more variety by introducing into it nude and draped figures (see II, pl. XXXIX); the insistence on a correct proportion between figures and architecture. In whatever form such ideas were presented, we can hardly doubt that they were prevalent in Alberti's Ferrarese surroundings.

Alberti's ideas on architecture, brought into the final form of his treatise *"De architectura"* only in 1452, were still in the making when Jacopo frequented Alberti's company. We are in the dark as to how far they may have caused Jacopo's evidently increasing interest in architecture. Unfortunately, the history of architecture has done little to help us toward a better understanding. Dagobert Frey, the only writer who in his studies on Giorgio di Sebenico (*Der Dom von Sebenico und sein Baumeister Orsini,* in *Jahrbuch des Kunsthistorischen Instituts der Zentralkommission für Denkmalpflege* VII, 1913) has dealt with Jacopo Bellini's relations to the architecture of his period, makes no decisive statements. He notes that Bellini's sketchbooks contain most of the elements appearing in Giorgio Orsini's buildings about 1450, without, however, settling the question of priority, and lists a number of precise similarities between the two artists without assuming a direct dependence of one on the other. Frey explains these conformities by the influence exercised by Florentines like Michelozzo and Donatello on both Jacopo Bellini and Giorgio Orsini. L. Fröhlich-Bum, following Frey, sees the decisive influence on Jacopo's architectural and ornamental achievements in Donatello, adding, however, a hint as to Lorenzo Ghiberti.

In our opinion, the strongest impulse in this direction that reached Jacopo Bellini came from Alberti. First of all, Jacopo owes him the initial encouragement to deal with architectural problems at all. Alberti emphasizes an amateurish attitude. He minimizes the merits of the craftsman and states (l. c. p. 90) that it is the painter from whom the architect takes over architraves, bases, capitols, columns and cornices. Such a theory sounds like an invitation to painters to try their hand in the invention of buildings and their decoration, and certainly Jacopo accepted the invitation. The later portions of the sketchbooks look like a collection of architectural patterns. They choose their models wherever they find them, and thereby reach an eclecticism that has proved most confusing. Frey when listing the relationship of Jacopo's drawings with architectural details found in Giorgio Orsini's cathedral of Sebenico and other buildings, stresses the fact that none of the numerous architectural designs in Jacopo's sketchbooks repeats any existing building. They are a fount of architectural ideas, reflecting in an eclectic manner the currents of the day and offering other artists an amount of architectural stimulus whose importance can scarcely be measured. It is difficult to say how far the pioneers of the Renaissance movement in Venetian architecture starting decisively in the 1460's, the last decade of Jacopo's life, drew from such a troubled source.

Jacopo is a witness of the new style, but is he its pioneer? A. Venturi (8, II, p. 485) points out his lack of understanding of the revolution taking place in architecture. "With childish curiosity for the new currents he combines triumphal arches, arcades, tabernacles and so on, mixing reminiscences from Donatello with those from the late Gothic, classic and Byzantine and oriental forms." Venturi denies him any clear idea about the new style. May we even credit him, a man in his sixties, with the faculty of absorbing all these new-fangled ornaments and reaching a spatial interpretation (as rightly emphasized by Fröhlich-Bum) inferior to that of no contemporary artist, not even in Florence where the real center of all these problems was?

Once more we may recall the fact that Jacopo was an amateur in architecture, as Alberti was in painting. We learn from Vasari that Alberti "made a picture of Venice with San Marco, but the figures therein were executed by other masters and this is one of the best examples of his paintings that are to be seen" (Vasari, *Lives*, London, 1912–14, III, p. 48). If we may presume Alberti made this painting in Venice, it would be interesting to know whether Jacopo may have been one of his collaborators. On the other hand, in the face of such an instance of division of artistic labor we may wonder whether the great number of purely architectural studies in Jacopo's sketchbooks may not be explained by the activity of a specialist in architecture within the workshop.

It is hardly the task of a catalogue of Venetian drawings to solve these problems. But we may at least help to clarify them by emphasizing the fact that, as indicated before, the question of Jacopo Bellini's architectural faculties is a double one: that of decoration and that of rendering space. As for the former, we must state that most of the surprisingly modern ornaments are found in the drawings in Paris which are so heavily retouched, that most of these ornamental novelties may simply be later additions. This reworking most likely happened (as pointed out on p. 107) in 1480 when Gentile Bellini presented the drawings to the Sultan, and was done either by Gentile himself (an idea rejected by Testi) or by a specialist in his shop. At any rate this part is due to an artist belonging to the generation after Jacopo; in 1480 these forms, surprising in Jacopo's lifetime, were the current style in Venice. Besides such advanced ornamental details of which hardly anything is found in those drawings which are certainly untouched, an astonishing modernity has been discovered in the rendering of space. In this faculty, still more than in the use of ornamental patterns, Jacopo would precede all his contemporaries, including the Florentines. No literary source mentions Jacopo's special importance in this field; in a period when perspective —in the broadest meaning of the word—was considered a kind of sorcery, could the tremendous part played by Jacopo in its development have been entirely forgotten? No authentic painting by Jacopo is available to substantiate the claims raised by those drawings. On the other hand, we know of numerous paintings distinguished by a remarkable interest in spatial problems and architectural faithfulness, executed by Gentile Bellini, the man whom we presume to have been Jacopo Bellini's most intimate collaborator in the last quarter of his life. Aglietti, in his *"Elogio storico di Jacopo e Giovanni Bellini"* (in *Discorsi letti nella I. R. Accademia di Belle Arti,* Venice, 1815), p. 34, drawing from an unknown source, informs us that Gentile and Giovanni Bellini studied perspective with Girolamo Malatini, a specialist in this field, and not with their father, to whose honor, by the way, half of the oration is devoted. And the great mathematician Luca Pacioli in the preface of his *Summa Matematicae* (Venice, 1494; the preface reprinted in *Courrier de l'Art,* 1880, p. 226) lists as experts in this field in Venice the brothers Bellini (Gentile and Giovanni) and the theoretician, Girolamo Malatini. We do not wish to exaggerate the importance of this passage in which Pacioli by no means intends to give a complete list of all authorities on perspective, but merely enumerates those with whom he had had an opportunity of talking over such matters. It remains a fact, however, that no word is said about Jacopo's leadership in this field, while the importance of his sons in it is

attested by literary sources. A measure of support for the tradition that they were greatly esteemed for their knowl-
edge in the higher degrees of drawing art is found in the wish of Elisabetta Morosini Frangipane, in a letter of
1471, that they might teach "la rason del desegno a p^re Domenego nostro" (*Nuovo Archivio Veneto,* II, p. 382),
a wording that cannot mean simply "drawing," but the "principles of drawing," something at that time certainly
identical with the study of perspective or proportions. In this letter—as in the passage quoted from Pacioli's
preface—the two brothers are enumerated as having the same merits in this regard. But in another contemporary
manuscript by Francesco Negri (already known to Crowe and Cavalcaselle, ed. Borenius I, p. 118) Gentile is
expressly called the one who excelled in the theory of art, while Giovanni is called a master in its practice. And,
indeed, while Giovanni's later works never display a special interest in perspective and other auxiliary branches
of art, Gentile's give us ample opportunity to recognize his special interests in this field. The "Martyrdom of St.
Mark" (ill. *Bellini, Klassiker,* 188) which in this regard is an exception in Giovanni's oeuvre, as well as the other
paintings of this series, might also go back to a design by Gentile.

We are fully aware of the difficulties of the situation. Jacopo's paintings are lost, and the early production
of both Gentile and Giovanni is veiled by impenetrable darkness. Gentile's earliest authenticated works are the
organ shutters of St. Mark's of 1464, so completely different from other works that they do not offer much help,
and his Lorenzo Giustiniani of 1465. We are still more in the dark regarding Giovanni. His first dated work,
the portrait of Jörg Fugger in the Contini Collection (*Klassiker, Bellini,* p. 69)—incidentally, exceptional as
a portrait, and moreover not universally accepted—is of 1474 and the next, the "Madonna degli Alberetti" (*Klas-
siker, Bellini,* p. 102) of 1487. In spite of numerous attributions the early period of both, the period corresponding
to their collaboration in Jacopo's workshop, remains obscure. We may try to guess their presumable share in the
output of this workshop by examining their later productions and retracing their beginning from that point.
Unfortunately, we can rely but very little on drawings for this purpose as our knowledge of Gentile's and of Gio-
vanni's style in drawing (as we point out when discussing their own drawings) rests on very shaky foundations.
We have to refer consistently to general features of their style, suggesting Gentile's authorship for those of the
drawings apparently advanced beyond the natural limits of Jacopo and anticipating Gentile's interest in spatial
depth and topographical clearness, while we propose Giovanni's name in cases where his pictorial tendencies
seem foreshadowed. The latter group is the less numerous and perhaps also less important: several drawings are
singled out which contrast more or less strongly with Jacopo's presumable characteristics. To reject his author-
ship for them or to leave them within his production while trying to explain in some way their exceptional
qualities, is an alternative familiar to current connoisseurship.

The problem of Gentile's stemming from Jacopo is more complicated and interesting. He was probably the
elder and perhaps the only legitimate son. At any rate he was Jacopo's first assistant for many years and his chief
heir when he died. Van Marle found it natural that under these conditions Gentile's early activities should be
merged with his father's production. Consequently, the borderline between the two will be very uncertain. Dis-
cussing the "St. Jerome in the Wilderness" in the Toledo Museum of Art, Toledo, Ohio (Cat. of the exhibition
"Four Centuries of Venetian Art", 1940, no. 4, and *Art in America,* 1940, p. 111) we pointed to the darkness of
this no-man's land, or both-men land, between their domains. We find the same difficulty with the drawings.
There are some that are so far advanced beyond Jacopo, that it seems legitimate to attribute them to his sons. But

there are others in which the transition seems so imperceptible—especially under the common veil of later retouches—that they bring us to a dead stop. They form a line so conherent that we do not dare to cut it at a definite point, but maintain a transitional zone between Jacopo and Gentile.

A 356 BERLIN, KUPFERSTICHKABINETT, 418. Unidentified subject (sometimes called "Meeting of Joachim and Ann"). Pen. 141 x 140. Slightly damaged. Ascr. to Venetian School, 15th century. Attr. to Ja. Bellini by Lionello Venturi, *Origini*, p. 153, questioned by Corrado Ricci p. 38, 40. According to Testi, II, 247, late school production, or perhaps forgery. **[MM]**

Without believing in the probability of a forgery we, too, doubt the authorship of Jacopo Bellini. There is a certain conformity of problems and general approach, but the proportions and types are decidedly different from his. Related in style to No. **A 359** q.v.

A 357 BOLOGNA, BIBLIOTECA DELL'UNIVERSITÀ, no. 1574. Illustrations in the manuscript of the Legend of St. Catherine of Siena, by Fra Tommaso Caffarini, probably written shortly after 1417 in the convent of S. Giovanni e Paolo in Venice. The pen drawings were publ. by Carlo Frati, *La Leggenda di S. Caterina da Siena, con disegni attribuiti a Jacopo Bellini*, in *La Bibliofilia* XXV, p. 97 ff.

The evidently erroneous attribution to Jacopo Bellini has rightly been disregarded by all authorities.

358 CAMBRIDGE, MASS., FOGG MUSEUM OF ART, No. 4. Funeral Procession of the Virgin. Pen, over bl. ch. 95 (l) or 210 (r) x 304. Cut and damaged. The upper l. section is in the Louvre, Gay Bequest, see No. **369**. The cut has destroyed half the figure of the Virgin. Charles A. Loeser Bequest 1932 — 275. Publ. by Agnes Mongan in *O. M. D.* XIII, No. 50, pl. 23, p. 24 s. Exh. Toledo, Ohio, 1940, No. 73. Mongan-Sachs No. 4 point to the representations of the same subject in the sketchbooks in London and Paris, Nos. **363**, pl. VI and **364**, pl. VI, and date the drawing in a period when the early "international style" was still combined with Jacopo's interest in perspective, but his interest in the antique world was not yet aroused. [*Pl. IV*, 2. **MM**]

In our opinion, the drawing is a further development of the composition in the sketchbook in Paris, No. **364**, pl. VI, from which numerous elements are taken over, while the manner of drawing is far advanced. A careful comparison of the apostles in the two drawings reveals a much better understanding of the bodies and their function. We place the drawing in Jacopo's late period and even suppose a participation of one of his sons who at least may have worked over the drawing.

A 359 DÜSSELDORF, AKADEMIE DER BILDENDEN KÜNSTE, no. 569. Battle scene, assault at a castle on the top of a hill by soldiers on horseback and on foot. Pen, br., on parchment. 227 x 217. Formerly attr. to Raphael, then to school of Pisanello. I. Budde in *Düsseldorf Cat.* pl. 81 referring to an opinion expressed by B. Berenson: Circle of Ja. Bellini. **[MM]**

We have not re-examined the original, but consider the former attribution to the school of Pisanello more trustworthy.

A 360 ———, no. 570. Adoration of the Magi with many musician angels in landscape. Pen, br., on parchment. 140 x 136. Attr. to Jacopo Bellini by Lion. Venturi, *Origini*, p. 153, and questioned by Ricci, p. 38, 40, while Testi, II, 247 who attr. the drawing to the same hand as No. **356** believes in an imitation or forgery of Jacopo's style. I. Budde, in *Düsseldorf Cat.* pl. 81, referring to an opinion expressed by B. Berenson, places the drawing in the circle of Jacopo Bellini. **[MM]**

As in the case of No. **356** we do not recognize any close affinity to Jacopo Bellini or his circle. The drawing belongs to another artist who resembles Ja. Bellini in some points, but differs in others. The material in paintings available for Giambono is too scanty to venture an attribution to him, although a certain resemblance to his types may be noticed. Both drawings belong to Venetian contemporaries of Bellini.

A 361 HAGUE, THE, COLL. FRITS LUGT. A horse standing, turned to the l., slightly foreshortened. Pen, lightbr. 210 x 145. Inscription in a handwriting of the 15th century: pater nost; modern inscription: Gentile Bellini. Coll. L. Grassi. Ascr. to Jacopo Bellini, mentioned by Mongan-Sachs I, p. 8, as by Jacopo Bellini. [*Pl. CLXXXVI*, 1. **MM**]

The attribution seems to rest on a certain resemblance to a horse in the Paris sketchbook, No. **364**, pl. XLII, but the way of modeling and foreshortening and the linework are different from Jacopo's and point rather to an artist more immediately under the influence of Pisanello. Compare Codex Vallardi Paris I, 54.

A 362 LONDON, COLL. HENRY OPPENHEIMER, FORMERLY, Rider on a rearing horse. Pen. 255 x 180. — *On verso:* Hasty sketch, according to Parker representing the embalming of a corpse. Cat. of Oppenheimer Sale (Parker) no. 146: Circle of Pisanello, but formerly thought to be by the German engraver known as the "Master of the Playing Cards." Parker, pl. 8 points to affinities both with Pisanello and Jacopo Bellini. Exh. London 1930, 612 (Popham *Cat.*: Veronese School). Van Marle XVII, p. 96: Jacopo Bellini.

We do not remember the original. The juxtaposition of this drawing and Jacopo Bellini's St. George in the London sketchbook, No. **363**, pl. VIII in Parker's book discloses, in our opinion, the fundamental difference between the two drawings. While the one under discussion displays a Gothic conciseness apt to develop into a late Gothic mannerism, the drawing in Paris is on the way to Titian's classic naturalism, which means that it stays within the Venetian tradition, in contrast to the other horseman.

363 LONDON, BRITISH MUSEUM. So-called sketchbook. 198 pages, seven of which are blank. Leadpoint, on prepared paper (watermark Briquet I, p. 183 ff., traceable in Venice from 1440 on, reproduced Goloubew I, Introduction) 415 x 335. As already noted by Gaye, *Kunstblatt* 1840, no. 23, most of the drawings are worked over by various hands, see Testi, in *Rass. d'A.* 1909, no. 5, p. V, and Frizzoni, ibidem 1909, p. 59. According to Goloubew I, Introduction, two hands are to be distinguished in this retouching, one of the 16th century, trying to bring out faded outlines, the other of the 18th century, renewing the compositions, without any understanding of the original linework. The reworking in ink occurring in a few drawings (pl. III, XXXIII, LII) may have been done by the same hand as similar additions in the Louvre Sketchbook, according to Goloubew. (We do not believe in the correctness of this statement.) The original binding of the book is decorated in Moorish style and is dated about 1500.

On the first page inscription "De mano de ms Jacopo bellino veneto 1430, in venetia." Formerly the inscription used to be read "de me jacopo" and was considered authentic as to signature and date. M. de Mas-Latrie and E. Galichon, in *Gaz. d. B. A.* 1866, p. 283 have already

given the correct reading unanimously accepted today. As Goloubew pointed out on the basis of a comparison with specimens of their handwriting, the inscription is certainly neither by Jacopo Bellini nor by one of his sons.

The book in London is as a rule identified with one of the books with drawings left by Anna, the widow of Jacopo Bellini, to Gentile Bellini in her last will of November 25, 1471 (*"quadros dessignatos et omnes libros de dessigniis"*) and with the one left by Gentile Bellini to his brother Giovanni in his testament of February 18, 1507 (*"dimitto et dari volo librum designamentorum qui fuit prefati patris nostri . . ."*). It is also supposed that the book is *"el libro grande in carte bombasina de dissegni de stil de piombo fu de man de Jacomo Bellino,"* seen by Marcantonio Michiel in the house of Gabriele Vendramin in Venice in 1530. Later on the book belonged to Marco Cornaro, bishop of Vicenza, Conte Bonomo Algarotti, the Corniani family, in 1802 to the art dealer Gian Maria Sasso, and from 1803 to 1855 to the Mantovani family from whom it was acquired by the British Museum. Shortly before this happened the book was thoroughly described by Gaye, *Jacopo Bellini und seine Handzeichnungen,* in *Schorn's Kunstblatt,* 1840, p. 90 ff.

For the further literature and the stylistic analysis of the drawings see No. **364**. As for the single drawings we do not wish to repeat the exhaustive lists and descriptions by L. Venturi, *Origini,* p. 138 ff. and L. Testi II, p. 213 ff. and in the two complete facsimile editions, by Goloubew and by Corrado Ricci. We limit ourselves to a few supplementary remarks and new observations and corrections, enumerating the drawings after Goloubew's edition to which we refer.

Pl. II (fol. 1b and 2a). We wish to point out two important features in this drawing. The archaic and ambitious rendering of the city at the left still recalls late Gothic arrangements, for instance, the architectural backgrounds of Altichiero's and Avanzo's paintings in the chapel of St. Felix in the Santo (ill. van Marle IV, fig. 63), where, too, the connection between architecture and figures is more or less casual. Jacopo is scarcely advanced here beyond the stage connected in Venice with Giambono. The second point, already emphasized by Goloubew, is the fact that the figures are drawn as nude, only later on covered with draperies. This procedure, not rooted in the Venetian tradition, is on the contrary one recommended by Alberti in his treatise *de pictura* (ed. *Quellenschriften* XI, p. 110). It may reasonably be presumed therefore, that this detail is an early evidence of the influence of Alberti's theories on Jacopo. The year of Alberti's stay in Venice, 1437, may be the earliest possible term; the early 1440's when Alberti lived in Ferrara might be still more probable.

Pl. III (fol. 2b and 3a). Jacopo's studies of lions, curiously mixing realistic and conventional elements might deserve a special study. In this sheet, early in Jacopo's work, the influence of Pisanello seems to prevail.

Pl. IV (fol. 3a). Already repeatedly connected with a monument for Borso d'Este by Ephrussi. For the motive of the winged genii carrying a globe, compare the genii supporting the balcony in the Palazzo Prosperi, Ferrara (ill. *Italia artistica, Ferrara e Pomposa,* p. 82).

Pl. V (fol. 4a). From 1442 on, when the equestrian statue for Niccolò d'Este was planned, up to 1451 when it was executed by Cristoforo and Niccolò di Giovanni Baroncelli, the Court of Ferrara took a great interest in the problem of the representation of horses. In his *"De equo animante"* which is a by-product of these interests

(first printed in 1556 in Basel and republished in Gir. Mancini's edition of Alberti's writings 1890, p. 238) Alberti mentions, in his dedication to Lionello d'Este, that he had been appointed the judge over the many projects presented by the best artists on this occasion. It is very likely that Jacopo Bellini's various studies of equestrian monuments and related studies belong to this period.

Pl. VI (fol. 4b and 5a). Variations of the representation of the same subject in Goloubew II, pl. VI. Simon, p. 43, places the drawing in what she calls Jacopo's middle period and stresses the lack of connection of the figures with the landscape. We date it in the 1450's and believe No. **358** to be a later and riper solution. In it the "stage" has been constructed first, and the figures, as easily recognizable as in that of St. Peter leading the procession, were put in later, while in our drawing here, as pointed out by Simon, the procedure went the other way round.

Pl. VIII (fol. 6b and 7a). Goloubew's reference to stage performances connected with the legend of St. George in Ferrara does not seem to hit the point, the relation between town and figures being much the same as in Goloubew I, pl. II. The part of the four columns there is here given to the pedestal of a candelabrum at left. The vividly moving warrior on horseback is prepared by similar figures in miniatures. We date it in the 1440's. [*Pl. I*, 4. **MM**]

Pl. XI (fol. 9a). Testi II, p. 215, suggests Samson. The motive of a man riding on the lion with whom he is wrestling, is found again in vol. II, LXXXIX (see there).

Pl. XII (fol. 9b and 10a). The identification of the man brandishing a club as St. George has rightly been questioned by C. Ricci, who suggested Hercules combatting the Hydra. Simon, p. 36, places the drawing in Jacopo's late period. We would not like to go farther than the 1450's.

Pl. XIV (fol. 11b and 12a). According to Goloubew, Giovanni Bellini gave this composition a further development in his painting in Pesaro, ill. *Klassiker, Bellini,* 50, r. Simon, p. 52, dates it late. By reason of the rendering of space we place the drawing about 1450.

Pl. XV (fol. 12b and 13a). Goloubew points to Ridolfi's description (I, 35) of Jacopo's painting of the "Annunciation" in the Scuola di San Giovanni Evangelista. On the one hand, however, the whole passage in Ridolfi referring to Jacopo's murals in the Scuola is a rather dubious piece of literature and on the other hand, Mrs. Fröhlich-Bum, speaking generally, denies the possibility of connecting the drawings in the sketchbooks with such planned or executed paintings. Speaking in particular of I, pl. XV (p. 46) she places the drawing very early by reason of the primitive character of the architecture. In our opinion, the drawing which, it is true, is in too poor a state of preservation to be judged is from the later 1450's. Compare our remarks concerning I, pl. XCIV and II, pl. XXVIII.

Pl. XVI (fol. 13b and 14a). These and other scenes from everyday life, listed by Goloubew under the heading "Études de costumes" might, in our opinion, best be placed in Jacopo's middle period in 1440–50, since they show a marked relationship with drawings connected by their subjects with the Court of Ferrara. [*Pl. III*, 1. **MM**]

Pl. XVII (fol. 14b and 15a). According to Simon, p. 41, middle period, in our opinion, late. The especially heavy retouches are a severe handicap in reaching a decision.

Pl. XVIII (fol. 15b and 16a). This version of the Baptism of Christ is later than the one in II, pl. XXIII, where the group of angels standing behind St. John and Jesus is very archaic and the landscape far more primitive, almost recalling arrangements by Gentile da Fabriano, while in our drawing it is much freer and, to a certain degree, anticipates Giovanni Bellini's "Baptism" at Vicenza (ill. *Klassiker, Bellini*, 145). Simon places the drawing in Jacopo's middle period because of its structural elements. The drawing II, pl. XXIII mentioned above, in our opinion, still belongs to the 1430's.

Pl. XIX (fol. 16b and 17a). We agree with Simon's (p. 52) dating of the drawing (as the related II, pl. XXI) in the last phase of Jacopo's late style.

Pl. XX (fol. 17b and 18a). The rigid arrangement of the heads on one level and the lack of solidity in the standing figures justify a dating in the 1440's.

Pl. XXI (fol. 18b and 19a). In spite of Goloubew's reference to Gentile da Fabriano we consider the influence of Mantegna far more important. Here, as in I, pl. LXX and II, pl. XXIX, Mantegna's "Adoration of the Magi" in the Uffizi (ill. *Klassiker, Mantegna*, 94) offers the main motive of the cavalcade riding through a ravine. In any case, the drawing is late.

Pl. XXII, XXIII (fol. 19b and 23). See I, pl. XVI. For the standing warrior compare Gentile Bellini's "San Teodoro" in the Museum of S. Mark, Venice, ill. van Marle XVII, fig. 76, dated about 1464. For the man on horseback see II, pl. LXVI or XCI.

Pl. XXV (fol. 21b and 22a). We agree with Fröhlich-Bum, p. 46 and Simon, p. 34, both of whom consider the drawing an earlier version of II, pl. XXV, but date it about 1450, rather than earlier. For Goloubew's reference to the painting in the Scuola di San Giovanni, see our general objections at I, pl. XV; moreover, the representation described by Ridolfi is different and illustrates the appearance of Christ, accompanied by the forefathers, to his mother. Schrade, *Ikonographie der christlichen Kunst, I, Die Auferstehung Christi*, Berlin, 1932, p. 254 f. points out that this representation of Christ floating over the sarcophagus has a counterpart in Luca della Robbia's relief from the 1440's. Schrade also suggests that Jacopo Bellini's two drawings prepare Giovanni Bellini's painting in Berlin (ill. *Klassiker, Bellini*, 67).

Pl. XXVII (fol. 23b and 24a). Late. For the rendering of the landscape compare also the "Saint Jerome" in the Museum of Art, Toledo, attr. to Gentile Bellini, ill. *A. in A.* 1940, p. 110.

Pl. XXVIII (fol. 24b and 25a). Goloubew's reference to Donatello's relief in the pedestal of his figure of S. George in Or San Michele, Florence, of 1416, is only partially convincing. As for the dating we agree with Simon's p. 28, placing the drawing in Jacopo's latest period.

Pl. XXIX (fol. 25b and 26a). See the slightly later version on II, pl. XIX. Late period.

Pl. XXXI (fol. 27b). Evidently connected with the monument erected for Niccolò d'Este in Ferrara. According to Gruyer, l. c. I, p. 511, it corresponds to the description of the lost monument.

Pl. XXXII (fol. 28a). Goloubew rightly points to II, pl. LXIX, where a similar arrangement occurs. This reference, however, makes the difference in the general style of both drawings more noticeable. II, pl. LXIX is far advanced, and we are rather inclined to give it to Gentile Bellini, while the style of I, pl. XXXII is the soft "international" of the early 15th century. In this connection we should like to refer to Gentile da Fabriano's murals in Siena, of 1424, representing besides other figures those of the St. Peter, Paul and John the Baptist (van Marle VIII, p. 4). It is very likely that Jacopo accompanied Gentile to Siena. Could the drawing be a reminiscence of those? — In 1454 Jacopo painted "St. Peter and Paul and another Saint" on canvas for the Patriarch of Aquileia in a room in San Pietro in Castello. We wonder whether the drawing forms a link between the two mentioned paintings.

Pl. XXXIII (fol. 28b and 29a). For the heap of bricks at l., evidently meant as a device for the study of perspective, see a surprisingly similar detail in Crivelli's "Adoration" in Strassburg, ill. van Marle XVIII, fig. 31, probably serving the same purpose. The figure of S. Christopher is one of the most archaic in the sketchbook; it is entirely "soft" and "pre-Mantegnesque." [*Pl. II*, 1. **MM**]

Pl. XXXIV (fol. 29b and 30a). Again we have to reject Goloubew's reference to Jacopo's paintings in the Scuola di San Giovanni Evangelista as described by Ridolfi I, p. 35 (see above I, pl. XIV), since no detail of the description corresponds. The style of the figures, in contrast to the landscape at l. which might be a later study independent from the r. half, points to Jacopo's earliest period, their types still resembling Gentile da Fabriano's, even in so early productions as his polyptych in the Brera (ill. van Marle VIII, fig. 2 to 7). At any rate, the drawing shows no acquaintance with Mantegna and we date it about 1440.

Pl. XXXV–XXXIX (fol. 30b–35a). Close in style to I, XXXIV, "pre-Mantegnesque" and more reminiscent of Florentine compositions (Masaccio). The subject of pl. XXXV might be the popular one of a women's bath, compare Dürer's representation of the subject.

Pl. XLII (fol. 37b and 38a). Heavy retouches make the judgment of this important drawing, placed by Simon, p. 44, in Jacopo's middle period, difficult. In our opinion, it is definitely late, compare I, pl. LXIX. Lionello Venturi's reference to Gio. Bellini's representation of this subject in his altar-piece in Pesaro (ill. *Klassiker, Bellini*, 50), where the composition is simplified, offers a vague *terminus ante quem*.

Pl. XLIV (fol. 39a). According to Simon, p. 52, late. In our opinion 1440–50. The sharp foreshortening of the horse is still a reminder of Pisanello, the types are those typical of Jacopo in his "Ferrarese" period.

Pl. XLV (fol. 40a). The motive of the playing children in the background does not occur in any other representation of this subject in the sketchbooks (I, pl. XXXIII, II, pl. XVIII, LII, LXXVIII). Goloubew refers to the beardless type of the saint used in the Ovetari chapel in Padua about 1450. Mantegna's influence is very noticeable and the drawing very far advanced for Jacopo. II, pl. LXXVIII, however, represents a still further progress. [*Pl. II*, 2. **MM**]

Pl. XLVI (fol. 40b and 41a). Goloubew points to analogies with Jacobello del Fiore's "Allegory of Justice" and Corr. Ricci, p. 10, refers to two reliefs representing deeds of Hercules in St. Mark's Cathedral. More important for the question of the date of origin is the resemblance to the sculpture of Domenico de Paris, the pupil of

Baroncelli, at Ferrara (ill. Venturi 6, fig. 106); it supports our dating the drawings about 1440–50. We have, however, to recall that Jacopo painted St. Michael for the church of this saint in Padua in 1430. The painting, apparently on canvas, and representing the saint alone in huge size with the dragon at his feet, is described as still existing by Rosetti in 1765 and was sold in the 19th century when the church was dismantled. (E. Rigoni, *Jacopo Bellini a Padova nel 1430*, in *Rivista d'A.* 1929, p. 261).

Pl. XLVII (fol. 41b and 42a). The iconographic type is still that of the Trecento. In an illustrated manuscript of the Visions of St. Catherine of Siena the illustrations of which have been attr. to Jacopo (see No. **A 357**) the representation of S. Francis is somewhat reminiscent, but only because it belongs to the same school tradition. A still better analogy is offered by Gentile Bellini's organ shutter in the Museum of S. Mark, Venice (ill. Venturi 7, IV, fig. 120, p. 222) which allows us to date the drawing in the 1450's. It may be that the composition is in some way connected with the murals executed in 1456 by Jacopo and his sons in the Gattamelata chapel in S. Antonio in Padua and representing episodes of the life of S. Francis and S. Bernardino (Aglietti, *Elogio Storico di Jacopo e Giovanni Bellini*, Venice 1812, p. 41).

Pl. L (fol. 43b and 44a). We agree with Simon's (p. 49) placing the drawing in Jacopo's late period. The approach to Giovanni Bellini's painting in London (ill. *Klassiker, Bellini*, 20) also noted there on p. XVII, is so close that we are disinclined to assume a long interval between both versions and willing to date the drawing about 1460 or even to presume an influence by, or a participation of, Giovanni Bellini.

Pl. LI (fol. 44b and 45a). The identification as David has already been questioned by Ricci, p. 10 and Testi II, p. 221; the representation would indeed be unique. Simon, p. 52: late period. In our opinion about 1450 or a little later.

Pl. LII (fol. 45b and 46a). Here the iconography is clear, but strangely enough a figure almost identical with that of Goliath here represents David in II, pl. LXXXII.

Pl. LIII, LIV (fol. 46b and 47a). Rightly dated by Simon, p. 32, among the latest of Jacopo's drawings. The vault resembles that in the "Death of the Virgin" in the Mascoli chapel at S. Mark's, ill. Testi II, pl. opp. p. 56, of about 1454. See I, pl. LXXIX.

Pl. LV (fol. 47b and 48a). See I, pl. XVI.

Pl. LVIII (fol. 50b and 51a). Fröhlich-Bum p. 46 and Simon, p. 30 disagree on the dating of this drawing, which the latter places late and the former rather early. In our opinion, it is from the 1440's and Goloubew's reference to an event that took place in Ferrara may at least help to fix the origin within Jacopo's Ferrarese period.

Pl. LIX (fol. 51b and 52a). Here again, as for the preceding drawing, the two authors disagree. In our opinion, the drawing is connected with I, pl. XVI or I, pl. LV, and other costume studies from the 1440's.

Pl. LXII (fol. 54b and 55a). Dated late by Simon, p. 31, with reference to the construction of the space. In our opinion, still connected with Jacopo's Ferrarese period.

Pl. LXIII (fol. 55b). Fröhlich-Bum, p. 47, emphasizes the understanding of the architectural construction. We date it in the 1450's. The subject has not been identified. In our opinion, the drawing might represent Brutus pointing to the dead Lucretia and summoning the people to revolt.

Pl. LXIV (fol. 56a). The iconographic motive reminds us of the mural in the Biblioteca Capitolare of Padua, erroneously attr. to Semitecolo (ill. Testi I, 310), and the style of another mural in the Frari (ill. ibidem I, 110) dated in the middle of the 15th century.

Pl. LXV, LXVI (fol. 56b and 57a). The composition has repeatedly been connected with Mantegna's Saint Christopher legend in the Eremitani church in Padua, cf. Graeff, in *Monatshefte*, 1910. We agree with Simon, p. 27, in dating the drawing in Jacopo's latest period.

Pl. LXVII (fol. 57b and 58a). Simon, p. 30 dates it very late, on the ground of the convincing rendering of a real situation. The advance is so positive that Jacopo Bellini can hardly be credited with it. The drawing is on the uncertain borderline dividing Jacopo's and Gentile's activities.

Pl. LXVIII (fol. 58a and 58b). Hardly early, as Simon, p. 33, suggests. More likely about 1450.

Pl. LXIX (fol. 59b). Goloubew's description of the children as "petits génies" is not quite correct, they are instead big boys such as Donatello uses on the base of his Judith in Florence. In support of Simon's placing the drawing in Jacopo's late period (p. 23) we point to a similar construction in the background of Benozzo Gozzoli's mural of the "Tower of Babel" in the Campo Santo in Pisa, connected by Fiocco, *Mantegna*, pl. 73, with Mantegna's visit to Florence and Pisa in 1466/67. The co-incidence is significant enough to make us presume that Jacopo might hardly have reached this stage before the 1460's and that the drawing might even belong to a younger member of the shop, possibly Gentile. [*Pl. III, 3.* **MM**]

Pl. LXX (fol. 60a). The "Adoration of the Child" and the "Approach of the Magi" are combined in the same fashion as in an anonymous Venetian painting in the Louvre (Arch. Phot. 11283), sometimes attr. to Jacopo Bellini (see the literature in van Marle VII, p. 396). As for the date, Simon, p. 41, suggests the middle period, while we believe in a very late origin and a close connection with I, pl. LXIX. Mantegna's painting in the Uffizi (*Klassiker, Mantegna,* 102), dated in the 1460's and sometimes connected with Mantegna's stay in Florence in 1466, offers the closest relationship. (See also our remarks at II, pl. XXIX.)

Pl. LXXI (fol. 60b). Markedly early, perhaps before 1440 (as I, pl. XXXIII), in view of the archaic style of the drapery. Compare also Michele Giambono's polyptych in Venice, Academy, ill. Testi II, p. 23.

Pl. LXXII (fol. 61a). Also early and further developed in II, pl. LXXXVII (see there).

Pl. LXXVI (fol. 64b). Again very early like I, pl. XXXIII. A comparison with the St. John the Baptist in II, pl. XXXI, reveals a very notable difference in style.

Pl. LXXVII (fol. 66a). Simon, p. 31, considers the drawing one of the most significant specimens of Jacopo's late style. In our opinion,

this classification is correct only for the left half and not connected with the other. The latter with the very slender proportions of the figures shows a certain approach to Byzantine models and may be explained by Jacopo's interest in mosaics when he worked for the Mascoli chapel in the early 1450's.

Pl. LXXIX (fol. 67a). This drawing has been the subject of discussion for two reasons. First its architectural frame has been compared by Testi II, p. 56 and p. 223, with the façade in the mosaic representing the same subject in the Mascoli chapel in St. Mark's, ill. Testi II, pl. opposite p. 56; the drawing is an important argument in the discussion of this work, attr. to Andrea Mantegna in collaboration with Jacopo Bellini (Fiocco, *Mantegna*, fig. 44) and dated about 1454. The mosaic is definitely more modern than Jacopo's drawing. The latter has been called by Schrade, in *Neue Heidelberger Jahrbücher*, N. S. 1930, p. 75 ff. and K. Rathe, *Die Ausdrucksfunktion extrem verkürzter Figuren*, London 1938, p. 12, fig. 7, the starting point for Mantegna's excessively foreshortened *Christo in Scurto*, in Milan (*Klassiker, Mantegna*, 115, compare also Hans Tietze, in *A. in A.*, 1941, p. 51). According to Schrade the composition is based on the arrangement of the "Office for the Dead," typical in illustrated manuscripts. Of the examples which he quotes, however, none is anterior to the Mascoli chapel, or exactly corresponding to its arrangements. We date the drawing in the early 1450's. II, pl. XXVI is a version in which the elements of I, pl. LXXIX are freely varied and very much further developed by a representative of the next generation, possibly Gentile. See II, pl. XXVI.

Pl. LXXX (fol. 67b). Evidently very late.

Pl. LXXXI (fol. 68a). Simon's dating in Jacopo's late period (p. 28) is supported by the resemblance with I, pl. LXXIX. The central architecture seems to have influenced Gentile's in his "Miracle of the Holy Cross" (ill. Venturi 7, IV, fig. 140, p. 249; see also Gentile's drawing No. **273** in Munich).

Pl. LXXXII, LXXXIII (fol. 68b and 69a). In these and the following drawings the l. half seems unconnected with the r., the l. halves containing landscape studies by Jacopo in his latest period, or by some collaborator, while the r. halves present figure compositions from various periods. It might be that these figure compositions were drawn first and later on the versos originally left blank filled up by Jacopo himself or by a later hand. The drawing here is, by the way, one of those to which Dagobert Frey, in *Jahrbuch des Kunsthist. Institutes* VII, p. 119, points to show the relationship of Jacopo Bellini's architectures with Giorgio Orsini and his cathedral in Sebenico.

Pl. LXXXV, LXXXVI (fol. 70a and 70b). Later, also according to Simon p. 26 f. and to be compared to I, pl. LXXVII.

Pl. LXXXVII (fol. 71a). Simon, p. 26: late. A similar central architecture is encountered in Bastiani's "Miracle of the Holy Cross," in Venice, ill. van Marle XVII, fig. 107, the stylistic approach of which to Gentile was emphasized by van Marle p. 190. We date the drawing in the 1460's.

Pl. LXXXIX (fol. 72b). Simon, p. 28, emphasizes the conformity of this construction with important currents within Venetian architecture. She wonders whether Jacopo was influenced by Fra Angelico or used models he had seen in Ferrara. Frey, in the passage quoted at I, pl. LXXXII, states that for all these architectural drawings of

Jacopo Bellini the imitation of a definite existing building has never been proved.

Pl. XC (fol. 73a). Agreeing with Simon, we date this very late. The motive in the pediment has a certain resemblance to the main entrance of the Arsenal in Venice, executed about 1460, but it might be a later addition by the artist who drew over the sheet.

Pl. XCI (fol. 73b and 74a). The l. half is unconnected with the r. See pl. LXXXII, LXXXIII. The façade shown in the latter resembles that of the Ospedale di San Marco, as represented in Gentile Bellini's "Procession" (see the detail ill. Testi II, 119). Simon, p. 17, dates it in Jacopo's middle period, we in his last period, by reason of the style of the figures. The drawing No. **367** is a playful further development of the motives here.

Pl. XCIV (fol. 76a). Bellini's Annunciations, always placed outdoors, follow the Byzantine tradition. (See Panofsky, *Art Bulletin*, vol. 19, 1935, p. 441.) The elements used in the drawing are much further developed in II, pl. XXVIII, possibly by Gentile Bellini (see there). The composition corresponds to Piero Pollajuolo's painting in the Kaiser Friedrich Museum and seems to have set a model for Venetian art; in painting it appears for the first time in Venice in the "Annunciation" in the Thyssen Collection, ascr. to Gentile Bellini's very earliest period, ill. van Marle XVII, fig. 78. The painting and the drawing may be of approximately the same time. Later on it was developed by Crivelli in his "Annunciation" in the N. G. of 1486, ill. van Marle XVIII, p. 39, fig. 27.

Pl. XCV (fol. 76b and 77a). Goloubew's reference to Bellini's painting in the cathedral of Verona is misleading for various reasons enumerated on p. 97. The most important point is that the composition of our drawing is by far the most advanced of all the representations of this subject in the sketchbooks and cannot possibly be connected with an invention of 1436. (see II, pl. XXXVI). A much better reference is that given by Testi II, p. 225 who quotes the contract of July 17, 1466 according to which Jacopo was to paint for the Scuola di San Marco *"la Istoria di Jerusalem con Cristo e i ladroni"* i.e. *"una passion de Christo richa di figure e altre che stia benissimo."* The drawing and the one on I, pl. XCVII, both offering a conspicuous view of Jerusalem might be preparatory designs for this painting. But even presuming an origin in the 1460's we doubt that Jacopo is to be credited with such a radical innovation as the oblique position of the three crosses. Even if the mural was ordered of Jacopo the design may have been contributed by his first assistant, Gentile. Many features of the composition are conformable to those of Mantegna's Calvary from the San Zeno altar-piece (ill. *Klassiker, Mantegna*, 85).

Pl. XCVI (fol. 77b). Between I, pl. XCV and XCVII the drawing appears strikingly archaic. For the arrangement of the heads on one level, fixed by horizontal lines, drawn with the help of a rule, compare I, pl. C.

Pl. XCVII (fol. 78a). In our opinion, Simon's reference (p. 37) to the "Crucifixion" of 1436 in Verona is erroneous. The drawing is a variation of I, pl. XCV which, it is true, is still more audacious in changing the time-honored central arrangement of the three crosses into an oblique placing.

Pl. XCVIII (fol. 78b and 79a). Again (see pl. LXXXII, LXXXIII — the l. half) scarcely recognizable, unconnected with the r. and much later in style. The Adoration, according to Simon, p. 43, originating

from Jacopo's middle period is the earliest of those in the sketchbooks; the drawing style corresponds to I, pl. XXXIV, XXXVI and points to an origin around 1440.

Pl. C (fol. 80a). According to Simon, p. 34, early, which in our opinion is correct. The arrangements of the heads on one level correspond to I, pl. XCVI.

Pl. CI, CV (fol. 80b and 82b). Testi II, 226, points to the sojourn of Saint Bernard in Padua in 1443 (see P. Th. Dangin, *The Life of St. Bernardino,* London 1911, p. 65). A more precise date may be obtained by pointing to the lost murals in the Gattamelata chapel in the Santo in Padua, where in 1456 Jacopo Bellini painted stories from the life of St. Francis and St. Bernardino (see I, pl. XLVII).

Pl. CVI (fol. 83a). This seems to be the design for a tomb and may be connected with the funeral monument of Lorenzo Giustiniani, for which Jacopo Bellini made his figure "placed on the tomb in S. Pietro di Castello" and in 1456 received a payment of 16 ducats. The tomb described in Sansovino, Venetia, ed. of 1663, p. 6, no longer exists. The style of the drawing fits very well to the date of 1456 and it may be worth mentioning, although certainly not a very strong argument, that the drawing facing this one, Goloubew pl. CV, might also be from the same year.

Pl. CVII (fol. 83b). Simon, p. 32: late.

Pl. CVIII (fol. 84a). The tabernacle in Gentile Bellini's "Miracle of the Holy Cross," in Venice (ill. Venturi 7, IV, p. 249, fig. 140), to which Goloubew refers, is octagonal, while the structure in the drawing is hexagonal.

Pl. CX (fol. 85a). Very late — also according to Simon, p. 28 — compare I, pl. XCVII.

Pl. CXI (fol. 85b and 86a). This is one of a few representations of warriors combatting dragons or serpents (I, pl. XVII, II, pl. XLIX, L, LXXX), for which Mandach, in *Gaz. d. B. A.* 1922, II, p. 91, referred to an illustration in the manuscript of Romuléon, in the Arsenal Library, representing "Cato of Utica and his soldiers fighting serpents." We may presume that this popular book was well known at Ferrara and that this drawing belongs to Jacopo's Ferrarese period.

Pl. CXII (fol. 86b). Early, "Pre-Mantegnesque."

Pl. CXIII (fol. 87a). Goloubew's reference to Nanni di Banco's relief of this subject of 1414 in Florence offers no help since it is very different and decidedly more "gothic" in style. Our drawing is very soft and belongs to Jacopo's earliest in these books (Compare I, pl. XXXIII or LXXI).

Pl. CXV (fol. 88a). Simon emphasizes the archaic elements of the whole arrangement in which the group of figures does not merge into the space. Nevertheless the architectural construction is so similar to that in I, pl. LXXIX and in the mosaic in the Mascoli chapel that we would not date it earlier than the late 1440's.

Pl. CXVII (fol. 89a). Very late (1460's). The architecture recalls Alberti's church of St. Andrea in Mantua (ill. Venturi 8, I, fig. 149).

Pl. CXXI (fol. 91a). Late. The façade has a certain relationship to the one of the Abbazzia della Misericordia, ill. Pietro Paoletti di

Osvaldo, *Architectura e la sculptura del Rinascimento in Venezia,* 1893, vol. I, 55.

Pl. CXXII (fol. 91b). Very early, like I, pl. XXXIII and LXXI, and still recalling the style of Gentile da Fabriano, compare for instance the latter's "Marriage of St. Catherine," at Urbino, or even his drawing in Edinburgh (ill. van Marle VIII, fig. 10) the authenticity of which, it is true, is not universally acknowledged (see Oscar Fischel, *Zeichnungen der Umbrer,* 1917, p. 75). The style corresponds to Francesco de' Franceschi's paintings in the Museo Civico in Padua, ill. Testi II, 67, or Jacopo Moranzone's polyptych in the Academy in Venice, no. 11 (ill. Testi II, 74). The general affinity makes us date this drawing in the 1430's. The *"petits génies sur un radeau au voisinage du ponton"* (Goloubew) are more likely people swimming, as in Gentile Bellini's painting "Rescue of the Cross."

Pl. CXXVII (fol. 94b). See I, pl. XVI.

Pl. CXXXI (fol. 96b and 97a). Apparently very late.

363 bis NEW YORK, COLL. S. SCHWARZ. Ornamental designs, including a scroll ending in a dragon's head from which the half figure of a woman emerges, and the head of Christ surrounded by adoring cherubs. Light br., on vellum. 117 x 123 mm. Cut. — On *verso:* on either side of a stylized tree a lion assaulting a middlesized animal and a deer grazing. Attr. to Jacopo Bellini because of the exact conformity to similar drawings in the Louvre sketchbook No. **364**, pl. XCV. [*Pl. CLXXXVI, 2*]

Since, however, the position of these drawings is not sufficiently clarified, see p. 110, the attribution remains hypothetic. The character of patterns, taken from models and intended to serve as models, prevails over individual characteristics.

364. PARIS, LOUVRE. So-called Sketch book. 92 pages, vellum and one (Goloubew II, IX) paper (watermark eagle, frequently used in Venice in the 15th century). Most of the drawings are executed in silver- or leadpoint on prepared vellum and almost completely reworked with the pen. The sheets Goloubew vol. II, pl. XIV, XVII, XX, LI, LII, LX, LXI, LXII, LXXI, LXXIV, LXXVII, LXXXI, LXXXII, LXXXV, LXXXVI, LXXXVII, LXXXVIII, LXXXIX, XCIII, XCIV are drawn with silverpoint on vellum tinted in various colors and partly destroyed, but not drawn over with the pen. The sheets LVIII, LIX, LXIX, LXXIX, LXXXIV are drawn with the brush and XCV with brush and pen. The sheets VI, VIII, IX, XVIII are drawn with the pen and apparently not drawn over, pl. LXXXIII with bl. ch. Pl. LII and pl. LVII are executed in watercolors. The measurements are 427 x 290. Pl. XCVI contains an index of the drawings in a handwriting universally considered not to be Jacopo's, but another hand of the 15th century. Arabic numerals on the pages refer to this index, but the conformity is not complete. A few of the drawings are missing in the index which are in the book (pl. XIV, XVII, XIX, XX, LII, LXXIV, LXXXI), but, on the other hand, the index lists a few more. The first ten lines of the index are indecipherable. The drawings are bound in a binding of the 15th century. They have suffered from humidity, tearing and other injuries, but on the whole the state of preservation is satisfactory except for the heavy retouches with the pen, mentioned before, and the almost complete destruction of some sheets solely drawn in silverpoint and not drawn over. The pages reproduced on pl. LI, LXXIV, LXXXI–LXXXIV which contained ornamental patterns, were painted out with an opaque wash

and then again used for other designs (see Meder, *Handzeichnung,* p. 92). The retouching with the pen, in Goloubew's opinion, might have been done by Jacopo's sons, Giovanni and Gentile, a theory expressly rejected by Testi II, p. 196 who insists that the reworking was done as routine work by a minor member of the shop. Evidently various hands are to be distinguished in this penwork, the efficacy of which in altering the total impression may best be checked on pages like Goloubew pl. IV, where the little dog in the foreground has been spared and shows a different character from the rest of the drawings. Another example would be pl. VIII (*Pl. VI,* 1), where the princess is in striking contrast to other parts of the drawing. In the latter example, the hand that did the reworking, aiming at pictorial effects far advanced over the original design, may be Giovanni Bellini's, whose presumptive early drawings (Nos. **286, 287, 308**) show a certain affinity of style. Most of the drawings, however, were retouched by another hand, whose cold correctness has rightly been emphasized by Testi. He quotes in this connection the letter of Antonio Salimbene, minister of Mantua in Venice, written to Francesco Gonzaga, on December 23, 1493 (*Archivio Storico* 1888, I, p. 277). This letter may elucidate the purpose of this reworking of drawings: "I talked with maestro Gentile Bellini about the view of Venice. He answered me that he had one made by his father and offered it to me. Because it is old so that it is impossible to figure it out, he tells me it will be necessary to rework it with the pen and for this task he would need two months at least. He begs Your Excellency to inform him if you wish to have the view, in order that he may at once have the work started." Testi drew the conclusions 1) that Gentile had no objections to reworking the drawings of his father, 2) that he had his assistants work on this task, 3) that the latter, calculated to take two months at least, had to be done in a careful and meticulous way. We learn besides why such a reworking took place: to make a faded design more easily accessible and therefore more pleasant to a customer. (As a matter of fact on pl. LXIV and LXV where by chance or negligence a few heads have not been retouched they completely disappeared). Applying this to the sketchbook in the Louvre we may suppose that the few more personal additions in pen were made when the book was still in practical use in Jacopo's or Gentile's workshop while the bulk was reworked as a routine job when Gentile parted with the volume.

The history of the volume in brief is the following: it was purchased by the Louvre only in 1884, from Marquis de Sabran Ponlevès in whose castle near Bordeaux it had been discovered. According to the tradition in the family it had been brought from Constantinople by some ancestor. As a matter of fact, the sketchbook may be identified with a volume of drawings existing early in the 18th century in Smyrna, and to which the antiquary Guérin drew the attention of Abbé Bignou, librarian of the king of France, in a letter of November 8, 1728, adding that the book was said to originate from the *seraglio* in Constantinople and to belong to the widow of a dragoman who did not wish to sell it. (Seymour de Ricci, *Un Album de Dessins de Jacopo Bellini au Musée du Louvre,* in *Revue Archéologique,* 5th series, vol. XVIII, 1923, p. 88, resting on the documents publ. by Henri Omont, *Missions Archéologiques Françaises en l'Orient,* Paris 1904). The identity of the list of drawings in Guérin's letter with the index contained in the sketchbook in Paris allows no doubt that both books are the same. The most convincing explanation would be that the book was brought to Constantinople by Bellini in 1479 and presented or sold there to the Sultan. According to E. Jacobs, in *Jahrb. Pr. K. S.* XLVIII, p. 1, it was removed from the library of the *seraglio* in 1677. As for the connection of the book with the other in London

(see No. **363**) the theory was advanced by Corrado Ricci, p. 43, that Jacopo Bellini may have prepared such a volume for each of his sons so that Gentile Bellini in his testament of 1507 had only one to leave to Giovanni who had already been in possession of the other for a number of years. This theory, also accepted by Testi II, p. 190, is contradicted by the facts since made known by Seymour de Ricci from Omont's earlier studies. It seems more likely that both books were bequeathed by Jacopo's widow Anna to Gentile (as the successor of Jacopo in heading the workshop) and that he presented one of them (and characteristically the more representative, on vellum and neatly retouched, perhaps by one of the two assistants who accompanied him on his mission to Turkey) to the Sultan and left only the remaining one to his brother and successor, Giovanni. It is the book, now in the British Museum, which in the house of Vendramin is mentioned as a single volume.

The book in Paris was first recognized as being by Jacopo Bellini by L. Courajod, in *Bulletin de la Société des Antiquaires de France,* 1884, and first described by E. Müntz, in *Gaz. d. B. A.* XXX, p. 346 ff. and 434 ff. It was later on more circumstantially described by Both de la Tauzia, *Musée du Louvre, Dessins etc., deuxième notice supplémentaire,* Paris 1888, p. 238 and by Testi II, 229–243 who also described the book in London (II, 213–229). Both books were, moreover, publ. in facsimile by Goloubew, Brussels, vol. II (Louvre) 1912, vol. I (Brit. Mus.) 1908 and Corrado Ricci, Florence, 1908. We quote after the edition of Goloubew.

As for the stylistic and historical analysis the Paris sketchbook cannot be separated from the one in the British Museum. The earlier scholars used to consider each volume as a complete unit and dated the book in London, the only one at first known, about 1430, starting from the date which is written on its first page, see above p. 106. As late as 1907 Lionello Venturi, *Origini,* p. 131, still clung to this date of origin which, otherwise, is now given up by most scholars who date both volumes around 1450, the one in London a little earlier than the one in the Louvre. F. Antal, in *Jahr. d. Pr. K. S.* XLVI, 1925, p. 21, note, tried to explain the difference in style between the two books by pointing to the stay of Andrea Castagno in Venice about 1440 to 1444, in his opinion just the period separating the origins of the two books. This theory, however, is contradicted by the numerous connections, especially frequent in the London book, with events taking place in Ferrara about 1440–41, just at the time when we know of Jacopo Bellini's stay in Ferrara and his manifold activities for the Court there. The connections of the drawings with Ferrara were first recognized by Paoletti, *Archittetura e Scultura in Venezia,* p. 265, and Gruyer, *L'Art Ferrarais,* p. 231, and were more thoroughly studied by Heiss, *Les Medailleurs de la Renaissance,* 1883, p. 18, Adolfo Venturi, *Rivista Storica Italiana* I, (1884), p. 604 and Georg Gronau, in *La Chronique des Arts et de la Curiosité,* VII, p. 55. The main points are that the monument of Niccolò III d'Este, with which several drawings seem to be connected, was executed by Antonio and Niccolò Baroncelli of Florence after 1451, and that the drawing II, pl. XXXI seems to be dependent on Donatello's monument of Gattamelata in Padua, started in 1446 and completed in 1453.

The older theories on the two sketchbooks have been overthrown by L. Fröhlich-Bum in *"Bemerkungen zu den Zeichnungen des Jacopo Bellini,"* in *Mitteilungen der Gesellschaft für vervielfältigende Kunst,* 1916, p. 41 ff., whose results have been amplified by Hertha Simon, *"Die Chronologie der Architektur- und Landschaftszeichnungen in den Skizzenbüchern des Jacopo Bellini,"* thesis of the University of Munich, 1936. For the idea that the books present units, the origin of which is separated by a longer or shorter lapse of time,

the two authors substitute the theory that the books are not units at all, but that each contains a casual choice of drawings from various periods. The difference between the two books, in their opinion, is not a chronological, but a technical one, the book in London containing drawings on paper, the book in Paris, with only one exception, drawings on vellum. The other point of difference which Mrs. Fröhlich-Bum emphasizes, namely, that the drawings in London are all done in metal point and those in Paris in pen, is partly erroneous since the latter too were originally drawn in lead- or silverpoint and later on reworked evenly with the pen. In the main point, however, the theory of Mrs. Fröhlich-Bum is correct: each volume is simply a compendium of drawings brought together without any systematic order. Goloubew's endeavor to find in the Paris sketchbook which starts with religious subjects, an illustration of Jacopo's development in the direction of humanistic ideals rests on a complete error. Mrs. Fröhlich-Bum distributes the drawings in both books over a period stretching from about 1425 to about 1450 endeavoring to distinguish four stages of spatial evolution, in a special study of the rendering of architecture and landscape. In spite of her break with the traditional interpretation, she is still inclined to consider the drawings in London which she describes as hasty preparatory sketches, as older than the ones in Paris which in her opinion are elaborate drawings and independent works of art. Miss Hertha Simon rightly drops this distinction and, on the contrary, has the feeling that the book in Paris contains fewer compositions from Jacopo Bellini's latest period than the book in London. She also extends the period in which the drawings might have been executed from about 1425 up to the death of Jacopo in 1470/71 and distinguishes only three stages, basing her studies on the same material as Mrs. Fröhlich-Bum. In the details, that is in the placing of single drawings within the supposed stages of the artist's evolution, the two authors do not always agree. Their essential idea, nevertheless, appears sound.

When we admit that the two sketchbooks do not each form a systematic unit, but represent a more or less casual collection of separate drawings, some conclusions drawn in the earlier literature concerning the purpose of these drawings have to be corrected. They used to be considered as completed works of art. The earliest author who dealt with them, Aglietti (*Elogio storico di Jacopo e Giovanni Bellini,* 1812), considered them to be designs for definite paintings, and Gaye, the first to give a critical description of the sketchbook in London (then the only one known) stressed the fact that the drawings were not sketches or casual records, but finished compositions. Later on, especially after the discovery of the second volume, the illustrative trend and charm of the drawings were emphasized. Müntz (*Gaz. d. B. A.* 1884, II, p. 440 f.), Gronau (Thieme-Becker III, p. 253) and A. Venturi (vol. 7, IV, p. 324) praise the richness of Jacopo's inventions and find him, first of all, interested in episodes and details. Conrad de Mandach, *Le symbolisme dans les dessins de Jacopo Bellini* (*Gaz. d. B. A.* 1922, II, p. 39), who made a special study of the iconographic sources of Bellini's compositions, reached the conclusion that the drawings are for the greater part designs for murals or painted panels and a few of them models for the decoration of church banners.

Mrs. Fröhlich-Bum, on the contrary, sees in them the material used by Jacopo Bellini for the study of the crucial artistic problems of his days. Comparing his efforts to the half scientific, half artistic research of his contemporaries in Tuscany she believes that Jacopo in his predominantly painter-like approach tried to investigate by drawings what the Florentines studied in theoretical treatises. She uses the striking expression that Jacopo's sketchbooks are the Venetian anal-

ogy to the Florentine *"trattato della pittura."* Her explanation elucidates the somewhat monotonous character of these drawings, strongly felt by Hadeln (*Quattrocento,* p. 31) who, still starting from the idea of the predominantly illustrative purposes of the sketchbooks, calls Jacopo a Pietro Longhi of the 15th century who "being an indefatigable narrator ends by fatiguing the others. Much of his work is charming, nothing really outstanding. We would not like to miss them, but on the whole we should prefer them less numerous." Hadeln's judgment is led astray by his appreciation of the drawings as independent works of art.

They are the working material of Jacopo's workshop which was carried on by his successor in business, Gentile, and perhaps even, Giovanni Bellini. Mrs. Fröhlich-Bum's theory is alluring, but too restrictive, if she means to say that Jacopo made these drawings solely to clarify problems of perspective and similar theoretical questions. Part of them may belong to this category, others are studies from nature, designs for definite purposes or *similes,* recording pictorial patterns and types in line with the ideas of the middle ages. This combination produces the uniqueness of Bellini's sketchbooks, uniqueness not only in the artistic sense, as proclaimed by Hadeln, l. c., but uniqueness also in comparison with other pattern books of the period. Hertha Simon compares Bellini's books with other examples of this category and establishes the fundamental difference from them. They are, indeed, only model books, containing a choice of models in a more or less systematic grouping, while Bellini's sketchbooks are not books at all, but a collection of separate drawings, brought together in volumes solely on the basis of exterior characteristics. From a number of last wills of Venetian painters of the 15th century — and later on too — we know the importance accorded to these *"designia"* which were left to the chosen successor as indispensable for carrying on the workshop. For this reason Gentile became the owner of the drawings piled up in his father's workshop and only later on, as the style of the bindings indicates, they were bound presumably to prevent their dispersal. This gesture of homage, intended to preserve the drawings for the future, may mark the moment at which they began to lose their importance for the present. The fact that Gentile parted with one of the volumes may be interpreted along the same line.

The result of Mrs. Fröhlich-Bum's new interpretation, that the sketchbooks are to be studied less as books than as sketches, means that the 230 drawings which they contain are to be investigated in just the same way as separate drawings left by other artists. This task has been undertaken by Mrs. Fröhlich-Bum and Miss H. Simon as far as the rendering of architecture and landscape goes. As for the general chronology only a few hints have been given by the former. In the following paragraphs we try to outline our own attitude.

First of all, before entering upon a critical discussion of the material, we must emphasize once more the fact that most of the drawings are so heavily reworked that their artistic character is almost completely obliterated. In volume I (No. **363**) especially, the drawings reworked in the 18th century have hardly anything of their original surface left. In volume II (No. **364**) the original structure, as pointed out above, is completely veiled by the dense network of pen lines drawn over the original metal point. By these retouches the drawings are made so uniform in style that it is very hard to distinguish their genuine features.

The second difficulty which we have to face rests on the specific character of shop material. The drawings were, so to speak, the common property of the shop and the fact that they were considered as Jacopo's, does by no means exclude the co-operation of other hands. The passage in Gentile Bellini's last will (see above) does not assert

that the drawings were all done by Jacopo, but only that they had been his property and working material. An example taken from Bellini's immediate neighborhood may illustrate the conditions prevailing in these workshops. (See *"Mantegna and his companions in Squarcione's shop"* in *A. in A.* 1942, January, p. 54.) In a contract of October 17, 1466 (publ. in *L'Arte,* 1906, p. 55) it is stipulated that a minor painter (Piero Calzetta) is to execute a painting for a chapel in Saint Anthony's Church in Padua following a design of Master Francesco Squarcione, executed by Niccolò Pizolo ("da un desegno de maistro Francesco Squarzon el qual fo de man de Nicolo Pizolo"). This means that the drawing belonged to the working material of Squarcione, although artistically it was Pizolo's property. There is no reason to doubt that the conditions in Jacopo Bellini's workshop were the same and that designs of his collaborators, first of all his sons, were added to the stock and that after his death this stock was still increased by his successor. We observed that in No. **364** a number of drawings were added after the completion of the index; it is noteworthy that all these drawings added later are not retouched as they belonged to another stock of the working material than the bulk of the drawings.

To appraise these facts properly we have to remember the specific character of these artists' workshops in the Renaissance, especially in Venice: they were first of all economic units which extended their activities through several generations (see H. Tietze, *Master and Workshop in the Venetian Renaissance,* in *Parnassus,* 1939). Conditions as we know them from Titian's, Tintoretto's and Veronese's and many other Venetian artists' studios, can also be supposed to have prevailed in the workshop of the Bellini, in whose working material the shares of the individual members of the family are merged.

The drawings of the two sketchbooks form a unit insofar as they represent one workshop, but they do not express a single artistic individuality. Studying them attentively and from an unbiased viewpoint we discover drawings covering a stretch from the "international style" of the early 15th century to the ripeness of the late Quattrocento. Is it possible that the same artist drew the "St. Christopher," I, pl. XXXIII, still in the style of Gentile da Fabriano's early works, and the "St. Christophers," II, pl. XVIII or LII, both in full command of the artistic means, typical of the third quarter of the 15th century? A still more striking example may be the "Crucifixion," II, pl. XXXVI, compared to the representations of the same subject I, pl. XCV and XCVII. In II, pl. XXXVI Goloubew rightly noted the connection with Altichiero's compositions of this subject (see, for instance, the one in San Felice in Padua, ill. van Marle IV, fig. 63, 64, or the shop production, ill. ibidem fig. 78). The same stage is reached in the "Crucifixion" in the Museo Civico in Verona, formerly in S. Trinità and strongly under the influence of Altichiero; we may suppose that Jacopo Bellini's highly praised composition of 1436 in the chapel of S. Niccolò in the cathedral in Verona used a similar composition, and that the drawing II, pl. XXVI is a fair example of Bellini's style about that time. The other two "Crucifixions" mentioned above are far advanced in style. With reference to them various authors have pointed to Jacopo's paintings in the Scuola di San Marco in Venice ("una pasion de christo in croce ricca de figure e altro che stia benissimo"), and to the composition preserved in a painted copy formerly in the Palazzo Albizzi and in an engraving by Paolo Caliari (1763–1835). To the latter composition both drawings show no notable resemblance. As for the paintings in the Scuola di San Marco, for which a contract dated July 17, 1466 exists, we have no idea how they looked, nor indeed who executed them. The style of I, pl. XCV, with the masterly subordination of the figures to the landscape would be

an amazing achievement for an artist who thirty years earlier had conceived the composition of the "Crucifixion" purely with human figures. II, pl. XCVII where the three crosses are placed vertical to the surface in order to stress the spatial depth is still more advanced and astonishing for any artist earlier than 1470.

As we said before, thirty years or so would separate the two compositions and in this stretch of time Jacopo Bellini might have gone through a far-reaching evolution. If he did so, and at an advanced age, succeeded in anticipating what the artists of the next generation were struggling for, he must indeed have been a man of outstanding genius. The older sources do not describe him as such, his sons were always supposed to have surpassed him by far. Newer authors, too, as a rule have the feeling that Jacopo was only an average artist who owes most of his reputation to the accidental preservation of the two sketchbooks and to the glory of his sons. Popham, for instance, basing his judgment on the study of his drawings (in his *Handbook,* p. 25) calls him "an artist of less importance than either his sons or his son-in-law," while, on the other hand, Mrs. Fröhlich-Bum from her studies of the spatial problems in the sketchbooks draws the conclusion that Jacopo Bellini found solutions of current problems which in his days none of the Florentines had reached. The rendering of space and the ornaments appearing in some pages of these sketchbooks correspond indeed to the stage of the general evolution reached in Italy between 1470 and 1480. When considering that these problems of perspective and rendering of space were first of all the principal subject of interest with the Florentines we cannot but be amazed by the alleged priority of a Venetian.

In our opinion, Jacopo Bellini was not a genius who anticipated Leonardo da Vinci's universality, but a craftsman whose activity is conditioned by the working habits of his period. The variety and amazing extension of the artistic evolution illustrated by the sketchbooks is to be explained by the fact that they contain the working material of two generations. We have to add that the borderline between the two generations cannot be traced with certainty. We know that on certain occasions both sons collaborated with the father, for instance, in the Gattamelata chapel in Padua, and we may, moreover, presume that Gentile was his permanent right-hand man and played the same part in Jacopo's workshop which one and two generations later made Orazio Vecelli and Domenico Robusti disappear in their fathers' greater art. Van Marle convincingly explained the complete lack of early works by Gentile Bellini by the fact that he spent the years of his early manhood in close co-operation with Jacopo whose works from these years, by the way, have almost completely been destroyed. As in discussing the painting of "St. Jerome" in the Toledo Art Museum (Hans Tietze, in *A. in A.* 1940, p. 114 ff.) we must confess our ignorance about the problem of how far Jacopo Bellini in his old age participated in the newer currents, or how closely Gentile in his beginnings approached his father's style. The expedient chosen there to reach a decision must help us to distinguish the respective shares within the two sketchbooks: the feeling whether a drawing might be the work of an old and experienced, or of a young and daring artist.

Our interpretation of the sketchbooks attempts to explain a confusing discrepancy felt in them by art critics, on one hand the mediocrity and handicraft character of the average drawings and on the other, the amazing prematurity of the books, if dated within Jacopo's activity. As Cantalamessa put it in *Atenco Veneto* 1898, in these books all the various characteristics of the later Venetian painters are already contained in the embryo. They are frequently called by Italian authors (Corrado Ricci in particular is fond of the expression) "the bible of

Venetian painting." An extremely happy expression, for like the bible the sketchbooks are composed of very heterogeneous elements, and again like the bible they nevertheless act as an unbreakable spiritual unity.

We do not include in the discussion vol. II, pl. XCV, a purely ornamental design for textiles closely following some Oriental patterns, because its dependence is so strong and the artistic individuality so thoroughly effaced that, as a matter of fact, the drawing may be by any artist of the early 15th century. Martin Weinberger, in his illuminating article *"Silk weaves of Lucca and Venice in contemporary painting and sculpture"* in the *Bull. of the Needle and Bobbin Club*, 1941, p. 20, justly remarked that Jacopo Bellini's drawings of this kind, and most of all the one in question here, are "variations of west Islamitic patterns lacking the inventive genius of Pisanello," and the penmanship is not personal enough to make an attribution to Jacopo Bellini convincing, the moment we no longer accept the presence of such drawings in the sketchbook as sufficient evidence in itself. The drawing, the similar ones on vol. II, fol. 77v, 78v pasted over, and the closely related No. **363 bis** may as well be working material by another hand inserted in the volume.

On the basis of our studies we make an attempt to group the drawings as follows:

Jacopo's early style: Vol. I, pl. II, III, VIII, IX, X, XX, XXXII, XXXIII, LXXI, LXXII, LXXVI, CXIII, CXXII. Vol. II, pl. XXXVI, LV, LVI.

Jacopo's style in the 1440's and early 1450's: Vol. I, pl. IV, V, VI, VII, XII, XIV, XVI, XXII, XXIII, XXIV, XXV, XXVI, XXX, XXXI, XXXIV, XXXV, XLI, XLIII, XLIV, XLVI, LI, LII, LV, LVI, LVIII to LXI, LXVIII, LXXVII, LXXXVIII, XCVI, XCVIII, XCIX, C, CI, CII, CV, CVIII, CIX, CXI, CXII, CXIV, CXV, CXXIV, CXXVII, CXXIX, CXXXII. Vol. II, pl. IV, XVI, XX, XXIII, XXX, XXXII, XXXVII, XXXVIII, XXXIX, XLV, L, LIII, LXV, LXXIII, LXXIV, LXXX, LXXXII, LXXXIII, LXXXV, LXXXVII, XC, XCL.

Jacopo's late style: Vol. I, pl. XIII, XV, XVII, XVIII, XIX, XXI, XXVII, XXVIII, XXIX, XLII, XLVII, XLVIII to L, LVII, LXV, LXVI, LXX, LXXII, LXXV, LXXIX, LXXX, LXXXI, LXXXII, LXXXV, LXXXVII, XCII, CI, CIII, CIV, CV, CVI, CX, CXV, CXVII, CXIX, CXXVI, CXXVIII, CXXX, CXXXI, CXXXIV. Vol. II, pl. IV, V, VI, XVII, XIX, XXII, XXV, XXXII, LIV, LXX, LXXVIII, LXXXIX.

Jacopo's late style or Gentile: Vol. I, pl. XLV, LIII, LIV, LXII, LXVIII, LXIX, LXXXIII, LXXXIV, LXXXIX, XC, XCI to XCV, XCVII, CXXI, CXXIII, CXXV, CXXXIII. Vol. II, pl. III, X, XI, XII, XIII, XV, XXI, XXVI, XXVII, XXVIII, XXXI, XXXIV, XL, XLI, XLVIII, LXVII, LXXII, XCII.

Gentile Bellini: Vol. II, pl. I, II, XIV, XXIV, XXIX, LVIII, LXIX.
Giovanni Bellini: Vol. II, pl. II, VIII, IX, XVIII, LII, LXXXI.

As explained on p. 102 we do not describe each drawing, but only supplement the numerous existing descriptions by a few additional remarks, according to the arrangement of the plates in Goloubew's edition of the sketchbooks to which we refer.

Pl. I (fol. 7a). For the composition, by reason of which Simon, p. 39, places the drawing in Jacopo's middle period, the conformity to Alberti's rules is evident, but it is hard to believe that the very advanced postures of the warriors are due only to the heavy retouching. The general impression resembles that of No. **269** and we conclude that the drawing is either by Gentile Bellini or that he drew over it so thoroughly that this determines the effect.

Pl. II (fol. 7b). The center is hardly touched, but the frame is re-touched or even redrawn by an artist, already in full possession of the modern forms of about 1470 (compare the decoration of the Scuola di San Giovanni Evangelista, ill. Testi II, 163), when Venetian art had absorbed many Florentine influences (see the lavabo in the sacristy of the cathedral of Florence, by Andrea di Lazaro, ill. Venturi 6, fig. 103). The Pietà in the middle is different from Jacopo's other drawings and might possibly be by Giovanni Bellini whose later representations of the subject it resembles.

Pl. III (fol. 8a). The arch, of course, like that on II, pl. XXXIV, is based on the arch of Titus in Rome, so influential in Quattrocento art. The composition develops that of I, pl. XXXVII, pushing it into the background and thus linking it with the architecture. The arrangement of the lateral figures outside the arch which frames the principal scene, reappears in Basaiti's "Prayer on the Mount of Olives" (ill. van Marle XVII, fig. 300) and elsewhere. For the relief on the arch representing Hercules shooting Nessus, Ilse Blum, *Andrea Mantegna und die Antike,* Strassburg 1936, p. 58, emphasized the fact that the same motive occurs in connection with the "Flagellation of Christ" on Goloubew II, pl. X, and accordingly may be a symbolical allusion to the suffering of Christ. Hercules as a prefiguration of Christ is not unknown to the theological literature of the late middle ages as pointed out by Panofsky, *Hercules am Scheidewege,* 1930, p. 146. Simon, p. 24, dates the drawing in Jacopo's middle period. We place it later.

Pl. IV (fol. 9a). The dog in the foreground makes us realize the profound alterations suffered by the rest of the sheet from the retouching. Simon, p. 24, places the drawing in the period of transition from Jacopo's middle to his late style.

Pl. V (fol. 10a). Fröhlich-Bum, p. 47, emphasizes the incongruities of the perspective wherein Simon, p. 47, agrees, dating the drawing in Jacopo's middle period. The ornaments resemble those used by Michelozzo in the Porta del Noviziato, in Santa Croce, Florence, (ill. Venturi 6, fig. 229) and in Venice, in the façade of San Zaccaria (ibidem, fig. 306), so that this whole part may be due to the hand that did the retouching.

Pl. VI (fol. 11a). According to Simon, late. Preparatory stage to No. **358**. In spite of the reworking of the figures their lack of structural solidity is recognizable, while in the drawing in Cambridge the functions are much better understood. (See there.) [*Pl. IV*, 1. **MM**]

Pl. VII (fol. 12a). There is again a great difference between the untouched corpse on the lid and the completely reworked front of the sarcophagus. The whole conception recalls the funeral monument of Bartolo da Saliceto, in San Giacomo, Bologna, by Jacopo della Quercia, ill. Venturi 8, I, fig. 47, but evidently the drawing is detached from any practical use and the front a playful enrichment of an old model.

Pl. VIII (fol. 13a). Simon, p. 52, dates the drawing late, but even the presumption of a complete reworking by a later hand (something that hardly seems to be the case) would not sufficiently explain the difference in style from Jacopo's other representations of this and similar subjects. The relation of the figures to the landscape is so entirely natural that the dragon does not threaten by its huge size, but by its agility and wickedness. The landscape is far advanced even over such an advanced stage as I, pl. L, and nearer to Giovanni Bellini's "Mount of Olives" in the N. G. (ill. *Klassiker, Bellini,* 20) or to his "St. George" at Pesaro (ill. ibid., 50r). We see a closer relationship to Giovanni's later style than to Jacopo's earlier style. [*Pl. VI*, 1. **MM**]

Pl. IX (fol. 14a). The only drawing in the Louvre sketchbook on paper, and therefore also somewhat different from pl. VIII, to which it is otherwise similar for the style in general.

Pl. X (fol. 15a). Simon, p. 23, dates the drawing in the middle period and contrasts it with II, pl. III; she also points out that the light is not yet used to clarify the composition, and that the attendants merely carry lanterns to indicate a night scene. Our interpretation of the drawing is very different. In our opinion, the essential point is the renunciation of any utilization of perspective; recalling Mantegna's compositions in the Eremitani chapel we feel at once, that in the drawing the interest in architecture has degenerated into a kind of play. Such an evolution might point to an artist posterior to Jacopo Bellini, possibly to one of his sons — at least for the extensive retouches (compare II, pl. I).

Pl. XI (fol. 15b and 16a). Simon who dates the drawing in Jacopo's middle period (p. 21), stresses the lack of structural solidity, combined with a profuseness of decoration. The impression of an advance beyond Jacopo may be due to the hand responsible for the reworking.

Pl. XII (fol. 16b and 17a). Based on I, pl. LXXXV. Heavily drawn over.

Pl. XIII (fol. 18a). The composition follows an older pattern and the increased modernity is due to the retouching. Gamba, *Rass. d'A.* 1915, p. 191 finds reminiscences of this "Crucifixion" in Ercole Roberti's painting in the B. Berenson Coll. (ill. *Esposizione della pittura Ferrarese,* Ferrara 1933, cat. p. 100).

Pl. XIV (fol. 18b). This drawing which is not drawn over, is one of those not listed in the index and hence originally did not form part of the book (see p. 106). The fusion of figures and landscapes, the lyrical qualities of the latter and the evident enjoyment of neatly distributed and rendered details reminds us of the painting of "St. Jerome" in Toledo (ill. *A. i. A.* 1940, p. 111) which, in our opinion, is situated on the same borderline between Jacopo and Gentile Bellini as the drawing. At any rate, Simon, p. 53, dates it in the last phase of Jacopo's latest style. We are inclined to imagine that Gentile added it to the stock of his father's drawings. Compare also Gentile's "Adoration of the Magi" in the N. G. (ill. van Marle XVII, fig. 88). The motive of the altar on which columns are standing appears also in Giorgione's "Tempest." [*Pl. VII,* 1. **MM**]

Pl. XV (fol. 19a). Simon, p. 27, late, with reminiscences of Jacopo's middle period.

Pl. XVI (fol. 20a). The retouching is not quite uniform, hence certain obscurities in the composition. The figures point to a rather early period.

Pl. XVII (fol. 20b). According to Simon, p. 32, one of the few late drawings in the Louvre sketchbook and, indeed, one of the supplements since it is not listed in the index. Further development of I, pl. LXXVII.

Pl. XVIII (fol. 21a). Fröhlich-Bum, p. 45, calls this drawing the apex of Jacopo's efforts at rendering space. According to her, it is anterior to every work in Italy as far advanced in style as this drawing; even in Florence, before 1470, no one would have dreamed of such a representation. Our explanation of this phenomenon, (as given on p. 109) is that the drawing is not by Jacopo at all, but by Giovanni

Bellini, and in this respect closely connected to II, pl. VIII and IX. We base our opinion, also, on the contrast to Jacopo's representation of the subject (confer I, pl. XXXIII), and on the amazing ease in the fusing of figures and landscape, also felt by Mrs. Fröhlich-Bum. Compare Bellini's "Crucifixion" in the Museo Correr (ill. *Klassiker, Bellini,* 24) and his "Mount of Olives" in the N. G. (ibid. 20). The manner of drawing leads to drawings like No. **308** and No. **319**.
[*Pl. VI,* 2. **MM**]

Pl. XIX (fol. 21b). While Fröhlich-Bum, p. 43, dates the drawing early and compares it with the stage of Giotto, Simon places it in Jacopo's late period. Certainly it is a somewhat later version of I, pl. XXIX. Goloubew's reference to the painting of the same subject in Padua (ill. van Marle XVII, fig. 72) is more in favor of a late origin.

Pl. XX (fol. 22a). Another drawing untouched and added afterwards. Van Marle XVII, fig. 73, refers to a portrait of a youth, formerly in the Dreyfuss Coll., now N. G. Washington, Kress Bequest, which, indeed, is very similar. The conception may possibly be traced back to Fra Filippo Lippi's portraits.

Pl. XXI (fol. 22b). Placed by Simon, p. 53, in the last phase of Jacopo's latest style. In our opinion, again on the borderline between him and Gentile.

Pl. XXII (fol. 23a). Further development of I, pl. LXXXIII. The ornamental parts, possibly due to the reworking are far advanced over the archaic style of the composition and the types. (See II, pl. V.)

Pl. XXIII (fol. 24a). While Simon, p. 36, finds here an advance over I, pl. XVIII, in our opinion, the latter version is later.

Pl. XXV (fol. 26a). Compare our notes to I, pl. XXV.

Pl. XXVI (fol. 27a). The relation of this drawing to I, pl. LXXIX is similar to that of II, pl. III to I, pl. XXXVII. Again a composition executed in large figures in the preparatory stage has been reduced to a smaller size, in order to obtain a more complete fusion with the architecture. This, in our opinion, is an evidence of an entirely different approach and, combined with the correctness of the construction (also emphasized by Fröhlich-Bum, p. 47) and with the resemblance to the foreshortened tunnel vault in Gentile's "St. Theodore" (ill. van Marle XVII, fig. 76), an argument for finding in this drawing a mixture of Jacopo and Gentile.

Pl. XXVIII (fol. 28b and 29a). The drawing is to be compared to I, pl. XCIV representing the same subject beyond which, it is true, it is far advanced. The closeness to Crivelli's painting in the N. G., of 1486, (ill. van Marle XVIII, fig. 27) is a further reason for doubting that Jacopo might already have reached this stage.

Pl. XXIX (fol. 29b and 30a). Fröhlich-Bum p. 44: middle period. Simon, p. 53: late period. The drawing shares with I, pl. XXI and LXX the motive of the cavalcade riding through a ravine, but is far advanced beyond both preceding versions, for which we emphasized the dependence on, or relationship to, Mantegna's representation of the subject in the Uffizi. (May we add that the man in the lower r. corner, seen from behind and sitting on a beam, resembles — and softens — a similar figure in Mantegna's engraved Flagellation, B. 1, *Klassiker, Mantegna,* 147). In the drawing here the meaning of the scene is entirely subordinated to the desire to represent space and

movement; we also notice in the linework a definite resemblance to Gentile Bellini. (For the different manner in which Gio. Bellini developed Jacopo Bellini's inheritance see II, pl. VIII and IX).

Pl. XXX (fol. 31a). Compare the preceding drawing in order to note the difficulty of bringing two so fundamentally contrasting versions within the limits of one single personality. II, pl. XXX is certainly the earliest of the Adorations as II, pl. XXXVI is the earliest of the Crucifixions. Goloubew's statement that it is still close to Gentile da Fabriano's famous composition seems correct.

Pl. XXXI (fol. 32a). Goloubew's suggestion that the drawing may be a design for the arrangement of Donatello's "St. John the Baptist" in the Frari, lacks any plausibility, this figure resembling the drawing but very little. The drawing has suffered heavily from retouching, the lateral candlesticks may be entirely new additions; their decoration recalls the tomb of Giovanni Sobota by Niccolò Fiorentino in San Domenico at Traù, of 1469, a date which seems very appropriate (ill. *Jahrbuch des kunsthistorischen Instituts*, 1913, fig. 111 opp. p. 137).

Pl. XXXII (fol. 33a). Simon, p. 50: late.

Pl. XXXIII (fol. 34a). The relationship to II, pl. XV is striking. Note the dependence of the group of the Marys in Mantegna's "Crucifixion" from S. Zeno in the Louvre (ill. *Klassiker, Mantegna*, 87) and, perhaps, of the Magdalene seen from behind in Mantegna's engraving B. 4 (ibid. 149).

Pl. XXXIV (fol. 35a). The architecture is based on the arch of Titus in Rome (compare II, pl. III), but enriched like Laurana's Triumphal Arch in Naples (ill. Venturi 6, fig. 50, and better Dedalo, 1932, p. 443). The popularity of the model in North Italian art is confirmed by Mantegna's use of it in his "Martyrdom of S. Jacob" in Padua, and by the main entrance of the Arsenal in Venice, of 1460. We question Simon's, p. 21, dating in Jacopo's middle period, and place the drawing among those in which a collaboration by Gentile — or even his authorship — seems more probable. [*Pl. III*, 4. **MM**]

Pl. XXXVI (fol. 37a). Goloubew's reference to Altichiero's "Crucifixion" in Padua (ill. van Marle IV, fig. 63, 64; see also the shop production, ibidem fig. 78) is correct, the composition is the earliest version of this subject within the sketchbooks and might offer a clue to Jacopo's mural of 1436 in the cathedral of Verona (see p. 106). Compare the "Crucified Christ" in the Museo Civico in Verona, attr. to Jacopo and usually connected with that lost mural. Its close connection with the Paduan tradition is confirmed by the "Crucifixion," formerly in the Trinity church, now in the Museo Civico in Verona "under the immediate influence of Altichiero and Avanzo" (Biadego, *Verona, Italia Artistica*, 45, p. 82, ill. ibidem p. 99) and Giusto's painting in the Baptistry, (ill. Moschetti, *Padua*, p. 75). [*Pl. V*, 1. **MM**]

Pl. XXXVII (fol. 37a and 38a). Goloubew's reference to Donatello's Gattamelata as a model for the horse confirms Simon's, p. 48, dating of the drawing in Jacopo's middle period, on the basis of the construction of space. "The scene represented offers a pretext for the landscape." The rendering of the horse accompanied by the dog recalls Dürer's engraving, B. 98. The motive of the eagle sitting on a stump is encountered also in Pisanello's medal of Alfonso I, 1449 (ill. van Marle VIII, p. 183, fig. 112).

Pl. XXXVIII (fol. 39a). Goloubew points to the neutral background, the same as in II, pl. XXXV, and suggests for the subject a theme derived from the humanistic currents of the time. Stylistic reasons lead us to date the drawing in the 1440's.

Pl. XXXIX (fol. 39b and 40a). The meaning of this drawing has not been satisfactorily explained. While Corrado Ricci, p. 70, points to the Italian proverb "Homo a cavallo sepoltura aperta," Molmenti (*Storia Privata*, I, p. 221) and Weizsaecker (*Das Pferd in der Kunst des Quattrocento, Jahrb. Pr. K. S.* VII, p. 159) find here a reminiscence of Marcus Curtius, and Testi (II, p. 234) suggests some illustration of the passage in the Gospel describing the opening of the tombs in the moment of the death of Christ. Testi refers to No. **312** and considers our drawing a special study of this iconographic detail. As for the magnificent figure of the rider at the r., Goloubew's reference to the man on horseback in II, pl. XXXVI, seems attractive; both might be traced back to the same plastic model, the more so as II, pl. XXXIX too, belongs to Jacopo's middle period. Fiocco, *L'Arte di Mantegna*, p. 38, compares the figure with the warriors in Uccello's "Battle of St. Egidio," in the N. G. The soldier at the l. reminds Goloubew of Alfonso d'Aragon as represented on Pisanello's medal and in drawings in the Codex Vallardi (see for instance van Marle VIII, fig. 115, p. 187). The resemblance, in our opinion, is purely accidental.

Pl. XL (fol. 41a). The correctness of the title as given by Goloubew "The head of Hannibal presented to Prusias" (based on the wording in the old index "uno Chaxamento come le apresenta la testa d'Annibal") is questioned by Mandach in *Gaz. d. B. A.*, 1922/II, such an event not being mentioned by any source. He suggests instead the head of Asdrubal presented to the Roman consul Claudius Nero, or sent by this consul to Hannibal. These scenes are encountered among the illustrations of the Romuléon, a popular book of the 15th century, compare Henri Martin, *Les Joyaux de l'Arsenal, II, Le Romuléon*, pl. IX. As for the architecture Testi I, p. 481, emphasizes the correctness of the construction, while Fröhlich-Bum, p. 49, fig. 13, used just the drawing as an example of the incorrectness of Bellini's constructions. Simon (p. 15) too considers the drawing a "struggle for scientific rules, not a knowledge of them." In our opinion, the general resemblance to II, pl. X or XII is notable; as there the perspective is not utilized as a means of expression, but used only for a pleasant decorative effect. This, and a comparison with such interiors as that in Mansueti's "Miracle of the Cross" (ill. Venturi 7, IV, fig. 344) makes us propose a very late date for the drawing.

Pl. XLII (fol. 42b and 43a). We see no point in Goloubew's reference to Mantegna's "Triumph of Caesar."

Pl. XLIV (fol. 45a). The horse at the l. is again inspired by Donatello's "Gattamelata."

Pl. XLV (fol. 45b and 46a). The second half of the middle period.

Pl. XLIX, L (fol. 48b and 49a, 49b and 50a). See I, pl. CXI, for Mandach's interpretation of the scene. For the shield formed by the carapace of a huge turtle compare Mantegna's engraving, "Entombment of Christ," B. 2, ill. *Klassiker, Mantegna*, p. 150.

Pl. LII (fol. 51b). Like II, pl. XIV one of the additional drawings. Goloubew is reminded of Bono da Ferrara's "St. Christopher" in the Ovetari chapel at Padua. In our opinion, the motive is still freer, more

advanced and beyond Jacopo, so that we are inclined to consider Giovanni Bellini as the author.

Pl. LIII (fol. 52a). Goloubew's tentative interpretation as the Sepulchre of Christ seems rather doubtful. Simon, p. 14: early. We call the attention to the decayed wall in lower l. corner, a popular symbol in Christian art.

Pl. LIV, LV (fol. 52b, 53a, 54a). The two studies are placed by Simon, p. 44, in Jacopo's middle period. Goloubew sees Florentine influences in the composition without specifying them. In our opinion, II, pl. LV, is more archaic than II, pl. LIV which by its composition already foreshadows Gio. Bellini's early painting in the Museo Correr (ill. *Klassiker, Bellini*, 24). [*Pl. VII*, 2. **MM**]

Pl. LVII (fol. 56a). This is the only drawing, the authenticity of which was questioned by Fröhlich-Bum because of the scarcity of material suitable for comparison. An iris of a similar character, however, appears in the border of Gentile da Fabriano's "Trinity" of 1423 (ill. Testi II, pl. facing p. 348). This seems to support Jacopo's claims.

Pl. LVIII (fol. 57a). This brush drawing, in its technique also different from the rest of the book, is, at any rate, very important as a point of departure for Gentile Bellini's sketches (see Nos. **263**, **270** and also No. **628**). In our opinion, its advance in a pictorial style and its spontaneity in the rendering of a spatial unity are so marked that we give the drawing to Gentile with whose landscape in the "St. Francis" in the Museo Marciano (ill. van Marle XVII, fig. 120) it should be compared. [*Pl. VI*, 3. **MM**]

Pl. LXIV (fol. 62a). A study of the retouches is instructive. Two heads which apparently were in a good shape and therefore were spared reworking, have entirely vanished. Moreover, Goloubew points out that the figure of St. Sebastian is reworked by a hand which otherwise is not to be discovered in the book. The linework in the figure, and in the pious widow beneath, shows a sharpness which recalls Crivelli's style.

Pl. LXV (fol. 63a). Compare the figure of St. George by Domenico de Paris, of 1455, in the cathedral at Ferrara, ill. Venturi 6, fig. 106. Domenico collaborated in Baroncelli's statue of Borso d'Este of Ferrara and may easily have been in personal contact with Jacopo.

Pl. LXVI (fol. 64a). Fiocco, *L'Arte di Mantegna*, p. 40 f., compares the condottiere with Uccello's painted monument of John Hawkwood, 1436, in the cathedral at Florence (ill. van Marle X, fig. 137, p. 213). The resemblance is, however, limited to the posture of the horse, which in both cases might go back to the classic model of the antique horses in the façade of St. Mark.

Pl. LXVII (fol. 64b and 65a). Fröhlich-Bum, p. 43, and Simon, p. 25, agree in placing the drawing, the composition of which is prepared in I, pl. XLVII, in Jacopo's middle period. We feel it to be advanced to the point where Jacopo's and Gentile's style run into one another.

Pl. LXVIII (fol. 66a). With good reason Goloubew adds a question mark to the caption identifying the warrior as St. George. All the characteristics of the latter, indeed, are missing (the dragon, the princess and the horse). It is more probably a representation of the local Venetian Saint Theodore, to whose representation by Gentile in the organ shutter of St. Mark's (ill. van Marle XVII, fig. 76) the resemblance is striking.

Pl. LXIX (fol. 67a). Only the two figures at the r. are retouched. The monk is identified as St. Francis by Goloubew, and as St. Bernard by L. Testi (II, p. 239), the latter identification suggesting an origin after May 24, 1450, the date of St. Bernard's canonization. In the unretouched parts the stylistic advance over the figures in the somewhat related composition I, pl. XXXII, seems so notable that we suggest Gentile. [*Pl. V*, 2. **MM**]

Pl. LXX (fol. 68a). Goloubew, who supposes the drawing to be a design for a church banner, points to one ordered in 1452 of Jacopo for the Scuola della Carità: "secundum formam et designum datum." The resemblance with Jacopo's "Madonna" in the Uffizi (ill. van Marle XVII, pl. facing p. 114) emphasized by Ricci and supported by Testi (II, p. 240) is notable, but no great help, since, vice versa, the attribution of the painting to Jacopo is chiefly based on this resemblance. The date suggested by Goloubew is confirmed by a rather close resemblance to the statue of the Virgin and Child in the Loggia at Udine, attr. to Bartolommeo Buon and dated about 1448 by Planiscig, fig. 21.

Pl. LXXII (fol. 69b). According to Simon, p. 27: late. This date is confirmed by the amazing clearness and preciseness, both recalling No. **265**. In our opinion, Jacopo is here very near to Gentile. [*Pl. VI*, 4. **MM**]

Pl. LXXIII (fol. 70a). For the unidentified subject Goloubew points to the plague of 1444, for the architectural frame to the "Death of the Virgin" in the Mascoli chapel in St. Mark. Taking both points into consideration we arrive at a date about 1450 or in the early 1450's. For the figures left outside the frame see II, pl. III.

Pl. LXXIV (fol. 70b). One of the additional silverpoint drawings, see II, pl. XIV, but this time certainly by Jacopo himself and even rather early.

Pl. LXXVIII (fol. 73a). Compare I, pl. XLV.

Pl. LXXIX (fol. 74a). Goloubew's reference to Donatello's "Christ" in Padua is, in our opinion, pointless; we are better satisfied by van Marle's reference to Jacopo's painting in Padua (XVII, p. 116, fig. 70).

Pl. LXXX (fol. 75a). For the subject, see I, pl. CXI.

Pl. LXXXI (fol. 76a). One of the additional silverpoint drawings, see II, pl. XIV and LXXIV. The identification as a study after an antique marble seems attractive; various models have been suggested. It seems to be the same figure that Donatello used in his relief in the Santo (ill. Venturi 7, III, fig. 102). The style is far advanced beyond Jacopo. For general stylistic reasons the authorship of Giovanni seems more likely. For a comparison with one of Jacopo's drawings of a similar character, see II, pl. LXXXIII.

Pl. LXXXII (fol. 76b). The figure of this David is identical with the one that appears as Goliath in I, pl. LXXII. The head in upper r. corner is a later addition.

Pl. LXXXIII (fol. 77a). We place the drawing between the early I, pl. LXXVI and the late II, pl. XXXI. The nearest in style of the St. John's might be the one in I, pl. XXXII.

Pl. LXXXVI (fol. 80a). Goloubew is right, when pointing to the heraldic character of this lion in contrast to many others in these books, for instance in II, pl. LXXVI, LXXVII. The posture is typical

of the official lions of St. Mark, compare for instance, the one in the painting in the Ducal Palace, ascr. to Jacobello del Fiore, ill. Testi I, p. 397.

Pl. LXXXIX (fol. 83a). Much later than the preparatory stage I, pl. XI. A very similar representation is found in a relief by Pietro Lombardi on the pedestal of the Pietro Mocenigo monument in San Giovanni e Paolo of 1476 (ill. Planiscig, fig. 40).

Pl. XCII (fol. 85 and 86a). Mandach's suggestion, *Gaz. d. B. A.* 1922/II, p. 58, that we identify the subject of this drawing as the Legend of St. Justina and St. Cyprian is not acceptable, since the pagan priest who was present at the martyrdom of the two saints was certainly devoured by the flames and cannot be the old man being carried in our drawing.

A 365 ————, 2029. Bust of the Virgin and Child.

According to Testi II, 244, the whole head of the Child and the shoulders of the Mother were added at the beginning of the 19th century. Coll. Vallardi. Formerly ascr. to Leonardo da Vinci, now to the school of Gentile da Fabriano. Attr. to Pisanello by A. Venturi (*Le Vite del Vasari, Gentile da Fabriano e il Pisanello*, p. 26) and to Jacopo Bellini by Corrado Ricci, in *Rass. d'A.* III, p. 164, further in *Emporium* XVIII, p. 345 and 354, and finally in *Jacopo Bellini*, p. 39. The attribution was accepted by Lionello Venturi, *Origini*, p. 152, and Gronau, in Thieme-Becker III, p. 255. Testi II, p. 245 after a thorough discussion denies the connections with Jacopo Bellini and Pisanello. Van Marle XVII, p. 127, note, also rejects the attribution to Jacopo, without offering another.

In our opinion, the cautious attribution of this ruin to the school of Gentile da Fabriano, but not to his pupil Jacopo Bellini, points in the right direction.

366 ————, 425. The story of the three living and the three dead. Pen, light br., on prepared, wh. vellum. 212 x 400. Coll. His de la Salle. Attr. by Both de Tauzia to Benozzo Gozzoli, recognized as Jacopo Bellini by E. Dobbert, in *Repertorium*, 1881, p. 10 and 12. After the appearance of the Paris sketchbook it was soon supposed that the drawing and the two others from the His de la Salle Collection (see Nos. **367, 368**) had originally formed part of the volume. This suggestion has been firmly established by Seymour de Ricci, in *Revue Archéologique*, 1923, p. 88 ff. The drawing is in fact mentioned in the index of the Paris sketchbook as folio 91. Goloubew who publ. the drawing in II, pl. B, points to the earlier version of the same subject in London, I, pl. LVII. Fröhlich-Bum, p. 45 rightly, however, emphasizes the primitive character of the drawing which she considers an example of Jacopo's early period. **[MM]**

We place the drawing in Jacopo's middle period and in the group which on p. 110 we list as originating from the 1440's and early 1450's, the period of Jacopo's connection with the Court of Ferrara. The drawing in London, which incidentally has no close resemblance to the representation of the same subject in Paris, in our opinion, is somewhat later and more advanced.

367 ————, 426. Flagellation of Christ, in a huge palace richly decorated with statues and reliefs. Pen, reddish br. 394 x 290. Coll. His de la Salle. At an unknown time detached from the book now in the Louvre, see No. **366**. The drawing is mentioned in the index as folio 29, now missing. Publ. by Corr. Ricci, pl. XXXI and Goloubew II (appendix) pl. C, who enumerates the other representations of the same subject in the two sketchbooks. Among these the one in London, Goloubew I, pl. XCI, appears as the immediate preparation of the drawing in Paris, which is similar for the general arrangement and for some separate figures, but is evidently advanced in its rendering of space, more elaborate in the details and certainly later. Simon, p. 17 and 19, also emphasizes the advanced stage of its perspective elements. We believe this advancement to be so striking that we prefer to place the drawing in the group whose authorship between Jacopo and Gentile remains uncertain (see p. 110).

368 ————, 428. Funeral monument: A nude corpse recumbent on the lid of a sarcophagus, the front of which is decorated with a relief representing the triumph of a hero. Pen, light br., on wh. vellum. 120 x 398. Coll. His de la Salle. Originally in the sketchbook in the Louvre, as supposed by Corrado Ricci, p. 69–71 and established by Seymour de Ricci, see No. **366**. It has already been supposed by Gruyer and Heiss that the introduction of eagles as a decorative motive points to some connection with the Este family. The drawing may be a project for a funeral monument of Borso d'Este whose features Ephrussi, *Gaz. d. B. A.* 2nd series, vol. 25, (1882), p. 234, believed might be recognized in the recumbent man. (See also Gronau, in *Chronique des Arts et de la Curiosité*, VII, p. 55). The drawing thereby would be dated about 1450. Publ. by Corrado Ricci, pl. 109, and Goloubew II, pl. A.

369 ————, Walter Gay Bequest. View of a fortified town with a castle in the middle. Cut, portion of the drawing No. **358**. Pen, br., on paper turned yellow. 105 x 205. See No. **358**. [*Pl. IV, 2.* **MM**]

A 370. VIENNA, ALBERTINA, 16. St. Christopher carrying the Infant Jesus on his shoulder. Over ch. sketch, pen, wash, height. w. wh. 330 x 238. Sheet patched up at lower right. Acquired 1923 from Coll. Luigi Grassi. Publ. as Jacopo Bellini by Stix, *Albertina, N. S.* II, 11, and dated in his last period. *Albertina Cat.* II (Stix-Fröhlich) 16: the same. Rejected by us in *Zeitschr. f. B. K.* 1926-7, *Kunstchronik*, p. 110, and by Hadeln, ibidem, p. 112, but accepted by van Marle XVII, p. 96.

The representations of St. Christopher in Jacopo Bellini's sketchbooks, to which Stix referred, for instance, Goloubew, II, pl. 52, are, as already pointed out by Hadeln, arguments against the attribution to Jacopo. Because of the complicated posture of the figure and its relation to the landscape the drawing looks far advanced beyond Jacopo Bellini. We believe the relationship to Liberale da Verona, according to Vasari an imitator of Jacopo (Vasari V, p. 274) is closer. Compare for the posture his signed painting of 1489 in Berlin, Kaiser Friedrich Museum (ill. Venturi 7, IV, fig. 519).

VITTORE BELLINIANO
[*Mentioned 1507–1529*]

371 BERLIN, KUPFERSTICHKABINETT, 14697. Portrait of a beardless man, with cap, turned slightly to the l. Charcoal, on brownish gray. 241 x 175. In Berlin anonymous. Attr. to Lotto by Ad. Venturi in *L'Arte* 25 (1922), p. 114 (erroneously Vienna, Albertina).
[*Pl. XXXIX, 4.* **MM**]

The remarkable resemblance to one of the heads in the upper l. corner of Gio. Bellini's "Martyrdom of St. Mark," completed by Vittore Belliniano, in the Scuola di San Marco, Venice (ill. *Burl. Mag.* LI, pl. facing p. 187) induces us to make a tentative attribution of the drawing to Belliniano. At any rate, the drawing combines a Bellin-

esque structure with a Titianesque touch, a mixture that should be typical of Belliniano. (Compare the portrait by him signed and dated 1521, formerly in the Han Coray Coll. Sale, Berlin, 1930, pl. 1.) We know the drawing only from the reproduction.

A 372 CHANTILLY, MUSÉE CONDÉ, no. 1136. Portrait of Giov. Bellini. Pen, height. w: wh. 108 x 88. Inscription: J. Bellini Victor discipulus 1505. Coll. Lenoir. Companion piece to No. **A 294.** Formerly attr. to Vittore Carpaccio, on the basis of the inscription, now usually to Vittore Belliniano for the same reason. Ill. *Klassiker, Bellini*, p. XIV in juxtaposition to Giov. Bellini's portrait medal by Camelio. See also Gamba, *Bellini*, pl. 170.

For our reasons in rejecting the attribution see No. **A 294.** We add that a portrait of Giovanni Bellini, apparently done by Vittore Belliniano, is listed in his last will (1529, August 16): *Item lego . . . retractum qm. domini Joannis Beliniani olim preceptoris mei. . . .* (Gustav Ludwig, in *Jahrb. Pr. K. S.* XXVI (1905), Appendix p. 77).

372 bis ERLANGEN, UNIVERSITAETSBIBLIOTHEK 1537. Portrait of a bearded young man with a cap. Bl. ch. 193 x 146. Bock no. 1537: Later copy after a portrait in the style of Gentile Bellini. Listed as Anonymous Venetian first half of 16th century. [*Pl. XXXIX*, 3. **MM**]

The mode of drawing reminds us of No. **371** which we attribute to Vittore Belliniano. This tentative attribution is supported by the general stylistic resemblance to Belliniano's signed portrait of 1521, formerly in the Han Coray Coll. (Sale Berlin 1930, pl. 1).

BENFATTI, ALVISE, see FRISO.

FRANCESCO BISSOLO

[Mentioned 1492–1554]

Bissolo has been called the most faithful and slavish follower of Giovanni Bellini to whose model he clung beyond the middle of the 16th century. It would be presumptuous to attribute drawings to an artist of such a conservative type, unless they are solidly linked to existing compositions of his. Some doubts remain even for the two cases of this sort we know, No. 373 and No. 374.

373 NEW YORK, PIERPONT MORGAN LIBRARY, 53. Saint Helena between Saint Lawrence and Dominic. Brush, bistre, height. w. wh. 361 x 208. Arched top. Coll. Barnard, F. Murray. Attr. to Bissolo apparently on the basis of the composition. Ill. *Morgan Dr.* pl. 53. [*Pl. XLI,* 1. **MM**]

A comparison, however, with No. **374** reveals a very different style of drawing and other types. The figures of the male saints seem to be taken from Giov. Bellini's inventory. Saint Dominic shows a close connection to Giov. Bellini's corresponding figure in the Academy in Venice, ill. *Klassiker, Bellini*, 85, while St. Lawrence combines the Saint Francis of the same altar with St. Anthony in the so-called Giorgione painting in the Prado (ill. Venturi 9, III, fig. 16) and St. Helena corresponds to Cima's St. Catherine in the Wallace Coll., London (ill. van Marle XVII, fig. 256). This mixture is not too far from conforming to the prevailing idea of Bissolo's style. If the drawing is his, it might be from an earlier period than No. **374.**

374 VENICE, R. GALLERIA, 15. Design for an altar-piece in the cathedral of Treviso, St. Justina between St. John the Baptist and Catherine. Pen, br., wash. 363 x 199. Later inscription: di Francesco Francia. Attr. to Morto da Feltre by Lionello Venturi and Fogolari, pl. 53, first identified as Bissolo by Gronau (Thieme-Becker IV, p. 68), according to whom No. **1315** might also be Bissolo's design for the portrait of the donor in the same altar-piece. Publ. by Hadeln, *Quattrocento*, pl. 87, and K. T. Parker, pl. 45. [*Pl. XLI,* 2. **MM**]

The drawing cannot merely be called a design for the altar-piece, the differences between the two versions being too essential and the figure of the donor missing. Moreover, the difference in style is remarkable, the two female figures in the drawing apparently being influenced by Palma, and St. John following a model typical of the Quattrocento (compare Mocetto's engraving after a lost altar-piece, ill. *Jahrb. Pr. K. S.* XLV, p. 208), while on the other hand the painting displays the homogeneous style typical of Bissolo. Gronau dates it about 1530. The drawing may preserve the first idea which in accordance with the wishes of the patron was transposed into a more conventional arrangement.

BONIFAZIO DE' PITATI, CALLED BONIFAZIO VERONESE

[Born 1487, died 1553]

Miss Dorothy Westphal who devoted a special paragraph of her monograph on Bonifazio Veronese to his drawings (p. 132) reached the conclusion that of the nine drawings attr. to him by earlier critics none is to be considered as really authentic. The result of our own studies is much the same, our point of departure being, as was Miss Westphal's, Bonifazio's total artistic personality as it expresses itself in his paintings. This furnishes, however, an utterly unreliable basis of comparison, Bonifazio's painted production being a kind of medley of all

trends opposed to the leading school of Titian. In his studio, artists who endeavored to stay independent of Titian's predominance received their training. Bonifazio appears as a secondary figure reigning on the backstage of Venetian art and fusing stubborn survivors of the Quattrocento tradition into the artistic opposition of His Majesty Titian.

As for the drawings, an analogous conception of Bonifazio as the anti-Titian, induced Westphal to reject a few attributions to him, Nos. 1282, 1283, suggested by Hadeln though with reservations. She found the drawings too positively influenced by Titian. Maybe we can go a little farther. On a pen drawing in the Museum of Rennes (No. 383) two earlier owners or connoisseurs have written the names Carpaccio and Bonifazio. This alternative is perhaps not so absurd as it sounds. There is something of Carpaccio's zest as a story teller and of his underlying simplicity, as compared with Titian's problems, to be felt in drawings that might be by Bonifazio; in No. 384, though apparently considerably later, the style of Carpaccio's late models (see No. 590) is followed. In the drawing in Rennes one could only think of a reminiscence of Carpaccio's sketching style (see No. 592), but the drawing is decidedly Cinquecentesque and borrows from Dürer and the late Bellini. Being vaguely related to compositions by Bonifazio, it may, with all the reservations necessary in such a case, be placed in the dim sphere in which Bonifazio's formation took place.

Another group of drawings leads us to just the opposite end of Bonifazio's career: to the point where Andrea Schiavone, supposedly the most important of his pupils (leaving aside the doubtful case of Jacopo Tintoretto) branches off from him. Busts of prophets (No. 376) formerly attributed to Bonifazio were claimed for Schiavone by Hadeln. However they fit less well into the latter's mannered style than into Bonifazio's as it is represented for instance, by the, certainly doubtful, No. 384. Miss Westphal omitted a discussion of the drawing in Berlin which apparently was merged into the new attribution to Schiavone when she made her studies; but she devoted to the general problem involved here a special study when publishing in the *Zeitschr. f. B.K.* 1927/28, p. 314 ff. sheets of a dispersed album (in the Louvre, No. 1448) as possible studies by Schiavone after compositions of his master Bonifazio. They are typical shop productions, exercises of a pupil made from paintings, too poor to be given to an individual artist, but suitable to illustrate the significance of the Bonifazio shop within Venetian art as a schooling place.

For an alleged point of contact between Jacopo Bassano and Bonifazio compare No. 378—for which among Bonifazio's numerous followers we select a somewhat forgotten man, Jacopo Pistoja. For his better known pupil Antonio Palma see No. 820.

A 375 BERGAMO, COLL. FRIZZONI (formerly). Head of a young man. Red ch. Publ. by G. Frizzoni, *Disegni della Raccolta Morelli*, pl. XXIV. Westphal, 132: close to Bonifazio, but too sculptural and precise to authorize the attribution.　　　　**[MM]**
In our opinion, the drawing, which we have not seen — is from the 18th century.

376 BERLIN, KUPFERSTICHKABINETT. Busts of prophets, each composed in a circle. Red ch. 97 x 102. Ascr. to Bonifazio, publ. by Hadeln, *Spätren.*, pl. 11, who replaced this attribution by one to Schiavone.　　　　**[Pl. XCVI, 1 and 2. MM]**
Without having been able to re-examine the drawing we consider the traditional name more convincing.

A CHATSWORTH, DUKE OF DEVONSHIRE. The Virgin with the Infant, St. Jacob and St. John as a child, see No. 1282.

A ——, Variation of No. 1282, see No. 1283.

377 CHELTENHAM, FENWICK COLL. Fenwick Cat.: Palma Vecchio, 2. Wedding of Cana. Pen, br., wash. 140 x 280. On the back inscription: Giorgione très rare. Squared. Coll. Lawrence, Woodburn Sale. Formerly attr. to Palma Vecchio. Popham questions this attribution, pointing to Vicentino's painting for Ognissanti, engraved by N. Cochin, and showing some resemblance in its architecture. "Perhaps Vicentino was influenced by the picture presumably painted from the present drawing."　　　　**[MM]**
In our opinion, the style of composition is close to Bonifazio to whom we tentatively attribute the drawing.

378 CHICAGO, ART INSTITUTE. Christ and the disciples at Emaus. Bl. ch., on blue. Squared in r. ch. 345 x 278. In lower r. corner scarcely legible inscription: Jacopo and two words interpreted by Dr. Middel-

dorf as da Ponte. Coll. Gurley. The drawing used to be ascr. to Bonifazio, but is considered by Dr. Middeldorf as an early drawing by Jacopo da Ponte (Bassano). [*Pl. XCVII*, 1. **MM**]

The disciple at the l. seems to have been drawn first since his legs are visible under the tablecloth. The style is not Jacopo Bassano's and the figures lack the rustic simplicity of his early paintings. There is a far closer resemblance to Bonifazio's compositions and types. A painting of the same subject in the Palazzo Pitti in Florence was publ. by Molmenti in *Emporium* XVII (1903), p. 434, as by Jacopo Pistoja, a painter whose identity with an artist called Pisbolica by Vasari has been made plausible by Ludwig (*Jahrb. d. Pr. K. S.* 22, 1901, p. 198). The drawing shows a certain relationship to this painting (compare for instance the hands) but a far closer approach to Bonifazio's style. In his painting in Riese, according to Ludwig, Pistoja reveals himself as an immediate follower of Bonifazio. These points may justify a tentative attribution of the drawing to this Jacopo whose second name may be the one to be guessed from the inscription.

A 379 FLORENCE, UFFIZI, 1754. Adoration of the Magi. Pen, br. and brush, gray and wh., on buff paper. 200 x 337. Later inscription: Bonifazio.— On the back: A child's head looking up. Pen, br. Hadeln in Thieme-Becker, Bonifazio, but not mentioned in his *Hochren*. Westphal, p. 132, rejects Hadeln's attr. because the drawing is too Giorgionesque and too plastic. "The drawing is clumsy and awkward, the composition trivial. Compare the body of the old king, the proportions of the Virgin, and the way she holds the Child." [**MM**]

In our opinion, the drawing is at any rate a copy from a painting; see for instance the l. side where the whole confusion of the dog's legs, the horse's legs, the broad sword, the servant's legs, each overlapping the other is set forth neatly and without any hesitation or error. We doubt whether the painting which the drawing reproduces was by Bonifazio. The two big horses in the foreground would be quite a novel feature even in his most advanced style. The anonymous painting no. 711 in the Museo Civico in Verona (Venetian, 16th century) is very close in style.

A 380 LONDON, BRITISH MUSEUM, 1902–6–17 — 3. The disciples at Emaus. Pen, br. 203 x 303. Paper slightly damaged by mold. In the collection: anonymous. Mentioned by Schönbrunner-Meder 1367 as Bonifazio. (Is this the same drawing as Sloane 5237–146 which Hadeln in Thieme-Becker listed as Bonifazio and Westphal l. c. 132 rejected?) [**MM**]

In our opinion, the drawing is a copy from a painting by an artist influenced by Bonifazio, but advanced beyond him. The drawing shows only the main part of a composition which on the r. contained some more servants; compare another copy in the Uffizi, attr. to Paolo Veronese on Philpot's photograph 1879. (Error by Philpot? Paolo Veronese instead of Bonifazio Veronese?)

381 MILAN, AMBROSIANA, Coll. Resta 100. Portrait of a young man. Bl. ch., height. with wh., on grayish green. 370 x 235. Inscription on lower l. corner: Bonifazio Ven. Hadeln, *Hochren*. p. 29: indubitable autograph. Westphal l. c., p. 132, fig. 74, rejects the attr.: too plastic and linear, not so pictorial as Westphal believes drawings by Bonifazio should be. She cannot find a kindred figure in Bonifazio's work. [**MM**]

In our opinion, the old tradition is to be maintained since there is not a single verified drawing by Bonifazio whose stylistic qualities would exclude the attr. It may be a drawing of his early time when his style was still in formation.

382 NEW YORK, COLL. ROBERT LEHMAN. Christ and the disciples at Emaus. Pen, brush, wash with yellow, on blue. 250 x 295. Inscription in pen: Bonifacio. Coll. Grahl, Habich, Archduke Frederick (Albertina), Henry Oppenheimer, London. Publ. by Schönbrunner-Meder, 1367 with the caption: the drawing has been recognized by Ludwig as a design for Bonifazio's painting in the Brera. According to Westphal, p. 133 "more likely a copy from a Bonifaciesque painting and later than the one in the Brera." [*Pl. XCVII*, 3. **MM**]

In our opinion, more likely a modello for a painting by Bonifazio himself. (The illustration in Schönbrunner-Meder is somewhat misleading.)

383 RENNES, MUSÉE. Lamentation. Pen. Inscription: Carpaccio — and — Bonifacio. [*Pl. XCV*, 4. **MM**]

The drawing is unpubl. We may drop the attribution (by a former owner?) to Carpaccio to whose style in sketching it shows only very little resemblance. We take up the other attribution for three reasons: 1) for the connection with Dürer, a characteristic feature of Bonifazio's compositions; 2) for the relationship of the composition to Bonifazio's two "Adoration of the Magi" (1536, Venice Academy, ill. Westphal 14 and Vienna Academy, Westphal 34). 3) Since the two first arguments represent only the conclusions of modern criticism the fairly old inscription "Bonifazio" may have had a special reason. The borrowings from Dürer are at the l., the two figures seen in front are taken from Dürer's woodcut B. 79, and the figure there seen from behind from woodcut B. 82. They date the drawing after 1504 whereas the central group with its approach to drawings attr., or at least attributable, to Giovanni Bellini might indicate an earlier date. Technique and style derive from the Bellini tradition, but at the same time are distinctly advanced beyond it. This fits rather well with the very little we know, or conjecture, about Bonifazio's first four decades, so that we consider our hypothetical suggestion, although very daring, still admissible as a basis for discussion.

384 WEIMAR, MUSEUM. Christ seated in glory, on the ground St. Francis and St. Rocchus. In the distance, view of Venice from the Riva degli Schiavoni. Pen and brush, wash. 173 x 272. In lower l. corner late inscription: Titianus. Photographed as Ja. Tintoretto, sketch "for the painting in the Scuola di San Rocco," by Braun 79769. [*Pl. XCVI*, 3. **MM**]

The composition corresponds to a painting attr. to Palma Vecchio, in the Collection of the Duke of Alba in Madrid, an attribution rejected by Spahn in her book on Palma and not discussed by Gombosi in *Klassiker, Palma Vecchio*. In our opinion, there are elements of Palma, but transposed to a later style, in which we recognize an affinity to Bonifazio and his school. The combination of these elements might point in the direction of Antonio Palma who, a problematical figure himself, can hardly be distinguished from the late Bonifazio.

PARIS BORDONE

[Born 1500, died 1571]

Paris Paschalinus Bordone is characterized by Vasari as the one artist who imitated Titian more closely than any other. The study of his pictures, however, leads to the result that Palma Vecchio may have had an even greater influence on his manner of painting. Vasari's statement however seems to be so competent for the drawings that quite a few of his most typical productions in this field had to be segregated from the inflated stock of Titian's drawings. The point of departure for the attributions to Bordone is the fact that some of the drawings may be connected with authentic paintings of his, and in this case the biographical circumstances seem to forbid the other explanation, namely, that Bordone used drawings of Titian for his own compositions. The bad relations between the two artists are explicitly emphasized by the literary sources.

Bordone, it is true, had for some time been working in Titian's studio, and the subsequent break between them does not nullify the early connections between them. In Titian's "Annunciation" in Treviso, about 1519, accepting Öttinger's suggestion, we notice a considerable collaboration of Bordone and, on the other hand, we believe that Bordone's masterpiece, "The Fisherman Delivering the Ring to the Doge," is notably influenced by Titian for the general arrangement (see Tietze, *Tizian,* p. 129). This, however, is one thing, and another the regular use of designs or *similes,* a proceeding typical of the normal relationship between master and pupil. We do not believe that something of this kind is to be supposed with Bordone and we therefore reject the attribution to Titian of No. **405**, representing the fisherboy in the foreground of the just mentioned picture only, on the ground that the drawing seems too good for Bordone.

It certainly looks good enough for Titian, but it is, at the same time, different from him in style; the same argument may be also applied to the other drawings of this group, despite their noticeable approach to Titian. In our opinion, Bordone who might have been with Titian about 1520 or in the early twenties, like many another weaker talent that for some time, and in particular in its early years, had been in close touch with a superior genius, never entirely overcame the impressions then experienced. His drawings continue to repeat and modify Titian's models of that time, an example of which is offered by No. **1929**. Favoring the medium of black chalk, Bordone tried in his drawings to express Titian's pictorial intentions—the play of light and shadow on the surfaces, the multitude of little folds and rumples in the draperies. Stubbornly clinging to a mode of expression already left behind by his secretly admired ideal Bordone obtained a kind of personal style, on the whole not too difficult to distinguish from Titian's. This style is represented by Nos. **388, 390, 391, 392, 393, 394, 396, 400, 401, 403, 405**, to which perhaps Nos. **395, 399** may be added. Several of these drawings were formerly ascr. to Titian and publ. by Hadeln under his name; their segregation from Titian was first attempted in our *Tizian-Studien* (p, 187) and continued by E. Tietze-Conrat in *Burl. Mag.* 1938, p. 189. Starting from this relatively well established idea of Bordone's drawings in black chalk, may we venture to also attribute to him pen drawings of which no authentic sample exists? Other critics have already assumed this responsibility with regard to No. **402** in the Rasini Coll., an attribution supported by certain resemblances to paintings by Bordone. We are still more audacious when accepting the traditional attribution to him for No. **398** and at least not contradicting it for No. **389**. No. **407** is completely without support, unless the traditional attribution to Pordenone gives a clue, since he and Bordone were frequently taken for one another by older collectors. Where other evidences are missing the traditional ascriptions gain importance, without, of course giving complete certainty.

Where even this insignificant help is lacking a still greater skepticism is justified. In the cases of No. **A 387** and No. **A 409** we feel a greater closeness to Romanino, and, in our opinion, the connection to Bordone in No. **A 385** is limited to the identity of the subject with that of Bordone's famous composition. The considerable difference in style makes us suppose that this very finished drawing, a *modello,* as Hadeln noticed, and therefore the final stage of the composition, may have been presented on the same occasion by another artist more closely allied to Bonifazio.

A 385 ASCHAFFENBURG, SCHLOSSBIBLIOTHEK. The Fisherman bringing the ring of S. Mark to the Doge. Pen and brush, height. with wh., on blue. 422 x 325. Much damaged and awkwardly repaired. Hadeln, *Hochren.,* 65: "*Modello*" for Bordone's famous painting (Venice, Academy) executed about 1533. In our *Tizian-Studien* p. 187, note 90, we rejected the attribution.

The composition is indeed based on principles different from those which Bordone followed as a rule. In spite of his liking for rich architecture in his paintings he never succeeded in placing his figures convincingly within the architectural frame. The painting in the Academy differs so far from his usual awkwardness in this point that a special reason for this exception may be sought, and in Tietze, *Tizian,* p. 129, a dependence on Titian's lost composition in the Sala del Maggior Consiglio, Ducal Palace, has been suggested. The architecture in the drawing is so far advanced beyond the stage reached by Bordone in the Academy painting, that it cannot be considered his preliminary study, even leaving aside the lack of real analogies between the two versions. In our opinion, the drawing might be the work of another artist competing for the same commission as Bordone, like Pordenone's project No. **1342**.

We see this artist more in the direction of Bonifazio to whose "Christ driving the merchants from the temple" (in the Royal Palace in Venice, Photo Anderson 11773) a distinct affinity exists. Compare the architecture in the r. half of this composition. The architectural scheme of the drawing reappears in a "Wedding of the Virgin," attr. to Paolo Veronese (ill. in *Apollo* 1930 XI, 61, January, from the property of the International Art Gallery Ltd., London). Also this painting of around 1550 follows the style of Bonifazio. For the mode of drawing see No. **384** where several details are very similar.

A BERLIN, KUPFERSTICHKABINETT, 5733, see No. **1878**.

386 BREMEN, KUNSTHALLE. The man of sorrows. Bl. ch., height. w. wh., on blue. 270 x 202. In the coll. anonymous. Publ. by O. Benesch, *Graph. Künste,* N. S. I., p. 60, as by Jacopo Bassano, in his latest period, under the influence of Titian's latest style.

[*Pl. LXXXVII, 2.* **MM**]

We are unable to find any connection with Jacopo Bassano's style as shown by his drawings. Titian's influence, moreover, could reasonably be supposed to have been effective only in Bassano's paintings, not in his drawings. We tentatively propose Bordone as the author, but admit that we have not seen the drawing in question and, furthermore, that the drawing by Bordone which is the closest to it — No. **403** — has been attr. to Bordone only for stylistic reasons. There is however, also a noteworthy resemblance to the better authenticated No. **405**.

A 387 BUDAPEST, MUSEUM, E. 18. Men on horseback riding to the right. Pen, br., on grayish green. 278 x 269. Later inscription: Titiano. Schönbrunner-Meder 585: Titian. L. Fröhlich-Bum, N. S. II, p. 187, fig. 253: Bordone, about 1525, with reference to the St. George by Bordone in the Vatican Gallery.

The handling is markedly different from that of Bordone's authentic drawings. On the contrary, it convincingly resembles Romanino's.

388 CAMBRIDGE, MASS., FOGG ART MUSEUM, no. 70. Partly draped nude woman, moving to the r., and looking back and down to the l., three quarter length. Ch., height. w. wh. 300 x 202. Inscription from the period: A. Slightly rubbed. Upper l. corner torn. Coll. Richardson. Charles Loeser Bequest 1932 — 283. Publ. as Titian by Hadeln, *Tizianzeichnungen,* pl. 29, and accepted as his and dated about 1550/60 by Fröhlich-Bum, N. S. II, no. 37. Exh. Toledo 1940, no. 74 as Paris Bordone, an attribution accepted, however, with a question mark, by Mongan-Sachs p. 56 fig. 60. At any rate they reject the attribution to Titian. [*Pl. LXXXIII.* **MM**]

Our attribution to Bordone is based on the stylistic resemblance to No. **390** and No. **391** which shows a similar head and the same way of accompanying the outlines by a foil of hatchings.

389 FLORENCE, UFFIZI, Paesi 501. Study of plants (for the foreground of a painting). Pen, br., on yellowish. 165 x 240. — On *verso* Bordone's name, cut and rewritten. [*Pl. LXXXVIII, 1.* **MM**]

By the linework the drawing is dated about 1520. It might be a study from nature by some young artist under Titian's influence (compare the similar treatment of plants in Giulio Campagnola's engraving Kristeller 13). We have no reason to question the tradition, although we cannot prove its correctness.

390 ————, 1804. Study of a female nude, half length. Bl. ch., height. with wh., on blue. 318 x 200. Hadeln, *Hochren.* 63. Popham, *Cat.* 275. Another version of No. **391**, more differing from the executed painting, see there.

391 ————, 1805. Study of a female nude. Bl. ch., height. with wh., on blue. 407 x 256. Bailo-Biscaro, p. 194, 3: Study for the painting "Bathseba" (1552) in the Wedell Coll. in Hamburg. *Uffizi Publ.* III, p. I, no. 24 Hadeln, *Hochren.* 62. [*Pl. LXXXVI, 1.* **MM**]

The figure in the painting (ill. in *Dedalo* XIII, 1933, p. 254) shows a very close connection with this drawing, except for the detail of the head placed in another position. In our opinion neither this drawing nor its companion No. **390** is dated by the painting (in 1552). Bordone might as well have used earlier studies he kept in store for the painting.

392 ————, 1806. Study for one of the Magi. Bl. ch., height. with wh., on blue. 297 x 182. Hadeln, *Hochren.* 60.

The drawing could not be connected with any of Bordone's paintings, but pose, type and style are indubitably Bordone's.

393 ————, 12911. Kneeling figure (probably for an Agony of Christ). Bl. ch., height. with wh., on faded blue. 233 x 200. — *Verso:*

hasty sketch for a St. Sebastian. *Uffizi Publ.* (text by Loeser) I, p. 2 no. 9: Titian about the time of the "Transfiguration" in S. Salvatore, Venice (i.e. late period). Hadeln, *Tizianzeichnungen,* pl. 36. L. Fröhlich-Bum, N. S. II: in connection with Titian's paintings of the Agony of Christ in Madrid and the Escurial (i.e. about 1567). Popham, *Cat.* 268. Our *Tizian-Studien* p. 187: The drawing does not present Titian's late style, but is derived from the style he used in his youth for his chalk drawings. The treatment of the surface is typical of Bordone. The saint on the *verso* whose type has no anology in Titian's work and recalls Bordone's figure in the altar-piece in Berlin (ill. Venturi 9, III, fig. 707). Degenhart (p. 284) mentions the drawing as an evidence of un-Venetian elements in Titian who was born in the Cadore. What is it with Bordone whose father was from Treviso and the mother from Venice?

[*Pl. LXXXVI, 3 and LXXXII,* 4. **MM**]

394 ————, 12913. Right arm of a man. Bl. ch., height. with wh., on blue. 124 x 163. Late inscription: Titiano. — Back: Hasty sketches of men, flying. Ascr. to Titian.

The drawing resembles the arm of St. Christopher in the Lovere painting (ill. Venturi 9, III, fig. 684). We suggest with reservations Bordone on the basis of No. **401** and No. **400**.

395 ————, 12918. Studies of two arms. Bl. ch., height. with wh., on blue, the r. upper corner added. 90 x 193. Late inscription: Titiano. Ascr. to Titian. [**MM**]

Our attribution to Bordone is merely hypothetical and based on the resemblance with No. **400** and No. **401**.

396 ————, 15019. Naked Christ, half length. Bl. ch., on blue. Slightly rubbed. 222 x 205. Recognized by C. Ricci, *La Pinacoteca di Brera,* p. 154, as a study for the "Baptism" in the Brera. Bailo-Biscaro 194. Hadeln, *Hochren.* 59. [*Pl. LXXXVI,* 2. **MM**]

The position of Christ's r. hand is changed in the painting.

397 ————, 15020. Drapery. Bl. ch., on blue. 260 x 184. Bailo-Biscaro p. 194, 4. Hadeln, *Hochren.* 61.

The style of drawing and the treatment of the surface are in complete conformity with the well established drawings, Nos. **392, 405**.

398 HAARLEM, COLL. KOENIGS, I, 202 (2). Allegorical subject (?): Seated naked man, and a woman with drapery, standing. Pen. 119 x 98. Inscription: P. Bordoné. Coll. Mariette (Basan *Cat.* 1775 no. 204.) Count de Fries. Heseltine (*North Ital. Drawings* 1906, no. 2, 3). Ascr. to Bordone. [*Pl. LXXXVI,* 4. **MM**]

The tradition which claims this drawing, together with two other small mythological subjects, for Bordone may be traced back to P. Mariette; of the three only this one, in our opinion, is Venetian and resembles Bordone as far as the posture of the man goes (compare the nudes in the background of the Baptism in the Brera). A definite judgment is made difficult by the complete lack of authentic pen-drawings by Bordone. We believe that the typical modeling of his draperies as seen in his chalk drawings might have undergone such a modification when he worked with the pen.

399 LONDON, BRITISH MUSEUM, 1936-10-10 — 2. Fully armed soldier sleeping (for a Resurrection?). Pen and brush, br., wash, height. with wh., on blue, the wash covers almost all the paper. 247 x 162. — *Verso:* Infant flying, a smaller one standing; a drapery; a big hand. Coll. Oppenheimer. Hadeln, *Hochren.* 64. Popham, *Cat.* 274.

The technique does not correspond to any authentic drawing by Bordone, neither is the treatment of the surface typical of him. Hadeln's attribution rests on a certain resemblance with Bordone's pictures. Their characteristics, the rather awkward way of isolating the figures, interrupting the rhythm of the composition, but on the other hand gaining a compensation by the simplicity of the motives, are to be noted in this drawing also. We accept the attribution, at least as an attractive suggestion.

400 LONDON, VICTORIA AND ALBERT MUSEUM, Dyce 265. Two studies for the same pose of a biblical figure — a seated old man — and a leg with drapery. — *Verso:* Two studies for a similar figure seen from back; contemporary inscription in ch.: Josef. Later inscription in pen: Titiano. Bl. ch., height. with wh., on blue. Irregularly cut at l. and upper border, at upper r. corner patched. 255 x 293. Hadeln, *Tizianzeichnungen* 21, 22: Titian. L. Fröhlich-Bum N. S. II: Tintoretto. In our Tizian-Studien p. 187 attr. to Bordone on stylistic grounds in general, and because of the use of the study of the leg in Bordone's "Pentecost" in the Brera (ill. Venturi 9, III, fig. 689). A. L. Mayer, *Gaz. d. B. A.* ser. 6, vol. 20 (1938), p. 300, attr. the drawing to Savoldo, apparently without cognizance of our attribution to Bordone. E. Tietze-Conrat in *Burl. Mag.* v. 72, 1938, p. 189, corroborates the attribution to Bordone by referring to a painting by Bordone in the Berenson Coll. (ill. *Burl. Mag.* 28, October 1915, p. 94, pl. B) in which the studies of St. Joseph are used.

[*Pl. LXXXV,* 1 and 2. **MM**]

The study of the leg was used again by Bordone for a St. Joseph in the painting "Madonna with Saints" in Glasgow, Simmons Coll. (Photo Witt), and, once more, in the "Holy Family" in the Strassburg Museum (Cat. 1938, no. 260). This confirms our theory that Bordone's studies of this kind were not made for specific paintings, but formed part of permanent working material.

401 ————, Dyce 280. Two studies for a right arm, the hands of which are holding flowers. Bl. ch., height. with wh., on blue. 218 x 167. Corners cut. Peter Lely Coll. Ascr. to Parmigianino.

[*Pl. LXXXIV,* 2. **MM**]

Our attribution is based on the stylistic resemblance with well established drawings by Bordone (see Nos. **390, 391**), on the use of the upper study in Bordone's "Allegory" in Vienna, no. 246, and on the use of the lower study in the signed "Allegory" in the Hermitage no. 1846.

402 MILAN, COLL. RASINI. Draped naked bearded man squatting, holding a stone tablet (?). Pen, dark br. 270 x 225. Late inscription: Paris Bordone. Coll. Albasini-Scrosati, Milan. Schönbrunner-Meder 1061: Bordone. Morassi 31, XXIII: Bordone.

We agree with reservations to this attribution, but must emphasize its hypothetical character. The linework points to an origin around 1530 and has some resemblance with No. **398** which is by no means better established for Bordone; compare the draperies. The posture of the prophet (?) shows for instance, some resemblance to the St. Jerome in the signed painting by Bordone in Glasgow, no. 570.

403 NEW YORK, PIERPONT MORGAN LIBRARY, 75. The cello-player. Bl. and wh. ch., on gray. Torn at the r. corner, at l. irregularly cut, mounted. 188 x 84. Coll. Udney. Murray *Cat.* 75: Jacopo Bassano, but not listed by Arslan. [*Pl. LXXXVII,* 1. **MM**]

The figure is copied after the Cello-Player in a composition preserved in a drawing (No. **1928**) which Betty Kurth (*Zeitschr. f. B. K.* 1926/27, 288, and at more length in *Graph. Künste* N. S. II (1937) 4,

139 ss. strove to prove a copy from a painting by Titian. She did not express her opinion on the author of the Morgan drawing acknowledging, however, its stylistic relationship to Titian. In our opinion, the drawing is close in style to Bordone, see No. **405**.

404 NEW YORK, COOPER UNION, 1938–88–2120. Portrait of a dignitary, a bearded man standing, three quarter length, seen from front. Bl. ch., height. w. wh., on faded blue. 282 x 193. Rubbed and stained by mold. On top a strip of paper is added. Inscription: 86. Ascr. to Bordone. [*Pl. LXXXIV*, 1. **MM**]

The style is indeed similar to that of Bordone which, as we said above, is derived from Titian's; but posture and composition of the figure are very different from his, and therefore another of Titian's pupils whom we do not know as a draftsman, should also be taken into consideration.

405 OXFORD, ASHMOLEAN MUSEUM. Fisherboy. Bl. ch., height. with w., on blue. 195 x 245. Contemporary inscription in ch.: per postar primo (to be put in the foreground). Late inscription: P. Veronese. Archib. G. B. Russell (in *O. M. D.* September 1926) attr. the drawing to Titian in spite of the existence of a corresponding figure in Bordone's well known painting "The Fisherman bringing the ring to the Doge" in the Academy in Venice. We rejected this attribution in our Tizian-Studien, p. 187, and gave the drawing to Bordone.
[*Pl. LXXXVII*, 3. **MM**]

The study was used for the painting with a modification in the posture of the boy's r. arm.

A 406 OXFORD, CHRISTCHURCH LIBRARY, C. C. 21. Frieze: Children carrying festoons. Bell: Bordone.

In our opinion, the drawing is not Venetian.

407 PARIS, ÉCOLE DES BEAUX ARTS, Masson Bequest. Christ resurrected appearing to the Virgin. Pen, br., wash, height. w. wh., on blue. 187 x 248. Coll. Lely. Ascr. to Pordenone. Not listed by Fiocco-Pordenone. [*Pl. LXXXVIII*, 2. **MM**]

We exclude Pordenone and are more tempted to include this charming, and certainly Venetian, drawing in the group of pen drawings which we tentatively ascr. to Paris Bordone. For the composition see Bordone's "Annunciation" in the Academy in Siena (ill. Venturi 9, III, fig. 703) where the Virgin shows a marked resemblance.

A STOCKHOLM, National Museum. Battle scene. See No. **A 1968**.

A 408 VIENNA, ALBERTINA, 86. Study for the bearded head of a young man, in lost profile, seen from behind. Bl. ch., height. with wh., on bluish prepared paper. 350 x 265. [*Pl. CXCI*, 3. **MM**]

The attribution of this recent acquisition (1924) is not supported by any tradition. The drawing is, in our opinion, by Agostino Carracci; compare the drawing representing a head and a foot, Bologna, Pinacoteca (Photo Croci 5184) where exactly the same head appears in an only slightly modified posture.

A 409 ————, 86 A. Group of draped and nude figures, and a dog. Pen. 99 x 184. [**MM**]

The attribution of this recently acquired (1926) drawing is not supported by any tradition. We recognize in this drawing Romanino's style as shown in his signed sketch in the Uffizi (no. 1465). For the group in the foreground see Romanino's "Sacrifice of Abraham" in the cathedral in Asolo, ill. *Rassegna d'A.* 1916, p. 159.

GIOVANNI BUONCONSIGLIO, CALLED MARESCALCO

[Born in Vicenza, active mostly in Venice, where he died between 1535 and 37]

Although, as just mentioned, mainly active in Venice, Buonconsiglio never merged completely into its school of painting, but, except in his decadent late years, remained firmly attached to the style of his native Vicenza. As for his drawings, there is hardly any solid ground to tread upon; even Borenius who more than any other critic has studied this group of painters (*Painters of Vicenza,* London, 1909) in most cases had to be satisfied with a *"non liquet."*

410 BAYONNE, MUSÉE BONNAT. Design for an altar-piece, Madonna and Child enthroned between St. John the Baptist and a sainted monk. Pen, br., wash, on br. parchment. 233 x 133. Coll. Baron Triquetti. Ascr. to Buonconsiglio. Mentioned by Borenius, *Painters of Vicenza,* p. 203, who does not decide about the attribution, not having seen the original, but emphasizes the dependence of the composition on that of Giorgione's altar-piece in Castelfranco.

The attribution rests solely on a resemblance to painted compositions, not on the style of the drawing. We feel unable to take a stand.
[**MM**]

A 411 LENINGRAD, HERMITAGE, 27311. Design for an altar-piece, St. Ann enthroned between a bishop saint and St. Ursula. In the predella an Annunciation and the Flight into Egypt. Pen, br., wash. 350 x 265. Esdaile Coll. Ascr. to Gio. Bellini. Publ. as Buonconsiglio by M. Dobroklonsky, in *Belvedere* 1931, I, p. 200, fig. 110, with reference to his altar-pieces in San Giacomo dell'Orio and in S. Spirito,

Venice. Dobroklonsky admits, however, that hardly any material for comparison exists.

In our opinion the paintings to which Dobroklonsky refers do not justify the attribution. The drawing shows no connection to the school of Vicenza nor to that of Venice.

A 412 PARIS, LOUVRE, R. F. 444. Studies of a Christ at the column, and other sketches. Pen, br., slightly washed. 396 x 244. Coll. Th. Lawrence, His de la Salle (Both de Tauzia, p. 53: B. Montagna). Ascr. to Bart. Montagna. Borenius, *Painters of Vicenza,* p. 204, attr. the drawing to Buonconsiglio with reference to the treatment of the nude in Buonconsiglio's Pietà from San Bartolomeo at Vicenza (ill. Venturi 7, IV, fig. 409) and to the posture of St. Sebastian in Buonconsiglio's altar-piece in San Giacomo dell' Orio, Venice (ill. ibidem, fig. 414). Parker, pl. 59 accepts the attribution to Buonconsiglio.
[**MM**]

The offered analogies are hardly sufficient to venture an attribution.

CALIARI, BENEDETTO, see p. 352

CALIARI, CARLO (CARLETTO), see p. 352

CALIARI, GABRIELE, see p. 352

CALIARI, PAOLO, see p. 334

DOMENICO CAMPAGNOLA

[Born 1500, last mentioned 1552]

Domenico Campagnola belongs to Venetian art only in the first half of his career, not because of the uncertainty of his origin (Michiel calls him *"Veneziano"*, another almost contemporary source *"Padovano"*, and more recent investigations have revealed his German origin), but because only in the first years of his activity and under the immediate influence of Titian was he a living factor within the Venetian School. The correctness of the formerly alleged year of birth 1482 or 84, already questioned by Hadeln on intrinsic grounds, was definitely disproved by Mrs. Ester Grazzini Cocco's studies of which unfortunately only a survey has been published in the *Bolletino del Museo Civico di Padova*, 1929, p. 86 ff., but which were vouched for by the author's teacher, Professor Giuseppe Fiocco. Taking the newly found birthdate of 1500 as the point of departure, we first note, that like his supposed relative and teacher Giulio Campagnola, Domenico, too, seems to have had an extremely precocious talent. He threw a lot of engravings and woodcuts on the market when he was only seventeen years old. The very considerable graphic output of 1517/18 also allows us to approach Domenico Campagnola's beginnings as a draftsman as has methodically been done by Hadeln. He started from the design of the engraved Recumbent Venus, No. 490, about which, it is true, the last word may not yet have been said, and from three drawings which form a group and by the ingenuity of their style apparently preceded the graphic production. All three are inscribed with "Domenico Campagnola" in a handwriting of the early 16th century. The significance of the inscription as a signature has been denied by L. Hourticq who rightly pointed out that such a signature on a drawing would be very unusual at the period in question. We may, however, recall that Domenico Campagnola had been trained in an engraver's studio where a signature had a commercial significance and, more generally, that this unusual stressing of his name may be explained by the natural boasting of an exceptionally young artist, something he renounced at a more mature age. But even if this thrice-repeated inscription were not a signature, but only an owner's annotation, it would be a very strong argument in favor of Campagnola's authorship which was questioned by Hourticq. A contemporary, as by paleographic reasons we suppose he was, should have known the author better than we, and even a later owner might be trusted, when he did not credit Titian, but Domenico Campagnola, for an equivocal drawing.

In our study on Domenico Campagnola's graphic art (in *P. C. Q.,* 1939, October–December) we enlarged the group of well-authenticated early drawings by emphasizing the importance of No. 548, a study used in Domenico Campagnola's engraving "The Beheading of St. Catherine," Hind 7. This drawing is by no means our discovery, and the history of its fluctuating attributions is a good example of how compulsory the erroneous connection of a work of art with a great name proves, even if the originator of the mistake long since withdrew it. The drawing in question was first published by Lavallée as a late work by Titian, an opinion accepted by Mrs. Fröhlich-Bum

who dated the drawing about 1540. Meanwhile Lavallée had noticed the indubitable connection with Campagnola's engraving of 1517 and, accordingly, gave the drawing to this artist. Suida in *Critica d'A*. VI, unable to deny the character of the drawing as a preparatory stage of the engraving, declared it a design by Titian of 1517 or earlier, used by Domenico Campagnola for his purposes. A drawing by Titian can simply be shifted from 1540 to 1517, the difference of a quarter of a century apparently being irrelevant in the evolution of an artist of Titian's rank! But there are still other objections to be raised. The drawing is identical in type, posture and graphic expression not only with the engraving with which it is connected, but also with Domenico Campagnola's other engravings from the same period. That means that if he used a design of Titian for the "Beheading of Saint Catherine," he must have done the same thing for all his other engravings, a conclusion which not even Suida dared to draw. The affinity to and dependence on Titian's style of drawing, as appearing in his sketches for St. Sebastian, No. 1880, is undeniable; but that does not justify Suida's theory since it can be explained by the fact that Domenico Campagnola worked under Titian for some time, a fact already recorded by G. B. Maganza, Campagnola's fellow pupil in Titian's studio. The closeness of their contacts at that time is further proved by the fact that Domenico Campagnola, when publishing his engraved "Assumption" of 1517 (ill. Venturi, 9, III, fig. 340) must have known Titian's famous painting which was then still in the making, and not accessible to anyone other than Titian's assistants. Otherwise, Campagnola, and not Titian, would have been the man who heightened the style of Venetian compositions by introducing into them a new sense of grandeur and pathos.

We may go still further and, indeed, did so in our above-mentioned article. By introducing into the discussion the woodcuts which, in spite of being the most original and impressive part of Campagnola's production, had hardly had the attention they deserved until then, we were in a position to show that Campagnola's petty personality in these years of contact with Titian had adapted itself to this model up to the point of occasionally almost equaling and in a certain sense even surpassing Titian. In his large woodcuts we meet groups and single figures that exaggerate inventions by Titian to the utmost violence. An especially good example is the "Massacre of the Innocents" (ill. *P. C. Q.*, 1939, p. 444, 446) in which against an unsightly crowd of figures formed in the manner of Campagnola's engravings and those imitated from Dürer's "Life of the Virgin," huge female bodies are predominant. These, if not drawings by Titian, certainly reveal his spirit. In his own drawings Campagnola may have passed through the same phase. Proceeding from those drawings established by Hadeln as the foundation of Campagnola's style of drawing, we reach, in drawings like Nos. **537, 1932, 1961**, an intermediate zone in which the decision between Titian and Domenico Campagnola is difficult and almost impossible. Our own articles in the *Jahrb. d. K. H. S.* and in *P. C. Q.* bear testimony to a difficulty which we candidly confess here and in our corresponding remarks on Titian (p. 307). Having at last and after excruciating hesitations decided in favor of Titian for the two drawings in question, we now face a no less difficult decision for No. **421** attributed to Titian by Mrs. Fröhlich-Bum, and without any doubt very close in style to the two drawings just mentioned. Nevertheless, we are still inclined to maintain the traditional name of Campagnola.

The last mentioned drawing leads us to Domenico's activities in the special field of landscape to which a considerable importance had already been devoted in Nos. **487, 567, 570** and on the *verso* of No. **548**. Here more than elsewhere Campagnola passed for Titian's double and for a prolific producer. Hadeln called him the first "draftsman by profession," and as early as 1537 Michiel mentions "large landscapes on canvas and the others in pen on paper" by Campagnola existing in a private collection at Padua. Accordingly, when art critics became conscious of the impossibility of ascribing to Titian all these obviously rather second-rate drawings handed down under his

name, the bulk was turned over to Domenico Campagnola whose name became a generic one for this class. Hadeln was the first to warn against such an undue generalization, pointing out that many of the drawings in question apparently are only copies from Campagnola. He might have added that Domenico, as we know from Mrs. Grazzini Cocco's fragmentary studies, had several sons and other pupils who carried on his activity, so that we may assume the existence of an active workshop busying itself especially with the production of landscapes. This mass production which evidently met a newly rising need, was taken over later on by the Bolognese School. We do not consider it our task to deal with this outburst of a purely provincial and predominantly commercial activity. The history of the local schools of Padua in the second half of the 16th and in the beginning of the 17th centuries will have to investigate these interrelations and mutual influences in order to differentiate and to establish several artistic individualities, if that seems necessary.

We limit ourselves to grasping Domenico's artistic personality as it appears in the first quarter of the 16th century and as vouched for by well established and dated engravings and woodcuts, and to outlining his style in the second quarter when the artist entered a second more lyric phase. Here again outstanding woodcuts like the "St. Jerome with the lions," (ill. *P. C. Q.* 1939, p. 464) or the "Landscape with the wandering family," (ibidem, p. 466) throw some light on Campagnola's drawings. For this group the characterization given by Mrs. Fröhlich-Bum in order to make a distinction between Domenico and Titian, seems very attractive and offers a good help: "Campagnola draws trees not to be climbed, houses not to be dwelt in." The engraver who transposes the elements of a composition into the ornamental rhythm of his professional medium, lacks devotion to details. He fails to be absorbed by the mystery and abundance of reality. A more devoted approach to reality in a few drawings, for instance No. **429**, may be explained by a stronger survival of Titian's influence still ripening a scanty aftermath in Campagnola who otherwise had long since stopped living up to his former ideal.

The same resignation prevails in the figure drawings of Domenico which sink into total insignificance outside a merely provincial sphere. In these, we repeat, any endeavor to distribute the existing drawings among the Campagnolas, Girolamo del Santo, the dall' Arzere, the brothers of Asola and others, whose existence has been proved by local investigators, would, with very few exceptions (for instance, No. **52**) be premature and untenable. A mere glance at the literature devoted to such problems (Fiocco's studies on Giulio Campagnola in *L'Arte,* 1915, and on the secondary masters of Padua in *Boll. d'A.,* 1925/27, or Andrea Moschetti's publication of the murals in the Scuola di San Rocco in Padova, Padua 1930) will demonstrate on what precarious and unproductive ground we move.

(For a special group of drawings ascribed to Domenico Campagnola, and incidentally to many another artist, we refer to No. **730**.)

Summing up our remarks on Domenico Campagnola, we wish to emphasize the odd fact that almost no drawings exist that are verified beyond doubt and universally accepted by an artist to whom hundreds of drawings have been attributed. Even No. **548**, backed by an authentic engraving, and in our opinion the very cornerstone of the whole structure, has been given to Titian. We admit that the boundary line between the two artists for us, too, is far from being definitely laid down.

413 AMSTERDAM, COLL. N. BEETS. People fishing. Pen, br., wash, on faded blue. 234 x 159.

R. half of a horizontal composition, existing in copies and engravings. Late shop.

A 414 AMSTERDAM, COLL. J. Q. VAN REGTEREN ALTENA. Town on a hill. Pen. 210 x 320. Exh. Amsterdam 1934, no. 507 (ill.): Do. Campagnola.

In our opinion, a copy probably from an original by Do. Campagnola in his middle period.

415 ———, Descent from the cross. Pen. 237 x 320. On

back inscription (Zoomer): Dominico Campagnola. Coll. Zoomer. Late shop.

416 ASCHAFFENBURG, SCHLOSSBIBLIOTHEK, formerly. Virgin and Child with the infant St. John, between a male and a female saint. Pen, br. 229 x 345. Modern inscription: Schitzo di Titiano. Formerly ascr. to Titian. Publ. as by Palma Vecchio by Fröhlich-Bum, in *Burl. Mag.* 1929, LV, pl. opp. p. 81, B. Accepted as his by Otto Weigmann, in *Münchn. Jahrb.,* N. F. IX, p. 88.

The whole collection of drawings in Aschaffenburg was stolen in June 1933 and, as far as we know, has not been recovered since. The drawing is somewhat similar in style to No. **423** and more likely by Campagnola.

417 BAYONNE, MUSÉE BONNAT, 1320. Landscape with a girl seated, a man with a rifle and a man driving a donkey. Pen, br., on paper turned yellow. 210 x 338. Publ. in *Bonnat Publ.* 1925, 17, as Titian. In our *Tizian-Studien* 180: Do. Campagnola with reference to his woodcut "Landscape with the wandering family," and other woodcuts and drawings.

Middle period.

418 ————, 1321. Landscape with a man on horseback and a driver on a bridge. Pen, br. 74 x 67. Ascr. to Titian.

In our opinion Do. Campagnola, middle period.

A 419 BERLIN, KUPFERSTICHKABINETT, 431. Landscape. Pen, black-br., on brownish paper. 206 x 270. Publ. by Fröhlich-Bum in *Belvedere* 1929, fig. 22.

In our opinion, by a Netherlandish artist of the 17th century.

420 ————, 433. Study for an altar-piece: St. Ann, the Virgin and the Child; below Ss. Peter, Paul, Marcus and John, and a seated musician angel. Pen, light-br. 350 x 207. **[MM]**

Belongs to a group of drawings in which, despite a general affinity with the later Campagnola, a differentiation between the latter and other Paduan artists is not yet possible.

421 ————, 434. Landscape with two figures. Pen, br. 198 x 285. Publ. by Fröhlich-Bum in *Belvedere* 1929, p. 70, a as by Titian.
 [*Pl. LXXXI,* 1. **MM**]

In spite of the very close approach to Titian — for instance the drawing No. **1932** which we believe to be by him — the older attribution to D. Campagnola to us seems better established.

422 ————, 437. Landscape. Pen, dark and light br. 195 x 330. Small holes, and bl. color spots. Coll. Paccetti. Publ. by Fröhlich-Bum in *Belvedere* 1929, fig. 20.

Early period.

423 ————, 2383. Group of monks. Pen, br. 223 x 236. Lower l. corner cut. Coll. King Frederick William. Ascr. to Do. Campagnola, publ. by O. Benesch in *Graph. Künste N. F.* I., p. 12, fig. 2 as Titian and explained as St. Jerome arriving with his lion in the convent.
 [*Pl. LXXVIII,* 2. **MM**]

In *P. C. Q.* 1939, Oct., p. 317, we pleaded for the former attribution, dating the drawing in Campagnola's early period.

424 ————, 4197. Adoration of the shepherds. Pen, br., on light br. paper. 374 x 261. **[MM]**

About 1520 to 30.

A 425 ————, 5094. Group of saints under trees. Pen, dark br.,

wash, on brownish paper. 224 x 203. Publ. by Fröhlich-Bum, in *Belvedere,* 1929, fig. 25 as Do. Campagnola.

In our opinion Bolognese School, about 1600.

426 ————, 5147. The pool of Bethesda. Pen, dark br., stained by mold. 238 x 377. Publ. in *P. C. Q.* 1939, December, p. 460, as an instance of Campagnola's middle period. **[MM]**

427 CAMBRIDGE (ENGLAND), FITZWILLIAM MUSEUM. Landscape with a resting couple and a man on horseback in the middle distance. Pen, light br. 191 x 285. Esdaile coll. Narley bequest 1912.

Mediocre drawing from the second period.

A 428 CAMBRIDGE (MASS.), FOGG ART MUSEUM, 77. Landscape with an enormous tree on the l. Pen, light br. 247 x 390. In lower l. corner monogram C and P (?). Coll. Thane, Esdaile. Loeser bequest 1932, 310. According to Mongan-Sachs p. 58, fig. 65: school of Domenico Campagnola. **[MM]**

We agree insofar as we consider the drawing an early work (about 1550) by Girolamo Muziano; this artist who in documents is sometimes called "from Padua" (Ugo da Como, *Gir. Muziano,* 1930 p. 11), may have been a pupil of Domenico Campagnola or at least influenced by him in his landscapes.

429 CHANTILLY, MUSÉE CONDÉ, 116. Landscape (fragment). Pen, br., on paper turned yellow. 400 x 310. Damaged by mold. In another ink inscription: di man del divin Titiano. Coll. Mariette, Grivis, Reiset. Publ. by us in *Critica d'A.* VIII, pl. 64, fig. 10: L. half of a composition double in size, a copy of which is preserved in the Louvre. Our ascription to Do. Campagnola is based on the woodcuts of his middle period. **[MM]**

430 CHATSWORTH, DUKE OF DEVONSHIRE, 247. Four cupids and a ram in landscape, in the air a dragon-like bird. Pen, br. 155 x 223.

Early period.

431 ————, 253. The Lord and St. Peter walking on the water. Pen, br. 118 x 206 (Photo Braun).

Late shop.

432 ————, 254. Holy Family with Elizabeth and St. John as a child. Pen, br. 207 x 279. Peter Lely Coll.

Late shop.

433 ————, 256. Old man and young man recumbent, two other figures behind them. Pen, br. 189 x 142. Damaged by mold. Morelli II, p. 292, attr. the drawing — formerly ascr. to Giorgione — to Do. Campagnola. We publ. it in *P. C. Q.* October 1939, p. 312 as a typical work from Do. Campagnola's early period. **[MM]**

434 ————, 257. The Lord in the house of Simon. Pen, br. 280 x 422.

Late period.

435 ————, 259. Boy playing the flute, a man pointing at angels making music on a cloud. Pen, br. 147 x 237, unfinished. Formerly ascr. to Heemskerk. Publ. by us in *P. C. Q* 1939, p. 314, as an early work of Domenico Campagnola. **[MM]**

436 ————, 260. Landscape, a town in the background, a young

man recumbent at the r. Above sign of the zodiac (bull). Pen, br. 250 x 276.

Late shop.

437 ———, 262. Landscape with a castle on a hill and two shepherds with a flock in the foreground. Pen, br. 206 x 390.

Shop.

438 ———, 263. Landscape, an angler at the l. Pen, br. 245 x 388. P. Lely Coll.

Shop.

439 ———, 264. Landscape, an archer and a fisherman on a bridge. Pen, br. 243 x 383. P. Lely Coll.

Shop.

440 ———, 268. Landscape, a peasant woman with two ducks in a basket, reclining in the foreground. Pen, br. 241 x 368. P. Lely Coll. (Photo Braun).

Middle period.

441 ———, 312. Landscape, a river and a group of buildings at r., figures walking and reclining. Pen, light br. 212 x 330.

Middle period.

442 CHELTENHAM, FENWICK COLL., Cat. 44, 1. Nativity of Christ. Pen, br. 154 x 135. Woodburn Sale. Late inscription: Tizian. Popham: Do. Campagnola.

In our opinion late shop.

443 ———, 44, 2. Christ among the doctors. Pen, br. 244 x 391, a narrow strip added on both sides. Coll. Lawrence, Woodburn.

Late shop.

444 ———, 44, 3. Christ carrying the cross. Pen, br. 120 x 296. Late inscription in pen: Titiano.

Late shop.

445 ———, 45, 4. Madonna with Child and two saints. Pen, br. 108 x 300. On the back old inscription: Campagnola.

A 446 ———, 45, 5. Madonna carried by angels. — *Verso:* Man with children and Madonna with Christ Child, angel and kneeling donor. Pen, br., 149 x 205. **[MM]**

On the main side: later copy from the upper portion of Titian's Assunta.

A 447 ———, 45, 6. St. Jerome in the wilderness. Pen, light br. 349 x 257. Lawrence, Woodburn. Inscription: *Campagnola.* — On the back: Ewer with frieze of Silenus on donkey. Old inscription: Battista del Moro.

In our opinion, both sides later copies from 16th century drawings.

448 ———, 45, 7. Stag-hunt. Pen, br. 286 x 422. Coll. Lawrence, Woodburn. Popham pl. XXVII.

Late shop.

449 ———, 45, 8. Landscape. Pen, br. 287 x 430. Inscription: Fra Sebastien. Coll. Lawrence, Woodburn. In cat. of the Woodburn Sale: Giorgione. Popham pl. XXVIII: Good early Campagnola.

In our opinion, a shop drawing.

450 ———, 45, 9. Landscape. Pen, br. 195 x 168, cut. Inscription in pen: Fra Sebastien, in pencil Campagnola. Popham: Attribution to Campagnola doubtful, but more probable than to Sebastiano.

[MM]

In our opinion, shop of Campagnola.

451 CHICAGO, ART INSTITUTE, L. H. Gurley Mem. Coll. 22. 16. Battle of antique warriors on horseback. Pen, br. 202 x 318. Old inscription: Campagnola. **[MM]**

Probably copy from antique relief and companion to No. **497**. The style of drawing not very typical of Do. Campagnola.

452 CLEVELAND, O., MUSEUM OF ART, 29557. Saint Jerome in landscape. Pen, br. 247 x 366. Sir George Donaldson Coll.

Middle period.

453 COPENHAGEN, KONG. KOBBERSTIKSAMLING. The banquet of Herodes. Pen, br., height. with wh., on blue. 449 x 362. Contemporary inscription: ad 5: maggio fu fatto l'accordo. **[MM]**

In the coll. anonymous. In our opinion, belonging to the Paduan School and very similar to the late drawings from the shop of Campagnola. Interesting as a *"modello,"* appended to the contract. Another version, attr. to Do. Campagnola in the Uffizi (Photo Philpot 1046).

454 DETROIT, MICH., ART INSTITUTE, 0910. Landscape with cottages at the l.; in the foreground traveler with dog. Pen, light br. 250 x 382. Below inscription on patched strip: Campagnola. Exh. Baltimore 1942, no. 25.

Shop.

455 ———, 3874. "Allegorical scene." Pen, br. 341 x 467. In lower l. corner inscription in another ink: c. da Tiziano. The drawing may represent the nymph Callisto changed into a bear after giving birth to Arcas. *[Pl. LXXXI, 3.* **MM]**

The figure of the child is similar to Giorgione's figure in the painting "The Finding of Paris," copied by Teniers, ill. Richter, *Giorgione,* pl. VII.

Typical, late period.

456 DIJON, MUSÉE, Coll. His de la Salle 776. Adoration of the Magi within a large building in ruins. Pen, light br. 378 x 521. **[MM]**

Middle period.

A 457 DRESDEN, KUPFERSTICHSAMMLUNG. The Monument. Pen, yellow. 125 x 182. Coll. Lawrence, Woodburn. Formerly ascr. to Titian, first attr. to Domenico Campagnola by Morelli II, p. 288 and publ. as his by Woermann.

In our opinion not by Campagnola, but considerably later.

458 ———, City on a lake. Pen, yellowish, 241 x 375. Coll. Lawrence, Woodburn. Crowe and Cavalcaselle. p. 548: Titian; Morelli, II, p. 288: Do. Campagnola. Publ. by Woermann, *Dresden VI,* pl. 13, no. 205 as Do. Campagnola.

The drawing of which a copy exists in the Uffizi (468) belongs to the middle period and may represent Sirmione.

459 DUBLIN, N. G. OF IRELAND, 2038. Landscape, at r. the penitent Magdalene. Pen, light br. 334 x 192. Coll. Cosway, Hodich, Wellesby. Formerly ascr. to Titian.

Perhaps r. half of horizontal composition. Middle period.

460 EDINBURGH, N. G. OF SCOTLAND, 873. Landscape. Pen, br. 256 x 401.

Shop.

461 ERLANGEN, UNIVERSITÄTSBIBLIOTHEK, Bock 1557. Two apostles preaching to a crowd. Pen, br. 216 x 207. Inscription in another ink: Palma. Bock: Anonymous, Venetian 16th century.　　　[MM]
In our opinion shop of Do. Campagnola.

462 FLORENCE, UFFIZI, 476. P. Landscape, in the distance cottages and trees on a hill. Pen, grayish br. 235 x 206, cut. On *verso* later inscription: di mano di marco Vivarino. In our article *P. C. Q.* 1939, October, p. 318: Early period.　　　[MM]

463 ————, 478. P. Landscape with shepherds and a lion-hunt. Pen, red br., on brownish paper. 238 x 360. Faded and rubbed.
Middle period.

464 ————, 479. P., 480. P., 481. P., 489. P. Landscapes of a similar character in the same technique and size, and from the same middle period.

465 ————, 496. P. Landscape with St. Jerome sleeping and a lion devouring a small animal. Pen, br. 298 x 393. Rubbed.　　　[MM]
Middle period. A copy from the drawing is in the Rasini Coll., Milan, publ. by Morassi as school of Titian, see No. **A 1994**.

466 ————, 1324. Landscape. Rock with buildings. Pen, reddish br. 281 x 213. — Back: Architectural sketches. Bl. ch. Later inscriptions: Tiziano, Dom. Campagnola.
Early period.

A ————, 1404, see No. **1987**.

467 ————, 1406. Landscape with a group of trees at l., and at r. view of a small town in the distance, sometimes identified as Cadore, placed against high mountains. Pen, br. 224 x 353. Ascr. to Titian. Publ. as his by Odoardo Giglioli, in *Dedalo* 1928, p. 180, and L. Fröhlich-Bum, in *Belvedere* 1929, p. 71, who calls the drawing finished in itself and intended to be engraved, about 1550.
We doubt the dating and the attribution. The composition is that of Titian's early paintings, dividing the space into a dark half, seen close at hand, and a view in the distance. Compare the "Flight into Egypt" in Leningrad (*Art in America*, July 1941), the Venus of Pardo (ill. Tietze, *Tizian*, pl. 120) and the early mythologies (ill. Tietze, Tizian, pl. 45). We do not see anything in Titian's production around 1550 comparable to this drawing. The manner of drawing, moreover, lacks the mixture of preciseness and intensity, typical of Titian, compare No. **1872**.
We attribute the drawing to Do. Campagnola, as he appears in No. **537** and the early woodcuts, but admit that the reflections in other artists of Titian's early achievements have not been sufficiently studied to exclude an attribution to one of them. Compare also the drawing Nos. **1987, 1988.**

A ————, 1407, see No. **1988**.

468 ————, 1772. Boy (John B.) led by two women to seated patriarch. Pen, br., unfinished. 302 x 209. Illegible old inscription and modern: *Campagnola*. Morelli, II, p. 290.　　　[*Pl. LXXIX, 2.* **MM**]
Early period. The figure of the patriarch is similar in style to Domenico Campagnola's signed engraving, St. Jerome with the lion, in Berlin (not ill. in Hind's Cat.).

469 ————, 1775. Saint Catherine kneeling. Pen, red br., cut. 137 x 198. Later inscription: Campagnola.

470 ————, 1778. Raising of the daughter of Jairus. Pen, br. 252 x 402. Later inscription: "Titiano XXXX" and "Campagnola." Late period.

471 ————, 1779. Salome dancing. Pen, br. 247 x 431. At the r. inscription: Domenico.
Late period.

472 ————, 1780. Christ in Gethsemane. Pen, red br. 234 x 380. Old inscription of the name.
Late period.

473 ————, 1781. Christ enthroned with Ss. Peter and Paul and a kneeling woman; landscape. Pen, br. 223 x 395. Mentioned by Morelli, II, p. 290: Do. Campagnola.
Middle period, poor drawing.

474 ————, 1782. Christ driving the merchants from the temple. Pen, br. 270 x 345.
Late period.

475 ————, 1783. Susannah bathing. Pen, br., on paper turned yellow. 406 x 276. On back late inscription: Campagnola.　　　[MM]
Remarkable drawing of the early period.

476 ————, 1786. Woman weaving. Pen, reddish br. 252 x 420.
Late shop.

477 ————, 12798. Design for an altar-piece: Bishop saint, enthroned with deacon and kneeling woman. Pen, br. 250 x 188. On back inscription: Campagnola.　　　[MM]
Shop.

478 HAARLEM, TEYLER STICHTING, A 46. Sketch for the portrait of a young lady. Pen, on wh. 121 x 122. Publ. by Hadeln, *Tizianzeichnungen* p. 20, 27, pl. 3: "Titian at his earliest, together with No. **1961** and No. **A 1951**; the technique shows but little affinity to that of Titian's predecessors and is unique in Italian art. An influence from Dürer's prints is evident. We find in these drawings the young artist's urge to clarify for himself by preparatory drawings a pictorial composition." Nicodemi, *Gir. Romanino*, Brescia 1925: Romanino. Suida, in *Pantheon* 1928, p. 531, Lotto, with reference to his portrait in the National Gallery in London. Fröhlich-Bum *N. S.* II: accepts Suida's attribution to Lotto. Fiocco in *Boll. d'A.* 1926/27, p. 305 ff.: Do. Campagnola. In our Tizian-Studien the drawing is not listed. A. L. Mayer in *Gaz. D. B. A.* 1937, II, p. 305 ff. seems to believe in Titian's authorship.　　　[*Pl. LXXVII, 3.* **MM**]
The attribution to Lotto can be easily rejected, since it is based merely on a superficial resemblance of costume and motive. The drawing is not executed in Lotto's style. The other three attributions are more substantial. All three artists have a connection with Padua. The young Titian worked in Padua and exercised a considerable influence on the artists of the local school, especially on the artists working in the Scuola del Santo. On the other hand, Brescian art, and especially Romanino's, influenced the same group of artists, as Fiocco stated in his article quoted above. The drawing displays indeed a notable stylistic resemblance to Romanino's drawing no. 1465 in the Uffizi. Type and posture of the lady in the drawing are very close to a corresponding one in an anonymous painting in the Scuola del Santo (ill. Venturi 9, III, fig. 336) ascr. by Fiocco to Do. Campagnola. The mode of drawing corresponds rather than to any other

to that of No. **537** the attribution of which also oscillates between Titian and Campagnola. We are more inclined to find Campagnola's hand in the portrait whose provoking attitude contradicts Titian's preference for simple poses. It must, however, be admitted that the affinity to Do. Campagnola's authentic early drawings is by no means convincing. The best label would be Paduan School about 1510 to 20.

479 ————, A X 89. Satyr and girl with mandolin, in landscape. Pen, br. 130 x 242. Inscription: Tician f. 3 f **[MM]**

Shop, influenced by a model by Titian. Copy in the Oppé Collection, London.

480 ————, B 14, Christ and the Captain of Capernaum **[MM]**
K XX 83, Three Apostles
6, 117, Stag-hunt
6, 128, Scene from Boccaccio
A X 87, Virgin with Child, St. Stephen and St. Mark **[MM]**
A X 84, St. Maria Magdalene **[MM]**
K II 4, St. Lawrence
K VI 119, Woman kneeling before a prophet, in landscape.

All pen, br. on wh., many inscribed: Tousian, Titiano a.o., but closer to the Paduan school as represented by the shop of Campagnola.

A 481 LEIPZIG, STÄDTISCHES MUSEUM. Pen. Inscription: Carracci. Publ. as Do. Campagnola in Vogel, *Studien und Entwürfe im Städtischen Museum zu Leipzig,* no. 9.

In our opinion, the ancient attribution to Annibale Carracci is quite satisfactory.

482 LENINGRAD, HERMITAGE, I. N. 14128. Breeding of silkworms. Red ch. 250 x 435. Coll. Jabach, Crozat, Jaremirz. Exh. in Leningrad as Do. Campagnola, 1926, No. 10, with reference to Benois, in *Starye Gody* 1913, No. 11, p. 11, fig. on p. 8.

Late shop. We have not seen the drawing.

483 LONDON, BRITISH MUSEUM, 1848–11–25 — 10. Landscape with men on horseback. Pen, br. 165 x 240; at r. an added strip of about 15 mm. Signed: Do. Campagnola. Publ. by L. Fröhlich-Bum in *Belvedere,* 1929, p. 259, fig. 27.

Early period.

484 ————, 1887–6–13 — 71, Cracherode. F. f. 1 — 69. Tree. Pen, br., on paper turned slightly yellow. Semicircular top. 272 x 205. Engraved by Pond from the Huldich Collection. Publ. by L. Fröhlich-Bum, in *Belvedere* 1929 (8, II), fig. 21.

Shop.

A 485 ————, 1892–4–11 — 3. Massacre of the Innocents. Pen, br., many-colored watercolors. 221 x 145. Publ. by L. C. Ragghianti in *Critica d'Arte* XVI–XVIII, p. XXVI, fig. 11 as Domenico Campagnola and important for the group of paintings and drawings in connection with the Scuola del Santo in Padua. **[MM]**

The faint resemblance to Do. Campagnola which the photograph may display, is missing in the original. Moreover, the reference to the Scuola del Santo seems unfounded.

486 ————, 1895–9–15 — 828. Assumption of the Virgin. Pen, br., worked over with red wash and height. with wh. 310 x 196.
 [MM]

The suggestion that the drawing may have been retouched by Rubens, expressed by Robinson 381, seems quite attractive.

487 ————, 1895–9–15 — 836. Landscape with two squatting boys. Pen, br., on paper turned slightly yellow. 182 x 272. Inscription, possibly signature: Domenico Campagnola; and in another ink: 76. Hadeln, *Tizianzeichnungen,* pl. 42. Fröhlich-Bum in *Belvedere* 1929, p. 258 f., fig. 19; L. Hourticq, *Le Problème de Giorgione,* p. 98 f. doubts the authenticity of the signature and attr. the drawing to Titian. We pleaded for Domenico Campagnola in *P. C. Q.,* Oct. 1939, p. 323. **[Pl. LXXVII, 2. MM]**

About 1515/16 as Nos. **567** and **570**.

488 ————, 1895–9–15 — 837. Resurrection of Christ. Pen, dark br. 286 x 196, the upper corners are cut off. Later inscription: Campagnola. A contemporary inscription on the top is cut off. **[MM]**

Middle period, perhaps in connection with the mural painting in the choir apsis in Praglia.

489 ————, 1895–9–15 — 839. The Virgin with Infant seated on the ground, in landscape, and three little angels. Pen, red br., on gray. 161 x 218. **[MM]**

The landscape is very poor, but the figures speak in favor of the authenticity of the drawing. Middle period.

490 ————, 1896–6–2 — 1. Venus in landscape. Pen, br., on paper turned yellow. 122 x 174. Hadeln, *Tizianzeichnungen* pl. 43: Do. Campagnola. Design for his engraving (in reverse) of 1517. In our article on Do. Campagnola in *P. C. Q.,* Oct. 1939, p. 332.

The drawing is unanimously accepted as the design by Do. Campagnola for his engraving; G. M. Richter in his *Giorgione* tried to trace back the composition to Giorgione, we (l. c. p. 323) to Palma Vecchio. Examining the material anew, we feel some doubt as to whether design and engraving must really be by the same hand. The drawing is different in its style from the other drawings verified as by Do. Campagnola from the same time (No. **548** and others); it lacks their energy. Preparatory drawings for engravings, of course, might be different. But is this drawing really a preparation for Domenico's print? Why should he have taken so much trouble with every detail, restraining his artistic temperament when at the end he dropped all the results and turned out an engraving absolutely in the style typical of all his other drawings? It is true, the figure itself is retained, but even the expression of the face is changed. The trees on the knoll, similar to Giulio's engraving Kristeller 11 no longer show clear differentiation, the trunks are covered with minutely modeled leaves. Every detail of the landscape is replaced by richer and stronger forms. A strangely primitive tree with foliage is added in the middle distance.

The linework, so different from Domenico's graphic style, is close to Giulio's. The trunks, especially, are treated exactly as those in No. **579**. But there is no material suitable for comparison; the only comparable figures by Giulio, the two seated peasants, are mere filling-in figures, and with a view to this intended use are executed in a more summary style. It thus remains doubtful whether the drawing may have been made by Giulio and used by Domenico for his engraving, or by the latter in a very early period under a strong influence of Giulio.

491 ————, 1897–4–10 — 5. The mystic marriage of St. Catherine. Pen, light br., on paper turned yellow. 173 x 264. Later inscription: Tiziano. Framed by lines.

Study for a painting.

492 ———, 5226. Two monks embracing. Pen, br. 207 x 155. Originally ascr. to Giorgione. Publ. in our article on Do. Campagnola in *P. C. Q.*, Oct. 1939, p. 329, ill. p. 316. **[MM]**
Early period, about 1517/20.

493 ———, 5237. Christ and the Pharisee. Pen, br., stained by mold. 217 x 389.
Late shop.

494 ———, 5337 — 146. Christ as Emaus. Pen, br. 356 x 398. Design for a painting, style of the late shop.

495 ———, P. P. 2 — 112. The Virgin and Child with little angels on clouds. Pen, br., on paper stained by mold. 208 x 189. — On back: Dancing and kneeling little angels. Payne Knight Coll. In the British Museum under the drawings "attributed to Do. Campagnola." **[MM]**

496 LONDON, COLL. BORENIUS. Holy Family with St. John as infant under a tree. Pen, br. 232 x 218. Coll. van den William.
Late period.

497 LONDON, COLL. V. KOCH. Warriors on horseback in classic costume. Pen, br., on paper turned yellow. 188 x 304. Contemporary inscription (almost illegible): Campagnola. Coll. P. Lely. **[MM]**
Shop (later member of the family); by the same hand as No. **451**.

498 MALVERN, MRS. JULIA RAYNER WOOD (SKIPPES COLLECTION). Madonna with Child, St. Sebastian and other saints. Pen, br., semicircular top. 220 x 150.
Late shop.

499 ———. Landscape with buildings in the middle (fragment?). Pen, br., on paper turned yellow. 147 x 117.
Early period.

A 500 ———. Landscape with wandering family. Publ. as design for the woodcut (in the same direction) by Domenico Campagnola B. XIII, 386, 4, in *Vasari Society* II, 12.
In our opinion, the drawing is copied from the woodcut whose details are in some places misinterpreted.

501 MILAN, AMBROSIANA. Landscape with a village in the middle. Pen, reddish br., on paper turned yellow. On show, c. 145 x 210.
Early period.

A 502 MILAN, COLL. RASINI. Landscape. Pen, 270 x 396. Coll. Dubini. Morassi, p. 32, pl. XXV: Do. Campagnola. Ragghianti, *Critica d'A.* XI-XII, p. XXXVII: Circle of Paul Bril.
Also in our opinion by a Northern artist.

503 ———. Landscape with riders. Pen, br., on paper turned yellow. 250 x 400. Coll. Henry Oppenheimer.
Late shop.

504 MUNICH, GRAPHISCHE SAMMLUNG, 3138. Landscape with a mountain torrent. Pen, 329 x 285. — On back: Studies of figures. Publ. in Schmidt III, 54, 55 as Titian. Fröhlich-Bum in *Belvedere* 1929, p. 261, fig. 24: Do. Campagnola.
Middle period.

505 NEW YORK, METROPOLITAN MUSEUM, 07.283.15. Landscape with antique ruins on seashore, and wandering peasants. Pen, br., 223 x 360. Later inscription: Campagnola.
Late shop.

506 NEW YORK, PIERPONT MORGAN LIBRARY, I 59. Buildings under a rock. Pen, br., 154 x 195. Somewhat damaged. *Morgan Dr.* I 59: Giulio Campagnola. **[*Pl. LXXXI*, 2. MM]**
In our opinion, closer to Do. Campagnola. Early period under the influence of Titian.

507 ———, I 62. Four cupids carrying a fruit basket. Pen, light br. 114 x 149.
Shop.

508 ———, I 63. Baptism of Christ. Pen, br. 194 x 277.
Middle period.

509 ———, I 64. Christ before Pilate. Pen, br. 210 x 371.
Middle period.

510 ———, I 65. Christ among the doctors. Pen, br., squared. 150 x 430.
The noticeable reminiscences of Titian's "Presentation of the Virgin" suggest a date about 1540. The style reminds us of Stefano dall' Arzere.

511 ———, I 66. Esau and Jacob before Isaac. Pen, br. 267 x 403.
Late shop.

512 ———, I 67. Landscape with a sail boat, Jesus and the apostles. Pen, br. 255 x 403.
Middle period.

513 ———, I 68. Landscape with seaport. Pen, br. 236 x 385. Publ. by Weitenkampf in *A. in A.*, V, p. 79, fig. 3.
Shop (perhaps copy).

A 514 ———, IV 59. Four angels adoring a monstrance framed by a border with evangelists and other saints in medallions. Pen, br., heightened with wh., on blue paper. 225 x 172. Coll. Mayor.
In our opinion, not by Do. Campagnola. Venetian folk art.

515 ———, IV 60. Flight into Egypt. Pen, black br., on yellow paper. 246 x 157. Coll. Robinson.
Typical, middle period.

516 ———, IV 61. Woman feeding chickens. Pen, br., wash, on blue. 131 x 129. Framed on three sides. Later inscription: Campagnola.
Late period. See No. **517**.

517 ———, IV 62. Mower. Pen, wash, on blue. 229 x 122. Framed. Originally forming one sheet with No. **516**, as shown by an engraving (18th century?).
Late period.

518 ———, IV 63. Descent from the cross. Pen, br., on paper turned yellow. 412 x 280. At l. and r. not brought to the border of the drawing. Coll. Peter Lely. **[MM]**
Near in style to Arzere's composition of the same subject in Padua, Museo Civico (ill. Venturi 9, VII, fig. 9).
Shop.

519 ———, IV 64. Banquet of the rich man and Lazarus. Pen, br. 231 x 383. Engraved.
Late shop.

520 ————, IV 65. Landscape with classic ruins on the r. and a donkey driven on the l. Pen, br. 230 x 374. Coll. Lely, Richardson.
Perhaps shop.

521 ————, IV 66. Landscape with a shepherd driving away a wolf. Pen, br. 241 x 378. Coll. Peter Lely.
Perhaps shop.

522 ————, IV 68. Madonna with Child, St. John B. and St. Joseph. Red ch., on yellow. 181 x 218. **[MM]**
Important as the only example of a drawing by Campagnola in this technique. The traditional attribution is confirmed by a stylistic resemblance to Campagnola's painting in the Papafava Coll., ill. Venturi 9, III, fig. 347.

523 Oxford, Ashmolean Museum. Heads of men and women. Pen, light br., on paper turned yellow. 205 x 148. Inscription: pordenone. Ascr. by K. T. Parker to Campagnola, an attribution which seems very plausible.

524 Oxford, Christchurch Library, I 14. David and Goliath. Pen, light br. 275 x 472. Coll. Peter Lely, Richardson.
Late.

525 ————, I 15. Landscape with two hunters. Pen, br., on yellow. 233 x 378.
Late shop.

526 ————, I 16. Landscape with two pedestrians and two men on horseback. Pen, br. 194 x 300.
Late.

527 ————, I 22. Landscape with shepherd and goats. Pen, br. 224 x 386. Coll. Peter Lely.
The architecture is found in later Bolognese engravings.
Late shop.

528 Paris, Louvre, 55. Landscape; at the r. an angel next to a seated pilgrim. Pen, br., on paper turned yellow. 243 x 323. Vente Joubert, 1870: Titian. His de la Salle. **[MM]**
Middle period.

529 ————, 479. Sheet with cupids. Pen, br. 153 x 197. — On *verso:* sketch of a horse, in bl. ch., and half-figure of an old man, seen from behind and a sitting figure seen from the front and bending forward, in pen. Coll. His de la Salle (Both de Tauzia, p. 84: Titian). Chennevières, *Louvre I* no. 7: Titian. Suida, *Critica d'A.* VI, p. 287, fig. 7: Titian, and used by Do. Campagnola for his engraving Galichon 15. **[***Pl. LXXIX, 1 and 3***]**
The relationship to the engravings Galichon 15 and Galichon 6 (Pietà) is much more easily explained by attributing the drawing to Do. Campagnola himself, whose mural in the Scuola del Carmine, Padua (Venturi 9, III p. 522, fig. 352) the drawing also resembles. Another argument in favor of Campagnola is the *verso.* The seated figure in its strained posture is familiar from Campagnola's engravings and his woodcut Galichon 3–4 (in reverse), the old man in profile from the drawing No. **423** (s. *P. C. Q.*, 1939, III, p. 317). A comparison of the cupids on the main side with those by Titian discloses fundamental differences in quality and interpretation; in his hasty sketches of such children (see No. **1923** in Lille) Titian is much coarser in movement and action, while in his more finished works inaccuracies, like some in the drawing, do not occur.

530 ————, 485. Virgin and the Infant and St. John as a child; at the r. St. Joseph with the donkey. Pen, br. 233 x 187. His de la Salle.
Late.

531 ————, 4726. Christ among the doctors. Pen, br., on paper turned yellow. 170 x 297. Inscribed: Campagnola.
Influenced by Tintoretto. Late shop.

532 ————, 4727. Entombment of Christ. Pen, br. and bl. 335 x 220. Late inscription: Dom. Campagnola. Coll. J. P. Zoomer. **[MM]**
Late shop.

533 ————, 4729. Design for an altar-piece: Madonna with Child and Saints. Pen, br. 294 x 233. **[MM]**
Shop.

534 ————, 4732. St. Mark Evangelist, seated on a cloud. Pen, br. 241 x 164. Late inscription of the name.
Late shop.

535 ————, 4735. Five satyrs making music and dancing under a tree. Pen, br., on paper turned yellow. 308 x 324.
Somewhat similar to No. **552**.

536 ————, 4737, 4740, 4741, 4742, 4744, 4747, 4748, 4749, 4750, 4751, 4752, 4753, 4757, 4758, 4759, 4760, 4761, 4765, 4768, 4770, 4783. Landscapes with various figures.
Late shop, some of them copies.

537 ————, 5519. Judgment of Paris. Pen, br., stained by mold, paper turned yellow. 248 x 200. Publ. by Lafenestre, *Le Titien*, p. 21 as Titian. Morelli, II, p. 292: Do. Campagnola. Gronau in *Gaz. d. B. A.* 1894, II, p. 330: Do. Campagnola. Gust. Frizzoni, in *L'Arte* VII, p. 251 f.: Do. Campagnola. Ricketts, *Titian:* Titian. Hadeln, *Titian-Drawings*, p. 18: Do. Campagnola, especially with respect to the woodcuts. In our article on Campagnola in *P. C. Q.*, 1939, IV, 451 ff.: Do. Campagnola, about 1517, perhaps transposing a composition by Titian. We refer to our analysis there. **[*Pl. LXXX*, 2. MM]**

538 ————, 5526. Rape of Europa. Pen, reddish br., stained by mold. 395 x 678. *Dessins du Louvre* II 71: Titian. Morelli, II, p. 292: Do. Campagnola. Gronau, *Gaz. d. B. A.*, 1894 (XII), p. 330.
Shop.

539 ————, 5527. Landscape with a girl sitting in the middle and other figures. Pen, reddish br., on paper turned yellow. 380 x 675.
About 1545.

A ————, 5531. See No. **2000**.

A 540 ————, 5532. Landscape with a warrior at the l. and men with dogs. Pen, br. 253 x 385. Inscribed apparently in the same ink: Titiano da Cador.
Copy from a Do. Campagnola drawing, of his middle period.

541 ————, 5533. Landscape with shrubs on a hill; a village in the background at l. Pen, wash. 135 x 218. Newer inscription: Tician fecit Venetiae. Ascr. to Titian. Mentioned by *Albertina Cat. II* (Stix-Fröhlich) no. 44 as being by the same hand as No. **2007**, in the opinion of Stix-Fröhlich "circle of Titian, first third of 16th century." They add: at any rate both drawings are very close to Titian." — In *Belvedere* 1930, p. 85, 86, pl. 65, 1, the drawing was publ. by Fröhlich-

Bum as Giorgione, with reference to the somewhat similar motive in the centre of the Fête Champêtre in the Louvre. [MM]

We find no connection with Giorgione, and specifically none with No. **713**, the reproduction of which on the same page in the Belvedere is deceptive, since only the considerable reduction in size produces a similar effect. More likely by Domenico Campagnola, see No. **548**.

542 ———, 5536. Landscape with a nymph on the r. Pen, br. 215 x 318. Ascr. to Titian, publ. as Schiavone by Fröhlich-Bum in *Jahrb. K. H. Samml.*, 1913/14, p. 168. In our *Tizian-Studien* p. 179, n. 75, we stated that the drawing forms part of a larger composition preserved in a woodcut which Galichon (No. 12) lists among Do. Campagnola's. In our opinion, the attribution to the latter is doubtful, but the style in general much closer to his school than to Schiavone.

543 ———, 5537. Landscape without figures, but with buildings in the middle ground. Pen, br. 215 x 375. Ascr. to Titian and publ. as his in *Dessins du Louvre*, I 26, in Lafenestre, *Le Titien*, p. 243, and in *l'Art* 1886, XLI, 254.

In our opinion nearer to Do. Campagnola.

544 ———, 5538. Landscape stretching into the distance, with seated woman and standing shepherd. Pen, dark br. 260 x 394. Somewhat damaged. Engraved with the Jabach drawings.

Late period.

545 ———, 5542. Landscape with town on seashore. Pen, br. faded. 240 x 380. Ascr. to Titian.

Late shop.

A ———, 5544. See No. **1446**.

546 ———, 5551. Madonna with Child and four Saints. Pen, br. 175 x 188. Ascr. to Titian.

Campagnola's late shop.

547 ———, 5553. Design for an altar-piece, Coronation of the Virgin, below saints and angels. Pen, br., on paper turned yellow. 300 x 208. Semicircular top, very much damaged. Ascr. to Titian. Publ. in our article in *Critica d'A.* VIII, pl. 63, no. 9, and in *P. C. Q.* 1939, Oct. 1939, p. 326 as early Do. Campagnola. [MM]

548 PARIS, ÉCOLE DES BEAUX ARTS, 34780. Susannah bathing. Pen, br., slightly faded. On the back: Sketches for the beheading of St. Catherine and the lower half of a standing man. Publ. by Lavallée, in *Gaz. d. B. A.* 1917, p. 273–5 as Titian about 1540, with reference to the legs on *verso*, supposed to be related to Titian's "St. John Baptist" in the Academy in Venice. Both suggestions were accepted by Fröhlich-Bum in *N. S.* II, no. 34,35. Meanwhile Lavallée had recognized his mistake and in the cat. of the exh. of Italian drawings in the 15th–16th centuries in the École des Beaux Arts 1935, No. 41, called the drawing a study by Do. Campagnola for his engraving Hind 7. Suida in *Critica d'A.* VI, 1936, Dec. p. 287, returned to Titian, dating 1517, and explained the indubitable connection with the engraving by the theory that Campagnola might have used a design by Titian. In our *Tizian-Studien* we had meanwhile endorsed Lavallée's attribution to Campagnola. In *Critica d'A.* VIII 78 ff. and in *P. C. Q.* 1939, Oct., p. 325 ff. we assembled further evidence for Do. Campagnola's authorship and refer to our arguments in these articles. Fröhlich-Bum in *Art Bulletin* 1938, Dec., p. 446, maintains the attribution to Titian

without giving new reasons and without explaining how a drawing which she first thought typical of Titian about 1540 can now be an example of his style before 1517. [*Pl. LXXVIII, 1 and 3.* MM]

549 ———, 34881. The marriage in Cana (with Mary as the only woman present). Pen, br., on yellow. 160 x 278. Here ascr. to school of Titian. [MM]

Typical product of Campagnola's late shop.

550 ———, 34888. Cupids playing under a tree. Pen, br., on paper turned yellow. 266 x 356. Damaged and patched. Exh. 1935, no. 40. [MM]

Perhaps copy from a drawing of the middle period.

551 ———, 34898. Sketch: Virgin with Christ Child standing, beneath, various saints and angels. At the l. a few further heads are added. Pen, br., on paper turned yellow. Upper corners cut. 380 x 260. Ascr. to school of Raphael. Exh. 1935, no. 124. [MM]

Typical early Do. Campagnola and so publ. in our article *P. C. Q.* 1939, Oct., p. 327.

552 PARIS, COLL. MME. PATISSOU. Landscape with a nymph at the l. and other figures at the r. Pen, br., on paper turned yellow. 251 x 400. Old inscription: 1543. Borghese Collection, Venice.

The drawing is poor, but interesting because of its date. It gives help in dating others in which the same typical pointed rocks, spectacular clouds, ruins and Parmigianinesque figures appear in the 1540's.

553 RENNES, MUSÉE, 29/2. The pool of Bethesda with the angel stirring the water. Pen, reddish br., on paper stained by mold. 217 x 276. Later inscription: Campagnola. Publ. in our article in *P. C. Q.*, Dec., 1939, p. 461, as a typical early work. [MM]

A 554 ROME, R. GABINETTO DELLE STAMPE, 125123. Tree on a rock and a head added. Pen, br., faded. 180 x 151. Later inscription: C. Ascr. to Lodovico Carracci. [MM]

See No. **2001**.

A 555 STOCKHOLM, NATIONAL MUSEUM, Inv. no. 1392. Landscape with hills. Pen, bl.-br., 271 x 395. Crozat Coll. Ascr. to Titian. Sirén Cat. 1917, 459: Do. Campagnola, with reference to the signed drawings No. **487** and No. **567**.

In our opinion, not a drawing from Campagnola's youth and probably not by him at all. We have not seen the original.

556 TURIN, BIBLIOTECA REALE, 15962. Landscape with a woman spinning and riders at the r. Pen, br. 248 x 391.

About 1540.

557 UPSALA, UNIVERSITY LIBRARY. Christ sleeping in the boat. Pen. 217 x 230. Publ. by C. Dodgson in *O. M. D.* June 1934. In our article *P. C. Q.*, Oct. 1939, p. 324: typical early work. [*Pl. LXXVII, 1.* MM]

The approach to Titian's early style (compare No. **1970**) is remarkable. We have not seen the original.

558 VIENNA, ALBERTINA, 43. Madonna with Christ Child, St. Jerome and two adoring shepherds. Pen, br. 252 x 346. *Albertina, Cat. I* (Wickhoff) 67: Do. Campagnola original. *Albertina Cat. II* (Stix-Fröhlich): Circle of Titian, first quarter of 16th century, without resemblance to Do. Campagnola's authentic works. Fröhlich-Bum in *Burl. Mag.* LV, p. 81, c: Palma Vecchio. In our article in *Critica*

d'A. 1937, p. 80: Do. Campagnola with reference to the woodcut Galichon 7 (ill. *P. C. Q.* 1939, Dec., p. 454). [*Pl. LXXX*, 3. **MM**]

559 ———, 47. St. Jerome kneeling. Pen, bister. 180 x 167. *Albertina Cat. I* (Wickhoff) 30: not Titian, but probably Venetian and 16th century. Hadeln, *Tizianzeichnungen,* p. 30, pl. 14: Titian, about 1540-50. *Albertina Cat II* (Stix-Fröhlich) 47: not by Titian himself, but by an artist of his circle. Fröhlich-Bum in *N. S.* II, 192, fig. 259: Savoldo. A. L. Mayer, *Gaz. d. B. A.* (1938) ser. 6, v. 20, p. 300: doubts Titian's authorship.
 In our opinion more likely Do. Campagnola, middle period.

560 ———, 68. Landscape with recumbent figure seen from behind. Pen, br. 243 x 385, in bad state of preservation. Crowe and Cavalcaselle II, p. 558: Titian. *Albertina Cat. I* (Wickhoff) 68: Do. Campagnola. *Albertina Cat. II* (Stix-Fröhlich) 68: A. Schiavone. Morassi, *Disegni* p. 32: rejects the attribution to Schiavone in favor of Do. Campagnola.
 In our opinion, copy from Campagnola.

561 ———, 56. Santa Conversazione in a landscape. Pen, br. 213 x 380. Old inscription: Campagnola. *Albertina Cat I* (Wickhoff) 68: Domenico Campagnola.
 In our opinion late shop.

562 ———, 57. A mountainous landscape with hamlets. Pen, br. 227 x 374. Inscription lower l. corner: 28 martio; at r.: 1558.
 Late shop.

563 ———, 58. Landscape with a mill and a millstream. Pen, br. 235 x 367. Late inscription: Campagnole.
 Late shop.

564 ——— In storage. Banquet. Pen, br. 373 x 640.
 Typical, late shop.

A 565 VIENNA, PRIVATE COLLECTION. Fantastic landscape. Pen. 293 x 445. Publ. by Fröhlich-Bum in *Belvedere,* 1929 (8/2, p. 260, fig. 23) as Do. Campagnola.

In the selection of alleged Do. Campagnola drawings presented in this article, this Northern example may be the greatest surprise.

566 VIENNA, AKADEMIE DER BILDENDEN KÜNSTE, I 4608. Landscape with a dragon. Pen, br. 154 x 235. At r. contemporary inscription: Campagnola. [**MM**]
 Late shop.

567 VIENNA, COLL. PRINCE LIECHTENSTEIN. Landscape with a boy fishing; two men on horseback in the distance. Pen. Inscription (signature?): Do. Campagnola. Coll. Klinkosch. Schönbrunner-Meder 955. In our *Tizian-Studien,* p. 170, fig. 150.
 Typical, about 1515/16. See Nos. **487, 570.**

568 WASHINGTON CROSSING, PA., COLL. F. J. MATHER JUNIOR. Mythological subject, composition of two men, two women and two children. Pen, br. 230 x 243. Lower r. corner added. Inscription: Ticianus fe. — On *verso* inscription: Del garzone del Podestà. Coll. Edouard André. [*Pl. LXXX,* 1. **MM**]
 Typical, about 1520.

569 ———. Landscape with old people next to a fire and a herd of swine. Pen, br. 270 x 385. Coll. Fagel, Esdaile, Thane. Exh. New York, Roerich Museum, 1930, 42.
 Typical, about 1530/40.

570 WEIMAR, MUSEUM. Stigmatization of St. Francis. Pen, 173 x 248. Inscription (signature?): Do. Campagnola. Publ. by Hadeln, *Tizianzeichnungen,* pl. 41, as Do. Campagnola. Again in our article in *P. C. Q.* 1939, Oct., p. 320, as typical Do. Campagnola shortly before 1517. (S. Nos. **487, 567.**)

571 WINDSOR, ROYAL LIBRARY 4773. Landscape with a castle in the middle. Pen, br., on paper turned yellow. 161 x 253.
 Late.

572 ——— 4774. Landscape with St. Jerome in contemplation. Pen, br., on paper turned yellow. 274 x 438.
 Late shop.

GIULIO CAMPAGNOLA

[*Born 1482, last mentioned in 1515*]

Literary and documentary evidences on Giulio Campagnola and his engravings, his best authenticated works, co-operate to produce the impression of a somewhat amateurish talent and activity. We do not think that objections against this conception raised by Fiocco in *L'Arte,* vol. XVIII, p. 150 ff., and K. F. Suter in *Zeitschr. f. B. K.* 1926–27, p. 132 ff., have succeeded in seriously readjusting it. Their efforts to gather a number of paintings under his name failed because of the complete heterogeneity of these productions, whose acceptance as Giulio's might have made him appear still more nebulous and unorganic than his detractors depicted him. Even Hourticq, who refuses any artistic honors to every Campagnola whatever his first name may be, did not destroy Giulio's individuality so completely. The designation as "amateurish" in this case means more an artistic than a social characterization and is not disproved by Michiel's mentioning some artist as Giulio's pupil or assistant. For example, even Squarcione, who seems not to have been an artist at all, had pupils and assistants. The essential point is that Giulio lacks the continuity and coherence that are the distinctive characteristics of an artist compared to an amateur; the

latter may casually succeed in producing a charming work, particularly when working within a tradition to give him support.

This is the case with Giulio Campagnola. His amiable and many-sided talent was carried along on the artistic wave brought to Venetian art by Giorgione's vital stimulation, and found an adequate medium in engraving which he succeeded in making a suitable means of personal artistic expression, in spite of his numerous borrowings from others. In an article in *P. C. Q.* in 1942, no. 2, we dealt with this side of Giulio's activity. He gains as much when examined as a master in a very limited sphere, as he loses when viewed as an artist competing with the great leaders of his generation.

Giulio Campagnola's destination was for good or evil to remain within Giorgione's sphere. First, his production as a draftsman was entirely swallowed by the greater man who permeated and absorbed every thing around him; later on, especially when he became better known as an engraver, a number of drawings were separated from the Giorgione stock because of their direct or indirect connection with Giulio's graphic works and attributed to him, though with the reservation that they are definitely reflections of Giorgione's style or even copies from him. In some cases Giulio manages to be Giorgione's double and even today the question of their respective claims for certain drawings are by no means definitely and unanimously settled. The borderline between their artistic domains remains unfixed. Is this possibility of his being taken for Giorgione not a striking argument against the low estimation of Giulio's creative power from which we started? It is, in our opinion, more an evidence of the bluntness of our critical tools which over the relatively short distance of four centuries succeed only with the utmost effort in differentiating between original and imitation, pioneer and follower, artist and amateur. Like every other historic phenomenon the artistic personality, too, consists of various layers. The individual is imbedded in concentric spheres, one or another of which for various reasons and at various moments may alternately prevail. In Giulio's specific case the diminutive nucleus of his personal style is completely imbedded in the Giorgionesque element. It is less a difference in essence than a difference, sometimes hard to define, in quality, that settles the point.

The question is especially intricate for landscapes. In this special field Giulio Campagnola seems to have been very conscious of his insufficiency since he inserted whole pieces from Dürer's engravings. In one single case, for his engraved Ganymede (Kristeller 6) he used an excellent design still existing, which we believe to be by Andrea Mantegna (No. 320). But to make the landscape more pleasant, and perhaps more modern, he fitted into the engraving a motive taken from Dürer's engraving B. 42, the "Virgin with the monkey." In view of this experience it is difficult to admit that Giulio may have made his own design for his engraving Kristeller 9, so poetical in its general mood and so rich in its landscape. The drawing, preserved in the Louvre No. 579, used to be ascribed to Giorgione and, as a matter of fact, was one of the very few ("three or four") that Morelli, the founder of the restrictive Giorgione interpretation, left him. When its connection to the engraving was discovered, it was attributed to Campagnola, though somewhat reluctantly in view of its high quality and predominantly Giorgionesque character. In spite of these characteristics the drawing can hardly be by Giorgione himself. There are no threads leading to the other landscape drawings, more or less convincingly claimed for him (Nos. 707, 709, 713). On the other hand, the conformity to other Campagnolas (engravings) in the rendering of landscape details is so close that we can hardly separate No. 579 from them. To speak here of strong reflections of Giorgione's art, as Hadeln does, seems insufficient. We must go further and surmise that Giulio, in some stage of his artistic career, became entirely involved by this art. The engraving Kristeller 9 is universally supposed to be Giulio Campa-

gnola's, since Do. Campagnola completed the plate left unfinished. We may therefore suppose that this complete absorption by Giorgione occurred in Giulio's late phase while those other engravings in which he appears so irresolute about the landscape belong to his early period. Such a theory might explain certain incongruities. A struggling young artist whose amateurish character and sporadic interests we pointed out above steadied himself in his riper years by complete allegiance to the great leader of his generation. He made himself the mouthpiece of Giorgione's tendencies by translating them into the medium he knew best. The adaptation to the specific needs of graphic art is Giulio's, but the invention is Giorgione's, whether the individual designs are in each case based on a sketch by him or merely saturated with his spirit. Probably there are gradual transitions between these two alternatives. For No. 579 a direct dependence on sketches of Giorgione seems more likely, since, besides the general spirit, the single motives are so very Giorgionesque. In No. 574 where the details are still completely dependent on this influence, Giulio appears more original, and Fiocco may be right in calling the drawing one of the most typical of Campagnola. In No. 578, whose complicated conditions of origin we discussed at length in *Critica d'A.,* VIII, p. 81, only the landscape is a transformation by Giulio of a Giorgionesque invention, while the figure, for which a space had been left, was filled in by a later hand, modernizing an older model.

The style of the landscape to which, incidentally, No. 581, also in the Louvre, offers an analogy, is an effort to translate the specific Giorgionesque mode of expression into the graphic medium. We refer the reader to our longer statements in the mentioned article, and also in the discussion of No. 578, and emphasize here only the distinct advance in style of the figure beyond Giulio Campagnola's engraving, Kr. 3, or beyond anything we might expect from him.

There is one more drawing (No. 580) whose place on the borderline between Giorgione and Giulio Campagnola is very difficult to establish exactly. The evident close connection with engraving Kr. 12 offers no exhaustive explanation. Evidently the drawing is neither copied from the engraving, since it shows in every detail a better understanding and a more direct approach to reality, nor is it the design for the engraving, since the group of buildings is seen from a slightly different angle and perhaps at another season. The drawing may be a study after the same motive which is represented in the engraving. In the interval between the execution of the drawing and that of the engraving Giulio may have reached this refinement under Giorgione's influence. It remains a possibility, however, that the drawing is by Giorgione himself by whom no late pen drawings of landscapes are known.

In rendering figures, too, Giulio's approach to Giorgione is very close as revealed by the "Young violinist," No. 582, behind whose figure stand Giorgione's inventions on the façade of the Fondaco. But the transformation of his style into a graphic mode of expression is so distinct that Ludwig Justi wondered whether the drawing might not be a copy from Giorgione, by Dürer. In view of the whole situation it seems more likely that the draftsman was Giulio Campagnola, Giorgione's customary representative in this field and likewise a well trained imitator of Dürer's style.

A BUDAPEST, MUSEUM. Landscape. See No. **1979**.

573 CHATSWORTH, DUKE OF DEVONSHIRE, 748. Landscape with a bridge on the l. and a tree upon a rock. Pen, br. 129 x 197.
The drawing ascr. to Titian's school at Chatsworth is more in Giulio Campagnola's manner and might be by a follower of his.

574 FLORENCE, UFFIZI, 463 P. Landscape with watermill. Pen, br. 175 x 280. The drawing formerly ascr. to Basaiti was attr. to Giulio Campagnola by Paul Kristeller and publ. as his, pl. XXVI. Accepted

by G. Fiocco in *L'Arte* 18, 1915, p. 156 and Hadeln, *Hochren.,* pl. 6.
[*Pl. LI,* 2. **MM**]

The drawing which Fiocco calls one of the most characteristic works by Giulio is very close to No. **490** in which we emphasized the approach to Giulio.

A 575 FRANKFORT, STAEDELSCHES KUNSTINSTITUT, 458. Landscape with two astronomers. Pen, bl. 179 x 253. At the r. somewhat worked over. Publ. in *Prestelgesellschaft* I, 6. [**MM**]
Later in style than Giulio, and more in the direction of Dosso

Dossi. Compare the latter's composition in Trento, ill. *Boll. d'A.* 1929-30, p. 259.

A LONDON, COLL. HOLLAND, formerly. Group of buildings with trees, see No. **1993**.

A NEW YORK, P. MORGAN LIBRARY, I, 59. See No. **506**.

A 576 OXFORD, ASHMOLEAN MUSEUM. Group of buildings on a shore, three pedestrians and a horseman at l. in the foreground. Pen, br., faded. 148 x 195. Bodleian Library, Douce. Publ. by S. Colvin III, 12 and Kristeller, *Campagnola* pl. XXVII (Giulio Campagnola?). Kristeller (p. 14) points to the landscape as very close to, but weaker than, that in No. **574**, No. **577** and No. **578**: "In favor of Giulio is the fact that the same group of figures appears in a fresco by Do. Campagnola in the Scuola del Santo, Padua (ill. *L'Arte* XVIII, 1915, p. 155), and in Agostino Veneziano's engraving of 1523, B. 423. The invention may, therefore, very possibly go back to Giulio Campagnola, while the somewhat awkward and dry linework recalls rather an artist near the "Master with the Mousetrap" who . . . like Agostino Veneziano was greatly influenced by Giulio Campagnola." Kristeller draws the conclusion that the somewhat damaged drawing might be a copy from Giulio Campagnola. Fiocco in *L'Arte* XVIII (1915), p. 156, in spite of Kristeller's doubts, accepts Colvin's attribution to Giulio Campagnola, supporting it by a reference to the fresco in Padua, which he dates 1511. Parker in *O. M. D.* June 1938, pl. 7, believes the drawing to be a counterproof of the original drawing, done by Agostino Veneziano, the engraver of B. 423.

Parker is right in his statement that the drawing in Oxford is a counterproof. Since Agostino Veneziano's engravings after Michelangelo's figures are done without using a mirror, it is obvious that he did not take the trouble to use one for the landscape details. Since these appear in the same direction as they are in the drawing, the drawing is certainly a counterproof of the original, as is also shown by the linework which is pale and smoothed-down. Another argument in favor of Parker's theory is that the sword on the l. is in the right position in the engraving (and in the preserved drawing). Accordingly the original drawing itself must have been made with a view at the engraving. It is of course tempting to attribute the (original) drawing, and its counterproof, to the engraver who used it, and we agree with Parker in giving it to Agostino Veneziano, since the attribution to Giulio Campagnola is untenable for stylistic grounds. Fiocco's conclusions, at any rate, are not convincing. Since the painting in the Scuola also corresponds to the engraving of 1523 in details which are not in the drawing, the painter certainly utilized the engraving, and the date of 1511 for the painting cannot be upheld.

577 PARIS, LOUVRE, 481 (2198). Landscape with buildings, at the r. a mill; man riding on a donkey, and pedestrians. Pen, 173 x 261. Lower l. corner torn. Coll. Richardson, His de la Salle. This drawing has been attr. to Giorgione, see Both de Tauzia, p. 18 s. and Morelli, II, p. 225 (together with No. **578**). While Gronau in *Gaz. d. B. A* 1892 II, p. 323 rejected Giorgione's authorship for No. **578**, he insisted on attributing our drawing to him, also repeating the same opinion in Thieme-Becker, vol. 14, p. 89. Kristeller, *Campagnola,* p. 13 f. agrees with Gronau as to a certain difference in style between the two drawings, but does not find it decisive enough for an attribution of the drawings to two different artists; he tries to explain the difference by ascribing No. **578** to Giulio Campagnola's early period and expresses his doubts by a question-mark in the caption of pl. XXV. Fiocco, *L'Arte* XVIII, p. 150 ff. and Hadeln, *Hochren.,* p. 31,

pl. 5: Giulio Campagnola. Ill. with the caption Giorgione in *L'Amour de l'Art,* 1931, p. 318, 1. [*Pl. LIII,* 1. **MM**]

In our opinion, the drawing of the landscape can hardly be separated from No. **578**, while the sketchy figures are not suitable for comparison, No. **578** being more carefully executed. Thus, this drawing shares with the other in difficulty of attribution. The motives of all these secular buildings and the efforts made to render the middle tones are in Giorgione's style. But No. **707** which we believe to be by Giorgione, is very different in style from ours which is less monumental and more graphic. It might, therefore, be only a modification of a Giorgione sketch by Giulio, the invention belonging to the one and the execution to the other.

578 ――――, 1979. St. John the Baptist in landscape. The r. arm repeated in an extended position. Pen and brush, br.; the repetition of the arm is scarcely visible. 320 x 219. The lines of the landscape are pricked. Connected with the engraving signed Julius Campagnola (Kr. 3) which in its turn, as far as the figure goes, corresponds to an engraving by Mocetto. Kristeller pointed out that both may go back to the same model, probably a drawing by A. Mantegna. The identity of our drawing with Campagnola's engraving is limited to the landscape (in reverse), while the figure corresponds only in the general outline. Coll. Galichon. Ascr. to Domenico Campagnola. According to Galichon in *Gaz. d. B. A.* 1862, XIII, p. 332 ff. the landscape is by Giulio Campagnola, and Domenico would have inserted into it the figure based on Mantegna. Gronau in *Gaz. d. B. A.* 1894, XII, accepts this opinion, while Ad. Venturi (*L'Arte* VIII, p. 249) places the drawing after the engraving. Hind (*Early engravings,* II, 494, 2) points out that no prints exist prior to those showing the address of Niccolò Nelli (who worked as late as 1564-72). In his opinion, the landscape is fully in the style of Giulio Campagnola while the figure displays a style posterior to the engraving and dependent on Titian. Despite this contrast he is inclined to see in the drawing as a whole a further development of the engraving. Hourticq, *Giorgione,* p. 88, deals chiefly with the figure, which on the ground of the corrected arm he considers a link between the engraving and Titian's painting St. John the B. in the Academy in Venice, and therefore ascribes the drawing to Titian. Another version, attr. to Mantegna, in the Ambrosiana and publ. in *L'Arte* VIII, p. 251, has been recognized as a copy from the engraving and is thus eliminated from the discussion. In *Critica d'A.* VIII, p. 81, pl. LXIII, fig. 8 we discussed the landscape only, which we attributed to Giulio Campagnola; he might have transposed a red ch. drawing by Giorgione into a technique suitable to his own graphic process. [*Pl. L,* 4. **MM**]

The starting point for the examination of the drawing is the stylistic difference between the figure and the landscape. While the former presents a well advanced Cinquecento style and may start from Titian's famous painting, the landscape with the high horizon is Giorgionesque in character and could be by Giulio. The existence of a drawing by Giulio, combining the general outline of the figure with a detailed landscape — the only part in the drawing which was pricked and thus apparently used — may be explained by the aspect of the engraving Kr. 3. The ground on which the saint stands, with its wavy outline, makes it probable that Campagnola first engraved the figure alone and that its Mantegnesque model had this monumental aspect. Later on, in order to fill up the composition, he traced the outline of his figure on a sheet and added the landscape which he then pricked to transfer it to the plate. A later artist experimented with the drawing, adding a figure in the modern style. This explana-

tion while it leaves unanswered the question as to why there are no prints prior to Nelli, nevertheless, seems to us the best possible solution of the puzzle. We consider the drawing a work by Giulio Campagnola as far as its landscape is concerned, while the figure is an addition from the second half of the 16th century.

579 ———, 4648. Landscape, buildings at the l., two men seated at the r. Pen, br. 133 x 257. Pricked. — On *verso:* small sketch of a landscape with buildings. Morelli, I, p. 225: Giorgione. Gronau, *Gaz. d. B. A.* 1894 XII, p. 32 recognized the connection of the l. half of the drawing on the *recto*, with the engraving Kristeller 9 left unfinished by Giulio Campagnola and completed by Domenico Campagnola who enriched it by another figure group of his own invention. Gronau attr. the drawing to Giulio Campagnola, finding a decisive argument against Giorgione in the types of the figures. Kristeller, *Campagnola*, p. 13 (ill. pl. XXIII and XXIV) accepts Gronau's attribution to Giulio, adding as a further reason for rejecting Giorgione the different relation of the figures to the landscape. Hadeln, *Hochren.*, pl. 7, p. 23: "Some pen drawings by Giulio Campagnola are precious as reflections of Giorgione's cultivated graphic style and his interpretation of the landscape. There is no doubt that Giorgione created this type of landscape. The imitations, to be sure, lack the charming animation of nature, but they offer the Giorgionesque feeling for clear and delicate articulation, for gracefully varied reality." [*Pl. LII*, 1 *and* 2. **MM**]

Since we attribute No. **320**, the model of Giulio's engraving Kristeller 6 not to Giulio himself — as it would be the most natural inference in such a case — but to Andrea Mantegna, we must re-examine the attribution of every other drawing connected with any engraving by him. We must in particular be cautious in attributing to Giulio the design for a landscape engraving, since the rendering of the landscape seems to have been his weak point. Moreover, we cannot agree with Gronau and Kristeller in rejecting Giorgione because of the type and proportion of the figures. The two lost paintings by Giorgione, "The Finding of Paris," and "The Assault," presented similar types and proportions, as seen in their copies by Teniers (Richter pl. VII, no. 10 and VIII, no. 29). Giulio Campagnola who experimented as an engraver in order to express the half-dark ("sfumato") of Giorgione's late style, and who in 1514 succeeded in interesting Aldus Manutius in his designs of a new alphabet, was scarcely the artistic temperament to penetrate deeply into nature and to draw from this source the emotional impetus for a new interpretation of it. We therefore agree with Hadeln in recognizing in these drawings reflections from Giorgione's art; we go even further and wonder whether the share of the latter might not be still greater. The motive of the buildings on the hill combined with monumental ruins reminds us of the corresponding motive in Giorgione's Venus in Dresden in its left half, which might depict the same locality. Could the drawing not be by Giorgione or copied from him? Its whole appearance, most of all the hasty study on the back, contradicts the idea of a copy. As for the alternatives established above the material verified for Giorgione does not allow an unequivocal answer. In order not to confuse Giorgione's figure still further, it seems wiser to list this evidently very Giorgionesque drawing under Giulio Campagnola.

580 ———, 5539. Landscape with a group of buildings and with a goat in the foreground. Pen, 161 x 222. Ascr. to Titian, publ. as Giulio Campagnola in L. Fröhlich-Bum in *Belvedere* 1930, p. 87, fig. 66, 1. In our *Tizian-Studien* p. 175, n. we referred to the close connection with Giulio Campagnola's engraving Kr. 12 and called

it a further development of the engraving, for the reason that both versions are in the same direction.

Having examined the drawing again, we must now revise our theory. The drawing shows the motive from a slightly different viewpoint, and is much more precise in the rendering of details than the engraving. The latter may go back to another study of the same object (compare the same coincidence in Nos. **1875, 1912**). The mode of drawing is not Giorgione's in his youth, but might be that of the late Giorgione, as reflected in the productions of his immediate followers. In view of the arguments presented for No. **579** and the connection with Giulio's engraving, we list the drawing with reservations under Giulio Campagnola, but wish to point out the possibility of Giorgione's authorship.

581 ———, 5906. Landscape with trees at the l. and a hamlet beyond a river at the r. Brush, wash. 170 x 225. The drawing in the Louvre ascr. to Do. Campagnola, has been publ. by Fröhlich-Bum in *Belvedere* 1929 p. 71 ff. fig. n, as by Titian; she calls it not a working material, but a self-sufficient drawing of a landscape. Suida in *Gaz. d. B. A.* 1935/II, p. 88, fig. 88, rejects this attribution and ascribes the drawing to Giorgione, at the time of the "Three Philosophers" in Vienna. He further compares the composition with a landscape detail of the landscape in the Giorgionesque "Judgment of Solomon" in the Uffizi. [**MM**]

From this comparison we learn that the drawing may also have been intended for the background of a painting. The intimate motive in any event indicates a date posterior to the Uffizi painting; it points to Giorgione in the first decade of the 16th century. If the drawing only derives from Giorgione, we are again on the borderline to his followers, as is indicated by Mrs. Fröhlich-Bum's attribution to Titian. The technique is identical with that of the landscape in No. **578**. In a similar manner, Giulio Campagnola, in our drawing, in order to prepare an engraving may have copied a red ch. drawing by Giorgione whose way of composing Suida correctly noted. The attribution to Giulio Campagnola, although far from being certain, is preferable to those to Giorgione or Titian, since it is supported by similar penmanship.

582 Paris, École des Beaux Arts, no. 34782. Seated youth with violin and bow. A face, at the r. repetition of the curls of the youth (cut). Pen. 192 x 146. Coll. R. Cosway, William Major. Paul Kristeller, Campagnola, appendix: Giulio Campagnola, a design for an engraving. Fiocco, in *L'Arte* XVIII, p. 150 ff.: Giulio Campagnola. Hadeln, *Hochren.* pl. 4: Giorgione, about 1508. Justi, *Giorgione 2*, II, p. 305, pl. XII: Giorgione, about 1508. His objection to Kristeller's arguments in favor of Campagnola, namely, that the mode of drawing contradicts Campagnola's preference for dots, is futile, since Campagnola prepared his engravings in lines, as shown by the first state of Kr. 8, and added the dots only afterwards. Lavallée, *Cat. de l'Exposition de dessins Italiens à l'École des Beaux Arts*, 1935, no. 42: Giulio Campagnola. Richter, *Giorgione*, p. 234: Copy from a drawing by Giorgione in his middle period. Richter, *Exh. Giorgione and his circle*, Baltimore, 1942, Cat. p. 16: Giorgione.

The attribution to Giorgione is, in our opinion, contradicted by the graphic character of the drawing, which, on the other hand, betrays a training by Dürer's engravings, a fact which pleads for Giulio Campagnola, copyist of Dürer. There is the sketch of a tree in the upper l. corner whose relationship to Dürer had been noted by Kristeller and Justi, (the latter even wondered whether Dürer might not have copied a drawing by Giorgione and added a tree of his own); it is,

however, sufficiently Venetian in character to justify an attribution to the same hand that drew the principal figure. The latter is merely more restrained, because of its graphic purpose (s. Tietze, *Der reife*

Dürer, II, 2, p. 134. no. A 401a). The motive corresponds to similar figures by Giorgione at the Fondaco dei Tedeschi to which Campagnola's drawing also may be traced back.

GIOVANNI CARIANI

[Born about 1485–90 at Bergamo, 1509 first listed as a painter in Venice, where he is mentioned up to 1547]

Cariani, whose earliest but very unsatisfactory biography was written by Ridolfi, was called the Proteus of Venetian painting by Crowe and Cavalcaselle (ed. Borenius III, p. 448s.). The efforts of later authors, in particular Baldass in *Jahrb. d. K. H. S. N. S.* III, p. 91ss. and E. G. Troche, *Jahrb. Pr. K. S. LV*, 1935, to clarify his figure are fairly successful, but do not suffice to make him tangible as a draftsman also. Troche himself (p. 124) emphasizes the fact that the two drawings he lists (Nos. **585, 1258**) are attributed merely on stylistic grounds and, therefore, not to be considered as well established. In our opinion the two mentioned drawings are quite different in character. The one, being an exact copy after Palma Vecchio, offers insufficient clues for an attribution, while the other, in style and subject a companion piece of No. **583**, displays very personal characteristics which indeed correspond better to Cariani than to any other artist. The two drawings, although their compositions were evidently, as noticed by Wilde, influenced by religious representations (No. **583** by a Wedding of the Virgin and No. **585** by a Presentation of Christ in the Temple) seem to illustrate a secular narrative, the wedding of a knight who then departs, and his return after the birth of a son, which we are unable to identify. (In this connection we may point to the murals from Ariost's Orlando Furioso, painted by Cariani on the façade of the Palazzo del Podestà at Bergamo.) Our tentative attribution of No. **584** rests solely on stylistic reasons.

583 BAYONNE, MUSÉE BONNAT, 118. Unidentified subject. Pen, dark br., on faded blue. 205 x 354. Slightly rubbed. (Photo Archives 252). [*Pl. LIV*, 1. **MM**]

The close connection with No. **585** is evident. Compare, for instance, the types of the old priest wearing a scarf on his head, or that of the curly-haired youth, resembling the portrait of Giorgione, and further the compositions given spatial depth by a low wall in the foreground and behind this loosely connected with the landscape. The subject matter, however, remains as mysterious as in the other drawing. Although the l. part apparently stems from the usual arrangement of a "Circumcision," this action is not represented. Some of the figures, first of all the knight in armor, with the strange hat, and the bearded man behind him, perhaps also the principal woman and the youth with the curly hair, seem to be identical persons in both drawings. They seem to represent two scenes of a secular story presented in a style borrowed from religious subjects. See No. **585**. The arguments in favor of Cariani are the same and so are the reservations necessary when treading on such uncertain ground.

584 BERLIN, KUPFERSTICHKABINETT, 238. Seated Virgin, the Child only sketched. Bl. ch., on faded blue. 279 x 209. Coll. von Beckerath. Recent inscriptions below: Lorenzo Lotto, Titiano (struck out), Sebastiano del Piombo. Ascr. to Lotto. [*Pl. LIII*, 3. **MM**]

In our opinion, the drawing lacks essential elements of Lotto's style, his mannerism as well as his almost rustic approach. It is closer to the style of Palma, compare his paintings in the Louvre (ill. *Klassiker, Palma*, 40) and Naples (ibidem 63) and for the drapery those in Vienna and Venice (ibidem 66 and 67), but is hardly by Palma him-

self. An attribution to his follower Cariani, based on a certain resemblance to his "Virgin and Child with Saints" in Munich (ill. in Max Göring, *Italienische Malerei des XVI. Jahrhunderts*, pl. 84, or Baldass, in *Jahrb. K. H. S.*, N. S. III, 102) can be presented only with the utmost reservations.

A DRESDEN, KUPFERSTICHSAMMLUNG, The Wedding of the Virgin. See No. **1258**.

585 VENICE, R. GALLERIA. Meeting of a young woman and a knight in armor, both accompanied by assistant figures. A building and trees behind the figures. Pen, wash, height. w. wh., on faded blue. 280 x 347. Strip added at l. Modern inscription: Giorgione. (Photo Anderson 15086, school of Palma). Publ. by J. Wilde, in *Jahrb. K. H. Samml.*, N. S. IV, p. 246, as by Giov. Cariani and a secular scene composed after the pattern of religious compositions with figures in half-length. Wilde points to the "Giorgionesque" elements in the composition and bases the attribution to Cariani exclusively on general resemblances with the types of the latter. E. G. Troche, *Jahrb. Pr. K. S. 1934* (LV), p. 124: The attribution rests on merely stylistic reasons, therefore, remains undecided for the present. [*Pl. LIV*, 2. **MM**]

The drawing is evidently by the same hand as No. **583**, and the attribution to Cariani, without being definitive, the best available at the present time. An origin in the second decade of the 16th century, and within the sphere of Giorgione, is attested by the resemblance in drawing style to No. **580**.

VITTORE CARPACCIO

[Mentioned 1486 to c.1525]

The first Venetian draftsman of whom we have a definite idea in this activity is Vittore Carpaccio. Around him enough authenticated drawings have been brought together to make his figure in this artistic category well defined and, to a certain extent, independent of his value as a painter. A great difference, certainly, from the cases of Jacopo and Giovanni Bellini. The latter, even for those who are less skeptical than we, is hardly to be grasped at all as a draftsman, and the former's sketchbooks which from whatever angle we approach them are something unique, offer, as we have tried to show, the output of a collective activity. Even if our distribution among various hands fails to convince the reader, it remains a fact that the slowly formed tradition of medieval painting forms the background of the artistic tendencies laid down in these drawings. Their author or authors dwell in a sort of twilight. Both the veiled character and the uniformity of the drawings are increased moreover by the complete retouching that modifies or falsifies their original character.

Carpaccio's drawings, on the contrary, form an artistic unity, the characteristics of which, concentrated in his personal production, naturally are blurred as we move toward the margins of the group. In this transition zone we may discover the shares of assistants, followers, imitators. It is typical of working conditions in Venice that in Carpaccio's workshop, as elsewhere, artistic forces of very different rank co-operated and carried its activity into, and even through, a second generation.

The separation of authentic and school works was begun by Hadeln who relied largely on Molmenti-Ludwig's extensive documentary studies. Later compilations by Fiocco in his monograph and van Marle in his Corpus added but little knowledge to his results, although they and others were in a position to deal with a considerably augmented material. We, too, are able to add some new drawings. More important, however, than this increase in bulk is our new critical approach to the involved problems.

These problems are in part connected with qualities which explain Carpaccio's impressive uniformity as a painter. From whatever period the compositions originate they are linked together by the same types repeated through the years, probably on the basis of drawings. Concluding from what is left of a material certainly much richer originally, we gain the impression that Carpaccio composed his pictures by combining a limited number of ready-made elements.

This assertion might at first sight seem to contradict the general impression of Carpaccio's personality; Lionello Venturi, for instance, characterizes him as an outsider, a kind of amateur, keeping aloof from the professional art activities in Venice. He is a most delightful story-teller whose inventive faculty equals his decorative fertility; his imagination overflows, his representations charm us by wit, humor and glamor. The spell he casts on us makes us overlook the shortcoming that his abundance is literary and poetical, not formal. The stories he tells are highly amusing, the moods he evokes are fascinating; but he is not keen to create new forms, in order to express himself and by no means opposed to employing cut and dried patterns which vary only slightly from picture to picture. An artist who has no scruples about repeating himself will hardly refuse to imitate others, his inventive urge being in some way weak or stunted. As a matter of fact, Carpaccio is an unprejudiced borrower. We shall later on have to discuss his borrowings from Gentile Bellini and Albrecht Dürer. This procedure on the part of Carpaccio was by no means shocking to his period. The medieval idea that artistic types were common property available to

everybody, was not yet entirely outgrown. This conservative element in Carpaccio is counterbalanced by his modernity in expressing his artistic individuality. All the traditional types he accepts are so thoroughly transformed by Carpaccio's personal touch that his deficiency in the inventive task has been overlooked. As far as we see, only C. L. Ragghianti (in *Critica d'Arte* VI, p. 276 ff.) has felt that this trend to acquiesce in ready-made forms is an essential feature in Carpaccio's artistic character.

In an artist of such a description, not particularly eager to express himself by forms invented for each individual emergency, we may presume the earliest accepted influences to be the most deeply rooted and to last the longest. Since the artist is not opposed to repeating himself, he will most probably make the most extensive use of the stock he piled up in his youth. The influence of his teachers ought to be permanently recognizable. We will not stir up here the discussion of Carpaccio's artistic education. By no means agreeing with Fiocco's wholesale rejection of Bastiani's claims, definitely recognizable in Carpaccio's rendering of space, we, nevertheless, admit that the stress laid on Gentile Bellini's importance to Carpaccio is well justified. Whatever he may have learned with Bastiani, Gentile was the decisive factor in his formation, as Berenson, following earlier authors, once more demonstrated in *Rassegna d'A.* LVI, p. 1 ff. As for the drawings, Hadeln had already recognized the important connection between the two; for him Carpaccio as a draftsman stems from no one but Gentile Bellini. The fact that Gentile's sketches, No. **263** and even No. **270**, were attributed to Carpaccio, in spite of Hadeln's preliminary protest concerning the former, is a subsequent confirmation of his theory.

Fiocco unfortunately lessened the force of his thesis by burdening Carpaccio's alleged early style with a number of provincial, and in our opinion certainly later, productions which do not anticipate the mature stage of his style, but, on the contrary, are derivations from it. They are, characteristically enough, located mostly in Dalmatia or Istria or other remote provincial places. As said above, we do not propose to discuss here these scraps left over from Carpaccio's abundance, but shall limit ourselves to the specific material of drawings. We begin with the "Adoration of the Magi" in the Uffizi (No. **606**) the connection of which with No. **590**, now in the Fogg Art Museum, has been observed by others. New and more important for our problem, is the fact of its dependence on Gentile Bellini's "Adoration of the Magi" in the N. G. (ill. van Marle XVII, fig. 88). St. Joseph in his strained posture and the three men at r. are exactly identical, but in the painting the group stands next to Joseph; the general arrangement, moreover, in which the contrast to Jacopo Bellini's favorite composition based on Gentile da Fabriano's famous version is significant, is taken over from Gentile Bellini. The bower at left recalls the cavern in the painting. What conclusions may be drawn from these points of conformity? Certainly that Carpaccio had some connection with Gentile Bellini, but not that the drawing must necessarily originate from his formative years, for the same Joseph appears also in Carpaccio's "Visitation" in the Museo Correr in Venice (ill. Fiocco, *Carpaccio*, pl. CXLV). The decoration of the Scuola degli Albanesi, whence this painting came, was begun in 1504. Carpaccio's panel accordingly is a mature work and the second appearance of the figure in it points to the use of a *simile* drawing. (Another figure from Gentile's painting, the Turk at r. of the group of three men mentioned above, is repeated in Carpaccio's "Consecration of St. Stephen," of 1511, in Berlin, ill. Fiocco, pl. CLX; Carpaccio certainly had a drawing of this Turk too.) Similar drawings may have been used for the Uffizi drawing, for the dating of which we must depend on stylistic considerations. A comparison with No. **592** points to the 1490's, and one with No. **606** confirms at least that the drawing in the Uffizi is earlier. Mongan-Sachs in their analysis of the drawing in the Fogg Art Museum emphasized its difference from the one in Florence. The simple and charming scene in the latter in No. **606** is loaded with symbolism, the scattered ruins in the background indicating the decay

of the old world that yields to a new one. To draw these buildings, drawings of a more archaeological character may have been used. For one at least, the Oriental minaret, we know something of the origin: it is the tower of "Rama," appearing in Reeuwich's woodcut of 1486 and also in Carpaccio's "Triumph of St. George" (the painting, ill. Fiocco, pl. LIX, not the drawing, No. 597). We shall presently return to the question of these Oriental elements in Carpaccio. We limit ourselves for the moment to emphasizing the difference in date between No. 606 and No. 590 and listing the former, as from the 1490's, as our first document for Carpaccio's connection with, or dependence on, Gentile Bellini. The second document is another drawing in the Uffizi, No. 284, from Molmenti-Ludwig onward universally acknowledged as by Carpaccio and even called by van Marle "one of the most important and finished" by him. Those who believed in Carpaccio's authorship could easily refer to numerous connections with his paintings. Molmenti-Ludwig, it is true, did not consider the drawing to be a study made for the painting in the Brera (again from the Scuola degli Albanesi) although the group of the principal actors is exactly identical, and the high priest, the man behind him bending over the railing, and the little boy beneath at least almost so. Molmenti-Ludwig referred instead to a painting of the same subject for which the Scuola della Carità arranged a competition in 1504. Carpaccio may have taken part in it, as we are told other artists did. It was, however, not he who won, but Pasqualino Veneto who, by the way, did not profit by his success, since he died soon afterward and left the space on the wall empty for a greater successor: Titian. According to Molmenti-Ludwig's thesis, partly endorsed by Hadeln in view of the *modello* style of the drawing, the latter might be a *modello* presented by Carpaccio on this occasion. Fiocco did not accept, nor even mention, this hypothesis, nor did he acknowledge the connection with the painting in the Brera, engrossed in his own observation of the occurrence of some of the figures from the drawing in the organshutters of 1523 at Capodistria (Fiocco, pl. CXCIV). The youth seen from behind is repeated, though not exactly, in this painting. Nevertheless, Fiocco was mistaken when dating the drawing in Carpaccio's late period for this reason. As most of his late works, the one in Capodistria repeats and rearranges old motives, flavoring them with details borrowed from other artists (see p. 72). Fiocco's observation only confirms that the old *"simile"* drawings, first utilized many years earlier, were still in use in the shop in 1523. His misdating of the drawing may at the same time bear witness to a serious difficulty in classifying No. 284 among Carpaccio's drawings.

It is indeed, as pointed out on p. 72, in most respects entirely different from all of them. We do not find among Carpaccio's works any composition like this, with the arrangement of the figures very much crowded together and placed on the same level in the foreground, and behind them, without overlapping, a second layer devoted solely to architecture. Nor do we find a building as solidly constructed and as clearly ordered as the one in No. 284. Carpaccio's buildings are dream architecture, the products of a painter's fancy, even when based in details on specific views. This ideal cathedral or palace, representing the Temple of Jerusalem looks, on the contrary, like the vision of an architect and is well grounded on a solid foundation. This approach, an architect's way of thinking, is not Carpaccio's, whom Gilles de la Tourette characterizes as one "who does not care for archaeology." It is Gentile Bellini's as we see him and, in any case, his is the general arrangement conforming to that of his classical "Procession in the Piazza di San Marco," or the "Sermon of St. Mark" in the Brera.

May Carpaccio in 1504, or even at some other time, have been so close to his presumed ideal, or teacher, Gentile Bellini? The magnificent buildings in the drawing might, if it has rightly been connected with the competition of 1504, have been part of the stipulated conditions; for in the other drawing, probably connected with the same occasion, No. A 641, the same elements occur. Might Carpaccio have used for the background an architect's design

placed at his disposal? Even if so, it still remains unlikely that the drawing is his. We have other models precisely from the supposed time of origin, establishing the final composition, for instance No. 592 or No. 636. A greater difference could scarcely be imagined. Are we obliged by the agreement of numerous figures with those in Carpaccio's works, enumerated on p. 72, to make such a bold leap and accept Carpaccio's authorship? We have learned by now to be suspicious about the origins of Carpaccio's individual figures. These figures pointed out in the drawing in question are striking in their structural solidity and increased vitality, qualities not considered characteristic of the charming story-teller, Carpaccio. They have the vigorous frame of Gentile's figures. The richly draped Turk with a turban at l., the young lady in the first row, the old man walking to the r., and others may be traced back to his stock. This means that in this drawing we notice a predominance of elements which are traceable to Gentile. They might prove that Carpaccio, at some time, if we do not insist on the conjectural 1504, approached Gentile to the point of being taken for him; or that the drawing is by Gentile, or at least copied after him by someone. The difference from Carpaccio's well-authenticated designs of a related character speaks against the first alternative; at least the benefit of the doubt is in favor of Gentile, since no drawing of his belonging to this specific class is left. The only one available for comparison (if actually by Gentile Bellini), No. 269, shows a striking relationship in the treatment of the crowd. There is still another possibility: that the Gentilesque elements used by Carpaccio in later works were also accessible to some other artist who in this drawing arranged them according to his own needs. Dim figures from the Venetian Quattrocento emerge: Mansueti, Bastiani, Diana, Pasqualino. We should not like to cause further confusion by introducing and discussing their respective claims. One point is confirmed beyond doubt by the drawing in Florence: Carpaccio's disquieting closeness to Gentile.

We have to keep in mind this general statement, the scanty yield of disproportionately long and complicated considerations, when turning to Carpaccio's Oriental drawings and his alleged borrowings from Reeuwich's woodcuts. The gist of this much discussed question is Sidney Colvin's and Molmenti-Ludwig's notation of an exact identity of figures and buildings in Carpaccio's paintings and drawings with those in woodcuts illustrating Breydenbach's famous *Pilgrimage to the Holy Land,* first published in 1486. By reason of the early date of the book, of the specific assurance in Breydenbach's preface that the illustrations were drawn by Erwin Reeuwich who accompanied the travelers for this special purpose, and further because of the fact that later on Reeuwich's illustrations became an inexhaustible source for numerous artists, Colvin and Molmenti-Ludwig reached the conclusion that Carpaccio, too, copied them. This conclusion was accepted by some authors, but also opposed by others, especially Fiocco, who became their most radical spokesman in his monograph. He flatly denied Carpaccio's dependence on Reeuwich. One of his arguments, that an artist of Carpaccio's rank would not have cared to imitate a mediocre illustrator, is certainly very questionable, but others are more valuable: that Carpaccio used many other models than those offered by Reeuwich's woodcuts and, therefore, other Oriental studies of a similar character must have existed which might have served for the woodcuts; that, on the whole, it seemed rather strange to suppose that a Venetian needed models by a Northern artist precisely for material more easily accessible to Venetians than to any other artists and which was, so to speak, the speciality of Venetian painters. Fiocco's conclusion is that Carpaccio, as well as Reeuwich, used studies made on the spot by Gentile Bellini when he visited Turkey in 1479/80, and that, moreover, Carpaccio may have had an opportunity of making such studies himself, an old tradition affirming that he, too, had traveled in the Orient. This tradition is voiced by Cesare Vecelli who in his *"Habiti"* of 1590 mentions that the Sultan had invited "un certo Vittore Scarpe, il quale era diligentissimo

pittore dei tempi suoi" (a passage, by the way, omitted in the later editions of 1598 and 1604). The identification of this Scarpe with Carpaccio (called Scarpazza in Venetian dialect), and the credibility of this witness, writing about a hundred years after the events, were called into question by Gilles de la Tourette (*L'Orient et les Peintres de Venise,* Paris, 1923). Studying the question from the standpoint of an Orientalist he reached the conclusion that Carpaccio had never visited the Orient himself and for his Oriental sites and costume figures must have relied on models by others. Gilles de la Tourette, also Fiocco so far as we know, did not include in his discussion Carpaccio's large view of Jerusalem, mentioned and highly praised as a work of singular importance in his letter of August 5, 1511 to Francesco Gonzaga (P. Molmenti, *Carpaccio,* Venice, 1903, p. 69). Since no trace is left of this apparently large view, there is indeed little to be said about it. Its existence certainly does not prove Carpaccio's visit to the Holy Land, such paintings, more or less faithfully following available authentic views, apparently having been a current stock in trade in Venetian painting shops. Gentile and Giovanni Bellini were ordered to paint views of Venice, Cairo, Paris and Genoa by Isabella d'Este, and we know from a letter of her agent how difficult it proved to procure a certain rare woodcut to serve as a model for the view of Cairo. Carpaccio may have used for his purpose the view of Jerusalem in Breydenbach's "Peregrinatio" or some other model, just as according to Gilles de la Tourette, he used various models for his other Oriental views. For in spite of his doubts about Carpaccio's pilgrimage, Gilles de la Tourette does not make him a copyist of Reeuwich's woodcuts only. And indeed, where the subjects are identical, Carpaccio's rendering as a rule is much more exact than Reeuwich's, so that he must have used other models, possibly the same drawings as Reeuwich himself.

Speaking of Gentile Bellini (p. 66f.) we tried to prove that these drawings were his, made during his stay at the Sultan's court in 1479/80. Contrary to Gilles de la Tourette, according to whom Carpaccio must at least have copied Reeuwich's amusing woodcuts for his figures, we are convinced that both categories may be traced back to Gentile's drawings. A drawing in Professor Mather's Collection at Washington Crossing, Pa., No. **640**, now published for the first time, seems to offer decisive evidence of this. With two heads on the *recto,* one of a beardless man and one of a lion, both to be traced back to the Bellini studio and both utilized in paintings by Carpaccio, the drawing combines a study of two Turkish women on the *verso,* a group long since in the very centre of the discussion of the Carpaccio-Reeuwich relations. They appear, evidently adapted to a more Gothic taste, in one of Reeuwich's woodcuts, and in various of Carpaccio's works. In the painted "Triumph of St. George" in San Giorgio degli Schiavoni the headgear of the woman at the left has the same high shape as indicated by a correction on No. **640**. Originally it was oval, as it is in Carpaccio's drawing, No. **597** (the sketch of the painting just mentioned), in Reeuwich's woodcut, and apparently in Gentile's original, on which these various repetitions are based. The same figure appears also in the mysterious drawing No. **284** in the Uffizi, circumstantially discussed above.

Once more we may emphasize that the apparent liveliness of a costume figure is not yet proof that it is drawn from life. The same deceptive spontaneity strikes us when approaching the drawing which is no less interesting for the discussion of Carpaccio's and Reeuwich's interrelations, No. **615**, in the B. M. The liveliness of the linework makes the drawing look like a hasty sketch made from nature. We know, however, that such a view does not exist in reality and that its elements are taken from various places. The tower at r. appears in Reeuwich's woodcut with the view of Candia and the one at l. is the "French Tower" at Rhodes as seen in Reeuwich's woodcuts of this town. To these observations of preceding authors we add the new one, that the castle on the hill and the stretch down to the town correspond to the view in Reeuwich's woodcut of "Coreun" (ill. Davies, pl. 15).

This strange mixture—no less strange if compiled from three woodcuts than if taken from their drawn models—was supposed to have been done for "The departure of the betrothed pair" in the Ursula Legend; there are indeed not only a number of resemblances, but also of deviations. The tower at l., for instance, based on the French Tower at Rhodes, appears in the painting at a different angle than in the drawing where it is shown from the corner. In fact, another design seems to have been used. The whole situation is changed insofar that the buildings in the drawing are on the seashore, while in the painting they are separated from the sea by an embankment filled with people. In our opinion, the drawing, grouping most of the elements used in the "Departure" differently might have been made for another painting by Carpaccio; the old inscription referred to the harbor of Ancona and the peace negotiated there between Emperor and Pope. This "Storia d'Ancona" had been the subject of one of the murals in the Ducal Palace executed by Carpaccio according to his own report. We are not informed what this painting, destroyed by the notorious fire of 1577, looked like, but may infer from the existence of a fortress on a steep hill over the shore in the substitute painted in the Sala del Gran Consiglio by Gambarato, that Carpaccio's painting contained a similar arrangement. It forms part of the Venetian system in "restoring" vanishing or vanished works of art, to take over essential formal elements.

This is a point to which we shall presently have to return when discussing another important link between Carpaccio and Gentile Bellini, No. 635, in Sacramento, first recognized and published as a sketch for the figures in the same "Storia d'Ancona," by E. Tietze-Conrat, in *Art Quarterly,* Winter 1940. For her the resemblance of the drawing to the substitute was again a strong argument for the identification of the drawing. As we remarked before, there is no doubt that Carpaccio executed the mural, but it remains doubtful whether the design was his. The task of decorating the Sala del Gran Consiglio formed part of Gentile Bellini's appointment from 1474 on; later Giovanni Bellini stepped in and in 1488 Alvise Vivarini also obtained a share, apparently because the decoration made such slow progress. But the private competitor seems not to have been more efficient than the official painters; when Alvise died in 1503, he left one painting half finished and two more, one of which was not even begun. Therefore, in 1507 Giovanni Bellini was appointed to finish the missing paintings with the help of assistants among whom Carpaccio is mentioned. How far may Carpaccio have been independent under such conditions? Certainly he prepared the details of the composition. No. 618 is an exact study of the two monks appearing at r. in the sketch; the style is that of Carpaccio's later years, it fits very well to the supposed date of 1507. But did he also provide a design of his own for the whole, or was he bound to somebody else's design? And if so, whose? Gentile Bellini's, Alvise Vivarini's or Giovanni Bellini's? The last one is mentioned as the supervisor of the undertaking in 1507. Alvise had left behind him a half-finished job, Gentile originally had been responsible for the whole decoration. It is a rather melancholy illustration of our insight into art in Venice that, offered a choice among four outstanding artists, we are unable to decide with absolute certainty. Alvise may be eliminated, and Giovanni's drawing style, especially as related to such a task, is completely unknown. Could he have chosen such almost crude linework to outline the frame for the planned composition for Carpaccio? In considering the latter we miss the grace of his figures and the facility of his drawing style. There remains Gentile, whose rendering of a crowd in the less ruined portions of No. 269 is rather close to our drawing, especially to that on the *verso*. There are also resemblances to No. 284. But are they conclusive? The most plausible assumption seems to be that Carpaccio, faced with the task of making a general design within a "Bellinesque" enterprise, may have once more adapted his style to that of his deceased former master and made this rough but impressive sketch.

The whole process of building up a composition contains a mechanical element inconsistent with our concep-

tion of a free artistic activity. Carpaccio fills a framework with details based on his own studies or borrowed from others. No. **A 602**, formerly considered an original, but convincingly described by Hadeln as a copy from a lost original drawing, is an especially enlightening example. Besides this general sketch or *modello* there are two drawings connected with the same composition, a sheet with heads in the B. M., No. **613**, from which a few were picked out to be used in the composition, and a sheet in the Uffizi, No. **601**, containing studies of two standing men, which Molmenti-Ludwig had already recognized in the final arrangement of the whole. How complicated the process is, has been pointed out by E. Tietze-Conrat in the *Graphische Künste,* 1929. In No. **A 602** two of the attendants are exactly taken over from two woodcuts by Dürer, one from B. 9, the other from B. 81, while a third no less prominent man, is a favorite type seemingly originating from Gentile Bellini. The man at l. on No. **601**, while the general posture conforms to the composition as shown in No. **A 602**, is much less dependent on Dürer; it might be a study after a model meant to replace the figure at first taken over from Dürer. The use of a borrowed pattern is only a temporary device to hold the place of the final figure. These *"similes"* are something like mannequins who try on the garments which later on will be worn by the real customers, or like the "stand-ins" used in the movies.

Our stressing the dependence of Vittore Carpaccio on various models and his habit of distributing these borrowed types over his compositions is no impediment in appreciating and enjoying his other side—his facile invention and vibrating linework. Here, we feel him modern or timeless. In this aspect too, Carpaccio, in quite another sense than when exploiting the drawings of his master, is Gentile's pupil. Like him he sets down his drawings, both the total compositions and separate details, with a view to their final place in the compositions. In both regards, as pointed out on p. 65 where we discussed Gentile's draftsmanship, new tasks expanded the older patterns no longer sufficient for subjects for which no tradition existed. Although not yet entirely rejecting the use of cribs the modern spirit imperatively demanded new solutions. Patterns of spatial construction or of typical compositions, as in Jacopo Bellini's drawings, made way for individual arrangements of unusual subjects within natural space, and *simile* figures were replaced by individual figures suitable only for a single or, at least, very restricted use.

Let us add at once that these contrasts are not absolute, and that connecting links and intermediate stages exist between the contradictory types. The urge for independence and originality seems to have been strongest in the middle period of Carpaccio's life, while in his youth he was hampered to some extent by his close ties to Gentile Bellini, and at the end of his career the increasing sterility and mannerism are also expressed in an endless self-repetition and weary resignation. Carpaccio by that time was hopelessly left behind by the young masters of the new generation and may have felt it. His general artistic evolution, as outlined by Berenson, is mirrored in the drawings, the chronology of which is fixed by the loose frame-work of his general development. By connecting drawings with dated paintings we obtain a sufficiently well-established sequence.

The start is marked by two drawings closely connected with the "Miracle of the Holy Cross" of 1494, forming part of an undertaking within which Gentile Bellini took the lead. For both drawings, No. **589** and No. **637**, the relationship to Gentile Bellini's types, but no direct dependence on them, is easily recognizable; Carpaccio might have drawn them for the special purpose under the inspiration of similar types of Gentile. They are not *similes,* although still made of their substance, but display a trend toward becoming types. One of them, the *"Cavaliere della Calza,"* seen from the back, was indeed introduced into Cesare Vecelli's costume book as a typical costume-figure. On the *verso* of the same drawing we find three studies from or for bearded saints, poorer than

the *recto,* and therefore declared "school of Carpaccio" by Fiocco. Considering the early date it might seem more proper to speak of "Carpaccio still at school," that is, to explain the undeniable archaic character of these figures by their dependence on older models. On the two sides of one drawing we have before us examples of two different types: the late gothic *simile* and the Renaissance study.

We might expect an abundance of studies of this description for the approximately contemporary cycle of St. Ursula, Carpaccio's masterpiece, unsurpassed for inventive power and narrative zest. Only very few, however, are left, all outstanding in quality and well illustrating Carpaccio's methods. Two are total sketches and by the way, quite different in character. No. **604** establishes not only the essential arrangement of "The Dream of St. Ursula," but also the whole spatial and atmospheric character of the painting. In the indifference to the individual forms and the faculty of attaining coloristic effects by the means of black and white the Venetian predilection for the pictorial is strongly felt; the aim is by no means to sum up forms to produce a total. The other sketch, No. **592**, for the "Departure of the Betrothed Pair," is entirely different, at least as far as the definite characteristics go. Here the composition is reduced to the arrangement of the figures; instead of a substitute for the painting its mere skeleton is presented. The final arrangement is already established in the main lines, including the kind of pier on which the scene takes place and the embankment behind it with the group of men rendered in the sketchy manner of Gentile Bellini. Again the individual figure and individual form are sacrificed, the penwork destroys the continuity of the outlines, and interior modeling is almost entirely foregone.

As for detailed studies, leaving aside the city view, No. **615**, already discussed on p. 142, only one is left, the head of a youth at Oxford (No. **629**), a study, if not for the prince in the "Arrival of the ambassadors," for some other figure of this cycle. Again the mode of drawing is very interesting and may, if we are really entitled to consider Carpaccio as Gentile's continuer, confirm our theory that of the two heads in Berlin only one (No. **260**) is by Gentile, and the other (No. **261**) by Giovanni Bellini. For to the same degree as the head in Oxford renounces the modeling and the psychological interpretation of No. **261**, it follows the line indicated by No. **260**, but on the level of the next generation and with the means of one who is consciously aiming at pictorial effects.

Having concentrated on this masterly study of a head we notice the difference in its rendering of the model from that of two other no less renowned heads in Donnington Priory, No. **594**, both used in the "Saint Ursula in Glory," and, as already made evident by Mr. Colvin, originally made for this painting although the heads appear also in the "Presentation" of 1510. The "Glory" is dated 1491; can the drawings be as early as that? In a thorough investigation, republished in his *Study and Criticism of Italian Art* (3rd series, 1916, p. 124) Mr. Berenson rejected this date for the painting which he placed in the neighborhood of the "Presentation." This theory was rejected by Fiocco and accepted by van Marle. The use of the same studies in both paintings would not in itself be a decisive argument in favor of their close neighborhood; we have emphasized that the use of various drawings in paintings stretches over many years. But these were drawings meant to represent types and, therefore, by their very character apt to be used as a later need might require. The two heads in Donnington Priory have another character. They were made for a specific purpose, notwithstanding their repetition when a second opportunity arose. Moreover, they are far advanced in style beyond the naive sweetness of No. **629**, have come of age, are knowing and conscious and, besides all this, much more carefully modeled. For the authors of this catalogue, who for so long were intent on Dürer's works, the relationship to Dürer's drawings for his "Feast of the Rose Garlands," made at Venice in 1506, is so close that they feel compelled to accept Mr. Berenson's theory.

On the contrary, by reasons of style and for its general spirit, we feel inclined to connect the one at Chats-

worth, No. 592, for which a much later date has been proposed with the early sketches for the Ursula Legend. The subject may have been rightly identified by Molmenti-Ludwig as the "Visit of Francesco Sforza to Lorenzo Giustiniani," while their further suggestion that it may be connected with an order for paintings given to Carpaccio in 1523 is certainly unfounded. Hadeln had already stated that there is no documentary evidence of subjects of such nature. Moreover, the date of 1523 contradicts the hypothesis since the style of the drawing displays all the sweetness and freshness of Carpaccio's early period, an eagerness which by 1523 had long since faded away. The resemblance of the landscape to Gentile Bellini's "Adoration" in the N. G. is a further argument in favor of an earlier date.

This is the heyday of Carpaccio's sketching activity: the period in which figures join easily to compositions and in which the linework, more than in other times, is personal. The strokes, so to speak, have dried up so that by their brittleness the little connection and verve they had aspired to has gone; the lines are incessantly interrupted, at some places entirely reduced to dots. Nowhere is the illusion admitted of an outline separating a figure, or part of it, from the surroundings. This decomposition of forms, sometimes combined with an indication of tone by a touch of wash, fills these drawings with a vibration which is Carpaccio's personal problem.

To this group belongs No. 606, already discussed as to its close dependence on Gentile Bellini's "Adoration" in the N. G., further two "Sacre Conversazioni," one in the Rasini Coll., No. 624 and the other in Donnington Priory, No. 595, both containing single figures that reappear in paintings not dated, but most probably to be placed around 1500. Further, connected with the preceding ones by their drawing style, the curious groups of Nos. 614, 625, both drawn on front and back of the sheet. The drawing in Moscow apparently was done on a page torn from an old account-book, and an annotation on it contains various dates, 1495 as the latest, thus offering to a certain degree a *terminus post quem*. We may presume a date not too distant from that *terminus*. As for the subject we suggest (on p. 152) a connection with certain portraits by Carpaccio of which literary evidence exists.

The sheet in the Louvre, on which many Oriental figures are drawn, No. 631, seems to have belonged to the same account-book; if so, this is a further argument against Fiocco's theory that such hasty sketches were drawn from nature somewhere in the Orient. It is rather unlikely that anyone should have carried along with him parts of an old account-book, while he may well have utilized these sheets at home when making notes after Gentile Bellini's Turkish studies (p. 70 f.). The drawing offers a choice of figures ready for use in backgrounds of paintings, like those on either side of No. 634, and indeed they can be discovered there in various paintings from Carpaccio's cycles in San Giorgio degli Schiavoni.

For these series, executed early in the 16th century, a few important general sketches exist: Nos. 597, 617, 636, and, besides, a few studies of single figures, for instance, No. 620v, made to replace a figure roughly indicated in the general sketch. Nevertheless, are we allowed to say that the best of Carpaccio's fire has died out? We cannot help noting some stiffness in these later compositions, partly due to the excessive use made of stereotyped figures. Compared with the sketches for the Ursula Legend No. 597 looks frozen. The dreams of the artist are restrained by too heavy a documentation. The buildings in the background are based on views of Oriental towns current in Venetian studios; the figures, especially accessory ones, are drawn from similar sources. The two Turks standing in the middle and almost above the dragon in the drawing, and, according to the prevailing opinion, derived from Reeuwich, according to ours from Reeuwich's model, Gentile Bellini, are shifted to the r. in the painting. Other figures, the man on horseback in the background, for instance, not existing in the first

sketch, are introduced from other drawings (Nos. **631, 634**). So much of the composition looks as if it were pieced together that the inner unity suffers. The heterogeneity of the separate elements reflects suspicion on the homogeneity of the whole. Something has gone wrong with Carpaccio's creative power.

The drawings connected with San Giorgio degli Schiavoni, as would be expected from their character as miscellaneous studies, were in part also used for other paintings; separate figures appear especially in the scenes from the "Life of the Virgin," painted from 1504 on for the Scuola degli Albanesi and now dispersed. To supplement these conventional types special studies were made, Nos. **621, 622**, the trends of which culminate toward a sharper individualization in the heads in Donnington Priory discussed above.

As for the technique of drawing, the trend toward a pictorial expression keeps on increasing. Nos. **603, 630** mark the transition. Although clinging to the older combination of curiously twisted strokes and light wash, the trend toward pictorial effects, competing with those of painting, is unmistakable. May we surmise that the coloristic tendencies of the younger generation may have somewhat bewildered Carpaccio who, a genuine quattrocentist, had needed the strong support of the tradition from which he sprang? What we have called before the flaw in his creative power may have been the increasinlgy felt discrepancy between his own art and the new currents.

Among his paintings one has frequently been mentioned as an evidence of Carpaccio's uprooting in his last period: the "Martyrdom of the ten thousand Christians" in the Academy of Venice, of 1515. It is an almost tragic spectacle to see how the aging master tries to modernize his Quattrocento heritage to which his sweet childish figure types still belong, by introducing motives borrowed from Michelangelo's cartoon. In the very hasty sketch, No. **623**, whose connection with this composition was first suggested by Molmenti-Ludwig, we feel strange hesitations. The connection, incidentally, is much looser than usually supposed, neither the general arrangement nor separate motives are really identical. The linework appears reminiscent of Gentile Bellini's process in setting down such first ideas; but Carpaccio is so wavering and indecisive that the drawing seems to hesitate between the arrangement of the whole composition and the visionary scene seen in the painting on the hill. The figures on the back of the drawings, unconnected with the painting, are so typical of Carpaccio's shop that an assistant may have drawn them on a discarded sheet.

We return to the more normal production when turning from this exceptional and ambitious drawing to No. **630**, the careful preparation of a great composition of which, however, no trace is left; a study for a single figure of it is preserved in No. **598** which, however, may not have been made for this special purpose, being in reverse. (This same figure appears in the right direction in an obvious shop production, the "Santa Conversazione" in Karlsruhe). In a schematic sketch for the general arrangement, on the back of the drawing in Paris, St. Jerome was planned as seen in the drawing in Florence; this inverting of the figures, as well as the pushing them around through various compositions, looks like another sign of slackening self-confidence.

The mode of drawing in this late period grows clearly from earlier stages, but the trends in them are now further developed. The wash has become more intense, the shadows deeper, up to the point of completely swallowing the framing linework. In the single studies parallel brush strokes, alternating white and black or gray, produce an iridescent surface, while the individual form is almost completely eliminated (**612** and verso, **601**).

The last mentioned drawing, the only known use of which occurs in a very late shop production, an altarpiece by Benedetto Carpaccio of 1541 in Capodistria, is drawn on the back of a sheet showing the two figures meant to replace and modernize two figures borrowed from Dürer's woodcuts for the composition "The trial

of St. Stephen" (see p. 150). The composition exists only in a copy, perhaps not so late as presumed by Hadeln, and the invention is placed at about 1515 by the painting to which it belongs. It displays the fictitious liveliness of a puppet show, the artificial co-ordination of figures each of which was invented and existed originally only for itself. The authentic drawings of this period, No. 596 the design for a lost altar-piece of 1519, and No. 590, the second infusion of a much older invention, originally inspired by Gentile Bellini's "Adoration of the Magi" are hardly superior. When speaking of the earlier version we have already pointed out the fundamental difference of the general conception, in spite of similar details and the spiritual dryness and overloading with sterile symbolism. We may add a word on the difference in the penmanship. The renunciation of plastic clearness under the influence of the modern currents, accepted, but not absorbed by Carpaccio, ends in almost an imitation of painted effects. The style of Bonifazio, whose artistic figure symbolizes all the forces opposed to the movement headed by Giorgione and Titian, takes up this technique as a substitute for a wholehearted modernism. Unable to compete, Carpaccio withdrew to provincial art patrons in Istria and Dalmatia; here his followers made a last stand. Their productions, both in painting and in drawing, are so poor that it seems unimportant to discuss the authorship of specific inventions. The "Coronation of the Virgin," in Copenhagen, No. 644, of the "Virgin and Child between St. John and St. Roch," existing in several versions, Nos. 643, 645, 646, may go back to Carpaccio, but his contribution is so diluted that little of its original charm is left. These types have been handled so much by the master himself and by his assistants and followers that by now they are inevitably well worn, to the point of hardly being recognizable.

586 Bassano, Museo Civico. St. Joseph or a saint hermit, standing turned to r. Pen. Claimed for Vittore Carpaccio by C. L. Ragghianti, *Critica d'A.* XX–XXII, p. XV, fig. 4, with reference to Nos. **591, 595, 606.**
We accept the attribution on the basis of the reproduction.

A Berlin, Kupferstichkabinett, 5065. St. Jerome. See No. **288.**

A 587 ————, 5138. The miraculous draught of fish. Brush, height. w. wh., on faded blue. 119 x 158. Publ. by Hadeln, *Quattrocento,* pl. 28. The attribution to Carpaccio is rejected by Fiocco, *Carpaccio,* p. 91, who says: later and poorer than Carpaccio, by an artist combining elements from Carpaccio and Cima in the fashion of Lattanzio da Rimini. The drawing is also rejected by van Marle XVIII, p. 326, note.
No connection either with Carpaccio or with Lattanzio da Rimini. A slight resemblance to the early drawing by Niccolò Giolfino "Christ taken prisoner in the Garden," formerly in the Wilton House Coll. (*Pembroke Dr.* I, pl. 4) makes us suppose an origin from the school of Verona.

A 588 ————, Body of the dead Christ. Pen, height. w. wh. 160 x 260. Ascr. to Ercole Roberti. Exh. under this name in Ferrara 1933, Cat. no. 238 as a study for Ercole Roberti's Pietà in Liverpool. Claimed for Carpaccio by Gamba in *Rivista di Ferrara* no. 4, p. 14, followed by Gronau, in Thieme-Becker XXVIII, p. 427, by Fiocco, in *L'Arte* 1934, p. 244, fig. 9 (with reference to a painting of the same subject at Agnews, which he ascribes to Carpaccio in his late years, while Gronau had given it to Giov. Bellini, *Klassiker* 96), and also Rob. Longhi, *Officina Ferrarese* 1934, p. 170. Longhi, by the way, rejects the connection with the "Pietà" at Agnews.
The drawing is certainly not the study for Ercole's painting in

Liverpool. On the other hand, the drawing looks Venetian in its use of blue paper, but otherwise very un-Venetian in style and in the rendering of the nude. In our opinion, it might be a copy by a Venetian from a model belonging to the Ferrarese School, but the connection with Carpaccio is unfounded. See for a similar case, No. **633.** Fiocco's reference to the painting at Agnew's is not a confirmation of his theory, since, on the contrary, this attribution of the painting rests on the supposed resemblance to the drawing.

589 Boston, Isabella Stewart Gardner Museum. Gondoliere; study used in the "Miracle of the Cross" (1494, ill. Fiocco, *Carpaccio,* pl. LIV). Brush, br. and white, on faded blue. 254 x 149. — On the back: Head of a youth. Touches of color. Old inscription in pen: del Carpazi. Coll. Robinson. Publ. by Molmenti-Ludwig, p. 259. Mentioned by Hadeln, *Quattrocento,* in connection with No. **637 v.** Fiocco, *Carpaccio,* pl. LVI. van Marle, XVIII, p. 334 f.
[*Pl. XVI, 2 and* 4. **MM**]
The corresponding figure in the painting differs in details from the drawing which is simpler and less fanciful. The style of the head on the *verso* points positively to the first decade of the 16th century.

590 Cambridge, Mass. Fogg Art Museum, no. 5. Adoration of the Magi. Pen, bistre, wash, over sketch in bl. ch., on bluish paper. 220 x 320. Charles Loeser Bequest 1932 — 281. Publ. in *Vas. Soc.* II, 9, and in Hadeln, *Quattrocento,* pl. 49. Fiocco, *Carpaccio,* pl. CLXXVI, p. 80: latest style. Van Marle, XVIII, p. 356. Mongan-Sachs, p. 8, fig. 6. Exh. Northampton, Smith College, 1941, no. 5.
[*Pl. XXI, 2.* **MM**]
In the Connoisseur XCII, 1933/II, p. 140 it is stated that the tower in the background is the same *"rama mosque"* which also appears in the view of Jerusalem in Breydenbach's *Peregrinatio;* it is also used in Carpaccio's "Triumph of St. George" (ill. Fiocco, *Carpaccio,* pl. CIX). Mongan-Sachs emphasize the symbolic meaning of the archi-

tectural detail. The connection with No. **606** has repeatedly been recognized. For the relationship of the composition to that of Dürer's painting in Florence see Tietze, *Dürer I*, p. 79.

A CHANTILLY, MUSÉE CONDÉ. Portrait of Giovanni Bellini. See No. **372**.

591 CHATSWORTH, DUKE OF DEVONSHIRE, 739. Unidentified scene, possibly San Lorenzo Giustiniani blessing Gian Galeazzo Sforza. Over red ch., pen, br. 166 x 197. In upper l. corner inscription in Padre Resta's hand: Gio. Bellini. *Chatsworth Dr.*, pl. 5. Colvin, in *Jahrb. Pr. K. S.* XVIII, p. 201. (The subject is correctly described, but not identified. Molmenti-Ludwig's reproach of Colvin for having connected the drawing with the Ursula Legend rests on a mistake.) Molmenti-Ludwig, 197 ff, fig. 211, suggested the identification of the scene with an episode of the life of Lorenzo Giustiniani and brought documentary evidence to show that in 1523 Carpaccio was commissioned to paint murals for the Patriarch's Palace in Venice. Hadeln, *Quattrocento*, pl. 16. Popham, *Cat.* 168. Fiocco, *Carpaccio*, pl. LXXX. van Marle XVIII, p. 332.

Certainly the drawing does not originate from Carpaccio's late years, but should be dated in the beginning of the 16th century.

592 ————, 740. Sketch for the painting "Prince Conon bidding farewell to his father" (1495, Ursula Legend, Venice, Academy, ill. Fiocco, *Carpaccio*, pl. XLV). Over hasty sketch in bl. ch., pen, br. and bl. 129 x 271. Inscription: dipinse in Venetia nella chiesa di S. Orsola in S. Gio. e Polo. — On *verso*: Various studies. In upper l. corner Annunciation, below a king threatening a woman (wrongly called by Strong: Martyrdom of St. Agatha), at the r. standing woman and unidentified Oriental scene. The main side publ. by Colvin, in *Jahrb. Pr. K. S.* vol. XVIII, p. 199. Strong, *Chatsworth Dr.* 1, pl. 31 a. Molmenti-Ludwig p. 96, pl. 85. Hadeln, *Quattrocento*, pl. 13. Fiocco, *Carpaccio*, pl. LI, p. 66. The drawing on the *verso*, ill. *Chatsworth Dr.*, p. 31, b, and Fiocco pl. CXXXIX is not mentioned by Colvin and Molmenti-Ludwig, but by Hadeln, who believes it to be by another hand than the *recto*. While Fiocco p. 91, following Hadeln, calls the studies on the back "evidently by another hand than the *recto*" he publishes the same *verso* on pl. CXXXIX and describes it on p. 76 as a hitherto unrecognized study by Carpaccio for his painting "The story of the Amazons," Paris, Musée Jacquemart-André (ill. Fiocco, pl. CXXXVI f). [*Pl. XVIII*, 4. **MM**]

The resemblance of the scene in the drawing to King Theseus in the painting, in our opinion, is purely accidental. The type of the angel in the upper l. corner resembles the angels in the painting "St. Thomas Aquinas" in Stockholm, ill. Molmenti-Ludwig p. 220.

A ————, Procession. See No. **263**.

593 CHELTENHAM, FENWICK COLL., Cat. p. 4, 1. Three studies of a bishop, used with modifications for the Pope and two bishops in the "Arrival of St. Ursula in Rome," in the Academy in Venice (ill. Fiocco, *Carpaccio*, pl. XXXVII). Brush, gray, height. w. wh., on green. 197 x 220. In many places touched up with pen and ink by a later hand. — On the back: Torso of a man in the position of a dead Christ, supported on the edge of the tomb, and a study of drapery. Bl. ch. Lawrence-Woodburn Sale lot 10. The *recto* publ. by A. E. Popham, in *O. M. D.* VIII, pl. 42, and together with the *verso* in *Fenwick-Cat.* pl. IV, where Popham adds: drawing on *verso* perhaps for a Pietà; they resemble, but do not correspond with, the central

figure of the painting in the Metropolitan Museum in New York (ill. Fiocco, *Carpaccio*, pl. XCV). Van Marle XVIII, p. 330.
[*Pl. XIV*, 4. **MM**]

A ————, 4, 2. See No. **249**.

594 DONNINGTON PRIORY, COLL. GATHORNE-HARDY. Female head, bent to the r., study used in Carpaccio's painting "St. Ursula in Glory" (ill. Fiocco, *Carpaccio*, pl. XXXII and XXXIV). Brush, height. w. wh., partly oxidized, on blue. 239 x 181. — On *verso*: Female head in profile, turned to the r. and staff with a scroll, study used in the "Presentation in the Temple," 1510, Venice, Academy, ill. Fiocco CLIII, resp. CLIV. Publ. by Colvin, in *Jahrb. Pr. K. S.*, XVIII, p. 201. Molmenti-Ludwig p. 110, fig. 106 and 107: the drawings were first used in the "Glorification of St. Ursula" and later in the "Presentation." Hadeln, *Quattrocento*, pl. 34, 35. Popham, *Cat.* 172. Fiocco, pl. XXXVI. Both used in the "Glorification of St. Ursula." Van Marle XVIII, p. 330, fig. 196. [*Pl. XXII*, 1. **MM**]

Both drawings apparently were prepared for the "Glory" as already stated by Colvin; one of his arguments is that the staff with the drapery evidently corresponds to the end of the banner in the painting, where, however, only the head drawn on the *recto* appears. Both heads appear slightly modified in the "Presentation" of 1510. B. Berenson, *Study and Criticism of Italian Art*, 3rd series 1916, p. 124 ff. advanced the theory that the date 1491 on the "Glorification" does not correspond to the style, and that the "Glorification" must be closer to the "Presentation." Fiocco, p. 64, rejected Berenson's conclusions while van Marle, XVIII, p. 290 f. accepted them.

For us, this discussion is important as bearing on the dating of the drawings. We agree with Hadeln's placing them around 1510. The striking resemblance of their technique with Dürer's drawings of about the same time supports this date.

595 ————, Sacra Conversazione. Pen. 138 x 235. Coll. Malcolm. Publ. by S. Colvin, in *Jahrb. Pr. K. S.* XVIII, 1897, p. 194; *Vasari-Soc.* IV, 7; Hadeln, *Quattrocento*, pl. 31; Popham, *Cat.* 167; Fiocco, *Carpaccio*, pl. LXXXIX; van Marle XVIII, p. 340, fig. 202.

The general arrangement of the composition resembles, as Fiocco noted on p. 84, Carpaccio's "Adoration of the Christ Child" in the Gallery of Caen, ill. Fiocco pl. CXCIII, where especially the male saint at the r. is almost identical. Another study for the same painting exists in the Rasini Coll., Milan, see No. **624**. The female saint sitting next to the Virgin appears in Carpaccio's painting in Bergamo, ill. Fiocco pl. CXLI, and a second time separately in a painting formerly in the Benson Coll. London, as already noticed by van Marle XVIII, p. 340. The painting in Caen is dated around 1502 by Molmenti-Ludwig, p. 203. We date the drawings about 1500, or shortly before, with reference to No. **593**. The composition develops that of Mantegna's (?) painting at the Isabella S. Gardner Museum, Boston. (Ph. Hendy, *Cat.* of the paintings p. 229).

596 DRESDEN, KUPFERSTICHSAMMLUNG. The Virgin enthroned between the Saints Faustinus and Giovita, model for a painting by Carpaccio dated 1519, originally in S. Giovanni in Brescia, later in Casa Averoldi in Brescia and perished in 1869, ill. Venturi 7, IV, fig. 480. Brush, on gray. 304 x 247. Squared. New inscription on top: Johan Bellino. Formerly ascr. to Gio. Bellini, first given to Carpaccio by Morelli, II, p. 214, publ. by Colvin, *Jahrb. Pr. K. S.* XVIII, p. 194, who first pointed to the connection with the painting, Molmenti-Ludwig, p. 196, fig. 206. Hadeln, *Quattrocento*, pl. 46; Parker, pl. 53; Malaguzzi-Valeri, in *Rass. d'A.* XIII, p. 72; Fiocco, *Carpaccio*, pl. CLXXX.

The differences between the painting and the drawing are very striking. The latter for the mode of drawing, as well as for the costumes, looks earlier than 1519, the date of the painting. Notice that the figure of the warrior saint at r. is taken over from No. **265** where the corresponding figure appears in the l. center. The middle group (Virgin and Child) and the angel playing the mandolin are again used in Benedetto Carpaccio's "Madonna and Saints" of 1538 in the Gallery Capodistria, ill. van Marle XVIII, fig. 208.

A ———, Head of a man with turban. See No. **250**.

597 FLORENCE, UFFIZI, 1287. Triumph of St. George, design for the painting in S. Giorgio degli Schiavoni. Over sketch in red. ch., pen, br. 235 x 419. Below scale, a few words in Greek and later inscription: de Vittor Carpaza. — On *verso* sketches: a minaret, a niche and a window, a chalice. Molmenti-Ludwig, p. 134, taking up a theory previously put forward by Colvin, in *Jahrb. Pr. K. S.* XVIII, p. 201, note: the building in the middle and the tower at the l. are taken from Reeuwich's woodcuts in Breydenbach's *Peregrinatio,* a book that also influenced some of the figures, for instance the group of women at the l. and the Saracen behind the dragon. *Uffizi Publ.* III, I, No. 13. Hadeln, *Quattrocento,* pl. 21. Gilles de la Tourette, *L'Orient et les peintres de Venise,* Paris, 1923, no. 122, supposes that Carpaccio used other models than Reeuwich's woodcuts for the buildings, but believes that the figures go back to these woodcuts. Popham, *Cat.* 170. Fiocco, *Carpaccio,* pl. CXV and (*verso*) CXVI: admits the resemblance to Reeuwich's woodcuts, but insists on Carpaccio's independence and finds an argument in favor of his theory in the architectural designs on the back which he takes for immediate studies made by Carpaccio on his journey to the Orient. Van Marle XVIII, fig. 198, p. 336 supports the theory of Carpaccio's dependence on Reeuwich, both for the buildings and for the figures.

[*Pl. XVII,* 2. **MM**]

The drawings on the back look like a page from a patternbook; their juxtaposition and their abstract drawing style contradict the idea of studies after nature. The minaret does not appear in the composition drawn on the principal side, but in the painting. It resembles only superficially the woodcut of the same tower in Breydenbach ("Rama"), but is richer in its details and may indeed go back to another model, perhaps the one used in "The Reception of the Venetian Ambassadors in Cairo of 1512" in the Louvre, ascr. to the school of Gentile Bellini. For the question of Carpaccio's dependence on Breydenbach, see No. **615** and p. 141 f.

A ———, 1292. See No. **284**.

598 ———, 1464. St. Jerome standing, a bearded head and a piece of drapery separately repeated. Brush and pen, slightly height. w. wh. 270 x 179. Damaged and repaired. Publ. by Molmenti-Ludwig, fig. 210, p. 197: study for the corresponding figure in the altar-piece prepared by No. **630**, facing, however, in the opposite direction. Hadeln, *Quattrocento,* pl. 45. Fiocco, *Carpaccio,* pl. CLXXXII, van Marle, XVIII, p. 346 accept Molmenti-Ludwig's suggestion. [**MM**]

In our opinion, the drawing is not a study for the composition in No. **630**, but the latter is one of those late productions in which Carpaccio with the help of his assistants rearranged older working material including this drawing of about 1508 (see No. **622**). It has also been used, in its original direction, in the "Santa Conversazione" in Karlsruhe, attr. to Benedetto Carpaccio by Molmenti-Ludwig, fig. 238, but to Vittore himself by Fiocco, pl. CXXXVII.

599 ———, 1469. A kneeling donor turned to the r. Gray ch., height. w. wh., on faded blue. 184 x 194. On lower border the drawing is regularly pricked as for measurement (?). Publ. by Molmenti-Ludwig, p. 194, fig. 205, as possibly a sketch for one of the portraits in the lost painting formerly in San Simeone Piccolo, described by Boschini, *Minere,* S. Croce 10, and by Zanetti, *Della Pittura Veneziana,* 1771, p. 41. Fiocco, *Carpaccio,* pl. CLXXXIX, p. 83 and van Marle XVIII, p. 350, accept this suggestion. [**MM**]

The drawing, not mentioned by Hadeln, resembles somewhat No. **593** and might be from the same period.

600 ———, 1470. Six studies of arms and hands. Grayish br. brush, height. w. wh., on faded blue. 271 x 208. Late inscription: di mano del Vettor Carpaccio. Another line of writing is erased or faded. — On *verso:* Head of a bearded man in profile, turned to the r. Bl. ch. *Recto* publ. by Molmenti-Ludwig, p. 176, fig. 181, as preparatory study for the "Death of the Virgin," now in the Cà d'Oro (ill. Fiocco, *Carpaccio,* pl. CXLVII). The hands holding the book, as well as the two keys, would belong to a St. Peter, moreover, the hand holding a stone to the "Stoning of St. Stephen" in Stuttgart, ill. Venturi 7, IV, fig. 483. Fiocco, pl. CXLVIII, p. 77, accepting in full Molmenti-Ludwig's suggestion, states that the same studies were partly used for the "Death of the Virgin" in 1508, in the Pinacoteca of Ferrara (ill. Fiocco pl. CLI). Also van Marle, XVIII, p. 338 finds links between the painting in the Cà d'Oro and the drawing. "This is particularly the case for the study of a hand holding an open book."

[**MM**]

This is indeed the only study that shows a certain resemblance to the painting in the Cà d'Oro, but even here the sleeve is entirely different. For all the other studies there is not the slightest connection with the three paintings supposed to be based on them. The technique of the drawing is very similar to that typical of Carpaccio's brush studies, and we might accept the attribution to him or his shop in spite of a certain crudeness which gives the drawing an older appearance. The drawing was not mentioned by Hadeln. In the whole discussion the head on the back is mentioned only by Fiocco, p. 78, who compares it with No. **627** and calls it very much crumbled. In our opinion, the resemblance to No. **627** is insignificant and moreover, the spiritual interpretation different from Carpaccio's, who in the material we know never tries to catch the individual model.

The *verso* gives still more weight to our doubts.

601 ———, 1471. Studies of two standing men, turned to the l. Brush, height. w. wh., on faded blue. 213 x 173. — On back: Kneeling monk, perhaps St. Francis. Publ. by Hadeln, *Quattrocento,* pl. 41, 42, p. 55: The two figures on the *recto* were used in a composition preserved only in a copy in the Uffizi, No. **602**, and placed by Hadeln in the second decade of the 16th century. E. Tietze-Conrat, in *Graph. Künste,* 1929, p. 48, describes the two figures as studies from nature while in the completed composition the corresponding figures follow Dürer's woodcuts B. 9 and 81 more closely. Fiocco, *Carpaccio,* pl. CLXXXVI and CLXXXVIIa, states that the *verso* is used by Benedetto in his painting of 1541 in Capodistria (ill. Fiocco, pl. CLXXXVIIb). Van Marle XVIII, p. 345.

For the date see No. **602**.

A **602** ———, 1687. The Trial of St. Stephen. Pen, wash. 229 x 270. Publ. by Molmenti-Ludwig, fig. 192, p. 186 as the original design for a painting forming part of the series representing the life of this saint. Hadeln, *Quattrocento,* pl. 50, p. 61: copy of the late 16th or

even of the 17th century after an original design by Carpaccio. E. Tietze-Conrat, in *Graph. Künste*, 1929, p. 48 discusses the connection with Dürer's woodcuts B. 9 and 81. Fiocco, *Carpaccio*, pl. CLXXXIV, p. 82 and van Marle XVIII, p. 344, follow Hadeln.

The original design from which this is a copy, is to be dated circa 1515 with the whole series, which date applies also to the studies No. **601**.

603 ———, 1688. Studies: two male and three female figures. Pen, wash.

Mentioned in Molmenti-Ludwig, p. 172 and erroneously connected with the "Presentation of the Virgin in the Temple," see No. **265**. See also Hausenstein, *Carpaccio*, p. 115. Publ. by Fiocco, *Carpaccio*, pl. LXXIX, p. 69, who adds: The page in the middle resembles somewhat No. **612v**, the figure at the r. is connected with that of St. Roch in the altar-piece of 1516 in the cathedral in Capodistria, ill. Fiocco pl. CLXXV. Van Marle XVIII, p. 346 notices the same connection and declares the intensive shading to be a characteristic feature of Carpaccio's late drawings.

In our opinion, the date of the painting is not to be applied to the drawing. As in other late productions Carpaccio used here his earlier material, the musician angel in the same painting being, for instance, an exact repetition of the one in Carpaccio's famous painting in the Academy, of 1510 (see the detail Fiocco pl. CLVI).

604 ———, 1689. The Dream of St. Ursula, design for the painting of 1495 in the Academy in Venice, ill. Fiocco, *Carpaccio*, pl. XLII. Pen, wash. 102 x 110. Molmenti-Ludwig, p. 101, fig. 87. Hadeln, *Quattrocento*, pl. 12. Fiocco, pl. XLIV, p. 65. Van Marle XVIII, p. 327 f., fig. 194. [*Pl. XVIII*, 1. **MM**]

605 ———, 1691. Presentation of the Christ Child in the temple. Pen, wash. 146 x 217. (The original is much lighter than any of the reproductions.) Molmenti-Ludwig, p. 199, fig. 214: perhaps the first idea for the "Presentation of the Christ Child" for S. Giobbe, now in the Academy, Venice (ill. Fiocco, *Carpaccio*, pl. CLIII). Hadeln, *Quattrocento*, pl. 39, 56 rejects this theory with regard to the horizontal composition while the order for the altar-piece must have referred to an upright composition. "Moreover the drawing is probably later than the mentioned altar-piece of 1510." Fiocco, pl. LXXXVIII, p. 71 agrees with Hadeln as far as the doubts concerning the "Presentation" of S. Giobbe go, but pleads for an earlier origin of the drawing than Hadeln suggested. Van Marle XVIII, p. 348.

We agree with Fiocco and date in the first decade of the 16th century.

606 ———, 1692. Adoration of the Magi. Pen, light br., wash. 197 x 250. Framed by borderline. — On the back: Sacra Conversazione (within borderline 120 x 180), indicated squaring. The *recto* publ. in *Uffizi Publ.* III, p. 1, no. 12, Molmenti-Ludwig p. 199, fig. 213, Parker, pl. 51. Both sides publ. in Hadeln, *Quattrocento*, pl. 29, 30 and Fiocco, *Carpaccio*, pl. LXXXVI f. Van Marle XVIII, p. 340 points to the resemblance (limited to the kneeling Virgin) of the l. part to the corresponding portion of Carpaccio's "Nativity" in the Gulbenkian Coll., Paris, ill. Van Marle l. cl. fig. 171.

[*Pl. XX*, 2 *and* 3. **MM**]

The closeness to No. **580** has already been noticed by Mongan-Sachs, no. 5. While the kneeling king may be traced back to Jacopo Bellini's Paris Sketchbook (Goloubew II, pl. XXX), the figure of St. Joseph and the group of the three men standing at r. correspond exactly to figures in Gentile Bellini's "Adoration of the Magi" in the

N. G. (ill. van Marle XVII, fig. 88) where, however, the three men are located next to St. Joseph. Carpaccio seems to have owned various *simile* drawings taken from Gentile's composition: the three men mentioned above appear once more in the background of the painting "St. Jerome in the Convent" (ill. Fiocco, *Carpaccio*, pl. CVII) and Joseph in the painting "Visitation" (ill Fiocco, pl. CXLV). Another Turk from Gentile Bellini's "Adoration" in the N. G., next to the group of three, is repeated by Carpaccio in his painting "St. George baptizing the gentiles" (Fiocco, pl. CXXXI). Details of this figure appear again in "The Consecration of St. Stephen" (Fiocco, pl. CLX). We may infer from these examples that a drawing of this figure too existed. The dependence on Gentile's composition gives no help for the dating of the drawing which by stylistic reasons we place about 1500.

A 607 ———, 1696. Heads of monks. Pen, black br., height. w. wh., on faded blue. 255 x 140. — On the back: Standing bearded monk, turned to the l. Brush. Damaged. Publ. by Molmenti-Ludwig, p. 126, fig. 120, 122 as studies for the "Death of St. Jerome" of 1502, in S. Giorgio degli Schiavoni, Venice (ill. Fiocco, *Carpaccio*, pl. XCVI). Hadeln, *Quattrocento*, p. 58 (ad pl. 19/20) considered both drawings as copies from the painting. Fiocco, pl. CI and CXLII, p. 72, resp. 77 agrees with Molmenti-Ludwig for the *recto*, but believes that the drawing on the back, although originally made for the "Death of St. Jerome," was used for the figure of St. Joachim in the "Birth of the Virgin," in the Accademia Carrara in Bergamo (ill. Fiocco, pl. CXLI). Van Marle XVIII, p. 238, fig. 199, 200, believes in the authenticity of both sides and sees in the bearded man a study for the figure on the extreme right in the "Death of St. Jerome." [**MM**]

The figure on the back is by no means a copy from the painting, where the corresponding figure is slightly different. This statement weakens Hadeln's theory concerning the heads on the *recto*: in our opinion both drawings which are poorer in quality and harder in the outlines than originals by Carpaccio, might be copies made in the shop from authentic drawings preparing details of the painting. There is not the slightest connection with the Joachim mentioned by Fiocco, but we may add a reference to the "Death of the Virgin" in Ferrara (ill. Fiocco pl. CLI) where the figure study, except for the head, was used for the bearded apostle at the r.

A 608 HAARLEM, COLL. KOENIGS, I, 35. The birth of the Virgin. Pen. 117 x 116. Coll. Valori, Vallardi, Wauters. Publ. by Hadeln, *Koenigszeichnungen*, as Carpaccio and possibly the first, later on abandoned, idea for the painting of the same subject in the Accademia Carrara, Bergamo (ill. Fiocco, *Carpaccio*, pl. CXLI).

[*Pl. XXV*, 1. **MM**]

Although believing in the Venetian origin we cannot recognize Carpaccio's hand. Cima's predella in San Giovanni in Bragorà in Venice shows the subject treated in a similar spirit. As for the penmanship, the nearest related piece might be No. **749**, and it should be remembered that the presumed author of that drawing, Lattanzio da Rimini, in a contract dated of 1500 and publ. by G. Ludwig, in *Jahrb. d. Pr. K. S.* XXVI (1905), Appendix, p. 28, was summoned to study Cima's painting in San Giovanni in Bragorà for his own altar-piece.

A 609 THE HAGUE, COLL. FRITS LUGT. An Organplayer. Pen, br. 152 x 188. Modern inscription: Giorgione. — On the back: Music with written notations. Coll. Moscardo, Calciolari, Grassi. Exh. Amsterdam 1934, Cat. 459 as Venetian artist about 1500, and in Paris,

1935, (Sterling Cat. 737) as Carpaccio. Mr. Lugt is inclined to attribute the drawing to Giovanni Bellini, with reference to No. **A 304**.

[*Pl. CLXXXVIII*, 3. **MM**. *Verso* **MM**]

We may also note a certain affinity in posture and general mood to Bellini's "Allegory" in the Academy in Venice (ill. *Klassiker, Bellini*, 92). The drawing style, however, is closer to Carpaccio's without being close enough to allow an attribution to him. The anonymous artist seems to have combined both influences. The drawing may represent King Solomon with reference to the illustration of the 97th psalm in the Mallermi Bible, Venice.

A ————. Four men. See No. **252**.

A ITALY, PRIVATE COLLECTION (formerly LONDON, COLL. HENRY OPPENHEIMER). Portraits of young men, s. Nos. **647, 648**.

610 LENINGRAD, HERMITAGE, 20001. Two sketches: A lady standing and turned to l., and a youth on a smaller scale, en face. The lady is the design for a figure in the "Departure of St. Ursula," in the N. G. in London (ill. Fiocco, *Carpaccio*, pl. CXL). Van Marle XVIII, p. 350, note.

The style of the drawing which we know only by the reproduction looks rather early, see No. **597**.

611 ————, 34846. Torso of a crucified man. Brush, height. w. wh., the head only sketched in charcoal, on faded blue. 265 x 160. Publ. by Dobroklonsky, in *Belvedere* 1931, I, p. 200, fig. 111, 1 as possibly a study for Carpaccio's painting "The Martyrdom of the ten thousand Saints." For the technique Dobroklonsky points to No. **612**.

As far as the reproduction allows an opinion the attribution seems correct, not the connection with the painting. We date the drawing about 1507.

612 LONDON, BRITISH MUSEUM, 1892-4-11 — 1. Head of a beardless man with a cap, turned to the l. Brush, gray, heightened with wh., on blue. 265 x 185. — On back: Two standing youths. Cut. Publ. by S. Colvin, in *Jahrb. Pr. K. S.* XVIII, p. 203, as possibly the study of one of the dignitaries next King Maurus in the painting of "The King receiving the ambassadors," Venice, Academy (ill. Fiocco, *Carpaccio*, pl. LXIV). Molmenti-Ludwig p. 89, fig. 75 follow Colvin and suggest that the head might be a portrait of the painter Bastiani. Hadeln, *Quattrocento*, pl. 43, p. 56 f. denies the connection with the above mentioned painting and dates the drawing as late as in the second decade of the 16th century. Fiocco, pl. LXXVIII, p. 69, seems to question Colvin's reference. Van Marle XVIII, p. 331 f. rejects it.

The style of drawing is most similar to No. **589**. We date it on the basis of No. **622** about 1507.

613 ————, 1892-4-11 — 2. Sheet with heads of Orientals with turbans, biblical figures and a monk. Brush, height. w. wh., on blue. 233 x 202. S. Colvin, in *Jahrb. Pr. K. S.* XVIII, p. 251 refers to "The Stoning of St. Stephen," in Stuttgart (ill. Fiocco, *Carpaccio*, pl. CLXXXVIII) where one of the heads is used. According to Molmenti-Ludwig p. 187, fig. 193 sketches for the (lost) painting "Trial of St. Stephen," see No. **A 602**. Hadeln, *Quattrocento*, pl. 40. Fiocco, *Carpaccio*, pl. CLXXXV. Van Marle XVIII, p. 345.

614 ————, 1895-9-15 — 806. Monk and musicians. Pen, light gray, wash, on faded blue. 187 x 277. — On the back: Scholar in his study. Pen. The main side publ. in *Vasari Soc.* II, 8, both sides in Hadeln, *Quattrocento*, pl. 32, 33 and Fiocco, *Carpaccio*, pl. XCI and

XC. He calls the drawing a St. Jerome with angels playing, resp. a St. Jerome in his studio. He erroneously believes this drawing to be identical with No. **625**. His remarks, therefore, refer to the latter, not to the drawing in London. Van Marle XVIII, fig. 205, p. 346 points to the "angel" tuning his lute as resembling the one in Pirano, which, as a matter of fact, is not only entirely different, but more exactly a repetition of the famous angel in the "Presentation in the temple," Venice. In the drawing on the back van Marle, p. 344 discovers somewhat Dantesque features. He dates the drawing in Carpaccio's late period with reference to the alleged connection with the altar-piece in Pirano of 1518, see No. **603**. [*Pl. XX*, 1 *and* 4. **MM**]

In our opinion, the musicians are not angels, but grown up women in contemporay costumes, one may be a youth. Further, the bearded monk on one side and the beardless scholar on the other cannot represent the same person, as Fiocco suggests. Possibly, the drawing on the back is a sketch for a portrait and we refer in this respect to one known from a literary source. Carpaccio was ordered by Alvise Contarini to make a portrait of the poet Strazzola who in a poem (see Molmenti-Ludwig p. 46 f.) asked Carpaccio not to interpret him as Gentile Bellini would: ". . . then take the diligence and care . . . to paint me enthroned in a professor's chair as one of those who teach at Padua . . ." Carpaccio painted the poet with vine leaves in his hair, thereby arousing Strazzola's wrath. That the general arrangement corresponds to that of a poet or a professor is confirmed by its resemblance to the title page of Donatus, *De octo orationis partibus*, Perugia 1517, designed by Eustachio Celebrino (compare Essling vol. III, p. 119 and Stanley Morison, *Eustachio Celebrino da Udene*, New York, n. d., fig. 2) which represents such a figure. Stylistically the connection of the drawing on the back with No. **625** is evident and we date the whole group shortly after 1495 (see there).

615 ————, 1897-4-10 — 1. View of the town in the background of the painting "Farewell to Saint Ursula," 1495, Venice, Academy, ill. Fiocco, *Carpaccio*, pl. XLV. Red ch., partly reworked with the pen. 171 x 190. Inscription: Porto Ancona dove . . . Coll. Padre Resta, Lord Somers, Richardson sen., Lord Charlemont, Barry Delany. Ascr. to Giovanni Bellini by Resta. First publ. as Carpaccio by S. Colvin, *Jahrb. Pr. K. S.* XVIII, p. 197, fig. 3, who recognized the use of the view in the painting (see above) and presented the theory of the dependence of the drawing on two woodcuts by Reeuwich in Breydenbach's *Sanctarum peregrinationum opusculum* 1496. Colvin's theory was accepted and supported with new arguments by Molmenti-Ludwig p. 96, fig. 82, by Hadeln, *Quattrocento*, pl. 14 and in part by Gilles de la Tourette, *L'Orient et les Peintres de Venise*, Paris 1923, p. 149 ff, but was vehemently contradicted by Fiocco, *Carpaccio*, pl. XLV and p. 65 f. In his opinion, Carpaccio and Reeuwich may have drawn from the same sources, possibly drawings made by Gentile Bellini, and Carpaccio himself, might even have made sketches on the spot during a trip to the Orient, mentioned by Cesare Vecelli, *Degli habiti antichi*, Venise 1590, p. 84. Van Marle XVIII, fig. 195, p. 330: The points of contact between drawing and canvas are not very important, in both, however, the towers of Candia and Rhodos are represented. On p. 246 van Marle explains his point of view that Carpaccio utilized Reeuwich's woodcuts, but other models as well. See also Popham, *Sebastiano Resta and his collections*, in *O. M. D.* 1936, June p. 9. [*Pl. XVIII*, 2. **MM**]

In our opinion, Fiocco is essentially right, see p. 141 ff. It is true that Carpaccio uses motives that also appear, partly in the same direction and partly in reverse, not only in two, but even in three of Reeuwich's woodcuts, for we can add to the observations of preceding writers

that the castle on the hill down to the town (of Rhodes) corresponds (in the same direction) with Reeuwich's view of Coreun. But the drawing is certainly not made after the woodcut, in which all architectural structures are much less understood and the details much less carefully rendered than in the drawing. (Compare especially the tower on the island in the foreground at r. with the corresponding one in the woodcut of Candia). Carpaccio may have used the same, or corresponding, drawings, most likely by Gentile Bellini, that served as models for Reeuwich's woodcuts.

We have still to emphasize another point touched on already by Fiocco (p. 27). The inscription "porto d'Ancona dove" originally went on "dove smontarono l'Imp^re e si trovò il Doge o la pace d'Aless^dro 3°" (see Popham in *O. M. D.* as above). This leads to the conjecture that the drawing had some connection with another of Carpaccio's paintings, the "Storia d'Ancona," painted 1507 to 1511 in the Ducal Palace and destroyed by fire in 1577, see No. **635**. Its substitute painted by Gambarato (ill. Venturi 9, VII, fig. 30 with an erroneous caption) contains a fortress on a steep hill over the shore, and in Carpaccio's composition the view seen in the drawing may have been placed in the background. The conformity with the painting of the Ursula Legend is rather general, the "French Tower" at l., for instance, has a different proportion and is put into a frontal position. Moreover, the town does not touch the sea as in the drawing, but is separated from it by an embankment with many figures.

A 616 ————, Sloane 5237 — 13. Group of monks. Pen, bl., br. wash, on faded blue. 172 x 225. Later inscription: Fran. Monsignori. Stained by mold and otherwise damaged and retouched. Mentioned by A. E. Popham in *O. M. D.* X, p. 11 as possibly orginal and a study of the kneeling group of monks at the r. in the "Death of St. Jerome" (ill. Fiocco, Carpaccio, XCVI).

In our opinion, old copy from the painting. The inscription Francesco Monsignori might refer to Battista Ponchino, called by Ridolfi "un monsignore detto Bazancho." See No. **1288**.

617 ————, 1924-12-5 — 1. St. Jerome in his cell, design for Carpaccio's mural in S. Giorgio degli Schiavoni, ill. Fiocco, *Carpaccio*, pl. CIII, executed between 1502 and 1507. Pen, blackgray, wash. 275 x 419. The architectural lines are partly drawn with the ruler. Publ. by Popham, in *British Museum Quarterly* IX, 1935, p. 83, pl. 22.
[*Pl. XXI*, 1. **MM**]
Slight deviations from the executed painting.

A ————, 1933-8-3 - - 12. See No. **270**.

A London, Coll. Earl of Harewood. Two groups of ecclesiastics. See No. **254**.

618 London, Coll. Captain Norman Colvill. Two ecclesiastics in vestments kneeling. Brush, gray and wh., on faded blue. 192 x 250. — On the back: Standing youth with a cap.
[*Pl. XXII*, 2 *and XVI*, 3. **MM**]
The kneeling ecclesiastics are studies for Carpaccio's lost "Storia d'Ancona," of 1507, see No. **635**. The standing figure on the back is used in the middle of Carpaccio's painting "St. Triphonius and the Basilisk" in San Giorgio degli Schiavoni (ill. Fiocco, *Carpaccio*, pl. CXXXIII, p. 75, about 1508).

A 619 London, Coll. Sir Robert Mond. Profile bust of a bearded man with various details further studied. Pen. 80 x 87. Publ. as Pisanello by Borenius-Witkower, no. 189, pl. XXXI, attr. to Carpaccio by

C. L. Ragghianti, in *Critica d'Arte* XI/XII: one of the most typical and beautiful drawings by Carpaccio.

In our opinion, an attribution to the manner of Pisanello seems justified by stylistic reasons (see *Pisanello's Drawings in the Louvre*, vol. I, pl. 71).

620 London, Coll. Henry Oppenheimer, formerly. The Christ Child in lively movement; the arm and the lap of the Virgin are indicated. Brush, height. w. wh., on blue. 194 x 142. — On the back: Study of one of the kneeling monks behind the bier in Carpaccio's "Death of St. Jerome" of 1502 (ill. Fiocco, *Carpaccio*, pl. XCIII). Coll. Sunderland, J. P. Heseltine, Henry Oppenheimer. Heseltine, *North Italian Drawings* 1906, no. 7, Hadeln, *Quattrocento*, pl. 19, 20, Fiocco, pl. CIIa and b, van Marle XVIII, p. 338, Parker in *Cat. Oppenheimer Sale*, 1936, no. 53, pl. 14.

621 ————. Head of an elderly man, turned three quarters to r. Over bl. ch., brush, height. w. wh., on br. 128 x 123. Coll. Sunderland, J. P. Heseltine, Henry Oppenheimer. Colvin, *Jahrb. Pr. K. S.* XVIII, p. 204, Hadeln, *Quattrocento*, pl. 25, K. T. Parker, p. 52; Fiocco, *Carpaccio*, pl. CLII, p. 78: used in the "Death of the Virgin" of 1508, in the Gallery of Ferrara (ill. Fiocco, pl. CLI).

The drawing, as also observed by Ragghianti, in *Critica d'Arte* V, p. 279, was also used in the figure of St. Peter in Carpaccio's polyptych in the cathedral of Zara (ill. Fiocco, pl. XXI), dated by Fiocco, Morassi and others 1480 or shortly after, but in the opinion of van Marle XVIII, p. 318, which we accept, executed during Carpaccio's stay in Dalmatia in 1518. The document produced by C. Cecchelli, *Catalogo . . . di Zara*, Roma 1932, p. 27 ff. offers no evidence of Carpaccio's paintings in 1508/9. The costumes and the landscape are further arguments for the later date. The drawing which nobody would be tempted to date around 1480 adds another argument. It is typical of Carpaccio's late shop to utilize older drawings. See, for instance, Nos. **625**, **640**.

622 ————. Head of an elderly man, turned three quarters to l. Over bl. ch. brush in bister, height. w. wh., on br. 197 x 140. — On back: Studies of a leg, a foot and a piece of drapery. Coll. Sunderland, J. P. Heseltine, Henry Oppenheimer. Colvin, in *Jahrb. Pr. K. S.* XVIII, p. 204, Hadeln, *Quattrocento*, pl. 26, 27 and p. 58: the studies on the back might have been intended for an Annunciation, compare similar motives from the Scuola degli Albanesi, Venice (ill. Fiocco, *Carpaccio*, CXLIV). Fiocco pl. CLII and p. 78 believes that both sides were used in Carpaccio's "Death of the Virgin" of 1508, in Ferrara (ill. Fiocco pl. CLI). Parker, *Cat. Oppenheimer Sale*, 1936, no. 54.

The resemblance of the head to that of the apostle in question is very superficial; Fiocco's other reference is completely unfounded. We find the resemblance of the head to the third from left in the "Call of St. Matthew" (ill. Fiocco, *Carpaccio*, pl. XCII) closer.

623 ————. Sketch for a composition with a number of tall crosses in a landscape. (Martyrdom of the 10,000 martyrs?) Red ch. 212 x 297. — On back: Three groups of full length figures standing and one seated, and a single standing figure on r. Coll. Sunderland, J. P. Heseltine, Henry Oppenheimer. First mentioned by S. Colvin, in *Jahrb. Pr. K. S.* XVIII, p. 194, who suggests that the drawing contains sketches of a (lost) Martyrdom of the ten thousand Christians, of which a fragment exists in the Uffizi (ill. Fiocco, pl. LXXXIV). Without discussing this reference Molmenti-Ludwig say p. 213: Sketch for the upper part of the "Martyrdom of the ten thousand

Christians" of 1515 in Venice (ill. Fiocco pl. CLXVIII), adding on p. 214: the single figures on the back might be studies for a "Crucifixion" of which only the fragment in the Uffizi exists. They date the fragment about 1515. Hadeln, *Quattrocento,* pl. 37, 38, p. 58, rightly rejected this date and placed the fragment (which he too calls fragment of a Crucifixion) in the early period of the Saint Ursula cycle. On the other hand, he accepts the connection on the *verso* with the "Martyrdom" of 1515, which, in his opinion, Carpaccio first planned to arrange in the manner of a "Crucifixion," and later modernized. Fiocco, *Carpaccio,* p. 81, at pl. CLXXX, connects both sides to the "Martyrdom" in Venice, and on p. 70 expressly rejects the reference to the fragment in Florence. K. T. Parker, *Oppenheimer Cat.* no. 52. Van Marle XVIII, p. 345, agrees with Fiocco, but states that nothing resembling the figures on the back is found in the painting, although originally they may have been intended for such a composition.

[*Pl. XVIII, 3.* **MM**]

In our opinion, Colvin was right and all the later discussion was a consequence of Molmenti's misunderstanding of Colvin's article. The painting in the Uffizi is not a fragment of a "Crucifixion" (and we wonder what connection Fiocco found to the drawing No. **A 628**), but of a "Martyrdom of the ten thousand Christians" as Colvin called it. There is no literary document concerning any such older version.

In our opinion, the connection between the sketch on the *recto* and the late version in Venice is so slight that the drawing could hardly be called a first idea of the painting. The drawing prepares a horizontal composition while the painting as an altar-piece (ordered by the Ottobuoni family for San Antonio di Castello) is upright and ends with an arched top. Further the drawing abounds with crosses, none of which appear in the painting. A striking argument in favor of the existence of an older painted version is the fact that the figures in the lower l. corner correspond to the unidentified group in Dürer's painting of this subject in the middleground at l. Dürer started with his painting in spring 1507, his preparations may go back to his stay in Venice. The drawing might well date from the beginning of the century.

624 MILAN, COLL. RASINI. Virgin and Child and St. John as an infant between the Saints Ann and Catherine. Pen., br., wash. 190 x 230. Coll. Dubini. Publ. by Morassi, p. 25 f., pl. VIII, as the first idea of the painting in Caen (ill. Fiocco, *Carpaccio,* pl. CXCIII). See also No. **595**.

625 MOSCOW, MUSEUM. A savant holding a compass, seated in his study. Pen. 120 x 170. Inscription: Gian Bellini. — On the back: Another scholar writing in his study. A long inscription that has not been satisfactorily deciphered, but apparently is unconnected with the drawing. The name of Sir Zuane da Brazo and the dates 1469, 1470 and 1495 are distinctly legible. Coll. Horace Walpole, Prince Dolgoroukow. Publ. by Goloubew, in *Rass. d'Arte* VII, p. 104 f. as St. Jerome. Mentioned by Hadeln, *Quattrocento,* p. 57, in connection with the stylistically related No. **614**. Fiocco, *Carpaccio,* p. 71 at pl. XC, erroneously identified this sheet with the drawing in London, No. **614**; in the inscription he reads only the dates of 1469 and 1470, but not 1495 in the first line. Van Marle XVIII, p. 344 doubts that the drawings are sketches for a St. Jerome, because the presence of geometrical instruments makes the representation of other personalities more likely. (See No. **614** where we suggested that these sort of drawings may be sketches for portraits.)

The date, 1495, offers a decisive *terminus post quem* for the drawing. The main features of the charming invention were vulgarized by the shop in the coarse paintings in Capodistria, now Pola, Museum (ill. Fiocco, in *Boll. d'A.* XXVI, p. 126 and idem, *Carpaccio,* pl. CXCV and CXCVI). Fiocco claims (p. 84) these provincial paintings for the master himself.

A 626 MUNICH, GRAPHISCHE SAMMLUNG, 2947. Huntsman with a pointed beard. Ch., height. w. wh., on faded blue. 238 x 169. Schönbrunner-Meder 692. Molmenti-Ludwig p. 199: study of the squire following S. Lorenzo Giustiniano in the composition No. **591**, a reference questioned by Hadeln, pl. 17, p. 59. Fiocco, *Carpaccio,* pl. LXXXI, p. 70 misquotes Molmenti-Ludwig by making them call the drawing a study for Gian Galeazzo Sforza before the Patriarch. Van Marle XVIII, p. 350, note, accepts the drawing, but of course rejects the identification with G. G. Sforza.

In our opinion, there is no connection with the composition preserved in No. **591**, and the authorship of Carpaccio is very doubtful. The technique would be unusual, and the un-gothic step and the heavy corporeality point in another direction, represented by the puzzling "Adoration" in London, attributed to Catena and others (ill. van Marle XVIII, fig. 224).

627 NEW YORK, PIERPONT MORGAN LIBRARY, 555. Man with cap, turned three quarters to l. Brush, height. w. wh., oxidized, on blue. 267 x 187. Retouched. — On back: Bust of a beardless man, turned to the r. Very much retouched. Coll. Marlborough, Fairfax Murray. Hadeln, *Quattrocento,* p. 40, note refers to Nos. **619**, **620** for the *recto* and doubts the authenticity of the *verso*. Fiocco, *Carpaccio,* pl. LXVIII a and b, p. 68 accepts both sides as authentic, and points for the *verso* to No. **A 600 v** which is also rubbed. Van Marle XVIII, p. 350, note accepts both sides with reservations. Exh. Northampton, Smith College, 1941, no. 3.

A 628 OXFORD, CHRISTCHURCH LIBRARY, H 25. Raising of the Cross. Pen., br., on paper turned yellow. 139 x 281. Coll. Ridolfi, Guise. S. Colvin, 34. Hadeln, *Quattrocento,* pl. 36. Fiocco, *Carpaccio,* pl. LXXXV, p. 70. Van Marle XVIII, p. 332 points to the difference of the technique from that of No. **591** and explains it by the difference in their dates of origin. [*Pl. CXC, 3.* **MM**]

Van Marle seems to have felt the more archaic style of this drawing in which, as a matter of fact, we do not find any of Carpaccio's characteristics. The nudity of the figures and the precision of their movements and actions are in contrast to Carpaccio's sketches. The scheme of the composition corresponds to arrangements in Jacopo Bellini's Sketchbooks (see Goloubew I, 95), and we occasionally also meet there the nudity of the figures (II, 58). The style, it is true, seems more advanced in our drawing, in spite of the "Mantegnesque" predilection for foreshortened figures; see the man on horseback or the man bending over a lying figure in the lower r. corner. (The iconological meaning of this group remains obscure. It seems to represent the Lamentation over the Dead Christ — *"Christo in Scurto".*) On p. 68 we pointed to the relationship with Gentile Bellini.

629 ——————, H 26. Bust of a young man with a cap, turned three quarter to l. Brush, br., height. w. wh., on blue. 260 x 185. Coll. Guise. C. Ricci, *Rass. d'A.* 1905, p. 76. Colvin, II, 33. Hadeln, *Quattrocento,* pl. 15. Fiocco, *Carpaccio,* pl. LXIX. Popham, *Cat.* 171. Van Marle XVIII, p. 330 points to the elongated shape of the face, frequently met in the Ursula cycle and more explicitly to the young prince in the "Arrival of the ambassadors" (ill. Fiocco, *Carpaccio,* pl. LXI). [*Pl. XVI, 1.* **MM**]

A OXFORD, ASHMOLEAN MUSEUM. Three standing figures. See No. **649**.

630 PARIS, LOUVRE, 437. Design for an altar-piece: Virgin and Child enthroned between two male saints on either side. Pen, wash. 150 x 150. Slightly damaged. — On back: Schematic arrangement of five roughly indicated figures, for which the names are written: Zuane Battista, Gerolimo, Pietro Martire, Franzescho (instead of another canceled name), Marta con lione legato. Coll. His de la Salle 33. Molmenti-Ludwig p. 197: for the figure of St. Jerome the drawing No. **598** served as a special study. Hadeln, *Quattrocento,* pl. 47. Fiocco, *Carpaccio,* pl. CLXXXI, p. 82: belongs to an altar-piece in the fashion of the lost one of the Averoldi family, see No. **596**.

The last mentioned drawing in Dresden, the preparation of the painting of 1519, is stylistically different from our drawing, which belongs to an earlier period. The figure of the monk saint at r. is derived from the same source as the corresponding figure in No. **373**, i.e. from Giovanni Bellini's altar-piece from S. Giobbe, now in the Academy in Venice. The reference (see above) to No. **598** as a special study for the St. Jerome, has to be modified, insofar as the latter is not a special study made for this figure, but an earlier drawing utilized in the later composition. The schematic figure on the back with the name Gerolimo corresponds to the original direction of No. **598**.

631 ————, 3094. Oriental warriors on horseback and on foot. Pen, br., wash. 264 x 194. — On back: Accounts containing the dates 1469 and 1470 (Carpaccio apparently drew on an old register, see No. **625**). Molmenti-Ludwig, p. 176, fig. 180: Studies used in the "Visitation," Venice, Museo Civico (ill. Fiocco, *Carpaccio,* pl. CXLV) and in "St. George baptizing Gentiles," in S. Giorgio degli Schiavoni (ill. Fiocco pl. CXXIX). Hadeln, *Quattrocento,* pl. 22 points further to the use of one of the horsemen in the "Triumph of St. George" (ill. Fiocco pl. CIX). Parker pl. 50. Fiocco pl. CXVII, p. 74: This sheet proves Carpaccio's direct contact with the Orient. He further points to the use of figures in the background of the "Adoration" of 1507 in the Gulbenkian Collection (ill. Fiocco, pl. CXVIII). Van Marle XVIII, p. 336 and 358.

The sheet offers a collection of typical figures to fill in the backgrounds of paintings and is as little an argument for Carpaccio's stay in the Orient as the appearance of similar figures in Dürer's work would be for Dürer's. The use of an old account-book, apparently the same as used in No. **625** is a further argument against the supposition that the drawing may be a sheet from a traveler's sketchbook. For the date, about 1500, see No. **605**.

A ————, 4795. See No. **651**.

A 632 ————, 4796. Composition of three figures at table. Red ch., height w. wh., on yellowish br. 254 x 233. Made up of two pieces patched together. Inscription in ink: Vetor Carpazo. Ascr. to Carpaccio. **[MM]**

Fragment of a horizontal composition, Christ at Emaus, the central part of which with the figures of Christ and another man is missing; as already recognized by B. Geiger in *Jahrb. Pr. K. S.* 1912, p. 131, fig. 14, old copy of a lost original by Giovanni Bellini, a later painted copy of which in Berlin, Kaiser Friedrich Museum, is ill. in *Klassiker, Bellini,* 184 above.

A 633 ————, 6793. Sleeping apostle. Pen, brush, height. w. wh. 144 x 234. Damaged. The r. hand is corrected, it had previously been under the l. one. Molmenti-Ludwig p. 123 f., fig. 116: copy, slightly

modified in the pose of the head, after Ercole Roberti's "Mount of Olives" in Dresden, by an unknown Bolognese; Carpaccio was probably inspired by this drawing for the corresponding figure in his painting of the same subject in San Giorgio degli Schiavoni (ill. Fiocco, *Carpaccio,* pl. XCIII). The modified pose of the head occurs also in a painted copy of Roberti's picture in the Accademia at Ravenna (ill. Cor. Ricci, *Raccolte Artistiche di Ravenna,* 32, as Bernardino Zaganelli). O. Fischel, Die *Zeichnungen der Umbrier,* 1917, fig. 332, p. 247: presumably by Timoteo Viti, with reference to a corresponding figure in Timoteo Viti's "Mount of Olives," existing in two versions, one of which now in the Art Museum in Cleveland, Ohio, he illustrates. (See also *Gaz. d. B. A.* 1900, I, p. 187). Fischel mentions that the figure, appearing with slight modifications in various other paintings might be traced back to some famous original. Fiocco, *Carpaccio,* pl. XCIV, p. 72: study by Carpaccio for his painting in S. Giorgio degli Schiavoni. Fiocco, apparently completely ignoring the previous discussion of the drawing, expresses his astonishment that Hadeln does not mention the drawing "although the attribution seems impossible to reject in spite of the minuteness of the treatment." Van Marle, XVIII, p. 326, nevertheless, flatly rejected Fiocco's attribution to Carpaccio.

We, too, do the same. The drawing is one of several existing copies after figures in Ercole Roberti's famous composition. A typical *simile*. Besides, the figure in the drawing and that in Carpaccio's painting are so strikingly different in their foreshortening that a connection between the two versions has to be excluded. The style is by no means Carpaccio's.

634 ————, Rothschild Foundation, 765. Sheet with various sketches: Man on horseback, four Turks at foot, further at r. another Turk approaching and raising his r. arm. Pen, brownish gray, wash. 110 x 275. Stained by mold, cut. — On *verso:* Further sketches: bearded monks, alone and in groups, one of them beardless, seated at a table. Coll. Reynolds, Hudson, Esdaile, Richardson, Lawrence, van Gottlob, Galichon. *[Pl. XXII, 3 and 4.* **MM]**

The drawing has been used in various paintings, where some of the figures appear otherwise arranged in the background. The paintings are "The death of St. Jerome" (ill. Fiocco, *Carpaccio* XCVI), "The disputation of St. Stephen" in the Brera and his "Preaching" in the Louvre (ill. Fiocco, pl. CLXI and CLXII).

635 SACRAMENTO, CAL., E. B. CROCKER ART GALLERY. Design for the so-called Historia d'Ancona: The Pope presents a ceremonial parasol to the Doge. Pen, wash. 210 x 295. — On *verso:* Another version of the same scene. Red. ch. Coll. J. van Sandrart, I. G. Schumann-Dresden (Lugt p. 438, no. 2344). Ascr. to Perugino. Publ. by E. Tietze-Conrat in *Art Quarterly,* Winter 1940, p. 20, fig. 4: The painting, representing the scene in Ancona when the Doge Ziani received the ceremonial parasol from the Pope, was ordered of Giovanni Bellini on September 28th, 1507, but is one of those executed by Carpaccio. This is ascertained from Carpaccio's letter to the Marquis of Mantua of August 20th, 1511 (Bertolotti, *Artisti in relazione coi Gonzaga,* Modena 1885, p. 152; also quoted in Molmenti-Ludwig, p. 240). Two of the kneeling clergymen are separately studied in No. **622**. See our remarks on p. 143. *[Pl. XVII,* 1. **MM.** Verso **MM]**

636 UPSALA, UNIVERSITY LIBRARY. Death of St. Jerome, design of Carpaccio's painting in the Scuola di San Giorgio of 1502, ill. Fiocco, *Carpaccio,* pl. XCVI. Pen, wash. 270 x 420. First recognized by van Regteren Altena and publ. by A. E. Popham, in *O. M. D.* 1935, June, pl. 13. *[Pl. XIX.* **MM]**

The figure seated under the roof at r. and the monk carrying a pail are filling-in figures and identical with those on No. **634** v. Other figures from the *recto* of the latter drawing do not appear in the drawing in Upsala, but were later introduced in the painting.

637 VIENNA, ALBERTINA, no. 20. Three studies of draped bearded men. Brush, br., height. w. wh., on faded blue. 220 x 276. — On back: Young man seen from the back and a boy seen from the side, both used in Carpaccio's "Miracle of the cross" (of about 1494), in the fore-, resp. middleground (ill. Fiocco, *Carpaccio,* pl. LIII). Inscription: Gio. Bellin. Coll. Vasari (O. Kurz, in *O. M. D.* 1937, p. 12), Mariette, Count Fries. While Wickhoff (*Albertina Cat I*) had ascr. the drawing to an anonymous Venetian artist of the 15th century, "who copied single figures out of paintings by famous artists," Colvin in *Jahrb. Pr. K. S.* 1897, p. 193 and 204, recognized the drawings on the *verso* as original studies by Carpaccio for his painting (see above). The *verso* first publ. by Molmenti-Ludwig, fig. 200 and 203, p. 191. They pointed out that the youth seen from behind is a cavalier of the *Calza* and was reproduced in a woodcut in Cesare Vecellio's *Degli habiti antichi.* Also publ. by Hadeln, *Quattrocento,* pl. 11, Fiocco pl. LV and Van Marle XVIII, p. 334. The *recto* publ. as Carpaccio by Schönbrunner-Meder 456, but questioned by Hadeln p. 60 and declared by Fiocco p. 91 the production of a pupil, somewhat related to No. **587**. *Albertina, Cat. II* (Stix-Fröhlich) accept both sides as originals. Kurz in *O. M. D.* 1937, No. 45, p. 12 identified the drawing, erroneously we believe, with one in the Crozat Coll. originating from the Vasari Coll. [*Pl. XIV,* 3 *and XXII,* 1. **MM**]

The drawings on the back, dated about 1494 by the painting, look different from those on the *recto,* which are more archaic. The attribution to a pupil of Carpaccio therefore seems very implausible. It might be an earlier drawing of his, perhaps based on models of predecessors.

A 638 ———, 21. Two horsemen. Pen, br., on brownish. 195 x 218. Originally ascr. to Mantegna, an attr. already rejected by Waagen, *Kunstschätze in Wien,* p. 132. *Albertina Cat. I* (Wickhoff) Sc. L. 11: Venetian contemporary of Mantegna. Schönbrunner-Meder no. 423: Unknown Venetian. A. Venturi in *L'Arte* 1925, p. 97: Ercole Roberti. *Albertina Cat. II* (Stix-Fröhlich): Carpaccio, with reference to a figure in the "Arrival of St. Ursula in Cologne," ill. Fiocco, *Carpaccio,* pl. XXXI, for which the man on horseback at r. is a study. The horseman at l. was used for a youth in the painting in the Musée Jacquemart-André in Paris, ill. Fiocco pl. CXXXVI. Fiocco himself passes over the drawing in silence, while Van Marle XVIII, p. 350, note, rejects it positively and Ragghianti in *Critica d'Arte* I, p. 280 ascr. it to the style of Ercole Roberti.

In our opinion, only the connection with the figure in the "Arrival of St. Ursula" is correct, but here, too, there are important differences: the posture of the horse, the r. arm of the man are different, and the hairdress is more modern in the painting than in the drawing. The latter which is not in the least Carpacciesque in its stylistic character, is closer to a follower of Ercole. The way in which the ground is drawn in order to produce depth, is un-Venetian. Carpaccio's studies are always isolated from the ground. The drawing might be a *"simile"* used by Carpaccio for his background. Such figures suitable for the filling of backgrounds are typical of *simile* drawings.

A 639 VIENNA, PRIVATE COLLECTION. Study of an unidentified composition. Pen, br. 225 x 165. The peacock and the flower pot at r. are pricked. Publ. by L. Fröhlich-Bum in *Burl. Mag.* 1937, p. 137, pl.

A, as a study by Carpaccio for a background in a lost painting. She dates the drawing in Carpaccio's late period and finds an analogy for it in No. **614**.

In our opinion, the two drawings offer a maximum of contrast. Knowing the drawing in Vienna only from the insufficient reproduction we can only with reservations express our opinion that the drawing is certainly not meant for a background, and its whole conception does not fit into Carpaccio's artistic procedure as it is known from so many drawings.

A WASHINGTON, D. C., CORCORAN GALLERY, CLARK COLL., 2186. See No. **738**.

640 WASHINGTON CROSSING, PA., COLLECTION F. J. MATHER JUNIOR. Head of a beardless man en face; head of a lion. Bl. ch., height. w. wh., on grayish yellow paper. 223 x 112. — On *verso:* Two Turkish women, the headdress of one of them corrected so as to appear in two different shapes. Collections Frothingham, Guastalla. Exh. Lyman Allan Museum, New London 1936, no. 16.

[*Pl. XV and XXIII,* 2. **MM**]

The drawing has a distinct importance for the problem of the complicated relationship between Carpaccio, Reeuwich and Gentile Bellini, since the two women on the back conform to two figures in one of Reeuwich's woodcuts in Breydenbach's *Peregrinatio.* Gilles de La Tourette who rejected Reeuwich's woodcuts as the models of Carpaccio's architectures, nevertheless, clung to the idea that Carpaccio may have copied figures from Reeuwich. Fiocco, *Carpaccio,* p. 66, offered the alternative: either there existed a common model used by Reeuwich and Carpaccio, perhaps by the hand of Gentile Bellini, or Carpaccio himself drew these figures on his travels in the Orient. We accept the first of these alternatives, the dependence of both, Reeuwich and Carpaccio, on Gentile Bellini, and find a support of this thesis in the frequent use of other models of Gentile Bellini (especially from his "Adoration of the Magi") by Carpaccio. Mr. Mather's drawing offers further decisive evidence. Both heads on the *recto* are traceable in Carpaccio's paintings, the man's in "The departure of the betrothed pair," of 1497 (ill. Fiocco, *Carpaccio,* pl. XLV), the lion's in the banner, painted in 1516 for the Magistrato dei Camerlenghi and still in the Ducal Palace (ill. Fiocco, pl. CLXXIII). The unusual power of conception in this lion, compared with the weakness of Carpaccio's average production in this late period, was thought significant by Molmenti-Ludwig, p. 215; it might be explained by the fact that Carpaccio made use of this earlier drawing. For these banners with the lion of St. Mark a well established formula existed (see Jacobello del Fiore's specimen, ill. Testi, I, p. 397) and Jacopo Bellini's drawing Goloubew II, pl. LXXXVI, may have prepared a version by Gentile. As for the head of the beardless man the drawing displays a greatness of invention and power of characterization superior to the head in the painting (in the group of men in the lower l. corner the foremost at right in the second row). The drawing seems to be influenced by Gentile's rendering of portraits, compare the man standing next to St. Joseph in Gentile's "Adoration of the Magi" in the N. G. The more sentimental attitude of the head, however, is advanced beyond Gentile in the same fashion as the Turk l. of the second kneeling magus in the same painting by Gentile was adapted by Carpaccio for the Turk standing at left in his "Consecration of the seven deacons" (ill. Fiocco, pl. CLX). The two women on the *verso,* in our opinion, are copied from a drawing by Gentile Bellini, repeatedly used by Carpaccio and also available to Reeuwich. Originally the hat of the woman at l. was oval as it appears in Reeu-

wich's woodcut and in Carpaccio's drawing No. **597**, while in the corresponding painting the hat has the same high shape as the correction in our drawing. The latter may have been done between No. **597** and the painted version.

No. **640** is an instructive evidence as to how Gentile Bellini's model was misunderstood by Reeuwich, and likewise adapted to his Northern taste. The tress, into which a ribbon ending in a double bow is neatly plaited, has become quite indistinct. So has the r. hand holding the fold. The powerful standing pose, almost like a pillar, may have looked barbaric to a late Gothic artist; he concealed the form behind folds of drapery such as he was used to. For us just this powerful motive of the woman standing is evidence that Carpaccio did not invent the drawing, but only copied it. It has the static calm of the preceding generation. The monumental woman was already attenuated by Carpaccio in No. **597** where another of Gentile's types, the Turk, taken from his "Adoration" in London, is equally reduced in importance; in the painting she almost disappears behind the woman with the altered headdress. When Carpaccio used this more dainty lady again, in the "Consecration of the seven deacons," Molmenti-Ludwig, fig. 189, Fiocco, pl. CLX, the heavy companion was completely canceled.

In No. **284** the woman at l., transformed into a Biblical figure, forms part of a new group. The conformity of this new group of women to Carpaccio's "Consecration of the seven deacons" may lead to the conclusion that Carpaccio had at his disposal not only his own

copy from Gentile's Turkish women, but likewise the version modified in Gentile's shop No. **284**.

A 641 WINDSOR, ROYAL LIBRARY. The Presentation of the Virgin in the temple. Pen, wash. Mentioned by Ludwig, in *Jahrb. P. K. S.* XXVI, (1905) Appendix p. 53 as preliminary study of No. **284**. Publ. by Molmenti-Ludwig, p. 172, fig. 176 as by Carpaccio and a variation of No. **284**. According to Hadeln, *Quattrocento,* p. 55, not by Carpaccio, but by a minor artist and according to Fiocco, *Carpaccio,* p. 91, an old copy from a deviating version of No. **284**. Van Marle XVIII, p. 326, note: production from Carpaccio's school.

[*Pl. CLXXXVIII,* 1. **MM**]

In our opinion, there is no reason for attributing the drawing to a member of Carpaccio's shop from whose style it is entirely different, nor is it by the same hand as No. **284**. They have in common only certain architectural elements that might have been indicated by the people who arranged the competition for the Presentation of the Virgin to be executed for the Carità (see No. **284**). Since we are told that various artists took part in the competition of 1504, the drawing may be by one of them, obviously very inferior to the author of No. **284**, but like the latter, dependent on Gentile Bellini's models. The Turkish woman as appearing for instance in No. **597** or the standing Turk from Gentile's "Adoration of the Magi" (see p. 72) are seen in the drawing although somewhat modified. We should add that a third version might have existed, the r. half of which is preserved in the (reversed) etching by Daniel Hopfer (B. 34), reproduced in E. Tietze-Conrat, *Die Vorbilder von Daniel Hopfers figuralem Werk,* in *Jahrb. K. H. S.,* N. S. IX, p. 105, fig. 67.

BENEDETTO CARPACCIO

[Mentioned between 1530 and 1545]

Son, or rather grandson (see van Marle XVIII, p. 362) or nephew, and pupil of Vittorio Carpaccio, whose immediate follower he appears to be in his paintings. As for the drawings the present stage of knowledge hardly permits distinguishing between the productions of various members of this shop, especially prolific in provincial places of Istria and Dalmatia. We, therefore, prefer to handle the whole material under the heading

SCHOOL OF CARPACCIO

642 BERLIN, KUPFERSTICHSAMMLUNG, 5118. Flagellation of Christ. Pen, br., wash, height. w. wh., on blue. 302 x 263. Stained by mold. Coll. Otto Mündler, Beckerath. Here ascr. to Rocco Marconi.

[*Pl. XXIII,* 4. **MM**]

In our opinion *"modello"* for the painting formerly in the cathedral of Capodistria, now in the Museo dell'Istria (Pola), ill. Fiocco, *Carpaccio,* pl. CXCVIIa. Fiocco ascr. the painting to Vittore Carpaccio with assistants, while van Marle XVII, pl. 372, lists it under the ordinary school productions. The drawing, too, belongs to this category.

643 CHICAGO, ILL., FINE ARTS INSTITUTE, L. H. Gurley Memorial Coll. Virgin and Child between St. John and St. Roch. Pen, br., gray wash, on buff. 136 x 213. In upper r. corner new inscription: Del Vivarino. Ascr. to Benedetto. [*Pl. XXIV,* 1. **MM**]

The composition is closely connected with No. **645** and No. **646**. Stylistically, the drawing is close to the latter. We prefer the attribution to the school of Carpaccio in general to that to Benedetto. See No. **646**.

644 COPENHAGEN, KONG. KOBBERSTIKSAMLING. The Coronation of the Virgin with four Saints, design for an altar-piece. Brush, height. w. wh., on blue. 480 x 214. Scale with measurements at r. Publ. by T. Borenius, in *Rassegna d'A.* X, p. 182, as Benedetto Carpaccio's design for his painting in Capodistria of 1538 (ill. Fiocco, *Carpaccio,* pl. CXCIX b). Hadeln, *Quattrocento,* p. 52, pl. 51 accepts this ascription, while Fiocco pl. CIX a, p. 84, considers the drawing a copy by Benedetto from an invention by Vittore. Van Marle XVIII, p. 365, speaks only in a general way of the resemblance between the two compositions.

We agree with Fiocco's theory that the invention later utilized by Benedetto is to be traced back to Vittore Carpaccio, but we see no reason for attributing the execution to Benedetto Carpaccio rather than to some other follower. In the drawing, special attention is given to the frame while the painting itself is treated in a superficial way. The whole is a typical shop production done by some assistant after Vittore.

645 FLORENCE, UFFIZI 1767. Virgin and Child between St. John

the Baptist and St. Roch, half-figures in landscape. Pen, br., wash. 213 x 303. — On *verso:* The general scheme of the composition existing on the *recto* is given twice (but the Child placed at the l. side as in No. 643), the three figures being left out, while the landscape between them is carefully executed. Further, a seated woman with a nude child seen from the back, in another — reddish br. — ink. Inscription: di mano di Vivarino (and by a later hand) Carpaccio, Bartol. Montagna. The *recto* mentioned by van Marle XVIII, p. 374 and (probably) by J. Byam Shaw, *O. M. D.* June 1939, p. 5, as a school production.

The drawing on the *recto* seems to be a copy or further development of the composition preserved in No. 646 compared with which the mode of drawing appears much later. We may think of a late follower of the type of Benedetto Carpaccio. The drawing on the back is closer in style to No. 646. See also No. 643.

[*Pl. XXIV, 3 and* 4. **MM**]

646 HAARLEM, COLL. KOENIGS, I 334. The Virgin and Child with two boys in contemporary dresses representing the Saints John the B. and St. George. Pen, brush, gray wash, on blue. 204 x 275. — On *verso:* Further figure studies: above an adoring man, below apostles and a female saint. Inscription: di Venezia (and Zorzon, crossed out). Marignane Collection. Publ. with reservations as Benedetto Carpaccio by J. Byam Shaw, in *O. M. D.* 1939, June, pl. 3 and 4, p. 5, who correctly observes the difference in style from No. 644.

[*Pl. XXIV, 2.* **MM**]

The arguments offered by Byam Shaw to prove the stylistic advance of the *recto* over Vittore are convincing, but his reasons for attributing the drawing to Benedetto are less so. The figures on the *verso*, especially, are so close to Vittore himself, see No. 634, that we had better refrain from selecting the author from the third generation. In view of the present state of knowledge we prefer to list the drawing under the general title school of Carpaccio. See No. 643, and **644.**

A 647 LONDON, COLLECTION HENRY OPPENHEIMER, formerly, now PRIVATE COLLECTION, ITALY. Portrait study of a young man, bust turned to right. Bl. ch., height. w. wh., on blue. 270 x 200. Cat. of Oppenheimer Sale no. 56 a: Style of Carpaccio. Publ. by C. L. Ragghianti, in *Critica d'A.* Vol. I, p. 280, fig. 1, as Carpaccio, without supporting his attribution by arguments.

A reference to analogous drawings would seem necessary as the technique is quite unique in Carpaccio's authenticated work and the style so loosely connected with his that even the cautious designation in the cat. seems too positive. The author may be some contemporary Venetian without a direct contact with Carpaccio whose approach to a portrait and whose rendering of costume are different. Compare No. **629.**

A 648 ———. Portrait study of a young man, bust turned to l. Bl. ch., on blue. 271 x 202. Cat. of Oppenheimer Sale 56 b: Style of Carpaccio. Publ. by Ragghianti as Carpaccio. See No. **647.**

Our general objections to the attribution to Carpaccio are the same as for No. **647,** although the drawings apparently are not by the same hand. We place this drawing, too, among the anonymous Venetians around 1500.

649 OXFORD, ASHMOLEAN MUSEUM. Three studies (two youths and a bearded man). Brush, br., height. w. wh., on blue. 209 x 266. A strip at r. is patched. — On the back: Two single figures. On mount old inscription: Giovanni Bellini Pittore Viniziano. Exh. London, Mathiessen Gallery 1939, no. 82 as Carpaccio.

[*Pl. XXV, 3.* **MM.** Verso **MM**]

The two figures at l. appear notably modernized in the background of Carpaccio's "Farewell of St. Ursula and her betrothed," ill. van Marle XVIII, fig. 122 (between Ursula's head and that of the woman behind her). The figure at right exists in Carpaccio's painting "The ambassadors received by King Teonato," ill. van Marle XVIII, fig. 129. The figure at r. on the *verso* again appears, very much modernized, in the background of "Ursula's farewell" (immediately above Ursula's head). The drawings are rather poor and may have been copied in the shop from older models used by the Master.

A 650 PARIS, LOUVRE. The Virgin and Child. Silverpoint, height. w. wh. 148 x 120. Publ. by Parker, pl. 54, with the caption: "Follower of Carpaccio." Parker points out the resemblance with the group in the top of Carpaccio's altar-piece in San Vitale, Venice, ill. Fiocco, *Carpaccio,* pl. CLXIV, but suggests a Lombard artist, probably of the type of Pseudo-Boccaccino. Van Marle XVIII, 374, note, lists the drawing among the productions of Carpaccio's school.

The whole invention so definitely conforms to the Lombard School that we presume Carpaccio used this representation of a sacred picture for his altar in San Vitale.

651 ———, 4795. Young man standing, seen from front. Brush, height. w. wh., on blue. 298 x 152. In the face some spots are worked over with the pen. Late inscription: Vittore Carpaccio . . . Scalapascia. Publ. by Hadeln, *Quattrocento,* pl. 52, p. 62, as by an imitator of Carpaccio, perhaps one of his sons, or by Mansueti in his late years. Van Marle XVIII, p. 374, note: School of Carpaccio.

[*Pl. XXIII, 3.* **MM**]

The figure is used in the middle background of the painting "Reception of the Venetian ambassadors in Cairo in 1512," in the Louvre, ill. van Marle XVII, fig. 103, p. 180, as a rule attr. to the school of Gentile Bellini and sometimes, less convincingly, to Mansueti or Catena. The drawing, in any case, seems to be a *"simile"* the use of which gives no evidence as to its author. We note a resemblance to No. **1403.**

VINCENZO CATENA

[Born about 1470, died shortly after September 10, 1531]

The question of Catena's draftsmanship in spite of his far richer artistic vitality resembles that of Bissolo's. His personal style cannot be grasped and attributions rest therefore on a presumed connection with paintings supposed to be by him. Even in such cases the attribution remains hazardous. The drawings tentatively attr. to Catena are typical *simile* drawings which may have circulated freely in the workshops of the Quattrocento

rearguard in Venice. We list two of them here, but feel it more logical to leave the third, No. 338, in the school of Giovanni Bellini. We do the same with two portraits of donors in Berlin, Nos. 330, 331, for which, too, Catena appears in the list of possible names.

A 652 BAYONNE, MUSÉE BONNAT, 693. Head of a child with curled hair, seen from below and turned slightly to the l. Pen, lightbr. 114 x 100. Inscription: Il Mantegna. Attr. to Catena. [*Pl. CXC*, 1. **MM**]

The drawing is typical working material as confirmed by the dotted line indicating the middle axis of the head; it was intended to facilitate the construction of a foreshortened head. A somewhat similar pose of the Christ Child's head in Catena's "Circumcision" existing in various versions (Naples; Metropolitan Museum, New York; Leuchtenberg Coll. and others), apparently led to the attribution to Catena. The head in the painting is, however, much less foreshortened, and even the actual use of the drawing in the painting would not yet prove that Catena drew it. The drawing is a *"simile"* typical of the school of Mantegna.

A FLORENCE, UFFIZI, 1697. See No. **338**.

A 653 VIENNA, ALBERTINA, 27. Virgin and Child with the infant St. John. Red ch., height. w. wh., on bluish gray. 208 x 183. Two later inscriptions: Giovan. Bellini, and G. Bellini. Waagen, *Kunstschätze in Wien*, II, p. 155: Gio. Bellini. *Albertina Cat. I.* (Wickhoff) 14: Old shop production after a Venetian painting of the late 15th century in the manner of Cima. A. Venturi, *La Galleria Estense in Modena*, fig.

108: Bissolo. Schönbrunner-Meder 534: Shop of Catena, with reference to the resemblance of the drawing to the painting in the Raczynski Coll. in Berlin, in which one figure is added to the Madonna on either side. Hadeln in Thieme-Becker vol. VI, p. 183: Copy from Catena. Berenson in *Dedalo* IV, p. 111: Catena. *Albertina, Cat. II* (Stix-Fröhlich): Francesco Bonsignori, referring to his Madonna of 1483 in the Museo Civico in Verona (ill. Venturi 7, IV, p. 799). Van Marle XVIII, p. 402: Catena, with reference to the close connection with the painting in the N. G. in London (ill. van Marle XVII, fig. 218). Also R. Pallucchini, in *Boll. d'A.* 1935/36, p. 537 rejects the attribution to Bonsignori.

The drawing does indeed correspond exactly to the painting in the N. G. in London, and its composition with slight modifications is also repeated in other paintings attr. to Catena (Modena). It is a typical *"simile"* drawing, possibly going back to a composition of the late 15th century, perhaps by Cima, and apparently popular in Catena's workshop. The linework is, however, different from that of other *simile* drawings which we know from the Bellini shop (see No. 316 and No. 352); this makes Catena's authorship rather doubtful. The dry rendering of the drapery, typical of a *simile* drawing, may have misled Stix-Fröhlich into their attribution.

GIOVANNI BATTISTA CIMA DA CONEGLIANO
[*Born c. 1459, died 1517 or 1518*]

Cima's charming personality has given additional proof of its power of attraction by making critics attribute some drawings to him that are not only different in style from his, but also superior to his mastery in a limited sphere. His own style of drawing is pretty well established by two specimens, No. 656 and No. 658 the identification of which is supported by the double criterion of a connection with one of his ascertained paintings and the general compatibility with Cima's personal expression as it emanates from his whole production. Both drawings are early—the paintings to which they belong are dated 1489 and 1496, respectively—and may support the theory maintained in R. Burckhardt's monograph of Montagna's important share in Cima's early formation. His independence of the purely Venetian currents before he moved to Venice some time between 1489 and 1492 is also illustrated by No. 657 which, in our opinion, is an interesting addition to Cima's work. Its archaic character, emphasized by Hadeln who first published the drawing, is partly due to the fact that one of its sides presents a typical *simile,* traceable to a "Mantegnesque" invention, but possibly executed by Cima.

Did his thoroughgoing allegiance to Venice, and especially to Giovanni Bellini, as emphasized by Gronau in Thieme-Becker vol. 6, p. 594, lessen Cima's individuality? His drawings are in any case entirely lost or merged in the Bellini School. In one drawing repeating a famous composition by Giovanni Bellini for the Ducal Palace, No. 337, we tentatively recognize his hand. Only in the Orpheus in the Uffizi, No. 655, can we perceive very distinctly Cima's personal mixture of grace and ingenuousness. The doubts expressed by Popham are, in our opinion, caused by the pricking of the outlines by which the drawing has greatly suffered. All other attributions to Cima's mature or late period rest on a misconception of his art, or of the character of the drawings in question.

There may even be several misconceptions. One is based on the mistake so explicitly denounced by Mr. Beren-

son in his *Florentine Drawings* and elsewhere, namely, that the use of a drawing in a painting is considered an evidence for an identity of authorship. One of a group of ornamental drawings in Berlin, No. 654, is used in the background of Cima's painting "The Healing of Ananias," also in Berlin. Burckhardt was mistaken in inferring from this fact that the drawings were Cima's too. (The same warning against misinterpretation of ornamental designs used in paintings is voiced by O. Fischel, speaking of a drawing of this character by Pinturicchio, in *"Zeichnungen der Umbrer,"* p. 190, no. 97). The intense demand for designs of this kind which led to their reproduction by engraving, was apparently met by specialists whose production was at the disposal of any workshop in need of such designs. Who the authors of this auxiliary material were, of which quite a number exists (in Berlin, and in the Fogg Art Museum in Cambridge) we do not know. But we may in this connection call attention to a sketchbook on parchment with pen drawings of "animals and candelabra" by Jacometto Veneziano which Michiel saw in Gabriele Vendramin's Collection in Venice in 1530. We do not intend to penetrate further into this domain of ornamental design.

We are, however, back in our special field when turning to two outstanding drawings in London, unanimously, or nearly so, accepted as Cima's, but distinctly by other, and greater, artists. For the landscape No. 309 we refer to our argumentation in favor of an attribution to Giovanni Bellini in his Mantegnesque early period (see p. 87). We feel Mantegna's nearness much more strongly in the "Savior," again in the B. M., No. A 659, the grandeur of which, not to speak of the single characteristics is far beyond Cima's span.

A 654 BERLIN, KUPFERSTICHKABINETT, 5616. Sheet with two ornamental designs, both representing friezes with marine deities. Pen. 245 x 195. — On *verso:* three other ornamental designs. Coll. von Beckerath. — Exh. as Cima (?) École des Beaux Arts 1879, no. 186. Publ. by Rud. Burckhardt, p. 123 as by Cima who would have used the ornament on the *recto* for his painting "The Healing of Ananias," of about 1499, in Berlin, Kaiser Friedrich Museum (ill. Venturi 7, IV, fig. 319). Burckhardt points to 12 other drawings in Berlin containing ornamental details, attr. to Cima, see below. Hadeln, in Thieme-Becker vol. 6, p. 596, accepts the attribution, but does not mention the drawings in his *"Quattrocento."* [*Pl. CXC,* 2. **MM**]

For the reasons given above we do not believe that the identification of the ornamental design in Cima's painting proves Cima's authorship. The stylistic examination of the drawing in Berlin reveals no connection with Cima's rendering of the nude nor with his usual types.

The ornamental drawings mentioned by Burckhardt, Berlin, 16615 to 16624, represent candelabra and other ornamental designs. We have not seen them, but imagine they belong to the same category as certain drawings in the Fogg Art Museum, Cambridge, Mongan-Sachs No. 54, ill. fig. 41.

655 FLORENCE UFFIZI, 1680. Orpheus. Pen, wash. 250 x 200. Outlines pricked. An old inscription, apparently unconnected with the drawing, is canceled. — On *verso:* Map. Bl. ch. and pen, with topographical inscriptions: Val Sugana, Val Piana, Fontana Chica, Cismon (river), La Brenta. Formerly ascr. to school of Mantegna, attr. to Cima by Gamba, *Uffizi Publ.* III, p. I, no. 10, with reference to the tondo in Parma, ill. Venturi 7, IV, fig, 334, p. 542, and other mythological paintings. Accepted by Hadeln, *Quattrocento,* pl. 75. Exh. London 1930, no. 716. Popham, *Cat.* 174, questions Cima's authorship because of the poor quality of the drawing and suggests an imitator of Cima, for instance, Girolamo Mocetto. Van Marle XVII, p. 460, accepts Cima. [*Pl. XLIV,* 1. **MM**]

We accept Cima, also. The poorer quality may be due to the pricking.

656 ————, 281. E. St. Jerome, design for the painting of 1489 in the Museo Civico, Vicenza, ill. van Marle XVII, fig. 230. Brush, br., height. with wh., on paper tinted red. 229 x 95. First identified by Burckhardt, *Cima,* p. 124, accepted by Hadeln, *Quattrocento,* pl. 73, Parker, pl. 46 and van Marle XVII, p. 457. [*Pl. XLII,* 1. **MM**]

657 HAARLEM, COLL. KOENIGS, I 335. The Virgin and Child enthroned. Brush and pen, brownish gray and wh., on faded blue. 257 x 157. Squared. — On *verso:* The Virgin kneeling, probably from an Adoration of the Child. Cut and also otherwise in an unsatisfactory state of preservation, as already noted by Hadeln. The Child is hardly recognizable, this portion of the drawing being badly rubbed. Publ. by Hadeln, *Koenigszeichnungen,* No. 2, the *recto* as a modified version of the Madonna in Cima's altar-piece in Vicenza of 1489 (ill. van Marle XVII, fig. 230), the two figures indeed exactly corresponding in their lower halves; the *verso* is still earlier. Hadeln refers to the polyptych in Olera, near Bergamo, and another from Oderzo in the Brera (ill. van Marle XVII, fig. 233). Exh. Amsterdam, 1934, no. 526. [*Pl. XLII,* 2 and *XLIII,* 3. **MM**]

Compare further for the *recto* the "Madonna" in the Cook coll., Richmond (ill. van Marle XVII, fig. 235). The drawing on the back corresponds exactly to the engraving in reverse, Hind, app. II, p. 588, 44, listed as "after a Mantegnesque drawing," with reference to the "Nativity" by Mantegna or his school, in the Metropolitan Museum, New York, and the drawing connected with it in the Uffizi, No. 2253. In our opinion, the style of the drawing in Haarlem is distinctly different from No. 2253 and the attribution to Cima seems plausible; the *recto* is typical of him, the *verso* is a *"simile"* drawing going back to a Mantegnesque invention, but the execution may be by Cima.

A LONDON, BRITISH MUSEUM, 1900–5–15 — 1. See No. 309.

658 ————, 1936–10–10 — 8. Head of a bearded man, turned to the r., design for Cima's St. Jerome in the altar-piece "The Virgin with the orange tree," about 1496 (ill. van Marle XVII, fig. 250). Brush, height. w. wh., on blue. 245 x 120. Cut along the outlines and inlaid. Coll. Sunderland, J. P. Heseltine, Henry Oppenheimer. Publ. by Hadeln, *Quattrocento,* pl. 74. Exh. London, 1930, Popham *Cat.* 173. Van Marle XVII, p. 460. [*Pl. XLIII,* 1. **MM**]

A 659 ————, 1895–9–15 — 803. The Savior standing on a cloud, surrounded by heads of angels and holding a globe. Brush, gray and wh., on faded blue. 390 x 194. Coll. Malcolm, Cat. Robinson 356. Exh. École des Beaux Arts 1879, no. 183 as Giov. Bellini. Publ. by Hadeln, *Quattrocento,* pl. 78, p. 63 as from Cima's latest period. Van Marle XVII, p. 457, fig. 274 accepts this attribution and finds Mantegna's influence, possibly transmitted through Giovanni

Bellini, evident in the incisive drapery. [*Pl. CLXXXIX,* 2. **MM**]

It is hardly possible to reconcile the style of this drawing with that of Cima's well-authenticated drawings No. **656** and No. **658** which, it is true, would belong to an earlier period than the one assumed for this drawing. But it is perhaps still more difficult to give an artist of the type of Cima credit for such a master drawing, equally outstanding in the grandeur of its invention and in the powerful modeling of the feet. Van Marle seems to have felt much the same when connecting the drawing with Mantegna through Bellini. But evidently the drawing shows none of the characteristics of Giovanni Bellini under the influence of Mantegna. The only style to which we feel a certain approach in this drawing, is Mantegna's very latest, as in his Trivulzio "Madonna" (ill. *Klassiker, Mantegna,* 110, 111). Compare the feet of the Madonna standing on the clouds, the similarly varied heads of angels around her, and the masterly invention of St. Jerome.

SCHOOL OF CIMA

660 MILAN, AMBROSIANA, Resta 11. Madonna and Child enthroned, at l. landscape with a bridge and a town. Pen, gray wash, height. w. wh., on grayish yellow. 335 x 241. Torn and damaged, in part unfinished and certainly cut at the r. In the coll. "Gentile Bellini." [**MM**]

In our opinion, by a minor follower of Cima in whose shop similar landscape motives are frequent. Compare for the Madonna the painting by Antonio di Tisoio of 1512, in the Liechtenstein Gallery, Vienna (ill. van Marle XVII, fig. 287).

661 WINDSOR, ROYAL LIBRARY, 12807. Altar-piece: Bishop saint

enthroned between two other saints, all placed in the niche of a chapel. Brush, height. w. wh., on faded blue. 372 x 248. Very much rubbed and probably cut at bottom. Berenson, *Study and criticism of Italian art,* 1903, p. 109: "Probably by Cima, and of great value as absolutely unique," an attribution rejected by Burckhardt, *Cima,* p. 123 who compares the sainted king with Cima's St. Constantine of 1502 in San Giovanni in Bragorà (ill. Venturi 7, IV, fig. 317) and attr. the drawing to the school of Cima. Herein he is followed by Hadeln, *Quattrocento,* pl. 79 and van Marle XVII, p. 461 note.

If really by a pupil of Cima, then it is by one from his latest period.

GIOVANNI CONTARINI

[*Born 1549, died shortly before 1604*]

We do not know with whom Contarini learned his art. The information offered by Ridolfi (II, p. 296) that Malombra was his fellow pupil might point to Giuseppe Salviati (Ridolfi II, p. 155). In 1597 Contarini is mentioned as a member of the painters' guild. Ridolfi tells us that he was more interested in painting than in drawing, having learned art with brush in hand; according to him Contarini painted from nature "while those who learn from casts or paintings obtain more precision in drawing and in composing." Under such conditions it is easily understandable that only a few drawings may be ascr. to him. The old signed No. **663** is a *"modello,"* closely related in style to the ceiling in San Francesco di Paolo, but not conforming to its composition. The attribution of No. **664** by Resta may be correct, but we have not succeeded in finding a connection with any of Contarini's paintings of which, it is true, some may be hidden among the anonymous Venetians (see Pan and Syrinx in Detroit, ill. *Art Quarterly,* Summer 1939, p. 213, fig. 4.) or under some other more popular names. The Thetis wrongly attributed to Palma Giov. in the Gallery in Bamberg, might be by Contarini and belong to the mythological series painted for the Emperor. Tentatively, we connect to No. **664** No. **229**, also claimed for Leandro Bassano; or is the drawing by Tinelli, Contarini's pupil who later went over to Bassano? The most imposing drawing given to Contarini is the one in Berlin No. **1977**, previously classified as school of Titian, but in view of its resemblance to Contarini's Battlepiece in the Ducal Palace (ill. Venturi 9, VII, fig. 166) publ. by Hadeln as the design for this painting. In our opinion (see p. 310) the drawing is not only superior to Contarini in quality, but also different from his general tendencies. (The interpretation, also accepted by Hadeln in Thieme-Becker

VII, 329 of the initials I. C. F. as "Joh. Contarini fecit" on a drawing in the Brera, No. **A 665**, is in our opinion erroneous.)

A BERLIN, KUPFERSTICHKABINETT, 624. See No. **1977**.

662 CHATSWORTH, *Duke of Devonshire*, 317. Mourning over the dead Christ. Pen, br. 208 x 195. Stained by mold. Collector's mark Lugt 2908. **[MM]**

663 FLORENCE, UFFIZI, 12841. Resurrection of Christ. Pen, br., washed with blue and yellow. Inscription: del Zan Contarini. Old label: Di mano di Gio Contarini certiss^mo. Lopera è in San Fran^co di Pavolo in Venetia nel soffitto, ma variata in alcuna cosa. **[MM]**

The composition has a close stylistic affinity to the ceiling, representing the same subject, in San Francesco di Paolo, but otherwise there is no great resemblance to it. It might, nevertheless, be a first *"modello"* for the painting.

664 MILAN, AMBROSIANA, Resta 113. Pageant of marine deities. Bl. and wh. ch., on blue. 336 x 272. Inscription in pen (Padre Resta's handwriting): Gio. Contarino Venetiano. [*Pl. CXXXIV*, 4. **MM**]

A painting representing Thetis in the Gallery in Bamberg, there ascr. to Palma Giovane, seems so close in style to the drawing that it might be also ascr. to Contarini.

A 665 MILAN, BRERA, St. Jerome. Pen. 125 x 100. Inscription: J. C. f. Malaguzzi-Valeri, *Brera*, 5, read Johannes Contarenus fecit, and saw in the drawing the first idea of the very different painting 112 in the Brera. Hadeln in Thieme-Becker VII, p. 328, accepted the attribution.

In our opinion, the drawing is later and close to Simone Cantarini whose initials may have been misread or altered.

666 PARIS, LOUVRE 5753. Temptation of Christ. Pen, dark br., height. w. wh., washed, on green. 323 x 237. Inscription on the mount: Gio. Contarini. **[MM]**

The drawing which differs notably from the best authenticated No. **663**, might be an early *"modello."* The figure of Satan is influenced by Dürer's woodcut B. 9.

CORDELIAGHI, see PREVITALI, ANDREA.

LEONARDO CORONA

[Mentioned about 1561 to 1605]

It is difficult to deal with Leonardo Corona as a draftsman. What is known about his artistic education offers no clue. He first studied with his father, Michele, who lived in Murano and made a living for himself and his large family as a painter of saints in miniature; later on he worked with Maestro Rocco, called da Silvestro, whose shop made a specialty of "copying from the paintings of good masters" and for this purpose employed a number of Flemish artists. After a short time his father took him back and made him paint small pictures on copper, the compositions of which in part were taken from engravings. This detailed description of the making of a young artist, as given by Ridolfi II, p. 101, reveals a combination of activities typical of every young artist, and for Corona personally, discloses that he received no systematic schooling from any outstanding artist and in his very early years was forced to earn his living. We hear further that he continued to copy from other artists among whom Titian and Tintoretto are expressly mentioned. One of the paintings he copied with remarkable success was Titian's "Battle of Cadore." We have no reason for supposing that Corona was interested in the drawings of these masters, or that he drew after their paintings. We are told only about painted copies. These years of study end about 1583/84 when Corona obtained his first important commissions. In 1587 he is already mentioned by Bardi as one of the painters busy in the Sala del Maggior Consiglio.

We are not in a position to connect with certainty any drawing to any of Corona's paintings and have only to rely on the sound tradition offered by Ridolfi's attribution of drawings, now in the Christ Church Library of Oxford, and, on the less trustworthy, of Padre Resta's attributions in Milan. Among the drawings in Christ Church, No. **675** being probably a model for an engraving, and accordingly executed with careful dryness, offers no help; a little better is No. **676** publ. by Hadeln, pl. 103, the free linework of which is to be considered the most valid expression of Corona's artistic personality. To it we may append No. **684** also inscribed with Corona's

name by an old hand. The angels in his painting of "St. Matthew" in S. Bartolommeo in Venice (ill. Venturi, 9, VII, fig. 149) present similar types, and what we are able to see in the early painting on the ceiling in the Ducal Palace "Caterina Cornaro renouncing Cyprus," matches rather well. From these putti in No. 684 there is a line to the design for a ceiling No. 672 at the Robert Witt Coll. (again with an old signature) and to the "Annunciation" in the Louvre, No. 682, which on the other hand is also related to No. 676. No. 673 is supported by Padre Resta's inscription and by the resemblance to paintings of the same subject in San Giovanni Elemosinario, Venice, and in the Academy. It adds a pictorial touch to our conception of Corona's drawing style, formed by the help of the preceding examples. The only study of a single figure claimed for Corona by tradition, No. 667, is likewise supported by the identity of the type with that of Magdalene in the "Crucifixion" in San Giovanni Elemosinario and that of the two women at l. in the "Crucifixion" in the Academy. Our further suggestions are merely based on stylistic reasons and are therefore expressed with utmost caution.

667 CHATSWORTH, DUKE OF DEVONSHIRE, 589. Head of a woman, bending to the left. Red ch. 131 x 105. Corners cut. On *verso* undecipherable words written in pen. Coll. Peter Lely. Ascr. to Leonardo Corona. [*Pl. CXXXIV*, 3. **MM**]
The attribution might go back to the writing on the back. The type is indubitably Corona's, compare his Magdalene in the "Crucifixion" in S. Giovanni Elemosinario and the two women at the left of the Virgin in the "Crucifixion" in the Academy in Venice (Photo Anderson).

668 FLORENCE, UFFIZI, 13291. Man seated, half-length, bent upon his arms. Bl. ch., height. w. wh., on blue. 113 x 169.
Close in style to No. **670**.

669 ————, 13292. Bearded head turned to the r. Bl. ch., on blue. 193 x 131. Slightly stained by mold. Lower r. corner patched. Old inscription: Di Lionardo Corona. [**MM**]

670 ————, 13293. Man seated, half-length, looking to the r. Bl. ch., height. w. wh. 116 x 170. On the back: Di mano di Leonardo Corona.
Companion piece to No. **668**.

671 ————, Santarelli 7474. Massacre of the Innocents. Over bl. ch., pen, lightbr., wash. 276 x 425. Ascr. to Tintoretto.
In our opinion close in style to Leonardo Corona. Compare No. **676**.

672 LONDON, COLL. SIR ROBERT WITT. Design for a ceiling, Mucius Scaevola. Pen, bl. gray, wash, on yellowish wh. paper. 253 x 265. Octangular. Inscription: Leond° Corona n° 14. [*Pl. CXXXIII*, 3. **MM**]

673 MILAN, AMBROSIANA, Resta 109. Crucifixion with saints. Pen, br., wash. 266 x 203. Inscription in pen, in Padre Resta's handwriting: Leon. Corona da Murano Veneziano. [*Pl. CXXXIV*, 1. **MM**]
Corona's paintings of a "Crucifixion" in S. Giovanni Elemosinario and in the Academy in Venice (Photo Anderson) confirm Resta's inscription.

674 NEW YORK, METROPOLITAN MUSEUM, 80.3.154. Design for an altar-piece, in upper zone Christ seated between two saints, below Communion of St. Lucy. Pen, bl., wash. 265 x 142. Ascr. to Jacopo Tintoretto (photo 41349). [**MM**]
We attr. the drawing to L. Corona by reason of its close stylistic resemblance to No. 676. A small painting ("tavoletta") representing

the same unusual subject is listed as by Contarini in the chapel of Santa Lucia in SS. Apostoli, Venice. (*Venezia e le sue lagune*, Venice 1847, II, 2, p. 245.)

675 OXFORD, CHRISTCHURCH LIBRARY, C. C. 12. Glorification of Venice, Venice enthroned between two allegorical women with crown and scepter; lower at l. and r. Hercules and Allegory of strength. Pen, br. 282 A 171. — On *verso* in Ridolfi's handwriting: Lionardo Corona. Ridolfi Coll.
Design for a frontispiece?

676 ————, L. 24. The Virgin and Child, two female saints. Pen, wash. 229 x 206. — On *verso* in Ridolfi's handwriting: Corona. Ridolfi Coll. Publ. by Hadeln, in *Spätren.*, pl. 103.

677 PARIS, LOUVRE, 5741. Sketch for an altar-piece: The Lord and Virgin on clouds, a kneeling dignitary, a standing saint and a kneeling allegorical figure on the ground. Broad pen, br., wash, over sketch in ch. 277 x 200. [**MM**]
Our attribution rests on the basis of a stylistic affinity to the rather well established No. **676**.

678 ————, 5744. The Virgin and Child on clouds, two female and two male saints on the ground. Pen, gray wash, on green. 277 x 154. Formerly attr. to Palma Gio., now anonymous.
Our attribution on the basis of the style.

679 ————, 5768. Entombment of the Virgin. Broad pen, br., wash, on yellowish. 270 x 390. Old inscription on the mount: L. Corona. [**MM**]
There is some affinity to No. **681**, but none to No. **676**. The similar pathetic composition in S. Nicolò dei Mendicoli (ill. Venturi 9, VII, p. 252, 253), however, makes the ascription acceptable.

680 ————, 5786. St. John as a child embracing the Christchild, surrounded by the Virgin and Saint Elizabeth and other members of the Holy Family. Pen, br., wash, in gray, over sketch in ch. 308 x 210. Stained by mold. In the Louvre anonymous. [**MM**]
Our ascription on the basis of the stylistic resemblance to No. **676**.

681 ————, 5795. Floating "Fame." Pen, reddish br., gray wash, height. w. wh., on reddish paper. Later inscription: Leonardo Corona. [**MM**]
The traditional attribution may be correct.

682 ————, 5815. Annunciation. Broad pen, wash with yellow, on yellow. 307 x 200. Later inscription: Leonardo Corona Muranese. [*Pl. CXXXII*, 4. **MM**]

The style of drawing slightly resembles that of No. **676**; an "Annunciation" by Corona existed in the Rosary chapel of S. Giovanni e Paolo and was destroyed when the chapel burned down in 1867 (Ridolfi I, 103).

683 VIENNA, ALBERTINA, 114. Nativity of the Virgin. Over bl. ch. pen, bister, wash. 250 x 228. Ascr. to school of Veronese. [**MM**]

Our tentative attribution of this drawing which apparently was intended for a ceiling rests on the resemblance to Nos. **684** and **679**. A painting of this subject by Corona existed above one of the doors in the Rosary chapel in San Giovanni e Paolo, burnt in 1867 (Ridolfi II, 104), apparently not a ceiling however.

684 VIENNA, AKADEMIE DER BILDENDEN KÜNSTE. Design for six children, each sitting on a cloud and holding a scroll, apparently meant to fit in an oval. Pen, br., wash. 181 x 296. Old inscription: Leonardo Corona. [*Pl. CXXXIII*, 2. **MM**]

Similar angels in Corona's "St. Matthew," in S. Bartolommeo, Venice (ill. Venturi 9, VII, fig. 149).

CARLO CRIVELLI
[Born c. 1430–35, died 1495]

A 685 BERLIN, KUPFERSTICHKABINETT, 4015. Shepherds (from an Adoration). Pen, on parchment. 102 x 95. Publ. by W. Boeck, in *Burl. Mag.* vol. 59, p. 72 (ill.), with reference to Crivelli's predella of the Odoni altar-piece in the N. G., London (no. 724) and to his earlier paintings. [**MM**]

The resemblance is limited to the motive of the nude Child lying upon the folds of the mantle of the Virgin. The references given by Boeck are by far too casual to allow an attribution. The resemblance of the motive in the drawing to one in Mantegna's "Adoration of the Shepherds" in the Metropolitan Museum in New York (ill. *Burl. Mag.* LVI, p. 71 A) is much closer. The drawing is by some anonymous follower of Mantegna.

686 CAMBRIDGE, Mass., FOGG ART MUSEUM, 8. Saint Peter. Pen on paper (not parchment). 198 x 123. Cut following the outlines, patched on the mount and repaired. Coll. Philippi. Charles Loeser Bequest 1932 — 280. Mentioned by G. McNeil Rushforth, *Carlo Crivelli*, p. 48 as a late drawing, publ. by Hadeln, *Quattrocento*, pl. 3, p. 15 as a mere working material, the design for one of the apostles, formerly in Montefiore, Fermo (between 1468 and 1470), now in the Art Institute in Detroit (ill. Franz Drey, *Crivelli*, pl. 19 and *Bulletin of the Detroit Institute of Arts*, IX, 1928, p. 72). Mongan-Sachs, p. 9, fig. 9: Early copy from Crivelli's painting, in view of a certain fussiness and emptiness of the drawing.

We agree with this opinion and believe the drawing to be a *"simile"* from Crivelli's shop.

A FLORENCE, UFFIZI, 335 E. See No. **692**.

PIETRO DAMINI
[Born 1592, died 1631]

Pietro Damini studied with G. B. Novelli of Castelfranco, a pupil of Palma Giovine. According to Ridolfi's biography (II, p. 243) he was very much interested in drawing and also a collector of other artists' drawings. A drawing in Sir Robert Witt's coll. in London, No. **688**, authenticated by an old inscription, testifies to the connection with Palma. Another drawing on which the name Pietro Damini appears perhaps written by the same old collector as on No. **688**, corresponds in style and format to Damini's two paintings from the legend of S. Domenico in Chioggia (dated 1617–19). Possibly the drawing is the design for another representation from the same series, now missing (perhaps identical with the one in the church of Martellago, compare Crico, *Lettere Trevigiane*, p. 176). A drawing in Frankfort, No. **687**, attr. to Titian by a collector, is closely related by its style.

687 FRANKFORT/M., STÄDELSCHES KUNSTINSTITUT, 15203. Dignitary standing, turned to the r. and backward. Pen. Late inscription: Tiziano. [**MM**]

Our attribution rests on the resemblance to No. **691**.

A 688 LONDON, COLL. SIR ROBERT MOND. Christ taken from the cross. Pen, wash in blue monochrome, height. w. wh. 261 x 215. Coll. Esdaile and Udney. Publ. by Borenius-Witkower pl. XIII B.

The attribution which seems to rest on a slight resemblance with Damini's "Deposition of Christ" in the Museum of Castelfranco Veneto (ill. Venturi 9, VII, fig. 93) does not convince us, the general style of the drawing being quite different.

689 LONDON, COLL. SIR ROBERT WITT. Magdalene. Pen, gray, wash. 284 x 173. Semicircular top. Inscription: Pietro Damini da Castelfr (anco). Cut. [**MM**]

690 NEW YORK, METROPOLITAN MUSEUM. 80.3.182. Saint Francis worshipping, between Saint Louis of France and a female saint. Pen, br., wash, on faded blue. 220 x 152. Semicircular top. Later inscription: Pietro Damini. Vanderbilt Coll. (Photo Metropolitan Museum 37062).

691 PARIS, LOUVRE, 4802. Scene from the legend of a saint. Pen, br., gray wash. Inscription: Pietro Damini da Castelfranco. [*Pl. CLXXXIV*, 2. **MM**]

The drawing resembles in style and format the "Miracles of St. Dominic" in the church of this saint in Chioggia, painted by Damini 1617–1619. It might be the design for one of the scenes which do not exist any more (see p. 164).

BENEDETTO DIANA (RUSCONI)

[Born c. 1460, died 1525]

692 FLORENCE, UFFIZI, 335 E. Youthful apostle standing, blessing with his r. hand. Pen, br. 155 x 113. Old inscription: Crivelli da Pesaro. Ascr. to Mantegna. [*Pl. XL*, 4. **MM**]

In our opinion, the drawing might be an early work by Benedetto Diana: we find similar proportions, postures and similar draperies in Diana's votive painting of 1486, in the Cà d'Oro in Venice, ill. Venturi 7, IV, fig. 389. The general approach of the mode of drawing to that of the Bellini supports our tentative attribution.

PAOLO DE' FRANCESCHI

[Born c. 1546, died 1596]

We feel justified in including this Flemish artist, known in Venice under the name of Paolo Fiammingo (Paul the Fleming), but nevertheless, listed among Ridolfi's biographies, in our Venetian Catalogue. He not only gained citizenship in Venice and obtained numerous official commissions, but by his style is so intimately connected with purely Venetian production that we may consider him a stimulating element within the evolution of this school. Only one drawing exists, vouched for by an old inscription, and by its close connection with an authentic painting (No. 693), but it is so typical that we feel encouraged to add a second, ascribed to Paolo Veronese in the Uffizi (No. 694). The fanciful, crowded and at the same time somewhat narrowminded, character of the extremely finished drawing points to a Northerner in the wake of Italian art. The indulgence of both drawings in petty details reminds us of certain compositions ascribed to Tintoretto as a rule, but scarcely to be given even to his shop. Their dry linework reappears in a group of drawings contained in Palma's sketchbooks in Munich. This group might be by a later artist following Palma, but showing also a connection with Paolo Fiammingo. The investigation of this problem would lead us beyond our present task.

693 AMSTERDAM, RIJKSMUSEUM. Rape of Proserpina. Pen. 207 x 305. On back inscription in faded ink: Paolo Fiamengho. The drawing formerly ascr. to Jacob Pijnas was identified by R. E. Peltzer in *Münchn. Jahrb.* N. S. I, p. 138, as by Franceschi, and a study for his painting in the Doria Coll. in Rome, ill. l. c. p. 136, fig. 6. Hadeln, *Spätren.*, pl. 91. [*Pl. CXXIX*, 1. **MM**]

694 FLORENCE, UFFIZI, 497. P. Landscape with two seated nymphs at the left and a boat with two women and a boatman in the middle ground. Pen, lightbr. 180 x 273. Poor state of preservation. Later inscription: Paolo Veron. [*Pl. CXXIX*, 2. **MM**]

Our tentative attribution rests on the stylistic resemblance to No. 693.

ALVISE BENFATTO, CALLED FRISO

[Born 1554, died 1611]

The nephew of Paolo Veronese in whose shop, according to Ridolfi, he worked for a long time, is expressly described as having imitated his uncle up to the point of being mistaken for him. Consequently, his drawings, like those of Benedetto Caliari, must be hidden among Paolo's drawings. They are the more difficult to pick out as only very few of Friso's paintings, as listed by Ridolfi, can be dated with certainty after Paolo's death. Only a single drawing, No. A 697, is inscribed with his name; but since the drawing has been acquired only in 1923 and the inscription is certainly not earlier than the 19th century, this testimony does not deserve much credit. The hand that wrote the name might be the same which on the mount of No. 695 first wrote the name of Carletto, then canceled it and replaced it by Alvise de Friso. In both cases the attribution apparently intends to stress the

supposed nearness to Paolo Veronese by adding the name of his imitator. For No. **695** the closeness to Paolo Veronese seems convincing; it is less so for No. **697** and we therefore reject it. Our own attribution of No. **696** is based on the resemblance of the composition to Veronese and the literary evidence offered by Ridolfi who tells us (I, p. 142) that Friso painted this subject for San Niccolò. The drawing, however, offers no help in claiming others for Friso from the inflated stock of drawings ascribed to Paolo.

The organ shutters for San Niccolò have been attributed by Ridolfi to Friso (Fiocco says erroneously, to Carletto to whom they were ascribed by Boschini who wrote later); Friso, too, is accordingly to be considered as a possible author of the designs for these paintings (see No. **2039**).

695 PARIS, COLL. MME. PATISSOU. Entombment of Christ. Pen, blackbr., wash. 165 x 267, irregularly cut. On the mount modern inscription (perhaps by the same hand as on No. **A 697**): Alvise de Friso; the word Carletto is canceled. [**MM**]
We distinguish two hands in the execution of this drawing, both leaning towards Paolo Veronese's style. In the upper composition the legs of Christ originally ended behind the man seen from behind the group at the r. and the second pair of legs was later added in order to adapt the composition to the one below. The attribution to Friso may be correct at least as far as the original nucleus goes.

696 TURIN, BIBLIOTECA REALE, 15913. Emperor Heraclius enters Jerusalem carrying the Holy Cross. Pen, br., slightly washed. 301 x 229. Ascr. to Palma Vecchio. [*Pl. CLXVIII, 4.* **MM**]

In our opinion, the drawing is a design by Friso for his (lost?) painting in S. Niccolò Grande, in Venice, described by Ridolfi I, 142: "in uno de' spatii magiori fece Heraclio Imperatore che . . . deposti gli Imperiali ornamenti co piedi scalci riporta il sacrato legno in Gerusalemme, seguito da Zaccaria Patriarcha . . . "

A 697 VIENNA, ALBERTINA, 126. The Judgment of Solomon (?) Pen, wash. 167 x 202. 19th century inscription: Alvise ben fato dal friso, nipote di Paolo Veronese. Acquired 1923 and publ. by Stix in *Albertina* N. S. II, pl. 30: Friso. [**MM**]
The inscription is too recent to deserve sufficient credit for an attribution: the connection with Veronese's style seems looser than might be expected from a direct imitator like Friso.

GIROLAMO GAMBARATO

[*Mentioned as a member of the Painters' Guild 1591–1606*]

Having been a pupil of Giuseppe Salviati who died shortly after 1573, Gambarato's birth year must be put about the middle of the century. According to Ridolfi, he collaborated with Palma Giovine and was helped by the latter with a painting he was commissioned to execute for the Sala del Maggior Consiglio. Ridolfi describes the composition as containing the Pope, the Emperor and the Doge to whom some townspeople bring ceremonial parasols "ed in questi per avventura fu coagiuto del Palma." The passage is somewhat obscure and may mean that Gambarato had Palma's help for the first mentioned main figures. The drawing No. **917** which we were able to identify as a study for the figure of the Doge and which for stylistic reasons is more easily compatible with Palma than with a pupil of Giuseppe Salviati, may accordingly be one of the studies supplied by Palma on this occasion. We have, however, to recall how close the connections between the two men were in still other ways: Palma used his friend Gambarato as a model for his paintings in San Giacomo dell'Orio and rewarded him by allowing him to make a copy of each drawing (Ridolfi II, p. 174).

698 AMSTERDAM, MUSEUM FODOR. The Doge accompanies Emperor Frederick to the Bucentoro. Brush, gray over charcoal sketch. 315 x 248. Coll. Crozat, Richardson Jun., Gréville, Warwick. Ascr. to Domenico Tintoretto. [*Pl. CLXXXV, 3.* **MM**]
We cannot find a resemblance to Domenico's fairly well known style and ascr. the drawing tentatively to Gambarato with whose style of composition and types, see Venturi 9, VII, fig. 30 (with the erroneous caption Giulio dal Moro), there is a certain general resemblance. It is true that the subject is not the same in the drawing and in the painting, the Pope not appearing in the former. According to G. Bardi whose *"Dichiarazione"* is a program for the redecoration of

the Ducal Palace after the great fires of 1574 and 1577, one episode of the legendary history to be represented was the arrival of the Emperor in Chioggia where he was met by the Doge with many attendants. Gambarato may first have intended to illustrate this scene for which, however, another was substituted.

698 bis CHATSWORTH, DUKE OF DEVONSHIRE. Ceremony at the papal Court. Three dignitaries standing in front of a seated Pope surrounded by cardinals and guards. Brush, wh. and gray. 310 x 244. Stained by mold. Collector's mark Lugt 1160. Ascr. to Paolo Veronese. [*Pl. CLXXXV, 4.* **MM**]

The composition is dependent on Palma's "Pope Anacletus found-ing the order of the Crociferi," in the Oratorio dei Crociferi in Venice (ill. Venturi 9, VII, fig. 105). Brushwork and types, however, are positively different from Palma's. They recall No. **698** which we attr. to Gambarato. The lack of originality in the composition fits well into this artist's characterization by Ridolfi (II, p. 205) who says: "mà non fu molto inventore," he was a poor inventor. For Gambarato's close connection with Palma see above and No. **917**.

699 FLORENCE, UFFIZI. Nude male seated, turned to the r., seen

from behind. Pen. About 249 x 172. Ascr. to Ja. Tintoretto. (Photo Alinari 1099).

The drawing displays Palma Giovine's early pen technique, but is too poor for Palma himself. It may perhaps be connected with the passage in Ridolfi II, p. 174, according to which Girolamo Gambarato copied all the studies which Palma had drawn after him (. . . molti ignudi . . quali trasse dal Gambarato pittore che seco conversava, contentandosi quegli servirgli per modello, con patto di voler una copia di ciascun disegno ch'egli faceva).

A ————, 12939. See No. **917**.

MICHELE GIAMBONO
[Mentioned 1420–1462]

All attributions of drawings to Giambono rest on their greater or lesser resemblance to paintings for which his name is no less daring a guess. The "San Crisogono" in San Trovaso, to which the sponsors of all these draw-ings refer, has been claimed for every painter mentioned in Venice in the second and third quarter of the 15th century. The name of Giambono is therefore as good as any for the drawings in question, as long as we keep in mind that among the contemporaries of Jacopo Bellini, Giambono is the first "anonymous" master to receive a name.

700 HAGUE, THE, COLL. FRITS LUGT. Sainted warrior on horse-back, galloping to the r. Over hasty sketch in charcoal, pen br., on reddish tinted paper. 180 x 156. Attr. to Giambono, apparently with reference to the painting of San Crisogono, in San Trovaso in Venice (ill. van Marle VII, fig. 248). **[MM]**

The attribution which appears defensible as far as the general stage of the artistic evolution goes, can scarcely be reconciled to the attribu-tion of No. **701** to Giambono, the stylistic difference between the two drawings being very marked. Our knowledge of individual artists in this early period is hardly sufficient to permit the attribution of draw-ings to them. The painting itself, on the vague resemblance to which the attribution solely rests has been given almost every name among the painter known in the middle of the 15th century in Venice.

701 NEW YORK, COLL. ROBERT LEHMAN. Man in armor on horse-back. Pen, bistre, wash. 203 x 146. Coll. Luigi Grassi, Florence. Ascr. to Giambono in cat. of Grassi Sale, London May 1924, No. 81, with reference to the painting in San Trovaso. The attribution is accepted

by van Marle VII, p. 376. Exh. Buffalo, Masterdrawings, 1935, no. 7. [Pl. I, 2. **MM**]

The drawing, in our opinion, is closer to the painting in San Tro-vaso than No. **700**, nevertheless, we have to make the same reserva-tions as for the latter.

702 VIENNA, ALBERTINA, no. 15. Sheet of studies: The Archangel Michael thrusting out the devil who is reaching for the scales of souls, beside (on a larger scale) a standing monk. Pen and bistre. 199 x 134. — Back: St. Christopher. Coll. Luigi Grassi, Florence. Publ. by Stix, in Albertina, N. S. II, 10, with reference to the polyptych in the Academy in Venice (ill. van Marle VII, fig. 242) and Saint Crisogono in San Trovaso (ill. l. c. fig. 248). Van Marle VII, p. 415 f. accepts the attribution. [Pl. I, 1. **MM**]

We recognize the Venetian style of about 1450 in the drawing and find a further argument in favor of Giambono in the resemblance of the drawing with the Archangel Michael in the Berenson Coll. Setti-gnano (ill. van Marle, l. c. fig. 243). See our general reservations under No. **700**.

GIORGIO BARBARELLI, CALLED GIORGIONE
[Born circa 1478, died shortly before October 25th, 1510]

The question of Giorgione's drawings is extremely confused, as anyone familiar with the problems of his paintings might have expected. The crucial problem, the contrast between the historic figure of the artist as handed down by documentary evidence, and the ideal conception derived from his influence on contempora-ries and posterity, is still further complicated for the drawings by another paradox, namely, that Giorgione's general tendency seems opposed to drawing and that, on the other hand, the Giorgionesque current which from the very beginning overshadowed Giorgione's person induced early and late amateurs to bestow on him innu-

merable works in which they felt something of his spirit. Lack and abundance of material combine to make Giorgione's historic figure a mystery.

The theory that Giorgione refused to be a draftsman reaches as far back as Vasari who asserts (VII, p. 427) that Giorgione painted without preparing his paintings by drawings and even emphasized the superiority of his method. ("He used to set himself before living and natural objects and . . . paint them broadly with tints crude or soft . . . without doing any drawing, holding it as certain that to paint with colors only, without the study of drawing on paper, was the true and best method of working, and the true design." Vasari, *Lives,* IX, p. 159). Of course, it is not to be inferred from Vasari's statement that Giorgione never drew. Vasari himself mentions his excellent pen drawings in his own collection, and still earlier (1543) Michiel saw a "Nude in a landscape" by Giorgione, executed in the same technique, in Messer Michiel Contarini's house. At any rate we find no trace of such a doctrine in Venetian sources and may easily recognize the passage in question as part of the more general theory favored in the Renaissance and later: that the Venetians were pure painters in contrast to the Florentines who were chiefly designers. Whether Giorgione expressed this aversion to drawing or not, at least the idea survived and also influenced the older attributions to him of drawings. The more pictorial they were, the better they seemed to fit into the picture the following generations had formed of Giorgione.

We need not discuss the very considerable stock of these oldest attributions to Giorgione—dozens of them in the Uffizi alone—interesting only because they illustrate the specific conception of Giorgione prevailing through the centuries following his period. We shall limit ourselves to mentioning the drawing in the Uffizi as a specimen, published as by Giorgione in a popular monograph on the artist, but probably the sketch by Caravaggio for his painting in San Luigi dei Francesi, in Rome; we have discussed it more thoroughly in *Critica d'A.* VIII, p. 82 ff., where we also rejected Longhi's extravagant suggestion that the drawing might be a forgery made by Federigo Zuccaro, in order to prove his theory of Caravaggio's close dependence on Giorgione. In our opinion, Longhi's paradoxical suggestion is more probably put forth in order to prove his own theory of Caravaggio's independence of Giorgione! However this may be, the drawing might illustrate what people thought of Giorgione at that time. The tenacity of this conception is illustrated by the recent attribution of No. A 715 to Giorgione, scarcely to be justified by any other argument than by the general pictorial character of the head.

In the era of more systematic art study the conception of Giorgione was considerably narrowed, but still remained broad enough to include productions of numerous artists who had fallen under the spell of the master. This stage which subconsciously still substitutes the Giorgionesque for Giorgione's personal style, is best represented for the paintings by the first edition of Ludwig Justi's monograph and for the drawings by attributions like that of No. 704 in Chatsworth, in which the *"Giorgionismo"* is so veiled and diluted that it might even be merely a renaissance of this style similar to that exemplified above by Caravaggio. No. 1372 which we find nearer to Previtali, or the violin player in the École des Beaux Arts, No. 582, belong to the same category. For the violinist we accept the name of Giulio Campagnola, suggested by several authorities. The connection with Giorgione hardly goes so far as to justify the classification of the drawing as a copy from Giorgione, as Richter suggested; the relationship seems limited to the general dependence of Giulio Campagnola on Giorgione whose graphic shieldbearer he may be called. To a certain degree the drawing actually preserves an invention by Giorgione, as many of Giulio's engravings do, but this indebtedness does not yet make it a work by Giorgione.

It will certainly remain difficult, and perhaps impossible, to draw dependable boundaries between the Giorgionesque in the wider and in the narrower sense of the word. This applies to the drawings still more than to the

paintings. But the critic is not allowed to retire in discouragement, and we have to press on in our effort to extricate from the mass of works reflecting Giorgione's art, those in which his essence appears concentrated enough to make them pass for personal productions. We have, however, to remain conscious of the necessarily vague character of this boundary line. Speaking of Giovanni Bellini's drawings we have already noticed such a no-man's land. In his last drawings a Giorgionesque element which is difficult to define emerges; is it the young artist's contribution to the production of his aging master, or is it the latter's own work, revivified by the presence of a young genius among his pupils? For the sketches of a bishop in M. de Hevesy's collection, Nos. 350, 351, we see the predominance of the older tradition, for the sketch in Budapest, No. 703, we have, on the contrary, the feeling that here the legacy of Bellini is transformed by a young artist. In the general structure the "Bellinesque" prevails; but it has gained a new freedom and, moreover, the composition of which the drawing seems to be a fragment, leads us to Giorgione's studio, see p. 172. Another drawing which marks the transition from one generation to the other is the "Nativity" in Windsor, No. 719, the classification of which has shared the fluctuations of opinion undergone by the "Allendale Nativity," with which it is connected. This painting is very close to Giorgione, but, in spite of its great qualities, some critics refuse to find Giorgione's hand in it. As for the drawing, some think it a study for the painting, others a derivation from it. In our opinion, more extensively demonstrated on p. 176, the drawing is a *simile,* derived from an earlier and more primitive composition than the "Allendale Nativity" and, therefore, neither a design for, nor a copy from it, or rather—as is the specific character of a *simile*—both at the same time. The invention leads to the late Bellini shop, to which, as we know by the correspondence of Isabella d'Este with Giovanni Bellini, the subject was familiar; the artist who made the drawing already belonged to the new generation, but seems to be too mediocre to be identified with Giorgione. Even if the Allendale painting were by Giorgione, a question that may be put aside here, this would not offer an argument in his favor for the drawing which, we repeat, is neither its preparation, nor its repetition, but a parallel version.

The three drawings which we have chosen to illustrate the branching off of a Giorgionesque drawing style from the older tradition, were executed in pen or brush, both techniques familiar to the Bellini shop. If there is something linking them together, it might be a certain disregard for graphic expression, a feature we might consider consistent with that opposition to "drawing on paper" expressed by Giorgione according to Vasari. But it may well be nothing more than the language of the new generation whose spokesman Giorgione was. Technique is a tool that every generation or group adapts to its specific needs; these same needs, on the other hand, in search of an especially effective medium of expression strive to invent or develop it. The new pictorial currents seem to have been especially attracted by red chalk; this soft medium offered considerable advantages for a school bent on abolishing the independent value of the single stroke.

Here enters the first drawing which might claim to expressing Giorgione's artistic personality, beyond such characteristics as he may have had in common with his fellow pupils, the view of Castelfranco in Mr. Koenigs' Coll. in Haarlem, No. 709. In our preliminary studies of Giorgione's drawings in *Critica d'A.,* VIII, p. 81 f., in spite of the poor state of preservation of the drawing, we considered the attribution to Giorgione the best founded of all proposed up to that time (1937). The rendering of the landscape breathes the spirit of the background in Giorgione's "Tempest," although the conformity is not sufficient to allow the classification of the drawing as a study for this specific painting. But it might be a study done from nature, with the purpose of using it for the background of some painting. It may be something, therefore, like those *similes* for landscapes that we met in the Bellini school, for instance No. 347. Are we entitled to assume a survival of these working habits in the

"modern" school of Giorgione? Evidence is offered by two drawings, one of which, No. **350**, in M. de Hevesy's Coll. in Paris, is instructive, moreover, for showing how such a red chalk drawing of Giorgione or his school looked before it had been washed, as according to Padre Resta's own acknowledgment, No. **709** had been. Notwithstanding the freshness of its execution the drawing may be a *simile*. The attractive motive appears in the background of Previtali's Madonna and Child (ill. *Burl. Mag.*, LXXI, p. 263, pl. IIA) and of the St. Sebastian in the Thyssen Coll. (ill. *Klassiker, Bellini,* 90). This painting, dated by Gronau and others in the 1480's, was on the basis of sound arguments declared by L. Dussler (*Kunstwart,* 1930, p. 326) a poor compilation of heterogeneous motives; he explicitly called the motive in question incoherent with the rest of the landscape. We, too, doubt that in spite of its more archaic aspect the motive was first used in the Bellini shop and later modernized by Giorgione or one of his partisans. The spontaneity of the drawing in the Hevesy Coll. is rather that of a study after nature, and the very poor craftsman who painted the "St. Sebastian" may have adapted the model in his primitive style which he was unable to transcend.

With the other landscape drawing we remain within the circle of Giorgione and his immediate surrounding. The silverpoint study after nature, No. **707** in the Koenigs Coll., was used with slight modifications in the "Finding of Paris" in the Allington Coll., a strikingly Giorgionesque painting, but probably only a shop production. As a rule we take for granted that such productions were based on the master's working material. The manner of drawing, in spite of the different technique, is rather close to that of No. **709**, and the drawing may be by Giorgione himself or a responsible assistant, silverpoint being the favorite medium for studies from nature.

To these early products we contrast a riper one when turning to the landscape in the Schwarz Coll. in New York, No. **712**, recognized and published as Giorgione by Mrs. Fröhlich-Bum. We endeavor on p. 174 to add further arguments by new findings: by a reference to works representing the same or an analogous subject mentioned by Michiel, by comparing the manner of drawing with that of Giorgione's pupil, Titian, when he was still near to his master, by emphasizing the general relationship to Giorgione's style about 1505. The style is still deeply endebted to the Quattrocento and produces the effects at which it aims by gathering and putting together many separate motives; but, on the other hand, it is already filled with all the unrest and longing for greater unity that will distinguish Giorgione's latest style.

Among the many aspects of Giorgione's artistic personality that remain in the dark—his figure seems to consist only of such aspects—one of the most obscure is his mastery in monumental compositions. The well justified confidence of newer authors in Marcanton Michiel's reports and the desire to draw their idea of the master's elusive figure from this most reliable source, has led to a one-sided construction. Michiel did not collect material for a general history of painting in Venice, but compiled notes on pictures existing in private collections. The Giorgione with whom he makes us acquainted is the Giorgione of the amateurs, the master of precious cabinet paintings while from the otherwise much less well informed Vasari we know that the major part of Giorgione's activity was devoted to murals, of which hardly anything subsists. This deficiency has built up suspicion against compositions which are supposed to belong to his ripest period; we do not know exactly how far this premature genius —highly praised as such from the very beginning—advanced as a painter of portraits and as an inventor of great compositions.

It is not our task in this book to fill this gap, but we must claim for Giorgione's late style a number of drawings, less by virtue of a connection with specific paintings than in view of their relationship with the frescoes of the Fondaco—almost more a literary than an artistic legacy—and because of their foreshadowing some features

of Giorgiones's pupil and supposed continuer, Titian. Our idea of Giorgione's last style rests largely on the theory that Titian, especially in his mythological pictures and in his old age, drew amply from Giorgione's inventions. Titian's late work looks to us as a treasure box of Giorgionesque motives. This theory is circumstantially set forth in Tietze, *Tizian,* p. 156. In its application to specific drawings we discussed it in our *Tizianstudien* for No. **706** and in *Art Quarterly,* Winter 1940, for No. **713**, old companions and already listed as by Giorgione in Mariette's collection. We refer to our statements there and go a step further today by adding No. **714** in the Louvre, executed like the other two in red chalk, and further related to them in its unacademic interpretation of antiquity. This freedom, both in the types of the figures and in the way of telling the story, the illustrative exactness so to speak, or still better the lack of it, ought to be sufficient to exclude Pordenone whose authorship was suggested by Gamba. A newer attribution to Moretto is still less deserving of attention. The threads which lead to specific works by Giorgione, or those of his school, including Titian, are enumerated in the discussion of the drawing on p. 175. At present we limit ourselves to a general classification of the drawing whose ruthless mutilation, unfortunately, does injustice to its outstanding qualities. Its general place is between Bellini and Titian. Compared with the former's mythological masterpiece, the "Bacchanale," it looks looser and far advanced. Compared with Titian, even his early "Poesie," it assumes a touch of surviving Quattrocento style. It is the spot where we might expect to meet Giorgione, and our method and result are different from our predecessors only insofar as we try to widen the space allotted to him.

We must also discuss a pen drawing, No. **710** in the Stroelin Coll. in Lausanne. It is certainly Venetian and from the early 16th century, more precisely from that very fertile moment when Dürer and Giorgione met, or at least may have done so. While Dürer would have penetrated the model more profoundly, he might at the same time not have reached the unrestrained ease of the pose in which the model is so happily caught. In our opinion, Giorgione's frescoes at the Fondaco offer the closest analogy and the resemblance to the draftsmanship of Titian's early productions adds a welcome confirmation. Other possibilities certainly exist—in our analysis of the drawing we point to Riccio's figures—the attribution to Giorgione still attracts us most. Perhaps because we, too, are willing to accept the Giorgionesque style in such an outstanding production as an evidence of Giorgione's own hand.

In view of this admission of the practical impossibility of separating Giorgione's authentic works from those of his surroundings, a study of his style in drawing would be incomplete without an investigation of his influence on others, especially on those for whom this influence remained the chief working capital. A man like Titian, as we shall demonstrate when discussing his drawings, accepted Giorgione's influence as a stimulation for his own forces, but a man like Giulio Campagnola remained so completely permeated by it that a good deal of his own production may be classified as an emanation from that center of inspiration. Giulio Campagnola's absorption by Giorgione forms part of his frequently observed adaptability, up to the point of self-extinction; in dealing with him we try to estimate how much of his own he might be credited with. Here we have to reconsider less his indebtedness to Giorgione than the latter's reflection in him. Or to put it crudely: are there drawings saturated with Giorgione's art up to the point of belonging to him rather than to Giulio? This question is inevitable since almost all the drawings nowadays claimed for Giulio were once ascribed to Giorgione and were taken away from him only when the study of Giorgione entered its restrictive stage. Some of them were claimed for Giulio Campagnola because of their connection with his engravings—none closer than No. **579**, one of the very few which Morelli had acknowledged as by Giorgione—but this is precisely the point. Might Giulio Campagnola who bor-

rowed on all sides have made the design for his engravings himself; in particular, might the man who stuffed the backgrounds of his engravings with motives taken from Dürer, and thus apparently did not feel very competent in this special field, have produced the poetical scenery seen in the drawing just mentioned? The presumption sounds preposterous; and hardly anyone has objected, or will object, to Hadeln's statement of considerable reflections of Giorgione's art in this drawing. Are we allowed to go further and claim for it more than the general invention and single motives, as, for instance, the buildings and trees on the hill at the left? The style in itself displays a ripeness hardly consistent with Giulio's flimsy adroitness, but on the other hand is no less advanced beyond the two sketches in Haarlem, Nos. **707, 709**, or No. **712** in the Schwarz Coll. All of them, it is true, must be earlier, while No. **579**, if by Giorgione, would have to belong to the obscure zone of his latest activity. In our lists we retain the drawing under the name of Giulio Campagnola, but if it is by him, we have to admit that it is no less full of Giorgione than some others which we list outright as his.

For a very different group of drawings, distributed upon various collections and branching off in another direction from Giorgione, see No. **730**, where we plead for Sebastiano as the most likely among the proposed authors.

Another group of drawings growing out of Giorgione's production will be discussed under Titian. But even at this point we must mention them because again the boundary line is vague and wavering and for Nos. **1928**, **1943**, good connoisseurs have seriously thought of Giorgione. To us, in particular, the famous "Cello player" from the Malcolm Collection (No. **1928**) offers a disconcerting and alluring mystery. Of the two layers of which the drawing consists, the older, including the female nude, is executed with the delicacy of the early 16th century and is, moreover, by its motive connected with Giorgione's "Fête Champêtre" in the Louvre; the other layer is drawn with bolder strokes and advanced in style to the stage of the second decade of the century. The older part reworked by the later hand in order to harmonize the whole, might be by Giorgione, or copied after Giorgione by Titian, to whom we attribute the completion of the drawing. The procedure, altogether not uncommon in the relation of master and pupil and certainly in accord with Titian's indebtedness to Giorgione for his mythological subjects, would link together the two leaders of the new school of painting in Venice.

A BERLIN, KUPFERSTICHKABINETT, 5105. See No. **721**.

A ————, 5109. See No. **722**.

703 BUDAPEST, MUSEUM, 16.9. Saint Elizabeth seated with the infant Saint John in her lap, at the right fragment of a further figure. Pen, br. 163 x 112. Lower l. corner added. Publ. by Schönbrunner-Meder 1337: Anonymous Venetian, 16th century; formerly ascr. to Hans von Kulmbach. The treatment of the foldings and the incoherent composition resemble Catena. [*Pl. XLVII, 2.* **MM**]

The drawing is a fragment, the l. half of a horizontal composition the r. side of which is lacking. The treatment of the drawing is close to the style generally called Giovanni Bellini's. We feel a more than casual relationship in the graphic treatment to No. **713** which we are, in agreement with Mrs. Fröhlich-Bum, inclined to attribute to Giorgione. The big tree at the right is very Giorgionesque in its shape, its location and its relation to the background (see the Judith in the Hermitage, Richter, pl. VI). The Leonardesque touch in the figures and the preference for half shades should be taken into consideration. The group isolated from the neighboring one by distance and concentration corresponds to the painted "Madonna in landscape" in the Hermitage (Richter, pl. X), attr. to Giorgione or an artist following

him. This painting, too, may be a fragment of a horizontal composition; one is tempted to see in the drawing in Budapest an idea for its missing l. half. The central figure of the composition, presumably St. Joseph, is indicated in our drawing. (Compare the related compositions A. Venturi 7, IV, fig. 356 and 357).

A 704 CHATSWORTH, DUKE OF DEVONSHIRE, 742. Martyrdom of a saint. Brush, br., wash in lightbr. Squared in bl. ch. 152 x 174. First ascr. to Giorgione by Morelli II, p. 225. Frizzoni: Giolfino. Wickhoff: Lotto. Gronau: *Gaz. d. B. A.* 1894, p. 322 f.: Giorgione late period. Justi, *Giorgione* II, p. 303 accepts with reservations. L. Venturi, *Giorgione,* p. 391, rejects. *Chatsworth Dr.* pl. 6: Giorgione. Arthur S. Strong points out the resemblance to a detail in the background in Lotto's fresco in Trascorre, a similarity which he believes to be accidental. Suida. *Gaz. d. B. A.* 1935 (per. 6, vol. 77, p. 90) accepts Giorgione. Richter, *Giorgione,* p. 213 rejects. [**MM**]

We, too, reject the attribution to Giorgione and see in the drawing a Giorgionesque revival. We thought for some time of Alessandro Casolani whose legendary scene (Louvre, drawing No. 1032) shows distinct affinities in style and technique, but consider the drawing in Chatsworth earlier, though hardly by a belated Quattrocento painter as suggested by L. Venturi.

A 705 ————, 814. Allegory: the triumph of peace over war.

We have identified this anonymous drawing as the copy of a fresco attr. to Giorgione, see E. Tietze-Conrat in *Art Quarterly*, Winter 1940, p. 31, fig. 13. [**MM**]

706 DARMSTADT, KUPFERSTICHKABINETT, 175. Mythological Scene. Red ch. 140 x 190. Later inscription: man di zorzon da Castel francho. Coll. Mariette (*Cat.* 1775: Giorgione), Lagoy and Dalberg. Schrey in *Kunstchronik*, 1915, p. 567 ff.: Callisto sleeping and Jupiter seen at her r. In the background Callisto transformed into a bear, chased by dogs. Schrey in *Stift und Feder* 1929, 79: Giorgione's first sketch for the Dresden Venus. In our *Tizianstudien*, p. 171: invention by Giorgione, important for Titian's Venus of the Pardo, the conception of which belongs to Titian's Giorgionesque early period while he finished the painting only much later. Richter, p. 214 no. 17: accepts the attribution to Giorgione in *Stift und Feder*, but dates the drawing later than the Venus in Dresden, the drawing being more advanced in style. [*Pl. XLVIII*, 3. **MM**]

See its companion in the Mariette's coll., No. **712**.

A FLORENCE, UFFIZI, 1757. See No. **1372**.

A ————, 725, 690, 692, 693, 696, 697, 1755. See Nos. **725–731**.

A FRANKFORT/MAIN, STAEDELSCHES KUNSTINSTITUT, 4174. See No. **733**.

A ————, 15180. See No. **967**.

707 HAARLEM, KOENIGS COLLECTION, I 122. Landscape. Silverpoint on prepared paper. 158 x 271. In the coll. anonymous, first half of the 16th century. [*Pl. XLVII*, 3. **MM**]

The character of this very important drawing as a study after nature is confirmed by the technique, adopted for this specific task. The study appears modified in the scenery in "the Finding of Paris" in the Allington coll. (ill. *Burl. Mag.*, vol. VI, p. 157).

The connection is indubitable, in spite of the changes and the dropping of several details; compare in particular the group of houses in the middle at the l. The literature on the various attributions of the two Allington panels is compiled in Richter p. 207, no. 1. They were formerly ascr. to Carpaccio and only in 1904 attr. to Giorgione by H. Cook (*Burl. Mag.* l. c.). L. Venturi suggests a follower of Lazzaro Bastiani. Gronau in *Rep. f. K. W.* 1908: Catena (a reference which we were unable to find). Richter himself points out a close connection to Giorgione's style. "The landscapes have many points of contact with Giorgione's and Bellini's landscapes. The quality, however, is not on a level with that of the pictures recognized as authentic Giorgiones." We have not seen the original paintings, but consider the compositions very much in Giorgione's early style. Just as happened in other workshops of artists busy with wall decorations, altar-pieces, portraits and pictures for patrons acquainted with humanistic literature, decorative panels like these Allington paintings, were executed in the shop with the help of the Master's working material. If this hypothesis is correct we may, though with reservations, attribute the drawing to Giorgione. Its style seems rather close to No. **709**, but the different technique makes the comparison of the two drawings difficult.

A 708 ————, I 187. Woman standing, seen from behind, holding a round basin(?). Bl. and wh. ch., on br. 265 x 140. Wauters Coll. (no. 12). Publ. by F. Lees, p. 44, fig. 57 as Giorgione, with reference to his "Fête Champêtre" in the Louvre. [*Pl. CXCII*, 2. **MM**]

In our opinion the manner of drawing is advanced beyond Giorgione's. Since the study is used without any modification for a figure on the right in a large painting "Golden Age" in Florence, Coll. Acton (Photo Brogi **MM**), we do not hesitate to attr. the drawing to the author of this painting. The name of Schiavone has been proposed, but we are more inclined to give it to some Flemish artist working in Venice in the third quarter of the 16th century. For the date of the drawing it might also be interesting to note its close resemblance to Giovanni Bologna's statues (see A. Venturi 10, III, p. 601).

A ————, I 484. See No. **1920**.

709 ————, I 485. View of Castelfranco. Red ch. 203 x 290. Inscription (Resta) in pen: k 44. Coll. Resta, Marchetti, Somers, Robinson, Boehler. Poor state of preservation. Felix Becker, *Handzeichnungen alter Meister in Privatsammlungen*, Leipzig 1922, fig. 36: Giorgione. Justi, *Giorgione 2*, p. 300, pl. 9: "the high quality, the spirit of the Quattrocento induce us to believe that Giorgione in his early years drew in this style." Hadeln, *Hochren.*, pl. 3. Popham in *O. M. D.* 1936, June, p. 19 published notes by Resta on "k 44, Vista di Castel Franco disegnata di Mano di Giorgione" which tell us a) that in Resta's collection another similar version of this drawing inscr. k 43 existed; b) that Resta tried to wash the drawing with hot water "the best he could." Our article in *Critica d'A.* VIII, p. 81 f.: the attribution of this drawing to Giorgione is the best founded of all. The resemblance with the background in Giorgione's "Tempesta" is indeed significant although the drawing cannot be taken for a study used in the painting. The red ch. produces a smooth effect which might have inspired the technique, a kind of stippled engraving, used by Giulio Campagnola in transposing Giorgione's models into graphic art. [*Pl. LI*, 1. **MM**]

Typical study of a motive to be placed in the background of a picture. The unreal figure — an insect rather than a man — must not be an indication of Giorgione's early style, but finds its explanation in the purpose of the study. As a matter of fact Giorgione also utilized working material of this kind in his later paintings.

710 LAUSANNE, COLL. STROELIN. Woman seated, seen from behind. Pen, br. 195 x 125. — Late inscription on back: Giorgione. Coll. Cérenville. [*Pl. XLVI*, 1. **MM**]

The pose resembles Riccio's Woman riding — compare for instance the Nymph carried by a centaur (Planiscig, *Riccio*, fig. 305–308), but we may conjecture from the towel round the head that the drawing is a study from nature. The linework of the corkscrew curls and the bathtowel dates the drawing in the very early 16th century. The spontaneity and impressiveness of the whole conception added to the presumable date recall Dürer's happy days in Venice. But even in a hasty sketch Dürer would have made a more penetrating study of the model; he would have been more interested in the organic functions of the limbs. (Compare for a somewhat similar motive Dürer's drawing L. 233.) In our opinion, Giorgione's frescoes at the Fondaco offer the closest analogy to this pose. Considering the linework of Titian's early pen-drawing No. **1970** we are inclined to ascribe this drawing to Giorgione's late period, the time of the frescoes of the Fondaco.

711 LONDON, COLL. V. KOCH. Landscape (motive of trees on a knoll). Pen, br., on paper turned yellow. 155 x 183. Rubbed and damaged by mold. Ascr. to Giorgione. On the mount a reference to the painting "Orpheus and Eurydice" in Bergamo (Richter, pl. LX, no. 6). [**MM**]

The motive of the trees on the knoll in the painting at Bergamo has no connection with that in the drawing. The latter recalls a motive familiar in paintings and woodcuts of the first half of the 16th century and probably made popular by Giorgione. The state of preservation of the drawing makes a decision as to whether the drawing is an autograph by Giorgione or a study by an imitator, difficult.

712 NEW YORK, METROPOLITAN MUSEUM, 11.66.5. (Ital. 38). Cupid. Red ch., on br. 158 x about 63. Purchased 1911. Coll. Mariette (Cat. Sale 1775): Giorgione, Amour tenant son arc (together with No. **706** sold for 12 francs). Count Moritz von Fries. Ascr.: Venetian, early 16th century. Publ. as Giorgione by E. Tietze-Conrat in *Art Quarterly*, Winter 1940, fig. 14, p. 32. *Metropolitan Museum Dr.* pl. 18: Giorgione (?). [*Pl. XLVIII*, 1. **MM**]

The careless covering of the ground has spoiled the outline of the calf of the standing leg. The inserting (done by Mariette) of the small and upright rectangular fragment in a semicircular niche alters the original effect of the drawing. The attribution is based on the high quality of the drawing, on the type of the child resembling Giorgione's type as well as Titian's types in his early paintings (paintings on the borderline with Giorgione, some of which have sometimes been ascr. to Giorgione himself, for instance, the "Gypsy" Madonna in Vienna). The attribution is corroborated by Vasari's mentioning of a similar motive in the decoration of the Fondaco dei Tedeschi. Vasari's very summary description runs: che ha una testa di lione appresso, altra con angelo a guisa di Cupido. J. Wilde in *Jahrb. K. H. S.*, N. S. 4, p. 252, connected this passage with the engraving by Marcanton (B. 311) Venus and Cupid. In our opinion, this group is much more advanced in style than anything by Giorgione, even taking into account that Marcantonio might have translated the Venetian model into his Roman classicism. The engraved group of Venus and Cupid must from the beginning have been conceived in the sculptural Florentine-Roman style. We therefore do not consider Wilde's suggestion plausible enough to invalidate ours.

The foreshortening of the Cupid is not the definite *"sotto in su"* suitable for ceiling — we do not need therefore to discuss Giorgione's alleged activity for such decorations (see Richter, pl. LIV). The Cupid looks more like a figure seen on a very elevated place, for instance, high on a wall.

713 NEW YORK, COLL. S. SHWARZ. Landscape with an old nude man seated (Saint Jerome?). Pen, darkbr., wash. 188 x 257. Inscription in pen: 1.112 (Somers; called Titian in his cat.). On the mount: Tiziano. Publ. by L. Fröhlich-Bum, in *Belvedere*, 1930 I, p. 86, fig. 65, 2 (citing Schilling's oral approval of this attribution): Giorgione in his middle period, with reference to the landscape in the "Tempesta" and the "Allendale Adoration." [*Pl. XLIX*. **MM**]

The drawing is cut. The tree originally did not reach the lower border. The tree in the foreground, moreover, was added by the artist after he had finished the drawing. There is a fragment in Rennes containing the principal part of the r. half of the drawing, including the tree, but without the details (grass etc.) behind the trunk and, moreover, without the nude. From these facts we may conclude that the drawing in the Schwarz coll. is the original, sufficiently appreciated as a landscape drawing to be copied. (The drawing in Rennes shows the later inscription "Titien" and is listed as Tizianello. **MM**.)

Mrs. Fröhlich-Bum based her attribution merely on the style of the composition. She appended the drawing to her attribution of No. **541**

to Giorgione (ascr. in the Louvre to Titian), dating No. **713** earlier than No. **541**. The two show some resemblance, especially in the reproduction in Mrs. Fröhlich-Bum's article in which the larger drawing in the Schwarz coll. is reproduced on a smaller scale than the Louvre drawing which in fact is smaller. The considerable reduction of No. **713** exaggerates the graphic character of its linework.

The landscape indeed recalls Giorgione's paintings to which Mrs. Fröhlich-Bum points. The juxtaposition of various motives without a definite aim is still Quattrocentesque. But it is difficult to find any real analogy in the mode of drawing. A methodically better reference would be to the close resemblance with No. **1970**, important because Titian was Giorgione's pupil and must have been influenced by him in his early period. A drawing of a related character should, incidentally, have been used by Titian for his mural in Padua, "Saint Anthony healing the youth" (ill. Tietze, *Titian*, pl. 12). A further argument in favor of the attribution is the mention of a pen-drawing by Michiel who saw it in 1543 in M. Michiel Contarini's house: il nudo a pena in un paese fu di man di Zorzi et è il nudo che ho io in pittura de li stesso Zorzi. Richter tried to identify the drawing, or rather the painting mentioned by Michiel, with the painting of the "Ignudo" which Vasari (in his second edition) describes as "seen from behind and with the aid of mirrors displaying all sides of the body." It is evident from the wording of Vasari's description that he had not seen the painting. It is, moreover, not probable that the painting ever existed, being only the illustration of a typical instructive anecdote. Pino, for instance, who includes the same anecdote — and earlier than Vasari — in his *Dialogo di Pittura* (Venice 1548) speaks of an armored St. George instead of a nude figure (see also Gronau, in *Repertorium f. K. W.*, vol. 31, 1908, p. 411). We do not however, insist on an identification of the drawing in the Schwarz Coll. with the passage in Michiel which might more likely refer to a composition with a nude predominant, especially since Michiel explicitly states that he owned a painting representing the same nude alone. We may, however, point to another Giorgione mentioned by the same authority: the St. Jerome, naked, seated in the desert by moonlight, was painted by from a picture on canvas by Giorgio da Castelfranco. (*The Anonimo* p. 101). We stress the following points: 1) from Michiel we learn that pen-drawings by Giorgione existed, and the statement is confirmed by Vasari whose collection included several drawings in this technique; 2) the style of the drawing corresponds to Giorgione's style about 1505; 3) the draftsmanship is close to the earliest style of Titian, Giorgione's pupil; 4) the subject is possibly supported by the passage in Michiel. For all these reasons we feel inclined to accept Fröhlich-Bum's attribution to Giorgione as an attractive working hypothesis.

A PARIS, LOUVRE, 4605. See No. **1956**.

714 ————, 4649. Sketches: Above nymphs around Callisto, below other nymphs and nude men and children. Red ch., damaged, cut and mounted, partly patched. Later inscription: Giorgione. 330 x 275. In the Louvre ascr. to Giorgione, attr. to Pordenone by Gamba in *Rassegna d'A.*, IX (1909), p. 37 f., in the period of the "Madonna del Carmelo," at that time attr. to him, in the Academy in Venice. On Fiocco's suggestion in *Boll. d'A.* 1921, October–November, this painting is now unanimously given to Moretto. In his *Pordenone*, p. 152 Fiocco jumps to the conclusion that the drawing, too, is by Moretto, thus carrying Gamba's casual hint too far. There is no connection at all between the Louvre drawing and the painting in Venice; moreover, Moretto's drawing style offers no analogy. [*Pl. XLVI*, 2. **MM**]

In our opinion, the attribution to Pordenone is no less wrong; Pordenone who experienced decisive influence from Central Italy would hardly have used for his nymphs contemporary costumes modified in a romantic fashion. Moreover, the types of the children and men are utterly different from his. The resemblance to Pordenone is limited to the use of red ch. We think that the drawing is very close in style to the *"poesia"* in Darmstadt No. **706** and the Cupid in the Metropolitan Museum No. **712**. It is again difficult to demonstrate our attribution with the limited material offered by Giorgione's works. A comparison of the types with the women in Giorgione's "Judgment of Solomon" in Kingston Lacy (ill. Richter, pl. XXIX) gives some help. We point, moreover, though without placing too much importance on this hint, to a painting representing Callisto which Ridolfi I, 98, lists among subjects drawn from Ovid by Giorgione. In Giorgione's composition of the "Finding of Paris" (preserved only in Teniers' copy, ill. Richter, pl. VII, no. 10) the pose of the woman resembles that of the woman in the lower l. corner of the drawing. Other analogies exist with paintings from Giorgione's school, for instance, with the well known "Concert party," belonging to the Marchioness of Landsdown. The figure of Callisto is, moreover, the prototype of the Danae of Titian whose mythologies frequently may be traced back to inventions by Giorgione.

A ———, 5533. See No. **541**.

A ———, 5906. See No. **581**.

A PARIS, ÉCOLE DES BEAUX ARTS. Seated youth holding a violin, see No. **582**.

A 715 ———. Head of a bearded man. Pen, wash. Ascr. to Pietro Perugino, attr. to Giorgione as the first idea of one of the astrologers in Giorgione's painting in Vienna, by Adolfo Venturi, in *Vita Artistica*, 1927, p. 127, and in 9, III, fig. 9.

In our opinion, without any connection with the mentioned painting nor with Giorgione.

A 716 PARIS, COLL. ANDRÉ DE HEVESY. Landscape with a fortified castle. Red ch. 62 x 104. [*Pl. XLVIII*, 2. **MM**]

The buildings resemble somewhat the castle of Castelfranco, No. **709**, see also the engraved view of Castelfranco, Richter, *Giorgione*, p. 100; the resemblance in style to No. **709** may even have been closer before the latter was washed and thereby smoothed down by Resta.

The motive does not appear in any of Giorgione's paintings, but it does appear in two other Venetian paintings. One is the "St. Sebastian" in the Baron Thyssen Coll. (ill. *Klassiker, Bellini,* 90) where the tree at l. is replaced by a tower and the whole motive presented in pedantic primitiveness; the other is the "Madonna and Child" by Previtali (ill. in *Burl. Mag.* LXXI, p. 263, pl. IIA) where the conformity is less exact. The St. Sebastian, though dated by Gronau about 1480, may, nevertheless, originate from the 16th century; in his article in *Kunstwart*, 1930, p. 325 ff, L. Dussler substantiated the character of the painting, enthusiastically praised by van Marle in *Dedalo* 1931, p. 1380, as a poor and late compilation. Its author might, in our opinion, have taken over the Giorgionesque motive and transformed it into his more archaic style. The drawing might be a study from nature.

A 717 ———. Sketch of a Nativity, in a hut. Pen-and-bistre, wash, height. w. wh., on faded blue. 147 x 188. Rubbed and badly damaged. Mentioned by Richter, p. 257, no. 99, 6 as closely connected with the "Allendale Adoration" which at that time he did not accept as by Giorgione. In the index on p. 517 Richter lists the drawing as "ascr. to Giorgione."

In our opinion, there is no other connection with the "Allendale painting" but the subject and a very slight resemblance in the pose of the Child. The state of preservation of the drawing does not allow a definitive classification.

A 718 VIENNA, ALBERTINA, 36. Nativity. Brush, br. 258 x 217. *Albertina Cat. I* (Wickhoff) 235: formerly Palma Vecchio; in his opinion, follower of Giovanni Bellini. Schönbrunner-Meder no. 953: school of Brescia, beginning of the 16th century. Frizzoni (according to Meder): Romanino, see his "Nativity" in Brescia (ill. Venturi 9, III, fig. 583). A. Venturi in *L'Arte* XXV, 1922, p. 112: Savoldo for his painting in San Giobbe. *Albertina Cat. II* (Stix-Fröhlich) attr. — very cautiously — to Giorgione (?) referring to the resemblance to the "Allendale Nativity" (Richter p. LVII), the Windsor drawing No. **719** and the "Benson Nativity" (ill. Richter pl. IV). In our review of the *Albertina Cat. II* in *Zeitschr. f. B. K.* 1926, p. 111, we refer to the engraving by F. N. of 1515 which later on, in *P. C. Q.* 1942, p. 200 ff. we proved dependent on the painted "Nativity" in the Hermitage, in our opinion by Giorgione or very close to him (ill. ibidem).

We cannot accept A. Venturi's attribution to Savoldo since the drawing lacks the solidity typical of Savoldo's style in drawing (and also painting, see Hadeln, *A. in A.,* vol. XIII, 1925, p. 72 to 82). We also reject Frizzoni's attribution to Romanino, based only on a slight resemblance to the composition of a painting while Romanino's well established drawings show an entirely different style. We need, therefore, discuss only Wickhoff's attribution to a Venetian follower of Giovanni Bellini and Stix-Fröhlich's more specific attribution to Giorgione (?). Stix-Fröhlich's attribution is based a) on the resemblance of the composition to two paintings; in our opinion the resemblance is not closer than would be natural in three works of art representing the same subject and belonging to the same school; b) on the resemblance in style to the Windsor drawing, which again is not closer than between two drawings of the same subject, the same school and the same technique. The style of the Albertina drawing is more summary, typical of a sketch for a painting or after a painting, and lacks the pedantry of a *"simile,"* something the Windsor drawing apparently was (see No. **719**). In our opinion, the Albertina drawing is more advanced in style than the Windsor drawing. We cannot accept the attribution made by Stix-Fröhlich to Giorgione for a drawing so indifferent in quality and prefer to keep it in its anonymity as Wickhoff did.

A 719 WINDSOR, ROYAL LIBRARY. Nativity (Adoration of the Child with one shepherd). Over ch. sketch brush, br., wash, height. w. wh., on bluish paper. 230 x 130. The upper l. corner added. According to Gronau, *Repertorium,* vol. XXXI, p. 508 and Justi, *Giorgione* I, p. 132 study for the painting then at Lord Allendale's, now in the N. G. in Washington, attr. by Justi to Giorgione, while Gronau, following Morelli, rejected this attribution and suggested Vicenzo Catena? (In *A. in A.* 1936, July, p. 95 ff. Gronau withdrew his former doubts.) Hadeln, *Hochren.* p. 32, pl. 1: Giorgione and design for the "Allendale painting." Popham, *Cat.* 256: Not a design for the painting, but a copy after it. W. G. Constable in *Dedalo* X, p. 740: a poor derivation from the painting. G. Fiocco, *Carpaccio* (Paris 1931, p. 94): not by Giorgione himself, but showing a Carpacciesque manner of drawing. Parker, pl. 55: Master of the "Allendale Adoration." Richter, *Giorgione*, p. 257, dates the drawing in Giorgione's early period and

stresses the differences in details of the draperies and in the faces of the Madonna and St. Joseph, in the drawing and the painting which he places in a later period of Giorgione's career than the drawing.

[Pl. XLVII, 1. **MM**]

We agree in essential points with Richter's theory; the drawing with the more vertical poses of the figures and the unnatural pose of the Child belongs to a more primitive style than the painting. But the drawing, in our opinion, is not a first invention, it is a "simile," a copy done from another drawing, or, more probably, from a painting in order to be used as working material. We find the same technique in other "simile" drawings from the Bellini school, see Nos. **339, 340, 352.** A still more important argument against the claim of the drawing to be an original invention is a significant "pentimento": the r. leg of the kneeling shepherd was first drawn below its actual place, and the first outline in chalk already shows every detail of the drapery which we find on the corrected leg. The reasonable conclusion is that there existed a finished model which the Windsor drawing copied.

Thus both recent critical analyses are correct: the drawing is earlier than the "Allendale painting" (Richter), and the drawing is not an original design (Popham). A more primitive composition consisting of three figures and still Quattrocentesque in its invention is preserved in a typical work-drawing, while in the painting the same model is enriched by a fourth figure and in every detail developed into the more pathetic modern style.

Where does this invention originate? It is still Quattrocentesque in its character, but the execution cannot be attributed to Giovanni Bellini himself. The treatment of the draperies (see, for instance, the broken outline of the kneeling shepherd) is as little Bellini's as it is Giorgione's. The connection of the drawing with the "Allendale Nativity" poses a difficult problem. The authorship of Giorgione, cautiously doubted by Richter in his monograph, was explicitly admitted by him in *Burl. Mag.* 1938, vol. 72, p. 33, note 7, and with special emphasis defended by Suida in *Pantheon,* Dec. 1940. Strictly speaking the problem is outside our immediate province. We may, however, recall that the painting belongs to a definite group brought together by Adolfo Venturi 7, IV p. 571 ff. and ascr. by him to a follower of Vincenzo Catena. The paintings in question (in the Museum in Messina, in the Contini Coll. [formerly Brownlow], formerly Heseltine, formerly Benson and in the N. G. in London [Venturi, l. c. fig. 356–361]) use the same models (whole figures, heads and draperies) and are so closely connected with each other that the "Allendale Nativity" cannot be entirely severed from them. The manner in which the added shepherd is patched in, overlapping and cutting the flock in the background, is hardly compatible with Giorgione.

SCHOOL OF GIORGIONE

720 BASSANO, MUSEO CIVICO, Riva 371. Male nude with a drapery over his r. arm. Pen, darkbr., on yellowish. 136 x 48. Upper r. corner added. Ascr. to Pordenone. **[MM]**

Close in style to the group of drawings discussed under No. **730.**

721 BERLIN, KUPFERSTICHKABINETT, 5105. Standing youth, seen from front, tied to a tree. Pen, darkbr. 209 x 142. Arched top. Damaged. Charles Loeser in *Repertorium* XXV, p. 354 connected the drawing correctly to the group discussed under No. **730,** although it may be somewhat inferior in quality. **[MM]**

722 ———, 5109. Head of a bearded man. Pen. 124 x 94. — On *verso:* Head of a man looking downward. Coll. Murray, von Beckerath, Publ. in *Berlin Publ.* I, pl. 80 a and b, as Giorgione, but belonging to a group also attr. to other artists (see No. **730**). Richter p. 218, no. 23: copy from No. **726.**

In our opinion, not a copy from No. **726,** but an independent study from the same head.

723 ———, 5109. Youth recumbent in landscape. Pen. 149 x 210. Upper r. corner added. Coll. Vallardi, von Beckerath. *Berlin Publ.* I, no. 81: Giorgione and belonging to a group of drawings also attr. to other artists. Otto Benesch, in *Graph. Künste* N. S. I, p. 11: Titian, especially in view of the style of the landscape. We, in *Tizian-Studien,* p. 172 ff. rejected the attribution to Titian and suggested Sebastiano del Piombo for the whole group, see No. **730.** F. Kieslinger, in *Belvedere* 1934/37 (publ. in 1938), p. 173 ff.: possibly by Titian, as proposed by Benesch, and a study after the so-called "Illissus" in the pediment of the Parthenon (!) who, however, should still have had his head when the drawing was made (!).

724 CHATSWORTH, DUKE OF DEVONSHIRE, 745. Bust of a woman with an embroidered headdress and head of a bearded man (after an antique sculpture, the same as in No. **1880**). Morelli, II, p. 225 note: Do. Campagnola. See No. **730.** **[MM]**

725 FLORENCE, UFFIZI, 682. Three heads (young woman, beardless monk and a bearded patriarch). Pen, br. 90 x 205. (Photo Braun 751; Brogi 1462 B). Morelli, II p. 225: Do. Campagnola. Boehn, *Giorgione,* p. 61: Giorgione. Hadeln, in Thieme-Becker V, 450: Do. Campagnola, part of the group discussed under No. **730.** **[MM]**

The types are extremely close to Giorgione's.

726 ———, 690. Head of a bearded man (study after an antique sculpture). Pen, br. 94 x 127. Hadeln, in Thieme-Becker V, 450: Do. Campagnola. Richter, p. 218, pl. XLIV, no. 23: apparently after an antique bust preserved in the Museo archaeologico in Venice and formerly in the Grimani Collection. The drawing, according to Richter is by Giorgione and copied in No. **722,** q.v. See No. **730.** **[MM]**

727 ———, 692. Nude youth seated, seen from behind. Pen, br., wash, 240 x 182. — On *verso:* In a cartouche which is decorated with heads of angels the words Glo. Vis. Below a vessel decorated with rams' heads. (Photo Brogi 1384 C). Morelli II, p. 225, note and Hadeln, in Thieme-Becker V, p. 450: Do. Campagnola. Richter, *Giorgione,* No. 27: Study after the torso of the Belvedere as it looked before the destruction of the legs. [Pl. L, 2. **MM**]

The theory that the torso in the Belvedere at the beginning of the 16th century still had its legs, advanced by Paul Kristeller in publishing Giovanni Antonio da Brescia's engraving (*Archivio Storico* 1891, p. 477), has been definitely rejected by the archeologists (see W. Amelung, *Die Skulpturen des Vatikanischen Museums,* Berlin 1908, v. II, p. 14). Nevertheless, a reconstruction of the torso with added legs has existed; A. Venturi publ. (in *L'Arte* 1898, p. 497) a bronze reduction of the torso existing in the Museo Ferrarese, Palazzo Schifanoja, in which the r. leg is intact, while the l. is missing, and pointed out a similar cast held by the young sculptor in Licinio's group portrait in the Borghese Gallery. A similar replica may have

served as a model for the mentioned engraving and for our drawing. For the stylistic classification see No. **730**.

728 ————, 693. Head of a man, and a child lying on the ground. Pen, br., on yellowish. 116 x 163. Badly damaged. Ascr. to Giorgione, accepted by Boehn, *Giorgione,* p. 61. Attr. to Do. Campagnola by Morelli, II, 225 and Hadeln, in Thieme-Becker V, p. 450.

A weaker production, belonging to the group described in No. **730**. The pose of the child resembles that of the one in No. **2012**, both may go back to the same plastic model. See No. **730**.

729 ————, 696. Saint Sebastian, three quarter length. Pen, br. 202 x 130. Late inscription: Giorgione. — On the back: Head of a curly-headed youth. (Photo Braun 753). Morelli, II, p. 225 n., and Hadeln, Thieme-Becker V, p. 450: Do. Campagnola. Richter, *Giorgione,* p. 218, no. 25, 26, pl. XLIV, XLV.

We call attention to the similarity, and dissimilarity, of the head on the *verso* to that of the youth at r. in No. **558**. For the attribution to Sebastiano see No. **730**, notice also the similarity of the head to one in Giorgione's "Judgment of Solomon" in Kingston Lacy (ill. Richter pl. XXIX) in the execution of which Richter gives a share to Sebastiano.

730 ————, 697. Nude woman, stabbing herself with a dagger; at l. coat of arms, cut. Pen, br. 172 x 139. Corners cut. (Photo Brogi 1383 C, Braun 252). First attr. to Giorgione by L. Lagrange, in *Gaz. d. B. A.* vol. XI, p. 437. Morelli, II, p. 225 n. and Hadeln, in Thieme-Becker V, p. 450: Do. Campagnola. Richter, *Giorgione,* p. 218: Giorgione. In his opinion, the figure represented is not Lucretia, as usually supposed, but probably Dido, and may even possibly be a study for a fresco representing Emperor Frederick I and Antonia da Brescia, mentioned by Ridolfi I, p. 97.

This suggestion does not seem convincing. The drawing belongs to a group assembled by Morelli, II, p. 225 note, Hadeln, in Thieme-Becker V, p. 450, ourselves, in *Tizian-Studien* p. 172 ff. and Richter, *Giorgione,* p. 218, No. 26; these drawings have been attr. to various artists: Giorgione (Boehn), Do. Campagnola (Morelli, Hadeln), also Sebastiano and Peruzzi were suggested (see Gamba, *Uffizi Publ.,* IX, 21) and No. **723** attr. to Titian by O. Benesch. Richter, *Giorgione,* p. 218 ff. reverted to the old attribution to Giorgione, however, with some reservations, since none of these drawings can be connected with any work by Giorgione. Nevertheless, with respect to No. **582** and No. **967** which he accepts as by Giorgione, Richter is inclined to recognize the best of these drawings as studies by Giorgione for mural paintings and belonging to his latest period. [*Pl. L,* 1. **MM**]

Our own standpoint, not yet taken into consideration by Richter, is set forth in our *Tizian-Studien,* p. 172. We reject the attribution to Giorgione, because of the pathetic mood and the interest in plastic forms, both in contradiction to our idea of Giorgione as a personality and as an artist. There is admittedly a close approach to Do. Campagnola in the linework (compare for instance No. **730** with No. **537**). But the technical characteristics appearing in both drawings are the common property of the generation, and both, Do. Campagnola and our draftsman, may have experienced the same influences. Campagnola's style in his earlier years — which alone could be considered — is so well circumscribed that its contrast to the essential tendencies represented in our group is evident. In our article we tried to demonstrate that these essentials — the passionate interest in plastic form, combined with a pathetic mood — are Sebastiano's. They are the predispositions enabling him to absorb Roman art in its most concen-

trated form: Michelangelo. This attribution is based on paintings like the second pair of saints in San Bartolomeo in Venice (see especially the "Saint Sebastian," ill. Leop. Dussler, *Sebastiano del Piombo,* 1942, fig. 7) or the "Death of Adonis" in the Uffizi (ill. ibidem fig. 22, see also Pallucchini, in *Critica d'A.* I, pl. 30), works typical of Sebastiano's transition from Venice to Rome. The attribution would fill a gap in his evolution as a draftsman. No. **1470,** after the elimination of the drawing in Berlin by O. Fischel (see p. 255), is the only authentic example from this period. The group of drawings discussed under No. **730** (the poorer of which, such as Nos. **720, 721,** might belong to followers) might form a connecting link between Sebastiano's early years in Venice and his mature years in Rome. For No. **730** see also the "Martyrdom of St. Agatha" in the Palazzo Pitti, ill. L. Dussler, fig. 46.

731 ————, 1755. Head of a youth, turned upward and to the right. Pen, darkbr. 111 x 133. See No. **730**.

732 ————, 1763. Youth seated, seen from behind, rendered like a torso. At l. a tree and a lamb at r. Pen, br. 257 x 199. — On the back ornamental design: a sphinx with scrollwork and leaves. Morelli II, p. 225 note and Hadeln, in Thieme-Becker, V, p. 450: Do. Campagnola; Richter, *Giorgione,* p. 218, no. 28, pl. XLV: Giorgione.

The ornamental design looks rather advanced for the presumed date, the second decade of the 16th century, but we find an analogy in the ornaments of the pedestal of the "Virgin with the Harpies" by Andrea del Sarto of 1517. For the attribution to Sebastiano see No. **730**. [**MM**]

733 FRANKFORT/MAIN, STAEDELSCHES KUNSTINSTITUT, 4174. Male nude seen from behind, probably a study from an antique torso. Pen-and-bistre. 212 x 150. — On *verso* inscription: Giorgione, (and in red chalk) 271. Coll. Ploos van Amstel, Comte d'Auffay, Geldner-Meiningen (as Raphael), F. Lugt. Publ. as Giorgione, in *Stift und Feder* 1926. Richter, *Giorgione,* p. 219, no. 31, pl. XLV, identified the drawing with one sold as Giorgione in Paris 1797, 28 Thermidor, no. 65, and referred to Michiel's mention of an antique torso in the house of M. Francesco Zio (1512), which might have been the model of the drawing.

Apparently the same figure, in this instance a torso with the head missing, is seen in Girolamo da Treviso's painting in Vienna (*Critica d'A.* I, 114).

734 LONDON, HOLLAND COLL., formerly. Group of buildings with trees. Pen, br. 177 x 273. Publ. by S. Colvin, in *Vasari Society* II, 11, as school of Giorgione, with reference to No. **506**: Both are drawings of the school of Giorgione and are too delicate to be attr. to Domenico Campagnola. Mr. Murray's attribution of his drawing (No. **506**) to Giulio, which with regard to the engravings might be reasonable, but seems less convincing than that of No. **734**. [**MM**]

We should say: still less convincing. We attr. the drawing to a not yet identified follower of Giorgione.

735 OXFORD, CHRISTCHURCH LIBRARY, H 19. Musicians — man and woman — in landscape. Pen, br., "wash of pinkish red has been passed over the drawing after it was finished" (Colvin). 187 x 321. Late inscription: Sciorsion. Coll. Guise. Publ. by Colvin, 11: The couple is adapted in Titian's "Three ages of man." A more precise attribution seems difficult. At any rate, the drawing cannot be by Do. Campagnola, nor by Giulio Campagnola, despite a relationship to the latter's engraved landscapes. Frizzoni (*L'Arte,* X, p. 91): Sebastiano del Piombo. [**MM**]

The part of the drawing which contains the couple looks as if a counterproof had been taken from it. A counterproof, indeed, exists in Bayonne, Musée Bonnat.

Frizzoni's attribution is, in our opinion, erroneous, since the drawing shows an idyllic character positively different from Sebastiano del Piombo's heroic pathos. We reject Frizzoni's suggestion, but cannot replace it by another. An impressive invention by Titian in his Giorgionesque period seems to have been adapted in this drawing to a rather unpretentious composition for which we find a certain analogy only in paintings of the "Idyllenmeister" whom Johannes Wilde segregated from the school of Giorgione in general (*Jahrb. K. H. S.,* N. S. VII, p. 104 ff.).

736 ————, H 20. Three men in a landscape. Pen, br. 269 x 305. Damaged by mold. Publ. by Colvin, II: School of Giorgione; not Do. Campagnola, probably not Giulio; the figures especially differ from his style. The knoll in the foreground and some of the nearer hills seem to be added. **[MM]**

We do not agree with the last assertion and believe the whole drawing to be by one hand. The figures resemble the enigmatic painting attr. to the school of Giorgione in the Gallery of the Academy in Vienna (Eigenberger, *Cat.* I, p. 424, pl. 11). On the whole, any attempt to attribute such drawings to individual artists is prema-

ture until the problems of the paintings have been solved; may we very cautiously point to the resemblance in the mode of drawing with No. **1956.**

A 737 VIENNA, ALBERTINA, 37. Landscape; a tree at l., buildings at r. Pen, br. 176 x 208. Bought in 1923 from the Grassi Coll. Stix in *Albertina, N. S.* II 15: Circle of Giorgione. *Albertina II* (Stix-Fröhlich): Probably study for the background in a painting.

In our opinion, not Giorgione's style, not his time and not even Venetian.

738 WASHINGTON, D. C., CORCORAN GALLERY, Clark Coll. 2186. Youth standing seen from the back. Brush, gray, touched with red, on paper turned yellow. 375 x 190. Damaged and irregularly cut. Below modern inscription: Giorgione (and) prima maniera (cut). In the gallery as Carpaccio and listed by van Marle XVIII, p. 374 as school of Carpaccio. [*Pl. L,* 3. **MM**]

In our opinion, the name of Giorgione fitted better than that of Carpaccio, beyond whose period and style the drawing is decidedly advanced. Similar types appear in works of the next generation, compare for instance No. **1372.**

A WASHINGTON CROSSING, PA., COLL. F. J. MATHER. Study of a nude child. See No. **2012.**

GIROLAMO DEL SANTO
[Mentioned in Padua from 1500 to 1549]

739 TURIN, BIBLIOTECA REALE, 15909. Pageant with musicians and a man carrying a model of a town inscribed Padua. Broad pen, gray wash, on wh. turned yellow. 264 x 167. Squared in red ch. Formerly ascr. to Giorgione, now to Girolamo del Santo. [*Pl. XLI,* 4. **MM**]

This attribution may be correct with reference to Giorlamo's paintings of the Scuola di San Rocco and the Santo (see A. Moschetti, *La*

Scuola di San Rocco in Padova e i suoi recenti restauri, in *"Padova," Rivista Comunale,* 1930, January, fig. 14), and the mural in San Francesco, Padua, ill. Venturi 9, III, fig. 370. Decorative paintings by Girolamo in the Loggia del Consiglio in Padua are mentioned in the *Rivista d'A.* 1939, II, p. 293 and on the basis of documents dated 1525. The subject of our drawing would suit such a purpose quite well.

GIROLAMO DA TREVISO (PENNACCHI)
[Born c. 1498, died 1544]

The last author to deal separately with Girolamo da Treviso was Luigi Coletti in *Critica d'A.,* IV, p. 172 ff. On p. 180 he devoted a special paragraph to Girolamo's activity as a draftsman without, however, adding anything valuable to the material already collected by Hadeln. Girolamo remains a somewhat indistinct figure — just as he appears in the paintings ascribed to him — and in his style reflects an uprooting quite understandable from the circumstances of his life. Girolamo belongs to the type of the wandering artist represented among Italians as well as among Northerners, and shares with them their unprofessional character and lack of connection with a specific school. We might say that he speaks an artistic language without a local dialect. This, of course, adds to the difficulty of identifying his drawings of which only one, No. **745,** is supported by an old inscription and two, Nos. **742, 743,** by rather vague and questionable connections with pictures no longer existing. Moreover, it remains doubtful, whether, or how far, Girolamo should be included in the Venetian School. Born in the Veneto, he spent most of his life outside his homeland, and his activity there, and especially in Venice, was short and incidental. Other Italian sections may claim him for themselves with equal rights.

A CHATSWORTH, DUKE OF DEVONSHIRE. Adoration of the Magi. See No. **A 1302.**

A 740 DRESDEN, KUPFERSTICHSAMMLUNG. Christ and Magdalene attended by two men. Red ch., on gray. 180 x 200. Cut. Woodburn

Coll. Publ. by Woermann VI, 2, as Lombard School about 1520. Also ascr. to Boltraffio and Albertinelli. Attr. to Girolamo da Treviso by Ragghianti and, following him, by Luigi Coletti, in *Critica d'A.* IV, p. 178, fig. 23. In his opinion the drawing was made after Carpaccio for practice.

There is not the slightest reason to connect the drawing with Girolamo da Treviso or any Venetian artist.

A 741 FLORENCE, UFFIZI, 1750. Unidentified legend. A sick man healed in the presence of a dead saint (?). Composition with numerous figures in an elaborate interior. Over ch. sketch, pen, br., gray wash, height. w. wh. 175 x 306. Arched top. Modern inscription: Girolamo da Trevigi. **[MM]**

The ascription to Girolamo da Treviso seems to rest mainly on an alleged resemblance to Girolamo's murals representing the "Legend of saint Anthony," in San Petronio, Bologna. The drawing, not similar to any of the murals in San Petronio, moreover, lacks the Raphaelesque elements so typical of Girolamo's compositions and is different in its style from Girolamo's best established drawing No. **745**.

742 LONDON, BRITISH MUSEUM, 1895-9-15 — 795. The Virgin and Child enthroned, below saint Catherine and a sainted monk recommending a donor. Bl. ch., height, w. wh., in part worked over with the pen. 540 x 417. In part squared. Malcolm Coll. (Robinson 348). Publ. by Hadeln, *Hochren.*, pl. 55, as the model possibly of a lost altar-piece in San Salvatore, Bologna, mentioned by Vasari, V, 136 f. Hadeln states himself that the drawing does not completely fit Vasari's description. Accepted by Coletti, in *Critica d'A.* IV, p. 180.

The influence of Raphael's Madonna di Foligno is striking.

743 ————, Pp. 2-100. Design for an altar-piece. Four saints standing, above child angels. Brush, br., height. w. wh., on gray. 392 x 243. Arched top. — On the back: Small sketches of various compositions, each of them framed. Pen. Formerly ascr. to Andrea del Sarto. Publ. by Hadeln, *Hochren.*, pl. 56, 57, the *recto* as *"modello"* of a lost

altar-piece by Girolamo da Treviso in San Salvatore in Venice, described by Boschini, *Minere*, p. 133; the *verso*, according to Hadeln, perhaps hasty sketches for the same composition as those on the other side. Coletti, *Critica d'A.* IV, p. 180 accepts Girolamo for the *recto*, but questions his authorship for the *verso*, the presumed sketches in his opinion being copies from well known compositions, the first in the top row from the "Madonna di Foligno" by Raphael.

Although the drawing does not correspond exactly to Boschini's description, the attribution to Girolamo seems well enough established. In our opinion, this statement applies also to the *verso*. The obvious studies after Raphael's "Madonna di Foligno" and his "St. Cecile" are typical elements in Girolamo's formation.

744 MODENA, PINACOTECA ESTENSE, 1174. Bishop saint standing, holding book and staff. Over bl. ch. sketch, red ch., on faded blue. 272 x 177. Squared. — On the back: inscription of the name, probably repeating one originally written on the *recto*. **[MM]**

745 VIENNA, ALBERTINA, 99. Archangel Gabriel. Pen, bistre, wash, height. w. wh. 386 x 236. Old inscription: Gironimo di Trevigi. *Albertina Cat. I* (Wickhoff) 92: authentic, from Girolamo's last period under the influence of Innocenzo da Imola. Publ. by Hadeln, *Hochren.*, pl. 58. Coletti, in *Critica d'A.* IV, p. 180.

The attribution is supported by the close resemblance with the angel in the Last Supper, woodcut by De Nanto, signed Hieronymus Tervisius pinxit. See further for the drapery the figure of the Virgin in the "Presentation," in San Salvatore, Bologna, ill. Coletti, l. c. fig. 20.

746 WINDSOR, ROYAL LIBRARY 5457. Virgin and Child, accompanied by angels; below a large musician angel between St. Jerome and a bishop saint. Brush, br., height. w. wh., on gray. 336 x 211. Above a strip of paper is added. Hadeln, *Hochren.*, pl. 54. Coletti, *Critica d'A.* IV, p. 180.

DOMENICO THEOTOCOPULI, CALLED EL GRECO

[1541–1614]

Had El Greco passed away in Venice in 1576 there would be no objection to our including him in our catalogue. Vasari who owned one of El Greco's drawings certainly considered him a Venetian, although he called him Domenico Greco in the label of the drawing. This name El Greco, the Greek, recalls his origin, just as Vassilacchi for the same reason became l'Aliense in the history of art. But since El Greco found his personal expression only in Spain and after 1577, we limit ourselves, as in the case of Sebastiano del Piombo, to a consideration of the early pre-Spanish El Greco.

It is well known that various theories exist about this part of his career. The last to discuss his formerly assumed dependence on Jacopo Bassano was A. L. Mayer in *Burl. Mag.*, vol. LXXIV, p. 28, who very cautiously limited El Greco's Bassanesque period to 1565/6, viz. the years preceding the triptych of Modena. Pallucchini in his publication of this triptych, pp. 13, 14, had completely rejected the theory of El Greco's dependence on Jacopo Bassano, and had, on the contrary laid greater stress on his having studied with Titian from about 1567 to 1570, an episode well established by documentary evidence. Pallucchini, moreover, pointed out abundant influence exercised on El Greco by various other Venetian painters, and most of all by Jacopo Tintoretto. The drawing

No. 748 which is supported by Vasari's inscription, is an argument in favor of Pallucchini's theory. It is true, Michelangelo's sculptures were copied not only by Tintoretto, but by other Venetian artists too, but the marked tendency to study the model chiefly for its foreshortening certainly points in Tintoretto's direction. Pallucchini designated the drawing as a scholastic exercise, and as such it is less helpful in making other attributions. Suida's suggestion that we enrich El Greco's oeuvre by the portrait of a youth in the Liechtenstein coll., Vienna (formerly ascr. to Annibale Carracci) was accepted by Meder, but has not been discussed in the literature on El Greco. At any rate the drawing is outside our limits in view of its general style which certainly does not belong to the 1570's. The attribution of No. 1978 to El Greco by Otto Benesch, based on a slight resemblance of the composition to El Greco's "Pietà" we definitely reject, and we wonder whether Benesch himself maintains it at present, after Pallucchini's enlightening publication of the triptych in Modena. The drawing is too poor and shows too much routine for an artist who dealt with other artists' compositions as summarily as El Greco did.

There remains only the red chalk drawing No. 747 which we ourselves attributed tentatively to El Greco accepting Mr. Oppé's suggestion and adding on stylistic grounds No. 202, listed in the Albertina as by Jacopo Bassano. The Oppé drawing has the advantage of being almost exactly dated; for the date in question hardly any other artist in Venice could be suggested. Further arguments are offered by the extraordinary artistic quality displayed in the unrestrained and striking rendering of the models, one of which, the Veronese ceiling on the back, we are in a position to check, and, last but not least, by the resemblance in style and general spirit to the small figures in Greco's triptych at Modena. We must, however, admit that both drawings, No. 747 and No. 202, are completely lacking in one element that is very marked in the panels in Modena and in the artist's entire later production: the mannered verticalism, the juxtaposition of consciously controlled structural lines, the omission of slanting diagonals. Looking back at No. 748, the only one of El Greco's early drawings really authenticated, we may, however, believe it possible that in the short span of El Greco's second stay in Venice, after his return from Rome, he might have allowed himself to be thus completely merged in the whole of Venetian painting of his days.

A BRNO, LANDESMUSEUM, formerly. The Lamentation over the body of Christ. See No. **1978**.

747 LONDON, COLL. PAUL OPPÉ. Sheet with two sketches drawn in different directions, both copies, one after Jacopo Tintoretto's "Excommunication of Emperor Frederick Barbarossa," the other after Veronese's "Emperor Frederick Barbarossa paying homage to Pope Hadrian," both in the Sala del Maggior Consiglio in Venice, destroyed by fire in 1577. Red ch. 204 x 307. — On the *verso:* Copies from Paolo Veronese's ceilings in the Sala del Collegio, in the Ducal Palace in Venice (ill. in Venturi 9, IV, fig. 642, 646, 647 and Meissner, *Veronese,* p. 103). Red ch. Identified and publ. by E. Tietze-Conrat, in the *Art Quarterly,* Winter 1940, p. 22 ff. in whose article, however, one mistake requires correction. The second composition on the *recto,* identified there as the "Crowning of Emperor Frederick Barbarossa," painted by Tintoretto, matches better with the description of Veronese's composition, painted in 1563–64 for the same hall (Vasari VI, p. 588 f; Ridolfi I, 304). The "Pope's music," especially mentioned by Vasari as an important part of Tintoretto's composition, is not to be found in the drawing. This correction does not interfere with the further interpretation of the drawings given in the *Art Quarterly* and its hypothetical attribution to El Greco between 1574

and 1576, immediately before his departure for Spain. See also No. **202**. [*Pl. CXXX,* 1 *and* 2. **MM**]

748 MUNICH, GRAPHISCHE SAMMLUNG, no. 41597. Nude figure of a man. Bl. ch., height. w. wh., on blue. 602 x 348. A strip is added below. Mount typical of Vasari's collection with inscription: Domenico Greco. Publ. as El Greco by E. Baumeister, in *Münchn. Jahrb.* 1929, p. 201; Liphart, in *Zeitschr. f. B. K.* 1930/31, p. 67: Paeseler and Kehrer, *Münchn. Jahrb.* 1933, p. XXVII ff., resp. XXX ff.; Kehrer in *Archivo Español de Arte, etc.* 1935, p. 238; O. Kurz, in *O. M. D.* 1937, p. 44. Baumeister refers to various early works by El Greco and presumes that the drawing was copied from a piece of sculpture by Michelangelo. Paeseler identified the model as Michelangelo's "Day" and emphasized the fact that clay sketches by Michelangelo existed in Venice (see No. **1729**) and that the bozzetto of the "Day" might possibly have had the leg missing, since Alessandro Vittoria mentions in his diary of April 20, 1563, that he bought "un piè del Giorno di Michelangelo . . . è questo il piede zanco (left foot) di modelo di sua mano." R. Pallucchini, *Il Polittico del Greco della R. Galleria Estense,* Rome, 1937, p. 15, stresses two points: that the attribution to El Greco is not absolutely convincing, and that the drawing should be dated several years after 1563.

We date the drawing shortly before 1570, the date of El Greco's arrival in Rome, and certainly before 1574, the date of Vasari's death. It is worth mentioning that the model of the "Day" which Tintoretto drew in No. 1739 apparently was a different one — perhaps the reproduction by Daniele da Volterra — since it shows the leg as it exists in the finished statue.

A VIENNA, ALBERTINA, 74. See No. A 202.

LANZIANO, POLIDORO DA, see POLIDORO.

LATTANZIO DA RIMINI

[Mentioned 1495–1505]

749 CHATSWORTH, DUKE OF DEVONSHIRE, 741. Sermon of St. Mark. Pen, reddish br. 172 x 144. Formerly ascr. to Carpaccio, publ. under this name in *Chatsworth Dr.,* pl. 42, and accepted by Hofstede de Groot who in *Jahrb. Pr. K. S.* vol. XV, p. 175, publ. a copy by Rembrandt from the drawing. See also Valentiner, *Rembrandt's Handzeichnungen,* pl. 193. The attr. to Carpaccio was also accepted by Hausenstein, *Carpaccio,* p. 154. Attr. to Lattanzio da Rimini by Hadeln, *Quattrocento,* pl. 83, p. 64, an attr. followed by Fiocco, *Carpaccio,* p. 93 and van Marle XVIII, p. 326, note. [*Pl. XXV,* 2. MM]

Hadeln's attr. starts from the fact that a set of four pictures representing the legend of St. Mark existed in the chapel of the silkweavers in St. Maria dei Crocicchieri in Venice; one of the pictures by Cima, and another by Mansueti still exist. A third one, representing the "Sermon of St. Mark," is listed by Boschini, *Minere,* p. 420, as by Lattanzio da Rimini and of 1499. The little that is preserved by this artist serves neither to support, nor to contradict the attribution.

The few authentic works by Lattanzio (ill. *Jahrb. Pr. K. S.* XXVI, Appendix, p. 27, 29) are indeed of no help, but Hadeln's suggestion seems compelling in view of the agreement in shape and composition with Cima's picture from the chapel of the silkweavers, in Berlin (ill. Venturi 7, IV, fig. 319).

A 750 NEW YORK, W. SCHAB. The sermon of St. Christopher. Pen. 123 x 123. Exhib. as Lattanzio da Rimini at the Matthiesen Gallery in London 1939, no. 84; publ. by H. Tietze, in *A. in A.* 1942, January.

We do not recognize any resemblance to No. 749 or to the style of Lattanzio da Rimini as it appears in his paintings. Another drawing by the same hand and representing another episode from the legend of St. Christopher exists in the British Museum (1895-9-15 — 802. Pen, br., height. w. watercolor. 127 x 127. MM). The drawing ascr. to Jacopo Bellini in Robinson's *Cat.* of the Malcolm Collection, no. 755, has been tentatively attr. to various Venetian artists, such as Mansueti and Bastiani, and also connected with a group of paintings representing martyrdoms of female saints, panels of which exist at Bergamo, Bassano and Washington, attr. to Jacopo Bellini, Antonio Vivarini, Dello Delli, Francesco degli Franceschi and others (ill. van Marle VII, fig. 260 and Frizzoni, *Le Gallerie in Bergamo,* fig. 62 and 63). This group of paintings, however, is much more Venetian in its character than the two drawings in which the Paduan stylistic element is distinctly predominant. This element is amply confirmed by the relationship of the linework to that of a drawing of 1466, connected with a painting by Pietro Calzetta, formerly in Sant' Antonio in Padua (ill. *L'Arte* 1906, p. 53). The drawing in the contract to which it belongs is explicitly called a copy from a design owned by Francesco Squarcione and executed by Niccolò Pizolo. This relationship is strong enough to make us weigh the hypothesis that our two drawings may in some way be connected with the murals representing scenes from the same legend of St. Christopher and also approximately square in format, in the Ovetari Chapel in Padua. These murals which were begun by Mantegna after the completion of the Legend of St. James and probably after the death of his collaborator Pizolo (about 1453) may originally have been planned by the latter. Or, some other Paduan artist of the Squarcione shop may have tried to secure the commission for himself after Pizolo's death. The drawings in our opinion represent the local school about 1450 to 1460 which Mantegna superseded by his more modern creations (s. more in full, H. Tietze, *A. in A.,* 1942, Jan.).

BERNARDO LICINIO

[Born 1489, died 1565]

Three drawings were given to Licinio by Hadeln and two of them reproduced in his *Hochren.* Wart Arslan (Thieme-Becker, vol. 23, p. 193) accepted only No. 192 and added no. 1735a in the Uffizi, the portrait of a young lady which we do not recall having seen.

Licinio originated from Bergamo and was not related to Pordenone as was formerly supposed. The alleged relationship to Pordenone perhaps was one of the reasons for attributing to Licinio the red chalk drawings in Berlin and London, red chalk being Pordenone's favorite technique. It may also be that the attribution rested on the dryness of their style, recalling that of Licinio's painted portraits. No. 192 is very different from the others and points to a more powerful artistic personality. The red chalk drawings offer a conscientious portrayal of the

faces studied with an objectivity not without real devotion to the task. The features are, figuratively speaking, fenced in by the outlines. No. **192** is freer and, furthermore, anticipates the highlight on cheeks and forehead in the painting. The drawing, in our opinion, belongs to an artist of the next generation, and Monsieur Linzeler's tentative attribution to Jacopo Bassano seems to us very attractive. We reject, on the other hand, a suggestion of Mrs. Fröhlich-Bum to attribute No. **754** to Licinio. It will be noted that all our statements are negative. One could not expect otherwise in the case of an artist who first of all was a portraitist and for whose works, therefore, invention and composition offer no help.

A 751 BERLIN, KUPPERSTICHKABINETT, 5066. Head of a woman, profile to the r. Red ch. 125 x 104. Coll. Beckerath. Publ. by Hadeln, *Hochren.*, pl. 14 and p. 32 as Bern. Licinio, with reference to the similar drawing in the British Museum No. **A 752**.

In our opinion, a study from nature by Callisto da Lodi for the woman on the l. in his "St. John the Baptist preaching," Incoronata, Lodi (Photo Anderson 11425).

A 752 LONDON, BRITISH MUSEUM, 1895-9-15 — 821. Profile of a young woman. Red ch. 147 x 123. Malcolm (Robinson 374: Titian). Mentioned by Hadeln, *Hochren.* p. 32 as Bernardo Licinio.

In our opinion, a companion piece to No. **A 751** and a study from nature by Callisto da Lodi for the woman at the r. in the painting "St. John the Baptist preaching," Incoronata, Lodi (Photo Anderson 11425). The woman in the painting shows the same dress and the same characteristic features while the head is turned into a full face view. [*Pl. CXCI*, 2. **MM**]

A 753 MILAN, COLL. DR. RASINI. Portrait of a young lady, seen full face. Red ch., on gray. 222 x 145. Oppenheim Coll. Since the ascription to Licinio is based on the affinity of the drawing to No. **A 751**, it also might be by Callisto da Lodi.

A 754 OXFORD, ASHMOLEAN MUSEUM. Two sketches for a painting, a lady playing the spinet, a gentleman standing next to her. Pen, bister, wash. 255 x 205. Publ. by L. Fröhlich-Bum in *O. M. D.* March 1938, pl. 54 as Licinio, with reference to his picture in Hampton Court (ill. Venturi 9, III, fig. 309, p. 471). [*Pl. CXCI*, 1. **MM**]

The connection with the painting in Hampton Court is limited to the general motive of the smaller sketch. The costume in the drawing is later, and so is the position of the head of the woman; the influence of Palma Vecchio prevails in the painting, while the drawing is more advanced in the direction of Niccolò dell' Abbate with whom the style of drawing is quite well compatible.

A PARIS, LOUVRE, 5679. See No. **192**.

LORENZO LOTTO

[Born c. 1480, died 1556]

Lorenzo Lotto is a Venetian by choice, not by origin. In the course of his long and nomadic life that took him through various sections of Italy he adapted himself no less willingly to their art without, however, ever completely surrendering his own personality. His versatility, on the contrary, forms part of his constancy; every influence that he accepted became so thoroughly absorbed that it enhanced Lotto's independence. This attitude also characterizes his connections with Venice and especially with Titian who among the Venetian artists was apparently the one whom he cultivated most assiduously at certain times. The contact with Titian evoked elements that lay deepest in Lotto's artistic essence and grew from the share of Venice in his early education, very much emphasized by B. Berenson in his monograph on Lotto.

As for his drawings, we shall not expect too much reliable information for an artist of this nature, and indeed our knowledge of this side of his activity is still more imperfect than that of others. On the other hand, we may assume a certain productivity of Lotto in precisely this field. In his account-books (publ. in *Musei Nazionali,* vol. II) drawings of every kind are so frequently mentioned that they seem to have belonged to the staple products of his shop, and the drawing which in his portrait in the N. G. in London (no. 4256, ill. in *More details from pictures in the N. G.,* London 1941, pl. 99) the lady holds in her hand may be a good example of a category then represented abundantly, but now, unfortunately, not by a single specimen. (An entry in the above mentioned account-book, publ. l. c., p. 208, runs: I have to supply drawings, namely eight heads in oil on paper, three drawn heads and eight landscapes. A sketch representing a pig killed by cupids, an allegory of Luxury, and a

Nativity, watercolor on pink paper. Two large cartoons drawn, to be washed and colored, the one with the Tower of Babel, the other the Prophet Elijah carried toward heaven in his chariot). Furthermore, at a very early age Lotto came into close contact with Dürer who stimulated drawing in Venice more perhaps than anybody else. It is very likely that an artist who studied so intensively Dürer's landscape watercolors (see E. Tietze-Conrat, in *Pantheon,* 1935, February) became interested also in other sides of his draftsmanship, especially as we discover traces of such studies in Lotto's early paintings.

This question was not taken up by Luigi Coletti who in a rather ambitious article in *Le Arti,* 1939, p. 348 ff., tried to establish a close connection between Lotto and Melozzo. This contact was explained by their working in neighboring places in the Marche. From this hypothesis Coletti drew a new argument for the attribution to Lotto of the "Knights" in Treviso—to which we shall return in a moment—and of the Bellinesque female portrait in Venice (No. 324), already claimed for Lotto by Adolfo Venturi. The noticeable stylistic difference of both works from Lotto's early production according to Coletti should be caused by Melozzo's strong and direct influence. Since no trace of such an influence appears in Lotto's later works, the whole structure is only a *deus ex machina* meant to back a few attributions and after that allowed to lapse.

If the knowledge of Lotto's early style in painting is sufficient to contradict this new theory, it does not suffice to permit the positive attribution of drawings to him. At the very beginning of his career an important work has been placed that also has a bearing on the question of Lotto's draftsmanship, since several drawings are connected with it. The painted knights forming part of the Onigo monument in San Niccolò in Treviso were formerly ascribed to Antonello da Messina, Giovanni Bellini, Jacopo de' Barbari, Giorgione and today by most critics given to Lotto. This attribution would also apply to two drawings, Nos. **A 768** and **A 769**, evidently connected with the painted figures. On p. 186 we set forth our historical and stylistic reasons for suggesting instead of Lotto Vincenzo dalle Destre as the painter of these murals, a thesis including also the two drawings. Their dryness alone should exclude Lotto's authorship. A question apart, only by mistake connected with the Onigo puzzle, is that of the splendid warrior in the Koenigs Coll., No. **A 763**. The suggestive power exercised by a related subject (knights in armor here and there) proved so strong in this case that Popham, otherwise so cautious a critic, admitted in the *Cat. of the Italian Exhibition in London,* 1930, that the drawing might be a rejected idea for the Onigo murals. As a matter of fact, Suida himself who was the first to claim the drawing for Lotto because of the alleged relationship to the painted knights, had frankly stated their basic stylistic difference from the drawing in Haarlem. Deprived of the support of the Onigo murals, no argument remains in favor of Lotto for this magnificent drawing which, in our opinion, is more sculptural in style than Lotto ever was.

In our article in *Critica d'Arte,* VIII, p. 84, we made an attempt to approach Lotto's early drawing style from another angle. We connected two washed pen drawings in the Museo Civico in Bassano, Nos. **755, 756**, with his predella panels from the early Recanati altar-piece, one of which is preserved in the Vienna Gallery. The drawings are not definite sketches for the painting, but very close to it in their general spirit and, most of all, in one point that was stressed by Gustav Glück when he first published the panel in Vienna: "No Italian painter in 1508 (when the altar-piece of Recanati originated) could have represented a crowd so convincingly." That is just what Dürer's "Life of the Virgin" taught Italian and other artists, and young Lotto may be supposed to have been ready and well prepared to accept such instruction. Of the two drawings which in the above mentioned article we tried to connect to those in Bassano on stylistic grounds, we now maintain only No. **772**, while for No.

A 758 we admit that we were rash in substituting Lotto for Romanino whose name after all may be the more appropriate. Hasty sketches have a uniformity of their own, as other techniques have theirs.

For another group of Lotto drawings, studies of single figures executed in black chalk, we are in a better position insofar as some of them can be connected with existing paintings: No. **766** in Malvern is the study for a saint in the altar-piece in Ancona, No. **779** a study for one of the apostles in the "Assumption of the Virgin" in Celena, No. **771** contains two studies for the figure of St. Joseph in the altar-piece in San Bernardino in Pignolo. For the last mentioned drawing, it is true, Mr. Berenson did not accept Lotto's authorship, but called the drawing a comparatively recent imitation. We have to confess that we do not quite see the point. The two studies are made from the same model in different postures, one of which was used with considerable modification in the painting. This fact alone seems to exclude an imitation; moreover, the style of the drawing is completely identical with the two other studies of this kind that became known only later. Together, the three provide a sufficient idea of Lotto's mode of drawing to justify the tentative addition of more drawings of a similar character: No. **774** which may have something to do with the "Visitation" of 1530 in Jesi; No. **757** in the Academy in Bergamo; finally No. **759** in the Fitzwilliam Museum in Cambridge, already recognized as a late Lotto by Mr. Berenson. A curious detail is the relationship in style to the antependium in Saint Mark's Church; we know that in Lotto's studio casts from contemporary sculptures were used as models. All these drawings are distinguished by the very soft handling of the black chalk, heightened with white and producing very pictorial effects on the blue ground on which they are drawn. The same technique occurs, very delicately used, in a drawing in Malvern, No. **767**, corresponding to a portion of Lotto's predella in the Library in Jesi, representing scenes from the legend of St. Lucy, so exactly, that the first impression is that of a copy. And it may be a copy, but one executed in the technique typical of Lotto's shop and therefore perhaps executed in this shop. Whether it was done as a *modello,* intended to set down a final composition, or was copied by some assistant in order to keep a record of the charming composition, it might be difficult to decide in a period when the tasks of drawing for a painting or from a painting were still so closely interwoven.

The above-mentioned study for the altar-piece at Celena, No. **779**, is still more important because the portrait of a beardless stout man is drawn on its *verso* undoubtedly by the same hand as the figure on the *recto*, and therefore, the first really well-authenticated example of a group of drawings for which the name of Lotto enjoyed an unjustified popularity. It may be a subject of regret that the attribution to Lotto of the drawing eliminates so entirely the former one to Titian, suggested by F. Kieslinger in *Belvedere,* 1934–36, p. 137 ff. It might have been useful to keep a record of this article in order to remember to what absurdities a frivolous approach to these difficult problems may lead. The drawing in the Kieslinger Coll. came up just in time: the attribution of large portrait drawings to Lotto had already begun to be the fashion, replacing the preceding tendency to ascribe all such heads to Bonsignori. We have now a reliable point of departure, less helpful for the verification of drawings of this class, as No. **777**, already acknowledged by Mr. Berenson and apparently much earlier in date, than for the reclassification of some portraits in the Albertina and elsewhere. It confirms the attribution of No. **777**, but contradicts those of Nos. **776, 778** while Nos. **764, 775** are so far away from Lotto that their attribution to him can hardly be taken into consideration at all. More problematic is No. **765** about which we could not repress most serious doubts until we reached the conclusion that a certain 18th century flavor in the drawing may be due to its not entirely satisfactory state of preservation.

For a special group of heads of youths, in dispute between Barbari, Giovanni Bellini, Lotto and Alvise Vivarini, see No. 2249; we list them under the last of these names.

755 BASSANO, MUSEO CIVICO. A Dominican monk preaching. Pen, wash. 168 x 256. Ascr. to Titian. Publ. in our article in *Critica d'A.* VIII, 1937, p. 84, pl. 66 as sketch for one of two panels in the predella of Lotto's altar-piece in Recanati, on the basis of the close resemblance to the one panel preserved in the Vienna Gallery (ill. Venturi 9, IV, fig. 9.). Companion piece No. **756**.　　　[*Pl. LXXXVIII*, 3. **MM**]

756 ———, A modified version of No. **755**. Publ. in *Critica d'A.* l. c.　　　[*Pl. LXXXVIII*, 4. **MM**]

757 BERGAMO, ACCADEMIA, 2497. Woman standing, turned to the r., seen from behind. Bl. ch., on faded blue. 310 x 215. Stained by mold, rubbed and torn. — On *verso* late inscription: Lotto.　　[**MM**]

We accept this attribution with reservations. The style of drawing shows a certain resemblance to Lotto's, while the special type of mannerism seen in the pose of the woman is slightly different from his.

A 758 BERLIN, KUPFERSTICHKABINETT. Dancing party in a landscape. Pen. 188 x 292. Coll. Richardson Sen., Liphart, von Beckerath. Publ. in *Berlin Publ.* vol. I, pl. 67, as Romanino and accepted as his by Suida in Thieme-Becker vol. 28, p. 551. In *Critica d'A.* VIII, p. 86, we attr. the drawing tentatively to Lorenzo Lotto.

After renewed study of the style of both artists we no longer maintain this suggestion and accept Romanino as the better name.

759 CAMBRIDGE, FITZWILLIAM MUSEUM. St. Peter and Paul carrying a monstrance; two flying angels. Pen, wash. Coll. G. T. Clough, Manchester; Whitworth Institute. Berenson, *Lotto,* 241: Late period. Hadeln, *Hochren.,* pl. 26.

The angel at l. is close in style to the sculptured angel from the antependium in St. Mark's Church, ill. Planiscig, *Jahrb. K. H. Samml.* XXXIII, p. 127, fig. 87. We know that Lotto used casts from (contemporary) sculptures in his studio.

760 FLORENCE, UFFIZI, 1741 F. Head of a young man, full face, with a hat. Bl. ch., on brownish paper. 210 x 165. Badly rubbed and damaged. Publ. by B. Berenson, *Lotto,* p. 298, who found in the drawing all the characteristics of Lotto's style including the influence of Alvise Vivarini.　　　[**MM**]

In our opinion Berenson's hint as to the altar-piece in Recanati (1508) dates the drawing too early.

761 ———, 1876 F. Head of a bearded man with a cap. Bl. ch., on brownish paper. 250 x 185. Later inscription: Lotto. Berenson, *Lotto,* p. 298. *Uffizi Publ.* III, p. 1, no. 18. Hadeln, *Hochren.,* pl. 25.

Compare the double portrait of the brothers dalla Torre in the N. G. in London (ill. Venturi 9, IV, fig. 18).

762 ———, 12912. Study for an apostle in profile. Bl. ch., height. w. wh., on blue. 270 x 180. Publ. in *Uffizi Publ.* I, p. 2, no. 10 as Titian, with reference to the figure of Moses in the "Transfiguration" in S. Salvatore.　　　[*Pl. XCI,* 3. **MM**]

There is no connection with the above mentioned painting nor does the style at all resemble Titian's draperies. We attr. the drawing tentatively to Lotto whose pedantic handling of the folds and violent attitudes it displays. For the line work see No. **766** and No. **779** between which, so different in style, it might form a link.

A FRANKFORT/M., STAEDELSCHES INSTITUT, no. 453. See No. **2244**.

A 763 HAARLEM, COLL. KOENIGS, I 486. Warrior standing, holding a lance. Bl. ch., yellowish wash. 396 x 223. Coll. Boehler. Publ. by Suida, in Pantheon 1928, p. 531, with reference to the painted figures of the Onigo Monument in San Niccolò, Treviso (Venturi 7, IV, p. 761, fig. 487, 488) and other paintings by Lotto of the second decade of the 16th century. Accepted by Hadeln, *Koenigszeichnungen,* pl. 3. Exh. London 1930, 618, Popham *Cat.* p. 258: might be a rejected drawing for the Onigo murals. Exh. Paris 1935, Cat. 587.　　　[*Pl. CXCII,* 1. **MM**]

We deny the close connection with the Onigo monument; the figures there, as already noted by Suida, are placed in static and monumental poses and intended as substitutes for sculptures, while the figure in the drawing, with its daring foreshortening, belongs to another category. The style has a greater resemblance to the Milanese School, see Bramante's engravings. We reject the attr. to Lotto, although unable to replace it by a more satisfactory suggestion.

A 764 ———, I 555. Head of a monk. Bl. ch. 212 x 174.— On back: the same head, smaller and still more sketchy; some architectural details. Reynolds Coll. Exh. Amsterdam Cat. 649 as "attr. to Luca Signorelli." Lionello Venturi in *L'Arte* XXXVII, p. 496, fig. 2 called this attr. an evident slip of the pen and attr. the drawing to Lotto. In the coll. it is called "North Italian about 1500."

The drawing belongs to a series of drawings in the Koenigs Coll. some of which are signed "L S" intertwined, read Luca Signorelli. In our opinion, they are copies from older models. We do not see any connection with Lotto's manner of drawing.

A LONDON, Coll. Oppenheimer, formerly. Head of a young woman. See No. **A 1373**.

765 LONDON, COLL. ARCH. G. B. RUSSELL. Portrait of a young man, en face. Bl. ch., height. w. wh., the lips in red ch., on gray. 335 x 270. Henry Wagner Coll., Berenson, *Lotto,* p. 241. Hadeln, *Hochren.,* pl 24. Exh. London, Burl. House, 601 (Popham *Cat.* 257). Paris 1935 (Cat. 589).　　　[*Pl. XCI,* 1. **MM**]

Half of the hair is rubbed or unfinished. A painted portrait very similar in its general character, perhaps even from the same model, was in 1939 in the Mortimer Brandt Gallery in New York.

766 MALVERN, MRS. JULIA RAYNER WOOD. (Skippes Coll.) Study for a saint in the altar-piece in the gallery in Ancona. Bl. ch., gray wash, height. w. wh., on greenish. 408 x 283. Squared in bl. Later inscription: Lorenzo, and Lorenzo Lot l'opera è in Ancona. Publ. by Popham in *O. M. D.* XII, March 1938, pl. 49.　　　[*Pl. XC,* 3. **MM**]

767 ———. Saint Lucy dragged by the oxen. Bl. ch., height. w. wh., on blue. 291 x 376. Damaged on top.　　　[*Pl. XC,* 1. **MM**]

Exactly corresponding with part of the predella by Lotto in the Library in Jesi, ill. Venturi 9 IV, fig. 57, but cut above and slightly modified in architectural details. The stylistic character of the drawing corresponds so closely to Lotto's, that the drawing may have formed part of the working process and have been executed by Lotto (*modello?*) or in his shop. At any rate, the drawing does not have the character of a later copy, especially in view of the fact that the Skippes Coll. was already formed by the end of the 18th century.

A 768 ———. Standing youth, repeated a second time on a slightly larger scale and more carefully executed. Pen, br. 182 x 187.

Stained by mold. The four corners cut. [*Pl. CXCII*, 5. **MM**]

Companion piece to No. **769**. Study for the l. squire of the Onigo Monument in Treviso (ill. Venturi 7, IV, fig. 487, p. 761). Numerous deviations from the painting induce us not to consider the drawing and its companion as copies, in spite of a certain dryness of the line-work. The murals which had been attributed to various painters, Antonello da Messina, Giovanni Bellini, Barbari, Giorgione, were ascr. by G. Biscaro, in *L'Arte* 1898, p. 138 ff. to Lotto and accepted as his by Luigi Coletti (*Catalogo delle cose d'arte*, vol. VII, p. 395 ff.) and dated 1498 to 1500. In *Le Arti* 1939, p. 348, Coletti finds a new argument for the attribution to Lotto in an alleged contact of Lotto with Melozzo da Forlì who painted in the Marche at the same time as the youthful Lotto (see also No. **763**), however, offers no corroboration of the attribution of the murals to Lotto — incidentally called fantastic by L. Justi, *Giorgione* II, p. 256 — and therefore, is an invitation to bring up once more the question of the authorship.

Agostino Onigo died in 1490 and his heir (Pileo) in 1502. These two dates are universally admitted as the probable limits of the activities on the monument. Lotto, as far as we know, came to Treviso only in 1503 where he was to make an estimate of a large altar-piece painted by Vincenzo dalle Destre for San Michele (ill. Coletti, *Treviso*, in *Monografie illustrate* p. 91). This dalle Destre must have been a respected local painter in Treviso, where he was born and lived from 1492 on except for stays in Venice. His altar-piece mentioned above which seems to have kept him busy from 1501 to 1503, offers a marked resemblance to the two squires in the Onigo Monument for the rendering of the heads while the resemblance to the murals of another altar-piece by dalle Destre, publ. by L. Coletti in *Boll. d'A.* N. S. vol. 6 (1927), p. 470, is still closer (compare not only the head but also the ornamental details). Under these circumstances we believe that dalle Destre might have painted the murals and see no reason not to attribute to him the drawings as well. The paintings may have been executed as substitutes for originally planned sculptures. The sudden departure of Antonio Rizzo from Venice in 1498 — if A. Venturi is right in attributing him the sculptural part of the monument — may have been the reason for replacing the planned sculptures by murals.

A 769 MILAN, COLL. RASINI. Standing youth, study for the r. squire in the Onigo Monument in Treviso, ill. Venturi 7, IV, fig. 488, p. 761. Pen, wash, on wh. paper, slightly turned yellow. 165 x 100. Damaged and restored. Coll. Richard Cosway, Sir Edmond Davis, Asher & Welcker. Publ. as Lorenzo Lotto by Borenius in *Burl. Mag.* 1930–1, p. 105. A. Morassi, p. 29, pl. XVII, accepts this attribution.
 [*Pl. CXCII*, 4. **MM**]

Companion piece to No. **A 768**. See there.

A 770 ————. Head of a stout man turned to the r. Red ch. 130 x 118. Coll. Albassini, Scrosati, Milan. Tentatively attr. by A. Morassi, p. 29, pl. 18, to Lotto or his circle, while Ragghianti in *Critica d'A.* XI–XII, p. XXXVII suggests Pordenone, pointing to a similar type in one of Pordenone's frescoes of Cremona and to the painting Brera no. 9, there ascr. to Bassano and attr. to Pordenone by Ragghianti.

In our opinion, the resemblance is only superficial, the style of drawing is neither Lotto's nor Pordenone's, and we doubt the Venetian origin of the drawing.

771 MILAN, AMBROSIANA, Resta. Two studies for the figure of Saint Joseph in the altar-piece in S. Bernardino in Pignolo, Bergamo,

ill. Venturi 9, IV, fig. 27. Bl. ch., on yellowish paper. 207 x 254. Rubbed. Resta Coll. Ascr. to Lotto. Mentioned by Morelli, *Berlin*, p. 90. Berenson, *Lotto*, p. 299: Comparatively recent imitation.
 [*Pl. XC*, 2. **MM**]

In our opinion, the two studies were made from the same model in different poses only one of which was later used in the painting with notable modifications. That alone would be an argument against the idea of an imitation. Moreover, the linework corresponds very well to No. **766** and No. **779**.

772 OXFORD, CHRISTCHURCH LIBRARY, k 4. Monk kneeling (?) in front of chalice on altar. Pen, darkbr. 150 x 110. Torn. — On *verso*: hasty sketch, woman kneeling before an enthroned figure. Bell p. 88: Titian.

We publ. both sides of the drawing in *Critica d'A.* VIII, p. 85 as by Lotto, with reference to his altar-piece in Recanati; for the architecture see Venturi 9, IV, fig. 7, 8, for the figure of the monk, ibidem fig. 5.

A 773 PARIS, ÉCOLE DES BEAUX ARTS. Virgin and Child surrounded by little angels. Pen, 144 x 188. Formerly attr. to Titian and exh. as "Circle of Titian," 1935, Cat. no. 123. Publ. by Mrs. Fröhlich-Bum in *Graph. Künste*, LI, p. 7, fig. 3 as Lotto, with reference to paintings from his Bergamasque period (1515–1528). Publ. by us in *Gaz. d. B. A.* 1942, p. 115 ff., fig. 1 as the sketch of the upper part of Giulio Campi's altar-piece in S. Sigismondo, Cremona, dated 1540, ill. Venturi 9, VI, p. 853, fig. 517. Other outstanding drawings by Giulio Campi have frequently been attr. to Titian in the older literature.
 [**MM**]

774 PARIS, Vente Drouot, November 24, 1924. Visitation. Bl. ch. 235 x 210. Inscribed: L. Lotus 1515.

We have not seen the original, the present location of which is unknown to us. The drawing may be a design for the painting of the subject in Jesi, dated 1530 (ill. Venturi 9, IV, fig. 70).

A 775 STOCKHOLM, NATIONAL MUSEUM, No. 99. Portrait of a cardinal, almost in front. Bl. ch., on blue, height. w. wh. 307 x 248. Inscription: André del Sarto. Publ. under this name by Sirén, *Dessins*, p. 124, no. 51, and by Schönbrunner-Meder 1203. Sirén, *Cat.* 1917, no. 454 and Sirén, 1933, p. 141, pl. 92: Lorenzo Lotto.

We have not seen the original, but consider a Florentine origin more plausible.

A 776 VIENNA, ALBERTINA, 82. Portrait of a bearded man, en face, slightly bending to his r. shoulder. Bl. ch., traces of heightening with wh., on brownish paper. 404 x 306. Late inscription: Sodoma. Formerly ascr. to Lionardo, Francesco Francia (Waagen, *Die vornehmsten Kunstdenkmäler in Wien*, II, 135), Giovanni Bellini (Rudolf Weigel, *Die Werke der Maler in ihren Handzeichnungen*, Leipzig 1865, 353), Sodoma (Morelli, Thausing), *Albertina Cat. I* (Wickhoff S. R. 69). Publ. by L. Cust, *Giovanni Antonio Bazzi*, London 1906 as Sodoma; Schönbrunner-Meder 479: Sodoma. *Albertina Cat. II* (Stix-Fröhlich): Lorenzo Lotto.

In our opinion, the style of drawing is different from the authentic drawing No. **779** which might approximately be of the same date.

777 ————, 83. Portrait of a bearded man, en face, turned slightly to the r. Bl. ch., height. w. wh., on brownish paper. 418 x 271. Formerly ascr. to Gentile Bellini. *Albertina Cat. I* (Wickhoff) 7: Autograph of Bonsignori. Schönbrunner-Meder 280: Lotto. Meder,

Facsimile 33: Lotto. *Albertina Cat. II* (Stix-Fröhlich): Lotto with reference to a note written by Berenson. Exh. Paris 1935, *Cat.* 588 as Lotto. [*Pl. XCI*, 2. **MM**]

Typical of Lotto's timid approach in his painted portraits and rather similar to the drawing style of No. **779**.

A ———, 84. See No. **326**.

A 778 ———, 85. Portrait of a beardless man in profile. Bl. ch., on brownish paper. 414 x 280. Formerly ascr. to Gentile Bellini and to Bonsignori by *Albertina Cat. I* (Wickhoff). Schönbrunner-Meder 367: School of Verona about 1500. *Albertina Cat. II* (Stix-Fröhlich): Lotto. W. Suida, in *Belvedere* XI, p. 59: Luini.

We agree with Suida to the Lombard origin of the drawing.

A VIENNA, COLL. PRINCE LIECHTENSTEIN. Portrait of a young man. See No. **2249**.

779 VIENNA, COLL. FRANZ KIESLINGER. Portrait of a beardless stout man, turned to the l. and raising his hand to his breast. Bl. ch. Cut on top, lower l. corner torn. — On *verso:* Study of an apostle standing, turned to the r. Squared. The *recto* publ. by F. Kieslinger, in *Belvedere* 1934/36, p. 137 ff., fig. 183 as Titian's study from nature for the portrait of Benedetto Pesaro and at the same time for the old man of the Pesaro family behind him, whatever this may mean. The striking differences between the drawing and the painted portraits are explained by the requirements of a representative portrait.
[*Pl. LXXXIX*, 1 *and* 2. **MM**]

It is unnecessary to discuss this singular theory which is scarcely supported by any valid argument, since the figure on the back allows a precise identification of the drawing: it is the design for the apostle on the l. side in the "Assumption of the Virgin" in Celena, of 1527, ill. in Gowan's *Art Books* no. 29, *The Masterpieces of Lotto*, pl. 50 (Photo A. Taramelli). The portrait on the *recto*, exactly conforming in style, is certainly by the same hand and of the same date. It offers a starting point for the attribution of other portraits, usually ascr. to Lotto, merely on the basis of their resemblance to his paintings.

COSTANTINO MALOMBRA

[*Active at Padua at the end of the 16th century*]

780 DRESDEN, ESTATE LAHMANN, 1447 (1937 — 384 g). Landscape with a fortified town in the middle. Pen, br., on yellowish. 192 x 290. Coll. Durazzo. Ascr. to Domenico Campagnola.

Possibly by Costantino Malombra, in view of the close stylistic resemblance to Malombra's signed etchings.

781 HAARLEM, TEYLER STICHTING, k 77. Landscape with shepherds at l. and buildings in the middle. Pen, br. 226 x 331. Ascr. to Domenico Campagnola whose late works the drawing indeed resembles.

In our opinion, it is nevertheless, closer to Costantino Malombra, as No. **780**.

782 HAARLEM, COLL. FRANZ KOENIGS, I 360. Landscape with a bridge. Pen. 162 x 283. Ascr. to Do. Campagnola.

Our attribution rests on the resemblance to the etchings of C. Malombra.

783 HAGUE, THE, COLL. FRITS LUGT. Landscape with a town on a river in the middle, and shepherds with their flock in lower l. corner. Pen, lightbr. 236 x 390. — On *verso* inscription: Campagnola.
[*Pl. LXXXI*, 4. **MM**]

Closer to Costantino Malombra, see No. **780**.

784 LWOW, OSSOLINSKI INSTITUTE, 3777. Landscape. Pen and sepia. 158 x 322.

Formerly among the anonymous Venetian, attr. to Do. Campagnola by Jan Zarnowski, in *Dawna Sztuka*. Lwow, 1938, p. 325.

785 NEW YORK, COLL. JANOS SCHOLZ. Landscape. Pen-and-bistre. 231 x 379.

Attr. on the basis of the resemblance to the etchings.

PIETRO MALOMBRA

[*Born 1556, died 1617*]

Pietro Malombra seems to have decided to become a painter at a more advanced age than is usual. Together with Giovanni Contarini he learned his art with Giuseppe Salviati who died about 1575 at a time when Malombra was still on the staff of the Ducal Chancery. We cannot form any clear idea of his artistic personality, since his works, the description of which fills the pages 155 to 160 of Ridolfi's second volume, are almost all lost. Praised by Ridolfi for his "prospettive" (stage settings) and for his representations of Venetian localities, and in this a kind of heir of Gentile Bellini's tradition, Malombra may have been an ardent draftsman. According to Ridolfi, p. 159, he left behind "molti modelli" ("painted sketches") and designs executed with bold strokes, and was quite capable in expressing his ideas. The fact, asserted by Ridolfi, that Malombra was an independent artist not only with regard to the form, but also with regard to the subject matter, makes us regret all the more that so very little of his work has been preserved.

As for his activity as a draftsman it has evidently been confused from the very beginning. There are several drawings inscribed with his name though certainly by Palma Giov. (Nos. 962–964) and in the case of No. 963 even connected with one of the latter's well-authenticated paintings. May we deduce from this fact that his pen-work was related to Palma's? Such a theory seems to be supported by the old attribution to Malombra of Louvre No. 790, the stylistic resemblance of which to Palma's drawings is evident. Also the black chalk sketches in Berlin and Milan, Nos. 786, 788 likewise given to Malombra by an old tradition, and No. 787 close in style to No. 786 approach Palma's style so definitely that, if the drawings were handed down without names, we should most probably place them within Palma's circle. It might, however, be that at some time all these drawings belonged to one collector and that the erroneous baptism of all of them therefore may have been caused by one single error; in this case they would offer no help for the construction of Malombra's style of drawing. We are not inclined to believe in such a theory, but think each drawing and its inscription should be examined separately. The ascription on No. 790, for instance, looks trustworthy to us, the penmanship being similar to that of No. 796 which is supported by its stylistic resemblance to Malombra's painting in San Trovaso. No. 792, and its alternative version No. 791, in which no trace of Palma is to be found, reveal Malombra as an artist interested in black and white effects, keeping large portions of his composition in light and shade and very competent in the arrangement of masses. His talent, even as a draftsman, must first of all have been painterlike; that is perhaps what Ridolfi meant when mentioning Malombra's "bold strokes." On the basis of Ridolfi's description of a lost painting E. Tietze-Conrat recognized the formerly anonymous drawing No. 789 in the Metropolitan Museum as the design of Malombra's *"lunettone"* in San Jacopo di Rialto. This magnificent drawing is the best we may with great probability attribute to the artist; its coloristic effect rests on the use of many-colored crayons, a technique typical of the Bassano, but certainly also familiar to other shops (see No. 1917). Is this exceptional performance sufficient to justify a tentative attribution to Malombra of No. 1898? It has become the current procedure to attribute the best drawings exclusively to the very best artists. Our attempt to give average artists the credit of occasional exceptional achievements is a hazardous undertaking. If we dare to run the inevitable risk, it is not in order to extol Malombra, but in order to purge Titian's oeuvre of illicit additions. For Malombra the attribution implies, mainly, a heightening of his quality, but no new stylistic feature. For Titian it would mean no enrichment in quality, but the addition of an extraneous stylistic element.

A concluding remark on Degenhart's treatment of Malombra. He reproduces only a detail from No. 963 attr. to Malombra in the Uffizi, and considers it together with a detail from a drawing by Battista Franco as a fair illustration of a specifically Venetian style in the period of mannerism (l.c. p. 281 f.). The drawing selected by Degenhart is one of those which were attr. to Malombra erroneously and, certainly, are by Palma Giovine. By the same Palma Giovine whose style Degenhart considers typically un-Venetian, Palma, it is true, being born in Venice, but of a family originating from Bergamo. Malombra too, incidentally, was only born in Venice; his family came from Cremona which is just as Lombard as Bergamo.

786 BERLIN, KUPFERSTICHKABINETT, 12373. Christ in limbo. Bl. ch., in places corrected in pen, on yellow. 135 x 187. Old inscription: Malombra. Hadeln, *Spätren.* 104.

 The attribution is based on the old inscription.

787 LONDON, BRITISH MUSEUM, 1856–7–12 — 14. Christ in limbo. Over ch. sketch pen, br. wash. 222 x 186.

 Ascr. to Ja. Tintoretto, but already by Hadeln, *Spätren.* p. 19 attr. to Malombra, referring to No. **786**.

788 MILAN, AMBROSIANA, Resta 138. Flagellation of Christ. Bl. ch. on wh., turned yellow, stained by mold. 265 x 192. Inscription in pen: Malombra. **[MM]**

 In view of No. **786** Padre Resta's attribution seems acceptable.

789 NEW YORK, METROPOLITAN MUSEUM, 80. 3. 364. Pope Alexander III placing his foot on Emperor Frederick's neck. Many-colored crayons, on faded blue. 292 x 428. Gift of Mr. C. Vanderbilt.

 [Pl. CXXXV, 3. **MM**]

Previously anonymous. Publ. as Malombra's design for his lost semicircular painting of this subject over a door in S. Jacopo di Rialto in Venice, by E. Tietze-Conrat in *Art Quarterly,* Winter 1940, fig. 30, p. 36. Exh. Toledo 1940, Cat. no. 81.

790 PARIS, LOUVRE, 5065. Seated Chronos to whom an infant is brought. Pen, br. wash, on yellowish paper. 235 x 169. Old inscription: Pietro Malombra — and, in later hand, a biographical note.
[**MM**]

As in No. **791** and **792** the stylistic approach to Palma is remarkable.

791 ————, 5066. Christ bearing the cross. Pen, br., wash, semicircular top, cut and mounted. 244 x 125. Inscription: Pietro Malombra.
Variation of No. **792**.

792 ————, 5067. Christ bearing the cross. Pen, br., wash, semicircular top, cut and mounted. 258 x 130. [*Pl. CXXXV, 1.* **MM**]
Somewhat modified version of No. **791**.

793 ————, 5225. Sheet with several groups of nude men. — On the back figure in violent action, and accounts. Pen, br., wash. 170 x 263. Old inscription: Malombra, new inscription: Palma. Ascr. to Palma Giov., publ. as his by Josef Meder, *Die Handzeichnung,* attr. to Farinati by E. Tietze-Conrat in *O. M. D.* vol. X (1935) December, p. 39–42. [**MM**]
Both authors were less interested in the attribution of the drawing than in its importance as a documentation for the use of plastic models in the study of movements. The attr. to Farinati certainly

is not acceptable. The approach to Palma, as in several other cases, is very close, but the older tradition deserves the more consideration as the stylistic affinity to the drawings Nos. **791, 792** is likewise noteworthy.

794 ————, 5234. One figure out of a Presentation of Christ. Pen, bl., wash. 150 x 140.
Ascr. to Palma, but in our opinion nearer to the style of Malombra.

795 ————, 5238. Sheet: from an album. Man seated, two women, head of an old man. Pen, br., wash. 234 x 170. Inscription: del Sg. Giacomo Palma Giovine.
Ascr. to Palma Giovine, but nearer to Malombra's style.

796 VIENNA, AKADEMIE DER BILDENDEN KÜNSTE, 3751. Design for an altar-piece, semicircular top, Coronation of the Virgin with many saints on the earth and in the air. Pen, wash, on gray. 367 x 220. Inscription: Malombra. [*Pl. CXXXV, 2.* **MM**]
An altar-piece by Malombra in San Trovaso in Venice shows a completely different version, but relationship in composition and style. Another altar-piece, in San Bartolommeo, according to Boschini, *Carta* p. 450, showed a combination of an "Assumption of the Virgin" and a "Combat of St. Michael." Our drawing might be a first project for this painting.

797 ————, 3753. Coronation of the Virgin surrounded by angels. Pen, wash. 115 x 222. Inscription: Malombra.

798 ————, 2823. Rape of Prosperpina. Pen, wash. 236 x 208. Late inscription: Pietro Malombra.

GIOVANNI DI NICCOLÒ MANSUETI

[Mentioned 1498 to 1527]

It may be considered arbitrary to deal with Mansueti under a separate heading, instead of leaving him among the School of Gentile Bellini, where he originates. One of the three drawings which we discuss is directly connected with this shop, No. **801** being a standard *simile.* The second, No. **800**, in Venice, is said to prepare a painting by Mansueti, in which he appears emancipated from Gentile, but the connection with the painting is as doubtful as the drawing is unimportant. There remains only No. **799** in which we believe we may discover something of Mansueti's personal qualities: a melancholy intenseness and sincerity by virtue of which he sometimes surpasses his rather insignificant average production. Compare his "Entombment" in the Careggiani Coll. in Venice (see *A. in A.,* April 1940), which as an underpainting maintains the freshness of a design.

A FLORENCE, UFFIZI, no. 1293. See No. **265**.

799 MILAN, COLL. RASINI. Head of a young woman. Bl. ch., height. w. wh. (and red on the lips), on tinted br. paper. 260 x 210. Later inscription: Gio^ni Mansueti pitt. (?) Venetiano (?) 1450/3. Coll. Dubini. Publ. by Morassi, *Rasini,* pl. 9, p. 26. [*Pl. XL, 2* **MM**]
The ascription is supported by the resemblance of this tense and melancholy type to other heads occurring in Mansueti's paintings.

800 VENICE, R. GALLERIA, no. 173. St. Sebastian in landscape. Pen, br., light wash. 155 x 77. Upper l. corner cut. Later inscription: Bramante. Formerly attr. to Fra Angelico. Publ. by Loeser in *Rassegna d'A.* III, p. 182 as a preparatory study of Mansueti's painting of

1500 in the Academy in Venice (ill. van Marle XVII, fig. 112). Accepted by Fogolari, no. 51, p. 20.
There is some resemblance in the poses, but in the painting the saint is placed in an interior and besides shows a different posture. The attribution remains doubtful.

801 WINDSOR, ROYAL LIBRARY, 062. Three standing Orientals with high headgears in full length. Brush, br., on greenish gray. 303 x 178. Tentatively ascr. to Gentile Bellini. [*Pl. XIII, 2.* **MM**]
In our opinion closer to Mansueti, compare his types in the "Adoration of the Magi," Verona, Castello, 276, and "St. Mark put out of the Synagogue," of 1499, Vienna, Liechtenstein Coll. (ill. van Marle XVII, fig. 108); compare also the "Reception of the Venetian Am-

bassadors," existing in various versions, ascr. to the school of Gentile Bellini. The figures in the drawing appear in the version in Mrs. Louis Stern Coll. in Paris (Photo Witt Library). The drawing is a *"simile"* which might go back to Gentile Bellini's studies in the East.

MARCO MARZIALE

[Mentioned 1495–1507]

802 LONDON, BRITISH MUSEUM, Sloane C 7–47. Portrait of a young man, full face. Bl. ch., on grayish yellowish. 399 x 311. Publ. by. S. Colvin, in *Vasari Society,* IV, 8, as an anonymous Venetian, cautiously suggesting, in view of the German stylistic influence, Marco Marziale as the painter, and as the sitter possibly Albrecht Dürer at the time of his stay in Venice 1505–7.　　　　[*Pl. XL*, 1. **MM**]

The man represented shows a remarkable resemblance indeed to Dürer's self portraits at that time. For instance, the one in the "Feast of the Rose Garlands" (ill. *Klassiker, Dürer,* 34 and 38). The tentative attribution to Marziale is not only supported by the general German influence typical of Marziale, but also by the close affinity to the man standing at the r. in Marziale's "Circumcision," in the Museo Correr in Venice, of 1499 (ill. van Marle XVIII, fig. 280).

DAMIANO MAZZA

[Mentioned c.1572, pupil of Titian]

A 803 MILAN, BRERA. St. Helen kneeling near the cross, two female saints behind her and two male saints, a bishop and a warrior, standing at r. Pen, wash, height. w. wh., on greenish. 400 x 230. Arched top. Publ. in Malaguzzi-Valeri, *Brera,* no. 6 as Carletto Caliari (?), attr. to Mazza by Hadeln, in *Zeitschr. f. B. K.,* N. S. XXIV, 1913, p. 254 as "probably a first idea for his (lost) painting in San Silvestro in Venice."

Afterwards the painting was found and publ. in *Boll. d'A.* 1930, p. 431, and shows no resemblance in composition and style to the drawing; even the saints represented are different. The style is evidently under Veronese's influence, something not to be expected in Mazza who was a follower of Titian.

PARRASIO MICHELI

[Born before 1516, died 1578]

This pupil and friend of Titian and Paolo Veronese can hardly be grasped as an individual artistic personality. The drawing in Berlin, No. **804**, authenticated by the inscription of Micheli's name and connected by Hadeln in a competent article with Micheli's painting of 1563 in the Ducal Palace destroyed by fire in 1574, is executed with hasty strokes which we have not encountered in other drawings. The seeming closeness to No. **1721** in Munich is better explained by the sketchy execution than by an identity of their authors. The inventive power of Micheli seems to have been rather poor since Ridolfi informs us that he executed paintings after drawings of Veronese (see No. **2094**). We do not remember the drawing in Turin mentioned as by Micheli in Thieme-Becker, vol. 24, p. 528.

804 BERLIN, KUPFERSTICHKABINETT, 2369. A group of Venetian procurators, studies for a lost painting in the Ducal Palace, Venice. Pen, on blue. 246 x 402. The names of the persons represented are added in script. The name of Parrasio is erased. — On the back: More figures of procurators and a nude boy. Coll. Storck, Vallardi, Preyer. Publ. in *Berlin Publ.* I, 88 as Jacopo Tintoretto. Hadeln, in *Jahrb. Pr. K. S.* XXXIV, 1913, p. 166 ff. and *Spätren.* pl. 21, p. 19, recognized the connection of the studies for a painting devoted to the memory of the Doge Lorenzo Priuli, formerly in the Sala del Collegio in the Ducal Palace. The painting was ordered in 1563, delivered and paid for in 1569, and destroyed by fire in 1574.　　[*Pl. CLXVI, 2.* **MM**]

MICHIELI, ANDREA DEI, see VICENTINO.

GIROLAMO MOCETTO

[Born before 1458, died 1531]

Vasari's assertion that Mocetto was a creature of Giovanni Bellini is contradicted by the strong "Mantegnesque" share in his style. At any rate his art appears as a mere reflection of passing influences so that attributing drawings to him remains mere guesswork.

We have nothing of our own to add to the tentative attributions listed by van Marle, XVIII, p. 436, mostly concerning drawings of a purely ornamental character remaining outside the scope of our book. We limit ourselves to referring to van Marle.

FRANCESCO MONTEMEZZANO
[Born about 1540, last mentioned 1602]

This Veronese artist studied with Paolo Veronese and continued to work in Venice where he took part in the re-decoration of the Ducal Palace. We may suppose that he was introduced to such tasks by his connection with Paolo. His studies with the latter are still more fully described in Ridolfi's biography of Aliense (II, p. 207) who copied Paolo's drawings and paintings in common with Montemezzano and Pietro dai Lunghi. From the fact that Aliense was the younger by sixteen years we may conclude that Montemezzano was a member of the shop for an unusually long period. In the 1580's he may already have been independent, as the design in Darmstadt of 1584 seems to confirm. The slightly asymmetric composition recalls Veronese and the extremely careful execution resembles that of Veronese's models. Montemezzano's artistic semblance, however, can hardly be considered as well established. The study at Oxford, No. 807, apparently well-authenticated, shows no stylistic relationship to No. 805 to which, on the other hand, the drawing in Dr. Mather's coll., No. 809, is closely related. From the same period as Nos. 806, 808 are two portraits, already identified as works by Montemezzano in the Mariette Coll. They are authenticated by Vasari who owned them, and by their use in the family portrait of the Regazzoni, independently attributed to Montemezzano (Dresden, no. 248 A). Their plain but convincing faculty of characterization confirms Ridolfi's statement (II, p. 140) that Montemezzano excelled as a portrait painter. The distance between him and his teacher remained noticeable in this field also, his coarser nature making no pretensions to the visual and spiritual nuances in which Paolo excelled.

805 DARMSTADT, KUPFERSTICHKABINETT. Design for an altar-piece, representing Saint Mary Magdalene carried towards heaven by angels, beneath bishop saint and Saint Margaret. Pen, wash. 449 x 277. Inscription, written and signed by the artist concerning the execution of the altar-piece and dated 1584, May 26. Coll. Mariette, Dalberg. Publ. by Schönbrunner-Meder 599, Hadeln, *Spätren.,* pl. 64.

806 ————, Portrait study of a girl, used in the family painting in the gallery in Dresden (ill. *Cicerone* XVII, pl. opposite p. 295). Bl. and red ch., height. w. wh., on blue. 288 x 208. On top a strip is added. Traces of an old annotation l. of the r. eye. Coll. Vasari, Mariette, (already recognized as Montemezzano in the Sale Cat. 1775, No. 526), Dalberg. Later ascr. to Paolo Veronese. Hadeln, *Spätren.,* pl. 65, p. 20: Montemezzano. *Stift und Feder* 1929, 12.
[*Pl. CLXVIII, 2.* MM]
See the companion piece No. 808.

807 OXFORD, CHRISTCHURCH LIBRARY, K 18 A. Crucifixion with the Magdalene at the foot of the cross. Pen, bl., wash, height, w. wh., on faded blue. 310 x 199. Stained by mold. Corrected in part on a piece of paper pasted over. Inscription in bl. ch.: Monte Mezzano. Ridolfi Coll. Ill. Bell, Pl. LXXVI. [*Pl. CLXVIII, 1.* MM]
There is hardly a possibility of checking the old attribution which, traceable to Ridolfi, seems trustworthy, in spite of the difference in technique from No. 805. The painting "Adoration of the Cross" in the Spinelli Coll. in Florence (Fiocco, Gronau and Salmi, *La raccolta Severino Spinelli di Firenze,* 1928, pl. 30), attr. there to Montemez-

zano, shows a certain resemblance. A "Crucifixion" by Montemezzano in San Giovanni Nuovo (called also San Giovanni in Oleo) is still mentioned by Zanetti p. 373.

808 PARIS, ÉCOLE DES BEAUX ARTS, Masson Bequest. Portrait study of a girl, used in the family portrait from the Regazzoni palace, now in Dresden. Bl. ch., height. w. wh. and a little red ch. 307 x 210. Coll. Vasari, Mariette (probably the second female head mentioned in Basan's *Cat. of the Mariette Sale* 1775, no. 526). Exh. École des Beaux Arts, 1935, *Cat.* no. 70, where the connection with the painting in Dresden and the companionship to the drawing in Darmstadt No. 805 were recognized. Otto Kurz in *O. M. D.* 1937, Dec. p. 44.
[*Pl. CLXVI, 1.* MM]

809 WASHINGTON CROSSING, PA., COLL. F. J. MATHER JUNIOR. Design for an altar-piece with the Martyrdom of St. Catherine in an architectural framing. Pen, wash, height. w. wh., on bluish paper. Coll. Grahl, Geiger. Publ. by Planiscig-Voss, pl. 46, as Montemezzano, correctly referring to No. 805. [MM]

810 WINDSOR, ROYAL LIBRARY, 043. Two ladies and a dwarf standing in the portico of a country house. Pen, wash, height. w. wh., on blue. 278 x 196. Inscription: P. Veronese. Publ. by Hadeln, *Spätren.,* pl. 66 as Montemezzano.
The general arrangement resembles the fresco in Dresden (see No. 806), now attr. to Montemezzano.

MORO DAL, see ANGOLO.

NATALINO DA MURANO

[Died about 1560]

The little that is known of Natalino, or Nadalino, da Murano is brought together in Hadeln's article in *Zeitschr. f. B. K.,* N. S. XXIV (1913), p. 163 ff. Our attributions of drawings to him rest almost entirely on traditions preserved in older collections. Such traditions deserve consideration in the case of an almost forgotten artist, especially in the case of No. 815 from Ridolfi's collection.

A BAYONNE, MUSÉE BONNAT, no. 1214. See No. **A 1292.**

A BERLIN, KUPFERSTICHKABINETT, no. 5042. See No. **A 1293.**

811 BESANCON, MUSÉE, No. 1377. St. Joseph seated, resting on his staff. Bl. ch., on blue. Ascr. to Titian.

Tentatively attr. to Natalino. The figure shows a stylistic dependency on that of St. Joseph in Titian's "Nativity" (painting and woodcut ill. in our *Tizian-Studien* fig. 122 and 123). The St. Joseph in an anonymous painting in the N. G., London, no. 1377, is similar in style.

812 FLORENCE, UFFIZI, 12787. Woman seated over clouds, holding a shepherd's staff; the r. hand resting on a cloud (?). Bl. ch., on blue. 225 x 182. Ascr. to Natalino. **[MM]**

Our attr. to Natalino rests merely on the old ascription.

813 ————, 12788. Apostle standing, to the r. Bl. ch., height. w. wh., on blue. 267 x 173. *[Pl. XCI,* 4. **MM]**

Close in style to the mosaics in the sacristy, St. Mark's Church in Venice, ascr. to Titian's shop.

814 ————, 12789. Apostle (?) standing, en face, to the r. Bl. ch., on faded blue. 250 x 188. White spots. **[MM]**

Possibly first idea for one of the figures on the ceiling in the sacristy of St. Mark's Church, attr. to the shop of Titian. Companion piece to No. 813.

815 OXFORD, CHRISTCHURCH LIBRARY, A 53. Group of nymphs and cupids with fruits. Pen, br., wash. 180 x 171. Very much damaged and patched. Coll. C. Ridolfi.

PACE PACE

[Mentioned in Venice in the last decade of the 16th century]

Pace Pace, son of Filippo Bontecchi and not to be confused with Titian's follower Zuan Paolo Pace, belongs to the intimate circle of the Caliari family, appearing as witness at Gabriele's wedding and in Benedetto's last will. The attribution to him of No. 818 supported by an old inscription, therefore seems trustworthy and allows to claim for him also No. 816, a copy from one of Veronese's paintings destroyed by fire in 1577. Taken together, the two drawings give a sufficient idea of a somewhat dry, but rather personal manner of drawing, to justify the attribution of two further drawings in the Uffizi, Nos. 817, 819, one ascr. to him of old, the other attr. in the collection to Carlo Caliari.

816 FLORENCE, UFFIZI, 1828 F. Copy from Paolo Veronese's painting "Emperor Frederick Barbarossa presenting his reverence to the Pope," in the Sala del Maggior Consiglio, destroyed by fire in 1577 (see No. **747).** Brush, br., height. w. wh., on blue. 390 x 270. Late inscription: Tintoretto. Ascr. to Tintoretto. Publ. by E. Tietze-Conrat in *Art Quarterly,* Winter 1940, p. 20, fig. 9, who already tentatively suggested the name of Pace Pace in view of the stylistic resemblance to No. **818,** but erroneously supposed the drawing to be copied from Tintoretto. *[Pl. CLXVIII,* 3. **MM]**

817 ————, 12884. Trinity surrounded by St. James, Mark and Justina, and three worshipping dignitaries recommended by allegorical female figures. Pen, br., wash. 175 x 308. Cut at all sides. Ascr. to Pace Pace. *[Pl. CLXVI,* 3. **MM]**

The iconographic elements suggest a representation of the Battle of Lepanto and thereby an origin after 1572. The composition is very close to Paolo Veronese, the style of drawing is that of a copy, compare No. **816.** The traditional attribution to Pace Pace is confirmed by the connection of both, No. 816 and No. 817, to Paolo Veronese.

818 ————, 12885. The Lord performing miracles, and apostles. Brush, gray, height. w. wh. (partly oxidized), on blue. 200 x 586. Badly damaged. On the back old inscription: Pase Pase.

819 ————, 12891. Madonna and Child, enthroned between two saints; in the foreground a family of donors (seven members) in half length. Brush, gray, height. w. wh., on blue. 185 x 300. Badly damaged. Ascr. to Carletto Caliari.

Close in style to No. **818.**

ANTONIO PALMA

[Born about 1510/15–died after 1575]

Squeezed in between the more domineering figures of his uncle and his son, Antonio Palma is hardly more than a shadow; as an artist he is almost entirely absorbed by Bonifazio Veronese who was his teacher, and the two signed paintings preserved are not sufficient to distinguish him from other members of Bonifazio's shop. The repeated efforts of Miss Westphal (*Bonifazio Veronese,* Munich, 1931; *Zeitschr. f. B. K.* 1931/32, p. 16; Thieme-Becker, vol. 26, p. 171) have not succeeded in giving him a more prominent place. As for drawings, Suida's ascription of one single drawing, or even only one side of a drawing, picked out from the hundreds in the two scrapbooks in Munich, rests on the fact (which we admit) that the drawing on the back of vol. I, 120, looks earlier than the typical Palma Giovine on the *recto*. Is this sufficient to list it as by the hand of Palma Giovine's father? We do not feel entitled to reject this daring hypothesis positively, our own thesis regarding the two portrait studies of a young woman in Erlangen (No. 820) also resting on rather feeble foundations.

820 ERLANGEN, UNIVERSITÄTSBIBLIOTHEK, Bock 1540. Two portrait studies of a young lady. Charcoal, height. w. wh., on blue. 207 x 279. Old inscription: giulia palma mglie (moglie?) di Antonio (?) palma. Bock's attr. to Palma Vecchio seems unlikely even on the basis of external reasons. Giulia who married Antonio Palma (born about 1515) only after his arrival in Venice in the 1530's was probably a child when Palma Vecchio died in 1528. The style, too, conforms less to Palma Vecchio's than to that of the next generation, and a certain approach to Bonifazio may justify the tentative attribution to his pupil Antonio Palma, Giulia's husband. See the later portrait of Giulia Palma by her son, No. **1029**. [*Pl. CLXIX*, 1. **MM**]

A MUNICH, GRAPHISCHE SAMMLUNG, Scrapbook I, 120 *verso*. See No. **1037**.

GIACOMO PALMA GIOVINE

[1544–1628]

Palma's course of education was the normal one for the scion of a family of painters: he learned his art with his father, the nephew of the great Palma Vecchio (Ridolfi II, p. 172: Jacopo was set to drawing by his father). Having reached the stage of copying great models with the brush and at the age of about fifteen years obtaining the patronage of the Duke of Urbino, Palma was permitted to continue his training in Rome for about eight years. Here he drew from the famous classic statues, from Michelangelo and Polidoro da Caravaggio. Some of these drawings even after his death were preserved by his pupil Jacopo Albarelli (see p. 198 f.). When he was twenty-three or twenty-four years old Palma came home and after some further minor wandering settled down in Venice. His life and work there starts at the end of the 1560's. In the years preceding his stay at Urbino and Rome we may imagine him copying drawings or paintings not only by Palma Vecchio, who was the glory of the family and an object of special devotion for Palma Giovine (see p. 226), but also by his father who, as a favorite pupil of Bonifazio and the husband of his niece, may have inherited part of the material from this prolific workshop. The "sketchbook" from the Bonifazio shop in the Louvre, tentatively ascr. to Schiavone (see No. 1448) and also containing vestiges of Palma Vecchio (see No. 1267) illustrates the background of Palma Giovine's first training. The technique and style of this school production clearly reveal relationships to authentic drawings of Palma (No. 837–857, 1241 ff.). In view of this sketchbook from Bonifazio's circle and Palma's presumable early education we understand why he felt Polidoro to be the most Venetian among the Romans ("perchè si approssimava allo stile Veneto," Ridolfi, II, p. 173).

When listing Palma Giovine's early paintings Ridolfi adds the following seemingly without any special connection: all his life he continued to study the works of Titian and Tintoretto whom he considered the fathers of art. May we deduce from this somewhat abruptly inserted passage that after his return to Venice Palma entered these two studios either to complete his education, or as an assistant? We have, however, to keep in mind that according to Borghini (p. 559), Palma worked independently in San Niccolò de' Frari when only 23 years old. There are a few arguments in favor of a contact with the two great masters. With regard to Titian, it fell to Palma to finish the "Pietà" left behind unfinished. With regard to Tintoretto, the curious passage in Palma Giovine's last will in which the 82-year-old artist pays a debt of gratitude contracted many decades earlier to the Tintoretto family. He even seems to apologize for not having entered into closer collaboration with Domenico Tintoretto. The most striking argument, however, in favor of a contact with these two leading artists in Venice is Palma's stylistic dependence on both.

If, besides this dependence of Palma, the painter, on Titian and Tintoretto, we desire also to investigate that of the draftsman, we enter a field that presents several difficulties. Titian's draftsmanship in his late years is represented only by very few examples. Good connoisseurs have added a few more which, however, are by Palma; this mistake itself may confirm the theory that at a certain period Palma's drawings approach Titian's latest style in drawing. The other theory, of Palma Giovine's relationship to Jacopo Tintoretto, gains a certain support from the fact that a whole group of drawings originating in Tintoretto's shop shows a close resemblance to Palma Giovine (see No. 1820). Might he have done them under the strong influence of Tintoretto? Before going further, we have to form for ourselves an idea of Palma's early style on the basis of well-authenticated drawings to justify our claim for him of part of the material passing under the names of Titian and Tintoretto.

The drawing usually supposed to be the earliest by Palma Giovine, the portrait of the Spanish painter Matteo Perez da Lecce (Perez de Alesio) of 1568 can be eliminated (see No. A 1045). There are, however, some drawings preserved that are connected with Palma's early paintings in the sacristy of San Giacomo dell' Orio and with his St. Lawrence in the same church. No. 1018 in Sir Robert Witt's collection, because of a superficial resemblance to the motive of one of the figures in Jacopo Tintoretto's "Gathering of Manna" in S. Giorgio Maggiore, is attributed to Tintoretto. It is, however, the exact study for one of the women in Palma's "Passover" in the sacristy in question. We connect the red ch. drawing, No. 1017, to the legal opinion which Palma Giovine jointly with Paolo Veronese, had to give in 1578 on Jacopo Tintoretto's four mythological representations in the Salotto Quadrato. Between 1578 and 1584 the two smaller ceilings in the Sala del Maggior Consiglio were executed; for one of them, the "Victory of the Venetians at Cremona," a study exists in the Liechtenstein Collection in Vienna (No. 1237). For the main work at the same place, the "Coronation of Venice," several sketches (and shop versions) from the same period exist which permit us to reconstruct the evolution of the ceiling (Nos. 911, 1015, 1030). The latest work mentioned by Borghini and accordingly executed in the early 1580's is the grandiose ceiling, the "Assumption of the Virgin," the lower part of which is preserved in the Hermitage, while the general sketch (in oil) of the whole exists in the Querini Stampalia Collection at Venice. The drawings connected with this composition, No. 1129 and No. 975 may safely be dated around 1580. Other works mentioned by Borghini are the "Visitation" in Santa Maria del Giglio (drawing No. 840), the "Apocalypse" in the Scuola di S. Giovanni Ev. (general sketch No. 1236, horseman No. 884), the "Legend of S. Lawrence" in S. Giacomo dell'Orio (modello, or more likely shop repetition, No. 1117; a man digging, No. 883). Therefore for quite a number of drawings an origin before 1580 is well established, and they illustrate sufficiently Palma Giovine's style of draw-

ing for the decade 1570/80. From the 1580's are most of the paintings in the Oratory of the Crociferi (Nos. 824, 1167, 889), the study for the Paradiso, of 1588 (No. 1143), the murals in the Sala del Maggior Consiglio (No. 1156), the "Last Judgment" (No. 1142). From the early 1590's are the paintings in the sacristy of the Gesuiti (total sketch, No. 1056, and a study of a separate figure, No. 1154). The "Brazen Serpent" in Siena (1599, designs Nos. 905, 918) and to its very end the ceiling in the Ateneo Veneto of 1600 (drawing No. 1180) belong approximately to the same period.

In looking over the drawings listed up to this point embracing the production of the young master from his establishment in Venice in the late 1560's to the end of the century, we notice that several of the more important ones have been published by recent authors under the names of Titian and Tintoretto. They are partly studies in black chalk and partly pen sketches. Let us first discuss the chalk drawings. No. 1180 made by Palma in 1600 was compared by Stix, when he first published it, to draperies drawn by Titian three quarters of a century earlier, to a Bordone erroneously attributed to Titian by Hadeln, and to a Cavedone. This indicates a very vague idea of Titian's mode of drawing. It is an important fact that Palma—in his style of around 1600—fits very well into such an idea of Titian, for such a misjudgment contains, nevertheless, something of a judgment. Part of Titian's very late style is revived in Palma's hasty routine work. If isolated and regarded as by Titian, the drawing assumes qualities which it loses at the very moment it is again absorbed into the mass of drawings by Palma. What might be considered a contempt for details in a work by Titian from his oldest age becomes superficial routine in one by Palma. Although we are willing to understand the psychological sources of the mistake we must still emphasize the stylistic difference between the two artists. Nothing in this drawing points to the early Titian's youthful liveliness that permeates every form; nothing, on the other hand, points to the late Titian's mastery in evoking the full meaning of a representation by a mere suggestion. Most important of all, however, the rhythm of the drawing is entirely different. It is curious to note that such a prolific draftsman as Palma Giovine should seem to have suffered from a restraint in his wrist. The flow is always suddenly brought to a stop, the inspiration drops before it reaches its aim. Rarely does Palma succeed in bringing his vision to fulfillment. When the chalk is replaced by the pen, the break is less striking, but the fragmentary character is still there, though now hidden in calligraphic flourishes. There is hardly a drawing in which the vision is sufficiently clear for the realization of the hands, and none in which the feet are realized. The painter who in his youth had drawn nudes after classical statues and Michelangelo's cartoons, had not learned to utilize their approach to reality in his own art.

We should like to point out, in this connection, a drawing in Berlin, No. 831, published in 1910 as by Titian, but not accepted by Hadeln and recognized and published by E. Tietze-Conrat as the study for a universally acknowledged early painting by Palma Giovine in the Cà d'Oro. In his analysis of the painting A. Venturi (v. 9, VII, p. 200) emphasized the late Titian's influences, and even E. Tietze-Conrat, then less familiar with Palma's manner of drawing, weighed the possibility that Palma Giovine might have based his painting on a drawing by Titian.

The fact, however, that second-rate artists sometimes, when working under the influence of a stimulating teacher, reach a point seemingly beyond their faculties, is by no means exceptional. When Palma completed Titian's "Pietà" he may have experienced such a stimulation which carried him beyond his limitations. At that time he may also have come to own No. 1897, the magnificent "Helmet," closer to Titian, in our opinion, than to anyone else. The study on the back, apparently outside of Titian's possibilities, might without difficulty be Palma's (compare the drawing No. 1037, II 246 connected with the votive painting in San Fantino).

The differences between Palma and Jacopo Tintoretto are easier to grasp, Tintoretto as a draftsman being

more distinct for us than Titian. We choose No. **883** as an example, the study of a man with a shovel, used in the "Martyrdom of S. Lawrence" in San Giacomo dell'Orio. The decisive difference lies in the desire for concreteness; the function is by far less important than the impression. In the arm hanging down, the elbow is just a crease in the sleeve; the knees are bulges in the trousers, and the modeling is limited to hatchings. Shadows on the floor determine the figure within the space. The artist is not interested in the foreshortening. Everything is casual, and nothing is definitely fixed. The person who had to use such a study for a painting could not with complete confidence, transfer it, squaring and all, to the canvas; much of the final inspiration is left to brush and color. In the ultimate execution, areas of shading will have to equalize superficially prepared elements.

No. **884**, also in Darmstadt, a study for Palma's "Apocalypse" in the Scuola di San Giovanni Ev., is to be compared to Tintoretto's so much more precise horseman, No. **1635**. For No. **824** we have no companion piece by Tintoretto; Hadeln himself who published the drawing as by the latter, stressed its uniqueness in his oeuvre. The insistence on individual resemblance, the momentary element in it correspond to the striving for concreteness that we found as the anti-Tintorettesque feature in Palma's figure drawings.

A more dangerous confusion than the erroneous attributions of this and other black chalk studies to Jacopo Tintoretto, were caused by the mistake concerning the drawings in Salzburg. While the spurious black chalk drawings obscured the picture of Tintoretto's style only slightly, the ascription of the pen drawings in Salzburg nullified Hadeln's successful efforts to purge Tintoretto's *oeuvre* and opened the door for numerous new attributions. Together with No. **1156**, rightly recognized by Meder as Palma's study for his painting in the Sala del Maggior Consiglio, they form a homogeneous group, so close in style to some of the drawings in Munich, that their attribution to Palma would be beyond doubt even if Palma's *modello* for his "Paradiso" in which the Salzburg drawing (No. **1143**) is used were not preserved both in the original and in an engraved copy.

Palma's style for pen drawings is by no means stereotyped. In the years from about 1580 to the beginning of the 17th century, for which abundant material for study is available, it is much varied and capable of development. Let us, for instance, examine the sheets, homogeneous in technique and date of origin, of the dismembered album in the Liechtenstein Collection and in the Albertina; the date is approximately established by the connection of No. **1237** to the painting in the Sala del Maggior Consiglio (1578 – about 1580). The drawings are done on brownish paper with strong outlines and a modeling produced by wash, heightening with white, and hatchings. The compositions, as far as they represent battle scenes, and some of the types recall the style of Tintoretto's ceilings in the Ducal Palace. The sheets of another dismembered sketchbook, now in Brno, are somewhat different. For the dating the only help is offered by No. **840**, a study for the "Visitation" in S. Maria Zobenigo, already mentioned by Borghini, and therefore anterior to about 1580. We do not know how far back we are allowed to go, the painting may be early since it is listed toward the first of Borghini's apparently chronological enumeration. The drawings are less rounded, the outlines uncertain and the modeling less plastic than those in the Liechtenstein Album. A comparison of No. **838** to the pen sketch No. **839** discloses such a difference that we are inclined to suppose a different date of origin. The conformity of the compositions may also be merely accidental. Still more confusing is the juxtaposition of No. **1233** and No. **1111**. Almost all the figures are similar, but while the style of No. **1233** corresponds exactly to that of the other drawings in the same album, and to their presumable date of origin about 1578–1580, No. **1111** is much closer in its style to the much later No. **991**, P. 67, No. 116, and may be explained by a later return of Palma to earlier tendencies.

Degenhart limited himself to Palma's pen drawings and he reproduces, as fig. 297, a detail of No. **912** as

evidence of Palma's un-Venetian style, while in fig. 246 he illustrates the "typically Venetian mannerism" by a detail from No. 913, of old, but nevertheless, incorrectly ascribed to Malombra. The un-Venetian element in Palma's style, according to Degenhart, is to be explained by the Bergamasque descent of Palma's family. Malombra, whom he accepts as a pure Venetian is Cremonese by origin—something that Degenhart overlooked—which means ethnically no less a Lombard than Palma. In Palma, it is true, we have also to assume besides the Lombard a Veronese element brought to him by his mother who, incidentally, was a niece of Bonifazio Pitati, and therefore possibly capable of influencing her son. Degenhart insisted on the Lombard element in Palma's style, while Heil had explained the difference from other Venetians by the contact with Polidoro da Caravaggio in Rome. In our opinion, it is Degenhart's most serious mistake to have deduced the characteristics of Palma's style exclusively from the pen drawings, while entirely neglecting other categories in which Palma certainly is soft and picturesque. The only one of these other studies which he mentions is No. 900, a huge *modello* executed with the brush over black chalk, formerly ascribed to Jacopo Tintoretto, but attributed to Palma Giovine by Heil. In view of "the dissolution of the line" appearing in the drawings, Degenhart prefers to attribute it to Jacopo Tintoretto, another pure Venetian, instead of Palma, who by his blood is a Bergamasque. The drawing should not be considered separately, since it is only one specimen, an unusually large one, to be sure, of a great number of *modelli,* several of which are firmly linked to Palma by the paintings to which they belong. No. 1108, for instance, for the altar-piece in San Geremia or No. 891 probably for an altar-piece in Murano or No. 974 for a painting in Sebenico are evidences that the drawing in the Uffizi, in spite of the dissolution of the line, is by the Bergamasque-Venetian, Palma Giovine.

Besides the pen drawings there are many washed broad pen sketches so fully corresponding to the most Venetian ideal of a picturesque dissolution of form that even von Hadeln's well trained eye was deceived for some time. He was the first to publish No. 830 as by Jacopo Tintoretto, but later withdrew this attribution.

The ascription of this group of drawings to Palma Giovine is difficult to prove, since, as a matter of fact, not one of them is backed beyond doubt by the connection with a painting. In Nos. 981 and 1095 we may perhaps recognize a connection with the "Entombment" in the Redentore, but it is too loose to make it the foundation of a convincing ascription of the whole group to Palma. This is why No. 1126 is so very welcome. It combines one of these puzzling specimens of Palma's picturesque style, on the *recto,* with a typical pen drawing on the *verso,* accompanied moreover by one of his typical scribbled heads and, last but not least, a calligraphic scrawl. What is the place of this very special group within the chronology of Palma's oeuvre? The altar-piece in the Redentore is not dated, Lorenzetti (p. 723) places it at the end of the 16th century. The composition is certainly dependent on Jacopo Tintoretto (Bridgewaterhouse). Moreover, the composition of No. 1126 is certainly dependent on Tintoretto's late style (ground floor of San Rocco). The mode of drawing on the *verso* points also to the end of the century. We are inclined to allot the whole group in this mixed technique which in No. 1043 looses itself in pure brush, to the 1590's, Palma Giovine's Tintorettesque period. It is Tintorettesque not so much for the penwork, but rather for the structure of the composition, the slanting diagonals, the subordination of the single elements within a general ornamental pattern. Like No. 1126, No. 861 also offers an important clue as it combines, in the unfinished body of Christ, a typical chalk study with figures typical of the puzzling group in question.

The scribbled head on the *verso* of No. 1126 leads us to a group of pen drawings corresponding in our opinion to Palma's "Academy," etched by Giacomo Franco and published in 1611, thus providing a date. Palma's friend-

ship with Giacomo Franco goes far back in the 16th century. (Franco was a witness when Andriana Palma made her last will in 1582.) He might therefore have used for his modelbook *"De eccelentia et nobilitate delineationis"* older drawings by Palma. They are, however, so homogeneous in style and to such a degree adapted to the special purpose of the etchings that we believe they form a unit; we place their origin in the vicinity of the year of publication. (We may also point to Odoardo Fialetti's similar *"Il vero modo et ordine per dissegnar tutte le parti e membra del corpo humano,"* Venice, 1605, which might have offered a model.)

These drawings are not washed, the lines play casually on the paper, ending in a flourish. A lack of preciseness becomes an *impromptu*, a deficiency is turned into an advantage. That such facility, a playing with the form, was meant to be the foundation of academic art and, indeed, became such a foundation (see Gino Fogolari, in *L'Arte,* vol. XVI, p. 242) illustrates the change art had undergone. What a long way from the precision of a study by Alvise Vivarini (No. 2245) to the looseness of such studies!

The date of this "Academy" marks the outer limit of our task. Here the end of the Venetian Renaissance is reached which, in spite of all the trends of the second half of the 16th century toward subordinating details, still remains devoted to individual reality. We witness in Domenico Tintoretto the dissolution of Jacopo Tintoretto who up to his end remained a classic. In Palma Giovine, the same dissolution supplies mere dry study material.

What we possess of his later drawings, from about 1610 to the year of his death in 1628 (quite a stock is gathered in the London Scrapbook (No. 991), but they also appear elsewhere in groups) shows an increasingly more exhausted and more exhausting repetition of earlier inventions. The linework becomes still more loose, the meshes grow wider until at the end, the structure is so void and fibrous that we feel the trembling of the hand that guided the pen. But Palma did not stop drawing. "The drawings which he made in various techniques from the Old and the New Testament and from which he drew inspiration for his compositions were innumerable, and he turned out also many drawings just by caprice. Hardly had the table cloth been removed after his meals when he asked for the pencil, all the time formulating some idea, and many of such drawings still exist." (Ridolfi, II, p. 203). Drawing was for him the most important outlet of his artistic personality. In his last will he inserted a long passage returning his thanks to the House of Tintoretto by bequeathing Domenico four drawings, which apparently he estimated highly, though adding that they were only trifles and asking Domenico Tintoretto to accept them as souvenirs. In the same last will the large studies made in Rome are bequeathed to Jacopo Albarelli, his pupil of long standing.

Drawings by Palma are also mentioned in Philip Esengren's last will. He bequeathed four volumes with drawings by Palma to the painter Iseppo Alabardi (Giuseppe Alabardi, called Schioppi) and to Matteo Ponzone "six volumes with drawings made by myself in the Academy" and to Filippo Zanimberti further volumes of the same description. He accordingly bequeathed volumes with drawings by Palma Giovine and volumes with drawings apparently made by himself in Palma's shop.

Zanimberti (born 1585) was a pupil of Peranda, who himself was a pupil of Palma Giovine. The material of studies handed down in the last will must necessarily have strengthened and spread the style of the school. We have to keep this in mind to grasp the meaning of the drawings gathered in the two volumes at Munich (No. 1037). Most of the material seems to be by Palma himself, but it also contains many drawings rather distant from him stylistically, and quite a few judging by the dates inscribed on their backs fall beyond his lifetime. The two volumes are certainly not sketchbooks by Palma Giovine, as the material preserved at the Liechtenstein collection and at Brno may have been, but scrapbooks illustrating the activities of the shop and its continuation. The hetero-

geneity of the material was already felt by Mrs. Fröhlich-Bum who tried to pick out of the cake some plums: Veronese, Tintoretto, Andrea del Sarto. It was easy to rectify such mistakes. In a scrapbook, easily recognizable by the character of the drawings as shop material and not as a collected stock, such a mixture of specimens by various leading artists, lined up like a list in a sales catalogue, seems *a priori* unlikely, if not impossible. The sketches, in part only shreds, in part in larger format, are chips from a workshop, carefully preserved by some pupil and later on enriched by his own material. The existence of such scrapbooks shortly after Palma's death is proved by Esengren's last will which mentions four of them. Those in Munich seem to have been brought together towards the end of Palma's lifetime, since they also contain drawings from his very latest period. Some are so poor in quality that at best they may be copies from Palma drawings. There is even one German among them (II, 214) and a few dated from the middle of the 17th century, which means a quarter of a century after Palma's death. Since the earliest, however, seem to go back as far as the 1580's, we imagine the material was collected by one of Palma's pupils who had worked with him for years, probably until his death. Such a description would very well apply to Albarelli who had been in Palma's service for 34 years. But we know his estate from his last will, and these books do not form part of it. Perhaps they were brought together within the shop, possibly under Palma's supervision, and may have belonged to the professional material bequeathed by Palma to his grandson. The boy was only 9 to 10 years old at that time, and Jacopo wished very much that he might become a painter and assume the name of Palma. It does not seem likely that either happened, since neither Ridolfi, nor any other source, tell us about a continuation of the shop after Palma's death. If the liquidation took place soon afterwards, Esengren, whose keen scent as an art dealer is mentioned with some malevolence by Ridolfi (I, p. 224), may have acquired the book, the later additions to which may be by Alabardi or some of his successors. The book in London is, in our opinion, homogeneous and contains drawings exclusively from Palma's late period. Together with the two volumes in Munich and the dismembered early sketchbooks at Liechtenstein's or in Brno, it is a late companion piece to Jacopo Bellini's books in London and Paris.

The great achievement of Jacopo Bellini's shop, in laying the foundation of the whole art of perspective and composition, in Palma's books is contrasted by the ultimate subjectivism of an artist who drew for relaxation. From the innumerable possibilities presenting themselves to the artist he occasionally chooses something to become final in a painting. Certainly for Palma Giovine, as it had been for the Bellini, art was an austere mistress. But drawing, just as its companion etching, seemed satisfied to be mere play.

821 AMSTERDAM, COLL. REGTEREN ALTENA. Baptism of Christ. The figure of Christ is separately repeated, above fragment of the Virgin and Child. Pen, traces of red ch., on white paper. 138 x 174.
Late 16th century.

822 ————. St. Jerome. Pen, wash, on greenish gray. 200 x 160. Late.

823 ————. Sketches: three angels flying. Pen, br., wash. 362 x 241. Stained by mold. — On *verso:* Girl seated and nude boy seated, seen from behind. Inscription: G. P. N° 158. Exh. Amsterdam 1934, Cat. 598, ill.: connected with Palma's "Last Judgment" in the Sala dello Scrutinio, in the Ducal Palace (1587–94). [Both sides **MM**]
The figures do not appear in the painting, but the style of drawing corresponds to its date.

824 BASEL, COLL. R. VON HIRSCH. Portrait of a bearded man. Bl. ch., height. with wh., on blue. 330 x 210. — On the back inscription:

J. T. N° 5. (Borghese Coll.?) Publ. by Hadeln, in *Pantheon*, 1929, II, 422 as Jacopo Tintoretto. Identified by E. Tietze-Conrat in *Graph. Künste* N. F. I, p. 140 as design by Palma used with very slight modification in his "Entombment of Christ" in the Oratorio dei Crociferi, Venice. According to Ridolfi II, p. 180 the person represented in the garb of Joseph of Arimathea is Luca Micchele, procurator of S. Marco. The paintings in the oratory were executed in the late 1580's.
[*Pl. CLXXII,* 2. **MM**]

825 BAYONNE, MUSÉE BONNAT. 1377. Annunciation. Pen, gray, wash, on yellowish paper. 270 x 163. Squared with bl. Semicircular top. (Photo Archives P 865). Anonymous. [**MM**]
In our opinion by Palma about 1620.

826 BERGAMO, ACCADEMIA, 794. Draped figure, seated on clouds. Bl. ch., height. w. wh., on blue. 146 x 223. — On *verso:* Nude flying downward.
Late 16th century.

827 ———, 810. Sketches: Christ enthroned, nude flying downward, head. Pen, reddish br., on blue. 290 x 275. — On *verso:* Figure flying downward. Inscription in pen: Palma.
Late 16th century.

828 ———, 812. Female nude recumbent on clouds. Pen, gray and br., on blue. 262 x 202. — On *verso:* Sketches: angel, below (in red ch.) worshipping souls.
Late 16th century.

829 ———, 2348. Sketches for a "Massacre of the Innocents" (?). Pen, br., on blue. 138 x 150.
About 1580 — 1590.

830 Berlin, Kupferstichkabinett, 4267. Christ with disciples in Emaus. Pen, wash, on grayish br. 207 x 296. — On *verso:* Study for the same composition. The *recto* publ. by Hadeln in *Jahrb. Pr. K. S.* XXXIV, p. 171, as by Jacopo Tintoretto, an attribution which he upheld in *Jahrb. Pr. K. S.* XLII, p. 84, but withdrew in his *Tintoretto-zeichnungen*, p. 31, note 1. [MM]
Identical in style to No. **1126** and other drawings.

831 ———, 5036. St. Mary Magdalene kneeling at the foot of the cross. Charcoal. 249 x 175. Coll. Passavant and Beckerath. Ascr. to Titian and publ. as his in *Berlin Publ.* I 84. E. Tietze-Conrat in *O. M. D.*, September 1936, pl. 19, p. 21 ff.: design by Palma Giovine for his Crucifixion in the Cà d'Oro (ill. Venturi 9, VII, p. 202, fig. 117). [*Pl. CLXX*, 1. MM]
Early.

832 ———, 5551. Venus and another goddess seated, standing god (?) punishing Cupid. Bl. ch., on yellowish paper. — On *verso:* Study for the same figure of Venus. Ascr. to Ja. Tintoretto. [MM]
Typical of Palma.

833 ———, 16380 (16390?). A miracle of the Mass, attended by kneeling worshippers. Two angels above. Design for a horizontal painting, the worshippers are repeated separately. Pen, br., wash, on bluish gray. 178 x 292. Late inscription: J. Palma fecit. Coll. King Frederick William I. [MM]
First idea for the painting in the Oratorio degli Crociferi in Venice, the "Doge Cicogna adoring the Holy Sacrament," dated 1585, ill. Venturi 9, VII, fig. 109. Sansovino (1663) p. 71.

834 Besançon, Musée, No. 1368. Adoration of the shepherds. Pen, br., rich br. and gray wash. 200 x 274. All corners cut. Ascr. to Ja. Tintoretto. [MM]
For the attribution to Palma see No. **1126**.

835 ——— 3128. Head of a bearded man, en face. Bl. ch., wash, on blue. Coll. Gigoux. Ascr. to Ja. Tintoretto. [*Pl. CLXXII*, 1. MM]
Study from nature for the second portrait in the votive painting for the "Battle of Lepanto" by Palma in S. Fantino in Venice. See No. **824** and No. **1037**, II, 246.

836 Bremen, Kunsthalle. The swooning Virgin lying in the lap of a woman sitting on the ground. The Virgin partly repeated in lower l. corner. Bl. ch., height. w. wh., on bluish gray. New acquisition, here ascr. to Ja. Tintoretto. [*Pl. CLXX*, 3. MM]
Study for a painting of the "Entombment of Christ," attr. to Palma Giovine, in the Amerling Sale, Vienna, Schidloff, Dec. 1–14, 1920, no. 58. The attr. to Palma is supported by the close resemblance of

the linework to many other well-authenticated drawings, see No. 1037 II 246.

837–857 Brno, Landesmuseum. 21 Sheets from a dismembered sketchbook, the single pages of which are numbered (between 1 and 59). Pen, bl., wash, height. w. wh., partly oxidized, on greenish gray. About 190 x 265. Coll. Skutetzky, Raigern. Publ. by F. M. Haberditzl, in *Graph. Künste* XXXVI, 1913, p. 86 ff. with three ill.

837, 560. Adoration of the Magi.

838, 561. Mystic marriage of Saint Catherine. — On *verso:* Triumph of a general. [MM]

839, 562. Mystic marriage of Saint Catherine. Pen, on white paper, possibly not from the same sketchbook.

840, 563. Visitation. [MM]
Design for the painting in S. Maria Zobenigo, ill. Venturi, 9, VII, fig. 121. Before 1580, since it is mentioned by Borghini.

841, 567. Queen of Sheba (ill. Haberditzl, p. 86).

842, 568. Martyrdom of St. Sebastian (ill. Haberditzl, p. 86).

843, 643. Baptism of Christ.

844, 648. Unidentified subject: Man sleeping in a tent, attended by two servants. [MM]

845, 649. Beheading of St. John the Baptist. [MM]

846, 650. Crucifixion. — On *verso:* Seated figure with crossed legs. The *recto* preparatory study for Palma's "Crucifixion," Madonna dell'Orto. [MM]

847, 651. Conversion of St. Paul. Haberditzl, p. 87, refers to a painting by Palma reproduced in a chiaroscuro by Kirkall. [MM]

848, 652. "Take up thy bed and walk!" Design for a horizontal composition, variations of some figures below the frameline. [MM]

849, 653. Figure of Christ flying between four large angels.

850, 654. Christ with the apostles, semicircular top.

851, 655. Adoration of the shepherds, semicircular top. [MM]

852, 656. Variation of No. **851**.

853, 657. Christ and the adulteress.

854, 658. Sketches: Doubting Thomas, half-length. — On *verso:* Nudes, hands, head of a horse.

855, 659. Annunciation. — On *verso:* Pentecost.

856, 660. St. Francis receiving the stigmata.

857, 670. Sheet with apparently unconnected studies. One is the first idea for the "Apotheosis of St. Catherine" in the Frari in Venice. [MM]

858 Cambridge, England, Fitzwilliam Museum, no. 69. Sketch for a painting: Christ in the house of Levi with the Magdalene at his

feet. Pen, br., wash. 195 x 290. Clough Coll. Reproduced by Ryland in an acquatint, dated 1767.
Late 16th century.

859 ———— 70. Christ praying, supported by an angel. Pen, br., wash, height. w. wh., on gray. 410 x 185. Semicircular top. Later inscription: Palma Giovine 1575.
From stylistic reasons more likely about 1600 or even later.

860 ———— Recumbent nude, resting on his r. elbow, l. arm raised, looking backward; a bearded man and a woman's head sketched. Pen, br., over bl. ch. sketch. 145 x 143. Coll. Abbot.
Early 17th century.

861 CAMBRIDGE, MASS., FOGG ART MUSEUM, No. 133. Crucifixion with three mourning women; the body of Christ is only sketched in red ch., the other figures washed in gray. 296 x 195. — On verso: Various sketches. Coll. Fries, Lawrence, Esdaile, C. S. Bale, Paul Sachs. Formerly attr. to Ja. Tintoretto, as his exh. Old Master Drawings, Junior League Pittsburgh, 1933, No. 4. Recognized as Palma Giovine by Agnes Mongan and exh. as his at Toledo 1940, Catalogue No. 82. Publ. by Mongan-Sachs, p. 78 f., fig. 79, who point out an evident resemblance with Tintoretto's "Crucifixion" in the Gesuati and with a "Crucifixion" attr. to Palma at Cassirer's, Amsterdam, in 1935. [Pl. CLXXVI, 1. MM]
Last quarter of the 16th century, see p. 197.

862 ————, No. 134. Two figures, one a sleeping apostle, the other a bearded man standing. Bl. ch., height. w. wh., on blue. 180 x 216. Stained by mold. — On verso: I. T. No. 35. (Collection Borghese, Venice) gift of Dr. Denman W. Ross, 1924 — 102. Mongan-Sachs, p. 79.

863 ————, No. 207. Virgin from an Annunciation. Bl. ch., height. w. wh., on yellow. 252 x 167. Badly rubbed, almost producing the effect of a counterproof. Coll. Lindner, Randall, as Paolo Veronese. Publ. as his by Mongan-Sachs, p. 111, fig 155, who acknowledge the weight of our arguments in favor of Palma Giov., expressed orally, but feel in the drawing a High-Renaissance element which induces them to adhere to the older attribution.
We agree to the survival of a High-Renaissance spirit in this drawing, but find the superficial execution so close to Nos. 831, 918, 929, 1018, that we maintain the oral attribution to Palma. Besides we do not see any stylistic connection with the figure studies attr. to Veronese.

864 CHATSWORTH, DUKE OF DEVONSHIRE, 313. Four studies for an Adoration; below the Virgin, Catherine and a king. Pen, br., wash. 168 x 159.
Typical, about 1580.

865 ————, 315. Sketch for the translation of the body of Saint Lucy. Pen, dark br., wash. 282 x 398. Inscription: In Stᵃ Lucia in Venetia. Below: Palma. [Pl. CLXXXII, 3. MM]
The (by now lost) painting which the drawing prepares is circumstantially described by Ridolfi II, 185 in the church of S. Lucia, formerly on the site where later the railroad station was built. According to Moschini II, 78, the chapel was built by Donato Baglione in 1592. This date fits well with the style of the drawing.

866 ————, 316. Studies for twelve saints, apparently all intended for pendentives. Brush, br., height. w. wh., on br. 252 x 402.

867 ————, 617. Saint Jerome writing, and lion. Pen, br., wash. 132 x 103. Signed: Giacomo Palma fecit.
Typical, early 17th century.

868 ————, 753 B. Pietà. Pen, br., height. w. wh., partly oxidized, 87 x 117. Coll. P. Lely.
Typical of late 16th century.

869 CHELTENHAM, FENWICK COLLECTION, Popham 1 to 36. Drawings of various subjects, most of them pen, br., wash, height. w. wh.; formerly in the Lawrence and Woodburn Coll. Because of their origin from Palma's latest period we mention them only summarily and refer to the detailed descriptions by Popham in Fenwick Cat.

870 ————, Popham 37–52. Leaves from an album, each inscribed on the back: P. G. and a number. Pen, br., wash, height. w. wh. All drawings from Palma's latest period, many of them dated. For full description we refer to Fenwick Cat.

871 CHICAGO, ART INSTITUTE, 22.890. Sketches: Single figures and a composition: Mourning over the dead Christ; heads, arms. Pen, br., wash. 273 x 190. — On verso: Similar sketches. [MM]
The composition definitely influenced by Titian's late "Pietà," completed by Palma. About 1580.

872 ————, 22. 2722. Sketches for an Ecce-Homo or a Crowning with thorns. Pen, br. 211 x 161. Gurley Coll.
Typical, end of the 16th century.

873 ————, 22. 888. Flagellation of Christ. Pen, br., height. w. wh., on br. 268 x 203. Framed by a line.
Late.

874 ————, 22. 805. An old man nude, seated, holding a cross (?, St. Jerome?). Pen, br., wash, on br. 233 x 135. Inscription: Palma V.
Late.

875 ————, 22. 887. Prophet, planned for a pendentive. Pen, dark br. 185 x 143. — On verso: Upper part of a man bending forward. Red ch. Old inscription in pen: Palma.
Typical, late 16th century.

876 ————, 22. 1039. Studies from nude men. Pen, br., on brownish paper. 214 x 178. Upper r. corner cut. — On verso: two similar studies.

877 ————, 22. 891. The Saints John the Baptist, Jacob and Francis. Pen, br., wash, height. w. wh., 173 x 122. Semicircular top.
About 1600.

878 CLEVELAND, OHIO. MUSEUM OF ART, 26265. Apollo and the Muses awakened by the call of Fame. Pen, wash. 204 x 261. Coll. Richardson, Mayor, Heseltine. Publ. by Heseltine, North Italian Drawings No. 18. Exh. Toledo, 1940, Catal. 84.
According to Mr. Francis the subject was identified by Dr. Panofsky.
End of the 16th century.

879 COPENHAGEN, KOBBERSTIKSAMLING. Flagellation of Christ. Pen, over red ch. sketch. 307 x 214. Later inscription in pen: Paduanino. [MM]

Typical, end of the 16th century. See No. **2239** where a Francesco Padovanino is mentioned as painter. (We have not seen this and the following drawings.)

880 ————. Sketches: Christ rising from the tomb, beneath in an indicated lunette kneeling nude figures. Pen, br. 298 x 207. The first words of a letter are written on the sheet. — On *verso*: similar figure with a cross. **[MM]**
About 1600.

881 ————. Two sketches for a votive painting of a doge. Pen. 204 x 305. Inscription above: Palma. *[Pl. CLXXIV, 3*. **MM]**
Sketches for the painting offered by the Doge Pasquale Cicogna in the Palazzo Ducale, ill. Venturi 9, VII, fig. 132. Other sketches for the same composition No. **922** and No. **1246**.

882 ————. Man bending to the l., carrying a bundle of wooden sticks. Bl. ch. 234 x 166. Later inscription: Paolo Venersio. In the collection anonymous. **[MM]**
Typical early Palma, study for the "Martyrdom of St. Lawrence," in San Giacomo dell'Orio in Venice, for the figure in lower r. corner, see Nos. **883** and **1117**.

883 DARMSTADT, KUPFERSTICHKABINETT, 1436. Man with a shovel. Charcoal, height. w. wh., on gray. 272 x 181. Publ. by Hadeln, *Tintorettozeichnungen,* pl. 67 as Ja. Tintoretto. *[Pl. CLXXI, 2.* **MM]**
Study by Palma for his early painting "Martyrdom of Saint Lawrence," in S. Giacomo dell'Orio in Venice, in which the influence of Tintoretto is striking. Another drawing for the same composition is No. **882**. For the whole composition see No. **1117**.

884 ————. Warrior on horseback, holding a sword in his r. hand. Bl. ch., height. w. wh., on buff. 240 x 168. Late inscription: Tintoret (and) 672. Coll. Crozat, Vente No. 672, Dalberg. Publ. in *Stift und Feder* 1928, 15, as Ja. Tintoretto. **[MM]**
Study by Palma Gio., for one of his apocalyptic horsemen in the Scuola of S. Giovanni Evangelista (Photo Alinari 18616). Early, since the painting is mentioned by Borghini.

885 DRESDEN, KUPFERSTICHKABINETT. Sketch for a composition, representing monks seated in a landscape. In the distance a figure walking to the r. Red ch. Publ. by Hans Posse in *Mitteilungen der Sächsischen Kunstsammlungen* III, 1912, p. 49, and in *Der Römische Maler A. Sacchi,* 1925, p. 63, fig 19, as a first idea of A. Sacchi for his "Vision of Saint Romuald" in the Vatican Gallery in Rome.
 [Pl. CLXXIII, 3. **MM]**
This suggestion is first of all contradicted by the fact that the drawing does not represent the vision visible in the background of the painting. Besides, the drawing lacks the heroic style typical of the Roman School and very noticeable in the painting in question. The drawing, on the contrary, is Venetian and so close to other chalk drawings by Palma, for instance Nos. **1083**, **1118** and **1177** that we attribute it to him. The composition recalls Palma's painting in San Polo, Venice, "St. Peter urging Saint Mark to preach the Gospel in Aquileja" (Phot. Sansoni, FARL 23353). Last quarter of the 16th century, probably companion piece to No. **1118**.

886 ————. Old stock. A draped man kneeling, seen from behind. Bl. ch., height. w. wh., on greenish gray. 256 x 175. Stained by mold. Ascr. to Ja. Tintoretto. **[MM]**
Typical of Palma's early studies.

887 ————. A nude man crouching to the r. Bl. ch., height. w. wh., on grayish green. 208 x 293. Stained by mold, corners added. Ascr. to Ja. Tintoretto. **[MM]**
Typical of Palma's early style and apparently a study for a figure in his painting "The Gathering of Manna" in San Giacomo dell'Orio in Venice, dated 1575.

A 888 DÜSSELDORF, KUNSTAKADEMIE, Budde 597. Nativity. Pen, over sketch in bl. and red ch., wash, on br. 243 x 191. Ill. Budde pl. 92.
In our opinion not by Palma, but later. **[MM]**

889 ————, 598. Sketches of flying nude Christ and angels. Pen, br., wash, on yellow. 230 x 355. Ill. Budde pl. 92. **[MM]**
Typical late 16th century, and perhaps connected with the painting in the Crociferi, ill. Venturi 9, VII, fig. 127; see No. **1167**.

890 ————, 599. Mourning over the dead Christ. Pen, over sketch in bl. ch., wash, height. w. wh., on br. 269 x 207. Ill. Budde pl. 92. **[MM]**
Budde's identification of the drawing as a design for the painting in Augsburg (ill. Heil, p. 61, fig. 3) is erroneous. Late style.

891 EDINBURGH, NATIONAL GALLERY OF SCOTLAND, 697. Saint Martin and the beggar, above in clouds the Virgin and Child between a bishop saint and another male saint (half-length). Brush. 392 x 259. Coll. Hudson, Royal Scotch Academy. Publ. in *Vasari Society* VIII 8 as Ja. Tintoretto, an ascription which Meder, *Handzeichnung,* p. 155, fig. 55, accepted, but Hadeln (in *Tintorettozeichnungen,* p. 16) questioned, who ascribed the drawing to the circle of Palma. Heil, p. 63, ill. 12: Palma Giovine. Hadeln, *Spätren.,* p. 21, pl. 98: Palma Giovine.
Possibly design for the lost altar-piece in S. Martino, Murano. According to Boschini, *Minere, Sestiere della Croce,* p. 33, the painting, which had been executed by Ja. Tintoretto, was "restored" by Palma; the description of the painting, in which a bishop saint is mentioned, a figure not usual in a painting of this subject, fits in with the drawing. According to Ridolfi II, 156, the painting in Murano was by Malombra.

892 ————, 708. Christ on the Mount of Olives. Pen, br. 90 x 75. Framed by lines. Coll. T. Hudson.
Typical of the end of the 16th century.

893 ————, 723. Queen of Sheba visiting King Solomon. Pen, br. 138 x 191. Squared. Mounted, a drawing on the back shows through the paper.
Typical of the end of the 16th century.

894 ————, 1616. A centaur shows the hermit the way (from the legend of St. Anthony). Pen, br., height. w. wh. (oxidized), on buff. 208 x 274. Dated: 1625. Coll. Arundel, Crozat.
Typical of latest period.

895 ————, Watson 2237. Portrait of a bearded man. Red and bl. ch., on yellowish gray. 239 x 200. Inscription (probably copied from an old one): Palmae effigies ab ipsomet delineata anno dni 1614 die 15 decembris. Coll. Watson.
Late self portrait.

896 ————, 3099. Christ standing in a chalice, supported by angels. Pen, br., on paper turned yellow. 169 x 192, the corners cut. Inscription: *Palma.* **[MM]**
Variation to No. **1179**, see there.

897 ———, 3100. The dead Christ supported by three women and a large angel. Over sketch in bl. ch., brush, dark and light br. 289 x 193. On mount later inscription: Squarchione, probably meaning Schiavone. **[MM]**

Modified version to No. **976**.

898 ———, 3156. Dead Christ carried by seven angels. Pen, br., wash. 218 x 192.

Typical of latest period.

899 FLORENCE, UFFIZI, 566 E. Floating figure. Bl. ch., on blue, drawn on back of No. **1897**, see there. [*Pl. CLXXI*, 4. **MM**]

900 ———, 738. Two angels carrying the body of Christ. Brush, over sketch in charcoal, on two sheets pasted together. 280 x 690. Oval. Publ. in *Uffizi Publ.* I/II, No. 12, as Jacopo Tintoretto, an attribution accepted by Hadeln, in *Tintorettozeichnungen*, p. 31, who, however, points out the uniqueness of the drawing: not a tentative sketch, but an idea put on paper with somewhat trivial elegance, planned as a *modello* for an exacting patron. Bercken-Mayer I, 263, note to chapter 2, ill. II, p. 200: Jacopo Tintoretto, early period. Heil, p. 63: Palma Giovine. Degenhart, p. 275, note 95: the attribution to Tintoretto or to some other purely Venetian artist is more plausible, Palma Giovine being born in Venice, but of Bergamasque origin.

We agree with Heil, with reference to the drawing style and the types which resemble well established models by Palma, see Nos. **891**, **974**, **1108**, but by no means those of Tintoretto.

901 ———, 1666 E. Martyrdom of St. Peter. Pen, br., wash, on wh. 308 x 206. — On *verso*: Another version of the same subject. Ascr. to Titian, and so publ. by Charles Ricketts, *Titian*, London, 1910, as the sketch for his painting in S. Giovanni e Paolo. Hadeln, *Tizianzeichnungen*, p. 42, rejected the attribution: by a considerably later imitator who loaned some superficial features from Titian's creation. Fröhlich-Bum who publ. both sides in *Burl. Mag.* XLV, 1924, p. 280, accepted Rickett's attribution to Titian: "Without doubt we here have the composition in an earlier state." Fröhlich-Bum *N. F. II*, no. 19–20 in her list of Titian's drawings. In our *Tizian-Studien*, p. 154, following Hadeln we rejected this attribution. **[MM]**

After re-examination of the problem we ascribe the drawing to Palma Giovine, with reference to No. **1031** and the Nos. **897**, **976** and others.

902 ———, (Ornati) 1710. Sketch for a seizure of Christ, in a very elaborate frame, probably design for a ceiling. Over bl. ch. sketch executed in pen, on faded blue. 236 x 360. **[MM]**

Typical of Palma's later style. Ridolfi II, 175 mentions a painting of this subject in the chapel of the high altar in Santa Trinità, Venice, which, however, no longer exists.

903 ———, 1732. Last Supper. Pen, light br., wash, in frame, drawn in bl. ch. 107 x 79. Inscription of the name. **[MM]**

904 ———, 1733. Last Supper. Pen, black br., wash, on buff. 250 x 383.

Typical, late period.

905 ———, 1814. Miracle of the serpents. In borderline of red ch. Pen, br., wash. 167 x 278. Inscription: Tintoretto Vecchio. Publ. by Hadeln, *Spätren.*, pl. 9 and p. 21 as Palma, possibly sketch for the organ shutters in the cathedral in Salò. 1602/3 (Ridolfi II, 193).

This suggestion seems to be very unconvincing in view of the shape of the drawing. In our opinion the drawing might be an early preparatory sketch for Palma's painting, now in the Academy in Siena (Photo Alinari 36692).

906 ———, 1863. Sketches: Nude recumbent, to the l., head of an old man and of a woman. Pen, br., wash, height. w. wh., on blue. 192 x 197.

About 1600, in the style of Palma's etched Academy.

907 ———, 1864. Man standing, looking up to the r., half-length. Charcoal, on faded blue. 212 x 160. An inscription of the name below is cut. Publ. by Hadeln, *Spätren.*, pl. 93: Female figure in half-length. **[MM]**

Typical, early.

908 ———, 1865. Saint John the Baptist in landscape. Pen, br., wash, height. w. wh., on buff. 281 x 190. — On *verso*: Seated woman (Susannah?) Bl. ch. Old inscription of the name.

Late.

909 ———, 1866. Venus seated and Cupid. Pen, bl. br., gray wash, on buff. 303 x 193.

Late.

910 ———, 1867. Saint Jerome seated, reading. Pen, bl., gray wash, height. w. wh., on faded blue. 303 x 198. Dated 1608.

A 911 ———, 1869. Ceiling: Venice crowned by Victory. Pen, reddish br., slightly washed. 297 x 200, oval. — On *verso*: schematic sketch of the ceiling with inscribed measures. Publ. by Heil, fig. 7 and p. 62, 67 as a preparatory sketch for Palma's ceiling in the Ducal Palace, ill. Venturi 9, VII, fig. 111.

The style of drawing is not compatible with the early date of the ceiling already mentioned by Borghini who gathered his material about 1580. The drawing is, in our opinion, a copy done in the late shop from Palma's original sketch No. **1015**.

912 ———, 1871. Sketches: Martyrdom of Saint Bartholomew, design for a painting, five studies of heads. Pen, br., on wh. paper. 261 x 194.

About 1600, in the style of Palma's etched Academy.

913 ———, 12851. Sheet with several heads. Pen, br., on wh., turned yellow. 206 x 143. Old inscription: del Malombra. A portion of this drawing is reproduced in Degenhart, p. 283, fig. 246, who presents this drawing as the work of Malombra and a specimen of a specifically Venetian feeling for art.

In our opinion, the style of the drawing resembles Palma Giovine's etched Academy, publ. by Giac. Franco, so closely that the attribution to Malombra arouses doubts in spite of the old inscription. For another erroneous attribution in the Uffizi of a well-ascertained drawing by Palma Giovine to Malombra see No. **914**.

914 ———, 12855. Entombment, framed by borderline, outside which the body of Christ is repeated separately. Pen, br. 130 x 414. Later inscription: Di Pietro Malombra. [*Pl. CLXXXII*, 1. **MM**]

Design for Palma's painting in S. Giacomo dell'Orio, chapel on r. side of the choir. About 1580. It is interesting to note that the old attribution to a minor name, as in this case to Malombra, is not always sufficient evidence. See also Nos. **913**, **915**.

915 ————, 12857. Design for an allegorical ceiling, Hercules and Apollo crowning a nude female figure. Pen, br., gray wash, on wh. 159 x 427. Damaged by moisture. Inscribed in the same ink: Vanitas Vanitatum et omnia Vanitas. — On *verso* inscribed: "Fontebasso" and "A Venezia dicono di mano di Pietro Malombra."

The inscription Vanitas etc. is one of Palma's typical scribbles. For the erroneous attribution to Malombra see Nos. **913, 914.**

916 ————, 12919. Two studies from the nude, half-length. Bl. ch., height. w. wh., on faded blue. 367 x 222. The upper part of the drawing is damaged by a large br. spot. Late inscription: Di Ticiano. Ascr. to Titian. **[MM]**

Our ascription to Palma rests on stylistic grounds.

917 ————, 12939. A Doge walking towards the l., grasping a staff with his r. hand. Charcoal, height. w. wh., on blue. 277 x 183. Ascr. to Jacopo Tintoretto. **[Pl. CLXXIII, 2. MM]**

The study is used in Girolamo Gambarato's painting in the Sala del Maggior Consiglio, Ducal Palace (ill. Venturi 9, VII, fig. 30, with an erroneous caption). The drawing nevertheless, does not have to be by Gambarato, since we are expressly informed by Ridolfi (II, p. 205) that in this particular painting Gambarato was helped by Palma for the principal figures. The penmanship is indeed Palma's. It it true, Gambarato may have followed his manner very faithfully (see Ridolfi II, p. 174), but we have no authentic example of his draftsmanship (see p. 166 and Nos. **698, 699**) and in view of the high quality of our drawing we are more inclined to consider it as by Palma. End of the 16th century.

918 ————, 13020. Study of a draped youth, seen from behind, stooping and raising his r. arm. Bl. ch., on faded blue. 210 x 304, cut. Ascr. to Ja. Tintoretto. **[MM]**

Study for the figure in the lower l. corner of Palma's painting "Miracle of the Serpents" in the Academy in Siena (Photo Alinari 36692).

919 ————, 13078. Page walking backward to the r. Bl. ch., on bluish green. 270 x 152.

Typical late 16th century, see No. **1245.**

920 ————, 13082. Sketches: two legs, three heads, half-length figure, floating. Pen, br. 186 x 140. — On *verso*: Nude and a female allegorical figure. Inscription in pen: del Palma.

About 1600, in the style of Palma's etched Academy.

921 ————, 13085. Sketches: two heads, female nude seated, male nude pouring water. Pen, grayish br. 193 x 284. Inscriptions: 1610 Febrar. . . . Invidia (?). . . . urna. **[MM]**

922 ————, 13088. Sketches: figures holding coat of arms and allegory referring to a Doge. Pen, br. 190 x 175. Inscription in pen: 322 (and) Palma. **[Pl. CLXXIV, 1. MM]**

First idea for the votive painting of the "Doge Pasquale Cicogna" in the Sala del Senato, Palazzo Ducale (Lorenzetti, p. 246, ill. Venturi 9, VII, fig. 132). See other sketches for the same painting No. **881** and No. **1246**. Dated with the painting 1585–1595.

923 ————, 13090. Aged saint, recumbent. Pen, black br., light gray wash, on paper turned yellow. 240 x 170.

Typical, beginning of the 17th century.

924 ————, 13092. The Flagellation of Christ. Pen, black br. 298 x 211. Old inscription: Jacobi Palma pictoris Venet. 1602.

925 ————, 13093. Sketches: Galleys, a foot, a nude, angel with mourning Virgin, Pieta. Pen, br. 206 x 300. Stained by mold. Inscription: Lasciate . . . voi che entr(ate), which is one of Palma's favorite scribbles.

About 1580.

926 ————, 13094. Sketches: Baptism of Christ in different versions. Red. ch. and pen, br. 300 x 203.

Typical, end of the 16th century.

927 ————, 13097. Various sketches: God the Father, Virgin and Child, worshiping figures, etc. Pen, br., slightly washed, on paper turned yellow. 290 x 196.

Typical, about 1580.

928 ————, 13098. Various sketches of God the Father in glory. Pen, br., wash. Semicircular top.

Late 16th century.

929 ————, 13104. Floating figure. Bl. ch., height. w. wh., on faded blue. 283 x 184. Late inscription in pen: Palma.

[CLXXI, 3. MM]

The study appears modified in the reclining soldier in the lower l. corner of Palma's "Resurrection" in S. Giovanni e Paolo — where also the corresponding soldier on the other side might go back to the study of a floating figure (Photo Frick).

930 ————, 13107. Women, half-length, holding a cloth. Bl. ch., on faded blue. 270 x 215. Stained by mold, rubbed. Inscription in pen: di mano di Palma. **[MM]**

We accept the attribution to Palma with some reservations, which rest on the close resemblance with the pupil of Tintoretto who drew Nos. **1786, 1788, 1805.**

931 ————, 13109. Beardless man seated. Bl. ch., height. w. wh., on blue. 220 x 148.

Late 16th century.

932 ————, 13110. Jacob's dream. Pen, br., wash, height. w. wh., on faded blue.

Latest period, perhaps return to an older composition preserved in Palma's painting in the Morpurgo Coll., ill. Venturi, 9, VII, fig. 146.

933 ————, 13113. Various sketches of nudes. Pen, br. 275 x 173. Late 16th century.

934 ————, 13114. Various sketches among which a horizontal composition of Susannah with the elders is twice repeated. Pen, br. 260 x 360. Signed: Jac.º Palma. Pasted, other sketches showing through from back. **[MM]**

End of the 16th century.

935 ————, 13116. Saint Jerome recumbent holding a skull. Pen, br., wash, height. w. wh. 230 x 204. Dated 1625.

Very typical of latest period.

936 ————, 13123. Two allegorical female figures seated on clouds. Pen and red ch., height, w. wh., gray wash. Stained by mold. Inscriptions: "1603 ad pr^mo genaro" and "de Jacopo Palma." **[MM]**

937 ———, 13126. Man rushing to the r. (warrior from a Resurrection?). Bl. ch.

938 ———, 13127. Head of an old man in profile. Bl. ch., height. w. wh., on greenish blue. 257 x 180.
Early period.

939 ———, 13145. Various sketches, mostly floating figures. Pen, br., wash, on yellow. 290 x 197. Corners cut. Inscription in reverse letters: *Credo in deum*. — On the back: the same figure in three variations. Inscription: *Jo. Monano* (?)
Late 16th century.

940 ———, 13327. Miracle of the Holy Cross. Pen, br., wash, height. w. wh., on faded blue. 253 x 261. Ascr. to Genoese School, 16th century.
In our opinion, late Palma.

941 ———, 17236. Last Supper. Pen, br., wash, on faded blue. 148 x 309. Squared, framed by borderline. Ascr. to Jacopo Tintoretto.
In our opinion, by Palma G. and close to No. **1186**.

942 ———, Santarelli 7864. Man lying under a horse. Bl. ch., on faded blue. 168 x 273. Late inscription: *Palma G.*
Typical, end of the 16th century.

943 ———, 7865. Youth and woman seated, seen from behind. Bl. ch., height. w. wh., on faded blue. 198 x 277. Squared. Late inscription: *Palma Giovane.* **[MM]**
Typical study for foreground figures, end of the 16th century.

944 ———, 7867. Kneeling youth, seen from behind, a woman rushing forward, apparently turned into a bird. Pen, br., on faded blue. 254 x 155. Cut at the l. Later inscription of name.
Typical of the last quarter of the 16th century.

945 ———, 7869. Bearded nude walking to the r. and stooping. Bl. ch., on faded blue. 264 x 172. Stained by mold. Late inscription of name.

946 ———, 7871. Sketch for an Assumption of the Virgin, or a similar subject. Pen, br. 169 x 264. Later inscription: Palma.
Typical of the last quarter of the 16th century.

947 ———, 7872. Sketch for a painting: Mourning over the dead Christ. Bl. ch., on faded blue. 172 x 124.
End of the 16th century.

948 ———, 7873. Calling of Saint Peter. Pen, br., heigh. w. wh., wash, on buff. 24 x 263.
Typical of late period.

949 ———, 7875. Saint Jerome and Saint John the Baptist, seated. Pen, grayish bl., wash, on faded blue. 270 x 205.
Beginning of the 17th century.

950 ———, 7887. Two nudes, studies for a ceiling ("Glory"). Pen, br. 132 x 86.
About 1600.

951 ———, 7892. Floating angel. Pen, br., slightly washed. 200 x 146.
About 1600.

952 ———, 7894. Sketch for an altar-piece: Saint John the Baptist between Anthony Abbott and Jerome, above Saint Jerome is repeated the head of a child drawn. Red ch. Inscription: P. G. n° 145. — On *verso*: Sketches of four heads, Saint John the Baptist and a seated figure. Pen, br. [*Pl. CLXXXI*, 2. **MM**]
The drawing on the *recto*, similar in composition and style to No. **1037**, I. 13, corresponds to an altar-piece which we have not seen, but, according to the note on the photograph, exists in Arqua. The drawing on the back very similar to No. **1037**, II, 178ᵛ.

953 ———, 7895. Saint John the Baptist seated in landscape. Pen, br., wash, on buff. 250 x 198. Dated 1625.

954 FLORENCE, HORNE FOUNDATION, 5948. Saint John Baptist seated under a tree. Pen, br., wash, on buff. 293 x 193. Later inscription: Palma — and traces of the date 1627. — On the back: Female nude looking back over r. shoulder. Bl. ch. Ascr. to school of Paolo Veronese.
In our opinion, typical of Palma's latest style.

955 FRANKFORT/M., STAEDELSCHES INSTITUT, 609. A saint ordering men to carry bags into boats. Pen, wash. 299 x 270. **[MM]**
Early 17th century.

956 ———, 3678. Dead Christ supported by two angels, three quarter length brush, br., yellow and wh. 195 x 262. Formerly ascr. to Van Dyck.
Typical of Palma.

A 957 ———, 4107. The Virgin and Child surrounded by child angel. Pen, wash. 195 x 294. Ascr. to Leonardo Corona. **[MM]**
Copy from the upper part of Palma Giovine's altar-piece in San Zaccaria, Venice, ill. Venturi, 9, VII, fig. 137.

958 ———, 4229. Christ and the Pharisee. Pen, height. w. wh., wash. 129 x 197. Dated 1623. **[MM]**
Companion piece to the two following numbers.

959 ———, 4230. Christ before Pilate. Pen, height. w. wh., wash. 128 x 198. Dated 1623. **[MM]**
Companion piece to Nos. **958, 960**.

960 ———, 4231. The Jews throwing stones at Christ. Pen, height. w. wh. (oxidized), wash. 136 x 215. Dated 1623. **[MM]**
Companion piece to the two preceding numbers.

961 ———, 4237. Sketch for a painting (probably intended to frame a miraculous image): Saint John Ev., Saint Charles Borromeo and two portraits of donors, above God the Father, the Dove and little angels. Pen, br., wash. 246 x 166. **[MM]**
Late period.

962 ———, 4238. Floating angels of various sizes, holding palms. Pen, on brownish green. 203 x 120. **[MM]**
Typical of Palma about 1580/90.

963 ———, 4239. Various sketches: figures in clouds, woman seated half-length, horse galloping. Pen. 215 x 218. **[MM]**
Typical of Palma's style at the end of the 16th century.

964 ———, 4241. Various sketches: Annunciation, woman seated, half-length, heads, a sainted monk with cross. Pen. 268 x 190.

Inscription: Lasciate ogni speranza — and others of Palma's typical scrawls and (later) J. Palma fec. [MM]
 Typical of late 16th century.

965 ———, 13774. Nude men seated on clouds — from a Paradise? Pen, height. w. wh., wash. 257 x 197. Late inscription: Palma originale. [MM]

966 ———, 14332. Two figures carrying vessels. Pen 72 x 62. Ascr. to Jacopo Tintoretto. [MM]
 In our opinion, by Palma, late 16th century.

967 ———, 15180. Sketches: Woman standing seen from front, arm and chest of another woman, youth recumbent seen from the back. Pen, dark br., on reddish br. prepared paper. 147 x 130. Watermark resembling Briquet 486, occurring only in the middle of the 16th century. Coll. Comte A. d'Auffay; Geldner, Meiningen. Sale Cat. Vienna March 27, 1883, no. 2233 as Raphael. Publ. by E. Schilling in *Festschrift für M. J. Friedländer* 1927, p. 216, as a sketch by Giorgione for a (lost) "Judgment of Paris," preserved only in copies. This attribution was rejected by Richter, p. 219, pl. 60, who, however, admits a connection with Giorgione's composition: The style of the drawing is in Giorgione's manner, but the execution points to Titian's hand. Also the figure of the youth lying to the r. is typical of Titian's penmanship. [MM]
 In our opinion type, linework, and paper are all typical of Palma, compare Nos. **1037**, I, 219, II 44, 100, 138; **1132**. A Paris seen from back in such a casual posture as the figure of the drawing is more advanced in style than Titian was, even in his latest phase. In the Kunthistorisches Institut in Florence, incidentally, the photograph of the drawing is also listed under Palma Giovane.

968 HAARLEM, TEYLER STICHTING, B 21. Holy Virgin and Child with a donor in landscape. Pen. 126 x 195. Inscription: Palma Vecchio. — On back: accounts in handwriting of the 16th century. Publ. as Palma Vecchio by Hadeln, *Hochren.*, pl. 8 and by Gombosi, *Klassiker, Palma*, p. 80, upper row.
 The drawing is identical in style with No. **983** and in our opinion, a copy from the second half of the 16th century after a painted composition of the first half of the same century and possibly by Palma Vecchio. As in the case of No. **983**, the copyist may have been Palma Giovane who very often in ancient collections is designated as Palma Vecchio. A drawing rather similar in the looseness of its style was publ. under the name of Simone Cantarini by A. Morassi, *Rasini*, pl. 50. (This attribution based on a vague resemblance to a drawing in the Brera, Malaguzzi-Valeri, pl. 34, does not seem convincing to us.)

969 ———, B 22. Thief on the cross; torso; two heads. Pen, br. 181 x 118.
 Old inscription: *Palma f.* — On the back: Armed woman standing.
 We accept the attribution to Palma with some reservation.

970 HAARLEM, COLL. KOENIGS, I. 71. Sketches for Christ on the cross and little angels. Pen, br., wash. 271 x 187. Corners cut. Coll. Dadda. Ascr. to the circle of Titian. [MM]
 Typical of Palma, late 16th century.

971 ———, I. 483. Nude youth. Pen. dark br., on br. 291 x 190. Damaged. Old inscription: A1 M...
 Typical of early 17th century.

972 HAGUE, THE, COLL. LUGT. Saint Jerome praying. Pen. br., wash. 295 x 190. Inscription: Jacopo Palma.
 Typical of early 17th century.

973 ——— Martyrdom of Saint Agatha. Pen, height. w. wh., on blue. 292 x 206. Dated 1627.

974 LAUSANNE, COLL. CÉRENVILLE. Allegorical figure of Venice, seated on clouds between two angels, beneath Saint John the Evangelist and a bishop saint. Brush, br. and wh. oilch., on faded blue. 335 x 238. Later inscription: Originale del Tintoretto.
 [*Pl. CLXXXI*, 3. **MM**]
Modello for Palma's painting in Sebenico, Chiesa di San Domenico (Photo Instituto Nazionale, 5966).

975 LAUSANNE, COLL. STROELIN. Various sketches: Floating figure of Christ, representations of abductions of women. Brush, oil, over bl. ch., on gray. 405 x 260. Late inscription: Giacomo Tintoretto. — On the back: Sketches for groups of Saints (?) in clouds. Inscription: I. T. No. 3. Ascr. to Jacopo Tintoretto. [*Verso* **MM**]
 In our opinion, by Palma Giovane. The drawing on the back is probably the first idea for Palma's ceiling "Assumption of the Virgin," formerly in the sacristy of the Scuola di San Fantino in Venice, now in the Hermitage; the painted sketch on the ceiling is in the Querini-Stampalia Coll. in Venice and ill. Venturi 9, VII, fig. 131. The drawing is dated before 1584 by the painting which is mentioned by Borghini. See also No. **1129**.

976 ——— Mourning over the dead Christ. Pen, br., wash, on gray. 265 x 192. [MM]
 Closely related to No. **897**.

977 LEIDEN, PRENTENCABINET, 2394. Four female saints standing, above God the Father in half figure. Pen. br. Semicircular top. Framed by a line in bl. ch. — On the back (partly cut): Baptism of Christ. Formerly ascr. to Jacopo Tintoretto or Zuccaro, now correctly to Palma G.
 Early 17th century.

978 LENINGRAD, HERMITAGE, 6332. "Presentation of the bride." Over red ch., pen. 230 x 170. Coll. Cobenzl. Ascr. to Jacopo, later to Domenico Tintoretto, exh. as Palma Giov. 1926, No. 43, ill. Klynder-Roettger No. 62.
 We have not seen the drawing, nor its illustration.

979 ———, 14127. Saint Jerome kneeling. Pen, on br. 400 x 260. Coll. Molinier, Jeremicz. Publ. by Benois, in *Starye Gody* 1913, No. 11, with reference to the composition by Palma, engraved by Sadeler and Goltzius. Exh. 1926 No. 42.

980 ——— Saint Zacharias carried towards heaven. Pen, wash, and red ch. 200 x 230. Publ. by N. Dobroklonski, *Esquisses de peintures monumentales des maîtres Venitiens de la Collection du Musée de l'Ermitage,* in *"Art"* 1934, p. 158, as design for the high altar in San Zaccaria, Venice.
 Not checked by us. The mural above the altar representing this subject is attr. to G. A. Pellegrini. (Lorenzetti, p. 283.)

981 LONDON, BRITISH MUSEUM, 1859–8–6 — 82. Entombment of Christ, in the foreground women supporting the fainting Virgin. Pen, br., wash, height. w. wh., partly oxidized, on faded blue. 204 x 117. Ascr. to Jacopo Tintoretto. [MM]

Perhaps first idea for Palma's painting in the Redentore in Venice. The upper part of the composition appears varied in No. **1095**.

982 ———, 1885–5–9 — 1661. Design for a portrait of a doge, full-length, seated. Pen, br., over bl. ch. sketch, wash. 245 x 182. Framed by lines. Late inscription: Tintoret. Anonymous, sometimes ascr. to Palma Giovine or to Leandro Bassano. **[MM]**

Corresponding to the (reversed) engraving representing the costume figure of a Doge in Giacomo Franco's *Venetorum habitus* etc., Venice, 1610. In the engraving, the curtain is replaced by a view of the Scuola di San Marco. The drawing which might be the design for the painting reproduced by the engraving, is a portrait of P. Cicogna (1585–1595). We prefer the attribution to Palma, supported by the style and by Palma's close relations to Franco.

983 ———, 1895–9–15 — 810. Holy Family with saints. At left, beyond border line, male nude, cut. Pen, br. 181 x 215. Old inscription (apparently 16th century, but not Palma Vecchio's handwriting): Giac° palma. — On *verso:* Studies from nude men, half-length. Face in profile. Malcolm Coll. (Robinson 363). Mentioned by Morelli II, p. 40 as by Palma Giovine to whom, in Morelli's opinion, the Italian signature also points. Publ. by Hadeln in *Burl. Mag.* XLIII, p. 168 and in *Hochren.*, pl. 9 as Palma Vecchio, however stating that the inscription does not correspond to Palma Vecchio's signature. Gombosi in *O. M. D.* 1929, March, who accepts this attribution, takes the inscription as authentic, as otherwise the scroll, the tree and the landscape with which it corresponds in penmanship, would not be authentic either. Ill. in *Klassiker, Palma,* p. 60, the *verso* on p. 73. The latter is there compared to the oarsmen in the painting "Miracle of St. Mark" in the Scuola di San Marco.
[Pl. CLXIX, 3. **MM]**

The nude (cut) on the *recto* side is apparently drawn with the same pen and ink as the figures on the back, the border line and St. Catherine and St. Joseph, while the main group and the landscape above are drawn in a darker ink. The composition is very close to Palma Vecchio (see his paintings *Klassiker Palma,* p. 24 ff.), but the character of the drawing is not that of a design or a sketch, but of a hasty copy from an existing painting. The essential impression of the whole is indicated, while no effort is made to build up an invention. In our opinion, the drawing is by Palma Giovane after a composition by Palma Vecchio. The nudes which indubitably are by the same hand as the main group are typical of Palma Giovine (see for the whole arrangement No. **1037**, II, 100). The signature, which, as noticed by Gombosi, forms an integral part of the background, may be his. Paintings by Palma Vecchio were restored by his nephew (see p. 226 f.).

984 ———, 1895–9–15 — 819. Copy of the three figures on the left in Titian's Madonna with saints in the Vatican Gallery, ill. Tietze, *Titian,* p. 145. Pen, br. 231 x 186. Old inscription: Titian. The penmanship is close to No. **983** which we attribute to Palma Giovine. **[MM]**

985 ———, 1900–8–24 — 131. Martyrdom of Saint Lawrence. Brush, br., on reddish paper. 273 x 200. Attr. to Jacopo Tintoretto. **[MM]**

Typical of Palma's pictorial style, see No. **1126**.

986 ———, 1900–8–24 — 132. The Wedding of Cana. Pen, br., wash, height. w. wh., oxidized, on greenish gray. 145 x 325. Ascr. to Jacopo Tintoretto. **[MM]**
More in the direction of Palma Giovine.

987 ———, 1922–6–22 — 5. Mourning over the dead Christ; in a frame elaborately decorated with figures. Pen, br., wash, on gray. 152 x 142. The central composition is inserted and drawn with a lighter ink. "Attr. to Palma." **[MM]**

The frame is very similar to the funeral monument of Alessandro Vittoria in San Zaccaria in Venice (Photo Alinari 38730), designed by Vittoria himself. The manner of drawing of the frame is somewhat similar to Vittoria's (see his drawing in the Uffizi and Louvre 5392), while the composition in the centre, different in its linework, might be by Palma who frequently collaborated with Vittoria.

988 ———, Fawkner 5210. Saint Martin and the beggar. Pen, br., gray wash, height. w. wh. (oxidized), on buff. 205 x 180.
Late period.

989 ———, Fawkner 5211 — 63. Portrait of Sebastiano Venier (?). Bl. ch., on faded blue. 297 x 233. Inscription: Titiano (crossed out). "Attr. to Titian." Mentioned by Suida, *Tizian,* as a copy of the portrait of an Admiral in the Boboni Coll., Milan, given to Titian (Suida, pl. CLXX b.). **[MM]**

Leaving aside the question of the author of the painting which we only know from its reproduction, we ascribe the drawing to Palma Giovine on the basis of its mode of drawing, see No. **1180**. Notice also the dependence on the statue of Moses in Titian's Pietà, ill. Tietze, *Titian* 288.

990 ———, Fawkner 5223. Various sketches repeating the same unidentified composition. Pen, br., 259 x 193.
Late 16th century.

991 ———, 197* d 1. Volume in folio in a binding of the 18th century, carrying the title "Studio di dissegni di Giachomo Palma" and containing 134 drawings pasted in. They are different in their subjects and their sizes, mostly drawn in pen, partly washed and heightened w. wh. The main bulk originates from the 17th century and a few of them carry dates and other inscriptions. Some of the latter are quite typical, being the sort of scribble found on many of Palma's drawings, for instance, those on P. 25, No. 46: Lasciate ogni speranza. Domine labbia mea. In te domine confido.

We enumerate only a selection of the drawings, limiting ourselves to those which might offer a special interest from their connection with executed paintings, from the possibility of identification or from their exceptional subject.

P. 1, No. 3: Portrait of Andria Palma, 1593, according to inscription. Pen, br. 88 x 63. — On *verso:* the portrait is repeated.

P. 4, No. 11. Saint Catherine, carried towards heaven by four large angels. Pen, br., wash. 295 x 268. Inscription: Sta Catarina 1613 Novembre. — On *verso:* Composition of three saints, some of whom are separately studied. Pen and red ch. Inscription: Per il Re^do Padre fra francisco Capucino da Brescia nel coro 1613 luglio.

The composition on the front side is connected with the painting in Santa Caterina in Venice, Ridolfi II, 197.

P. 6, No. 14. Eight sketches for St. John the Baptist, Pen, br., wash, 375 x 269. One of the sketches in its composition resembles the drawing publ. as J. Tintoretto in the cat. of the Weinmüller Sale, Munich, 1938, no. 678.

P. 20, No. 36. Landscape with woman and child sitting in the foreground. Pen, br., wash. 119 x 167. Stained by mold. About 1580. **[MM]**

P. 38, No. 69. St. Mary Magdalene penitent. Pen, light br., wash. 157 x 111. Framed by lines. Inscription: fatta per lo ecc.mo Giambattista Tiraboscho.

Late.

P. 44, No. 78. Dying doge (?) seated in chair, surrounded by a boy, a kneeling woman and four other persons. Pen, br., gray wash, on buff paper. 283 x 205.

Late.

P. 57, No. 99. The Virgin and Child between a bishop saint and Venezia (?), at r. ten dignitaries led to the Virgin by a female allegorical figure (Abundance). Pen, br., gray wash. 101 x 283. Cut at the left. [MM]

Late 16th century.

P. 59, No. 103 and 104. Saint Zacharias and Saint Ligerius, represented as statues, accompanied by angels. Pen, br. 200 x 74. Inscriptions: S.to Zacharia. S.to Ligier (on the basis) S. Ligerius. Framed in lines. [Pl. CLXXX, 1 and 2. MM]

Design for the organ shutters formerly in S. Zaccaria, Venice, Ridolfi II, p. 188. About 1600.

P. 67, No. 116. Crowning of a poet by Apollo and the Muses. Pen, br., wash. 272 x 265. In the book held by the poet inscription: "Il Marini poetta ill.stre." — On verso: Bearded head and fragments of figures. Marino's visit to Venice in 1606-7 might have offered an occasion for this drawing, the style of which fits this date. Marino's relations with Palma are confirmed by Ridolfi II, p. 202 and 203.
[Pl. CLXXXI, 1. MM]

P. 71, No. 124. Three female figures on clouds, named by inscriptions "Materia," "Forma," "Praeventio"(?). Pen, br., wash, height. w. wh., on buff. 171 x 249.

P. 72, No. 125. Baptism of St. Catherine. Pen, br., wash. 194 x 242. Inscription: Sta Caterina.

For the still existing painting in S. Caterina in Venice. Ridolfi II, p. 197.

P. 74, No. 128. Martyrdom of St. Stephen. Pen, br., wash. 396 x 267. [MM]

Sketch for the painting in Cividale, engraved by Egidius Sadeler.

992 London, Victoria and Albert Museum, Dyce 252. Design for an altar-piece. St. John Evangelist, St. Mark and St. Paul; above Christ surrounded by angels. Pen, br., wash. 412 x 269. Squared in ch., the squares numbered in pen. Semicircular top indicated. Coll. Esdale, Dyce. [Pl. CLXXX, 5. MM]

Design for Palma's altar-piece, signed and dated 1614, still existing in the Scuola di San Marco. The painting had originally been ordered from Domenico Tintoretto, see his sketch No. **1526**, 39. Apparently the same subject later on was ordered from Palma G.

993 ———, 253. Male nude turned to the l. Pen. br., on buff. 263 x 117. Coll. Reynolds, Dyce. [MM]

Modified copy from the youth at the l. of Raphael's "Fire in the Borgo." Palma's early period.

994 ———, 254. Pilgrim seated. Pen, br., height. w. wh. (oxidized), on buff. 149 x 108. Dated 1623.

995 ———, 262. Mount of Olives. Pen, br. 113 x 156. [MM]

End of 16th century. The two sleeping apostles at the l. are separately studied in No. **1177**.

996 ———, 264. Saint Jerome penitent. Pen, br., gray wash, height. w. wh., on buff. 140 x 116.

Late style.

997 London, Coll. Earl of Harewood. Saint Jerome with book. Pen, blackish gray, height. w. wh., on buff. 399 x 267. Dated 1615.

998 London, Coll. Sir Robert Mond. Lazarus in heaven and the rich man in hell. Pen, br., on paper turned yellow. 115 x 182. Framed by lines. Inscription: Per Mg. Pietro Antonio Fiastri (?) da Reggio. — On verso: Two female nudes. Bl. ch. Coll. J. Richardson Junior, Dr. Pearl. Borenius-Witkower 114. [Pl. CLXXV, 1. MM]

Typical of Palma G. about 1580/90. The composition, somewhat modified, was engraved by E. Sadeler 1595.

999 ———. Various studies of human figures. Pen, br., wash. 263 x 182 The corners cut. Inscription: Giacomo Palma — Coll. Ginsburg. Borenius-Witkower 174.

In the style of Palma's etched Academy.

1000 London, Coll. Paul Oppé. Jesus among the doctors. Pen, br., wash. 282 x 247. Inscription: 1621 gennaro.

1001 ———. "Take up thy bed and walk!" Pen, br., gray wash, on buff. Dated 1626.

1002 London, Coll. A. P. and C. R. Rudolf. Susanna and the elders. Pen, br., wash, height. w. wh. 187 x 235.

Early 17th century.

1003 ———. Nativity. Pen, br., wash. 210 x 205. — On verso: Another version of the same composition.

End of the 16th century.

1004 ———. Christ healing the blind. Pen, br., height. w. wh., on yellow. 130 x 227. Dated 1623.

1005 ———. Christ driving the merchants from the temple. Pen, br., wash, on blue. 157 x 243.

End of the 16th century.

1006 ———. Last Supper. Pen, wash. 297 x 197. Dated 1627 zenaro (January).

1007 ———. Christ between Pilate and a soldier. Pen, br., wash, on blue. 295 x 188. Inscribed: Palma.

Late period.

1008 ———. Mourning over the dead Christ. Pen, wash, height. w. wh., on faded blue. 273 v 200. Dated 1628.

1009 ———. Mourning over the dead Christ. Pen, br., 225 x 305. Damaged by mold.

Late period.

1010 ———. Funeral of the Virgin. Pen, wash, height. w. wh. 143 x 212. Dated 1623. Warwick Coll. [MM]

1011 ———. Virgin and Child in clouds, beneath Saint Jerome and a sainted monk. Pen, brush, wash. 194 x 109. Semicircular top. Peter Lely Coll. [**MM**]
End of 16th century.

1012 ———. Saint Francis in landscape. Pen, br., wash. 300 x 175.
Late period.

1013 ———. Apparition of Saint Michael (on Monte Galgano, see Mrs. Jameson, Sacred Art p. 197). Pen, br., wash. 325 x 230. Inscription in pen: farsi a Candiana.
Evidently design for Palma's ceiling in the church of Candiana, Ridolfi II, 199.

1014 ———. Martyrdom of Saint Sebastian, in rich architectural frame. Pen, br., wash, height. w. wh. 310 x 210.
Late period.

1015 ———. Venice crowned by Victory. Pen, br., wash. 297 x 192, oval. Coll. Reynolds and Heseltine. [*Pl. CLXXIX, 4.* **MM**]
First idea for Palma's painting in the Ducal Palace, ill. Venturi 9, VII, fig. 111. See also No. **911**. Dated 1578–1584 by the painting.

1016 ———. Various sketches: Sainted monk healing a person lying on the ground; heads of old men. Pen, br., wash. 143 x 87.
In the style of Palma's etched Academy.

1017 LONDON, COLL. ARCHIBALD G. B. RUSSELL, formerly. Study of a nude woman, connected with Venus in Ja. Tintoretto's "Bacchus and Ariadne," ill. Bercken-Mayer 105; her r. leg is separately drawn. Red ch. 253 x 290. In Geiger Sale, Sotheby 7 to 10 December 1920, no. 22: Baroccio. In Mr. Russel's opinion, study by Jacopo Tintoretto for the above mentioned figure. [**MM**]
Not having seen the original we suggest only with reservations: copy by Palma Giovine from Jacopo Tintoretto. The style of the drawing differs distinctly from Tintoretto's — about 1578 — while it corresponds perfectly with a number of Palma's drawings (see No. **1141**). Palma's interest in this specific painting may be explained by the fact that he participated in the committee that had to estimate the group of four paintings by Tintoretto, now in the Antecollegio, to which "Bacchus and Ariadne" belongs.

1018 LONDON, COLL. SIR ROBERT WITT, 2495. Woman, half-length, bending to the r. Bl. ch., on faded blue. 166 x 125. Squared. Ascr. to Jacopo Tintoretto and supposed to be a study for one of the women in Tintoretto's late painting "The Gathering of Manna." in San Giorgio Maggiore. [*Pl. CLXXI, 1.* **MM**]
The resemblance, however, is very slight, see the reproduction of the detail in the cat. of the *Mostra del Tintoretto*, p. 200. The manner of drawing, moreover, is basically different from Jacopo Tintoretto's and, on the contrary, typical of Palma's early period. The drawing is the final study for the central figure in his "Passover" in the sacristy of San Giacomo dell'Orio in Venice of 1575 (Photo Tomaso Filippi, Venice). This well-ascertained drawing forms a cornerstone for the knowledge of Palma's early style.

1019 ———. Martyrdom of Saint Lawrence. Pen, wash, height. w. wh., oxidized, on buff. 296 x 220. Inscription: I. P. F. 1628 14 Otobre (and) palma. Coll. Thana.

1020 ———. Assumption of the Virgin. Pen, br., wash, height. w. wh., oxidized, on buff. 305 x 212. Signed 1626. Coll. Gowan and Brewer.

1021 ———. Adoration of the shepherds. Pen, br., wash, height. w. wh., on buff. 191 x 284. Dated 1625. Coll. Warwick, Sir Greville.

1022 ———. Wedding at Cana. Pen, br., wash, on buff. 203 x 290. Dated 1625. Coll. Warwick and Greville.

1023 LONDON, GEIGER SALE, SOTHEBY 7 TO 10 DECEMBER 1920. No. 32. Studies of a soldier in a Resurrection. Bl. ch., on blue. 400 x 250. Ascr. to Cavedone. Publ. by E. Tietze-Conrat in *O. M. D.* 1936, No. 42, p. 23, pl. 20, as Palma Giovine, by reason of the painting of the "Resurrection" which Palma is shown painting in his self-portrait in the Brera, Milan, ill. Venturi 9, VII, p. 216, fig. 128. [**MM**]
We have not seen the original.

A 1024 LONDON, SOTHEBY 1930, Nov. 5. Adoration of the shepherds. Pen, wash, semicircular top. Inscription: J. P. F. Coll. J. Barnard, W. Bates. Ascr. to Palma Giov.
In our opinion, old copy after Palma's painting in Munich, ill. Venturi 9, VII, fig. 123, and interesting insofar as it reveals the changes subsequently suffered by the painting.

1025 MALVERN, MRS. JULIA RAYNER WOOD (SKIPPES COLL.). Kneeling bearded man, turned to the r. Bl. ch., on brownish yellow. 285 x 178. Old inscription in pen: Andrea Schiav(one). [**MM**]
In our opinion, closer to Palma Giov.

1026 ———. Shepherd from an Adoration. Bl. ch., on paper turned yellow. 210 x 136. Colorspots.
Very close to No. **1018**.

1027 ———. Saint Paul standing, carrying books and sword, in two different versions. Pen, gray wash, on buff. 213 x 210. [**MM**]
Late.

A 1028 ———. Adoration of the magi. Brush, bluish gray, the outlines partly br., on faded blue. 388 x 262. Semicircular top. Ascr. to Aliense. [**MM**]
Copy from Palma Giovine's painting of 1608 in the Pinacoteca Estense in Modena. Done in Palma's shop.

1029 MILAN, BRERA, 205. Portrait of a lady in profile, turned to the r. Bl. ch., on blue. 286 x 192. Old inscription in pen: Giulia moglie di Antonio palma, madre di Giacomo Palma. In lower r. corner: Jacopo Palma. Ascr. to Antonio Palma. [*Pl. CLXIX, 2.* **MM**]
In our opinion, too far advanced in style for Antonio and too timid for an artist in his maturity. More likely an early drawing by Palma Giovine. The model is apparently the same as in No. **820** which we tentatively attribute to Antonio Palma and which shows the same woman at an earlier age. The manner of drawing is most precise in spite of evident weaknesses, for instance, the rendering of the ear. The drawing is somewhat exceptional in Palma's work because of its subject, but by its style logically related to other early studies, see No. **882**.

1030 MILAN, COLL. RASINI. Study for the ceiling in the Sala del Maggior Consiglio, in Venice. Bl. ch. 420 x 245. Col. Gritti, Bergamo. Publ. by Morassi, p. 37, pl. XXXVII, and dated between 1578 and 85, on the basis of the painting.

The sketch is closer to the final composition than No. **1015**. In the lower part there are some figures which are not yet finally settled.

1031 —————. Study for two figures (Christ, Saint Jerome?). Pen, on yellow. 220 x 165. Coll. Guidini, Milan. Morassi p. 37, pl. XXXVIII.

Typical, late 16th century.

1032 —————. Mourning over the dead Christ. Pen, br., height. w. gold, on brownish. 267 x 170. Damaged. In lower l. corner: Palma. Late period.

1033 —————. Annunciation. Pen. 125 x 112. Coll. Grahl, Geiger. Publ. by L. Planiscig and H. Voss No. 17 as Titian and probably sketch for the late painting in San Salvatore (ill. Tietze, *Titian* pl. 260). This attribution was rejected by Morassi, p. 31, pl. XXII, who ascr. the drawing to the school of Paolo Veronese.

In our opinion, the linework is typical of Palma and the study was used in a lost painting by him preserved in an engraving which we have seen only in the Bibliothèque Nationale in Paris.

1034 MODENA, GALLERIA ESTENSE, 726. Saint Francis supported by two angels. Pen, br., wash, on faded blue. 194 x 144. Inscription Palma (and) 157.

Typical, end of 16th century.

1035 —————, 780. Saint Christopher carrying the Christ Child. Pen, br., wash, height. w. wh., on brownish. 277 x 180. Later inscription: Palma (and various numbers).

Late period.

1036 —————, 1161. Various sketches, especially guardian angel carrying a soul towards heaven. Pen, red and bl. ch. 231 x 161.

1037 MUNICH, GRAPHISCHE SAMMLUNG. Two scrapbooks in bindings of the 18th century. The title page carries the inscription: Disegni del Palma — and the first volume contains a dedication to Palma followed by a sonnet in his honor. (Ad spectabilem virum dominum Jacobum Palmam pictorem dignum. Joannes Brunus Ariminensis S. P. D. — For the wording of the sonnet see Heil, p. 61, note.) A poet of the name of Joannes Brunus publ. a volume *"Cose Volgari"* in 1506. If the sonnet is by him, it might refer to Palma Vecchio and in that case have been pasted into the volume as a family record. It might also be by a later author of the same name and refer to Palma Giovine. At any rate Heil, l. c. p. 61, concludes rightly that the scrapbooks must have been connected of old with the name of Palma and probably may be traced back as a whole to his shop. Books of this kind are mentioned in the last will of the painter and art dealer, Philip Esengren (May 19, 1631), who bequeathed four of them to the painter Giuseppe Alabardi (Ludwig, *Archivalische Beiträge,* p. 92).

When introducing the volume in the literature of art, W. Heil (*Palma Giovane als Zeichner, Jahrb. Pr. K. S.* vol. 47, p. 60 ff.) insisted on the essential homogeneity of the material and the authenticity of the predominant part of the drawings. L. Fröhlich-Bum in *Münchn. Jahrb.* N. F. VI, p. 1 ff. separated a number of drawings from the mass, and attr. them to Paolo Veronese; later she publ. one (I, 167 v) as by Jacopo Tintoretto and another (II, 190) as by Andrea del Sarto in *Graph. Künste,* LI, p. 9. In our opinion, she has not given sufficient evidence for justifying such a differentiation which is also rejected by Fiocco, *Veronese* II, p. 83 and Suida in *Belvedere* 1934–36, p. 197, note. The drawings which she picked out are not different in

style from the others. (For one drawing attr. by Suida to Antonio Palma see below I, 120.) We agree with Heil that the vast majority of the drawings are by Palma Giovine. There are, however, quite a few which are different in style. Some of them carry dates (1658, 1659 and 1660) which alone exclude Palma's authorship. They may have been executed by those artists to whom the numerous sketch- and scrapbooks of Palma had passed, and who continued to follow his style many years after his death.

In our survey of the drawings which is limited to a selection of drawings contained in the two volumes in Munich, we point out some of the most typical of these additions to the original stock. We do not doubt, however, that a more thorough investigation of this rich material would bring further results. It ought to be possible to distinguish various definite hands besides Palma's. Even a superficial examination of the drawings discloses the presence in the Munich books of several groups of drawings connected with one another by style and different from Palma's personal expression. Such a group is formed, for instance, by the drawings I, 47, 57, 67, 86, 89, 163, 188, II, 28, 62, 132, 185, 204, another by I, 135, 221, 223 and II, 105, a third by II, 13 to 16 and 244. The first mentioned drawing in the first group, I, 47, represents St. Francis in ecstasy while an angel plays the viol, an unusual subject which Ridolfi II, p. 254, mentions among the paintings by Francesco Zugni, a pupil of Palma who died in 1636. This hint may help for the classification of the whole group. The second group is distinguished by a spirited mode of sketching different from Palma's typical routine. The relationship to Paolo de' Franceschi (see p. 165) may be noted. For the third group the resemblance of II, 16 to a painted still life in the Municipio of Dignano in Istria (ill. *Inventario . . . di Pola,* 1935, p. 92) would offer a clue if the whole problem of Italian still life painting of the 17th century had been more thoroughly studied. The Venetian literary sources mention a few specialists in this field, Antonio Bacci, B. Stalli, Francesco Mantovano; even Baschenis should be taken into consideration who was a Bergamasque and whose dependence on Venetian influences must be assumed (Michele Biancale in *L'Arte* vol. XV, p. 326). An adequate investigation of the corresponding group of drawings in the books in Munich would lead deep into the almost entirely unknown regions of Venetian drawing in the 17th century. The discussion of these problems lies beyond the limits of our studies for which even Palma Giovine is in a way a postscript as the heir and epilogue of the classic age of Venetian painting.

Our list follows the numeration in the two volumes in Munich. (The added "Photo Munich" refers to photographs available in the coll.)

I, 2. Baptism of Christ, composition with many figures in landscape. Pen. 79 x 145. **[MM]**

I, 3. Assumption of the Virgin, over whom the Holy Spirit is floating, a host of large and small angels surrounding her. Pen. 145 x 124. Framed by a borderline. **[MM]**

I, 5. Figure of a man flying upward. Pen. 144 x 95. (Photo Munich) Mentioned by Heil, p. 67.

I, 13. Saint John the Baptist (or Christ Savior?) standing between two kneeling saints. Red ch. 180 x 130. Mentioned by Heil, p. 67. The composition shows a distinct resemblance to one existing in several versions by Palma (Arqua, Val de Biadene, Mirano, the latter now property of Conte Careggiani, Venice). **[MM]**

I, 18. Wedding at Cana in rich architecture; the table repeated at the l. Pen. 99 x 171. [MM]

A I, 19. Rest on the flight into Egypt, with many angels in landscape; in the distance at r. pyramids. (Photo Munich.) Pen, 106 x 209. Damaged. [MM]

I, 23. Adoration of the magi, above three separate figures repeated. Pen. 177 x 134. Inscription: fatta del 1593 (and) per Getelene (?) nella Cappella chi vene i tre magi adorare christum. — On the back: Sketch of a ceiling, Coronation of the Virgin by the Holy Trinity, below horizontal composition: Judgment of Solomon.
[Verso Pl. CLXXXIII, 3. MM]
The sketch for the Coronation of the Virgin might be connected with Palma's ceiling in the Capella del Rosario in SS. Giovanni e Paolo, as described by Ridolfi II, 187 (burnt 1867).

I, 25. Coronation of the Virgin, composition with many figures in an oval. The general arrangement is hastily sketched in the upper r. corner. Pen. 232 x 134. Stained by mold. — Verso: Assumption of the Virgin and the dead Christ supported by angels. [MM]

I, 26. Various sketches: in upper row Jacob wrestling with the angel, in middle row Christ and the Samaritan, below two separate female saints in half figures. Pen. 199 x 95. [MM]

I, 29. Two flying angels adoring. Red ch. 133 x 96. (Photo Munich.) Mentioned by Heil, p. 67.

I, 30. Woman carrying a child, half-length. Bl. ch. 125 x 113. The drawing was used in Palma's "Presentation in the Temple," in the cathedral of Castelfranco where the Child is somewhat modified. The painting is dated 1610, the drawing looks a few years earlier.
[Pl. CLXXIX, 1. MM.]

I, 31. Figure of Christ for a Baptism. Bl. ch. and pen. 207 x 148. (Photo Munich.) Mentioned by Heil, p. 66 and 67, as connected with II, 51.

I, 32. Male nude seated; two heads of old men. Pen, br. 154 x 101. Mentioned by Heil, p. 70, with reference to Palma's Academy of 1611, chiefly B. 13.

I, 33. Sketch for an altar-piece, representing the Assumption of the Virgin. Bl. ch. 169 x 98. Mentioned by Heil, p. 70, and dated about 1610. [MM]
The drawing might be a first idea for Palma's painting in San Giuliano (ill. Venturi 9, VII, fig. 122). It is, at any rate, from the same period, from the end of the 16th century. A study for two groups in the same composition on II, 242.

I, 36. Sketch for a Crucifixion. Pen. 156 x 242. — Verso: Fragments of a letter. Mentioned by Heil, p. 62, with reference to Palma's Crucifixion of St. Andrew in Dresden and publ. by Fröhlich-Bum in Münchn. Jahrb. N. S. VI, fig. 1 as by Paolo Veronese. [MM]
First idea for Palma's painting in the Pinacoteca, Bologna (C 757, i,161) where the whole arrangement and many details correspond exactly, while others are modified. Very typical of Palma's style in the late 16th century.

I, 39. Four sketches of seated evangelists (?), two of them in indicated triangular frame. Pen. 165 x 216. [MM]

I, 42. Body of Christ from a Pietà. Pen. 119 x 142. (Photo Munich.) Mentioned by Heil, p. 70, as a late work, some years before 1628.

I, 46. Sketch for a composition: Monk praying over skull, in landscape, behind him a second monk. Pen, br. 92 x 144. Stained by mold. Inscription: al molto . . . Benedetto R(?) idolfi pittor in Venezia.

A I, 47. Sketch for a composition Saint Francis on his deathbed in his cell, an angel playing the violin. Pen. 207 x 141. Inscribed: 5 : 15.
[Pl. CXCIX, 2. MM]
Later than Palma, possibly by Francesco Zugni, see p. 210.

A I, 49. Christ washing the feet of the apostles. Sketch for a painting. Pen, br. 135 x 103. — On the back a letter signed Madalena Lepidi, and dated 1658.
The date suffices to exclude Palma's authorship.

A I, 57. Adoration of the magi (?), composed for a semicircular lunette. 75 x 122. (Photo Munich.) [MM]
Similar in style to I, 47.

I, 59. The Virgin unveiling the Child, circular composition. 97 x 86. [MM]

A I, 67. Saint Sebastian, helmet and armor on the ground. 111 x 96. (Photo Munich.) [MM]
The motive of the armor at the foot of the martyr seems to be inspired by Titian's "Saint Sebastian" in the Hermitage (Tietze, Titian, pl. 271). Follower of Palma, s. I, 47.

I, 71. Mystical marriage of St. Catherine, in landscape. Pen, dark br. 101 x 78. Publ. by Fröhlich-Bum, Münch. Jahrb. p. 4, fig. 3, as by Paolo Veronese.

I, 74. Mourning over the dead Christ, composition with five figures. 92 x 73. (Photo Munich.) Mentioned by Heil, p. 68 f. and connected with the "Pietà" in Augsburg, dated 1600.

I, 79. Sketch for an altar-piece: The Virgin and Child in clouds, Saint Florian (?) and another saint on the ground. Beside several single figures. 264 x 168. Semicircular top. — Verso: Various sketches: Christ floating, angel of an Annunciation and others. Inscription: A sinque ore di notte, (below) dosso (or domine?). The same scribbling appears on other of Palma's drawings. The recto publ. by Fröhlich-Bum in Münchn. Jahrb. fig. 4, p. 5, as by Paolo Veronese. The drawing on the back mentioned by Heil, p. 66, with reference to the figure of Christ on Palma's self-portrait in Milan (ill. Venturi 9, VII, fig. 128). [Verso MM]
The resemblance is only general, but, at any rate, the drawing is typical of Palma in the late 16th century.

A I, 86. Sheet with various sketches, separated from each other by lines. Hermit meditating, a lion at his foot (Saint Jerome?). Head of the same saint studied separately. Saint Mary Magdalene penitent, (a somewhat different sketch below is crossed out). Presentation of the Christ Child in the temple. 189 x 152. — Verso: Nude in half-length. Red ch. [MM]
Follower of Palma.

A I, 89. Hasty sketch for the triumph of a divinity in large landscape. 117 x 89. Stained by mold. — Verso: Studies of various saints, Jerome, Sebastian, Magdalene and other figures. (Photo Munich.) [MM]

By a follower of Palma. The subject of the main side appears also in I, 159.

I, 93. Portrait of a man in profile, turned to r., once in pen, once in red ch. 193 x 130. Inscription: Mabonis (?) d 1593 di febraro. — *Verso:* Seated nude, from behind. [Both sides, **MM**]

I, 94. Bust of a lady, turned to the l., above sketch of a figure. 180 x 128. Inscription: Andriana Palma. (Photo Munich.) — *Verso:* Cain and Abel. Red ch. and pen. Mentioned by Heil, p. 68.

Late 16th century.

I, 97. Jonas spewed out by the whale. 133 x 182. — *Verso:* The head of the whale repeated and sketch for a composition representing a monk saint healing a sick man, in presence of a prince seated on a throne.

The latter composition is connected perhaps with Palma's composition in San Pantaleone in Venice, the saint healing a paralytic in the presence of the Emperor (Ridolfi II, 186). A similar sketch I, 88.

A I, 100. Bust of a lady, seen from behind, study for a painting. Pen, br. over ch. sketch. 127 x 95. — On the back: Infant angels holding a coat of arms (or a heart?). Red ch.

Both sides different in style from Palma and probably later.

I, 101. Bust of a lady. Pen and bl. ch. 170 x 134. Inscription: Andria Palma 1593. — *Verso:* Mourning over the dead Christ. Pen. *Recto* mentioned by Heil, p. 68.

I, 102. Bust of Andria Palma. Pen, light br. 133 x 133. Inscription: Andria Palma 1596. Mentioned by Heil, p. 68.

I, 103. Composition formed by three figures, one of which an angel. Ch. 129 x 189. — *Verso:* A nude woman seen from front and two old women seen from behind. Below in lighter ink, female head with inscription: 1605 a di 22 xbre.

Connected with Palma's painting "Venus at her toilet" in Cassel.

I, 106. The Virgin and Child and Saint Joseph (?). Above unidentified scene. Original inscription: del 1593 di settembre. 176 x 137. — *Verso:* The Holy Family traced from other side. Mentioned by Heil, p. 68.

I, 115. Two women seated. 168 x 131. — *Verso:* View of a village with a church. Red ch. (Photo Munich.) According to Heil, p. 62 and p. 68 connected with Palma's painting of Andromeda in Cassel and dated in the 1590's.

I, 117. Flagellation with three figures. Red ch. 64 x 87. — *Verso:* Angel. Red ch. (Photo Munich.) Mentioned by Heil, p. 62 and 69 and dated about 1602 on the basis of the similar drawing No. **924**. He connects the drawing tentatively with the painting on marble of the same subject in the Pinakothek in Munich, which in turn may be perhaps connected with the "Flagellation" in S. Zaccaria in Venice.

I, 120. Sketch for an Adoration of the magi with many figures. Pen, br. 74 x 177. — *Verso:* Youth in front of a couple of Oriental rulers. Bl. ch. The *verso* publ. by W. Suida, *Belvedere,* vol. 12, fig. 229, and tentatively attr. to Antonio Palma on p. 197, note.

Apparently, the drawing on the back is by another hand. The attribution to Antonio Palma remains hypothetical (see p. 193).

I, 122. Three female allegories sitting side by side. Pen, light br. 110 x 157. — *Verso:* Head of an old man, typical of Palma. Publ. by Fröhlich-Bum, *Münch. Jahrb.* l. c., p. 8, as by Paolo Veronese.

Another version of the same allegorical composition on II, 240.

I, 124. Virgin and Child. Red ch. 190 x 133. — *Verso:* Female nude in pen. The latter connected by Heil, p. 62, with the drawing II, 247 v. and with Palma's painting of Andromeda in Cassel.

We question the validity of this statement.

I, 128. Saint Francis receiving the stigmata. 164 x 102. Semicircular top indicated. (Photo Munich.) Publ. by D. Westphal and identified as Palma's sketch for his painting of the same subject in the Franciscan Church in Hvar, ill. in *Rad Jugoslavenske Akademije Znanosti i Umjetnosti,* Zagreb MCMXXXVII, p. 40, fig. 35. [**MM**]

A I, 135. Descent from the cross. Pen. 198 x 286. [**MM**]
Closely connected with I, 221 and I, 223.

A I, 137. Nude woman recumbent on clouds. Pen, light br. 268 x 213. Inscription in the same ink: 1659 novembre.
By a follower.

I, 138. Portrait of a bearded man, seen from front. Pen. 159 x 86. (Photo Munich.) [**MM**]
About 1600.

A I, 145. Venus and Cupid. Pen, br., wash. 191 x 150.
Resembles in style I, 137, of 1659.

I, 151. Two standing nudes. Pen and red ch. 196 x 133. — *Verso:* Female heads, in pen, one repeated in bl. ch. (Photo Munich.) [**MM**]

About 1600.

A I, 163. Saint Lawrence seated on the grill, two sketches for a composition Job and his wife. Pen. 141 x 111. — Pasted to the mount, an ornamental design shows through. [**MM**]
For the St. Lawrence see another sketch I, 65, for the Job I, 69. The drawing resembles I, 47 and the group listed on p. 210.

I, 167. An angel floating, three times repeated. Pen, br. 133 x 97. — *Verso:* Nude standing, holding a stone in his r. hand. Bl. ch. Publ. by Fröhlich-Bum in *Graph. Künste* LI, p. 9, fig. 4 as by J. Tintoretto, with reference to his "Stoning of St. Stephen" in San Giorgio Maggiore, in Venice, where, however, such a figure does not occur. The attribution is entirely unfounded.

I, 184. Four sketches, a) Saint Joseph and Child, in circular panel, b) Virgin and Child in circular panel, corresponding to I 59, c) and d) busts of female saints in rectangular panel. Pen. 210 x 206. Inscription: Zoane Badoaer di Canaregio . . . [**MM**]

A I, 188. Nativity, at r. (separated by line?) four men busy with a cradle or box. Pen. 86 x 145. (Photo Munich.) [**MM**]
The style is close to I, 47.

A I, 189. Crucifixion with many figures. Pen, br. 152 x 123. — On the back portion of a letter containing the date 1666. Publ. by Fröhlich-Bum, *Münchn. Jahrb.* l. c. p. 3, fig. 2 as by Paolo Veronese.

The date of the letter suffices to exclude Paolo Veronese's authorship.

I, 199. Beheading of a female saint, sketch for a painting. At r. a single figure. Pen, dark br. 115 x 115. Inscription: Per Cremona. — *Verso:* hasty sketch of the same composition.

I, 202. Bathsheba (?) with several maidservants. Pen. 88 x 95. Mentioned by Heil, p. 69 and dated about 1600.

I, 219. Portrait of Andriana Palma, turned to the l., two cupids and a female figure in sharp foreshortening. Pen and red ch. 188 x 134. — *Verso:* the same portrait traced, and portrait of a man, see I, 93. Inscriptions: Andriana Palma del 1593 (and a prayer).
[*Pl. CLXXXIII,* 2. **MM**]

A I, 221. The Descent from the cross. Pen. 193 x 280.
[*Pl. CXCIX,* 1. **MM**]
Modified version of the drawings I, 135, I, 223.

I, 222. Apollo playing the violin, while cupids dance. Pen, wash. 138 x 285.
The subject which is also treated in II, 244, is somewhat related to a painting attr. to Palma in the Six Coll., Amsterdam, Holland, and reproduced in an engraving. The style of the drawing, typical of Palma's, is different from that of II, 244.

A I, 223. Descent from the cross. Pen. 187 x 275. [**MM**]
Modified version of the drawings I, 135, I, 221.

II, 5. Resurrection of Christ. Composed in a vertical oval. Pen, wash, on br. 270 x 204. Inscription: 1628 30 luglio in Al . . . (damaged). Mentioned by Heil, p. 70. [**MM**]
Typical of Palma's latest style. If the date here is authentic, the inscription on No. **1178** is incorrect.

II, 8. Saint Sebastian and Saint Roch. Pen. wash. 209 x 145. (Photo Munich.) Mentioned by Heil, p. 62, and connected with Palma's painted "St. Sebastian" in Dresden.
Close in style to No. **1198**, dated 1611.

II, 10. Two sketches for organ shutters, on one a monk saint, on the other unidentified (biblical) figure, head in profile, and many scribbles. Pen. 200 x 144. [**MM**]
Late 16th century.

II, 12. Sketch for Saint Sebastian, hastily repeated at the r. Pen. 248 x 171. — On the back letter dated 1605. (Photo Munich.) Mentioned by Heil, p. 69. [*Pl. CLXXX,* 3. **MM**]
Other studies for the same figure II, 135, used in the altar-piece in S. Zaccaria, in Venice (ill. Venturi 9, VII, fig. 137). See also No. **1051.**

A II, 13. Various sketches: Orpheus in the underworld, Apollo and Midas, a still life with a bust, single figures. Pen. 83 x 123. [**MM**]
See II, 16.

A II, 14. Sketches for a composition representing a woman handling articles of food. Pen. 73 x 57. Cut. [**MM**]
See II, 16.

A II, 15. Two sketches for compositions, one combining a man, the other a woman, with a still life. Pen. 72 x 65. [**MM**]
See II, 16.

A II, 16. Still life, combining a flowerpot, fruit, a cupid on a dolphin and the torso of a statue of Venus. Pen. 41 x 67. [**MM**]

The drawing, and the others, II, 13, 14, 15, connected with it, different from Palma's manner, should be compared with a painting publ. in the *"Inventario di Pola,"* and called "Anonymous Venetian," 17th century, in which a sculpture is similarly combined with a still life. See also *Dedalo* IV, p. 622.

A II, 23. Rape of the Sabines. Pen. 80 x 115. (Photo Munich.)
[**MM**]
In our opinion not by Palma.

II, 25. Portrait of a bearded man in armor. Pen. 161 x 138. (Photo Munich.) Mentioned by Heil, p. 67.

II, 27. Girl kneeling (?), seen from behind. Bl. ch. 196 x 136. Inscription: Verginia 1596. [**MM**]
Used in the votive painting for the Battle of Lepanto in San Fantino and thereby dating the painting about 1596 or later. See No. **835.**

A II, 28. Saint Sebastian (?) and a man tying him to the tree. Pen. 118 x 90. (Photo Munich.) [**MM**]
Close in style to I, 47.

II, 36. Baptism of Christ in landscape, God the Father in glory above. Pen. 227 x 172, framed by borderline, beneath indicated measurement. [*Pl. CC,* 1. **MM**]

II, 38. Saint Mary Magdalene seated, penitent. Pen. 196 x 142. Publ. by Heil, p. 62, fig. 5, where the corresponding painting, engraved by Th. von Kessel, is also reproduced. (Photo Munich.)

A II, 39. Sketches: twice an Adoration of the magi, and Rest on the Flight into Egypt. Further four sketches of compositions and six separate figures. Pen, dark br. 290 x 200. Publ. by Fröhlich-Bum, *Münch. Jahrb.* l. c., fig. 6, p. 7, as by Paolo Veronese.
The composition of the Flight into Egypt is very similar to I, 19.

II, 44. Christ seated on clouds, between two saints. Pen. 178 x 143.
[**MM**]
Typical, late 16th century.

II, 46. Saint Francis kneeling. Bl. ch., hatching blurred. Pen. 197 x 134. Mentioned by Heil, p. 67.

II, 50. A horse turned backward to the r. The head separately studied. Pen. 89 x 114. (Photo Munich.) Mentioned by Heil, p. 65.

II, 57. Study of a bearded man, half-length, and of a boy's head. Bl. ch., the boy's head in broad pen strokes. 189 x 138. Attr. by Fröhlich-Bum, *Münch. Jahrb.* l. c., fig. 11 to Paolo Veronese. Westphal, in *Rad Jugoslavenske Akademije Znanosti I Umjetnosti,* Zagreb 1937, p. 39 (ill.) considers it together with the closely related drawing II, 149 as a study by Palma for his painting "Saint Anthony and Saint Paul," in the Franciscan Church in Trogir. [**MM**]
We can neither recognize a connection with Paolo Veronese, nor see in it a study for the painting mentioned. The resemblance of the heads is too general and the postures of the bodies completely different. The drawing shows a typical Palmesque style about the end of the 16th century.

A II, 62. Adoration of the shepherds, in rich architecture. Pen. 140 x 183. [**MM**]

The motive of the Virgin unveiling the Child resembles the one in I, 59. Belongs to the group connected with I, 47.

II, 72. Sketches for a composition of the miracle of the serpents. Pen. 135 x 423. (Photo Munich.)
The subject is typical of Palma, the painting most resembling the drawing is the one in San Bartolomeo in Venice (Ridolfi II, 186). Separate groups are studied in II, 160. About 1580.

II, 80. Studies for a Mourning over the dead Christ. 134 x 114. — On the back: The body of Christ supported by a bearded man. (Photo Munich.) Mentioned by Heil, p. 68, in connection with the painting in Augsburg dated 1600.

II, 83. Seated woman in antique costume, holding a mirror (?). Pen. 183 x 132. Inscription: Al Signor Giacomo Franco 1609 Novembr. 23. — *Verso:* Coronation of the Virgin (pen and oil chalk) and single figures of saints (pen). (Photo Munich.)
[*Pl. CLXXXIII*, 1. **MM**. *Verso* **MM**]
Franco, Palma's friend of old, was the publisher of Palma's etched Academy, where similar etchings occur. The drawing in the Albertina No. **1189**ᵛ is similar in style.

A II, 89. Christ carrying the cross. Composed for a lunette. Pen. 179 x 175. Similar in style to I, 135, I, 221, I, 223. Moreover, we notice a remarkable resemblance in style to Jacques Callot's Passion of Christ (Lieure 546, 457), of 1624, according to Meaume 28, 29.
[*Pl. CXCIX*, 3. **MM**]

A II, 92. Christ appearing to the Magdalene in the garden. In the background the angels guarding the tomb; rich landscape with fountains, bowers, etc. Pen. 116 x 164. — Letter pasted on back. [**MM**]
Other versions of this composition II, 224, II, 225.

A II, 93. Adoration of the magi. Pen. 120 x 185. — *On verso:* letter. According to Suida in *Belvedere* vol. 12, 1934/36, issue 9–12, fig. 228: copy by Palma from Jacopo Bassano.
We agree with Suida as to Bassano's authorship of the original, but doubt Palma's authorship in the drawing which seems closer to Peranda.

II, 100. Various sketches: In upper row "Martyrdom of Saint Lawrence," below female head in profile and the body of Saint Lawrence separately studied. Pen. 188 x 145. [**MM**]
About 1580/90.

A II, 104. Entrance of Christ in Jerusalem, elaborate composition in landscape. Pen. 142 x 203. [**MM**]
Close in style to the three sketches "The descent from the cross" I, 135, I, 221, I, 223; they are not typical of Palma and rather recall the style of Paolo de' Franceschi (see No. **693**).

II, 106. Head of Christ, crowned with thorns; head of the Virgin (?); two putti below. Pen. 199 x 142. In upper r. corner old number 81. [**MM**]
About 1600, in the style of Palma's etched Academy.

II, 112. Last Judgment. Pen. 194 x 198. [**MM**]
Close in style to II, 36.

II, 114. Three sketches for a composition "The Virgin enthroned presenting a robe to two saints." Each composition is arranged with

a semicircular top. Pen. 211 x 130. Inscription: La Beata Vergine con il Bambino imbrazio che da il ab(ito)a Sᵗᵒ Bernᵈᵒ Sᵒ Tomaso a Poctolo S.ᵗᵒ Benedetto Banda sinistra. [**MM**]

II, 122. Half figure of a woman nursing her child. Bl. ch. 123 x 108. Publ. by Fröhlich-Bum, *Münch. Jahrb.* l. c., p. 10, fig. 12, as Paolo Veronese.

A II, 132. Jonas spewed out by the whale, two details repeated below. Pen. 170 x 178. [**MM**]
The same subject in I, 97 and II, 151.

II, 134. Bearded head with hat, turned to the l. Red ch. 115 x 129. Inscription in pen: Piero Turi (?) del 1592. (Photo Munich.) Mentioned by Heil, p. 67.

II, 135. Five studies for a Saint Sebastian, one has a figure of a kneeling man added at the l. Pen. 258 x 185. The paper is pasted together from two sheets. — *Verso:* Flying angel and accounts. Mentioned by Heil, p. 65. [**MM**]
The figure is studied on a larger scale in the drawing No. II, 12 and used in the altar-piece in San Zaccaria, Venice; (ill. Venturi 9, VII, fig. 137), see No. **1051**. About 1605.

II, 138. The Coronation of the Virgin, by the Trinity, below three single figures. Bl. ch., pen. 204 x 147. [**MM**]
II, 139 is a companion piece. Late 16th century.

II, 142. Sketches for a Last Judgment. Pen, dark br. 140 x 200. Stained by mold.
Probably connected with the composition in the Ducal Palace.

II, 149. Bearded man, half-length, both hands folded on his chest. Bl. ch., on yellow. (Photo Munich.) Publ. by Westphal, see II, 57, in connection with Palma's painting in Trogir. [**MM**]
Only a loose connection. Late 16th century.

II, 153. Saint Mary Magdalene, half-length, seen from front. Bl. ch. 177 x 140. Mentioned by Heil, p. 67.

A II, 175. Portrait of a prelate looking over his l. shoulder. Beside him an old man, nude, bent forward. Inscription: Domine labia mea aperie (and) 12 otteᵉ 1660.
By a later follower who drew also II, 96 and II, 189.

II, 178. Three busts of bearded men, with hats, one with spectacles. — On the back: The Virgin and Child over clouds, monk receiving a garment from the Virgin. Pen. 183 x 129. (Photo Munich.)
Late 16th century. [*Verso* **MM**]

II, 180. Four medallions with female busts, representing the four elements. Below a female figure cut. Pen. 159 x 135. [**MM**]
One of the heads is studied on a larger scale in the drawing II, 181.

A II, 189. Various sketches: at l. St. John the Baptist seated, holding a bowl, at r. St. Mary Magdalene, above large half figure of a man and a head en face crowned with a garland. Pen, dark br., 274 x 182. Stained by mold. Inscription: Initium Sapientiae est timor domini. — On the back: bust of a woman looking to the r. In lower l. corner inscription: 13 otteᵉ 1660. (This date seems to be copied from another identical pasted over in lower l. corner.)

Certainly not by Palma, but by a follower. Compare II, 175 with an analogous inscription and similar in style.

A II, 190. Woman looking upward, half figure. Bl. ch. 99 x 64. Publ. by Fröhlich-Bum, *Graph. Künste* 1928, p. 7 as Andrea del Sarto.

A II, 204. Two sketches for scenes of the myth of Marsyas. Pen. 162 x 112. Stained by mold. — *Verso:* Mythological scene with Daphne and Apollo in the distance. Accounts. [MM]
Belongs to the group around I, 47.

A II, 208. The Wedding of Cana, rich composition in imposing architecture. 148 x 136. [MM]
Close in style to II, 36. The arrangement is definitely similar to a composition by Andrea Vicentino, preserved only in an engraving.

II, 212. Cupid leaving Psyche; his figure studied separately. Pen. 134 x 103. Publ. by Heil, p. 68, fig. 11 and p. 69 f. and dated shortly before 1609. In connection with Palma's paintings for Mirandola (Ridolfi II, 193).

A II, 214. Two women walking. Pen, dark gray, wash. 139 x 95. — On the back a letter written in German.
Not by Palma. The style of the drawing reminds us of Hans von Aachen.

II, 220. The Martyrdom of Saint John Evangelist boiled in a cauldron, the surrounding people fleeing in different directions. Pen. 182 x 273. [MM]
Late 16th century.

II, 222. Man clothed, walking backward. Pen. 118 x 64. (Photo Munich.) Mentioned by Heil, p. 67.

A II, 224. Various sketches, two of which represent the "Noli me tangere." 266 x 190. [MM]
Other versions of the same compositions II, 92, II, 225.

II, 226. A man supporting a fainting woman. Pen, on faded blue. 51 x 35.
Modified version of a group in No. 905, see there.

A II, 232. Various sketches: A man seated at table and a standing woman playing guitar, in landscape. Beneath female head and a rich vase, surrounded by three figures. Pen, dark br. 223 x 177. Illegible inscription and (doubtful) date 1660.
In any case by a later artist.

II, 233. Biblical scene? Shepherds and shepherdesses with a flock. Pen. 83 x 116. [MM]

II, 234. Finding of Moses. Pen. 90 x 115. [MM]
Other versions I, 6, II, 185.

II, 240. Three allegorical female figures (one with a cornucopia) seated. Pen. 143 x 177. In octagon. Sketch for a ceiling. [MM]
Other versions I, 111, I, 132, the latter publ. by Fröhlich-Bum, fig. 7, as Paolo Veronese.

II, 242. Two groups of seated and standing men (apostles?). Bl. ch. 178 x 100. Publ. by Fröhlich-Bum, in *Münchn. Jahrb.* l. c., p. 9, fig. 9, as Paolo Veronese.

Studies for the composition by Palma set down in final form in the sketch I, 33.

A II, 244. Apollo playing the violin, while cupids dance, in landscape. At r., separated by a line, still life with fruit and fowl. Pen. 66 x 202. Stained by mold. [*Pl. CLXXXII*, 2. MM]
Another version of Apollo and the cupids I, 222. For other still lives similar in style see I, 14–16 with which the drawing shares the style different from Palma's.

II, 246. Group of standing and crouching men. Bl. ch. 195 x 136. Cut at the r. Inscription in pen: 61.
Study for the lower l. corner of the votive painting of Doge Mocenigo, in San Fantino, Venice. (The crouching woman there modified). Other drawings connected with the same painting II, 27, and No. 835. Late 16th century.

II, 247. Various sketches: Saint Sebastian in various postures and stages of development. Two little angels. (One saint and angel above within indicated semicircular top.) Pen. 184 x 129. — *Verso:* Various sketches in red ch., Venice enthroned with two kneeling figures; Virgin and Child. (*Recto:* Photo Munich.) [MM]
The Allegory of Venice connected perhaps with Palma's painting in the Sala dei Pregadi, in the Ducal Palace, representing the Doge Priuli kneeling before a figure representing Venice (Ridolfi II, 183). Late 16th century.

A II, 249. Crucifixion. Broad pen, dark br., on brownish paper. 293 x 210. Badly damaged.
Entirely different in style from the bulk of the drawings.

II, 250. Various sketches for a mourning over the dead Christ. Pen. 262 x 176. (Photo Munich.) Mentioned by Heil, p. 62, in connection with the painting in Augsburg and ill. p. 60, fig. 2.

II, 251. Various sketches: Baptism of Christ composed with a semicircular top, repeated below, beside John the B. and angels separately studied. Pen. 205 x 135. (Photo Munich.) Mentioned by Heil p. 66.

Separate study of Christ: I, 3. Late 16th century. [MM]

II, 252. Various sketches for a composition: Mourning over the dead Christ. Pen. 199 x 148. (Photo Munich.) [MM]
The composition in the center corresponds in essential points with a painting of the subject in San Trovaso (Lorenzetti 516), where, however, the gesture of the hands is more similar to the sketch in the upper r. corner.

1038 MUNICH, GRAPHISCHE SAMMLUNG, 2963. Old man seated, supporting himself on a stick. Bl. and wh. ch., on faded blue. 261 x 167. Publ. by Hadeln, *Spätren.*, pl. 67 as Jacopo Bassano, probably for a St. Joseph. Accepted by Arslan, 192.
In our opinion typical of Palma, late 16th century.

1039 ————, 34854. Various sketches of Susanna or Bathsheba bathing, with a maid servant. Pen, br. 164 x 248. Late inscription of the name.
About 1580.

A 1040 MUNICH, PRIVATE COLLECTION. Lamentation over the dead Christ. Pen, wash. Late inscription: Palma. Publ. by Heil, p. 62, fig. 4, as a study for Palma's painting of the same subject in Augsburg (ill. Heil fig. 3).

In our opinion by a pupil of Palma and later than the painting in Augsburg. We have not seen the drawing.

1041 ———— (?) PRIVATE COLLECTION. Copy from Michelangelo's "Prophet Jonas" on the ceiling of the Sistine Chapel. Pen, wash, on blue. "Large size." Later inscription: *Giacomo Palma.* Publ. by B. von Liphart-Rathshoff, in *Zeitschr. f. Bild. Kunst,* vol. 64, p. 68, fig. p. 70.

The drawing, which we have not seen, might be the only existing specimen of Palma's copies after Michelangelo, mentioned by Ridolfi II, 173, as in the property of his pupil, Jacopo Albarelli.

1042 MUNICH, SALE WEINMÜLLER, OCTOBER 13–14, 1938. Cat. No. 678. St. John the Baptist seated. Over sketch in charcoal brush, height. w. wh. 350 x 245. Coll. Simonini. Attr. to Tintoretto and so mentioned in *Pantheon* 1938, p. 331.

Typical of Palma's workshop.

1043 NEW YORK, METROPOLITAN MUSEUM, 12.56.8. Adoration of the shepherds. Brush, gray, on buff (or faded blue). 306 x 168. Photo 12397. [**MM**]

1044 NEW YORK, PIERPONT MORGAN LIBRARY, 73. Self-portrait in decorative frame. Pen, br., wash. 295 x 215. Signed Palma. Inscription, formerly on the back, according to which the drawing had been presented to Nicolaus Lanière by the artist. Coll. Gainière, Lely, Richardson, Palmerston.

About 1600.

A 1045 ————, 74. Youth, seated, reading. Bl. and red ch. 192 x 140, irregularly cut. Inscription: Mateo da Leze pittor in Roma nel 1568 (in another ink) qual morse poi nel Peru (?) compagno di Jacomo Palma carissimo. — *Verso:* Nude striding toward the l. Bl. ch. and pen. Coll. William Sharp. Publ. by Heil, fig. 8 and mentioned by Arslan, in Thieme-Becker vol. 26, p. 176 as Palma's earliest drawing.

The man represented is Mateo Pérez da Lecce, follower of Michelangelo and Francesco Salviati. The attribution to Palma is completely unjustified and in view of the typical Roman linework of the drawing hardly consistent with Palma's well known manner of drawing.

1046 ————, 82, 1. Bust of a bearded man, almost en face, turned to the r. Pen, br. over red ch. 152 x 99. AP (monogram). Inscription: 1606 (the last figure corrected), Jacobus Palma (in red ch.), below in pen: *etat. suae 58.* — On the back: two heads and a hand. Inscription: adi il sette febraro 1608.

1047 ————, 82. 2. Portrait of a lady (Andriana Palma). Red ch. and pen. 143 x 94. Monogram AP and date 1605. — On the back the same portrait traced by a poorer hand.

1048 ————, 82. 3. Portrait of a boy. Red ch. and pen. 147 x 97. Inscription: 1606 adi 20 zugno . . . nasce . . . 1606 Gianne Vassilachi di età di ani quattro e mesi sei che tanto vise di un quondam morse 20 di novembre 1610.

1049 ————, 82, 4. Head of a young woman. Bl. and red ch. 143 x 93. Inscription: Regina Palma del 1596.

1050 ————, 82, 5. Portrait bust of a boy, turned to the l. Red ch. and pen, wash. 144 x 98. Inscription: del 1605 adi 17 novembre

Belisario Palma . . . di anni quatro e mesi cinque. Below in pen: 1601 . . . nacque il giov. Belisario. — On the back: the same head by a poorer hand.

1051 ————, 84, v. Design for the altar-piece in San Zaccaria in Venice, ill. Venturi 9, VII, fig. 137. Pen, br. gray, wash, on yellowish paper. 390 x 211. Semicircular top. — On the back: Studies for Saint Jerome, used in the composition on the *recto,* and another figure. Exh. Toledo, Ohio, 1940, No. 83. Exh. Northampton, Smith College, 1941, No. 38. [*Pl. CLXXX,* 4. **MM**]

The painting is dated after 1599 and probably 1605, see No. **1037,** II, 12 and 135.

1052 NEW YORK, COOPER UNION. Susanna and one of the Elders. Pen, br., on paper turned br. 198 x 167. Inscription: Giovanni. Cut. Late style.

1053 NEW YORK, COLL. JANOS SCHOLZ. Study of kneeling saints, one of whom is identified as St. Margaret by a contemporary inscription. Pen and bister, height. w. wh., wash, on gray. 115 x 130. [**MM**]

About 1580–90.

1054 NEW YORK, COLL. S. SCHWARZ. Flaying of Marsyas. Pen, br., wash, on paper turned yellow. 200 x 284. Inscriptions: Palma Vecchio (and) molto magnifico. — On *verso:* Another study of the same subject.

About 1580–90.

1055 ————. Bearded man standing. Over ch. sketch pen, br., red and br. crayon. 203 x 125. — On *verso:* Madonna and Child, in three variations, and the Child studied separately. Inscribed: Palma.

1056 OXFORD, CHRISTCHURCH LIBRARY, H 34. A pope presenting a cross. Pen, br., wash, height. w. wh. 183 x 237. Inscription: Sto Ciriachus. [**MM**]

Possibly first idea for the painting in the sacristy of the Gesuiti in Venice, "Pope Cletus confirms the order of the Crociferi," 1592–93, with addition of another scene of the story not shown in the painting in which instead the reformation of the order by St. Cyriac appears.

1057 ————, H 36. The gathering of manna. Pen, br., wash, over ch. 263 x 430. Stained by mold. Inscription: Palma.

Typical, late.

1058 ————, H 38. Death and assumption of a sainted monk. Pen, br., wash. 122 x 145. Placed in a horizontal oval (for ceiling?). Inscription: Palma.

1059 ————. Martyrdom of various saints. Broad pen, br., wash, height. w. wh., oxidized. 535 x 384. Modern inscription: Jacomo Tintoretto. In the coll. anonymous. [**MM**]

Copy drawn in the shop or *modello* (?) connected with Palma's signed painting in S. Afra, Brescia, presented in 1585 (Ridolfi II, p. 193, note 3).

1060 ————. Martyrdom of several saints, in background the Castel St. Angelo. Pen, over bl. ch., wash, on buff. 338 x 233. Squared. Inscription: No. 503 (and in another ink) Giacomo Palma.

Typical, late. Perhaps design for the painting "Martyrdom of the Saints Tiburtio and Valerian" in S. Niccolò da Tolentino, Venice, Ridolfi II, 185.

1061 ———, A 65 (Ridolfi coll.) Sketch of a skirmish. Pen, br. 58 x 138.

1062 ———, L 12 A. Two rearing horses, one ridden by a man. Bl. ch., height. w. wh., on faded blue. 259 x 132. — On the back: Virgin and child. Ascr. to J. Tintoretto already by Ridolfi.
[*Pl. CLXXIX, 2.* **MM**]

The upper figure used for the man on horseback in the middle of Palma's painting "Battle of St. Quentin" in the R. Palace in Torino; another drawing for the same composition No. **1240**. The Virgin on the back corresponds exactly to a drawing in Munich No. **1037**, II 178 *verso*. About 1580.

It is interesting to note how early such mistakes in attributions occur.

1063 OXFORD, ASHMOLEAN MUSEUM. Saint Virgin (from an Assumption?). Bl. ch., height. w. wh., on faded blue. 322 x 220. Cut. Slightly stained and torn. Mariette Coll. Attr. to Veronese and others.
[**MM**]

In our opinion, by Palma Giov., and probably a study for the Virgin in the ceiling prepared in No. **1101**.

1064 PARIS, LOUVRE, 5147. God the Father warning Adam and Eve. Pen, br., wash. 143 x 195. Later inscription: Palme.

Typical of the 1580's. The composition originates from Tintoretto's early painting of this subject, formerly in the Scuola della Trinità, now in the Uffizi.

1065 ———, 5148. Gathering of manna. Pen, dark br., partly height. w. wh., wash. 258 x 412. Cut and patched. [**MM**]

Style and composition resemble closely the "Feeding of the five thousand" in S. Giacomo dell'Orio in Venice; it is true, no companion piece to the painting is mentioned.

1066 ———, 5150. Sketches: Moses carrying the tables of law; four heads. Pen, black br. 208 x 137. Authentic inscription: Domine lab . . .

Typical, style of Palma's etched Academy.

1067 ———, 5153. Annunciation. Pen, bl., wash, height. w. wh., on brownish. 258 x 372.
Late.

1068 ———, 5154. Annunciation. Pen, br., height. w. wh., on buff. 403 x 262. Originally dated: 1622 Martis 25.

1069 ———, 5155. Annunciation. Pen, br., wash. 323 x 225.
Late.

1070 ———, 5156. Nativity. Brush, br., wash. 220 x 205.
Late. [*Pl. CLXXVIII, 2.* **MM**]

1071 ———, 5158. Adoration of the shepherds. Pen, br., wash. 123 x 145. [**MM**]
Late.

1072 ———, 5160. Adoration under a hut. Pen, br., wash. 287 x 204. Formerly attr. to Tintoretto. [**MM**]

1073 ———, 5164. Virgin and Child, below two monk saints kneeling. Oil ch., br., height. w. wh. 390 x 235. Semicircular top.
[**MM**]
"Modello" of an altar-piece, for which No. **1122v.** may be a sketch.

1074 ———, 5165. Assumption of the Virgin, below St. Stephen, a bishop saint, a sainted monk and nun. Pen, br., wash, on yellow. 245 x 174.
Typical, compare with No. **1209**.

1075 ———, 5166. The Virgin standing on a cloud, above half figure of God the Father, below a monk and a bishop saint adoring. Pen, br., wash, on yellow. 275 x 167. Semicircular top indicated.
[**MM**]
Typical, early 17th century.

1076 ———, 5167. Virgin and Child between St. Andrew and a sainted monk. Pen, bl., gray wash, height. w. wh., on yellow. Framed by borderline. 190 x 250.
Late, perhaps by a follower.

1077 ———, 5169 a. Jesus among the doctors. Over ch. sketch, pen, br., wash, on yellow. Circular, diameter 125.
Perhaps by a follower.

1078 ———, 5169 b. Visitation. Companion of No. **1077**.

1079 ———, 5170. St. John the Baptist, in a very mannered posture. Pen, br., wash, height. w. gold, on buff. 276 x 189.
Late, close in style to No. **1089**.

1080 ———, 5171. John the Baptist, seated. Pen, br., wash, height. w. wh., on buff. 194 x 133. Cut.
Late.

1081 ———, 5172. Baptism of Christ. Pen, br., wash, height. w. wh., on brownish. 268 x 196.
Late.

1082 ———, 5173. Baptism of Christ. The figure of St. John repeated at the side. Pen, dark br., wash, on blue. 290 x 164. Damaged.
About 1580.

1083 ———, 5174. Last Supper. Red ch. 145 x 193. Formerly ascr. to Ja. Tintoretto. [**MM**]
Typical, last quarter of the 16th century.

1084 ———, 5175. Last Supper. Pen, br., wash. 200 x 310.
Typical, about 1580.

1085 ———, 5176. Last Supper. Broad pen, dark br., wash. 483 x 780. Composed as an oval.
Typical of late period.

1086 ———, 5177. Sketches: Flagellation of Christ; draped male figure; design for an elaborate carved frame containing the Lion of St. Mark. Pen, br., wash. 167 x 185. — On the back: sketch for a scourging man; the same frame in red. ch. [**MM**]
Last quarter of the 16th century.

1087 ———, 5178. Flagellation of Christ. Over red ch. sketch, pen, br., on yellow. 127 x 160. Framed by borderline. [**MM**]
The composition to a certain extent resembles the painting of the

same subject in the Oratorio dei Crociferi in Venice and still more the one in the sacristy of S. Francesco della Vigna, but is not a design for either. End of the 16th century.

1088 ———, 5179. Ecce Homo. Pen, br., wash. 187 x 213. Framed by borderline. Inscription: Jacobus Palma fecit.
End of 16th century.

1089 ———, 5180. Christ carrying a cross. Pen, black br., wash, height. w. gold. 285 x 183. Inscription: In te domine speravi (and) 1611 decembris. — On the back: Two female heads, one of which apparently Andriana Palma, and hasty plan of a building with inserted measurements.
Typical, close in style to No. **1079**.

1090 ———, 5181. Christ nailed to the cross. Pen, bl., gray wash, height. w. wh., on buff. 196 x 287. Inscription: Palma Giovine.
Early 17th century.

1091 ———, 5183. Descent from the cross, with Saint Jerome kneeling in lower l. corner. Pen, bl., wash, on buff. 285 x 187. Squared in bl. and red. Obliterated inscription of the name. [**MM**]
Late 16th century.

1092 ———, 5185. Mourning over the dead Christ; above God the Father in clouds and four angels with the instruments of the passion. Pen, br., wash. 410 x 265.
Late style.

1093 ———, 5188. Dead Christ supported by angels. Brush, br., height. w. wh., oil color. 343 x 270. Pricked. Publ. by Hadeln, *Spätren.*, pl. 99, with reference to Reiset, *Notices des dessins du Louvre*, Paris 1866, p. 82, and by W. Heil, p. 63.

1094 ———, 5191. Mourning over the body of Christ, six figures, in candle light. Over red ch., pen and brush, wash. 195 x 134. — On the back: In landscape nude woman supported by a clothed one.

1095 ———, 5192. Entombment of Christ. Brush, br., gray and br., wash, height. w. wh. 167 x 198. [*Pl. CLXXVI, 2.* **MM**]
Variation of the upper part of No. **981**.

1096 ———, 5193. Entombment of Christ. Pen, br., wash, on yellowish. 128 x 113.
End of the 16th century.

1097 ———, 5194. Entombment. Over bl. ch. sketch, pen, br., wash. 179 x 263. Composed for a lunette.
End of the 16th century.

1098 ———, 5196. Christ rising from the tomb. Pen, br., wash. 285 x 204. Pasted. From the back heads en face and in profile are discernible.
Late.

1099 ———, 5197. Noli me tangere. Pen, br., gray wash, height. w. wh., on buff. 367 x 263. At r. original inscription: 1622 aprilis.

1100 ———, 5198. Christ and the incredulous Thomas surrounded by the other apostles. Brush and oil ch., br., height. w. wh., on buff. 275 x 416. [**MM**]
Executed in the manner of a *"modello."*

1101 ———, 5199. Design for ceiling: Reception of the Virgin in heaven, by the Holy Trinity, four large angels supporting a globe. Architectural frame indicated. Pen, bl. br., gray wash, height. w. wh., on grayish violet. 243 x 266. [**MM**]
For the figure of the Virgin see No. **1063**.

1102 ———, 5201. St. Jerome with sleeping lion. Pen, br., wash. 213 x 110. Later inscription: Tintoret.
Typical, late.

1103 ———, 5203. St. Jerome standing, the lion at his feet and looking up to him. Pen, br., wash, height. w. wh., on buff. 267 x 167. [**MM**]
Looks like design for a sculpture.

1104 ———, 5205. St. Jerome standing, busy with two books. Pen, br., wash, height. w. wh., on buff. 267 x 168. [**MM**]
Late.

1105 ———, 5207. Five saints, above glory of angels. Pen, black br., gray wash. 263 x 165.
Late 16th century.

1106 ———, 5208. Martyrdom of Saint Lawrence. Pen, br., wash, on yellowish. 199 x 272. [**MM**]
Probably a sketch for the composition of the same subject in S. Giacomo dell'Orio, Venice, a copy of which exists in the Louvre, No. **1117**. See also No. **1037**, II, 100.

1107 ———, 5214. Martyrdom of a female saint (Justina?). Pen, br., wash. 295 x 157. Semicircular top. — On the back: Several small sketches for a Queen of Sheba (?). [**MM**]
A painting representing the "Martyrdom of St. Justina" existed in the church of this saint in Venice, Ridolfi II, p. 187; Boschini, *Minere*, p. 209. The style of the drawing is not entirely convincing for Palma.

1108 ———, 5215. Madonna and Child above clouds, below bishop saint crowning Venice, on the other side personification of Faith. Brush and oil ch., height. w. wh. 370 x 231. Semicircular top indicated. [*CLXXXI, 4.* **MM**]
"Modello" for the painting in S. Geremia: The Virgin and St. Magno crowning Venice (Ridolfi II, p. 197).

A 1109 ———, 5219. Allegory. Pen, wash. 229 x 177. — On the back inscription according to which the drawing was attr. to Tintoretto by good experts at the sale of the Crozat Coll. Publ. by Camille Gronkowski as by Palma, in Lumet, *Les dessins par les grands maîtres*, 15, who emphasized certain characteristics pointing to the 18th century. In the Louvre ascr. to Palma G.
In our opinion without connection with Palma, probably by a court painter of Emperor Rodolphe II, possibly B. Spranger, see Schilling-Swarzenski 28.

1110 ———, 5220. Lovers with magic mirror (Armida and Rinaldo). Pen, dark br., wash, on blue. 210 x 165.
About 1600.

1111 ———, 5222. Mythological scene. Pen, br., wash, over bl. ch. 118 x 163. [**MM**]
The same subject and composition in the drawing No. **1233**. Late 16th century.

1112 ———, 5235. Various sketches: nude woman, heads, feet. Pen, br. 296 x 197. Inscr. on mount: Malombra Pietro. In the Louvre ascr. to Malombra. **[MM]**

In our opinion, typical of Palma Giovine, see No. **913**. For a like-wise erroneous attribution of a Palma drawing to Malombra see Nos. **914, 915**.

1113 ———, 5239. Saint John the Baptist as a youth, sitting in a landscape. Pen, br. 180 x 142. Old inscription: 1580 (and by a later hand) Palma Giovine. **[MM]**

1114 ———, 5241. Seated youth (John the Baptist), in background figure seen from behind. Pen, br., on blue. 136 x 103.
About 1580.

1115 ———, 5259. Various sketches: Two male nudes recumbent, female heads, seen from front and in the profile. Pen, br., wash, height. w. wh., on blue. 160 x 195. Coll. Crozat.
Late 16th century.

1116 ———, 5381. Floating nude figures (from a Last Judgment?). Pen, br., wash, height. w. wh., on blue. 189 x 278. Inscr.: Tintoret. Ascr. to Ja. Tintoretto. **[MM]**
Typical of Palma in the 1580's; see No. **1101**.

1117 ———, 5373. Martyrdom of St. Lawrence. Over bl. ch. sketch broad pen, grayish br., wash, on paper turned yellow. 308 x 444. Ascr. to Ja. Tintoretto. **[MM]**
Shop copy from Palma Giovine's early painting of this subject in S. Giacomo dell'Orio. A man on horseback at l. in the painting is missing in the drawing. Compare the two original, but very modified sketches No. **1106** and No. **1037**, II, 100, and the two studies for single figures Nos. **882, 883**.

1118 ———, 5756. Group of biblical figures in landscape. Bl. ch., on faded blue. 244 x 141. Colorspots. Formerly ascr. to Titian, now among the anonymous. *[Pl. CLXXIII, 4.* **MM]**
Typical of Palma and perhaps first idea for his painting "Christ delivering the keys to St. Peter," in San Polo, Venice (Photo Sansoni, Photo Frick 23354). Compare the companion piece No. **885**.

1119 ———, 087. Assault of a fortress or a ship. Pen, black br., wash. 260 x 140. On the r. the outlines of a monument or a door seem to cut in, so that the composition would have surrounded the architecture. Reproduced in *Galérie Denon* II, 144 r. (in reverse). **[MM]**
Companion piece of No. **1120**. In the 1580's.

1120 ———, 087. Galley and rowboat. Pen, black br., wash. **[MM]**
Companion piece of No. **1119**, planned for the other side of the same architecture.

1121 PARIS, ÉCOLE DES BEAUX ARTS, 3337. Christ teaching. Pen, grayish br., wash, height. w. wh., oxidized, on faded blue. 205 x 300. Inscribed 1628.

1122 ———, 37849. St. Sebastian tied to a tree. Pen, br., wash. 362 x 182. Stained by mold. — On the back: Design for an altar-piece showing the Virgin and Child in clouds and two monk saints beneath. At the r. one of the saints was studied separately. Various inscriptions: per Sinigaglia (and) per la sig^ra Servilia di Visconti Vinaldo (?) del 1601 . . . brii (and) per cinque d(uc) ati(?) (and)

genaro 1621 ano Roman. By a later hand G.P. n° 150. Exh. École des Beaux Arts 1935, no. 76, **[Both sides MM]**

The date of 1601 seems to suit the style of drawing better. For another version of the composition see Sale Sotheby 1920, December 7–10, no. 204. For the *verso* see No. **1073**.

1123 PARIS, COLL. MARIGNANE. Four nude men working at a forge. One of the arms studied separately. Pen, br., gray wash, on faded blue. 180 x 227. **[MM]**
Other versions of this Forge of Vulcan, are the No. **1226** and No. **1227**. About 1590, perhaps connected with Palma's painting in Cassel.

1124 ———. The Coronation of the Virgin, with many saints above and with others of the orders of St. Francis and St. Dominic standing on the ground. Brush, br., height. w. wh., on yellowish. 550 x 410. Semicircular top. Stained by mold.
Perhaps *"modello"* for the painting of this subject formerly existing in S. Girolamo in Venice and described by Ridolfi II, p. 197.

1125 ———. Resurrection of Christ. Pen, br., wash. 310 x 235. Semicircular top.
Beginning of the 17th century.

1126 PARIS, COLL. MME. PATISSOU. Adoration of the shepherds. Brush and broad pen, br. and blackish gray, wash. 144 x 205. Coll. Prince Argoutinsky-Dolgoroukow, Sale Sotheby, London 1923, July 4, no. 21 as Jacopo Tintoretto. — On the back: Various sketches, entombment of Christ, female head in profile, many inscriptions of religious character in Palma's handwriting and the beginning of a letter. *[Pl. CLXXVIII, 1 and CLXXVI, 3. Both sides* **MM]**
The drawing is a very important document combining on one single sheet one drawing in a style usually ascr. to Palma Giovine in various collections, but without any authentication by a corresponding painting, to another drawing on the other side in Palma's most typical and best authenticated style. The *verso* is, moreover, supported by the inscriptions, which are Palma's typical scribbles.

1127 PARIS, COLL. L. GODEFROY, formerly. Beheading of a female saint. Pen, wash. 212 x 315. Cut. Ill. in Sale Drouot (1924, April 11) no. 86 as Ja. Tintoretto.
Most typical of Palma in the style of No. **1240** and perhaps the design for Palma's painting in the Frari, which we were not able to check. For the group of two youths in the foreground No. **1245** is a separate study.

1128 PAVIA, MUSEO CIVICO MALASPINA, 84. The Saints Sebastian, Roch and a third saint. Pen, br., wash, on faded blue. 380 x 284. Inscr: Giorgone.
Late.

1129 PITTSBURGH, COLL. TÖRÖK, formerly. Sketches for groups of figures on clouds. Pen, br. 252 x 167. Ill. in Leporini, *Die Handzeichnungen der Sammlung Török*, Wien, 1927, pl. XV.
We have not seen the drawing itself. It is a sketch for the upper part of the "Assumption of the Virgin," formerly in the Scuola di San Fantino, now as a fragment in the Hermitage. The painted sketch of the whole composition is in the Galleria Querini-Stampalia, Venice, ill. Venturi, 9, VII, fig. 131. The painting is mentioned by Borghini as just in the making and is therefore to be dated about 1580.

1130 Rennes, Musée, 31/2. Two draped women in half-length and a man seen from the back and lying on the ground. Broad pen, br., gray wash, on faded blue. 260 x 403. Inscription: Palma J. (later added: Junior).

A 1131 Rome, Gabinetto Delle Stampe, 16026. Group of men carrying a dead saint. Over ch. sketch, brush, bl. br. wash, on light gray. 157 x 186. Damaged. Ascr. to Palma G. (?) **[MM]**
Old copy from the main group of Jacopo Tintoretto's painting, "The carrying of the body of Saint Mark," in Venice. There is no reason to believe in Palma's authorship.

1132 ———, 128270. The Flagellation of Christ. Pen, br., on paper turned yellow. 121 x 264. At the r. faded inscription: Ticiano (and number) 23. Ascr. to Titian. **[MM]**
Typical of Palma about 1580–90.

1133 ———, 128383. Two studies of half-nude women. Half-length. Bl. ch., height. w. wh., on blue. The surrounding shadows seem to be put in with the brush. Ascr. to J. Tintoretto and publ. as his by Hadeln, *Tintorettozeichnungen*, pl. 18 and p. 41. Hadeln himself points out that this drawing would be an exception in Tintoretto's work. The corporeality for which Tintoretto is striving in his paintings is sought here with the means of draftsmanship. **[MM]**
In our opinion, the exceptional style of this drawing emphasized by Hadeln excludes Tintoretto's authorship, the more so as it has no connection with any of his known paintings. The drawing style is close to Palma's, see Nos. **916, 918, 929.**

A 1134 ———, 129580. Flagellation of Christ. Pen, light br., on yellow. 220 x 270. Composed in a lunette. Inscriptions: Civoli, Titiano. Ascr. to Sebastiano del Piombo by A. Fleres, in *Le Gallerie Nazionali Italiane* 1896, p. 154, an attribution accepted by C. Justi, *Michelangelo, Neue Beiträge*, p. 419 and Pietro d'Achiardi, *Sebastiano del Piombo*, 1908, fig. 28, but rejected by F. Wickhoff, in *Jahrb. Pr. K. S.* 1899, p. 207 who gave the drawing to Palma Giov. Ill. as Palma ? in Giorgio Bernardini, *Sebastiano del Piombo*, Bergamo 1908, p. 27 and accepted as Palma by Bucarelli, in *Gaz. d.B.A.* 1935, I, p. 253. Dussler, *Sebastiano del Piombo*, p. 197, no. 245, calls the drawing a derivate from Sebastiano's mural.
In our opinion, not only not by Palma, but hardly by any Venetian artist at all. Dussler's hint to North Italy may be correct.

1135 ———, 129796. Saint Jerome kneeling to the r. and adoring the crucifix which he holds in his r. hand. Pen, dark br., light gray wash, on buff. 216 x 138. Listed as anonymous.
Typical of Palma's latest period.

1136 ———. Various sketches, scene from the life of a pope, three studies of heads. Pen, wash. 170 x 250. — On the back: Another sketch of the same pope. Publ. in *Le Gallerie Nazionali* II, p. 154 as by Palma Giovine.
We could not locate the drawing which may by now be listed under the name of some other artist.

1137 Rugby, School Art Museum, 1655. Upper part of a Last Judgment: Christ enthroned, surrounded by the Holy Virgin and many saints. Pen, br., grayish br. wash, height. w. wh., oxidized. 97 x 250. — On the back: Christ carrying a large cross. Bl. ch. Gift of Mathew H. Bloxam, 1880.
Typical of the 1580's, similar to No. **1193.** The drawing on the

back seems to be dependent on Michelangelo's statue in Santa Maria Minerva.

1138 Sacramento, Cal., E. B. Crocker Art Gallery. 238. Three saints kneeling. Pen, br., wash. 91 x 86. Cut. Ascr. to Fra Bartolommeo. Typical, about 1580–90.

1139 Salzburg, Studienbibliothek, H 123. Various sketches: five female heads, two women half-length, a hand. Pen, grayish br. 157 x 207. Stained by mold.
Typical of the late 16th century.

1140 ———, H 136. Various sketches: figure of a young girl, five times repeated; in lower l. corner seated figure. Bl. ch. and pen. 273 x 205, Watermark crossbow. **[MM]**
Last quarter of 16th century.

1141 ———, H 145. Woman with drapery around waist, kneeling on a cloud. Red ch. 297 x 200. — On the back: Various sketches, the same figure kneeling in opposite direction, seated and kneeling women and other studies of nudes. Watermark: enthroned king in circle. **[MM]**
Typical of last quarter of the 16th century; very close in style to No. **1017.**

1142 ———, H 179. Christ and the Holy Virgin, from a Paradise. Pen. 95 x 155. — On the back: Various sketches: sleeping figure in horizontal oval; below a large angel. Publ. by J. Meder in *Graph. Künste* 1931, p. 79 as Jacopo Tintoretto, an attribution rejected by E. Tietze-Conrat, in *Graph. Künste* N.F.I., p. 100. **[MM]**
The connection with Palma's "Paradise" seems doubtful, the drawing may belong to his "Last Judgment" in the Sala dello Scrutinio (as also suggested by W. Suida in *Rivista d'A.*, 1938, p. 83, n. 1).

1143 ———, H 180. Sketches for a Paradise. Pen. 420 x 240. Watermark Briquet 728 or 766. The architectural structure and the door in the middle are sketched in ch. — On the back: Single figures and groups varying those on the *recto*. Pen and ch. The lines of a kind of squaring are executed in ch. Publ. by J. Meder in *Graph. Künste* 1931, p. 75, pl. I and II as J. Tintoretto's sketches for his "Paradise" in the Sala del Gran Consiglio. The attribution to Palma Giovine was amply substantiated by E. Tietze-Conrat in *Graph. Künste* N.F. I. (1936), p. 97 ff. The sketches prepare Palma's painting made in competition with Tintoretto's "Paradise." Palma's painted sketch is preserved in the Contini Coll. in Florence, see Suida in *Rivista d'A.*, 1938, p. 77–83, and has been etched as Palma's invention by Pierre Brebiette. *[Pl. CLXXVII, 1 and 2.* **MM]**

1144 ———, H 194. Sketches for a Paradise. Pen, br., on yellowish. 217 x 267. Stained by mold. — On the back: hardly discernible nude figures. Bl. ch. Anonymous. **[MM]**
Close to Palma, although not entirely convincing.

1145 ———, H 195. Three evangelists in horizontal ovals, and three other similar sketches; accounts. Pen, br. 153 x 227. — On the back: Letter dated April 2, 1614.

1146 ———, H 196. Saint Stephen kneeling above clouds. Beneath unidentified scene. Pen, light br. 150 x 62. Framed by lines. **[MM]**
Last quarter of 16th century.

1147 ———, H 204/1. Saint Mary Magdalene recumbent. Pen, br. 195 x 275. Watermark anchor in circle.
Last style; companion piece to No. 1149.

1148 ———, 204/2. Various sketches: recumbent figures, others in half-length, heads of men and women. Pen, reddish br. 188 x 297.
— On the back: Head of a man and portrait of Andriana Palma, in red ch. Dated 1603. [MM]

1149 ———, H 204/3. The dead Christ; Saint Mary Magdalene, recumbent. Pen, light br., on paper turned yellow. 198 x 305.
Companion piece to No. 1147.

1150 ———, H/205. Virgin and Child, Saint Joseph and the donkey are only sketched. Pen, br. 145 x 95. Stained by mold. — On the back inscription in charcoal: Conte Priuli.
Companion piece of No. 1151.

1151 ———, H 206. Sketches for a composition Virgin and Child riding on the donkey, the two figures studied separately at the side. Pen, br., wash, on brownish. 170 x 149.
Companion piece to the preceding No. 1150.

1152 ———, H 207. Venus and Cupid. Pen, br., wash, height. w. wh. 265 x 210. — On back old inscription: Palma.
Late style or pupil of latest period.

1153 ———, H 274. Resurrection of Christ; below two collapsing guards. Bl. ch., on faded blue. 303 x 202. Watermark two wheels. Very much faded.
Late 16th century.

1154 ———, 453/1. Man leading a horse. Charcoal, height w. wh., on br. 227 x 180. Ascr. to the circle of Tintoretto by Meder. [MM]
Study for the figure at l. in the "Entrance of Emperor Eraclius in Jerusalem," in the sacristy of the Gesuiti, in Venice, painted 1590 for the Crociferi.

1155 ———, 453/2. The man as in No. 1154 without the horse. Companion to No. 1154. Very much faded.

1156 ———, 478. Sketch for the painting "The storming of Constantinople" in the Sala del Maggior Consiglio, Ducal Palace (ill. Venturi 9, VII, fig. 103). Pen, on brownish. 206 x 287. — On the back: Two floating figures (Flight of Cupid). The main side publ. by Meder, in Graph. Künste 1933, p. 28, fig. 3. [Verso MM]
For the sketch on the back see the corresponding drawing No. 1037, II, 212 (ill. Heil fig. 11).

1157 ———, 484. Two figures kneeling and standing on clouds. Bl. ch., on wh. paper. 256 x 195. Stained by mold and oil spots. Very much damaged. Ascr. to Jacopo Tintoretto.
Possibly in connection with a "Paradise."

1158 ———, 485. Baptism of Christ. Pen, on br. 270 x 341. Three corners patched. — On the back: Female saint, nude, supported by angels. Both sides publ. as Ja. Tintoretto by Meder, Graph. Künste, 1933, fig. 3 and 4, the verso with reference to Tintoretto's painting in Santa Caterina in Venice (ill. Bercken-Mayer pl. 102).
Typical of Palma's style in the beginning of the 17th century.

1159 ———, 486. Various sketches of a composition, three times repeated. At l. a boy recumbent, seen from behind. Pen, on blue. 205

x 305. Publ. as Jacopo Tintoretto by Meder, in Graph. Künste 1933, p. 1 ff. (only r. half reproduced) and connected with the central group in the Paradise, see No. 1143.
In our opinion not necessarily connected with the Paradise, but typical of Palma.

1160 ———, 487. Two sketches for Adam and Eve. Pen, br. 240 x 170. Watermark: crossbow, identical with No. 1140. Inscription: Per Cremona. Publ. by Meder, in Graph. Künste 1933, fig. 2 as Jacopo Tintoretto.
Typical of Palma as confirmed by the handwriting (see for instance No. 1037, I, 199). Note the resemblance to Palma's painting "Adam and Eve" in the Galleria Querini-Stampalia, Venice (ill. Venturi 9, VII, fig. 168 with the erroneous caption Giovanni Contarini).

1161 ———, 490. Seated woman doing penance, half-length. Pen, br., on blue turned green. Watermark: crossbow in oval. Ascr. to Venetian school, second half of the 16th century.
Typical of Palma Giovine in the 1590's.

1162 STUTTGART, COLL. FLEISCHHAUER, formerly. Studies of four figures. Bl. ch. Publ. by Fröhlich-Bum in Zeitschr. f. B. K. 65, p. 126 as Jacopo Bassano with reference to Nos. 145, 160.
In our opinion, indubitably by Palma Giovine and possibly a detailed study for his (lost) mural in the Ducal Palace, see Nos. 1231, 1239.

1163 TURIN, BIBLIOTECA REALE, 15959. Portrait of a man, in decorated frame. Pen, br., wash. 247 x 177. Above the female genius on the frame inscription: Virtus; in the shield below: anno 1593.

1164 ———, 86. Saint John baptizing. Bl. ch., height. w. wh., on faded blue. 250 x 140.
Late 16th century.

1165 UDINE, MUSEO COMMUNALE, 81. Dead Christ supported by five little angels, above clouds, below two seated male saints. Pen, br., height. w. wh., on blue. About 300 x 200.
Late style.

A 1166 ———. Virgin and Child above clouds, below St. Charles and other saints. Design for an altar-piece. Ill. as Palma Giovine in Chino Ermacora, Guida di Udine, Udine 1932, p. 68, but certainly by a much later artist.

1167 VENICE, REALE GALLERIA, 111. Christ appearing to the Doge Zeno, his wife and senators. Pen, wash. 205 x 202. Formerly ascr. to Jacopo Tintoretto, recognized as Palma by Fogolari 62. Hadeln, Spätren. pl. 96: design for Palma's painting in the Oratorio degli Crociferi, (ill. Venturi 9, VII, fig. 127), painted about 1583 (Ridolfi II, 180, note 3). In the painting, the composition is modified in many points.
See No. 889, which might be connected with the same composition.

1168 ———, 387. Three sketches for a Pietà. Pen, br. 132 x 82. About 1580–90.

1169 ———, 388. Dead Christ seated. Pen, br. wash. 130 x 74. Sketch for Palma's painting "Mourning over the Dead Christ" in San Trovaso, Venice, late 16th century.

1170 ———, 484. Two nudes recumbent. Pen, dark br., wash. 90 x 137.
Typical of the 1580's.

1171 ————, 494. Bust of a bearded old man, turned to the l. (Saint Jerome?). Pen, light br., 160 x 199. Inscription: Dal palma Vecchio.

In the style of Palma's etched Academy.

1172 ————, 498. Hercules and Antaeus, influenced by Giovanni Bologna's group. Pen, br., wash, 227 x 135.

1173 ————, 519. Saint Jerome kneeling. Pen, br., on buff. 280 x 164.

Typical of latest period.

1174 ————, 549. Nude seated, seen from behind. Pen, br., on bluish gray. 247 x 170.

Late.

1175 ————, 562. Youth standing in a pose similar to that of Michelangelo's slave. Pen, br., gray wash. 197 x 199. Lower l. corner inscription: Palma.

Early period.

A 1176 ————, 563. Madonna holding the dead Christ. Pen, dark br., wash, height. w. wh. On a patched strip later inscription: Palma. Ascr. to Palma.

The attribution to Palma is, in our opinion, unfounded.

1177 ————, 566. Three sleeping apostles, part of Mount of Olives. Red ch. 144 x 187. [MM]

Connected with the drawing No. 995, in which the two figures at the l. are almost identical. The apostle at the r. shows an affinity to Palma's Mount of Olives, engraved by J. Matham (Bartsch vol. III, p. 177, no. 187).

1178 ————, Frame 14. Figures climbing upward. Pen, br., wash, on yellow. Inscription: 1628 adi 16 marti. Questo sono lultimo disegnio disegnato dal signor Palma, mio carissimo maestro.

[Pl. CLXXXIII, 4. MM]

1179 VENICE, MUSEO CIVICO CORRER, 1242. Christ standing in a chalice supported by angels. Composed in an oval. Pen, br. 268 x 191. In lower l. corner inscription: No. 61 Palma.

Variation of No. 896. The composition is apparently connected with the Scuola del Santissimo Corpo di Cristo, in S. Agnese in Venice. The front page of the Mariegola of this brotherhood in the Museo Correr (Ms. IV, 25) contains a miniature showing the same arrangement except that the angels carry the instruments of the passion of Christ.

1180 VIENNA, ALBERTINA, 41. Two fathers of the church. Charcoal, height. w. wh., on brownish paper. 231 x 427. Grassi Coll. Publ. and attr. to Titian by Stix, Albertina, N. F. II, 18 and in Albertina Cat. II (Stix-Fröhlich). Identified by E. Tietze-Conrat in Graph. Künste N. F. II, p. 90, as Palma Giovine's design for his ceiling in the Ateneo Veneto, ill. Venturi 9, VII, fig. 139, executed in 1600.

[Pl. CLXX, 2. MM]

1181 ————, 89. Youth in armor, kneeling. Bl. ch., height. w. wh. 262 x 172. Ascr. to Jacopo Tintoretto in Albertina Cat. II (Stix-Fröhlich).

In our opinion, typical of Palma's earlier style, compare No. 831.

1182 ————, 100. An angel flying. Pen, wash, 187 x 152. Ascr. to the school of Tintoretto.

Typical of Palma Giovine in the late 16th century, compare No. 1143. Similar figures in Palma's painting "The guardian angels" in the Gesuiti at Venice.

1183 ————, 101. A nude man soaring upward. Pen, wash. 187 x 152. Ascr. to the school of Tintoretto.

Companion to No. 1182.

1184 ————, 174. Christ on the Mount of Olives. Pen and bister, wash. 275 x 204. Albertina Cat. I (Wickhoff): authentic. Schönbrunner-Meder 1377. Dated by Heil, p. 62 about 1590.

A 1185 ————, 175. Study for an Entombment of Christ. Brush, bister, wash, 247 x 188. Formerly ascr. to Titian, attr. to Palma Giov. in his early years by Schönbrunner-Meder 878 and Albertina Cat. I (Wickhoff) 26. Albertina Cat. II (Stix-Fröhlich): Palma.

In our opinion, not Venetian at all, but Bolognese, in the manner of Pietro Faccini. Compare his signed "Entombment" in the British Museum and the Kneeling Apostle, Louvre 8240.

1186 ————, 176. Last Supper. Pen, wash, height. w. yellow and reddish br. Coll. of Prince de Ligne.

Variation in the Louvre No. 1083.

1187 ————, 177. Christ on the cross. Brush, bister, height, w. wh. 510 x 263. Schönbrunner-Meder 467. Albertina Cat. I (Wickhoff) 257. Albertina Cat. II (Stix-Fröhlich). [MM]

In our opinion a "modello," closely related in style and technique to No. 891.

A 1188 ————, 178. Flagellation of Christ. Pen, bister, wash. 103 x 163. Albertina Cat. I (Wickhoff) 255: original. Albertina Cat. II (Stix-Fröhlich).

Not convincing, either for the composition, or for the penmanship.

1189 ————, 179. Sheet of studies: Resurrection of Christ, some figures studied separately. Pen and wash, height. w. yellow, on brownish tinted paper. 161 x 228. — On the back: Lucretia. Over bl. ch. sketch, pen. Albertina Cat. I (Wickhoff) 275: originally belonging to the same sketchbook as Nos. 1193, 1194, 1195. Albertina Cat. II (Stix-Fröhlich).

About 1600. Compare 1037, II, 83.

1190 ————, 180. Entombment with a donor. Pen and bister, wash, height. with yellow, on br. paper. 147 x 117. Albertina Cat. I (Wickhoff) 273. Albertina Cat. II (Stix-Fröhlich).

Beginning of the 16th century.

1191 ————, 181. Beheading of Saint John the Baptist, design for the altar-piece in the church of the Gesuiti in Venice (Ridolfi II, 181). Pen, bister, wash, height. w. yellow. 146 x 101. Coll. of Prince de Ligne. Albertina Cat. I (Wickhoff) 277. Albertina Cat. II (Stix-Fröhlich). Identified as the design for the above-mentioned painting and publ. by Hadeln, Spätren. pl. 94.

Dated by the painting shortly before 1604.

1192 ————, 182. The Virgin and Child between St. John the Baptist, Saint Helena and other saints, half-length. Pen, bister, wash. 166 x 163. — On the back: Two sketches for an Adoration of the shepherds. Height. w. yellow. Coll. Prince de Ligne. Albertina Cat. I (Wickhoff) 277. Albertina Cat. II (Stix-Fröhlich).

Beginning of the 17th century.

1193 ————, 183. Sheet of sketches, divided into three zones, containing elements of a Last Judgment and various biblical scenes. Pen, wash, height. w. yellow. 188 x 224. — On the back: The Last Supper with single figures studied separately. *Albertina Cat. I* (Wickhoff) 271. *Albertina Cat. II* (Stix-Fröhlich).

Late 16th century. The sketch in the middle row at l. resembles the foreground figures in the (lost) painting in the Ducal Palace (see No. 1231).

1194 ————, 184. The seizure of Christ. Pen br., wash w. yellow. 191 x 252. *Albertina Cat. I* (Wickhoff) 272. *Albertina Cat. II* (Stix-Fröhlich).

Late 16th century.

1195 ————, 185. Various sketches, among them design for a Resurrection of Christ, above study of a leg. Pen, wash, height. w. wh. 258 x 170. — On the back: sketch for a Gathering of Manna. Pen. *Albertina Cat. I* (Wickhoff) 274. *Albertina Cat. II* (Stix-Fröhlich).

Late 16th century.

A 1196 ————, 186. Female saint between St. Lawrence and a bishop saint, standing in semicircular niche. Pen, wash, height. w. yellow. 132 x 83. Coll. Prince de Ligne. Acknowledged as Palma by *Albertina Cat. I* (Wickhoff) 278 and *II* (Stix-Fröhlich).

In our opinion, lacking the characteristics of Palma's style.

1197 ————, 187. The Virgin and Child in clouds, on the ground three adoring bearded monks. Over bl. ch. sketch, pen and brush, on yellowish tinted paper. 182 x 101. Coll. Prince de Ligne. *Albertina Cat. I* (Wickhoff) 279 and *II* (Stix-Fröhlich).

Late 16th century.

1198 ————, 188. Martyrdom of St. Sebastian. Over bl. ch. sketch, pen, wash. 318 x 244. Below inscription. 1611 Genuarii anac (. . . cut). *Albertina Cat. I* (Wickhoff) 261 and *II* (Stix-Fröhlich).

1199 ————, 189. Massacre of the Innocents. Over sketch in bl. ch., pen, wash. 316 x 264. Cut. *Albertina Cat. I* (Wickhoff) 251. *Albertina Cat. II* (Stix-Fröhlich). **[MM]**

Early 17th century.

1200 ————, 190. Various sketches: St. Jerome, four nudes. Pen, wash, 248 x 198. Coll. Kutschera-Woborsky. *Albertina Cat. II* (Stix-Fröhlich).

Typical, late.

1201 ————, 191. Arrival of Henry III in Venice, design for Palma's painting in Dresden No. 525 B. Pen, over bl. ch. sketch. 212 x 319. *Albertina Cat. I* (Wickhoff) 284: attr. to Vicentino and erroneously connected with his painting of the same subject in the Ducal Palace. Hadeln, *Spätren.,* pl. 95 and p. 22 recognized the connection with the painting in Dresden and returned to the traditional attribution to Palma. *Albertina Cat. II* (Stix-Fröhlich)

[*Pl. CLXXV,* 2. **MM**]

Dated by the painting shortly after 1574.

A 1202 ————, 192. The golden calf. Pen, wash, height, w. wh., on greenish paper. 300 x 396. *Albertina Cat. I* (Wickhoff) 108: copy from Jacopo Tintoretto's painting in the Madonna dell'Orto (ill. Bercken-Mayer 62), probably by a direct follower or pupil of the master. *Albertina Cat. II* (Stix-Fröhlich): Palma Giovine, mentioning that Meder had attr. the drawing to Farinato, but not that it is a

copy from Tintoretto. In our review of *Cat. II* in *Zeitschr. f. B. K.* 1926, p. 111 we repeated the reference to Jacopo Tintoretto's painting.

1203 ————, 193. Seizure of Christ. Pen, wash, height, w. wh., on greenish paper. 210 x 306. *Albertina Cat. I* (Wickhoff) 383. *Albertina Cat. II* (Stix-Fröhlich). **[MM]**

Late.

1204 ————, 194. Hercules and Omphale. Pen, wash, height. w. wh. 174 x 193. *Albertina Cat. I* (Wickhoff) 283. *Albertina Cat. II* (Stix-Fröhlich).

Late period.

1205 ————, 195. Mourning over the dead Christ. Pen, wash, height. w. wh. 234 x 267. Original inscription: 1621. Later inscription: Palma. *Albertina Cat. I* (Wickhoff) 258. *Albertina Cat. II* (Stix-Fröhlich).

1206 ————, 196. Annunciation of the Virgin in clouds, below St. John the Evangelist, St. Jerome and two sainted monks. Pen, wash. 280 x 164. Lower r. corner: 1623 (?) and another word canceled. *Albertina Cat. I* (Wickhoff) 264. *Albertina Cat. II* (Stix-Fröhlich).

Design for an altar-piece, late period.

A 1207 ————, 197. Adoration of the shepherds. Pen, on brownish. 403 x 270. Inscription: Palma. *Albertina Cat. I* (Wickhoff) 250. *Albertina Cat. II* (Stix-Fröhlich).

The typical characteristics of Palma's style are missing. The drawing might be by a contemporary artist, compare for instance No. **788.**

A 1208 ————, 198. The incredulity of Thomas. Pen, wash, height. w. wh. 187 x 316. Formerly attr. to Francesco Bonifazio (born 1637 in Viterbo and pupil of Pietro da Cortona), an attribution accepted by *Albertina Cat. I* (Wickhoff) Sc. Romana 1233. Ascr. to Palma in *Albertina Cat. II* (Stix-Fröhlich).

Not by Palma. The old attribution, although hardly to be checked, seems more plausible.

1209 ————, 199. Assumption of the Virgin. Pen, wash, height. w. wh. 291 x 210. Original inscription: 1627 agosto 15. *Albertina Cat. I* (Wickhoff) 259. *Albertina Cat. II* (Stix-Fröhlich).

Compare No. **1074.**

1210 ————, 200. Vision of a saint. Pen, wash. 270 x 192. The sheet is enlarged by a strip, pieced on above and below over which the drawing extends. Inscription in later hand: Palma Giovane. *Albertina Cat I* (Wickhoff) 265. *Albertina Cat. II* (Stix-Fröhlich).

Typical of latest period.

1211 ————, 201. Martyrdom of St. Sebastian. Pen, wash. 212 x 238. Richardson Coll. Schönbrunner-Meder 1045. *Albertina Cat. I* (Wickhoff) 262. *Albertina Cat. II* (Stix-Fröhlich). **[MM]**

Late 16th century. A separate study for the figure of St. Sebastian and the angel above in Sale Sotheby, London 1920, December 7–10, no. 204 (ill.).

A 1212 ————, 202. Resurrection of Christ. Pen, wash, height. w. wh. 200 x 157. Formerly ascr. to J. Tintoretto, attr. to Palma in *Albertina Cat. I* (Wickhoff) 120, followed in *Albertina Cat. II* (Stix-Fröhlich). **[MM]**

In our opinion, the drawing style is entirely different from Palma's

and closer to the mannerism of Santi di Tito (cf. his study for the Resurrection in Santa Croce, ill. Voss, *Malerei der Spätrenaissance*, 1920, fig. 146) and other central Italian painters.

A 1213 ————, 203. Madonna enthroned with Saint Peter and Saint Paul. Over bl. ch., pen, wash. Above framed by curved border-line. 244 x 237. Formerly ascr. to Palma Vecchio, and to Palma Giovine in *Albertina Cat. I* (Wickhoff) 236, followed by *Albertina Cat. II* (Stix-Fröhlich).

In our opinion, not by Palma and scarcely Venetian at all. Perhaps Bolognese (compare Sisto Badalocchio's "Madonna with Saint Francis and Joseph," ill. *Budapest Yearbook* IV, p. 152, fig. 38).

1214 ————, 204. Sheet with sketches for a composition of the Virgin and Child between St. Sebastian and St. Roch, and four small designs for a figure in a three-cornered panel. Pen, bister, wash, height. w. yellow. 157 x 188. *Albertina Cat. I* (Wickhoff) 281. *Albertina Cat. II* (Stix-Fröhlich).

Late 16th century.

A 1215 ————, 205. Dead Christ supported by two angels. Composed in a vertical oval. Over red ch. sketch, pen, wash. 203 x 127. Formerly listed under Palma Vecchio, ascr. to Palma Gio. in *Albertina Cat. I* (Wickhoff) 119. Followed by *Albertina Cat. II* (Stix-Fröhlich).

The drawing style not typical of Palma.

1216 ————, 206. Christ crowned with thorns. Pen, wash, height. w. wh., on brownish paper. 299 x 209. *Albertina Cat. I* (Wickhoff) 256. *Albertina Cat. II* (Stix-Fröhlich).

Variation of the simpler composition on the high-altar in San Zaccaria in Venice. Late.

1217 ————, 207. Design for a painting: angel appearing to a woman. Pen, wash, height. w. yellowish br. 129 x 64. Semicircular top. *Albertina Cat. I* (Wickhoff) 276. *Albertina Cat. II* (Stix-Fröhlich). [MM]

From the same sketch book as Nos. **1221** ff. in the Liechtenstein Coll. in Vienna. The subject is called "The Angel appearing to Manoah's wife" in *Albertina Cat. II* (Stix-Fröhlich). In our opinion, it more likely represents Hagar in the desert. Late 16th century.

A 1218 ————, 208. Return of the Prodigal Son (?). Pen, wash. 161 x 203. Formerly ascr. to G. B. Angolo dal Moro, an attribution accepted in *Albertina Cat. I* (Wickhoff) 206. *Albertina Cat. II* (Stix-Fröhlich): Palma Gio.

In our opinion, neither by G. B. Angolo nor by Palma. Perhaps not Venetian, at any rate, later.

1219 ————, Reserve 113. Two sketches of St. Jerome in meditation. Pen, wash, height. w. wh., on buff. 198 x 290. Both drawings are dated 1625. *Albertina Cat. I* (Wickhoff) 268.

1220 ————, Reserve 112. St. Jerome reading. Pen, wash, height. w. wh., on buff. 226 x 187. Old inscription: Palma. *Albertina Cat. I* (Wickhoff) 267.

Typical of Palma's latest period.

1221 VIENNA, COLL. PRINCE LIECHTENSTEIN, Ital. 33, 10, a. Baptism of Christ. Pen, wash, on brownish prepared paper. 201 x 168. Inscription: 24. — On the back: various sketches and scribbles. [MM]

Part of a sketchbook, to which most of the other drawings in this

collection and those in Brno, Nos. **837–857** belong. A few more fragments of the same book in the Albertina, see No. **1217**. About 1580. See Nos. **1222, 1223**.

1222 ————, Ital. 33, 10, b. Baptism of Christ. See No. **1221**. 162 x 86. Inscription: 48.

A variation of the composition No. **1223**.

1223 ————, Ital. 33, 10, c. Baptism of Christ. The figure of St. John studied separately in upper l. corner. See No. **1221**. 180 x 170. Inscription: 33. [MM]

Variation of the compositions Nos. **1221, 1222**.

1224 ————, Ital. 34, a. Three apostles seated. See No. **1221**. 270 x 190. Inscription: 11. [MM]

Very close to a section of the ceiling in the dome of the Cathedral of Salò, ill., *Italia Artistica* X, p. 55. According to Ridolfi II, p. 215, Aliense collaborated in this decoration for which he not only invented the figures, but also drew the cartoons.

1225 ————, Ital. 34, b. Christ and the disciples in Emaus. See No. **1221**, on somewhat lighter paper. 122 x 60. In borderline, semicircular top. Inscription: 8. [MM]

About 1580.

1226 ————, Ital. 35, a. Forge of Vulcan with Venus and Cupid present. See No. **1221**. 105 x 163. Borderline. [MM]

Variations of the composition are No. **1227** and No. **1123**, perhaps connected with the corresponding group in Palma's "Venus" in Cassel. About 1580. A chiaroscuro painting by Palma representing "Vulcan and the Cyclops" in the Zecca in Venice is also mentioned by Boschini, *Le Minere*, 1664, p. 85.

1227 ————, Ital. 35, b. Four men in a forge. See. No. **1221**. 160 x 173. [MM]

Connected with No. **1226**.

1228 ————, Ital. 35, c. Orpheus playing to Pluto and Proserpina. See No. **1221**. 134 x 255. Stained by mold. Inscription: 8. — On verso a richer variation of the same composition. [Verso **MM**]

About 1580.

1229 ————, Ital. 35, d. Mucius Scaevola burning his arm. The figures are foreshortened as for a high location. See No. **1221**. 80 x 118. Inscription: 56. [MM]

About 1580.

1230 ————, Ital. 35, e. Various sketches for the story of Saint Catherine, her discussion with the doctors, martyrdom, and a few separate studies. See No. **1221**. 230 x 166. Inscription: 23. [MM]

Paintings by Palma representing the legend of Saint Catherine are mentioned by Ridolfi (II, 175) in San Jacopo di Murano and (II, 197) in Santa Caterina in Venice.

About 1580.

1231 ————, Ital. 36, a. Study for Palma's (lost) painting in the Sala dello Scrutinio, The Siege of Venice by Pepin. See No. **1221**. 170 x 167. Inscription: 17. Publ. by E. Tietze-Conrat in *The Art Quarterly*, Winter 1940. [MM]

About 1580. See the variation No. **1239**, and No. **1193**.

1232 ————, Ital. 36, b. Sketches (5) for a composition, Meeting

of two heroes crowned by a genius. 202 x 238. Inscription: 34. [MM]
About 1580.

1233 ———, Ital. 36, c. Mythological subject (Psyche in the Hades?), woman kneeling in front of seated couple surrounded by attendants. 170 x 88. Inscription: 29. See No. 1221. [MM]
Another version of the same scene in Paris, Louvre, No. 1111. Late 16th century.

1234 ———, Ital. 36, d. Mercury leaving the three Graces, above female nude seen from behind. See No. 1221. 155 x 154, irregularly cut. Inscription: 44. [MM]
Perhaps in connection with one of the cycles representing the story of Cupid and Psyche, for the Duke of Mirandola and for King Sigismund III of Poland (Ridolfi II, 193, 194). About 1580.

1235 ———, Ital. 36, e. Triumphal chariot, drawn by two horses. 115 x 165. — Verso: Actaeon and the nymphs bathing.
About 1580. A painting representing Nymphs bathing is mentioned in Ridolfi II, p. 203.

1236 ———, Ital. 37, a. Vision of Saint John the Evangelist, beholding the four Apocalyptic Horsemen. See No. 1221. 190 x 268. Inscription: 2. [MM]
Partly used in Palma's (modified) composition in the Scuola di San Giovanni Evangelista, Ridolfi II, 175. Since the painting is already mentioned by Borghini the drawing might be dated about 1580. Another study for the same composition is No. 884.

1237 ———, Ital. 37, b. Sketch for a battle scene on a ceiling. See No. 1221. 180 x 270. Inscription: 3. [Pl. CLXXXII, 4. MM]
Study for Palma's (modified) painting "Victory of the Venetians at Cremona" in the Sala del Maggior Consiglio, ill. Venturi 9, VII, fig. 113. Mentioned by Borghini, accordingly before or about 1580.

1238 ———, Ital. 37, c. Antique battle. In borderline, below which some figures are repeated. See No. 1221. 160 x 220. [MM]
About 1580.

1239 ———, Ital. 38, a. Study for Palma's (lost) painting in the Sala dello Scrutinio, "The Siege of Venice by Pepin"; companion to No. 1231. See No. 1221. 265 x 195. Inscription: 18. Publ. by E. Tietze-Conrat in Art Quarterly, Winter 1940, p. 20. [MM]
About 1580.

1240 ———, Ital. 38, b. Battle scene before a fortress. See No. 1221. 240 x 180. Inscription: 20. [Pl. CLXXIX, 3. MM]
Preparatory study for Palma's painting "The Battle of St. Quentin" in the Palazzo Reale in Turin. About 1580. A study for one of the riders No. 1062.

1241 ———, Ital. 39, a. Three sketches for Cain slaying Abel. See No. 1221. 118 x 137. Inscription: 52.
About 1580.

1242 ———, Ital. 39, b. Cain and Abel, and Adam and Eve. See No. 1221. 118 x 137. Inscription: 52.
The sketch of Cain and Abel is influenced by Jacopo Tintoretto's composition of this subject in Venice, ill. Bercken-Mayer 31. The figure of Abel is used in Palma's painting "The brazen serpent" in Siena, dated 1598 (Photo Alinari 36692). "Adam and Eve" is a variation of Palma's painting in Querini-Stampalia, Venice, ill. 9, VII,

fig. 168 (erroneously with the caption Giovanni Contarini). About 1580.

1243 WASHINGTON CROSSING, PA., COLL. FRANK J. MATHER. Design for an altar-piece, the Virgin and Child above clouds, three male and two female saints below. Pen, br., light wash. 278 x 165. Semicircular top. Coll. Reynolds. Exh. New York, Roerich Museum, 1930, 50. [MM]
Late style.

1244 WINDSOR, R. LIBRARY, 4796. Woman kneeling to the l. Charcoal, height. w. wh., on grayish blue. 215 x 136. Publ. by K. Clark, in O. M. D. March 1931 as J. Tintoretto, with reservations, and with reference to Palma's "Entombment of Christ" in the Herbert Cook Coll., Richmond. "If Palma is the author of this drawing, it is well worth the attention of students, as showing how very closely he could imitate his master."
In our opinion certainly by Palma, compare No. 831.

1245 ———, 4797. Two men seen from behind. Charcoal, wash, on greenish. 272 x 191. Faintly squared for transfer. Publ. by K. Clark in O. M. D. March 1931, as J. Tintoretto, with reference to the "Last Supper" in San Trovaso and the drawing No. 1133.
 [Pl. CLXXIII, 1. MM]
Study by Palma Giovine intended for filling figures in the foreground of a composition. These figures appear in No. 1127.

1246 ———, 4800. Sketch for a votive painting of a Doge. Pen, br., wash. 192 x 235. Newer inscription: Jac. Palma.
 [Pl. CLXXIV, 2. MM]
Preparatory sketch for Palma's painting in honor of Doge Pasquale Cicogna, (1525–95), in the Sala del Senato in the Ducal Palace. Other sketches for the same painting in Copenhagen No. 881 and in the Uffizi, No. 922.

1247 ———, 4801. Various sketches, studies for a Presentation, a Pietà and an Assumption of the Virgin, besides single nudes. Pen, br., wash, on yellowish. 180 x 227. Later inscription: Palma.
Late 16th century.

1248 ———, 4802. Various sketches, Christ and the adulteress, single figures repeated around. Pen, br., wash, on paper turned yellow. 166 x 265: Inscription: Giacomo Palma.
About 1600.

1249 ———, 4803. Various nudes. Pen, br., on paper turned yellow. 270 x 177. In another ink: palma.
Late 16th century.

1250 ———, 4804. Various sketches, an unidentified composition, bearded head. Pen, br. 126 x 74.
In the style of Palma's etched Academy.

1251 ———, 4805. Two heads in profile turned to the l. Broad pen, on pinkish yellow. 160 x 128. Old inscription: Palma.

1252 WÜRZBURG, UNIVERSITÄTSMUSEUM. Inv. 29, 13. Massacre of the Innocents. Pen, br., wash, height. w. wh., on yellowish. Dated 1623. Publ. in Stift und Feder 1931, 38 with reference to the composition of the same subject in the Albertina No. 1199. [MM]
In our opinion, the conformity of the two drawings is limited to the subject.

GIACOMO PALMA VECCHIO

[Born about 1480, died 1528]

Although Palma Vecchio has been considered worthy of being admitted to the *Klassiker der Kunst* series, a distinction rather bewildering for an artist of his rank, his figure has not been sufficiently clarified to allow the attribution of drawings. The compiler of the volume mentioned accepted a number of traditional ascriptions without recognizing, much less discussing, the problems involved.

They are caused less by the nearness of Titian whose relations to Palma Vecchio in the early years of both gave Cavalcaselle and later authors so much to ponder about, than by the confusing insertion of two groups of much later drawings into Palma's presumed work. For, although Titian may be near, he hardly infringes on Palma's originality. Examining a head like the one in Paris (No. **1269**) we should scarcely be tempted to think of Titian, even if the connection with female figures in two paintings by Palma did not offer additional evidence. Palma, apparently, enjoys the soft modeling of the surface, an interest not existing for Titian at any point of his career, and sacrifices to it the clearness of structure at which Titian would have aimed. This impression of Palma's earliest tendencies is confirmed by a still more juvenile production (No. **1266**, in the Ambrosiana) preparing a figure in Palma's Triptych in Serina, dated 1505/08 by Gombosi. The original of No. **1260** in Leiden, which we believe to be a copy from a lost pen drawing, may belong to the same early period. The lack of structural energy, evidently a basic feature of Palma's artistic essence, remains unchanged throughout his later Venetian existence in spite of his contacts there with Titian and others which otherwise so positively added to his pictorial richness and enhanced vitality. Drawings that seem to belong to his later and even latest period, as Nos. **1253, 1254, 1271** show the further and final development of trends we have met in their germ. The voluptuous glamor of his female ideal is typical of Palma.

(A sheet with two female heads in Erlangen, No. **820**, which because of this female type has been attributed to Palma Vecchio, has been discussed and tentatively attributed to Antonio Palma on p. 193.)

Palma remained the old, the *Vecchio,* especially to distinguish him from his homonymous grandnephew, Palma Giovine, who, however, living to reach the age of 84 years, was apparently (and deservedly) called *"il Vecchio"* by his contemporaries. In our opinion, the inscription, Palma Vecchio, on dozens of drawings typical of Palma Giovine in his late years was hardly meant to deceive anyone, but simply did not take into consideration the exclusive use by posterity of this designation for Palma Vecchio. The identity of the names would not be so dangerous, if it were not accompanied by other symptoms of a family cult, so typical of Venice and so important for its artistic tradition. Palma Giovine longed for a successor belonging to his family to perpetuate the famous name for another generation and in his last will, of August 1st, 1628, left all his artistic material to his grandnephew Giacomo in the event that he, then only a child, should turn out to be a painter. On the other hand, he very distinctly felt himself the heir of a family tradition and especially indebted to his grand uncle, Palma Vecchio, to whom (and to his companion Titian) he erected a monument in S. Giovanni e Paolo. In some cases he became the restorer—which in Venice meant the renewer—of Palma Vecchio's decaying paintings. The best known instance is that of the "Marriage of the Virgin," executed in 1520/22 by Palma Vecchio for San Antonio di Castello, and, in view of the bad state of its preservation, replaced in 1611 by a painting by Palma Giovine, now in the church of the Spirito Santo. How closely he followed and how freely he repeated his model can be

checked by a still existing fragment of the old version (formerly in the Giovanelli Coll., ill. *Klassiker, Palma, 78* and a copy in San Niccolò, Treviso). A drawing in Dresden, No. **1258**, has been taken by some as Palma's sketch or *modello* for the painting, but is more probably a copy from it.

This painting is by no means the only case of the kind, and at some other time we propose to discuss thoroughly the question of such modernisations of Palma Vecchio by Palma Giovine. At present we confine ourselves to corresponding drawings, two of which (Nos. **968, 983**) were made cornerstones of the knowledge of Palma's draftsmanship by Hadeln, but have proved stumbling blocks for its better understanding. Looking with unbiased mind at the two drawings, we may wonder what they were taken for, if attributed to Palma Vecchio. Evidently, they are not sketches, nothing being uncertain, or groping in them. The rich compositions are entirely settled, and merely reproduced. This means they are copies in which, we may add, nothing in the linework points to the period of Palma Vecchio; it has the looseness of the well advanced 16th century. The compositions, it is true, are more archaic, and we may even admit that both are close to Palma Vecchio's Holy Conversations. Apparently, the copyist tried hard to evoke the general impression of the paintings that served as models. Both drawings bear the name of Palma; on No. **968** the *"Palma Vecchio"* near the lower border was evidently written by a later hand, some owner of the drawing perhaps who either believed in Palma Vecchio's authorship, or who, as mentioned above, meant by this name the Palma whom he knew as *"vecchio"* in the first decade of the 17th century. More instructive is the inscription on No. **983**, apparently written by the hand that made the drawing; its wording may refer to either uncle or nephew, but its insertion in an ornamental scroll, quite unusual in a drawing of the period, confirms our theory that the drawings are copies from paintings. In a painting such a *cartellino* would be quite appropriate. The clue to the author is offered by studies from nude men on the *verso*: they are typical of Palma Giovine who, on the other hand, may be supposed more than any other to have been interested in such a repetition or restoration of a work by his uncle, the founder of the family fame and family workshop.

The misleading classification of two such outstanding drawings could not help but become the source of further evil: it opened the door for the no less erroneous attribution to Palma Vecchio of another pair of drawings, No. **1256** in Chantilly, and No. **1270** in Paris. Again we have to start by recalling that Palma Vecchio died in 1528, and that we are fully acquainted with his late and latest style; we know that there is not the slightest reason for burdening the master with such loose and mannered productions far beyond his personal style and his period. Only in the penwork might some relationship be found, not to Palma's authentic drawings, but to those two in London and Haarlem with which they share not the general style, but approximately, the date of origin—the well advanced second half of the 16th century. We do not believe that they are by the same hand as the other group (Palma Giovine's)—they are much more mannered. Their Venetian origin is by no means beyond doubt, a Central Italian element being distinct in them. Still greater is the distance from Palma Vecchio in a drawing formerly in the Feldman Coll. in Brno (No. **1255**), linked by Suida to the two others (just discussed and rejected) by the help of the well known dangerous chain argument of connoisseurship.

A ASCHAFFENBURG, SCHLOSSBIBLIOTHEK. Virgin and Child, with saints. See No. **416**.

1253 BASEL, COLL. R. VON HIRSCH. The Virgin seated and Child, half-length. Red ch. 140 x 118. A line indicates the frame below. Coll. de Chennevières (as Palma Vecchio), Heseltine, Oppenheim. Ephrussi, *Les dessins des maîtres anciens*, p. 145: Palma condensé. Morelli, *Berlin*, p. 90: Pordenone. Hadeln, *Burl. Mag.* XLIII, p. 173:

Palma Vecchio, late period. Idem in *Hochren.*, pl. 12. Gombosi, *Klassiker, Palma*, p. 71.

The ascription to Palma was based by Hadeln on the style of composition resembling that of the painting in the coll. Marchese Visconti-Venosta in Rome (ill. *Klassiker, Palma*, p. 71). We accept the attribution though with reservations, since for the time being we cannot link its style to better established drawings.

1254 BERLIN, KUPFERSTICHKABINETT, 603. Woman standing, combing her hair, seen from behind turned to the r. Bl. ch. height. w., wh., on brownish paper. 267 x 176. Cut. Formerly attr. to Romanino. Publ. by Hadeln, *Hochren.*, pl. 11, as Palma Vecchio. Gombosi, *O. M. D.* 1929, p. 60 and *Klassiker, Palma*, p. 34, note p. 135: apparently a sketch, perhaps the first idea for a (lost) painting, which existed in the Orléans Gallery and is preserved in an engraving by Bouillard (ill. Gombosi, *Klassiker, Palma*, p. 34). [*Pl. LVI*, 1. **MM**]

We accept Hadeln's attr. to Palma Vecchio, in view of the stylistic resemblance to No. **1269**. There is, in our opinion, no close connection of the drawing with the lost painting in the Orléans Gallery, since the painting appears in reverse in Bouillard's engraving. The original arrangement is shown in a painted copy, ascr. to Titian, in the Fleischhauer Sale, in which the figure turns to the l. (Photo Witt Library). From Palma's late period.

A 1255 BRNO, FELDMANN COLL., formerly. The Raising of Lazarus. Pen — on brownish paper, 115 x 180. Later inscription "Palma." — On the back according to Suida, p. 142, note, studies in red ch. representing Putti, inscr. "Badalocchio" and again, according to Suida, by a later hand. Coll. Conte Gelosi. Publ. by Wilhelm Suida, *Belvedere* 1931, II, p. 141, pl. 71, 2, as by Palma Vecchio, with reference to Palma's painting of this subject in the Uffizi, ill. ibidem 71, 1, and to the drawings Nos. **968, 983**. Rejected by Gombosi in Thieme-Becker XXVI, p. 175.

The resemblance to the painting is, in our opinion, not closer than the identity of the subject might lead us to expect. The style (by the way that of the two drawings to which Suida refers) is positively later than Palma's and the drawing might be by any eclectic artist of the early 17th century, including Sisto Badalocchio.

A 1256 CHANTILLY, MUSÉE CONDÉ, 117. Seven sleeping men. Pen, br., on buff. 195 x 295. The l. corner cut, rounded on top. Coll. Dupan and Reiset. Ascr. to Titian, attr. to Palma Vecchio by Reiset (Photo Giraudon 7985).

[*Pl. CLXXXVIII*, 4. **MM**]

The subject of the drawing, usually called "Sleeping apostles," might be the seven sleepers of Ephesus, Christians, according to the legend, sleeping for 196 years in a cave near Ephesus, unless it represents only "Sleep in summerheat," as Giulio Romano's mural in the Casino della Grotta, in the Palazzo del Tè at Mantua. In our opinion, the drawing is neither by Titian nor by Palma, and not Venetian at all. The school of Mantua should also be taken in consideration.

A 1257 CHELTENHAM, FENWICK COLL., Cat. 1. Four studies of female saints. Red and bl. ch. 229 x 161. Coll. Lanière, Lawrence, Woodburn Sale. Ascr. to Palma Vecchio. Popham cannot find any connection with Palma's paintings, but adds: "the attribution may, however, rest on some firm basis."

This basis might be offered by the fact that Lanière was personally acquainted with Palma Giovine (see No. **1044**) who, as pointed out on p. 226, is frequently called Il Vecchio my his contemporaries. We do not remember the drawing which we saw many years ago, and leave the question undecided as to whether it might be by Palma Giovine. At any rate it has nothing to do with Palma Vecchio.

A ————, Cat. 2. See No. **377**.

A 1258 DRESDEN, KUPFERSTICHSAMMLUNG. The wedding of the Virgin. Red ch., on yellowish gray. 235 x 314. The outlines pricked. Coll. Sir Th. Dimsdale, Woodburne. Formerly ascr. to Pordenone,

by Hadeln, *Hochren.*, pl. 13, to Cariani, while Gombosi, in *O. M. D.* March 1929, pl. 51, p. 60, and in *Klassiker, Palma*, p. 79 and 136 ff. attr. the drawing to Palma Vecchio and calls it a model for his lost painting in Santo Spirito in Venice, a portion of which existed in the Giovanelli Coll. in Venice (ill. *Klassiker, Palma*, p. 78). Baldass in *Jahrb. K. H. Samml.* 1929, p. 102, questions the attribution of the drawing to Cariani and to Palma, while Wilde, ibid. 1930, p. 246 note, accepts the attr. to Cariani without mentioning Gombosi's theory about Palma. Rod. Gallo, in *Rivista della Città di Venezia*, 1932, p. 547 follows Gombosi and considers the drawing, the *modello* included in the contract between Marino Querini and Palma Vecchio of 1520. Spahn, *Palma*, 1932, pl. XXIX, fig. 44, p. 61: copy from Palma's painting, an opinion accepted by J. G. Troche, *Jahrb. Pr. K. S.* 1934, p. 124.

In our opinion, too, the drawing is probably a copy which in view of Cariani's alleged dependence on Palma might even be by Cariani. It is true, there are some slight modifications which might contradict the idea of a copy, the headgear of the priest, for instance, having another shape. This shape, however, occurs in the old painted copy in S. Niccolò, Treviso (ill. *Klassiker, Palma*, p. 79). The mitre, as appearing in the Giovanelli fragment, may have been, together with the rest of the background, changed by Palma Giovine, who is supposed to have kept the fragment after having executed the new version of his uncle's picture for the church.

A ERLANGEN, UNIVERSITAETSBIBLIOTHEK, Bock 1840. See No. **820**.

A 1259 FLORENCE, UFFIZI, 1766. Madonna and Child enthroned; at the l. a doge and two attendants, at the r. four Venetian dignitaries, kneeling. Over bl. ch. sketch brush, gray wash, on gray. 296 x 317. Cut in the format of a lunette. Ascr. to Palma Vecchio. [**MM**]

The poor draftsmanship contrasts with the grandiosity of the composition which seems more progressive than anything of Palma's known to us. The symmetry of the composition points to the first half of the 16th century, the greatness of the motive of the Virgin to a greater inventor. Might the drawing be a copy of a lost mural closer to Titian?

A HAARLEM, TEYLER STICHTING no. B 21, see No. **968**.

A 1260 LEIDEN, PRENTENKABINET, 2352. Female saint standing. Red ch. 213 x 152. Rubbed. On old mount with inscription: Jiacomo Palma. Pitt. Veniziano. — Coll. N. C. de Gijselaar. Exh. in Amsterdam 1934 (*Catalogue* No. 600): early work by Palma under direct influence of Giorgione, whose style the drawing resembles. [**MM**]

The figure indeed shows a certain resemblance to Palma, compare, for instance, his "St. Jacob" in Peghera (Bergamo), ill. *Klassiker, Palma*, p. 30, or the small-headed "St. Lawrence" in the Madonna dell'Orto, ill. ibidem 21, but the linework has no analogy among Palma's drawings. It recalls the imitation of a pen drawing executed in red ch., and we have the feeling that the drawing might be a late copy, like Padre Resta's, from an original possibly by Palma.

A 1261 LENINGRAD, HERMITAGE, 6967. Madonna and Child. Pen, 130 x 85. Coll. Cobenzl. Publ. by Dobroklonsky, *Belvedere* 1931 I p. 202, pl. 110 as Palma Vecchio, with reference to No. **968** and No. **983**.

Late 16th century copy from a painting different in style from Palma Vecchio.

1262 LONDON, BRITISH MUSEUM, Sloane 5236. Study of two heads. Bl. ch., traces of heightening w. wh., on blue. 290 x 218. Later inscription: *Campagnola*. — On *verso*: Nude, half-length, seen from front, and stretching out his arm; one hand is separately studied below. Brush, gray. Publ. by L. Fröhlich-Bum in *Burl. Mag.* LV, p. 81, pl. A, but called doubtful — probably rightly — by Gombosi in Thieme-Becker XXVI, p. 175.

A ————, 1895-9-15 — 810. See No. **983**.

A 1263 ————, Sloane 5237. The Virgin and Child with four saints. Pen, br. Publ. by Gombosi, *O. M. D.* 1929, pl. 60, and in *Klassiker, Palma,* p. 140 as Palma?, late, in the style of Palma's painting in Naples, ill. *Klassiker,* p. 94.

In our opinion, later copy from a painting by Palma Vecchio, (see the very similar one in the Hermitage, ill. *Klassiker, Palma,* p. 51).

A 1264 LONDON, COLL. SIR ROBERT MOND, No. 175. Head of a youth, turned to the r. Bl. and red ch., on br. 259 x 105. Ill. in Borenius-Witkower pl. 27, and listed as Palma on p. 42 with reservations in which we join. C. L. Ragghianti in *Critica d'A.* XX/XXII, p. 16: Copy after Bronzino.

1265 LONDON, COLL. DR. LÖWENSTEIN. Portrait of a young lady. Three quarter length. Bl. ch., slightly colored with red ch. 222 x 190. Ill. in *Sales Cat.* Karl E. Maison, Berlin W. 10, as Palma Vecchio, adding that according to Professor Suida the drawing may be an early work by Titian. **[MM]**

We have not seen the original, but consider the attribution to Palma attractive, both the linework and the invention corresponding to his. Especially typical of Palma is the shape and gesture of the hand, see his paintings ill. in *Klassiker, Palma* 48, 49, 63, 64.

1266 MILAN, AMBROSIANA, Resta 97. Study of a saint, standing and holding a book in both hands. Bl. ch., height. w. wh., on blue. 360 x 175. Lower l. corner old inscription in pen: Lorenzino di Titiano Veneto. **[Pl. LIII, 2. MM]**

Design for saint on one of the wings in Palma's altar-piece in Serina, Prov. Bergamo (ill. *Klassiker, Palma,* p. 3), universally dated early, by Gombosi 1505 to 1508. The old attribution to Lorenzino is strange, since nothing is known of this pupil of Titian, but the execution of a mural in the Cavalli Chapel in San Giovanni e Paolo (Tietze, *Titian,* p. 233 and pl. XXX). There is no stylistic connection between this grandiose mural and the drawing in the Ambrosiana which again proves that even an old ascription to an unimportant master may occasionally be wrong.

A 1267 NEW YORK, P. MORGAN LIBRARY, 57. Young woman standing, seen from behind. Pen, br., 273 x 137. — On the *verso*: Hasty sketch of a group of peasant houses under trees. Ascr. to Palma Vecchio. **[Pl. CLXXXVII, 3. MM]**

We cannot see any reason for this ascription. The manner in which the woman is drawn displays the dryness of a copy. The model might have been a famous drawing, since another copy from it exists in the so-called sketchbook of Bonifazio or Schiavone in the Louvre (see No. **1448**, Louvre no. 5591). This original might have dated from the first decade of the 16th century or even a little earlier. We have in mind something like the single costume figures painted by Giorgione and Titian on the façade of the Fondaco, or of costume figures like those which Dürer drew (after Gentile Bellini?) at the occasion of his first stay in Venice in 1495. Some characteristics recall Dürer himself, for instance, the outline of the neck which in the model may have been constructed with the compass, the hatching alternating parallel strokes with crossed ones (see the Dürer drawing L. 187), the feet which resemble those of Dürer drawings in Paris L. 624 and 657. All these characteristics, however, are rendered without deeper understanding by the copyist. He may be placed in the second half of the 16th century, a date supported by the character of the landscape on the back.

A 1268 OXFORD CHRISTCHURCH LIBRARY, H 30. St. Peter holding a book and the keys. Charcoal, slightly height. w. wh., on gray. 327 x 248. Old inscription in ch. (?): Pietro Vecchia. **[MM]**

The ascription to Palma Vecchio may rest merely on a misreading of the inscription.

1269 PARIS, LOUVRE, 482. Study for a woman's head, turned to the l. Bl. ch., height. w. wh., on faded blue. 222 x 160. Coll. His de la Salle (Both de Tauzia, p. 54: Palma Vecchio). Publ. by Hadeln, in *Burl. Mag.* XLIII, p. 169 and *Hochren.*, pl. 10 as study for the head of S. Lucy in the altar-piece in S. Stefano in Vicenza, ill. *Klassiker, Palma,* p. 96. Gombosi, *Klassiker, Palma,* p. 33: study for the head of Eve in the painting in Brunswick (*Klassiker* p. 31). **[Pl. LVI, 2. MM]**

Study from nature, resembling in its type both the paintings just mentioned, but not an immediate design for either.

A 1270 ————, 5522. Rustic company resting. Pen. Publ. by Lafenestre, *Le Titien,* p. 305 as Titian, and by W. Suida, in *Belvedere* 1931 II, fig. 66, I, as unmistakably Palma Vecchio in a popular style later carried on by Bassano. Rejected by Gombosi in Thieme-Becker, XXVI, p. 175. **[MM]**

The drawing, in our opinion, is typical of the style of book illustrations current in the middle of the 16th century. It may be a copy from such a model.

1271 ZÜRICH, KUNSTHAUS. Lucretia. Bl. ch., height. w. wh., fixed with brush, on grayish green Venetian paper. Stained by mold and damp. Late inscription in pen lower l. corner: Tiziano, and upper r. corner: No. 14. Publ. by Hugelshofer, in *Pantheon* 1933, XI as Palma Vecchio, late. **[Pl. LV. MM]**

The fact that the woman is thrusting the dagger with her l. hand, combined with the general haziness of the linework makes us suspect that the drawing is a counterproof. We agree with Hugelshofer's placing the drawing in Palma's late period and refer to his unfinished portrait of Laura Querini Priuli (1528), ill. *Klassiker, Palma,* p. 108, for the comparison of the hand.

PELLEGRINO DA SAN DANIELE

[Mentioned 1491, died 1547]

A 1272 BERLIN, KUPFERSTICHKABINETT. Head of a beardless man. Brush. 320 x 234. Coll. Rodrigues, Paris. Publ. by B. Berenson in *Rassegna d'A.* 1916. November/December, p. 275, who rejects the former attribution to Signorelli, and points to the identity of the head with that of Isaiah in Pellegrino da San Daniele's mural in Sant'Antonio, San Daniele, Friuli, executed 1513–14. Exh. London 1930, no.

495. Popham *Cat.* 181 as Pellegrino, while Meder, *Handzeichnung,* fig. 183 held to Signorelli.

We cannot agree with Berenson's opinion that the drawing is poor in quality and provincial in character and, therefore, more probably by a man like Pellegrino than by an artist of the rank of Signorelli. In our opinion, on the contrary, the drawing is so far superior to

Pellegrino's mural and to any other of his works, that we are inclined to believe he must have used a drawing by some prominent painter which he happened to have at his disposal. The whole character of the drawing makes a Venetian origin less likely. In our opinion the attribution to Signorelli gave a much more acceptable suggestion.

SANTE PERANDA
[*Born 1566, died 1638*]

According to Ridolfi, Peranda studied with Lionardo Corona and later with Palma Giovine; he stayed with the latter for three years according to Ridolfi (II, 261), and according to Boschini's *Carta* even fourteen years. A sojourn in Rome, 1592 to 1594, is described by Ridolfi in almost the same phrases which he uses for the same episode in Palma's life. As for Peranda's activity as a draftsman we are thrown almost entirely on a few attributions by old owners. As a specimen of ch. drawings we have No. **1274** and as a specimen of pen drawings, No. **1276**. The contact with Corona appears almost greater than that with Palma in spite of the length of the second connection; Peranda is not only different in his artistic temper: his handling of the pen is also different. No. **1275**, traditionally given to Palma Giovine, illustrates this difference best. Peranda lacks the fluid and experienced character of Palma's style. While the latter is prolific in painting and drawing and with his increasing production becomes more and more sallow, Peranda is one of those who never reaches a final conclusion, always makes changes and is never satisfied. Painting was a strain for him, and so he may have had a reluctant hand in drawing too.

1273 FLORENCE, UFFIZI, 12876. Presentation of Christ. Over bl. ch. brush, br., wash. 200 x 180. Unfinished. Inscription in pen: Dello Tintoretto e se non è del Tintoretto, e al meno del Palma. — On the mount old inscription: Sante Peranda. — On the back: Nude woman, seen from behind, and part of a drapery. Pen. Probably by another hand than the *recto.*

The old attribution to Peranda is supported by the stylistic resemblance of the composition to Peranda's painting "Adoration of the Magi," in S. Niccolò dei Tolentini (ill. Venturi, 9, VII, fig. 159.)

1274 ————, Santarelli 7951. Virgin and Infant, half-length. Bl. ch., height. w. wh., on faded blue. 269 x 310. Old inscription in pen: Sante Peranda. [*Pl. CLXXXIV*, 4. **MM**]

1275 PARIS, LOUVRE, 5149. Unidentified composition (Gathering of manna?). Pen, br., on blue. 241 x 159. Damaged by mold. — On the back: Figures, perhaps for the same composition. Ascribed to Palma Giovine. [**MM**]

In our opinion to be attributed to Peranda for stylistic reasons, especially the resemblance to No. **1276**.

1276 ————, 5754. Christ healing (?). Pen, br., gray wash. on faded blue. 159 x 187. Later inscription: Santa Peranda. — On the back: four sketches, cut. [*Pl. CLXXXIV*, 3. **MM**]

1277 ————, 5789. Design for a ceiling: Assumption of a monk saint between St. Peter and Paul. Pen, br. wash. 338 x 268. — On the back inscription on mount: Sante Peranda. Attractive, though not thoroughly convincing attribution. [*Pl. CLXXXV*, 1. **MM**]

1278 ————, 5168. Presentation of the Infant in the temple. Pen, br., gray wash, on yellow. 135 x 216. Ascr. to Palma Giov., the old inscription on the mount: Sante Peranda, appears more convincing. [**MM**]

1279 PARIS, COLL. ANDRÉ DE HEVESY. Dead Christ on sarcophagus, supported by three angels. Pen, dark br., gray wash, height. w. wh., on blue. 215 x 164. Inscription in pen: Santo Peranda Venez. — On the back: St. John kneeling. Bl. ch.

PAOLO PIAZZA
[*Born c.1557, died 1621*]

1280 FLORENCE, UFFIZI, 13096. Royal couple enthroned receiving the homage of warriors on horseback and on foot. Pen, brownish gray, slight wash, on faded blue. 205 x 300. Above inscription: il terzo ... per .. (?). Ascr. to Palma Giovine. [*Pl. CLXXXII*, 5. **MM**]

In our opinion not by Palma himself, but closer in style to Piazza (see No. **1281**) and perhaps in connection with Piazza's (lost) cycle

of Antonius and Cleopatra in the large gallery of the Palazzo Borghese in Rome (Ridolfi II, p. 163; Baglione, *Le Vite dei Pittori . . ,* Napoli, 1733, p. 152).

1281 VIENNA, ALBERTINA, 113. Beheading of Pope Cornelius. Pen, bistre, wash, height. w. wh. 307 x 134. *Albertina Cat. I* (Wickhoff)

263: original by Palma Giov. *Albertina Cat. II* (Stix-Fröhlich): Paolo Veronese's workshop. [*Pl. CLXXXV,* 2. **MM**]

In our opinion, Wickhoff's suggestion points in a better direction, the drawing being very close indeed to Palma's late style. Ridolfi II, 163 and Federigi, *Memorie Trevigiane* (Venetia 1803, II, p. 91) mention an altar-piece "Martyrdom of a sainted pope" in the church of the Crociferi alla Fontana Trevi in Rome, painted by Paolo Piazza

between 1608 and 1616. We have had no opportunity of checking this reference.

There is a discussion as to whether Piazza was a pupil of Palma Giovine, as Baglione, p. 152 and Federigi, l. c. assert, or of Jacopo Bassano, according to Hadeln's theory. Arslan in Thieme-Becker vol. 26, p. 567 is inclined to follow Hadeln. This drawing, if by Piazza, would speak in favor of the older tradition.

PITATI, BONIFAZIO DEI, see BONIFAZIO.

POLIDORO DA LANZANO

[Born c.1515, died 1565]

Though a native from the Abruzzi mountains Polidoro as an artist is entirely Venetian and well deserves his by-name, Veneziano. The fact that as a painter he is almost absorbed by Titian, gives his claim to the attribution of Nos. **1282/3** a better foundation than Bonifazio's, whose style, it is true, Polidoro sometimes approaches (see Ludwig, *Jahrb. Pr. K. S.* XXII, p. 196 ff.). Nevertheless, the Titianesque element in him is the decisive one. This is confirmed by No. **1285** ascr. to Polidoro by an old owner and a cruder reflection of the style of No. **1920**, the attribution of which fluctuates between Giorgione and the early Titian.

1282 CHATSWORTH, DUKE OF DEVONSHIRE, 910 a. The Virgin and the Infant, St. James and St. John as a child. Pen on wh. 190 x 242. Ascr. to Titian, publ. by Hadeln, *Hochren.,* pl. 16 as Bonifazio (?) adding: "The mixture of Titian's and Palma's style leads me to assume Bonifazio as the author. But I should add that I have thought also of Polidoro." [*Pl. XCV,* 2. **MM**]

Westphal, p. 132 rejects this attribution to Bonifazio, the drawing being too "Titianesque." In our article in the *Critica d'A.* VIII, p. 84 we referred to Hadeln's wording to demonstrate the difficulty of method incurred in basing an attribution exclusively on the characterization of a painter which fits, as admitted in this case, another painter also.

We agree with Westphal as to the rejection and cannot find such Titianesque details as, for instance, both hands of the Madonna in any authentic painting by Bonifazio. On the other hand, we take up Hadeln's alternative suggestion and list the drawing and its companion piece No. **1283** under Polidoro on the basis of a certain affinity of style with No. **1285**, at least ascertained for Polidoro by a traditional ascription. The landscape with the buildings is very close to that in the painting "The Virgin between St. Paul and St. John the Baptist," formerly in the Leuchtenberg Coll. (there erroneously ascr. to Titian), now at a dealer's in the United States.

1283 ———, 910b. Variation of No. **1282**. Pen on wh. paper.

146 x 203. Formerly ascr. to Titian. *Vasari-Society* V 10: might also be school of Brescia, showing a certain relationship to Romanino. Hadeln, *Hochren.* pl. 17: Bonifazio (?). Degenhart, p. 284, emphasizes the interest of the alternative Titian or a Veronese artist. According to him the drawing might be by Bonifazio. [**MM**]

For our opinion see No. **1282**.

1284 FLORENCE, UFFIZI, 1808. Adoration of the shepherds. Pen, br. 133 x 220. Patched at the l. Ascr. to Polidoro. [**MM**]

1285 ———, 12818. Female nude standing, seen from behind, drapery indicated. Bl. and wh. ch., on buff. 290 x 180. Upper r. corner cut. Inscription in lower l. corner (pen): Questa si di man di Polidoro. [*Pl. XCVII,* 2. **MM**]

The ascription might be right, since the drawing shows the influence of Titian's early style, see No. **1920**. It is however, later and differs from Titian's Giorgionesque style in standard and proportions.

1286 PARIS, LOUVRE, 484. Adoration of the shepherds. Pen, br. 162 x 250. Cut. Several corrections. His de la Salle. Ascr. to Polidoro. [**MM**]

The drawing slightly resembles No. **1284**, but differs in the more archaic mode of hatching. We accept the traditional ascription, though with reservations.

BATTISTA PONCHINO, CALLED BOZATO

[Born c.1500, died 1570]

According to Vasari (VI, p. 594), Ponchino was a creature of the Grimani Family and spent many years in Rome before settling in the Veneto in 1546. (From 1551 on he was a citizen of Castelfranco Veneto.) We do not know whether his style was already well established before he went to Rome, or was formed there. In 1553/54,

Ponchino collaborated with Zelotti and Paolo Veronese in the decoration of the Ducal Palace (Sala del Consiglio dei Dieci). His share here is so well adapted to the manner of his companions that it offers but little help in recognizing his personal style. Hadeln found a sample of his drawings in No. **A 1288** which he rightly connected with Ponchino on the basis of its inscription. The style of the drawing, in our opinion, recalls rather the Florentine School of the period although, it is true, Ponchino, who had copied Michelangelo's "Last Judgment" for Enea Vico's engraving, might have absorbed many Florentine-Roman elements. The second drawing, which we connect with a painting given to Ponchino by A. Venturi, is close in style to Vasari while the painting itself which the drawing prepares is more Venetian in its treatment. On the whole, Ponchino as a draftsman remains an utterly uncertain figure. He does not seem to have been so for older collectors. In the collection of the Cardinal Granvella, in Besançon (gathered by three generations from 1541 to 1607), two of his drawings are mentioned: no. 128, tête de mort, au crayon noir, dessin sur papier bleu, and no. 129, femme nue, dessin au crayon noir sur papier bleu (Jules Gauthier, *Le Cardinal de Granvella*, 1901, p. 337).

1287 HAARLEM, TEYLER STICHTING, K 94. Allegory, Seated woman surrounded by three bearded men. Pen, br., wash. height. w. wh. 129 x 287. Damaged by mold. Anonymous. [*Pl. XCVIII, 3.* **MM**]
 The drawing corresponds exactly to a painting in the Giovanelli Gallery in Venice, formerly ascr. to Vasari, but attr. to Ponchino by Adolfo Venturi 9, IV, p. 1058, fig. 755. The design which seems to be the immediate *"modello"* of the painting shows a marked approach to Vasari's style while the painting, differing especially for the types of the men, displays a stronger Venetian softness.

A 1288 VIENNA, ALBERTINA, 116. Sheet with studies from the nude. Pen, bistre, wash. 283 x 257. Cut across at the corners. Old inscription: Del Batcacco bonsigniore. Originally ascr. to Bonsignori, by *Albertina Cat. I* (Wickhoff) Sc. V. 20 to Francesco da Poppi. Hadeln, in *Jahrb. Pr. K. S.* XXXV, p. 207 f. and *Spätren.*, pl. 4 made

and substantiated the attribution to Ponchino (Ridolfi calls Ponchino un Monsignore detto Bazzanco, Vasari VI, 594 calls him Brazzacco, and Aretino, *Lettere*, Bazzacco.) *Albertina Cat. II* (Stix-Fröhlich) follow Hadeln.
 The style of the drawing seems, however, too closely connected with the manneristic style of Central Italy to justify Hadeln's reference to Ponchino's painting in the Ducal Palace (ill. Hadeln, *Jahrb. Pr. K. S.* XXXV) and the attribution of the drawing rests solely on the spurious inscription. We rather think of Bronzino with whose compositions for the wedding of Francesco de' Medici and Giovanna d'Austria in 1565 (ill. Voss, *Jahrb. Pr. K. S.* XXXIV, p. 315, fig. 12) the drawing is related by its subject and in various details. (The drawing in the Fogg Art Museum, Mongan-Sachs no. 570, fig. 287, in our opinion, may be connected with the same task.)

PONTE, DA, see BASSANO.

GIOVANNI ANTONIO SACCHIENSE, CALLED PORDENONE
[Born 1484, died 1539]

Fiocco, on p. 99 of his recent monograph, states that on the whole Pordenone's drawings attracted students more than his paintings had. No wonder, since as a painter Pordenone devoted most of his activity to murals and church paintings of which naturally only a limited number entered public or private collections while, on the other hand, a relatively large number of drawings has been handed down. As Pordenone's style in drawing is rather personal and characteristic, it was not too difficult to survey his production. This survey was made by Hadeln in his *Hochrenaissance,* who, basing his own researches on preliminary studies by Carlo Gamba, gathered 27 drawings to which a few more were subsequently added by L. Fröhlich-Bum in *Münchn. Jahrb. N. S.* II, p. 68 ff., by E. Tietze-Conrat in *Graph. Künste N. S.* II, p. 87, and in *Burl. Mag.,* vol. 74, 1939, p. 91, by K. Schwarzweller, in his thesis of 1935, and, finally, by Fiocco in his monograph.

 As said before, the style of Pordenone's drawings being rather characteristic, there was less danger of confusion with productions of other artists than of taking works of his followers for works of the master himself. In this connection, a group of drawings in Windsor, Nos. 28–31, is interesting, publ. by Hadeln as Pordenone, and

recognized by Schwarzweller as designs for the ceilings in the parish church in Lestans, claimed by Fiocco for Pomponio Amalteo. As for the drawings, Fiocco is remarkably irresolute, placing them on p. 152 among the doubtful productions, but on p. 105 considering them as Pordenone's designs for Amalteo's murals. In our opinion, the style of the drawings is so much coarser than Pordenone's that they may as well also be by Amalteo.

To a somewhat similar class belongs the "Carrying of the Cross" in the Uffizi, No. 1318, publ. by Hadeln as Pordenone's design for his mural of 1520 in the cathedral of Cremona. E. Tietze-Conrat proved that except for the group at left surrounding Veronica, a portion definitely derived from the painting, not a single figure of the drawing is connected with the painted composition in style, type or even motive. Moreover, late Titianesque and Michelangelesque types are inserted into the drawing, the style of which offers no analogy to Pordenone's authentic drawings, for instance, to No. 1340, a genuine general sketch of a large composition. E. Tietze-Conrat suggested as author a member of the Cremonese School which, as a whole, was brought up on Pordenone's stupendous paintings. Fiocco rejected the suggestion and held to Pordenone without intimating his reasons for doing so.

Pordenone's own typical drawings were divided into two groups by Hadeln and Fiocco, the sketches in red ch. and the *modelli*. Of the sketches for the "Crucifixion" in Cremona, one of Pordenone's most spectacular creations, fortunately at least four (Nos. 1323, 1340, 1346, 1358) are preserved. An important addition to this group is the sketch of the "Martyrdom of S. Peter" in Chatsworth, No. 1301, made in competition with Titian, and thereby dated about 1525. It offers, moreover, a very instructive opportunity of comparing the essentially different style of a sketch and of a *"modello,"* in No. 1311 all the spontaneity of the former being frozen to a cold perfection. As long as this final stage, immediately preceding the execution, is not yet reached the artist remains free to change his mind, even if he previously considered his preparations completed. No. 1362 is already squared for transfer on canvas, nevertheless, the painting on the high altar in Santa Maria degli Angeli in Murano shows modifications in almost every detail. For No. 1317 the comparison with the painting which it prepared is made more difficult by the fact that the decoration of the apse of S. Rocco no longer exists in its original shape, but was replaced by paintings by Giuseppe Angeli in the 18th century. But such a Venetian "restoration," as repeatedly emphasized by us, tried to conserve as much as possible of the original. There is reason to believe that Hadeln was well justified in identifying the drawing as the sketch for the lost painting of 1527–29, on the basis of its conformity with its substitute. But again such a conformity alone is not yet in itself an evidence for the qualification of a drawing as a sketch. A good example for discussion is No. 1355, the two sides of which were publ. as Pordenone's sketches for two works of art, a mural and an altar-piece placed side by side in Santa Maria di Campagna at Piacenza. The two sides are drawn in an evidently different style, a circumstance for which Fiocco made allowance by acknowledging as probably authentic only the *verso* and declaring the *recto* as doubtful. As a matter of fact, neither side recalls Pordenone stylistically, and it is just as unlikely that an artist would have drawn on the two sides of one sheet sketches of two works, the execution of which stretches over seven years. It is also unlikely that another artist would have made his copy on the original sketch for the neighboring composition. If two such works are drawn on one sheet, it is most likely that both were there before the eyes of the copyist who in one case worked with more neatness than in the other.

The second important group of Pordenone drawings, discussed by previous writers, are the *"modelli,"* those very finished versions of planned compositions, which invited reproduction in the chiaroscuro technique so much favored by the period. Two such chiaroscuros may be traced to Pordenone's murals on the façade of the

Palazzo d'Ana: one the Marcus Curtius, the other the Saturn. Both can be checked by the help of a very inter-
esting old copy containing the whole façade, No. 1332 in the Victoria and Albert Museum; for the Saturn, more-
over, the drawing exists in Chatsworth (No. 1299), possibly done in view of the chiaroscuro (Bartsch XII, 177,
77). The status of the whole case was elucidated by E. Tietze-Conrat in an article in *Burlington Magazine*, LXXIV,
p. 91, cited, but apparently not read, by Fiocco.

Between these two contrasting groups of drawings an intermediary class exists represented by No. 1344, a
further design for one of the painted panels of the Palazzo d'Ana façade, a pen sketch much more precise than
the sketches in red chalk mentioned above, and apparently a working material which lies between the intimate
jotting down of a first idea and the flattering presentation of a composition in a model. On stylistic grounds, we
may add a few related drawings, the ultimate destination of which is unknown.

Such minor additions, however, do not very much modify the general aspect of Pordenone's draftsmanship.
We do not always agree with Fiocco's criticism of Hadeln's attributions. For the "Adoration of the Magi," in
Chatsworth (No. 1302), an attribution to the school of Pordenone seems much more attractive than one to the
chimerical Girolamo da Treviso. We have more serious misgiving for No. 1327, connected as a matter of fact with
Pordenone's painting in the cathedral of Spilimbergo by nothing but the subject. By its style the drawing is
divergent from that of every authentic drawing by Pordenone, and the composition is not only different from
that in Spilimbergo, but entirely contrasting with it. If any connection between the two exists, it could only be
the circumstance that the drawing might be a design done by another artist who was interested in the same sub-
ject. The artistic principle is diverse, and so are the details. The falling Simon, perhaps at first sight an argument
in favor of the connection of drawing and painting, looks very different in the two versions, legs and arms being
differently placed and differently foreshortened. The postures of the figures in the drawing already recall Titian's
"Presentation of the Virgin" and are advanced beyond Pordenone's style in 1524, the year of the organshutters
of Spilimbergo.

Leaving aside such differences of opinion, there still remains one point, in which we have the feeling that
Pordenone's figure as a draftsman has been confused by Fiocco. That is his acceptance of three portraits of men,
first attributed to Pordenone by Gamba (Nos. 1308–1310), but not accepted by Hadeln, and, moreover, the attri-
bution to Pordenone of No. 1295, publ. as Correggio by Mauceri. Here the whole interpretation of the artist,
emerging rather powerful and homogeneous in Fiocco's book, is at stake. Never did Pordenone, always self-
confident and aiming at sculptural effects, concentrate on such a self-centered intensity. In view of such a contrast
of principles, the casual resemblance to single heads in paintings by Pordenone offers no help. Still more serious
objections are to be raised against the acceptance of a drawing of so outspoken a Correggiesque character. That
Pordenone's healthy receptiveness did not shun Correggio's influence has already been pointed out as early as
by Cavalcaselle, and Fiocco accepted this suggestion. Since he does so with special reference to the prophets and
decorative friezes in Cremona, it seems tempting to turn the tables and to look for Pordenone's in the poorly
sifted material of Correggio's drawings. In this regard we wish to provoke a discussion of the red ch. drawing
(No. 1360), formerly in the Pembroke Collection, in its motives very much resembling corresponding orna-
mental parts in Cremona and also some in Piacenza, some ten years later.

A 1289 AMSTERDAM, COLL. REGTEREN ALTENA. The apostles sur-
rounding the tomb, fragment of an Assumption of the Virgin. Pen,
br., height. w. wh., on greenish gray. 97 x 81. Squared. Old inscrip-
tion: di man propria del Pordenon. Coll. Brownlow. Exh. Amster-
dam 1934 (Cat. No. 622): Supposed to be a sketch for Pordenone's
organ shutters in the cathedral of Spilimbergo (ill. Fiocco, *Pordenone*
pl. 117). This suggestion, apparently first proposed by Stechow, and
accepted by K. Schwarzweller, p. 140, was rightly rejected by Fiocco,

Pordenone, pl. 116, p. 151, who does not even accept the attribution to Pordenone. **[MM]**

1290 AMSTERDAM, SALE R. W. P. DE VRIES, 1929. Group of Biblical figures. Pen, wash, height. w. wh., on blue. 445 x 280. Coll. Th. Lawrence. Reproduced in *Dessins de Maitres Anciens et Modernes,* 289 (*Cat.* of de Vries sale 1929) as Martyrdom of a saint, study for a fresco. Not listed by Fiocco-Pordenone.

In our opinion, design for one of the fragments in the cupola of the Madonna di Campagna, Piacenza, ill. Fiocco, *Pordenone,* pl. 166; the painting is seriously damaged. We have not seen the drawing which would be dated by the painting about 1535. See No. **1307.**

A 1291 BAYONNE, MUSÉE BONNAT. St. Sebastian. Pen. Publ. by Fiocco, *Pordenone* pl. 215, p. 151, as design for the painting in the Harrach Collection, Vienna, ill. Fiocco, *Pordenone* pl. 214, which Venturi, 9, III, p. 676 and Schwarzweller p. 144 attr. to Pordenone, but Fiocco attr. to an unknown follower of Titian. Accordingly, Fiocco lists the drawing among the doubtful. **[MM]**

In our opinion, the drawing is certainly a copy after the painting, see for instance, the letter in the niche, repeated in the drawing.

A 1292 ———, 1214. St. Roch standing. Red ch., on yellow. 250 x 130. Ascr. to the school of Giovanni Bellini. Publ. by Fiocco, *Pordenone,* pl. 213, p. 151: by the same hand as No. **A 1293,** that is by a follower of Titian, in his opinion, probably Natalino da Murano.

In our opinion, not by the same hand as No. **A 1293,** and in its stylistic character earlier than Natalino. (See Nos. **811–815.**) More in the direction of Romanino; compare the drawing Uffizi 2113, publ. *Uffizi Publ.* III, I, No. 15.

A 1293 BERLIN, KUPFERSTICHKABINETT, 5042. Virgin and Child enthroned between the saints Sebastian and Roch. Red ch. 204 x 196. Publ. in *Berlin Publ.* I, 85, and Hadeln, *Hochren.,* pl. 35, as Pordenone. According to Hadeln perhaps design for a lost altar-piece in Spilimbergo (Ridolfi I, 119). Fiocco, *Pordenone* pl. 212, p. 151 and 103: by a follower of Titian, Natalino da Murano ?, like No. **1292.**

We agree with Fiocco as far as the rejection of Pordenone goes without, however, recognizing Natalino's style in this drawing (see No. **1292**).

A 1294 ———, 15261. Entombment of Christ. Red ch., on yellow. 187 x 268. Stained by mold. Later inscription: Giacomo Antonio Licinio da Pordenone (and) 10. Coll. Paccetti.

Copy after Pordenone's painting in the Franciscan church in Cortemaggiore (ill. Venturi 9, III, fig. 489).

A 1295 BOLOGNA, PINACOTECA. Holy Family seated on the ground. Many-colored ch. 230 x 300. Discovered by E. Mauceri and publ. in *Apollo* 1931, p. 39 as Correggio. Attr. to Pordenone by Fiocco, *Pordenone,* pl. 147, p. 104 and 153, without giving special reasons besides the fact that the figures are placed under an arch, a composition allegedly resembling Pordenone's "Resurrection of Lazarus," in San Marco, Venice (ill. Fiocco, *Pordenone,* pl. 194). Exh. Udine, Mostra del Pordenone 1939.

The reference to the arch is not convincing, and the style of the drawing, in our opinion, points to Central Italy, and more specifically to Correggio and his school. See for the composition *Klassiker, Correggio,* 22, 50, 52. There is not the slightest analogy to be found in Pordenone's work which Fiocco himself has so completely assembled.

A 1296 BRUNSWICK, ME., BOWDOIN COLLEGE (Loan of Professor Henry Johnson). Conversion of St. Paul. Pen. Publ. as Pordenone by

F. J. Mather Junior, in *Art in America* I, p. 248, fig. 17, and perhaps a trial study for Pordenone's organ shutters in Spilimbergo which, it is true, Professor Mather remarks he has not seen in original or reproduction.

Certainly not by Pordenone, but in the direction of Luca Cambiaso, perhaps by one of his numerous imitators.

1297 CAMBRIDGE, MASS., FOGG ART MUSEUM, 147. Head of a bearded man, turned left. Red ch., on buff. 110 x 95. Charles Loeser Bequest 1932 — 289. Mongan-Sachs p. 84: formerly attr. to Romanino, in their opinion Pordenone, with reference to Nos. **1301** and **1358.** **[MM]**

1298 CHANTILLY, MUSÉE CONDÉ 118. St. Martin on horseback, of the beggar only one arm is seen. Red ch. 300 x 165. Upper l. corner patched. — On *verso:* The horse is traced, but combined with a rider in a different posture. Very much damaged. Coll. Grivis, Reiset. Formerly attr. to Caroto, now to Pordenone with reference to his painting in the church of St. Rocco, Venice. Both sides publ. by Fiocco, *Pordenone,* pl. 133 and 132, p. 103 and 153 as Pordenone. **[MM]**

A copy of the *recto* — or of the corresponding painting ? — in Dresden.

1299 CHATSWORTH, DUKE OF DEVONSHIRE 234. Allegory of Time. Pen, br., height. w. wh., on faded blue. 275 x 420. Later inscription: Pourdenon. Reproduced in a chiaroscuro by Ugo da Carpi, copied by Adriani and given by Bartsch XII, p. 125, no. 27, to Parmigianino. Mentioned by E. Tietze-Conrat, in *Burl. Mag.* vol. 74, 1939, p. 91, as design for one of the lost murals on the façade of the Palazzo d'Ana, see No. **1332.** **[MM]**

Possibly preparatory design for the chiaroscuro, perhaps by Ugo da Carpi.

1300 ———, 236. God the Father surrounded by angels. Red ch. 207 x 207. The upper corners cut. According to Gamba, in *Rass. d'A.* IX, p. 37, study for the painting in the chapel of the Conception, in the Franciscan church in Cortemaggiore (ill. Venturi 9, III, fig. 486). According to Hadeln, *Hochren.,* pl. 43, p. 34, evidently design for the fresco in San Rocco in Venice, faithfully renewed in composition and style by Giuseppe Angeli in the 18th century. Fiocco, *Pordenone,* pl. 140, p. 104 and 153 accepts Gamba's suggestion.

We prefer Hadeln's.

1301 ———, 746. Preliminary sketch for Pordenone's *"modello,"* Martyrdom of St. Peter, executed in competition with Titian and others, 1925. Red ch. 239 x 202. Morelli, I, p. 305: Pordenone; *Chatsworth Dr.,* pl. 24: Cariani. Gamba, *Rass. d'A.* IX, p. 37 ff.: Pordenone. Hadeln, *Hochren.,* pl. 37, p. 34, was the first to recognize the connection with No. **1311.** Mentioned by Fröhlich-Bum, *Münchn. Jahrb.* N. S. II, p. 72. Exh. London 1930 (Popham, *Cat.* 273). Fiocco, *Pordenone,* pl. 184, p. 153; according to him Pordenone might here be influenced by Giorgione on whom Titian's related drawing No. **1961** would be dependent. See No. **1311.** **[*Pl. XCIII,* 3. MM]**

1302 ———. Adoration of the magi. Pen, bl., wash, height. w. wh., on prepared blue paper. 146 x 236. Modern inscription of the name. *Chatsworth Dr.,* pl. 44, tentatively proposed Romanino, but in the caption maintained the traditional attribution to Pordenone. Hadeln, *Hochren.,* pl. 29, p. 34 and Fröhlich-Bum, *Münchn. Jahrb.* N. S. II, p. 79: Pordenone, the latter with reference to Pordenone's

murals in Treviso and Piacenza. Fiocco, *Pordenone*, pl. 207, p. 151:
Girolamo da Treviso the younger, because of the mixture of Porde-
none's and of Emilian influences. **[MM]**

We share Fiocco's doubts as to Pordenone's authorship, but find in
the composition a marked resemblance to Pordenone's mural in
Castello di San Salvatore, Susegana (ill. A. Moschetti, *Danni della
Guerra*, p. 220). Girolamo da Treviso's drawing style, on the other
hand, is not well enough established to venture an attribution to him.
It seems, therefore, more advisable to leave the drawing in the school
of Pordenone.

A 1303 ————. Four groups of little angels floating in clouds.
Red ch. Identified by Fiocco, *Pordenone*, pl. 124 to 127, p. 104 and
153, as studies by Pordenone for the cupola in San Rocco in Venice.

We believe that Fiocco formed his opinion on the basis of the pho-
tographs by Braun, the originals being so inferior in quality to No.
1300, that they should at the utmost be ascr. to one of Pordenone's
provincial followers.

1304 CHELTENHAM, FENWICK COLLECTION, Popham p. 85, l. Float-
ing infant angels, corresponding with a portion of Pordenone's paint-
ing in Cortemaggiore, ill. Venturi 9, III, fig. 487. Red ch. 173 x 206.
Traces of squaring. Rubbed. Lawrence-Woodburn Sale. Identified by
Popham on the basis of No. **1300**. Not listed by Fiocco, *Pordenone*.
 [MM]

The drawing is dated by the painting in the year 1529.

A 1305 ————, Popham 85, 2. Study for Christ rising from the
tomb. Red ch. 203 x 217. Old inscription: disegno del Pordenone.
Popham who illustrates the drawing on pl. 9, attr. it to Pordenone's
last style. Not listed by Fiocco, *Pordenone*.

In our opinion later than Pordenone and not Venetian.

A 1306 DARMSTADT, KUPFERSTICHKABINETT. Virgin and Child en-
throned, surrounded by four male saints. Brush, br., height. w. wh.,
on blue. 253 x 367. Made up of two pieces stuck together, irregularly
cut, Coll. Dalberg. Publ. in *Stift und Feder* 1929, pl. 177, as Porde-
none. Not listed by Fiocco, *Pordenone*. **[MM]**

Stylistically far advanced over Pordenone. We have thought of
some one in the direction of Stefano dall'Arzere (see No. **52**), but
were unable to examine the drawing again.

1307 DETROIT, ART INSTITUTE, 34150. God the Father supported
by infant angels, design of the mural in the center of the cupola of
Santa Maria di Campagna, Piacenza. Brush, wash, on blue. 373 x 258.
Schwarzweller p. 137. Fiocco, *Pordenone*, p. 153. **[MM]**

The poor state of preservation makes it difficult to judge the
authenticity.

A 1308 FLORENCE, UFFIZI, 677. Bust of a man with a cap. Bl. ch.,
on blue. Formerly ascr. to Giorgione. Publ. as Pordenone by Gamba,
Rassegna d'A. IX, p. 38 (ill. plate). Not listed by Hadeln, but ac-
cepted as Pordenone by Fiocco, *Pordenone*, pl. 67, p. 105 and 153,
with reference to the portrait of Doge Andrea Gritti, London, Gute-
kunst (ill. Fiocco pl. 192). Exh. in Mostra di Pordenone, Udine 1939.

We do not see any stylistic connection between the drawing and
the Gutekunst portrait and question the Venetian origin of the
drawing as well as the attribution of the painting to Pordenone. In
our opinion, the drawing is Florentine in its general approach (com-
pare Ridolfo Ghirlandajo's "Portrait of a man" in Chicago, ill.
Tietze, *Masterpieces,* 109).

A 1309 ————, 685 E. Portrait of a beardless man, turned to the
l. Bl. ch., on faded blue. 430 x 320. Formerly ascr. to Giorgione, given
to Pordenone by Gamba, in *Rassegna d'A.* IX, p. 38, an attribution
accepted by Fiocco, *Pordenone*, pl. 67, p. 105 and 153, with reference
to the head of the Emperor in the "Fall of Simon Magus," in Spilim-
bergo, ill. Fiocco, *Pordenone* pl. 115. Not listed by Hadeln.

The alleged resemblance to the Emperor rests only on the placing
of both heads in profile. A more thorough comparison discloses, on
the contrary, such a decisive difference in psychological approach and
artistic temperament that Pordenone's authorship seems to be out of
the question, the more so as the linework, as well, has no analogy in
his authentic works. The excellent drawing seems to be Venetian in
its character. Giorgione, to whom this group of drawings (see Nos.
1308, 1310) was formerly ascribed, cannot be taken into considera-
tion as the author, since no material for comparison is available. We
believe, however, that the artist in question belongs to his generation
and consider an attribution to the Cremonese Boccaccio Boccaccino,
an outstanding portraitist.

A 1310 ————, 688. Portrait of a beardless man, seen from
front. Bl. ch. Formerly ascr. to Giorgione, attr. to Pordenone by
Gamba, *Rassegna d'A.* IX, p. 38. Not listed by Hadeln, but accepted
as Pordenone by Fiocco, *Pordenone*, pl. 66, p. 105 and 153, who
identifies the model with the one of No. **1309**. At any rate both
drawings belong together as far as their style is concerned.

Certainly companion piece of No. **1309**, see our notes there. In the
frontal position the late "Bellinesque" character and the gentleness,
so different from Pordenone's impetuosity, are still more conspicuous.

1311 ————, 725. Death of St. Peter Martyr. Model done in
competition with Titian and others, 1525, for the church of S. Gio-
vanni e Paolo, Venice. Brush, height. w. wh., on blue. 562 x 400.
Publ. by Gamba, *Rassegna d'A.* IX, p. 40, and Hadeln, *Hochren.* pl.
38, p. 35. Exh. Mostra del Pordenone 1939. For the acquisition in
1654, see O. Giglioli in *Riv. d'A.* 1936, p. 316. **[Pl. XCIII, 4. MM]**

Prepared by the sketch No. **1301**.

1312 ————, 729. Dancing cupids. Bl. ch., on blue. 200 x 360.
Uffizi Publ. III, I, No. 21 (Gamba). Hadeln, *Hochren.*, pl. 44. On the
acquisition in 1654 and a copy mentioned in a document of 1655, see
O. Giglioli in *Riv. d'A.* 1936, p. 316. Fiocco, *Pordenone*, pl. 177,
p. 154: possibly *modello* for a very badly damaged painting in the
Collection Cini-Cappello in Noventa Padovana. **[MM]**

We have not seen this painting which Fiocco himself does not in-
clude in his list of Pordenone's paintings.

1313 ————, 730. Birth of the Virgin, design for a mural in the
Madonna di Campagna at Piacenza. Pen, wash, height. w. wh., on
blue. 232 x 306. Gamba, in *Rassegna d'A.* IX, p. 38. Hadeln,
Hochren., pl. 47. Fiocco, *Pordenone*, pl. 158. On the acquisition in
1654, see O. Giglioli in *Riv. d'A.* 1936, p. 316.

1314 ————, 731. Joachim driven from the temple. Pen, wash,
height. w. wh., on blue. 235 x 310. Damaged. According to Hadeln,
Hochren., pl. 48, p. 35 probably *modello* for a planned, but not exe-
cuted, mural in the Madonna di Campagna in Piacenza. Fiocco,
Pordenone, pl. 159, p. 154. On the acquisition, see O. Giglioli in
Riv. d'A. 1936, p. 316.

There exists an engraving (in reverse) of this drawing in the
Peintres célèbres, Paris 1844, where the composition is attr. to
Parmigianino.

1315 ————, 1460. Portrait of a beardless man, turned to the r. Red ch., on yellowish. 205 x 160. Formerly ascr. to Giorgione, attr. by Gronau, in Thieme-Becker IV, p. 68, to Bissolo, on the basis of an alleged resemblance with the donor's portrait in Bissolo's altar-piece in the cathedral of Treviso. Attr. to Pordenone by Gamba, in *Rassegna d'A*. IX, p. 41, and in *Uffizi Publ*. III, I, No. 19, with reference to certain types in Pordenone's early frescoes in the chapel of San Salvatore in Collalto, and by Hadeln, *Hochren.*, pl. 28. Fiocco, *Pordenone,* pl. 64, p. 105 and 153: Pordenone and possibly a portrait of Sannazzaro.

We accept the attribution to Pordenone with reservations, since the simple attitude is by no means typical of his style. In our opinion, there is no resemblance with Sannazzaro's portrait, preserved in the Uffizi and used by Vasari in his mural (ill. *Burl. Mag.,* vol. 63, 1933, pl. opposite p. 198) and by Palma Giovine in his mural (ill. Venturi 9, VII, fig. 102).

1316 ————, 1739. Diacon saint standing and carrying the model of a town (St. Daniel?, see No. 1321). Bl. ch., on blue. 264 x 198. Listed by Gamba, in *Rassegna d'A*. IX, p. 38. Publ. by Hadeln, *Hochren.*, pl. 36, p. 36, and Fiocco, *Pordenone,* pl. 202, p. 154.

The attribution is not wholly convincing.

1317 ————, 1747. Study for the figure of Christ, raising both arms; design for the "Transfiguration," formerly in the apse of San Rocco, Venice, of 1527–29. Red ch. 273 x 192. Cut, following the upper outline of the figure. Listed by Gamba, *Rassegna d'A.,* IX, p. 38, publ. and identified by Hadeln, *Hochren.*, pl. 42, p. 36 on the basis of the paintings by Giuseppe Angeli which replace the original ones, repeating the compositions and the types of Pordenone. Fiocco, *Pordenone,* pl. 129, p. 154 (erroneously listed as being in Chatsworth).

A 1318 ————, 1651. Christ carrying the cross. Pen, wash, on blue. 240 x 390. — *Verso:* Sketch for a Mount of Olives. Listed by Gamba, *Rassegna d'A.,* IX, p. 38; publ. by Hadeln, *Hochren.*, pl. 33, p. 36 as Pordenone's design for one of the murals in the cathedral of Cremona, ill. Fiocco, *Pordenone,* pl. 85. E. Tietze-Conrat, *Graph. Künste,* N. S. I, p. 86 f. rejected the attribution and from the advanced mannerism of the style drew the conclusion that some later painter, possibly Antonio Campi, may have taken his departure from Pordenone's composition. Fiocco, *Pordenone,* pl. 84, p. 101, and 153, returned to Pordenone without, however, discussing any of E. Tietze-Conrat's objections and without pointing out any stylistic analogy to Pordenone's authentic drawings.

The style of the drawing on the *verso* confirms the attribution to one of the Campi.

1319 ————, 1742. Monk saint with book and lily in his hands. Ch., on blue, 300 x 140. Damaged. Not listed by Gamba or Hadeln, but by Fiocco, *Pordenone,* p. 154, who calls the drawing typical, but does not illustrate it.

We do not remember the drawing.

A 1320 ————, 684. Group of singers, six women and two young men. Bl. ch. and pen, wash, height. w. wh., on blue. 320 x 250. Squared. Formerly ascr. to Giorgione, attr. by E. Ferri, *Cat.* 1890, p. 211, to Niccolò dell'Abate, to Pordenone by Gamba, *Rass. d'A.* IX, p. 38, and *Uffizi Publ.* III, I, No. 20. Not listed by Hadeln and explicitly rejected by Fiocco, *Pordenone,* p. 151, where Florigero is suggested as author.

We do not believe in Pordenone either, but see no basis for an attribution to Florigero. Linework and composition remind us most of Romanino.

A 1321 ————, 1769. Design for a church banner (or tapestry?). In the center a Diacon saint with town model and standard, as in No. 1316, surrounded by seven musician angels; in the border symbols of the Evangelists, further Daniel and David and two martyrdoms. Pen, reddish br. 304 x 247. Damaged. A modern inscription "Campagnola" is erased. Tentatively ascr. to Pordenone and thus captioned by Alinari 598.

Probably the drawing to which *Albertina Cat. II* (Stix-Fröhlich) refers for No. 1356. Rightly not listed in the literature on Pordenone.

A 1322 FLORENCE, HORNE FOUNDATION. Landscape with a mythological couple of lovers in small figures. Pen, br., on yellowish. 196 x 256. Borderline framing an oval, cut. Inscriptions indicating colors: terra dombra (on hill), verde (on tree), azuro (on sky). — On back old inscription: Pordenon. Publ. as his in *Vasari Society* II, No. 10, with reference to No. 1329. Not listed by Hadeln or Fiocco.

In the *Vasari Society* text the suggestion was made that the indications of colors might have been meant for an assistant who was to execute the painting with their help. The drawing may instead have been copied after a painting, the coloring of which the copyist wished to recollect. Neither the style nor the whole approach to nature show any connection with Pordenone. The drawing to which the *Vasari Society* refers is incidentally neither authentic, nor does it resemble the drawing in Florence.

1323 HAARLEM, COLL. KOENIGS, I 37. Study for the running nude in the Cremona "Crucifixion," ill. Fiocco, *Pordenone,* pl. 90. Red ch. 276 x 188. The lower r. corner added. Late inscription: Pordenone. — *Verso:* small hasty sketches of a Virgin and Child and a male nude. Collection de Burlet. Hadeln, *Hochren.*, pl. 40. Hadeln, *Spätren.,* p. 11, note 4 identified the use of the drawing; E. Tietze-Conrat, in *Graph. Künste,* N. S. I, p. 37, grouped Pordenone's studies for Cremona and accordingly dated them 1520. Fiocco, *Pordenone,* pl. 96, p. 154. [*Pl. XCIII, 1 and 2.* MM]

1324 ————, I 292. Saint Mary Magdalene. Bl. ch., on blue. 193 x 172. Coll. A. G. B. Russell. Publ. by Hadeln, *Hochren.*, pl. 49. Fiocco, *Pordenone,* pl. 190, and p. 154, with reference to the type of the Magdalene in the late "Noli me tangere" at Cividale (ill. Fiocco, pl. 191).

1325 ————, I 329. Warrior on horseback galloping to the r. Bl. ch. on blue. 267 x 241. Rubbed. Coll. Reynolds, Valori. Not listed by Hadeln and Fiocco.

With insignificant deviations corresponding to one of the murals on the façade of the Palazzo d'Ana (see No. 1332). The poor state of preservation makes it difficult to decide whether the drawing is original or copy. The latter seems more likely.

A 1326 LEIDEN, PRENTENCABINET 2397. Saint Andrew with three kneeling donors. Red ch. 280 x 162. Inscription: Andrea da Soriente p. (or q?). At the r. dashes indicating the scale. Exh. Amsterdam 1934, *Cat.* No. 61 and attr. to Pordenone by Byam Shaw. The written name is supposed to refer to the principal donor.

Perhaps design for a wing (organ shutter?). The attribution to Pordenone is not convincing, nor is the Venetian origin beyond doubt.

A 1327 LONDON, BRITISH MUSEUM, 1854–6–28 — 112. The fall of Simon Magus. Pen, reddish br. 257 x 167. Upper corners cut. Formerly ascr. to Giovanni Bellini. Hadeln, *Hochren.*, pl. 34 as Pordenone, so also Fiocco, *Pordenone* pl. 114, p. 154, who on p. 137 hints to a connection with the organ-shutters in Spilimbergo, ill. Fiocco, *Pordenone*, pl. 115. Popham, *Handbook*, p. 44: study for the named painting.

The resemblance of drawing and painting is limited to a slight analogy in the posture of the falling Simon, canceled and replaced by another figure. The painting accepts all the achievements of contemporary Venetian painting based on Titian's "Assunta." The drawing, though pointing to a later origin in some details, follows the older illustrative tendencies (compare the group on the balcony, or the anecdotic episodes in the crowd beneath). It is unlikely that Pordenone, who already four years earlier had painted the murals in Cremona in the modern style, should have relapsed into such an archaic expression. His authorship, therefore, seems very doubtful, the more so as the linework has no analogy in other of his drawings.

A 1328 ————, 1862–7–12 — 192. Saint Christopher. Bl. ch., height. w. wh. 363 x 226. At r. a strip is added. The outlines of the drawings are pricked. Accepted by Morelli, I, p. 305, publ. by Hadeln, *Hochren.*, pl. 27, p. 36, rejected by A. G. B. Russell, in *Burl. Mag.* v. 48 (1926), p. 212. Fiocco, *Pordenone*, pl. 9, p. 154 considers the drawing an early product by Pordenone; it is mentioned as his by Popham, *Handbook*, p. 44.

We cannot see a connection with Pordenone's well established early works or with the style of his later years. The well advanced mannerism points to a follower who took over Pordenone's slender type of the Christ Child.

A 1329 ————, 1889–8–6 — 309. Adoration of the magi. Pen, light br. 159 x 249. Semicircular top. Slightly stained by mold. Later inscription: Benvenuto Garo (?falo). Publ. as Pordenone in *Vasari Society* II, 10. Rejected by Fiocco, *Pordenone*, pl. 208, p. 152, adding: by a Lombard, influenced by Pordenone.

We agree with Fiocco. Copy in Detroit Institute of Arts, acquired 1938 from Frederick Stearns Coll., publ. in *Bulletin* 1939, February, p. 11 as by Vincenzo Foppa.

A 1330 ————, 1895–9–15 — 824. Charity. Red ch. 248 x 155. Publ. by Hadeln, *Hochren.*, pl. 55, rejected by Fiocco, *Pordenone*, p. 151 as ugly and clumsy.

We, too, question Pordenone's authorship, chiefly with respect to the illusionistic perspective which is in contrast to Pordenone's principles. The drawing belongs to a positively later period, its drapery being based on Alessandro Vittoria's sculpture; compare Venturi 10, III, p. 108, fig. 80.

A 1331 ————, 1936–10–10 — 11. The battle of the bridge fought by cupids, Jupiter and Juno looking down. Broad pen, br. and gray, on brownish yellow. 282 x 405. Cut. Coll. Mariette, Count Fries, William Russell, Heseltine (*North Italian*, 1906, No. 16), Oppenheimer (Parker, *Cat.* No. 151). The ascription to Pordenone (Heseltine) is questioned in the B. M., and the drawing considered as probably more in the style of Romanino. Not listed by Hadeln and Fiocco.

The composition is a kind of parody of the combat on the bridge, famous in the local tradition in Venice and repeatedly represented.

The reference to Romanino seems attractive with respect to the linework, see Uffizi 4065, but is not entirely convincing. The com-

position and the subject point rather to a pure Venetian artist from the circle of Titian and the middle of the 16th century.

A 1332 LONDON, VICTORIA AND ALBERT MUSEUM. Façade of the Palazzo d'Ana, Venice. Pen. Long inscription referring to Pordenone's murals. Publ. by Hadeln, in *Burl. Mag.* 1924, March, p. 124 as a drawing after Pordenone's paintings and as the same by Fiocco, *Pordenone*, pl. 136, p. 152. (In the caption by mistake called "a design for the façade"). Ludovico Foscari, *Affreschi esterni a Venezia*, Milano 1936, p. 57: Perhaps a study by Pordenone himself.

[*Pl. CXCV*, 2. **MM**]

Typical copy after Pordenone's murals.

A 1333 LONDON, COLNAGHI GALLERIES. Nude on horseback. Pen and bister. 245 x 190. — *Verso:* Seated Cupid with fruit-basket. Exh. London, Saville Gallery 1930 and publ. by K. T. Parker, *Burl. Mag.* 56, p. 319, pl. B as a sketch by Pordenone, connected with one of the paintings in the façade of the Palazzo d'Ana (see No. **1332**). E. Tietze-Conrat, in *Burl. Mag.* 74, p. 91, corrected this statement: the motive is in Pordenone's style, but the penmanship different from his; it may be the copy from another no longer existing mural by Pordenone of 1520, formerly on a façade at Conegliano. (Ridolfi I, p. 117).

1334 MALVERN, MRS. JULIA RAYNER WOOD (Skippes Coll.). Saint Christopher. Brush, gray and white, on blue. 260 x 248. Squared in red and bl. Inscription: Pordenone. Not listed by Fiocco.

[*Pl. XCIV*, 4. **MM**]

Corresponding to Pordenone's painted "portelli" in the Church of S. Rocco in Venice (ill. Fiocco, *Pordenone*, pl. 131) and probably part of the working material. Dated 1527–29 by the painting. Compare No. **1350**.

A 1335 MILAN, MUSEO DEL CASTELLO, 936. Saint Sebastian. Red ch. 305 x 125. Coll. S. Maria in Celso. Ascr. to Pordenone.

In spite of the general Pordenonesque spirit (compare the figure in the altar-piece at Vallenoncello, ill. Fiocco, *Pordenone*, pl. 43, or the fresco of "Saint Sebastian" in San Rocco, Venice, Photo Böhm 3685), the drawing is by Giulio Cesare Procaccini and a design for the main figure in the painting in the Museo del Castello in Milan.

[*Pl. CXCII*, 3. **MM**]

A 1336 ————, 1310. Diana seated, caressing a dog. Brush, br., on yellowish. 160 x 242. Coll. S. Maria del Celso. Anonymous Venetian 17th.

The drawing is a copy of a lost mural by Pordenone (Ridolfi I, 119), engraved by Odoardo Fialetti (B. XVIII, 270, no. 20).

1337 MODENA, PINACOTECA ESTENSE, 753. Head of a bearded man with a turban. Red ch. on yellowish. 130 x 86. Inscription in pen: Pordenone. Badly damaged. Fiocco, *Pordenone*, pl. 146.

[*Pl. XCII*, 1. **MM**]

The study, similar in character to No. **1358**, might also have been used in the "Crucifixion" in Cremona (Fiocco, *Pordenone* pl. 90) for the Oriental figure at the r. At any rate, early.

1338 ————. Warrior, full length, seen from front, perhaps a groom. Red ch., on yellow. 208 x 94. Cut and damaged. — On *verso* inscription: Pordenone. Publ. by Fiocco, *Pordenone*, pl. 146.

We note a striking resemblance to Parmigianino's St. George in San Giovanni Evangelista in Parma (ill. Fröhlich-Bum, *Parmigianino und der Manierismus*, fig. 5).

1339 MUNICH, GRAPHISCHE SAMMLUNG, 7444. Descent from the cross. Pen, height. w. wh., on greenish, 348 x 273. — On the back: God the Father surrounded by infant angels. Coll. Mannheim. Ascr. to Pordenone, but not listed in the literature on Pordenone.

We have not seen the drawing.

1340 NEW YORK, PIERPONT MORGAN LIBRARY, 469. Crucifixion, sketch for the l. half of Pordenone's mural in Cremona, ill. Fiocco, *Pordenone* pl. 90. Red ch. 182 x 204. Coll. Richarson, Murray. E. Tietze-Conrat, in *Graph. Künste* N. S. II, p. 86. Schwarzweller 133, Fiocco, *Pordenone* pl. 94, p. 154. [*Pl. XCII, 3.* **MM**]

1341 ———, 470. Conversion of St. Paul. Pen, br., wash, height. w. wh., on blue. 273 x 411. Coll. Robinson, Esdaile, Murray. Fröhlich-Bum, in *Münchn. Jahrb.* N. S. II, p. 85, Fiocco, *Pordenone* pl. 180, p. 154 (listed under London).

The suggestion that the drawing prepared a painting is supported by two illustrations in the inventory of the Vendramin Collection, rendering two details of this composition as separate pictures, the horse and the running man at l., and the man on horseback at r. T. Borenius, *The picture gallery of Andrea Vendramin*, 1923, pl. 28 and 32. A "Conversion of St. Paul" by Pordenone is mentioned by Boschini (*Carta p.* 309) in Casa Tebaldi.

1342 PARIS, LOUVRE, 3465. The legend of the fisherman presenting the ring to the doge. Pen, wash, height. w. wh., on blue. 361 x 254. Publ. by Hadeln, *Hochren.*, pl. 51, p. 37 as a model presented by Pordenone for the competition for the painting in the Scuola di San Marco, in which Paris Bordone won. A copy of the drawing in the Louvre no. 3464. Fiocco, *Pordenone*, pl. 211, p. 152: at best copy of a drawing by Pordenone.

The copy mentioned by Hadeln has a late inscription: Pordenone. We do not share Fiocco's doubts, the style of the drawing is typical of Pordenone's late years.

A ———, 4649. See No. **714**.

1343 ———, 5423. Noah ordered by God the Father to enter the ark with his family. Pen, br., wash, height. w. wh., on blue. 270 x 207. [*Pl. XCIV, 2.* **MM**]

The style is close enough to No. **1344** to justify the traditional attribution to Pordenone.

1344 ———, 5429. Abduction of women, design for one of the portions on the façade of Palazzo d'Ana, see No. **1332**. Pen, br., wash., height. w. wh., on blue. 258 x 147. Squared. Modern inscription: Pordenone. Not listed by Hadeln and Fiocco. Publ. by E. Tietze-Conrat in *Art Quarterly*, Winter 1940, p. 31. [*Pl. XCIV, 3.* **MM**]

1345 ———, 5430. Group of antique deities. Pen, br., wash in gray, height. w. wh., on green. 160 x 160. Squared. Damaged and restored. Not listed by Hadeln and Fiocco.

In our opinion, close in style to Pordenone's later drawings, see No. **1344**. Ridolfi mentions (I, 124) mythological murals by Pordenone on the façade of Palazzo Ceresari in Mantua, now almost completely destroyed. A connection of the drawings with these murals, however, seems hardly possible, since the latter must have been painted in the early 1520's.

1346 ———, 5671. Design for the principle horseman in Pordenone's "Crucifixion" in Cremona of 1520, ill. Fiocco, *Pordenone*, pl. 90. Red ch. 196 x 85. Hadeln, *Hochren.*, pl. 41, p. 37. E. Tietze-

Conrat, in *Graph. Künste* N. S. II, p. 86. Fiocco, *Pordenone* pl. 95, p. 154.

Dated around 1520 by the painting.

A 1347 PARIS, ÉCOLE DES BEAUX ARTS. Saint Martin and the beggar. Brush, wash, on blue. 353 x 235. Coll. Reynolds, Banks, Triquetti, Armand-Valton. Publ. by Fiocco, *Pordenone*, pl. 42, p. 139 and 154 as an earlier version of the subject, later treated in the shutter painting in San Rocco, Venice (Fiocco pl. 130), or as an earlier study for this painting (p. 103).

We do not remember the drawing, which is probably the one attributed to the school of Pinturicchio by Lavallée (*Exposition de Dessins Italiens, École des Beaux Arts*, Paris 1935, No. 94). Certainly the drawing is not a study for the "St. Martin" in S. Rocco, and the stylistic contrast between the primitiveness of the saint and the advanced forms of the heroic beggar makes its dating difficult. There are hardly any convincing analogies to be found in Pordenone's work. We note the anomaly that St. Martin draws the sword with the left hand and carries the sheath at his right side.

A 1348 PIACENZA, MUSEO CIVICO. Five sketches of nudes. Red ch. (on the back of oil sketches). Publ. by A. Pettorelli, in *Rassegna d'A.* 1908, p. 178 (one ill.). The attribution is rightly rejected by Fiocco, *Pordenone*, pl. 151, p. 152.

1349 PORDENONE, COLL. POLETTI. *Modello* for the high altar-piece in the cathedral of Pordenone, 1535, ill. Fiocco, *Pordenone* pl. 172. Publ. by Fiocco, pl. 216 and called authentic, although very much ruined.

We have not seen the drawing.

A 1350 SACRAMENTO, CROCKER ART GALLERY. It. I. St. Christopher. Brush. height, w. wh., 316 x 234. Upper r. corner added. Coll. F. H. (No. 683). [**MM**]

Corresponding to the painting in San Rocco, Venice, of 1527–28 (Fiocco, *Pordenone* pl. 131) and perhaps a reduction made for a chiaroscuro by some other artist. Compare No. **1334**.

1351 UDINE, MUSEO COMMUNALE. Design for one of the sectors in the cupola of the Madonna di Campagna, at Piacenza, ill. Fiocco *Pordenone*, pl. 168. Publ. by Fiocco, *Pordenone*, pl. 169, p. 154. Exh. Udine, Mostra del Pordenone, 1939, Cat. no. XVI.

We have not seen the drawing, of which a much modified copy (pen, wash, height, w. wh.) formerly existed in the Pembroke Coll. Wilton House. It was ascr. to Pordenone, but publ. by Strong in *Pembroke Dr.*, IV, 40 as a copy after him, possibly by the school of the Campi. The stylistic approach to Giulio Campi is indeed noticeable.

A 1352 VENICE, R. GALLERIA, no. 112. Presentation in the temple. Red ch. 385 x 286. Squared. Badly damaged. Oil inscription: Pordenone (*veramente Bernardino Pordenone*). Mentioned by Morelli, I, p. 305, as Pordenone. Publ. as his by Fogolari, 55. Rejected by Fiocco, *Pordenone*, p. 152: possibly by Altobello Meloni, influenced by Boccaccino.

We accept the rejection of the attribution to Pordenone, without accepting that to Altobello Meloni.

A 1353 ———, No. 116. The bust of a woman, bending her head. Red ch., on wh. 285 x 248. Badly damaged. Inscription: Giorgione. Formerly ascr. to Giorgione, later to Cariani, an attribution rejected by Charles Loeser, in *Rassegna d'A.* 1903, p. 180. Given to

Pordenone by Hadeln, *Hochren.*, pl. 39; Popham, *Cat.* 272; Fiocco, *Pordenone*, p. 152 rejects this attribution and suggests a Lombard artist. **[MM]**

We share Fiocco's opinion.

A 1354 ————, Warrior, head of Christ. Ch. 350 x 210. Inscription: Pordenone. Publ. as his by Elena Bassi, in *Rivista d'A.* 1939, April/June, p. 175.

In our opinion, without any connection to Pordenone.

A 1355 VIENNA, ALBERTINA, 49. Disputation of St. Catherine. Pen, wash, on partly reddened paper. 208 x 250. Inscription: M° Biagio. — On the back: Mystical marriage of St. Catherine. Pen. Formerly ascr. to Biagio Pupini, in *Albertina Cat. I* (Wickhoff) Sc. B. 40, to Pordenone as design for his mural, resp. altar-piece in Santa Maria di Campagna, Piacenza (ill. Fiocco, *Pordenone* pl. 160 and 161). This attribution was accepted by L. Fröhlich-Bum, *Münchn. Jahrb.* N. S. II, p. 74 to 76 and in *Albertina Cat II* (Stix-Fröhlich). Fiocco, *Pordenone*, pl. 162, p. 152, 154 believes the two sides were drawn by different hands and accepts the attribution to Pordenone with reservations only for the sketch on the back, while listing the other side among the spurious works.

In our opinion, this theory is implausible. The difference between the two sides rests on the difference of technique and stage of execution. It is just as unlikely that Pordenone woud have drawn sketches for two various works on one leaf, as it is unlikely that another artist might have used for his copy the original drawing of the master for the neighboring composition. In our opinion, the character of a copy is unmistakable for the "Disputation." The use of more slender proportions points to the next generation. There is a certain resemblance to the style of Schiavone supporting the old attribution to Biagio Pupini, whose work is very similar to that of Schiavone (compare No. **1452** and Pupini's drawing in the Pierpont Morgan Library, *Morgan Dr.* I, pl. 22). No material is available for comparison, for the hasty linework of the drawing on the back, at any rate, it is quite different from Pordenone's sketches, see Nos. **1323, 1301**.

A 1356 ————, 50. Annunciation. Pen, wash. 106 x 281. A strip is added. Originally ascr. to Giorgione, in *Albertina Cat. I* (Wickhoff), 61 to a follower of Titian, by Schönbrunner-Meder 1362 to Girolamo da Santacroce for an organ loft. Attr. to Pordenone by Frizzoni, with reference "to a drawing by Pordenone in the Uffizi" (probably No. **1321**) and in *Albertina Cat. II* (Stix-Fröhlich). Not listed by Hadeln and Fiocco.

No connection with Pordenone. The attribution to Girolamo da Santacroce seems to be the best offered up to this time.

A 1357 ————, 51. Female nude. Red, ch. 274 x 182. Additions to form a rectangle. The traditional attribution to Pordenone was rejected in *Albertina Cat. I* (Wickhoff) 80, but maintained by Schönbrunner-Meder 1230 and in *Albertina Cat. II* (Stix-Fröhlich)., while Adolfo Venturi, in *L'Arte* 1922, p. 112 ascr. the drawing to Raphael as a study for the figure climbing the stairs in the "Fire at the Borgo." Not listed by Hadeln and Fiocco.

The stressing of the plastic values contradicts the attribution to Pordenone and makes an attribution to the Roman School more attractive.

1358 ————, 53. Bust of a man, study for the man on horseback in the "Crucifixion" in Cremona, ill. Fiocco, *Pordenone* pl. 90,

1520. Red ch. 156 x 118. The attribution (Sc. Bologn. 469) to Romanino in *Albertina Cat. I* (Wickhoff) was accepted by Stix-Fröhlich in *Albertina Cat. II*. E. Tietze-Conrat, in *Graph. Künste* N. S. II, p. 87 recognized the author and the use of the drawing. Fiocco, *Pordenone* pl. 95, p. 154. **[*Pl. XCII*, 2. MM]**

A ————, Reserve. Two Biblical figures fallen on the ground. See No. **27**.

A ————, Reserve. God the Father and angels. See No. **1368**.

A VIENNA, COLL. LEDERER. Design for an altar. See No. **1369**.

A 1359 WASHINGTON CROSSING, PA., COLL. F. J. MATHER JUN. Female nude recumbent and unconnected, dressed woman half-length. Red ch. Coll. Richardson Sen., Rutland. Traditionally ascr. to Pordenone and publ. as his, with the caption: "Diana and perhaps a Danae," in *Art in America* vol. 28, 1940, p. 87.

Later than Pordenone and not Venetian.

1360 WILTON HOUSE, PEMBROKE COLL., formerly. A trophy heaped up by cupids, satyrs, and animals out of the spoils and emblems of peace and war. At r. a separate sketch of a kneeling figure and a nude child. Red ch. 316 x 214. Late inscription: Correggio. Publ. as his in *Pembroke Dr.*, No. 47, but already rejected by C. Ricci, *Correggio*, London-New York, 1930, p. 185.

The construction of this ornamental design has no analogy in Correggio's decorations in which the architectural frame and the figural parts remain clearly separated. Its nearest analogy are Pordenone's decorations in the cathedral of Cremona, a specimen of which is ill. Fiocco, pl. 89. This ornamental style continued to be used by Pordenone himself and by his local followers; compare, for instance, decorations in Madonna di Campagna at Piacenza, painted about 1535 by Pordenone himself and in San Sigismondo at Piacenza, by his followers. The style of the drawing seems too free for Pordenone to have executed it as early as 1520 (Cremona), it may more likely originate from 1535. Fiocco, *Pordenone*, p. 84, emphasizes the abundant use of mythological details in this church decoration. An ornamental design in the Pierpont Morgan Library (*Morgan Dr.* IV, pl. 53) ascr. to Giulio Campi, though very similar in its motives, is so different and restrained in its style that we prefer to place the Pembroke drawing closer to Pordenone himself.

A WINDSOR, ROYAL LIBRARY, 4775. See No. **28**.

1361 ————, 5458. St. Augustine, surrounded by angels. Brush, height. w. wh., on faded blue. 246 x 194. Publ. by Hadeln, *Hochren.*, pl., 46 as Pordenone's design for his mural in the Madonna di Campagna in Piacenza, according to Ridolfi I, p. 125 the earliest work executed there by Pordenone (1529). Accepted by Fiocco, *Pordenone*, pl. 148, p. 155.

In spite of a certain resemblance between the two compositions the deviations of every single figure are too considerable to allow the identification of the drawing as a design for the painting, especially since the drawing has the final character of a *modello* already. It may have prepared another version of the same subject.

1362 ————, 6658. Annunciation, design for Pordenone's high altar in Santa Maria degli Angeli in Murano, ill. Fiocco, *Pordenone* pl. 187. Bl. ch., height. w. wh., on faded blue. 385 x 250. Squared in bl., stained by mold. Hadeln, *Hochren.*, pl. 53, Fiocco, *Pordenone*,

pl. 186, p. 155. According to Ridolfi I, 123, the painting was executed about 1537, a date which applies to the drawing also. The painting presents essential modifications of the drawing, although the latter is squared.

A 1363 ————, 6659. Adoration of the magi. Brush, gray, height. w. wh., on blue. 154 x 287. Cut? badly damaged. On a label

later inscription: Pordenone f. 1520. Publ. by Hadeln, *Hochren.*, pl. 54, p. 37, who believes the inscription to refer erroneously to Pordenone's painting in Treviso. Fiocco, *Pordenone*, p. 152. At the best a poor copy.

We agree with Fiocco.

A ————, 6660, 6661, 6662. See **29, 30, 31**.

SHOP OF PORDENONE

1364 BERLIN, KUPFERSTICHSAMMLUNG, 5128. Cupids dancing. Brush, green, on gray. 250 x 420. Coll. Beckerath. Mentioned by Hadeln, *Hochren.*, p. 15, note, as school of Pordenone. **[MM]**

1365 PARIS, LOUVRE, 5428. The continence of Scipio. Pen, dark br., gray wash, height. w. wh., on blue. 276 x 336. Ascr. to Pordenone. **[MM]**

1366 ————, 5427. Beheading of Manlius Torquatus. Pen, br., height. w. wh., on green. 75 x 140. Old inscription: Divo Manlio Torquato. Later inscription: da man propria del Pordenon. Ascr. to Pordenone. **[Pl. XCIV, 1. MM]**

The drawing shows a general resemblance with Pordenone's style, but belongs to a provincial follower with a more sedate temperament. Compare the painting "Brennus throwing his sword into the scales" in the Galleria Corsini in Rome, photographed as Schiavone by Anderson 23791, but not accepted as his by the authorities.

1367 PAVIA, MUSEO CIVICO, 311. Martyrdom of Petrus Martyr. Bl. ch., height. w. wh., on faded blue. 208 x 203. Corners cut, damaged. Listed as anonymous. **[MM]**

Evidently in connection with Pordenone's *modello* in the Uffizi (see No. **1311**), the figure of the saint is identical and so is the armor of the murderer, while his posture is different. Still more different

are the secondary figures. Possibly copy of an earlier version, made in the shop.

1368 VIENNA, ALBERTINA, Reserve. God the Father, half-length, in clouds. (From an Ascension of the Virgin?). Oil ch., bl., wash, height. w. wh., on blue, 204 x 265. Stained by mold and torn. (Photo Braun 270.) Originally ascr. to Pordenone. *Albertina Cat. I* (Wickhoff) 74: not Pordenone. Meder, *Albertina N. S.* I, 16: Pordenone. Stix-Fröhlich in *Albertina Cat. II* do not list the drawing. **[MM]**

In our opinion, not by Pordenone himself, but by a follower, perhaps influenced by Titian's "Assunta."

1369 VIENNA, COLL. A. LEDERER. Design for a richly decorated altar with the Virgin between St. Andrew and Paul in the center and St. Peter and John the Evangelist in the wings. Pen, wash, partly watercolor. 380 x 295. Inscription: di mano del Pordenone. Coll. Lely, Professor Karl König (Sale Cat. Gilhofer and Ranschburg 1917, May 12, No. 228, pl. VIII). Accepted by Fiocco, *Pordenone* pl. 102, p. 154. **[MM]**

While the general arrangement of the polyptych is rather typical of Pordenone (compare the altar in Varmo, ill. Fiocco pl. 103), the linework shows a timidity hardly compatible with Pordenone. The draftsman evidently laid the main stress on the decorative details of the frame. He may have been a member of the shop in charge of this special branch.

ANDREA PREVITALI (CORDELIAGHI)

[Born c. 1470, died 1528]

Previtali, who calls himself a pupil of Gentile Bellini, combines Bergamasque and Venetian elements in his rather uneven style. It is first of all the Giorgionesque alloy in him that allows him to be taken into consideration as the possible author of a few drawings of landscapes (No. **1370**) and figures (No. **1372**). We need hardly emphasize how widespread, however, the Giorgionesque influence was within and beyond the Venetian borders, and how daring is the attempt to differentiate single individuals in this crowd, especially in the still more confused material of drawings. Morelli (II, p. 239) admitted never to have met any drawings which might be attr. to Previtali.

The difficulties with which we have to deal are illustrated by two other drawings which we discuss here. The one is the lovely head of a young woman (No. **A 1373**), the attribution of which fluctuates between Lotto and Previtali, either attribution resting merely on a casual resemblance of the woman's head-dress with the one in paintings by the two artists in question. This conformity, however, due to a very widespread fashion and not supported by decisive stylistic arguments, is not sufficient for an attribution. Another problem is presented by No.

1371 whose grandeur, almost beyond Previtali's possibilities, might be explained by a strong reminiscence of Previtali's teacher, Gentile Bellini. The drawing is used in a painting now attributed to Previtali and which had been made to replace one of the same subject by Gentile Bellini.

1370 BERLIN, KUPFERSTICHKABINETT, 5130. Group of cottages, in the foreground peasants with cattle and a cart. Pen. 230 x 289. Later inscription: Giorgion. Coll. von Beckerath. Publ. in *Berlin Publ*. I, pl. 79 as anonymous Venetian about 1500. [*Pl. XLIV*, 2. **MM**]

Resembling in style the four panels in the N. G. in London, there attr. to Giorgione, and by Richter, in our opinion, more rightly to Andrea Previtali. Very similar background in Previtali's "Madonna" in the N. G. 695 or in the one in the Yerkes Sale New York, 1910, April 5.

A 1371 FLORENCE, UFFIZI, 335. Draped figure corresponding to the Moses in "The Passage through the Red Sea," attributed to Previtali in the Academy in Venice, (Phot. Alinari 13284). Brush, on gray. 280 x 140, cut all around and remounted. Publ. as Previtali in Schönbrunner-Meder 677 and called a study for the above-mentioned painting. Attr. to Bart. Montagna by Gamba, in *Uffizi Publ*. III, p. 1, no. 6. "in spite of its having served as a model for Previtali's painting." *Hadeln, Quattrocento*, pl. 84: Previtali. [*Pl. XII*, 2. **MM**]

We understand Gamba's doubts as to Previtali's authorship. The figure, as well as the one opposite to it and the draped man at the r., stands out by its superior quality from the bulk of the figures in the painting. The latter may be a substitute for, or reminiscence of, Gentile Bellini's representation of the same subject painted in 1466 for the Scuola di San Marco ("come el so populo se somerse e chome l'altro populo de Moise fuzi nel deserto", Lionello Venturi, *Origini*, p. 326), destroyed by fire in 1485. The Bellini got the commission to replace the destroyed older compositions. Our drawing for stylistic reasons could not be by Gentile in 1466, nor a copy from a Gentile drawing of this period, but might go back to a new version prepared in Gentile's shop of which Previtali was a member. Gamba's hint of Montagna does not seem justified, since not only single figures, but the whole composition of the painting in the Academy follow Gentile's tradition closely. (See his "Adoration of the magi" in the N. G. and drawing No. **269**.)

1372 ———, 1757. Youth seen from behind. Pen according to Hadeln later worked over with ch. 202 x 110. Damaged by stains. Hadeln, *Hochren.*, pl. 2: Giorgione. Exh. London 1930. Popham, *Cat.*, 255: attributed to Giorgione. "The drawing has been damaged

and reworked to such an extent that it is hard to feel any certainty as to the attribution." Not discussed by Richter. [*Pl. XLIII*, 2. **MM**]

Our doubts concerning the attribution to Giorgione have already been expressed in *Critica d'A*. VIII, p. 81. In our opinion the figure is too smart to accord with Giorgione's predilection for idyllic types. We find more resemblance to the postures of figures by Previtali, compare, for instance, similar figures in his frescoes in the Palazzo Suardi, Bergamo (Photo Witt).

A 1373 LONDON, COLL. OPPENHEIMER, formerly. Head of a young lady. Bl. ch., on grayish. 350 x 257. Coll. Heseltine. In the collection attr. to Lotto, an attribution maintained by A. Venturi, *L'Arte* XXXIX (1926), p. 10, *Studi*, p. 268, fig. 168 and *Storia* 9, IV, fig. 78, Holmes, in *Burl. Mag*. LI, 1927, p. 113, Öttinger, *Belvedere* IX, II, 1930, while Popham accepts it only with reservations in the *Cat. of the Exh*. London (No. 259): attributed to Lotto. Hadeln, *Quattrocento*, pl. 85 attr. the drawing to Andrea Previtali with reference to a lady with a similar hairdress in the Madonna Cassoli, in Bergamo, Academy (Photo Alinari 16894).

The resemblance is limited to the hairdress fashionable in the early 16th century and therefore not sufficient to justify an attribution, if the patterns are different, as is the case here. It is true, the attribution to Lotto is not better founded, and the beautiful drawing has to remain anonymous for the time being.

A 1374 VIENNA, ALBERTINA, 31. Sheet with studies for a flagellation of Christ (?). Bl. ch., pen and bister, wash. 177 x 235. — *Verso*: Studies for a Saint Sebastian (the shadow in the background of the large St. Sebastian according to *Albertina Cat. II* (Stix-Fröhlich) is a later addition). Formerly ascr. to Orcagna, attr. by *Albertina Cat. I* (Wickhoff) Sc. R. 19 to Previtali, the figures on the back supposed to be a study for his St. Sebastian in the signed painting in Bergamo of 1506 (ill. *Elenco dei Quadri dell'Accademia in Bergamo* pl. 11). Wickhoff's attribution was accepted by Stix--Fröhlich.

The resemblance to the Sebastian in the painting, however, is much too slight to base an attribution upon it. The postures and proportions of the figures make us assume an origin of the drawing in Central Italy instead.

NICCOLÒ RONDINELLI

[*About 1500*]

According to Vasari III, p. 117 ff., the one pupil of Giovanni Bellini's from whom he gained most credit and who, according to the same authority, collaborated extensively in his master's paintings.

1375 PARIS, ÉCOLE DES BEAUX ARTS, 260. Portrait of a young woman, turned three quarter to l. Bl. ch., fixed with the brush, on yellowish. 219 x 160. Color-spots and other damages. Upper l. corner patched. Coll. His de la Salle. Originally attr. to Masaccio, by His de la Salle to Lionardo. Exh. Dessins des Maitres à l'École des Beaux Arts, 1879, No. 180 as Gentile Bellini. Mentioned by Müntz, *Guide de l'École des Beaux Arts*, p. 151 and Müntz, in *Gaz. d. B. A.*, IIIème pér. vol. IV, p. 294 as Luini or Sodoma. [*Pl. XXXIX*, 2. **MM**]

The drawing very closely resembles the saint on the r. in the paint-

ing no. 50 in the Prado, attr. to Gio. Bellini (*Klassiker* 87), but usually considered as a school production. (Gronau in *Klassiker, Bellini*, p. 207, ad 86–87, and van Marle XVII, p. 296). The tentative attribution to Rondinelli is supported by the striking resemblance of the head with Rondinelli's fresco fragment, Madonna and Child, in the Monte di Pietà in Ravenna, ill. C. Ricci, *Raccolte artistiche di Ravenna*, p. 10, fig. 2. The type with the somewhat heavy features appears in several other paintings grouped around Rondinelli. No drawing is available for comparison.

SALVIATI, GIUSEPPE (PORTA)

[Born c.1520, died c.1575?]

As a boy of fifteen, Giuseppe Porta became a pupil of Francesco Salviati in Rome (whose name he adopted) and stayed with him until he was twenty years old. We may presume that his mode of drawing was influenced by this training. The very pathetic and intensive drawings Nos. 1379, 1380 best represent Salviati's early style; dating to this period is further supported by the possible connection of No. 1379 with a series of such allegorical figures painted by Giuseppe Salviati in the Villa Priuli, Treville, in 1542. For stylistic reasons No. 1386 and, in view of its resemblance with No. 1380, No. 1395 may be added. Although the latter was attributed to Schiavone, we hardly feel any Venetian element. The attribution to Schiavone seems to rest solely on those features in his style that are not Venetian. Our knowledge of Salviati's early style, as imported by him to Venice, is deepened by his woodcuts for Francesco Marcolini's *"Sorti,"* publ. in 1540, which means before he had absorbed much of the new influences surrounding him in Venice.

Here Giuseppe Salviati's pathos did not diminish, only it is now less heroic and conscious than emotional and instinctive. The figures become more slender and more casual, he no longer makes a show of his anatomical knowledge. A good example publ. by Hadeln is the design of the "Descent from the cross" in Murano, No. 1389 in the Louvre, of which another version, modified and reversed, exists in the B. M. (No. 1381).

To this design, or designs, we have to add two well-authenticated *"modelli,"* one, No. 1388 in the Louvre, for a painting in San Zaccaria at Venice, the other, No. 1376 in Chatsworth, for a mural in the Vatican Palace. The latter seems to prove that Salviati maintained certain contacts with the school to which he owed his first training. Otherwise, the Pope would hardly have appointed him to paint the mural in the Sala Regia in the Vatican. According to Vasari (VII, p. 46) Giuseppe on the same occasion finished a painting left incomplete by his former teacher Francesco who died in 1563. And Ridolfi amplifies this statement by telling us (according to Hadeln I, 243, note 2, following Cornelio Frangipani, *Per la historia di Papa Alessandro III publica nella Sala Reggia di Roma e del Maggior Consiglio a Venezia,* 1615, p. 10) that by order of Pope Pius IV Giuseppe Salviati went to Rome to paint this picture, receiving for it a salary of 100 scudi: "And at that occasion he finished another composition begun by his master Salviati." This passage leaves no doubt that the painting in question is exclusively by Giuseppe and not originally designed by Francesco, as surmised by Adolfo Venturi, 9, VII, p. 421 and in Thieme-Becker, vol. 29, p. 367. Two large drawings connected with the painting exist, one No. 1376 in Chatsworth, the other, No. 1383, in the Louvre. They differ considerably in their style, but both are so carefully finished that they require examination for the alternative "copy or *modello.*" Up to now, both seem to have been taken for copies, since neither of them is mentioned by the authorities. Although closely corresponding to the mural they display too many significant differences as to be considered copies from the painting. As for No. 1376 we list on p. 244 the deviations and consider the drawing a *"modello"* made for the painting. No. 1383 is more difficult to classify. As far as the composition goes, the conformity of the two drawings is complete while the execution is different, No. 1383 being more hasty and more interested in light and shade than in details. Is it Giuseppe's design more carefully carried out by the *modello* No. 1376, or is it a copy after the *modello* done by a later artist who even when copying could not resist his interest in setting down the masses of light and shadow? If it were a copy from a painting such an introduction of pictorial purposes might easily be understandable. But to reduce

the dry modello of a rich composition to values of light, while dropping details on the other hand, apparently rather points to a definite stage in the working process. We are, therefore, more inclined to accept also No. **1376** as an original; the technique is by no means incompatible with that of No. **1381**.

While sufficiently provided with finished models and designs almost as far advanced, the actual sketch is missing. Here the drawing in the B. M. preparing a *"paliotto,"* No. **1382**, enters and to a certain degree closes the gap. By external reasons laid down below we date it about 1556. The drawing shows a certain connection with Schiavone, probably sufficiently explained by the latter's Central Italian contacts.

To such more or less well-authenticated works we tentatively add a few more, emphasizing, however, that the real framework exists in the Nos. **1379, 1380, 1382, 1388, 1389**. No. **1385** in spite of its authentication by an old inscription might be still closer to Palma Giovine.

1376 CHATSWORTH, DUKE OF DEVONSHIRE. The Emperor Frederic Barbarossa kneeling before Pope Alexander III. Pen, wash, height. w. wh. Listed as anonymous, Venetian School. [*Pl. XCVIII*, 1. **MM**]

In our opinion *"modello"* for Giuseppe Salviati's painting of 1563 in the Sala Regia in the Vatican, ill. Venturi 9, VII, fig. 235 from which it differs in essential points. The architecture and the figures in the background are almost identical, but in the painting the Pope is seated, while in the drawing he is standing supported by an assistant. Many of the figures in the first row in the drawing are typical filling-in figures, while in the painting they are replaced by portraits in modified postures. See also No. **1383**.

1377 CHICAGO, ART INSTITUTE. Gurley 22.920. Study of a prophet for a pendentive. Pen, br. wash. height. w. wh., on blue. 141 x 124.

1378 FLORENCE, UFFIZI, 1846. Apostle preaching. Pen, br., wash. 245 x 400. Publ. by Fröhlich-Bum, *Schiavone I*, fig. 37, p. 177 as Schiavone. [**MM**]

The composition differs as a whole and in every detail from Schiavone's etching of the same subject B. XVI, 22 (ill. Fröhlich-Bum, *Schiavone I*, fig. 13). On the other hand, the drawing style is not Schiavone's, but recalls rather the more Roman pathos of Giuseppe Salviati.

1379 ————, 12878. Allegorical figure, Justice. Pen, wash, height. w. wh., on blue. 270 x 165. Publ. by Hadeln, *Spätren.*, pl. 2. Traditionally ascr. to Giuseppe Salviati and engraved under his name by Mulinari, 1774.

This drawing with its Florentine-Roman character might be early; a series of allegorical figures was painted by Giuseppe Salviati for the Villa Priuli, Treville (1542), Ridolfi I. 120.

1380 ————, 12880. A warrior and three women attending a dying (?) woman. Design for a round mural. Pen, wash, height. w. wh., on blue. 250 x 166. Traditionally ascr. to Salviati and engraved as his by Mulinari, 1774. Hadeln, *Spätren.*, pl. 3. [*Pl. C*, 1. **MM**]

1381 LONDON, BRITISH MUSEUM, 1856–7–12 — 1. The Descent from the cross. Pen, br., wash, height, w. wh., on blue. 379 x 213. [*Pl. XCIX*, 2. **MM**]

Altered version from the squared *modello* in the Louvre No. **1389** for the high altar in S. Pietro Martire in Murano.

1382 ————, 1938–12–10 — 2. Design for an embroidery: Allegorical coronation of a doge Grimani. Pen, wash. 220 x 549. Inscrip-

tions: Innocentia — Prudentia — Fede — Grimanus. Further: Giuseppe Porta da Salviati, evidently by another hand than the other inscriptions. [*Pl. C*, 4. **MM**]

The drawing is apparently the design for a *"paliotto"* for the high altar in S. Mark's church, one of which had to be presented by each doge. Two examples still exist in the Museo Marciano in Venice (Lorenzetti p. 224). One of the two is a donation of Doge Marino Grimani (1595–1605), but does not correspond to our drawing. The Doge Grimani nearest in date is Antonio, 1521–23, who died at about the time when Giuseppe Salviati was born (1520). In our opinion the *"paliotto"* might have been planned later (1556?), when Doge Francesco Venier ordered from Titian the votive painting of the same Doge Antonio Grimani, which had not been executed during the latter's short reign (see Tietze, *Tizian* II, p. 310).

1383 PARIS, LOUVRE, R. F. 91. The Emperor Frederick Barbarossa kneeling before Pope Alexander III. Pen, brush, br., wash. 295 x 379. Cut at top and bottom. [*Pl. XCVIII*, 2. **MM**]

Conforming in its general arrangement to No. **1376**, but not to the mural in the Sala Regia in Rome with which both drawings are connected. In our opinion, the drawing in Paris is Salviati's design, while the one in Chatsworth is a more carefully executed *modello*. See also No. **1376** and p. 243.

1384 ————, 1661. Immaculata, below Adam and Eve and four saints. Pen, darkbr., wash., on faded blue. Inscription: Josepe Salviati.

A 1385 ————, 1664. Banquet of Mars and Venus, with the Graces attending and cupids playing musical instruments. Pen, br., wash, height. w. wh., on yellowish gray. 280 x 410. Squared in bl. ch. Later inscription in pen: Giuseppe Salviati Pitt. Veneziano. [**MM**]

Despite the inscription closer in style to Palma Giovine.

1386 ————, 4894. The three Fates. Pen, brush, br., on faded blue. 265 x 158. Ascr. to Paolo Veronese, later to Farinato. [*Pl. C*, 2. **MM**]

Our attr. to Salviati is based on the stylistic relationship with No. **1380**. A mural by G. Salviati representing the Fates is mentioned by Ridolfi I, 241 as existing on a façade in Campo di S. Polo. Early.

1387 ————, 5054. Virgin and Child between a deacon saint and St. Lucy, half figures. Ch. and pen, bistre, height. w. wh., on faded blue. 180 x 257. In upper r. corner a name has been erased. Listed as anonymous. [**MM**]

The mannerism of the drawing which is evidently under Roman influence, reminds us of Giuseppe Salviati, see No. **1380**.

1388 ————, 5221. Design for an altar-piece: Christ in glory, below the Saints Cosmas and Damian, John the Baptist and Zacharias. Pen, br., wash, height. w. wh., on faded blue. 313 x 180. Semicircular top. Ascr. to Palma Giov. [*Pl. XCIX,* 4. **MM**]
"*Modello*" for Salviati's painting in S. Zaccaria, Venice, ill. Venturi 9, VII, fig. 231 which, however, shows some modifications.

1389 ————, 5761. Descent from the cross. "*Modello*" for the altar-piece in S. Pietro Martire, Murano. Pen, wash, height. w. wh., on blue. 290 x 171. Squared in reddish br. Many corrections in charcoal. Publ. by Hadeln, *Spätren.* pl. 1. [*Pl. XCIX,* 1. **MM**]
See the other version, No. **1381**.

1390 ————, 5804. Skirmish. Pen, grayish br., height. w. wh., on faded blue. 240 x 421. Later inscription: *Tiziano.* Anonymous.
[**MM**]
We ascribe the drawing tentatively to Salviati.

1391 ROME, GABINETTO NAZIONALE DELLE STAMPE, 126108. Design for an altar-piece: The Virgin and Infant enthroned, with two angels worshiping; a bearded Doge in armor and St. George to the l., two other standing saints and a kneeling abbot to the r. Pen, wash, traces of heightening w. wh., on blue. 370 x 252. Publ. as Paolo Veronese in Le Gallerie Nazionali, II, 154, pl. III.
[*Pl. XCIX,* 3. **MM**]
In our opinion close to G. Salviati, see No. **1388**.

A half finished copy (?) of the drawing is in Turin (anonymous).

1392 SACRAMENTO, CAL., E. B. CROCKER ART GALLERY, 278. Unidentified subject. Pen. br., wash, height. w. wh., on blue. 284 x 218. Squared. Collector's mark Lugt 2886.
Attr. for stylistic reasons.

1393 ————, It. I, no. 18. Holy Family and a female saint. 266 x 183. Ascr. to Paolo Veronese. [*Pl. XCVIII,* 4. **MM**]
Tentatively attr. to G. Salviati, with reference to Nos. **1379**, **1380**.

A 1394 STOCKHOLM, NATIONAL MUSEUM, 169. Adoration of the shepherds. Pen, br., wash, height. w. wh., on green. 205 x 243. Semicircular. Squared. Inscription: Joseph Salviati. As his in Sirén, *Cat.* 1917, no. 112.
In our opinion, based only on the reproduction, the drawing has no connection with Giuseppe Salviati.

1395 TURIN, BIBLIOTECA REALE, 15932. The Virgin seated, bending down to the Infant who is standing in the cradle. Pen, br., wash, height. w. wh. 198 x 121. Ascr. to Schiavone. [**MM**]
In our opinion closer in style to Salviati, see No. **1380**.

1396 WINDSOR, ROYAL LIBRARY, 4788. Allegorical figure, Temperantia, standing. Pen, br., wash, height. w. wh., on faded blue. 225 x 98. Anonymous. [**MM**]
In our opinion the manner of drawing is close to Salviati's; his "sibyls" in San Francesco della Vigna show similar compositions.

THE SANTACROCE

The Santacroce, and especially Girolamo, mentioned in 1503 to 1556, and Francesco, 1516? to 1584, are considered the prototypes of a businesslike art production, dependent on the most heterogeneous models and almost entirely void of originality. It is to Fiocco's merit, in an exhaustive study published in *L'Arte* XIX, p. 179 ff., to have established and described their poor qualities and numerous limitations. Nevertheless, he clung to the possibility of distributing paintings and drawings among the various members of the clan. The paintings concern us only insofar as they illustrate the amazing naiveté and facility of these craftsmen in compiling their compositions from the most different sources (compare H. Tietze, in *The Journal of the Walters Art Gallery,* 1941, p. 89–95).

As for drawings, we are unable to see how artists of such a description can be differentiated as individuals. If the various parts of their paintings are stolen, who made their drawings? The conformity to a painting in such a case, of course, cannot prove anything. As a matter of fact all the drawings, attributed to Girolamo or Francesco Santacroce, look different.

At first sight No. **1403** seems fairly well-authenticated, the resemblance of one of the figures with the former organ-shutters in San Giovanni Crisostomo is beyond doubt. Is this, however, an evidence for Girolamo's authorship? Formerly, the organ-shutters were ascribed to Alvise Vivarini or to Giovanni Mansueti. Only Fiocco, without presenting his reasons, gave them to Girolamo, assisted by Francesco. Moreover, one of the figures, St. Onuphrius, in the drawing evidently influenced by the figure of St. Sebastian in Giovanni Bellini's altar-piece in San Giobbe, was changed in the painting into a (reverse) variation of the St. Onuphrius in the same altar. That means that both drawing and painting originate in the same sphere of Giovanni Bellini, but need not necessarily

be by the same hand. The drawing, at any rate, as far as its style goes, shows no relationship to any other drawing claimed for one of the Santacroce, certainly less than to No. **651** which might be by Mansueti. He and Girolamo di Santacroce were school fellows in Gentile Bellini's shop.

A counterevidence is offered by No. **1400**, ascr. to Girolamo by the same authors who attribute to him the preceding No. **1403**, again because of its resemblance to a painting, Santacroce's "Last Supper" of 1549, in San Martino, Venice. It is sufficient to put the two drawings side by side to understand the fallacy of the whole method. Fiocco notes an influence here of Bonifazio dei Pitati; this may be an evidence for the endeavors of the Santacroce shop to keep up to date with their models. The man who drew the design certainly belonged to a younger generation than Girolamo.

We need not repeat our objections raised when describing the individual drawings; our intention is to emphasize that we do not know the drawing style of either Girolamo or Francesco. It remains possible that Nos. **1397, 1401, 1404** (the latter at least attested by the inscription of an old owner) are by one of them, but it is a mere guess based on the almost incredible poorness and backwardness of their style. Even for the Santacroces such imputations ought to have a limit. The two drawings in the Querini-Stampalia Coll. in Venice, designs perhaps for a tapestry or for a church banner, are attributed to Francesco Santacroce, and dated 1559 by Fiocco. The composition is a late echo of Giovanni Bellini's altar-piece with the adoring Doge Barbarigo of 1488 in San Pietro Martire, Murano, and even for a member of the Santacroce family the proposed date, 1559, would be outrageous.

FRANCESCO DA SANTACROCE

1397 MILAN, AMBROSIANA, Resta no. 54. *Modello* of an altar-piece: in the center Flight into Egypt, in the wings St. Peter and Paul, St. Lawrence and a bishop respectively. In the lunette Nativity. Pen, lightbr., on yellowish. 274 x 218. According to a note by Resta the name of Francesco Santacroce was written under the drawing. Morelli (*Berlin*, p. 92) suggested Resta might have confused the names of Francesco and Girolamo Santacroce. [MM]

In our opinion, the characteristics of both Girolamo and Francesco, are hardly so well established as to allow such a theory. Both are dependent on various models from Giov. Bellini on, and Francesco, moreover, is the collaborator and continuator of his father. The type of the altar is certainly more archaic than would fit Francesco's dates, but the specific customers of the Santacroce workshop seem to have followed a noticeably conservative trend. See H. Tietze, in *The Journal of the Walters Art Gallery*, 1941, p. 89–95.

1398 VENICE, RACCOLTA QUERINI-STAMPALIA, 147. Design for a tapestry? St. Mark recommending the Doge Girolamo Priuli to

Christ. Ch. and pen, wash. Above an ornamental frieze with a coat of arms in a rich frame. Formerly attr. to Girolamo da Santacroce, by Fiocco, in *L'Arte* XIX, p. 195 and 205, fig. 31, to Francesco and dated 1559, the date of the coronation of Girolamo Priuli.

The composition very closely follows that of Gio. Bellini's altar-piece with the adoring Doge A. Barbarigo of 1488, now in S. Pietro Martire, Murano (ill. *Klassiker, Bellini*, 106). See No. **1399**.

1399 ————, 148. Another version of No. **1398**, the Virgin recommending the kneeling doge. Technique as above. Attr. by Fiocco, l. c. to Francesco da Santacroce. Fiocco believes the two drawings are not designs for tapestries, but for the two sides of a church banner executed in 1559 for the Doge Priuli. A painting of the Tintoretto school representing a somewhat similar subject and described by Boschini (*Minere, S. Croce*, p. 19), to which Fiocco refers, gives no clue. If the drawings are indeed of 1559 their archaic character is amazing, even in view of the conservative trends of the Santacroce family.

GIROLAMO DA SANTACROCE

A 1400 DARMSTADT, KUPFERSTICHKABINETT, I, 65. Last Supper, connected with the painting of this subject in San Martino, Venice, of 1549, ill. Venturi 9, VII, fig. 2. Over sketch in ch., pen and bistre, light yellow wash. Inscription: Paris Bourdon. Publ. by Schönbrunner-Meder 529 and Fiocco, *L'Arte*, XIX, p. 191.

The style is entirely different from other drawings ascr. to Girolamo, and much freer than the painting to the composition of which the drawings correspond. While Fiocco noticed the influence of Bonifazio dei Pitati — which might be right for the composition, but not

for the linework — we believe that a younger member of the Santacroce workshop made the design.

A 1401 LONDON, BRITISH MUSEUM, 1900–7–17 — 32. *Modello* for a church banner with St. Rochus standing between Sebastian and Christopher. In the border busts of bishop saints and symbols of the evangelists. Pen, br., wash, on yellowish. 331 x 228. Cut. Canceled inscription: Gian Bellino. Coll. Vasari (Gio. Bellini, see O. Kurz, *O. M. D.* June 1937, p. 12), Jabach, Crozat, Mariette, Woodburn,

Habich. Publ. by Fiocco, *L'Arte*, XIX, p. 195, fig. 23, and Hadeln, *Quattrocento*, pl. 91.

In our opinion without any resemblance to other drawings given to Girolamo da Santacroce.

A 1402 LONDON, EARL OF HAREWOOD. Design for a polyptych. Pen, br., wash. 335 x 222. Below a contemporary, now indecipherable inscription with the date 1526, and a line indicating measurements. — On the back inscription: No. 422 Monsieur Alessio. Lord Amherst Coll. (Sotheby Sale December 1921, no. 9, as Lorenzo Costa). Publ. by Hadeln, *Quattrocento*, pl. 89 as Girolamo da Santacroce.

The attribution seems doubtful, since the style of this *modello* again differs from the other drawings attr. to Girolamo.

1403 OXFORD, CHRISTCHURCH LIBRARY. St. John Chrysostomus and Onuphrius, design for the former organ-shutters in San Giovanni Crisostomo, Venice. Brush and pen, br., height. w. wh., on faded blue. 270 x 197. Publ. by Hadeln, *Quattrocento*, pl. 90, p. 66.

The St. Chrysostomus is almost exactly identical with the one in the painting, while the figure of St. Onuphrius, in the drawing evidently influenced by the figure of St. Sebastian in Gio. Bellini's altarpiece from S. Giobbe, was changed in the painting into a variation (in reverse) of St. Onuphrius in the same altar-piece (ill. *Klassiker, Bellini, 85*). We have to state, however, that the organ-shutters in San Crisostomo (Photo Tomaso Filippi, Venice), ascr. to Alvise Vivarini by Moschini, were attr. to Mansueti by Cavalcaselle (vol. 2, p. 439 ff.) and after him by many authors; the attribution to "Girolamo with the assistance of Francesco da Santacroce" is Fiocco's (*L'Arte* XIX, 1916, p. 203) who, however, gives no special reasons for it. Hadeln and Berenson accept the attribution. Accordingly, the attribution of the drawing, too, is merely hypothetical. The stylistic relationship to No. **651** is interesting, both Girolamo da Santacroce and Mansueti belonging to Gentile Bellini's immediate followers.

A 1404 VIENNA, ALBERTINA, 54. Christ crucified between the Virgin and St. John. Bl. chalk and bistre and wash, height. w. wh. 286 x 200. Inscription: Girolam S. Croce. According to *Albertina Cat II* (Stix-Fröhlich) the inscription might be the signature and is certainly contemporary.

In our opinion, the inscription is of the period of the drawing and both belong to a period posterior to Girolamo's. There is certainly no resemblance to No. **1400** which might be by a younger member of the shop, or to any other of the drawings attributed to Girolamo.

SANTO, GIROLAMO DAL, see GIROLAMO DAL SANTO

GIOVANNI GIROLAMO SAVOLDO
[Born before 1480, died 1548]

Although he spent a considerable part of his life in Venice and was noticeably influenced by Venetian paintings, Savoldo's art may only in a restricted sense be counted as part of the Venetian School. Hadeln, for instance, considers him a pupil of Florence. Of the two groups of drawings which were connected with him, one offers little difficulty: for certain very elaborate studies of single heads, in part preparing well-authenticated paintings, a reasonable unanimity has been reached. To the examples already published by Hadeln, three in the Uffizi (Nos. 1407–1409) and two in the Louvre (Nos. 1414, 1415) a few more may be added: The study for Saint Paul, first recognized by its former owner, Mr. Charles Loeser, and connected with a figure in the altarpiece of 1533 in Santa Maria in Organo in Verona by Suida (No. 1406); the head of a bearded man in the Bertel Hintze Coll. at Helsinki (No. 1411), recognized and publ. as Savoldo by its present owner in contradiction to other earlier attributions; finally two heads for the tentative attribution of one of which to Savoldo, No. 1412, in Malvern, we ourselves have to assume the responsibility, while the other is already listed under his name in Berlin (No. 1405). Both attributions are based solely on stylistic reasons and subject to reservations (see No. 1405). The only study of a full-length figure, No. 1418 in the Albertina, is supported by an old trustworthy tradition.

After having enjoyed the rare privilege of agreeing wholeheartedly with the attributions of preceding critics we are the more sorry to disagree positively with Mrs. Fröhlich-Bum's attempt to enrich Savoldo's work by a number of landscape drawings. Some of them are not pure landscapes, figures still predominating in them: No. **A 1927** and Nos. **559, A 2010**, all three pen drawings representing St. Jerome, a saint who was also painted by Savoldo, though in a completely different interpretation, and another pen drawing in the Teyler Stichting in Haarlem, Holland (No. 1410) listed under the no less faulty name of Titian. A second version of the same drawing exists in the École des Beaux Arts and was exhibited there under the correct name of Annibale Carracci

in 1937. As far as we know, Mrs. Fröhlich-Bum has meanwhile dropped her suggestion. We are, however, uninformed as to how far she is willing to withdraw the no less questionable attributions of landscape drawings to Savoldo. They are hard to disprove, because hardly any facts were advanced to prove them, besides the alleged relationship to No. **1410** meanwhile withdrawn by Mrs. Fröhlich-Bum herself, and to Nos. **A 1927, A 2010** which no one could accept as authenticated for Savoldo. When first discovering Savoldo as a draftsman of landscapes, Mrs. Fröhlich-Bum only gave him two (Nos. **A 1413, A 1884**): two years later, three more were added. This is the method of attributing which we may call "by contagion."

1405 BERLIN, KUPFERSTICHKABINETT, 605. Head of a youth. Bl. ch., on greenish paper. Later inscription in pen: Tintoretto. Ascr. to Savoldo. [*Pl. LVII,* 4. **MM**]
Close in style to No. **1412**. There is, however, a remarkable resemblance of either head to the types in the painting "Concert" by Lorenzo Zacchia of Lucca, dated 1523 (ill. *Burl. Mag.* LIX, 1931 August, pl. III A opp. p. 66). We are not informed about Zacchia's mode of drawing.

A BRNO, FELDMANN COLL. formerly, Landscape, see No. **A 1884**.

1406 FLORENCE, COLL. CHARLES LOESER. Study for St. Paul in the altar-piece in S. Maria in Organo, Verona, 1533, ill. Venturi 9, III, fig. 527 (the same figure, half-length, was painted separately, Lord Lee Coll., ill. Venturi 9, III, fig. 525). Bl. ch. Ch. Loeser Coll., Florence. The attribution to Savoldo was first made by Loeser, the connection with the painting recognized by Suida; the drawing is publ. in Schönbrunner-Meder 1007.
We were unable to locate the drawing.

1407 FLORENCE, UFFIZI, 572 F. Head of a boy. Charcoal, on faded blue. 225 x 180. Publ. by Gamba, in *Uffizi Publ.* III, I, No. 17, who first attr. the drawing — formerly ascr. to Bronzino — to Savoldo. Hadeln, *Hochren.*, pl. 19. [*Pl. LVI,* 3. **MM**]
A similar type is St. John in the painted "Pietà" in Berlin.

1408 ———, 12805. Study for the head of St. Peter in the "Transfiguration" in the Uffizi. Charcoal, height. w. wh., on gray. 275 x 212. Rubbed. — On the back old inscription: Giovanni Girolamo Bresciano. Mentioned in *Uffizi Publ.*, III, I, no. 16 and publ. by Hadeln, *Hochren.*, pl. 22.
The head in the painting is slightly raised.

1409 ———, 12806. Female head, looking down. Charcoal, height. w. wh., on br. 250 x 190. Somewhat rubbed. — *Verso:* old inscription: Giovanni Girolamo Bresciano, formerly supposed to refer to Muziano. *Uffizi Publ.* III, I, pl. 16. Hadeln, *Hochren.* pl. 18. Popham, *Cat.* 260. [*Pl. LVII,* 2. **MM**]
A similar type and expression are found in the Virgin in Savoldo's "Nativity" in Brescia, ill. Venturi 9, III, fig. 535.

A 1410 HAARLEM, TEYLER STICHTING. Two fishermen. Pen. Ascr. to Titian. Fröhlich-Bum in *Jahrb. K. H. Samml.* N. F. II, p. 192: Savoldo. In 1935, Mrs. Fröhlich-Bum verbally withdrew her attribution. Another version of this drawing mentioned by Mrs. Fröhlich-Bum p. 192, note, as a copy, in Paris, École des Beaux-Arts, was exh. as Annibale Carracci 1937, Cat. no. 29.
Also No. **1410** belongs to the Bolognese School.

1411 HELSINKI, COLL. BERTEL HINTZE. Head of a bearded man. Bl., red and wh. ch., on gray. 400 x 250. Late inscription (18th):

Bassano. Ehlers Coll., Göttingen. Publ. by Kenneth Clark in *O. M. D.* December 1927, pl. 39, who refers to various attr. — Bassano (Parker), Lotto, Veronese without reaching a decision himself. Ill. Sale Börner, May 9th and 10th, 1930, Cat. no. 520, pl. XXXIII. B. Hintze, in *Lillägnad Yrjö Hirn* XII, 7, 1930, p. 145: Savoldo with reference to No. **1406**. [*Pl. LVIII,* 1. **MM**]
We have not seen the original.

A LONDON, BRITISH MUSEUM 1846–7–9 — 10. See No. **A 1927**.

1412 MALVERN, MRS. JULIA RAYNER WOOD (SKIPPES COLL.). Bust of a bearded man, seen from front, slightly bending to the r. Bl. ch., height. w. wh., on blue. 268 x 194. Colorspots. Corners cut. Formerly given to Bordone or Lotto. [*Pl. LVII,* 3. **MM**]
Close in style to No. **1405**, see there.

A 1413 PARIS, LOUVRE, 4766. Landscape with a castle on a hill in the middle. Pen, br. 150 x 165. Ascr. to Domenico Campagnola. Publ. by L. Fröhlich-Bum, in *Belvedere* 1930 I, p. 88, fig. 68 II as Savoldo.
In our opinion, without any connection to Savoldo.

1414 ———, 5524. Head of a bearded man resting on his hand. Charcoal, on gray, height. w. wh. 361 x 265. Publ. by Hadeln, *Hochren.*, pl. 21: The wh. lights later addition. [*Pl. LVI,* 4. **MM**]
Fairly close to a similar motive in the painting in Florence, Coll. Loeser, ill. Venturi 9, III, p. 751 fig. 504.

1415 ———, 5525. Head of a bearded man, turned to the r. Study for the "Saint Jerome" in London, N. G. (ill. Venturi, 9, III, p. 779, fig. 529). Charcoal, on gray, according to Hadeln subsequently height. w. wh. 315 x 230. In lower l. corner later inscription: Titian. Hadeln, *Hochren.* pl. 20. [*Pl. LVII,* 1. **MM**]

A 1416 ———, 5541. Landscape, with an Adoration of the Child in the foreground. Pen. 265 x 340. Ascr. to Titian. Publ. as his in Lafenestre, *Titien*, p. 207. Fröhlich-Bum, *Belvedere* 1930 I, p. 89, fig. 69, II: Savoldo.
In our opinion, Bolognese and later.

A 1417 ———, 5545. Landscape. Pen, br. 193 x 314. Ascr. to Titian. Publ. by L. Fröhlich-Bum in *Jahrb. K. H. Samml.* N. S. II, p. 194, fig. 263 as Savoldo, with reference to No. **A 2010**.
In our opinion, without any connection to Savoldo.

1418 VIENNA, ALBERTINA, 52. Pilgrim, resting. Charcoal, height. w. wh., on greenish paper. 273 x 168. A strip of paper patched below with the old inscription: Gironimo bressano.

A ———, 47. See No. **559**.

A ———, 48. See No. **2010**.

A 1419 VIENNA, COLL. MAX HEVESI. Landscape with a group of buildings and swallows. Pen. 258 x 367. Publ. by L. Fröhlich-Bum in *Belvedere* 1930 I, p. 89, fig. 69 I.
Without any connection to Savoldo.

ANDREA SCHIAVONE
[Born 1522 (?), died 1563]

Andrea Meldolla, called Schiavone, is a well known figure as a painter and engraver. We possess, moreover, contemporary literary and documentary evidence about him. Nevertheless, his artistic personality is far from being clarified. He seems to have learned his art with Bonifazio, but his artistic evolution is not clearly discernible. Tintoretto highly esteemed his purely painterlike qualities. But we may also suppose that in his early years his qualifications for designing and composing must have been remarkable, otherwise Vasari would hardly—on the occasion of his first stay in Venice in 1541/42—have ordered from him the painting representing the battle between Charles V and Sultan Barbarossa. According to this piece of information we will be inclined to place the date of Schiavone's birth earlier than 1522, given by Ridolfi. The date of death, 1563, is well established.

On the whole, Schiavone's figure remains extremely uncertain. Degenhart (p. 316) on the ground of his specific method explains this uncertainty by pointing to the fact that Schiavone in an unusual fashion combined Parma and Venice in his drawings. "These exceptional features are only possible because he originated from Dalmatia, a sector without any well established graphic tradition." Mrs. Fröhlich-Bum to whom we owe the only existing modern monograph on the artist, in order to reach solid ground had taken his engravings as a point of departure. For our special purpose, the study of drawings, this method seems especially adequate, the linework in an etching being closely akin to that in a drawing. Parmigianino's influence is palpable, Mrs. Fröhlich-Bum even calling Schiavone a pupil of Parmigianino. The latter died in 1540, Meldolla's etchings all seem to belong to his early years, at any rate not to stretch over a long period. Their style is homogeneous, the most important print, "The Rape of Helena," is dated 1547. We can hardly overestimate Parmigianino's influence on Schiavone as an engraver, but, on the other hand, must not overlook the evidence that other influences, too, acted upon him. From Parmigianino he took the technique, the better part of his types and the silky flow of the draperies. Other types originate from Titian, for instance, the beardless "Vitellius" appearing in various of Meldolla's backgrounds, or occasionally the plump Infant Jesus contrasting with the more frequent slender type, or the beggar in the engraving of the "Circumcision." Though certainly most of Meldolla's etchings are Parmigianinesque, the magnificent "Moses and the burning bush" (B. Meldolla 3) is purely Venetian. The careful rendering of the landscape and the animals recall Titian when still under the influence of Giorgione. Schiavone who painted a modified copy from Titian's "Wedding of St. Catherine" (in the N. G.), may have found inspiration for his etchings in Titian's drawings. When, for instance, comparing Parmigianino's engraving B. 5 (Entombment) to Schiavone's copy from it, we may note that the modification of the body of Christ may be traced back to an influence of Titian ("St. Sebastian" in Brescia). Beside this positive connection with Titian Domenico Campagnola's engravings of 1517–18 also may have led Schiavone's to deviate from Parmigianino's types and compositions (compare for instance the distorted figure in the foreground of B. (Meldolla) 81 to Domenico's "Healing of the paralytic").

For two of Schiavone's etchings the designs exist, No. **1429** and No. **1456**. They differ so widely in technique and style that they ought to offer a wide span for further attributions. All drawings, however, that have been claimed for Schiavone up to this time are close to No. **1456**. In such attributions two dangers are to be avoided. One, not to be led too far into Central Italy by stressing the Parmigianinesque element in Schiavone and thus to

mistake Schiavone for Giuseppe Salviati who had come to Venice from Rome. The other is to mistake Schiavone for Biagio Pupini whose chiaroscuro technique is extremely close to his (compare No. 1452). Both mistakes are best avoided by keeping in mind the Venetian keynote of Schiavone's style. While doing so, it is true, we run into another difficulty, namely that of confusing Schiavone with Tintoretto whose tendencies are parallel to his and whose closeness to Schiavone, as it has long been known, caused difficulties for the attribution of a certain group of cassoni (s. Hadeln, *Zeitschr. f. B. K.,* N. S. v. 33). Concentrating our attention on the un-Roman, un-Parmigianinesque element in Schiavone, his lack of preciseness and his tendency to efface the figures, we recognize his difference from Tintoretto's powerful mechanism. A borderline case, however, is the "Lamentation of Christ" in the Academy in Venice (No. 1453) in which the approach to Tintoretto's early style offers a bewildering analogy to the problem of the above mentioned cassoni. Another border clash seems to occur in the red ch. drawing in Berlin, No. 376, containing busts of prophets, previously given to Bonifazio, and attributed to Schiavone by Hadeln who, however, did not advance valid reasons for his suggestion. We prefer, therefore, to hold to the older tradition, since the drawing does not fit too badly into Bonfazio's work as we see it, with all the uncertainties of which we are well aware.

The most difficult differentiation may be the above mentioned relationship to Giuseppe Salviati. He had definitely softened his Florentine-Roman pathos after settling in Venice. Since his types were also influenced by Parmigianino and his technique resembles Schiavone's, it is difficult to distinguish them. No. 1382, the design for a *"paliotto"* recording a member of the Grimani family is as close to Schiavone as to Salviati's woodcuts, as they appear as illustrations in numerous Venetian books. Singling out and comparing a detail like the lion in this drawing with the corresponding lion in No. 1426 one is tempted to consider the analogy as complete. And yet in spite of the resemblance there are fundamental differences. The breasts of the female figures are so correctly placed that we have to suppose a Central Italian training in anatomy and give credit to the old inscription, though not a signature, of Salviati's name.

On the other hand, No. 1426, in spite of the lion and of the historical difficulties which it offers, must remain with Schiavone, whose Virgin and Child, No. 1433, it duplicates in reverse. The lack of precision, typical of Schiavone, is made more unpleasant in this case by the dryness and smoothness suitable for a *modello.*

Mrs. Fröhlich-Bum sought to enrich Schiavone's oeuvre by introducing into it a number of landscapes. Examining his etchings we find only in B. (Meldolla) 3 some elements that might be connected with the Venetian tradition established in this field by Giorgione and Titian. In the others there is hardly more of landscape to be found than occasionally a tree used for a foil as in other cases architectural detail is used. Nowhere is any attention given to the rendering of landscape and of space. The same is true with the paintings, except those in Oxford, Chatsworth and in the Hermitage (ill. Venturi 9, IV, fig. 497, 521, 526), the attributions of which to Schiavone is by no means beyond doubt. (A group of landscape paintings first claimed for Schiavone by Fröhlich-Bum were taken from him by Peltzer and ascribed to a Northern artist, correctly in our opinion, although Mrs. Fröhlich-Bum in Thieme-Becker XXIV, p. 357, maintains her attribution.)

If Schiavone cultivated this field at all, the numerous landscapes attributed to him by Mrs. Fröhlich-Bum would have to display a more or less homogeneous style which, however, is not the case. In not one single instance has she succeeded in proving the use of a drawing in a painting or etching or any connection with either of them. Consequently, we reject the whole hypothesis of Schiavone's landscape drawings.

At the same time we reject the connection of No. 1465 with Schiavone, attributed to him by Mrs. Fröhlich-

Bum on the basis of an alleged resemblance to etchings given by Bartsch to Schiavone, not to Meldolla; we believe that Bartsch was right in distinguishing these two artists whom Mrs. Fröhlich-Bum, following other critics, fuses into one. To include Bartsch's "Schiavone" in the artistic personality of Meldolla-Schiavone would present another danger, namely, that of infecting the oeuvre of our Venetian artist with productions from the school of Fontainebleau, another offspring from Parmigianino.

1420 AMSTERDAM, COLL. VAN REGTEREN ALTENA. Adoration of the Magi. Brush, br., height. w. wh., on blue. 185 x 176.

A 1421 BERLIN, KUPFERSTICHKABINETT, 5033. Venus and Adonis. Bl. ch., washed with brush, on blue. 326 x 230. Coll. Beckerath. Ascr. to Schiavone. [MM]

In our opinion, typical of Pietro Liberi in view of its composition. Compare Liberi's "Allegory," ill. *Starye Gody*, 1916, p. 28. A painting by Liberi representing Venus and Adonis, formerly at the De Burlet Galleries is mentioned in Thieme-Becker vol. 29, p. 185. We had no opportunity of checking it.

1422 ———, Reserve. Nude woman seated, seen from behind, with cupids. Bl. ch., height. w. wh., on grayish blue. 210 x 187. Inscription: Andrea Schiavon. Publ. by Fröhlich-Bum, *Schiavone I*, p. 177, fig. 36 and dated about 1540/50.

A ———. Two busts of prophets. See No. **376**.

A 1423 ———. Landscape. Pen, br., wash. 268 x 243. Cut. Coll. Beckerath. Publ. by Fröhlich-Bum, *Schiavone I*, p. 178, fig. 44: Important as a pure landscape using figures only as accessories.

The attribution to Schiavone is in our opinion unfounded.

1424 COPENHAGEN, COLL. J. F. WILLUMSEN. Pentecost. Bl. ch., wash. 226 x 332. Stained by mold. An old inscription of Schiavone's name at the r. and on the back. Publ. by Willumsen, II, p. 561, pl. 76, with reference to the etching B. XVI, (Meldolla) 23.

We notice a striking resemblance to Titian's painting of the same subject in S. Maria della Salute (ill. Tietze, *Tizian*, 239).

A 1425 DARMSTADT, KUPFERSTICHSAMMLUNG, 249. Christ and the adulteress. Pen, bistre, wash, height. w. wh. 196 x 281. Publ. in *Stift und Feder* 1930, 57 as Schiavone. [MM]

The clear structure of the composition is not Venetian. The drawing seems closer to Biagio Puppini, compare his numerous drawings in Turin, Royal Library (for instance 15825).

1426 DONNINGTON PRIORY, COLL. GATHORNE-HARDY. Mystical wedding of St. Catherine in presence of the Doge Francesco Donato. Design for a lost painting in the Ducal Palace? Pen, wash, height. w. wh., on br. 274 x 317. Publ. by Hadeln in *Jahrb. Pr. K.S.* XLVI, p. 135, and in *Spätren.*, pl. 10. He refers to the fact that a votive painting in memory of the Doge Francesco Donato (1545-53) existed in the Sala del Collegio where it was destroyed by fire in 1574 and replaced by a composition by Jacopo Tintoretto which conforms with the drawing only as far as the subject goes. According to Hadeln the painting may have been by Schiavone and the drawing its design. This theory is accepted by Fröhlich-Bum in Thieme-Becker XXIV, p. 358. [*Pl. CII, 3.* MM]

We wish to emphasize the fact that the name of the painter of the lost votive picture is nowhere mentioned, the document of 1563 quoted by Hadeln proves only that a painting of this description

existed. Nor have we any evidence that Schiavone was ever commissioned to paint for the Ducal Palace. Since Tintoretto's composition, painted after the fire (ill. Bercken-Mayer 148), is entirely different in its composition, it seems unlikely that a painting corresponding to the drawing ever existed. The latter may, however, be a project presented by Schiavone as an attempt to obtain, during Titian's absence from Venice, this official commission which otherwise would have been Titian's task. At any rate, stylistic reasons, especially the exact conformity of the main group to the group in No. **1433** (in reverse), are strongly in favor of the attribution to Schiavone in spite of the resemblance of some details to Giuseppe Salviati (see p. 250).

A 1427 DRESDEN, COLL. PRINZ FRIEDRICH AUGUST, formerly. Adoration of the magi. Pen, br., wash. 195 x 203. Publ. by Fröhlich-Bum, *Schiavone I*, fig. 40, p. 177 as study of the etching B. XVI, 7, under the influence of Ja. Tintoretto.

In our opinion, the drawing which follows the same direction as the etching, is a copy of the latter. The drawing style is more typical of a painter than of a graphic artist.

1428 FLORENCE, UFFIZI 845. Virgin and Child, with St. John and a kneeling female saint offering flowers. Brush, green, wash. 205 x 140. Inscription in pen: Schiavon. Publ. by Fröhlich-Bum, *Schiavone I*, fig. 15, p. 169. Hadeln, *Spätren.*, pl. 12.

A ———, 1846. See No. **1378**.

1429 ———, 1993. Entombment of Christ, design for the etching (in reverse) B. XVI, 19. Pen, br., wash. 210 x 150. Formerly ascr. to Parmegianino, recognized and publ. by Fröhlich-Bum, *Schiavone II*, fig. 1, p. 367. [*Pl. C, 3.* MM]

Fundamental, as one of the few authenticated drawings by Schiavone.

1430 ———, 9295. A beggar sitting on the ground. Pen, wash. 160 x 188. Publ. by Fröhlich-Bum, *Schiavone II*, fig. 2, with reference to No. **1443** and the figure of the beggar in Schiavone's etched Circumcision.

1431 HAARLEM, COLL. KOENIGS, I, 36. Woman in armor (Bellona?) Brush, bl. and wh., on br. 200 x 133. Upper r. and lower r. corner damaged. Inscription in pen: Andrea Schiavon. — On the back: S.L. no. 3. [MM]

We emphasize the resemblance with Schiavone's etching B. XVI, 68.

A 1432 HAMBURG, KUNSTHALLE, 21283. The delivery of the keys to Saint Peter. Pen, wash, on green. 225 x 130. Arched top. — On *verso* inscription: (16 century) Francesco Rosso, Publ. as Schiavone by Alfred Neumeyer, in *Zeitschr. f. B.K.* vol. 62, p. 45 f. with reference to No. **1378**. [MM]

The drawing to which Neumeyer refers is, in our opinion, by

Giuseppe Salviati. The drawing in Hamburg is still more Roman in its composition and might be by the same hand as a drawing in the Reitlinger Coll. in London, ill. Reitlinger, *Masterdrawings* pl. 6, traditionally ascr. to Francesco Salviati, but tentatively to Rosso Fiorentino by Reitlinger.

1433 LONDON, BRITISH MUSEUM, 1855-10-8 — 6. Mystical wedding of Saint Catherine. Pen, br., height. w. wh., on lightbr. 243 x 208. Publ. by Fröhlich-Bum, *Schiavone I*, fig. 12, p. 169, with reference to the etching B. XVI, 59. Hadeln, *Spätren.*, pl. 9.

1434 ———, 1895-9-15 — 854. Judith carrying the head of Holofernes. Brush, br., height. w. wh., on br., partly worked over with the pen. 250 x 192. Malcolm Coll. (Robinson 405). Publ. by Fröhlich-Bum, *Schiavone I*, fig. 6, p. 169 who stresses the connection with the etching by Parmegianino B. 1, resp. its copy B. "Schiavone" XVI, p. 86, no. 20 and dates the drawing after the etching.

A 1435 ———. Minerva. Pen. 117 x 55. In London ascr. to Parmegianino, publ. by Fröhlich-Bum, *Schiavone I*, fig. 25, p. 172 as Schiavone's first study for his etching of the same subject.

We agree with Fröhlich-Bum as far as the rejection of Parmegianino's authorship goes, but cannot find a resemblance to the style of Schiavone's early drawings; compare for instance No. **1429**, also a design for an etching.

1436 LONDON, COLL. SIR ROBERT WITT, 2452. The Virgin bathing the Christ Child (Rest on the Flight into Egypt?). Brush, greenish, on yellowish. 228 x 142. Coll. Richardson, Lawrence, Bishop, Philpott. [*Pl. CI, 2*. **MM**]

1437 MILAN, COLL. RASINI. The Anointing of the dead Christ. Pen, br., wash. 250 x 310. Coll. Dubini. Publ. by Morassi, pl. XXIV, p. 32 as typical of Schiavone, notably influenced by Parmegianino.

1438 NEW YORK, PIERPONT MORGAN LIBRARY, IV, 80. St. John the Baptist preaching. Pen, br., light wash, height. w. wh., on bluish gray. 211 x 300. Damaged and restored. [*Pl. CII, 4*. **MM**]

The general arrangement recalls in its spirit the central group in Schiavone's painting of the same subject in Chatsworth, ill. Venturi 9, IV, fig. 521; details recall the painting in Hampton Court, ibid. fig. 505. For the penmanship compare the well-authenticated No. **1440**. Ridolfi I, p. 256 mentions paintings by Schiavone representing episodes of the life of St. John the Baptist in Casa Priola, Venice, district of San Salvatore.

A 1439 PARIS, LOUVRE, 4767. Landscape. Pen. 250 x 400. Worm eaten holes. Formerly ascr. to Titian, later to Do. Campagnola. Publ. by Fröhlich-Bum, in *Belvedere* 1930, I, p. 87, fig. 66, 2 as Schiavone, with reference to the landscape in the painting "Jupiter and Antiope" in the Hermitage, ill. Venturi 9, III, fig. 497.

In our opinion, the conformity is not so striking as to justify the attribution of both works to the same hand, and thus to make the drawing a keystone for the knowledge of Schiavone's landscape drawings. Especially as the attribution to Schiavone of the painting in the Hermitage is not beyond question. The drawing was engraved by Massé as by Carracci, and its Bolognese character (direction of Grimaldi) seems indeed predominant.

1440 ———, 5450. Last Supper. Brush, green wash, height. w. wh. 300 x 552. Badly damaged. Coll. Vasari, Jabach. Publ. by Fröh-

lich-Bum, *Schiavone I*, p. 177, fig. 39 and O. Kurz in *O.M.D.*, December 1937, p. 40, pl. 41. [*Pl. CII*. 1. **MM**]

The composition is a very personal transformation of Lionardo's composition. A painting by Schiavone of this subject is mentioned by Ridolfi I, 257, as owned by the Count of Arundel.

1441 ———, 5451. Entombment of Christ. Pen, br., height. w. wh., on reddish prepared paper. 230 x 195. Publ. by Fröhlich-Bum, *Schiavone I*, p. 176, fig. 35, who mentions a somewhat modified copy in the Albertina, reproduced in an etching by Bartsch.

1442 ———, 5452. The Flaying of Marsyas. Red. ch. 250 x 240 together with No. **1443** in the mount typical of Vasari's collection, labeled: Andrea da Zara pittore Schiavone. Publ. by Fröhlich-Bum, *Schiavone I*, p. 176, fig. 8, with reference to a resemblance of the kneeling figure at the l. with a falling horseman in Schiavone's etching B. XVI, 81. O. Kurz, in *O. M. D.* XLVII, pl. 42. [**MM**]

A painting of this subject by Schiavone was presented to King Louis XIII of France, according to Ridolfi I, 257. The composition, showing Marsyas tied to the tree with his head downward, might have influenced Titian's and Veronese's representations of this subject (Titian's painting in Kremsier, ill. Tietze, *Tizian* 283. Veronese's composition was engraved from the Cabinet du Roy, see the drawing No. **2166**).

1443 ———, 5452 a. Unidentified subject: three standing men in conversation with a fourth seated man. Pen, wash, on blue. 185 x 178. Together with No. **1442** in the Vasari mount. Publ. by Fröhlich-Bum, *Schiavone I*, p. 178, fig. 41. O. Kurz, in *O. M. D.* XLVII, pl. 42. Corresponding in style of drawing to No. **1438**.

A 1444 ———, 5535. Landscape with a couple of lovers at the r. Pen, darkbr. 148 x 240. Old inscription: Titiano. Ascr. to Titian, publ. by Fröhlich-Bum, *Schiavone I*, p. 178, fig. 42 as Schiavone, with reference to the rendering of the foliage and the treatment of the middleground. [**MM**]

In our opinion, the drawing is later as are all the landscapes grouped under the name Schiavone by Mrs. Fröhlich-Bum.

A 1445 ———, 5536. Landscape with two bridges at the r. Pen. 215 x 318. Listed under Titian. Publ. by Fröhlich-Bum, *Schiavone I*, p. 178, fig. 43 as Schiavone, with the same arguments as for No. **1444**.

We noted in our *Tizian-Studien*, p. 179 the conformity of the drawing with a portion of the woodcut in reverse attr. to Domenico Campagnola by Galichon (no. 12, *Le Vieilleur*). The penmanship, however, shows no resemblance to Campagnola's. The drawing might be a copy after him.

A 1446 ———, 5544. Landscape with girl holding a fruitbasket, and a youth. Pen. 300 x 430. Coll. Crozat, where the drawing was first attr. to Titian, later to Giuseppe Salviati. In the Louvre ascr. to Titian. Publ. by Fröhlich-Bum, in *Belvedere* 1930, p. 87, fig. 67/1 as Schiavone, with reference to the group of landscape paintings (Berlin, Kaiser-Friedrich-Museum and Venice, Coll. Brass, ill. Fröhlich-Bum, *Schiavone I*, fig. 65 and 66, resp. *Schiavone II*, p. 371 below), for which she maintains Schiavone's authorship, while other authorities attribute them to Northern artists. On p. 88 (note) she points to the striking resemblance of the figure group in this drawing with the one in the background in No. **A 1951**. In our *Tizian-Studien*, p. 179, note 75, we remarked that No. **1446** conforms to a woodcut (in the same direction) B. XIII, 386, 5, which Galichon tentatively attr. to Domenico Campagnola. [**MM**]

The composition is indeed close to the large woodcuts by Do. Campagnola, but the penmanship is different from his which makes the drawing a puzzle. Moreover, there existed in the Henry Oppenheimer Coll. in London under the name of "Titian" (Sale 1936, July 10–14, lot D) a pen drawing (337 x 463) rendering the same composition in reverse to the drawing No. **A 1446** and to the woodcut. This drawing in the Oppenheim Coll. is certainly only a very poor copy. Could it be a copy from a lost original by Domenico Campagnola and the drawing in Paris a copy after the woodcut? The spontaneity and high quality of the drawing and its differences from the woodcut contradict such a theory. In any event, there is no path leading to Schiavone. (G. Muziano is another artist who might be taken into account.)

1447 ————. Circumcision of the Christ Child. Pen, greenish, height. w. wh. 146 x 89. Mentioned by Fröhlich-Bum, *Schiavone I,* p. 217 as design for the etching B. XVI, 13.
We did not succeed in finding the drawing in the Louvre.

A 1448 ————, 5688–5726. Album (now loose sheets) containing figures grouped in two rows. Brush, bl., height. w. wh., on red prepared paper. About 190 x 190. Most sheets are used on both sides. Coll. Jabach? Publ. by Dorothea Westphal, *Zeitschr. f. B. K.* 1927/28, p. 314 ff. (with reproduction of 5690 and 5702) as probably by Schiavone at the time he worked in the studio of Bonifazio. Motives taken from the latter are copied in these drawings. Comparing 5690 with Bonifazio's "Adoration" in the Royal Palace in Venice (ill. by Westphal on p. 316) and 5702 with Bonifazio's "Holy Family" in the Ambrosiana, Miss Westphal arrives at the conclusion that the drawings are not sketches by Bonifazio for his paintings, but copies by a member of the younger generation, identified by her with Schiavone. **[MM]**
In our opinion, the lot contains two stylistically different groups of drawings. The one, embraces 5687 to 5691, 5693–5695, 5697–5705, 5714–5715, 5720, 5721, 5726; the other drawings are un-Venetian in style. Those mentioned before are poor and schoolboyish. They are typical shop productions from the second half of the 16th century, studies by a beginner after pictures, too impersonal to be attributed to an individual artist. A further drawing of this group with figures and draperies in the Louvre, Gay Bequest. The model of the female figure seen from behind in no. 5691 has also been copied by another hand in No. **1276.**

A ————, Walter Gay Bequest, figures and draperies. See No. **1448.**

A 1449 PARIS, ART MARKET, Landscape with men on horseback. Pen. 257 X 406. Sale Drouot 1924, February 25, no. 61: as Titian. Publ. by Fröhlich-Bum in *Belvedere* 1930, I, p. 88, fig. 67, 2, as Schiavone.
We reject the attribution, not seeing any reasons for giving to Schiavone this whole group brought together by Mrs. Fröhlich-Bum. In this individual case, moreover, the drawing is clearly based on Domenico Campagnola's style, see No. **483.**

1449 bis PRINCETON, N. J., MUSEUM OF HISTORIC ART. Goddess seated on a chariot pulled by dragons (Cybele). Brush, br., height. w. wh., on greenish. 390 x 255. Coll. Platt. Modern inscription: Parmigiano. Attr. to Schiavone by Dr. F. J. Mather. [*Pl. CIII,* 2. **MM**]
The attr. to Schiavone seems convincing to us with regard to the stylistic resemblance with No. **1451.** These two drawings, by far

superior in the greatness of their style to the other drawings by Schiavone, may reveal an otherwise lost side of his art. His murals on the façades highly praised by old authors (Ridolfi I, 149, 156) may have been executed in such a grandiose manner. Boschini, Minere p. 427 describes the one at the Palazzo di Casa Zena as "di terribile maniera."

1450 RENNES, MUSÉE, 4/2. Adoration of the shepherds. Brush, wh., gray, br. and reddish. 290 x 207. Photo Gernsheim 497.
[*Pl. CI,* 3. **MM**]

1451 TURIN, ROYAL LIBRARY, 15935. Adoration of the magi. Pen, br., wash, on faded blue. 225 x 158. Below later illegible inscription. Publ. by Hadeln, *Spätren.,* pl. 14. [*Pl. CIII,* 1. **MM**]
Close in penmanship to Nos. **1438, 1440.** The Child is similar to the painted St. John in the "Holy Family" in Vienna, the Virgin, as far as the greatness of style goes, to the one in Parmegianino's "Entombment," etching B. 3.

1452 ————, 16027. The healing of the paralytic. Brush, height. w. wh. 225 x 400. Ascr. to Biagio Pupini dalle Lame.
[*Pl. CII,* 2. **MM**]
In our opinion, the resemblance of the general arrangement to that of Jacopo Tintoretto's painting of the same subject in San Rocco in Venice is so striking that we are tempted to presume the dependence of either version on Pordenone's triptych to which the "Healing" was to form a companion piece. The drawing in Turin might be a design for a painting planned for the same location, perhaps executed in competition with Tintoretto in 1559. As for the style the drawing differs unmistakably from the many drawings by Puppini existing in the Royal Library in Turin and to which we may add the Marriage of the Virgin in the Pierpont Morgan Library (Murray I, 22). In spite of certain Raphaelesque reminiscences (see for instance St. John standing behind Jesus) reminding one of Pupini, other parts approach the style of Schiavone so definitely that we venture a tentative attribution of the drawing to him. Tentatively, because Puppini might have based his composition directly on Raphael's tapestry, by which Pordenone was also influenced.

1453 VENICE, R. GALLERIA, 548. Descent from the cross. Brush, br. and bl., height. w. wh., on bluish green. 206 x 210. Publ. by Fröhlich-Bum, *Schiavone I,* p. 176, fig. 3/4, with reference to No. **1455** — in our opinion different in its types and probably earlier — and Hadeln, *Spätren.,* pl. 13. [*Pl. CI,* 4. **MM**]
We date the drawing with reference to No. **1469** in Schiavone's late period and point to the resemblance of the composition with Tintoretto's drawing No. **1737** which by stylistic and exterior reasons might be done about 1560. The resemblance even seems sufficient to suggest Tintoretto's authorship in his early years for this drawing. At that time, as we know, Tintoretto's approach to Schiavone was closest.

1454 VIENNA, ALBERTINA, 59. Judith holding the head of Holofernes. Over ch. sketch, brush, br., wash, height. w. wh., on purple tinted paper. 182 x 164. Later inscription: 1570. *Albertina Cat. I* (Wickhoff) Sc. V. 159, ill. pl. IV: autograph by Schiavone. Fröhlich-Bum, *Schiavone I,* p. 176. Hadeln, *Spätren.,* pl. 7.

1455 ————, 60. Entombment. Pen, br., wash, height. w. wh. 200 x 270. Old inscription: Andrea Schiavone f. 1550. *Albertina Cat. I* (Wickhoff) 163: autograph or at least very closely related. Fröh-

lich-Bum, *Schiavone I*, p. 176, fig. 33. *Albertina N.S. I*, 13. Giulio Lorenzetti, in *L'Arte* N. S. III (1932), p. 23.

The still Parmegianinesque elements confirm the inscribed date.

1456 ———, 61. St. Paul healing the sick, design for Schiavone's etching B. XVI, 15 (in reverse). Pen, br., wash, on yellowish tinted paper. 226 x 161. *Albertina Cat. I* (Wickhoff) Sc. L. 91: After Parmegianino. Recognized by Fröhlich-Bum, *Schiavone I*, p. 169, fig. 30.

1457 ———, 62. Unidentified subject. Red ch., wash. 425 x 300. Late inscription: Andrea Schiavon. *Albertina Cat. I* (Wickhoff) Sc. V. 166: very close to authentic drawings. Publ. by Fröhlich-Bum, *Schiavone I*, p. 178, fig. 38 as Massacre of the Innocents, a title repeated in *Albertina Cat. II* (Stix-Fröhlich).

We agree neither with the title (the people in the crowd are evidently protecting themselves from something descending from above) nor with her reference to No. **1378**, but accept the attribution to Schiavone. The represented subject may be the one mentioned by Lomazzo, *Trattato* II, p. 256: In the year when Hannibal left Carthage blood was seen raining in the city according to Livy.

A 1458 ———, 63. Adoration of the shepherds. Pen, br., wash. 187 x 152. Coll. Zoomer, Reynolds. Companion piece of No. **1459**. *Albertina Cat.* I (Wickhoff) Sc. V, 160: Imitator of Schiavone's style. Fröhlich-Bum, *Schiavone I*, p. 173: Schiavone. Accepted as such in *Albertina Cat. II* (Stix-Fröhlich).

In our opinion, neither the composition nor the penmanship justifies the attribution to Schiavone. The drawing does not look Venetian at all.

A 1459 ———, 64. Adoration of the magi. Pen, br., wash. 188 x 153. Companion piece to No. **1458**. Coll. Zoomer, Reynolds. *Albertina Cat. I* (Wickhoff) Sc. V. 161: Follower of Schiavone's style. Fröhlich-Bum, *Schiavone I*, p. 173, fig. 19: Schiavone, with reference to kneeling figures in the etchings B. XVI, 3 and 12.

Certainly later than Schiavone and not Venetian.

A 1460 ———, 65. Allegorical female figure, holding a large bowl, and a cupid blowing a trumpet. Bl. ch., wash, height. w. wh., on lightgray tinted paper. 218 x 259. Lower r. corner made up. Coll. Richardson, Reynolds. The traditional ascription to Schiavone rejected by *Albertina Cat. I* (Wickhoff) Sc. V. 167, but maintained by *Albertina Cat. II* (Stix-Fröhlich).

We cannot find any connection with Schiavone.

A 1461 ———, 66. King crouching on the ground and a second figure, fragment. (Death of Saul ?) Pen, bistre, wash, height. w. wh., on blue. 118 x 182. Squared with ch. *Albertina Cat. I* (Wickhoff) Sc. V. 60: not by Schiavone. *Albertina Cat. II* (Stix-Fröhlich): by Schiavone and representing Nebuchadnezzar lying on the ground and eating grass (Daniel V, 21).

We doubt the correctness of this identification and of the attr. to Schiavone.

A 1462 ———, 67. Two men seated at a well. Red ch. 80 x 150. In our opinion later and not Venetian.

A ———, 68. See No. **560**.

A 1463 ———, 69. Landscape with a village and a pond. Pen, br. 224 x 332. New acquisition. Publ. in *Albertina, N. S.* II, 20 and in *Albertina Cat. II* (Stix-Fröhlich) as Schiavone, an attribution rejected by Hadeln, *Zeitschr. f. B. K.* 1926/27, p. 112 as entirely unfounded: more likely by Titian than by Schiavone. Morassi p. 32 suggests Domenico Campagnola.

In our opinion by a Bolognese imitator of Titian.

A 1464 ———, 70. Wooded landscape with groups of houses. Pen, br. 136 x 211. Kutschera Bequest. Publ. as Schiavone by Fröhlich-Bum in *Burl. Mag.* 1923, July, an attribution repeated in *Albertina Cat. II* (Stix-Fröhlich). Morassi p. 32: Domenico Campagnola.

In our opinion, without any connection with Schiavone and perhaps not even Venetian.

A 1465 ———, formerly. Sketches of two female figures and decorative details. Pen. 153 x 195. Contemporary inscription: stranona (?) Publ. by Fröhlich-Bum, *Schiavone I*, p. 172, fig. 24: Schiavone's design for an engraved cartouche in the manner of B. XVI, p. 80, no. 10 ("Schiavone," s. p. 250 f.).

We neither agree with Mrs. Fröhlich-Bum that the inscription reads Schiavone, nor that this would mean a signature. Further, we cannot find any connection to any work by Schiavone. The sketches do not even show the Venetian style of his time.

A 1466 VIENNA, COLL. ZATZKA, formerly. Moses and the burning bush. Pen. 136 x 240. Retouched. Publ. by Fröhlich-Bum, *Schiavone II*, p. 368, fig. 3 as design for Schiavone's etching B. XVI, 41, No. 3.

The drawing, which we only know by the reproduction, is certainly a copy after the etching (in the same direction).

A 1467 ———. Female genius. Pen, wash. — On the back a similar figure, perhaps partly traced from the other side. Publ. by Fröhlich-Bum, *Schiavone II*, p. 369, fig. 4 and 5 as Schiavone.

We do not see any connection to Schiavone.

1468 WASHINGTON CROSSING, PA., COLL. F. J. MATHER JR. Adoration of the shepherds. Brush, purple, height. w. wh., on gray. 147 x 300. Coll. P. Lely, Richardson, Esdaile, Barnard.

1469 WINDSOR, ROYAL LIBRARY, 6677. Apparition of St. Mark. Brush, bluish gray, on paper turned yellow. 325 x 264. Inscription in pen: di A. Schiavone. Publ. by Hadeln, in *Jahrb. Pr. K. S.* XLVI, p. 138 and in *Spätren.*, pl. 15 as Schiavone's design for a painting on which he is supposed to have been working for the Scuola di San Marco in June 1562, but which he left behind unfinished when he died the next year. The "Apparition of St. Mark" was later on painted for the Scuola by Domenico Tintoretto (see also *Jahrb. Pr. K. S.* XXXII, 1911, p. 52). [*Pl. CI*, 1. **MM**]

SEBASTIANO DEL PIOMBO

[Born about 1485, in Rome from 1511]

Sebastiano's description as a draftsman, first formulated by Franz Wickhoff, and ultimately developed by Mr. Berenson, in his *Drawings* II, p. 318 ss., has vigorously, though courteously, been attacked and substantially

revised by O. Fischel in *O. M. D.* September to March, 1939/40, p. 21 ff. We do not need to enter this discussion here since almost all its points belong to Sebastiano's Roman period in which, at any rate, we would not claim him for the Venetian School. There is, however, one point where we are directly interested: Dr. Fischel's criticism shatters the trustworthiness of a pen-drawing in Berlin (Berenson, *Drawings,* no. 2475), the one drawing that seemed well-authenticated, if not for Sebastiano's Venetian period, at least for his very beginning in Rome, when he still was closely connected with the school of his native city. We, ourselves, accepted the traditional name and drew conclusions from it (in our *Tizian-Studien,* p. 174 ff.) which we are unable to maintain in the face of Fischel's objections; the fact that besides the conformity of one of the drawn figures with Sebastiano's lunette in the Farnesina in Rome (ill. Venturi 9, III, fig. 31) a second figure appears exactly conforming to another painting in the same gallery, not by Sebastiano, however, but by B. Peruzzi (best ill. in Delacre, *Dessins de Michelange,* 1938, fig. 8; see also F. Hermanin, *La Farnesina,* 1927, pl. IX), revealing the drawing as a copy. Once suspicious, one readily notes the characteristics of a typical copy made from the murals and, as Dr. Fischel suggests, by a considerably later artist. Under these changed circumstances the insight we believed to have gained into Sebastiano's Venetian drawing style has vanished. We cannot use the drawing in Berlin any longer as an argument against the attribution of No. **1926** to him, but still see no reason for yielding to Morelli's old arguments (I, p. 42), though accepted by Berenson. That the hand is still Giorgionesque is no more an argument in favor of the youthful Sebastiano, than of the youthful Titian, and the ear, touchstone for that school of critics, is not Sebastiano's, but a typical faun's.

Can the deficiency caused by the elimination of the drawing in Berlin be made up by No. **1470** in the Ambrosiana, proposed by Fischel as a study for Sebastiano's "Death of Adonis" in the Uffizi and a sample of his style, before merging in Michelangelo's sphere?

We appreciate Fischel's strong reasons for his suggestion (see p. 256), but miss a convincing link to Sebastiano's later drawings, even to the specimens gathered by Fischel himself, and, on the other hand, to the specific style of Venetian drawings as exemplified in the Giovanni Bellini workshop, in the circle of Giorgione, and by Titian in his earliest experiments in this field. It must, however, be admitted that no drawings of Titian in the same technique are preserved to be dated before 1515. The attribution to Sebastiano is too new and too surprising; further studies will perhaps clarify the connection of this drawing with preceding and succeeding stages.

We should add a few words on a group of pen drawings (see under No. **730**) which do not fall into line either with the evolution as drawn by Berenson or with that suggested by Fischel, but formerly were sometimes claimed for Sebastiano, a thesis to which we adhered with reservations in our *Tizian-Studien.* Our reservations, at present, weigh still heavier, since the attribution rests entirely on an interpretation of Sebastiano's artistic character gained from the study of his early paintings. At a time when he could hardly be very deeply penetrated by the new Roman models, he already developed a marked interest for plastic form. That means to say that his later career within Michelangelo's orbit was foreshadowed by his innate trends. Sebastiano is a Roman born in Venice, a pupil of Giorgione destined to become a pupil of Michelangelo. This definition induces us to consider him seriously when pondering over the attribution of that group of Venetian drawings, previously taken for granted as by Giorgione, but since the end of the age of innocence offered for attributions in all directions, even including Giorgione's latest period, that is, the period when we are hardly able to distinguish him from Sebastiano or Titian. We still believe that the name of Sebastiano is a little better than others, but after all prefer to keep the group for a prolonged quarantine in the circle of Giorgione (see No. **730**).

A LILLE, MUSÉE WICAR. Bust of a faun. See No. **1926**.

1470 MILAN, AMBROSIANA. Studies of Venus and Cupid (not connected with each other). Bl. ch., height. w. wh. 195 x 280. Watermark: anchor. Old inscription: Fra Bastiano del Piombo. — *Verso:* Torso of a recumbent male figure. Bl. ch., height. w. wh. In lower r. corner detached studies of a bearded satyr and a female head and in the center an Ionic capital, red ch. Publ. by O. Fischel, in *O.M.D.* September to March 1939–40, p. 28, 17, 18, as by Sebastiano, the Venus on the *recto* supposed to be a study for Sebastiano's "Death of Adonis" in the Uffizi (ill. ibidem fig. 6) and the whole drawing an example of Sebastiano's style immediately after his arrival in Rome and before his absorption by Michelangelo. Fischel's thesis was accepted by L. Dussler, *Sebastiano del Piombo*, Basel 1942, p. 172, no. 161. [*Pl. LVIII,* 2 *and* 3. **MM**]

Fischel's reference to the painting in Florence, endorsing the independent old attribution to Sebastiano, is indeed tempting, the conformity of the seated Venus to the one in the painting seemingly being more than accidental. The dating of the painting in Sebastiano's pre-Michelangelo period is supported by the relationship of the composition and several types to Giorgione, by the shape of the Campanile (in the view of Venice in the background) still lacking

the roof built in 1510–16 (compare the later shape in Titian's altarpiece in Ancona of 1520, ill. Tietze, *Tizian,* pl. 68) and the very similar arrangement of figures in Peruzzi's mural in the Farnesina, ill. Venturi 9, V, fig. 221. On the other hand, the style of our drawing if supposed to be a preparatory sketch could hardly be reconciled to a date about 1510. The nearest analogies in Venice would be Titian's No. **1929** about 1516–18 and Bordone's black chalk drawings that are still later. The solution of the puzzle may be that the execution of the painting is later and that for the invention Sebastiano may have used the same model as Peruzzi in his mural in the Farnesina — a composition by Giorgione, for whom the subject is ascertained by a literary source. Ridolfi (I, p. 99) in his long list of mythologic *cassoni* painted by Giorgione, mentions a "Death of Adonis," owned by the Widmann family.

A 1471 Moscow, UNIVERSITY. Unidentified composition of standing figures. Pen, br. 98 x 142. Publ. by M. A. Sidorow in *Drawings of the Ancient Masters in the University of Moscow,* no. II, as an early work of Piombo, still betraying his Venetian origin, 1511–14.

In our opinion, only based on the reproduction, much later and in the direction of Domenico Fetti.

THEOTOCOPULI DOMENICO, see GRECO, EL

DOMENICO ROBUSTI, CALLED IL TINTORETTO
[*Born c. 1560, died 1635*]

The case of Domenico Tintoretto is in principle somewhat similar to that of Orazio Vecelli: it is the problem of the son and collaborator absorbed by a greater father's personality and activity. But while in the case of Orazio the absorption is almost complete, and even a modest amount of artistic independence is hardly ever accorded to him, in the case of Domenico Tintoretto (it is true, contrary to Orazio, he survived his father for more than forty years) it was possible to build up a sizable oeuvre with the help of Ridolfi's biography (II, p. 257 ff.) and documentary sources. An important point in this construction is the fact that Ridolfi emphasized the outstanding qualities displayed by Domenico in his youth. Just in the years when Jacopo was still living may we expect a marked originality and a distinctive evolution in Domenico's activities.

Ridolfi (II, p. 262) informs us that Domenico had a predilection for subjects of a complicated literary character having devoted himself to related studies in his early years. This sophistication places him in contrast to his father whose simplicity, verging on illiteracy, is reported by literary sources and confirmed by authentic works. Domenico who, characteristically enough in his late years planned the foundation of an academy in Venice is the "academic" artist as contrasted with the craftsman. Miss Tozzi applied Ridolfi's indications to various paintings listed under Jacopo's name and returned them to Domenico. For his drawings (as far as we feel justified to propose definite dates at all) we do not reach a period before Jacopo's death with the one exception of No. **1536** in Oxford. Some of the subjects described by Ridolfi as especially favored by Domenico are to be identified among the drawings of the so-called sketchbook in the British Museum: an allegory of human life, based, as Ridolfi states, on Lucretius or on Cavaliere Marino; the virgin compared to a rose, following an idea of Ariosto. Since Marino's· *"Rime,"* the more likely of the two sources, was published at Venice in 1602, this may be the

approximate date of the drawings referring to this subject. This date may also be applied to a number of sketches executed in a somewhat different style and preparing Domenico's painting in Modena, "The Lord delivering the keys to St. Peter," of 1601 (No. **1526**, 82 ff.). The secular inventions among the sketches in London belong to the most fascinating creations of the late Renaissance in Venice; they show Jacopo's style in pure essence, a kind of super-Tintoretto, and, consequently, as long as they were accepted as Jacopo's, they appeared as peaks of his art. They are no less outstanding as works by Domenico and confirm Ridolfi's judgment on his early period. Other parts of the sketchbook are far inferior in quality and betray Domenico's increasing tendency toward routine. Miss Tozzi made a mistake in dating those representing the miracles of St. Mark very early and connecting them with a series of pictures from the legend of St. Mark, ordered for the Scuola Grande of the Saint in 1585. The subjects of the sketches do not correspond to those of the paintings and might as well refer to the two "miracles of St. Mark" painted much later by Domenico for the convent church of SS. Mark and Andrew (Boschini-Zanetti, p. 451).

After the discovery of sketches executed by Jacopo in the same technique, in Naples (Nos. **1723, 1724, 1725**), it is easier to recognize the specific and distinctive stylistic character of the sketches in London. The whole academic attitude, the lack of spontaneity, the luxuriating in endless repetition of an invention contradict Jacopo's approach; for him the essential point of a composition from the first conception on seems to be irrevocably established. Another contrast exists between the coloristic abstractness of the sketches in London and Jacopo who even in his sketches did not sacrifice the plastic values. The material in London is supplemented by sketches in other collections, among which the sketch of the "Martyrdom of St. Stephen" in Oxford (No. **1536**) is especially important. The corresponding painting was ordered for S. Giorgio Maggiore immediately before Jacopo's death, and Hadeln started from the sketch with his criticism of the sketchbook in London. The last stage of Domenico's development in this specific field of color sketches is marked by the sketch for the "Plague in Venice" (the painting in San Francesco della Vigna, Venice, the sketch in the F. J. Mather Coll. in Washington Crossing, No. **1554**).

From this material of color sketches we are also in a position to derive the qualities of Domenico's pure drawing style. Some of the sketches in London are already on the edge of transition to real drawings. No. **1510** in Mr. Lugt's coll. looks like a more intense preparatory stage of the sketch No. **1526**, 77. On the *verso* of No. **1546** we find drawn studies connected with the color sketch on the *recto,* offering important supplements to our knowledge of the draftsman Domenico, presumably in the late 1590's (see p. 267). These drawings (like Nos. **1488, 1541**, both inscribed with the name of Domenico Tintoretto by a later owner) are remarkable for their careful interior modeling, their uncertain outlines and, in spite of that modeling, their lack of volume. The homogeneous character of these drawings for which the attribution to Domenico is backed by other factors, helps to identify other drawings as works of Domenico, as for instance No. **1513** ascr. to Jacopo. All these drawings differ from Jacopo's by their intention to clarify the locality. They are not abstracts unconnected to space as Jacopo's are, and seemingly the results of a different working process. Jacopo's abstractions recall the net by the help of which they were drawn while Domenico's study the model in its natural surrounding.

We wonder whether this distinction is in all cases decisive. No. **1603**, for instance, is rather abstract, but was Hadeln right in accepting the tradition of the Uffizi and publishing the drawing as by Jacopo? The drawing is used in "St. Bridget's vision of the flagellation" in the Pinacoteca Capitolina, a typical and unquestioned Domenico. This, however, is only a second use in which the position is slightly modified, the drawing is still closer to the Christ in the painting of the Flagellation recently acquired in Vienna under the name of Jacopo and pub-

lished as his by Hadeln. In spite of all the arguments in favor of Jacopo under whose name we list the drawing, we remain suspicious, especially since the general character of the painting in Vienna recalls Domenico as does the drawing. The outlines lack the plastic anatomical clearness that shows through Jacopo's hastiest sketches. Another example holding its place between the father and son is No. **1533**, a design used for the figure in the lower right corner of the ceiling "Venice ruling the sea" in the Sala del Senato in the Ducal Palace. From John Ruskin on most critics have doubted Jacopo's participation in the execution, and some even in the invention. The style of the drawing confirms such doubts. It seems nearer to Domenico who, even if Jacopo invented the composition as a whole, apparently prepared the detailed studies for the execution.

We have, of course, to admit that the boundary line between father and son is far from being absolutely certain. No less uncertain is the line, on the other hand, toward the other secondary members of the shop. That their production, too, is included in the common working material of the shop is not only consistent with the general usage, but confirmed furthermore by the testaments of Jacopo and Domenico Tintoretto. Jacopo's, dated May 30, 1594, is important in certifying that the general conditions in such a Venetian family workshop were practically still identical with those in the Bellini shop a hundred years earlier: "I order all my property, as far as appertaining to my profession, to go to my son Domenico under the condition, however, that all this professional material be used in common by him and by my son Marco, as long as they hold together as brothers should. I also order my son Domenico to complete with his own hand my works left unfinished, and to employ in this task the same pains that he used to bestow upon many of my works." Evidently Domenico, the elder brother and approved assistant of his father for many years, appears as predominant here, as Gentile Bellini was the successor of Jacopo Bellini.

Still more instructive with respect to the organization of such a workshop is Domenico's last will, dated October 20, 1630: "I bequeath to my brother (Marco) all the casts in the studio. And if Bastian, my boy, (*giovane,* apprentice) will be still in my service at the time of my death, I bequeath to him four of these casts, namely a head of Vitellius, a full-size figure, and two torsos at his own choice, moreover, all drawings inscribed Bastian and all those inscribed Zuane. To the mentioned Bastian I also bequeath 150 studies from nature after men and 50 after women, at his own choice. I bequeath to him also the ground colors and all the brushes, a porphyry rock and a *"corrente"* (?). To my brother I bequeath all sketches and paintings of our father except his portrait on panel which I bequeath to my sister Octavia."

The Bastian who shares with Marco Robusti in the artistic part of the inheritance is Sebastiano Casser, later the husband of Domenico's youngest sister Octavia, the heir apparent to the Tintoretto shop. Besides other working material he inherited two categories of drawings: *"disegni"* and *"schizzi."* To begin with the latter, they evidently belong to that stock of studies from nature, the bulk of which was still kept together in the 18th century and the enormous number of which still amazes us today after so much destruction and dispersal. It is not said that these drawings were by Jacopo, on the contrary, from the last passage of the will we might presume that they were not, since *"tutti gli schizzi . . . di mio padre"* were bequeathed to Marco Tintoretto. Perhaps they were by Domenico or belonged to an indiscriminate stock, the common working material of the shop. Such an interpretation seems alluring with regard to the other group of drawings mentioned in Domenico's last will, designs bearing the name either of Bastian or of Zuan. Bastian evidently is Casser himself, but who is Zuan? Miss Tozzi in *Rivista di Venezia,* June 1933, discussed the documents for Domenico's biography and pointed out that Domenico when he was made a member of the Scuola di San Marco in 1585 is designated as Zuan Bat-

tista. She concluded that he must have also had this name, although this fact is not supported by any other evidence. The *"disegni"* in question apparently were Casser's and Domenico's share in this group; not studies after nature, which here are designated as *"schizzi dal natural,"* but more finished total compositions. At least the word is used in this sense by Ridolfi in his biography of Aliense and elsewhere. Within the considerable number of drawings connected with the Tintoretto shop we know of none inscribed with either of the two names mentioned in the last will (except perhaps No. **1822**?). Are we to imagine they were so exclusively working material that after having fulfilled their practical scope they offered no interest? We are not very well satisfied by this explanation, since, in our opinion, the survival of drawings is not regulated by reasons of quality, but by pure chance. We might also consider the possibility that the drawings mentioned in the last will were kept together in folders on which the names were inscribed.

At any rate, from the quoted passages we draw the conclusion that the material gathered in a large workshop consisted of drawings done by various hands, and that the contemporaries were fully aware of its heterogeneous origin. This burdens the critic with the task of differentiating various hands within the total production of the Tintoretto shop. We add at once that, in view of the present state of knowledge in this field, we do not feel ready to take on this task; it is not sufficient to recognize a problem; to solve it an adequate preparatory stage must have been reached.

It is relatively easy to distinguish the share of Tintoretto's daughter Marietta from that of the others (see p. 293). For other members of the shop, see our paragraph about Marco Tintoretto, p. 294, and Tintoretto's shop, p. 295. As for Domenico himself, we may suppose that his turbulent period, acknowledged as especially promising and fascinating by Ridolfi, came to an end with the century, when after his father's death Domenico became the head of the great shop left in his care. Now he was the master to direct the assistants and even, if necessary, to engage other artists for special tasks. The decoration of the Scuola Grande di San Giovanni Evangelista seems to be an example of the latter sort. No. **1526**, 2, belonging to the sketchbook in London, is the sketch of the painting representing "S. John Evangelist and the philosopher Crates" (Lorenzetti, p. 572), executed by Vicentino. Since not only the general arrangement, but many details as well (for instance, the man on horseback at l., or the architecture in the background) are identical in both versions we believe that Vicentino used Domenico's design rather than that they competed for this commission.

Our attempt to reconstruct Domenico's artistic personality, based on Hadeln's hints and on Miss Tozzi's two fundamental articles, ought to secure a more appropriate place for an unjustly neglected artist. The urgency of such a rehabilitation is illustrated by Domenico's biography in Thieme-Becker vol. 33, p. 188 ff., only recently published, in which Suida, although listing Tozzi's article in his bibliography, cannot spare a word for the shifting of the drawings in London from Jacopo to Domenico, and does not even mention the latter's activity and importance as a draftsman.

We recall that good authorities, on the ground of an esthetic reaction whose sensitiveness we acknowledge, considered this "sketchbook" as Jacopo's final and highest achievement. The formal unrestraint, the free emanation of the artistic subjectiveness without regard to a patron or a public, fill these sketches with an immediate feeling of modernity, that is, a timelessness we are willing to accord only to the greatest masters of the past. How intensely such sketches convey this specific modernity is illustrated by No. **1509** ascr. in the Horne Foundation, in spite of the old paper on which it is drawn, to an anonymous artist of the 19th century.

1472 AMSTERDAM, COLL. NICHOLAS BEETS. The Muses in landscape. Oil, monochrome, br. and bl., height. w. wh. (partly oxidized), on br. 272 x 400. Badly damaged and patched. Late inscription: Tintoretto. [*Pl. CXVII*, 1. **MM**]

The subject is represented in a different manner in No. **1476**, ascribed to Jacopo Tintoretto.

1473 AMSTERDAM, GOUDSTIKKER GALLERY. Allegory of war and peace (called in the cat. "Episode from the life of Hercules"). Oil on paper. 285 x 215. Inscripiton in pen: Tintoretto. Coll. Cardinal Albani, A. G. B. Russel. Ill. cat. of Goudstikker Gallery 1929, No. 41 as by Jacopo Tintoretto.

Like the following three numbers closely related to the material in the London sketchbook, No. **1526** and typical of Domenico.

1474 ———. St. Mark enthroned, worshiped by a kneeling donor with numerous attendants. Oil on paper. 315 x 250. Coll. Cardinal Albani, A. G. B. Russel. Ill. cat. of Goudstikker Gallery 1929, no. 42 and attr. to Ja. Tintoretto. Mentioned by Tozzi, *Boll. d'A.,* July 1937, p. 30 as connected with Domenico Tintoretto's late paintings in the Sala dell'Avogaria in the Ducal Palace.

See No. **1473**.

1475 ———. Allegory of human life, see No. **1526**, 28 ff. Oil, on paper. 256 x 305. Coll. Cardinal Albani, A. G. B. Russel. Ill. cat. of Goudstikker Gallery 1929, No. 43, ascr. to Ja. Tintoretto.

Other version of the same composition in the British Museum No. **1526**, 28 ff.

1476 ———. Apollo and the Muses. Oil, on paper. 260 x 320. Coll. Cardinal Albani, A. G. B. Russel. Ill. in cat. of Goudstikker Gallery 1929, No. 44, ascr. to Jacopo Tintoretto.

The composition is related to the painting of the same subject in the Banks Coll. in Kingston Lacy, now attr. to Domenico Tintoretto. See No. **1473**.

1477 BASEL, COLL. ROBERT VON HIRSCH. Figures in violent assault, a burning town in the distance. Brush, oil, on green. 195 x 243. For other versions of this composition see No. **1526**, 79 ff. [*Pl. CXVII*, 2. **MM**]

1478 BERLIN, KUPFERSTICHKABINETT, 5736. Study from Michelangelo's head of Giuliano de' Medici. Bl. ch., height. w. wh., on greenish. 420 x 280. Coll. von Beckerath. *Berlin Publ.* 189; Hadeln, *Tintorettozeichnungen,* pl. 8: Jacopo Tintoretto. [*Pl. CXXIV, 2.* **MM**]

Companion piece of No. **1526**, 30 which forms part of Domenico's sketchbook. In spite of the fascinating quality of the drawing it must consequently be claimed for Domenico for whom the underlined sentimentality is a further argument. We have to add that the technique would have no analogy in Jacopo's production.

1478 bis ———, 15457. Two separate studies of nudes, one recumbent and seen from front, the other kneeling from behind. Charcoal and traces of wh., on blue. 281 x 426. Squared in charcoal. Damaged and stained. [**MM**]

The figure at l. is, in our opinion, a study for a figure in a "Mocking of Christ" (see the sketch of the whole composition No. **1528**).

1479 BESANÇON, MUSÉE, 3130. Head of a youth, turned to the l., foreshortened. Bl. ch. with traces of red ch., on buff. 145 x 82. Inscription in pen (18th century?): Dom Tentoretto [**MM**]

The traditional inscription may be trustworthy.

A BREMEN, KUNSTHALLE. Study for five figures, see No. **A 1568**.

1480 CAMBRIDGE, ENGLAND, FITZWILLIAM MUSEUM, 73. St. Jerome with the lion. Bl. br. ch. 221 x 203. Sketch for a pendentive, cut. Ascr. to Jacopo Tintoretto. [**MM**]

1481 ———, 2252. Figure turned to the l., next to it a nude. Charcoal, on buff. 335 x 270. Stained by mold and colorspots, rubbed. Late inscription: Tintoretto. — *Verso:* Hasty sketch of a composition the subject of which cannot be identified. Ascr. to Ja. Tintoretto. [Both sides **MM**]

The composition on the back is similar in style, and possibly related in subject as well, to No. **1536**. The figure turned to the l. on the *recto* appears also in No. **1528** at r., with the l. arm in the position as the correction in the drawing indicates.

1482 ———. St. Peter receiving the keys. Brush, oil, on greenish gray. 363 x 226. Indication of semicircular top. Presented by A. M. Hind in 1919.

One of the studies for Domenico Tintoretto's painting in Modena, see No. **1526**, 82 ff. Dated by the painting.

1483 CHATSWORTH, DUKE OF DEVONSHIRE, 273. Virgin and Child in clouds presenting a rosary to a saint (Dominic); below other saints, among them a bishop. Brush, oil, monochrome, 407 x 249, semicircular top. Coll. Padre Resta, Lord Somers. Ascr. to Ja. Tintoretto. [**MM**]

Similar in style to the composition in the sketchbook in London, No. **1526**, and like the latter by Domenico. The sketch may prepare Domenico's painting "Madonna of the Rosary" in Ferrara, ill. Osmaston II, pl. CCV.

1484 CHICAGO, ILL. ART INSTITUTE 22.2.973. Recumbent woman. Bl. ch., on blue. 173 x 220.

1485 COPENHAGEN, COLL. I. F. WILLUMSEN. Nude, male, recumbent, seen from behind. Bl. ch., height. w. wh., on grayish green. 205 x 300. Squared. Irregularly torn. Stained by mold and color spots. Publ. by Willumsen, II, pl. 77, p. 565 as a study by Jacopo Tintoretto after nature, from the 1570's or later.

In our opinion which rests only on the reproduction, the uncertainty of the outlines, the abundance of hatching, and, on the whole, the lack of abstraction are arguments more in favor of Domenico than of Jacopo.

1486 ———. Nude male figure, rowing (?), seen from front. Bl. ch., height. w. wh., on gray. 245 x 186. Reworked with brush and bl. oil color. Damaged by stains and a large hole in upper r. corner. Publ. by Willumsen, II, pl. 78, p. 570 as Jacopo Tintoretto's study for his painting "St. Michael combatting Lucifer" in S. Giuseppe di Castello (ill. Bercken-Mayer, 166). [**MM**]

In our opinion, the drawing whose original we have not seen, has been worked over with the brush for later use in the opposite direction. Of the original linework so little is left that it is difficult to form an opinion. The few less damaged parts, however, point to Domenico. There is no connection with the painting mentioned above.

A DARMSTADT, KUPFERSTICHKABINETT, E 2135. See No. **1776**.

1487 DRESDEN, KUPFERSTICHSAMMLUNG. Man working with a spade. Bl. ch., height. w. wh., on bluish gray. 302 x 169. Squared. Publ. by Hadeln, *Tintorettozeichnungen* pl. 53 as Jacopo Tintoretto.

In our opinion the drawing is by Domenico by reason of its resemblance to No. **1488**.

1488 EDINBURGH, NATIONAL GALLERY, 1655. Nude standing, seen from front, bending forward and to the r. Bl. ch., on gray. 247 x 169. Old inscription: Dom^co Tintoretto. **[MM]**
The authentication of this drawing by the inscription makes it for us the point of departure for the attribution of several other drawings. All of them imitate Jacopo's manner in representing nudes without attaining his sureness and power of conviction. The attribution is, moreover, supported by the stylistic relationship of the drawing No. **1546** *verso,* another well-authenticated piece.

1489 FLORENCE, UFFIZI, 1839. Female nude, recumbent to the r., seen from behind; the hasty sketch of a child is added at the r. Charcoal, on blue, with traces of heightening w. wh. 264 x 418. Publ. by Loeser in *Uffizi Publ.* I, 2, no. 23 as a study for the woman in the lower r. corner of the "Miracle of the Loaves and Fishes" in the Scuola di San Rocco (ill. Bercken-Mayer 126). This attribution is accepted by Hadeln, p. 34. [*Pl. CXXIII,* 3. **MM**]
We find no connection to Jacopo's figure mentioned by Loeser. The style of drawing, the realistic approach and the type of the woman justify the attribution to Domenico.

1490 ————, 12928. Saint Jerome praying. Pen, dark br., wash, height. w. wh., on faded blue. 261 x 198. — *Verso:* Sketches for a "Pietà" and a "Baptism of Christ," also a frieze of cupids and lions. Ascr. to Ja. Tintoretto. **[MM]**
The *recto* corresponds almost exactly to the painting of the same subject, attributed to D. Tintoretto in the Capitol Gallery, Rome. The Baptism on the *verso* starts from the central part in the composition in San Rocco and resembles the painting of this subject by Domenico in the Capitol Gallery in Rome. Both sides were in our opinion executed in Domenico's shop.

1491 ————, 12933. Kneeling youth, turned to the r., raising both hands to his breast in a worshipping gesture. Bl. ch., on blue. 303 x 146. Ascr. to Jacopo Tintoretto. **[MM]**
Similar in pose to the figure in lower l. corner of No. **1526**, 90. Compare the variations of the figure in No. **1492**. Accordingly we give the drawing, the style of which definitely is not Jacopo's, to Domenico.

1492 ————, 12945. Nude youth kneeling, used for a female saint in the painting of the "Immaculate Conception," in Stuttgart, ill. *Zeitschr. f. B. K.,* N. S. XXXIII (1922), p. 97. Bl. ch., on brownish. 340 x 250. Squared. Height. w. wh. in top of the squaring. Publ. by Hadeln, *Tintorettozeichnungen,* pl. 41 as Jacopo Tintoretto. Exh. London, 1931, Popham, *Cat.* 281.
The painting, according to Thode, *Tintoretto,* p. 126, was in part executed by Domenico Tintoretto, an opinion shared by Hadeln p. 49. The drawing too may be by Domenico Tintoretto in his early years. It is a further development of No. **1491**, however in reverse and with some modifications. The sentimental head speaks especially for Domenico.

1493 ————, 12947. Nude man stooping and advancing with extended l. arm. Charcoal, on gray. 373 x 199. Hadeln, *Tintorettozeichnungen,* pl. 44: Jacopo. According to Waldmann, *Tintoretto,* p. 76, caption of no. 13: study for the "Martyrdom of St. Stephen," in San Giorgio Maggiore (ill. Bercken-Mayer 197).

We reject Waldmann's suggestion and consider the drawing rather the first idea for the altar-piece in the upper hall in the Scuola di San Rocco, ill. R. Pallucchini, *Tintoretto a San Rocco,* pl. 63. In the execution of this painting, Tintoretto's shop had a large part. Even in the drawing the very marked interest in details might be an argument against Jacopo and in favor of Domenico. Compare the similar motive in No. **1609** to realize the stylistic difference.

1494 ————, 12958. Draped male figure, seen from front, kneeling or flying. Charcoal. 212 x 158. Squared. Stained by mold. — *Verso:* The same figure traced and seen from behind. Ascr. to Jacopo, but in our opinion too poor for an authentic work. **[MM]**

1495 ————, 12972. Man seated, holding a musical instrument or an oar. The l. hand is several times repeated. Bl. ch., on blue. 298 x 189. Hadeln, *Tintorettozeichnungen,* pl. 36: Jacopo. **[MM]**
Perhaps by Domenico rather than by Jacopo Tintoretto.

1496 ————, 12980. Nude, turned to the r., kneeling and holding a rope. Bl. ch., on gray. 227 x 285. Color spots. Ascr. to Jacopo Tintoretto. **[MM]**
Perhaps by Domenico.

1497 ————, 12992. Nude bearded man, standing, seen from front, raising his folded hands to the r. Bl. ch., on blue. 351 x 140. Squared. Worked over with the brush. Irregularly cut. Stained by mold. Ascr. to Jacopo. **[MM]**
In our opinion more likely by Domenico, see No. **1541**.

1498 ————, 12993. Nude, standing, seen from front, bending to the r. Bl. ch., on gray paper. 249 x 202. Squared. Stained by mold. Ascr. to Jacopo Tintoretto. **[MM]**
In spite of a certain resemblance to the Christ in the "Multiplication of the Loaves" (ill. Bercken-Mayer 126), in our opinion probably by Domenico Tintoretto.

1499 ————, 13001. Female nude, seen from behind, recumbent in landscape. Charcoal, on bluish paper. 255 x 380. Squared. According to Hadeln the heightening w. wh. was added later. Hadeln, *Tintorettozeichnungen,* pl. 29: Jacopo Tintoretto.
In our opinion more likely by Domenico.

1500 ————, 13002. Two clothed men kneeling toward the r. Bl. ch., on faded blue. 201 x 284. Stained by mold. Color spots. Ascr. to Jacopo Tintoretto and erroneously connected with the "Baptism of Christ" in San Rocco, ill. Bercken-Mayer 123.

1501 ————, 13003. Three men kneeling and praying. Bl. ch., on blue. 192 x 296. Stained by mold. Ascr. to Jacopo Tintoretto. **[MM]**
Companion piece to No. **1500** and in our opinion also by Domenico.

1502 ————, 13015. Bearded kneeling man, turned to the l. Brush, gray, height. w. wh., on faded blue. 234 x 148. Ascr. to Jacopo Tintoretto.
More likely a poorer production by Domenico.

1503 ————, 13022. Bearded man, kneeling toward the r. Charcoal, height. w. wh., on faded blue. 256 x 181. Ascr. to Jacopo Tintoretto. **[MM]**
More likely by Dominico Tintoretto.

1504 ————, 13039. Nude standing, bending to the l. and forward, his r. arm hanging. Bl. ch., on blue. 305 x 190. Squared. Stained by color spots. Corresponding in style to No. **1546** *verso.*

1505 ———, Santarelli 7477. Study of a nude (St. Sebastian?) Bl. ch., on faded blue. 335 x 177. Squared. (Photo Cipriani 10067).

Either copy from a drawing by Domenico or an original so intensively reworked that hardly anything of the original linework is left.

1506 ———, Santarelli 7513. Female nude recumbent to the r., seen from behind. Bl. ch., height. w. wh., on faded blue. 183 x 283. Cut at the bottom. Mentioned by Hadeln, *Tintorettozeichnungen,* p. 35 as by Jacopo Tintoretto.

In our opinion typical of Domenico.

1507 ———, Santarelli 7514. Nude woman recumbent, sleeping. Over sketch in ch. outlines drawn in brush. 207 x 400, irregularly cut.

Typical of Domenico's style, but perhaps by one of his pupils, close to the poorer drawings in the London sketchbook No. **1526.**

1508 ———, Ornamenti 1612. Christ Child recumbent. Bl. ch., height. w. wh., on faded blue. 160 x 187. [*Pl. CXXII, 3.* **MM**]

The posture of the child in spite of slight deviations shows a marked resemblance to the one in the "Madonna with the Camerlenghi," Academy, Venice, ill. Bercken-Mayer 84, usually dated about 1567. A. Venturi, 9, IV, in the caption of fig. 671, attr. the painting to Jacopo and Domenico Tintoretto, and on p. 974 to Domenico with an assistant, especially emphasizing the contrast of this composition to Jacopo's representations of analogous subjects. At any rate, the drawing could not be an early Jacopo. In our opinion, it belongs to Domenico.

1509 FLORENCE, HORNE FOUNDATION, 5934. An oxcart with people unloading it, in the foreground woman and child. Bl. ch., wash, height. w. wh., on faded blue. 255 x 370. Torn and patched. Simonetti Gallery. Listed among "Anonymous foreign schools 19th century." [*Pl. CXVIII, 4.* **MM**]

In our opinion, study for a background by Domenico Tintoretto. Similar details occur in the background of the paintings "Pax tibi Marce" ill. Venturi 9, IV, p. 337 and "Apparition of St. Mark," ill. *Rivista di Venezia* 1933, June, p. 307.

A FRANKFORT/M, STAEDELSCHES INSTITUT, 4420. See No. **1819.**

1510 THE HAGUE, COLL. FRITS LUGT. Female nude recumbent. Bl. ch. 200 x 290. Modern inscription of Tintoretto's name. Publ. by L. Dussler, in *Burl. Mag.* vol. 51 (1927), p. 32, pl. III A, as Jacopo Tintoretto, an attribution rejected by Hadeln, ibid. p. 102, who correctly suggests Domenico Tintoretto. [*Pl. CXVI, 3* **MM**]

A HAARLEM, COLL. FRANZ KOENIGS, I 51, see No. **1820.**

1511 ———, I 74. Nude seated on cloud, turned to the l. Bl., on blue. 200 x 339. Squared. Coll. Dadda. Ascr. to Jacopo Tintoretto. [**MM**]

1512 ———, I 87. Assumption of the Virgin. Bl. ch., on brownish. 376 x 250. Cut, the corners added. Coll. Dadda. Ascr. to Domenico Tintoretto. [**MM**]

1513 ———, I 399. Three recumbent women. Bl. and wh. ch., on blue. 280 x 420. Squared. — On *verso:* Kneeling infant, charcoal. Coll. J. Boehler. Purchased 1929. Ascr. to Jacopo Tintoretto. [Both sides **MM**]

1514 ———, I 403. Study of a figure of Christ for a "Nailing to the Cross." Bl. ch., on blue. 207 x 308. Coll. J. Boehler. Exh. in Amsterdam 1934, Cat. no. 677 as Jacopo Tintoretto. Ascr. to him also in the collection. [**MM**]

1515 ———, I 542. Temptation of St. Anthony, in half-length figures. Brush, oil, on brownish green. 162 x 242.

Thirteen other versions in the London sketchbook, see No. **1526,** 42 ff.

1516 ———, I 543. Temptation of St. Anthony, in full-length figures. Brush, oil, on brownish green. 264 x 293.

See No. **1526,** 42 ff.

1517 ———, I 544. Temptation of St. Anthony, in full length figures. Brush, oil, on brownish green. 274 x 356. Squared. [**MM**]

See No. **1526,** 42 ff.

1518 ———, I 545. Allegorical composition with a kneeling doge in the corner. Brush, oil, on brownish green. 237 x 377. [*Pl. CXVIII, 3.* **MM**]

Probably the first idea for Domenico Tintoretto's votive painting for Doge Giovanni Bembo (1615–1618), in the passage to the Sala del Maggior Consiglio in the Ducal Palace.

1519 LONDON, BRITISH MUSEUM, 1904-6-14 — 1. Adoration of the magi. Brush, oil, br. bl. and wh., on grayish green. 224 x 329. Publ. as Jacopo Tintoretto by S. Colvin in *Burl. Mag.* XVI, p. 189; in style and technique closely related to Domenico's sketchbook (No. **1526**). [**MM**]

1520 ———, 1906-7-19 — 1. Assumption of the Virgin, beneath the apostles. Brush, oil, monochrome in br. and gray. 259 x 483. Squared.

Corresponding in style and technique to the sketchbook in London, No. **1526.** Publ. by S. Colvin, in *Burl. Mag.* vol. XVI, p. 189 as Jacopo Tintoretto and revindicated to Domenico by Tozzi in *Boll. d'A.* 1937, July, p. 26, fig. 7. According to Tozzi the sketch may be connected with Domenico's lost altar-piece representing the same subject and mentioned by Ridolfi II, 259, in San Eustachio in Venice.

1521 ———, 1913-3-31 — 190. Figure flying downward. Charcoal, on blue. 221 x 156. Squared. Lower r. corner patched. Late inscription: G. Tintoretto. [*Pl. CXXIII, 1.* **MM**]

In our opinion similar in style to No. **1522** and probably design for the companion genius.

1522 ———, 1913-3-31 — 191. Nude figure, flying, design for the draped female genius holding the cloak of Venetia in the ceiling of the Sala del Maggior Consiglio in the Ducal Palace, ill. Thode, p. 111, fig. 95. Charcoal, on blue. 211 x 235. Squared. Both upper corners added, below a strip patched. — *Verso:* the same figure traced and somewhat modified. Squared. Publ. as Jacopo Tintoretto by Hadeln in *Burl. Mag.* 44 (1924) p. 278 ff. (pl. F). [**MM**]

It is universally admitted that Jacopo had nothing to do with the execution of the ceiling which was entirely left to his assistants. By stylistic reasons the two drawings Nos. **1521** and **1522** connected with this composition belong to Domenico.

1523 ———, 1913-3-31 — 193. Two kneeling men, the l. one worked over, the r. one more sketchy. Bl. ch., on paper turned yellow.

157 x 265. Squared. Late inscription: G. Tintoretto. Mentioned as his by Hadeln, *Tintorettozeichnungen*, p. 33, note 1. [MM]

In our opinion, the style is closer to Domenico.

1524 ———, 1913-3-31 — 194. Two kneeling nudes bending forward. Bl. ch., on blue. 135 x 290. The r. figure is squared. Oil color spots. Mentioned by Hadeln, *Tintorettozeichnungen,* p. 33. note 1 as Jacopo Tintoretto. [MM]

Close in style to No. **1488.**

1525 ———, 1913-3-31—198. Standing nude, his hands crossed over his chest. Charcoal. 263 x 141. Publ. by Hadeln, *Tintorettozeich-nungen,* pl. 54 as Jacopo Tintoretto. According to E. Tietze-Conrat, in *Graph. Künste* N. S. I, p. 90 used in a clothed figure in the paint-ing of St. Agnes in the Madonna dell'Orto (ill. Bercken-Mayer 19).

We reject this reference, resting only on a superficial resemblance of the posture and attr. the drawing to Domenico with reference to No. **1488.**

1526 ———, 1907-7-17 — 1 to 90. So-called sketchbook, more correctly an album or scrapbook dismembered after its acquisition in 1907. Most of the drawings are oilsketches, monochrome with brown, gray, white predominating, but in some cases adding other colors too. Most of them are varnished, quite a few squared. A minority are in bl. ch. For the measurements see the separate drawings. When pur-chased, the drawings were in a rather precarious condition. Over most of them a coat of mastic varnish had been pasted at an early date, and also over many of them an egg glaze. These decayed var-nishes have been removed.

The drawings originally were contained in an album of the 17th century. According to a long inscription in the volume, reproduced in full by S. Colvin and Osmaston (see below) they were brought together or owned in 1682, or a little later, by Don Gasparo d'Haro y Guzman, Spanish ambassador at the Papal Court. Later on the album is said to have been in private hands at Valparaiso for several generations. First publ. by S. Colvin in *Burl. Mag.* XVI, 190 ff. and 234 ff. Colvin attr. the bulk, about 80 drawings, to Jacopo Tintoretto and a few, five or six, to his assistants, possibly Domenico or Marietta. The attr. to Jacopo was wholeheartedly accepted by E. M. Phillipps, 1911, by Osmaston, who devoted a separate appendix of his book (II, p. 155 ff.) to a detailed description and analysis of the drawings, and by Bercken-Mayer, who dated the drawings in Jacopo Tintoretto's early period. The first to doubt Jacopo's authorship was Hadeln, who advanced his doubts cautiously in *Tintorettozeichnungen* p. 16, but in *Spätren,* p. 25 ff. attr. the whole lot to Domenico Tintoretto to-gether with a number of separate similar sketches. J. F. Willumsen considered the bulk of the drawings to have been done for practice by Domenico, while a few of them might be by Jacopo himself. So did K. T. Parker in *O. M. D.* 1927, p. 6. The attribution to Domenico was definitely established by Rosanna Tozzi in *Boll. d'Arte* 1937, July. Her arguments, to which we add several new ones, in our opin-ion, are conclusive. They have been accepted also by Popham, *Hand-book,* p. 45.

The homogeneity of the material is on the whole universally ad-mitted, except those few evidently poorer copies which Colvin already had pointed out. Another striking feature is the fact that some sub-jects appear in many variations. For instance, the "Temptation of a saint by women" twenty times, and the "Temptation of a saint by animals" thirteen times or the "Delivery of the keys to St. Peter" nine times. Some of these variations are in whole or in part in reverse.

Many of these various versions are squared, a procedure usually supposed to mark the version immediately preceding the final execu-tion in painting. We are unable to give a satisfactory explanation of this phenomenon. Quite a number of compositions can be connected with still existing paintings of Domenico; in other cases the paintings are lost and known only through Ridolfi. The painting of the "De-livery of the keys" in Modena shows so close a connection with one of the drawings (90), that the latter might be called the final design, while the other versions might be variations in which the artist tried to fix his idea. For other subjects this groping procedure appears still more striking. It absolutely contradicts all we know about Jacopo Tintoretto's way of working. Many of the subjects themselves are distinctly different from Jacopo's. Those that were also treated by him, as for instance, the "Temptation of St. Anthony" (in San Tro-vaso in Venice, ill. Bercken-Mayer 100) are dealt with in the sketch-book in a pedantic way conforming to the literary currents of the later generation. This literary trend is typical of Domenico, as Ridolfi (II, 262) states in Domenico's biography. Another historical argu-ment in favor of Domenico is the following: the existing paintings to which the sketches belong, are ascertained for Domenico and none of them for Jacopo (see 2, 3, 4, 6, 13, 21 ff., 28 ff., 36 ff., 39, 79 ff.)

The objection that Domenico might have used sketches of his father for his own compositions is refuted by the fact that some of them have not been ordered and painted until many years after Jacopo's death. Their subjects, moreover, are too unusual to permit the theory that Domenico might have drawn his inspirations from an existing stock of sketches. Such imitativeness is especially unlikely in an artist who, as we hear from Ridolfi, was especially proud of the abundance of his inventions.

The stylistic arguments in disfavor of Jacopo and in favor of Dome-nico have already been put forward by Hadeln. His argumentation can now very effectively be supported by the sketch in Naples (see No. **1724**), indubitably by Jacopo about 1579, and essentially different from the material in question. It bears witness to Jacopo's conception, classic even in his late period, while the sketches in London and their relatives exaggerate Jacopo's characteristics to a mannerism typical of a follower. The concentration of Jacopo's qualities (Tintorettesque essence so to speak in Tintoretto) in these sketches explains their tre-mendous success with art critics. They are sometimes praised as the purest expression of his genius (see Max Dvořák, *Italienische Kunst* II, p. 160 where they are placed in Jacopo's latest period), and Osmas-ton based his chapter on Jacopo's drawings almost entirely on the sketchbook in London, adding a few no less spurious productions from other collections. This high estimation is well deserved and should not be disavowed when they are restored to their author Do-menico. He continued his father and drew the conclusions from his art. But at the same time he added the subjective release of the form and the dissolution of the traditional interpretation of his own and of his period, thereby producing an immediateness and intimacy that, in another sense than Jacopo's immortal production, strike us as modern. Renouncing an enrichment of Jacopo's personality by these borrowed charms, we gain in his son an important and independent artist whose figure has until now been unjustly overshadowed by Jacopo. See E. Tietze-Conrat in *Art Bulletin,* 1944 (in print).

1. St. John the Baptist, standing, carrying a banner, and accom-panied by the lamb. 387 x 270. Squared. Cut. [MM]

2. Resurrection or Healing. 283 x 338. Squared and bordered by a line. [*Pl. CXVIII,* 2. **MM**]

The composition seems to be connected with that of p. 3, only the figure of the saint is missing. There is a strong resemblance to the painting "St. John the Evangelist and the philosopher Crates," in the Scuola di San Giovanni Evangelista in Venice. It may be presumed that Vicentino based his painting on a sketch by Domenico (see p. 259).

3. Christ (?) resuscitating or healing a person lying on a stretcher. Rich composition in magnificent architecture. 271 x 223. Squared. Ill. by Tozzi in *Boll. d'Arte,* 1937, July, fig. 8 and connected with Domenico Tintoretto's painting "St. John the Evangelist resuscitating the dead by his prayers" in the Scuola di San Giovanni Evangelista in Venice, where, it is true, the composition is completely remodeled.
Another version No. **1548.** **[MM]**

4. (not in book, separately mounted). Man on horseback galloping; the rider is only sketched, the horse carefully modeled. 517 x 395. Squared. Folded in the middle, upper r. corner patched. **[MM]**
A horse of a similar type appears in "St. George slaying the dragon" in San Giorgio Maggiore in Venice, painted by Sebastiano Casser, Domenico's pupil and brother-in-law.

5. St. Sebastian tied to a tree, surrounded by women and angels. 287 x 175.

6. A pope, surrounded by many attendants, presents a habit to a kneeling monk; rich architecture. 245 x 274. Ill. in *Burl. Mag.* XVI, pl. 2. **[MM]**
Probably connected with Domenico Tintoretto's painting in Rimini, St. Dominic kneeling before the Pope.

7. St. Mary Magdalene(?) recumbent on a mat, a vase beside her. 295 x 243.

8. Allegory, at l. a figure seated bending over books and a globe, at r. Neptune with marine deities. 185 x 235. Squared. **[MM]**

9. Diana and Callisto. 242 x 396. Squared in bl. ch. Ill. Osmaston pl. CLXXXIV.

10. Other version of the composition in 9. 278 x 396. Squared.
 [MM]

11. Youth with waistcloth, kneeling, turned to the r., lifting his arms to his chest (from a "Baptism"?). 299 x 192.

12. Unidentified composition formed of five figures surrounding a seated man. A man and a woman in lower l. corner, apparently donors. 194 x 251.

13. Temptation of a saint. 222 x 280. Ill. in *Burl. Mag.* XVI, pl. 3. Discussed by Tozzi, in *Boll. d'A.* 1937, July, fig. 13 and connected with the other versions of this subject in this book (42 ff.) and with a painting by Domenico Tintoretto in the Harrach Coll. in Vienna, possibly the "Temptation of St. Anthony" mentioned by Ridolfi (II, p. 259 note) in San Jacopo di Rialto.

14. Various sketches: at l. a woman seated with a child in her lap; a r. four nude children in various postures. Over bl. ch. brush, on yellow. 195 x 293. **[MM]**

15. Nude lying on back and protecting his eyes with his right hand. Bl. ch., on faded blue. 270 x 233. *[Pl. CXXI,* 2. **MM]**

16. Seated youth, seen from front, the l. knee pulled up, the l. hand extended. Charcoal, on blue. 294 x 168. — *Verso:* St. Anthony carrying the Christ Child. **[MM]**

17. Bacchus seated on a barrel, attended by nudes with musical instruments and a warrior in modern armor offering a sword. 183 x 244. Compare the following drawing.

18. Same composition as in 17, slightly modified and differently cut, more hastily executed. 203 x 255. Considered a copy from 17.

19. Nude woman recumbent; bearded man, only sketched (according to Colvin Aurora and Tithonius). 257 x 366. Compare the following number. Ill. in *Burl. Mag.* XVI, pl. II and E. M. Phillipps, *Tintoretto* pl. LV.

20. The same composition as 19, more elaborately executed. 260 x 368. Ill. in Osmaston, pl. CLXXXIII. *[Pl. CXV,* 2. **MM]**

21. Miraculous rescue of the shipwrecked Saracen (legend of St. Mark). 383 x 159. Ill. in *Burl. Mag.* XVI, pl. I. Discussed, together with the following drawing, by Tozzi in *Boll. d'A.,* 1937, July, fig. 2. The composition does not conform with J. Tintoretto's well known painting in the Academy in Venice, but starts from the latter. Tozzi connects the composition with the series from the legend of St. Mark executed by Domenico for the Scuola di San Marco from 1585 on.
 [MM]
We state that the subjects represented in this drawing and in 23 do not form part of the mentioned series, that the style of the sketches is very close to Domenico's later works and that he painted "two miracles of St. Mark" in the nuns' church of SS. Marco and Andrea in Venice (Boschini-Zanetti, p. 452).

22. Variation of the composition in the preceding number. 421 x 160. Ill. in *Burl. Mag.* XVI, pl. 1. **[MM]**

23. Saint Mark rescuing a slave from torture. 392 x 200. Ill. in Phillipps, *Tintoretto,* pl. LVI. Discussed by Tozzi, in *Boll. d'A.* 1937, July, fig. 1 together with 24: No connection with Jacopo's painting in the Academy in Venice, the type of St. Mark, on the contrary, being dependent on Jacopo's late paintings.
See the following numbers.

24. Variation of the composition in 23. 394 x 200. Squared.

25. Variation of the composition in 23 and 24. 405 x 210.

26. Variation of the composition in the preceding numbers, some of the figures used in reverse. 395 x 194. Squared. **[MM]**

27. Variation of the composition in the preceding numbers. 395 x 200. Squared.

28. A nude woman bending over a cradle, under which a dead boy is lying on the ground; clothed figures around carrying various attributes. 225 x 277. Mentioned by Tozzi, *Boll. d'A.* 1937, July.
 [MM]
Tozzi overlooked the fact that this composition, varied in 29, 33, and the drawing in Trieste (No. **1551**) is connected with a painting by Domenico Tintoretto, mentioned by Ridolfi II, p. 262: "Formò da Lucretio e dal Marino la vita humana accompagnata dalle molte miserie, seduta sopra una crulla e con un piede sul orlo del Sepolcro ..." Marino's *"Rime"* was first publ. in Venice in 1602.

29. Variation of the preceding drawing. 256 x 344. Squared.

30. Modified version of the preceding composition. 253 x 345. — *Verso:* Head of Giuliano de' Medici after Michelangelo's sculpture. Bl. ch., height. w. wh., on grayish green. Publ. as Jacopo Tintoretto by K. T. Parker, *O. M. D.* 1927, pl. 5.

The high quality of this drawing and of its companion piece No. **1478**, traditionally ascr. to Jacopo, speaks in favor of the latter. But the close connection to Domenico's book and the absence of this specific technique in Jacopo's well established production make us prefer the attribution to Domenico. The sentimental intensity is typical of Domenico. Such a rendering of a sculptural model would correspond to the exuberance of his oilsketches.

31. Variation of the preceding composition, partly in reverse. 225 x 275. [**MM**]

32. Variation of the preceding composition. 227 x 274.

33. Variation of the preceding composition. 335 x 236. Squared. Ill. in *Burl. Mag.* XVI, p. 256, pl. I. [**MM**]

34. Unidentified mythological or allegorical subject. 216 x 261. Squared.
See 35 and 38.

35. Variation of 34. 255 x 308.

36. Mythological subject: Jupiter, Neptune, Pluto, in the middle a youth (Prometheus?) in violent movement. 241 x 179. Squared. Sketchy execution. According to E. M. Phillipps Hercules seeking Cerberus.

In our opinion, probably a sketch for a composition of the four elements. See the following drawing.

37. Variation of the preceding composition, more carefully executed. 277 x 193. Ill. Phillipps, *Tintoretto,* pl. LX and Osmaston II, 163. [*Pl. CXXI,* 1. **MM**]
Possibly connected with Domenico's painting mentioned by Ridolfi II, 262: l'aura, l'alba, l'aqua e la terra se gli inchinano.

38. Variation of the composition in 34. 263 x 315.

39. Sketch for altar-piece: above Christ floating, beneath St. Mark and St. John Evangelist enthroned. Various standing and seated saints. 418 x 235. Semicircular top. Publ. by Tozzi, in *Boll. d'A.* 1937, July, fig. 4 as Domenico's sketch for his high altar-piece in the Scuola di San Marco of 1612. [*Pl. CXX,* 2. **MM**]
Tozzi seems to have compared the sketch and its variation in 40 with the painting still existing in the Scuola di San Marco which, however, is not by Domenico Tintoretto, but by Palma Giovine, see No. **992**. Palma's painting may have replaced the one by Domenico Tintoretto, which appeared recently in the art market.

40. Variation of the preceding number. Only underpaint. 423 x 245. Squared. Considered a copy, perhaps a shop production used as a technical help for the execution of the painting.

41. Sketch for altar-piece, the Holy Trinity in glory, beneath the Virgin, St. John Evangelist and several other male and female saints. At l. kneeling donor in the costume of a Venetian dignitary. 357 x 198. Semicircular top. Partly squared.

42. Temptation of a saint. 250 x 303. — *Verso:* head of Vitellius. Charcoal, height. w. wh., on green.
The stylistic character of this copy from the antique is distinctly different from studies of this description usually attr. to Jacopo.
For the *recto* see 13 and 43 ff.

43. Variation of the Temptation of a saint. 260 x 319. — *Verso:* head of Vitellius, resembling in style the one on the back of 42.

44. Variation of the Temptation of a saint. 183 x 240. See 13, 42, 43, 45 to 74.

45. Variation of Temptation of a saint. 266 x 331. See 44.

46. Variation of the Temptation of a saint. 245 x 285. See 44.

47. Variation of Temptation of a saint. 244 x 291.
The woman at l. corresponds to No. **1539** and reappears in reverse in No. **1476**.

48. Variation of a Temptation of a saint. 260 x 343. See 44.

49. Variation of Temptation of a saint, who here is clearly characterized as St. Anthony by his robe. 241 x 297. Squared. See 44.

50. Variation of 44. 245 x 298. Very similar to 49.

51. Variation of 44. 248 x 308.

52. Variation of 44. 252 x 294.

53. Variation of 44. 255 x 312. — *Verso:* head of Vitellius. Charcoal, on green. Very poor like most of the other studies from the antique in this set.

54. Variation of 44. 202 x 493. Especially poor and turning the composition of 44 in the opposite direction.

55. Variation of 44. 252 x 248. — *Verso:* Male nude. Charcoal, on greenish yellow.

56. Variation of 44. 247 x 303.

57. Variation of 44, placed in an elaborate building. 238 x 293.

58. Variation of 44. 255 x 316.

59. Variation of 44. 243 x 297.

60. Variation of 44. 249 x 397.

61. Variation of 44. 243 x 397.

62. Variation of 44. 264 x 424.

63. Variation of 44. 261 x 323. Squared. [*Pl. CXVIII,* 1. **MM**]

64. Variation of 44. 253 x 330. Squared.

65. Variation of 44. 250 x 299. Very close to 64.

66. Variation of 44. 265 x 317.

67. Variation of 44. 237 x 301.

68. Variation of 44. 258 x 320. Very close to 66.

69. Variation of 44. 262 x 322. Damaged. — On back: Study after the same male figure as seen on 55.

70. Variation of 44. 259 x 307.

71. Variation of 44. 261 x 319.

72. Variation of 44. 259 x 322.

73. Variation of 44. 260 x 319.

74. Variation of 44. 255 x 305.

75. Nude woman recumbent, less finished sketch of 76, 77. 212 x 272.

76. The same subject as 75, somewhat more finished. 224 x 283.

77. The same subject as 75, 76, the woman recumbent beneath a curtain, at r. view of a garden with a house. 232 x 272. The same motive in 75.

78. Outlines and underpaint of the same subject as 76. 195 x 278.

79. Youth rushing over dead bodies, in the background a burning house. At l. a seated woman. 182 x 224. Ill. in *Boll. d'Arte* 1937, July, fig. 9 and connected by Tozzi with the episode in Tasso's *Gerusalemme Liberata* of Clorinda and Tancred sowing death among the enemies. Tozzi refers to the painting "The Baptism of Clorinda" in the Frank Logan Coll. in Chicago which she attr. to Domenico. Willumsen (II, p. 573) considered the drawing especially typical of Domenico and referred to his "Conquest of Constantinople" in the Ducal Palace.

80. Variation of 79, in reverse in its arrangement. 190 x 240. Squared. Ill. Osmaston, pl. CLXXXV under the name "Allegory of War." **[MM]**

81. Variation of 79, 80. 187 x 232. Ill. *Boll. d'A.* 1937, July. **[MM]**

82. Delivery of the keys to St. Peter by Christ. 253 x 223. Squared. Apparently for the painting (dated 1601) ordered in 1599 of Domenico by the Benedictine nuns in Reggio for their church San Pietro, and later in the Gallery in Modena (Venturi, *Galleria Estense*, p. 154).

83. Variation of 82. 378 x 228. Ill. E. M. Phillipps, *Tintoretto*, pl. LV and Osmaston, frontplate.

84. Variation of 82. 403 x 222. Semicircular top.

85. Variation of 82. 397 x 245.

86. Variation of 82, in reverse. 367 x 219. Ill. in *Burl. Mag.* XVI, colorplate opp. p. 309.

87. Variation of 82, limited to the lower part. 305 x 250.

88. Variation of 82. Pen, br., wash, on blue. 393 x 202. Semicircular top.

89. Variation of 82. 392 x 205. Ill. Osmaston, pl. CLXXX and Tozzi, *Boll. d'A.* 1937, July, fig. 6.

90. Variation of 82, simplified version of 86. 370 x 216.
[*Pl. CXX,* 1. **MM**]

In view of the two women kneeling in the lower corners closer to the final composition as appearing in the painting.

1527 LONDON, VICTORIA AND ALBERT MUSEUM, Dyce 240. Standing nude, seen from front, bending to the l. and holding his r. arm over his chest. Charcoal, height. w. wh. 397 x 245. Squared. Corrections at the arms and the head. Ascr. to Jacopo Tintoretto. [*Pl. CXXI,* 4. **MM**]
The upper part of the body might have been used with modifications in the painting of the "Purgatory" in Parma (Photo Anderson 10654), sometimes ascr. to Jacopo Tintoretto, but certainly only a shop production. We base our attr. to Domenico on the stylistic resemblance to No. **1488.**

1528 LONDON, EARL OF HAREWOOD. The mocking of Christ. Brush, oil, br. and wh., on blue. 232 x 406. Squared in bl. and br. Publ. by Hadeln, *Spätren.,* pl. 101, and p. 25 as Domenico Tintoretto.
The figure in the lower r. corner repeats a figure studied in No. **1481.**

1529 LONDON, COLL. A. G. B. RUSSELL, formerly. Study of a man sleeping. Charcoal, height. w. wh., on blue? [*Pl. CXVI,* 1. **MM**]
We have not seen the drawing whose present location we do not know. Study for the main figure in the painting "Pax tibi Marce" (ill. *Mostra del Tintoretto,* no. 71). Quite different in style from No. **1675,** likewise used in the same painting. The drawing may be a late production by Jacopo, but, as far as the photograph allows a judgment, we are rather inclined to attr. it to Domenico Tintoretto, since the drawing shows no resemblance to any authentic drawing by Jacopo and, with its interest in the rendering of realistic accessories and the type of the face, recalls the style of Domenico.

1530 MILAN, AMBROSIANA, 1224. Martyrdom of a saint, tied to a column. Brush, oil, in br. and yellow, on blue. 300 x 328. Very much damaged up to the point of being hardly recognizable. Ascr. to Jacopo.

1531 ———, Vol. F 232. A saint preaching or baptizing. Brush, oil, gray and br., height. w. wh. 304 x 244, cut. Squared. Lower r. corner torn. Listed among the anonymous. **[MM]**
Typical of Domenico Tintoretto, to whose composition in the Scuola di San Giovanni Evangelista in Venice "St. John Evangelist resuscitating a dead person" the sketch shows a great resemblance.

1532 MILAN, COLL. RASINI. Study of a nude carrying a dish. Charcoal, on blue. 300 x 210. Many corrections. Coll. Dubbini. Publ. in Morassi p. 33, pl. 27 as Jacopo Tintoretto. **[MM]**

1533 NAPLES, GABINETTO DELLE STAMPE, 0193. Nude seen from behind, leg not finished. Bl. ch., on wh. turned yellow. 365 x 196. Squared. Stained. — *Verso:* Hasty tracing of the same figure.
[*Pl. CXXIII,* 2. **MM**]
Design for the figure in lower r. corner in the ceiling "Venice as a queen of the sea" in the Sala del Senato in the Ducal Palace. The corresponding figure in the painting also shows only one leg. Dated by the painting about 1581 to 84. Ruskin, *Stones of Venice,* p. 206 and Thode, *Tintoretto* p. 118 and *Repertorium* XXIV, p. 30 questioned Jacopo's authorship in this ceiling; Thode gave the execution to Domenico and was uncertain even about the invention. Pittaluga p. 229 attributes the invention to Jacopo.
The style of our drawing confirms these doubts. It is by Domenico, who accordingly was charged at least with preparing the studies for the details.

1534 NEW YORK, METROPOLITAN MUSEUM OF ART, 41.187.2. Male nude reclining on cushions. Bl. ch., height. w. wh., on gray. 184 x 275. Coll. Luigi Grassi, Robert Lehman. (Photo Metropolitan Museum 125981). Ascr. to Jacopo Tintoretto.

Belongs to the group discussed under No. **1535**.

1535 NEW YORK, COLL. ROBERT LEHMAN. Series of ten drawings, each representing a female nude, seated or recumbent, in varied postures, partly sharply foreshortened. Bl. ch., height. w. wh., on blue. 210 x 305. Two are squared. Coll. Luigi Grassi. One exh. Buffalo 1935, no. 28. Ascr. to Jacopo Tintoretto.

The ten drawings are certainly by the same hand. They are not studies made for a definite use in a composition, but quick sketches after nature done for practice. For stylistic reasons certainly not by Jacopo, but by Domenico. Also Nos. **1534** and **1553** belong to the same group.

1536 OXFORD, CHRISTCHURCH LIBRARY, L 12. Martyrdom of St. Stephen, design for the altar-piece in San Giorgio Maggiore. Brush, oil, height. w. wh. 344 x 188. Squared. Previously ascr. to Jacopo Tintoretto, publ. by Hadeln, *Tintorettozeichnungen,* pl. 72 as Domenico: The altar-piece, usually ascr. to Jacopo, probably was ordered only in 1594, a few months before Jacopo's death, so that Domenico inherited the commission. The style of the drawing allows the same conclusion. The attr. to Domenico was accepted by Tozzi, in *Boll. d'A.* 1937, July, p. 24, fig. 5.

The *verso* of No. **1481** may be connected with this composition.

1537 PARIS, LOUVRE, 5365. The delivery of the keys to St. Peter. Brush, oil. 393 x 296. Semicircular top. Publ. by A. L. Mayer in *Burl. Mag.* XLIII, p. 34 f. as an early work of Jacopo Tintoretto.

[Pl. CXX, 3. **MM**]

It is an immediate companion piece to No. **1526**, 82 ff. and a sketch for Domenico's painting in Modena, Galleria Estense, No. 200, formerly in Reggio Emilia and dated 1601.

1538 ————, 5378. Study for Prometheus tortured by the eagle. Bl. ch., height. w. wh., on greenish blue. 306 x 411. Upper r. corner patched. Late inscription: Mano del Tintoretto. Publ. by A. L. Mayer, in *Burl. Mag.* XLIII, p. 34 as Jacopo. **[MM]**

The insistence on realistic details, the ornamental rendering of muscles and the type of the head point to Domenico.

1539 ————, 5383. Female nude seated. Bl. ch., height. w. wh., on greenish blue. 395 x 265. Squared. Stained by mold. Publ. by A. L. Mayer in *Burl. Mag.* XLIII, p. 33, pl. A, as Jacopo's sketch for his "Susanna" in the Louvre (ill. Bercken-Mayer 33). *[Pl. CXXI, 3.* **MM**]

The resemblance of the drawing to this painting is limited to the posture of the legs. Otherwise, the body is entirely different. Since the drawing is squared, and therefore in a stage immediately preceding the execution, its connection with the painting is most unlikely. The drawing is indeed much closer to corresponding figures in Domenico's sketchbook in London, see No. **1526**, 42, 45, 46, 47, 49, 63 which, it is true, in A. L. Mayer's opinion is also by Jacopo.

1540 ————, 5385. Nude male seated, seen from front. Charcoal, height. w. wh., on blue. 373 x 243. Squared. Stained by mold. Late inscription of the name. Mentioned by A. L. Mayer, *Burl. Mag.* XLIII, p. 34, as by Jacopo Tintoretto. **[MM]**

In spite of an unquestioned closeness to Jacopo we attr. the drawing to Domenico with reference to No. **1492**; both may belong to Domenico's early period.

1541 PARIS, COLL. MARIGNANE. Nude standing, turned to the r., resting his head on his l. hand, and holding the r. one to his chest. Bl. ch. 285 x 133. Late inscription: Dom^(co) Tintoretto. — *Verso:* J:T. no. 13. (Borghese Coll., Venice). **[MM]**

The attribution to Domenico is supported by the stylistic resemblance to No. **1546**.

1542 PITTSBURGH, PA., CARNEGIE INSTITUTE. Study of a downward flying figure. Bl. ch. 160 x 155. Late inscription: J. Tintoretto. 28. Coll. Sir Joshua Reynolds, Herbert Du Puy. Exh. Pittsburgh 1914 (*Drawings by Old Masters*) as connected with the "Last Judgment" in the Madonna dell'Orto, and Toledo, Ohio, 1940, cat no. 94. **[MM]**

The supposed connection is, in our opinion, erroneous, the drawing belongs to a later period and to Domenico rather than to Jacopo. Compare No. **1521** with which the relationship is very close.

1543 ROME, GABINETTO DELLE STAMPE, 125043. Nude woman, recumbent. Charcoal, on blue. 220 x 362. Publ. by Hadeln, *Tintorettozeichnungen,* pl. 71, as by a pupil of J. Tintoretto, the same who did No. **1544**.

In our opinion typical of Domenico.

1544 ————, 125524. Nude woman, recumbent, her head at the l. Bl. ch., height. w. wh., on blue. 227 x 386. Many corrections. Mentioned by Hadeln, *Tintorettozeichnungen,* p. 54 as drawn by a pupil of Jacopo Tintoretto, same hand as No. **1543**. **[MM]**

1545 ————, 125525. Study of a nude man, recumbent. Bl. ch., on blue. Height. w. wh. (according to Hadeln by a later hand). 313 x 240. Late inscription: Mano del Tintoretto. Publ. by Hadeln, *Tintorettozeichnungen,* pl. 16 and p. 41 as Jacopo Tintoretto. Hadeln emphasizes the exceptional stress laid by this drawing on a rude plasticity, typical of Jacopo's early style. *[Pl. CXVI, 2.* **MM**]

In our opinion closer to Nos. **1510**, **1526**, and consequently by Domenico.

1546 ROME, COLL. SOHN-RETHEL, formerly. Study for Domenico Tintoretto's mural "The second conquest of Constantinople," in the Sala del Maggior Consiglio, Ducal Palace (ill. in Luigi Serra, *Palazzo Ducale di Venezia,* p. 103 at l., with erroneous caption). Brush, oil color. — *Verso:* Studies of two figures, one of which evidently for the warrior at the l. in the foreground of the composition on the *recto.* Bl. ch. Mentioned by Hadeln, *Spätren.* p. 26.

[Pl. CXXII, 1 and 2. **MM**]

The mural was painted after Jacopo's death of whom it had been commissioned, since Jacopo's name is given as the author in Bardi, c 42 v.

1546 bis ————. Another study for the r. half of the same composition as No. **1546**. **[MM]**

1547 ————. Study for a historical composition. Brush, oil, color, irregularly cut. *[Pl. CXIX, 1.* **MM**]

Sketch (in reverse) of Domenico Tintoretto's mural "Surrender of Zara" in the Sala del Maggior Consiglio in the Ducal Palace (ill. Venturi 9, IV, fig. 458 where the mural is attr. to Andrea Vicentino; see, however, Ridolfi II, p. 258). Dated by the painting between Jacopo's death and Stringa's second edition of Sansovino's *Venezia* (1604) where the painting is mentioned as already existing.

1548 TRIESTE, MUSEO CIVICO, COLL. SARTORIO, 1072. Raising of

a dead woman (the daughter of Jairus?) Brush, oil color, white, yellow, gray. 270 x 310. Squared in bl. In lower l. corner modern inscription: Jacopo Tintoretto. [MM]

Another version of the same composition in Domenico's sketchbook in London, see No. **1526**, 3.

1549 ————, 1073. Unidentified biblical or legendary subject. Brush, oil color, white, yellow, gray. 270 x 300. Traces of squaring.
[*Pl. CXIX*, 2. **MM**]

Typical of Domenico.

1550 ————, 1924. Flagellation of Christ. Brush, oil color. White, yellow, gray, on blue. 305 x 360. Modern inscription: Giacomo Tintoretto Venez." [MM]

Hasty sketch, somewhat different from Domenico's typical style, but still closer to him than to Jacopo.

1551 ————, 1925. Allegory of human life. Brush, oil color, wh., yellow, gray, on faded blue. 283 x 395. Later inscription: Tintoretto f.
[MM]

Other versions of this composition typical of Domenico Tintoretto No. **1526**, 28 ff.

A 1552 ————, Venice, R. Galleria. Origin of the Milky Way. Over bl. ch., pen, br., wash. 355 x 246. Late inscription in lower r. corner: Do. Tintoretto. Publ. by Loeser, in *Rassegna d'A.* III, 177 as design by Domenico Tintoretto, for the painting in the N. G. which

Loeser attr. also to Domenico. In the painting the woman lying in the lower l. corner is missing. [MM]

In our opinion, the drawing is not a design for, but a copy made from the original composition, before it had been cut. The penmanship points to the 17th century and specifically to the style of Odoardo Fialetti, a posthumous follower of Tintoretto.

1553 Vienna, Albertina, 102. Female nude, foreshortened. Bl. ch., height. w. wh., on blue. 244 x 209. Squared. Coll. Luigi Grassi, acquired 1923. *Albertina Cat. II* (Stix-Fröhlich): School of Tintoretto, 2nd half of 16th century.

Companion piece to Nos. **1534, 1535**. The foreshortening of the legs reminds us of the dead Christ, in the painting in the museum in Basel, ill. Cor. Ricci, *Pinacoteca di Brera*, p. 77.

1554 Washington Crossing, Pa., Coll. Frank J. Mather Junior. Allegory, Venice imploring the Lord to stop the plague, sketch for Domenico's painting of this subject in San Francesco della Vigna, of 1631. Brush, oil color, br., gray, reddish and wh., on gray. 395 x 198. Exh. New York, Roerich Museum, 1930, 51 a. Publ. by Tozzi in *Bolletino d'A.* 1937, July, p. 21, fig. 3. [*Pl. CXX*, 4. **MM**]

Important as a specimen of Domenico's late style. (The next earlier plague at Venice was 1576, a date which is out of the question for the drawing.)

1555 ————, Adoration of the shepherds. Brush, br., gray and wh., on yellowish. 376 x 191. Semicircular top. Exh. New York, Roerich Museum, 1930, no. 51. [MM]

JACOPO ROBUSTI, CALLED IL TINTORETTO
[*Born 1518, died 1594*]

We know of a great many drawings by Tintoretto, the vast majority of which are studies of single figures. Palma Giovine's drawings are still more numerous, a fact easily explained by his producing drawings as a kind of play (see p. 198); he drew as other people relax. Not so Tintoretto. For the sake of drawing, which means without regard to a picture to be prepared by the drawing, he drew only after casts from the antique or from other statues. As a rule, he only made studies from the model, in order to use them in paintings. This fits very well into his working process as it is described by Ridolfi (II, p. 15, 18). Tintoretto used to build up a kind of stage on which he placed draped modeled figures while others hung by threads from the ceiling—in order to make the foreshortening clear—and the light was let in through windows in order to clarify the distribution of light and shadow. We do not know when Tintoretto started to work this way. The method is by no means his invention. Julius von Schlosser in his extensive and instructive article (in *Jahrb. d. K. H. Samml.* XXXI, p. 111) grouped a great number of literary references to other artists of the 16th century using it too, and there are many ways in which Tintoretto may have become acquainted with it. There is hardly any reason to doubt that Tintoretto prepared these modeled compositions by drawings or by painted sketches. Two drawings exist that might give an idea of this kind of general sketches, No. **1561** and No. **1635**. In both cases, however, we have also to consider the possibility of their origin from such a stage-like construction and not preceding it. No. **1561**, so ambitious in its perspective and in the arrangement of light and shadow, seems to be based on a completely constructed "stage" and also in No. **1635** the very abstract representation, combined with the rendering of the floor, is an argument in favor of a supposedly well advanced phase within the working process. (Note in the drawing the missing rear of the horse just where in the painting the mantle of the Saint covers it.)

An attempt to introduce real sketches by Tintoretto has been made by Joseph Meder who published a group of pen drawings in the University Library at Salzburg (No. 1143 and others) as preparatory sketches for the "Paradiso" in the Ducal Palace. These drawings not only fit perfectly well into Palma's style of drawing about 1580–90, but one of them is, without any doubt, a study for the large *modello,* still existing and, moreover, engraved by Brébiette, which Palma made in competition with Tintoretto. The status of the case has been entirely cleared up by E. Tietze-Conrat and by W. Suida, independently from one another. Nevertheless, we are quite justified in continuing the search for such general sketches by Tintoretto, considering that a jotting down of the general idea, at least a preliminary one, seems to be the natural beginning to work on a composition. The painted sketches which we discuss a little later on p. 277 are not to be considered as this first step. At least for Tintoretto's late years we have evidence that he made them only after having finished the study of the separate figures. A very instructive sketch of this kind, for the "Battle on the Taro" at Munich, was recently discovered (No. 1724). With its stress laid on plastic value it offers a specific counterpart and contrast to Domenico's sketches in London (see No. 1526).

When describing Tintoretto's painting "Cain and Abel" Ridolfi explicitly mentions that the two figures were drawn by the help of a wire screen. The importance of such separate studies for the preparation of a painting is emphasized by Tintoretto himself, when he mentions the great expenses incurred by paying so many models when preparing the "Battle of Lepanto." Their place within the working process may be imagined as follows: after having established on his diminutive stage the posture of the figures and their relations to each other, Tintoretto turned over to drawing the various figures by the help of the screen, isolated and without regard to the total composition. This is how we may explain the complete detachment of the figures from their natural surroundings, resulting in an elimination of weight and volume in these figures. They stand, lie or move within a vacuum. They do not breathe or smell and suggest no association of material. Even when they hurl themselves forward, everything seems to happen behind a pane of glass, in planes or depths which are not a part of experience. They are not principal figures or accessory figures, but elements of a composition. Their connection with one another rests upon a pre-established harmony. The law ruling them is not the rendering of events accessible to human experience, but a stylized abstraction comparable to music and transposing reality into symbols. Just as any indication of space, any indication of light or coloristic effect is also lacking. The abstract bodies cast no shadows; the internal linework is only a chart of the play of muscles. Their foreshortenings are geometrical projections. These principles apply even to the earliest drawings we are able to date, those connected with the decoration of the ceiling in the Albergo of the Scuola di San Rocco (Nos. 1565, 1586, 1597, 1613, 1631). But from the same period, besides these abstract productions there are others that show some added warmth. It might be that Jacopo's studies from sculpture, striving for the understanding of foreshortened parts as plastic values, and for the rendering of sharp light and deep shadow in their effects (see Ridolfi's circumstantial description II, p. 14) produced a concentration also in some studies of a different character. Examples are the figure of Eve of 1568 (No. 1620) or the Magdalene of 1565 for the "Crucifixion," San Rocco (No. 1585). (The study after nature, however, connected by Hadeln, *Tintorettozeichnungen,* pl. 14, to the studies from sculpture and listed by him p. 41 as an exception has to be eliminated as certainly by Palma Giovine, see No. 1133. Such a closeness to the model is beyond Tintoretto, even at his nearest approach to reality.)

The vast majority of the drawings still existing are the abstract studies. Hadeln had already stressed the difficulty of dating, even approximately, Jacopo's drawings by stylistic arguments exclusively. When we compare the

well-authenticated sketches for the ceiling in the Albergo (Nos. **1565, 1586, 1597, 1613, 1631**) of 1564 with sketches connected with the late "Battle of Zara" (Nos. **1588, 1590, 1592, 1615, 1621**), in spite of the quarter of a century separating the two groups, the common traits seem to prevail at first sight. Jacopo's handwriting is so distinctive that the differences vanish. Nevertheless, they do exist. They consist not only in a greater tension of the figures, something that might also be explained by the difference of subject. In the late sketches the functions of the joints, the moving back and forth of the figures is more intense and better understood, and the outlines are accordingly richer. The moving bodies are better rounded and more thickset than the loose and somewhat empty early figures.

Such a working method bent on abstract studies evidently was apt to lead the artist to mannerism and routine, and we are inclined to find this trend neutralized by the study from sculpture, stretching over many years, as Zanetti supposed and Hadeln emphasized. We have rather precise accounts of Tintoretto's store of casts; the most circumstantial enumeration is given in his *Carta del Navegar* by Boschini who listed them as the property "Bastiano's (Casser) who also claimed the name of Tintoretto for himself." For some time it had been Domenico's idea to endow an academy with these casts which after all remained in the family. It is reasonable to suppose that in the family, in other words in the shop, they were used as a kind of academy and, accordingly, we may distinguish between authentic studies by Jacopo from sculpture and those done by his pupils. (For Marietta's studies from sculpture see No. **1762** and also p. 293; Domenico's hand is discernible among the sketches in London, see No. **1526**, 30 v; another pupil made Nos. **1526**, 42, 43, 53.) When we remember that Jacopo, according to Ridolfi II, p. 54, drew these casts by artificial light, favoring the closest approach and the most daring views and foreshortenings, and that he painted his early self-portrait holding in his hand a cast, probably a reduction from Michelangelo's Crepuscolo, we reach a rather early date for this kind of study as far as he personally indulged in it. The upper boundary line, at least for the studies after Michelangelo, is supposed to be 1557, the year in which Daniele da Volterra made his reduction of the Crepuscolo.

We are inclined to link the characteristic manner in which Tintoretto drew from sculpture to an influence by Titian who, according to Lomazzo, *Idea del Tempio della Pittura*, 1590, p. 53, employed similar expedients: "he used models made of wood, clay or plaster for the postures, placing these models at a very short distance and under a very wide angle, in order to make the foremost figures appear larger and more impressive ('terribili') and the figures behind very small." The word "terribile" is frequently applied to Tintoretto, too. That the latter counterbalanced his habit of drawing nudes with the help of the screen, by studying after sculpture is expressly testified by Ridolfi (p. 18) when he speaks about "Adam and Eve," now in the Academy, Venice. The alleged studies from corpses also mentioned by Ridolfi (p. 15) would belong to a similar category; (No. **1577** in Cheltenham may illustrate this side of Tintoretto's activity).

In endeavoring to date the drawings from sculpture—an attempt also made by Hadeln, *Tintorettozeichnungen*, p. 23 ff—we move on uncertain ground. The only point of departure is the date of 1557 mentioned above as the upper boundary line. Of Tintoretto's studies, mentioned in Borghini's *Riposo*, after Sansovino's Mars and Neptune, figures which were begun in 1554 and put up in 1567, none is preserved. What Boschini lists as existing in the shop: besides Michelangelo's "Notte" and "Crepuscolo" "all the famous groups by Gian Bologna, the Laocoön, the Torso of the Belvedere, busts of Emperors, the Farnese Hercules, the Medici Venus," offers no further help, since drawings by Tintoretto after Bologna's figures do not exist and the antiques do not supply dates. The use of such studies in paintings, in our opinion, cannot be demonstrated with certainty. Hadeln put No. **1854**

in Christchurch at the beginning of his chronological list because of its bungling character and the resemblance of the male figure to one in the "Contest of Apollo and Marsyas," executed for Pietro Aretino as early as 1545. In our opinion, it is not permissible to assume that the drawing was really used in the painting, and a relationship of the motives, if there really is any, only proves that Tintoretto may have known the figure at that period, but gives no clue for the date of the drawing. The foreshortened Head at Oxford, No. 1731, is very similar to the sleeping S. John in the "Mount of Olives" in the Scuola di San Rocco, the "Tempting Demon" reminds us of the drawing No. 1478. We have to limit ourselves to stating that Tintoretto's two studies after Michelangelo, No. 1643 and No. 1739, present the whole richness of Tintoretto's maturity, but that for the rest of these studies we do better to distribute most of the material over Tintoretto's school. What by its superiority in quality or other reasons remains for Tintoretto himself, is hardly sufficient to construct a chronological order. The first to make a breach in the former belief that all these studies from sculpture had to be by Tintoretto, was Morassi, see No. 1762. That a drawing looks inexperienced is not yet a sufficient reason to claim it for Jacopo's youth, it might as well be by one of his pupils.

The drawing, with respect to which Hadeln stressed the difficulty of dating Tintoretto's drawings exclusively on stylistic bases, was No. 1819 at Frankort which he published as a canceled study for the corpse in the "Miracle of St. Mark" of 1562, a suggestion contradicted outright by the mode of drawing. Hadeln's attempt to select from the enormous quantity of drawings, listed in older collections as by Tintoretto a corpus of really authentic works turned out so extremely well in its method and principles that various mistakes that crept in seem excusable. Whoever is acquainted with the material ascribed to Tintoretto in the great collections and, we are sorry to say, given to him even in catalogues published after Hadeln's studies, must needs be astonished at his courage in eliminating spurious productions. As example we may mention only the *Albertina Catalogue* II which, after Hadeln and in spite of Hadeln, in its list of twelve contains only one authentic drawing by Jacopo. We accept Hadeln's method, and by its help alone we are able to purge his own list. We try to proceed cautiously by first drawing up the framework of studies that are doubtless authentic and permit dating. Our first list accordingly consists of drawings connected with authentic works, meaning with paintings ordered of Jacopo and datable by documentary evidence. There is the greatest probability (but by no means an absolute certainty) that these drawings are authentic.

List A

Date		Connected Painting	
About 1562	No. 1711	The Salvage of the Body of S. Mark	
About 1562	No. 1692	The Finding of the Body of S. Mark	
About 1564/65	No. 1586	Ceiling of Albergo of Scuola di San Rocco	
	No. 1597	"	"
	No. 1613	"	"
	No. 1631	"	"
	No. 1565	"	"
1565	No. 1585	Crucifixion	"
	No. 1664	"	"
	No. 1702	"	"

Date		*Connected Painting*
1565	No. 1594	Crucifixion, Scuola San Rocco
	No. 1710	” ”
1566	No. 1640	Christ Carrying the Cross
1568	No. 1620	Christ in Limbo, San Cassiano
	No. 1558	”
1571/72	No. 1625	Philosopher, Libreria, Venice
	No. 1650	”
1577/81	No. 1653	Baptism of Christ, Scuola San Rocco
	No. 1704	Last Supper ”
	No. 1712	Resurrection ”
	No. 1758	” ”
	No. 1660	Adam and Eve ”
	No. 1680	Elijah in the Wilderness ”
About 1579	No. 1571	Gonzaga Cycle, Munich
	No. 1626	”
	No. 1642	”
	No. 1719	”
	No. 1724	”
	No. 1727	”
About 1580/84	No. 1691	Ceiling in the Sala del Maggior Consiglio
	No. 1593	” ”
	No. 1657	” ”
	No. 1658	” ”
1584/87	No. 1588	Battle of Zara, Ducal Palace
	No. 1590	” ”
	No. 1592	” ”
	No. 1615	” ”
	No. 1621	” ”
About 1590	No. 1604	Reception of the Ambassadors, Ducal Palace.

By the help of this material, the most fully authenticated for its chronological order as well as for its author-ship, we shall try to form for ourselves a definite idea of Jacopo's style and its evolution. An anecdote told by Ridolfi (II, p. 65) gives the keynote: "Some young Flemish artists who visited Tintoretto on their way back from Rome showed him some heads they had drawn in red chalk and executed with utmost care. To his inquiry how long they had worked on them, they answered, some ten to fifteen days. Certainly you could not have done it in less time, said Tintoretto, and dipping his brush in black color brushed down a figure, heightening it daringly with white. Then, turning to his visitors, he said: We poor Venetians cannot draw but in this manner . . ." Abstract drawing concentrating solely on the essential functions in bodies is typical of Tintoretto's mature style. In his basic article on Tintoretto's drawings, in *Jahrb. Pr. K. S.* XLII, and in the introduction of his Corpus, Hadeln cautiously and convincingly threw into relief the essential qualities of these drawings and E. Tietze-Conrat made

a few additions in *Graphische Künste* N. S. I. We agree with Hadeln's theory that the poses of dressed women were first studied by the help of male models, and that only for occasional female nudes were female models studied. (As a matter of fact the only authentic drawing of this kind is No. **1620**, since the Venus in No. **1561** belongs to another category; for No. **1539** attributed to Jacopo by A. L. Mayer, see our remarks there). On the other hand, of Hadeln's examples of postures prepared by two different studies we accept only the one referring to the woman in the lower l. corner in the "Golden Calf" in Santa Maria dell' Orto, since both drawings in question, No. **1584** and No. **1591**, are identical in style. The drawing No. **1634** connected by Hadeln with the man servant in the "Wedding of Cana" is far advanced beyond the style which we might expect in 1562, the date of the painting; the slender and small-headed figure in the drawing is in sharp contrast to No. **1633** to which it ought to be close in style if it really were an abandoned first idea for the "Wedding of Cana" as supposed by Hadeln. Another "first idea," this time for the "Holofernes" in Madrid, No. **1835** first proposed by Bercken-Mayer and accepted by Hadeln, is not a first idea at all, but the closely resembling design for the "Descent from the Cross" (versions at Strassburg and at Caen). Neither the painting nor the drawing is by Jacopo, both belong to the shop. No. **1819** at Frankfort (whence our digression on Hadeln's conclusions took its start) is not a canceled sketch for the "Miracle of St. Mark," but a study by a pupil apparently used in a shop production existing in a collection in Switzerland, see p. 301.

These rectifications of some of Hadeln's statements reveal the necessity of caution in connecting drawings with specific paintings. A few mistakes in this regard committed by E. Tietze-Conrat are set right in our text. It is the natural trend in pupils to modify the master's ideas as little as possible; these minor modifications vouch for the continuity of the leading artistic personality through the following generations. Besides the pictorial separate studies from the 1560's there exist a few hasty designs with loose outlines and very little inner tension; the latter is seen gradually increasing. The two preserved drawings for the "Christ in Limbo" in San Cassiano, No. **1558**, the study for Christ himself modeled by many petty strokes and the calm and great Eve (No. **1620**), reveal by their difference how great is the span we have to concede to the master. His art seems to evolve in the direction of the drawing of Christ: its disintegration of the body into small portions edged by broken lines anticipates the studies for the upper floor of the Scuola di San Rocco and for the warriors in the "Battle of Zara." It is true, part of the superiority of the latter is to be explained by the dramatic character of the subject. Quietly resting figures like No. **1653** for the "Baptism of Christ" in the Scuola di San Rocco, or No. **1719** for one of the paintings in Munich, replace the twisted outlines by a calmly encompassed volume.

It is remarkable that in our list of well dated drawings none is anterior to 1562 and, moreover, that no drawing is preserved that might be connected with one of the paintings in the ground floor of the Scuola di San Rocco. Before venturing any conclusions from this statement we present a second list containing drawings reliably connected with authentic paintings by Tintoretto which, however, cannot be dated with certainty and, indeed, are differently dated by various authorities.

List B

Connected painting

No. **1561** Venus and Vulcan, in Munich
No. **1563** Last Supper, San Trovaso
No. **1584** Adoration of the Golden Calf, Madonna dell' Orto

Connected painting

No. **1591** Adoration of the Golden Calf, Madonna dell' Orto
No. **1674** Adoration of the Golden Calf, Madonna dell' Orto
No. **1598** Baptism of Christ, San Silvestro, Venice
No. **1609** Baptism of Christ, San Silvestro, Venice
No. **1632** Christ washing the feet of the Apostles, Sto. Stefano, Venice
No. **1633** Crucifixion, Academy, Venice
No. **1759** Crucifixion, Academy, Venice
No. **1635** S. Martin, Murano (lost)
No. **1648** Prodigal Son, Ducal Palace
No. **1656** Last Supper, San Giorgio Maggiore
No. **1682** Martyrdom of S. Lawrence, Oxford, Christchurch
No. **1700** Martyrdom of S. Lawrence, Oxford, Christchurch
No. **1677** Martyrdom of S. Lawrence, Oxford, Christchurch
No. **1697** Mount of Olives, Sto. Stefano
No. **1701** Last Supper, San Polo
No. **1738** S. George fighting the Dragon, N. G.

Were our first list really satisfactory it should offer sufficient help to arrange chronologically the paintings mentioned in the second list on the basis of the drawings preparing them. That means to back up, or to overthrow their already attempted classification. The "St. George" in the N. G., for instance, has always been considered an early work and the pictorial drawing in the Louvre, No. **1738**, confirms this opinion. The drawing No. **1563** for the "Last Supper" in S. Trovaso, usually dated 1562 to 1566 and No. **1692** for the "Miracle of St. Mark" in the Brera supposed to have been executed shortly after 1562 displayed an identical style. On the other hand, the controversial dating of the painting "Venus and Vulcan" is not made easier by the drawing in Berlin, No. **1561**. The painting is placed in Tintoretto's early period by Bercken-Mayer and by Suida in Thieme-Becker (XXXIII, p. 190), while Pittaluga, and following her the *cat.* of the *Mostra* believes in a later origin. As for the drawing, it seems to exclude an early date. The ornamental interlacing of the bodies, their connection by a network of slanting strips cutting each other at oblique angles, are in contrast to the authentic works of Tintoretto's early period. On the other hand, the evident pleasure, notable in the painting, in stressing the bodily substance of the female nude is an argument against a later date. If we stick to a date about 1550–60, this suggestion is without connection with the drawing which, at any rate, remains so special a case that it offers no clue. We stated above, without drawing any further conclusions from the statement that no drawings exist to be dated reliably before 1562. Possibly earlier are Nos. **1591, 1584, 1674** connected with the "Golden Calf" in Madonna dell'Orto, perhaps from the 1550's (Suida p. 191: 1552–1559). Considering that Jacopo was already designated as an independent master in 1539 when he was only 21 years old, the lack of early drawings is a considerable loss. It deprives us of the possibility of interrelating Tintoretto's drawing style with the general development of drawing in Venice. We get something of a hint by the story that Tintoretto had worked with Titian and that it was precisely his drawings which aroused Titian's jealousy so that he dismissed his gifted pupil. The further tradition that he continued his training with Bonifazio does not even give a hint, since nothing is known of Bonifazio's

drawings. Another theory, namely, that Bordone may have been Tintoretto's second teacher, confirms only the Titianesque foundation of Tintoretto's style. Again the early paintings offer no help; as a matter of fact only one, the ceiling "Apollo and Marsyas," of 1545, is solidly established. No. **1854**, which Hadeln tried to connect with this painting, shows only a very slight resemblance to the figure of Apollo in the painting which in every direction remains something unique in Tintoretto's production. We might only annex it to the somewhat similar *cassone* paintings, first claimed for Tintoretto by Hadeln in *Zeitschr. f. B. K.* XXXIII, p. 27 ff., but not universally accepted. The gap between the ceiling of 1545 — incidentally the time which by the stay of Francesco Salviati, the visit of Vasari, the establishment of Giuseppe Salviati and Schiavone's graphic production, marks the peak of mannerism in Venice — and the first "Miracle of S. Mark," of 1548, in which Tintoretto reveals himself so definitely Titianesque, is not satisfactorily bridged by paintings. The thesis which attracts us most, is to imagine Tintoretto in search of general working methods, as he reveals himself in his paintings. If he was as close to Schiavone as Ridolfi suggests and the "Apollo" seems to confirm, he may not have as yet formulated the methods which later on became typical of him, based on the intensive study of individual figures. This might offer the best explanation of why we do not have any of his drawings earlier than 1562.

As for the other anomaly which we pointed out, namely, that we do not know of any drawings connected with the paintings in the groundfloor in San Rocco, the explanation may simply be that by some misfortune none of them has been preserved. With very few exceptions the paintings here seem to be Jacopo's most personal inventions and even if he, then a very old man, employed his shop in their execution, the designs and studies on which the execution rested must have been his own. The only conclusion we may draw is that the drawings were "consumed" by the execution, just as it might be the case with those for the "Paradise," another undertaking left mostly to the shop and for which too, no drawings are preserved. (Pittaluga's assertion, in *L'Arte*, v. 25, 1922, p. 97 that "the many detailed studies in the Uffizi, in the Capitolina (!) and elsewhere prove how carefully Jacopo had prepared the Paradise" is evidently a slip of the pen. No drawings for this composition exist.)

For some paintings, however, the execution of which was left to assistants, Jacopo did not make a special design or did not contribute his own studies. Hadeln, who dealt with the question of the shop productions, discussed as methods employed the reversion and the amplification of original compositions. Such productions, in contrast to the honorary, but hardly profitable commissions from the state or the *scuole,* seem to have provided the daily income of the shop. We may take it for granted that the shop as a rule when reversing a composition, would have used a tracing from an original, or when amplifying a composition, further original studies which were at hand in the studio. But when a drawing used in such a shop production differs from the style typical of the master himself, we had better attribute the drawing to a member of the shop. Domenico's last will (p. 258) in which his own and Sebastiano Casser's drawings are clearly distinguished from the others, offers a clue. On three drawings we find the name of Marietta inscribed, and we may suppose that Marco, who in 1635 inherited all the drawings by Jacopo, also made, owned and bequeathed drawings of his own. Consequently, we append now a list of such drawings that are reliably connected with paintings executed by the shop.

List C

Connected painting

No. **1492** Immaculate Virgin, Stuttgart
No. **1622** St. Catherine, Lyons

Connected painting

No. **1627** Finding of Moses, Vienna

No. **1810** Adoration of the Shepherds, Boston

No. **1799, 1801** Triumph of David, 1939/40 Seligmann Galleries

No. **1603** Flagellation of Christ, Vienna

No. **1661** Vision of S. Bridget, Capitol Gallery, Rome

No. **1662** The Medianite Maidens, Madrid

No. **1675** Pax tibi Marce, Venice

No. **1681** S. Justina, Venice, Academy

No. **1835** Descent from the Cross, Caen

No. **1521, 1522** Ceiling in Sala del Gran Consiglio

No. **1694** Resurrection, formerly Alsberg Coll., Berlin

No. **1846** The Birth of S. John the Baptist, Hermitage

No. **1529** Pax tibi Marce, Venice, Academy

No. **1638** Annunciation, Bologna

No. **1725** Annunciation, Bologna

No. **1792** Ahasuerus and Esther, Hampton Court

In each separate case the quality of the drawing is decisive for the question as to whether the assistant who executed the painting may also have made his own drawing, or used one by Jacopo. The attribution of the painting and its date offers no help, unless paintings certainly executed after Jacopo's death are prepared by special studies. (Such a case would be "The Triumph of David" the drawings of which are discussed under "Shop" Nos. **1799, 1801**.)

To these three lists containing the drawings connected with still existing paintings, we have to add further drawings that we consider authentic and try to date by stylistic reasons, but which we can only hypothetically (if at all) connect with lost works of Tintoretto. This group obviously is subject to many mistakes, since the inclusion of drawings in it rests entirely on their style, without any other support but some literary or documentary evidence of their alleged use. Of Jacopo's mural in the Ducal Palace, "The Excommunication of Emperor Frederick Barbarossa," we have a very interesting copy which we tentatively attribute to El Greco (No. **747**). The copy, however, does not repeat the composition precisely enough to allow the identification of separate studies as preparing the composition. Moreover, this work leads into that early period in which, as said above on p. 274, studies of this nature perhaps were not yet made by Tintoretto. The principal compositions for which we may imagine such studies were made are the "Last Judgment" about 1570 and the "Battle of Lepanto" of 1572/3.

For the "Last Judgment" we may imagine a composition similar to that of Palma Giovine's later substitute for Tintoretto's painting destroyed by fire. In view of the appearance of a closely related St. Catherine in Palma's painting we may connect a magnificent sketch for a figure of this saint (No. **1723**) with Tintoretto's composition. The task of reconstructing the "Battle of Lepanto" seems somewhat different. In this case, the painting substituted after the destruction of Tintoretto's composition in 1577 was made by Vicentino, but, as the documentary evidence seems to establish, offering a certain contrast to Tintoretto. We are, therefore, not justified in accepting the general arrangement of Vicentino's composition as a reminiscence of Jacopo's. It follows a convention sur-

prisingly soon established for the representation of this naval battle.[1] The numerous studies from models which in his application to the government Tintoretto claimed to have made for this composition ("I had to pay so many models since every figure had to be done from nature") would hardly fit into this conventional scheme. We have to search for principal and accessory figures such as those that appear a few years later in the "Battles of the Gonzaga" in Munich.

Summing up Tintoretto's process in preparing his compositions we have also to take into consideration the painted sketch in which the final location of the work in question is already taken care of. (Compare Ridolfi's well known report of the events connected with the ceiling "The Glorification of S. Roch" in the Scuola di San Rocco.) In *Jahrb. Pr. K. S.* XLII, p. 182 ff., and especially p. 186 ff., Hadeln made a special study of Tintoretto's oil-sketches on canvas; they are so different from the paintings to which they are supposed to belong that they can by no means be considered as their designs. Hadeln calls them *"modelli"* and supposes they were made to give exacting customers an approximate idea of the projected work. The five which he lists ("Miracle of S. Agnes," Berlin, "Miracle of St. Mark," Brussels, "Votive painting," Metropolitan Museum in New York, two versions of "Paradise," Louvre and Prado), incidentally, an extremely heterogeneous material as well for its authenticity as for its purposes, corroborate Hadeln's theory and are therefore to be taken as a sidelight on the working process. The only specimen that may claim the character of a genuine sketch is the one in the Metropolitan Museum.

The real labor begins only afterwards. The composition is constructed on its diminutive stage, the individual figures are studied by the help of the network; the last stage is the colorsketch with the help of which the shop is able to prepare the canvas. It is likely that such colorsketches were also made for individual figures (No. **1725**).

This completes the preparation as far as it is done in drawings. There are, however, two more bits of information to be connected with this working process. Just as we noted of Titian, Tintoretto left behind him *"pitture"* that remained in the studio and were utilized first by Domenico, then by Marco, finally by Casser. They were intended not for the customer, but for domestic use. They are incomplete, but only in a commercial sense; artistically they are the purest expression of an idea, the perfect realization of the artistic vision, without regard to the layman. These are the kind of sketches that speak most directly to the artist who understands them, the kind that Tintoretto himself bought from Titian's estate.

Besides, at some time Tintoretto planned to make in drawings a kind of inventory of his countless compositions. "He had the idea of making a quantity of drawings in which he intended to leave behind *'impresse'* some of his inventions, to serve as a seal to the infinite works he had done" (Ridolfi II, 64). If we understand this project correctly as a kind of *liber veritatis,* what a help it would not offer the students of Tintoretto's art!

A 1556 AMSTERDAM, COLL. I. Q. VAN REGTEREN ALTENA. The elevation of the cross. Pen, wash, on gray. 167 x 431. Coll. Lord Brown- low. Exh. Amsterdam 1934, *Cat.* 674: Ja. Tintoretto's first idea of the mural in the Scuola di San Rocco, Venice 1565. **[MM]**

[1] According to F. Sarre, *Jahrb. Pr. K. S.,* 1938, p. 233, Vicentino followed Tintoretto's composition in which, however, foreground and middleground were sharply differentiated. Ridolfi, who for his description relies on an unknown source extols the clearness of the arrangement that emphasized the essential events: the grappling of the Turkish flagship; Sebastiano Venier, Giovanni d'Austria, the Papal commander encouraging the warriors; Agostino Barbarigo hit by an arrow in his eye; galleys with soldiers, drowning Turks, and so on. Sarre's attempt to reconstruct Tintoretto's composition by the help of a painting in a private collection in Berlin, ill. l. c. p. 234, is a failure which we must correct in view of the importance of this composition. Sarre points to the boat of Giovanni Andrea Doria at l. and takes the painting for Tintoretto's "small battlepiece," painted for Ercole Gonzaga — Prince Ottavio Gonzaga taking part in the Battle of Lepanto aboard Doria's ship. Sarre overlooked that the "small battle" had already been ordered on May 9, 1562, almost a decade before the Battle of Lepanto (Luzio, in *Archivio Storico* III, p. 207; Pittaluga, p. 193). Moreover, we miss in it the clearness that we might expect in any battle piece by Tintoretto. Conformities of details prove only Vicentino's stylistic dependence on Tintoretto, but, in our opinion, in this case are by no means close enough to establish Vicentino's discipleship (s. p. 297).

In our opinion, the drawing is Venetian and may derive from Jacopo Tintoretto's famous composition where, however, another episode is represented. The proportions in the two versions are different; furthermore, the drawing shows no resemblance to Tintoretto's penmanship. We fail to see any argument in favor of Regteren's hypothesis.

A AMSTERDAM, GOUDSTIKKER GALLERY. Four sketches. See Nos. 1473-1476.

A 1557 ASCOLI PICENO, PINACOTECA. The raising of Lazarus. Pen, wash. Publ. by L. Fiocca, in *Rass. d'A.*, 1912, p. 98 (ill.) as Jacopo Tintoretto.

In our opinion, a northern drawing, perhaps by Johann Rottenhammer. We have not seen the original.

1558 BASEL, COLL. ROBERT VON HIRSCH. Study for the Christ in the painting "Christ in Limbo" in San Cassiano in Venice. Bl. ch., on blue. 337 x 199. Stained with wh. color; lower r. corner added. Damaged. — *Verso*: two studies for the l. arm of a woman carrying a tall vessel. Publ. in Swarzenski-Schilling, p. XIX, pl. 58. The drawing is dated 1568 by the painting. [Both sides. **MM**]

A ————. Bearded head. See No. **824**.

1559 BAYONNE, MUSÉE BONNAT, 143. Study from Michelangelo's group Samson slaying the Philistine. Bl. ch., height. w. wh., on faded blue. About 395 x 325. (Photo Doucet 262) Publ. by L. Dussler, in *Burl. Mag.* LI, p. 32, pl. B. Hadeln, *Burl. Mag.* LI, p. 102. Venturi, *Studi*, p. 310, fig. 197. [*Pl. CXII*, 1. **MM**]

A 1560 ————. Christ carrying the cross. Pen, wash. Publ. by Venturi, *Studi*, p. 310, fig. 198, as J. Tintoretto, with reference to the group in the background of the painting of this subject in the Scuola di San Rocco.

In our opinion, this excellent drawing is without any connection with Jacopo Tintoretto and probably not Venetian at all.

1561 BERLIN, KUPFERSTICHSAMMLUNG, 4193. Design for the painting "Venus and Vulcan" in Munich (ill. Bercken-Mayer, 2). Pen, wash, height. w. wh., on blue. 204 x 273. The connection discovered by Elfr. Bock, publ. by Bercken-Mayer I, p. 51 and Hadeln, *Tintorettozeichnungen*, p. 31, pl. 12, who all dated the drawing about 1545, with reference to the painting. Pittaluga p. 262 and *Mostra del Tintoretto* p. 183, No. 66, date the painting about 1580.
[*Pl. CXV*, 1. **MM**]

The drawing is unique in its technique and therefore difficult to compare with other authenticated and dated drawings by Jacopo Tintoretto. The painting, "Mercury's message to Aeneas" (copy? ill. *Kunstchronik*, N. S. 34, 1922/23, p. 37) by Daniele da Volterra, which in our opinion might have influenced Tintoretto's composition, was dated 1550/55 by Stechow (Thieme-Becker vol. 28, p. 257). Daniele da Volterra's copies from Michelangelo's figures in the Medici Chapel, probably used by Tintoretto for his drawings (Hadeln, p. 25) are dated 1557. We may suppose a connection between Jacopo Tintoretto and Daniele in the 1550's and date the drawing in this period (s. also p. 274).

A ————, 4267. See No. **830**.

A 1562 ————, 5063. The Massacre of the Innocents. Pen, br.,

wash. 274 x 394. Coll. Beckerath. Publ. in *Berlin Publ.* I, pl. 87 as battle scene, by Jacopo Tintoretto.

In our opinion, the drawing not listed in Hadeln's *Tintorettozeichnungen* is by Vittorio Bigari (1692-1776). The composition is very close to Bigari's painting in the Salvadori Collection in Florence (Photo Witt).

1563 ————, 5084. Three studies from a clothed model, used in the "Last Supper" in San Trovaso, ill. Bercken-Mayer 82. Bl. ch., height. w. wh., on blue. 385 x 262. Squared for enlargement. Publ. by Hadeln, *Tintorettozeichnungen*, pl. 61 and p. 33: The squares of one of the half-length figures are smaller than the others, the figure, therefore, was not intended to be used in the same painting. E. Tietze-Conrat, in *Graph. Künste*, N. S. I., p. 90, however, found all three studies used in the "Last Supper," in San Trovaso, Venice. The drawing is dated about 1555/1560 by the painting.

1564 ————, 5228. Study from Michelangelo's group Samson slaying the Philistine. Bl. ch., height. w. wh., on blue. 404 x 258. — *Verso*: Study from the same group. Coll. von Beckerath. The *recto* publ. by Hadeln, *Tintorettozeichnungen*, pl. 4 and p. 25.

A ————, 5736. See No. **1478**.

1565 BERLIN, COLL. PAUL CASSIRER, formerly. Design for the figure of "Truth" on the ceiling in the Albergo of the Scuola di San Rocco. Charcoal, on wh. 161 x 265. Squared for enlargement. Original inscription: verità. Publ. by Hadeln, in *Burl. Mag.* XLIV, p. 281, pl. II. H. Dated 1564-5 by the ceiling.

We have not seen the drawing and were told by the present owners of the Cassirer Gallery that the later whereabouts of the drawing is unknown.

A 1566 BESANÇON, MUSÉE, 3126. Tarquinius and Lucretia. Pen, br. 212 x 178. Stained with mold. New inscription: Tintoret. Coll. Deperret, Gigoux. The drawing, apparently drawn after a sculpture, is a good example of the earliest style of Paolo Farinato, as shown in his sketchbook in Milan, Castello.

1567 ————, 3229. Studies from Michelangelo's group Samson slaying the Philistine. Bl. ch., height. w. wh., on blue. 420 x 255. Damaged by humidity. Coll. Gigoux. [**MM**]

In spite of the poor state of preservation, very good drawing.

A BIRMINGHAM, BARBER INSTITUTE. Study of a man bending his knee. See No. **1764**.

A 1568 BREMEN, KUNSTHALLE. Study for three crouching and two standing figures. Brush, bl., height. w. wh., on blue. 219 x 221. Coll. J. H. Albers, acquired 1856. Publ. in *Jahresberichte des Bremer Kunstvereins* 1910-11, p. 5 and in *Prestel-Gesellsch. Bremen II*, 11 as Jacopo Tintoretto. Tozzi, in *Boll. d'Arte* 1937, p. 19-31: Domenico Tintoretto, detail of a Resurrection. [**MM**]

In our opinion, the drawing which we have not seen is even later than Domenico.

1569 BUDAPEST, MUSEUM OF FINE ARTS, I 117. Study after the so-called Atlas. Charcoal, on blue. 256 x 186. — *Verso*: the same figure. Hadeln, *Tintorettozeichnungen*, p. 27. Meder, *Handzeichnung*, fig. 171, 172 below. Edith Hoffmann, in the *Budapest Yearbook* IV, p. 133, fig. 19 and 20. [**MM**]

Companion of the following number.

1570 ————, I 117 a. Two studies of the so-called Atlas. Charcoal, on blue. 275 x 273. — *Verso:* the same figure. Companion of No. **1569**, see literature there.

1571 CAMBRIDGE, ENGLAND, FITZWILLIAM MUSEUM, 2247. Study of an oarsman, turned to the l., half-length. Bl. ch., on blue. 181 x 247. The outlines are worked over with the brush. Damaged. Coll. Ricketts. [*Pl. CVIII,* 3. **MM**]

In our opinion, the original study was reworked in the shop in order to obtain an impression in reverse to be used for the oarsman in the r. half of the middleground in the Battle of Legnago, Munich, Pinakothek (Ill. Bercken-Mayer, p. 137).

A ————, 73. See No. **1480**.

A ————, 2248. See No. **1767**.

A ————, 2251. See No. **1769**.

A ————, 2252. See No. **1481**.

1572 ————, 2253. Nude seated and turned to the r. The hands holding some object. Charcoal, on buff, 299 x 203. Squared for enlargement. Coll. Reynolds, Ricketts. [**MM**]

The posture resembles that of "Christ crowning the Virgin" in San Giorgio Maggiore and may have prepared a similar figure.

1573 ————, 2254. Study of a nude kneeling on one knee, turned to the l., and pulling a rope with both hands. Bl. ch. on gray. 190 x 190. Late inscription of the name. Coll. Reynolds, Ricketts. [**MM**]

1574 CAMBRIDGE, MASS. FOGG ART MUSEUM, 182. Seated nude, on clouds, playing a musical instrument. At l. hardly recognizable study of a bearded man. Bl. ch., height. w. wh., on faded blue. 396 x 297. Squared. Stained by mold and water. Contemporary inscription: "piedi 10" (?) and below that "pie 8" (?). — *Verso:* Seated nude turned one quarter l. At l. another identified figure. Loeser Bequest 1932 — 284. Mongan-Sachs p. 98, fig. 95, 94. [Both sides. **MM**]

The reading of the inscription "piadiso" (paradiso?) induced Mongan-Sachs to consider the drawing on the *recto* as a study connected with J. Tintoretto's "Paradise" in the Ducal Palace. Although the reading is doubtful (we read the words as measures) and "paradiso" can never turn into "piadiso" in the Venetian dialect (see A. Michelagnoli, *Dizionario Veneziano,* Venice 1935 and Giuseppe Boerio, *Dizionario del dialetto Veneziano,* Venice 1856), we, too, date the drawing in Jacopo's late period. The difference in style and quality between the two sides leads us to suppose that only the *recto* is authentic and the drawing on the *verso* by some member of the shop.

1575 ————, 183. Study of Virgin and Child, seated on clouds. Charcoal, height. w. wh., on blue. 285 x 165. Squared and patched in many places. Later inscription of the name. Loeser Bequest 1932 — 287. Publ. by Hadeln, *Tintorettozeichnungen,* pl. 58, p. 36, 52, with reference to the related motive in the "Madonna with the saints Cosmas and Damian," in the Academy in Venice, ill. Bercken-Meyer 144.

Mongan-Sachs, p. 98, fig. 93 are right in finding the Madonna and Child in the painting in Berlin, ill. ibidem 145, still closer. The figure of the Child appears adapted also in Domenico Tintoretto's painting

"Madonna and Child with four senators," Academy, Venice (Venturi, Storia 9, IV, p. 666).

A ————, 184. See **1770**.

A ————, 185. See **1771**.

A ————, 186. See **1772**.

A 1576 ————, 187. Various studies for a Martyrdom of St. Sebastian. Pen and bistre, wash, on yellow. 121 x 223. — *Verso:* Sketches of archers. Coll. P. H. (Lugt 2083), Houlditch, Bellingham-Smith, P. Sachs. Ill. Sales cat., Frederik Muller, Amsterdam, July 5, 1927, No. 6 as Paolo Veronese. Mongan-Sachs p. 100, fig. 99, 100: Jacopo Tintoretto with reference to No. **1143**. [Both sides. **MM**]

Mongan-Sachs' order of thought seems to be the following: the drawing reminds them of the above-mentioned No. **1143**, publ. by Meder as Jacopo Tintoretto, but claimed for Palma Giovine by E. Tietze-Conrat and Suida. Mongan-Sachs' reference to representations of St. Sebastian by Palma in the sketchbooks in Munich (not in Dresden, as they put it by an evident slip of the pen) certainly dissimilar to the drawing in Cambridge, tends to invalidate the objections against Meder's attribution. We agree as to the difference between the drawing in Cambridge and the many St. Sebastians by Palma in Munich, but find as little resemblance to the drawings in Salzburg which indubitably are by Palma. Leaving aside this spurious material for comparison, we find no resemblance to J. Tintoretto's style of composition, to his types and postures, or to his style of drawing. In spite of a certain resemblance of the linework to that of Aliense's sketches (see No. **12**) the very marked contrast between the dark silhouettes in the foreground and the light background points to an origin in the 17th century. Only at that time were such painterlike effects aimed at in drawings in Venice, as well as elsewhere. Drawings by Salvatore Rosa, for instance, have a very similar character, compare *O. M. D.* vol. VI, pl. 54 to 56.

A CHATSWORTH, DUKE OF DEVONSHIRE, no. 273. See No. **1483**.

A CHELTENHAM, FENWICK COLL., Popham p. 104, 1. See No. **1774**.

1577 ————, Popham p. 104, 2. Studies of legs and an ornamental pattern. Charcoal, height. w. wh., on blue. 408 x 473.

Early period in which we are told by Ridolfi, Jacopo drew studies from separate limbs.

A COPENHAGEN, COLL. I. F. WILLUMSEN. Nude male figure, recumbent, see No. **1485**.

A ————. Nude male rowing. See No. **1486**.

1578 DARMSTADT, KUPFERSTICHKABINETT, 1439. Nude male figure seated, turned to the l.; drapery indicated. Bl. ch., on blue. 242 x 142. Squared for enlargement. Hadeln, *Tintorettozeichnungen,* pl. 21 and p. 35: resembling the figure of Aaron in the "Worshipping of the Golden Calf" in the Madonna dell'Orto (ill. Bercken-Mayer 62). E. Tietze-Conrat, in *Graph. Künste* N. S. I. p. 91 stressed the connection of the drawing with this figure.

Hadeln was right in acknowledging only a general similarity of the postures of the two figures. The drawing belongs more probably to another composition from Tintoretto's early period.

A ———— 1436, 1437, and Man on horseback. See Nos. **883**, **1775**, **884**.

1579 DETROIT, MICH., ART INSTITUTE 34153. Head of a bearded man, turned to the r., and foreshortened. Bl. ch., fixed with brush, height. w. wh., on bluish paper. 285 x 203. The outline at the r. damaged or worked over, the paper torn. E. Scheyer, *Drawings and Miniatures from the 12th to the 20th century in the Art Institute in Detroit:* J. Tintoretto, study from a sculpture, the eyes being left blank. **[MM]**

The attribution is made difficult by the bad state of preservation. In our opinion, the character of the drawing is close enough to that of heads behind Eve in the painting "Christ in Limbo" in S. Cassiano, Venice (compare the details in *Mostra del Tintoretto*, p. 135), to justify the attribution to Jacopo.

A DRESDEN, KUPFERSTICHKABINET. Man working with a spade. See No. **1487**.

A EDINBURGH, NATIONAL GALLERY OF SCOTLAND, 697. See No. **891**.

A ———, 758, See No. **1777**.

A ———, 1853, 1854, 1855. See Nos. **1778, 1779, 1780**.

1580 ERLANGEN, UNIVERSITÄTSBIBLIOTHEK, Bock 1542. Study from sculpture, head of a Roman emperor. Bl. ch., height, w. wh., on buff. 411 x 272. Late inscription: Jacopo Tintoretto. — *Verso:* the same head.

We have not seen this and the following drawing.

A 1581 ———, Bock 1543. Pilgrim saint, seated and reading, turned to the l., half-length. Bl. ch., height. w. wh. 336 x 320. Upper l. corner cut. Later inscription in pen: Domenico Tintoret. Ascr. to Jacopo Tintoretto, an attr. already rejected by Bock. **[MM]**

In our opinion, not Venetian but more likely by a Netherland artist about 1600; compare the series of apostles engraved after Goltzius by Jacob de Gheyn. With respect to the presumable connections between Jacob de Gheyn and Spanish painters we should also like to point out the notable resemblance of this drawing to others attr. (mostly with well justified reservations) to Velasquez. (See A. L. Mayer, *Dibujos originales* pl. 79 or 85.)

A FLORENCE, UFFIZI, 738. See No. **900**.

A ———, 1662 E. See No. **1782**.

A ———, 1811. See No. **1784**.

A ———, 1815 F. See No. **1785**.

A 1582 ———, 1816. Elevation of the Cross. Brush, gray, on faded blue. 80 x 132. (Photo Alinari 1825). Ascr. to J. Tintoretto.
 [*Pl. CLXXXVIII*, 2. **MM**]

In our opinion, nothing speaks in favor of Ja. Tintoretto. There is no connection with any of his paintings and the vertical postures contradict his style. The hastiness of the sketch makes an attribution difficult. At any event, the drawing seems to belong to an artist anterior to Jacopo Tintoretto.

A ———, 1827. See No. **1786**.

A ———, 1830. See No. **3**.

1583 ———, 1833. Draped female nude standing, imitating an antique figure. Charcoal, subsequently reworked with the brush, on brownish gray. 350 x 134. Stained by spots of oil color. — On *verso:*

an inscription apparently by the same hand as the drawing. *Uffizi Publ.* I, 2, no. 13. Meder, *Handzeichnung*, p. 108 reproduces the drawing as a typical example of a drawing in oilchalk. Hadeln, *Tintorettozeichnungen*, pl. 55, p. 13 rejects this technical description; Meder may have been misled by the wrong impression of the reproduction. E. Tietze-Conrat, in *Graph. Künste* N. S. I, p. 89 suggests that a sculpture was used as model and points to similar ones ascr. to Aspetti (ill. Planiscig, *Venezianische Bildhauer*, fig. 632 ff.); the figure at the r. in the "Last Supper" in San Simeone (Ill. Bercken-Mayer 45) may go back to a drawing after the same sculpture.

We do not maintain the later suggestion.

1584 ———, 1834. Study from a seated male figure, seen from behind. Preparatory study for No. **1591** used for the female figure in the lower l. corner of the "Adoration of the Golden Calf," in the Madonna dell'Orto. The r. leg of the next figure in the painting is clearly recognizable at l. Bl. ch., on blue. 287 x 207. Squared. Publ. by Hadeln, *Tintorettozeichnungen*, pl. 19, p. 34 ff., 42, 57.
 [*Pl. CVI*, 2. **MM**]

1585 ———, 1837. Draped standing figure in half-length, seen from behind, used in the "Crucifixion" in the Scuola di San Rocco, Venice. Bl. ch., height. w. wh., on blue. 334 x 180. Cut and damaged. Publ. by E. Tietze-Conrat, *Graph. Künste*, N. S. I, p. 100, fig. 11. The drawing is dated 1565 by the painting. [*Pl. CV*, 2. **MM**]

A ———, 1838. See No. **1788**.

A ———, 1839. See No. **1489**.

A ———, 1840. See No. **1789**.

1586 ———, 12922. Bearded man, nude, recumbent, design for ceiling in the Albergo in the Scuola di San Rocco. Charcoal on yellow. 174 x 302. Squared. Original inscription: San marco. Hadeln, *Tintorettozeichnungen*, pl. 22. **[MM]**

Dated 1564 by the painting.

1587 ———, 12923. Study from draped model. Bl. ch. 245 x 114. Squared. — *Verso:* the same figure, traced, with a different squaring. Hadeln, *Tintorettozeichnungen*, pl. 65.

1588 ———, 12924. Study for one of the archers in the "Battle of Zara." Bl. ch., on gray. 370 x 209. Original inscription: fatto. Ill. *Uffizi Publ.*, I/2, no. 25. Mentioned by Hadeln, in *Tintorettozeichnungen*, p. 48.

Belongs to the same group of drawings as No. **1590, 1592**(?), **1615, 1621**.

1589 ———, 12925. Draped figure standing. Bl. ch., on blue. 281 x 174. — *Verso:* Hasty study for the upper part of the same figure. Mentioned by Hadeln, *Tintorettozeichnungen* p. 36. Perhaps first idea for one of the attendants (next to the head of the horse) in the "Crucifixion" in the Scuola di San Rocco, dated 1565. **[MM]**

A ———, 12928, see No. **1490**.

1590 ———, 12929. Design for one of the archers in "The Battle of Zara," Ducal Palace (ill. B.-M. 182). Charcoal, on br. 366 x 220. Squared. Colorspots. Hadeln, *Tintorettozeichnungen*, pl. 47: about 1590; typical of Tintoretto's latest style.

See Nos. **1588, 1590, 1592, 1615, 1621**.

1591 ———, 12930. Design for female figure in lower corner of "Adoration of the Golden Calf," in Madonna dell'Orto. The figure is

male and naked. A second figure next to her is indicated. Bl. ch., on blue. 287 x 207. Squared. Worked over on the squaring. Hadeln, *Tintorettozeichnungen* pl. 20 and p. 35: example for Tintoretto's habit of using male nude models for his draped female figures.

A dating in the early 1560's as suggested by the style of the painting, is confirmed by the resemblance with No. **1586**. The figure is prepared by No. **1584**.

1592 ————, 12931. Hasty sketch, perhaps for one of the archers in the "Battle of Zara." Charcoal. 325 x 208. Squared. [**MM**]
Resembling in style to Nos. **1588**, **1590**, **1615**, **1621**.

1593 ————, 12932. Design for the standard bearer in the "Capture of Gallipoli," Sala del Maggior Consiglio (Bercken-Mayer, 153). Bl. ch. 278 x 200. Squared. Hadeln, *Tintorettozeichnungen*, pl. 42: about 1580.
In the r. corner a sharply foreshortened head (according to Hadeln a caricature).

A ————, 12933. See No. **1491**.

1594 ————, 12935. Design of one of the men who raise the l. cross in the "Crucifixion," in the Scuola di San Rocco. Bl. ch. on blue. 289 x 158. Squared. Reworked with brush and pen. Colorspots. Ill. by Hadeln, in *Jahrb. Pr. K. S.* XXXIV, p. 96 and mentioned *Tintorettozeichnungen*, p. 16, note 8 as an example for a drawing disfigured by reworking. [*Pl. CV*, 3. **MM**]

A ————, 12936. See No. **1790**.

1595 ————, 12937. Draped standing figure. Bl. ch., on blue. 257 x 116. Squared. — *Verso:* The same figure in reverse, without the mantle. Mentioned by Hadeln, *Tintorettozeichnungen*, p. 36: connected with the "Philosophers" in the Libreria (see *Jahrb. Pr. K. S.* XXXII, p. 33); the drawing has been thoroughly reworked by an unskilled hand and has thereby lost most of its value. [**MM**]
In our opinion, the mantle was added in order to adapt the study for the philosopher. This addition filling the outline with parallel hatches, might have been done by a member of the shop, perhaps the same who drew No. **1790**.

1596 ————, 12938. Kneeling youth, carrying a beam (?) on his shoulder. Bl. ch., on blue. 354 x 194. Faded and rubbed. Squared in br. Later inscription: di Tintoretto. — *Verso:* Very indistinct sketch: flying figures or battle scene. [Both sides. **MM**]
Late in style, perhaps connected with the lost painting of the "Battle of Lepanto."

A ————, 12940. See No. **1791**.

1597 ————, 12941. Design for the ceiling in the Albergo of the Scuola di San Rocco, seated youth, turned to l. Charcoal. 210 x 280. Squared. Original inscription: Bontà. Hadeln, *Tintorettozeichnungen*, pl. 25. [**MM**]
Dated 1564 and forming a group with Nos. **1565**, **1586**, **1613**, **1631**.

A ————, 12942. See No. **1792**.

1598 ————, 12943. Design for a figure of S. John the Baptist in the "Baptism of Christ" in San Silvestro. In lower l. corner head and bust of Christ are sketched, deviating from execution. Charcoal. 305 x 196. Squared. Hadeln, *Tintorettozeichnungen*, pl. 35.

1599 ————, 12944. Nude figure kneeling, seen from behind. Bl. ch., on buff. 303 x 251. Squared. — *Verso:* the same figure traced, differently squared. [**MM**]
Late, possibly in connection with "Battle of Lepanto."

A ————, 12945. See No. **1492**.

1600 ————, 12946. Nude male figure, standing with legs far apart and outstretched arms. Bl ch. 308 x 214. Squared. Lower l. corner torn. [**MM**]

A ————, 12947. See No. **1493**.

A ————, 12948. See No. **1793**.

1601 ————, 12949. Standing male nude, turned to r., seen from front; l. arm lifted, behind the back drapery is indicated. Bl. ch. 301 x 186.
Hastily sketched and, perhaps for that reason, not very impressive.

1602 ————, 12950. Kneeling male nude, turned to l. Bl. ch., on buff. 185 x 267. Squared. Original inscription: temperantia. Modern inscription: Di Tintoretto. [**MM**]

A ————, 12951. See No. **1794**.

1603 ————, 12952. Study from a nude used for a Christ at the column. Bl. ch. 295 x 193. Modern inscription: del Tintoretto. — *Verso:* Nude traced from the other side and in part modified. Squared. Mentioned by Hadeln in *Burl. Mag.* XLVIII, p. 116, as Jacopo's study from the model, forming a link between Giovanni Bologna's relief of this subject and the recently acquired painting in Vienna (no. 254A), ill. ibid. pl. III, E. [*Pl. CIX*, 4. **MM**. Verso **MM**]
By reasons given on p. 258 we consider the drawing closely related to Domenico.

A ————, 12953. See No. **1795**.

1604 ————, 12954. Design for one of the soldiers in the "Reception of the Venetian legates by Barbarossa," in the Ducal Palace. Bl. ch. 309 x 189. Partly squared, but Hadeln questions whether the squaring is original. Stained by mold. Hadeln, *Tintorettozeichnungen*, pl. 43, dates in the late 1580's on the basis of the date of the painting. The connection with the painting first recognized by E. Waldmann, *Tintoretto*, p. 76, no. 6, caption. [*Pl. CXI*, 2. **MM**]
The drawing seems to have been used a second time for a knight in the foreground of the painting by Vicentino, "A king crowned by bishops," Gallery of Schleissheim in Germany.

1605 ————, 12955. Male nude sitting or floating, seen from behind. One leg is drawn a second time. Bl. ch., on gray. 278 x 185. Irregularly cut. [**MM**]
Late.

1606 ————, 12956. Crouching figure, turned to the l. Bl. ch. 290 x 207. Squared. Stained by mold. [**MM**]
Late.

1607 ————, 12957. Male nude, lifting the r. arm and holding a weapon in the l. hand. At the r. two studies for the lifted arm. Charcoal. 251 x 190. Original inscription: "no." Hadeln, *Tintorettozeichnungen* pl. 39. Waldmann, *Tintoretto*, p. 76. no. 12: Study for the "All Saints" painting in San Giorgio Maggiore (ill. Bercken-Mayer

196). The same reference was made by E. Tietze-Conrat, in *Graph. Künste*, N. S. I, p. 91. [MM]

The drawing might be the first idea, but does not correspond completely to the painting; the "no" may confirm that the drawing was not chosen for execution.

A ———, 12958, see No. **1494**.

1608 ———, 12959. Kneeling nude, the hands folded and looking over his own shoulder. Bl. ch., on buff. 274 x 170. — On the back: The same figure holding an object (grill?) in its hands. Squared. [MM]

Perhaps study for a "Last Judgment," and possibly used again for the figure of Saint Catherine in her "Martyrdom" in S. Caterina in Venice, ill. Bercken-Mayer 193.

A ———, 12960. See No. **1796**.

1609 ———, 12961. Design for the figure of Christ in the "Baptism of Christ" in San Silvestro. Bl. ch. 305 x 196. Squared. Hadeln, *Tintorettozeichnungen*, pl. 34. [*Pl. CVII*, 3. **MM**]
Dated about 1570, by the style of the painting.

1610 ———, 12962. A man standing, turned to the r., arm partly corrected. Bl. ch., on gray. 285 x 164. Squared. The outlines worked over by another hand. Stains of oilcolor. — *Verso:* the same figure hastily traced.

A ———, 12963. See No. **1797**.

1611 ———, 12964. Crouching figure seen from above. Bl. ch., on blue. Squared. The outlines worked over with the brush. Much damaged by mold. — *Verso:* the outlines of the figure traced. [MM]
The reworking and bad state of preservation make it difficult to judge the drawing.

1612 ———, 12965. Bearded warrior with a shield seen from front, rushing forward. Bl. ch., on buff. Squared. 227 x 158. [MM]
Late, perhaps study for the "Battle of Lepanto."

1613 ———, 12966. Study for Saint Theodore, in the ceiling in the Albergo of the Scuola di San Rocco. Bl. ch. 212 x 298. Squared. Original inscription: S. Todaro. Hadeln, *Tintorettozeichnungen*, pl. 23. [*Pl. CIV*, 1. **MM**]
Dated 1564 by the date of the ceiling.

1614 ———, 12967. Nude archer. Charcoal. 223 x 167. — On the back: inscription in Tintoretto's hand: noson p . . . bursa(?). Hadeln, *Tintorettozeichnungen*, pl. 45. Hadeln in *Jahrb. Pr. K. S.* XLII, p. 179 connects the drawing tentatively with a soldier in the "Battle of Argenta" in the Ducal Palace (Bercken-Mayer, 152), a suggestion which he later dropped probably because of the different posture of the legs. E. Tietze-Conrat in *Graph. Künste* N. S. I, p. 91 accepted Hadeln's first suggestion. [MM]

1615 ———, 12968. Design for an archer in the "Battle of Zara" in the Ducal Palace. Charcoal, on br. 322 x 207. Squared. Spots of oilcolor. — *Verso:* the same figure crudely traced and in reverse. Hadeln, *Tintorettozeichnungen*, pl. 48. [*Pl. CXI*, 1. **MM**]
Dated in the 1580's by the painting. See Nos. **1588, 1590, 1592, 1621**.

1616 ———, 12969. Male nude seen from behind, draped with waistcloth and indicated drapery. Bl. ch. 332 x 224. Squared. — *Verso:*

The same figure traced and seen from front. Hadeln, *Tintorettozeichnungen*, pl. 52 and p. 34: example of a casual indication of drapery. [MM]

A ———, 12970. See No. **1798**.

A ———, 12971. See No. **1799**.

A ———, 12972. See No. **1495**.

1617 ———, 12973. Kneeling man worshipping, seen from front. Bl. ch., on gray, outlines retouched with brush. 296 x 193. — *Verso:* Sketch of composition and figure traced from *recto*. The figure has a certain resemblance to one in the "Disputation of St. Catherine," ill. Bercken-Mayer, 188.

A ———, 12974. See No. **1800**.

1618 ———, 12975. Draped youth seated and seen from front. Bl. ch., on gray. 259 x 137. Squared. [MM]
Weaknesses of execution make us doubt the authenticity of the drawing.

1619 ———, 12976. Standing nude, turned to the r., resting on l. hand. Charcoal, on bluish gray. 247 x 115. Squared. Stained by mold, badly reworked and thereby almost unrecognizable.

1620 ———, 12977. Study for Eve in the painting "Christ in Limbo," in San Cassiano in Venice. Bl. ch., on bluish. 250 x 148. Squared. Publ. by Hadeln, *Tintorettozeichnungen*, pl. 28, who dates 1568 on the basis of the painting and p. 35, points out that Tintoretto used nude studies from female models for nude females, but studies from male nudes for draped women. Compare Nos. **1506, 1788**. [*Pl. CIV*, 3. **MM**]
In *Burl. Mag.* September 1939, vol. 75, p. 127, Mrs. L. Fröhlich-Bum publ. "An unrecognized painting by Tintoretto," ascr. to Schiavone in an Exhibition at Agnew & Sons. Discussing the painting the author points to our drawing and advances the theory that it was used not only for the painting in San Cassiano, but also — with the altered arm as indicated in the drawing — in the painting at Agnew's. With the best will, we are unable to recognize any connection between the drawing and the painting.

1621 ———, 12978. Study for one of the archers in the "Battle of Zara" in the Ducal Palace. Bl. ch., on blue. 324 x 265. Squared. [MM]
See Nos. **1588, 1590, 1592, 1615**.

A ———, 12979. See No. **1801**.

A ———, 12980. See No. **1496**.

A ———, 12981. See No. **1802**.

A ———, 12982. See No. **1803**.

1622 ———, 12983. Male nude with a mitre standing, seen from front. Bl. ch., on blue. 291 x 148. Squared. Stained with oil. — *Verso:* tracing of the same figure, worked over with the brush, and a poor variation of the figure on the *recto*. [*Pl. CVII*, 4. **MM**]
This figure is used in the votive painting of St. Catherine in the museum in Lyons.

1623 ———, 12984. Nude man seated, turned to the l., his head bent. Bl. ch., on gray. 202 x 192. Squared. [MM]

1624 ———, 12985. Seated youth, lifting both arms. Bl. ch. 271 x 197. Squared. Publ. by Hadeln, *Tintorettozeichnungen*, pl. 37. E. Tietze-Conrat, *Graph. Künste*, N. F. I, p. 91 points tentatively to the man crouching on the ground in the "Discovery of the body of S. Mark," ill. Bercken-Mayer, 69.

We do not maintain this suggestion, but consider the figure rather as the study for an angel sitting on clouds (perhaps in a Paradise). From the 1570's, 80's.

1625 ———, 12986. Design for one of the philosophers in the Libreria in Venice. Charcoal, height. w. wh., on gray. 298 x 201. Squared. Hadeln, *Tintorettozeichnungen*, pl. 56 and p. 50: The drapery is drawn over the squaring. According to Neumeyer, *Zeitschr. f. B. K.* 1928–29, p. 44 connected with the drawing No. **1678** and like the latter put in reverse in the final execution.

1626 ———, 12987. A youth running. Bl. ch., on gray. 225 x 230. Inscription in brush and oil: Fa. (Make it!) — *Verso:* tracing of the same figure, seen from behind. Some indecipherable words. The *recto* publ. by Hadeln, *Tintorettozeichnungen*, pl. 66. According to E. Tietze-Conrat, *Graph. Künste*, N. F. I, p. 90 study for one of the soldiers in the "Battle of Legnano," in Munich, ill. Bercken-Mayer pl. 137. **[MM]**

Dated before 1580 by the painting.

1627 ———, 12988. Draped female figure, standing. Bl. ch., height. w. wh., worked over with brush. 309 x 106. Squared. Mentioned by Hadeln, *Tintorettozeichnungen*, p. 16, note as an example of a drawing spoiled by retouching. **[*Pl. CXIII*, 1. MM]**

Used in Tintoretto's "Finding of Moses" in Vienna (Photo Wolfrum 1686), apparently a shop production, which enriches, reversing the direction, Jacopo's original composition in the Metropolitan Museum in New York (no. 39.55). The drawing was used for one of the figures added in the later version. The bad state of preservation of the drawing makes it impossible to judge its authenticity.

A ———, 12989. See No. **1804**.

1628 ———, 12991. Nude seen from behind, raising the l. leg in a vehement movement. Bl. ch., on blue. 375 x 253. Squared. Stained by mold and colorspots. — *Verso:* the same nude with notable modifications. **[MM]**

Similar in style to No. **1616**.

A ———, 12992. See No. **1497**.

A ———, 12993. See No. **1498**.

1629 ———, 12994. Kneeling figure turned to l., lifting his clasped hands to his chest. Ch., almost entirely worked over with the brush. 206 x 175. Mentioned by Hadeln, *Tintorettozeichnungen*, p. 35, in connection with No. **1672** and with reference to a similar figure in an "Adoration" in the Escorial. Ill. by E. Waldmann, *Tintoretto*, p. 76, no. 15, as an example of a charcoal drawing.

1630 ———, 12995. Standing youth, seen from front, bending to the r. and looking to the l., with indicated drapery. Bl. ch., on blue, the outlines worked over with the brush. 400 x 213. Squared. Ruined by reworking. — *Verso:* Head (resembling Laocoön's) and authentic inscription: Matteus(?) **[*Verso* MM]**

The same head only less hastily executed in No. **1673**.

A ———, 12996. See No. **1805**.

1631 ———, 12997. Seated youth, design for ceiling in the Albergo of the Scuola di San Rocco. Charcoal. 214 x 276. Squared. Lower r. corner added. Original inscription: felicità. Publ. by Hadeln, *Tintorettozeichnungen*, pl. 24. **[MM]**

Companion piece of Nos. **1565**, **1586**, **1597**, **1613**, all to be dated 1564.

1632 ———, 12999. Study for the painting "Christ washing the feet of the apostles" in Sto. Stefano. Charcoal. 345 x 395. Partly squared. Publ. by Hadeln, *Tintorettozeichnungen*, pl. 15: dated in the late 1570's on the basis of the painting and on p. 33 called a combination of separate study and composition.

A ———, 13001. See No. **1499**.

A ———, 13002. See No. **1500**.

A ———, 13003. See No. **1501**.

A ———, 13004. See No. **1806**.

1633 ———, 13005. Study for the two soldiers throwing at dice in the foreground of the "Crucifixion" in the Academy in Venice. Bl. ch., on two pieces of bluish paper patched together. 215 x 430. Publ. by Hadeln, *Tintorettozeichnungen*, pl. 60, who dates about 1560 and describes the proceeding as following: Each figure was drawn separately, then they were patched and squared, subsequently somewhat height. w. wh. and also otherwise reworked.

1634 ———, 13006. Young man bending to the l. and carrying a vessel. Charcoal, on grayish blue. 261 x 295. Publ. by Hadeln, *Tintorettozeichnungen*, pl. 62 as a study for one of the servants in the "Wedding of Cana" in Santa Maria della Salute; he dates the drawing 1561 with reference to the painting, and on p. 37 mentions it as an example of a drawing not squared and not used in the final execution. **[MM]**

In our opinion, there is only a general resemblance between the two figures. The pose is typical of Tintoretto and appears as early as the "Queen of Sheba" in Vienna, ill. *Zeitschr. f. B. K.*, vol. XXXIII (1922), p. 31, fig. 8 and very similar in Domenico's "Martyrdom of St. Stephen" (ill. Venturi 9, IV, fig. 450). Such a figure intended for the foreground, in 1561, should be more voluminous, more in the style of No. **1633**. If by Jacopo, the drawing should positively be later.

A ———, 13008. See No. **1807**.

1635 ———, 13009. Design for "Saint Martin with the beggar." Charcoal, on brownish gray. 400 x 242. Squared. According to Hadeln height. w. wh. over the squaring. — On the back inscription (17th century): del Tintoretto Vecchio l'opera è afresco a Sto Stefano di Venetia. Publ. by Hadeln, *Tintorettozeichnungen*, pl. 14, who (p. 51) mentions a no longer existing mural painting on the chimney of a house on the Campo Santo Stefano (Ridolfi II, 42 and Boschini, *Minere, San Marco*, p. 87) where, however, not Saint Martin, but S. Vitale was represented. **[*Pl. CXIII*, 3. MM]**

In our opinion design perhaps for a likewise vanished altar-piece in San Martino in Murano, which according to Boschini was "restored" by Palma Giovine, according to Ridolfi by Malombra. See No. **891**.

1636 ———, 13013. Bishop kneeling, turned to the l. Charcoal height. w. wh., on blue. Squared. 294 x 200. Worked over with the brush. Publ. by Hadeln, *Tintorettozeichnungen*, pl. 59.

A ————, 13015. See No. **1502**.

1637 ————, 13017. Bishop. Study of drapery, the head scarcely discernible. Bl. ch., height. w. wh., on blue. Squared. — *Verso:* later inscription: Del Tintoretto nel organo de Frati de Servi. **[MM]**

Accordingly the drawing might refer to Tintoretto's lost paintings of the Saints Augustine and Paul in the Servi, mentioned by Ridolfi II, p. 17.

A ————, 13019. See No. **1808**.

A ————, 13022. See No. **1503**.

1638 ————, 13023. Annunciate Virgin. Bl. ch., height. w. wh., on faded blue. 202 x 162. — *Verso:* Group of indistinct figures.
 [*Pl. CX*, 2. **MM**]

The study is used in the colorsketch, No. **1725** and in the painting, formerly in San Matteo (Ridolfi II, 49), later in San Isaia, and now in the Pinacoteca of Bologna, discovered and publ. by Matteo Marangoni, in *Rass. d'A.* 1911, p. 99. According to Pittaluga, p. 263, the painting is a typical shop production with hardly any participation of the Master himself.

The design, nevertheless, seems to be Jacopo's, especially in view of the outstanding quality of No. **1725**.

A ————, 13024. See No. **1809**.

A ————, 13025. See No. **1810**.

1639 ————, 13026. Study for an archer. Charcoal, height. w. wh., on blue. 288 x 220. Squared. Publ. by Hadeln, *Tintorettozeichnungen*, pl. 68, according to whom the drawing prepares one of the archers in the middleground of the "Battle on the Taro" in Munich (Bercken-Mayer, 139). Popham *Cat.* 282. **[MM]**

The study which we failed to identify in the painting in Munich, might belong to the (lost) "Battle of Lepanto."

A ————, 13027. See No. **1910**.

1640 ————, 13028. Nude, used for one of the thieves in "Christ carrying the Cross" in the Scuola di San Rocco. Charcoal, on greenish gray. 378 x 201. Squared. — On *verso:* the same nude, not squared. Hadeln, *Tintorettozeichnungen*, pl. 27 (*verso*). Dated 1566 by the painting.

A 1641 ————, 13030. Female head with snakes in the hair. Bl. ch., height. w. wh., on blue. 413 x 268. Colorspots. Inscription in pen: Tintoretto sicuro. — On *verso:* Presentation of Christ, corresponding to the painting in the Academy in spite of interesting modifications, ill. Bercken-Mayer, 50. Inscription: Tintoretto. L'opera è in chiesa de Crociferi. [Both sides. **MM**]

Notwithstanding the deviations from the painting, the drawing is not a design, but a typical copy, which in view of the style of the *recto* we are inclined to place in the 17th century.

1642 ————, 13041. Study for a warrior at r. in the painting "Investiture of Giov. Franc. Gonzaga," in Munich (ill. Bercken-Mayer 136). Bl. ch., on grayish blue. 347 x 167. Squared. Somewhat rubbed. According to Hadeln the armor is possibly drawn over the nude and height. w. wh. over the squaring. Publ. by Hadeln, *Tintorettozeichnungen*, pl. 70, adding that the figure in the painting is slightly modified.

Dated 1579/80 by the painting.

A ————, 13045. See No. **1811**.

A ————, 13046. See No. **1812**.

1643 ————, 13048. Study after Michelangelo's Crepuscolo. Bl. ch., on blue. 273 x 371. — On the back: Study from the same sculpture in the same position. Publ. by Hadeln, *Tintorettozeichnungen*, pl. 6. According to Hadeln the heightening with white mostly, if not entirely, by another hand. Exh. London, 1930, Popham, *Cat.* 277.
 [*Pl. CXII*, 2. **MM**]

A ————, 17133. See No. **1813**.

A ————, 17134. See No. **1814**.

1644 ————, 17237. Study from an antique bust. Charcoal, height. w. wh., on blue. 355 x 236. — *Verso:* Two armed warriors shooting, half-length. A few written notes, apparently authentic, but very much rubbed. *Recto* reproduced in Hadeln, *Tintorettozeichnungen*, pl. 3, p. 52. The authenticity of the heightening on the *recto* is questionable, on the *verso* it is certainly to be denied; p. 24; mature period. [Both sides. **MM**]

In our opinion about 1580, the warriors on the *verso* possibly connected with the "Battle of Lepanto."

1645 ————, Santarelli, 7475. Standing nude, bending to the r., raising his hands to the chest. Bl. ch., height. w. wh. 350 x 135. Squared. The outlines reworked with the brush.

The drawing is so much damaged by the retouching that it seems difficult to judge its authenticity.

1646 ————, Santarelli 7476. Study of a nude man, standing, seen from front, his r. hand holding a cloth to his upper thigh. His l. hand, which shows many corrections, raised. Charcoal, on gray. 379 x 227. — On *verso:* Arm with sleeve. The *recto* publ. by Hadeln, *Tintorettozeichnungen*, pl. 26. Suida in his review of Hadeln's book (*Belvedere* IV, p. 155): probably for a Saint Roch. E. Tietze-Conrat, in *Graph. Künste*, N. S. I, p. 90: design for the bishop at the r. in the painting "The Doge Mocenigo intercedes with the Savior," Sala del Collegio, Ducal Palace, Venice (ill. in Luigi Serra, *Il Palazzo Ducale di Venezia*, p. 71).

The legs of the bishop in the painting differ in their position from the drawing so that we withdraw this reference.

1647 ————, Santarelli 7484. Clay figure, so-called Atlas, turned to the r. Charcoal, on blue. 266 x 170. Very much rubbed. Mentioned by Hadeln, *Tintorettozeichnungen*, p. 27.

1648 ————, Santarelli 7498. Design for a composition, "the Return of the Prodigal Son." Bl. ch., on blue. 378 x 272. Publ. by Hadeln, *Tintorettozeichnungen* pl. 13 as a design for a "Flagellation of Christ," and dated posterior to No. **1561**. The connection with the ceiling in the Palazzo Ducale (Bercken-Mayer 31) was first suggested by E. Tietze-Conrat in *Graph. Künste* N. S. I, p. 92.

A ————, Santarelli 7487. See No. **1816**.

A ————, Santarelli 7499. See No. **1817**.

A ————, Santarelli 7512. See No. **1818**.

A ————, Santarelli 7513. See No. **1506**.

1649 FLORENCE, HORNE FOUNDATION, 5665. Study from Michelangelo's head of Giuliano de' Medici. Bl. ch., height. w. wh.. on br.

340 x 229. Much damaged. Mentioned by Hadeln, *Tintorettozeich-nungen* p. 26.

We accept the attribution to Jacopo with reservations; the state of preservation makes the decision difficult.

1650 ———, 5666. Study for a draped bearded man. Bl. ch. 234 x 142. Squared for enlargement. All the lines including the squaring reworked with brush and oilcolor. Mounted. Hadeln, *Jahrb. Pr. K. S.* XLII, p. 182, note 1: Counterproof of a lost original, which was a design for J. Tintoretto's painting of St. Jerome in Vienna (no. 254A); since the strokes appeared feeble they were retouched with the pen. Pittaluga, *Tintoretto*, p. 268: study for the St. Jerome in Vienna. Joh. Wilde, in *Zeitschr. für Kunstgeschichte*, 1938, p. 140 notes the connection of the drawing with one of the "Philosophers" in the Libreria in Venice and suggests that the retouching of the drawing occurred in connection with its use in the opposite direction for the "St. Jerome" whose attribution to J. Tintoretto he supports. [*Pl. CVI*, 3. **MM**]

We agree with Wilde for the connection of the drawing with one of the "Philosophers," but we do not agree with his further conclusions. In our opinion, the drawing is the original design for the "Philosopher" and was worked over with oil to give a print in the opposite direction and in this shape was used by the shop for the execution of the "Saint Jerome." The drawing may have originated about 1571/2.

1651 FRANKFORT/M., STAEDELSCHES INSTITUT, 464. Study from an antique head, the so-called Apollo. Bl. ch. height. w. wh., on buff. 288 x 197. Publ. in *Stift und Feder* 1927, 82 as study after Michelangelo's Giuliano. [**MM**]

1652 ———, 15701. Study from an antique head, the so-called Apollo. Bl. ch., height. w. wh. — 383 x 262. — *Verso:* Similar study. Lahmann Coll. Publ. by Swarzenski-Schilling No. 60 as study after Michelangelo's Giuliano. [*Pl. CXXIV*, 1. **MM**, *Verso* **MM**]

A ———, 4420. See No. **1819**.

1653 FRANKFORT, PRIVATE COLL. Design for the crouching figure at the l. in the Baptism of Christ, Scuola di San Rocco (ill. Bercken-Mayer 123). Bl. ch. 237 x 215. Squared for enlargement Coll. Sir Joshua Reynolds. Mentioned by Hadeln, in *Burl. Mag.* XLIV, p. 283. Ill. in Swarzenski-Schilling, No. 59.

The drawing is dated 1577–1581 by the painting.

A 1654 GENOA, PALAZZO BIANCO. Head of an old man. Charcoal, height. w. wh., on gray. 240 x 185. Publ. by O. Grosso–A. Pettorelli, *I Disegni di Palazzo Bianco*, 1910, No. 3.

In our opinion, without connection with Jacopo Tintoretto.

1655 HAARLEM, COLL. KOENIGS, I 72. Male nude seated, turned to the r. Bl. ch., on br. 371 x 282. Squared. Late inscription: Tintoretto. Coll. Dadda. Stylistically related to No. **1558**. [**MM**]

A ———, I 73. See No. **1821**.

A ———, I 74. See No. **1511**.

1656 ———, I 75. Study of the figure of Judas in the Last Supper in San Giorgio Maggiore (ill. Bercken-Mayer, 199). Bl. ch., on blue. 313 x 205. Squared. — On the back: the same figure, slightly modified. Publ. by Hadeln, in *Burl. Mag.* XLIV, p. 284 pl. I, B. Dated by the painting about 1590. [*Pl. CXIII*, 2. **MM**]

1657 ———, I 76. Design for the man in the middle of the "Defense of Brescia" in the Ducal Palace, ill. Bercken-Mayer 150. Bl. ch. 301 x 302. Squared. Damaged by mold. Late inscription: Tintoretto. — On *verso:* the outlines of the drawing on the *recto* are traced, but the figure is shown from behind. Coll. Dadda. Publ. by Hadeln, *Koenigszeichnungen*, 11. Exh. Paris 1935, Cat. Sterling 711. [*Pl. CIX*, 1. **MM**]

Dated by the painting in the early 1580's.

1658 ———, I 77. First idea of a man shooting with a gun, used in the ceiling "Battle on the Lake of Garda," ill. Bercken-Mayer 151. Bl. ch., on blue. 358 x 286. — On *verso:* the outlines traced, the figure shown from behind. Coll. Dadda. Exh. Amsterdam, *Cat. Oude Kunst* 1929, no. 297, and Amsterdam 1935, Cat. no. 683. [**MM**]

The drawing which shows several corrections, is dated in the early 1580's by the painting.

1659 ———, I 80. Study of a nude bearded man, seen from front and a child seen from behind. Bl. ch. 328 x 225. Late inscription: Tintoretto. Coll. Dadda. [**MM**]

The posture of the man corresponds to that in No. **1808** done in the shop. Both drawings are studied perhaps from a sculpture. The middle figure in the "Battle on the Lake of Garda" (Bercken-Mayer 151) is very similar to the drawing, especially when we take into account the corrections indicated at the l. leg. This modified posture might have been taken over in a definitive design for this figure.

1660 ———, I 81. Design for Adam and Eve, in Scuola di San Rocco (ill. Bercken-Mayer 112). Bl. ch. 278 x 433. Squared. Coll. Dadda. Publ. by Hadeln, *O. M. D.* I, pl. 25 and in *Koenigszeichnungen*, No. 12. Exh. Paris 1935. [*Pl. CVIII*, 2. **MM**]

Dated in the 1570's by the painting.

1661 ———, I 82. Study of a nude, seen from behind, seated on a globe (?). Bl. ch., 397 x 264. Late inscription: Tintoretto. — On *verso:* the outlines traced, the figure shown from the front. Coll. Dadda. [*Pl. CIX*, 3. **MM**]

The *recto* may have been used by Do. Tintoretto in his "Vision of St. Bridget," Capitol Gallery, Rome, although in reverse.

1662 ———, I 83. Man, bending to the r., two figures seated, hardly discernible. Bl. ch., on blue. 266 x 418. Squared. [**MM**]

The figure may have been used in reverse in the shop painting "The Medianite maidens," in Madrid, ill. Bercken-Mayer 94.

1663 ———, I 205. Study from an antique head. Bl. ch., on faded blue. 340 x 226. — On *verso:* another study from the same head. Publ. in Hadeln, *Koenigszeichnungen*, No. 8. Exh. Amsterdam 1935, Cat. no. 676.

The same model is used in No. **1644**.

1664 ———, I 206. Nude. Design for the man with the sponge in the "Crucifixion" in the Scuola di San Rocco, ill. Bercken-Mayer 73. Bl. ch., on blue. 286 x 235. Squared. Coll. Bellingham-Smith. Publ. by Hadeln, in *Burl. Mag.* XLVIII, p. 117, pl. II, C and in *Koenigszeichnungen* No. 9. [*Pl. CV*, 4. **MM**]

Dated 1565 by the painting.

1665 ———, I 223. Sheet with four studies from the so-called Atlas. Ch. and brush, on gray. Late inscription: No. 4b (and) Jacomo Tintoretto. — On *verso:* Four other studies from the same figure.

1666 ———, I 224. Study after Michelangelo's group "Samson

slaying the Philistine." Bl. ch., height. w. wh., on gray. 429 x 272. Coll. Vallardi, Locarno, Simonetti. Exh. Amsterdam 1934, Cat. 679 and Paris 1935, Sterling Cat. no. 713.

Closely resembling No. **1564.**

A ———, 255. See No. **1825.**

1667 ———, I 331. Bearded nude seated, turned to the l.; the r. arm is repeated in a second position. Bl. ch., on blue. 375 x 230. Squared with pen. Late inscription: G. Tintoretto. **[MM]**

For stylistic reasons to be placed in the late 1560's.

1668 ———, I 341. Study from an antique head of Vitellius. Bl. and wh. ch., on br. 395 x 260. — On *verso:* Another study from the same head. Coll. Simonetti. Exh. Amsterdam 1934. Cat. 675.
 [*Pl. CXXIV,* 3. **MM**]

1669 ———, I 343. Study of the so-called Atlas. Bl. ch., height. w. wh., on blue. 268 x 181. — On *verso:* Study of the same figure. Coll. A. G. B. Russell. Mentioned by Hadeln, *Tintorettozeichnungen,* p. 28, note, publ. by the same in *Burl. Mag.* XLIV, p. 278, pl. I, A as a study after a plastic model and in *Koenigszeichnungen,* 7. Exh. Amsterdam 1934, Cat. 680.

1670 ———, I 374. Male nude recumbent with outstretched l. arm. Bl. ch., on faded blue. 326 x 250. Squared. Coll. Reynolds.
 [MM]

The posture resembles the dead body in the early painting "Saint George fighting the dragon," in London, but the drawing is later.

1671 ———, I 396. Study from the so-called Atlas. Bl. and wh. ch., on br. 330 x 218. Coll. J. Boehler.

1672 ———, I 397. Study of a male nude, with hands clasped. Bl. ch. 349 x 198. Squared. Stained by mold. Late inscription: G. Tintoretto. Coll. J. Boehler. Acquired in 1929. Hadeln, *Tintorettozeichnungen,* pl. 40, and p. 35: perhaps for the "Last Judgment."

1673 ———, I 398. Study from head of Laocoön. Bl. ch., height. w. wh. (partly oxidized), on blue. 395 x 285. Late inscription: questi e seguenti schizzi del Tintoretti. Col. J. Boehler. **[MM]**

See No. **1630.**

A ———, I 399. See No. **1513.**

1674 ———, I 400. Man clothed, walking to the r., bending back. Bl. ch., on blue. 402 x 272. Squared. — On *verso:* Kneeling nude, turned to the r. Coll. J. Boehler. Acquired 1929.
 [*Pl. CVI,* 1. **MM**]

The drawing on the *recto* is a design for one of the men carrying the golden calf in the painting in the Madonna dell'Orto, ill. Bercken-Mayer 62. The figure on the *verso* is definitely poorer and may have been drawn by some member of the shop.

A ———, I 403. See No. **1514.**

1675 ———, I 405. Study for the sleeping oarsman in the painting "Pax tibi Marce," ill. *Mostra del Tintoretto,* No. 71. Bl. ch., on blue. 288 x 202. Squared. Coll. J. Boehler. Acquired 1929. Publ. by Hadeln, *Burl. Mag.* XLVIII, p. 117, pl. II, D. Exh. Amsterdam 1934, Cat. No. 684. [*Pl. CVII,* 2. **MM**]

Hadeln dated the drawing in 1568, the date then presumed for

the painting. In the cat. of the Mostra the question of the date is reconsidered with the result that the connection with the date 1568 is declared erroneous; the series to which the Pax tibi Marce belongs would have been started by Jacopo after 1585 and continued by Domenico. Leaving aside the question as to whether the painting was executed by Jacopo alone, shows evidence of Domenico's collaboration, or is by the latter as a whole, we must at least state that our drawing is very different from No. **1529** connected with the same painting. This difference may be explained by surmising that the drawing in question is earlier and that the painter, whoever he was, may have gone back to a study kept in the studio.

1676 ———, I 406. Nude seen en face, holding a staff in both hands. The r. arm is drawn in various positions. Bl. ch., on blue. 432 x 273. — On *verso:* Head of a young woman. Coll. Julius Boehler. Acquired 1929. **[MM]**

The drawing on the *recto* may be one of the studies for the "Battle of Lepanto." — For the back see No. **1761.**

1677 ———, I 452. Study for one of the executioners in the "Martyrdom of St. Lawrence," Christchurch Library, Oxford. Bl. ch., on bluish green. 261 x 192. Squared. Modern inscription: G. Tintoretto. Coll. Reynolds, Boehler. Acquired in 1929. Publ. by Hadeln, *Tintorettozeichnungen* p. 43, 53, 58, pl. 46 as design for a warrior in the "Rape of Helena" (ill. Bercken-Mayer 194) and dated about 1590. Accepted by Bercken-Mayer 208. Hadeln, in *Burl. Mag.* XLVIII, p. 116 noted that the drawing was first used in the painting in Oxford (ill. ibidem pl. II D) and modified in the "Rape of Helena."

See No. **1682** and No. **1700.**

A 1677 bis ———, I 681. Portrait of a bearded man, en face. Bl. and wh. ch., on gray. 120 x 100. Inscription (partly cut): Gio. . . . Maganza ritratto del Tintoretto. — On *verso:* I. T. No. 12 (Borghese Collection, Venice) and above, again cut: Effigies . . . del gran Titiano. Exh. Amsterdam 1934, no. 681 as Jacopo Tintoretto. **[MM]**

The drawing might be a portrait of Gio. Battista Maganza the younger, but certainly has nothing to do with Tintoretto.

1678 HAMBURG, KUNSTHALLE, 21547. Design used for one of the "Philosophers" in the Libreria, Venice. Charcoal, on blue. 255 x 137. Squared. The outlines are heavily reworked with the brush. In lower r. corner late inscription: G. Tintoretto. Publ. by Neumeyer, in *Zeitschr. f. B. K.,* 1928/29, p. 44: the painting shows the figure in reverse. Hadeln, who in *Jahrb. Pr. K. S.* XXXII, p. 36 had attr. this painting to Pietro Vecchia "rather than to Jacopo Tintoretto," corrected this statement in *Jahrb. Pr. K. S.* XLII, p. 172, note I in "Production of Jacopo's shop." **[MM]**

The reworking, probably done in order to get a counter-proof, has practically ruined the drawing so that the question of Jacopo or a pupil must remain undecided.

1679 LAUSANNE, COLL. STROELIN. Study from Michelangelo's group "Samson slaying the Philistine." Bl. ch., height. w. wh., on brownish. 350 x 215. Inscription: di Michelangelo Buonaroti. — On *verso:* Study after the same group.

1680 LENINGRAD, HERMITAGE. Design for the angel in the ceiling "Elija in the wilderness" in the Scuola di San Rocco, ill. Bercken-Mayer 117. Charcoal, on light br. 360 x 260. Squared. Publ. and identified by Dobroklonski, *Apollo,* 1932, I, p. 148, fig. III, and in Art

1934, 4, 145 f. Dated by the painting in the 1570's. [*Pl. CVI, 4.* **MM**]
We have not seen this and the following drawings in Leningrad.

1681 ————. Nude, design for Saint Justina, in the painting in the Academy in Venice, ill. Bercken-Mayer 146 where the figure is slightly modified. Bl. ch., on gray. 350 x 265. Squared. Publ. and identified by Dobroklonski, in *Apollo* 1932, I, p. 149, fig. IV, with reference to Nos. **1492**, **1584**, **1591**. [**MM**]

In our opinion, the drawing is closer in style to No. **1632** and is to be placed in the 1570's.

1682 ————. Male nude, floating, seen from front. Bl. ch., worked over with brush and oil. 345 x 240. Partly squared. Contemporary indecipherable inscription. — On *verso:* the same figure traced. Exh. Leningrad 1926, No. 71. Publ. by Dobroklonski, in *Apollo*, 1932, I, p. 147, fig. I and II. The inscription in his opinion reads: a Za(nco?) red (isegnare?). He further considers the figure on the *recto* as resembling the lying figure in the "Temptation of S. Anthony" in San Trovaso, and the one on the *verso* to have served for a fallen soldier in the "Battle of Legnago" in Munich (Bercken-Mayer 100, resp. 137). [Both sides. **MM**]

Both references fail to convince us. The figure on the *verso*, in our opinion, resembles far more the figure of St. Lawrence in the painting of his martyrdom in Oxford, Christchurch (*Burl. Mag.* 48, pl. II D opposite 116). The r. arm which in the drawing is worked over with the brush to the point of not being discernible, is modified in the painting.

1683 ————. Study of a male figure, flying and blowing a trumpet which he holds in his l. hand. Bl. ch., on brownish paper. 285 x 220. Squared. Publ. by M. Dobroklonski, in *Apollo*, 1932, I, p. 149, fig. V. [**MM**]

A 1684 LONDON, BRITISH MUSEUM, 1856-7-12 — 1000. Youth kneeling (executioner from a Crucifixion?) Bl. ch., on blue. 255 x 184. Ascr. to Jacopo Tintoretto. [**MM**]

In our opinion, without any connection with J. Tintoretto. Close in style, and even in costume, to No. **1750** which also was attr. to Tintoretto, but is an authentic work by Lattanzio Gambara.

A ————, 1885-5-9 — 1656 to 1660. See No. **1832**.

A 1685 ————, 1893-7-31 — 17. Martyrdom of S. Lawrence; above glory of large angels surrounding Christ. Over red and bl. ch. pen, br., on faded blue. 340 x 230. Ascr. to Jacopo Tintoretto. [**MM**]

In our opinion, close in style to the painting of the same subject by Lazzaro Tavarone (1662), on the ceiling of the choir of the cathedral of Genoa, ill. Venturi 9, VII, p. 868, fig. 478.

A ————, 1907-7-17 — 30, back. See No. **1526**, 30.

A 1686 ————, 1910-9-15 — 853. Jacob wrestling with the angel. Pen, br., wash, height. w. wh., on faded blue. 276 x 245. Squared in bl. ch. Inscription: Tintoreti. Malcolm Coll. (Robinson 404). Publ. by Osmaston, II, pl. CLXXVII as Jacopo Tintoretto.

In our opinion, entirely without the typical rhythm of Jacopo, and a considerably later production.

A ————, 1913-3-31 — 179. See No. **1834**.

A ————, 1913-3-31 — 180. See No. **1835**.

1687 ————, 1913-3-31 — 182. Nude youth, flying to the r., stretching both arms. Charcoal. 200 x 307. Stained by mold, damaged by a fold in the middle. Lower r. corner torn. [**MM**]

1688 ————, 1913-3-31 — 183. Standing nude, turned to the r., both arms crossed over chest. Bl. ch., on blue. 290 x 180. Squared. Late inscription: G. Tintoretto. [**MM**]

Similar in style to No. **1713** and perhaps a study for a Last Judgment.

1689 ————, 1913-3-31 — 184. Man standing, spading (?), turned to the r. Charcoal, on gray. 293 x 176. Squared. Stained by mold. [**MM**]

Similar in style and subject to No. **1592** and perhaps part of the material connected with the "Battle of Lepanto."

A ————, 1913-3-31 — 185. See No. **1837**.

1690 ————, 1913-3-31 — 186. Seated nude, the l. arm only indicated or covered by a drapery. Charcoal, on buff. 368 x 220.

1691 ————, 1913-3-31 — 188. Figure bending to the r., seen from behind, stretching the arms. Indication of costume. Charcoal, on buff. 198 x 270. The outlines reworked with the brush. [**MM**]

The counterproof was used in the ceiling "Battle of the Lake Garda," in the Ducal Palace, ill. Thode, p. 114, which was executed by the shop.

1692 ————, 1913-3-31 — 189. Design for a figure in the painting "The Finding of the body of Saint Mark," in the Brera. Bl. ch., height. w. wh. 348 x 237. Squared. Hadeln, *Tintorettozeichnungen,* pl. 53. Popham, *Handbook,* p. 45.

Dated 1562 or a little later by the painting.

A ————, 1913-3-31 — 190. See No. **1521**.

A ————, 1913-3-31 — 191. See No. **1522**.

1693 ————, 1913-3-31 — 192. A clothed man, kneeling, turned to the l. Charcoal. 149 x 235. Squared. Stained by mold, damaged. Late inscription: G. Tintoretto. [**MM**]

Possibly used in the "Legend of S. Catherine," Bercken-Mayer 189.

A ————, 1913-3-31 — 193. See No. **1523**.

1694 ————, 1913-3-31 — 195. Design for one of the guards in the "Resurrection of Christ," in Dr. Alsberg Coll., Berlin, ill. Cat. De Nemes Coll. Sale, Galerie Manzi, Paris, June 17-18, 1913, pl. 14. Bl. ch., on blue. 215 x 231. Squared. Lower l. corner added. Publ. by Hadeln, *Tintorettozeichnungen,* pl. 64, who dates the drawing in the second half of the 1560's, with reference to the style of the painting.

In the reproduction the painting looks like a shop production; we accept, however, Hadeln's dating of the drawing with regard to No. **1692**.

1695 ————, 1913-3-31 — 196. Study of a soldier, rushing forward, holding a weapon in both hands. Bl. ch., on buff. 212 x 159. Squared. Damaged. Late inscription: G. Tintoretto. [**MM**]
Similar in style to No. **1696**.

1696 ————, 1913-3-31 — 197. Study of a standing soldier, seen from front, turned to the r. Bl. ch., on buff. 217 x 163. Squared. Late inscription: G. Tintoretto. [**MM**]
Similar in style to No. **1695**.

A ————, 1913-3-31 — 198. See No. **1525**.

1697 ————, 1913-3-31 — 199. Nude, design for one of the sleeping apostles in the "Mount of Olives," in Santo Stefano, ill. *Mostra Tintoretto*, p. 191. Charcoal, on br. 177 x 157. Squared. Upper r. corner added. Late inscription: G. Tintoretto. Publ. by Hadeln, *Burl. Mag.* XLIV, p. 281, pl. II, G. Dated by the painting shortly before 1584. **[MM]**

A 1698 LONDON, VICTORIA AND ALBERT MUSEUM, Dyce 234. Pentecost. Pen, br., slightly washed, on blue. 283 x 209. Semicircular top. Coll. Richardson, Reynolds. Ascr. to Jacopo Tintoretto. **[MM]**

The drawing does not show either in the style of composition, or in its types any connection to Jacopo Tintoretto. A superficial resemblance of the composition to Titian's painting of the same subject in the Salute might be due only to the identity of the subject. Possibly we may go further and recognize in this drawing the design of another artist who might have taken part in the competition in which Titian won in 1541. The linework is related to the somewhat doubtful pendrawings by Paris Bordone (see No. **398**). This hint is meant as a mere suggestion which some day may be taken into consideration in a special study of Bordone's drawings.

1699 ————, Dyce 235. Design for the figure of Christ in a Crucifixion. Bl. ch., height. w. wh., on blue. 395 x 264. Squared. Cut at the sides. Retouched. Coll. Benjamin West, Dyce. Publ. by Borenius in *Burl. Mag.* XXXIX, p. 224, pl. II C: Reminds one of the figure in the "Crucifixion" in the Albergo della Scuola di San Rocco, in spite of the fact that the posture of the head does not occur in any painting by Tintoretto. **[MM]**

May we add that according to Ridolfi II, 41 a "Crucifixion" by J. Tintoretto existed in San Cosmo della Giudecca. We accept the drawing with reservations, since the retouches make it difficult to judge.

A ————, Dyce 236. See No. **1840**.

1700 ————, Dyce 241. Nude man stooping, carrying an object in both hands. Bl. ch., height. w. wh., on faded blue. 308 x 205. Squared. Stained by mold, torn. Late inscription: Giacomo Tintore (cut). *[Pl. CXIII, 4.* **MM]**

Design for the man carrying wood at the r. in the "Martyrdom of S. Lawrence," in Oxford, Christchurch, ill. *Burl. Mag.* XLVIII, p. 116 pl. II D. Companion of No. **1682v**.

1701 ————, Dyce 242. Design (drapery study) for the landlord in the Last Supper in San Polo, Venice, ill. Bercken-Mayer 83. Charcoal, height. w. wh., on blue. 307 x 191. Damaged by humidity. Late inscription: G. Tintoretto. Publ. by Hadeln, in *Burl. Mag.* XLIV, p. 280, pl. I D. *[Pl. CVII, 1.* **MM]**

Dated about 1570 by the painting.

1702 ————, Dyce 243. Study of a clothed man, seated. Bl. ch., height. w. wh., on blue. 312 x 219. Squared. — On the back: fragment of a nude. Publ. by Hadeln, in *Burl. Mag.* XLIV, p. 280, pl. I B as similar to one of the apostles in the "Last Supper" in Sto Stefano, Venice.

Design for the youth on horseback, in the "Crucifixion," Albergo, Scuola di San Rocco, ill. Bercken-Mayer 74, dated by the painting 1565.

This drawing confirms Hadeln's statement that the dating of Tintoretto's studies is extremely difficult. He placed it, though very early, in the master's latest period.

1703 ————, Dyce 245. Seated nude turned to the r. Charcoal, on faded blue. 217 x 181. Squared. Stained by mold. **[MM]**

1704 ————, Dyce 246. Seated nude, design for the woman in the foreground of the "Last Supper" in the Scuola di San Rocco, ill. Bercken-Mayer 128. Charcoal, on blue. 229 x 198. Coll. Sir Joshua Reynolds. Publ. by Hadeln, in *Burl. Mag.* XLIV, p. 280 pl. I C.
 [Pl. CIX, 2. **MM]**

Dated in the 1570's by the painting.

1705 ————, Dyce 247. Hasty sketch of a youth, with the drapery indicated. Bl. ch., on buff. 300 x 148. **[MM]**

1706 LONDON, COLL. COLNAGHI, formerly. Seated man, clothed, turned to the l., seen from behind. Bl. ch., height. w. wh. 425 x 310. Ill. in the Cat. of Colnaghi galleries, Christmas 1937, No. 81.

The posture is somewhat similar to that of one of the women surrounding the Virgin in the "Crucifixion" in the Academy in Venice (Bercken-Mayer 32).

1707 LONDON, ROBERT FRANK LIMITED, formerly (1937). Study after Michelangelo's group "Samson slaying the Philistine." Bl. ch., height. w. wh., on faded blue. 363 x 224. Late inscription: Jacopo Robusti detto il Tintoretto. — On the back: Variation of the same figure. Inscription: J. T. No. 10. Damaged and patched. Coll. Borghese, Venice.

The drawing seems to be identical with one exhibited from the Richard Deutsch Coll., New York, at the Golden Gate Exposition 1940, no. 500.

1708 ———— Study after Michelangelo's group Samson slaying the Philistine. Bl. ch., height. w. wh. 387 x 290. — On *verso:* another study from the same sculpture. Coll. Count Polcenigo, Venice.
 [MM]

The model seems to have been in wax or clay, since in the drawing a support is to be seen.

A LONDON, COLL. CAPTAIN REITLINGER. Kneeling woman, see No. **1846**.

1709 LONDON, GALLERY DR. A. SCHARF. Crouching nude; a second figure behind? Bl. ch., on blue. 217 x 193. Squared. Stained by mold. Late inscription: G. Tintoretto. — On *verso:* the same figure traced, but with added garments. Squared. [Both sides. **MM]**

Late style, perhaps for the "Battle of Lepanto."

1710 ————, formerly (1937), now Private Coll., England, according to former owner. Standing man, seen from behind, clothed, carrying a vessel. Bl. ch., height. w. wh., on faded blue. 361 x 209. Squared. The l. arm is drawn in two positions. — On *verso:* the outlines of the figure are traced, but it is shown from front.
 [Pl. CV, 1. **MM]**

The drawing is a design for the man next to the Magdalene in the "Crucifixion" in the Albergo di San Rocco, 1565.

1711 LONDON, THE SPANISH GALLERY (Th. Harris). Design for the youth fallen upon the ground at the l. in the painting "Transportation of the body of St. Mark," in the Academy in Venice (Bercken-Mayer, 67). Bl. ch., worked over with the brush. 140 x 240. Coll. A. G. B. Russell. Publ. by Borenius, in *Connoisseur* 1923, May, p. 1 no. IV. Mentioned by Hadeln, *Tintorettozeichnungen*, p. 57. Cat. of the Saville Gallery, *Drawings by Old Masters* 1929, no. 44. The

painting in the Academy has been cut at the l., so that the figure in question is partly missing. The old copy, ill. in Venturi 9, IV, p. 523, confirms that it appeared originally in the painting, just as the drawing shows it. The retouching with the brush was probably done in the shop, in order to obtain a counterproof.

[*Pl. CIV*, 2. **MM**]

1712 ———. Nude youth, standing, turned to the r. Bl. ch., on buff. 273 x 183. Squared. Rubbed. Late inscription: J. Tintoretto. Coll. Sir Joshua Reynolds. **[MM]**

Design for the angel in the lower row at the l. in the "Resurrection," Scuola di San Rocco, Venice, ill. Bercken-Mayer 130. Companion piece No. **1758**.

1713 LONDON, COLL. SIR ROBERT WITT. Male nude, standing. Bl. ch., height. w. wh., on greenish blue. 330 x 207. Squared. Late inscription: G. Tintoretto. — On *verso:* rapid tracing of the figure. Coll. Reynolds, Fitzgerald, Morrison. Exh. London, 1930, 665 Popham Cat. 283: probably a study for a Flagellation. Exh. Paris 1935, Sterling *Cat.* 709. **[MM]**

In our opinion, probably study for a figure in the lost "Last Judgment" and companion piece to No. **1688**.

1714 ——— 674. Male nude, recumbent. Bl. ch., on faded blue. 202 x 300. Squared. Late inscription: G. Tintoretto. — On *verso:* Hasty sketch of the same figure without the arms. Coll. Sir Joshua Reynolds. **[MM]**

Late period.

1715 ———. Crouching figure with a harp (or an instrument of torture?) Charcoal, on gray. Late inscription: G. Tintoretto. Coll. Sir Joshua Reynolds, G. M. Fitzgerald. **[MM]**

Poor state of preservation, difficult to judge. Late.

A ———, 2495. See No. **1018**.

A 1716 LUETZSCHENA, COLL. SPECK VON STERNBURG. Esther and Ahasuerus. Pen, wash. Publ. in Becker, *Handzeichnungen alter Meister,* pl. 42.

In our opinion, late imitator in the style of Sebastiano Ricci.

1717 MALVERN, MRS. JULIA RAYNER WOOD (SKIPPES COLL). Study from an antique head. Charcoal, on br., height. w. wh. 385 x 264. Both lower corners are extensively patched and worked over; the upper l. corner is only patched. Publ. in *Vasari Society* XI, pl. 7 (A. G. B. Russell) as J. Tintoretto's copy from Michelangelo's Giuliano Medici, with reference to the drawing No. **1652**.

In our *Tizian-Studien,* p. 188 ff. we identified the drawing as a copy not from Michelangelo, but from an antique, probably the so-called "Heracles" now in the Museo Archeologico in Venice, and attr. it to Titian who, in our opinion, used it for the head of the young shepherd in his painting in Vienna. We made our suggestion with some reservations, not having seen the original at that time. L. Fröhlich-Bum in *Art Bulletin* 1938, p. 446: "The style of this drawing is so evidently 18th century, that the sculpture was probably a Rococo imitation of an ancient piece. If there should turn up such an antique which Titian might have seen, then either it or a copy must have influenced both, Titian's picture and the Rococo drawing."

Since the publication of our studies we have twice had the opportunity of examining the drawing. Although not doubting for a moment its origin in the 16th century and in Venice, we have to admit that the general impression is very much determined by later additions. Precisely the elements which produced the resemblance to Titian's "Shepherd," are such additions. After discounting them, too little is left to maintain our attribution to Titian. Under these circumstances it might be the wisest to leave the drawing with Tintoretto.

A 1718 ———. Bearded head, turned to the r. Bl. ch., on grayish green. 360 x 245. Damaged. Additions at the neck; a triangle patched above. Publ. by Lawrence Binyon, in *Vasari Society* I, 28 as J. Tintoretto? (with reservations). In our *Tizian-Studien,* p. 190, note 94 we found the peasant type of the man more in Titian's than Tintoretto's line. [*Pl. CXCVIII,* 1. **MM**]

We are still puzzled by the drawing, being unable to maintain the tentative reference in Titian's direction, and, on the other hand, finding no analogy to such a simplified linework, a sort of a preparation of a fresco, in Jacopo Tintoretto's work.

A MILAN, AMBROSIANA, 1224. See No. **1530**.

1719 MILAN, COLL. RASINI. Seated nude, seen from behind. Bl. ch. 180 x 170. Squared. Late inscription of the name. Morassi, p. 32, pl. XXVI: Study probably for a figure *"da quinta"* in the foreground of a composition.

As a matter of fact, design for the second (from the l.) figure in the foreground of the painting "Investiture of Gian Francesco Gonzaga, Margrave of Mantua," (ill. Bercken-Mayer 136) and dated about 1579 by the painting.

A ———, Morassi, XXVII. See No. **1532**.

A 1720 MOSCOW, MUSEUM. Entombment of Christ. Pen, wash. Pensky Coll. Publ. by Sidorow, in *Zeitschr. f. B. K.* 63., p. 229/230 (ill.) as Jacopo Tintoretto.

We have not seen the drawing, which, in our opinion, has no resemblance to Jacopo Tintoretto.

A MUNICH, GRAPHISCHE SAMMLUNG, 2982. See No. **1850**.

A 1721 ———, 10483. Rapid sketch, Seven dignitaries seated at a table. Pen, br., on blue. 245 x 390. Coll. Stengel. Publ. in Schmidt, *Handzeichnungen,* pl. 93 as Jacopo Tintoretto.

There is no reason to attr. this symmetrical composition to Ja. Tintoretto. (See p. 190).

A ———. So-called sketchbook by Palma Giovine I, 167 v. See No. **1037**, I, 167 v.

A 1722 MUNICH, SALE WEINMÜLLER, 1938, October 13/14, Cat. No. 674. Study of a head after an antique sculpture. Bl. ch. 310 x 255. Publ. and ill. as Jacopo Tintoretto, in *Pantheon,* 1938, p. 388. **[MM]**

Entirely different from Tintoretto's style.

1723 NAPLES, GABINETTO DELLE STAMPE, 0248. Woman seated on the fragment of a wheel over clouds (St. Catherine?). Over hasty sketch in bl. ch., brush, blackbrown and wh., on blue. 338 x 246. Squared in ch. Pasted on mount. Upper l. corner torn. Director Ortolani (orally): the figure is seated on a zodiac sphere.

[*Pl. CX,* 1. **MM**]

A figure very similar in pose and style appears in J. Tintoretto's painting "Adam and Eve" in Ottawa, Can. The sketch may possibly have been meant for a Saint Catherine in the (lost) "Last Judgment"

in the Ducal Palace, since Palma Giovine's mural painted as a substitute for Tintoretto's shows such a saint at a conspicuous place.

1724 ————, 0375. Sketch of the "Battle on the Taro," in Munich (ill. Bercken-Mayer 139). Brush, gray, yellowish br. and wh., on blue. 238 x 379. — *Verso:* contemporary illegible script in the character of those on Nos. **1565, 1586, 1613, 1631.** [*Pl. CXIV.* **MM**]

Director Ortolani who discovered J. Tintoretto's drawings in Naples recognized the connection of this one with the painting in Munich. It is unique in Tintoretto's work as a pictorial sketch on paper for a painting.

1725 ————, 0210. Annunciate Virgin. Over ch. sketch brush, pink, wh. and br. oil colors. 210 x 210. Squared. The sketch is based on No. **1638** and prepares a painting of the "Annunciation," see our notes to No. **1638.** With Nos. **1723, 1724** in Naples the drawing is one of the few color sketches which may be attributed to Jacopo.
[*Pl. CX, 2.* **MM**]

A NEW YORK, METROPOLITAN MUSEUM, 41. 187.2. See No. **1534.**

1726 NEW YORK, PIERPONT MORGAN LIBRARY, IV, 75. Studies of two crouching nudes. Bl. ch., on grayish. 201 x 311. Original inscription: David (?) Late inscription: G. Tintoretto. — *Verso:* Two other studies of nudes, one seated from front, the other in profile. Late inscription: G. Tintoretto. The *recto* publ. in *Morgan Dr.* IV, 75 as study for the "Miracle of S. Mark." Exh. Toledo, Ohio, 1940, Cat. No. 92: the drawing, probably a sketch for a "Paradise" belongs to the late style of Tintoretto. Since the drawing is not squared for enlargement it is questionable whether it ever was used in a composition. [**MM**]

1727 ————, IV, 76. Man climbing into a boat, design for a figure in the "Battle of Legnano" in Munich, ill. Bercken-Mayer 137. Bl. ch., on gray. 202 x 312. Squared. Late inscription: G. Tintoretto. — *Verso:* Tracing of the same figure and the sketch of a similar one. E. Tietze-Conrat, in *Graph. Künste* N. S. I, 1936, p. 91, recognized the connection of the drawing with the painting in Munich. Exh. Toledo, Ohio, 1940, *Cat.* No. 93, and Northampton, Mass. 1941, *Cat.* 40. The compiler of the latter cat. applied a reference by Fairfax Murray to the "Miracle of St. Mark," made, wrongly to our mind, in connection with No. **1726,** to No. **1727** where it fits still less. This unfortunate start leads to utmost confusion in the analysis of the drawing which is more than thirty years later than the "Miracle."
[Both sides. **MM**]

In the painting in Munich the figure appears in reverse and may be based on the tracing.

A 1728 NEW YORK, COLL. MORTIMER SCHIFF, formerly. Upper part of Jacopo Tintoretto's "Last Judgment" in the Madonna dell' Orto. Broad pen, wash, on br. 512 x 375. Late inscription: Jac⁰ Tint⁰. Publ. by George S. Hellman, in the privately printed *Cat. of the Mortimer Schiff Coll.* formed by Joseph Green Cogswell (1786–1871), New York 1915, p. 128, pl. XXXI as Jacopo Tintoretto's sketch for his "Last Judgment" and one of the most magnificent drawings existing by him.

In our opinion, typical 17th century copy after the mural.

A NEW YORK, COLL. ROBERT LEHMAN. See No. **1535.**

A OXFORD, CHRISTCHURCH LIBRARY, L 1. See No. **1854.**

1729 ————, L 2. Study from a model by Michelangelo for the statue of Giuliano de' Medici? Bl. ch., height. w. wh. 410 x 267. Stained by mold. — *Verso:* study from the same figure in reverse. The *recto* publ. by Colvin, II, 17: after a model by Michelangelo changed in the execution. Hadeln, *Tintorettozeichnungen,* pl. 7 and p. 27, agrees with Colvin. W. Paeseler, *Münchn. Jahrb.,* N. S. X. (1933) p. XXIX, discusses the place of the presumed model within Michelangelo's work.

1730 ————, L 3. Study from Michelangelo's statue of "Day." Bl. ch., height. w. wh., on faded blue. 330 x 275. — *Verso:* Study of the same figure. Hadeln, *Tintorettozeichnungen,* pl. 5, p. 26.

We have to make some reservations, the linework looking smoother than is normal in Tintoretto's drawings.

1731 ————, L 4. Study from the head of Michelangelo's statue of Giuliano de' Medici. Bl. ch., height. w. wh., on gray. 353 x 233, cut. — *Verso:* the same head. Hadeln, *Tintorettozeichnungen,* pl. 9, p. 27, where the relations to other versions of the same subject are discussed. Popham, *Cat.* 279. Morassi-Rasini p. 34: Shop production.

A study similar to this drawing has been used for St. John in the "Mount of Olives" in the Scuola di San Rocco, ill. Bercken-Mayer 129.

1732 ————, L 5. Study from the head of Michelangelo's Giuliano de' Medici. Bl. ch., height. w. wh., on br. 368 x 272. Damaged by mold. — *Verso:* the same head. Bell p. 87: Giuliano or David? Hadeln, *Tintorettozeichnungen,* p. 27. [**MM**]

1733 ————, L 6. Study from Michelangelo's group of Samson, slaying the Philistine. Bl. ch., height. w. wh., on faded blue. 303 x 263. Damaged by humidity. — *Verso:* Study from the same group. Colvin, II, 17. Hadeln, *Tintorettozeichnungen,* p. 25.

1734 ————, L 7. Study from Michelangelo's group Samson slaying the Philistine. Bl. ch., height. w. wh., on faded blue. 383 x 244. Very much rubbed. Hadeln, *Tintorettozeichnungen,* p. 25.

The state of preservation makes it difficult to judge the authenticity.

A ————, L 9, see No. **1855.**

A 1735 ————, L 11. Study from an antique bust of an old man. Bl. ch., height. w. wh., on buff. 383 x 257. — On *verso* inscription in pen: Cavedone. Mentioned as Tintoretto by Hadeln, *Tintorettozeichnungen,* p. 24.

In our opinion, not even by one of his pupils, but possibly by Cavedone.

A ————, L 12, see No. **1536.**

A PARIS, LOUVRE, 5365, see No. **1537.**

A 1736 ————, 5370. Descent from the Cross. Broad pen, br., wash, height. w. wh. 554 x 412. All corners patched. Publ. in Alinari-Louvre as Jacopo Tintoretto.

In our opinion, certainly not by J. Tintoretto, but more likely by a Florentine mannerist. The composition reminds us of the painting of the same subject in the Prado, attributed there to Daniele da Volterra, by Voss, *Malerei der Spätrenaissance* 1920, p. 142, to Jacopino del Conte, and in *Rivista d'A.* 1932, p. 487 (ill.), to Alessandro Allori.

1737 ————, 5371. The Lamentation. Brush, oil grisaille. 247 x 164. Damaged. Mounted in the frame typical of the Vasari Coll.; in

the label inscription: Tintoretto Pittor Venetiano. Coll. Vasari, Jabach. Publ. by Otto Kurz, in *O. M. D.* XII, pl. 40. **[MM]**

About 1560/65. If the drawing were not authenticated by Vasari its halting linework might arouse doubts.

A ————, 5378, see No. **1538**.

1738 ————, 5382. Nude lying on his back. Charcoal, height. w. wh., on faded blue. 254 x 409. Squared. Stained with colorspots and torn. — *Verso:* Study from the head of Vitellius. Publ. by A. L. Mayer in *Burl. Mag.* XLIII, p. 34 as a study for Prometheus. Exh. in the Mostra del Tintoretto, Cat. p. 218.

Design for the lying corpse in the painting "St. George slaying the dragon," in the N. G., London (Bercken-Mayer 44) and therefore early. (We regret that our photograph of this important drawing has been lost and is irreplaceable at present.)

The drawing on the *verso* is very much rubbed, but apparently was weak from the very beginning and may belong to a pupil.

A ————, 5383, see No. **1539**.

1739 ————, 5384. Study from Michelangelo's "Day," seen from behind. Charcoal, height. w. wh. 263 x 272. Stained by humidity. The borders torn. Late inscription: Tintoret. — *Verso:* Study from the same sculpture on a larger scale, without the legs. Mentioned by A. L. Mayer, in *Burl. Mag.* XLIII, p. 34. Exh. in the Mostra del Tintoretto, Cat. p. 218. **[MM]**

A ————, 5385. See No. **1540**.

A 1740 ————, 5386. Study of a standing nude, seen from behind. Charcoal, height. w. wh., on brownish yellow. 397 x 167. Publ. by A. L. Mayer, in *Burl. Mag.* XLIII, p. 34, p. 32, B (with erroneous caption), ill. and placed in Jacopo's late period. Exh. Paris 1935, Sterling *Cat.* no. 708. **[MM]**

In our opinion, neither by J. Tintoretto, nor by one of his immediate pupils. By the same hand as I 84 in the Koenigs Coll., also erroneously ascr. to Jacopo Tintoretto. **[MM]**

1741 ————, 5394. Study from Michelangelo's group Samson slaying the Philistine. Bl. ch., height. w. wh., on faded blue. 385 x 255. Damaged by mold, torn, lower l. corner patched. — *Verso:* the same figure in the same position. A. L. Mayer, *Burl. Mag.* XLIII, p. 34.

A 1742 ————, 5396. Recumbent satyr with a goat. Bl. ch., height. w. wh., on blue. 202 x 265. Stained by mold. A. L. Mayer, *Burl. Mag.* XLIII, p. 34: Jacopo Tintoretto.

In our opinion, Bolognese School 17th century.

1743 PARIS, ÉCOLE DES BEAUX ARTS, 12054. Study from the bust of Vitellius. Bl. ch., height. w. wh., on gray. 295 x 224. Formerly attr. to Baroccio, but recognized as Jacopo Tintoretto by G. Nicodemi and exh. as his in École des Beaux Arts 1935, Cat. no. 144. **[MM]**

A 1744 ————, Coll. Masson. Study of Christ for a Crucifixion, twice repeated. Bl. ch., height. w. wh., on faded blue. 220 x 375. Stained by mold. — *Verso:* A stooping figure and a drapery. Label with inscription (18th century): Pierre Francois Mazzucchelli dit le Morazzone. Ascr. to J. Tintoretto and as his exh. in École des Beaux Arts 1935, Cat. No. 143. **[MM]**

The style of the drawing corresponds exactly to Morazzone's (see No. **1753**), and there is no reason to doubt the old attribution.

A PARIS, COLL. E. WAUTERS, formerly. Study for the robes of a Venetian Senator, see No. **244**.

A PITTSBURGH, CARNEGIE INSTITUTE. Study. See No. **1542**.

1745 ROME, GABINETTO DELLE STAMPE, 125523. Drapery for a seated figure. Bl. ch., height. w. wh., on blue. 313 x 240. Upper l. corner patched. Publ. by Hadeln, *Tintorettozeichnungen,* pl. 57 and p. 36, and by the same author in *Burl. Mag.* XXXIV, p. 284.

Resembling, but not identical with, the figure of Christ in the painting in Munich, "Christ in the house of Martha" (ill. Bercken-Mayer 101). This might suggest a date about 1570/80.

A ————, 125525. See No. **1545**.

1746 ————, 125529. Studies from the so-called Atlas; three from the front, three from the back. Bl. ch., height. w. wh., on brownish yellow. 275 x 420. Late inscription: Tintoretto. Mentioned by Hadeln, *Tintorettozeichnungen,* p. 27.

A 1747 ————, 125530. Sketch of a Crucifixion. Brush grayish br., over ch. 270 x 391. A missing part in the middle has been restored. Late inscription: Tintoretto. Publ. by E. Waldmann, *Tintoretto* as Jacopo Tintoretto. Hadeln, in *Jahrb. Pr. K. S.* XLII, p. 189, note rejects this attribution after long hesitations. **[MM]**

We share Hadeln's doubts, since neither the composition, nor the types and the linework are Tintoretto's.

1748 ————, 125859. Study of a nude man. Charcoal, on br. 360 x 222. Late inscription: Mano del Tintoretto. Publ. by Hadeln, *Tintorettozeichnungen,* pl. 49.

Probably for the lost "Last Judgment."

1748 bis ————, 125578. Man seen from behind, perhaps rowing. Charcoal. 259 x 219. According to Hadeln the clothes possibly drawn on top of the nude. Publ. by Hadeln, *Tintorettozeichnungen* pl. 69, p. 36, 44. **[MM]**

A ————, 128383. See No. **1133**.

A 1749 VENICE, R. GALLERIA, 120. Crucifix between the two thieves. Pen and red ch., wash. 444 x 365. The paper is patched together. Fogolari 95: Only the middle part authentic (by J. Tintoretto), the two other crosses added by a mannerist.

In our opinion, there is no reason for questioning the homogeneity of the drawing, which is close in style to G. Sozzo's signed "Descent from the Cross" in the British Museum, acquired 1938.

A 1750 ————, 185. Man seated, taking off his stockings. Charcoal, on blue. 250 x 203. Formerly attr. to Michelangelo. Publ. by Fogolari 58 as J. Tintoretto. E. Tietze-Conrat in *Critica d'A,* April 1938, Issue XIV, p. 68 identified the drawing as a study by Lattanzio Gambara for a figure in a mural (c. 1567) in the cathedral in Parma, representing the "Baptism of Christ," ill. Venturi 9, VII, fig. 191.

A 1751 VIENNA, ALBERTINA, 87. Adoration of the Infant Jesus by the Virgin and S. Joseph. Charcoal, height. w. wh., on brownish. 187 x 253. Publ. as J. Tintoretto by L. Fröhlich-Bum, in *Burl. Mag.* vol. XLIII, 1923, p. 28, pl. II F and by Stix, in *Albertina N. S.* II,

no. 22. This attribution was accepted by Bercken, in *Burl. Mag.* XLIV, p. 113, who calls the drawing a preliminary study for a painting by J. Tintoretto, existing in a private coll. in Milan and publ. by Hadeln, in *Zeitschr. f. B. K.,* 1921, p. 192. Bercken used this drawing as a further proof against Hadeln's theory, that Tintoretto made no preliminary studies for his compositions, referring also to the sketchbook in the B. M. (now attr. to Domenico Tintoretto, see No. **1526**) and to the Albertina drawing No. **1753** (which is by Morazzone). Hadeln, in *Burl. Mag.* vol. XLIV, 1924, p. 284 rejected the connection between the drawing and the painting in Milan, and the attribution of the drawing to J. Tintoretto. *Albertina Cat. II* (Stix-Fröhlich) publ. the drawing as Jacopo, without mentioning Hadeln's rejection. E. Tietze-Conrat in *Graph. Künste,* N. S. I. p. 93/94 rejected the attribution to Jacopo on the basis of the penmanship and the types, and moreover, with regard to the indications of colors, written in German (for instance: grinlet plau, *i.e.* greenish blue), in German cursive letters, and with the same charcoal as the drawing is done. This circumstance speaks in favor of a copy by a German artist from an Italian painting.

A ————, 88. See No. **1863**.

A ————, 89. See No. **1181**.

1752 ————, 90. Male nude, seated, seen from front. Charcoal. 328 x 227. Late inscription: G. Tintoretto. Publ. by Stix in *Albertina. N. S.* II, 25. Accepted by E. Tietze-Conrat in *Graph. Künste* N. S. I, p. 91 as a study in reverse for one of the executioners in the "Martyrdom" in San Giorgio Maggiore (ill. Bercken-Mayer 196).

In our opinion, the reference to the painting in San Giorgio is erroneous, but the drawing at any rate from Tintoretto's late period.

A ————, 91. See No. **1864**.

A 1752 bis ————, 92. The Last Supper. Over bl. ch., brush, pen and bister. 558 x 447. — *Verso:* Sketch from a sculpture of a nude figure (bl. ch.) and sketch of a Paradise (pen). Acquired 1924 and ascr. to Jacopo Tintoretto in *Albertina Cat.* II (Stix-Fröhlich) while E. Tietze-Conrat, rejecting this attribution in *Graph. Künste* N. S. I, p. 94, tentatively suggested Alessandro Maganza.

The latter suggestion cannot be maintained. A certain resemblance to No. **816** may be noted.

A 1753 ————, 93. Studies of two prophets. Bl. ch., height. w. wh., on bluish. 246 x 363. Late inscription: Tintoretto. — *Verso:* Two studies for a king and two other studies for Biblical figures. The traditional name, J. Tintoretto, is accepted by *Albertina Cat. I* (Wickhoff) 132, Schönbrunner-Meder 612 and *Albertina Cat. II* (Stix-Fröhlich). E. Tietze-Conrat in *Critica d'A.* XIV, p. 68 identified the drawings as studies by Morazzone for his murals in the Capella della Buona Morte, in S. Gaudenzio, Novara (ill. Nicodemi, *Morazzone,* 1927, pl. 73). [**MM**]

A 1754 ————, 94. Unidentified subject. Over sketch in bl. ch., pen, bistre. 154 x 206. — *Verso:* Three allegorical figures in the same technique. Acquired in 1923 from L. Grassi Collection. Publ. by Stix, *Albertina N. S.* II, 24 as J. Tintoretto. Hadeln rejected this attr. in *Zeitschr. f. B. K.* 1927, I, p. 112, and felt reminded of L. Corona. E. Tietze-Conrat in *Graph. Künste* N. S. I, p. 95, 96 suggested a follower of Veronese. [**MM**]

The drawing belongs to a group of drawings, formerly in the Grassi Coll. most of which are now in the Koenigs and the Lugt collections. (Koenigs Coll. S. 18, 19, 20, 21, 23, 25, 26, 27, 29; [All **MM**] Lugt Coll., The death of the righteous man [**MM**], The foolish Virgins [**MM**], Martyrdom of a Saint at the foot of an outside staircase [**MM**], Priest in procession healing plague stricken persons [**MM**].) The drawings in the Koenigs Coll. are ascr. to El Greco, the drawings owned by Mr. Lugt to the school of Venice at the end of the 16th century in general, except the last mentioned drawing attr. to Sante Peranda (which we are unable to separate from the others with respect to its style). The common stylistic features of all these drawings are a later development of the 16th century and correspond to painters of the middle of the 17th century (see p. 27). Some of the drawings lead over to a related, but perhaps somewhat earlier group which we tentatively ascribe to Alessandro Maganza and discuss under No. **1757**.

A 1755 ————, 95. Study of a composition with five figures. Over bl. ch., brush, bistre, height. w. wh. 187 x 263. Inscription: Tint° orig. Coll. Stephan Licht, Vienna. E. Tietze-Conrat in *Graph. Künste,* N. S. I, p. 96 rejected the attribution to Jacopo Tintoretto, with reference to the decorative character of the composition, which seems to suggest a follower of Paolo Veronese. [**MM**]

This follower, anyhow, would belong to the late 17th century (compare for the composition Sebastiano Ricci's painting no. 454 in Berlin, ill. Berlin, Gemäldegalerie, 1930).

A ————, 96. See No. **1865**.

A 1756 ————, 97. The Assumption of the Virgin. Over charcoal brush, oil on br. tinted paper. 344 x 258. The upper part squared. The old attribution to J. Tintoretto was considered rather doubtful by Osmaston II, p. 121, pl. 176, but has again been accepted in the *Albertina Cat. II* (Stix-Fröhlich). E. Tietze-Conrat in *Graph. Künste* N. S. I, p. 95 attr. the sketch to Pier Franceschi Mazzucchelli, named Morazzone, a later imitator of Jacopo Tintoretto, see G. Nicodemi, *Il Morazzone,* passim.

A 1757 ————, 98. Martyrdom of a saint. Over sketch in bl. ch. pen and bistre. 167 x 139. — *Verso:* Studies for the same scene. Bl. ch. Acquired from Grassi Collection 1923, publ. as Jacopo Tintoretto by Stix, *Albertina, N. S.* II, 25. The attribution was rejected by Hadeln, in *Zeitschr. f. B. K.* 1927, p. 112, but maintained in *Albertina Cat. II* (Stix-Fröhlich). [*Pl. CC, 2.* **MM**]

The drawing belongs to a group of drawings coming from the same source (Grassi Coll.) and at present for the most part in the Koenigs and Lugt Collections. (Koenigs S 24 [**MM**] and possibly 22 [**MM**], and Lugt, Preparation for the Crucifixion [**MM**] and a Legendary Scene [**MM**]). The drawings of the Koenigs Coll. are ascr. to El Greco, of those in the Lugt Coll. the first is attr. to Jacopo Tintoretto, the second to Malombra. The Preparation of the Crucifixion in the Lugt Coll., the sketch for a mural round the top of a door, seems to contain the key to the puzzle of this interesting group which seems to precede the related drawings discussed under No. **1754**. The sketch in ch. beneath the penwork resembles the finished composition of a "Crucifixion" in the Uffizi, no. 12862 [**MM**], inscribed on the back as by the Vicentine painter Alessandro Maganza (1556, died well after 1630). The numerous paintings by this prolific artist in Vicenza offer no further evidence in favor of this attribution.

1758 WASHINGTON CROSSING, PA., COLL. F. J. MATHER JUNIOR. Man standing, turned to the r. Bl. ch., on yellow. 270 x 175. Squared.

Design for the angel at the r. in the "Resurrection" in the Scuola di San Rocco, ill. Bercken-Mayer 130. Companion piece of No. **1712**.
[Pl. CVIII, 1. **MM**]

A WEIMAR, MUSEUM. Christ in Glory. See No. **384**.

A WINDSOR, ROYAL LIBRARY, 4796. See No. **1244**.

A ———, 4797. See No. **1245**.

1759 ———, 4823. Nude seen from behind, design for the man holding the ladder in the "Crucifixion" in the Academy in Venice (ill. Bercken-Mayer 32). Charcoal, height. w. wh., on greenish blue. 368 x 188. Publ. by Kenneth Clark, in *O. M. D.* 1931, March, pl. 44. Dated by the painting c. 1565.

MARIETTA ROBUSTI, TINTORETTA

[Born c. 1556, died 1590]

Raffaele Borghini, who published his *Riposo* in 1584, included in it a biography of Marietta, but none of either Domenico or of Marco. It is generally admitted that Borghini collected his Venetian material a few years earlier, probably by getting direct information from the artists themselves. In the case of Marietta, of whose works Borghini candidly admits he had not seen anything, his information might go back to Jacopo Tintoretto whose special attachment to his daughter is well known and, as E. Tietze-Conrat tried to explain in *Gaz. d. B. A.* December 1934, might offer a psychological help in establishing Marietta's historical position. Apparently he did not care to say anything about his sons whose efforts, in his opinion and that of his period, were a dutiful contribution to the activity of the family workshop and therefore not worth special mention. The gifted girl, overrated and at the same time coached by her father, was something exceptional.

Her share in the shop production is made more easily recognizable by the discovery of her name on two drawings in the Rasini coll., No. **1762**, and on the drawing No. **1760** in the Museo Civico in Cremona. These drawings, to which a few more (see Nos. **1761, 1833, 1850, 1859**) may be tentatively added on stylistic grounds, reveal her as a draftsman entirely dependent on models for the composition and rather impersonal and unambitious in her formal expression. Marietta aims more at neatness of execution than at picturesque effects; she is not urged by an abundance of creative ideas as was her brother Domenico.

1760 CREMONA, MUSEO CIVICO, No. 4. Sketch for a composition: A sainted bishop healing the sick. Bl. ch., on faded blue. 195 x 270. Inscription Ma^tta Tintoretta. The same inscription apparently shows through from the back. Ascr. to Jacopo Tintoretto. [**MM**]
The poor composition, every single figure of which recalls one of Jacopo's, might support the attribution to Marietta.

1761 HAARLEM, COLL. KOENIGS, I 406, *verso.* (For the front side see No. **1676**). Various sketches: a female head, drapery, female leg. Bl. ch., on blue. 433 x 273. Ascr. to Jacopo Tintoretto as the *recto*. [**MM**]
The head shows a striking resemblance to the head of the statue seen behind Ottavio Strada in his portrait, attr. to Jacopo Tintoretto, and now in the Tietje Coll. in Amsterdam (ill. *Jahrb. Pr. K. S.* XLI, p. 41). This coincidence encourages us to reconsider the problem of this portrait, called by Hadeln a convincing manifestation of Jacopo Tintoretto's genius, but which we are rather inclined to attribute to a member of his shop. Ridolfi (II, 79), in the life of Marietta, mentions a portrait of Jacopo Strada by her presented to Emperor Rudolph II.

This information may be a mistake and refer to the portrait of Strada's son Ottavio, and more particularly to the portrait mentioned above. The style of the drawing with its dry and minute rendering of the drapery and its way of hatching the woman's face, by no means contradicts Marietta's authorship. (The painting, by a later inscription, is dated 1567, a date that might exclude Marietta, if the date of her birth is correctly put about 1556. But according to Hadeln, Ridolfi II, 79, note 1, her birthday is to be pushed back for several years. How could she otherwise have painted her grandfather, Marco de'Vescovi, who died in 1571?)

1762 MILAN, COLL. RASINI. Study after the bust of Vitellius. Ch., height. w. wh., on bluish. 430 x 280. Contemporary inscription: Questa testa si e di man de madona Marieta. — *Verso:* Study after Michelangelo's head of Giuliano de' Medici. Coll. Dubini. Publ. by Morassi, p. 33, pl. 28/29, with reference to No. **1731** and **1850** which he eliminates from Jacopo's authentic work, proposing Marietta's authorship for them also. *[Pl. CXXIV, 4.* **MM**]

MARCO ROBUSTI, CALLED IL TINTORETTO

[Born c. 1565, died 1637]

Marco Robusti is considered the black sheep of the family. The passage in Jacopo's last will referring to him (see p. 258) has been interpreted with some acrimony by Venturi, 9, IV, p. 677, and Tozzi (*Rivista di Venezia*, 1933, p. 302). Has not this underscored contrast between Tintoretto's two sons perhaps been constructed merely as a parallel to the sons of Titian? Strictly speaking the passage in question says only that Marco, being the younger son, had to subordinate himself to his elder brother who inherited the shop and was appointed to finish the pictures left incomplete by their father. Nevertheless, Marco was to have the benefit of the whole material assembled in the shop as long as he chose to remain there. The arrangements in favor of Domenico and the additional exhortation: "I beg my son Marco to live in peace with his brother and to stick to the noble and virtuous profession of an artist" need not mean that he was a bad painter, and that his father considered him such. It may only mean that there may have been conflicts between the brothers, as frequently happens, and that Marco was less steady in the pursuit of his career than Domenico. What he did between the dates of Jacopo's and Domenico's death, we do not know; Marco is never mentioned in any source. Apparently, he lived in peace with his brother and continued to work in the shop; otherwise, Domenico would not have bequeathed to him the better part of its inventory. He was to have all the casts and, moreover, all the paintings and drawings of their father Jacopo. Domenico's pupil Sebastiano Casser, who later married Ottavia Robusti and became the head of the shop, was only to pick out a few casts specifically enumerated and those drawings which he himself and Domenico had contributed to the common stock, under the condition that he should still be serving in the workshop at the moment of Domenico's death.

Hence, it is Marco who went on with the activity of the firm. He was its head until he died in 1637, after having made his last will on September 15, 1635, shortly after the death of Domenico. It has been supposed (Thieme-Becker 33, p. 99) that Marco was born about 1560. Apparently he was the younger son and is first mentioned in 1583 (as a witness in a family document). Borghini is completely silent about him, but so is he about Domenico. In 1585 only Domenico and not Marco, entered the Scuola di San Marco. If for Domenico the date of birth is rightly presumed to be 1560, for Marco we reach a slightly later date. As we stated before, the archives offer no help. In the opinion of more recent critics, particularly Adolfo Venturi, Marco was responsible for poorer parts in certain paintings. His was the hand that was too weak to be considered Jacopo's, and even Domenico's who was Jacopo II. Marco, so to speak, was Jacopo III.

We make an attempt, although fully aware of its hypothetical character, at a new approach to Marco by the help of Domenico's personality. When Jacopo was still living we note a renewal in the activity of the shop, a kind of rejuvenescence, or even recrudescence, scarcely to be credited to the master's own account. For even in his latest authentic productions Jacopo in his clearness and spirituality remains a classic. This classic and quiet element was taken over by Domenico, about 35 years old, when his father died, and later carried on and developed to actual dryness. The older he grew, the more awkward and the more coarse his paintings became, and their vocabulary of forms was apparently taken over in a still further deteriorated style by Casser who first of all was a portraitist. If, therefore, in the production from Jacopo's late shop besides the official altar-pieces which certainly for the greater part were executed by Domenico, we discover wild mannerisms, a turbulence in composi-

tion and in coloring, we can hardly suspect the well balanced and controlled young Domenico to be responsible for them, but rather the other painter who by birth was a member of the shop: Marco.

A confirmation of such a hypothesis which, by the way, comes close to Miss Pittaluga's cautious suggestions for the division of labor in the series from the "Legend of St. Catherine," may be found in the material offered by the drawings. Within the enormous stock of evident shop productions we may distinguish various groups. Domenico's share, sufficiently supported by Ridolfi's report and by documents, is best represented by the sketches in London. The poorer drawings in Domenico's style might be given to Casser, still in Domenico's last will his *"giovane"*; there is no immediate connection whatsoever with Jacopo. Alongside them there was a more temperamental draftsman in the studio analogous to the corresponding trends noticed in the paintings. There are also a few threads connecting the two activities. Thus we try to provide the tentatively constructed personality of the younger son with an oeuvre. The objection that the group of drawings in question might belong to a phase of Jacopo's activity not supported by any existing works may be disproved by Jacopo's well established late creations: his sketches for Mantua are very different, and so are the studies for the "Battle of Zara." They inform us about Jacopo's style from 1584 to 1587, still later is No. **1604**, the latest by Jacopo which can be dated. The difference from all these is not only one of quality. In the last mentioned drawings in the Uffizi we discover the experience of a lifetime devoted to the understanding of the anatomy and function of human figures. The group of drawings which we tentatively ascribe to Marco are mere jugglery compared to them.

The drawings which we tentatively attribute to Marco are Nos. **1799, 1801, 1792**, which, however, in view of the hypothetical character of our thesis we list under the more general category of "Shop of Tintoretto."

THE TINTORETTO SHOP

The Tintoretto shop was founded by Jacopo who as early as 1539 is mentioned as an independent master; he headed it until his death in 1594. The first member of his family to assist him seems to have been the precocious Marietta. Jacopo gave some information about her to Raffaele Borghini who around 1580 collected the material for his biographies published in 1584: she copied Jacopo's compositions and also made inventions and portraits of her own. This preference given to Marietta may partly be due to her father's special fixation on her and partly to the piquancy of a woman painter. When she married the jeweler, Mario Augusta, and when Domenico, whose coming of age is marked by his becoming a member of the Scuola di San Marco in 1585, entered the shop he became the foreman there and the official assistant of his father; in addition to this he also executed orders of his own. Marietta died prematurely in 1590. The situation in the shop remained much the same until Jacopo's death (see his last will, p. 258); the younger son, Marco, in his father's lifetime as far as we know, never had any independence in the shop. After Jacopo's death Domenico became the head of the shop, in which Marco seems to have continued to work as a sort of junior partner of the firm (see p. 294). Since Sebastiano Casser is especially designated as Domenico's *"giovane"* and received Domenico's and his own drawings as his share in Domenico's last will, we may suppose that Marco had a place of his own. This documentary evidence is further confirmed by stylistic evidence: after Jacopo's death besides pictures clearly executed in Domenico's manner others are produced in a style typical of Jacopo's latest stage. That might lead us, as pointed out above, to the hypothesis that a second personality, more likely Marco than any other, had a share in the shop after Jacopo's death and is responsible for the more "Tintorettesque" productions in contrast to Domenico's. After Domenico's death Marco seems to have headed the shop for two years, perhaps no longer in his full strength, since he made his last will

(mentioned but not published by Hadeln) only a few months after his brother's death. Sebastiano Casser, a German from Switzerland, who is said to have even adopted the name of Tintoretto, followed him after having married Jacopo's daughter Ottavia under circumstances revealed by her last will of October 1645: "I married Sebastiano Casser by order of my brothers Domenico and Marco who before they died made me promise to marry him if I considered him a good painter, in order to keep up the name of the House of the Tintoretto. I put off my decision for a few years, but having made sure that as a painter he was inferior to none and in portraits superior to most, I took him for a husband." Casser married into the firm, a procedure quite in line with the economic and social conditions of the period.

There are, consequently, three generations of "Tintoretti" whom we should distinguish also in their drawings: Jacopo; his two sons, both starting from his late style, but apparently evolving in different directions; finally Casser, who was so much younger that he had no contact with Jacopo except through Domenico's late style. This is a very loose connection.

Besides these three consecutive generations there were other artists to keep the shop going. Jacopo's first pupils may have drawn on his early style, and their drawings have passed into the common working material used in the shop as happened with Casser's drawings at the time of Domenico.

In *Burlington Mag.*, vol. 43, p. 286 ff., Hadeln made an attempt to separate some shop productions from the originals of Jacopo; the latter were repeated in reverse or were enriched by additional figures. It is possible that the numerous tracings preserved on the backs of drawings were intended to facilitate such manipulations. Other auxiliary means to the same end are the frequent retracings in oil of the outlines used to supply inverted impressions of these outlines. Besides original drawings used for shop productions, there are doubtless designs and studies also by pupils themselves within the Tintorettesque material. One of Hadeln's examples was the "Birth of St. John the Evangelist" in San Zaccaria, Venice, and its inverted and enriched version in the Hermitage; we may point out a drawing connected with this composition, No. 1846, that lacks the quality of a drawing by Jacopo and certainly is a shop production the author of which remains anonymous.

A number of members of Tintoretto's shop are known by name. Among those who originated from the North Ridolfi lists Paolo de' Franceschi (see p. 165), Martin de Vos and Rottenhammer. Only the two first mentioned may have stayed at Venice during Jacopo's middle period, Rottenhammer can hardly have arrived there before Jacopo's death. He is to be considered a posthumous pupil whose copies after Jacopo's works are frequent in collections. The style of the two others, of whom Paolo became entirely Venetian, is sufficiently known to prevent the attribution to them of typical productions from the Tintoretto shop.

Other artists listed as pupils of Jacopo are Leonardo Corona, Aliense, Giovanni Francesco Crivelli, Cesare delle Ninfe, the last of whom, incidentally, is the only one called a pupil of Tintoretto by Ridolfi. The three first named are mentioned by him (II, p. 42) as the artists who defended Jacopo Tintoretto's ceiling in the Sala del Maggior Consiglio when it was severely criticized after its unveiling. This ceiling, already mentioned by Borghini and dated 1581 to 1584 by Pittaluga, seems to have been considered a mere routine production from the very beginning. We are told that the three artists who had hidden themselves behind the scaffolds, jumped to Tintoretto's defense when the first criticisms were heard, and Pittaluga (*L'Arte,* vol. 25, 1922, p. 94) interprets this passage to mean that the three young men had largely contributed to these paintings. Thode (*Repertorium,* vol. 24, p. 25 ff.) assumed a considerable collaboration of Vicentino in Jacopo Tintoretto's paintings in the Ducal Palace and A. Venturi construed a considerable part of the oeuvre he gives Vicentino, on the basis of

portions of Jacopo's decorations there which for him, Venturi, are Vicentino's on stylistic grounds. Mongan-Sachs, p. 113, accept this theory.

A special opportunity for discussing the relations between Vicentino and Jacopo is offered by the "Battle of Lepanto" in the Sala dello Scrutinio. Tintoretto's painting was executed in 1573 and destroyed by fire, four years later. In Bardi's program for the restoration of 1587, the painting is listed as by Jacopo Tintoretto. P. L. Rambaldi (in *Rivista d'A.* 1910, p. 17, note) calls this an evident mistake. In our opinion it is, in analogy to many other passages in Bardi's booklet, an evidence that this painting was originally intended for Jacopo, and that in 1587 it had not yet been ordered of Vicentino. The application of Tintoretto's widow of 1600 (*Rivista d'A.* 1910, p. 14) contains a broad hint as to Vicentino's composition in saying that her late husband had worked so hard on his version and received only a modest remuneration "while other people got 1000 and more ducats for their inferior production." We know from another document referring to the widow's application that the payment to Vicentino had indeed been 1100 ducats. All this does not suggest particularly good terms between Tintoretto and Vicentino, and certainly does not allow the inference that Vicentino had completed a composition planned or even begun by Tintoretto. A certain amount of stylistic dependence or stylistic relationship must not be allowed to outweigh the well-established conditions prevailing in the family shops which continued to dominate Venetian art. An artist entered the Tintoretto shop by becoming an apprentice there and became absorbed by its style. Corona had had an entirely different training before some protector helped him to a share in the redecoration of the Ducal Palace. In the case of Vicentino who had spent his early years in Vicenza and is not referred to at Venice before 1583 we are expressly told that he obtained the job through a member of the Cicogna Family who was one of the directors of the decoration, and his close friend. Aliense came from the school of Veronese, and accepted "only later" the manner of Tintoretto, as we are told by Ridolfi, very well informed in this instance. He adds that this manner of Tintoretto was the most imitated by the students of the period in Venice.

A further group of draftsmen to be taken into consideration are Jacopo's posthumous followers, men like Odoardo Fialetti (1573–1638), Camillo Marpegano (1564–1640), Marcantonio Bassetti (1588–1630). They are too loosely connected with Tintoretto to be included in our catalogue except for such works as have been ascribed to him. And so are those drawings, in part translations of his pictorial intentions into graphic expression, which (on p. 292) we discuss as a special group.

1763 BASSANO, MUSEO CIVICO, Coll. Riva, 91. Study from Michelangelo's group Samson slaying the Philistine. Bl. ch., with traces of wh., on buff. 421 x 193. Anonymous.

The linework points to the school of Tintoretto, but the connection is rather loose.

1764 BIRMINGHAM, THE BARBER INSTITUTE. Study of a man bending his knee. Bl. ch., on gray. 258 x 164. Partly squared. — On *verso* a similar study. Coll. Sir J. Reynolds, H. Oppenheimer. Sale Cat. No. 195, pl. 50 as Jacopo Tintoretto. Exh. London, Mathiesen Gall. 1939, No. 99. [Both sides. MM]

The drawing lacks the convincing energy of a drawing by Jacopo himself.

A 1765 BRNO, LANDESMUSEUM, Coll. Arnold Skutetzky. Siege of a fortified town. Bl. ch., wash. 292 x 386. Publ. by O. Benesch, in *Graph. Künste* N. S. I, 62, fig. 14 as school of Tintoretto, possibly Vicentino, with reference to No. **A 1867**.

While the resemblance to No. **A 1867** is so striking that both drawings may be variations of the same composition, the connection with the school of Tintoretto, or with Vicentino, seems less convincing. The types and the short proportions point to a Northern influence.

1766 BUDAPEST, FINE ART MUSEUM, 1914 — 116. Clothed youth seen from behind. Charcoal, on buff. 241 x 449. Rubbed and stained. Late inscription: Tintoretto. — *Verso:* A similar figure seen from front. Ascr. to Jacopo Tintoretto. [MM]

1767 CAMBRIDGE, ENGLAND, FITZWILLIAM MUSEUM, 2248. Standing nude looking over his r. shoulder, his l. arm stretched out. Charcoal, on buff. 372 x 215. Squared. Late inscription: Tintoretto. Coll. Ricketts. Ascr. to Jacopo Tintoretto. [MM]

The point of departure for this study might be Jacopo's Moses in the Scuola di San Rocco, ill. Bercken-Mayer, 111. The (reversed) figure in the drawing shows, however, a different proportion.

1768 ————, 2250. Study of a nude bending to the l., his l. hand

drawn to his chest, the r. hand holding some sort of rope (from an Elevation of the Cross?). Bl. ch., on wh. 251 x 291. Traces of squaring. Late inscription: Tintoretto. Coll. Ricketts. Ascr. to J. Tintoretto.
[MM]

1769 ———, 2251. Study of a seated nude, turned to the l. Charcoal, on buff. 243 x 175. Squared. — *Verso:* a figure falling. Coll. Ricketts.
[MM]

The pose is similar to that of St. Luke, in the painting "The Madonna with the Evangelists," in Berlin (ill. Bercken-Mayer 145). The drawing, however, is not a study for the painting. The poor state of preservation makes it difficult to form an opinion; on the whole the impression of a school production prevails.

1770 CAMBRIDGE, MASS., FOGG ART MUSEUM, 184. Figure study of a partly nude man. Charcoal, on faded blue. 319 x 223. Watermark according to the cat. not in Briquet, but similar to 4871. Modern inscription of Jacopo Tintoretto's name. — On *verso* in an old hand three times the number 4 and the words "Al signor" and "sola." Loeser Bequest 1932 — 288. Mongan-Sachs, p. 98 f., fig. 96, as Jacopo Tintoretto, and possibly a study for one of the flying figures in the "Paradise" in the Ducal Palace.
[MM]

In our opinion not intense enough for Jacopo, but typical of his school.

1771 ———, 185. Study from Michelangelo's group Samson slaying the Philistine. Bl. ch., height. w. wh., on blue. Watermark similar Briquet 1190. 452 x 271. Damaged and stained by mold. Colorspots. — *Verso:* study from the same group, twice repeated. Loeser Bequest, 1932 — 285. Mentioned by Hadeln, *Tintorettozeichnungen,* p. 25, and by L. Dussler, in *Burl. Mag.* vol. 51, p. 33 as by Jacopo. Mongan-Sachs 185: Jacopo.

The group, probably in clay, since a stick supporting the figure is discernable, apparently belongs to the material used by Jacopo in his studio. So inferior in quality to No. **1567** where the arrangement otherwise is similar, that No. **1771** should only be listed as shop production.

1772 ———, 186. Study from Michelangelo's group, Samson slaying the Philistine. Bl. ch., height. w. wh., on faded blue. 382 x 235. Inscription (17th century, according to Cat. "Ridolfi?") Tintoretto, beneath added: "dietro a questo vi è lo stesso gruppo." — *Verso:* the same group. Charles Loeser to Paul Sachs 1933,991. Mongan-Sachs 186, fig. 98: Jacopo Tintoretto.

In our opinion, by a pupil, for the same reasons as No. **1771**.

A 1773 ——— 188. A matron accompanied by five other women in front of an enthroned dignitary; she opens her dress to show her breast. Oil on paper, monochrome. 216 x 328, oval. Bequest Charles Loeser 286. Mongan-Sachs, p. 100: School of Jacopo Tintoretto, close to Domenico.
[MM]

In our opinion, not Venetian. The technique which may have led to the attribution exists also in other schools.

1774 CHELTENHAM, FENWICK COLL., Popham 104, 1. Study from Michelangelo's sculpture "Crepusculo." Charcoal, height. w. wh., on bluish. 262 x 422. — *Verso:* Study from the same figure, seen from approximately the same point. Ascr. to Jacopo Tintoretto.

1775 DARMSTADT, KUPFERSTICHKABINETT, 1437. Study for an angel; the raised arm is studied separately. Bl. ch., on blue. 181 x 156. Publ.

by Hadeln, *Tintorettozeichnungen,* pl. 33 and p. 35, where Hadeln admits that the use of wings for an angel is exceptional with Tintoretto.

In our opinion, the drawing is by a follower of J. Tintoretto.

1776 ———, 2135. Study of a St. John the Baptist. Charcoal, height. w. wh., on blue. 228 x 151. Late inscription: Tintoretto. Ascr. to J. Tintoretto, but publ. by Hadeln, *Spätren.,* pl. 100, as Domenico with reference to No. **1528** and No. **1540**.

In our opinion the drawing is poorer in quality than Domenico's and might be by some other member of Jacopo Tintoretto's shop.

1777 EDINBURGH, NATIONAL GALLERY, Murray bequest 758. Study of a clothed bearded man, seen from front, in a running posture. Bl. ch., on blue. 343 x 235. Late inscription in pen: Giacomo Tintoretto. Ascr. to Jacopo Tintoretto.
[MM]

1778 ———, 1853. Study from an antique head of Apollo. Bl. ch., height. w. wh., on br. gray. 338 x 243. Stained by mold. — *Verso:* the same head (upside down). Ascr. to Jacopo Tintoretto.

1779 ———, 1854. Study from sculpture, head of Roman emperor. Bl. ch., height. w. wh., on br. gray. 302 x 227. Stained by mold and oilspots, torn. — *Verso:* the same head. Ascr. to J. Tintoretto.

1780 ———, 1855. Study from sculpture, head of Apollo. Bl. ch., height. w. wh. 353 x 249. — *Verso:* the same head (upside down). Ascr. to Jacopo Tintoretto.

1781 FLORENCE, UFFIZI, 734. Study from the head of Vitellius. Bl. ch., height. w. wh., on faded blue. 320 x 228. — *Verso:* the same head. Ascr. to Jacopo Tintoretto.

1782 ———, 1662 E. Study from the head of Vitellius. Bl. ch., height. w. wh. 377 x 240. — *Verso:* hasty sketches, a woman's face twice in profile and once en face. Bl. ch. Giglioli, in *Boll. d'A.* 1937, June, p. 542, fig. 9 attr. the drawing, formerly ascr. to Titian, to Jacopo Tintoretto.
[MM]

In our opinion only a shop production.

1783 ———, 1817. Kneeling youth, praying, turned to l. Bl. ch. 233 x 162. Ascr. to Jacopo Tintoretto.
[MM]

1784 ———, 1811. Study after Michelangelo's head of Giuliano de' Medici. Bl. ch., on buff. 393 x 261. — *Verso:* the same sculpture studied in another position. Mentioned by Hadeln, *Tintorettozeichnungen,* p. 27, note 1 as Jacopo.

1785 ———, 1815. St. John the Baptist as a youth, seated and draped. In the lower r. corner his l. leg is repeated. Bl. ch. 290 x 185. — *Verso:* hasty tracing of the same sketch. Publ. by Hadeln, *Tintorettozeichnungen,* pl. 32; on p. 43 Hadeln says the correction of the outline was done by Jacopo himself to make the lines which originally had been very thin more precise.

In our opinion, the type, the lack of clearness in the posture and the insistence on realistic details contradict the attribution to Jacopo and speak for a school production.

1786 ———, 1827. Christ crucified. Bl. ch., on blue. 312 x 209. Squared. Stained with mold and oilcolor. Cut at three sides. Ascr. to Jacopo Tintoretto.
[MM]

Perhaps by a member of his shop influenced also by Palma Giovine

and who drew also Nos. **1788, 1805, 1820.** The stylistic relationship to Palma's "Crucifix" in the Cà d'Oro (ill. Venturi 9, VII, fig. 117) is very noticeable. S. No. **1820.**

1787 ———, 1829. Kneeling bishop, in episcopal vestments, turned to the l. Bl. ch., height. w. wh. 400 x 254. Squared. Mentioned by Hadeln, *Tintorettozeichnungen*, p. 36 in connection with No. **1636.** [**MM**]

Hadeln's reference in our opinion makes the difference between the two drawings still more striking. Ours is poor and sticks to details, No. **1636** is far superior. The figure appears without the mitre in a painting in Narbonne, formerly attributed to Paolo Veronese, now to Jacopo Tintoretto by Venturi, *Studi* p. 312 and *Storia* 9, IV, p. 442, fig. 312.

1788 ———, 1838. A nude with a loin cloth seated and bending to the l. Bl. ch., height. w. wh., on bluish paper. 207 x 301. — *Verso:* Study for the body of Christ, a very hasty sketch of the head of the Virgin, a slightly more finished sketch of the legs. All for a Pietà. The drawing on the back publ. by Hadeln, *Tintorettozeichnungen*, pl. 30, p. 35 and 44 as Jacopo Tintoretto: The difference between this more carefully executed study and others which are more abstract, is understandable by the importance of the figure in the centre of a devotional painting. [*Pl. CXXIX*, 4. **MM**]

In our opinion, this explanation is not sufficient, since the figure on the *recto*, not reproduced by Hadeln, shows the same style. We reject the attribution to Jacopo and ascr. the drawing to the pupil who drew Nos. **1786, 1805, 1820** and others.

1789 ———, 1840. Study from the antique, so-called Apollo, in profile. Bl. ch., on buff. 395 x 279. — *Verso:* the same head. Mentioned by Hadeln, *Tintorettozeichnungen*, p. 27 (by mistake named Head of Giuliano de' Medici).

1790 ———, 12936. Soldier dashing to the r., holding a sword or pole in his r. hand. Bl. ch., on faded blue. 342 x 251. Squared. Damaged by mold. — *Verso:* same figure traced, but shown from behind. Study of the lower part of a human leg sharply foreshortened. Ascr. to Jacopo. [*Both sides.* **MM**]

1791 ———, 12940. Female nude, standing, seen from front, drapery indicated. Bl. ch., on faded blue. 368 x 210. Squared, stained by mold. Ascr. to Jacopo Tintoretto. [**MM**]

In our opinion, a shop production, similar to No. **1767.**

1792 ———, 12942. Standing nude, turning backward. Charcoal, on faded blue. 408 x 249. Squared, worked over. Ascr. to Jacopo Tintoretto. [*Pl. CXXVIII*, 3. **MM**]

In our opinion too poor for him or spoiled by retouches. Shop, perhaps by Marco. A very similar figure appears in reverse at l. in the painting "Esther and Ahasuerus" in Hampton Court (no. 69, Pittaluga p. 269).

1793 ———, 12948. Christ enthroned. Charcoal. 248 x 216. Somewhat stained by mold. Ascr. to Jacopo Tintoretto. [**MM**]

Resembling the figure of Christ in the top of the "Last Judgment" in the Madonna dell'Orto and perhaps derived from this by a pupil. See No. **1822.**

1794 ———, 12951. Nude walking to the r., looking back and carrying a ladder in both hands. Bl. ch. 291 x 186. Ascr. to Jacopo Tintoretto. [**MM**]

In our opinion, a shop production.

1795 ———, 12953. Virgin and Child standing. Bl. ch., on faded blue. 273 x 184. Squared. Publ. by E. Waldmann as design for the "Presentation" in the Academy in Venice, an attribution rejected by Hadeln, in *Jahr. Pr. K. S.* XLII, p. 189 note, because of the mediocrity of the drawing. [*Pl. CXXVII*, 2. **MM**]

We share Hadeln's doubts; the lack of certainty in the linework, contrasting with the elaborate minuteness of the face, indicates a copy. The draftsman may be the same pupil of Ja. Tintoretto, who drew No. **1846.**

1796 ———, 12960. Clothed man standing, seen from front, his legs far apart, raising both arms toward l. Charcoal, height. w. wh., on buff. 226 x 112. Stained by mold. — *Verso:* the same figure as a nude and seen from behind. Ascr. to Jacopo Tintoretto. [**MM**]

In our opinion, a school production.

1797 ———, 12963. Figure with indicated drapery, rushing towards the l. and looking to the r. Bl. ch. 241 x 165. — *Verso:* the same figure traced as a nude and shown from behind. Ascr. to Jacopo Tintoretto. [**MM**]

In our opinion, more likely by Domenico Tintoretto or another pupil. For the use of drawings in reverse and with inverted front, see p. 296.

1798 ———, 12970. Bearded nude standing, holding a book in his hands, bending toward the r. Bl. ch., height. w. wh., on buff. 310 x 202. Squared. The outline of the shoulder is partly retouched with red color. — On the back: the same figure traced and reversed. Ascr. to Jacopo Tintoretto. [**MM**]

Shop production, connected with the "Philosophers" in the Library in Venice.

1799 ———, 12971. Study of a standing youth, seen from the l. His r. foot lifted, his l. hand akimbo. Bl. ch. Squared. Ascr. to Jacopo Tintoretto. [*Pl. CXXVIII*, 2. **MM**]

Used in the painting "The Triumph of David," publ. in *Art News* 1936, January 11, p. 5, and ascr. to Jacopo Tintoretto. Another drawing connected with the same painting is No. **1801.** In our opinion, neither the painting nor the drawings are by Jacopo, but belong to his school. A painting of this subject is mentioned by Boschini-Zanetti, p. 452 as by Domenico Tintoretto and existing in the church of SS. Marco and Andrea. The painting, however, to which the drawings are connected is stylistically different from Domenico by the combination of ornamental detail and of elements recalling Jacopo Tintoretto. It belongs to a group of shop productions which we are tempted to attribute to Marco (some parts of the "Legend of St. Catherine" in Venice, "Esther and Ahasuerus," in Hampton Court and others). If the painting is identical with the one mentioned by Boschini-Zanetti, it may have been executed by Marco at the time when Domenico headed the shop.

1800 ———, 12974. Seated youth, bending to the r., behind him a second figure holding a cloth. Bl. ch., on blue, worked over with brush and oil. 257 x 168. — *Verso:* the same figure traced. [**MM**]

The pose resembles in reverse that of one of the women in the "Adoration of the Golden Calf" in the Madonna dell'Orto (middle ground). The drawing is in such a poor state of preservation that an attribution to Jacopo himself seems unwise.

1801 ———, 12979. Youth walking to the r., carrying in his l. hand some round object, in his r. hand a spear (?). Bl. ch., on faded

blue. 312 x 165. Squared. Damaged in lower l. corner. Ascr. to Jacopo Tintoretto. [*Pl. CXXVIII*, 1. **MM**]

Used for the principal figure in the "Triumph of David," ill. *Art News* 1936, January 11, p. 5. Ascr. to Jacopo Tintoretto. Both, painting and drawing, in our opinion, belongs to Tintoretto's school and perhaps to Marco Robusti (see No. **1799**).

1802 ————, 12981. Nude with a ladder. Bl. ch., on wh. 283 x 176. According to E. Waldmann study for a "Crucifixion." Ascr. to Jacopo Tintoretto. [**MM**]

In our opinion, perhaps a study for a battle-piece and by a pupil in view of the rickety links and the circumstantial rendering of details. Compare No. **1794**.

1803 ————, 12982. Recumbent bearded man, seen from behind, pouring water from an urn; indication of the surroundings. Bl. ch. 153 x 210. Ascr. to Jacopo Tintoretto. [**MM**]

1804 ————, 12989. Nude bearded man, half-length, seen from front; his r. arm is stretched out. Bl. and wh. ch., on buff. 218 x 210. Ascr. to Jacopo Tintoretto, publ. as his by E. Waldmann, *Tintoretto*, p. 76, No. 3, called there a study for the Preaching of St. John the Baptist. [**MM**]

In our opinion, a typical representation of a martyrdom of St. John the Evangelist and more likely by a pupil than by Jacopo himself. Compare No. **1493**.

1805 ————, 12996. Standing youth, seen from behind, turned to the l., stretching his arms. Bl. ch., height. w. wh., on blue. 398 x 247. Ascr. to Jacopo Tintoretto. [**MM**]

Perhaps shepherd of an "Adoration." Compare a similar figure in the painting attr. to Bassano, ill. Cat. Sale Bangel, 1906, November 27, no. 93. See No. **1820**.

1806 ————, 13004. Sketch for a composition Joseph and the wife of Potiphar. Bl. ch., on blue, height. w. wh. 234 x 148. Ascr. to Jacopo Tintoretto. [*Pl. CXXVI*, 4. **MM**]

Very close to Domenico.

1807 ————, 13008. Study after a heap of so-called Atlas figures. Bl. ch., height. w. wh., on blue. 266 x 286. — *Verso:* Another version of the same study. Publ. by Hadeln, *Tintorettozeichnungen*, pl. 10 under the erroneous heading "Study after Michelangelo's Samson."

Similar figures are drawn separately in Nos. **1569**, **1570**, **1746**, **1812**, **1818**, **1858**. Evidently they were working material in use in the studios. A similar heap of such figures appears in the upper l. corner in J. Stradanus' Dante illustration (Inferno, canto 5) in the Laurentiana in Florence (Photo Frick).

1808 ————, 13019. Kneeling nude, turned to the r., loincloth indicated. Charcoal, height. w. wh., on blue. 250 x 323. Squared. Colorspots. — *Verso:* Hasty sketch of a man rushing toward the l., raising his l. arm. Ascr. to Jacopo Tintoretto. [*Both sides.* **MM**]

The figure on the back seems to be drawn from the same sculpture which was used in the painting "Battle on the Lake Garda"; compare No. **1659**.

1809 ————, 13024. Draped biblical figure sitting on the ground (the Virgin of a Crucifixion?). Bl. ch., height. w. wh., on blue. 296 x 192. Ascr. to Jacopo Tintoretto. [*Pl. CXXVII*, 3. **MM**]

Perhaps by a pupil influenced also by Palma Giovine, see for instance Nos. **1786**, **1820**.

1810 ————, 13025. Woman stooping, turned to the l., with outstretched arms (Magdalene of a Lamentation for Christ?). Bl. ch., height. w. wh., on blue. 310 x 210. Squared. Ascr. to Jacopo Tintoretto. [**MM**]

Used (perhaps for a second time) for the female figure in the "Adoration of the shepherds" in the Quincy A. Shaw Coll., Boston (on loan in the Fine Arts Museum, Boston). Perhaps by the same pupil, also influenced by Palma Giovine, to whom we ascr. Nos. **1786**, **1788** and others, see No. **1820**.

1811 ————, 13045. Study from Michelangelo's group, Samson slaying the Philistine. Bl. ch., height. w. wh., on br. 304 x 156. — *Verso:* the same figure. This drawing, formerly called School of Michelangelo and later Jacopo Tintoretto, is now ascr. to Domenico Tintoretto.

In our opinion a mediocre shop production.

1812 ————, 13046. Studies from the so-called Atlas. Bl. ch., height. w. wh., on br. 190 x 202. — *Verso:* the same figure. Formerly called School of Michelangelo, later Jacopo Tintoretto, now ascr. to Domenico.

In our opinion, a shop production.

1813 ————, 17133. Study from Michelangelo's group, Samson slaying the Philistine. Bl. ch., height. w. wh., on blue. 408 x 259. — *Verso:* the same group in another position and a design for a composition of three figures, framed. Mentioned by Hadeln, *Tintorettozeichnungen*, p. 25, note 3.

In our opinion, a shop production.

1814 ————, 17134. The same group as No. **1813**, the upper half of Samson repeated. Bl. ch., height. w. wh., on blue. 414 x 264. — *Verso:* the same group. Mentioned by Hadeln, as above (No. **1813**).

1815 ————, Santarelli, 7477. Study for a St. Sebastian? Bl. ch. Squared. (Photo Cipriani 10067.) Ascr. to Jacopo Tintoretto.

In our opinion, a late shop production under the influence of Domenico Tintoretto (Sebastiano Casser?).

1816 ————, Santarelli 7487. A youth recumbent, his arms under the head. Bl. ch., on yellowish br. 210 x 227. Publ. in Hadeln, *Tintorettozeichnungen*, pl. 17, as J. Tintoretto and companionpiece of Nos. **1545** and **1133**, but to a higher extent emancipated from the model. Exh. London 1931, Popham *Cat.* 280.

Perhaps a study after the same sculpture which in another posture is also used in the centre of the "Miracle of the serpents" in the Scuola di San Rocco (ill. Bercken-Mayer 110) and perhaps in another view in one of the "Allegories of cities" in the Ducal Palace (ill. ibid. 134).

1817 ————, Santarelli, 7499. St. John the Baptist seen from front, seated on the ground, in landscape. Bl. ch., height. w. wh., on faded blue. 321 x 262. Traces of squaring. Ascr. to Jacopo Tintoretto. [*Pl. CXXVI*, 3. **MM**]

Close in style to Nos. **1535**, **1806**.

1818 ————, Santarelli, 7512. So-called Atlas, three times repeated. Bl. ch., height. w. wh. on blue turned br. 270 x 409. — *Verso:* three other studies from the same figure. Publ. by Hadeln, *Tintorettozeichnungen*, pl. 11 as Jacopo Tintoretto.

In our opinion too poor for the master himself and more likely the production of a follower.

1819 FRANKFORT/M., STAEDEL'SCHES KUNSTINSTITUT, 4420. Male nude, recumbent, foreshortened. Charcoal, on blue. 142 x 181. Ac-

cording to Corrado Ricci, *Pinacoteca di Brera*, 1907, p. 76 study for the corpse in the painting at the Brera "Finding of the body of S. Mark" (ill. Bercken-Mayer 69). Hadeln, *Tintorettozeichnungen*, pl. 50 and p. 44 and 57, accepted this identification, with reservations, however, since the style of the drawing differs from that of the other designs for the Albergo in the Scuola di San Rocco (Nos. **1565, 1586, 1597, 1613**), which ought to be of the same period. Ricci's suggestion was accepted by Pittaluga p. 278 and by H. Schrade, *Über Mantegnas Christo in Scurto*, in *Neue Heidelberger Jahrbücher*, 1930, p. 83.
[*Pl. CXXVIII, 4.* **MM**]

In our opinion, the drawing is not a study for the corpse, but a later derivation from it; only the foreshortening is the same in the drawing and in the painting, while the position of the nude differs. The linework corresponds to Nos. **1527, 1830**. The draftsman belonged to Jacopo Tintoretto's shop and might be the same who painted the picture in the Museum in Basel (ill. Ricci, *Pinacoteca di Brera*, p. 77) where the drawing is used for the corpse.

1820 HAARLEM, COLL. FRANZ KOENIGS, I 51. Seated nude turned to the r. Bl. ch., height. w. wh., on gray. 240 x 174. Inscription: Dom⁰ Tintoretto. — In the back inscription in pen: J. T. 27, and "Tintoretto" written by another hand. Ascr. to Domenico Tintoretto. [**MM**]

Resembling in style the drawings which we attr. to a pupil of Jacopo, also under the influence of Palma Giovine. See Nos. **1786, 1788, 1805, 1809, 1810.**

1821 ———, I 73. Nude seated, turned to the r. Bl. ch., height. w. wh. (oxidized), on light blue. 364 x 265. Lower r. corner added. Coll. Dadda. Ascr. to Jacopo Tintoretto. [**MM**]

1822 ———, I 78. Study of a nude climbing down a ladder (?). Bl. ch., on blue. 402 x 271. — *Verso:* Inscription in bl. ch. "Zovan" (?) and in pen "Tintoretto." [*Pl. CXXVII, 4.* **MM**]

The figure appears slightly modified, but similar in style in the "Descent from the cross," ill. in *Pantheon* XVII, p. 118, attr. to Jacopo Tintoretto, but (orally) tentatively given to El Greco by Rod. Pallucchini. (For the inscribed name "Zovan," see p. 258 f.)

1823 ———, I 79. Study from Michelangelo's bust of Giuliano de' Medici; profile, turned to the r. Bl. and wh. ch., on blue. 404 x 243. Rubbed. Inscription (pen): Tintoretto. — *Verso:* study from the same bust. Coll. Dadda. Ascr. to Jacopo.

1824 ———, I 85. Study from Michelangelo's "Crepuscolo." Bl. ch., on blue. 262 x 390. — *Verso:* the same figure. Rubbed. Ascr. to Jacopo Tintoretto.

1825 ———, I 225. Study from the sculpture of a standing nude. Bl. ch., height. w. wh., on faded blue. 425 x 262. — *Verso:* the same figure. Coll. Vallardi, Locarno, Simonetti. Exh. Amsterdam, 1934, Cat. 678; Paris 1935, Cat. Sterling 714. Publ. by Hadeln, in *Pantheon*, 1929, p. 421 f. as by Jacopo Tintoretto and probably drawn from a clay model in view of the support seen between the legs. Regteren in the Cat. of the exhibition in Amsterdam was the first to recognize the connection with No. **1854** where the same sculptural model is drawn from a different angle. [*Pl. CXXV, 3.* **MM**]

In our opinion the drawing was made in Tintoretto's school or academy just as No. **1854** was (perhaps Marvetta).

1826 ———, I 340. Study from the bust of Vitellius. Bl. and wh. ch., on brownish. 260 x 200. Damaged. Ascr. to Jacopo Tintoretto.

1827 ———, I 342. Study from Michelangelo's group, Samson slaying the Philistine. Bl. and wh. ch. 360 x 240. — *Verso:* the same group. Ascr. to Jacopo Tintoretto.

1828 ———, I 401. Study of a standing nude (St. John the Bapt.?). Bl. ch., on br. 300 x 205. Coll. Julius Böhler. Ascr. to Jacopo Tintoretto. [*Pl. CXXVI, 2.* **MM**]

1829 ———, I 402. Nude kneeling, turned to the r. Bl. ch., height. w. wh., on br. 297 x 216. Squared. Damaged by mold. Coll. Julius Böhler. Ascr. to Jacopo Tintoretto. [**MM**]

1830 ———, I 404. Study of a human body foreshortened. Bl. ch. on faded blue. 205 x 295. Coll. J. Böhler, purchased 1929. Ascr. to Jacopo Tintoretto. [**MM**]

In our opinion, probably by the same member of the shop who drew No. **1819.**

1831 LAUSANNE, COLL. STRÖLIN. Two clothed men, crouching on the floor, writing on the tablet of the cross. Bl. ch., height. w. wh., on greenish. 178 x 315. Squared in ch. Ascr. to Jacopo Tintoretto.

The realistic rendering of the brutal types is an argument against the attribution to Jacopo himself. [**MM**]

1832 LONDON, BRITISH MUSEUM, 1885-5-9 — 1656 to 1660. Five studies from the bust of Vitellius, all drawn *recto* and *verso*. Bl. ch., height. w. wh., on blue. Mentioned by Hadeln, *Tintorettozeichnungen*, p. 24, note 1 as Jacopo Tintoretto, accepted as his by Popham, *Handbook*, p. 45. [*Pl. CXXV, 1.* **MM**]

In our opinion all these drawings were done in the shop, the first of them probably by Marietta because of some resemblance to No. **1762.**

A **1833** ———, 1900-8-24 — 130. Beheading of St. John the Baptist. Pen, br., wash., height. w. wh. (oxidized), on greenish. 266 x 230. Listed as "attributed to Tintoretto."

Old copy from Jacopo Palma Giovine's altar-piece in the Gesuiti church, Venice.

1834 ———, 1913-3-31 — 179. Nude recumbent, used in the "Resurrection" in the F. and H. Farrer coll., London (Berenson 482). Charcoal, on blue. 236 x 316. Late inscription: G. Tintoretto. Publ. by Hadeln, in *Burl. Mag.* vol. 44, p. 281, pl. II, E, as Jacopo Tintoretto. [**MM**]

The linework differs notably from authentic drawings so that a classification as school production seems more advisable. We are unable to say how far the painting which we saw only once several years ago supports our standpoint.

1835 ———, 1913-3-31 — 180. Study of a nude. Charcoal, on bluish. 182 x 319. Many corrections. Publ. by Hadeln, *Tintorettozeichnungen*, pl. 51, and p. 37 as a canceled study by Jacopo for his "Holofernes" in Madrid, dated by Hadeln in the 1580's and by Bercken-Mayer I, p. 185 (ill. 93) in the 1570's. The identification is accepted by Popham, *Handbook*, p. 45, who by a slip of the pen says Munich instead of Madrid. [*Pl. CXXVIII, 5.* **MM**]

The resemblance to the body of Holofernes is only superficial. The drawing is a design done by some member of the shop for the figure of Christ in the "Descent from the Cross" in Caen (ill. Osmaston, vol. II, pl. CCV).

1836 ———, 1913-3-31 — 181. Recumbent nude, seen from behind, the l. hand resting on a staff. Charcoal, on blue. 218 x 327. A few corrections. Ascr. to Jacopo Tintoretto. [**MM**]

1837 ———, 1913-3-31 — 185. Study from an antique bust. Bl. ch., on blue. 368 x 218. Stained by mold. — *Verso:* Seated nude seen from behind. Squared. Colorspots. The drawing on the *verso* publ. by Hadeln, *Tintorettozeichnungen*, pl. 38 as Jacopo Tintoretto. [*Both sides.* **MM**]

In our opinion, the study of the bust might be by some member of Tintoretto's shop, the *verso* is stylistically close to Domenico.

1838 ———, 1913-3-31 — 187. Clothed youth kneeling, turned to the r. and holding a staff in his l. hand. (Viol-player?) Charcoal, with traces of heightening, on blue. 215 x 199. Squared. Ascr. to Jacopo Tintoretto. [**MM**]

The very good drawing has only a loose connection with Tintoretto's school.

1839 ———, Fawkner 7212. Clothed man seated seen from front, his r. hand on his chest. Bl. ch., height. w. wh., on faded blue. 236 x 171. Squared. Listed as "doubtful Tintoretto." [**MM**]

A comparison with No. **1702** somewhat resembling it in its posture reveals the difference from an outstanding drawing. Realistic details are more emphasized (see the bench, the modeling of the shoes by shadows); moreover, there are weaknesses in the foreshortening (see for instance the upper thigh) which do not occur in Jacopo's authentic drawings.

1840 LONDON, VICTORIA AND ALBERT MUSEUM, Dyce 236. Kneeling monk. Bl. ch., height. w. wh., on blue. 370 x 240. Squared. Ascr. to Jacopo Tintoretto, Reitlinger *Cat.* 1921, no. 24, ill. [**MM**]

In our opinion, at best by a later imitator.

1841 ———, Dyce 237. Study from Michelangelo's group, Samson slaying the Philistine. Seen from behind. Bl. ch., on faded blue. 413 x 263. Coll. Sir Joshua Reynolds. Ascr. to Jacopo Tintoretto.

1842 ———, Dyce 238. Study from Michelangelo's group, Samson slaying the Philistine. Bl. ch., height. w. wh., on brownish. 273 x 135. Corners cut. Later inscription in pen: Tintoretto. Ascr. to Jacopo Tintoretto.

1843 ———, Dyce 244. Study of a Christ (from a Flagellation). Bl. ch., height. w. wh., on faded blue. 322 x 180. — *Verso:* Study from the so-called Atlas. Ascr. to Jacopo Tintoretto. [*Pl. CXXVII, 1.* **MM**]

The study of Christ was used in the painting of a "Flagellation" in the Hausmann Coll. in Berlin, publ. as by Jacopo by Herm. Voss, in the *Zeitschr. f. B. K.* 65, p. 163.

In our opinion, the drawing, just as the painting, of which we have seen only a photograph in the Witt Library, is a shop production.

1844 LONDON, COLL. COLNAGHI. Kneeling man, clothed, turned to the l., and holding a staff with the r. hand. Charcoal, height. w. wh., on blue. 325 x 216. — *Verso:* hasty sketch of a nude, whose arms are almost unrecognizable. Below an original mark in the form of a cross. [*Both sides.* **MM**]

1845 LONDON, COLL. EARL OF HAREWOOD. Study from Michelangelo's group "Samson slaying the Philistine." Bl. ch., height. w. wh., on faded blue. 416 x 263. — *Verso:* the same group.

1846 LONDON, COLL. CAPTAIN REITLINGER. Design for the woman kneeling at the l. in the painting "Birth of St. John the Baptist" in the Hermitage, ill. *Burl. Mag.* vol. XLIII, pl. III, D. Bl. ch., on blue. 198 x

315. Squared. Late inscription: G. Tintoretto. Publ. by Reitlinger in *O. M. D.* 1922, pl. 5: study for the figure in a lost painting of which a copy exists in the Hermitage.

In the drawing the posture of the head and of the r. arm and the drapery differ notably from the painting, which according to Hadeln is a reversed and enriched version of the painting in San Zaccaria, Venice (ill. l. c. pl. I A) and a typical shop production. (See p. 296.) The drawing connected with one of the additional figures confirms Hadeln's theory being by its inferior quality recognizable as a shop production too.

1847 LONDON, COLL. A. P. AND C. R. RUDOLPH. Study of a seated man, seen from behind. Bl. ch., on blue. 289 x 198. Inscription in pen: G. Tintoretto. Coll. Heseltine and Vicomte d'Hendrecourt. Publ. by Hadeln, *Spätren.*, pl. 54 as Paolo Veronese. Fiocco, *Veronese II*, p. 129 (under Londra, di Hendecourt): Paolo Veronese or Jacopo Bassano or really Tintoretto.

We do not see the reasons why this drawing, formerly ascr. to Jacopo Tintoretto, should be by Veronese. The only two studies for separate figures by the latter, Nos. **2078, 2084**, are quite different in their linework. Also the posture of the figure would be unique among Veronese's accessory figures. Compare for the difference in style the somewhat similar problem in Veronese's "Christ among the Doctors" in Madrid (ill. Fiocco, pl. X). In our opinion, the style is much closer to Tintoretto's or his followers. Vicentino is one of the artists who also should be taken into consideration, see Nos. **2226-2227 bis**.

1848 MILAN, COLL. RASINI. Study from Michelangelo's group "Samson slaying the Philistine." Bl. ch., height. w. wh., on faded blue. 376 x 263. In lower r. corner inscription: Disegno del Tintoretto. — *Verso:* the same group.

1849 MODENA, PINACOTECA ESTENSE, 1021. Kneeling bearded man, clothed, turned to the r., in worshipping gesture. Bl. ch., height. w. wh., on faded blue. 230 x 146. Squared. Worked over with the brush. Ascr. to Jacopo.

1850 MUNICH, GRAPHISCHE SAMMLUNG, 2982. Study from the bust of Vitellius. Bl. ch., height. w. wh., on greenish. 283 x 230. Rather damaged by retouching. Mannheim Collection. Publ. by Schmidt, *Handzeichnungen*, 158 and Hadeln, *Tintorettozeichnungen*, pl. 2 and p. 24 as Jacopo Tintoretto, but given to Jacopo's school, perhaps Marietta, by Morassi, p. 33, because of its inferior quality.

1851 NAPLES, GABINETTO DELLE STAMPE, 0710. Floating figure, nude with waist-cloth. Brush, darkbr. over ch., on blue. 334 x 180. Very much damaged. Ascr. to Jacopo.

In our opinion, by a pupil of Domenico Tintoretto.

1852 ———. Study from the bust of Vitellius. Bl. ch., height. w. wh., on brownish. 300 x 204. Listed as anonymous Venetian, 16th century. [*Pl. CXXV, 2.* **MM**]

1853 OXFORD, CHRISTCHURCH LIBRARY, L 1. Studies from the so-called model of Michelangelo's Giuliano de' Medici. Bl. ch., height. w. wh., on faded blue. 315 x 266. — *Verso:* the same figure. Mentioned by Hadeln, *Tintorettozeichnungen*, p. 27 as Jacopo. W. Paeseler, *Münch. Jahrb.* N. S. X, p. XXIX. See No. **1729**.

1854 ———, L 1. Study from two antique figures, a youth and a woman with the arms broken off. Bl. ch., height. w. wh., on faded

blue. 320 x 280. — On *verso:* Studies from the same figures. The drawing on the *verso* publ. by Hadeln, *Tintorettozeichnungen,* pl. 1 and p. 23 as Jacopo Tintoretto: "The differentiation between outlines and modeling is typical of an inexperienced hand and the drawing therefore an early work. A further argument in favor of the early date is the figure of Apollo in Jacopo's ceiling dated 1545 (owned by Colonel Bromley-Davenport) resembling the study of the youth in its posture."

This connection, if it really exists, would only prove that the figure was already in Tintoretto's studio when he was young. The poor penmanship, rightly noticed and emphasized by Hadeln, induces us to ascribe the studies to one of Jacopo's pupils, maybe to Marietta, with regard to No. **1762.** Another study of the same youth, probably by the same hand, is No. **1825.**

1855 ————, L 9. Study after bust of Vitellius. Bl. ch., height. w. wh., on buff. 393 x 263. — *Verso:* the same head. Much rubbed. Mentioned Hadeln, *Tintorettozeichnungen,* p. 24 as Jacopo Tintoretto.

1856 PARIS, LOUVRE, 5395. Kneeling man, seen from front (loosening his shoe or wiping his foot?). Bl. ch., height. w. wh., on grayish blue. 194 x 194. Publ. by A. L. Mayer in *Burl. Mag.* XLIII, p. 34 as Jacopo Tintoretto. [**MM**]

Some features point to Palma Giovine in whose painting "Christ washing the feet of the apostles," in San Giovanni in Bragora, Saint Peter appears in a similar pose. The style, however, is not typical of Palma's, nor is it of Jacopo Tintoretto. The drawing may be by a follower of the latter, perhaps the same who drew No. **1862.**

A ————, PARIS, ÉCOLE DES BEAUX ARTS, 34924. See No. **2236.**

1857 ROME, GABINETTO DELLE STAMPE, F. N. 3463. Study from the so-called Atlas. Bl. ch., height. w. wh., on faded blue. 305 x 210. — *Verso:* Study from the same figure. Mentioned by Hadeln, *Tintorettozeichnungen,* p. 27 as Jacopo Tintoretto.

1858 ————, F. N. 3464. Study from the so-called Atlas. Bl. ch., height. w. wh., on blue. 310 x 203. — *Verso:* Study from the same figure, seen from another side. Mentioned by Hadeln, *Tintorettozeichnungen,* p. 27, as Jacopo Tintoretto. [*Pl. CXXV,* 4. **MM**]

A ————, 125043. See No. **1543.**

A ————, 125524. See No. **1544.**

1859 ————, 125526. Study of Saint John the Baptist. Bl. ch., on faded blue. 354 x 221. The l. arm is drawn in three positions. Ascr. to Jacopo Tintoretto. [*Pl. CXXVI,* 1. **MM**]

In our opinion, shop production and in view of the timid strokes perhaps by Marietta (See No. **1761**). Note the stylistic contrast to the rendering of a similar subject by another member of the shop, No. **1776.**

1860 ————, 125527. Study from Michelangelo's group "Samson slaying the Philistine." Bl. ch., height. w. wh., on blue. 404 x 258. In upper l. corner modern inscription: Tintoretto. — *Verso:* Study from the same figure. Ascr. to Jacopo Tintoretto.

1861 ————, 125528. Nude, kneeling, turned to the r., with a mitre on his head. Bl. ch., on blue. 366 x 207. At the man's l. shoulder a mantle seems to be indicated. Ascr. to Jacopo Tintoretto. [**MM**]

In our opinion, closer to Domenico or another pupil.

A STOCKHOLM, NATIONAL MUSEUM, 1399. See No. **55.**

1862 VENICE, R. GALLERIA, 188. Study from Michelangelo's group "Samson slaying the Philistine." Bl. ch., on br. Mentioned by Hadeln, *Tintorettozeichnungen,* p. 25, note 6 as Jacopo Tintoretto.

1863 VIENNA, ALBERTINA, 88. Study from an antique head. Bl. and wh. ch., 354 x 248. Rubbed. Formerly ascr. to Schiavone. *Albertina Cat. I* (Wickhoff) 169: Not by Schiavone. Mentioned by Hadeln, *Tintorettozeichnungen,* p. 24 as by Jacopo. Ascr. to Jacopo Tintoretto.

In our opinion, mediocre workshop production; a companion piece of which exists also in the Albertina (Reserve).

1864 ————, 91. Study of a clothed youth, seen from behind. Bl. ch., 257 x 149. Squared. Publ. by J. Meder, *Handzeichnung,* 420, as a study for a figure in the "Birth of St. John the Baptist" in the Hermitage. This reference was rejected by Hadeln, *Tintorettozeichnungen,* p. 35 who also questioned the authenticity of the drawing. Again ascr. to Jacopo by Stix-Fröhlich in *Albertina Cat. II.*

We agree with Hadeln.

1865 ————, 96. Moses. Brush, oil color, on greenish paper. 337 x 228. In upper l. corner later inscription: Jacomo Tintoretto 1577. *Albertina Cat. I* (Wickhoff), 133 b.

The attribution to Jacopo was maintained by Stix-Fröhlich in *Albertina Cat. II* "with reference to the authentic drawings in the London sketchbook," and rejected by E. Tietze-Conrat, in *Graph. Künste,* N. S. I, p. 95; she ascribed the drawing to a follower of J. Tintoretto and pointed to L. Corona's painting in San Bartolomeo in Venice, ill. Venturi 9, VII, p. 248 as an analogous figure. [**MM**]

Since the style of drawing is not compatible with Corona's, we limit ourselves to keeping the drawing among the anonymous works of Tintoretto's shop.

A ————, 100. See No. **1182.**

A ————, 101. See No. **1183.**

A ————, 102. See No. **1553.**

A ————, 103. See No. **19.**

A 1866 ————, 104. The deluge. Bl. and red ch., pen, wash, height. w. wh., 280 x 410. In the middle a strip has been cut out, the two parts of the drawing were mounted on another sheet and the gap filled. Formerly ascr. to A. Turchi; *Albertina Cat. I* (Wickhoff), 298 accepted this attribution, but expressly denied any connection with Turchi's painting of this subject in the Louvre. In *Albertina Cat. II* (Stix-Fröhlich) ascr. to the School of Tintoretto. [**MM**]

In our opinion certainly not Venetian. Perhaps more in the direction of Pier Francesco Mola.

A 1867 ————, Roman school, 350. Siege of a fortified town. Pen, bistre, wash. 204 x 247. *Albertina Cat. II,* Roman School 350: Tempesta. O. Benesch, in *Graph. Künste* I, p. 62: School of Tintoretto, probably Vicentino and a companion piece to No. **1765.**

In our opinion the style is different from Vicentino's and from that of the Tintoretto school. See No. **1765.**

1868 WÜRZBURG, UNIVERSITÄTSMUSEUM, Folder 29, no. 3. Study

of a nude man, standing, clasping his hands above his head. Charcoal, on br. 311 x 121. Publ. by Hadeln, *Tintorettozeichnungen,* pl. 31 and p. 43 as Jacopo Tintoretto and called exceptional for its solid outlines. W. Suida, in *Belvedere* 1923, IV, p. 154: more likely by an imitator of Jacopo.

We agree with Suida.

TIZIANO VECELLI

[Born about 1485–88, died 1576]

Three times an attempt has been made to deal critically and systematically with the enormous number of drawings traditionally ascribed to Titian in older collections and with the smaller number picked out at random by recent authors. The first list was Hadeln's in his *Tizianzeichnungen,* the second, Mrs. Fröhlich-Bum's in *Jahrb. K. H. S., N. S.* II, p. 195 ff. (intentionally excluding the landscapes on which she later published a separate study in *Belvedere,* 1929, p. 71 ff., the third, our own list published in our *Tizian-Studien.* In her review of the latter in *Art Bulletin* 1938, p. 44, Mrs. Fröhlich-Bum stated her willingness to modify some of her former opinions without specifying them, and presumed that the late Baron Hadeln would have reacted the same way. As far as we are concerned, we certainly claim for ourselves the same privilege to withdraw or change positive or negative statements we have previously made, in spite of the fact that our studies were published so much later than Hadeln's or Fröhlich-Bum's.

This futility of efforts all of which may claim an equal degree of conscientiousness and competence, make clear that the problems involved are extremely difficult, to the point of eluding the most painstaking criticism. This truism is still more expressly confirmed when we compare the three lists. Hadeln's contains 36 drawings of which Mrs. Fröhlich-Bum rejected 13 and we 19, besides questioning four of the six which he added in the English edition of his book. Mrs. Fröhlich-Bum enumerated 45 drawings, 28 of which we do not believe to be by Titian, and she subsequently added twelve landscape drawings ten of which, in our opinion, are not by him. Our own list contained 39 drawings, four or five of which we now judge differently. On the other hand, we increase the number by attributing eight or nine new drawings to Titian, on the basis of our studies continued incessantly from 1935 on.

These 42 or 45 or 39, fluctuating as they are, are certainly a surprisingly small number in view of the unusual duration of Titian's activity. The lack of material and tradition may be explained by two reasons.

It is a matter of experience that an important stock of drawings was preserved in olden times only when either a proud family watched over this part of an artist's legacy, as a rule still kept together at the time of his death, or when the material continued to be used by the surviving shop. It is well known that in both these regards Titian was not favored by the circumstances of his death during the plague of 1576. Because his son and chief assistant for many years, Orazio Vecelli, died nearly at the same moment as Titian himself, the studio went almost suddenly out of existence. Titian's residence was plundered during the confusion in the plague-stricken town; what the robbers left was shortly after dispersed by the surviving son, Pomponio, who was not interested in his father's memory.

The second point is Titian's real or alleged aversion to drawing. When Vasari blamed Giorgione for having intentionally neglected drawing (see p. 4, 168) he added that this part of his doctrine was adopted by Giorgione's followers amongst whom Titian held a prominent place. The pontifical authority exercised by Vasari in the formation of artistic taste, worked, of course, to retard the rise of an interest in Titian's drawings.

When later on collectors, driven by an urge for completeness (an integrant part of a collector's attitude),

began to look out for drawings which might be attributed to him, their choice fell on those reminding them of Titian's painted compositions, and on landscapes. As a specialist in this field he was praised as early as by Lomazzo, in his *Trattato* of 1584 (ed. 1844 II, p. 443) and continued to be so highly esteemed that his activity and that of his double, Domenico Campagnola, absorbed almost the entire production of the late Renaissance in Italy, even including part of the Northern too. Almost all landscape drawings up to the middle of the 17th century were boldly attributed to one or the other, and we have to go back to the attributions made by Mariette and the engravers of the Jabach Coll. in order to find other names suggested besides those of Titian and Campagnola. When critical study began in the second half of the 19th century this branch was left almost untouched by Morelli, whose whole treatment incidentally of the Titian drawings was hardly more than a hasty sketch. Hadeln admitted only one drawing of this class in his *corpus* of the Titian drawings, No. **A 1892** in Darmstadt. It is interesting to note that even such an outstanding scholar was deceived in this much confused and confusing special field. The drawing is at best a reflection of Titian's enormous influence, even on Northern artists, in the 17th century. Later on Hadeln added No. **A 1946** which, however, we are no longer in a position to acknowledge as by Titian. The few further specimens which he picked out as worth discussing (Nos. **1991, 1992**) from the rich available material, were cautiously stored away by him under the name "School of Titian."

The first to essay a more systematic investigation of Titian's landscape drawings was Mrs. Fröhlich-Bum who devoted to them an article in *Belvedere;* moreover, she discussed them and neighboring groups in her articles on Schiavone, Savoldo and Domenico Campagnola (*Jahrb. K. H. S.* vol. XXXI, p. 137 ff.; vol. XXXIII, p. 367 ff.; *N. S.* II, p. 195 ff.; *Belvedere* 1929 (VIII), p. 71 ff. and 1930 (IX), p. 85 ff.). Her mistake was to have permitted sentimental reactions to have guided her in distributing the drawings at random, among the existing artists. As for Titian her results were still more reduced in value by her start from a deplorable point of departure, No. **A 1873** in Bayonne, a more or less Carraccesque aftermath of Titian's style. She was misled by her regrettable mania of attributing all the drawings representing the "Martyrdom of St. Peter Martyr" to the author of the most famous painting of this subject. In the same *Tizian-Studien* where we presented our objections to this thesis, we also endeavored to reach more solid ground by introducing into the discussion, woodcuts, reliably dated in Titian's early period and such later graphic material as allowed conclusions bearing on an earlier date of origin for the drawings used in it.

With the help of "The Sacrifice of Abraham," authenticated for 1516, we were able to tie the study of trees in the Metropolitan Museum, No. **1943**, hitherto left floating unanchored, to Titian's early period. This important discovery (if we may be allowed to infringe the law of modesty in order to underscore a relevant scientific point) is supported by the recognition of the "Flight into Egypt" in the Hermitage (ill. *Art in America* 1941, 114) in which the figure style is identical with the one in the "Sacrifice of Abraham." This double evidence confirms Vasari's explicit statement that Titian made his studies after nature *in his early years,* in the period between the strong influence of Giorgione and the beginning of his monumental style. No. **1875** in Bayonne, and No. **1912** in a private collection in France, are to be added for stylistic reasons both linked together by the appearance of the same building in the background and authenticated for Titian by use in two woodcuts that have always been connected with him. By grouping these rather reliably dated studies from nature we obtain a sufficiently secure insight into Titian's early style of landscape drawing.

For a second phase of his evolution in this field, No. **1872**, again in Bayonne, appears to us as the most representative; it is authenticated by Cornelis Cort's engraving of 1565. Since two other versions of the drawings

exist, one in Chatsworth and one in the Louvre, there might be a doubt as to which of them is authentic, a doubt which, in our opinion, vanishes in the face of the originals, the one in Bayonne being incomparably superior to the others. A. L. Mayer himself, although doubting its authenticity, admits its superiority; in the presence of the original drawing he would probably yield his doubts. A similar yielding disposition might not be expected from Mrs. Fröhlich-Bum whose oracular pronouncement runs "study for Cort's engraving after an invention of Titian." Cort's engravings, as universally known, were the official reproductions of Titian's works. In this case, we have such an official engraving and a corresponding drawing which, in our opinion, is too good to be a copy. Why should not Titian have made the drawing himself, as he did in analogous cases? A. L. Mayer refers to Titian's letter of August 15, 1571 to King Philip II in which two prints from the design (disegno) of St. Lawrence are mentioned. Cort's print of Titian's "Martyrdom of St. Lawrence" is not exactly like either of the painted versions (Venice, Gesuiti, c. 1555, and Escorial), but is based on a third version, probably consisting of a painted *modello*. We suppose the same procedure exactly for the Prometheus, see No. 1999. But there is no reason why in other cases, drawings should not have served as models for engravings and especially here, where the engraving does not reproduce a painting. It is not correct to say, as A. L. Mayer asserts, that cartoons or preparations in drawing were no longer made at that time. We have many drawn *modelli* among our Venetian drawings of the second half of the 16th century (e.g. Nos. 805, 2045, 2056), and in his life of Aliense, Ridolfi differentiates between *modello* and *disegno,* that is, between painted and drawn models and also expressly mentions cartoons (II, 215). Another possibility would be that Cort made his own design in which he would have transposed Titian's design for his graphic purposes. This, however, cannot apply to our drawing which looks different in style from Cort's authentic drawings (see *Vasari Society* VI, pl. 18). Furthermore, the drawing was not made at the time of the engraving, 1565, but its style is congruent with the period, the 1540's, when Titian indulged in such mythological or romantic subjects.

The different artistic approach of the two groups which we tried to characterize is striking. No. 1872 meant as the preparation of a complete composition lacks the spontaneity and directness of those earlier drawings which are eagerly struggling for penetration of reality. We may add that to a certain extent this lack of freshness explains the hesitations as to original or copy. The drawing style or penmanship, however, is common to both groups. It offers a purely graphic expression for which the intervals between the strokes are as important as the strokes themselves. This sincere and complete devotion, corresponding to Poussin's formula, *"je n'ai rien négligé,"* is the patent of nobility for great mastership in general, but we certainly feel it especially strong in Titian's drawings which are tender and vigorous at the same time. In many cases when pupils and followers come very close to him this mixture of daring and delicacy remains the essential touchstone. It gives us certainty for a number of drawings, which we group round the "Angelica": Nos. 1871, 1954, 1955, 1974. All these drawings have been attributed to other artists as well. We will not repeat our arguments, discussed at length when we describe the drawings in question. They form part of our effort to replace attributions based predominantly on sentiments by attributions backed up by the belief in an organic artistic personality in Titian.

These efforts to discover the presumable place of a drawing by the help of other better authenticated works are, of course, nothing new. On the contrary, this method has been so severely criticized that it may in fact be obsolete. The essential task remains that of establishing the specific nature of the supposed connection. A greater or lesser conformity, or resemblance, of several portions or even of the whole, is not yet sufficient evidence. The drawing may be derived from a painting and imitate it as well as prepare and precede it. Such is the case with

Nos. **A 1913, A 1921**, connected with Titian's murals in the Scuola at Padua. The most instructive example, however, of the confusion of these two fundamentally different kinds of connection is the attribution to Titian mentioned above (p. 305) of a score of drawings representing the martyrdom of St. Peter Martyr, on the basis of a vague resemblance to his painting of the subject, destroyed by fire in 1867. Before this event it was one of the most admired and most imitated models for numerous generations of artists. The drawings in question are to the better part placed in the dangerous category of "first ideas" — "ideas" because of being so hasty, and "first" because their resemblance to the painted composition is so slight. Their hastiness however is not that of a sketch, but that of a later period, intent first of all on seizing the pictorial effect of a Titian painting. A confrontation of the spurious group with the genuine sketches in Lille, Nos. **1923–25**, legitimate first ideas in which the growth of the artistic conception can be observed, is more instructive than a long-winded dissertation. (Note especially the strange case of Nos. **1997, 1998** in the Louvre, both obviously belonging together, the one publ. by Mrs. Fröhlich-Bum in 1925 as another first idea of the "Martyrdom of St. Peter," i.e., of 1528/30, the other in 1924 as a preliminary sketch of Titian's "Jealous Husband" in Padua of 1511 and thence, according to her, a companion piece of No. **1961** in the École des Beaux Arts!)

Unfortunately, early sketches for total compositions are very scarce and almost entirely confined to Titian's youth. The one in Lille is preceded by the two sketches in Frankfort and Berlin for the "St. Sebastian" in Brescia (Nos. **1880, 1915**), one of the figures which Titian prepared most carefully, and reliably dated 1520; still earlier is the sketch in the École des Beaux Arts, No. **1961**, for the "Jealous Husband" in the Scuola in Padua, but here again we may strike a snag: these murals in Padua, and of course, their preparatory stages still more, are so tightly linked with Titian's formation that his figure does not stand out clearly from its environment. The late Dr. Richter was very much inclined to attribute the invention of this dramatic composition (not of this drawing) to Giorgione, and we, ourselves, in our article on Domenico Campagnola listed strong reasons for seriously considering this artist as the draftsman. It seems, however, impossible to abstract from the outstanding quality of the drawing whose weaknesses, so confusingly near to Domenico's characteristics, might be typical of a highly gifted youth. At any rate, No. **1961** stands and falls with the "Two shepherds in landscape" in the B. M. (No. **1932**). There is hardly another drawing which has caused us to rack our brains so much. In our *Tizian-Studien,* p. 172 and 190 we proposed Titian as the author, in our studies on Domenico Campagnola we pondered seriously over Domenico Campagnola, but now, after so many hesitations, we are more inclined to hold to our first proposition unless No. **1961**, too, is given to Campagnola. We do not see how the two drawings could be separated. They are, in our opinion, twin productions. For a few allegedly related drawings, "The two boys" in the Albertina (No. **1970**), the "Madonna and Christchild" in the Louvre (No. **A 1951**), "The Judgment of Paris" in the Louvre (No. **537**), the ultimate decision concerning their attribution seems to depend on their quality. For the first mentioned, the decision is unanimous in favor of Titian although some critics have refused to see his hand in the landscape; for the last mentioned, a no less complete agreement has been reached in ascribing it to Domenico Campagnola. For the middle one, No. **A 1951,** we must confess our reluctance to join in the almost unanimous acceptance of Titian's authorship. We give our reasons (on p. 323) for connecting the drawing with the Titian renaissance of the ending 16th century as represented by the Carracci.

We are, of course, aware that in accepting evident weaknesses as results of the hastiness of youth we enter slippery ground. The recognition of such productions is apt to lead to the acknowledgment of others similarly

objectionable. Hadeln fell into this error when attributing to Titian such poor drawings as Nos. **A 1927, A 1930, A 2010.**

Before turning from the general sketches to studies for details, we must mention No. **1952** which holds a place midway between the two categories. The drawing was strangely misdated by Morelli, and in his wake by Fröhlich-Bum, who assumed some connection with Titian's late "Pentecost" in the Salute (1554/60). The general spirit and the penmanship combine to support Suida's dating of the drawing as early as 1518 or even shortly before. For Titian's invention is certainly reflected, if not directly used, as Suida suggested, in D. Campagnola's engraving of the same subject of 1518. It forms part of Titian's new monumentality which reaches its first peak in the "Assunta."

Of studies in a restricted meaning of the word, only a few are universally (or almost so) accepted: No. **1929** in London for the figure of St. Peter in the "Assunta"; No. **1904** in Florence used for the figure of St. Bernardin, in the votive painting for the Doge Gritti, no longer existing, but preserved in an almost contemporary woodcut; the drapery on the back of No. **1904v**, used in the figure of the kneeling Doge; No. **1935** possibly a study for one of the kneeling apostles in the first version of the "Descent of the Holy Ghost," painted for Santo Spirito, between 1541 and 1544; finally No. **1906**, the study for the legs of the executioner in the "Martyrdom of St. Lawrence" in the Gesuiti, painted between 1548 and 1558. (For possible roots in an earlier stage of Titian's evolution, see p. 316.) The existence of such a careful study for a secondary figure makes us wonder what amount of such studies may have perished!

A further drawing belonging to this class of studies, No. **1908**, again in the Uffizi, aroused no opposition at the Titian Exhibition in Venice in 1935; its publication, however, in *O. M. D.* in 1936 and in *Tizian-Studien* met with no support, although in our opinion the drawing is doubly authenticated, by the conformity of the horseman to a figure in the "Battle of Cadore," and by the resemblance of the study of a head on the *verso* to a secondary figure in the Pesaro altar-piece. The rejections of our suggestions by Fröhlich-Bum in *Art Bulletin* 1938, p. 445, and by Franz Kieslinger in *Belvedere* 1934/36, p. 173 ff. are so vehement that they miss the mark and make us prefer to leave the matter open to discussion. The Moor's head on the back, which according to Fröhlich-Bum "cannot even be associated with Titian's circle" is, on the contrary, close in spirit and style to those underpaintings of Titian's portraits, the brutal force and directness of which have been revealed only by X-ray photography (see Tietze, *Tizian*, fig. 173).

In this connection, we should like to emphasize once more that a drawing is not to be considered as a mere esthetic creation, but should be studied within the process of production in an organized studio. As the coarsely indicated heads discovered by the X-ray lamp beneath highly accomplished portraits cannot be considered as independent works of art, thus a drawing like the head on the verso of No. **1908** might be properly judged only as working material. The same is the case, though in another sense, with two other heads we bring up for discussion. One is No. **1982** in Chatsworth, the powerful head of a prelate executed in somewhat dry linework to which notations of colors have been added. The old tradition suggesting Titian seems attractive insofar as the drawing may have been made or perhaps traced in the shop from an original of the master, in order to permit further repetitions of the portrait. The other drawing we have in mind is a woman's head that appeared at a public sale in Paris, in the winter of 1939, No. **1964**. It is drawn on very thin paper and the principal outlines look as if traced, while the accessory details (hair and so on) are freely handled. The head is used with slight modifications for the main figure in Titian's "Education of Cupid," but the same type appears

also in earlier paintings. The general outlines may have been traced from one of these paintings by Titian himself or some member of his shop and modifications added which the new purpose required. This origin might explain a certain dullness of the linework, typical of cartoons preparing the final execution.

It would be easier to explain the second rate character of No. 1964 (and perhaps also to support the claims of No. 1908v) if authentic portraits existed among Titian's drawings. Unfortunately, this is not the case. The only drawing in this category, No. A 1899, up to now never doubted except by Th. Hetzer and ourselves, as Titian's masterpiece in this field, owes its reputation to high quality and charming appearance rather than to a specific relationship to Titian's style. It is, however, difficult to combat an attribution for which, as a matter of fact, no reasons have ever been offered. We gave our negative ones when suggesting the name of Romanino for this charming portrait and hope to emphasize its difference from Titian when claiming for him another outstanding study of a head, No. 1878, fluctuating up to now between Bordone and Moretto. Both attributions rest only on casual resemblances with types familiar to these two painters, and fail to recognize the specific Titianesque glamor of this portrait which because of its resemblance to the bearded rider in the "Ecce Homo" in Vienna and to medals might represent some number (Daniele?) of the Hanna family. Their family portrait, now no longer existent or not yet identified, was painted by Titian.

To the category of definitely fixed designs for portraits belongs the one for the "Portrait of the Duke of Urbino" in the Uffizi (No. 1911). It possibly preserves the original composition of the painting, but its penmanship is rather dry and uninspiring. The head of a woman in Erlangen, No. 1894, resembles somewhat the "Duke of Urbino" in its linework and may also be considered as working material. The same applies to No. 1962, in the École des Beaux Arts, the design of the "Sacrifice of Abraham," which exactly corresponds to the ceiling now in the sacristy of Santa Maria della Salute in Venice. Such a very finished drawing may have been Titian's principal contribution at a time when the execution of larger works began to be left to assistants. A splendid work drawing, for the lion of St. Mark in the lower left corner of the "Fede" in the Ducal Palace, one of those official commissions on which Titian seems to have worked with great reluctance, exists in the Koenigs Coll. (No. 1917). In his later years Titian may have limited his collaboration to designs of this sort. We find the difference in quality and style from another lion significant, the one in Venice (No. 2006) and connected with Titian's ceiling in Brescia of 1568, which is preserved only by an engraving. Titian seems not to have taken any interest in this work destined for a provincial town. When his assistant, Orazio Vecelli, brought it to Brescia, the town councillors at first refused to accept it, because they did not acknowledge in it Titian's hand at all. Perhaps it belonged entirely to Orazio, who in this case may also have made the drawing, unless a still more secondary member of the shop is responsible for it.

The bifurcation of Titian's path in its last stretch, into a mass production chiefly carried by the shop and hardly more than touched up by the master, and in consummate lone masterpieces of the most intimate personal character, is one of the most fascinating problems of Titian's old age (see Tietze, *Tizian,* p. 231 ff.). As far as drawing is concerned the result is a still greater uncertainty than in other periods, or, if not greater, certainly different from the earlier stages. The darkness connected with the last efforts of a great artist adds to the awe inspiring mysteriousness of his figure. For Titian's late drawings we grope in the dark as Hadeln did. It is interesting to note that in criticizing the Louvre copy of No. 1886 which Franz Wickhoff had published as a genuine Titian, Hadeln did not even acknowledge Titian's invention, while Wickhoff, less interested in the question of penmanship, had recognized and hailed a great masterpiece through the copy. Later on, when Hadeln

found the original, then in the Ricketts Coll., he gladly forgot all about his former objections to the composition.

The mythological couple in the drawing at Cambridge (England) leads to the world of Titian's "poesie," while another of his late drawings, No. **1905** in Florence, is related to his sporadic religious creations. It is not correct to say, as Loeser did, that the drawing is a study for the "Annunciation" in San Salvatore at Venice, but the spirit is very much the same in both angels. Still more typical of the death and apotheosis of a great art are, in our opinion, the two horsemen in Munich and Oxford, Nos. **1941, 1949.** Only the latter was known when Hadeln published the German edition of his *Titian Drawings,* but he subsequently added the other in the English edition. These horsemen (and a few more military subjects, including the unique and, therefore, very puzzling Helmet No. **1897**) by virtue of a superficial association very typical of art criticism, used to be connected with Titian's chief creation in this field, the "Battle of Cadore," although not only is none of the motives in question found in this composition, but they are also entirely contrary in spirit and style to the painting. For the reasons expounded in *O. M. D.* 1936, March and in our *Tizian-Studien* (see also No. **1941**) we still believe that the only drawing connected with the "Battle of Cadore" is No. **1908,** while the others are much later and may possibly be drawings which Titian made to assist his son Orazio for his "Battle on the Tiber" of 1562. A foreshortened horseman jumping over a soldier in armor seemed so superior to other parts of this mural that Vasari felt obliged to mention the rumors that Titian had a share in this work.

Obliged to discover the increasing share of the assistants in Titian's late productions the critic may easily overlook the contrary possibility. No trace is left of Orazio's mural, unless possibly that design, or those designs, contributed by his father. We notice a similar relationship to Titian in a very impressive mural painting in SS. Giovanni e Paolo in Venice, attributed by local writers to an otherwise unknown Lorenzino, a late pupil of Titian. The conformity to Titian is so noteworthy that it can hardly be sufficiently explained by mere imitation, but makes us suppose that Lorenzino may have used drawings of his master. His case may not be a unique exception. We are inclined to surmise a similar nearness of Titian in the magnificent drawing representing a battle scene, No. **1977** in Berlin, formerly ascribed to the Circle of Titian, but claimed for Giovanni Contarini by Hadeln, who, however, admitted the considerable differences between the drawing and the painting in the Ducal Palace with which he connected it. Contarini, who accepted Titian's influence like that of others, nevertheless did not belong to his intimate circle and the attribution to him of a drawing so deeply permeated by the spirit of the old master is therefore not justified. By whom else may the drawing be? As far as Titian is concerned pen drawings from the presumed period are not available for comparison. (The "Entombment" in the N. Brown Coll. in Providence, No. **2004,** deserves attention as a similar combination of late Titianesque and more advanced elements in a technique that makes comparison difficult.)

In these last mentioned drawings we witness the dissolution of Titian's latest style in the production of his school. How his earliest style stemmed from Giorgione has already been touched on in the discussion of the "Jealous Husband" and related pieces (p. 307). We return to this point because in an artist of such an eminently conservative constitution as Titian retrospect view of his course promises some additional insight. As a matter of fact some artistic motives seem to have accompanied him through all his life, linking creations of his maturest age to his school days with Giorgione. This has been observed by various critics in paintings like the "Pardo Venus" in the Louvre, the "Idyll" in Vienna and others. A root or germ of these two famous late works is contained in the drawing No. **1948,** whose approach to the land of Titian's youth (Dom. Campagnola), was recognized even when it was still in the Pembroke Coll. and whose greater attractiveness was hinted at by Parker

in the catalogue of the Henry Oppenheimer Sale. Our attribution to Titian did not meet approbation, but neither did it provoke discussion, and we refuse to accept pontifical judgments by any authorities who have not made an effort to disprove our thoroughly documented and still valid arguments: that this is a drawing in a technique and style typical of Titian in his youth, and that his motives reappear in two late compositions, both universally accepted as reminiscent of Titian's early impressions.

We must insist that another much discussed question, that of the Faun in Lille, No. 1926, also cannot be solved by decrees. Referring to our statements on p. 319 we summarize: as L. Dussler though sticking to Sebastiano for the drawing explicitly admits, the drawing is by no means a design of Sebastiano del Piombo's mural in the Farnesina with which, from Morelli on, it has been connected; it shows the greatest imaginable stylistic contrast to the only plausible drawing of Sebastiano from this period or close to it, No. 1470. It shows, on the other hand, a very close stylistic resemblance to well established works of Titian from the same period, for instance, the woodcut St. Jerome, and breathes the mood which lingered over Titian's whole mythological production as an inheritance from his training with Giorgione. As for Mrs. Fröhlich-Bum's attribution to Annibale Carracci and her reference to the Earl of Leicester's picture we have not seen this picture nor have we ever been able to find a photograph or other reproduction of it. We seriously doubt, however, that any connection between drawing and painting exists and, moreover, by virtue of the year-long special studies one of us has devoted to the Carracci, assert that the drawing has nothing to do either with Annibale Carracci, or with his period or school.

How indispensable a careful and objective study of a drawing is may be illustrated by No. 1928, already much discussed when still forming part of the Malcolm Coll. We return it to Titian who lost it when Domenico Campagnola began to play his ominous part as Titian's double. A more thorough examination than former ones have been, discloses two distinctly different stages in the drawing (see p. 319), one very close to Giorgione, the other recalling Titian's more energetic way of expression. In the 17th century the composition was considered to be by Titian, as testified by Lefèvre's engraving, and in two articles Mrs. Betty Kurth endeavored to bring new evidence for this tradition. In our opinion, the best witness is the drawing itself, in which so to speak the composition grows before our eyes: the seated girl is Giorgione's from whose "Concert Champêtre" she originates; Titian inserted her in a new composition, at the same time partly drawing over her soft outline with coarser strokes identical with those used in his additions. The difference is so sensible that the drawing may be by Giorgione, and rounded up by Titian for the new purpose. It is, however, more likely that its nucleus is an early study by Titian after Giorgione, which he brought up to date somewhat later, perhaps about 1520.

A 1869 AMSTERDAM, COLL. VAN REGTEREN ALTENA. Study for Saint Joseph. Pen, grayish bl. 130 x 108. W. König Coll. (Vienna). Exh. Amsterdam 1934, no. 686: Titian, with reference to St. Joseph in the lost painting of the "Holy Family" by Titian, some time in the possession of King Charles I of England and copied in a miniature by Teniers (Cat. of the Italian Exh. in London, 1930, no. 365), reproduced in the *"Theatrum Pictorum"* (No. 55). [MM]

We cannot find a striking resemblance to this figure. Regteren's attribution to Titian apparently rests on a certain resemblance to the linework in Nos. 1915 and 1923–25, these drawings being indeed the only ones which offer a groundwork for discussion. In our opinion, the resemblance is only superficial, the hatchings in Titian's drawings, temperamental as they are, aim at clearness, while those of the St. Joseph aim at a summary pictorial effect. The drawing which in every line of the face emphasizes a spiritual tension belongs to the 17th century. We find a similar type of St. Joseph in Simone Cantarini's painting "Rest on the Flight into Egypt" in the Louvre, where only the posture of the body is different.

A 1870 BASEL, COLL. DE BURLET. Draped man, half-length, looking upward. The drawing of the hand separately repeated. — *Verso:* Two studies of a draped r. leg. Bl. ch. on blue, damaged by mold. 270 x 415. Formerly Nebehay, Berlin 1932, at that time publ. by C. E. Cooke, *Some recently discovered drawings by Titian* (reprint in the Witt Library; we were unable to locate the publication).

The drawing belongs to the school of Bologna, about 1600. Compare, for example, the drawing of Pietro Faccini, Uffizi 6194.

1871 BAYONNE, MUSÉE BONNAT, 150. Landscape with satyrs and nymphs. Pen, br. 265 x 410. Inscription: *Di Ticiano.* Coll. Andreossy, Chennevières. The drawing was twice engraved in the 17th century (Mariette, *Abedecedario V,* 333–338). Exh. École des Beaux Arts

1879, No. 204 as Titian. Ephrussi in *Gaz. d. B. A.* 1879, II, p. 316 questioned the attr. to Titian and suggested "timidly and with reservations" G. M. Verdizotti. Morelli II, p. 293: Do. Campagnola. *Bonnat-Publ.* 1926, 16: Titian. In our *Tizian-Studien* 182: Titian, with reference to the scenes in the background of "Bacchus and Ariadne" in the N. G. in London and of the "Pardo Venus" in the Louvre, and to details in the left of the "Rest on the Flight into Egypt" in the Prado. For the Giorgionesque reminiscence of the satyr see also No. **714**. Tietze, *Tizian*, fig. 71: 1530–1540. A. L. Mayer in *Gaz. d. B. A.* 1937, 305 ff.: Does not feel sure whether it is not a copy from a lost original. Fröhlich-Bum's idea (in *Art Bulletin* December 1938) placing the drawing in the time and milieu of the Carracci should be mentioned only as a curiosity.

We understand Mayer's doubts which are caused by the reproduction. In our *Tizian-Studien* we commented explicitly on the difference between the impression made by the original which is full of atmosphere, and that of the reproduction on a smaller scale which presses line against line.

1872 ————, 652. Romantic scene (so-called Roger and Angelica; by others called Medea, or Apocalyptic scene). Pen, br., somewhat damaged, especially in the body of the woman. 250 x 395. Cut at l. and at the upper border. Contemporary inscription: Titianus. In our *Tizian-Studien* p. 162, fig. 137: Titian, certified by Cornelis Cort's official engraving of 1565 (in reverse, ill. ibidem fig. 136). We dated the drawing about 1540 to 50, with reference to the mythological paintings for King Philip. The drawing corresponds almost exactly to the engraving, except that the magic vessel is lacking which in the engraving is seen next to the head of the woman. A copy from the drawing in Chatsworth (exh. London Matthiesen Gallery 1939, no. 91) was ascr. to Domenico Campagnola by Morelli II, p. 291 and by Gronau in *Gaz. d. B. A.* 1894 (XII) p. 330 who did not recognize the connection with the engraving by Cort. Publ. also as Campagnola in *Chatsworth Dr.* pl. 52. Other copies are in the Louvre and at Cheltenham (*Fenwick Cat.* p. 46, 11: copy perhaps done in the Carracci school after the drawing by Campagnola at Chatsworth). Our attribution to Titian was rejected by Mrs. Fröhlich-Bum in *Art Bull.* 1938, p. 445 where the drawing is called: study for Cort's engraving after an invention of Titian. A. L. Mayer in *Gaz. d. B. A.* 1937, p. 305 questions the authenticity of the drawing although admitting that the version is superior to the one in the Louvre. In *Gaz. d. B. A.* 1938, p. 299 Mayer says: the drawing reproduces at best a drawing by Titian about 1545, but he prefers the idea that Cort worked on the basis of *modelli* in grisaille as the engravers after Rubens and Van Dyck did.
[*Pl. LXIX,* 3. **MM**]

We can understand Mayer's doubts because of the strange fold at the abdomen of the woman appearing only in the reproduction. This disturbing detail does not exist in the original; the paper is damaged and produces the wrong impression in the photograph. Compare our fuller discussion of Mayer's theory on p. 305.

A 1873 ————, 1318. Sketch for a martyrdom of St. Peter Martyr. Pen, reddish darkbr. 220 x 135. — *Verso:* Another version of the same composition. Publ. by Fröhlich-Bum in *Burl. Mag.* 1924, December as Titian's sketches for his (destroyed) painting in SS. Giovanni e Paolo. In our *Tizian-Studien* p. 152 ff. we rejected the attr. to Titian and gave reasons for our opinion that both sketches deviate from the finished painting. The penmanship and the slender figures point to the end of the century or the beginning of the 17th century. The penwork recalls Agostino Carracci's. [Both sides. **MM**]

A third version of the composition by the same hand (Photo Witt Library) exists in the Fitzwilliam Museum in Cambridge, England, no. 76, under the name of Agostino Carracci. A painting of the same subject similar in style exists in Christchurch Library, Oxford, and is ascr. to Annibale Carracci (Borenius, *Pictures by the old masters in the library of Christchurch*, Oxford, 1916, no. 135, pl. XXXIV). Compare also Domenichino's representation of the subject in Bologna.

A 1874 ————, 1319. St. John the Baptist in landscape, and St. Jerome contemplating the crucifix. At the left the foot of St. John is repeated on a larger scale. Pen, br. on paper turned yellow. 272 x 270. — *Verso:* late inscription: Titien Vecelli. Venturi, *Studi*, p. 284, fig. 179 and *Storia* 9, III, p. 343, fig. 204: Titian, for a painting which contained both saints, of the same date as the "St. Jerome" in the Brera.
[**MM**]

In our opinion, the latter suggestion is as erroneous as the attr. to Titian. The drawing which is cut on both sides, combines separate and unconnected models for saints and might even have contained more since it is cut on both sides.

1875 ————, 1323. Landscape with a castle (used in Titian's woodcut Landscape with milkmaid, Pass. VI, p. 242, No. 96). Pen, br., on paper turned yellow. 217 x 347. Grosvenor Gall. 1877, Russell Coll. (Archives photographiques 835.) Publ. in our article in *Graph. Künste* N. S. III, p. 57, fig. 4: Titian; the castle is the same as in No. **1912**, but seen a little more from the l. *P. C. Q.* 1938, October, p. 356.
[*Pl. LXIII,* 1. **MM**]

Very good drawing from nature, of the second decade of the 16th century, probably made at the same time as No. **1912**. Similar castles apparently typical of Titian's homeland Cadore appear in Titian's paintings (for instance in the "Battle of Cadore," ill. Tietze, *Tizian* I, pl. XVII). The high house at the r. and the towers are used for the background in the drawing No. **1974**. The same castle is represented on a sheet containing various sketches in the F. J. Mather Coll. at Washington Crossing, Pa., in our opinion, a work of an artist of the 17th century [**MM**]. Because of the many differences of details the drawing evidently is not a copy from No. **1875** or No. **1912**.

A 1876 ————. St. Francis receiving the stigmata. Pen, br., on paper turned slightly yellow. 231 x 312. Cut above, semicircular top. Publ. as Giovanni Bellini in *Bonnat Publ.* I, pl. 1. Attr. by Venturi, *Studi* p. 284, fig. 178 to Titian, when still under the influence of Giovanni Bellini, and by Berenson, *Drawings* no. 1848 B, to Piero di Cosimo. [**MM**]

Neither by Tizian, nor Bellini whose painting of the same subject in the Palazzo Ducale in Pesaro (*Klassiker, Bellini* 52 l.) shows an absolutely different approach. The attr. to Piero di Cosimo convinces us as little, but the Florentine origin may be acceptable.

A BERLIN, KUPFERSTICHKABINETT, 434. See No. **421**.

A ————, 2383. See No. **423**.

A 1877 ————, 4542. Historical scene. Pen, on wh. paper. 380 x 263. Slightly damaged by a gummy substance which gives the impression of wash. Hadeln, *Tizianzeichnungen* 17: Titian. Fröhlich-Bum, *N. S.* II: rejects the attribution to Titian, suggesting Vicentino or Aliense. A. L. Mayer, *Gaz. d. B. A.* 1938, vol. 20, p. 300: later than Titian, related to the period of Van Dyck.

We agree with Mayer's dating in the well-advanced 17th century and believe that the drawing is not purely Venetian, though hardly Flemish.

A ———, 5036. See No. **831**.

1878 ———, 5733. Portrait of a bearded man, looking up to the r. Bl. ch., height. w. wh., on br. Cut. 312 x 230. Coll. F. Murray, von Beckerath. Bailo-Biscaro, p. 194: Bordone, possibly a study for the "St. Fabian" in Berlin. *Berlin Publ.* 86: Bordone. Anna Maria Brizio in *L'Arte* 31, 1928, p. 57: Moretto, together with No. **2118**, ascr. to Paolo Veronese in Munich, an attribution accepted by G. Gombosi, *Moretto da Brescia*, Basel 1943, p. 116. 1. Exh. London 1930 Popham *cat.* 176: Bordone. "The handling is definitely different from that of the other undoubted drawings by Bordone, but the type is so exactly his that the attribution appears a reasonable one." [*Pl. LXVI*, 2. **MM**]

We first reject Bailo-Biscaro's reference to the St. Fabian (ill. Venturi 9, III, fig. 685); the saint looks to the l. and at the onlooker. Only the general type is somewhat similar. The same coincidence of type led A. M. Brizio to make her ascr. to Moretto. However, the few drawings we have by Moretto show a dryness very different from the lively and atmospheric treatment of this drawing. The type of a bearded man with abundant hair is not a monopoly of Bordone and Moretto. Accordingly, we drop Mr. Popham's reference to the Bordonesque type and endorse only his doubts. We, too, find the penmanship different from that of Bordone's undoubted drawings, but similar to that of the Moor's head, No. **1908** *verso*. Perhaps the drawing was a portrait study for Titian's lost family portrait of the d'Ana (de Hanna) family whose portraits are handed down in medals by Leone Leoni (compare that of Daniele de Hanna, Venturi 10, III, p. 411, fig. 326). The bearded rider in the "Ecce Homo" in Vienna painted for this family in 1543 shows a close resemblance to the sitter in the drawing. Compare also the resemblance to type and posture in Titian's earlier portrait "The Man with the Falcon," whose left hand resembles the one indicated in the drawing (Tietze, *Tizian* II, pl. 77).

A ———, 5109. See No. **723**.

A 1879 ———, 5163. Group of nude men (according to O. Benesch perhaps Apollo and Marsyas). Pen, br. 223 x 236. Ascr. to D. Campagnola, publ. by Benesch, *Graph. Künste* N. S. I, p. 14, pl. 3 as Titian, with the restriction that the figure at the r. (called Midas by Benesch) may have had its finishing touches added by a later hand. Benesch placed the drawing between 1516 and 1522, perhaps in connection with Titian's mythological paintings for Ferrara. In our article in *Critica d'A.* VIII, p. 80 we rejected the attribution to Titian and gave the drawing to an antiquarian engraver in the younger G. Franco's style. We are now certain that Franco himself, whose style is different, is out of the question, but still reject the attr. to Titian. [**MM**]

1880 ———, 5962. Six sketches for the Saint Sebasian in the altar-piece in Brescia, and a seated Madonna with Child. Pentests, accounts. Pen, on wh. paper. 162 x 136. Beckerath Coll. Hadeln, *Tizianzeichnungen* 6: Latest date 1520, as the painting of this wing with St. Sebastian, date 1522, was finished by 1520 (Campori, *Tiziano e gli Estensi*, p. 11). Fröhlich-Bum *N. S.* II, no. 11. In our *Tizian-Studien* p. 191, 13. Tietze, *Tizian*, p. 103: The group of the Madonna and Child may be a first idea for the corresponding figures in the Ancona altar-piece (1520). [*Pl. LXV*, 2. **MM**]

The drawing is probably earlier than No. **1915**.

1881 BOLOGNA, COLL. CARLO BIANCONI, formerly. Two eagles fighting a winged dragon. Pen. The drawing is lost, but its facsimile

reproduction is preserved, inscribed: Dal disegno del Sig. Carlo Bianconi in Bologna. Reproduced in Tietze, *Tizian*, I p. 262. [**MM**]

In our opinion, the attribution may be correct, but we accept it only with reservations, since the reproduction is somewhat subjective. The drawing probably represents an allegorical device for the cover of a painting. It is an ornamental counterpart of the naturalistic motive in the background of the early "Baptism" in the Capitol Gallery. A similar motive occurs in the signboard of Julio Leal of Mantua which relates to Virgil's tomb in Mantua (compare *Graph. Künste*, LII, p. 43, No. 9).

A 1882 BRISTOL, ALDERSON COLLEGE, COLL. PROFESSOR C. E. COOKE. Adam and Eve. Bl. ch. height. with wh., on blue. 250 x 180. We were told in 1937 that the drawing had recently been cut by a broken glass and damaged. Coll. d'Hendrecourt. Publ. by Hadeln, *Titian drawings*, pl. 39. [**MM**]

We agree with Professor Suida who (orally) rejected Hadeln's attribution and dated the drawing in the 17th century. The way the planes are unified by hatchings in order to give a pictorial impression goes far beyond Titian. Similar types are to be found in Bernardino Cavallini's paintings and a motive resembling Eve's in his "Woman tending the wounded St. Sebastian" (ill. *Boll. d'A.* 1924, July). Cavallini's way of drawing, however, is not sufficiently known to allow the attr. of the drawing to him.

A 1883 BRNO, FELDMANN COLL., formerly. Study for a knight saint. Bl. ch. or charcoal, height. w. wh., on bluish green. 313 x 234. Inscription (18th century): Cavedone. — On the *verso*: Saint deacon. Publ. by O. Benesch in *Graph. Künste* N. S. I, p. 15, fig. 4 and 5: Titian, related in style to the drawings Nos. **1904** and **1897** and Titian's painting in the Vatican Gall. (ill. Tietze, *Titian* 148). E. Tietze-Conrat in *O. M. D.* 1936, September p. 24 rejected the attr, and returned to the older attr. to Cavedone, with reference to the similar style of Cavedone's paintings, ill. *Boll. d'A.* 1930, p. 417 ff., fig. 4, 8.

A 1884 ———, formerly. Landscape. Pen, 143 x 395. Coll. Lely, Richardson sen., W. G. Becker. Attr. to Savoldo by Fröhlich-Bum, *N. S.* II, fig. 264, to Titian by Suida, *Tizian* CXXIIa, with reference to an alleged resemblance of the rocky mountain to the background of the "Presentation of the Virgin."

The alleged resemblance is only superficial and the mountain range entirely typical. The drawing is hardly Venetian at all and certainly has no resemblance either to Savoldo or Titian.

A BUDAPEST, MUSEUM, E 18. Men on horseback, see No. **387**.

A 1885 ———, E 1. 21. Christ carrying the cross. Bl. charcoal or ch., fixed with brush, on faded blue. 192 x 292. Later inscription: Tician. Hadeln, *Titian Drawings* pl. 31: Titian. [**MM**]

The parallel strokes are meant to homogenize the composition. There is no analogy in Titian's work for this procedure and the absolute subordination of every individual figure to an ornamental scheme points to a later stage than Titian ever reached.

A CAMBRIDGE, MASS., FOGG ART MUSEUM, no. 70. See No. **388**.

1886 CAMBRIDGE, ENGLAND, FITZWILLIAM MUSEUM. Mythologic couple in embrace. Bl. ch., on blue. 225 x 265. Coll. Charles Ricketts. Hadeln, *Tizianzeichnungen*, pl. 33. Fröhlich-Bum *N. S.* II, p. 198. Popham. *Cat.* 266. Our *Tizian-Studien*, p. 186, no. 36. The drawing is unanimously dated in Titian's late period. A copy of the drawing

in the Louvre, no. 5660 (bl. ch., on br., 302 x 210) was publ. by Wickhoff in *Jahrb. d. Zentral-Kommission* 1907, p. 24, as an original by Titian and dated in the period of the "Assunta." Hadeln, in *Jahrb. Pr. K. S.* XXXIV, p. 245 denied any connection, even of the composition with Titian, but when the original emerged accepted it without hesitation. [*Pl. LXX*, 1 **MM**]

A 1887 CASSEL, KUPFERSTICHKABINETT. Kneeling priest, turned to the r. Over ch. sketch, bl. ch., on faded blue. 260 x 190. Cut. Inscription: Carlo Maratti, and formerly ascr. to him. Attr. to Titian by Franz Voigt, in *Graph. Künste*, N. S. III, p. 17 f. (ill.), with reference to No. **1916**.

The reference is excellent and the drawing in Cassel by Cavedone like No. **1916**.

A CHANTILLY, MUSÉE CONDÉ, 117, Seven men sleeping. See No. **1256**.

A 1888 ————. Martyrdom of Saint Peter Martyr. Pen, wash. Publ. by Willumsen, II, 75: sketch for Titian's (lost) painting in San Giovanni e Paolo. Accepted by Fröhlich-Bum, *Belvedere* 1929, p. 74. We rejected this attr. in our *Tizian-Studien* p. 153 (fig. 130): copy from the painting, late 16th century.

A CHATSWORTH, DUKE OF DEVONSHIRE, 910. See No. **1982**.

A ————. Landscape with a man carrying a bag. See No. **1974**.

A 1889 COPENHAGEN, COLL. J.-F. WILLUMSEN. Adoration of the Magi. Pen, sepia, wash. A detail of the r. side with the Negro king is ill. in Willumsen, I, p. 150 who adds: the posture of this Negro king was copied exactly by Schiavone in his Brera "Nativity."

In our opinion, there is neither a connection between the two figures, nor one between the drawing and Titian. The drawing is much later and, as far as we can judge from the reproduction, not even Venetian.

A 1890 ————. Sketch for a frieze: Nude cupids with masks dancing, in the middle a draped cupid as an actor. Pen. Publ. by Willumsen, I, p. 284.

There is no connection with the fragments of murals in Titian's house attr. to him; the drawing is, in our opinion, much later and has nothing to do with Venetian art.

A 1891 DARMSTADT, KUPFERSTICHKABINETT, 174. St. Anthony healing the cut leg of a youth. Brush and pen, height. with wh. and red ch. Schrey in *Stift und Feder* 1929, 174: Titian's design for his fresco in the Scuola del Santo in Padua.

The drawing has not been accepted by the literature on Titian. It is indeed a later derivation from the painting in the style of the 17th century (B. Castiglione?).

A 1892 ————. Landscape. Pen, wash, on wh. 114 x 163. Hadeln, *Jahrb. Pr. K. S.* 1922, p. 108: Titian, with reference to a drawing in Oxford, No. **1950**. Hadeln, *Tizianzeichnungen*, pl. 16. Fröhlich-Bum *N. S.* II, 42: Titian, about 1560-70. We rejected the attribution in our *Tizian-Studien* 182. Hadeln himself dropped the only drawing to which he had referred, when first publishing the Darmstadt landscape, in his *Tizianzeichnungen* p. 43, and ascribed it to an imitator of Titian in the 17th century. The style of the drawing corresponds, in our opinion, to Elsheimer's sketchbook in Frankfort

(compare Weizsaecker's edition 1923, nos. 171, 174 and others) and the closest analogy is a drawing by P. A. Patel in the British Museum, publ. in *O.M.D.* 1931, June. A. L. Mayer, *Gaz. d. B.A.* ser. 6, vol. 20 (1938), p. 300 rejects Titian's authorship, dating the drawing in the 17th century.

A 1893 EDINBURGH, NATIONAL GALLERY OF SCOTLAND. Landscape, Pen. The drawing is probably cut at the l. Publ. in *Vasari-Society* IX, 8: Titian. Hadeln, *Tizianzeichnungen* p. 42: probably Bolognese, 17th century. *Albertina Cat. II* (Stix-Fröhlich) (and no. 46, our No. **2009**): Probably by the same hand as No. **1943** and No. **2009**, Circle of Titian, first third of the 16th century. [**MM**]

We accept Hadeln's attribution.

1894 ERLANGEN, UNIVERSITÄTSBIBLIOTHEK (Bock 1541). Head of a woman, looking down to the r. Pen, on reddish paper. 94 x 90. Apparently cut. On the back of the mount later inscription: Titian. Publ. by Bock: Venetian; first half of the 16th century. An unpretentious, but not unimportant drawing. [*Pl. LXV*, 1. **MM**]

In our opinion, the drawing is a work drawing by Titian himself comparable to his preparation for the portrait of the Duke of Urbino (No. **1911**) where the penwork is very similar. The round shape of the ear is Titian's. The study (perhaps cut) might have prepared the underpainting of the nude woman in Titian's "Sacred and profane Love." The lack of flattering loveliness and the different posture make a copy from the painting unlikely.

A 1895 FLORENCE, UFFIZI, 470 P. Saint Jerome in the wilderness. Pen, on paper turned yellow. 195 x 305. Damaged. Publ. in *Uffizi Publ.* I, p. 2, 1: Titian, design for the woodcut Pass. VI, 235, 42, which is larger and different in graphic style. Hadeln, *Tizianzeichnungen* p. 42: Copy after the woodcut. Morassi-Rasini p. 30, ad XX: accepts the attribution to Titian.

When a drawing is in the same direction as the engraving connected with it, it is more likely to be a copy. The drawing is indeed different in style from Titian's other drawings and so poor in quality that Hadeln's opinion seems well founded.

A 1896 ————, 538 P. Landscape: wild forest with rocks, in the lower r. corner a dog seen from back, and a shepherd recumbent (cut). Pen, brownish gray on whitish paper. 420 x 278. — On *verso* later inscription (17th century?): Di Tiziano della piu diligente maniera. [**MM**]

The drawing belongs to a group with No. **1445** and G. Muziano's landscapes (compare Ugo da Como, *Muziano*, p. 16, 105 f., 160 and others) and might illustrate the manner in which this artist sketched. Mariette seems to have thought of Francesco Salviati for this group of drawings. See the copy No. **A 1975**.

1897 ————, 566 E. Helmet. Bl. charcoal. height. with wh., on blue. 450 x 356. Late inscription: Titian. Contemporary inscription in charcoal: '2' and '4'. — *Verso:* Small figure — Christ? — flying downwards, another flying figure and separate arm. See No. **899**. *Uffizi. Publ.* I, 2 no. 6: Titian in his middle period (Loeser). Ricketts, *Titian:* Tintoretto. Hadeln, *Tizianzeichnungen* pl. 25: Titian. Fröhlich-Bum *N. S.* II, p. 197: P. Veronese. Suida, *Tizian*, p. 76: Titian, in connection with the "Battle of Cadore." [*Pl. LXXI.* **MM**]

The drawing on the back might be by Palma Giovine. Although as a rule the two sides of a drawing should not be separated, in this case the attr. of the "Helmet" to Palma seems inadmissable. It shows neither his style of drawing, nor the approach of his period to such

a problem. The style fits into the middle of the 16th century. The high quality of the drawing, a point on which all experts agree, led to attributions to the three greatest masters of the Venetian Renaissance. The difficulty is that for none of them is a really compatible material for comparison available. By Veronese we have, it is true, an authentic study of a suit of armor No. **2034**, but its entirely different technique and the smaller size preclude a satisfactory comparison. For Tintoretto, we do not see any justification at all; the interest in characterizing the material and in clearly indicating weight, position and surroundings are in contrast to his abstractness and to his habit of keeping his pictorial interests outside his drawing. The best arguments still speak for Titian in his later age, 1550–60. Compare, for instance, the penmanship of No. **1906**. We find in the "Helmet" Titian's deliberate approach to reality (compare, for instance, the helmet in the portrait of Francesco Maria della Rovere, Uffizi (Tietze, *Tizian* 102) which an older tradition erroneously connected with our drawing) and the indifference and wisdom of an old man. For all these reasons we prefer the hypothesis that Palma drew his sketches on the back of a drawing by Titian, rather than to the other alternative that Palma, so intimately acquainted with Titian's style, approximating it very closely in some of his paintings and drawings (see No. **831**) might have reached such mastership in his youth. Palma's late style of drawing is so well known, that it is out of the question.

A 1898 ————, 717. Two recumbent male nudes, the one behind reading a book is only sketched. Charcoal, somewhat height. with wh., on gray. 285 x 415. Ascr. to Titian, and publ. as his by Loeser in *Uffizi Publ.* II, 2, No. 3: probably design for the decoration of a concave surface. Hadeln, *Tizianzeichnungen*, pl. 28 and p. 23: " Titian about 1540, under the influence of the Roman-Florentine mannerism; ... of so daring a manner of drawing that one feels inclined to wonder whether the drawing was originally connected with a painting or should be considered as a mere display of brilliant draftsmanship." Fröhlich-Bum *N. F.* II, p. 195 rejected the attr. to Titian, and ascr. the drawing with reservations to Tintoretto. We agreed with her in our *Tizian-Studien* p. 189, note 92, with reference to a similar group in Tintoretto's paintings in S. Maria del Giglio (Venturi 9, IV, p. 484, fig. 336) and to the pose and type of the nude in his "Last Supper" in the Scuola di San Rocco (ill. ibidem fig. 416). A. L. Mayer, *Gaz. d. B.A.* ser. 6, vol. 20 (1938) p. 200 rejected the attr. to Tintoretto without giving his own opinion regarding Titian. [*Pl. CXCV*, 1. **MM**]

We still find compositions and types close to the two paintings by Tintoretto mentioned in our article, but not close enough to allow the attr. to him of a drawing otherwise basically different from his manner of drawing. The linework, with the hatchings in the background and the curved outlines, recalls Malombra's "Flagellation" in the Ambrosiana (No. **788**), and the types and draperies are related to Malombra's composition in the Metropolitan Museum No. **789**. We feel, of course, a certain reluctance to attribute as impressive a drawing as this to a minor artist, especially when we even cannot connect it with any of his authentic paintings. But Malombra must have been a capable draftsman (comp. No. **789**) and is described as such by Ridolfi II, p. 159: "after his death many designs and studies, bravely treated, were found in his house."

A 1899 ————, 718. Portrait of a young woman. Bl. ch., height. with wh., on br. 419 x 265. Slightly rubbed. Monneret, *Giorgione: Giorgione*, will reference to the "Shiavona," likewise attr. to Giorgione by the author. *Uffizi Publ.* I, 2: Titian. Hetzer, *Tizians frühe*

Gemälde, Basel 1920, 132 questions the attribution to Titian, with reference to its contrast to the murals in Padua. Hadeln, *Tizianzeichnungen* 18: Titian. Fröhlich-Bum *N.S.* II, p. 195, No. 7: 1515–20. Popham, *Cat.* 262: Titian early period. Suida, *Tizian* p. 34, pl. LXVII: Titian, 1517–20. Our *Tizian-Studien* p. 183: Girolamo Romanino.

We consider the arguments put forward there still valid and emphasize the basically different structure of the head when compared with Titian's in the second decade (cf. the two details Tietze, *Tizian* Pl. 31, 32). The small eyes set in boneless sockets are typical of Romanino. Moreover, his female type as a whole is familiar (compare the "Circumcision" in the cathedral of Brescia, Nicodemi, *Romanino* p. 154). For his way of enclosing soft flesh in precise outlines compare the "Madonna and Child" in the Brera (Nicodemi, p. 65).

A 1900 ————, 755. Biblical figure seated. Bl. ch., on faded blue. 188 x 325. Ascr. to Titian and photographed as his by Philpot. Our article in *Gaz. d. B.A.* 1943, p. 121: Study by Cristoforo Magnani, called Pizzighettone, for the Apostle on the left in Piacenza, Sta. Maria della Campagna.

1901 ————, 776. Dog. Pen, br., on white paper. 101 x 130. Ascr. to Titian. In our *Tizian-Studien* p. 163, fig. 142: Sketch by Titian, used with slight modifications in Titian's woodcut "Passage through the Red Sea" (reversed). Fröhlich-Bum in *Art Bulletin*, 1938, p. 446, rejects the attribution to Titian, because of the poor quality of the drawing and does not acknowledge the connection with the woodcut.

1902 ————, 1405. Landscape with St. John as an infant, caressing a lamb. Over sketch in ch., pen, light br., on white. 228 x 371. Fröhlich-Bum in *Belvedere* 1929, p. 78: Titian. Benesch in *Graph. Künste* N. S. I, p. 14 ff.: Giulio or Domenico Campagnola. Rod. Pallucchini, *Ateneo Veneto* 1935, IX and Suida, *Pantheon* 1936, p. 102: Copy after a drawing by Titian. Our *Tizian-Studien* p. 191, 5): Autograph from the beginning of the second decade.

We agree with Pallucchini and Suida to a certain dryness in the drawing, the bad rendering of the r. arm may be the result of retouches. The differentiation between autograph and copy is difficult, even if we can sometimes compare two versions (for instance No. **2007** and the drawing in the Oppé coll. in London); It is still more difficult if only one version exists. At least we should correct our dating it in the beginning of the second decade; the drawing must be later.

A 1903 ————, 1661. E. Study for the portrait of an elderly seated man and a smaller sketch on the left, representing a bearded old man, half-length. Pen, on green. 266 x 200. Lower l. corner added. — On *verso*: the same figure (without the cap) on a slightly larger scale. Ch. Publ. by Hadeln, *Tizianzeichnungen* 15: Study for a self-portrait (?) by Titian; the drawing on *verso* apparently by another hand. Fröhlich-Bum *N. S.* II: rejects the attribution. Degenhart p. 277, 283, fig. 231, accepts it and adds many conclusions concerning the racial foundation of drawing in Venice. [**MM**]

In our opinion, the drawings on both sides are by the same artist neither Venetian nor of the 16th century.

A ————, 1666. See No. **901**.

1904 ————, 1713. Study for the Saint Bernard in the votive painting for the Doge Gritti. Ch., height. with wh., on blue. 380 x 264. — On *verso*: Study for the mantle of the Doge in the same paint-

ing. *Uffizi Publ.* I, 2, 4 (Loeser), Study of St. Francis, used with modifications in the painting in the Vatican Gallery. Hadeln, *Jahrb. Pr. K. S.* XXXIV, p. 234: recognized the connection of the study of the saint with the votive painting in the Sala del Collegio (Ducal Palace), finished shortly before October 6, 1531 and destroyed by fire in 1574. Hadeln, *Tizianzeichnungen* 23 and 24, recognized the connection of the studies on the *verso* with the robe of the Doge. Fröhlich-Bum *N. S.* II, No. 26 and 27. In our *Tizian-Studien* p. 184 and 191, 23 and 24. Attr. to Giacomo Cavedone by H. Bodmer, in *Die Graph. Künste,* N. S. V, 1940, p. 111, who in his attempt to draw a borderline between Titian and his imitator, Cavedone, unfortunately overlooked E. Tietze-Conrat's discussion of the same problem in *O.M.D.* v. 11 (1936, September) p. 23 ff. and, still more unfortunately, limited himself to examining Hadeln's arguments in *Jahrb. Pr. K. S.* and not those in his book. The folds on the *verso* recognized by Hadeln as studies for the robe of Doge Gritti in the painting are modified in the woodcut (incidentally, not an engraving as Bodmer says) which reproduces the painting. The connection with Titian's composition is therefore doubly established. Moreover, the drawing is different in style from Cavedone and lacks all the hatchings typical of him as Bodmer's own illustrations best confirm.

[*Pl. LXIX,* 1. **MM**]

1905 ———, 12903. Angel of an Annunciation. Bl. ch., height. with wh., on blue. — On *verso:* Study of a draped standing figure. 420 x 280. *Uffizi Publ.* (Loeser): last style, study for the angel in S. Salvatore, in Venice, used with modifications. Hadeln, *Tizianzeichnungen* 35. Fröhlich-Bum *N. S.* II, p. 198, No. 44: perhaps for the "Annunciation" in San Salvatore. Popham, *Cat.* 269: a study on the *verso* is only partially visible as the drawing was fastened down. In our *Tizian-Studien* p. 186 and 192, 37. A. L. Mayer in *Gaz. d. B.A.* 1937 II, 305 ff. first publ. the drawing on the back.

[*Pl. LXVIII,* 1 *and LXIX,* 2. **MM**]

The study on the back shows the drapery of a male figure (St. John Evangelist?). The undramatic pose and the classical drapery do not fit very well into Titian's latest period to which the *recto* certainly points. A certain analogy is, however, offered by the two saints in the wings of the altar-piece at Castel Roganzuolo (1549, ill. A. Moschetti, *I Danni Artistici delle Venezie nella Guerra Mondiale,* Venice, 1932, p. 332). The somewhat old-fashioned character may be explained by a similar provincial destination. Another explanation is that Titian might have drawn from a work of sculpture. We call attention to a noticeable resemblance to the (reversed) drapery of the central figure of an altar in the Bargello, attr. to a follower of Andrea Sansovino (ill. Venturi, 10, I, fig. 436).

1906 ———, 12907. Study for the legs of the executioner in the "Martyrdom of St. Lawrence," in the Gesuiti, the r. hand only indicated. Charcoal, height. with wh., on blue. 403 x 253. — On *verso:* Hasty sketches: Recumbent man, half-length; two small seated figures carrying vases, one seen from behind, the other from front; a leg and an amateurish drawing of a man's profile. The *recto* was publ. by Hadeln, *Tizianzeichnungen* 31, but he did not recognize the connection with the painting in the Gesuiti. Fröhlich-Bum *N. S.* II p. 198, No. 38: 1550–60. Popham *Cat.* 263: Possibly studies for the St. Christopher in the Ducal Palace. . . The position of the arms . . . is that of a man supporting himself on a staff, but the pose is very different from that of the completed work. Eugen von Rothschild, in *Belvedere* 1931, 205, refers to the executioner in the painting in Venice. Suida, *Tizian,* p. 174: study for the executioner. In our *Tizian-*

Studien 186 and 192, 34: The half-length figure on the back presumably for an "Entombment"; the same foreshortening of the head in a painting in S. Fedele, Milan (ill. Venturi 9, VII, p. 383) by Petrazano who had been Titian's pupil and also otherwise borrowed from his drawings. For the seated figures compare the painted frames of the large decorative paintings in the Ducal Palace.

[*Pl. LXXII,* 1. **MM**]

Popham's reference to Titian's "St. Christopher" is interesting, corroborating once more the continuity in Titian's creative imagination. The drawing, however, does not have the style of the early period and, therefore, cannot be a study for the mural in the Ducal Palace, completed soon after 1523. The pose, nevertheless, reminds one of Titian's early study of the "Laocoön" and Michelangelo's "Slave" which are certified by the "St. Sebastian" in Brescia. Bordone, who especially in his early years reflects Titian's evolution, offers the closest analogy to the pose of the executioner in his "St. Christopher" (in the Galleria Tadini, Lovere), his earliest altar-piece, certainly inspired by a model of Titian. Oettinger calls this painting the closest approach of Bordone to Titian (*Magyar Müvészeti* 1931, IV). It is indeed instructive to compare the pose of Bordone's "Christopher" with Titian's study for the executioner: the latter with the loosening of his knees is already typical of the later generation. The "Martyrdom of St. Lawrence" was painted between 1548 and 1558 (Gallo, in *Rivista di Venezia,* 1935, 155).

A ———, 12911. See No. **393**.

A ———, 12912. See No. **762**.

A 1907 ———, 12914. Male nude. Bl. ch., height. with wh., on blue. 295 x 400. *Uffizi Publ.* (Loeser) I, 2, 8: reminds one of Michelangelo's "Crepusculo" or the Adam in the "Creation of Adam," in the Sistine Chapel. Perhaps adapted for a mythological subject as, for instance, the "Prometheus" in Madrid, but without any connection with an existing painting. Hadeln, *Tizianzeichnungen,* pl. 27 and text p. 34: The motive is somewhat unfamiliar, it must be inspired from outside. Fröhlich-Bum *N. S.* II, p. 193, note: Tintoretto, to which attribution we agreed in our *Tizian-Studien* p. 189. Delacre, *Les Dessins de Michelange,* p. 345: not copied from the Crepusculo. A. L. Mayer, *Gaz. d. B.A.* ser. 6, vol. 20 (1930) p. 300: Titian inspired by the Aurora.

In our opinion, the drawing is certainly inspired by a sculpture in the style of Michelangelo, since it combines motives of the Adam and the Crepusculo (compare the rivergods in *Rivista d'A.* IV, 1906, p. 75). The model may have been by some follower (Sansovino?). It was, however, not directly copied as the drapery in the lap shows, but adapted for the intended subject, the enchained Prometheus with the Eagle. (The fetters are easily recognizable on both arms and the head of the eagle is visible between the man's head and his knee.) This procedure differs from Tintoretto's, the attribution to whom is moreover contradicted by the modeling and by the careful rendering of the surroundings. The statement that the drawing is not one of the typical studies from a sculpture, but presents a complete dramatic composition modifies its appearance. As far as the bad state of preservation allows a judgment, a certain affinity in type and composition to Titian's pathetic period — "Prometheus" in the Prado, ceilings in the Salute, "Gloria" in the Prado — can be admitted. But the scrupulousness with which the rendering of the hair in the plastic model is imitated, contradicts Titian's aloofness from such detail and his longsightedness in his old age.

1908 ————, 12915. Soldier on horseback, riding over a dead body, study for the "Battle of Cadore." Bl. ch., on blue. 524 x 395. Inscription: 247. — On *verso:* Sketch for a Moor's head. Exh. *Mostra di Tiziano,* No. XIV. Publ. by E. Tietze-Conrat in *O.M.D.* 1936, April: About 1525, on the basis of the style and of the connection of the Moor's head to a similar head on the l. border in the "Pesaro Madonna." In our *Tizian-Studien* 155 ff. and 191, 20, 21. Kieslinger, in *Belvedere* 1934–36, pp. 173 ff. rejects the attribution of the Moor's head to Titian without giving his reasons. Fröhlich-Bum in *Art Bull.* 1938, p. 445 calls the *recto* an exact copy from the figure in the painting. "The derivation is corroborated by the *verso* which Tietze arbitrarily identifies with a head in the 'Pesaro Madonna,' but which cannot even be associated with Titian's circle."

[*Pl. LXVII,* 2 and *Pl. LXVI,* 1. **MM**]

We maintain our attribution (see p. 308).

A 1909 ————, 12916. Two men fighting. Bl. ch., slightly height. with wh., on gray. 370 x 240. *Uffizi Publ.* (Loeser) I, p. 2, no. 7: Hercules and Cacus? Recalls "Cain and Abel" in the Salute (of 1544), but the style of drawing is at least a decade later. Hadeln, *Tizianzeichnungen* 34. Fröhlich-Bum *N. S.* II, p. 195: Florentine, about 1600. Not listed in our *Tizian-Studien.*

Loeser's reference to the ceilings, now in the Salute, is correct as the figures show a foreshortening corresponding to a ceiling. But we cannot agree with him as to Titian's authorship. The drawing (whose subject, by the way, may rather be "Samson slaying a Philistine," since the slayer seems to brandish the jawbone of an ass) shows the complete composition, something without analogy in Titian's late studies. This completeness, especially conspicuous in the careful noting of details, is strange in a stage where other essential points, as the posture of the figures, are still vague. We see here an artistic temperament entirely different from Titian's.

A 1910 ————, 13027. Saint Francis, kneeling. Ch., on blue. 380 x 260. Inscription in pen (17th century): Di mano del Tintoretto. — On *verso:* Study of a hand holding a lance and study of the two feet of the figure on the *recto. Uffizi Publ.* (Loeser) I, p. 2, no. 3: Tintoretto, in spite of some dryness. O. Giglioli in *Boll. d'A.* June, 1937: Titian; it is interesting that Cavedone made a drawing (No. 2048F) representing a figure so similar as if he had seen Titian's drawing.

In our opinion, Giglioli was right in rejecting the old attr. to Tintoretto, but we do not agree with his attr. to Titian. The folds do not give the impression of enclosing a human body, the sleeve is only a superficial play of light and shadow. The drawing seems to us another version of 2048F by the same later artist (Cavedone?) and very close in No. **A 1935.**

1911 ————, 20767. Working design for the "Portrait of the Duke of Urbino" in the Uffizi. Pen on wh. 240 x 142. Morelli Coll. *Uffizi Publ.* (Loeser) I, p. 2, no. 5: The treatment of the hair is remarkably different from that in the painting. Hadeln, *Tizianzeichnungen* 11: Study for the painting, 1536 or a little earlier or, since the Duke appears in full-length in the drawing and in three-quarters length in the painting, done after the painting for a woodcut. In Hadeln's opinion, the latter is less probable; he suggests that the original painting corresponded to the figure in the drawing, but was cut because the Duke objected to the contrast between the upper part and the thin legs, or it was cut later to make it a companion to the portrait of the Duchess. Fröhlich-Bum *N.S.* II, p. 197, No. 33. Popham *Cat.* 264. Our *Tizian-Studien* 186 and 191. 25.

[*Pl. LXV,* 3. **MM**]

Hadeln's suggestion that the portrait may originally have been planned in full-length seems attractive to us.

1912 FRANCE, PRIVATE COLLECTION. Study from nature: tree and view of a castle. Pen. 383 x 265. Possibly cut at l. Sale Drouot 1924, February 24, No. 52. Publ. by Godefroy, in *L'Amateur d'Estampes,* 1925, March ill. 48, 49 as Titian; the tree appears in reverse in the woodcut Saint Jerome in the wilderness, Pass. 58. Fröhlich-Bum in *Belvedere* 1929, p. 78. Our *Tizian-Studien* p. 177 f. and 191, 9. Our article in *Graph. Künste* N. S. III, p. 57: Miss Mary Kalat recognized that the castle is the same as in the woodcut Pass. VI, p. 242, 96. Another drawing representing the same castle is No. **1875** in Bayonne.

[*Pl. LXII,* 1. **MM**]

We have not seen the original.

A 1913 FRANKFORT/M., STAEDEL'SCHES INSTITUT, 414. Five men standing. Pen. 265 x 203. Schönbrunner-Meder 398: Titian, sketch for a group in the mural "St. Anthony healing the leg of the hasty youth" in the Scuola del Santo in Padua. This attribution was accepted by Hadeln, *Jahrb. Pr. K. S.,* p. 43, but later rejected in his *Tizianzeichnungen* p. 53 and also by Hetzer, *Die frühen Gemälde Tizians* pp. 28 ff. We did the same in our *Tizian-Studien* p. 155, note 53, calling by mistake the corresponding painting Saint Anthony's "Miracle with the Infant." A note (in Frankfort) by V. Regteren Altena attr. the drawing to Lievens. Since the figures selected from Titian's fresco (Tietze, *Tizian,* pl. 12) are all in reverse to the painting, a graphic reproduction rather than the painting itself may have served as model for the copyist. [**MM**]

A 1914 ————, 4458. The Virgin seated, holding the standing Child. Pen and ch. 150 x 198. Ascr. to Paolo Veronese, but attr. by Venturi, *Studi,* p. 283, fig. 177, and *Storia* 9, III, fig. 79 to Titian as a study for the "Virgin with the cherries" in Vienna. Accepted by Fröhlich-Bum *N.S.* II, p. 196, No. 14 (as about 1525) and Rudolf Schrey, *Stift und Feder* III (1927), p. 35. [*Pl. CXCIV,* 1. **MM**]

In our opinion, a drawing by Donato Creti, not even derived from the painting in question.

1915 ————, 5518. Sketch for the "Saint Sebastian," finished autumn 1520, in the altar-piece in Brescia. Pen. 183 x 114. — On *verso:* Sketches, a head in profile, feet and part of a leg. Hadeln, *Tizianzeichnungen* 7, 8, gave the drawing, whose authenticity had previously been questioned, definitely to Titian. Fröhlich-Bum *N. S.* II, p. 196, No. 9, 10. Our *Tizian-Studien* 191, 14, 15.

[*Pl. LXII,* 2 and *LXV,* 4. **MM**]

The sheet is cut on the top, the second hand above the saint's head is still recognizable. The column in the drawing has a different position from that in the painting. The saint wears a cloth round the waist which in the earlier sketches in Berlin No. **1880** is still missing. The studies on the back are, in our opinion, done after an antique figure. The head resembles a Roman emperor's head like the one in Lotto's portrait of Andrea Odoni in Hampton Court. The feet separately studied, modified in detail and position, were taken over into the painting.

A HAARLEM, TEYLER STICHTING, A 46. See No. **478.**

A 1916 HAARLEM, COLL. KOENIGS, I 38. Bearded dignitary stepping to the r. Bl. ch., on blue. 375 x 246. — *Verso:* Sketches: a bearded head and two studies of a drapery (sleeve). Inscription in pen: Cavedone. The front side publ. by Hadeln, *Tizianzeichnungen,* 32 as Titian, the *verso* by the same in his *Titian Drawings* pl. 25 (where

by mistake the text refers to the kneeling apostle in the Viscount Lascelles coll., London, see No. 1935). Fröhlich-Bum *N. S.* II, 40: Titian, not earlier than 1555, without mentioning the *verso*. E. Tietze-Conrat in *O.M.D.* 1936, September 23 f. rejects the attr. to Titian in favor of the older one to Cavedone. H. Bodmer, too, in *Graph. Künste*, N. S. IV, p. 16, rejects Hadeln's attribution apparently without knowledge of E. Tietze-Conrat's article.

Related to No. 1883. A further drawing by the same hand, almost identical with the bearded man on *verso,* in Malvern.

1917 ———, I 57. Lion. Bl. and yellow ch., on gray. 155 x 378. Later inscription: Bassan. On the back inscription: B. B. No. 75. (Borghese Coll. Venice.) Listed as Jacopo Bassano.
[*Pl. LXVIII, 2.* MM]
This excellent drawing is Titian's design for the painting of the "Fede" in the Ducal Palace in Venice, ordered 1555, certainly begun before 1566, when Vasari saw it unfinished in Titian's studio, and completed only after Titian's death. The drawing was done expressly for the painting, seeing that the garment of St. Mark which covers part of the lion is indicated.

A 1918 ———, I 307. Group of trees. Pen. 275 x 180. Hevesi Coll. (Vienna). Publ. by L. Fröhlich-Bum in *Belvedere,* 1929, p. 74, fig. c, as Titian and connected with No. A 1873. [MM]
Identical in style with No. A 1975 and seemingly coming from the same source, probably also a copy from an original in the style of G. Muziano.

1919 ———, I 449. Drapery. Bl. ch. height. with wh., on blue. 166 x 109. In very bad state of preservation. Coll. Lely and Boehler. Acquired 1929. [MM]
The state of preservation makes the decision whether the drawing is authentic difficult. The style of drawing and the simple and great conception, point to the master's hand or at least to his sphere. The nearest analogy to the drapery is to be found in the allegorical figure at l. in Lorenzino's mural in SS. Giovanni e Paolo, ill. in Tietze, *Tizian* I, pl. 30. The suggestion that Lorenzino might have used drawings by Titian for his figures seems attractive.

1920 ———, I 484. Study of a nude woman, seen from behind. Bl. and wh. ch., on dark br. paper. 233 x 163. The posture of the head is corrected. Coll. Bouverie, Wellesly, R. Johnson, Bateson. Formerly ascr. to Fra Bartolomeo, publ. by Roger Fry in *Burl. Mag.* XXXII, p. 60 as Giorgione or Titian. Fröhlich-Bum *N. S.* II, p. 196, No. 8: More likely Titian, in the style of the Venus in the Bridgewater House. Popham, *Cat.* 254: "attr. to Giorgione." Hadeln, *Koenigs-zeichnungen* no. 5 accepts Fröhlich-Bum's suggestion and points out that in as much as the drawing, if genuine, is the only draped female figure among Titian's drawings and thus fills a gap. The hatches which cross the first sketched head allow no doubt that the erect posture was meant to be the definite one. [*Pl. LXI, 3.* MM]
The alternative Giorgione or Titian reveals unanimity as far as the date goes; it is 1510–20. The resemblance of the nude in Sebastiano del Piombo's "Death of Adonis" in the Uffizi (ill. Dussler, *Sebastiano del Piombo,* pl. 22) which may be part of Sebastiano's "Giorgionesque" inheritance points to the same period. On the other hand, the motive which might be Giorgione's in the drawing is translated in a figure already filled with Titian's energy. Mrs. Fröhlich-Bum's reference to the Bridgewater Venus is convincing so far as the new feeling for corporeal volume goes, but the clearness and activity of the motive in the painting is in contrast to its passivity in the draw-

ing. In our opinion, the new feeling for the body is the essential point since the drawing was begun as a study from the nude. As he worked on it, the artist lost his interest in the original motive — a woman hiding her face in her arm. The later position of the head which he finally chose has not been brought into a satisfactory relation to the arm and to the back with its drooping right shoulder.

This study is thus very exceptional. It goes back to a Giorgionesque invention of the type of the nude seen from behind in the Louvre "Pastorale," just as Titian's "Pardo Venus" stems from Giorgione's "Venus" in Dresden. But Titian never used the study in a painting; the change in the posture of the head would have demanded a modification of the whole body. The technique is unique among Titian's drawings, but since the drawing no. 12818 in the Uffizi (see No. 1285), traditionally ascr. to Polidoro Veneziano, uses the same, it may have been familiar to Titian. The diagonal hatchings on the left are typical of him (see Nos. 1908v and 1878). We find tender lights indicating the drapery in drawings of his school (see No. 811); the studies for the dancers in the "Bacchanale" in Madrid might have been executed with similar delicacy.

A 1921 HAGUE, THE COLL. FRITS LUGT. The Miracle of St. Anthony and the infant. Pen. 148 x 308. Coll. Lanière, Cosway, Wellesly, Locker-Lampson. Sale Drouot 1924, February 25, No. 32: Giorgione. Publ. as Titian's design for the fresco in the Scuola del Santo in Padua, by Adolfo Venturi, in *L'Arte* 1927, p. 241, and in *Storia* 9, III, fig. 71. As Titian exh. Amsterdam 1935, No. 685 and acknowledged by Richter p. 235, No. 68. Mentioned in our *Tizian-Studien,* p. 155, note 53 as a copy after the fresco. [MM]
The sheet was originally larger; it is cut at the top and at the l., so that the landscape is missing and the figures at the left are defective. There are, however, slight deviations from the painting, for instance, in the ornament, the mantle of the woman and legging of the youth. But the grouping of the figures and all the movements are identical in both versions. Even the deep dark at the left, behind the jealous husband's face, and the half-dark setting off of his wife's profile correspond. In our opinion, a drawing in this style, hasty, but nevertheless, exactly corresponding to the painting, cannot be a preliminary sketch. The artist who has permanently settled the details of his composition would use another style of drawing for his final design. The manner of drawing in our leaf is typical of a study after an existing painting. The trifling deviations from the fresco may be explained by the fact that, according to Francesco Zannoni's description of 1784, the murals were heavily overpainted. Consequently even as a copy the drawing maintains its importance as a document.

A ———. Landscape. See No. 1990.

A 1922 LENINGRAD, HERMITAGE, 8207. Cupid with a violin. Pen. 140 x 180. Publ. by Dobroklonsky, *Pantheon* II, p. 482 as Titian. Exh. in Leningrad 1926, no. 80.
The motive does not occur in any painting by Titian, nor does the type of the child resemble his. In our opinion, the alleged stylistic resemblance is only accidental.

We have not seen the drawing.

1923 LILLE, MUSÉE WICAR. Sketches for the "Martyrdom of St. Peter Martyr," in SS. Giovanni e Paolo, destroyed by fire in 1867. Beneath, sketch for the figure group and above, on larger scale, hasty sketches for separate angels and for the pair of angels taken into the painting. Pen, 141 x 188. Hadeln, *Tizianzeichnungen* 9. Fröhlich-Bum *N. S.* II, p. 197, No. 21. Our *Tizian-Studien* 152 and 191, no.

18: Among the three sketches in Lille the larger leaf is the closest to the final composition. Kieslinger in *Belvedere*, 1934–36, p. 174 points out that the angel with the arrow on the left appears in reverse in Titian's late "Rape of Europa," in the Gardner Museum in Boston. (This reference is wrong.) — The sheet was originally larger, it is cut on each side and may have formed one piece with the two following numbers. Dated 1528–30 by the painting. [*Pl. LXIV*, 3. **MM**]

1924 ————. Sketch for the main figures in the "Martyrdom of St. Peter Martyr" (as above). Pen. 55 x 86. Hadeln, *Tizianzeichnungen* 10, above. Fröhlich-Bum *N. S.* II, p. 197, No. 22. Our *Tizian-Studien* 152 and 191, 19. [*Pl. LXIV*, 2. **MM**]
To be placed between No, **1923** and No. **1925**.

1925 ————. Sketch for the main group in the "Martyrdom of St. Peter Martyr" (see above). Pen, irregularly cut. 63 x 87. Hadeln, *Tizianzeichnungen* 10, below. Fröhlich-Bum, *N. S.* II, p. 197, No. 22. Our *Tizian-Studien* p. 152 and 191, 19: this seems to be the first idea of the composition, earlier than the two other sketches in Lille (Nos. **1923, 1924**). [*Pl. LXIV*, 4. **MM**]

1926 ————. Faun in half-length. Pen. 128 x 130. Traditionally ascr. to Titian and publ. as close to him by Gonse, in *Gaz. d. B. A.* 1878. Morelli, I, p. 21 ff. attr. the drawing to Sebastiano del Piombo's early years, before his move to Rome in 1511: "The shape of the hand is still "Giorgionesque," the shape of the ear is the same which appears in his first Roman paintings (1511–13)." Delacre et Lavallée, *Dessins de Maitres anciens*, 1927, no. 6: Sebastiano del Piombo, study for the fresco in the Farnesina which, however, in almost every detail differs from the drawing. Sebastiano would thus have replaced his first idea still conceived under Giorgione's influence by another, closer to the Roman style. In our *Tizian-Studien* p. 174 and 191, 6 we returned the drawing to Titian, emphasizing the stylistic difference from the drawing by Sebastiano in Berlin which we then thought to be authentic, and its resemblance to the few drawings we possess from Titian's early period. We picked out for special note the faun at the right side in the Pardo Venus whose first conception goes back to Titian's "Giorgionesque" period. Rodolfo Pallucchini in his review of Tietze, *Tizian* in *L'Arte* N. S. VIII, p. 332 sticks to Morelli's attr. So do Berenson, *Drawings*, 2481, and L. Dussler, *Sebastiano del Piombo*, 1942, p. 93 and 169. Fröhlich-Bum in her review in *Art Bull.*, December 1938: Annibale Carracci, to whom it is similar in style and whose Polyphemus in the Earl of Leicester's painting is closely related in type and details. [*Pl. LIX*, 2. **MM**]

We cannot find any affinity to Annibale Carracci's style, of whose drawings one of us has made a special study for many years. On the contrary, in our opinion, the origin of the drawing — whoever the author may be — is indubitably in the early 16th century. As for the alternative between Titian and Sebastiano we refer (withdrawing our remarks however on the drawing in Berlin) to our circumstantial argumentation in our *Tizian-Studien*, to which in *Graph. Künste* N. S. III, 53 we added another argument by pointing to the identical hatching and modeling in Titian's signed woodcut St. Jerome which we date around 1515, the date of the woodcut, and Suida in *Critica d'A.* VI, 285 even about 1512 [**MM**]. See also p. 311.

A 1927 LONDON, BRITISH MUSEUM, 1846-7-9 — 10. Sheet with two studies of a St. Jerome. Pen. 252 x 212. Later inscription: Titiano. Publ. by Hadeln, *Tizianzeichnungen*, pl. 13 as Titian. Hadeln tried to explain the contrast between the dull linework and Titian's authentic drawings by the theory that in this drawing Titian may have

experimented in a new technique suitable to woodcuts. These experiments would have to be dated before Titian drew his most important woodcut, the "Passage through the Red Sea" in 1549. *Albertina Cat. II* (Stix-Fröhlich) p. 34 and 47 f.: not Titian himself, but circle of Titian, first third of 16th century. The attr. to Titian is accepted by Sirèn 1933, p. 155 who refers to the painted "St. Jerome" in the Louvre (ill. Tietze, *Tizian*, pl. 89). Fröhlich-Bum, *N. S.* II, 190, fig. 258: Savoldo, without giving any other argument besides the fact that Saint Jerome had twice been painted by Savoldo. A. L. Mayer in *Gaz. d. B. A.* ser. 6, vol. 20 (1938), p. 300 doubts Titian's authorship.

Hadeln was caught up in a vicious circle; after having accepted the drawing as an autograph, he had to explain its unusual style by putting forward a daring hypothesis which has no foundation at all. The sketches on this sheet are not technical exercises of a great artist to accommodate his hand to a new enterprise, but objective studies varying the subject. They may have been intended as illustrations. The connection with Titian's art is the typical reflection of leading art in applied art. The attribution to Savoldo of a drawing entirely without analogy among his auhentic drawings could only be discussed if any connection with one of his paintings existed.

1928 ————, 1895-9-15 — 817. Young man playing a viol da gamba, and girl seen from behind in a landscape. Pen. The woman was first drawn in grayish bl., with modeling parallel strokes; afterwards some parts, especially at the drapery and at her r. leg, were reworked in br., in lines much coarser than the first drawn ones are. The landscape and the man with the viol have no delicate lines beneath, but are done in br., in the same coarse manner. 224 x 226. Coll. Six; 1731 Valerius Roever as Giorgione (cf. Richter, *Giorgione*, p. 332); Malcolm (Robinson *Cat.* 1869: Titian). The drawing was exh. as Giorgione in École des Beaux Arts, 1879, No. 1 and publ. as his by Chennevières in *Gaz. d. B. A.* XIX (1879), p. 519. Morelli I, 292, attr. to Domenico Campagnola, suggesting that the female figure was taken from Giorgione's "Fête Champêtre" and the man also is Giorgionesque. Betty Kurth in *Zeitschr. f. B. K.* 60, 1926–27, p. 290: the man's dress is later than Giorgione; the drawing is a copy by D. Campagnola after a painting by Titian. Ludwig Justi, *Giorgione oder Campagnola?*, ibidem 61. (1927–28), p. 79 ff.: The drawing is by Campagnola, combining an authentic Giorgione and a Giorgionesque figure in a new composition. Betty Kurth again in *Graph. Künste* N. S. II (1937, p. 139 ff.): The drawing is certainly by Dom. Campagnola on the ground of his signed drawings; D. Campagnola took the composition from a painting by Titian. Valentin Lefèvre engraved this (lost) painting in 1680, since he inscribed the engraving: Titianus inv. p., and since the linework of Lefèvre's print differs from that in the drawing. She considers the copy of the musician No. **403** as additional proof for the existence of such a painting by Titian. The style of the drawing is very Titianesque and cannot derive from the pendrawing. Hourticq (*Problème de Giorgione*, p. 98) and Phillips (*Leadership of Giorgione*, p. 86) attr. the drawing to Titian. In our article on Domenico Campagnola in *P. C. Q.* 1939, October the drawing which we did not discuss has been reproduced on p. 330 by mistake with the caption Domenico Campagnola. [*Pl. LXI*, 1. **MM**]

We agree with Mrs. Kurth's theory that a painting of this composition by Titian existed. To clarify the relation of the drawing to this painting its technical state (as described above) is to be taken into account. To this purpose, however, a careful examination of the original is necessary, no reproduction being exact enough. Since two different modes of drawing are distinguishable a copy from a painting

is extremely unlikely. The female figure, as universally admitted, corresponds to Giorgione's "Pastorale." Originally, the drawing may have contained only this figure. The rest of the composition, including the drapery of the woman, was added with another pen. The mode of drawing of these additions has no analogy in D. Campagnola's work. The proportions of the man are different from his, the landscape with its play of light and shadow and the atmosphere within the foliage contradict his graphic abstractness. The female figure decorating the viol is so far advanced in style beyond the sitting woman that the additions may be later and the origin in the second decade of the 16th century. The style of the added parts, in our opinion, resembles those drawings by Titian which (for instance, No. **1954**) turn a study after nature into a finished composition. The seated woman is more difficult to place. This portion might be an original by Giorgione or, more probably, a copy after such a drawing. The resemblance to the drawing of the Venus, No. **490**, is undeniable, but may rest merely on their common character as work designs. Moreover, Domenico's authorship is by no means beyond doubt (see p. 128). We have no evidence how a copy by Titian in his earliest period might have looked, but consider it the best working theory that the drawing was originally made by himself, after a model by Giorgione, and that he later added another figure.

A ————, 1895-9-15 — 822. See No. **22**.

1929 ————, 1895-9-15 — 823. Study for St. Peter in the "Assunta," half-length. Ch., on blue. 157 x 134. Malcolm Coll. Hadeln, *Tizianzeichnungen* 20. Fröhlich-Bum *N. S.* II, p. 195, No. 6. Our *Tizian-Studien* 184 and 191, 10. [*Pl. LXI*, 2. **MM**]
Dated about 1516 to 1518 by the painting.

A 1930 ————, 1895-9-15 — 825. Group of an old man, a young woman and a youth, sitting at a table, a book in front of them. Pen, on wh. 83 x 127. Malcolm Coll. Publ. by Hadeln, *Tizianzeichnungen* 12. Fröhlich-Bum *N. S.* II, p. 197, No. 32: about 1535 to 45. Not included in the list in our *Tizian-Studien*.

The nervous stroke, neglecting the structure and emphasizing a definite mood speaks against Titian's habits as a draftsman. The drawing, in our opinion, belongs to the renaissance of Giorgione in the late 16th century; an anology is Caravaggio's sketch for the left part of his "Calling of St. Matthew" (Rome, San Luigi degli Francesi) in the Uffizi, formerly given to Giorgione (ill. in Max von Boehn, *Giorgione und Palma Vecchio*, 1908, fig. 61).

A 1931 ————, Sloane vol. 9, p. 2, 114. Flying putto. Red ch. Listed among Anonymous Italians, style of Raphael. Publ. by Suida, *Dedalo* XI, p. 897 as Titian about 1520, with reference to the cupids in the "Bacchanal" in Madrid.
In our opinion, the relationship to the Roman School predominates.

1932 ————, Cracherode F. f. 1 — 65. Two shepherds in landscape. Pen, br., on wh. paper slightly damaged by mold. 193 x 290. Later inscription: No. 89. G., Titien (and) 82. Publ. in our *Tizian-Studien* p. 172 and 190, 2 as Titian, because of its relationship to No. **1961** and dated about 1511. Not having been able to re-examine the original, we expressed our opinion with reservations. Fröhlich-Bum in *Art Bull.* 1938, p. 446: Do. Campagnola, with reference to No. **567** and No. **487**. In our article on Do. Campagnola's woodcuts, in *P. C. Q.* 1939, December, p. 457 ff., independent of Fröhlich-Bum's review, we admitted the very close resemblance to Domenico Campagnola and, at the same time, emphasized the difficulty of separating the drawing from No. **1961**. [*Pl. LX*, 2. **MM**]

Both are either by Titian or by D. Campagnola. The question-mark with which our deliberations ended has erroneously been omitted in the caption of the illustration. Having decided in favor of Titian's authorship for the drawing in the École des Beaux Arts in spite of serious doubts, we cannot but maintain our attribution of the Cracherode drawing to Titian, especially since the style of its figures is so strikingly different from the childish No. **567**, one of the very best established early Campagnolas.

A 1933 LONDON, VICTORIA AND ALBERT MUSEUM, Ionides Bequest C. A. J. 418. Studies for two young men, one kneeling to the r., the other behind him. Bl. ch., height. with wh., on blue. 280 x 192. Late inscription: Giorgion. Ascr. to Titian. Reitlinger 93: rather school of Titian. Hadeln, *Tizianzeichnungen,* pl. 19 and p. 22: Titian, about 1511, the time of the frescoes in Padua. This attr. was rejected by L. Fröhlich-Bum, *N. S.* II, p. 195: School of Brescia, perhaps Moretto.

To begin with, we cannot accept the early date proposed by Hadeln. The postures reveal a sentimentality typical of the last quarter of the century. The lack of understanding of the organic form is a further argument against Titian: it is difficult to tell on which knee the man is kneeling; his r. shoulder and the arm beneath the mantle cannot be felt and the foreshortened hand is a surprise; the relation between the two figures is not clear. The drawing, striking on first view, looses when studied closer, it is hardly by a great artist.

A 1934 ————, Dyce 230. The Virgin and Child. Bl. ch., height. w. wh., on blue. Upper corners cut. 301 x 230. Coll. Richardson, Pond, Barnard, Dyce. Reitlinger *Cat.* 19: Titian?, however adding that the attribution had been doubted by Borenius. We publ. the drawing in *Gaz. d. B. A.* 1943, p. 119, fig. 6 as by Sebastiano del Piombo and refer to the material gathered there for comparison. The drawing apparently prepared a painting, a copy of which exists in Van Dyck's sketchbook in Chatsworth. [**MM**]

A ————, Dyce 265. See No. **400**.

1935 LONDON, COLL. EARL OF HAREWOOD. Study of a kneeling man, seen from the back (without the head). Bl. ch. 257 x 183. The paper is stained by mold. Old inscription: Titia (no). Coll. T. Banks, Sir E. J. Poynter. Publ. by Hadeln, *Titian Drawings,* pl. 37 (erroneously described as being in the Koenigs Coll.). Popham, *Cat.* 267: Perhaps a study for a kneeling Apostle in the "Descent of the Holy Spirit" in Santa Maria della Salute in Venice, painted about 1544 to 60. Our *Tizian-Studien* 150 and 192, 33: the study was not used for Titian's present painting in the Salute, but since the latter is only a later version of an earlier "Pentecost" painted by Titian between 1541 and 1544, it is tempting to connect the drawing to that earlier version. [*Pl. LXXII*, 2. **MM**]

A 1936 LONDON, GAL. THOMAS AGNEW. A monk meditating. Bl. ch., on greenish gray (formerly blue) paper. 276 x 196. Coll. Professor C. E. Cooke, Alderson College. Publ. by Hadeln in *Vasari-Society* II. ser., X, No. 4 as Titian about 1530, close to No. **1904** and No. **400**, attr. to Titian by Hadeln. [**MM**]
The drawing is not connected with any painting by Titian, and in our opinion is not by him. The gestures are used only to illustrate meditation, the pose is superficial. The same might be said about the drapery which accentuates the silhouette, although the essential structural points are not yet settled. Is the monk sitting or kneeling? Where is his l. hand resting, what upon his r. elbow? Titian would first have realized these essential points before balancing light and

shadow on skull and face in order to produce a spiritual expression and before placing an open book, a mere accessory, on the ground. Hadeln's reference to No. **1904** makes the difference from Titian's way of proceeding still more striking.

A 1937 LONDON, COLL. KENNARD. A man in full-length, standing. Ch. The drawing, then in the Luigi Grassi Collection, was publ. by Adolfo Venturi in *L'Arte* 1927, p. 244, fig. 7 as a self-portrait by Titian.

We have not seen the original, but on the basis of the photograph deny any connection with Titian. In our opinion, the drawing is much later.

A 1938 LONDON, COLL. VICTOR KOCH. Christ led to Calvary. Pen and bistre. 192 x 287. Coll. Richardson; Dr. Christ. D. Ginsburg. Exh. London, Matthiesen Gallery 1939, at. no. 87 as Titian's study for the lost picture formerly at S. Andrea della Certosa, engraved by Cornelis Cort (1567), respectively by Hogenberg . . . 1581.

All the arguments in favor of Titian are futile. 1) No one knows how the painting in S. Andrea mentioned only by Sansovino looked; the wording of the passage makes us suppose that it was the typical half-figure of Christ bearing the Cross. 2) The engraving by Cort [**MM**], copied in reverse by H. Hogenberg, represents a composition not by Titian, but by Girolamo Muziano, still existing in the Cathedral in Orvieto (compare our article in *Graph. Künste*, N. S. III, 1938, p. 11). 3) The drawing shows no resemblance whatever to the engraving mentioned which the compiler of the catalogue seems to have known only from the list in Crowe and Cavalcaselle, *Tizian,* German edition, p. 791. — Moreover, the drawing shows no stylistic relationship to Titian.

A 1939 (LONDON), COLLECTION MORANT, formerly. Landscape. Pen, Publ. by Fröhlich-Bum in *Belvedere* 1929, p. 71 ff., as by Titian and the beginning of the new style of landscape painting as it appears in the engravings from landscapes by Titian and passes over the Carracci to Poussin and Claude Lorrain.

There is no contemporary engraving from a landscape by Titian, except the so-called "Angelica" engraved by Cort in 1565 and displaying an entirely different style. All other engravings from landscapes attr. to Titian belong to the 17th or later centuries and therefore have no documenary value. The drawing in question, which we have not seen, is, in our opinion, later than Titian and its Venetian origin is doubtful. Some of the landscapes usually attr. to Annibale Carracci have the same character, for instance, the one with a city in the middle ground in the Albertina.

A 1940 LONDON, COLLECTION ARCHIBALD G. B. RUSSELL. Head of a youth. Bl. ch. on br., with touches of red and wh. 280 x 222. Collection W. Esdaile. Exh. as Titian in the Burl. Exhibit. 1930, 662, Popham, *Cat.* 270: The authorship of the drawing is under dispute. A. Stix in *Belvedere* IX, p. 124, ill. pl. 83 questions the attr. to Titian.
[*Pl. CXCVIII, 2.* **MM**]
We endorse these doubts. Linework and expression belong to a later period. The type of the head with its childlike frail shoulders is close to Schidone's blind boy in the "Carità cristiana," Naples (ill. Ojetti, *La Pittura Italiana del Seicento e del Settecento alla Mostra del Palazzo Pitti*, 263). The very good drawing might have been Schidone's study from nature, since we notice the same model in other paintings by the same artist.

A MALVERN, MRS. JULIA RAYNER WOOD (SKIPPES COLLECTION). Study from an antique head. See No. **1717**.

A MILAN, COLL. RASINI. Men wrestling in a boat. See No. **12**.

1941 MUNICH, GRAPHISCHE SAMMLUNG, Mannheim 2981. Rider and fallen foe. Charcoal on faded blue, height. with wh. 346 x 252. Cut, especially on the lower border. Squared. First publ. by E. Baumeister, in *Münchn. Jahrb.* 1924, N. S. I, 22 as a companion to No. **1949** and in loose connection with the "Battle of Cadore." Fröhlich-Bum, *N. S.* II, p. 197, No. 3 and Hadeln, *Titian Drawings:* in connection with the "Battle of Cadore." Popham, *Cat.* 265: "Presumed to be a study for . . . "Battle of Cadore" . . . The drawing does not exactly correspond with any figure in G. Fontana's engraving." E. Tietze-Conrat in *O. M. D.* March 1936, p. 54 ff.: The drawing in Munich and the drawing in Oxford belong to the same period, but not to the early one when Titian painted the "Battle of Cadore" (ordered 1513, completed 1538). Both drawings are possibly studies by Titian for a painting by his son Orazio, representing the "Battle between the German troops under Frederick Barbarossa and the Romans near to the Castel Sant'Angelo and the Tiber." This picture was commissioned from Orazio for the Sala del Maggior Consiglio in 1562 and paid for in 1564. Vasari (VI, 588) who came to Venice shortly after this date describes the composition thus: ed in questa è fra altre cose un cavallo in iscorto che salta sopra un soldato armato che è bellissimo; ma vogliono chè in quest' opera Orazio fu aiutato da Tiziano suo padre. ("In quest' opera" seems not to be meant to refer to the one figure alone, but, as Hadeln already pointed out in his edition of Ridolfi, to the work as a whole). L. Dussler, *Italienische Meisterzeichnungen,* Frankfort, 1938, No. 33 dates the drawing around 1535 and calls it a study of the "Battle of Cadore"; at the same time he emphasizes the influence of Roman mannerism in the drawing, an influence never appearing in Titian before the 1540's. [*Pl. LXVII, 1.*]

We refer to our earlier statements and add a reference to No. **2161 bis**, a production of the Veronese shop, in which a warrior on horseback, evidently dependent on Titian's, appears in a "Calvary."

A 1942 MUNICH, WEINMÜLLER SALE, 1938 October 13–14, no. 688. Kneeling priest. Bl. ch. 275 x 190 (230 at bottom). — On the *back:* Various sketches of hands and knees. Red ch. According to the cat. the figure might be the first idea for St. Blaise (standing, it is true) in the altar-piece in San Domenico, Ragusa (*Klassiker, Tizian,* 217 r.), the hands on the back evidently a study for "The woman in a fur wrap" in Vienna (*Klassiker,* 65), the knees, studies for the r. leg of "Europa" (*Klassiker,* 168). H. Leporini, who not only wrote the preface of the mentioned cat., but also praised the collection in *Pantheon* vol. 22, p. 331 here drops the precise statements of the cat. and limits himself to saying that the main figure is typical of Titian in spirit and linework, and that the sketches on the back are evidently used in well known paintings by Titian.

The cat. may be right in emphasizing that the drawing is not by Cavedone, the style is indeed closer to that of Giulio Cesare Procaccini, and the drawing might be by one of his followers. As for the *verso* which, in spite of being said to contain authentic studies by Titian for paintings thirty years apart, was not considered worthy of reproduction, we have no opinion.

1943 NEW YORK, METROPOLITAN MUSEUM. Group of trees, study after nature. Pen. 218 x 320. Late inscription: Giorgione. Publ. by Sidney Colvin, in *Vasari Soc.* V, 9: Titian's early period or D. Campagnola at his best. Meder, *Handzeichnung,* p. 504, fig. 233: Titian (without argumentation). Hadeln, *Tizianzeichnungen* p. 39, pl. 39: No autograph, but by a pupil of Titian. *Albertina, Cat. II* (Stix-

Fröhlich) ad 46: circle of Titian, probably by the same artist who did No. **2009**. Fröhlich-Bum, *Belvedere* 1929, p. 71 ff.: authentic, but very late. In our *Tizian-Studien* p. 167 and 191, 7 we publ. the drawing as a study used in Titian's woodcut "Sacrifice of Abraham," dated about 1516. It was used in two places, the l. half being repeated in reverse on the rock in the middle, the r. one, also in reverse, at the r. border. Exh. Toledo 1940, cat. no. 95. *Metropolitan Museum Dr.*, pl. 14.

[*Pl. LXIII*, 2. **MM**]

A 1944 ————, 11.66.13. Cupid. Red ch., on faded blue. 180 x 148. Coll. P. Lely, Reynolds, William Mayor, Luisa and Lucy Cohen, London. Purchased 1911. Ascr. to Pordenone. Publ. by Hadeln, in *A. in A.* XV, 1926–27 as Titian, with reference to the Christ Child in the Pesaro altar-piece. Venturi 9, III, p. 247, fig. 121: Titian. In our *Tizian-Studien* p. 185 f. we rejected this attribution: Titian's putti, mythological or religious, are real children who will naturally grow to be Christ, male angels or Venus. This Cupid, however, will never grow up, his proportions are complete. We found such an ornamental interpretation of a child resembling Romanino's and referred to his mural paintings in Trento (ill. *Boll d'A.* IX, 1929–30, fig. 20 and 21). We suggested his name only with reservations, at that moment chiefly interested in an elimination from Titian's work. The attribution to Pordenone, in our opinion, is out of the question, since his putti repeat a more slender Michelangelesque type. A. L. Mayer, in *Gaz. d. B. A.* LXXIX, 1937, p. 310 pleads for Titian with reference to the putti in the painting in the Vatican Gall. (ill. Tietze, *Tizian*, pl. 145) and an angel in Francesco Vecelli's organshutter in San Salvatore (ill. Venturi 9, VII, fig. 43). *Metropolitan Museum Dr.* 15: Titian (?).

Mayer's references do not invalidate our doubts.

A 1945 NEW YORK, PRIVATE COLL. Various sketches, some of them representing scenes from a Rape of Europa. Brush, faded gray; pen, br. A portion is cut from the rest, but the original unity of the sheet recognizable from the back. 103 x 207, resp. 85 x 72. — On *verso:* fragment of a sketch for a ceiling with two crouching figures. Red ch. The otherwise unknown drawing is reproduced by W. Suida in *A. in A.* 1941, p. 13, fig. 6 as by Titian.

It is difficult to discuss this attribution, since no basis for it is advanced. The two essential features of the drawing seem to be: 1) that the sketches resemble neither the composition of Titian's "Rape of Europa," in the I. S. Gardner Museum, nor the "small version" of the same subject, discussed by Suida, 2) that the linework shows no analogy to authentic drawings by Titian. It follows much more the direction of the school of Paolo Veronese. Incidentally, we do not believe that the small version preserved in copies and engravings was by Titian himself. Imagine an artist of his stature exactly repeating a group invented for a monumental size as a small-sized staffage in a landscape!

A 1946 NEW YORK, COLL. ROBERT LEHMAN. Landscape with a couple under trees and with houses in the middle ground. Pen, br., on yellowish. 185 x 238. Publ. by Hadeln, *A. in A.* XV, 1927, p. 129, as Titian. Exhib. Buffalo 1935, No. 28 (ill. in Cat.) In our *Tizian-Studien* p. 181 and 191, No. 17.

[**MM**]

After having studied the drawing which at that time we knew only from its reproduction, we feel unable to maintain our former assertions. We do not find Titian's penmanship, but only motives typical of him and his period, taken up by a later artist for whom we have no name to propose for the time being.

A 1947 NEW YORK, COLL. A. LEWISOHN. "Madonna with the Rabbit." Pen and brush, gouache in various colors. Coll. Jon. Richardson Jr., Duke of Rutland. — On *verso* inscription: Picture is call'd the Madonna with the Rabbit; 'tis in the King of France's collection; and exceeding good one; a little different from the dr. R. jun. (Richardson)." Publ. by Alfred M. Frankfurter in *Art News* (The 1939 Annual) p. 100, as Titian's design for the painting in the Louvre, with reference to No. **A 1951**, No. **A 1891** and No. **1970**.

Typical copy as made evident by the hatching, imitating the shadows in the painting; perhaps by the same copyist by whom we saw a copy after Bassano's "Rest on the Flight into Egypt," at Colnaghie's in London 1939 [**MM**]. Van Dyck's watercolored copies after Titian indicate the approximate date of this drawing.

1948 NEW YORK, E. & A. SILBERMAN GALLERIES. Two satyrs seated in a landscape. Pen, darkbr. 213 x 152. Late inscription: Lovini Milanese. Coll. Pembroke (Wiltonhouse), Oppenheimer. Publ. by A. Strong in *Pembroke Dr.* (1900, VI, p. 54): Venetian School; a forgery or Campagnola at his worst. — Parker in *Oppenheimer Cat.*, p. 24: The attribution to D. Campagnola is not altogether convincing, and it would seem that the drawing deserves a more interesting name. There is affinity in feeling with the works of Dosso. — In our *Tizian-Studien* p. 169 f. and 191, 4 we attr. the drawing to Titian in his "Giorgionesque" period; the satyr seen from behind corresponds to a figure in the "Venus of Pardo" and the other satyr reminds us of the "Idyll" in Vienna (the "*pentimento*"!) both paintings completed in Titian's late period, but originating in his Giorgionesque time. — Tietze, *Tizian* pl. 7: about 1512. In most reviews of Tietze's book the attribution was rejected: Pallucchini in *L'Arte* N. S. VIII, 1937, p. 322: Sebastiano del Piombo. A. L. Mayer in *Gaz. d. B. A.* 1937, II, p. 305 ff.: At best copy from a Titian drawing. L. Fröhlich-Bum in *Art Bullet.* 1938, p. 446: Do. Campagnola, perhaps after Titian's invention.

[*Pl. LIX*, 1. **MM**]

The drawing is cut at both sides, and we are not certain as to its original shape. A copy from the drawing in the Louvre (no. 5663, pen, darkgray, 171 x 138, very poor) is no help, since it is cut at the right and below.

Dr. Richter orally suggested Giorgione as the author of the drawing. The drawing is indeed not unfamiliar in Giorgione's circle and the relation of the figures to the landscape is close to Giorgione's "Pastorale." In our article we called this late style of Giorgione the starting point for Titian, Sebastiano del Piombo and Giulio Campagnola (not for Domenico Campagnola whose drawings before and about 1517, now mostly ill. in *P. C. Q.*, October 1939, are too well known to allow a connection of the drawing with him), and thereby stressed the close affinity of their productions about 1512. Against Giorgione himself our principal argument is a certain forcefulness contradicting an artist in his maturity; in our feeling, the drawing belongs to an unbalanced and still searching artist. As for Sebastiano, after elimination of the drawing in Berlin (see p. 255), there is hardly any material available for comparison. The doubts concerning Titian, on the other hand, seem to start mostly from the treatment of the landscape where the close devotion to nature characteristic of some of Titian's drawings, is missing. We tried in our article to place the origin of this approach to nature around 1516 and found a similar limitation to typical motives in the only authentic landscape drawing anterior to this date (No.**1970**). Our essential argument has not even been mentioned by our critics: the figure of a drawing, orginating in the Giorgionesque sphere which deeply influenced the entire generation of Venetian artists including Titian, reappear in two independent compositions which Titian completed in his late years, but which,

for reasons completely apart from the drawing in question, can be and have been traced back to Titian's Giorgionesque period. The most natural explanation is to give the invention to Titian in his youth, since in our opinion Giorgione himself is out of the question. As for the execution the original drawing is distinguished by a glamor which to our mind excludes the idea of a copy.

1949 OXFORD, ASHMOLEAN MUSEUM. A horseman falling; in the upper l. corner another drawing (of a horse?) is canceled. Bl. ch., on greenish gray (formerly blue) paper. 274 x 262. Squared in pen, reddish br., for enlargement. Inscription (18th century?): Titiano F. Coll. Lawrence, Esdaile, West, King Charles, Richardson. Publ. first by S. Colvin II, 40: Titian, but not for the "Battle of Cadore," more probably for a Conversion of St. Paul. Hadeln, *Tizianzeichnungen*, p. 52, pl. 26: A direct connection of the study with a corresponding figure in the "Battle of Cadore" is not absolutely certain, since there are too many differences. But it is possible that Titian modified the sketch when he completed the painting, ordered a quarter of a century earlier. Baumeister in *Münchn. Jahrb.* 1924: Since the Munich and the Oxford drawings belong together, the Oxford drawing must also have been a preparatory study for the "Battle of Cadore" and not for a Conversion of St. Paul. — Fröhlich-Bum *N. S.* II, p. 197, No. 28: Study for the "Battle of Cadore," between 1530 and 1538. E. Tietze-Conrat, in *O. M. D.* March 1936: Study by Titian for Orazio Vecelli's painting in the Sala del Maggior Consiglio, 1562–64, Titian's share in this painting being testified by Vasari, see No. **1941**.

[*Pl. LXVIII*, 3. **MM**]

A OXFORD, CHRISTCHURCH LIBRARY, K 4. See No. **772**.

A 1950 ————, 41 B. Holy family in landscape. Pen. Publ. by Colvin II, 41 as Titian. Bell, Cat. pl. CXVI. Accepted by Hadeln in *Jahrb. Pr. K. S.* XXXIII, p. 108, but later rejected by himself in *Tizianzeichnungen* p. 43 and attr. to an imitator of Titian in the 17th century. Fröhlich-Bum in *Belvedere* VIII, p. 71 ill. h. and *N. S.* II, p. 197, No. 25: Titian.

We agree with Hadeln's second opinion.

A 1951 PARIS, LOUVRE 1515. Virgin and Christ Child. Pen on wh. 131 x 196. Later inscription: Tician (cut). Hadeln, *Tizianzeichnungen*, p. 27, pl. 2: the technique shows scarcely any connection with Bellini's or Carpaccio's, and none with any other Italian School. Titian must have learned it from Dürer's prints. — Fröhlich-Bum *N. S.* II, p. 195, No. 5 and in *Belvedere* 1930, p. 87, note, where she stresses the striking resemblance of the small figures with those in No. **1446**. — Luigi Serra in *Boll. d'A.* 1935, p. 549, doubts the authenticity. In our *Tizian-Studien* p. 191, 12: Titian. Despite of some dryness an autograph. The motive is related to the "Madonna with the cherries" in Vienna, the penmanship to Nos. **1880**, **1911**, **1915**.

[*Pl. CXCIV*, 2. **MM**]

Having studied the drawing anew we no longer consider the reference to the "Madonna with the cherries" as a convincing argument in favor of Titian. The contrast between the archaic motive of the curtain in the middle and the views on both sides is very striking. Even the choice of naturalistic motives and the lack of symmetry, indispensable to the curtain motive in the early 16th century, point to a later manner. The same may be said of the way of drawing the landscape. A comparison with early landscapes, the one in the Albertina drawing No. **1970** for instance and even in No. **1961** reveals different forms. Those in the drawing recall pen drawings of landscapes by Annibale Carracci. (Compare the well-authenticated drawing in the

École des Beaux Arts in Paris [Exh. of Italian Drawings 1931, no. 28], and specifically, the rendering of buildings, the foliage, the treatment of the sky, the sitting couple in the middleground.) Once doubting the traditional name and date, we discover other grounds for suspicion. The folds of the curtain are naturalistic. The Madonna, distinguished by a halo, a motive not occurring in Titian's work before the late "Madonna" in Munich, differs from the intimacy and tenderness of Titian's early Madonnas, and, with her erect head, adopts a more heroic style which is matched by the agitated posture and action of the Christ Child. The Infants in Titian's authentic early works are more childlike. In this one we find a trace of an influence of Correggio which together with the outspoken imitation of Titian leads in the same direction as the scrutiny of the landscape, namely, the renaissance of Titian in the early production of the Carracci. In their works we also note types of Mother and Child resembling those in our drawing. See, for instance, the "Virgin with St. Dominic," in Bologna (ill. Venturi IX, 7, fig. 651) or Annibale's "Virgin with saints," in Bologna (ill. Venturi IX, 7, fig. 665).

1952 ————, 5516. Group of Apostles. Pen on wh. 231 x 302. Cut and damaged by mold. On the top a patched strip of paper on which the hand of one of the apostles has been added. Morelli II, p. 293: Titian, in connection with his late "Pentecost" in the Salute. Hadeln, *Tizianzeichnungen*, 5: Titian, sketch for the "Assunta" (1516–18). Fröhlich-Bum *N. S.* II, p. 198, No. 41: Titian, for the "Pentecost" in the Salute (1554–60). Suida, *Pantheon*, 1936, p. 102: Sketch for an early work, preserved in D. Campagnola's engraving "Pentecost," dated 1518. In our *Tizian-Studien* 158 and 191, 11: sketch for an early "Pentecost" which inspired Do. Campagnola's engraving. The grand and clear organization of Titian's composition of which only a portion is preserved in the drawing was compressed and crowded by Campagnola. Suida's theory (*Critica d'A.* VI) according to which Domenico Campagnola in his engravings merely reproduced drawings by Titian is rejected in our articles in *Graph. Künste* N. S. III, p. 58 ff., and in *P. C. Q.* October 1939, p. 331. [*Pl. LXIV*, 1. **MM**]

A ————, 5517a. See No. **1997**.

A ————, 5517b. See No. **1998**.

A ————, 5518. See No. **1999**.

A 1953 ————, 5523. Two men seated on the trunk of a tree, one of them repairing a scythe. Pen, br. 214 x 196. Old inscription in two lines, hardly decipherable, apparently on the paper before the drawing. Only the last words "di . . . a Padua" are legible. Coll. Mariette (not in the Sale Cat., Paris 1775). In the Louvre ascr. to Titian, and publ. as his in Lafenestre, *Le Titien*, p. 11, and by Fröhlich-Bum *N. S.* II, p. 183 ff.; she dates the drawing between 1534 and 44 because of an alleged resemblance to No. **A 1930**. [*Pl. XXXV*, 3. **MM**]

Neglecting the reference to this extremely spurious drawing we disagree with Mrs. Fröhlich-Bum's dating and place the drawing between 1510 and 20. Among Titian's drawings No. **1915** seems the most closely related, while No. **1911** which is well established for the period proposed by Mrs. Fröhlich-Bum is decidedly advanced in style. (Her mistake is partly explained by her misdating of No. **1952**.) The drawing in Paris is much more primitive and even when compared with **1915** easily recognized as a production of the preceding generation. The close clinging to the model (compare, for instance, the folds in both drawings) still corresponds to the naturalistic tradition of the Quattrocento. There is no evidence that Titian ever came so close to

the style of his master, Bellini. His temperament in his youth, or even later, is very different from these calm and reserved types. We feel a spiritual kinship to the peasants in Giovanni Bellini's late "Bacchanal" (ill. *Klassiker, Bellini,* 173). However, we do not attribute the drawing to Bellini himself, since reflections of this phase of his style are recognizable in various contemporary productions, for instance, No. **719**, whose author, in the opinion of G. M. Richter as expressed in his book, might have been brought up in Bellini's studio.

As for the subject we point to the striking resemblance of the represented scene to the woodcut in Francesco Marcolini's *Sorti,* Venezia 1540, p. 180 representing the visit of the philosopher Anacharsis to the philosopher Myson, just when the latter was repairing a ploughshare [**MM**]. The woodcut belongs to a series by G. Salviati, representing the philosophers in situations described by Diogenes Laertius in his *Lives of the Philosophers,* and it has already been convincingly suggested by Sotzmann (*Die Loosbücher des Mittelalters, Serapaeum* 1850, p. 72) that these woodcuts were originally planned for an edition of Diogenes Laertius, of which, however, we know only a reprint of 1602 (*Le vite de' Filosofi cavati da Laertio e altri. Adornati di bellissime et vaghe figure di Giuseppe Salviati. Nuovamente ristampate Venetia 1602.*—We quote from Passavant VI, 215). The popularity of the book of Diogenes Laertius, especially in Venice, is established by various older editions from 1490 on (Hain 6202, Proctor 5024). The drawing in Paris might be an illustration of the same passage. The fact that the two men, and particularly the one sitting behind, are not draped in the conventional robes of philosophers might conform to the freedom typical of Venetian artists about 1500, and even later, in the rendering of classical subjects. See for instance, the unclassical array of the gods in Bellini's "Bacchanal," or the puzzling mythological representations of Giorgione.

1954 ———, 5528. Landscape with shepherd and flock; the dog identical with the one in Titian's "Pardo Venus." Pen, br., very much faded and on the whole in bad state of preservation. 263 x 377. In our *Tizian-Studien* p. 168 and 191, No. 27 attr. to Titian about 1540. A. L. Mayer in *Gaz. d. B. A.* 1937, p. 310 denies the identity of the dog with the one in the "Pardo Venus." He seems to accept the attr. to Titian and believes that the drawing has been blurred by the making of a counterproof. (We wonder whether we understood Mayer correctly.) L. Fröhlich-Bum in *Art Bulletin,* 1938, Dec., p. 445 f., believes the dog to be "a stock property current in all Venetian pictures" and rejects the attr. to Titian of No. **1954** as that of No. **1955**.

No. **1954** differs from the latter which is a study for a detail, while ours is a complete composition, perhaps meant to be engraved, comparable to No. **1974**.

A ———, 5533. See No. **541**.

1955 ———, 5534. Sleeping shepherd with a flock of sheep and goats. Pen, br., faded. 250 x 400. Cut at l. and probably at the top. Engraved by Lefèvre, about 1680. Coll. Crozat, Chennevières: Titian. Ill. Lafenestre, *Le Titien,* p. 183. In our *Tizian-Studien* p. 180 and 191, No. 16: Titian, about 1520. A. L. Mayer in *Gaz. d. B. A.* 1937 (LXXIX), p. 310: copy from Titian. L. Fröhlich-Bum in *Art Bulletin* 1938, p. 445: not even enough evidence to deny Titian.

We have but little to add to our argumentation in our article where we already pointed to the resemblance of the composition to that in No.**1872** and of the types to the woodcut from Titian's studio, ill. in the article on p. 165, fig. 146. The great quality of the drawing can hardly be guessed from the reproduction of the faded original. Our

reattribution of the drawing to Titian rests on our new knowledge of his early style, based on the study of his woodcuts and recently confirmed by the newly discovered early landscape in Leningrad, "The flight into Egypt" (see E. Tietze-Conrat, in *A. in A.,* 1941, p. 144) whch ought to uproot obsolete prejudices.

1956 ———, 4605. Abraham and two youths with a donkey. Pen, lightbr., faded. 164 x 132. Late inscription: Giorgione da Castelfranco f. 1510. Listed as Giorgione. First publ. in our *Tizian-Studien,* p. 168, note 66, and fig. 147, as a copy from an original study by Titian, used about 1516 for his woodcut "The sacrifice of Abraham." In the woodcut, one of the youths has been replaced by another figure. [*Pl. LXXIV,* 2. **MM**]

The types in the drawing are quite different from those in the woodcut. In the drawing, the heads of the youths are lyric and pictorial, and the bearded patriarch shows the lively emotion of an apostle, in the woodcut, all features are hardened and Abraham's head is much larger, almost a caricature. The woodcut translates Italian into German, perhaps by the interference of assistants who helped to prepare the woodcut. The mixture of Düreresque and Giorgionesque elements is striking in the drawing. For Giorgionesque influences compare the youth standing at l. in the "Judgment of Solomon" in Kingston Lacy, ill. Richter, p. XXIX, for the borrowings from Dürer, the arm with the hat in Dürer's woodcut B. 78, the donkey in B. 89. We published the drawing as a copy from an original by Titian, but might as an afterthought admit the possibility of its being an original. The dryness may be explained by its purpose to serve for a woodcut, and its flatness by the fact that a counterproof has been taken from it. The inscribed date of 1510, though modern, may rest on a sound foundation. We may suppose a strong influence on Titian at that time by Giorgione and, on the other hand, a marked Düreresque alloy as appears in the woodcuts of the Trionfo della Fede.

A 1957 ———, 5547. Landscape. Pen, br. 135 x 195. Coll. Mariette. Publ. by Fröhlich-Bum, *Belvedere* VIII, 1929–30, p. 76, ill. g: Titian, listed after No. **A 1950**. Accepted by Suida, *Tizian,* p. 77, pl. CCXXVb. Rejected in our *Tizian-Studien* p. 178. [**MM**]

Evidently this drawing does not belong to the first half of the 16th century. This makes a comparison with Titian difficult, since no authentic landscape exists from his later years. In our opinion, the drawing is a hundred years later, as is No. **A 1950** to which Mrs. Fröhlich-Bum refers. Compare, for instance, Castiglione's drawing in the Louvre, Rouchès, *Italian drawings of the 17th century,* no. 20.

A ———, 5548. See No. **2001**.

A 1958 ———, 5555. Mother and Child (Madonna?). Bl. ch., height. w. wh., on buff. 383 x 247. Stained by mold. Later inscription: Di Tiziano. Ascr. to Cesare Vecelli, publ. by Hadeln, *Titian Drawings,* pl. 35 as by Titian. [**MM**]

We do not know on what tradition the ascription to Cesare Vecelli rests and do not find any connection with his paintings and illustrations. On the other hand, we cannot agree with Hadeln. The approach to Titian is very superficial and reminds us of Palma Giovine's early style. We do not, however, feel sure enough to attr. the drawing to him outright.

A ———, 5756. See No. **1118**.

A 1959 ———, 5573. Landscape with a milkmaid. Pen, br., wash, faded, on paper turned yellow. 367 x 522. The drawing is in

opposite direction to the woodcut Pass VI, 242, 96, to which it also corresponds in size. It is not an original, but a drawing done in the shop, either on the basis of a complete sketch by the master or of various studies by him, as for instance, No. **1912**. [**MM**]

A ———, 5906. See No. **581**.

A 1960 ———, Walter Gay Bequest. Repeated study of a biblical figure. Bl. ch., on grayish blue. Traces of squaring. Formerly ascr. to Pordenone, publ. by E. Tietze-Conrat, in *Belvedere*, 1928, III, p. 65 as Titian, accepted as his by Fröhlich-Bum *N. S.* II, p. 197, No. 13 and dated about 1525, in connection with Titian's "Entombment" in the Louvre (ill. Tietze, *Titian* pl. 65). We questioned the attr. in our *Tizian-Studien* p. 186, note 86 and supplemented this correction in *Gaz. d. B. A.* 1942, p. 117 by identifying the drawing as a study by Federigo Baroccio, used in his "Entombment of Christ," in the Archiginnasio, Bologna, painted in 1600 (ill. ibidem fig. 5). [**MM**]

1961 PARIS, ÉCOLE DES BEAUX ARTS. Sketch for the "Jealous husband killing his wife," mural in the Scuola del Santo in Padua, 1511. Pen, br., faded, on wh. paper. 188 x 177. A *"pentimento"* at the man's l. arm. Exh. École des Beaux Arts, 1879, no. 199. Publ. by Lafenestre, *Le Titien*, p. 57 (erroneously as being in the Malcolm Coll.). Hadeln, *Tizianzeichnungen* pl. 1. Fröhlich-Bum *N. S.* II, 2. In our *Tizian-Studien* p. 173 and 191, 1. Richter, *Giorgione*, p. 233, pl. 64 accepts the connection with the fresco and agrees to the attribution to Titian in view of the style of drawing. But he attr. the invention to Giorgione, of whom the frescoes might have been ordered and who might have made sketches for them before his death late in 1510. Fiocco, *Pordenone*, p. 102, too, considers the drawing far superior to the mural and believes in Titian's dependence on Giorgione (who might have also influenced Pordenone's Petrus Martyr, No. **1301**. In our article on Do. Campagnola in *P. C. Q.*, December 1939 we, on the other hand, pointed to certain weaknesses of the drawing which made us hesitate as to whether to place it after the painting instead of before it. In this case it could be a derivation from Titian's work by his early imitator, Domenico Campagnola. [*Pl. LX*, 1. **MM**]

We still acknowledge the weight of Richter's argument. The changing of the original idea into a completely different composition is indeed very surprising, especially in view of Titian's otherwise known way of holding to his first idea (see Nos. **1880, 1915, 1923**). Accordingly, we are unable to suppress some doubts. Although listing the drawing under the universally accepted name of Titian, we still feel the stylistic approach to Campagnola as dangerously close and, most of all, the resemblance to No. **1932** confusing.

1962 ———. The Sacrifice of Abraham, design for the ceiling, (now) in the sacristy of St. Maria della Salute. Bl. ch., height. with wh., on gray. 232 x 258. Squared in red ch. Inscription in pen: di Titiano. Coll. Lely, Lawrence, Esdale. Not listed by Hadeln. Fröhlich-Bum *N. S.* II, 36. Our *Tizian-Studien* 191, 29. [*Pl. LXX*, 2. **MM**]

The drawing is dated by the painting: 1543-44. Strange as it seems, no later author has noted that Vasari (VII, p. 446) boasts of having had the commission for the three ceilings in Santo Spirito and of having made designs for them to the end "that he might execute them in painting." After Vasari's departure the pictures were allotted to Titian whose daring foreshortenings won Vasari's special praise. In view of the fact that Vasari as a Central Italian did not appreciate Titian's achievements in this particular field, the passage seems to intimate that Titian for his designs had made some use of those made by Vasari. The Central Italian influence on Titian in this period and

especially in these three ceilings has frequently been noticed, it might even be that Titian did indeed draw some inspiration from Vasari's designs, his compositions showing some relationship to Vasari's (later) ceilings in the Palazzo Vecchio in Florence. Even in our drawing, certainly purely Titianesque in style, some reminiscence of Vasari may be found in the treatment of the drapery at left.

A 1963 PARIS, COLL. ANDRÉ DE HEVESY. Head of a horse. Bl. ch., on reddish br. paper. 310 x 130. Collection mark: P. D. (unidentified). Exh. London, Matthiesen Gallery, 1939 *Cat.* No. 88 (ill.) as attr. to Titian and study of the horse in the "Martyrdom of S. Lawrence" in the Escurial (ill. Tietze, *Tizian*, pl. 264, 265). [**MM**]

We recognize neither a connection with the painting mentioned, nor a stylistic resemblance to Titian's drawings.

1964 PARIS COLLECTION D'UN AMATEUR. Sale, Hotel Drouot, February 13, 1939. A woman's head. Bl. ch. and brush, many-colored wash, on brownish, very thin paper. 368 x 256, cut on top at the r. On the back inscription by F. Villot: P. Véronèse. Portrait de sa fille. Ill. in the sales cat. (Jacques Mathey). [*Pl. LXXIII*, 2. **MM**]

In our opinion, this drawing is a work drawing by Titian. The main outlines look as if traced, in evident contrast to the free handling of the accessory detail. Titian used the drawing with slight modifications for the main figure in the "Education of Cupid" (Tietze, *Tizian*, pl. 250): the hairdressing is changed, the veil does not appear in the picture, loose hair above the r. shoulder is added. The head sits straighter in the drawing and the pearl is distinctly seen hanging from the hidden ear. The differences make it clear that the drawing is not a copy from the painting, but more likely a link in the working process. The thin paper and the dead stroke of the main outlines indicate that the drawing was begun with a tracing. This may have been done by Titian or any member of his shop, on the basis of an original study from nature. The same study may have been used earlier for other paintings, as the same head appears in the "Rest on the flight into Egypt" in Madrid and in the "Annunciation" in San Salvatore in Venice.

1965 PITTSBURGH, PA., COLL. TÖRÖK, formerly. Study of a horse to the l., the head turned to the r. The l. foreleg is separately repeated. Bl. ch. 294 x 272. Coll. W. König, Vienna. Leporini, *Handzeichnungen der Samml. Török*, Vienna, 1927, pl. 29. Sale Török, Pittsburgh, Pa., November 8, 1928, No. 147 (ill.). Fröhlich-Bum *N. S.* II, p. 197, No. 29: Titian, similar to the study in Oxford No. **1949**, possibly for the same group, although in reverse. Accordingly, perhaps a study for the "Battle of Cadore," shortly before 1538. In our *Tizian-Studien* p. 155, 158 note 57, and 191, 30, we corrected the date of the study in Oxford and hence Fröhlich-Bum's early dating of No. **1949**. We did not agree with Fröhlich-Bum about the stylistic connection with the Munich and Oxford "cavalli," but dated the drawing in the middle of the century.

We have not seen the original and, therefore, express our opinion with reservations. The motive is typical of a horse in a "Passage through the Red Sea," and similar motives are indeed found in Titian's woodcut of 1549. The (burned) painting by Orazio (1562-64, see No. **1941** and No. **1949**), however, might also have contained the motive, since it represented a battle on the bank of the Tiber.

A PROVIDENCE, COLL. J. N. BROWN. Entombment of Christ, see No. **2004**.

A 1966 SIENA, BIBLIOTECA COMMUNALE, S I, 4, 25. Mythological couple of lovers and cupid in landscape. Broad pen, br., traces of the

sketching in red ch., on paper, turned yellow. 226 x 189. Mounted. Publ. by Zocco in *L'Arte* 1935, 377, as Titian, with reference to No. **1923**.

In our opinion, the drawing is later, not by Titian, but belonging to the Titian renaissance at the end of the 16th century. We refer to the similar pen drawing of two women and cupid, in the Ambrosiana, no. 187, signed "Annibale in Venezia" (Carracci).

A 1967 STOCKHOLM, NATIONAL MUSEUM, no. 1385. Woman lying on the ground, her r. arm stretched out. Bl. ch., height. with wh. Irregularly cut, 120 x 240. Inscription on the mount: Tiziano. Sirèn, 1917, 464: Closer to Tintoretto's style than to Titian's circle.
[*Pl. CXCIII, 3.* **MM**]

We have not seen the original, but Sir Kenneth Clark, who saw the drawing in Stockholm, emphasized its outstanding quality. Its violence, its technique, the summary way the legs and feet are only indicated, recall Titian's style (compare, for instance, No. **1904** and No. **1929**). This resemblance, however, is not sufficient to overcome our scruples. When Titian neglected hands or a head, he did so in order to concentrate on the drapery. His draperies add the weight of their own material to the volume of the bodies beneath. The figure in Stockholm aims at a different effect which belongs to a later period; it strives for the indissoluble unity of nude, clothes and ground. We do not recognize Titian's hand, but are for the time being unable to propose another author for this excellent drawing.

A 1968 ————. Battle scene with a fortified castle in the background. Pen. 188 x 275. Cut. Late inscription: Tician. Publ. as Titian by Schönbrunner-Meder 1075 and by Sirén, *Dessins* p. 64, No. 152. Sirén, *Cat.* 1917, no. 455 and Sirén 1933, pl. 95: Romanino, Nicodemi who lists a pendrawing of a battle scene in Stockholm (*Romanino*, p. 202) may have meant this drawing. L. Fröhlich-Bum in *Jahrb. K. H. Samml.* N. S. II, p. 187, ascr. it to Paris Bordone with reference to No. **387**, but admits that the mode of drawing is essentially different from Bordone's.

No. **387**, in our opinion, is by Romanino, but his style seems less clear in No. **1968** the original of which we have not seen.

A 1969 VENICE, R. GALLERIA, 118. Sketches of a boar. Pen, br. 173 x 135. The lower l. corner added. On *verso:* inscription confirming that Morelli accepted the attribution to Titian. Loeser, in *Rass. d'A.* III, p. 181 accepted it with reservations: probably copied from a Meleager sarcophagus. We accepted the attr. in our *Tizian-Studien* p. 191, 32.

We withdraw this attribution. The drawing has an ornamental style contrasting with Titian's faithfulness to nature. It is more in the style of Niccolò dell'Abate.

1970 VIENNA, ALBERTINA, 38. Two kneeling boys in a landscape. Pen, bistre, on wh. 236 x 213. Lower r. corner added. Acquired in 1923. W. G. Constable in *Burl. Mag.* XLII, p. 192 ff.: Only the lower half by Titian. Hadeln, *Tizianzeichnungen,* p. 28 and p. 53 f., pl. 4 accepts Constable's theory. *Albertina Cat. II.* (Stix-Fröhlich): Both parts of the drawing are by the same hand, but are two separate sketches on one leaf, perhaps for the same painting. Fröhlich-Bum in *Belvedere* 1929, p. 71 ff.: lists the drawing as the earliest of Titian's landscape drawings and compares it with the background in the Padua frescoes and the "Sacred and profane love." In our *Tizian-Studien* p. 190, 3 we accepted Fröhlich-Bum's theory that the whole drawing is by Titian.
[*Pl. LIX, 3.* **MM**]

In our opinion, the group forms a unit with the landscape. The rolling hills are typical of Titian's middle distance and the whole sheet (evidently cut on both sides) could refer to a motive like the group of the two shepherds in the middleground in the "Flight into Egypt," Hermitage (ill. *A. in A.* 1941, p. 144).

A 1971 ————, 39. Beheading of a female saint. Red ch. and brush, gray wash. 200 x 149. Coll. Prince de Ligne (A. Bartsch, *Cat. raisonné* 412). The drawing, listed in *Albertina-Cat. I* (Wickhoff) under Scuole diverse 159, was publ. by Fröhlich-Bum in *Burl. Mag.* July 1923 as Titian, "Beheading of Saint Valentine," dated between 1504 (her presumed date of "St. Mark surrounded by other saints" in the Salute) and 1519, the beginning of the "Pesaro Madonna." Hadeln, *Tizianzeichnungen,* p. 43: first half of the 18th century. *Albertina Cat. II* (Stix-Fröhlich) 39 repeats Fröhlich-Bum's former theory. We publ. the drawing in *Gaz. d. B. A.* 1942, p. 119 as a work of the Milanese painter, Federigo Panza (born 1630 to 40, died 1703) by whom a great number of drawings of this character exists in the Ambrosiana (one ill. l. c.) and two drawings in the Albertina. It is a typical mistaken method to make an attr. on the basis of a slight resemblance of a motive (here the enthroned draped figure of St. Mark in the Salute painting) without regard to the style of drawing.
[**MM**]

A 1972 ————, 40. Rest on the flight into Egypt. Pen, bistre, on wh. 317 x 260. Coll. Prince de Ligne. *Albertina Cat. I* (Wickhoff) Sc. D. 241: By an artist of the Carracci circle. Attr. to Titian by Fröhlich-Bum in *Burl. Mag.* 1923, July, with reference to the "Holy family" in Oxford, No. **A 1950**. Hadeln, *Tizianzeichnungen,* p. 43: 17th century, with a touch of Elsheimer's style. *Albertina Cat. II* (Stix-Fröhlich) 40: Titian, first quarter of the 16th century. Fröhlich-Bum in *Belvedere* 1929, p. 71 ff. lists the drawing after the sketches for the "Martyrdom of St. Peter" No. **1923**, No. **A 1918**, No. **A 1973** and before No. **A 1950**.

We agree with Wickhoff's and Hadeln's rejection.

A ————, 41. See No. **1180**.

A 1973 ————, 42. An extensive landscape with a flock of sheep and a shepherdess. Pen, bistre. 280 x 427. Coll. Earl Spencer and F. Abbott. Acquired 1923 as D. Campagnola. Attr. to Titian by Stix in *Albertina, N. S.* II, pl. 17; as Titian also in *Albertina Cat. II* (Stix-Fröhlich). The attributions, both to D. Campagnola and to Titian, are rejected by Hadeln in *Zeitschr. f. B. K.* 1927, Kunstchronik p. 112, without offering a name. Fröhlich-Bum in *Belvedere* 1929, p. 77, fig. 3, maintained the attribution to Titian, which she bases especially on the style of the figure in the lower r. corner.
[**MM**]

We share Hadeln's doubts and expressly reject the reference to the figure style which is merely typical of any sketch. The Venetian character is not absolutely dominant, the drawing might originate from some other North Italian School under Venetian influence.

1974 ————, 79. Landscape with three shepherds — one playing the flute, and moving toward the r. — and a flock of sheep. Pen, bl. br. (faded). 302 x 434. Late inscription: Titien. *Albertina Cat. I* (Wickhoff) Sc. Ven. 40: repetition of a drawing by D. Campagnola in the Louvre (there listed as Titian). *Albertina Cat. II* (Stix-Fröhlich): Francesco Bassano; no. 5570 in the Louvre is a copy from this drawing. The composition occurs in a contemporary Venetian woodcut. Van Marle, *International Studio,* 1930 (vol. 96), p. 39 ff. and 116 ff.: copy after Titian's painting in reverse.
[**MM**]

Stix-Fröhlich's reference to a woodcut seems to be a mistake; as far as we know, no contemporary woodcut exists, only an engraving from 1680 by Lefèvre. The engraving publ. by G. D. Rossi in Rome is, in our opinion, a copy from Lefèvre's and not, as Van Marle suggests, anterior to it. The drawing is in so bad a state of preservation that it is difficult to decide whether it is an autograph or a copy. (In our opinion it is an autograph.) At any rate, the version is far superior to the very dry one in the Louvre. The style is Titian's (see No. **1872**) and definitely not Francesco Bassano's. No pen-drawing by Francesco Bassano is preserved and to make an attr. in this new field a better founded evidence should be chosen than this one which is connected with Francesco Bassano solely by representing sheep and shepherds. Also, the composition is Titian's. Typical of him are the treatment of the foreground, a sudden thrust into depth, and a brook and its bank placed parallel to the lower border; the gradual advance into the middle zone; beyond this a summarily treated zone passing into a sharply indicated extreme distance. No. **1872** follows a similar pattern of composition typical of Titian. The drawing is a finished composition, a combination of elements for an artistic purpose, not merely an interesting motive casually taken from nature — a kind of snapshot. Of one of these elements — the buildings in the middle of the background — we even know the study from nature: it is the part on the right in No. **1875**. It is a rare chance to have a study of this type preserved which allows us to follow Titian's methods of working. The drawing may have been intended for graphic reproduction (like No. **1872** in which older motives are combined to make a new composition).

The authenticity of the Albertina drawing was called into question by Van Marle from another point of view. In the Beets Coll. in Amsterdam there exists a painting of the same composition which **Van Marle** publ. as an original by Titian. It presents the composition in reverse, and accordingly, in the same direction as Lefèvre's engraving. If the picture were by Titian and consequently the direction of its composition the original one, the Albertina drawing should reasonably be considered a copy from the painting in reverse (done with the help of a mirror), to serve as preparation for an engraving. The sketch from nature No. **1875**, however, contra-

dicts Van Marle's theory since it is in the same direction as the drawing in the Albertina. Part of the impressive composition is copied in a painting in the Johnson Coll. in Philadelphia, attr. to Farinato or Padovanino or Schiavone (ill. in Venturi 9, IV, fig. 528) and in a drawing in Chatsworth (*Chatsworth Dr.* 58 under Titian, attr. by Hadeln, *Tizianzeichnungen* p. 41 to the 17th century, probably school of Bologna), as already noted by Van Marle. These copies, too, are in reverse to the Albertina drawing and may be dependent on the engraving, the most easily available model. The group of buildings in the background is copied in a large landscape with a "Flight into Egypt" engraved after Agostino Carracci.

A VIENNA, COLL. GEIGER, formerly. Annunciation, See No. **1033**.

A 1975 VIENNA, COLL. MAX HEVESI, formerly. Wild landscape with a big tree in the center. Pen, bistre. 400 x 270. Earl of Warwick Coll. Publ. by L. Fröhlich-Bum in *Belvedere* 1929, p. 75, fig. i, as Titian. "Here again the grandiose conception and the immediate and fresh vision, in my opinion, are combined with such directness of execution that the drawing cannot be done but by the initiator of landscape painting, by Titian himself."

Instead of "initiator" imitator would have been the better word. The drawing is a slightly cut later copy from No. **A 1896**, a typical production of Muziano. Companion piece of No. **A 1918**.

A VIENNA, COLL. KIESLINGER. Portrait of an elderly man. See No. **779**.

A 1976 WILTON HOUSE, COLL. EARL OF PEMBROKE, formerly, now in a private coll. in the United States. God the Father creating the world. Pen-and-bistre, height. w. wh. 316 x 256. Publ. *Pembroke Dr.,* pl. IX as Titian.

The erroneous attribution was corrected by Licia Collobi, in *Critica d'A.* XIV, p. 72, where the drawing is publ. as a design by Federigo Zuccari for his painting in the Palazzo Farnese, Caprarola, ill. ibidem fig. 1.

A WINDSOR, ROYAL LIBRARY, 4794. See No. **2014**.

CIRCLE OF TITIAN

1977 BERLIN, KUPFERSTICHKABINETT, 624. Battle scene. Pen. 192 x 272. Formerly ascr. to Circle of Titian. Hadeln, in *Jahrb. Pr. K. S.* XXXII, Beiheft p. 22 and *Spätren.,* pl. 102: Design by Giovanni Contarini for his mural, "Retaking of Verona," in the Ducal Palace (ill. Venturi, 9, VII, fig. 166, p. 279). Hadeln himself points out the considerable differences between drawing and painting.

[*Pl. LXXIII,* 3. **MM**]

These differences in our opinion, are so considerable, that they make the alleged connection between the two versions questionable, especially since the subject evidently is not identical. The manner of drawing differs notably from other pendrawings given to Contarini and resembles No. **664** only slightly with which, however, it is difficult to compare it. The origin of this magnificent drawing in the circle of Titian seems more plausible. This fact must not exclude Contarini who in his "Retaking of Verona" accepted many elements from Titian's "Battle of Cadore" and on the whole was manifestly under its influence. But the much greater independence and higher quality of the drawing are arguments against Contarini's authorship and in favor of a closer connection to Titian himself. The lack of

pendrawings from his later years forbids us to take his own authorship into consideration without the help of external evidence. Tentatively we point to the lost painting of a "Battle on the Tiber" by Orazio Vecelli (1562–1564) and the alleged collaboration of his father (see Nos. **1941, 1949**).

A 1978 BRNO, LANDESMUSEUM, formerly. Mourning over the dead Christ. Pen and bistre. 243 x 209. — On *verso:* Inscriptions: "Del Tintoretto" (and) "che para de' Carracci e molti lo credono." Coll. Skutetzky. Ascr. to the school of Titian and under this name publ. by O. Benesch, in *Graph. Künste* N. S. I, 1936, p. 60 f., who tentatively attributes the drawing to El Greco. He refers to the evolution of the iconological motive, carefully investigated by Kurt Rathe, *Graph. Künste,* vol. 37, Mitteilungen, p. 5. [**MM**]

In our opinion, the connection of the composition with El Greco is limited to dependence on the same influences. However, the grandiose invention in the drawing is weakened by the addition of lateral figures while El Greco holds to Michelangelo's more concentrated version. It is, therefore, inconceivable that the drawing

might represent a preparatory stage. Moreover, the mode of drawing has no resemblence to El Greco's early style or to Venetian painters who might have influenced him. The drawing is a weak, manneristic production, probably by a Central Italian artist.

1979 BUDAPEST, MUSEUM. Landscape with a "curtain" of trees at the l. and buildings in the distance at the r. Pen, br., partly faded. 225 x 336. Damaged by mold. **[MM]**

The drawing ascr. to Giulio Campagnola, is, in our opinion, a copy from, or inspired by, an early Titian drawing dating from the time of the "Flight into Egypt" (ill. *Art in America*, 1941, p. 144). Compare also Nos. **1987, 1988.**

1980 CHANTILLY, MUSÉE CONDÉ, 114. Recumbent Venus asleep in a landscape surrounded by three putti also sleeping. Pen, br., wash. 85 x 245. The outlines are pricked. Coll. Grivis and Reiset. Ill. in Lafenestre, *Le Titien*, fig. 1.

Not listed by any other author on Titian. When we saw the drawing in 1938, we had the impression of a mediocre imitation of Titian's style. Considering the bad state of preservation on one hand and a number of details closely resembling Titian's early production, on the other, we believe in a possible connection with Titian in the 1530's. The exact repetition of the composition in one of the drawings in Van Dyck's sketchbook in Chatworth (ill. Cust, pl. XLV who refers to Giorgione's "Venus" in Dresden) adds a further argument in favor of a connection with Titian.

A 1981 CHATSWORTH, DUKE OF DEVONSHIRE, 749 B. Group of buildings with a tree in the foreground. Pen, bl. and br. 140 x 211. P. Lely Coll.

Ascr. to school of Titian, but more probably a copy. There is another version of this drawing in the same coll., no. 749 A. It is difficult to decide whether it is copied from 749 B, or whether both drawings were copied from a lost original.

1982 ————, 910. Head of a prelate. Bl. ch., on br. 406 x 298. Later inscription: Titianus f. (and) Alciati morto nel 1550. At the l. contemporary notations of colors, for instance chiomi bianche (white hair). Photo Braun 202. *Chatsworth Dr.*, pl. 20. Hadeln, *Tizianzeichnungen*, pl. 41: probably not Venetian. In our *Tizian-Studien*, p. 148, note 83: working material, probably from Titian's shop.
 [*Pl. LXXIII*, 1. **MM**]

This drawing, the dry linework of which is typical of a copy, might have served for keeping a record of the colors for further repetition of the original portrait.

A 1983 ————, 237. A procession led by a bishop, met by Venetian dignitaries. Over ch. sketch pen, br., on faded blue. 180 x 430. Two pieces put together into one. Ascr. to Titian, as his Photo Braun 200. [*Pl. CXXIX*, 3. **MM**]

Certainly not by Titian, but by an artist who imitated Titian's compositions and his types from the middle of the century, transferring both into a more decorative routine. We saw a photograph of Jacopo Fallaro's organ-shutters, formerly in the Gesuiti in Venice, described by Vasari (VII, p. 532), the general style of which resembled that of the drawing.

A 1984 CHELTENHAM, FENWICK COLL., Cat. 104, 1. Landscape with men climbing a tree and others pulling them down. Pen, br., over bl. ch. 237 x 287. Coll. Esdaile. The anonymous drawing was attr. to the circle of Titian and Campagnola about 1530, by Popham.
 [MM]

In our opinion, the drawing is a fragment as the r. half is missing. The slender proportions of the figures and the parallel hatchings make us date the drawing far later.

1985 DIJON, MUSÉE. Coll. His de la Salle III, 172. Five children in landscape. Pen, br., 246 x 205. Late inscription: Titiano de 1520.
 [*Pl. CXCIII*, 1. **MM**]

The group of children corresponds (in reverse) to those in a rough woodcut signed DN where the group is placed in another landscape. Moreover, the unfinished figure is replaced by a dog in the woodcut. The dry and rather poor drawing could be a copy from an original by Titian of 1520 or by Domenico Campagnola, the two artists at that time being close to each other.

1986 FLORENCE, UFFIZI, 472. P. Landscape with Rape of Europa and two girls sitting on the shore. Pen, br. 214 x 311. Engraved by Lefèvre (about 1680). Formerly ascr. to Titian, publ. in *Uffizi Publ.* III, p. 1, no. 22 as D. Campagnola, into whose style it does not fit, neither in his early nor in his later period. [*Pl. LXXVI*, 2. **MM**]

In our opinion, the drawing is nearer to Titian; compare No. **1872** where the l. half of the landscape especially is very similar.

1987 ————, 1404. Landscape with two big trees in the foreground, buildings, a castle on a hill and mountains at r. in the distance. Pen, light br., on wh. 223 x 368. **[MM]**

The drawing is very similar to No. **1988**, formerly ascr. to Titian, now believed to be by Domenico Campagnola. The style of drawing is close to the young D. Campagnola, but the composition of the landscape is different from his. When D. Campagnola drew in so "Titianesque" a manner he was not capable of producing such unity of space. The "Rest on the flight into Egypt" by Francesco Vecelli (ill. Venturi 9, VII, p. 69) in the Academy of Venice shows a similar landscape. The reference to Francesco Vecelli is only a suggestion because the resemblance is not close enough for an identification. We prefer to keep the drawing anonymous in the sphere of the early Titian.

1988 ————, 1407. Landscape. Pen, on wh. 260 x 390. Formerly attr. to Titian, publ. in *Uffizi Publ.* III, p. 1, no. 23 (C. Gamba) as D. Campagnola, with reference to the landscape in Titian's "Pardo Venus" (ill. Tietze, *Tizian*, pl. 120). **[MM]**

The general resemblance to Titian's "Flight into Egypt" in Leningrad (ill. *A. in A.* 1941, 144) confirms the origin of the drawing in the sphere of the early Titian. Stylistically it is closely connected to No. **1987.**

1989 HAARLEM, COLL. FRANZ KOENIGS, I 455. Allegorical figure: Woman seated with burning torch in her l. and something indiscernible in her r. hand. Bl. ch. (or charcoal?), on blue, turned green. 184 x 159. Lower l. corner added; badly preserved, much damaged by mold, as a result the outline of the woman's l. shoulder is changed. In the collection listed as Titian. [*Pl. LXXIV*, 3. **MM**]

The motive is very close to the lost mural by Titian on the Fondaco (incidentally, claimed for Giorgione by Piero H. de Minerbi, in *Boll. d'A.* 1936–37, p. 170 ff.) preserved only in the smooth and pedantic reproduction by Zanetti. The general style, however, is so far advanced that the drawing can hardly be connected with the period of these frescoes and, therefore, with Titian himself.

1990 HAGUE, THE, COLL. FRITS LUGT. Landscape, Pen, br. 238 x 363. Old addition on the top. Sale Drouot 1924, February 25, No. 60. Mentioned by Godefroy in *Amateur d'Estampes* 1925, March as bv

Titian and a study for the background of Titian's woodcut St. Jerome in the wilderness. We rejected this attribution, which Mr. Lugt himself does not accept, in our *Tizian-Studien* p. 178, note 74. **[MM]**

The drawing shows a resemblance to Titian's early landscapes (compare especially the "Flight into Egypt," now at the Hermitage, ill. *A. in A.* 1941, 144), but the interest in extravagant motives and the dryness of the execution forbid an attribution to the master himself. The follower who made this drawing might be D. Campagnola, about 1517–20, but the authenticated material offers no striking evidence.

1991 LONDON, BRITISH MUSEUM, 1895–9–15 — 818. St. Eustace (Hubert) in landscape. Pen, br., on wh. 214 x 316. Inscription in pen: "Titian" and "22." At the r. framing line, cutting the horse — On the back inscription of the 16th century: d Tician D10 (= 510?). Coll. Denon, Esdaile, Malcolm. Exh. under the name of Titian in École des Beaux Arts 1879, No. 203. Hadeln, *Tizianzeichnungen* p. 38 ff. and pl. 38: Pupil of Titian. "The composition is definitely 'Titianesque,' and the linework shows close connection to Titian's. But the short strokes put over the folds to stress their pictorial values, a procedure with which we are familiar from Titian, are applied in a thoughtless routine typical of a technical imitation. The rendering of the foliage also reveals the lack of personal observation." Popham, *Handbook*, p. 44: perhaps original by Titian. Suida, *Tizian*, p. 147, note 13: Titian; Suida reads the inscription on the back with utmost probability as 1510 and in spite of Hadeln's conclusion declares the drawing to be indubitably by the young Titian (p. 17) in preparation for a painting of this subject. "This painting which exists in a private collection in Vienna can be attributed to Titian's first period, on the basis of the identity of its landscape with the murals in Padua."
 [*Pl. LXXVI*, 1. **MM**]

The painting reproduced in the French edition of Suida's *Titian*, pl. CCCV, in our opinion, shows no connection with the drawing except in the subject, incidentally treated in a completely different manner. Moreover, it shows no resemblance to Titian's style at any time and especially not in his youth. It can not therefore, decide the problem of the drawing. In our opinion, Hadeln's analysis of the drawing is correct. Its author may have worked in Titian's early workshop and have known his drawings.

1992 ———, 1895–9–15 — 832. View of a castle. Pen, br., on paper turned slightly yellow. 135 x 263. Malcolm Coll. (Robinson 385.) Publ. in *Vasari-Society* I, 13: probably by Titian. Hadeln, *Tizianzeichnungen*, pl. 37: anonymous, school of Titian. Popham, *Handbook*, p. 44: perhaps original by Titian.

In our opinion this is one of the drawings which might be by Titian, but which offer no certainty that they are. Such studies after nature may have been made and kept for later use by many artists who also copied models of other masters for the same purpose. A drawing very similar to this one, for instance, was used in one of De Nante's woodcuts after Girolamo da Traviso's design for a view in the distance.

A 1993 LONDON, COLL. SIR ROBERT MOND, No. 255. A large ruin surrounded by trees. Pen. 183 x 306. Formerly attr. to Carracci and to Gaspard Poussin. Mond Cat. p. 62, pl. XLIV: the drawing is very definitely in the style of the drawings by Titian and his immediate following.

The style resembles that of the landscapes in G. B. Pittoni's *"Praecipua aliquot Romanae antiquitatis ruinarum monimenta,"* publ.

1575 by Girolamo Porro in Venice. Since several of the etchings are signed *B. P. V. pinxit* the designs might be Pittoni's. The drawing was engraved (in reverse) by Van Uden who enriched it with figures (ill. Herrmann, *Landschaftszeichnungen des Rubens*, 1936, fig. 41).

A LONDON, COLL. P. OPPÉ. Landscape. See No. **2007**.

A 1994 MILAN, COLL. RASINI, XX. St. Jerome in the wilderness. Pen, on paper turned yellow. 330 x 510. Damaged. Coll. Dubini. Morassi p. 30, pl. XX: School of Titian referring to No. **A 1895**. C. L. Ragghianti in *Critica d'A.* XI, XII, p. XXXVII: indubitably Muziano.

This drawing at Milan corresponds exactly to the Uffizi drawing 489 P. by D. Campagnola, see No. **465**, and might be its copy.

1995 NEW YORK, FRICK COLLECTION. Satyr seated holding a vessel and gazing at a goat; in landscape. Pen, br. 189 x 207. Cut at l. Coll. Paul Sandby, W. Esdaile, James J. P. Heseltine, Oppenheimer. Publ. by A. M. H(ind) in *Vasari-Society* 2nd ser. II, No. 9 (1921) who holds to the traditional name of Titian, although in his opinion the drawing is closer to those now believed to be by D. Campagnola. Popham, *Cat.* 271: "School of Titian. Exh. as by D. Campagnola, whose style of drawing it does not closely resemble." Parker in *Oppenheimer Cat.* 196, pl. 51: Titian. In our *Tizian-Studien* p. 175, note 71.
 [*Pl. LXXIV*, 4. **MM**]

In our opinion, the very attractive drawing is close to Titian in his Giorgionesque period, but can hardly be attributed to Titian himself. It shows more routine than Titian's early drawings, displaying in a superficial manner Titianesque elements, as for instance, the plant in the foreground or the cloud-like rocks in the background (compare the corresponding detail in the landscape fig. 155 of our *Tizian-Studien*). The construction of the depth by receding rolling hills recalls D. Campagnola, but the figure of the satyr is utterly different from the latter by invention and handling. The alternative: Titian or D. Campagnola for drawings of this kind must be expanded to include other artists educated under the same influences. We group them on the basis of their style around Titian until some external help, as for instance a signature, might turn up to unveil their anonymity.

A 1996 NEW YORK, PIERPONT MORGAN LIBRARY, CAT. IV, 71. Virgin and Child, with St. John the Baptist as a child and a donor. Pen, br., wash. 205 x 272. In lower r. corner erased inscription. Coll. Lely, Murray. Ascr. to School of Titian, or simply Venetian school.

No connection with Titian.

1997 PARIS, LOUVRE, 5517 a. Martyrdom of St. Peter Martyr. Pen. 170 x 170. Publ. by Lafenestre, *Le Titien*, p. 133 as Titian's sketch for the burned painting in SS. Giovanni e Paolo (ill. Tietze, *Tizian*, pl. XIV). The same attr. by L. Fröhlich-Bum in *Burl. Mag.* 1924, p. 281. She backs her attr. by pointing out the resemblance in style and composition with No. **1998**, which according to her is a preliminary sketch of Titian's mural in the Scuola del Santo, of 1511. Fröhlich-Bum N. S. II, p. 196, No. 16. [*Pl. LXXV*, 1. **MM**]

In our *Tizian-Studien*, p. 154, we rejected the attribution to Titian, see No. **1998**.

1998 ———, 5517 b. Martyrdom of St. Peter Martyr. Pen. 120 x 118. Coll. Mariette. Publ. by Lafenestre, *Le Titien*, p. 137, as a sketch for Titian's painting burned in SS. Giovanni e Paolo in 1867, and by Fröhlich-Bum in *Kunstchronik*, 1925, p. 221, as Titian's

sketch for his early mural in the Scuola del Santo in Padua, "The jealous husband killing his wife." Fröhlich-Bum, *N. S.* II, p. 195, No. 1. In our *Tizian-Studien*, p. 154, we discussed the drawing, in subject and style a companion piece to No. **1997**. We dated both later and called them evidently influenced by Titian's famous composition, but admitted that they were closer to Titian than any of the other numerous "Martyrdoms of S. Peter Martyr" published as Titian's sketches by Mrs. Fröhlich-Bum. [*Pl. LXXV,* 2. **MM**]

We correct our previous view in so far as we now connect the drawing with Titian's later version of the same subject sent to Pope Pius V in 1567 (ill. after Bertelli's engraving in Tietze, *Tizian,* pl. XXIII) and certainly based on Titian's older composition. The stylistic resemblance to No. **1999** might confirm a late date, a period from which no authentic pendrawings by Titian are preserved. Though acknowledging the closeness to Titian we believe rather in the authorship of a follower (compare No. **2021**, by Verdizotti).

1999 ————, 5518. So-called Prometheus, chained to the rock and tormented by the eagle. Pen, br. 127 x 103. Coll. Mariette. Ascr. to Titian. Publ. as Titian's sketch for his painting in the Prado (ill. Tietze, *Titian,* pl. 224) by Lafenestre, *Le Titien,* p. 237.
 [*Pl. LXXIV,* 5. **MM**]
The mediocre small drawing has not been considered by newer authors. Its connection with Cornelis de Cort's engraving after Titian's painting (ill. Lafenestre, p. 239) is in numerous details definitely closer than that to the painting itself whose wretched state of preservation makes it impossible to judge how far it is an original. The drawing is in opposite direction to the engraving and therefore, certainly not copied from it. When Cort worked for Titian in 1566 the original painting was no longer available at Venice since it had been delivered to Queen Mary in 1549 or 1553. Cort might have used the original sketch from which the execution of the painting may have deviated. It seems, however, more likely that the composition was preserved in the studio by a painted "*abbozzo*" on the basis of which our drawing was done for the special purpose of preparing the graphic reproduction. It is certainly not by Cort whose drawing style is different, but whether it has been done by Titian himself or by some assistant is difficult to decide for the lack of authentic pen drawings from Titian's late years. In view of the inferior quality of the drawing, of the difference of its linework from that of Titian's earlier pen drawings, and of the scrupulous emphasis laid on details as the hands we are more inclined to question the authenticity and to place the drawing in the circle of Titian. There is a striking stylistic resemblance to Nos. **1997** and **1998**.

2000 ————, 5531. Village on a mountain with view over the plain at the r. Pen, br., somewhat faded. 235 x 325.
 [*Pl. LXXVI,* 3. **MM**]
The drawing was engraved by Caylus under the name of Giorgione, is ascr. to Titian, in the Louvre and was publ. by L. Fröhlich-Bum in *Belvedere* 1929, p. 260, fig. 28 as by D. Campagnola.

It is true such homely motives occur in Giorgione's paintings under Dürer's influence, but the penmanship and the minute penetration of the organic structure and every detail point to a later period which is best represented by Titian's studies after nature about 1516 (cf. No. **1943**). Titian's hand, however, is hardly recognizable in the linework which is more typical of a graphic artist; on the other hand, we do not recognize Campagnola's well known style of that time, unless he replaced his usual superficiality by a greater intimacy under Titian's influence, a theory which is not sup-

ported by any evidence. We prefer, therefore, to leave the drawing in the circle of Titian about 1516, admitting that Campagnola might have approached him so closely. No. **506**, it is true, although similar as to the graphic rendering, is notably different in style.

2001 ————, 5548. Tree on a rock. Pen, br. 148 x 193. Ascr. to Titian. Fröhlich-Bum, in *Belvedere* 1929 (VIII, 2), p. 260, fig. 26: Do. Campagnola. In our *Tizian-Studien* p. 177, 191: Titian with reference to the corresponding motive in the woodcut of the milkmaid (ill. in our *Tizian-Studien* p. 176, fig. 155). [**MM**]
In the Corsini Collection in Rome (No. **554**) there is another version of this drawing ascr. to Lodovico Carracci, with the addition of the head of a bearded man. Neither of the drawings copies the other, but both seem to go back to an original which might have been by Titian.

2002 ————, 5546. Landscape with a mill at the l. and trees at the r. Pen, light br., delicately drawn and very much faded. 248 x 358. Damaged and torn. [*Pl. LXXVI,* 4. **MM**]
Perhaps a copy from a drawing by Titian in his early period or the work of a close follower.

A ————, 5573. See No. **1959**.

2003 PARIS, COLL. MARIGNANE. Young angler? Bl. ch., on greenish blue. 255 x 215. Inscription in pen: K 28. Attr. to Titian by the owner. [*Pl. LXXIV,* 1. **MM**]
If this attribution is correct, the drawing must be a hasty sketch, to be used for a figure in a background. It could be a poorer counterpart to No. **1970**, difficult to compare, however, because of its differing technique. The daring pose reminds us of the boy in Giorgione's late "Judgment of Solomon" in Kingston Lacy and of the young man in the so-called "Adulteress" in Glasgow, but the figure displays the directness and plainness of the new generation; compare, for instance, the figure of Isaac carrying the bundle in Titian's woodcut of about 1516 (Tietze, *Tizian* I, p. 70–74). Early studies of a similar character may have been used in the later woodcut of the "Passage through the Red Sea." The lack of comparable material and the impossibility of connecting the figure with an authentic work by Titian prevent a definite attribution to him, although the drawing is closer to his style than to that of any other Venetian artist. A certain relationship to Natalino (see Nos. **811–815**) confirms our attribution to Titian's circle.

2004 PROVIDENCE, R. I., COLL. JOHN NIC. BROWN. Sketch for an Entombment of Christ. Pen. 294 x 421. Later inscription: Tiziano. Coll. L. Grassi, Florence. Sale London, Sotheby's 1924, May 13, No. 139, as Titian, with reference to Titian's mural "The Miracle of the child" in the Scuola del Santo at Padua (ill. Tietze, *Tizian,* pl. 8) in which a woman is said to resemble the one at l. in our drawing, and to the so-called portrait of Caterina Cornaro at the Cook Coll. at Richmond (ill. ibidem 5). Publ. by Fröhlich-Bum, in *Burl. Mag.* 1927, p. 228: Titian, presumably for the painting in the Louvre (ill. ibidem 65). In *Graph. Künste* N. S. III, p. 12, we rejected the attr. to Titian, and most of all to Titian about 1525, but also found, along with some weaknesses, a remarkable relationship to Titian's style, even in the acceptance of Roman influence. We tried to explain this mixture by ascribing the drawing to a member of Titian's late shop who might have developed an idea of Titian's in his own style.
 [**MM**]

A 2005 PROVIDENCE, R. I., RHODE ISLAND SCHOOL OF DESIGN. Hunting scene. Pen. 379 x 594. Coll. Alphonse Legros. Publ. by Claude Phillips, *The later work of Titian*, p. 110, fig. on p. 78 as "the finest extant drawing of Titian's later period." Charles Ricketts, *Titian*, p. 160: late Titian. *Bull. of the Rhode Island School of Design* XI (1923), p. 4.

Certainly not by Titian, and in our opinion by a Northern artist of the late 16th century.

2006 VENICE, MUSEO CORRER, 1297 (LXXXVIII). Lion. Brush, br. wash, on rough paper. 222 x 335. The anonymous drawing was publ. by E. Tietze-Conrat in *The Art Quarterly* 1940, p. 33, fig. 18 as a working design for Titian's ceiling in Brescia, painted in 1568 and burned in 1575. There are very slight differences from the engraving after the lost picture, but the lion is more lively and on a larger scale than in the engraving, so that a copy from the engraving seems unlikely. Style and quality are not Titian's, the drawing may, therefore, be a design done by another member of his shop or a contemporary copy from the painting. We list it with reservations as a working design done in the shop for a painting which the people of Brescia refused to accept as a Titian of full value when it was delivered. **[MM]**

A VIENNA, ALBERTINA, 43. See No. **558.**

A 2007 ———, 44. View of a mill and other buildings in a landscape. Pen-and-bistre. 151 x 209. Cut. Mariette Collection. Waagen, *Kunstschätze in Wien II*, p. 154: Titian. *Albertina-Cat. I* (Wickhoff) 44: Venetian, First half of 16th century, perhaps by Titian himself. Schönbrunner-Meder 1353: Domenico Campagnola. *Albertina-Cat. II* (Stix-Fröhlich) 44: school of Titian with reference to No. **541** and supposed to be very close to the master. Fröhlich-Bum in *Belvedere* 1930, p. 87: Giulio Campagnola. **[MM]**

An almost identical version (pen-and-bistre, 196 x 291, not cut!, damaged by mold and dirt) in the Paul Oppé Coll. in London. Perhaps both derive from an original which in view of the relationship to No. **713** might have been from the circle of Giorgione.

A 2008 ———, 45. Jacob wrestling with the angel. Pen, bistre. 170 x 238. Acquired 1923. Publ. by Stix-Albertina N. F. II and in *Albertina Cat. II* (Stix-Fröhlich) as Circle of Titian.

In our opinion, the Titianesque element is not sufficient to allow this attribution. On the other hand there are features pointing to Palma Giovine's school (see for instance No. **1037**, I 26, II 28). They do not, however, suffice to allow a definite attr. of the drawing.

A 2009 ———, 46. Trees on a knoll. Pen, bistre. 191 x 237. Formerly ascr. to D. Campagnola. *Albertina Cat. I* (Wickhoff) 73: Not Campagnola. *Albertina Cat. II* (Stix-Fröhlich): Circle of Titian, perhaps by the same hand as No. **1893** and No. **1943.**

The latter drawing was given to Titian's very late years by Mrs. Fröhlich-Bum (in *Belvedere* 1929, p. 71 ff.) who, however, did not indicate whether this changed date applied also to the other drawings. In our opinion, without any connection with either of the presumed companions, and moreover, not belonging to Titian's circle.

A ———, 47. See No. **559.**

A 2010 ———, 48. St. Jerome in landscape, kneeling before a statue of the Virgin. Pen, bistre. 210 x 268. Coll. Richardson sen. and Peter Lely. *Albertina Cat. I* (Wickhoff) 32: Venetian, 16th century.

Albertina Cat. II (Stix-Fröhlich) 48: Circle of Titian; probably by the same artist who drew No. **559** and No. **A 1927.** Fröhlich-Bum in *Jahrb. K. H. S., N. S.* II, p. 192, fig. 260: Savoldo, with reference to the fact that Savoldo once painted the same saint. She also attr. No. **559** to the same artist on the same ground.

In our opinion, this drawing and No. **559** as well, have nothing in common and as little to do with Savoldo. The motive of St. Jerome praying in front of a statue of the Virgin placed under a primitive shelter is unknown in Venetian art of the 16th century. The penwork, too, points to a later origin.

A 2011 ———, 81. Troup of horsemen in a wooded landscape. Pen-and-bistre. 232 x 360. Cut. Coll. Count Fries. Formerly ascr. to Francesco Vecelli, by Wickhoff in *Albertina Cat.* I, 65, tentatively to Pieter Brueghel the Elder. *Albertina Cat. II* (Stix-Fröhlich) lists the drawing under Venetian School, second half of 16th century, and describes it as a design for an engraving by a follower of Titian, possibly after a drawing of the Master's. **[MM]**

(Their reference to the engraving B. XVI, 100, 7 and to a signed engraving by Lefèvre is by mistake placed here instead of under no. 79, our No. **1974**, where it belongs.) The attr. to a follower of Titian is, in our opinion, unfounded. Wickhoff's suggestion has at least the merit of pointing to a Northern artist of the third quarter of the 16th century. This ascription receives an important support by our interpretation of the subject as the greater portion of a "Conversion of St. Paul"; the scene with the fall of Saul would have been at l. as in the similar engraving by Lucas van Leyden, B. 107 (ill. M. J. Friedländer, *Lucas van Leyden*, Leipzig 1924, pl. 24).

2012 WASHINGTON CROSSING, PA., COLL. FRANK J. MATHER. Study of a nude child. Bl. ch., height, w. wh., on gray. 199 x 291. Later inscription in pen: Zorzon. — On *verso*: Nude youth, half-length, his l. hand on his breast, the r. one cut. The drawing seems to be damaged, especially the r. leg of the child where the foot can hardly be made out. Coll. L. Grassi. Exh. Baltimore 1942 (*Giorgione and his circle*), no. 16 as by Giorgione. **[Pl. LXXV, 3 and 4. MM]**

The connection with Giorgione claimed by an older owner, and the present too, is confirmed by the close resemblance to the child on the *verso* of No. **728** connected of old with Giorgione or his school. Neither drawing, however, is copied from the other nor can both be traced back to a third model. The posture of the child is different in both drawing and, in view of the general resemblance of the poses, we suppose that a plastic model in either case was seen from a slightly different angle.

If the *recto* of the drawing goes back to a plastic model the style of which, incidentally, appears more Florentine than Venetian, the connection with the Giorgione studio is uncertain. The drawing on the *verso*, too, although recalling to a certain degree figures from Giorgione's late period — (as e.g. the lost murals of the Fondaco) is no argument in favor of such an origin. The general style, however, is definitely Venetian (compare No. **1920**) and points to a period when Venice had absorbed sufficient Central Italian influences to develop a marked interest in the rendering of muscular bodies. Such tendencies appear in Titian's art about 1540 and the drawing can hardly be anterior to this date. The general Titianesque character of the drawing justifies a listing among the productions of Titian's shop or circle.

2013 ———, Landscape; in the foreground a warrior in antique costume facing a slain dragon. Pen, br. 180 x 210. Cut. **[MM]**

An engraving apparently after this drawing is described by Nagler, v. XXII, p. 272, and ascr. to B. Angolo dal Moro after Titian's invention. The very rare first state is avant la lettre, the second shows the address: appresso Gio. Franc. Camocio (active in Venice 1560–1572). The figure repeats in reverse the motive of Acteon in Titian's painting in the Bridgewater House (ill. Tietze, *Titian*, pl. 232), a circumstance much in favor of an origin in Titian's workshop.

2014 WINDSOR, ROYAL LIBRARY, 0961. Study of a nude child standing. Red and in part bl. ch., height. w. wh., 227 x 171. Squared in red ch. Listed as anonymous Venetian, 17th century.

The pose of the boy is almost identical, although in reverse to the Christ Child in the "Madonna with the cherries" (Tietze, *Titian*, 30). The origin of the motive in the circle of Titian is confirmed by the appearance of an angel in identical posture in the painting over "Christ carrying the cross" in San Rocco in Venice (compare

the woodcut of 1520, reproducing this votive painting, ill. Richter, *Giorgione*, p. 247). This painting has been attr. to Francesco Vecelli, but the drawing is so different from No. **2019** in style and type that we prefer to keep the drawing among the anonymous followers of Titian.

2015 ————, 4794. Study for an Ecce Homo (half-length). Bl. ch., height. w. wh., on blue. 145 x 95. Inscription 18th century: Titiano. Slightly rubbed. Publ. as Titian by Hadeln, *Tizianzeichnungen*, pl. 30. Rejected by Fröhlich-Bum in *Jahrb. N. S.* II, p. 190, who calls the drawing strikingly resembling Bordone's drawing No. **396**.

In our opinion, the drawing does not fit into the newly gained picture of Bordone as a draftsman. The posture descends from Titian's later period and may be by some immediate follower with regard to its minor quality.

VASSILLACCHI ANTONIO, SEE ALIENSE

CESARE VECELLI

[Born c. 1521, died 1601]

The son of one Ettore, a cousin of Titian's father, and best known by two facts: Cesare accompanied Titian on his journey to Augsburg in 1548, and in 1590 published an illustrated book *"Degli habiti antichi e moderni,"* important for the knowledge of Italian and other costumes. The erroneous tradition that Cesare used drawings by Titian for its illustrations came from the title of a reprint of the book of 1664: *Raccolta di figure delineate dal gran Tiziano e da Cesare Vecelli suo fratello diligentemente intagliate.* Apparently, much of Cesare's activity was absorbed by Titian. As early as 1817, Ticozzi (*Vite dei pittori Vecelli di Cadore*, p. 287) expressed the opinion that the desire for having as many works by Titian as possible made critics take some from Cesare in order to give them to Titian. Our unique attribution of a drawing to him rests on its resemblance to Cesare's paintings.

2016 CHATSWORTH, DUKE OF DEVONSHIRE, 241. Two men thrashing, a nude boy carrying a sheaf toward a barn. Pen, br., gray wash, touched with red ch. 149 x 274. Design for a ceiling as indicated by the framing lines. The figures 1 to 4 are repeatedly inscribed in the landscape, apparently indicating the colors for the execution of the painting. Ascr. to Titian.

Certainly not by Titian, but perhaps by Cesare Vecelli to whose "Seasons" in Belluno (ill. Venturi 9, VII, fig. 47 ff.) there is a striking resemblance.

FRANCESCO VECELLI

[Born c. 1490(?), died c. 1559–60]

The biography of Francesco Vecelli rests on very feeble foundations, and we do not even know with certainty whether he was Titian's elder or younger brother. His artistic career was interrupted, evidently in his early years, by military service and after 1527 confined to towns in the province of Cadore where he had returned. Part of his later years were given to lumber trade, and in this respect he represented his brother's financial interests also. Thus, a considerable portion of his production was purely provincial, and its importance apparently has been exaggerated by the local authors. During his stay in Venice, Francesco seems to have depended on his brother's

art although we are unable to decide whether he ever collaborated in Titian's workshop. Under these conditions his activity as a draftsman remains uncertain, as confirmed by the diverging opinions on No. **2019**, the only drawing for which a sort of documentation can be claimed.

2017 BERLIN, KUPFERSTICHKABINETT, 15468. Seated infant angel shaking a tambourine. Charcoal, wash, height. w. wh., on bluish gray. 159 x 92. Traces of red ch. Stained by mold. Later inscription LIX. Design for the angel at the r. in the painting, attr. to Francesco Vecelli in the chancellery in Berlin, see No. **2019**.

[*Pl. LXXXII, 3.* **MM**]

We have not re-examined the drawing which looks a little different in style and temperament than No. **2019**.

2018 FLORENCE, UFFIZI, 716 E. Saint Nicholas enthroned. Bl. ch., on paper faded and stained by mold. 325 x 264. Ascr. to Titian, but never mentioned in the special literature. [**MM**]

Our tentative attribution to Francesco Vecelli rests on the transformation of a general Titianesque style into a more rustic style, on the relative closeness to Francesco's organshutters in San Salvatore in Venice (ill. Venturi 9, VII, fig. 44) and on the resemblance of the linework to that of No. **2019**.

2019 OXFORD, CHRISTCHURCH LIBRARY. Virgin and Child enthroned, an angel playing the violin at her feet. The head of a cherub sketched at r. Red ch. 265 x 184. Reworked with the pen, the head of the cherub entirely pen. Coll. P. Lely. Publ. by Colvin, II, 39 as Venetian School about 1520, attr. to Titian by Frizzoni, *L'Arte*

XI, 174 and to Pordenone by A. von Beckerath, *Repertorium* XXXI, p. 112. Hadeln, in *Jahrb. d. Pr. K. S.* XXXIV, p. 244 f. and *Tizianzeichnungen* pl. 40 noted the use of the drawing in a painting in Santa Croce in Belluno, later in the chancellery in Berlin, ill. l.c. p. 243, fig. 13. On the basis of the local tradition this picture was given to Francesco Vecelli by Crowe and Cavalcaselle, *Titian,* p. 740, who stress the inferior quality of the painting and assume the collaboration of some minor local painter. Rob. Longhi. in *L'Arte*, 1917, p. 359, returned to the attribution of the drawing to Titian, and declared the painting a copy of a composition by Titian, which the drawing would have prepared. [*Pl. LXXXII, 2.* **MM**]

We neither recognize Titian's composition in the archaic arrangement of this rather provincial painting, which is hardly advanced over the stage reached in Giovanni Bellini's altar-piece in San Zaccaria, Venice (1505), nor do we find Titian's hand in the awkward penmanship of the drawing (note how badly the function of the body and the draperies are understood!) With regard to the general Titianesque character and the local tradition for the painting we consider Hadeln's attribution of the drawing to Francesco Vecelli convincing. The painting which modifies the original arrangement is far inferior and the participation of a weaker hand, as suggested Crowe and Cavalcaselle, seems likely. See No. **2017**.

MARCO VECELLI

[*Born 1545, died 1611*]

Ridolfi (II, 145) calls Marco Vecelli a pupil of Titian and brought up in his house.

A 2020 DRESDEN, KUPFERSTICHKABINETT. Madonna and Child in cloud, below the saints Anthony, Mark (standing) and Jerome (kneeling). Pen, wash. 230 x 300. Inscription: Paolo Veronese. Publ. by Hadeln, *Spätren.*, pl. 92 as probably the design for Marco Vecelli's lost painting in the Magistrato delle Ragion Vecchie, described by Boschini, *Minere,* 1664, San Polo p. 278. In the painting, it is true, besides the saints there were two portraits of donors. Hadeln mentions another version of the same composition, somewhat smaller in size and also in Dresden.

We have not seen the two drawings, but notwithstanding the fairly complete conformity of the drawing to Boschini's description, the linework is so opposite to the Titianesque style which we might expect in an artist brought up in Titian's house, that we cannot but doubt the correctness of this attribution. The drawing might have been by another artist, perhaps for the same commission, who is closer to the Flemish artists working in Venice in the second half of the 16th century. Compare Pozzoserrato's drawing in Basel, ill. *O. M. D.* 1936, pl. 27.

GIOVANNI MARIA VERDIZOTTI

[*Born 1525, died 1600*]

Verdizotti was more an amateur than a professional artist. His close connections with Titian whom he helped write his official letters are testified to by Ridolfi (I, 208). For the woodcuts, which according to the preface of his *"Cento Favole"* (Venice 1570) he drew directly on the block, the material of Titian's drawings may have been available to him (see our article in *Graph. Künste* N. S. III, p. 62 and fig. 10). Verdizotti's best authenticated drawing No. **2021** in Brunswick may be a reflection of Titian's pen drawings in his late years, of which not one

example is preserved. We attribute to him tentatively No. **2022** and a few others because of their resemblance to Verdizotti's woodcuts on the one hand and the connection of their subjects to Titian on the other hand.

2021 BRUNSWICK, GERMANY, LANDESMUSEUM. Cephalus and Procris. Contemporary inscription: Zuan Mario Verdizotti. Sketched with bl. ch. (Cephalus) and finished with the pen. 141 x 103. Cut. Publ. by Hadeln, *Tizianzeichnungen*, pl. 44. [*Pl. CXXXI*, 2, **MM**]

2022 FLORENCE, UFFIZI, 1321 E. She-bear and another small animal, in landscape. Pen, br. 204 x 148. R. upper corner added. Ascr. to Titian. [*Pl. CXXXI*, 4. **MM**]

In our opinion, the drawing represents Titian's device "Naturam ars vincit": the bear's cub, born shapeless, is licked by its mother until it assumes its normal bear's shape. See the representation in *Horapollo*, Paris edition 1551, ill. in Ludwig Volkmann, *Bilderschriften der Renaissance*, 1923, p. 69, fig. 64.

The style of the composition corresponds exactly to that of Verdizotti's woodcuts in his *"Cento Favole"* (Venice 1570) and the linework to No. **2021** which is, however, more sketchy.

2023 HAARLEM, TEYLER MUSEUM, A 49. Portrait of Titian (?) in alpine costume, seated in landscape. Pen, br. c. 190 x 190. Upper r. corner patched. Attr. to Titian's school. [*Pl. CXXXI*, 3. **MM**]

We suggest Verdizotti with reservations, on the basis of the similar handling of the tree in No. **2021**, in order to be in a position to publ. this very curious document.

2024 OXFORD, CHRISTCHURCH, K 3. Man seated next to a pool with ducks. Pen. Publ. by Bell, pl. CXVII as Titian. Hadeln, *Tizianzeichnungen*, p. 41, suggests Verdizotti.

We agree with Hadeln.

PAOLO CALIARI, CALLED VERONESE

[Born c. 1530, died 1588]

Paolo Veronese left behind an enormous number of drawings. An inventory of 1682, of drawings when still the property of the family, lists:

> 94 chiaroscuri
> 126 drawings in charcoal and black chalk
> 646 others
> 620 sketches, in part pen, in part chalk

Moreover, many *modeletti* in chiaroscuro. (Quoted from Fiocco, *Veronese,* II, p. 83). This huge stock certainly included besides autographs the whole working material of the shop, drawings by the master himself and by his assistants. (Compare our remarks about the analogous material from the Tintoretto shop on p. 258.)

At that time art lovers had already started collecting drawings by Veronese. A lot of 168 such drawings was offered for sale, sometime in the 17th century, for four doubloons apiece (Campori, *Raccolta di cataloghi,* Modena 1870, p. 427). Some of the earliest collections are even mentioned by Ridolfi. Being in a position to identify several of the drawings listed by him (No. **2131**; No. **2139**, Ridolfi I, 320 ff.) we may imagine what kind of drawing was favored by these earliest patrons, namely, finished compositions which by their technique (brush on tinted paper) have the character of chiaroscuros. G. Fiocco suggested that Paolo Veronese may have made them especially for reproduction in this technique. There is, however, the objection to be raised that no chiaroscuro after Paolo Veronese exists anterior to those by Raffaelo Schiaminossi who was born in 1570 and, therefore, could not have worked for Paolo himself.

The circumstantial description by Ridolfi (I, p. 321) of the series of such drawings belonging to Cristoforo and Francesco Muselli in Verona, perhaps already brought together by their father, and that of the family property then in the hand of Giuseppe Caliari (Ridolfi I, p. 345) testifies to the special care devoted to these drawings by Paolo himself, and the appreciation they met. In the family property "many drawings" in this technique are listed, "no less valuable than the paintings, since Paolo drew with as incomparable mastership and ease as he painted." This collection was kept very carefully by Giuseppe Caliari, together with the golden chain which

Paolo had received from the procurators of St. Mark for his work at the Library. The drawings owned by the brothers Muselli who as late as 1649 refused to sell them to some keen collectors in Genoa (Campori, *Raccolta,* 192 ff.) had long inscriptions on their backs. According to Ridolfi they were by Veronese's own hand, a suggestion rightly doubted by Pietro Caliari, *Paolo Veronese,* p. 234, note. The series contained at least six drawings, since for his description Ridolfi picked out those bearing the numbers 4, 5, and 6. (The drawing in Frankfort, No. 2066, apparently belongs to the same set, though it is not described by Ridolfi.) The inscriptions refer to the subjects represented. On no. 4, a remark points to the rendering of the subject by Dürer, Byzantine art, Michelangelo, and adds: "I should like to represent . . ." On no. 5 the wording is: "I once painted this for myself"; on no. 6: "If I ever have time I should like to paint . . ." This chance choice discloses two different motives. In one case, the composition seems to repeat an already existing painting, in the two other cases, the drawings were ideas for paintings to be executed. Designs of this description were carefully prepared, as is made evident by No. 2044, a preparatory sketch of the "pittura" described by Ridolfi as no. 6. Apparently, the final painting, too, was executed. Ridolfi (II, p. 113) mentions one representing this very subject in the Curtoni Coll., Verona.

Was this curious series meant to be a kind of *Liber Veritatis* analogous to the one which seems to have been planned by Tintoretto in his late years (see p. 277), or was it a book of models for patrons like the engravings from his works which Titian used for this purpose? Whatever their original purpose was, they form, at any rate, a group of their own unconnected with other drawings and on the whole perhaps less attractive to the taste of modern collectors.

The bulk of Paolo's *modelli* must have remained in the shop which after his death became a firm signing by the name of *"Haeredes Paoli."* In addition to them the shop kept the inconspicuous sketches, as the inventory mentioned above discloses. No. 2152 in which the main features of two compositions executed by the *Haeredes* in the Ducal Palace, "The reception of Pope Alexander III by Doge Ziani" and "The Pope and the Doge introducing messengers to the Emperor," are laid down, may be an example of how such original designs were used by the shop after Paolo's death. These sketches, however, were only preparatory, for we are informed by Ridolfi that real models by Paolo for the two paintings in question existed in the property of Giuseppe Caliari. This case, accordingly, permits no conclusions, but the inscription "questi" and others (for instance, "fatto") on Paolo's drawings may disclose that even in his lifetime the shop was trained to execute paintings on the basis of such sketches. The organization of the shop seems almost unique as design, architectural accessories and figures were distributed among various smoothly cooperating hands.

These rapid and spirited sketches have attracted attention only in the last 25 years. Formerly, they were neither collected, nor were they considered works by Paolo Veronese and mentioned as his in the literature of art. Borenius (*Burl. Mag.* XXXVIII, p. 547 f.) and Hadeln (*Burl. Mag.* XLVII, p. 298 and *Spätren.*) may claim to have laid the foundation for the knowledge of the most interesting and inspiring group of Paolo Veronese drawings.

The third group of his drawings is made up of studies of separate figures of which up to the present only very few have been published. To No. 2084 we add No. 2078 supported by its connection with a painting.

These three groups offer the critic very different problems with regard to their authenticity. The "finished drawings," easily understood from their character as material patronized by collectors, could have been copied frequently. Some of them, as a matter of fact, exist in duplicates. In this category, therefore, as soon as the invention is certified beyond question for Paolo, the quality alone will be relevant for the attribution. Without any

doubt a very subjective criterion! Considering the passage in Ridolfi's life of Aliense (see p. 336) according to which Aliense, Montemezzano and Pietro Longo copied Paolo's drawings to obtain a groundwork for their own production, and learning from the same source that Parrasio Micheli made his paintings after Paolo's drawings (see No. 2094) we are warned to go cautiously in judging finished compositions and individual figures. This is why we reject No. 2163, unique in its closeness to a painted composition, but differing in its drawing style from Paolo's, and are hesitant about No. 2084 in spite of its resemblance to the corresponding figure in the "Adoration of the Magi" in London. The difference between the pedantic style of this drawing and that of No. 2078 is striking. Both studies are definitely connected with well-authenticated paintings by Paolo, but stylistically differ widely from one another. There is no sufficient evidence that either one of them is by Paolo himself.

The most reliable material is supplied by the sketches because on one hand they were never merchandise and on the other were hardly ever exactly copied by the pupils. Here, the danger lies within the shop itself. It is obvious that Paolo had no monopoly on making designs. For instance, his brother Benedetto made them too, to say nothing of the following generation when new commissions came in after Paolo's death. We must try to build up a definite idea of Paolo's sketching style by concentrating on those sketches which may be attributed to him with certainty.

List of drawings connected with paintings, ordered of Paolo or otherwise reliably dated

No. 2110 About 1555–57, for murals in Palazzo Trevisani, Murano
No. 2029 About 1565, for "Martyrdom of St. George," Verona
No. 2040 1563–71, for "Wedding at Cana," Dresden
No. 2072 About 1564. (Date on sheet)
No. 2073 In or after 1568. (Date on sheet)
No. 2111 Before 1566, possibly from the 1550's, for a ceiling in Casa Cappelli, Venice, already seen by Vasari
No. 2123 About 1565 for a ceiling in the Palazzo Pisani
No. 2117 1570, for the "Feast in the House of Simon," Brera
No. 2057 Probably after 1571, for the "Carrying of the cross," Dresden
No. 2070 1573, for "Adoration of the Magi," N. G.
No. 2049 1576–77, for a cartoon for tapestry in the Ducal Palace
No. 2030 About 1577, for the decoration in the Sala del Collegio
No. 2028 In or after 1582. (Date on sheet)
No. 2141 In or after 1584. (Date on sheet)
No. 2043 In or after 1584. (Date on sheet)
No. 2075 In the 1580's, for the decoration in the Sala del Collegio
No. 2152 In the 1580's, for the murals in the Sala del Maggior Consiglio
No. 2052 In or after 1587. (Date on sheet)

We must add a number of *"modelli"* of paintings dated or to be dated:

No. 2094 Before 1573, utilized in the painting in San Giuseppe
No. 2045 About 1575, for the "Marriage of S. Catherine," Venice, Academy
No. 2056 1575, for "Martyrdom of S. Justina," Padua

No. 2092 About 1571–81, for the "Allegory of the Battle of Lepanto," Ducal Palace, Venice
No. 2101 1585. For ceiling in the Ducal Palace

Even within this choice of drawings we have to make a few restrictions. How great is the share of the shop in the fair version of the "models"? Is it absolutely certain that the artist to whom the execution fell did not also have a part in the invention? This applies especially to works which belong to the late period when the activity of the shop was at its peak and not only Paolo's brother, but also his son collaborated. To answer this question we must first of all gain an idea of Benedetto Caliari's sketching style. He was Paolo's junior by ten years and the specialist for the architectural parts of great compositions, as mentioned by Ridolfi (I, p. 354). But in his letter written after Paolo's death to Giacomo Contarini he designates himself as the one who made the design of the whole composition. The two drawings, No. 2193, 2195 connected with Benedetto by old tradition and by Ridolfi's description of a similar painting offer no help. The attribution of No. 2189 to him is a mere hypothesis. For Gabriele, the eldest of Paolo's sons, we are in no better position. He appears as the least ambitious of the family who, according to the above cited letter (the date of which is bound by the years of Paolo's death 1588 and that of Carletto, 1596) was satisfied with finishing the composition invented by his uncle and sketched by his younger brother. As for Carletto himself, who despite his youth gave proofs of his talent even in Paolo's lifetime, we hardly have enough evidence to distinguish him from his father. The problem is especially crucial in the drawings, Nos. 2103 and 2039. The one is connected with a painting specifically given to Carletto, the other with one attr. to Friso. Both, moreover, are coarser in their linework than, for instance, No. 2152, a drawing which according to the whole set of circumstances ought to belong to Paolo's latest years. Fiocco, the first to discover the connection between No. 2039 and the organshutters from S. Niccolò drew the opposite conclusion: he deduced from the drawing, which he accepts, the authenticity of the organshutters. In his opinion, Boschini was mistaken when listing them by Carletto (p. 86), while Ridolfi ascribed them (not to Carletto, as Fiocco erroneously says, but) to Friso. The drawing in the Mond Coll., No. 2103, closely related in its style to those just discussed in Berlin, in view of the measurements on the sheet may with great probability be connected with the painting by Carletto described by Ridolfi in the Widman Coll. in Venice. Are we justified in attributing both drawings without more ado to Carletto? The letter of Benedetto which describes the close co-operation of the "Haeredes" contains a warning: it shows that a painting circulating under Carletto's name might, nevertheless, go back to an invention of his uncle. On the other hand, Carletto (or Friso as well) might have used an old drawing by Paolo. Although the decoration of San Niccolò was apparently executed not earlier than the late years of the 16th century, and exclusively by members of the next generation, the exact date of the order is not known. The stylistic difference of the drawings from better established late productions by Paolo is not strong enough for segregating drawings by Carletto or Friso with certainty. We pointed out the many possible mistakes, but accept as Paolo's those drawings for which his authorship is not excluded.

The style of these sketches was not subject to many changes in the thirty years which we survey. The earliest example, No. 2110, avoids hatchings and aims at picturesque effects by the use of the brush. No. 2029, dated about 1565 by the painting, is the next of kin. The heads hardly more than indicated in the earlier drawing, gradually gain plastic values. One figure (in upper l. corner) has a foil formed of hatching. This procedure is taken up in a more purposeful manner in No. 2040 the date of which must be after 1563, perhaps nearer to 1570. Next in the series is No. 2072 with 1564 as latest possible date. No. 2070 by its blue paper and heightening lights produces a unique impression in the original. In later drawings, as e.g., No. 2043, a certain relationship to the

picturesque early productions may be noted. A common feature is the loose distribution of the various scenes on the leaf (compare Degenhart, p. 291 ff.). The composition is first drawn with the pen and developed almost playfully; an attractive solution is varied, almost in the manner of a choice pattern, as in the case of No. 2052.

We have to annex to this series of more or less satisfactorily dated drawings others which for stylistic reasons are authentic beyond doubt, but not connected to any existing, or at least to any well-dated painting. No. 2122 may have belonged to the decorations of the Palazzo Trevisani or some other corresponding decoration of the same early period. No. 2095 possibly related to Paolo's painting in S. Maria dei Servi (Ridolfi 325) is close in style and date to No. 2040. Similar, but more modulated in its invention, is No. 2088 which we consider a study for the lost painting in the Scuola dell Misericordia (anterior to 1582). We suggest approximate dates for the various drawings, but prefer to insist less on a reconstruction of the stylistic evolution than on the stylistic homogeneity. This homogeneity of style is so striking that we may use it as a point of departure for the rejection of stylistically deviating drawings. In his sketches Paolo was another man than in his finished compositions. Though occasionally a figure is washed in a picturesque manner, the brush remains subordinated to the pen. The pen plays, the hand glides, and pen and paper modify the creative tension. A kind of graphic play prepares the vision. No. A 2114 which has always been considered the sketch of the "Centurion" in the Prado contradicts this process in every detail. On this sheet an artist interested in pictorial expression took notes of various points in a completed composition. The technique would be exceptional (that is, not a decisive argument for so is the technique of No. 2070), but the spirit, too, is exceptional. Another explanation seems more attractive: the drawing is a free copy from the painting in Madrid by a later artist, probably a Spaniard, and made in Spain.

Having eliminated this spurious drawing we gain a homogeneous picture of Paolo's sketching style. Whence does this very personal mode of expression originate? What we know of Paolo's contemporaries, Fasolo and Zelotti, offers so little analogy that we are not encouraged to suppose a decisive influence of Badile, or of the local style of Verona as a whole. Degenhart, p. 292, with his leading theory, consistently points to much older masters, Stefano da Zevio and Pisanello, in order to prove a local Veronese heritage in the linework of his drawing No. 2040. Ridolfi's detailed biography of Paolo Veronese offers three hints: that Veronese was first trained as a sculptor; that he drew from Dürer in his early beginnings; that "having come of age he enjoyed Parmigianino's drawings and copied many of them." We know from various examples that very frequently a trained sculptor likes to relax in the light graphic play of his drawings; but in Paolo, then only a boy, we should hardly expect the need of such a compensation. The copies from Dürer's engravings "which Paolo kept for the study of the draperies, however loosening them afterwards," as Ridolfi puts it, are more a curiosity and a handy studio expedient. The only hint worth consideration is the one regarding Parmigianino. Paolo's slender nudes and the slanting draperies are Parmigianesque. Still more so is the gliding, continuous character of the strokes, the lack of accentuation. Such negative statements prevail as long as we look at this suppression of the individual from the viewpoint of the High Renaissance. As soon as we place ourselves on the basis of the subsequent development the same qualities become positive: they mean the musical merging into one another of the motives, the dissolution of the separate elements in the totality of a homogeneous decoration. A parallel is offered by Veronese's painting which anticipates the aesthetic trends of coming centuries. In Paolo's paintings, too, there is no peak. Where is the main accent? Is it the principal figure of the story, the saint who is being tortured, Christ sitting at the table? It is not. We do not stop at these figures which carry the action. The delicate touch of color in some distant spectator on a balcony has no less importance in the precious tapestry of the total composition. Herein we

feel the closeness to Tintoretto from whom, however, Paolo is severed by the postulate of the plane surface. The insistance on the latter, at the same time, means the elimination of spiritual profoundity. Paolo is the triumph of the counter-reformation, but without the stake which it demanded. For this reason the late 17th and 18th centuries started from Paolo, not from Tintoretto.

This point is also important for the study of Paolo Veronese's drawings. In the old collections even today innumerable drawings are listed under Paolo Veronese's name, which certainly originate from a much later period. The return to Paolo Veronese is one of the essential features of the silver age of painting in Venice. In drawing, as in painting also, the generation of Sebastiano Ricci and G. B. Tiepolo absorbed the style of the Cinquecento master so thoroughly, that even the critical eye may at times be deceived. We discuss in their respective places a few examples for which the name of Paolo has been put forth. The decisive criterion in our opinion is that in these drawings Paolesque elements in composition and types have gone through the classical tendencies of the late Baroque. They renew the Venetian tradition and in doing so testify to its indestructible unity.

A AMSTERDAM, REMBRANDTHUIS, Martyrdom see No. **2158**.

A 2025 AMSTERDAM, COLL. VAN REGTEREN ALTENA. Three figures on clouds. Pen, gray wash, height. w. wh., on blue. 240 x 202. Amsterdam Exh. *Cat.* no. 700.
We do not agree with this attribution.

2026 ————. Two palmtrees. Bl. ch., height. with wh., on grayish blue. — On *verso:* Study of a figure. The heightening oxidized. Coll. J. Dupan. [*Pl. CLXI*, 1. **MM**]
Document interesting for showing in a work study an effect similar to that aimed at in finished drawings like No. **2139**.

A 2027 AMSTERDAM, COLL. N. BEETS. Holy Family with the infant St. John the Baptist. Pen and brush, wash in gray, height. w. wh., on blue. 140 x 210. Amsterdam Exh. *Cat.* no. 698 (ill.): Paolo Veronese. The composition is typical of Paolo Veronese, comp. Fiocco, *Veronese I*, p. 71 or pl. XXV, but the linework is not Paolo's but later.

2028 BASEL, COLL. R. VON HIRSCH. Sketches: Judith and Holofernes, the Virgin and Child, and other sketches. Pen, br., wash. 284 x 188. The paper is the back of a letter to Paolo Veronese and shows his address: AI . . . Mag. Paolo/ Caliari Veronese/ . . . Venezia. "Presepio" and "Una Giudita che talia la testa al Holoferno" (a Judith cutting Holofernes' head off) is written next to the sketches. — On *verso* sketches: Christ and the captain of Capernaum; the Magdalene annointing Christ's feet (twice), a woman selecting jewelry. Pen, br., wash. Short letter dated: Di Trivigi a 18 ottobre 1582. Coll. Wauters. Publ. by Lees, p. 52. Borenius in *Burl. Mag.* February 1921: The Judith sketch in connection with the painting of this subject in the Brignole Coll. Sale Cat. Mensing June 1926, No. 32 (ill.). Mentioned by Hadeln, *Spätren.,* p. 27. Fiocco, *Veronese I*, p. 210 rejected the connection with the Brignole painting, which is early while the drawing must be dated after October 18th 1582. On p. 194 Fiocco suggested a connection with the painting of the same subject in Caen. Osmond 100. [*Pl. CLIII and CLII*, 2. **MM**]
We have to add that the sketches of the horses on the *recto* are related to Paolo Veronese's painting "The Conversion of St. Paul," in the Hermitage (ill. in *Starye Gody* 1915, January), which is probably identical with the one in the Widman collection, mentioned by Ridolfi I, 340. The David kneeling and thanking the Lord beside the dead Goliath might belong to a lost composition which Paolo painted for the Duke of Savoy (Ridolfi I, 335). For the woman selecting jewelry compare No. **2168**.

2029 ———— Sketches for the "Martyrdom of St. George" in Verona, S. Giorgio in Braida. Pen, wash. 290 x 220. Coll. Heyl zu Hernsheim; Wauters. Publ. by Borenius in *Burl. Mag.*, February 1921. Hadeln, *Spätren.,* pl. 24. Osmond 100. Fiocco, *Veronese, I,* p. 210.
The drawing is dated about 1565 by the painting (Fiocco).

2030 BASEL, COLL. DE BURLET. Various sketches of allegorical figures for the decoration of the Sala del Collegio, Ducal Palace, Venice. Pen, wash. 208 x 308. Formerly in the Pribram Coll. in Munich, at that time publ. by L. Planiscig, p. 562 as Tiziano Aspetti. Recognized as Veronese by Fiocco, *Veronese, I*, p. 140, with reference to a similar group in chiaroscuro by Veronese, representing "Charity," in the Sala del Collegio, Ducal Palace, ill. Fiocco, *Veronese* II, p. CXLIII B.
The drawing is dated about 1577 by the decoration. The other allegorical figures appear in the same decoration.

A BAYONNE, MUSÉE BONNAT, 126. Three saints. See No. **2191**.

2031 ————, 127. Study for a Crucifixion. Pen, height. with wh. Venturi, Studi, p. 328, fig. 211, G. Gombosi, in *Magyar Müvészel* 1928, pl. 185 b, p. 726 and Fiocco, *Veronese I,* p. 207: Paolo Veronese study for the "Crucifixion" in Dresden. (Photo Doucet 257). [**MM**]
The suggested connection with the Dresden painting is rather loose and was correctly replaced by Fiocco himself (*Veronese II*, p. 128) by a reference to a much closer related composition in Budapest, no. 117.

A 2031 bis ————, 692. The Virgin and Child enthroned, on either side a dignitary presented by an angel. Pen-and-bistre, wash. 170 x 148. Inscription: 1572. 5. 7 bris (Septembris). Ascr. to Paolo Veronese. (Arch. Ph. 3865) [**MM**]
A composition of a similar description by Paolo Veronese is mentioned by Ridolfi I, p. 320 in the Muselli Coll.: Madonna col fanciullo nel grembo in dolce sonno sopito. According to later catalogues the painting in question also contained the saints Joseph and John and thus cannot be connected with the drawing. The latter, moreover, shows no resemblance to Veronese's style about 1572. In our opinion,

a local Veronese painter such as Felice Brusasorci may be taken into consideration.

A BERLIN, KUPFERSTICHKABINETT, 1549. See No. **2192**.

2032 ————, 5049. The Virgin and Child in clouds, on the ground St. Thomas and St. Cecilia kneeling. Brush, height. with wh., on blue. 367 x 261. Publ. in *Berlin Publ.* pl. 91; Hadeln, *Spätren.* pl. 60 and p. 26: The outlines are cut for tracing, probably by Raffaele Schiaminossi, who engraved the drawing (B. 97). Fiocco, *Veronese, I,* p. 207 believes that Veronese might have made drawings in this style in order to have them engraved and points to this drawing in Berlin as an evidence for this theory. In *Veronese II,* p. 85 he points to the front page of *"De re anatomica"* by Realdo Colombo, of 1559, (pl. LVI a) traditionally supposed to be based on a design by Paolo Veronese.

The drawing of which a poorer version exists in the Lugt coll., in our opinion, is independent of the engraving, since no contemporary engraving of this kind exists (Schiaminossi was born only in 1570). This mode of drawing goes back to the 15th century and was much in favor with Carpaccio, especially for his impressive pictorial *"modelli."*

2033 ————, 5072. Cephalus and Procris (?) Brush, br., height. with wh., on blue. 174 x196. Von Beckerath Coll. **[MM]**

The composition corresponds, with unimportant variations, to a painting in the Strassburg museum (ill. *Sale Cat.* Lepke, Berlin, October 1, 1912, no. 124, pl. XII, and Suida in *Gaz. d. B. A.* 1931 I, p. 176.)

The drawing might belong to the working material used in Veronese's shop.

2034 ————, 5120. Study from a suit of armor. Brush, height. w. wh., on gray. 381 x 253. *Berlin Publ.* pl. 92; Hadeln, *Spätren.* pl. 55; Popham, *Cat.* 284; Osmond p. 100; Fiocco, *Veronese I,* 207. L. Dussler, *Italienische Meisterzeichnungen,* Basel 1938, pl. 38. According to Charles Loeser in *Gaz. d. B. A.* 1902, II, p. 482 study for "St. Sebastian" in S. Sebastiano, Venice; according to Fiocco II, p. 85 possibly a study for the portrait of Pase Guarienti, at Verona. According to *Mostra Veronese,* p. 131, No. 52 study for the portrait of Agostino Barbarigo in Cleveland, Ohio. **[*Pl. CLXI,* 2. MM]**

The armor in the drawing might have belonged to Veronese's studio since it appears in several of his compositions, for instance in the "Martyrdom of S. Justina" in Padua and in the painting "Mars armed by Venus" in the Duke of Orléans Coll., provided that this lost painting was engraved in reverse, as many of this coll., as a matter of fact, were.

A 2035 ————, 5127. Christ and disciples at Emaus. Pen, br. wash, over charcoal, on grayish blue. Stained by mold. 271 x 363. Later inscription: Tintoretto. **[MM]**

The figures are copied from the best part of a Veronese composition which at the r. added Christ as a pilgrim and the disciples, as may be deduced from the whole composition existing at Chatsworth in a shop version (Photo Braun).

A 2036 ————, 16438. Sketches: Christ taken from the cross and other religious compositions. Pen. Ascr. to Veronese? **[MM]**

In our opinion, close to the drawings, ascr. to Cigoli, Vienna, Albertina, *Toskanische, Umbrische und Römische Schulen* nos. 330, 331.

2037 BERLIN, PRIVATE COLLECTION (deposed in the Kupferstichkabinett). Studies for a painting: The Lord washing the feet of Saint Peter. Pen, wash. 150 x 212. Inscription. il saboteco alla instoria (?). Publ. by Hadeln, *Spätren.,* pl. 43. Osmond p. 102. Fiocco, *Veronese I,* p. 207.

Summary design for a painting, the scale of measurements indicated below. A variation of the two figures behind the seated St. Peter and the head of the Lord were separately studied.

2038 ————. Studies for a coronation of a saint; other saints seated on clouds. Pen, wash. 153 x 207. Inscriptions: apostoli. S P (id est Peter), issepo (id est Joseph), Fio (id est figlio, son). Hadeln, *Spätren.* pl. 40: Late period, perhaps the first idea for the "Coronation of the Virgin," now in Venice, Academy. Osmond p. 100. Fiocco, *Veronese,* I, p. 207.

The drawing has, in our opinion, no connection with the mentioned painting (ill. in Venturi, 9, IV, fig. 741, attr. there to Montemezzano). The figure kneeling at the l. seems to be a monk, at any rate a man, the figure at the r. not an angel, as in the painting, but again a man, and probably Saint Joseph (Iseppo).

2039 ————. Studies for the organshutters, formerly in San Nicolò Grande in Venice, later in the Coll. of the Duke of Northumberland, ill. Fiocco, *Veronese, II,* p. CXCVI. The sketches above are for "Christ and Veronica," a composition studied separately a second time, and the "Raising of Lazarus" at l. The other sketches prepare the "Ordination of St. Nicholas." Pen, wash, on wh. 212 x 133. Publ. by Hadeln, *Spätren.,* pl. 46, p. 29, who interpreted the subject as a "Pietà" and a "Noli me tangere." Osmond, p. 100. Fiocco, *Veronese, I,* p. 208 identified the subjects as the "Magdalene anointing Christ's feet," and "Noli me tangere." in *Veronese II,* p. 128, Fiocco recognized the connection with the shutters which he attr. to Paolo Veronese himself.

In the old literature the shutters are listed as school of Paolo Veronese; they were attr. to Friso by Ridolfi (II, p. 142) and to Carletto Caliari by Boschini. The drawing may nevertheless, be by Paolo himself, see p. 337.

2040 ————. Design for a detail of the painting "Wedding of Cana" in Dresden. Pen. 206 x 173. Publ. by Borenius in *Burl. Mag.* XXXVIII, p. 547. Hadeln, ibidem XLVII, p. 298 f. Hadeln, *Spätren.,* pl. 23. Osmond p. 100. Fiocco, *Veronese, I,* p. 207. **[*Pl. CLVI,* 3. MM]**

The drawing is important for the development of the conception of the painting, ill. Fiocco pl. XLVII. We see that the first idea of this very complicated horizontal composition was much simpler, a round table with figures seated close together, at the left. The figure of Christ in the middle was taken over into the painting, but the characteristic group at his r. has been shifted to his l. The grouping of the seated "Vitellius," turning his head toward the standing drinker was maintained from the very beginning shown in this drawing, up to the final execution. The painting in Dresden, formerly dated about 1560 (Hadeln and Fiocco, p. 196) has recently been shifted by Rodolfo Gallo (*Emporium,* March 1939, p. 148) to shortly after 1571. Gallo based his dating on the portraits of the Cuccina family in "The Madonna," another painting now in Dresden, which, however, is not a companion piece of the "Wedding at Cana" and need not necessarily have been the first painted of the series. At any rate, from the documents publ. by Gallo, it seems impossible to date the painting before 1563, the year when the family palace was constructed.

2041 ————. Groups of saints seated on clouds. Pen. 302 x 210. Inscriptions: Monica; Andrea; Bartol(omeo). — On *verso* other

sketches showing through the paper. Publ. by Hadeln, *Spätren.*, pl. 42, p. 28: Perhaps first idea for the sketch of a "Paradise" in Lille, painted in competition with other painters for the Sala del Maggior Consiglio in the Ducal Palace, Venice. Osmond p. 100. Fiocco, *Veronese, I*, p. 207.

In our opinion, more probably sketches for an executed (and lost) painting of a "Paradise," to which Ridolfi I, 328 f. refers. This painting had been ordered by the nuns of Santa Caterina who belonged to the Augustinian order. The two sketches above vary the theme of St. Monica standing in the midst of seated saints, and this predominance of St. Augustine's mother might confirm our theory.

2042 ————. Sketches for Christ and the disciples at Emaus; study for a "Mourning under the cross" and separate figures. Pen, wash. 155 x 200. Notes and numbers inscribed. Publ. by Hadeln, *Spätren.*, pl. 44. Osmond p. 102. Missing in Fiocco's list.

2043 ————. Study for an "Adoration of the shepherds." Pen, wash. — On *verso* rough draft of a letter in Paolo's handwriting, dated 19 zener (genaro) 1584. Publ. by Hadeln, *Spätren*, pl. 45. Osmond p. 100. Fiocco, *Veronese, I*, p. 207.

The letter dates the drawing: 1584 or later.

2044 ————. Study for a Biblical feast, and other sketches of women seated and children — Virgin from a Rest on the flight into Egypt — and angels. Pen, wash. 195 x 202. — On *verso* notes of an account, written by Paolo Veronese himself (Hadeln). Publ. by Hadeln, *Spätren.*, pl. 37. Osmond p. 100. Fiocco, *Veronese, I*, p. 207. [*Pl. CLVI*, 4. **MM**]

The main study is, in our opinion connected, with a lost painting in the Curtoni Coll., "Christ, the Virgin and Saint Joseph at table, served by angels with miraculous food" (Ridolfi II, 113). The composition of this painting seems to have been thoroughly prepared by Paolo; Ridolfi I, p. 321 describes some drawings on colored paper, height. with white, in the collection of Christoforo and Francesco Muselli showing explanations written by Paolo himself on the back; no. 6 had the explanation: "If I had any time I should like to paint a sumptuous meal in an exquisite open hall (*loggia*), in which the Virgin, the Savior and St. Joseph would be served by a host of angels etc." This drawing was later in Mariette's collection (compare Mariette's letters to Temanza from December 12, 1769 and January 5, 1776, Bottari-Ticozzi VIII, 373 f. and p. 406). The inscription makes it certain that Paolo, himself, made drawings in this finished style as models for paintings, and that not all of them were copies from paintings as has been suggested.

A BESANÇON, MUSÉE, 3165. See No. **2161.**

2045 BOSTON, J. S. GARDNER MUSEUM. Mystical marriage of St. Catherine. Pen and brush, wash, height. w. wh., on grayish blue paper. 453 x 302. Damaged and restored. Coll. Peter Lely, Charles Robinson, Agnew (Sale at Christie's 12–14 May, 1902). Publ. by Philip Hendy in the *Cat.* of 1931, p. 409 as the first study for Veronese's painting now in the Academy in Venice; there are many differences between the picture and the drawing. [*Pl. CLIX*, 2. **MM**]

The drawing is probably the "modello" which Veronese submitted to the nuns of Santa Caterina when they ordered the altarpiece which has recently been dated about 1575 (*Mostra Veronese* 1939, p. 161).

A 2046 BRNO, LANDESMUSEUM. Battle scene. Pen, bl. br., wash, height. w. wh., on blue. 158 x 420. Framed with a borderline above

and below. An inscription at the lower r. corner canceled. Coll. Skutetzky. The drawing came from an Artaria Sale, *Cat.* 1180, where it was called: In the manner of Paolo Veronese. [**MM**]

This is an old copy from Jacopo Tintoretto's mural in the choir of S. Rocco, representing the "Seizure of St. Roch."

A 2047 BRNO, COLL. FELDMANN, formerly. A Doge worshipping the Madonna. Pen, bistre. 135 x 200. Cut at l. Otto Benesch in *Sale Cat.* Gilhofer, Lucerne, June 28, 1934, no. 316, p. 29: Paolo Veronese, with reference to No. **A 2114.**

In our opinion, the last mentioned drawing is neither by Veronese, nor has it any other connection with our drawing but the dependence of both drawings on compositions by Paolo Veronese. No. **2063** shows a similar style.

A 2048 BUDAPEST, MUSEUM, E. 6. 22. S. Mary Magdalene anointing the feet of Christ. Pen, darkbr. over bl. ch. 201 x 267. Schönbrunner-Meder no. 556 and Meder, *Handzeichnung* p. 614: Paolo Veronese. Osmond p. 103 accepts the attribution. Fiocco, *Veronese I*, p. 140: rejects the drawing as a mannered production of the school, showing Tintoretto's influence, at the best by Friso, but lists it among the authentic drawings in *Veronese, II*, p. 128. [**MM**]

In our opinion, Fiocco's first reaction was more correct, as far as the rejection goes, but we do not agree with the attr. to Friso. The drawing is stylistically posterior to him and more likely an example of Veronese's first renaissance in the art of painters like Francesco Maffei, compare **A 2054.**

2049 ————, N. E. 6. 24. Sketch for St. Peter d'Amiens before the Doge Vitale Michiel. Pen, gray wash. 140 x 274. — On *verso:* The same scene in reverse. Inscriptions naming the figures. Coll. Poggi and Esterhazy. E. Hoffman in *Budapest Yearbook*, 1924–26, IV, 138, fig. 23, 24: Design for a cartoon on canvas, done by Veronese as a model for a tapestry in the Sala del Collegio, Ducal Palace (Ridolfi I, 344). Hadeln had recognized the lost composition in an engraving by Lorenzini. Gombosi in *Magyar Müvészet* 1928, 728. *Mostra Veronese* 1939, p. 224. [*Pl. CLIV*, 2. **MM**]

The cartoon has recently been discovered in the R. Istituto d'Arte "A. Passaglia" at Lucca and was exh. in the *Mostra Veronese*, No. 73. The version of the drawing which shows the Doge to the r. was chosen for the painted cartoon. It should be dated 1576–77.

2050 ————, E. 15. 1. Design for a tomb. Pen. br. wash. The inscription states that the drawing is by Palladio, but the figures by Paolo Veronese. Collections: Vasari, Mariette (Mariette, *Abecedario* IV, 73; Basan, *Cabinet Mariette* 1775, no. 551). *Budapest Yearbook* IV, 1927. Otto Kurz in *O. M. D.* December 1937, p. 41, pl. 45. [**MM**]

Vasari's attribution seems trustworthy especially since the style of drawing does not contradict it.

A CAMBRIDGE, ENGLAND, FITZWILLIAM MUSEUM, 77. See No. **2162.**

A CAMBRIDGE, MASS., FOGG ART MUSEUM, no. 203. See No. **2163.**

2051 ————, 204. Rest on the flight into Egypt. Pen and brush, green and wh., on blue. 248 x 198. Coll. Lawrence, Arozarena, Heseltine (*North Italian Drawings* 1906, p. 32: a copy of this drawing by Van Dyck in the Albertina). P. J. Sachs 681–1928. Cat. of Gustav Nebehay, *Die Zeichnung* IV, 160 (ill.). Mongan-Sachs p. 108, fig. 111.

The copy in the Albertina now in storage V. II, 90.

2052 ————, 205. Four studies for a Baptism of Christ. Pen-and-bistre, on yellow. 200 x 180. — On the back a letter in Veronese's hand dated February 2, 1587. Gift of Denman W. Ross, 1924. 101. Publ. by Agnes Mongan in *O. M. D.* 1931, p. 21, pl. 19 as possibly a study for Veronese's painting in the sacristy in the Redentore, Venice, or for the one on an altar in the same church. Mongan-Sachs p. 108, fig. 112, 113 now eliminate the reference to the first painting, which according to Ridolfi I, 354 and *Mostra di Veronese*, 1939, No. 37 was executed as early as 1561, while the drawing is linked to a later date by the letter on its back. The other painting mentioned above was ordered of Paolo Veronese in the 1580's and executed after his death by his heirs (another version of this painting, also by the "heirs," in the Cathedral of St. John the Divine in New York). Mongan-Sachs, moreover, find in the sheet reminiscences of various earlier Baptisms of Christ by Veronese, and an especially close connection with J. Tintoretto's painting of this subject in San Silvestro (ill. *Mostra del Tintoretto*, p. 178), usually dated about 1580.

[*Pl. CLVII*, 1. **MM**]

A 2053 ————, 206. Study of a young woman seen from behind, in her l. arm a child is indicated. Bl. ch., on gray wh. 415 x 327. Lower r. corner cut. Wauters Coll., Sale Cat. June 15–16, 1926, Mensing No. 31, pl. 31: Paolo Veronese. Gift of Carl E. Pforzheim 1927. Osmond p. 104. Robert Allerton Parker, in *International Studio* 1930, XCV, January p. 37. A. Pope in *The Arts* 1927, p. 25 to 28. Mongan-Sachs p. 110s., fig. 114: Veronese (?); the profile shows a pentimento, the artist began the drawing on a larger scale. [**MM**]

In our opinion, the drawing does not belong to the 16th century and for this reason cannot be by Veronese. The contraposto of the figure is different from that of Veronese's figures seen from behind, compare, for instance, the Charity in the "Martyrdom of St. George," ill. Fiocco, *Veronese I*, pl. 57. The pose is based on Tintoretto's as well as on Veronese's style. The drawing has a realistic approach to details like the hands, the head, and the costume, but renders them in a summary manner. The Venetian Cinquecento when interested in a drapery studied it more faithfully. The few drawings of separate figures by Veronese which we have show a quite different style which still keeps the classic tradition.

We suggest an artist under the influence of Venetian art, as for instance, Matteo Preti, but do so only with reservations, since this suggestion rests only on the style of his paintings and not of his drawings.

A ————, 207. See No. **863**.

A 2054 CHANTILLY, MUSÉE CONDÉ, 120. Unidentified subject: a young cavalier apparently drawing his sword and approaching a bearded nobleman seated at a table. Brush. Ascr. to Paolo Veronese. Publ. as his in *Revue de l'Art*, January 1922. [*Pl. CXCIX*, 4. **MM**]

In our opinion by Francesco Maffei; compare his painting "Miracle of St. Anthony at Padua," in San Francesco, Brescia, ill. *Dedalo* V. 5 (1924), p. 236.

2055 CHATSWORTH, DUKE OF DEVONSHIRE, 277. Christ and the disciples at Emaus. Pen, bl. br., height. w. wh., on greenish paper. 421 x 576. Peter Lely Coll. (Photo Braun 177–C. 92).

This drawing might be a "*modello*," and was probably done in the shop. The main figure group alone exists in Berlin, see No. **2035**.

2056 ————, 279. Martyrdom of St. Justina. Brush and pen, br., wash, on grayish blue. Squared. 470 x 240. Cut.

[*Pl. CLIX*, 1. **MM**]

A copy of this drawing exists in the museum in Dijon. [**MM**]

The drawing is, in our opinion, the "*modello*" of the altar-piece in the church of St. Justina in Padua and identical with the model, mentioned by Ridolfi (I, p. 317) as existing in the apartment of the abbot of the monastery; he states that the model differed in some parts from the painting, as is the case with our drawing. We reject Hadeln's (ibid., note 7) and Fiocco's (p. 189) suggestion that the painting now in the Museo Civico in Padua (Fiocco, fig. 59) might be the one to which Ridolfi refers. There is no resemblance at all between the two versions except the subject. The one in the Museo Civico is, in our opinion, later than the one in the church, the contract for which is dated October 1575. This date may also apply to the drawing. — According to a letter of Algarotti to Francesco Zanetti (reprinted in Pietro Caliari, *Paolo Veronese*, p. 266 ff.) Zanetti owned a pen drawing for the painting in Santa Justina, which Algarotti considered an earlier *modello* made for the abbot. He describes it as approximately corresponding to our drawing, but different in that only one angel appeared in the sky.

2057 CHELTENHAM, FENWICK COLL. Studies for "Christ carrying the cross." Pen, br., slightly washed. 202 x 296. Coll. Reynolds, L. Woodburn Sale. Popham-Cat. p. 110, 1, pl., L: In connection with the Louvre painting.

In our opinion, a slip of the pen instead of Dresden painting (ill. Fiocco, *Veronese II*, pl. CVII), to be dated between 1563 and shortly after 1571.

A 2057 bis ————, 110, no. 2. Double sheet of a sketchbook with studies for an upright composition of Delilah cutting Samson's hair. Pen, br., br. wash in some cases and, in two instances, over a preliminary sketch in red ch. 265 x 400. Woodburn Sale. *Fenwick Cat.*: Somewhat related to sketchbooks of Ambrogio Figino, but rather in the manner in which the sketches are distributed than in the actual handling. [**MM**]

We agree to Popham's rejection of the traditional attr. to Veronese and consider his hint to Figino attractive.

A 2058 DRESDEN, KUPFERSTICHSAMMLUNG. Pietà. Pen. 169 x 119. Publ. by Meissner, Veronese, p. 48, fig. 37: Veronese. Questioned by Osmond, p. 103. Fiocco, *Veronese II*, p. 128: school production. O. Kurz in *O. M. D.* December 1937, p. 37: The drawing in Dresden (attr. in former times to Paolo Veronese) is a copy from a drawing by Battista Angolo dal Moro in the Louvre, ill. *O. M. D.* June 1937, pl. 14 (No. 39).

A 2059 FLORENCE, UFFIZI, 1715 F. Seated lady seen from behind. Bl. ch., height. w. wh., on grayish blue. 346 x 230. Formerly ascr. to Titian. Giorgio Bernardini, in *Boll. d'A.*, 1910, p. 147, fig. 1 and Hadeln, *Spätren.*, pl. 50: Veronese. Accepted by Fiocco, *Veronese, I*, p. 138 and 208, who notices the sympathy of Veronese in his late years for Bassano. *Mostra Veronese* (R. Pallucchini) 1939, p. 229, XV: might be of his latest time, compare the female figures in the "Triumph of Venice," (No. **2101**) about 1585. [**MM**]

The drawing is usually called "the lady at the clavichord"; this description might be correct. The number of ascertained separate studies by Paolo Veronese suitable for comparison is surprisingly small. In fact there are only No. **2084**, of 1573, and No. **2078**, probably shortly after 1572. Their style is no closer to that of No. **A 2059** than an identity of school and an origin at approximately the same time would lead us to expect. A comparison with the figures in No. **2101** reveals decisive differences: Veronese's type is more delicate

than that of this lady, every figure by its posture, bending toward and connecting with others, is a link in an ornamental harmony, while this study is self-sufficient. The costume is similar to the one in Veronese's portrait in Munich, dated by Fiocco p. 197 about 1560. But it is likewise similar to Zuana Cuccina's costume in the painting in Dresden, "The Cuccina family worshipping the Virgin" (about 1570–71). In our opinion, the drawing is not by Paolo, but rather by some artist closer to Titian.

A ——————, 1852. See No. **2168**.

A 2060 —————, 1857. Copy from Paolo Veronese's painting "Holy Family," in the Uffizi. Bl. ch., wash. 260 x 300 (Photo Anderson 77). Accepted by Osmond p. 103, but correctly rejected by Fiocco, *Veronese, I*, p. 140.

A 2061 —————, 7417. Sketches: allegorical figures representing Time, Truth, Justice. Pen, br. and traces of red ch. 140 x 190. Osmond p. 102.

In our opinion, not by Veronese and probably not Venetian.

A 2062 —————, 7421. Christ among the doctors. Bistre, washed in red, height. with wh. 266 x 420. Osmond p. 103.

The connection with Veronese's painting in the Prado (ill. Meissner, p. 13, fig. 9) is evident, but the deviations from it and the penmanship indicate that in this drawing Veronese's composition served as the point of departure for an artist of the 17th century.

A 2063 —————, Santarelli. 7425. King in adoration seen from behind, attended by two pages. Broad pen, br., on paper turned yellow. 118 x 125. The drawing overlaps a few lines in Spanish, evidently written beforehand. [**MM**]

Copy from a painting or sketch by a follower of Veronese, exaggerating the typical postures similar in character and penmanship to No. **A 2047**.

2064 —————, Santarelli 7431. Head of a young woman. Bl. ch. height. w. wh., on grayish blue. 347 x 231. Pricked and rubbed. Hadeln, *Spätren.*, pl. 49; Osmond 105. Their attribution of the drawing to Veronese was rejected by Fiocco, *Veronese, I*, p. 142, who considered it a study for a woman in Benedetto Caliari's "Birth of the Virgin," formerly in the Scuola dei Mercanti and now in the Academy in Venice, and accordingly ascr. it to Benedetto Caliari.

In our opinion, the drawing is not a study for this head, the posture and the hairdress being different. But even if the connection noticed by Fiocco existed, it would not be a decisive argument against the authorship of Paolo whose drawings continued to be used by his heirs. At any rate, the close relationship to No. **2097** makes us prefer Hadeln's attr. to Paolo Veronese.

A 2065 —————, 99383. Sheet with sketches, single figures. Pen, grayish br., on wh. 297 x 437. — On *verso:* Other sketches, among them an executioner. Coll. De Nicola, recently acquired. Publ. by O. Giglioli, *Boll. d'A.* 1926–27, p. 459 as Paolo Veronese. Rejected by Fiocco, *Veronese, I*, p. 141s.: Manner of Ricci.

We agree with Fiocco as far as the rejection goes. The executioner on the back seems to be copied from N. dell'Abbate's painting in Dresden (ill. Venturi 9, VI, p. 599, fig. 349) or Correggio's Martyrdom in Parma. The style of drawing reminds us of Donato Creti's.

2066 Frankfort/M., Staedelsches Institut, 457. Allegory: female figure standing pushing crowns, mitres and other paraphernalia down off a pedestal. Brush and pen, height. w. wh., on green. 275 x 200. — On *verso:* long contemporary inscription describing the subject of the composition. Coll. Peter Lely. Publ. in *Staedel-Dr.* XI, 6. [**MM**]

The drawing probably belongs to a group of *"modelli,"* all in the same technique three of which in the Muselli coll. Ridolfi (I, 321) describes at length. See Nos. **2131, 2135**.

A 2067 —————. Allegorical female figure, seated. Bl. ch., height. w. wh., on blue. 230 x 200. Ill. in *Sale Cat.* Amsterdam, de Vries, 1929 II, p. 119: Paolo Veronese. [**MM**]

In our opinion, contemporary hasty copy from the "Fortuna" in the Sala del Collegio, ill. Meissner, p. 104: the section beneath the foot is a later addition.

2068 —————, 4461. Unidentified subject: several figures (cut) and heads (Baptism). Pen, wash, on bluish paper. 116 x 190. In the upper l. corner handwriting of the period. Publ. in *Stift und Feder* 1926, 34 and attr. to Paolo Veronese on the basis of the sketches publ. by Borenius and Hadeln. Neither Hadeln in his *Spätren.*, nor Fiocco mention the drawing. [**MM**]

In our opinion very close indeed to Veronese's sketches and in its composition resembling Veronese's "Healing of the Paralytic" in Rouen, ill. Venturi, 9, IV, fig. 612 and 613.

A 2069 —————, 14191. Portrait of a youth. Bl. and wh. ch., on grayish br., somewhat stained paper (mounted). 254 x 198. Richardson Coll. Originally ascr. to G. B. Moroni, publ. by Venturi, *Studi*, p. 320, fig. 205 as Paolo Veronese. [**MM**]

Judging from the photograph alone we feel unable to find Veronese's style in this drawing. It aims at expression, at a very definite sweetness, at being complete in itself, and lacks the graphic character of a preparatory study which is typical of other portrait studies by Veronese.

2070 Haarlem, Teyler Stichting, B 65. Sketches for the "Adoration of the magi," now in the N. G. in London (dated 1573). Pen, height. w. wh., on blue. 283 x 198. Inscription at middle l. undecipherable. Coll. Christina Queen of Sweden, Teyler. Publ. by Hadeln *Spätren.*, pl. 32. Exh. London 1930. Popham *Cat.* 287. Osmond 101. Fiocco, *Veronese, I*, p. 208.

Exceptional by its use of blue paper for a sketch.

A 2071 —————, C 54. Head looking upward. Bl. ch., on greenish gray. 260 x 186. — On *verso:* Female figure, half-length. Listed among the anonymous Italians, ascr. to Paolo Veronese by O. Benesch in *Graph. Künste*, N. S. I, 1, p. 19 f. with reference to No. **2118**, the paintings of the "Evangelists" now in the Academy in Venice, and, for the back, to the posture of the princess in the "Finding of Moses" in Madrid.

In our opinion, there is no connection between this study in a classical style, emphasizing the tactile values, and Veronese's Venetian manner. It is best left among the anonymous drawings.

2072 Haarlem, Coll. Franz Koenigs, I 39. Sheet with sketches, one, in the middle, of an altar-piece with the Virgin and Child, St. Martin (?) and other saints, several versions of Madonna and Child and a musician angel. Pen, br., washed with gray. 148 x 131. — On *verso* notes containing several dates 1560, 1561, 1562 and 1564. Coll. Lely, Huldich. [*Pl. CLVII*, 2. **MM**]

The two sketches in the upper row seem to belong to a Circumci-

sion, compare No. **2163**. The angel in the lower row resembles closely one of the sketches in No. **2075**.

2073 ———, I 40. Sketches for a Mystic marriage of St. Catherine (?) and other compositions. Pen, brush. 304 x 199. Inscription in Veronese's handwriting: con Sᵖ Zuani — con una Santa — Sposi — Mada. — On the back a letter, apparently addressed to Paolo Veronese, dated Castel Franco August 11 1568. Publ. by Hadeln, *Spätren.*, pl. 31. Hadeln, *Koenigszeichnungen* 13. Osmond 101. Fiocco, *Veronese* I, p. 208.

The sketch in the bottom row corresponds to a composition by Veronese, a version of which, the property of Mr. Norman Clark Neill, was exh. in the Burl. Fine Art Club in 1925–26; another from the R. Owen Coll. in Paris was sold at the Salomon Sale, American Art Assoc., New York April 4–7, 1923. The subject is described among the paintings belonging to Giuseppe Caliari, the heir of the family paintings (Ridolfi I, 344): "Le Nozze di Santa Caterina Martire, e Sant'Anna che svolge una fascia." The figures in the upper row may belong to a composition of Esther before Ahasuerus.

2074 ———, I 41. Sketches for figure compositions and buildings of a medieval character. Pen. 251 x 194. Coll. Reynolds, Bauts, de Triquetti. Hadeln, *Spätren.*, pl. 34. Osmond 101. Fiocco, *Veronese* I, 208.

The figures seem to represent the martyrdom of a female saint. The architectural elements, typical of Veronese's liking of imaginary architecture resemble those in his ceiling "The conquest of Smyrna," in the Ducal Palace (ill. Fiocco, *Veronese I*, pl. XCVI) and of the organshutters, formerly in San Niccolò Grande (ill. Fiocco, *Veronese II*, pl. CXCVI).

2075 ———, I 42. Sketches for a Visitation, for a Mourning over Christ, for a musician angel, an architectural detail (lantern) and the section of a harness or coat. Inscriptions: "Io Carlo" — and "Joach(im)." — On *verso*: Sketches: Allegorical figures of Faith, Charity and Hope; older musician angels and four pairs of little angels; two large angels flying and carrying a figure. Inscriptions: "fato ... del ... del doze," "Carita," "Fede," and accounts. Hadeln, *Spätren.* pl. 35, 36 recognized the connection of the three sketches of the "Visitation" with the painting formerly in S. Giacomo, Murano, later on in Lord Powis Coll., England, ill. Ingersol Smouse, *Gaz. d. B. A.* 1924, I, p. 98. Sale Drouot 1924, February 25, No. 68: Carletto Carliari. Osmond p. 101; Fiocco, *Veronese I*, p. 208: Paolo Veronese.

According to Hadeln the inscription "Io Carlo" has no bearing upon the attr. The sketched Pietà in clouds recalls, although in reverse, a similar group in the painting in San Giuliano, *Mostra Veronese* 88. The three sketches for Hope, Faith and Charity may be connected with the decoration of the Sala del Collegio in the Ducal Palace, see No. **2030**.

2076 ———, I 43. Sketches: Madonna and Child, a bearded saint (Joseph?) and musician angels in a glory, in which couples and separate little angels alternate. A female nude bust. Pen, wash. 267 x 200. Inscription connected by a line to the head of the Infant: "testa bianca," and below "Paulo Veronese" (later). — On *verso*: Sketches for angels and saints and another pair of little angels with inscription: "questi." Formerly Boehler, Munich, publ. by Hadeln, *Burl. Mag. XLVII*, p. 303 and *Spätren.* 29, 30. Osmond 101. Fiocco, *Veronese, I*, 209. Hadeln, *Koenigszeichnungen* 12.

A "glory," similar, but not identical, in Veronese's "Martyrdom of St. George," Verona, ill. Fiocco, *Veronese I*, pl. LVII.

2077 ———, I 91. Study for the portrait of a seated lady. Bl. ch., height, w. wh., on gray. 395 x 209, cut. — On *verso* inscription in pen: I T n°28 — and written with another pen: Aque'ta 38 (— aquista? see Nos. **2079** and **2163**). Exh. Amsterdam 1934, *Cat.* No. 696 and Paris 1935 Sterling No. 732. **[MM]**

The mode of drawing slightly resembles that of No. **2078**, but is rather loose and advanced for Veronese. A similar painting in the Roehrer Coll., Augsburg (ill. *Klassischer Bilderschatz* VII 94), ascr. to Paolo Veronese, is now attr. to Montemezzano. The few authentic drawings by Montemezzano are not sufficient to have us reach a decision. We list the drawing as by Veronese with reservations.

2078 ———, I 93. St. Lawrence, standing (half-length). Bl. and wh. ch., on blue. 296 x 201. — On the back inscription: P. n° 65. Ascr. to Paolo Veronese. **[*Pl. CLX*, 2. MM]**

Study for Veronese's painting "Pala Malipiero," in S. Giacomo dell'Orio, ill. Fiocco, *Veronese, I*, pl. XXXII; dated about 1573.

2079 ———, I 94. Study for a man seen from behind, holding a flagstaff; above study of a right arm, grasping the staff covered by the flag. Bl. and wh. ch., on blue. 295 x 187. In lower r. corner later inscription in pen: P. V. — On the back: study for drapery or flag. Inscription: S. P. n° 58. (and) 582, corresponding to the figures written on No. **2163**v. Ascr. to Paolo Veronese. **[MM]**

2080 ———, I 95. Draped figure, seated. Bl. and wh. ch., on blue. 270 x 210. — On the back inscription in pen: P n° 61. Exh. Amsterdam 1935 (Cat. no. 697). Ascr. to Paolo Veronese.

Apparently study for a decorative painting and closely connected in its style with No. **2077** and No. **2078**. **[MM]**

2081 ———, I 96. Study of armor. Bl. and wh. ch., wash, on blue. 202 x 288. — On *verso*: studies of draperies. Exh. Amsterdam 1935, Cat. No. 695. **[MM]**

Apparently the same armor as No. **2034**, where the same technique is used.

2082 ———, I 97. Study for a drapery (l. sleeve of senatorial robe). Bl. and wh. ch., on blue. 300 x 153. — On *verso* in pen: P. n° 62. Ascr. to Veronese. **[MM]**

The ascription is supported by the stylistic affinity to No. **2077**.

2083 ———, I 98. Page, seen from behind, holding his cap in his hand. Bl. and wh. ch., wash, on blue. 277 x 152. Cut. Ascr. to Paolo Veronese. **[MM]**

The figure appears in the opposite direction in a composition by Carletto, "Queen Catherine of Cornaro surrendering her crown to the Doge," see No. **2167**. The use of figures by reverting them, is typical of compositions done by the shop.

2084 ———, I 177. Study for a kneeling king in Veronese's painting, "Adoration of the magi," in the N. G. in London (ill. Fiocco, *Veronese* I, pl. LXVIII). Bl. ch. 163 x 165. Rubbed and stained. Coll. E. Wauters. Publ. by F. Lees p. 55. Hadeln, in *Burl. Mag.* 1925, Dec., p. 303, idem in *Spätren.*, p. 29 and *Koenigszeichnungen* No. 14. Osmond 104. Fiocco, Veronese I, p. 210. **[*Pl. CLX*, 3. MM]**

The drawing, if authentic, would be dated in 1573 by the painting. However, we should note that the state of preservation is very poor and that the penmanship is so much less free and immediate than that of No. **2078** that a few reservations should be made. See p. 336.

A 2085 ———, I 407. Woman kneeling, embracing a child. Bl.

and wh. ch., on faded blue. 274 x 287. Late inscription: Titianus d. Coll. Wellesly, Boehler. Exh. Amsterdam 1935 (*Cat.* no. 500, attr. to Paris Bordone by Regteren Altena). Osmond 105: possibly early work by Paolo Veronese. **[MM]**

The initial impression of the drawing is more striking than its quality. It may have been copied from a painting which, however, was neither by Veronese nor by Bordone.

A 2086 ———, I 496. Sheet with three figural groups. Pen, wash. 239 x 188. — On *verso:* Standing saint. Pen and red ch. Inscription: Cant . . . Listed as "Italian about 1600." Exh. Amsterdam 1934, No. 692: Paolo Veronese. [*Pl. CXCVII*, 1. **MM**]

In our opinion by Simone Cantarini, to whom the inscription points. The attribution is supported by the stylistic relationship to the many authentic drawings by Cantarini in the Brera.

2087 ———, I 514. Allegory of Vigilance. Woman seated with attributes such as candle, cat and crane. Pen, brush, gray and wh., on blue. 211 x 309. Oxidized, stained by mold. Later inscription in lower l. corner: da Paolo V. Supposed to be the design for the ceiling in the Sala del Collegio in the Ducal Palace. **[MM]**

In our opinion, perhaps working material used in the shop, in spite of slight deviations from the painting.

2088 ———, I 515. Sheet with several sketches for the composition of an altar-piece: The Madonna standing, spreading her mantle over kneeling men. Pen, br. 132 x 213. Coll. Lankrink. Ascr. to Paolo Veronese. **[MM]**

The sketches prepare a painting formerly existing in the Scuola della Misericordia under the name of Paolo Veronese, described by Boschini, *Minere,* p. 441 and engraved by Agostino Carracci (ill. *Graph. Künste* N. S. IV, 1939, p. 141, fig. 22). Most of Agostino Carracci's engravings from Venetian paintings were done in 1582.

2089 LENINGRAD, HERMITAGE, 7741. Saint Margaret. Ch., wash, height. w. wh., on blue. 275 x 160. Coll. Brühl. Exh. in Leningrad 1926, *Cat.* No. 81. The attr. to Veronese was made by Liphart with reference to No. **2066** and other drawings of a similar character.

We have seen neither the original nor a reproduction.

2090 LONDON, BRITISH MUSEUM, 1854-6-28 — 4. Rest on the flight into Egypt. Pen, height. w. wh., slightly washed, on gray. 316 x 237. Hadeln, *Spätren.* 58; Fiocco, *Veronese I,* p. 208.

Identical in style with No. **2139**.

A 2091 ———, 1854-6-28—10. Historical subject. An armored knight is standing before an enthroned Oriental ruler. 338 x 280. Reproduced in Meissner, fig. 29.

German copy, as proved by indications of colors written in German, of a composition which might have been by a follower of Veronese. The date 1726 which is to be found on the drawing fits very well into its style. Another fragmentary copy of the same painting in the Uffizi, ill. Meissner l. c. fig. 34.

2092 ———, 1861-8-10 — 4. Allegory of the victory of Lepanto. Oil sketch in chiaroscuro, on prepared red paper. 297 x 470. Parker in *O. M. D.* 1930, March: closely connected with the painting in the Sala del Collegio in the Ducal Palace in Venice, but by no means identical. Not listed by Fiocco. [*Pl. CLVII*, 3. **MM**]

The sketch is to be dated between 1571 and 1581 by the dates of the battle and of the painting. It was meant as a final *modello* (see the in-

dication of the column at the r.); later the upper part was changed and the figure of Agostino Barbarigo who had been killed in the battle, inserted into the composition.

A 2093 ———, 1861-8-10 — 5. Head of a man. Brush br., wash. 220 x 165. (Photo Braun 73126) Ill. Meissner p. 60. Osmond 104. Rejected by Fiocco, *Veronese, I,* p. 141 as close to G. B. Tiepolo.

A ———, 1890-4-15 — 172. See No. **2170**.

2094 ———, 1895-9-15 — 841. The dead Christ on a bier, under which a skeleton is lying. Brush, gray and wh., on grayish blue. 138 x 278. Inscription in pen: Qui mortem (nostram) moriendo destruxit. Malcolm coll. (Robinson 293). Exh. École des Beaux Arts 1879, No. 218 (ill. Meissner p. 107, fig. 86).

The drawing seems to be the one seen by Ridolfi ("disegno di Paolo da noi veduto") and used by Parrasio Micheli for his painting in San Giuseppe in Venice (Ridolfi II, 138), another smaller version of which exists in the Prado (ill. Venturi 9, IV, fig. 745). Hadeln in *Jahrb. Pr. K. S.* XXXIII, p. 161 f. questions the correctness of Ridolfi's statement and surmises that the drawing Ridolfi had seen may have been by Parrasio himself. The drawing in London which Hadeln had overlooked is certainly typical of Veronese and his family. The painting in San Giuseppe is dated 1573, and the drawing must, therefore, be earlier. It is unknown whether Paolo used his invention only in this drawing or also in a painting which might be identical with an "Estinto Salvatore," now lost, but mentioned by Ridolfi I, p. 317, 322.

2095 ———, Ff-1 — 73. Sketch for a painting, Madonna enthroned between two saints. Pen, br. 141 x 129. Upper corners cut. Formerly listed among the "doubtful Veronese," publ. by Hadeln, *Spätren.,* pl. 28, as by Veronese himself. Osmond, 101: perhaps preparatory study for the Bevilacqua Madonna, Verona, ill. *Mostra Veronese,* p. 1. Fiocco, *Veronese I,* p. 208.

We reject Osmond's reference; the composition is much freer than that of the painting which, incidentally, we ascribe to Zelotti (see No. **2255**). The drawing may be connected with Paolo's painting in Santa Maria dei Servi (Ridolfi I, p. 325): "La Regina de' Celi sopra ad uno pergolato, San Giovanni ed un Vescovo abasso," later stolen and replaced by a painting by A. Varotari, now in the Academy, Venice.

A 2096 ——— Payne Knight. Marriage in presence of a doge. Pen, dark br., wash. 190 x 296. Stained with mold. Late inscription: P. Veronese (Photo Braun 128). Ascr. to Paolo Veronese and mentioned as his by Hadeln, in Thieme-Becker V, p. 397, but not in Hadeln's *Spätren.* Rejected by Osmond p. 103. Not listed by Fiocco. **[MM]**

The composition recalls L. Corona's ceiling in the Sala del Maggior Consiglio in Venice, representing "Caterina Cornaro ceding Cyprus to Venice" (Photo Böhm 498), but the manner of drawing is definitely different from Corona's. Despite some resemblance to Vicentino we prefer to keep the drawing in the sphere of Veronese's influence.

2097 LONDON, COLL. SIR THOMAS BARLOW. Head of a woman, slightly bent to the l. Bl. ch., on blue. 260 x 180. Ill. in Colnaghi *Cat.* Nov.–Dec. 1936, No. 64. [*Pl. CLVIII*, 1. **MM**]

In our opinion, study after nature, used in the painting of Esther, Cracow, Czartoryski Gallery, ill. Meissner, p. 32, fig. 23 (Photo Braun). Closely related to No. **2064**.

A 2098 LONDON, COLL. G. BELLINGHAM-SMITH, formerly. Couple

of mythological lovers and Cupid. Pen. 100 x 135. Coll. Woodburn. Publ. by Borenius, *Burl. Mag.* XXXVIII, p. 54 f., pl. II D. Not listed by Hadeln, Osmond, Fiocco.

In our opinion, later, more in the style of Francesco Allegrini. We have not seen the original.

2099 LONDON, COLL. TANCRED BORENIUS. Sketches for a "Finding of Moses." Pen, wash. 307 x 211. Cut. Inscription: strada (and above an indecipherable word). Coll. Peter Lely, Richardson, Sir Joshua Reynolds, A. N. Champernowne, Bellingham-Smith. Publ. by Borenius, *Burl. Mag.* XXXVIII, p. 34 f. Hadeln, *Spätren.* pl. 33. Osmond 101, Fiocco, *Veronese I,* 208. The latter three follow Borenius's statement that the drawing is reminiscent of Paolo's picture in the Prado.

We have to correct this statement. In his life of Veronese, Ridolfi briefly mentions several versions of this subject, but finally on p. 338 describes a version, then in the Collection of the Senator Domenico Ruzini, differing in its composition from the paintings listed before ("diversamente dispregato degli accennati"). Only the Ruzini painting, circumstantially described by Ridolfi, is identical in its invention with the painting in Madrid (and the other, formerly in the Hermitage, now in the N. G. in Washington). The drawing evidently belongs to the other type preserved in a version in Turin and contrasted by Ridolfi with the Ruzini type (Madrid); the two types have in common only the subject. While the drawing and the painting in Turin correspond exactly in essential points, several figures are turned the other way. Fiocco was right in ascribing the painting to Paolo's assistants. It is indeed typical of a shop product to combine elements of the Master's invention, partly in the original and partly in the opposite direction.

A 2100 LONDON, COLL. GERNSHEIM. Study of a rape of Europa (for Annibale Carracci's fresco in the Palazzo Fava, Bologna, photo Alinari 37751 and Croci 5486). Bl. ch., height. w. wh., on grayish green. 380 x 326. Coll. Henry Oppenheimer. *Sale cat.* p. 103, pl. 52: Paolo Veronese, probably a rejected study for one of his paintings of this subject (Parker). Ill. in *Critica d'A.* XVI–XVIII, p. XX where Annibale Carracci's authorship and the connection with the above mentioned mural was recognized by Ragghianti.

2101 LONDON, COLL. EARL OF HAREWOOD. *Modello* for the "Triumph of Venice," ceiling in the Sala del Maggior Consiglio, in the Ducal Palace. Pen and brush, wash, height. w. wh., on br. 533 x 353. *Pembroke Dr.* No. 3. T. Borenius, in *Apollo* I, p. 190. Hadeln, *Spätren.,* pl. 62. Fiocco, *Veronese* I, p. 209. T. Borenius, *Catalogue of Pictures and Drawings at Harewood,* 1936, pl. XXVIII. *Mostra del Veronese,* 1939, p. 231, pl. XVI.

The *modello* is dated as not after 1585 by the painting.

2102 ——— Sketches for two hands, heads of camels and figures. Pen. 152 x 160. Cut at the l. Inscription also cut. Publ. by Borenius *Burl. Mag.* XXXVIII, p. 54, No. 7 and Hadeln, *Spätren.,* pl. 27. Osmond 101. Fiocco, *Veronese I,* 208. *Mostra del Veronese,* 1939, p. 222, no. VIII.

The former attr. to Van Dyck, mentioned by Borenius, may have rested on a certain resemblance to some drawings in his sketchbook at Chatsworth. The camels and the figures prepare a painting of "Rebecca at the well," formerly existing in the Cabinet du Roi and engraved in 1758. This painting came from Jabach who had bought it from Bonalda a Santo Eustachio where it had been mentioned by Ridolfi I, 339 (Crozat, *Recueil* II, 13). The camel's head in the center is identical with one in Carletto Carliari's painting of the same sub-

ject, Sale Gigoux, March 11, 1928, Brussels, No. 39, in which one of the figures of the drawing also appears in reverse. The reference to the painting "Solomon and the Queen of Sheba," in Turin, given in the *cat.* of the Mostra del Veronese, is erroneous.

2103 LONDON, COLL. SIR ROBERT MOND. Christ at the pool of Bethesda. Pen, wash. 152 x 203. Inscription (measurements): piedi nro 8. Publ. by Borenius in *Burl. Mag.* LVI, p. 105: In connection with the organshutters in San Sebastiano, perhaps their first sketch, and therefore anterior to 1560, since these paintings were finished April 1st, 1560. Borenius-Witkower p. 66, No. 269, pl. XLVIII. The date is accepted by C. L. Ragghianti in *Critica d'A.* XX–XXII, p. XVI. [*Pl. CLV,* 1. **MM**]

In our opinion, the drawing whose differences from the composition in San Sebastiano were pointed out by Borenius himself, could hardly be connected with this work. First, because the indicated width of eight feet seems too small, second, because the construction in the drawing does not take into consideration the elevated location of the painting, a circumstance very striking in the shutters. We should remember that Ridolfi (I, 340) mentions a "Healing of the paralytic" in the Collection of the Counts Widman in Venice and (I, 357) a painting about 10 feet in width of the same subject with many figures, attributing the latter painting to Carletto, in collaboration with his brother. The style of our drawing is Paolo's, but certainly later than 1560. The Haeredes might have used his sketch.

2104 LONDON, COLL. A. P. OPPÉ. Sheet with various sketches, many of them apparently for sculpture. Pen, br. 304 x 200. Coll. Sir Joshua Reynolds. Hadeln, *Spätren.* pl. 22: perhaps in connection with the decoration in Villa Maser. Osmond p. 101. Fiocco, *Veronese I,* p. 209.

In accepting this drawing which seems to prepare decorative statues or paintings imitating such statues we have to make a few reservations. In spite of a close resemblance to Veronese's way of drawing there are some features that are not to be found in his authentic sketches, for instance, the *sotto in su* (in the figure at l., or the detailed rendering of a hand holding a drapery; moreover, the figure in the middle (Venus punishing Cupid) is more mannered in style than we expect to find with Veronese. On the other hand, we point to a decoration mentioned in Ridolfi I, p. 324, formed by statues, one of which, Mars, was made by Paolo himself, originally a sculptor, the others by Alessandro Vittoria.

A 2105 LONDON, COLL. C. R. AND A. P. RUDOLF. Martyrdom of Saint Lawrence. Bl. ch., height. w. wh., on blue 261 x 400. Coll. Baron von der Halm. Exh. Mathiesen Gallery, London, 1938, No. 107.
[**MM**]

The very good drawing belongs to the late 17th century by its style of composition and its penmanship.

A ———. Seated man, seen from back. See No. **1847.**

2106 ———. Sheet with various sketches: Baptism of Christ; Madonna and Child enthroned; Allegory of Venice, receiving tribute from the provinces. Pen, bistre, gray wash. 205 x 298. Signature and later repetition of the name. Inscription: Venezia che sedi apresa tribut (dalle?) provincie città castele pr (per) il buon governo ed (?) da grazie. — On the back: Inverted version of the Allegory on the *recto.* Signature and later repetition of Veronese's name. Inscription: Primo nel fianco a la banda (?) destra del Coligio. Publ. by J. Byam Shaw in *O. M. D.* vol. X, 1935–36, p. 20 ff., pl. 23, 24. Shaw connected

the main scene with the ceiling in the Sala del Collegio, begun by Veronese after the fire of 1574 and finished in 1577. In Shaw's opinion, it is the first idea of the composition "Venice enthroned between Justice and Peace"; he notes the differences between the two compositions and believes that the subject represented in the drawing, but not in the painting, may have influenced Palma Giovine's painting in the adjacent Sala del Senato. [*Pl. CLV*, 2. **MM**. *Verso*. **MM**]

We do not believe that this suggestion is acceptable. The starting point of such a composition is obviously the subject chosen by the authorities, not by the artist. If Veronese drew the allegory "Venice receiving the homage of the provinces," he would hardly have prepared a painting "Venice between Justice and Peace," but he might have made the drawing for some other composition, perhaps the one later allotted to Palma.

2107 LONDON, COLL. A. G. B. RUSSELL. Gondoliere. Bl. and red ch., height. w. wh., on blue turned br. 368 x 212. Another position of the whole figure is indicated in light strokes. Coll. John Bayley, Robert Crozier. Hadeln, *Spätren.*, pl. 53. Osmond 104. Fiocco, *Veronese, I,* 137, 219. Popham, *Cat.* 286; Sterling, *Cat.* No. 280. *Mostra del Veronese*, 1929, p. 228. Fiocco, *Veronese II*, p. 129: hesitates between Veronese and Jacopo Bassano. [*Pl. CLX*, 1. **MM**]

Fiocco's description "more Tintorettesque in the movement than in the style of drawing, light and downy, like an anticipation of Guardi" reveals the difficulty of locating this magnificent drawing which, moreover, shows a marked affinity to Titian's late style. The attr. to Veronese, which rests primarily on the silky treatment of the surface, may be a false conclusion, and we have some doubts about the correctness.

A 2108 ————. Head of a Negro, turned to the r. Bl. ch., on br. 201 x 175. Borenius, in the *Connoisseur*, 1924, p. 10. Hadeln, *Spätren.*, pl. 52. Osmond 104. Fiocco, *Veronese I*, 142. Popham, *Cat.* 285. *Mostra del Veronese*, p. 217, no. III. [*Pl. CXCVI*, 1. **MM**]

Preparatory study the use of which has not been established. In our opinion, the style of drawing, with its concentration on pictorial effects and its lack of modeling, points to a later period, in which such an interpretation of figures had universally been accepted on the basis of Veronese's paintings. The contrast to Nos. **2064** and **2097** in the general conception, in the rendering of details (compare e.g. the ears) and in penmanship, contradicts the attr. of this excellent drawing to Veronese.

A 2109 ————. Seated Negro, eating. Bl. and wh. ch., on brownish. 152 x 186. At the r. a strip is added. Publ. by Hadeln, in *Vasari Society*, N. S. VIII, 4, as one of Veronese's rare studies after nature, referring to No. **2108** and No. **2133**. [*Pl. CXCVI*, 4. **MM**]

There is hardly any argument in favor of the attr. to Veronese, while the style of drawing differs widely from the two other drawings (Nos. **2108** and **2133**) usually ascr. to him. The whole realistic motive conforms better to the Bolognese School.

2110 LONDON, THE SPANISH ART GALLERY. Sketches for a pair of cupids and other figures in the Palazzo Trevisani, Murano. Pen, br. 120 x 110. Coll. Reynolds, Fr. Fleming, P. M. Turner. First publ. by Borenius, *Burl. Mag.* XXXVIII, No. 6, accepted by Hadeln, *Spätren.*, p. 27, and Osmond 101. Not listed by Fiocco. Contrasted by E. Tietze-Conrat, *Art Quarterly*, 1940, Winter p. 37, fig. 21 with the shop drawings connected with the same murals, see No. **2171**. [*Pl. CLI*, 4. **MM**]

The drawing is dated by the paintings which were executed about

1555 to 1557. The exact conformity to the illustration in Vincenzo Cartari's *Le immagini degli Dei,* publ. Venice 1556, may allow a more precise dating. Part of the decoration still exists on the spot (ill. Venturi 9, IV, fig. 556 and 557).

2111 LONDON, SALE SOTHEBY, July 9, 1924, Coll. I. B. Sketches for a ceiling, representing an unidentified mythological subject (a woman on a chariot drawn by two lions). Pen-and-bistre, wash. 314 x 212. Accepted by Hadeln, *Spätren.*, p. 27 and Osmond p. 101.

We were unable to locate the drawing. Probably it is the sketch for Veronese's ceiling in the Casa de' Capelli (later Palazzo Layard) in Venice. Ridolfi (I, p. 367) describes the ceiling of the upper hall: "a scene apparently representing Cybele on a chariot, but little is left to be recognized," as by Zelotti. Hadeln in his comment (p. 367, note 2 and p. 322, note 5) states that Ridolfi confused the two floors: the ceilings in the ground floor were painted by Zelotti, they are described by Boschini, *Minere*, and illustrated in Zanetti, *Varie Pitture*, 15–18. The upper floor according to Tassini, *Palazzi di Venezia*, p. 220, was destroyed by fire in 1627. Hadeln pointed out that this date seems to contradict the fact that the paintings are still mentioned by Ridolfi. It may be that Ridolfi's remark that little is left of the ceiling, may refer to the damage caused by the fire. According to Vasari (VI, p. 369) the ceiling in question was painted before the one in the Consiglio dei Dieci. At any rate, 1566, the year of Vasari's second visit to Venice, would offer the last possible term.

2112 LUCERNE, COLL. OTTO BÖHLER, formerly. The Holy family. Pen, wash. Inscription? Osmond, p. 104: connected with the painting in Dresden No. 241, ascr. to the Heirs of Paolo Veronese. The attr. of the drawing to Veronese seems doubtful, in spite of the inscription which resembles Paolo's handwriting.

We did not succeed in locating the drawing, not even in finding a reproduction.

A 2113 LÜTZSCHENA, COLL. SPECK VON STERNBURG. Presentation in the temple. Pen, brush, yellow gray wash. 170 x 290. Cut at the sides and at top. Publ. in Becker, *Handzeichnungen*, pl. 41, as Paolo Veronese. Called by Osmond, p. 103, a copy from No. **2119** and rejected by Fiocco, *Veronese I*, p. 140.

In our opinion, 18th century.

A 2114 MADRID, BIBLIOTECA NACIONAL, no. 7254. Christ and the captain of Capernaum. Brush. 114 x 187. Later inscription: Verones 40. Another inscription is cut. Publ. by A. I. B. Russell, in *Burl. Mag.* XLV, p. 124 as the study for the painting in Madrid, ill. Fiocco, *Veronese I*, pl. LXXXV. Accepted by Hadeln, *Spätren.*, pl. 26, Osmond 104, Fiocco, *Veronese I*, p. 209, ill. p. 133. [*Pl. CXCVI*, 3. **MM**]

Not having re-examined the original we have to express our doubts concerning the attr. to Veronese with reservations. All authors agree that the style of drawing would be unique in his work. The deviations from the painted version are such as to make it difficult to believe in a direct copy, but on the other hand the drawing is by no means typical of a sketch preparing a painting. The manner in which the figure is cut on the l. borderline or in which the architecture in the background is indicated, leads us to suppose that the painting was the model from which the draftsman took over only the general arrangement and some details. The modifications which he introduced (compare, for instance, the centurion with his attendants) differ by loosening the compactness and simplicity typical of Veronese. In our opinion, they belong to a later artist. Moreover, the drawing shows weaknesses incompatible with a great master like

Veronese; see, for instance, the figure of Christ, the shapelessness of which is by no means caused by the hastiness of a first idea. The presence of the drawing in Madrid (*Cat.* no. 492), where the painting may be traced back to the middle of the 17th century, supports our opinion that the drawing might be a study based on the painting and done by some Spanish artist. We notice a marked resemblance to a "Nativity," exhibited from the A. P. Oppé Coll. in the Burl. Fine Art Club 1925, *Cat.* pl. XLI, and there attr. to Massimo Stanzone.

A 2115 ————, 7255. Study of three figures; the soldier at l. in bl. ch., his r. arm worked over with a broad pen; the young man carrying a helmet at r. in broad pen, the hasty sketch of a figure in half-length, at r., in pen. 135 x 117. Inscription in ch.: P. Verones. Osmond p. 104 and Fiocco, *Veronese II,* p. 209: *Veronese,* study of the centurion and the page behind him for the painting in Madrid (see No. **A 2114**). [*Pl. CXCVI, 2.* **MM**]
Fiocco, following the incorrect description by Osmond, calls the figure at l. the Centurion and evidently has not seen the drawing. We at least saw the photograph. The drawing is apparently by the same hand as No. **A 2114** and in our opinion makes it still more evident that the draftsman started from the composition and did not prepare it.

2116 MILAN, COLL. RASINI. Sketches of a group of saints. Pen, wash. 301 x 211. Inscription: Mario (?) (and) Zuano Mate (and in lower l. corner) Paolo Veronese. Coll. Peter Lely, Esdaile, Thane, Henry Oppenheimer (Parker, *Cat.* 104, No. 206, pl. 53). Borenius, *Burl. Mag.* XXXVIII, p. 55. Hadeln, *Spätren.,* pl. 41: Probably details of a Paradise. Osmond 101. Fiocco, *Veronese I,* 209.

A ————. Annunciation. See No. **1033**.

A MILAN, AMBROSIANA. Pope with two other saints. See No. **2191**.

A ————. Crucifixion. See No. **2172**.

A ————. Adam and Even with the two little children. See No. **2174**.

2117 Moscow, UNIVERSITY. Sketches for the feast in the house of Simon, Brera no. 140. Pen, br. 130 x 265. Coll. Sir Joshua Reynolds (engraved by S. Watts, in C. Rogers, *Imitations of Drawings,* London, 1778). The engraving publ. by Borenius, in *Burl. Mag.* XXXVIII, p. 59. The drawing publ. in *Handzeichnungen alter Meister in Moskau,* V. Osmond 104. Fiocco, *Veronese I,* 139 and 209.
The drawing is dated 1570 by the painting (Ridolfi I, 314 and note 1). Adolfo Venturi, without taking the drawing in consideration, ascr. the painting to Benedetto who in his opinion would have exploited a number of motives belonging to his brother (Venturi 9, IV, p. 1091, ill. fig. 785).

2118 MUNICH, GRAPHISCHE SAMMLUNG, 12893. Portrait of a prelate, perhaps Daniele Barbaro. Bl. ch., height. w. wh., on yellowish green prepared paper. 216 x 181. According to Hadeln the drawing is partly retouched. The upper two corners are added. Hadeln, *Spätren.,* pl. 48: The traditional attr. to Paolo Veronese is trustworthy. Anna Maria Brizio, in *L'Arte* XXXI (1928), 5, ascr. the drawing to Moretto, an attr. accepted by *La Pittura Bresciana del Rinascimento,* 1939, p. 339, No. 2, while Fiocco, *Veronese I,* p. 142 held to Veronese and called the drawing typical of the latter's contact with the School of Brescia. Fiocco, *Veronese II,* p. 130, recognized the portrait of Bar-

baro on the basis of a portrait in the Lanz Coll., Amsterdam (ill. ibidem pl. CV B). The attribution to Moretto has recently been questioned by G. Gombosi, *Moretto da Brescia,* 1943, p. 116 and replaced by one to Lotto.
The same head appears in another posture and with a more serious expression in the "portrait of the Barbaro Family" in Dresden, ill. *Cicerone* 1925, March, which is also ascr. to Montemezzano. This would confirm the traditional attr. to Veronese which seems also preferable for stylistic reasons. We have, however, to point to the remarkable resemblance to another portrait, in the Prado, no. 369, attr. to Jacopo Tintoretto, and inscr. Petrus Archiepiscopus. (Photo Anderson 16351). Brizio's attr. to Moretto rested on an alleged resemblance to No. **1878** in Berlin, formerly ascr. to Paris Bordone, later tentatively to Moretto, in our opinion, by Titian. For Veronese, compare also the shape of the ear with Veronese's self-portrait in the Uffizi, ill. Meissner fig. 1 and with the detail from the "Adoration" in Dresden, ill. in *Emporium* 1939, p. 148.

A 2119 ————, 21452. Purification of the Virgin. Pen, wash. 263 x 394. Late inscription: P. Veronese. Watermark: six-pointed star within circle. Attr. to Paolo Veronese by Osmond 103, ill. pl. 63 a, with reference to the painting in Dresden, called Farinati, which Osmond also attr. to Veronese (ill. Fiocco, *Veronese II,* pl. IXb). The drawing in Lützschena (see No. **A 2113**) shows the same composition (cut); according to Osmond it is a copy from the drawing in Munich.
In our opinion, the composition is based on Veronese, but belongs to a later period.

A ————. Several drawings from Palma's so-called sketchbook, publ. by L. Fröhlich-Bum as Paolo Veronese, see No. **1037** and p. 199.

A 2120 NEW LONDON, CONNECTICUT, COLL. W. AMES. Sheet with sketches for a Christ on the Mount of Olives. Pen, br., slightly washed. 287 x 210. — On *verso:* Sketches for Christ taken prisoner. Publ. and ill. in *Cat.* No. 68 of The Heck Gallery, Vienna, No. 12.
 [*Both sides.* **MM**]
In our opinion neither by Paolo Veronese nor Venetian at all.

2121 NEW YORK, PIERPONT MORGAN LIBRARY, IV, 90. Sketches for a "Finding of Moses." Pen, br., wash. 168 x 185. Coll. Reynolds, Aylesford, Fairfax Murray. Hadeln, *Spätren.* p. 27. Borenius, *Burl. Mag.* XXXVIII, p. 547 ff. Osmond 100. Fiocco, *Veronese I,* 209. Exh. Toledo, O., 1940, *Cat.* No. 97. [*Pl. CLXI, 3.* **MM**]
The composition corresponds to the well known picture in Madrid only as far as the general arrangement goes, while in its architectural parts it bears a greater resemblance to another version of the same subject in Dresden, no. 229.

2122 ————, I, 90. Various sketches. A clothed woman enthroned, holding a bowl and a staff (?), further sketches for decorative figures and a small hastily sketched woman tying her sandal (?). Pen, bl. br., wash. 174 x 154. Inscr.: 38. [*Pl. CLI, 3.* **MM**]
Early period (compare No. **2110**) and perhaps likewise connected with the ceiling in the Palazzo Trevisani, Murano. See Fiocco, *Veronese II,* pl. XLIII.

2123 ————, I, 90a. Various sketches: Cupid riding on a dolphin (or ram?) three times repeated as a group and in single figures. Pen, br., wash. 148 x 87. — On *verso:* Woman seated, with variation.

Inscription: B. A. B. No. 124. Mentioned by Hadeln, *Spätren.*, p. 27. Osmond p. 100, Fiocco, *Veronese, I*, p. 209. [*Pl. CLI*, 2. **MM**]

In our opinion, sketches in connection with the ceiling formerly in the Palazzo Pisani, Venice, now in Berlin, Kaiser-Friedrichs-Museum (ill. Fiocco, *Veronese II*, pl. CLV). Fiocco (on p. 119) dates the ceiling which by the way is not mentioned by Ridolfi, about 1565.

A ————, IV 88. See No. **2175**.

2124 NEW YORK, COLL. ROBERT LEHMAN. Various sketches, above for an Assumption of the Virgin, below for an Adoration of the shepherds. Pen, wash, on reddish paper. 211 x 209. Sale Sotheby's May 13, 1924. Mentioned as authentic by Hadeln, *Spätren.*, p. 27, and Osmond, p. 101. Not listed by Fiocco. [*Pl. CLIV*, 1. **MM**]

The upper part presents various versions mostly utilized in Veronese's "Assumption of the Virgin," formerly in Santa Maria Maggiore, now in the Academy in Venice (ill. Fiocco, *Veronese II*, pl. CLXXXIII a). The apostle at l. pointing upward resembles the one in Veronese's "Assumption" in the Rosary chapel in SS. Giovanni e Paolo. The lower part of the drawing seems to be connected with the "Adoration of the Shepherds" on the ceiling of the same chapel, the closest resemblance being found in the Virgin and Child. According to Fiocco the ceilings in SS. Giovanni e Paolo belong to Veronese's maturity, the "Assumption" in the Academy to his late period. On the basis of the drawing a late origin may be supposed.

A 2125 ————. Head of a bearded man, turned to the r. Bl. ch., on faded blue. 267 x 197. Inscription in pen: Paolo Veronese 267. Exh. Buffalo 1935, No. 30, as Veronese.

While the type of the profile seems to fit, or at least not to contradict Veronese's art, the penmanship is definitely not his.

A 2126 OSLO, PRINT DEPARTMENT OF THE NATIONAL GALLERY. Martyrdom of the Saints Mark and Marcellinus. Pen, wash. 215 x 315. Inscription: Polo Veronese. Coll. von Rumohr and attr. in the *cat.* of that collection (Sale Dresden, 1846, no. 3209) to Jacopo Tintoretto. Publ. by Anthony de Witt, in *Le Arti* II, p. 258 as connected with Veronese's painting in S. Sebastiano, Venice (ill. Fiocco, *Veronese I*, pl. XXI). He refers to No. **A 2149**.

In our opinion, a late and free copy from the painting.

A 2127 OXFORD, ASHMOLEAN MUSEUM. Many sketches for a composition Virgin and Child with Saint Joseph, adding in some of them Saint John as an infant. Pen, br., wash. 246 x 185. Inscription: . . . fare Santo Giuseppe con Giovannino(?) la Madonna . . . Cristo. Some of the compositions are framed by lines. — On *verso*: hasty sketches for a Baptism of Christ and a Beheading of Saint John. Coll. Count Gelosi, W. Esdaile, W. Bateson. Sale Sotheby, April 23 to 24, 1929, p. 41 (129). [*Both sides.* **MM**]

In our opinion, certainly by Simone Cantarini, compare his "Holy Family" in the Gallery Borghese in Rome, Photo Anderson 17557, his drawings in Naples 185 and 0178 and many of his etchings.

2128 OXFORD, CHRISTCHURCH LIBRARY, K 18. Studies for the "Coronation of the Virgin," painting in the Academy in Venice, formerly in Ognissanti, Venice. Pen, wash. 307 x 209. — On *verso*: in upper row study of the upper part of the same composition, in lower row Annunciation, perhaps for organ-shutters, and eight decorative figures for door frames. Hadeln, *Spätren.*, pl. 38, 39. Osmond 101. Fiocco, *Veronese I*, 210.

The drawing is dated shortly before 1586 by the painting. Two of the decorative figures on the back are studies for two fragments in the

Victoria and Albert Museum in London (C. A. I. 166, 167), ascr. to Zelotti by Berenson p. 521, to Paolo Veronese by Venturi, *Studi*, p. 320 ff., ill. fig. 206, 207.

A 2129 ————, K 15. Venus, Satyr and sleeping Cupid. Pen, wash. Ridolfi Coll. Bell, who calls the subject an unidentified allegorical composition, ascr. the drawing to the school of Veronese.

It is a poor copy from a composition offered in 1571 by Veronese to Emperor Maximilian II, but apparently not sold to him, since the painting appears in Veronese's estate which passed into the property of Giuseppe Caliari. It is circumstantially described by Ridolfi (I, 344). The painting itself was publ. by Hadeln, in *Burl. Mag.* 1928, July, p. 3 from the Collection of Conte Contini, Rome.

2130 PARIS, LOUVRE, RF. 61. Landscape. Pen, br., on yellow. 241 x 200. Coll. Gatteaux, His de la Salle. We publ. the until then anonymous drawing in *Critica d'A*. VIII, p. 79, pl. 61, fig. 4 as a work by Paolo Veronese, making some reservations. [*Pl. CXCVII*, 4. **MM**]

Its affinity to Brusasorci's landscapes in the sacristy of Santa Maria dell'Organo in Verona makes us underscore still further these reservations.

2131 ————, RF. 600. Allegory of Virtue defeating Vice. Brush, gray and wh., on gray violet. 362 x 275. — On *verso* long inscription explaining the allegory. Coll. Marquis de Lagoy, His de la Salle (Both de la Tauzia p. 29). Publ. by Hadeln, *Spätren.* pl. 59. Fiocco, *Veronese I*, p. 210. A chiaroscuro woodcut of this drawing, undescribed by the older literature, was publ. by A. Reichel, *Die Clairobscur-Schnitte des 16., 17., 18. Jahrhunderts,* pl. 79, from the print in the Albertina; Reichel attr. the execution to a French xylographer of the early 18th century.

The drawing belongs to a series of which Ridolfi (I, 320) describes a few samples.

A 2132 ————, 4648. Design for a tabernacle, showing the Savior standing on the globe which is supported by five angels. Pen, lightbr., slightly washed, on yellowish. 355 x 150. Coll. Mariette (compare his letter from July 28, 1772, to Temanza, publ. in Bottari, *Raccolta* VIII, 434, where he already points to the somewhat similar tabernacle in San Giorgio Maggiore in Venice, executed by Girolamo and Giuseppe Campagna after a design by Aliense). [**MM**]

A general resemblance with the tabernacle just mentioned does exist, and the drawing may be one of the "numerous designs for this tabernacle" by other artists, anterior to Aliense's definitive *modello* and mentioned by Ridolfi (II, 212). Veronese's authorship is unlikely, even on the basis of the date of the construction of the choir of San Giorgio (1589). Moreover, the style of this pure working design has nothing to do with Veronese's.

A 2133 ————, 4649. Head of a Negro boy, turned to the r. Bl. ch. and a little red in the lips. 278 x 205. Pasted, at the l. a strip is added. Coll. Mariette (Basan in *Cat. of the Mariette Coll.* p. 42: Study for "Martyrdom of Saint Justine" in Padua, an affirmation rejected by Reiset p. 48, who suggested a connection with a figure at the l. in the "Banquet in the house of Levi," Venice). Hadeln, *Spätren.*, pl. 51. Osmond 104. Fiocco, *Veronese, I*, 210.

Both references to definite figures are erroneous. The head is not identified in Veronese's work. Moreover, the psychological approach and most of all the emphasis laid on spatial depth differ from the interpretation in No. **2097** and No. **2118** and make us doubtful about the attribution.

A 2134 ————, 4662. The Wedding of the Virgin, under a great

architecture. Over ch. pen, br., wash, on blue. 218 x 353. Cut at all sides. Inscription: Sposalizi di Sto Iseppe con la Mad^a.

Too poor for Paolo, perhaps copy from one of his paintings by a follower.

2135 ——, 4666. Madonna and Child surrounded by angels. Brush, gray and wh., on violet. 377 x 289. — On the back: Long original inscription: Pictura quarta etc., see Ridolfi I, 321, note 1. Coll. Mariette. Hadeln, *Spätren*, pl. 57. Ingersoll-Smouse in *Gaz. d. B. A.,* 1928, p. 25. Fiocco, *Veronese, I,* 210.

The drawing is well-authenticated by Ridolfi who described it in the coll. of Cristoforo and Francesco Muselli, and is a typical example of Veronese's *modelli*.

A ——, 4667. See No. **2196**.

A 2136 ——, 4674. Historical scene. Pen, reddish br. 206 x 303. Damaged by mold, some holes at r. Mounted. — On the back a few words: Zaniachomo molto magio(?) Veneti — can be read. Ascr. to Paolo Veronese. (Archives Photographiques 7601).
 [*Pl. CXXXVIII, 2.* **MM**]
We do not find any stylistic connection to Veronese and feel rather a relationship to Andrea Vicentino. This relationship rests on the general composition and certain types, while the penmanship is different. As for the subject matter, we interpret the scene as "Martyrdom of the Saints Mark and Marcellinus" with reference to Paolo Veronese's representation of this subject in San Sebastiano in Venice (ill. Fiocco, *Veronese I*, pl. XXIX).

A 2137 ——, 4676. Mars and Venus sleeping while Cupid carries away the weapons of Mars. Brush, gray, height. w. wh., on grayish. 277 x 208. Ascr. to Paolo Veronese. [**MM**]
In our opinion this very good composition is not by Veronese. On a copy (or second version) in the Teyler Museum in Haarlem the name of Paolo Farinato is inscribed in an old handwriting. This attr. seems correct and, at any rate, points in the right direction.

A 2138 ——, 4678. Study of a standing bearded nobleman and his son. Pen, gray wash, height. w. wh., on yellowish gray. Modern inscription: Paul Veronese. — On the back various inscriptions by a hand of the 16th century, partly canceled. Damaged. (Photo Braun 62405.) Publ. Meissner, p. 2. Fiocco, *Veronese II*, p. 130, pl. 56, pointed to the connection with the "portrait of Count Giuseppe da Porto and his son Adriano," in the Coll. Conte Contini-Bonacossi, Florence. *Mostra del Veronese 1939*, p. 73.

In spite of slight variations — which contradict the idea of a copy from the painting — the connection with the latter seems convincing. But the penwork is so different from Veronese's that the question of the authorship of the painting should be reconsidered. The companion piece of the painting in the Walters Art Gallery in Baltimore (ill. Fiocco, *Veronese II, pl.* 57 B) was formerly called Zelotti (Berenson). In our opinion, the name of Fasolo should be taken into consideration even more seriously since he was the leading portraitist in Vicenza and especially favored by the Porto family. His stylistic relationship to the whole group of portraits in question is confirmed by his portrait of the Pajetto family in the Museo Civico in Vicenza, ill. Venturi 9, IV, fig. 716 (with the erroneous caption Zelotti). Fasolo's way of drawing, judging from his drawing of the "Nativity," in the Teyler Stichting, Haarlem, by no means contradicts our tentative attribution of the Louvre drawing to him.

2139 PARIS, ÉCOLE DES BEAUX ARTS, 2852. Allegory, woman flying from a satyr and a serpent. Pen, br., gray wash, height. w. wh., on gray prepared paper. 297 x 272. All four corners cut. Coll. His de la Salle. Publ. in *Gaz. d. B. A.* 1891, I, 48 and by Ingersoll-Smouse, *Gaz. d. B. A.* 1928, p. 25. Exh. École des Beaux Arts 1935, No. 156.
 [*Pl. CLVIII, 2.* **MM**]
The drawing is mentioned by Ridolfi (I, 320) in the Coll. of Dottore Curtoni in Venice: un disegno a chiaroscuro della Virtù che fugge da un brutto serpe, significato per il Vitio. It was later, as already stated by Hadeln in his edition of Ridolfi, in Mariette's property; compare his letter to Temanza from December 12, 1769, in Bottari-Ticozzi, *Lettere Pittoriche* VIII, 406.

2140 ——, 24290. Portrait of a bearded man. Bl. ch., on faded blue. 185 x 131. Damaged, especially at the forehead. Mounted in the middle of the 18th century and inscribed: Ritratto di Paolo Veronese originale di sua mano. Coll. Esdaile. Exh. École des Beaux Arts 1935, No. 24 as Jacopo Bassano. [**MM**]
The model appears in various paintings by Veronese; in his "Feast in the House of Levi," Venice, Academy, he is the second figure from the r. seated at the table, where the posture is different from the drawing, but the drapery is identical; he appears also in the painting of Christ and the Centurion, publ. in *L'Arte* 1930, XXXIII, p. 293. The drawing might be connected with a portrait by Veronese; the model may have been a Venetian nobleman, compare his bust by Vittoria, ill. Venturi 10, III, p. 162. The state of preservation makes it difficult to decide whether the drawing is an original study or the copy from a painting.

2141 ——, 35608 (?) Sheet with sketches of various separate figures. Pen. 263 x 206. Inscriptions: 1584 (and five lines); below five lines possibly in Veronese's handwriting, accounts, referring to the past year 1583 and the current year 1584. There are further inscriptions above the drawn figures naming them: fio de la R^a (son of the Queen), servito (re, servant), R^a (Queen), Dona da Governo (Governess). Below the drawings partly cut: fatte tute quatro. Un nativo (?) Vechio (?) — might belong to another group of figures now cut. — On *verso*: Four figures in two zones, seven of which are accompanied by inscriptions: pagg°-fato; homo della guardia — fatto; consigliere — fatto (Page, done, member of the guard, done, councillor, done.) Below: sacerdote, fanciulo, nobile de la Regina — fato, un Cieco vechio — fato, fanciulo innob — fato (priest, noble child of the Queen — done; an old blind man — done; an ordinary child — done). Publ. by Delacre et Lavallée, *Dessins de Maitres Anciens*, Paris 1927, pl. 8 and 9. Ingersoll-Smouse, *Gaz. d. B. A.* 1928, p. 25. Exh. École des Beaux Arts 1935, no. 154: Possibly costume figures for the stage.
 [*Verso Pl. CLVI, 1. Both sides.* **MM**]

A 2142 ——, 11987. Adoration of the magi. Pen, on buff. 192 x 250. Recent inscription: Paolo Veronese. Coll. Gatteaux. Exh. École des Beaux Arts, 1935, No. 155.
Modified copy from a composition by Veronese existing in the store room of the Ducal Palace in Venice (Photo Alinari 13854); another copy in the Royal Library in Turin, no. 15954 [**MM**].

A 2143 RENNES, MUSÉE. Woman kneeling, seen from behind, another figure, only sketched, crowning her. Pen. Later inscription: P. Veronese. Photo Doucet 209. [*Pl. CXCVII, 3.* **MM**]
The figure corresponds exactly to one of St. Stephen in an engraving after Orazio Sammachini, dated 1588. While even the accessories are exactly copied, the bald head of the saint is changed into a

woman's head and his bare feet are now in sandals. The manner of drawing shows affinity to drawings ascr. to Friso and Orbetto. There is also some resemblance to O. Sammachini's drawing in the Uffizi 12178, but not sufficient to attr. the drawing to him.

A ROME, GABINETTO DELLE STAMPE, 12608. See No. **1391.**

2144 SALZBURG, STUDIENBIBLIOTHEK, VI, 489 (817). Studies for a composition Rachel at the well. Pen and brush. 265 x 175. — On the back: Accounts. Publ. by J. Meder, in the *Graph. Künste* 1933, p. 25, fig. 2, as studies by Paolo Veronese, probably for a painting mentioned by Ridolfi I, 320, in the Muselli Coll. and later on repeatedly engraved, but on these prints by mistake ascr. to J. Tintoretto. The *cat.* of the *Mostra Veronese* 1939, p. 221, VII, mentions Roberto Longhi's agreement to Meder's attr. [*Pl. CLII*, 1. **MM**]

The drawing is unique in Veronese's work insofar as it studies the main figure from various sides as if the painter went around his model. This model may have been a little figurine used as an aid made by Paolo himself. Such a procedure would conform to the customary practice in Venetian studios. (A sculpture by Paolo, educated as a sculptor by his father, is mentioned by Ridolfi I, 324.) The posture, furthermore, recalls the antique statue known as "the man who ties his sandal" (compare Konrad Lange, *Das Motiv des aufgestützten Fusses in der antiken Kunst,* Leipzig 1879, pl. II ff.). The linework is close to No. **2102.** A copy in Haarlem, Teyler Stichting I 33.

A STOCKHOLM, MUSEUM, 1463. See No. **2265.**

A ————, 1456. See No. **2209.**

A 2145 ————, 1459, Saint Anthony. Pen, br., wash. 135 x 70. Sirén, *Cat. 1917,* no. 477 rejects the traditional attr. to Paolo Veronese.

The style makes us think of Maffei Verona, compare his paintings in the Museo Marciano in Venice. [**MM**]

A 2146 ————, 457, Design for the portrait of a lady holding a heron. Bl. ch. 250 x 210. Ill. in Sirén, *1933,* pl. 114. Questioned by Fiocco, *Veronese II,* p. 131.

The curtain behind the figure appearing in the drawing is not visible in the painting in the Vienna Gallery no. 397. Otherwise, the drawing resembles it very closely. This painting, originally attr. to Paolo Veronese, later to Antonio Badile, in the new cat. of 1938 was returned to Paolo Veronese in his early years. The style of the drawing has no resemblance to authentic drawings by Veronese, a statement which might lead to a reconsideration of the much discussed attr. of the painting.

A 2147 ————, 467, Head of a girl. Bl. ch., on greenish gray. 295 x 194. Ill. in Sirén, *Dessins,* 1902, p. 67 as Paolo Veronese. This attr. is accepted by Osmond 105, who admits that some critics believe the drawing to be by G. B. Tiepolo (e.g. Fiocco *Veronese, II,* p. 131).

We have not seen the original, but in our opinion it is much later than Paolo, compare its style with the drawing by Carle van Loo in the Louvre, ill. Lumet, *Le Dessin par les Grands Maitres* I, 9.

A 2148 TURIN, BIBLIOTECA REALE, 15953. Martyrdom of S. Justina. Pen. 352 x 274. Modern inscription of the name. — On *verso:* Studies for architecture, and Virgin and Child with Saint John and other saints. Publ. by Hadeln, *Jahrb. Pr. K. S.* XXXIII, p. 104, fig. 8, as Paolo's first idea for his painting in Padua, executed about 1574; the drawing, however, is not mentioned in Hadeln, *Spätren.* Its attr.

to Veronese is accepted by Borenius, *Burl. Mag.* XXXVIII, p. 55, note, and Osmond p. 63, pl. 47. Fiocco, *Veronese II,* p. 140 attr. it tentatively to Friso. [**MM**]

In our opinion, later in style than Paolo Veronese and even Friso, more probably by some follower in the 17th century who started from Veronese's composition.

A ————, 15954. See No. **A 2142.**

A 2149 VIENNA, ALBERTINA, 105. Adoration of the magi. Pen, bistre, wash. 200 x 267. Inscription. P. Veronese. Schönbrunner-Meder 239 and *Albertina Cat. I* (Wickhoff) 211: Paolo Veronese. Osmond p. 102: study for the painting in the Brera (ill. Fiocco, Veronese I, pl. XCVIII). Fiocco (ibidem p. 140) rejects the attr. to Veronese. Hanna Mayer, in *Graph. Künste,* N. S. I, p. 101 points to a drawing in Düsseldorf to which its composition conforms; in her opinion, the drawing in Düsseldorf, ascr. to Andrea Sacchi, is a copy by Seb. Ricci from the Albertina drawing which she accepts as by Paolo Veronese. In our article in *Critica d'A.* VIII, p. 83 we questioned this theory and attr. both drawings to the same artist of the 18th century (Seb. Ricci?). However, in the Albertina drawing the composition is more finished than in the sketch in Düsseldorf. The composition rests on Paolo's "Adoration" in the N. G. in London (and not on the Brera painting, see above) the Cinquecento style of which is smoothed down. Recently M. Goering in *Jahrb. Pr. K. S.* (1940), p. 103, discusses the drawing without knowledge of our article, accepts Mayer's suggestion with some reservations, considering the drawing at least as originating from Veronese's surroundings. In his opinion, such a faithful imitation of a Veronese model as suggested for the drawing in Düsseldorf would be unusual within Ricci's production.

A 2150 ————, 106. Ecce Homo. Pen, bistre, wash. 258 x 406. *Albertina-Cat. I* and *II:* Paolo Veronese. Accepted by Osmond p. 102, but rejected by Fiocco, *Veronese I,* p. 140.

In our opinion neither the composition nor the linework justify an attr. to Veronese. We find some relationship with No. **676** by Lionardo Corona and with the same artist's paintings in the Ateneo Veneto in Venice.

A 2151 ————, 107. Various sketches for an altar-piece: Madonna enthroned with saints, two of whom present a kneeling man. Pen, bistre. 185 x 170, cut. Zatzka Coll., acquired 1923. Publ. as Paolo Veronese by L. Fröhlich-Bum in *Burl. Mag.,* 1923, July, pl. II, E, and by Stix, *Albertina, N. F.* pl. 27. Hadeln, *Spätren.,* pl. 25. Osmond 100. Fiocco, *Veronese* I, 210. [**MM**]

In our opinion the penmanship is somewhat different from the examples best authenticated for Paolo Veronese. The composition looks like a later development of the Pala Giustiniani; the draftsman may have been some follower of Paolo Veronese.

2152 ————, 108. Sheet with various sketches: at the l. three variations of a composition in an architectural frame; the others for the painting "Sebastiano Ziani welcoming Pope Alexander III^d" ordered of Paolo and executed by his heirs (Ill. Luigi Serra, *Il Palazzo Ducale di Venezia,* p. 99 1.). Pen, bistre, wash. 298 x 217.—On *verso:* Sketches for the boats in the same painting. L. Grassi Coll. Acquired in 1923 and publ. in Stix, *Albertina N. S.* p. 28. Accepted by Hadeln, *Spätren,* p. 27. Osmond 100. Fiocco, *Veronese I,* p. 210, No. 3. [*Pl. CLVI,* 2. **MM**]

In our opinion the sketches at the l. are connected with another painting in the Sala del Maggior Consiglio, ordered of Paolo and

executed by his heirs: "The Pope and the Doge sending messengers to the Emperor." Photo O. Boehm 467. Paolo's *modelli* for both paintings are mentioned by Ridolfi (I, p. 345) in the collection of Giuseppe Caliari who at that time had inherited the whole family estate. Ridolfi adds that the paintings deviated from the designs. If our identification is correct the heirs simplified the architectural frame and reversed the composition.

A 2153 ———, 109. Young woman seated, attended by a maid servant, while a page picks up jewels scattered on the floor. Pen, bistre, washed, height. w. wh. 226 x 174. James Hazard Coll. In *Albertina-Cat.* I (Wickhoff) the drawing is listed among the "Various schools"; it was attr. to Paolo Veronese in *Albertina-Cat. II* (Stix-Fröhlich). This attr. was rejected by Fiocco, *Veronese I*, p. 140.

We agree with Fiocco.

A 2154 ———, 110. Salome carrying the head of Saint John the Baptist. Pen, bistre, wash. 390 x 186. Coll. Prince de Ligne. Listed by Wickhoff in *Albertina Cat. I*, 225 among the "Various Schools," 18th century. Publ. as Paolo Veronese by L. Fröhlich-Bum, in *Burl. Mag.* 1923, July, pl. II D. Fiocco, *Veronese I*, 140 rejects this attribution and gives the drawing, together with No. **2188**, to Odoardo Fialetti, on the basis of a signed painting of this artist in the cathedral of Tolmezzo, for which, in his opinion, the drawing is the design.

We were unable to check the painting in Tolmezzo, but agree with Fiocco in rejecting the attribution to Paolo Veronese.

A 2155 ———, 111. Various sketches: Kneeling noblewoman; a general kneeling before an altar, the relief of which has been repeated above, but was crossed out; view of a town in the distance, a falcon pouncing on the lamb on the altar. Pen, bistre. 140 x 147. Inscription in Greek letters: Cardia. Acquired in 1924. Ascr. to Vero-

nese by Fiocco and publ. under his name by Stix, *Albertina N. S. II*, pl. 29. Fiocco, *Veronese I*, p. 210, No. 2. **[MM]**

In our opinion, the drawing is not an autograph by Veronese, but shows a certain dependence on his penwork. In the event that the inscription reads Candia (instead of Cardia) the kneeling general might be Pasquale Cicogna who defended Candia in 1571; the stork on the helmcrest would allude to his name. If so, the drawing should be dated between 1571 and 1585 since it contains no hint at Cicogna's dogeship (1585-1595).

A 2156 ———, 26666. Sheet with various sketches for a decorative mural. Below mystic marriage of S. Catherine. Over ch. pen, grayish br. 274 x 420. — On *verso:* Two landscapes; a pine cone. Recent acquisition. Publ. by O. Benesch, in *Graph. Künste* N. S. I, p. 17, with reference to the landscapes in Villa Maser. "The pine cone seems to be by the hand of another painter, close to Battista Franco." We circumstantially rejected this attr. in our article in *Critica d'A.* VIII, p. 78.

A 2157 ———, 148. Saint Jerome. Brush, bistre, wash, on green paper. 245 x 168. *Albertina Cat.* I (Wickhoff), 29: Copy from Jacopo Bassano. *Albertina Cat. II* (Stix-Fröhlich), 148: Girolamo Muziano. Suida, in *Belvedere* 1927, p. 58 ff: Paolo Veronese with reference to his painting in S. Pietro M. in Murano (ill. *Mostra*, p. 116). This attribution is accepted by Ugo da Como, *Muziano*, p. 17, note 2, and by Fiocco, *Veronese I*, p. 137, who points for the composition to Veronese's "almost identical" Saint Jerome in S. Andrea della Zirada, Venice.

In our opinion, the drawing is by an artist of the 17th century, under the influence of Paolo's style. The composition of the painting in S. Andrea della Zirada has nothing in common with the drawing, except the subject.

THE HAEREDES PAOLI, BENEDETTO, GABRIELE, CARLETTO
[Benedetto 1538–98; Gabriele 1568–1631; Carletto 1570–96]

The succession in Paolo's shop is entirely different from that in Jacopo Tintoretto's. While in the latter, Domenico's leadership is beyond doubt, in the former, Paolo's heirs, the *"Haeredes Paoli,"* ran the shop jointly. This curious and supposedly unique signature in itself makes the difference clear. Still weightier is the evidence offered by the letter written to Giacomo Contarini by Benedetto, Paolo's brother, and describing the cooperation in executing one single painting, the subject of which, a complicated allegory, had been figured out by the patron himself. Benedetto made the first sketch, apparently on paper, Carletto sketched this idea on canvas, while the final execution fell to Gabriele.

It would, of course, be a mistake, to accept such far reaching division of labor as a rule and to attribute all drawings preparing post-Paolesque paintings to Benedetto, or to consider all such paintings as a joint production of the three kinsmen. Besides the paintings expressly signed by "Haeredes Paoli," there are others authenticated by literary sources as works of Benedetto or of Carletto, and some of the latter are even fully signed. What paintings are we accordingly permitted to ascribe to the *Haeredes?* First of all, certainly repetitions of old compositions of Paolo; further, those which had already been commissioned in Paolo's lifetime so that his sketches or studies may have been available, and finally, those possibly, which were ordered from the shop without expressly insisting on a specific artist. For others we have hardly any reason to doubt the traditional attributions to Benedetto

or to Carletto or even to "Carletto helped by Gabriele." Nevertheless, Benedetto's letter may caution us against being too cocksure in attributing the designs. Remembering the unusual harmony among the members of this family as illustrated by Benedetto's last will, we may imagine that they supplied each other with designs even in cases where the execution is well certified for another member of the family.

This confusing uncertainty, as far as the attribution of single inventions goes, leads to an analogous uncertainty in discriminating the drawings. None of those claimed for Benedetto can boast of an older tradition, not even by an inscription, and none consequently can vouch for other attributions. No. 2158 has the general character of a shop production, repeating a composition and separate figures of Paolo Veronese. No. 2195, because it represents a subject also painted by Benedetto is, in our opinion, better authenticated, but is too much of a *modello* to serve as a point of departure. In No. 2064 shifted by Fiocco from Paolo to Benedetto because of its presumed use in one of the latter's paintings, we prefer to recognize Paolo's hand as Hadeln had done; Benedetto may have found the drawing in the shop material. Another tentative attribution of ours to Benedetto, No. 2189, is too hypothetical to be used as a foundation.

The case is different with Carletto. Ridolfi's description of his early years may throw some light on his style in drawing. Even as a boy Carletto is said to have copied from his father and from Jacopo Bassano "whose brushwork Paolo liked." On the occasion of a stay in a village in the district of Treviso he drew shepherds, flocks, flowers, all kind of tools, and a number of these drawings giving evidence of Carletto's premature talent, were seen by Ridolfi in Giuseppe Caliari's property (I, p. 354). Thus, an early sketchbook seems to have existed in which besides the vestiges of Carletto's education in his father's studio the influence of Jacopo Bassano or his school might have been recognizable. (For a portrait, the attribution of which hesitates between Carletto and Leandro Bassano, see No. 210.) We may presume a certain versatility in the precocious talent and even suppose that Carletto sometimes deviated from the tradition and training that he owed to his origin. The rather well-authenticated portrait of Andriana Palma (No. 2207), drawn by Carletto in 1591 on the day and occasion of her wedding is an example of such a very personal deviation from Veronese's to Palma's style. Other drawings handed down as by Carletto are no less erratic, as for instance, No. 2208, supported by an old inscription which Hadeln accepted, and we, too, are willing to accept, although there is no connection with a painting and hardly any relationship to Carletto's style to be found. More reliable is the inscription on the back of No. 2199, but being a special study of hands the drawing is less suited to give an idea of the artist's capacity in drawing his inventions. A special case is No. 2206 in Munich. It would be the ideal specimen of Carletto's sketching style if the evidence were not too good to be true. If Carletto at the age of seventeen, or less, had really painted ceilings in the Casa Cornaro at Poisolo (perhaps Asolo?) he must have done so under his father's supervision, or at the bidding of his father who had the order and therefore made the sketch. Carletto's mailing of the drawing to his father's address in Venice makes little sense. Moreover, the composition is so different from Veronese's that even Carletto could not be credited with so much independence. We had no opportunity of checking the inscription, but are rather inclined to doubt its authenticity. Is it mere coincidence that in this circumstantial inscription a Casa Cornaro again appears as happened on that alleged Domenico Campagnola drawing in Düsseldorf, the inscription of which was unveiled by Hadeln in *Repertorium* XXXI, p. 168 as a forgery? At any rate, there are enough grounds warning us not to construct our idea of Carletto's drawing style on this sheet.

As for Gabriele who in the above mentioned letter is introduced as the one who finished the painting after the death of Benedetto (Carletto had already died two years earlier) he completed only a few pictures which

were already begun, and then retired to live on his own means. Of so unambitious a man we shall not expect very much. In the family collection kept together by Giuseppe Caliari, to whom incidentally Ridolfi dedicated his life of Paolo, several portraits in crayon are mentioned as by Gabriele and especially well done. Of pieces executed in this delicate and therefore very perishable technique we tentatively propose for Gabriele No. **2215**, closely connected with Veronese's art.

SCHOOL OF PAOLO VERONESE

Our list first enumerates the drawings which we ascr. to Veronese's shop in general and then adds those which we attribute to Benedetto, Carletto and Gabriele Caliari, respectively.

A 2158 AMSTERDAM, REMBRANDTHUIS. Martyrdom of a saint. Pen, br., wash, on wh. 155 x 95. Cut at the l. — On *verso:* Woman sewing (or cutting her nails). Inscription in pen: paolo Veronese. Coll. Zoomer and Schmidt-Degener. Publ. by Schmidt-Degener, in *l'Art Flamand et Hollandais*, 1913, p. 180 f. and in Onze Kunst 1913, II, p. 8 and 9 as Paolo Veronese's first sketch for his painting in the Prado no. 530, representing the "Martyrdom of Saint Genesius." The drawing on the *verso* according to Schmidt-Degener might have inspired Rembrandt's portrait drawing of Tilia van Uylenburgh in Stockholm. Fiocco, Veronese I, p. 167, note 5 rejects the attr. to Paolo Veronese and suggests Benedetto as the author. [*Both sides.* **MM**]

The "Martyrdom of S. Genesius" in Madrid, ill. Venturi 9, IV, fig. 623 is completely different from the drawing which, on the contrary (as already recognized by Osmond p. 103), is identical in its composition with "The martyrdom of St. Sebastian" in the church of this saint in Venice, ill. Fiocco, I, p. 57. The section at the l. of the painting has been cut in the drawing. In our opinion, the drawing is a typical copy done from the painting confirmed by the way in which the shadows are rendered. Since the copy is contemporary and hasty — compare the missing hand holding the club above the head of the executioner in the middle — it was mistaken for a sketch. Fiocco's attr. to Benedetto shows that he, too, did not believe in Paolo. There are not sufficient characteristics to enable us to believe in Benedetto rather than in someone else.

2159 BERLIN, KUPFERSTICHKABINETT, 5552. Adoration of the magi. Pen, brush, wash. 165 x 181. Ascr. to Paolo Veronese. [**MM**]

In our opinion, shop production.

2160 BESANÇON, MUSÉE, 3164. Adoration of the magi. Pen, bl. br., gray wash, on blue. Horizontal. Ascr. to Paolo Veronese.
[*Pl. CLXII,* 2. **MM**]

Modello or shop copy of a painting a version of which exists in the museum in Lyons. This version and probably the whole invention belongs to Veronese's school.

2161 ————, 3165. Draped woman (Susanna?). Brush, gray and br., on blue. 226 x 139. F. Ingersoll-Smouse mentions this drawing in *Gaz. d. B. A.* 1928, p. 29 as connected with the painting in the Yarborough coll: which she ascr. to Parrasio Micheli. [**MM**]

In our opinion, this drawing is not an original design, but fragmentary working material from Veronese's shop.

2161 bis ————, 2244. Calvary. The three crosses to the l., a group of soldiers, some on horseback, to the r. Pen, dark br.-gray br. wash, on blue. 199 x 297. Inscription: Tintoretto f. 52. Ascr. to Jacopo Tintoretto. (Arch. Ph. BAP 2585). [*Pl. CLXII,* 3. **MM**]

The composition shows some relationship to Paolo Veronese's "Calvary" in the Academy in Venice (no. 255, ill. Fiocco *Veronese, II,* pl. CLXXX, top). The penwork resembles that of No. **2206**, attr., perhaps wrongly, to Carletto. We note a remarkable dependence of the warrior on horseback on Titian's invention (No. **1941**) which apparently enjoyed popularity in Venice.

2162 CAMBRIDGE, ENGLAND, FITZWILLIAM MUSEUM, 77. Saint Menna. Brush, brownish gray, on blue. 395 x 200. Stained by mold. Cut below so that the feet of the saint are missing.

The drawing believed to be Veronese's design for his painting in Modena, ill. Fiocco, *Veronese II,* 114, is, in our opinion, working material or a copy done in the shop.

2163 CAMBRIDGE, MASS., FOGG ART MUSEUM, 203. Crucifixion; a second version of the Virgin, supported by one of the women, below. Pen, wash. 295 x 200. — On *verso:* Two versions of a Circumcision. Inscription: 387 aque'to (in the same handwriting as 582 on the back of No. **2079**. For "aque'to" see No. **2077**). Watermark a cross within a circle surmounted by a star (Briquet 3075). Gift of Philip Hofer. Ascr. to Paolo Veronese. Publ. in *Art News* 1939 by Frankfurter who dates the drawing about 1580. *Mostra Paolo Veronese* p. 219, V: the technique of the drawing, still typical of the 1560's induces us to date the painting in the Louvre which the drawing prepares, not too far after 1570. Exh. Toledo 1940, *Cat.* no. 98 raises doubts however not taken up by Mongan-Sachs p. 107 ff. [*Pl. CLXIII,* 1 *and* 2. **MM**]

The *recto* is believed to be Veronese's design for his painting in the Louvre no. 1195 (ill. *Mostra* p. 136, fig. 54). This painting formerly ascr. to Veronese's school, is now considered an important work of his late period. There are, however, a few points which make us return to the former opinion: 1) The painting, without being a sketch, is a small and simplified version of the far more important painting now in the Academy, Venice (ill. Fiocco, *Veronese, II,* pl. CLXXX, top). In the latter, the arrangement of the crosses at l. is clearly counterbalanced while in the small version this part gives the impression of a section from a larger composition. 2) The view of the town lacks the unreality typical of Veronese's views of this kind.

This analysis was necessary for the discussion of the drawing which, likewise, does not convincingly display Veronese's characteristics. The connection with the Louvre painting is obvious. There are only a few deviations. (Compare the posture of the kneeling woman next to the Magdalene, and the thief at r., less foreshortened than the one in the painting.) But a sketch indulging in such minute details would be unique among Veronese's drawings. A sketch in which the female figures would not be discernible under their draperies! Such an exception might, of course, be explained by the fact that the draw-

ing contains the final composition as we also find it in the painting in the Louvre. But the same minuteness, the same interest in the types and their expression appears also on the *verso* where the arrangement of the figures is far from being final, since two different versions are offered. (A "Circumcision" by Paolo Veronese is mentioned in Cà Bonfadini by Boschini, *Carta*, p. 332.) The penmanship, moreover, resembles Veronese's early style, while the drawing would have to be later in view of the date of the "Crucifixion." In our opinion, the penmanship is by no means so masterly as in the other drawings, but rather feeble and hesitating. Compare, for instance, two authentic sketches of the same subject in No. 2072.

The drawing may have been done by a pupil of Veronese, influenced by the "Crucifixion" in Venice, and have been a design for the painting in the Louvre which the same pupil might have executed. It is typical of a pupil to imitate his master's style in a somewhat earlier stage. Both figures of the thieves are apparently under the influence of Veronese's "Calvary." In the one at l. the *pentimenti* allows us to recognize how the figure took shape, the legs of the other at r. are fastened to the cross at the same point as is the case in the painting in Venice. In the one in the Louvre their posture is modified. The various points enumerated explain why we doubt that the drawing is an exception in Veronese's production, but consider it rather the work of a pupil. The alternative that the drawing was done by a pupil after the Louvre painting seems less plausible, for in that case the connection with the Calvary in Venice would not be explained.

2164 CHANTILLY, MUSÉE CONDÉ, 122. Madonna and Child seated above cloud. Pen, brush, br., height. w. wh. 85 x 140. Old inscription: Paolo V. Coll. Denon and Reiset. **[MM]**

Typical of Veronese's shop. The composition is similar to No. 2032, but poorer in quality.

2165 CHATSWORTH, DUKE OF DEVONSHIRE, 278. Allegory: Female figure holding chalice and ring, and facing a pope and a doge, while clergymen and other attendants seem to be leading up an old man. In the clouds Saint Mark, Saint James and a third saint. Pen, br., height. w. wh. and pink, on green. 437 x 583. (Photo Braun B 176–91.) Ascr. to Paolo Veronese.

In our opinion, a typical shop production.

A 2166 DRESDEN, KUPFERSTICHKABINETT. The flaying of Marsyas. Pen, wash. Ill. in Meissner, p. 38, fig. 28.

The composition resembles a painting which existed in the Cabinet du Roi under the name of Paolo Veronese and has been engraved in reverse. The mediocre drawing might be a copy from this painting. (We have not seen the original.)

2167 EDINBURGH, NATIONAL GALLERY, 668. Catarina Cornaro presenting her crown to the Doge. Over red ch. pen, darkgray, wash. 164 x 310. The corners are cut. Ascr. to Federigo Zuccaro. **[MM]**

In our opinion *modello* of the painting of this subject (Fr. Zanotto, *La Regina Caterina Cornaro in atto di cedere la corona. . . ,* Venice 1840) sold around 1842 from the Infants' Asylum in Venice and later on in the Schönlank Coll. in Cologne in the sale of which it appeared in 1896. Ill. in an engraving by Marco Comirato, a lithograph by B. Marcovich, and in *Monatshefte für Kunstwiss.* IV, p. 16. The identification of this painting with one mentioned by Ridolfi (I, p. 356, note) in the Palazzo Cornaro as a work of the Haeredes was rejected by Ingersoll-Smouse in *Gaz. d. B. A.* 1929, p. 29, n. 3, who identified a painting in the Museum in Lyons with the one in the Palazzo Cornaro. Both paintings are typical shop productions.

2168 FLORENCE, UFFIZI, 1852. Various sketches. Pen. 88 x 164. Cut. Later inscription: Paolo Veronese f. — On *verso:* hasty sketch for a Rachel at the well. Hadeln, *Spätren.,* pl. 47, main side only: Paolo Veronese. Accepted by Osmond 103. Fiocco, *Veronese I,* p. 208. **[MM]**

Hadeln's explanation of the subject, accepted by Fiocco, as Christ in the House of Levi, is erroneous. The scene in the middle shows people busy around a chest, the sketches at the l. and at the r. refer to a Rape of Europa. We date the drawing after 1580, the date of Veronese's famous composition now in the Ducal Palace, the influence of which is very conspicuous on all of Veronese's pupils. One of them may be the author of this drawing in which Paolo's personal characteristics are lacking.

2169 HAARLEM, COLL. FR. KOENIGS, I 92. Mystical marriage of St. Catherine, surrounded by large angels. Bl. ch., wash, height. w. wh., partly oxidized. 207 x 311. — On *verso* inscription: Paulo V. Nº 21. Ascr. to Paolo Veronese. **[MM]**

The drawing is spoiled by oxidation, but, at any rate, seems too poor to be by Paolo himself. The subject is one of Paolo's favorites, and Ridolfi lists half a dozen versions in various collections. The existing compositions formed by full-length figures were altar-pieces and consequently arranged vertically, while horizontal compositions are more intimate and limited to half-length figures. The composition in our drawing points to a later development.

2170 LONDON, BRITISH MUSEUM, 1890–4–5 — 172. Ecce Homo. Over ch. pen, lightbr., washed in grayish br., height. w. wh. 326 x 285. Ascr. to Paolo Veronese. Osmond 103: extradubious. **[MM]**

The composition with its emphasis on the rendering of depth shows a certain resemblance to the "Healing of the paralytic" by Fasolo in the Museo Civico in Vicenza, ill. Venturi 9, IV, fig. 728, but the manner of drawing is closer to the school of Veronese than might be expected of Fasolo.

2171 MILAN, MUSEO DEL CASTELLO. A group of drawings representing allegorical figures. Brush, blue or gray wash, height. w. wh., on blue. Coll. Bolognini, except i), which came from the Camillo Tanzi coll.

 a) 165 x 207. **[MM]**

Identical with the Fama in Paolo Veronese's ceiling, formerly in Villa Soranzo, now in the sacristy of the cathedral in Castelfranco, ill. Fiocco, *Veronese I,* p. 20, fig. 14.

 b) Female genius recumbent. 204 x 285. Exactly like Paolo's fresco from Villa Soranzo, now in the Seminario Arcivescovile in Venice, ill. Fiocco p. 22, fig. 16. **[MM]**

 c) Two cupids pouring water on a burning torch. 183 x 131. Corresponding to Veronese's ceiling in Palazzo Trevisan, in Murano, ill. Venturi 9, IV, p. 790, fig. 556. The drawing is ill. in E. Tietze-Conrat's article in *Art Quarterly* 1940, Winter, p. 34, fig. 22 and contrasted to No. 2110. **[MM]**

 d) Two female figures seated. 200 x 285. **[MM]**

 e) Flying angel with a palm branch. 160 x 205. **[MM]**

 f) Female figure seated, turned to the r. 205 x 160. **[MM]**

 g) Companion to the preceding drawing, turned to the l. **[MM]**

 h) Mercury embracing a woman. 168 x 250. **[MM]**

 i) Seated female figure with musical instruments. 205 x 152. **[MM]**

 j) A couple embracing. 187 x 250 **[MM]**

 k) Woman seen from behind, holding a harp. 197 x 160. **[MM]**

 l) Two female figures recumbent. 278 x 278. **[MM]**

The last drawing (l), formerly ascr. to the school of Paolo Veronese, is now atributed to Andrea Vicentino, but, in our opinion, forms part of the series, here attr. to Zelotti. The identification of two of them as connected with the Villa Soranzo and of one as connected with the Palazzo Trevisan in Murano, leads us to suppose that the others which are identical in their character were also connected with these two decorations, now partly or entirely destroyed. None can with certainty be identified with the fragments from Villa Soranzo, as described in the *Giornale dell'Italiana Letteratura* 1818, p. 188 when they had just been transferred to canvas. In both places, Villa Soranzo and Palazzo Trevisan, Paolo Veronese and Zelotti are supposed to have worked in 1551 and about 1557, respectively. In these years, according to Hadeln, they seem to have regularly co-operated and to have had a common workshop. The drawings in Milan, in our opinion, are productions of this workshop and connected with the execution of the murals. Their difference in quality and character from an original sketch by Veronese is made clear by a comparison with No. **2110** corresponding with No. c) above. The difference from Zelotti's authentic drawings is also noticeable so that we have to allot to these drawings another place within the execution of the decorations, compare E. Tietze-Conrat, in *Art Quarterly,* Winter 1940, p. 37 ff.

2172 MILAN, AMBROSIANA. Crucifixion. Brush, height, w. wh. (Photo Braun 75183). Ill. Meissner p. 34, fig. 25 as Paolo Veronese. Fiocco, *Veronese I,* p. 209: Probably shop.

The composition exists as a painting in Dresden no. 232, attr. to Carletto by Fiocco, p. 197, and a second time under the name of Benedetto Caliari in the Art Museum of Yale University in New Haven. Working material of the shop.

2173 ————. The Holy Cross surrounded by four angels above and five saints below (at l. St. Helena and two women, at r. a bishop and an Oriental king). Brush, height. w. wh. Semicircular top. (Photo Braun 75183) Meissner fig. 19: Paolo Veronese. Fiocco, *Veronese, I,* p. 209: Probably school.

In our opinion, a shop production at best.

2174 ————. Resta Coll. On show. Adam and Eve and two little children. Pen and brush, bl. br., wash, on blue. About 200 x 275. Upper l. corner damaged. Publ. by Suida, in *Gaz. d. B. A.* 1938, I, p. 170 as Paolo Veronese's design for a painting which Suida has seen in Switzerland and which he supposes to have had been sold to a private collector in Dresden. Suida dates the painting which he does not illustrate about 1560, earlier than the other versions of this subject. Morassi in *Boll. d'A.* S. III, December 1937, p. 241 independently stated the connection of the drawing with two paintings of the same subject in Vienna and in the storerooms of the Ducal Palace in Venice. The *cat.* of the Vienna Gallery 1938, p. 188, no. 388, calls the drawing a design for the painting in Vienna.

We have not seen even a reproduction of the painting in Dresden. As for the drawing, the composition must be much later than 1560, in our opinion, and its style is typical of a school production in which the formal elements typical of the master are diluted.

2175 NEW YORK CITY, PIERPONT MORGAN LIBRARY, IV, 88. Three saints: Mark, Leonhard, Francis. Brush, height. w. wh., on gray. 290 x 210. Semicircular top. Coll. Lely, Lanckring, Mayor, Fairfax Murray. Ascr. to Paolo Veronese.

More likely a shop production, in the direction of Benedetto Caliari, see No. **2195**.

2176 OXFORD, ASHMOLEAN MUSEUM. Sketch for an unidentified subject, group of three persons worshipping a standing man. Pen, grayish br., on faded paper. 75 x 128. Inscription in upper l. corner: P. C. V., in lower r. corner: Paolo Caliari Veronese. — On *verso:* first lines of a letter in a handwriting of the 16th century. Coll. Sir Joshua Reynolds. **[MM]**

The figure at the l. resembles to a certain extent the figure of Christ in the painting "Christ and the Centurion," Dresden no. 228, ill. Meissner, p. 11, fig. 8, but the style is not that of the master himself, but of his school.

2177 PARIS, LOUVRE, 4671. Saint John the Baptist, Saint Andrew and between them a sainted bishop to whom a kneeling page presents an open book. Pen and brush, height. w. wh., on gray. 280 x 234. **[MM]**

The page is almost identical with the (reversed) figure in Paolo Veronese's altar-piece of S. Anthony, in the Brera, ill. Venturi 9, IV, p. 1098. This circumstance confirms our attr. of the drawing to Veronese's shop.

2178 ————, 4672. Saints Mark, Francis and Norbert (?). Pen, br., height. w. wh., on gray. 282 x 245.

Companion of the preceding number, also a shop production.

2179 ————, 4673. The Martyrdom of St. Justina. Pen, br., wash. 198 x 156. **[MM]**

The composition is typical of a school production. Some sections are taken in the same direction, others in reverse from the master's painting representing the same subject and now in the museum in Padua, ill. Fiocco, *Veronese I,* fig. 59. (The drawing allows us to suppose that Paolo's painting, too, originally was vertical and is now cut.) The style of the drawing with the slender figures and the nervous touches of wash points to the younger generation, see No. **2158** and **2212** which we list as productions of the school. A painting similar to the drawing existed in the Coll. Willi Streit, Hamburg, where it was listed as copy from Veronese (Photo 105792, in the Kunsthistorisches Institut, Florence).

2180 ———— 4681. Saint George and a monk worshipping the Holy Virgin. Pen and brush, wash, height. w. wh., on prepared green paper. 300 x 200. Cut below.

Another version (copy?), not cut below, in the Skippes Coll. Malvern **[MM]**. Both are productions of Veronese's shop.

2181 ———— 4686. Adoration of the shepherds: above two angels holding scrolls. Pen, br., wash. 300 x 196; edges damaged. — On the back inscription: Alessio Sugana No. 41 (former owner?). In its style similar to No. **2212**. M. André Linzeler drew our attention to a very similar painting by Veronese's "heirs" in the Academy in Venice (Alinari 36404).

2182 ————, 4699. God the Father and the dead Christ with two angels, S. Peter and S. Paul. Pen, gray, wash, height. w. wh., on blue. 398 x 224. Semicircular top. **[MM]**

The composition resembles the altar-piece in S. Croce in Vicenza, ascr. to Paolo Veronese, ill. in Wart Arslan, *Boll. della Società Letteraria di Verona* No. II, March 1933. In our opinion, the drawing is a shop production.

2183 ———— 5293. Adoration of the magi. Pen, wash, height. w. wh., on faded blue. 268 x 336. Inscription three times repeated: J. Bassan. **[MM]**

Slightly different copy from Paolo Veronese's vertical composition in the N. G. in London, ill. Fiocco, *Veronese I*, pl. LXVIII, executed by a follower of Paolo.

2184 PITTSBURGH, PA., CARNEGIE INSTITUTE. Woman kneeling holding a cloth in both hands. Bl. ch., fixed with brush, on faded blue. 259 x 171. On lower margin: Frate Bartolommeo. Coll. Sir Joshua Reynolds. [*Pl. CLXIII*, 3. **MM**]

The attr. to Fra Bartolommeo is void of sense. The motive and the penmanship point to Veronese's studio, although hardly to the master himself. Compare his "Mystic marriage of Saint Catherine" existing in various versions (see No. **2073**).

2185 STOCKHOLM, NATIONAL MUSEUM, 1433. Visitation. Pen, br., wash, on grayish blue. 300 x 193. Sirén, *Cat. 1917*, no. 468: Circle of Paolo Veronese, perhaps by the artist himself. [**MM**]

In our opinion, typical copy done in the shop, from a painting of the type of the De Powis picture, in Alnwich Castle, ill. *Gaz. d. B. A.* XXXV, p. 569. A copy of this painting in Parenzo, Museo Civico. We have not seen this and the following drawing.

A 2186 ———, 1467. Women on a terrace busy with homework. Pen, br., wash. 196 x 288. Inscriptions: (below) Andre Vicentino, (upper r. corner) Toutiano. Sirén *Cat. 1917*, no. 521: the style of the figures recalls the circle of Veronese. [**MM**]

Our knowledge of the minor masters in Venice in the early 17th century, and especially those with a popular trend, is hardly sufficient to venture an individual attribution.

2187 VIENNA, ALBERTINA, 112. Allegory of Victory. Pen, bistre, height. w. wh., on blue. 286 x 276. *Albertina Cat. I* (Wickhoff), 223: School of Paolo Veronese. Fiocco, *Veronese I*, p. 210, No. 5: Carletto?

In our opinion, the style is not sufficienty personal to attribute the drawing to a specific member of the shop.

A ———, 113. See No. **1281**.

A ———, 114. See No. **683**.

A 2188 ———, 115. Beheading of St. John the Baptist. Pen, bistre, wash. 292 x 180. The drawing listed in *Albertina Cat. I* (Wickhoff) as Venetian 18th century, was ascr. by Stix-Fröhlich in *Albertina Cat. II* to the workshop of Paolo Veronese, probably the same hand as No. **1281**. Fiocco, *Veronese I*, p. 140 gave the drawing, together with No. **2154** to Odoardo Fialetti.

The drawing is the design for an altar-piece in Clusone, Chiesa dell'Assunta. The author, listed as anonymous in Venturi 9, VII, p. 377 has been identified with Domenico Carpinoni, a pupil of Palma Giovine. The painting is ill. in *Inventario degli oggetti d'arte d'Italia, I, Provincia di Bergamo* (1931), p. 240.

2189 WINDSOR, ROYAL LIBRARY, 6696. Venice enthroned surrounded by five (four?) figures of Doges worshipping her. Over ch. pen, reddish br. 205 x 285. Late inscription: Paolo Veronese. Anonymous. [*Pl. CLXII*, 4. **MM**]

A general relationship to the school of Paolo Veronese is striking. The composition which might have left a trace in Van Dyck's no-longer-existing portrait group of the Brussels City Council (see Glück, in *O. M. D.* 1932, June, p. 2, fig. 1) might refer to the Morosini family which up to the end of the 16th century was the only one to have produced four Doges. (One of the five has not donned his Doge's cap.) In Villa di Strà Benedetto Caliari painted no-longer-existing pictures from the history of the Morosini family.

2190 ———, 6704. Presentation in the temple? Brush, bl. ch., br. wash, height. w. wh., on blue. 231 x 144. Listed as anonymous.

Our attr. rests on the resemblance with the paintings ascr. to the shop of Veronese in the upper "Albergo" of the Ateneo Veneto, and Paolo's chiaroscuros brought from San Antonio di Torcello to the Villa Reale in Strà, *Mostra Veronese*, p. 139.

BENEDETTO CALIARI

[See p. 352 f.]

A AMSTERDAM, REMBRANDTHUIS. Martyrdom of Saint Sebastian. See No. **2158**.

2191 BAYONNE, MUSÉE BONNAT, 126. Sainted pope between two other saints. Over ch. pen, br., wash, height. w. wh. 290 x 233. Coll. Gelosi. (Arch. phot. 16494.) Exh. as Paolo Veronese, École des Beaux Arts 1879, no. 216. Publ. by A. Venturi, *Studi*, p. 326, fig. 210 as Paolo Veronese and accepted as his by Fiocco, *Veronese I*, p. 207. An exact copy in the Ambrosiana is reproduced Meissner p. 27. Another repetition in the B. M. 1900–8–24—133. [*Pl. CLXIII*, 4. **MM**]

Our tentative attribution to Benedetto (instead of the shop of Paolo in general) is based on the resemblance of the types to those in Benedetto's painting "The birth of the Virgin" in the Academy in Venice, ill. Venturi 9, IV, fig. 778, and on the conformity of the line-work with the few authentic drawings by Benedetto.

2192 BERLIN, KUPFERSTICHKABINETT, 1549. The Virgin and Child and St. John Baptist as infant. Pen, br., height. w. wh., on grayish green. 220 x 169. Publ. in *Berlin Publ*, pl. 90 as Paolo Veronese. Accepted as his by Hadeln, *Spätren*, pl. 56. Fiocco, *Veronese I*, p. 142:

School, probably Benedetto. According to Fiocco another version exists in the Royal Library in Turin.

We agree with Fiocco for the attr. to Benedetto.

2193 EDINBURGH, N. G. OF SCOTLAND, Watson 225. Saint Jerome kneeling. Charcoal, fixed with brush, wash, on faded blue. 392 x 217. Old inscription: Benedetto Caliari. Slightly damaged by horizontal folding. [**MM**]

The old tradition seems trustworthy.

A FLORENCE, UFFIZI, Santarelli 7431. See No. **2064**.

A 2194 HAARLEM, COLL. KOENIGS, I 47. Two female fauns with children sitting on pedestals. Bl. and wh. ch., on blue. 151 x 267. Later inscription in pen: Benedetto Caliari. — *Verso:* B. C. No. 12. [**MM**]

The inscription Benedetto Caliari may rest on the initials written on the other side. In our opinion, the drawing is closer in style to Benedetto Castiglione's drawings of such subjects, some of which were etched by Saint-Non.

2195 LILLE, MUSÉE WICAR, 127. Christ accompanied by the ancestors appearing to the Holy Virgin. Brush and pen, height. w. wh. 260 x 350. Carefully executed like a *"modello."* Ascr. to Paolo Veronese. **[MM]**

The composition is certified for Benedetto by Ridolfi (I, 360) who mentions in the property of Giuseppe Caliari, the universal heir of this whole family, a painting by Benedetto "il Redentore che visita la Madre dopo la Risorrezione col seguito de' Santi Padri." Perhaps to be identified with the painting of this rare subject in the Escorial. Another later version, called Venetian School 16th century, in the Wohltätigkeitshaus in Baden, near Vienna, is reproduced in *Oester-*

reichische Kunsttopographie, vol. 18, p. 92, fig. 144. The drawing combines a general approach to Paolo Veronese's style with a dry execution. It might have been the *"modello"* for the painting in the Escorial.

2196 PARIS, LOUVRE, 4667. Christ holding a cross and standing above clouds between the SS. Peter and Dominic. Pen and br., height. w. wh., on gray. 234 x 241. Publ. by Hadeln, *Spätren.,* pl. 61 as Paolo Veronese. Fiocco, *Veronese I,* p. 142: School.

We join in Fiocco's doubts and attr. the drawing to Benedetto Caliari with reference to No. **2195.**

CARLETTO CALIARI

[See p. 352 f.]

2197 BERLIN, KUPFERSTICHKABINETT. Reserve. Annunciation. Pen, br., wash. 201 x 156. Stained by mold. Inscription: Carlo Caliari figlio di Paolo Vero^se. — On the back: Part of a letter not signed. The name of Carletto is repeated here.

We have not seen the drawing.

2198 CHICAGO, ILL., ART INSTITUTE, 2212. Adoration of the magi. Pen, wash, height. w. wh., on blue. 203 x 305. Upper r. corner torn off, also otherwise damaged. Coll. Padre Resta, L. H. Gurley. **[MM]**

Already ascr. to Carletto by Padre Resta.

2199 CLEVELAND, OHIO, ART MUSEUM, 29549. Studies of hands. Bl. ch., height. w. wh., on bluish gray. 273 x 179. Inscription (pen): di Carlo Caliari figlio di Paolo Ver.^se — On *verso* old inscription: Amor di meritrice. Carletto Calliari è matto. Acquisto 1603. *[Pl. CLXIV, 1.* **MM]**

2200 FLORENCE, UFFIZI 12889. Design for an altar-piece: Madonna and Child with S. Nicholas, S. Catherine and two angels. Pen, br., wash. 180 x 142. *[Pl. CLXVII, 2.* **MM]**

The traditional attribution to Carletto seems plausible.

A 2201 ————, Ornati 118. Decorated frame with the lion of S. Mark in the top, and Christian and secular allegories between elaborate ornaments. Brush, br., height. w. wh., on faded blue. 463 x 673. **[MM]**

The ascr. to Carletto seems to be modern and corresponds very well with the date of origin, but the emphasizing of plastic values and depth, in our opinion, seems hardly compatible with Carletto's authentic works.

2202 HAARLEM, COLL. KOENIGS, I 46. Male nude recumbent seen from behind. Bl. ch., height. w. wh., on blue. 240 x 196. Old inscription in pen: Di Carletto. — On *verso:* Male nude seen from front. Inscription: C. C. No. 15.

A 2203 LISBON, ROYAL ACADEMY. The Holy Trinity crowning the Virgin. Pen, wash, height. w. wh. Semicircular top. Ascr. to Carletto Caliari.

In our opinion, which is based only on a photograph, the drawing is a copy from the painting in the Academy in Venice, attr. to Paolo Veronese's shop by Fiocco and to Francesco Montemezzano by A. Venturi (ill. Fiocco, *Veronese II,* pl. CLXXXIII B and Venturi 9, IV, fig. 741). An authentic sketch connected with the same painting is No. **2038.**

2204 LONDON, VICTORIA AND ALBERT MUSEUM, Dyce 250. Mythological scene (Medea?). Pen, br., wash, on paper turned yellow, upper l. corner added. 181 x 353. An inscription in upper l. corner is cut and illegible. — On the back recent inscription: School of Paolo Veronese. *[Pl. CLXVII, 3.* **MM]**

The drawing is apparently cut at the r.; originally it had more the shape of a frieze. In our opinion, the drawing might be connected with Carletto's paintings (in collaboration with Gabriele) in the "tinello del Fondaco dei Tedeschi" (Ridolfi I, 357), later ascr. to Paolo Veronese by Boschini, *R. Minere,* San Marco, p. 110, and Zanetti, p. 266. See also No. **2213.**

A 2205 MUNICH, GRAPHISCHE SAMMLUNG, 10497. Musicians sitting on a gallery. Pen, br. 131 x 143. Cut on both sides (at the l. a figure playing the clavicembalo has been cut). Later inscription: Carletto C. — On the back a letter (of which we have not even seen a reproduction). *[Pl. CXCIV, 3.* **MM]**

The realistic treatment of the figures and their costume are not compatible with the period of Carletto. Compare similar motives in the murals executed by the Bolognese painters Mitelli and Colonna in the Palazzo Estense in Sassuolo, in 1646, ill. in *L'Arte* XX, p. 72 ff.

2206 ————, 34850. Cupid and Psyche. Pen, br., wash. 185 x 240. — On the back inscription: Io Carlo Caliari feci il presente dissegno per la Sala di Ca Cornaro a Poisolo per il spazio grande. Al' honorando Sign. Paolo Caliaro S. Apostolo, Venezia. — Mannheim Coll. *[Pl. CXCIV, 4.* **MM]**

We have not seen the drawing and therefore were not in a position to examine the inscription which in Munich is considered authentic. Its very minuteness of details arouses suspicion. Had Carletto executed such an important work in his father's lifetime (Carletto was only 17 or 18 years old when Paolo died) he would most probably have worked after a sketch of his father's or at least would have followed the father's style. Under these circumstances we recommend caution and prefer not to make the drawing the point of departure for other attributions. See p. 353.

2207 NEW YORK, PIERPONT MORGAN LIBRARY, IV, 85. Portrait of Andriana Palma. Many-colored crayons. 277 x 185. Inscription in ch.: 1591 adi 8 deceb si maritò. In upper r. corner inscription in pen: Andriana Palma 1591 decembris. In lower r. corner: Carletto Caliari 1591. Exh. Toledo 1940, *Cat.* No. 75. *[Pl. CLXV.* **MM]**

A OXFORD, ASHMOLEAN MUSEUM. Head of a bearded man. See **230.**

2208 Paris, Louvre, 5575. Saint John the Evangelist. Bl. ch. 245 x 193. Old inscription: (pen) Carletto Veronese (and number 730). At r.: Carletto (partly canceled). Publ. by Hadeln, *Spätren.*, pl. 63.

2209 Stockholm, National Museum, 1456. Adoration of the magi. Pen, br., wash, on br. 274 x 184. Sirén, *Cat. 1917*, no. 469: Paolo Veronese, with reference to No. **A 2148**. The attr. was accepted by Borenius, *Burl. Mag.* XXXVIII, p. 55, note. **[MM]**

In our opinion, not by Paolo Veronese but by a member of the shop who simplified the composition of the "Adoration" in the Brera, ill. Fiocco, *Veronese I*, pl. XCV. The style is close to drawings bearing Carletto's name of old.

A 2210 Vienna, Albertina, Reserve. Raising of Lazarus. Photo Braun 70232. Mentioned by Hadeln, in *Thieme-Becker* V, p. 391 as design for Carletto's signed painting in the Academy in Venice, no. 246, but not listed in *Albertina Cat. II* (Stix-Fröhlich). Fiocco, *Veronese I*, p. 160 agrees with Hadeln, with reference to No. **2208**.

In our opinion, the drawing is certainly a copy after the painting.

2211 Windsor, Royal Library, 4789. Allegorical composition: Venice enthroned accompanied by SS. James and Justina, below

Turkish prisoners and men offering booty. Over ch. pen, br., wash, on yellow. Circular 220 x 230. Ornamental frame indicated. Inscription in pen: Carletto. A more finished version of the same composition with slight modifications in Düsseldorf, Academy, Budde 947, there attr. to Rottenhammer and considered the design for a dish. Another very finished version in the Cat. of the Graupe Sale, Berlin 1929, April 17, no. 198, pl. V, as design for a ceiling; the pendentives are filled with marine deities. [*Pl. CLXIV, 3.* **MM**]

The design apparently connected with the Battle of Lepanto shows the general character of the Veronese School and the old attribution to Carletto might be trustworthy.

2212 ———, 6689. Holy Family with adoring saints; architecture and landscape. Pen, br., wash, on yellowish. 246 x 207. Ascr. to Zelotti. [*Pl. CLXXVII, 1.* **MM**]

In our opinion, closer to Carletto. Compare the drawing No. **2204**, and for the mannered style the painting in Sarasota, Florida, "Rest on the flight into Egypt" (ill. Venturi 9, IV, fig. 608) which, on the ground of its signature: Paoli Caliari Veronesi (Filius?) Faciebat and its advanced style we are inclined to ascribe to Carletto, contrary to our *cat.* of Toledo exh. 1940.

GABRIELE CALIARI

[*See p. 352 f.*]

2213 Paris, Louvre, 4677. The Rape of the Sabines. Pen, br., touched with watercolors and washed with br. 118 x 418. Crozat Coll. [*Pl. CLXII, 1.* **MM**]

The drawing might be in connection with the friezes painted on leather by Carletto and Gabriele Caliari in the Fondaco dei Tedeschi in Venice (Ridolfi I, 357: Sabine capite concorse ad una solennità de' Romani). Since the style is more conventional and the penwork different from Carletto's more or less authentic drawings we tentatively attr. the drawing to the other collaborator.

2214 ———, 5640. Saint Peter standing and Saint Mark seated. Pen, br., wash, height. w. wh., on faded blue. 210 x 201. Old inscription Gabriel Caliari. **[MM]**

The attribution has no other justification but the inscription.

2215 Paris, Coll. Mme Patissou. Head of a young woman with an Oriental hairdress. Many-colored ch., on faded blue. 205 x 145. Corners cut. Inscription in pen: Scuola di Paolo. Coll. Sir Joshua Reynolds. Exh. London, Mathiesen Gallery 1939, *Cat.* No. 111 as Paolo Veronese, possibly study for a woman taken in adultery. [*Pl. CLXIV, 2.* **MM**]

The Oriental headgear might make us think of figures like those in the painting "Esther before Ahasuerus" in Florence, but types and linework differ so widely from Paolo's that we suggest the attr. to Gabriele on the basis of Ridolfi's (I, 361) reference to "ritratti a pastelli rarissimi" by Gabriele.

ANDREA DEI MICHIELI, CALLED IL VICENTINO

[*Born c. 1542, died c. 1617*]

What we know of Vicentino's formation as an artist is next to nothing. Since he was Vicentine by origin and is not mentioned in Venice before 1583 (book of the painters' guild), our guess is that he developed his style under the guidance of G. B. Maganza, whose pupil he is called (Thieme-Becker, vol. XXIV, p. 532). This theory is supported by a marked affinity of Maganza's large Calvary (Uffizi 12862) to a group of drawings which, for other reasons, we are inclined to ascribe to Vicentino's early period.

To avoid the risks attending the critic who dares to penetrate the unknown lands of almost any artist's early period, we must start from a well-established position. Such a position is offered by those few drawings which we consider the best authenticated for our artist. They are: No. **2216**, established by the close connection with one of Vicentino's principal paintings, Nos. **2218**, **2229**, certified by trustworthy signatures, No. **2241**, the *modello* of a signed painting. The date of the latter places the drawing also around 1606; the other three cannot be much

earlier, judging from stylistic criteria. The earliest, but still from the last quarter of the 16th century, is No. **2216** which represents the sensational visit of the King of France in 1574.

To this nucleus of best established documents a few others may be added by reason of their close stylistic relationship to them: **2222, 2232, 2235**. They help round out our idea of Vicentino's mode of drawing of about 1600.

Prior to this date, Vicentino had painted his "Battle of Lepanto" which replaced Tintoretto's mural destroyed by fire in 1577. As in the case of "King Henry III's reception in Venice," no precise date is handed down, but from the petition made by Tintoretto's widow in 1600 we know that at that time the substitute painting was already on the wall in the Sala dello Scrutinio. There is a temptation to connect the sketch No. **2228** with this famous battle-piece: it follows the early established scheme for the Battle of Lepanto, but shows no striking stylistic relationship to Vicentino.

Those alleged early works to which we alluded at the beginning of this introduction, most of which are listed in their respective collections under the general heading of Tintoretto or School of Tintoretto, form a group. We refer to Nos. **2231, 2233, 2236, 2240**, to which we add No. **2219**, the first drawing published as Vicentino's after the erroneous ascription to him of No. A **2239**. We do not agree with Giglioli who interpreted an inscription on the drawing as Vicentino's signature; we wonder whether the reading "Visentini" of the second word is correct; furthermore, there is no doubt that the first name is Dominique and not Andrea. Also the connection with an almost identical painting in the Palazzo Pitti is no genuine evidence, since this painting was formerly ascr. to Mirabello da Salincorno, and was attributed to Vicentino only from its resemblance to the drawing. Despite all these objections we feel inclined to accept Giglioli's suggestion, in view of the very marked approach of the drawing to the Circle of Maganza whence we would expect Vicentino to have taken his departure.

This construction is certainly far from being stable, but it helps us to understand Vicentino's specific place within the art of Venice and confirms what Ridolfi, disapproving of Vicentino as a designer, said about his prevailing coloristic interests. Vicentino's pictures and painted sketches produce indeed a homogeneous idea which the drawings at the most confirm, but hardly enrich. The demarcation toward the schools of Titian and Tintoretto and also toward Palma Giovine is quite simple: Vicentino is not capable of sustaining his mood of pathos. In every composition, even if it starts on a most pathetic key, we discover some straddling lansquenet who adds a note of triviality. Vicentino is spirited as a painter, lively as a draftsman, and yet nothing invites more intensive penetration. He remains what his name implies: a provincial artist from Vicenza, in spite of his honest efforts to adjust himself to his new home. His more careful studies of single figures like Nos. **2225, 2226**, are homages to the style of Venice, most of all to Jacopo and Domenico Tintoretto. It is even possible that he occasionally worked under Domenico's supervision. The latter's drawing No. **1526, 2** is a design for a mural in the Scuola di San Giovanni Evangelista, executed by Vicentino. Nevertheless, he cannot be considered a member of the Tintoretto shop as Adolfo Venturi made him when claiming for him an important share in the execution of decorative paintings in the Ducal Palace ordered of Jacopo and ascertained for him by drawings (see Nos. **1593, 1657, 1658**). See above, p. 297.

Vicentino's early style, as we have tried to construct it, was continued in a number of drawings, for instance No. **2234**, in which the same elements reach a mannerism too far advanced for Vicentino himself. Listing them as "School of Vicentino" (thinking first of all of Vicentino's son Marco) we nevertheless remain aware that such attributions are not supported by connections with individual paintings or with documents. There is also a

distinct relationship to the drawings discussed under No. 1754. Accordingly these drawings may as well derive from Maganza whose style had influenced Vicentino in his beginnings.

2216 CAMBRIDGE, MASS., FOGG MUSEUM OF ART, 211. Reception of King Henry III in Venice, in 1574, preparatory study of Vicentino's mural in the Sala delle Quattro Porte in the Ducal Palace (ill. Venturi 9, IV, fig. 457). Pen, gray wash. Circular, diameter 286. Watermark: Siren in a circle. Coll. Barnard, Charles Loeser Bequest 1932, 345. Formerly ascr. to Taddeo Zuccaro, identified by Mongan-Sachs p. 112 ff., fig. 108. [Pl. CXXXIX, 2. MM]

A 2217 CHELTENHAM, FENWICK COLL. Battle. Pen, br., wash, height. w. wh., on green. 552 x 420. Coll. B. West. Formerly ascr. to J. Tintoretto. In Fenwick Cat. p. 110, 1: perhaps Vicentino, with reference to his paintings of such subjects in the Ducal Palace in Venice. [MM]
We agree with this reference as far as the composition goes, but do not recognize Vicentino's style for the draftsmanship.

2218 FLORENCE, UFFIZI, 1862. Scene in a kitchen, pen and brush, br. wash. 210 x 276. Inscr. (17th century); di Vicentino.
[Pl. CXL, 3. MM]
The correctness of this attr. is confirmed by the resemblance to No. 2229.

2219 FRANKFORT/M. STAEDELSCHES INSTITUT, 13449. The head of St. John the Baptist brought to Herode. Pen, wash. The margins slightly restored. 191 x 305. Coll. A. von Lanna, de Lagoy. Fairly old inscription: Dominique Visen(?)tini. O. Giglioli publ. the drawing in Rivista d'A. 1929 p. 364, as a design for a painting in the Palazzo Pitti in Florence formerly ascr. to Mirabello da Salincorno and later, more correctly, to an anonymous Venetian of the second half of the 16th century. [Pl. CXL, 1. MM]
The inscription which might refer to an earlier owner or might be incorrect because of a slip of the pen, is certainly not sufficient evidence for Andrea Vicentino's authorship. But the stylistic relationship with Maganza, supposedly Vicentino's teacher, makes us accept Giglioli's attribution. The drawing, if his, would belong to Vicentino's early period.

2220 ————, 6901. Martyrdom of St. Thomas. Pen, reddish br., wash. Squared with brush. 275 x 210. Long inscription referring to the legend of the saint. Coll. de Lagoy and W. Mayor. Ascr. to J. Tintoretto, but informally attr. to Vicentino by E. Schilling. [MM]
We accept the attr. and place the drawing in Vicentino's early period, though noting that his painting of the legend of St. Thomas in San Niccolò in Treviso, executed in 1590, is entirely different from the drawing.

2221 LONDON, BRITISH MUSEUM, 1856–7–12 — 1001. Beheading of St. John the Baptist on a staircase leading to the banquet hall. Pen, br., wash on yellow. 203 x 151. Ascr. to Jacopo Tintoretto.
[Pl. CC, 4. MM]
Possibly by a follower of Vicentino.

2222 ————, 1859–8–6 — 81. Studies for a gathering of Manna, patched together, to form a composition. Pen (over ch.). Br., wash. 247 x 347. Ascr. to Tintoretto. [MM]
In our opinion, closer to Vicentino (compare Nos. 2229 and 2218). A painting of this subject by Vicentino existed in the demolished church Santa Marta in Venice, mentioned in Boschini-Zanetti, Descrizione, p. 317.

2223 ————, 1910–2–12 — 38 (Salting Bequest). St. Lawrence before the Judge; at the foot of the stair the grate is being prepared for his martyrdom. Pen, br. wash. 292 x 194. Several words show through from the back. Ascr. to Ja. Tintoretto. [MM]
In our opinion, related to No. 2221 and perhaps by a follower of Vicentino.

2224 ————, 1938–10–8 — 169. Sketch of the "Floating Theatre" in Venice. Pen, br., on wh. turned yellow. 210 x 325. In lower l. corner later inscription: Tintoretto. Coll. René de Cérenville.
[Pl. CXXXVIII, 4. MM]
The "Floating theatre" was built in 1564 by the Compagnia della Calza in Venice. It is ill. in miniature, formerly in the Guggenheim Coll. in Venice, and in a woodcut in Cesare Vecellio, Degli habiti antichi, Venezia 1590, fol. 39, [MM] where it is circumstantially described. (The whole material is thoroughly treated in Lion. Venturi, Le Compagnie della Calza, in Nuovo Archivio Veneto, N. S. IX, vol. 17, p. 237 ff.). The buildings hastily sketched in the drawing are the Ducal Palace and the prisons ("Prigioni") with the Ponte degli Sospiri between them. Since the Prigioni still lack the rich façade which was begun in 1589, the drawing is to be dated between 1564 and 1589. Our attribution is merely hypothetical, based on the vivacity of the penstroke and on the general character.

2225 LONDON, VICTORIA AND ALBERT MUSEUM, Dyce 239. Youth in shirt and leggings seated on a folding chair. Bl. ch., on grayish wh. 260 x 276. Late inscription: G. Tintoretto. Coll. Reynolds. Reittlinger, Cat. No. 25: Jacopo Tintoretto. [Pl. CXXXIX, 1. MM]
Many details, such as the uncertainty of stroke and foreshortening, the indication of the chair, the shadow under the figure and the costume, the marked expressiveness of the pose, contradict Tintoretto's abstract style, in spite of the obvious approach to his mode of drawing. It is not the Master himself, but a follower. Moreover, two figures in Vicentino's "Allegory" in Schleissheim (Photo Witt), representing dance couples and spectators and personifications of virtues sitting on clouds (the second and the fourth spectator from left) seem to be based on this study.

2226 LONDON, THE SPANISH GALLERY. Dressed youth sitting and bending down toward left. Bl. ch., on buff. 160 x 145. Patched in two places. Late inscription (of the same hand as in No. 2225: G. Tintore (cut). Coll. Reynolds, A. G. B. Russell. Ascr. to Tintoretto.
[MM]
Our attr. is based on the resemblance to No. 2225 and the general style.

2227 ————. Dressed youth seen from behind, half-length, looking down over his l. shoulder. Bl. ch., height. w. wh. 250 x 170. Ascr. to Jacopo Tintoretto. [MM]
Our attr. to Vicentino is based on the resemblance with Vicentino's style, see No. 2225 and No. 2226. Moreover, figure and pose are typical of Vicentino (see the youth in the middle of the foreground in Vicentino's "Gathering of Manna" in the Carmine, in Venice, and various figures in Vicentino's historical paintings in the Ducal Palace).

2227 bis MALVERN, MRS. JULIA RAYNER-WOOD (SKIPPES COLL.). Dressed man seated hugging the elbow-rest of his chair. Bl. ch., height. w. wh., on faded blue. Colorspots. 280 x 175. Ascr. to Domenico Tintoretto. [MM]
Typical production of Vicentino.

2228 MILAN, MUSEO DEL CASTELLO, 95. Lagune with big boats in the foreground and city-view in the distance. Brush, br., on faded paper. 163 x 258. From Santa Maria in Celso. Listed as Anonymous Venetian 16th century. [MM]
There is a certain resemblance to the group of boats in the middleground at r. of Vicentino's "Battle of Lepanto," in the Ducal Palace, specifically to the battleship of the Papal commander Colonna. We must, however, keep in mind that the pattern of the representation of this famous battle had originated very early, and that a similar arrangement of boats appears quite frequently in Venetian paintings. Compare, for instance, the view in Sebastiano Venier's portrait by Jacopo Tintoretto in Vienna (ill. Bercken-Mayer, 174). Our attr. to Vicentino is entirely hypothetical.

2229 OXFORD, ASHMOLEAN MUSEUM. The flaying of Marsyas. Pen, reddish br., wash on wh. 158 x 226. Signed Andrea Vic° pittor.
Resembling in style the small mythological paintings in the museum in Padua. [Pl. CXXXIX, 3. MM]

2230 ———, Personification of Venice enthroned, surrounded by allegorical figures. Pen, wash on blue. 202 x 187. Ascr. to Vicentino.

2231 PARIS, LOUVRE, 597. Last Supper. Brush, reddish br., wash. 204 x 306. Late inscription: Tintoretto. Coll. His de la Salle. [MM]
Tentative attr.; companion piece of No. **2236**, perhaps an early work.

2232 ———, 5075. Venetian senators kneeling before the Doge. Pen, br., wash. 225 x 313. In the r. lower corner the inscription Andrea Vi(centino) has been erased. (Arch. Phot.) [MM]
About 1600.

2233 ———, 5367. Flagellation of Christ. Over ch. pen (?), brush, br., wash. 183 x 150. One of the executioners is patched over with another version. Ascr. to Jacopo Tintoretto. [MM]
Perhaps an early work of Vicentino.

2234 ———, 5377. Ceremony in a church (a bishop baptizing a kneeling woman?). Over red ch., pen, darkbr., gray and br. wash. 260 x 295. Ascr. to Jacopo Tintoretto. [Pl. CC, 3. MM]
This magnificent sketch shows a certain resemblance to Vicentino's painting "St. Charles distributing alms" in S. Sebastiano at Venice, but is so definitely advanced in style that we list it (together with Louvre 5374, 5376 and others) as school of Vicentino.

2235 ———, 5379. Two allegorical female figures enthroned, beneath them Sins or Passions tumbling and rushing away. Over ch., pen, reddish br., wash. 272 x 217. Coll. Alfonso III d'Este. Ascr. to Jacopo Tintoretto. [MM]
Stylistically very close to the best-established No. **2229**.

2236 PARIS, ÉCOLE DES BEAUX ARTS, 34924. Pilate washing his hands. Brush br., wash, height. with wh. 197 x 273. Ascr. to J. Tintoretto, exh. as his in 1935, Cat. no. 146. [Pl. CXXXVIII, 3. MM]
Companion piece of No. **2231**. Early.

2237 STOCKHOLM, NATIONAL MUSEUM, Sirén 520. Christ healing

the lame at the pool of Bethesda. Pen, br., wash. 462 x 350. Late inscription with biographical dates of Andrea Vicentino. [MM]
More prabably a shop production.

A ———, Sirén 1456. See No. **2209**.

A 2238 ———, Sirén 522. The Judgment of Paris. Pen, br., wash, on br. 300 x 420. Inscription: Vicentini. [MM]
Sirén questions the traditional ascription to Vicentino. Indeed the penwork is not quite convincing. But since the composition is rather near to Vicentino's painting of the same subject in Padua, the drawing may be a copy after Vicentino in his workshop.

A 2239 VIENNA, ALBERTINA, 119. "The Doge Zani presenting Prince Otto to Pope Alexander III." Ch., on gray. 343 x 288. Formerly ascr. to Francesco Padovanino. *Albertina Cat. I* (Wickhoff), 290 attr. it to Vicentino as a design for his painting in the Sala del Maggior Consiglio in the Ducal Palace in Venice. Schönbrunner-Meder 845: Manner of Tintoretto. Stix-Fröhlich in *Albertina Cat. II* accept Wickhoff's suggestion, however, stating that the execution deviates very much from the drawing. [MM]
The differences are indeed so considerable that we question the identity of the subject. The principal actors of the scene, Pope, Doge and Prince Otto, cannot be found in the drawing and, moreover, the presentation of the ring is left out. Striking differences between design and execution occur at times and do not need to exclude a connection between the two versions. A more serious objection is that not one of the figures in the drawing would have passed into the painting which, in spite of the similar general arrangement, differs completely from the drawing in its rendering of space. The attr. to Vicentino, therefore, is not satisfactory; the drawing may be a sketch by a contemporary artist for some similar subject. In this connection it might be worth remembering that the drawing in the Albertina originally was ascribed to an unknown Francesco Padovanino; a likewise unknown Francesco Crivelli (of whose Padovan origin, it is true, we know nothing) is mentioned by Ridolfi (II, 48) as one of Tintoretto's partisans. (See p. 296; see also No. **879**.)

2240 ———, 124. Episode from the Venetian Crusade. Pen, wash. 247 x 274. Wickhoff in *Albertina Cat.* I, 285 identified the drawing as Aliense's design for his painting in the Sala del Maggior Consiglio representing the "Coronation of Baldwin by the Doge Enrico Dandolo." He admitted that the composition was very much changed in the execution. *Albertina Cat. II* (Stix-Fröhlich) accepts this suggestion. [Pl. CXL, 4. MM]
We neither recognize Aliense's style in the drawing nor see any connection with the above mentioned composition. In our opinion, the style is Vicentino's, for whose painting at the same place, "The Election of Baldwin as Emperor," the drawing could be a preliminary sketch. Probably it has been cut at the top. His other painting "Alessio Commeno implores the assistance of the Doge against the Turks" is also closely related. Stylistically, the drawing would well fit into Vicentino's early period.

2241 WINDSOR, ROYAL LIBRARY, 6712. Religious ceremony in the open air. Pen, br., wash, on wh. paper turned yellow. 153 x 363. In Windsor anonymous. [Pl. CXL, 3. MM]
Carefully executed *"modello"* by Vicentino for his painting in the sacristy of SS. Giovanni e Paolo in Venice "The Doge Jacopo Tiepolo presenting to the Dominicans of SS. Giovanni e Paolo the territory for their church and convent," signed and dated 1606. The modifications in the painting contradict the possibility that the drawing might be a copy.

ALVISE VIVARINI

[Mentioned 1457 to 1503]

In spite of Mr. Berenson's efforts to make Alvise Vivarini's well circumscribed figure Giovanni Bellini's counterpart, the artist has remained somewhat hybrid. He remains so perhaps less as far as the attribution of individual paintings goes, than for the whole individuality which should show through all sorts of production. In the field of drawings where Mr. Berenson's claims for Alvise were less lucky, we are still groping in the dark to a great extent. The only reliable point of departure is No. 2245 in Mr. Lugt's Coll. in the Hague, not yet discussed by Berenson and made known by Parker long after the publication of his book. The sheet contains studies of hands, used in Alvise's altar-piece of 1480 in the Academy in Venice, and is so closely linked to this painting that besides an insight into Alvise's general style of drawing, at least around 1480, it aids us in verifying No. 2247 on the back of which a somewhat similar hand is seen. It does, not however, help us to identify drawings of a different character.

This deficiency is all too evident in the discussion of an interesting group of portraits of youths, some of which were attributed to Giovanni Bellini and Lotto, but whose classification as Alvise Vivarini, may have been Berenson's best contribution to the knowledge of this artist's drawings (Nos. 2242, 2244, 2249). We have stated before why a final decision seems impossible. The suggestion has rather to be supported by the negative argument that the better defined personalities of Giovanni Bellini and Lotto, the two runners-up for the attribution of these drawings, seem to be less plausible. Positive evidence is much more difficult to produce; No. 2247 at least does not disavow the hypothesis. For the drapery, No. 310, also ascribed to Alvise by Parker, see there.

A BERLIN, KUPFERSTICHKABINETT, 4192. See No. 329.

2242 ————, 5050. Head of a boy with a high cap, turned three quarters to l. Bl. ch., on gray tinted paper. 404 x 264. Coll. von Beckerath. Exh. Berlin, Renaissanceausstellung 1898 (Mackowski in the *Album* of this Exhibition 1899, p. 51). Publ. in *Berlin Publ. I*, pl. 66 as Francesco Bonsignori. A. L. Mayer, in *Pantheon* 1929, p. 345, questioned this attribution, stressing the difference of the drawing from Bonsignori's best-authenticated no. 28 in the Albertina, dated 1487. The drawing would fit still less into his later period. [MM]

In our opinion, the connection with Bonsignori is less close than the resemblance to Nos. 2244, 2246, 2249 with which the drawing forms a group. We attr. it tentatively to Alvise Vivarini's latest period, but notice also a certain resemblance to the school of Romagna under Venetian influence, as, for instance, Filippo Mazzola or Cristoforo Caselli. See No. 342.

A BESANÇON, MUSÉE, Gigoux Bequest. Bust of a bearded man. See No. 290.

A 2243 FLORENCE, UFFIZI, 256. Study for a knight in armor. Point of the brush, greenish watercolor and bodycolor, on gray prepared ground. 404 x 262. Edges straightened by added strips. Publ. by Byam Shaw in *O. M. D.*, June 1931, pl. 7, p. 5 ff. as Alvise Vivarini with reference to the allegedly corresponding figure in the altar-piece in Berlin, ill. Van Marle XVIII, pl. fac. p. 155, and, for the head, to the portrait in the N. G., publ. in *Klassiker, Bellini*, pl. 121, but formerly, and again by Shaw, attr. to Alvise. The attr. of the

drawing was rejected by Van Marle XVIII, p. 168, note. Exh. Ferrara, 1933, 235 bis, as Ercole Roberti.

We find no Ferrarese elements in the drawing, the reference to Alvise seems more attractive, although the resemblance of the armor with that in Berlin is invalidated by Shaw himself who lists a number of closely resembling suits of armor in the works of various other painters. We add the woodcut in the Venetian pamphlet *"Guerino detto Meschiero"* of 1493, repeated with slight modifications in the *"Libro della regina Ancroia,"* of 1494, [MM] and in other pamphlets, compare Prince d'Essling, *Les livres à figures Vénitiens* I, II, p. 183, 204. The free posture brings the drawing very close to the above mentioned group of woodcuts, which, however, gives no help, since their authors are completely unknown.

2244 FRANKFORT/M., STAEDELSCHES KUNSTINSTITUT, no. 453. Bust of a youth, with a cap, looking upward and turned three quarters to l. Bl. ch., on grayish br. 354 x 255. Schönbrunner-Meder 593: Unknown Venetian. Gustav Glück, *Jahrb. der Zentralkommission* 1910, p. 224: Lotto, companion piece of No. 2249 and connected with the murals in Treviso. Berenson, in *Gaz. d. B. Arts* 1913, I, p. 478: Alvise Vivarini together with No. 2249. Hadeln, *Quattrocento*, pl. 55 (without mentioning Glück's article): Giovanni Bellini, in his early years, referring to the polyptych in SS. Giovanni e Paolo, ill. *Klassiker, Bellini*, 32 (attr. to Alvise Vivarini by Ridolfi and Boschini, and to Giovanni Bellini by Sansovino, whose attr. was taken up by R. Longhi in *L'Arte* 1914, p. 241). The attr. of the drawing to Bellini is questioned by Dussler, p. 160, and to a certain degree by Van Marle XVII, p. 352, who would prefer to compare the drawing with a

"Pietà" in the Brera Gallery (ill. *Klassiker, Bellini,* 27) rather than with the altar-piece mentioned above. [*Pl. XXVI,* 2. **MM**]

The drawing belongs with Nos. **2246, 2249,** as already noticed by Voss (in *Zeitschr. f. B. K.,* N. S. XXIV, p. 207); see No. **2249.**

2245 Hague, The, Coll. Lugt. Sheet with studies of hands, used in Alvise's altar-piece of 1480, in the Academy in Venice, ill. Van Marle XVIII, fig. 84. Silverpoint, height. w. wh., on pink. 278 x 193. Publ. by K. T. Parker in *O. M. D.* I, pl. 5, and *North Ital.,* pl. 43. Accepted by Van Marle XVIII, p. 167. [*Pl. XXVII.* **MM**]

The best-authenticated example of Alvise Vivarini's drawings. See p. 363.

2246 Leipzig, Staedtisches Museum. Bust of a youth, seen from front. Bl. ch., on gray. 367 x 279. Exh. Leipzig, Summer 1913, no. 144, and publ. by Herm. Voss, in *Zeitschr. f. B. K.,* N. S. XXIV, p. 227, fig. 18 as Alvise Vivarini, with reference to No. **2244,** ascr. to Alvise by Berenson. [*Pl. XXVI,* 3. **MM**]

The resemblance to No. **2249** is even greater, see there.

2247 London, British Museum, 1876-12-9 — 619. Beardless head, turned three quarters to r. Brush, height. w. wh., on faded blue. 213 x 156. — On *verso:* Study of a hand, holding a pen. Slightly stained by mold. The height. with wh. dominates the impression. Coll. W. Mayer. Publ. as Alvise Vivarini by Hadeln, *Quattrocento,* pl. 80, with reference to the somewhat similar heads in the painting in the Academy in Venice of 1480, ill. Van Marle XVIII, fig. 84 and in the triptych in Naples of 1485 (ill. l.c. fig. 90.) Parker in *O. M. D.* 1926, June refers to the same examples as Hadeln. Van Marle XVIII, fig. 104, p. 166, dates the drawing later than 1485, but not in Alvise's latest period.

We are inclined to accept the attr. to Alvise and Hadeln's dating about 1480–85, in view of the hand on the back, which shows a marked resemblance to No. **2245.**

A **2248** Vienna, Albertina, No. 19. St. Sebastian with a kneeling donor. Pen, br., bluish wash. 260 x 160. Coll. Lely, Mariette. Formerly attr. to Gentile Bellini, an attr. rejected by Wickhoff in *Albertina Cat. I,* 4, who mentions that the same subject is represented in a painting by Sebastiano Zuccato in the Museo Correr in Venice (ill. Van Marle XVIII, fig. 293). Schönbrunner-Meder 393: Sebastiano Zuccato. Stix-Fröhlich in *Albertina Cat. II:* Alvise Vivarini, adding that the composition of Zuccato's painting in Venice might rest on a picture by Alvise, prepared by No. **2248.** Parker, *O. M. D.* 1928, September, calls the attr. to Alvise more or less gratuitous. [**MM**]

We agree with Parker, but believe with Stix-Fröhlich that there is no direct connection between the painting in the Museo Correr and the drawing. In our opinion, the latter is much more archaic in style and may be listed as school of Carlo Crivelli; compare for the composition his painting in the Museo Poldi Pezzuoli and for the draperies the "Pietà" at the Metropolitan Museum (ill. Testi II, p. 509 and p. 641 resp.)

2249 Vienna, Coll. Prince Liechtenstein. Bust of a youth with a cap, seen from front. Bl. ch., on bluish gray. 370 x 265. Coll. Habich, Cassel, publ. by Eisenmann, *Sammlung Habich* I, pl. 4 as Jacopo Barbari, to whom Morelli, II, p. 198, note, also attr. the drawing on the basis of his attr. to Barbari of the paintings of the Onigo Monument in San Niccolò, Treviso, ill. Venturi 7, IV, fig. 487, 488. Berenson, *Lotto,* p. 32, hesitates between Barbari and Alvise Vivarini. G. Glück, in *Jahrb. der Zentralkommission* N. S. 1910, p. 224, attr. the drawing, together with No. **2244,** to Lotto, in his opinion, the painter of the Onigo murals. Berenson, in *Gaz. d. B. A.* 1913, I, p. 478, acknowledged the connection with No. **2244** and gave both drawings to Alvise Vivarini, while Voss, in *Zeitschr. f. Bild. Kunst* 1913, p. 22 f., fig. 18, added the drawing in Leipzig (see No. **2246**) to the two others. Hadeln, *Hochren.,* pl. 23, p. 33, ascr. the drawing to Lotto, without mentioning Glück or No. **2244** which he previously had publ. as by Giovanni Bellini. Hadeln, too, bases his attr. uniquely on the Onigo paintings. [*Pl. XXVI,* 4. **MM**]

In our opinion, the three drawings certainly are by the same hand and Nos. **2246** and **2249** may even represent the same model, apparently an apprentice in the shop. They belong together not only because they are of approximately the same size and technique, but because they also have in common the use of a dark foil in the l. half of the background. All of them share the simplicity and directness typical of the Quattrocento, to which period, in our opinion, they belong by their origin. The attribution to Lotto rests only on the resemblance to the Onigo murals. A resemblance, which, however, is not convincing. Moreover, the attr. of these murals to Lotto is highly hypothetical (see No. **768**). At any rate, there is no link between these drawings and others ascertained for Lotto. As for G. Bellini, to whom No. **2244** was given by Hadeln and, with reservations, by Van Marle, this attr., too, rests on a very vague resemblance to a much discussed work and not on a connection with other drawings. Nor can the attr. to Alvise Vivarini boast of such a connection, since the best-established drawing No. **2245** can hardly be compared because of its different subject, technique and presumable date. No. **2247** which ought to be much earlier than our group, at least does not disavow it, while the general approach to Alvise's latest works, as the altar-piece in Berlin or the Savior in San Giovanni in Bragora in Venice, or the altar-piece in the Townhall in Cherso, may support our acceptance of the attr. to Alvise. We date the drawings about 1500, but are fully aware of the hypothetical character of the attr.

A **2250** Windsor, Royal Library, 061. Portrait of an old man, seen from front. Bl. ch., height. w. wh., on wh. turned yellow. 235 x 223. Formerly ascr. to Timoteo delle Vite (or, according to Berenson, *Lotto,* p. 93, Lorenzo Credi), publ. by Berenson, l.c. p. 92, pl. facing p. 92, as "obviously" by Alvise Vivarini. Nevertheless, the drawing is not listed by Hadeln nor by Van Marle, and we, too, see no relation to the other heads which we give to Alvise Vivarini (Nos. **2244, 2246, 2249**), or to any of the other portraits of this kind, which are undoubtedly Venetian and originate from the 15th century. [**MM**]

ANTONIO VIVARINI

[Mentioned 1446 to 1476]

2251 New York, Metropolitan Museum, 08.227.26. Standing figure of a youthful martyr (San Nazaro?). Brush, in br. and wh., on brownish tinted paper. 302 x 167. Disfigured by varnishing. Ascr. to the School of Ferrara 16th century. Publ. by Hadeln, *O. M. D.,* De-

cember 1927, pl. 36, p. 34 as Antonio Vivarini, and dated about 1450, with reference to the figures in the "Adoration of the Magi" in Berlin (ill. Van Marle XVIII, fig. 15), the figure of St. Achilleus in the altar-piece of Santa Sabina of 1443, in San Zaccaria, in Venice (ill. ibid. fig. 5) and that of St. Venantius in the Vatican polyptych of 1465 (ill. ibid. fig. 18). Exh. Northampton, Smith College 1941, no. 30, as Ferrarese School c. 1444 (apparently a misprint, for the *cat.*

seems to accept Hadeln's attr.). The name of the saint is given as Icerius. [*Pl. I*, 3. **MM**]

We do not see any point of comparison in the Ferrarese School which, incidentally, at that early period had hardly taken shape. The attribution to Antonio Vivarini seems acceptable though with all the reservations inevitable on such an uncertain ground as Venetian painting in the early 15th century.

BARTOLOMEO VIVARINI

[Mentioned 1458 to 1499(?)]

A 2252 CHANTILLY, MUSÉE CONDÉ, 112. Design for an altar-piece: Madonna enthroned between St. John the Baptist and another saint holding a book. Pen, blue, wash, height. w. wh., on bluish gray. 198 x 237. Coll. Revil, Reiset. Ascr. to Giovanni Bellini and exh. as his École des Beaux Arts 1879, no. 182. Publ. as Bartolomeo Vivarini's by Byam Shaw, in *O. M. D.* VIII, pl. 1, with reference to Bart. Vivarini's altar-piece of 1474 in the Frari, ill. Van Marle XVIII, fig. 67. Accepted by Van Marle XVIII, p. 134. [*Pl. XXV,* 4. **MM**]

A still better subject for comparison would be the triptych in San Giovanni in Bragorà of 1478, where the figures correspond in subject and thereby reveal the essential stylistic difference. Bartolomeo's figures are, as his compositions too, immensely tense and dynamic, while those in the drawing are empty, boneless and on the whole of a much inferior quality. We find a much closer approach to Andrea da Murano's "Madonna and saints" in the parish church in Mussolente (ill. Van Marle XVIII, fig. 288) where the proportions of the figures and the style of the draperies are exactly the same.

A 2253 FLORENCE, UFFIZI, 397. The Virgin kneeling and worshipping the Infant Jesus lying on the ground. Brush, wash, height. w. wh., on blue. 230 x 195. Ascr. to Marco Zoppo. Publ. as Andrea Mantegna in *Gaz. d. B. A.* 1872 II, p. 103. Mentioned by Kristeller, *Mantegna* p. 453, as a study made in Mantegna's workshop for the painting of the "Adoration," now in the Metropolitan Museum in New York, ill. *Klassiker, Mantegna* 2, pl. 91. Publ. by Van Marle XVIII, p. 135, fig. 83, as Bartolommeo Vivarini, with reference to his altar-piece in the Academy in Venice, formerly at Conversano, ill. Van Marle XVIII, fig. 70, with which, however, there is no connection.
 [*Pl. CLXXXVII,* 1. **MM**]

The invention is a typical *"simile"* from Mantegna's workshop, likewise used in Mansueti's "Adoration of the magi" in the Museo Civico in Padua (ill. Cavalcaselle I, 222). In view of the softness of the strokes the drawing may be executed not by a Paduan artist, but a Venetian painter under his influence.

BATTISTA ZELOTTI

[Born 1526, died 1578]

Because our artist is called either Veronese or Venetian by contemporaries, but received his first training from his uncle Antonio Badile at Verona, Hadeln (Ridolfi I, p. 364) suggested he may have been of Venetian descent, but born in Verona. His alleged supplementary education in Titian's studio is hardly traceable. At any rate, there is no reason to expect in his drawings a dependence on Veronese who was Zelotti's junior by two years. If there are resemblances they may be explained by the analogies in their education. A by-product is preserved of their cooperation, continued through several years, in a group of working drawings in the Castello in Milan discussed by us under the title "shop of Paolo Veronese" (No. **2171**). Zelotti's more personal expression is best illustrated by No. **2266**, preparing a ceiling in the monastery library of Praglia, described at length by Ridolfi. The old attribution to Zelotti of a drawing formerly in the Pembroke Coll. No. **2254**, but presented under the name of Paolo Veronese in an exhibition at London in 1939, is confirmed by its composition and its figure style. A further argument is the execution in the very peculiar technique favored by Zelotti, a combination of red ch., pen and wash. Most of the drawings traditionally ascr. to Zelotti are on the borderline toward purely ornamental designs. He might have made such designs when he was the clerk of the artistic undertakings of the Duke of Mantua, an activity of which we are informed by Avena's investigations in Mantuan archives (*L'Arte* XV, 1912,

p. 206). Our own attr. of No. **2265** in Stockholm to Zelotti rests on its use in a painting attr. to him. Furthermore, we claim No. **2255** for him the place of which had correctly been established by older critics, but was confused by recent ones.

2254 CAMBRIDGE, ENGLAND, COLL. LOUIS CLERKE. The Virgin and Child, surrounded by saints. Red ch., height. w. wh. 260 x 385. Coll. Peter Lely, Earl of Pembroke. Publ. in *Pembroke Dr.* pl. XLII as Zelotti. Exh. London, Mathiesen Gallery 1939, 104 as Paolo Veronese.

The older attr. to Zelotti, in our opinion, fits the style well.

2255 CHATSWORTH, DUKE OF DEVONSHIRE. Virgin and Child enthroned, below John the Baptist and bishop saint with a book. In lower corners the busts of an elderly couple of donors. Pen, reddish br. 313 x 231. Identified by J. P. Richter as the design of a picture in the Museo del Castel Vecchio in Verona, no. 243, there attr. to Paolo Veronese. Publ. as Zelotti by S. A. Strong, in *Chatsworth Drawings*, pl. LIII, p. 14. In the cat. of the *Mostra Veronese*, Pallucchini calls the drawing a derivation from the painting, explaining the differences between the two versions by extensive restorations of the painting. [*Pl. CLI,* 1. **MM**]

In our opinion, the drawing is not a copy from the painting, but its preparation. The style has the spontaneity of a design and so close a resemblance to No. **2265** that Richter's attr. to Zelotti seems to be beyond objection. As for the painting with which the drawing is connected, it is already listed by Ridolfi (I, p. 298) as an early production by Paolo Veronese, a tradition maintained by the local tradition, but seriously questioned by the connoisseurs at the beginning of our century. In 1911 a member of the Bevilacqua family for which the panel had been painted, defended the attr. to Paolo Veronese in *Madonna Verona*, p. 106–111, under the title: *"Un quadro di autore controverso,"* and in 1914 Hadeln called the state of preservation so poor that the discussion of attr. and dating had become difficult. A. Venturi, too, seems to have had his doubts, for he does not mention the painting which, otherwise, would be of first rate importance. More recent authors, e.g. Fiocco, *Veronese II*, p. 23, 110, and following him Pallucchini, in *Mostra del Veronese*, no. 1, p. 36, ascr. the picture with absolute certainty to Paolo Veronese, and assigned it to the year 1548, Fiocco without mentioning and apparently without knowing the drawing. But the moment the drawing, so convincingly by Zelotti, and so certainly the design of the altar-piece, is taken into consideration, the conformity of poses, types and draperies of the painting with those of Zelotti becomes evident. In the middle of the century, Paolo Veronese and Zelotti are fairly related in style, and the typical excuse that the painting is very early (which means, originating from a period preceding the formation of an artist's personal style) is no longer valid for ascribing to Veronese a production which does not show his mode of drawing and composing.

2256 CHELTENHAM, FENWICK COLL., Popham p. 141, 1. Decorative design with seated female figures and the lion of S. Mark above over coat of arms. Pen, lightbr. wash. 192 x 227. Coll. Count Gelosi. [**MM**]

The drawing might be connected with the decorative tasks that fell to Zelotti when he supervised the Ducal buildings in Mantua. When he died in 1578 he had many such designs in his house, legally belonging to the Duke. They were dispersed, as we learn from a letter of 1583, see Avena in *L'Arte XV*, 1912, p. 206.

A 2257 ———, Popham 141, 2. Two allegorical female figures. Pen, br. wash. 207 x 293. — On *verso* inscription: Zelotti.

In our opinion, copy by a draftsman of the 18th century from an earlier decoration.

A 2258 FLORENCE, UFFIZI, 12837. The daughters of Niobe. Bl. ch., on blue, traces of heightening in wh. 280 x 404. Squared for enlargement. — On *verso:* Female allegory kneeling over trophies (?) in clouds. Old inscription in pen: questa sono lavaricia chom (?) di dinari (?). Ascr. to Zelotti. [**MM**]

In our opinion, nothing of the Parmigianinesque delicacy or of the affinity to Veronese, both of which we should expect in Zelotti, is to be found in this drawing. It is closer in style to Lattanzio Gambara, who painted a mural with the rare subject represented on the *recto* (Ridolfi I, 275).

2259 ———, 12838. Decorative design: Female bust between two cupids. Brush, wh. and gray, on faded blue. 230 x 272. Damaged. — On *verso* inscribed: del Zillotti.

2260 ———, Ornati 1675. Frieze formed by cupids with masks and musical instruments. Pen and red ch., wash, on faded blue. 141 x 1025.

A 2261 FLORENCE, R. BIBLIOTECA MARUCELLIANA, vol. B, no. 168. Virgin and Child enthroned in niche, at the r. bust of adoring donor. Bl. ch., on blue. 270 x 210. Publ. by E. Ferri, in *Boll. d'A.* vol. 5, p. 285 f. as Zelotti and very similar to the painted sketch in the Uffizi, no. 1015, ascr. to Paolo Veronese, but believed by Ferri to be by Zelotti. (no. 1015 is in Pallucchini's opinion a copy from the Bevilaqua altar-piece in Verona, see No. **2255**.)

The drawing is not connected with the mentioned painting, nor is the attr. to Zelotti convincing, as already noted in a review of Ferri's article, in *Madonna Verona* 1912, p. 62.

2262 LONDON, BRITISH MUSEUM, 1861–8–10 — 36. Design for an octagonal ceiling. Over ch. pen, br., wash, on blue. 232 x 232.

The attr. to Zelotti is supported by the resemblance to the "Concert" in the Castel Vecchio in Verona, ill. Venturi 9, IV, fig. 690.

A MILAN, MUSEO DEL CASTELLO. Group of allegorical figures, see No. **2171**.

2263 PARIS, LOUVRE, 5598. Fireplace with female caryatides, mythological representation in the tympanum. Pen, bl. and br., wash. 397 x 283. Architectural lines drawn with the help of a ruler. At bottom scale. [**MM**]

For such decorative drawings see No. **2256**.

2264 ———, 5599. The Evangelists Saint Mark and Saint Luke. Brush, gray and wh., on br. 201 x 306. Old inscription: Zellotti. [**MM**]

2265 STOCKHOLM, NATIONAL MUSEUM, 1463. Female head. Bl. and red ch., on bluish gray. 176 x 143. Inscription: P. Veron. Sirén, 1917, no. 473. School of Paolo Veronese. [**MM**]

Our attr. rests on the conformity with the head of the Virgin in Zelotti's painting "The Virgin with S. Ann and angels," in the Capitol Gallery in Rome (Photo Brogi).

2266 VIENNA, ALBERTINA, 117. Design for a ceiling in the library of the monastery at Praglia: Faith inspiring the four evangelists. Red ch. and pen, wash. 230 x 307. Old inscription: B. Zelotti. Coll. Mariette (*Sales Cat.* 1775, No. 802); Count Fries. *Albertina Cat. I* (Wickhoff), 204. Publ. by Hadeln, in *Jahrb. Pr. K. S.* XXXVI, p. 127, and in *Spätren.,* pl. 19. [*Pl. CL.* 3. **MM**]

2267 ————, 118. Design for an architectural detail with two different suggestions for the pillars. Pen, bistre, wash. 142 x 382. *Albertina Cat. I* (Wickhoff) 205: autograph by Zelotti. [**MM**]
See No. **2256**.

A WINDSOR, ROYAL LIBRARY, 6689. See No. **2212**.

GENERAL INDEX

Numbers in italics refer to the pages on which the drawings of the artists in question are listed and discussed. Where a writer is referred to, it means that not only the illustrations, but the opinions of the writer are mentioned. This mention is omitted where the writer simply endorses the current opinion.

GENERAL PLACE INDEX

Collections which contain the drawings listed in our Catalogue are not mentioned here. For them see Place Index of Drawings. Where the name of the artist follows directly that of the town, the public gallery is to be understood.

PLACE INDEX OF DRAWINGS

Giovine, Palma Vecchio, Domenico Tintoretto, Jacopo Tintoretto, Marco Vecelli, Paolo Veronese, School of Paolo Veronese
—— Prinz Friedrich August, formerly: Schiavone
—— Lahmann Estate: Costantino Malombra
DUBLIN, N. G. of Ireland: Giovanni Bellini, Domenico Campagnola
DÜSSELDORF, Akademie der Bildenden Künste: Jacopo Bassano, Bastiani, School of Giovanni Bellini, Jacopo Bellini, Palma Giovine

EDINBURGH, N. G. of Scotland: Jacopo Bassano, Domenico Campagnola, Palma Giovine, Domenico Tintoretto, Tintoretto Shop, Titian, School of Paolo Veronese, Benedetto Caliari
ERLANGEN, Universitätsbibliothek: Belliano, Domenico Campagnola, Antonio Palma, Palma Vecchio, Jacopo Tintoretto, Titian

FLORENCE, Uffizi: Aliense, Giulio Angolo, Barbari, Basaiti, Francesco Bassano, Girolamo Bassano, Jacopo Bassano, Leandro Bassano, Gentile Bellini, Shop of Gentile Bellini, Giovanni Bellini, School of Giovanni Bellini, Bonifazio, Bordone, Domenico Campagnola, Giulio Campagnola, Vittore Carpaccio, School of Carpaccio, Catena, Cima, Contarini, Corona, Crivelli, Paolo de' Franceschi, Gambarato, Giorgione, School of Giorgione, Girolamo da Treviso, Lotto, Mansueti, Natalino da Murano, Pace Pace, Palma Giovine, Palma Vecchio, Peranda, Piazza, Polidoro, Pordenone, Previtali, Salviati, Savoldo, Schiavone, Domenico Tintoretto, Jacopo Tintoretto, Tintoretto Shop, Titian, Circle of Titian, Francesco Vecelli, Verdizotti, Paolo Veronese, School of Paolo Veronese (Carletto Caliari), Vicentino, Alvise Vivarini, Bartolommeo Vivarini, Zelotti
—— Horne Foundation: Jacopo Bassano, Leandro Bassano, Palma Giovine, Pordenone, Domenico Tintoretto, Jacopo Tintoretto
—— Biblioteca Marucelliana: Zelotti
—— Coll. Charles Loeser, formerly: Savoldo
FRANCE, Private Coll.: Titian
FRANKFORT/M., Staedel'sches Institut: Antonello, Jacopo Bassano, Gentile Bellini, Giovanni Bellini, Giulio Campagnola, Damini, Giorgione, School of Giorgione, Lotto, Palma Giovine, Domenico Tintoretto, Jacopo Tintoretto, Tintoretto Shop, Titian, Paolo Veronese, Vicentino, Alvise Vivarini
—— Private Coll.: Jacopo Tintoretto

GENOA, Palazzo Bianco: Jacopo Tintoretto

HAARLEM, Teyler Stichting: Domenico Campagnola, Costantino Malombra, Palma Giovine, Palma Vecchio, Ponchino, Savoldo, Titian, Verdizotti, Paolo Veronese
—— Coll. Koenigs: Aliense, Jacopo Bassano, Leandro Bassano, Gentile Bellini, Giovanni Bellini, Bordone, Vittore Carpaccio, School of Carpaccio, Cima, Giorgione, Lotto, Costantino Malombra, Palma Giovine, Pordenone, Schiavone, Domenico Tintoretto, Jacopo Tintoretto, Marietta Tintoretta, Tintoretto Shop, Titian, Circle of Titian, Paolo Veronese, School of Paolo Veronese, Benedetto Caliari, Carletto Caliari
HAGUE, The, Coll. Frits Lugt: Bastiani, School of Giovanni Bellini, Jacopo Bellini, Vittore Carpaccio, Giambono, Costantino Malombra, Palma Giovine, Domenico Tintoretto, Titian, Circle of Titian, Alvise Vivarini
HAMBURG, Kunsthalle: Schiavone, Jacopo Tintoretto
HELSINKI, Coll. Bertel Hintze: Savoldo

ITALY, Private Coll.: Vittore Carpaccio

KREMSIER, Coll. of the Archbishop: School of Giovanni Bellini

LAUSANNE, Coll. Cerenville: Palma Giovine
—— Coll. Stroelin: Giorgione, Palma Giovine, Jacopo Tintoretto, Tintoretto Shop
LEIDEN, Prentencabinet: Palma Giovine, Palma Vecchio, Pordenone
LEIPZIG, Städtisches Museum: Domenico Campagnola, Alvise Vivarini
LENINGRAD, Hermitage: Leandro Bassano, Giovanni Bellini, Buonconsiglio, Domenico Campagnola, Vittore Carpaccio, Palma Giovine, Palma Vecchio, Jacopo Tintoretto, Titian, Paolo Veronese
LILLE, Musée Wicar: Sebastiano del Piombo, Titian, Benedetto Caliari
LIVERPOOL, Walker Art Gallery: Jacopo Bassano, Leandro Bassano
LISBON, Royal Academy: Carletto Caliari
LONDON, British Museum: Aliense, Amalteo, Battista Angolo, Antonello, Barbari, Jacopo Bassano, Leandro Bassano, Bastiani, Gentile Bellini, Giovanni Bellini, Jacopo Bellini, Bonifazio, Bordone, Domenico Campagnola, Vittore Carpaccio, Cima, Girolamo da Treviso, Licinio, Pietro Malombra, Marco Marziale, Palma Giovine, Palma Vecchio, Pordenone, Salviati, Girolamo da Santacroce, Schiavone, Domenico Tintoretto, Jacopo Tintoretto, Tintoretto Shop, Titian, Circle of Titian, Paolo Veronese, School of Paolo Veronese, Vicentino, Alvise Vivarini, Zelotti
—— Victoria and Albert Museum: Francesco Bassano, Jacopo Bassano, Bordone, Palma Giovine, Pordenone, Domenico Tintoretto, Jacopo Tintoretto, Tintoretto Shop, Titian, Carletto Caliari, Vicentino
—— Coll. Barlow: Paolo Veronese
—— Coll. Bellingham-Smith, formerly: Paolo Veronese
—— Coll. T. Borenius: Giovanni Bellini, Domenico Campagnola, Paolo Veronese
—— Coll. Broun Lindsay: Giovanni Bellini
—— Coll. Norman Colvill: Vittore Carpaccio
—— Coll. Earl of Harewood: Bastiani, Vittore Carpaccio, Palma Giovine, Girolamo da Santacroce, Domenico Tintoretto, Tintoretto Shop, Titian, Paolo Veronese
—— Coll. Holland, formerly: Giulio Campagnola, School of Giorgione
—— Coll. Hungerford Pollen, formerly: Bastiani
—— Coll. Kennard, formerly: Titian
—— Coll. Victor Koch: Domenico Campagnola, Giorgione, Titian
—— Coll. Dr. Löwenstein: Palma Vecchio
—— Coll. Sir Robert Mond: Marco Angolo, Vittore Carpaccio, Damini, Palma Giovine, Palma Vecchio, Circle of Titian
—— Coll. Morant, formerly: Titian, Paolo Veronese
—— Coll. Paul Oppé: Francesco Bassano, El Greco, Palma Giovine, Circle of Titian, Paolo Veronese
—— Coll. Henry Oppenheimer, formerly: Jacopo Bellini, Vittore Carpaccio, School of Carpaccio, Lotto, Previtali
—— Coll. Captain H. Reitlinger: Jacopo Tintoretto, Tintoretto Shop
—— Coll. A. P. and C. R. Rudolf: Palma Giovine, Tintoretto Shop, Paolo Veronese
—— Coll. Archibald G. B. Russell: Jacopo Bassano, Lotto, Palma Giovine, Domenico Tintoretto, Titian, Paolo Veronese
—— Coll. Sir Robert Witt: Corona, Damini, Palma Giovine, Schiavone, Jacopo Tintoretto
—— Th. Agnew Gallery: Titian
—— Calman Gallery: Jacopo Bassano
—— Colnaghi Gallery: Pordenone, Jacopo Tintoretto, Tintoretto Shop
—— Robert Frank Gallery: Jacopo Tintoretto

—— Walter Gernsheim Gallery: Paolo Veronese
—— A. Scharf Gallery: Jacopo Bassano, Jacopo Tintoretto
—— E. Schilling: Leandro Bassano, School of Giovanni Bellini
—— The Spanish Gallery: Leandro Bassano, School of Giovanni Bellini, Jacopo Tintoretto, Paolo Veronese, Vicentino
—— Geiger Sale: Jacopo Bassano, Leandro Bassano, Palma Giovine
—— Sale Sotheby July 19, 1924: Paolo Veronese
Lucerne, Coll. J. Boehler, formerly: Paolo Veronese
Lützschena, Coll. Speck von Sternburg: Jacopo Tintoretto, Paolo Veronese
Lwow, Ossolinski Institute: Costantino Malombra

Madrid, Biblioteca Nacional: Paolo Veronese
Malvern, Coll. Mrs. Julia Rayner Wood (Skippes): Arzere, Jacopo Bassano, Giovanni Bellini, Domenico Campagnola, Lotto, Palma Giovine, Pordenone, Jacopo Tintoretto, Titian, Vicentino
Milan, Brera: Contarini, Mazza, Palma Giovine
—— Museo del Castello: Pordenone, School of Paolo Veronese, Vicentino, Zelotti
—— Ambrosiana: Battista Angolo, Baldassare d'Anna, Ballini, Barbari, Bartolommeo Veneto, School of Giovanni Bellini, Bonifazio, Domenico Campagnola, School of Cima, Contarini, Corona, Lotto, Pietro Malombra, Palma Vecchio, Francesco da Santacroce, Sebastiano del Piombo, Domenico Tintoretto, Jacopo Tintoretto, Paolo Veronese, School of Paolo Veronese
—— Coll. G. Frizzoni, formerly: Jacopo Bassano
—— Coll. Dr. Rasini: Aliense, Bordone, Domenico Campagnola, Vittore Carpaccio, Licinio, Lotto, Mansueti, Palma Giovine, Schiavone, Domenico Tintoretto, Jacopo Tintoretto, Marietta Tintoretta, Tintoretto Shop, Titian, Circle of Titian, Paolo Veronese
Modena, Pinacoteca Estense: Aliense, Bartolomeo Veneto, Francesco Bassano, Jacopo Bassano, Leandro Bassano, Girolamo da Treviso, Palma Giovine, Pordenone, Tintoretto Shop
Montpellier, Musée: Girolamo Bassano
Moscow, Museum: Vittore Carpaccio, Jacopo Tintoretto
—— University: Sebastiano del Piombo, Paolo Veronese
Munich, Graphische Sammlung: Francesco Bassano, Jacopo Bassano, Leandro Bassano, Gentile Bellini, Carletto Caliari, Domenico Campagnola, Vittore Carpaccio, Giorgione, Palma Giovine, Pordenone, Tintoretto Shop, Titian, Paolo Veronese
—— Private Coll.: Palma Giovine
—— Sale Weinmüller: Palma Giovine, Jacopo Tintoretto, Titian

Naples, Gabinetto delle Stampe: Domenico Tintoretto, Jacopo Tintoretto, Tintoretto Shop
New London, Conn., Coll. W. Ames: Paolo Veronese
New York, Metropolitan Museum of Art: Leandro Bassano, Domenico Campagnola, Corona, Damini, Palma Giovine, Domenico Tintoretto, Jacopo Tintoretto, Titian, Antonio Vivarini
—— Pierpont Morgan Library: Amalteo, Francesco Bassano, Bastiani, Bissolo, Bordone, Domenico Campagnola, Giulio Campagnola, Vittore Carpaccio, Giorgione, Pietro Malombra, Palma Giovine, Palma Vecchio, Pordenone, Schiavone, Jacopo Tintoretto, Circle of Titian, Paolo Veronese, School of Paolo Veronese (Carletto Caliari)
—— Cooper Union: Bordone, Palma Giovine
—— Frick Coll.: Circle of Titian
—— Coll. Robert Lehman: Bonifazio, Giambono, Domenico Tintoretto, Jacopo Tintoretto, Titian, Paolo Veronese
—— Coll. A. Lewisohn: Titian
—— Private Coll.: Titian

—— Coll. Mortimer Schiff, formerly: Jacopo Tintoretto
—— Coll. Janos Scholz: Jacopo Bassano, Costantino Malombra, Palma Giovine
—— Coll. S. Schwarz: Jacopo Bassano, Jacopo Bellini, Giorgione, Palma Giovine
—— W. Schab Gallery: Lattanzio da Rimini
—— E. & A. Silberman Galleries: Titian

Oslo, Print Department of N. G.: Paolo Veronese
Ottawa, N. G. of Canada: Jacopo Bassano
Oxford, Ashmolean Museum: Aliense, Leandro Bassano, Bordone, Domenico Campagnola, Giulio Campagnola, Carpaccio, School of Carpaccio, Licinio, Palma Giovine, Titian, Paolo Veronese, School of Paolo Veronese, Carletto Caliari, Vicentino
—— Christchurch Library: Aliense, Battista Angolo, Barbari, Jacopo Bassano, Giovanni Bellini, Bordone, Domenico Campagnola, Vittore Carpaccio, Corona, School of Giorgione, Lotto, Montemezzano, Natalino da Murano, Palma Giovine, Palma Vecchio, Girolamo da Santacroce, Domenico Tintoretto, Jacopo Tintoretto, Tintoretto Shop, Titian, Francesco Vecelli, Verdizotti, Paolo Veronese

Paris, Louvre: Aliense, Amalteo, Battista Angolo, Giulio Angolo, Marco Angolo, Barbari, Francesco Bassano, Jacopo Bassano, Leandro Bassano, Bastiani, Gentile Bellini, Giovanni Bellini, School of Giovanni Bellini, Jacopo Bellini, Buonconsiglio, Domenico Campagnola, Vittore Carpaccio, School of Carpaccio, Contarini, Corana, Damini, Giorgione, Licinio, Pietro Malombra, Palma Giovine, Palma Vecchio, Peranda, Polidoro, Pordenone, Shop of Pordenone, Salviati, Schiavone, Domenico Tintoretto, Jacopo Tintoretto, Tintoretto Shop, Titian, Circle of Titian, Paolo Veronese, School of Paolo Veronese (Benedetto Caliari, Carletto Caliari, Gabriele Caliari), Vicentino, Zelotti
—— École des Beaux Arts: Jacopo Bassano, Bordone, Domenico Campagnola, Giulio Campagnola, Giorgione, Lotto, Montemezzano, Palma Giovine, Pordenone, Rondinelli, Jacopo Tintoretto, Titian, Paolo Veronese, Vicentino
—— Coll. André de Hevesy: Giovanni Bellini, School of Giovanni Bellini, Giorgione, Peranda, Titian
—— Coll. Maurice Marignane: Jacopo Bassano, Leandro Bassano, Palma Giovine, Domenico Tintoretto, Circle of Titian
—— Coll. Mme Patissou: Leandro Bassano, Domenico Campagnola, Friso, Palma Giovine, Gabriele Caliari
—— Coll. Wauters, formerly: Jacopo Tintoretto
—— Coll. Godefroy, formerly: Palma Giovine
—— Private Coll.: Titian
—— Vente Drouot: Lotto
Pavia, Museo Civico: Palma Giovine, Shop of Pordenone
Piacenza, Museo Civico: Pordenone
Pittsburgh, Pa., Carnegie Institute: Domenico Tintoretto, Jacopo Tintoretto, School of Paolo Veronese
—— Coll. Török, formerly: Palma Giovine, Titian
Pordenone, Coll. Poletti: Pordenone
Princeton, N. J., Museum of Historic Art: Girolamo Bassano, Schiavone
Providence, R. I., School of Design: Circle of Titian
—— Coll. I. N. Brown: Titian

Rennes, Musée: Leandro Bassano, Giovanni Bellini, Bonifazio, Domenico Campagnola, Palma Giovine, Schiavone, Paolo Veronese
Rome, Gabinetto delle Stampe: Giovanni Bellini, Domenico Campa-

gnola, Palma Giovine, Salviati, Domenico Tintoretto, Jacopo Tintoretto, Paolo Veronese
—— Coll. Sohn-Rethel, formerly: Domenico Tintoretto
RUGBY, School Art Museum: Palma Giovine

SACRAMENTO, Cal., E. B. Crocker Art Gallery: Jacopo Bassano, Vittore Carpaccio, Palma Giovine, Pordenone, Salviati
SALZBURG, Studienbibliothek: Jacopo Bassano, Palma Giovine, Paolo Veronese
SIENA, Biblioteca Communale: Titian
STOCKHOLM, National Museum: Ballini, Bordone, Domenico Campagnola, Lotto, Salviati, Tintoretto Shop, Titian, Paolo Veronese, School of Paolo Veronese, Carletto Caliari, Vicentino, Zelotti
—— Private Coll.: Jacopo Bassano
STUTTGART, Coll. Fleischhauer, formerly: Jacopo Bassano, Palma Giovine

TRIESTE, Museo Civico: Domenico Tintoretto
TURIN, Biblioteca Reale: Amalteo, Bastiani, Gentile Bellini, Domenico Campagnola, Friso, Palma Giovine, Salviati, Schiavone, Paolo Veronese

UDINE, Museo Communale: Palma Giovine, Pordenone
UPSALA, University Library: Domenico Campagnola, Vittore Carpaccio

VENICE, R. Galleria: Giovanni Bellini, Bissolo, Cariani, Mansueti, Palma Giovine, Pordenone, Schiavone, Domenico Tintoretto, Jacopo Tintoretto, Tintoretto Shop, Titian, Circle of Titian
—— Museo Civico Correr: Palma Giovine
—— Galleria Querini Stampalia: Francesco da Santacroce
VIENNA, Albertina: Aliense, Amalteo, Antonello, Ballini, Bartolommeo Veneto, Basaiti, Francesco Bassano, Girolamo Bassano, Jacopo Bassano, Shop of the Bassano, Bastiani, Giovanni Bellini, School of Giovanni Bellini, Jacopo Bellini, Bordone, Domenico Campagnola, Vittore Carpaccio, Catena, Corona, Friso, Giambono, Giorgione,

School of Giorgione, Girolamo da Treviso, El Greco, Lotto, Palma Giovine, Piazza, Ponchino, Pordenone, Shop of Pordenone, Previtali, Girolamo da Santacroce, Schiavone, Domenico Tintoretto, Jacopo Tintoretto, Tintoretto Shop, Titian, Circle of Titian, Paolo Veronese, School of Paolo Veronese (Carletto Caliari), Vicentino, Alvise Vivarini, Zelotti
—— Akademie der Bildenden Künste: School of Giovanni Bellini, Domenico Campagnola, Corona, Pietro Malombra
—— Coll. Prince Liechtenstein: Jacopo Bassano, Domenico Campagnola, Lotto, Palma Giovine, Alvise Vivarini
—— Coll. B. Geiger, formerly: Titian
—— Coll. August Lederer: Shop of Pordenone
—— Private Coll.: Domenico Campagnola, Vittore Carpaccio
—— Artaria Gallery, formerly: Giovanni Bellini
—— Max Hevesi Gallery: Titian
—— Franz Kieslinger Gallery: Lotto, Titian

WASHINGTON, D. C., Corcoran Gallery: Shop of Gentile Bellini, School of Giovanni Bellini, Carpaccio, School of Giorgione
WASHINGTON CROSSING, Pa., Coll. Frank J. Mather Junior: Jacopo Bassano, Domenico Campagnola, Vittore Carpaccio, School of Giorgione, Montemezzano, Palma Giovine, Pordenone, Schiavone, Domenico Tintoretto, Jacopo Tintoretto, Circle of Titian
WEIMAR, Museum: Bonifazio, Domenico Campagnola, Jacopo Tintoretto
WILTON HOUSE, Pembroke Coll., formerly: Pordenone, Titian
WINDSOR, Royal Library: Amalteo, Francesco Bassano, Giovanni Bellini, Domenico Campagnola, Vittore Carpaccio, School of Cima, Giorgione, Girolamo da Treviso, Mansueti, Montemezzano, Palma Giovine, Pordenone, Salviati, Schiavone, Jacopo Tintoretto, Titian, Circle of Titian, School of Paolo Veronese (Carletto Caliari), Vicentino, Alvise Vivarini, Zelotti
WÜRZBURG, Kunstgeschichtliches Museum der Universität: Francesco Bassano, Palma Giovine, Tintoretto Shop

ZURICH, Kunsthaus: Palma Vecchio

SUPPLEMENT TO INDEX OF DRAWINGS

References to drawings of this Catalogue in addition to the pages on which they are described:

LIST OF ILLUSTRATIONS

ACKNOWLEDGMENT OF COPYRIGHT

We are grateful to the following institutions and persons for granting permission to reproduce the illustrations:

AMSTERDAM, Van Regteren Altena No. 2026
—— Gemeente Museum No. 698
BASEL, Robert Von Hirsch Nos. 824, 1477, 2028, 2028ᵛ
BERLIN, Kupferstichkabinett Nos. 77, 107, 331, 371, 383, 421, 642, 654, 831, 1478, 1561, 1878, 1880, 2017
BOSTON, Isabella Stewart Gardner Museum Nos. 589, 589ᵛ, 2045
CAMBRIDGE, England, Fitzwilliam Museum No. 1886
—— Mass., Fogg Art Museum Nos. 263, 263ᵛ, 358, 388, 861, 2052, 2163, 2216
CHATSWORTH, Duke of Devonshire, No. 1982
CHICAGO, Art Institute Nos. 378, 643
CLEVELAND, Museum of Art No. 2199
COPENHAGEN, Kongelige Kobbertstiksamling No. 881
DARMSTADT, F. van der Smissen No. 706
DETROIT, Art Institute No. 455
FLORENCE, Fratelli Alinari Nos. 374, 645, 692, 1489, 1594, 1795, 1898, 2253
—— Brogi Nos. 4, 83, 84, 299, 727, 730
—— Lionello Ciacchi No. 1585
—— Fototeca Italiana Nos. 146, 214, 606ᵛ, 816
—— Sopraintendenza Arte Medievale e Moderna Nos. 393ᵛ, 1627, 1650, 1905ᵛ
FRANKFORT/M., Prestel-Gesellschaft No. 1920
HAARLEM, Franz Koenigs Nos. 657, 657ᵛ, 707, 709
—— Teyler Stichting No. 2023
HAGUE, The, Frits Lugt Nos. 252, 339, 361, 609, 1510, 2245
LONDON, British Museum Nos. 269, 270, 310, 312, 617, 766, 1928, 1932
—— Victoria and Albert Museum Nos. 94, 400, 400ᵛ, 401, 992, 1332, 1529, 1700, 1701, 1704, 1843, 2204, 2225
—— Sir Th. Barlow No. 2092
—— Colnaghi No. 2216
—— A. C. Cooper No. 177
—— Captain Colvill No. 618
—— W. Gernsheim No. 899, 1450
—— Th. Harris Nos. 1711, 1758, 2110
—— Sir Robert Mond No. 998
—— Paul Oppé Nos. 747, 747ᵛ
—— A. G. B. Russell Nos. 166, 765, 1529, 1940, 2107, 2108
MADRID, Biblioteca Nacional No. 2115
MILAN, Ambrosiana No. 771
—— Archivio Fotografico del Comune di Milano 1335
MODENA, Pinacoteca Estense No. 1337
MUNICH, Staatliche Graphische Sammlung Nos. 274, 278, 137 II 112, 1941, 2205, 2206
NAPLES, Museo Nazionale Nos. 1533, 1723, 1724, 1725, 1852
NEW YORK, Metropolitan Museum Nos. 229, 712, 789, 1943, 2251
—— Pierpont Morgan Library Nos. 23, 98, 207, 373, 506, 1051, 1267, 1438, 2121, 2122, 2123, 2207
—— Cooper Union No. 404
—— Frick Art Reference Library No. 1554
—— Frick Collection No. 1995
—— Robert Lehman Nos. 382, 701, 2124
—— S. Schwarz Nos. 363bis, 713
OXFORD, Ashmolean Museum Nos. 405, 754
—— Christchurch Library Nos. 318, 807

PARIS, Louvre Nos. 41, 186, 359, 578, 634, 634ᵛ, 1539, 2002, 2130, 2234
—— École des Beaux Arts No. 2141ᵛ
—— Archives Photographiques Nos. 16, 192, 286, 287, 529ᵛ, 548, 548ᵛ, 583, 652, 714, 792, 835, 1070, 1095, 1559, 1875, 1956, 1962, 2000, 2136, 2143, 2161bis, 2191
—— A. Braun & Co. Nos. 289, 347, 384, 558, 1282, 1201, 1375
—— Fiorillo No. 1382
—— Giraudon Nos. 364 XVIII, 537, 577, 1256, 1997, 1998, 2139
—— André de Hevesy Nos. 350, 351, 716
—— Matthey No. 1964
PITTSBURGH, Carnegie Institute No. 2184
PRINCETON, Museum of Historic Art Nos. 109bis, 1368bis
ROME, Anderson Nos. 52, 585, 1451
ROTTERDAM, Boymans Museum Nos. 646, 708, 788, 1323ᵛ, 1472, 1656, 1657, 1660, 1661, 1664, 1668, 1674, 1675, 1828, 1989, 2078
SACRAMENTO, Cal., E. B. Crocker Art Gallery Nos. 635, 1392
SALZBURG, Studienbibliothek No. 2144
STOCKHOLM, National Museum No. 1967
TURIN, Cometto Guido Nos. 696, 739, 1452
UPSALA, University Library No. 557
VENICE, Cavaliere Pietro Fiorentini Nos. 1453, 1584, 1604, 1609, 1613, 1615, 1620, 1635, 1643, 1908, 1908ᵛ
VIENNA, Albertina No. 1970
—— Franz Kieslinger Nos. 779, 779ᵛ
WASHINGTON, D.C., Corcoran Gallery Nos. 285, 738
WASHINGTON, D. C., National Gallery, Richter Archives Nos. 1905, 1906
WASHINGTON CROSSING, Pa., F. J. Mather Junior Nos. 568, 640, 640ᵛ, 2012, 2012ᵛ
WINDSOR, Copyright of the King No. 328
ZURICH, Kunsthaus No. 1271

Illustrations taken from books:

ALBERTINA N. S. II No. 2152
—— Facsimile No. 777
BERLIN Publ. Nos. 260, 1370
FENWICK Cat. Nos. 249, 593
GOLOUBEW Nos. 363 VIII, XVI, XXIII, XLV, LXIX, CIX, 364 VI, VIII, XIV, XXXIV, XXXVI, LIII, LVIII, LXIX, LXXII
GRAPHISCHE Gesellschaft Nos. 579, 579ᵛ
GRAPHISCHE Künste Nos. 1143, 1143ᵛ
HADELN, Hochren. Nos 391, 393, 396, 719, 745, 983, 1254, 1269, 1301, 1311, 1323, 1407, 1414, 2249
—— Quattrocento Nos. 51, 73, 75, 254, 263, 271, 272, 304, 305, 308, 309, 309ᵛ, 326, 352, 353, 400, 594, 592, 604, 606, 614, 614ᵛ, 615, 623, 628, 629, 637, 651, 655, 656
—— Spätren. Nos. 82, 200, 212, 222, 376, 674, 804, 806, 1380, 1389, 1426, 1469, 1977, 2034, 2040, 2044, 2114
—— Tintorettozeichnungen Nos. 883, 1835
—— Tizianzeichnungen Nos. 1872, 1904, 1911, 1924, 1925, 1929, 1932, 1935, 1949, 1951, 1952, 1961, 2019
LAFENESTRE, Le Titien No. 1999
MORASSI-RASINI Nos. 12, 1762
MORGAN Dr. Nos. 403, 1340
PEMBROKE Dr. No. 2255
UFFIZI Publ. Nos. 265, 284, 762, 1371, 1409, 1415, 1897

ERRATA

P. 53, No. **192**: Pl. *CXLI* instead of *CLXI*.
P. 60, No. **248**: insert [*Pl. XIV*, 2. **MM**]
P. 60, No. **251**: insert [*Pl. CXCI*, 4. **MM**]
P. 61, No. **254**: cancel [*Pl. XIV*, 2. **MM**]
P. 61, No. **256**, line seven: Olschki instead of Olschi.
P. 179, No. **745**: insert [*Pl. XLI*, 3. **MM**]
P. 191, No. **805**: insert [*Pl. CLXVI*, 1. **MM**]

P. 191, No. **808**: cancel [*Pl. CLXVI*, 1. **MM**]
P. 237, No. **A1330**, left column, line next to last and
right column, line two: Florigerio instead of Florigero.
P. 329, No. **1991**: *Pl. LXXVI*, 3 instead of *LXXVI*, 1.
P. 330, No. **2000**: *Pl. LXXVI*, 1 instead of *LXXVI*, 3.
P. 359, No. **2212**: *Pl. CLXVII* instead of *CLXXVII*.
P. 362, No. **2241**: *Pl. CXL*, 2 instead of *CXL*, 3.

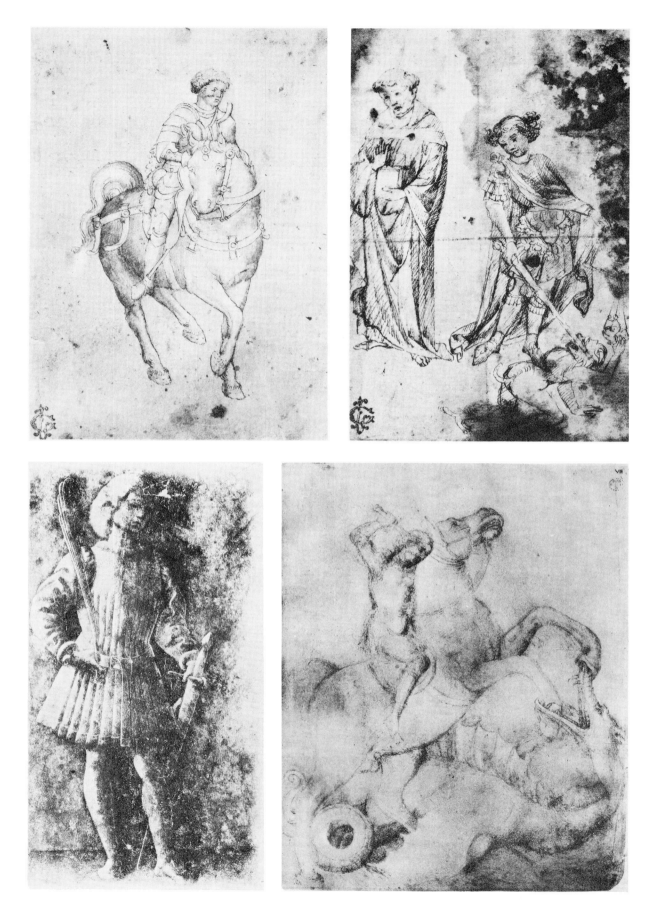

Pl I

1. No. **702** Giambono.—*2*. No. **701** Giambono.—*3*. No. **2251** Antonio Vivarini.—*4*. No. **363**, VIII Jacopo Bellini.

Pl II

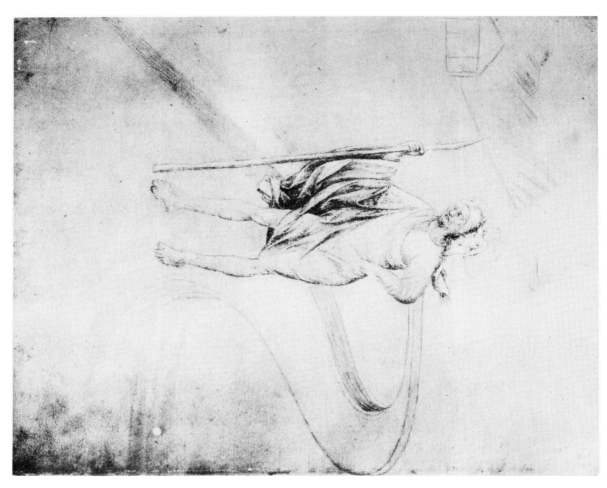

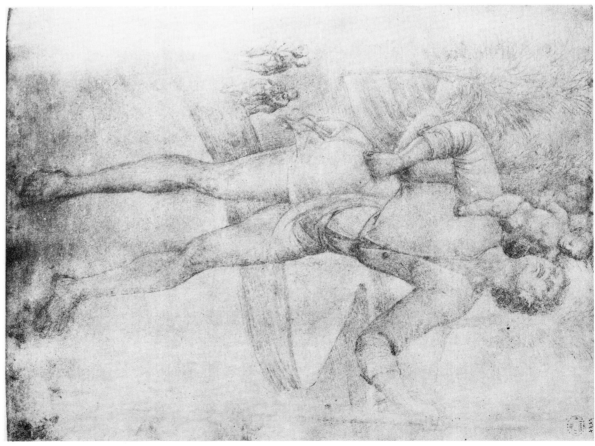

Jacopo Bellini 1. No. 363, XXXIII.—2. No. 363, XLV.

Pl III

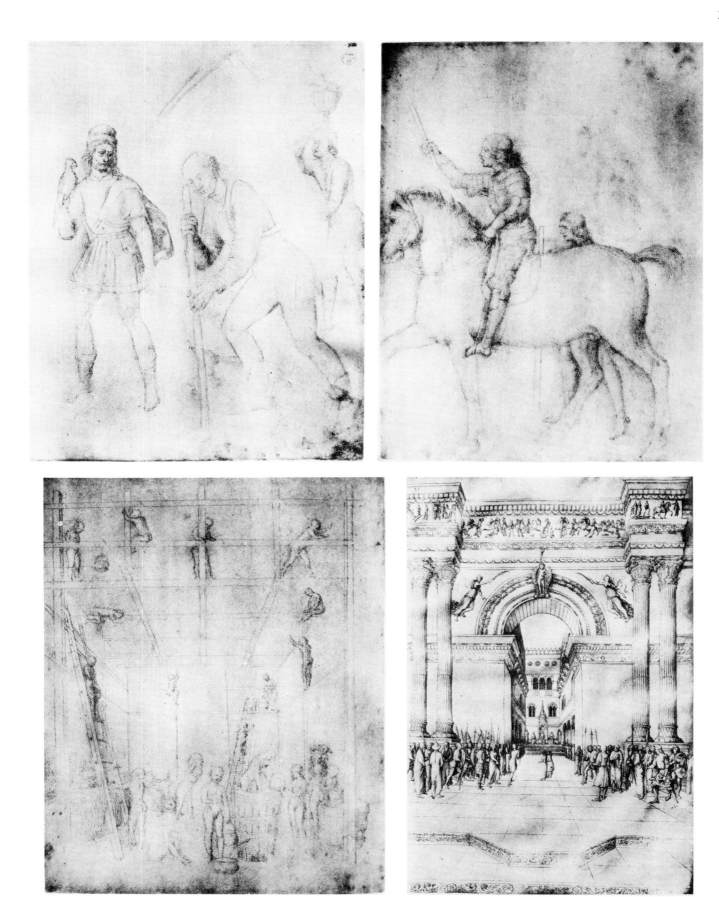

Jacopo Bellini *1*. No. **363**, XVI.—*2*. No. **363**, CIX.—*3*. No. **363**, LXIX.—*4*. No. **364**, XXXIV.

Pl IV

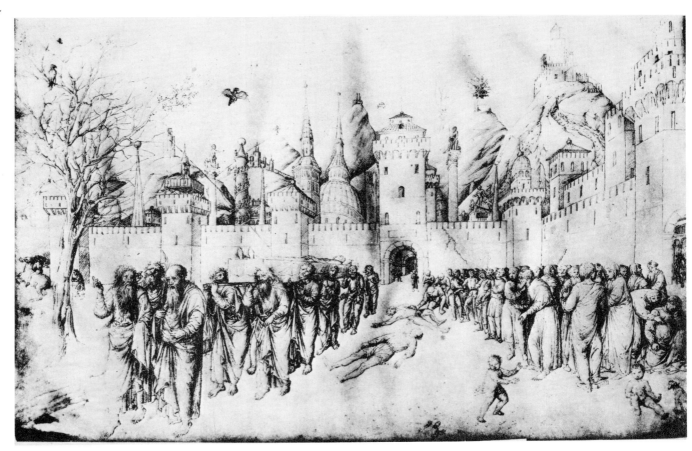

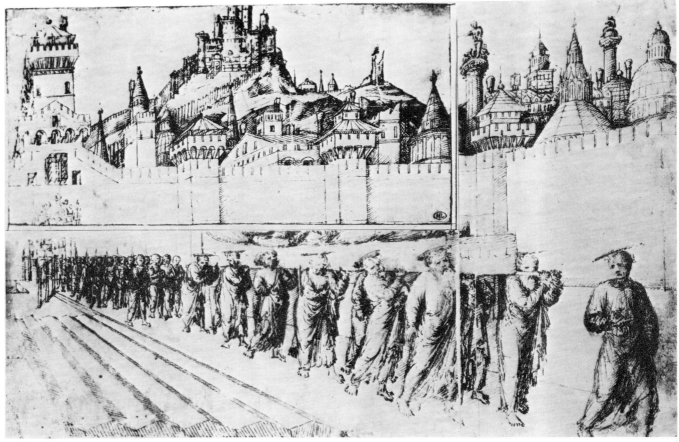

Jacopo Bellini *1*. No. **364**, VI.—*2*. No. **358** and **369**.

Pl V

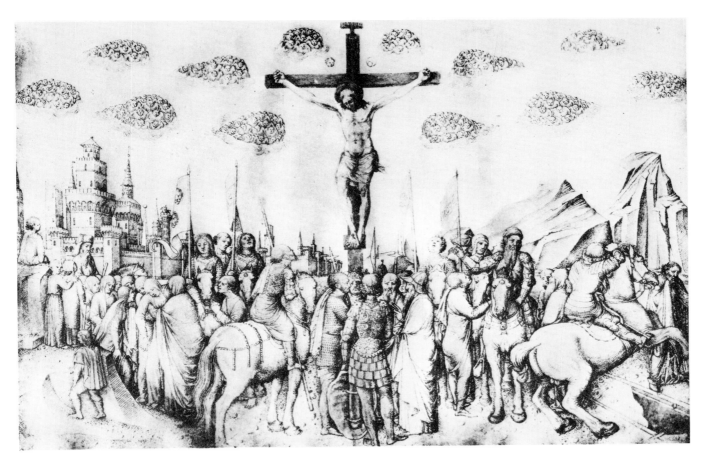

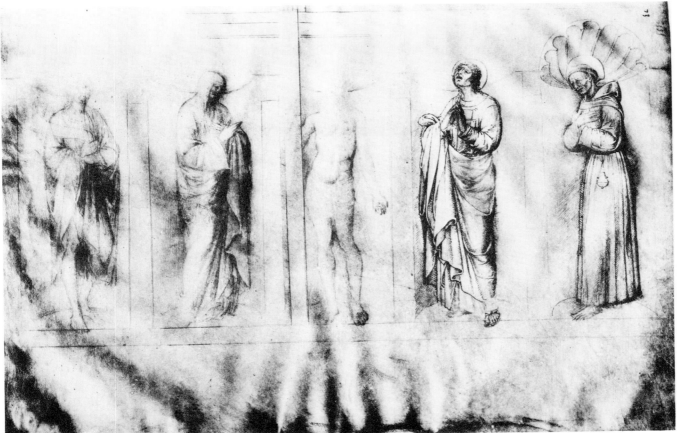

Jacopo Bellini *1*. No. **364**, XXXVI.—*2*. No. **364**, LXIX.

Pl VI

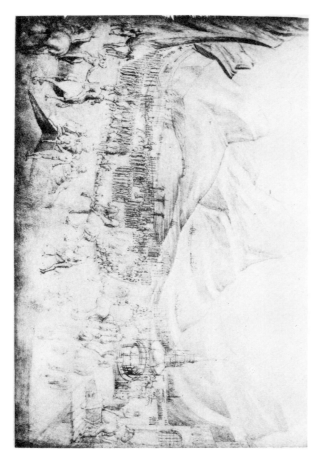

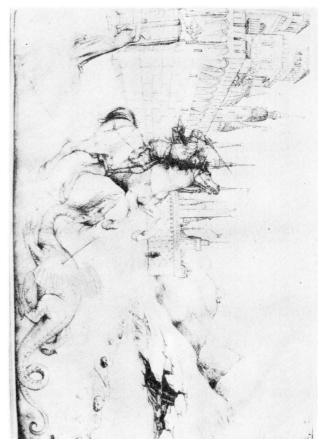

Jacopo Bellini *1.* No. **364,** VIII.—*2.* No. **364,** XVIII.—*3.* No. **364,** LVIII.—*4.* No. **364,** LXXII.

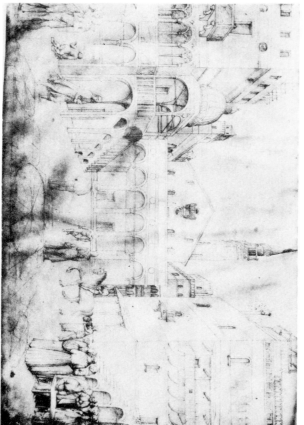

Pl. VII

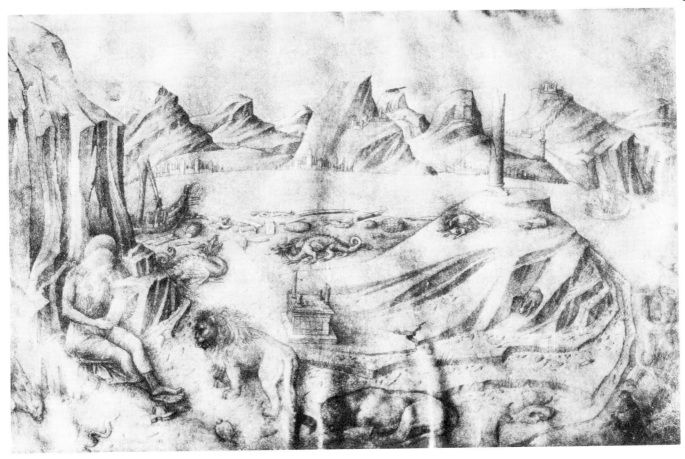

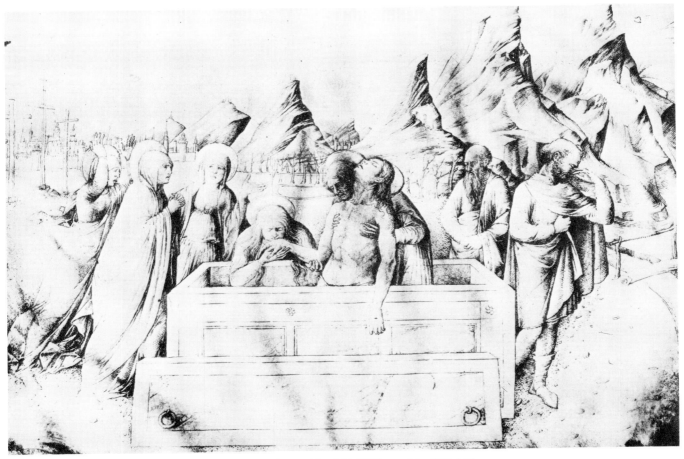

Jacopo Bellini *1*. No. **364**, XIV.—*2*. No. **364**, LV.

Pl VIII

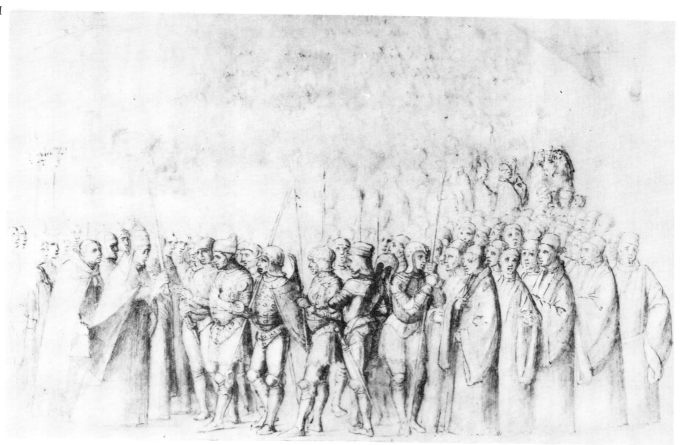

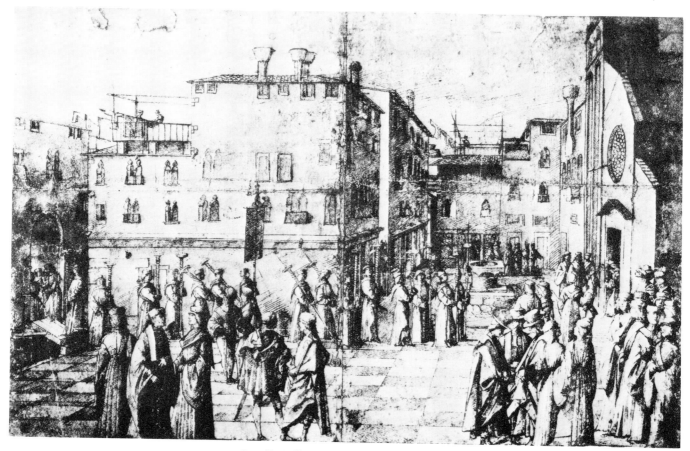

Gentile Bellini *1*. No. **269**.—*2*. No. **265**.

Pl IX

Gentile Bellini *1*. No. 263.—*2*. No. 270.—*3*. No. 274.—*4*. No. 278.

Pl X

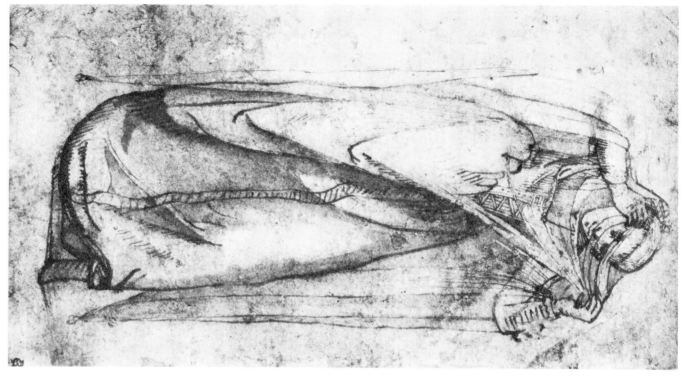

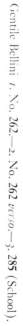

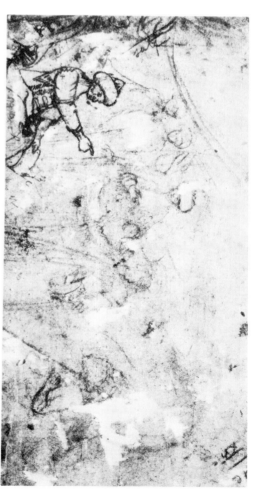

Gentile Bellini 1. No. 262.—2. No. 262 verso.—3. 285 (School).

Pl. XI

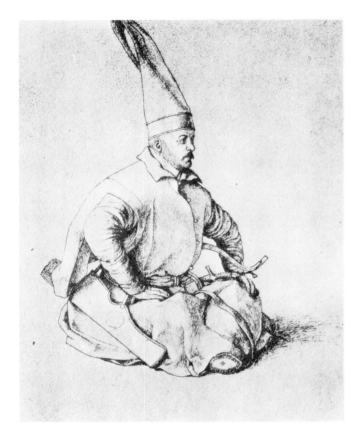

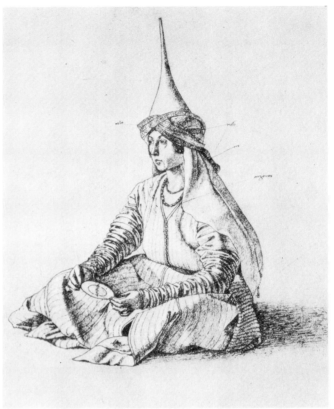

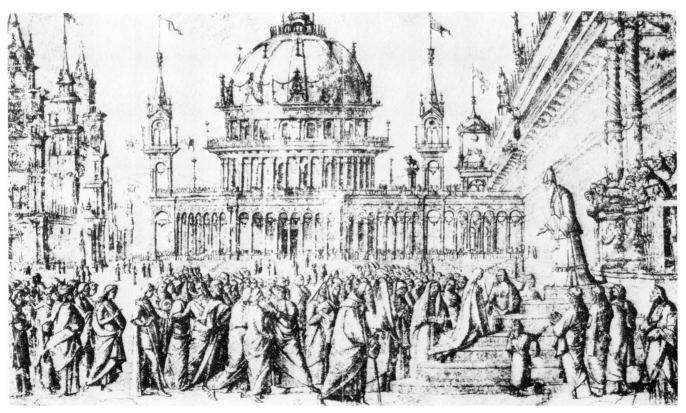

Gentile Bellini *1*. No. **271**.—*2*. No. **272**.—*3*. No. **284** (School).

Pl XII

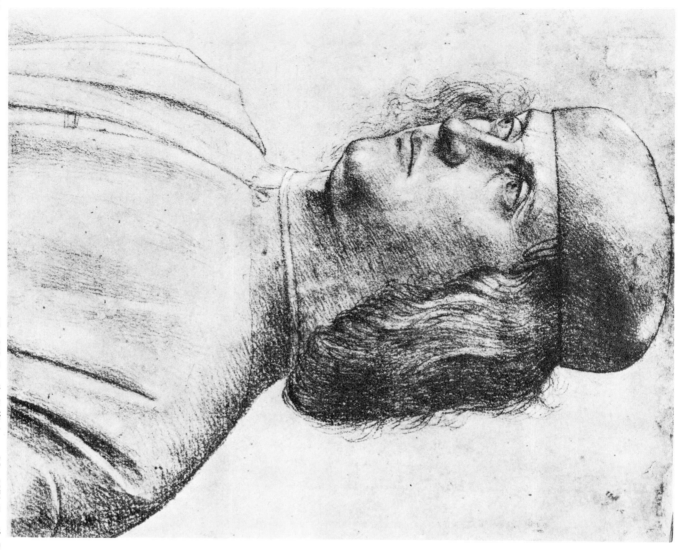

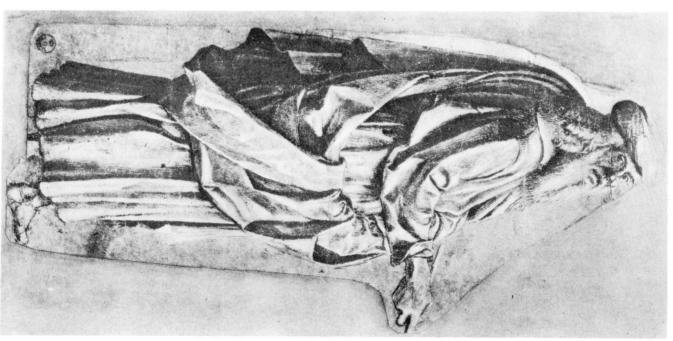

1. No. 260 Gentile Bellini.—*2*. No. **1371** Gentile Bellini?

Pl XIII

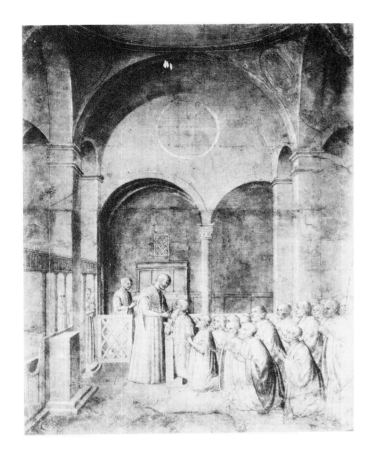

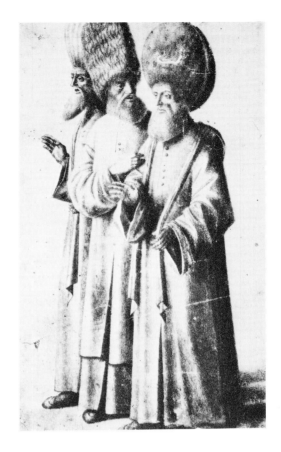

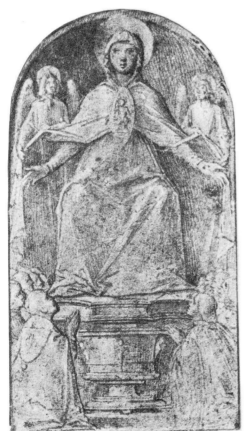

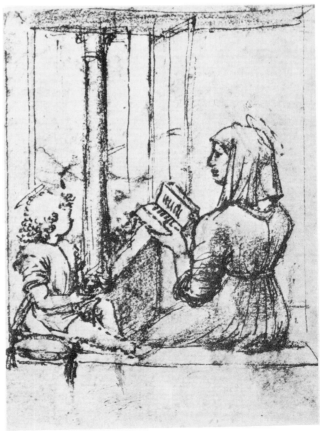

1. No. **283** School of Gentile Bellini.—*2*. No. **801** Giov. Mansueti.—*3-4*. Bastiani No. **253, 249.**

Pl. XIV

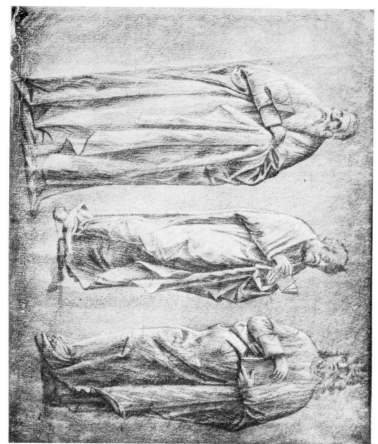

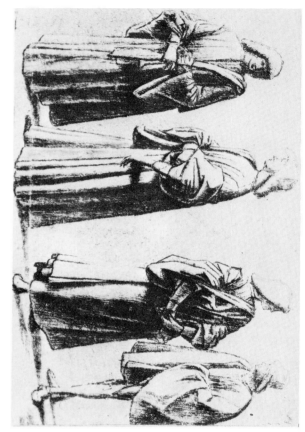

1–2. Bastiani No. 252. 248 — 3–4. Vittore Carpaccio No. 637. 593.

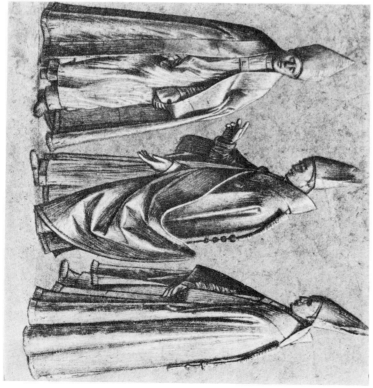

Pl. XV

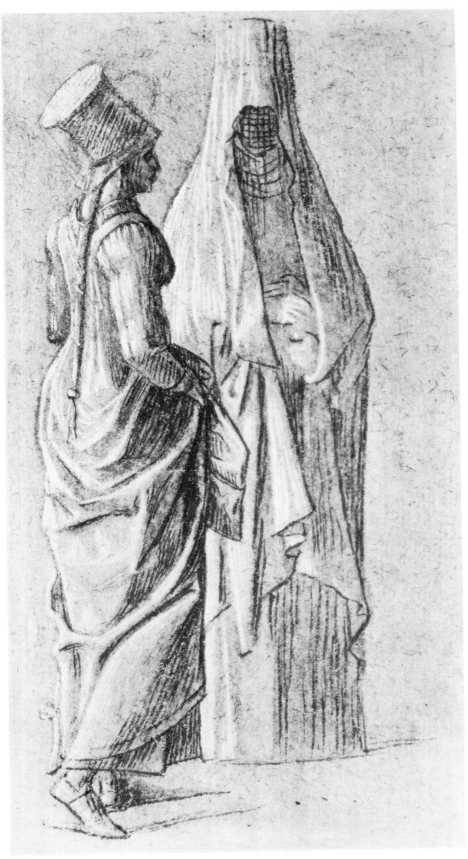

No. **640** *verso* Vittore Carpaccio.

Pl XVI

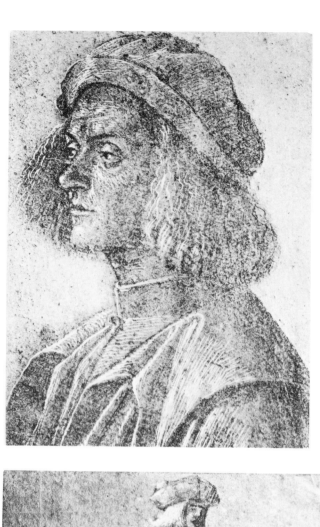

'Vittore Carpaccio *1*. No. **629**.—*2*. No. **589** *verso*.—*3*. No. **618** *verso*.—*4*. No. **589**.

Pl XVII

Vittore Carpaccio *1.* No. **635.**—*2.* No. **597.**

Pl XVIII

Vittore Carpaccio. *1.* No. **604**.— *2.* No. **615**.— *3.* No. **623**.— *4.* No. **592**.

Pl XIX

No. 636 Vittore Carpaccio.

Pl XX

Vittore Carpaccio 1. No. **614**.—2. No. **606** verso.—3. No. **606**.—4. No. **614** verso.

Pl XXI

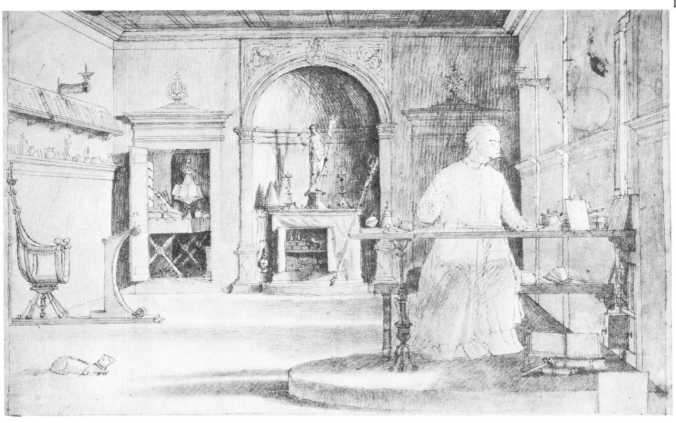

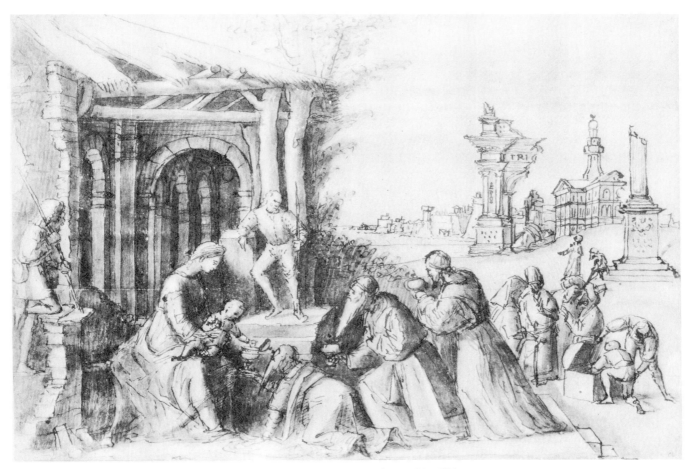

Vittore Carpaccio *1*. No. **617**.—*2*. No. **590**.

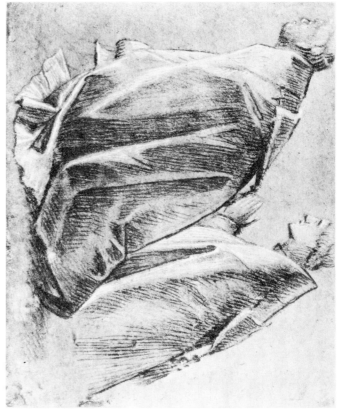

Vittore Carpaccio 1 No. 637 *verso.*—2. No. 618.—3. No. 634 *verso.*—4. No. 634.

Pl XXIII

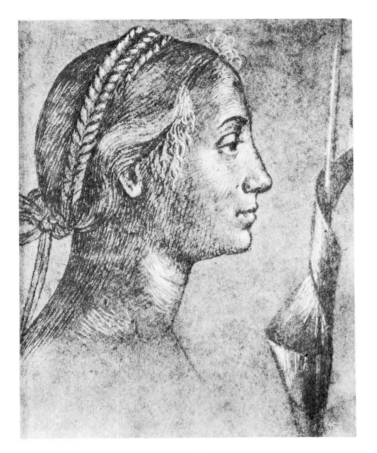

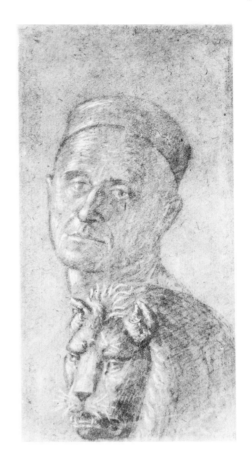

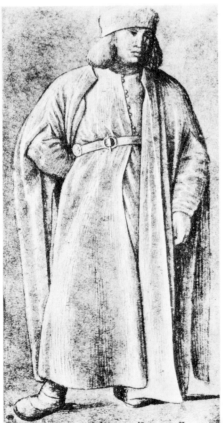

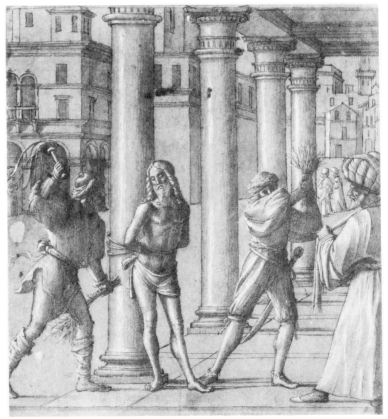

Vittore Carpaccio *1*. No. **594**.—*2*. No. **640** *verso*.—School of Carpaccio *3*. No. **651**.—*4*. No. **642**.

Pl XXIV

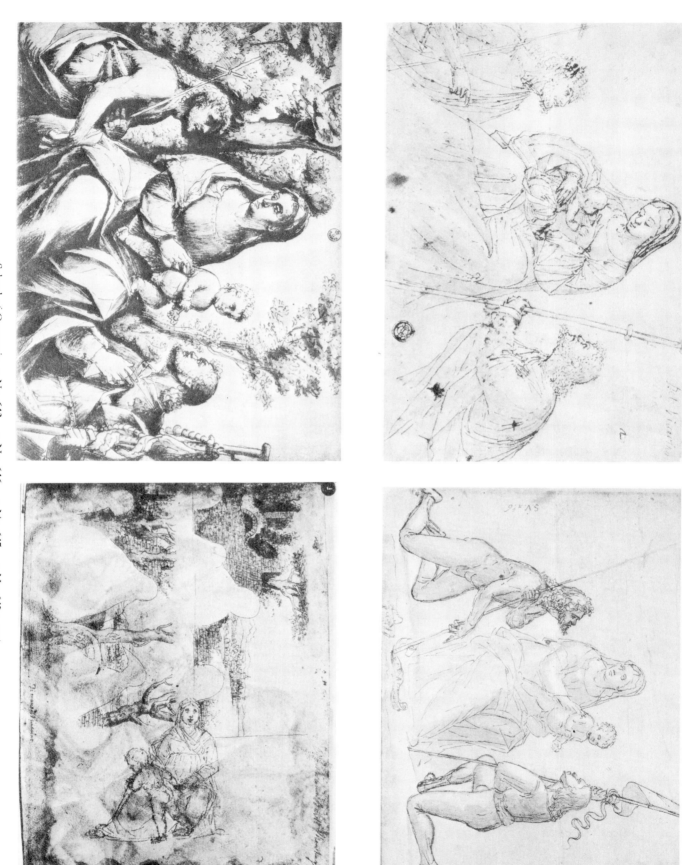

School of Carpaccio 1. No. 643.—2. No. 646.—3. No. 645.—4. No. 645 verso.

Pl XXV

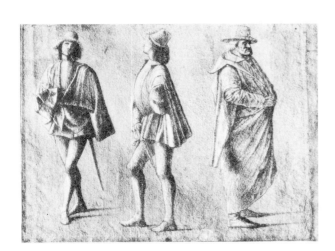

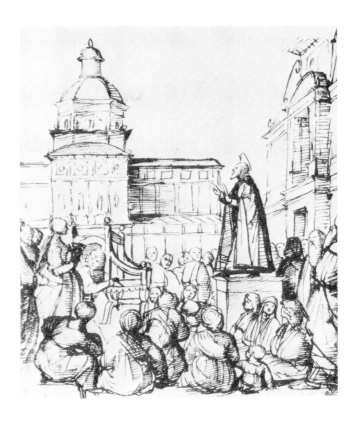

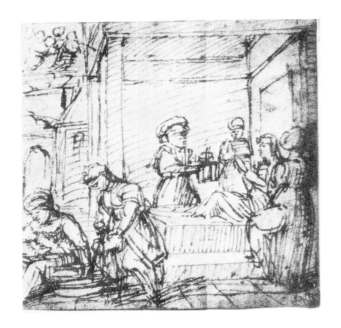

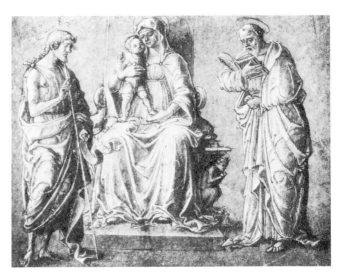

1. No. **608** Vittore Carpaccio.—*2*. No. **749** Lattanzio da Rimini.—*3*. No. **649** School of Carpaccio.—*4*. No. **2252** Andrea da Murano?

Pl XXVI

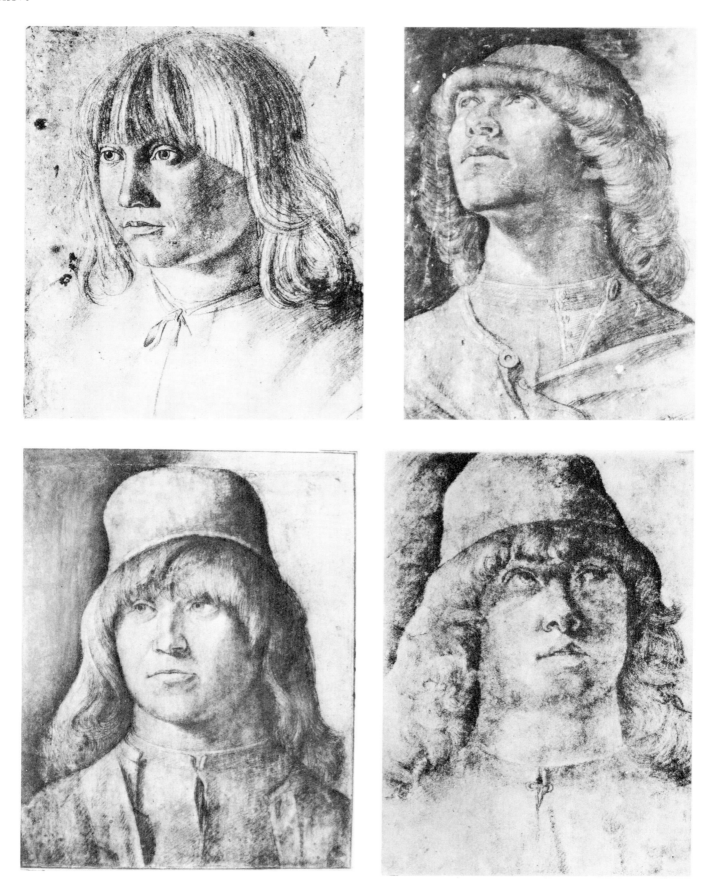

1. No. **51** Alvise Vivarini?—*2–4.* Alvise Vivarini No. **2244, 2246, 2249.**

Pl XXVII

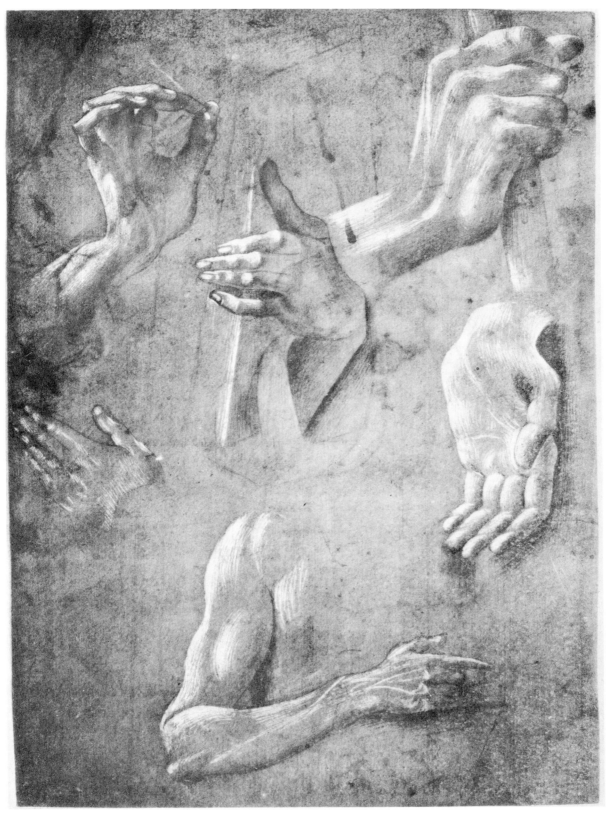

No. 2245 Alvise Vivarini.

Pl XXVIII

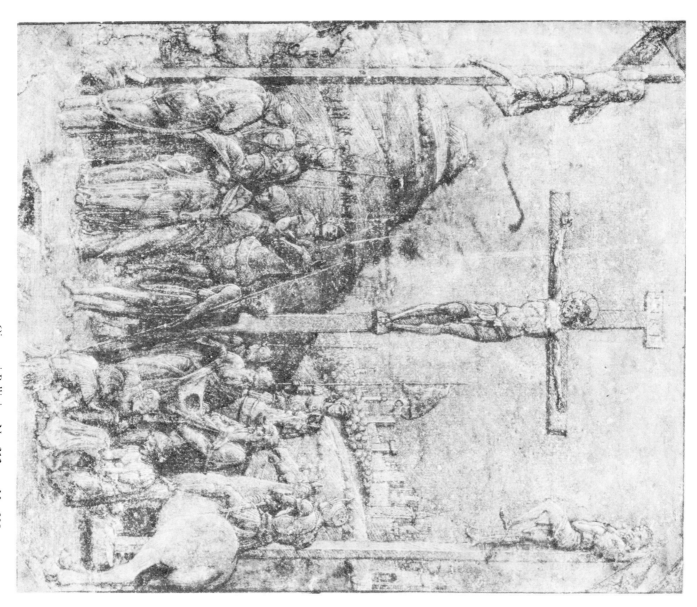

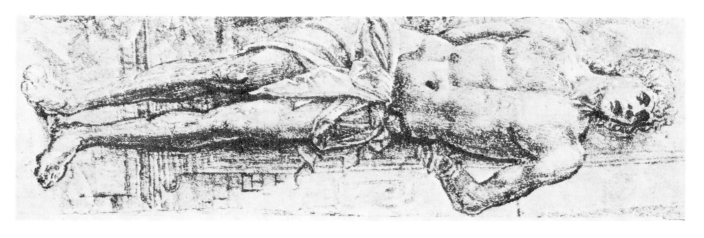

Giovanni Bellini 1. No. 312.—2. No. 308.

Pl XXIX

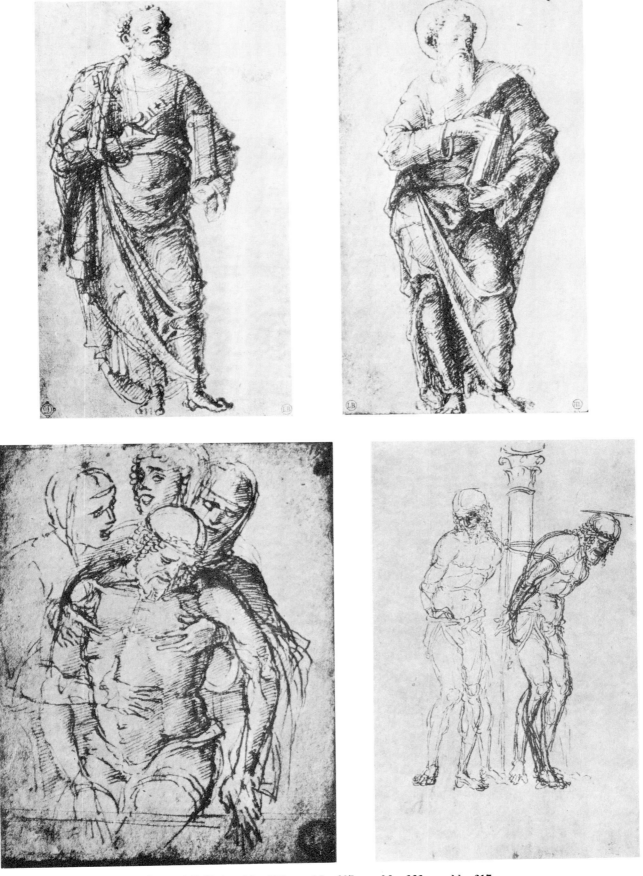

Giovanni Bellini *1*. No. **286**.—*2*. No. **287**.—*3*. No. **323**.—*4*. No. **317**.

Pl XXX

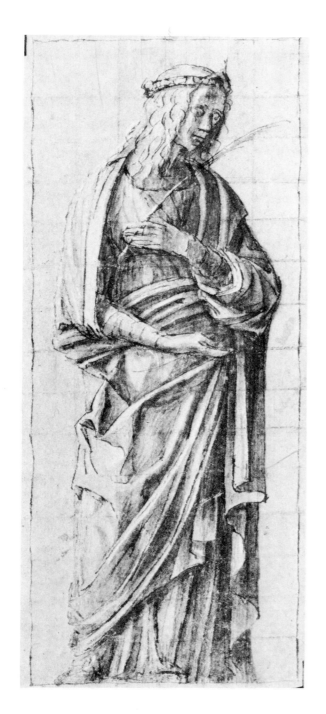
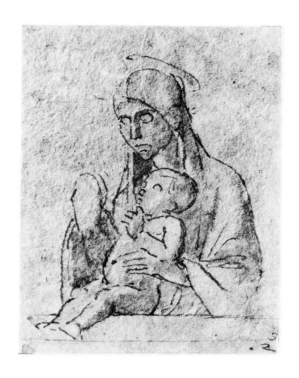
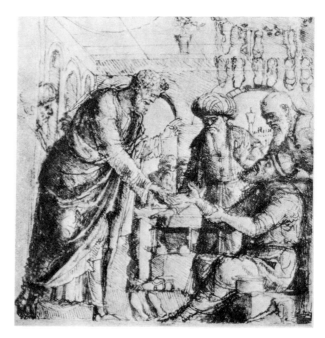

Giovanni Bellini *1*. No. **316** *verso* (cut).—*2*. No. **313**.—*3*. No. **289**.

Pl XXXI

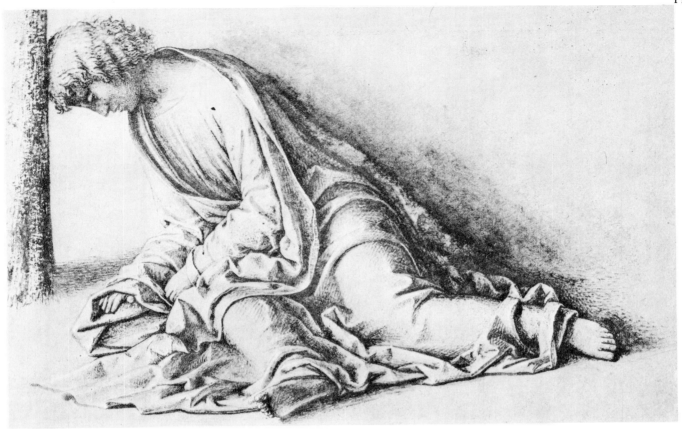

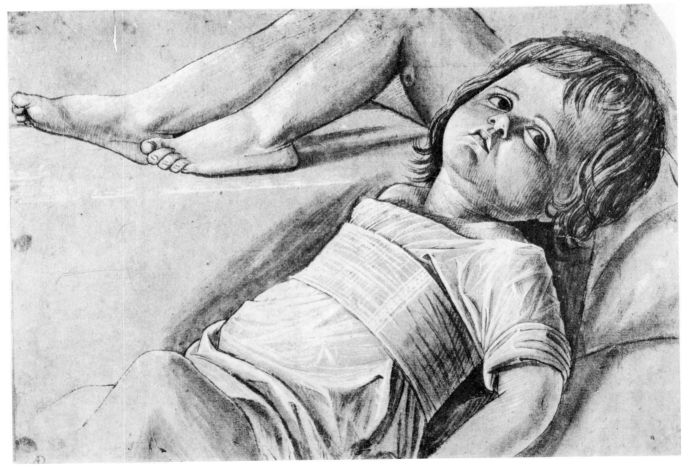

Giovanni Bellini *1*. No. **334** (Shop).—*2*. No. **316**.

Pl XXXII

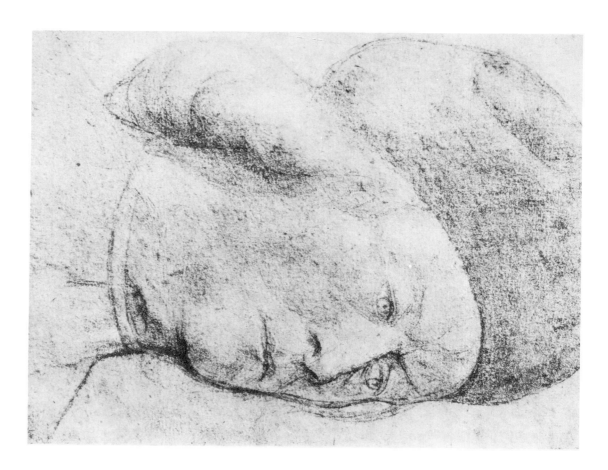

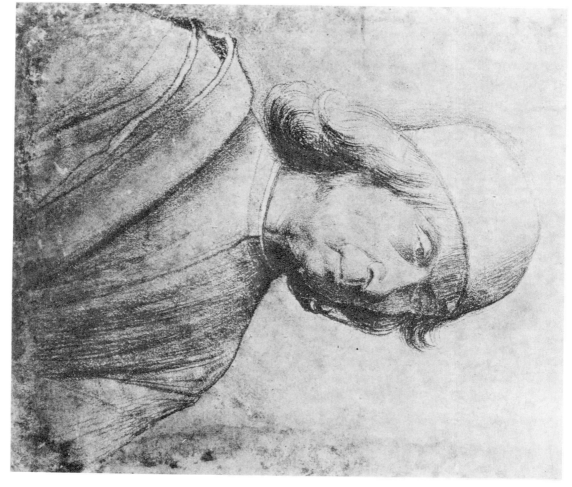

Giovanni Bellini 1. No. 329 (Shop).—2. No. 261.

Pl XXXIII

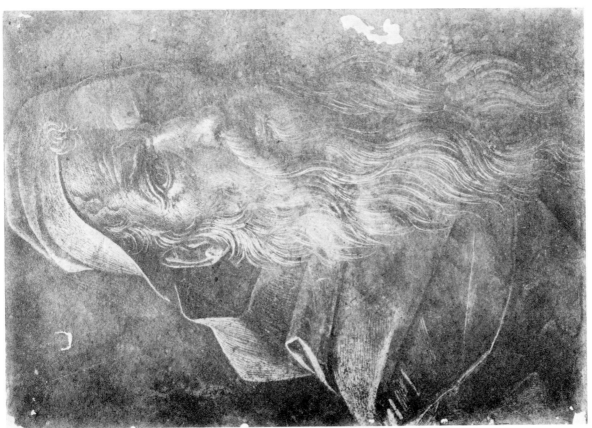

Giovanni Bellini *1*. No. 328.—*2*. No. 324.

Pl XXXIV

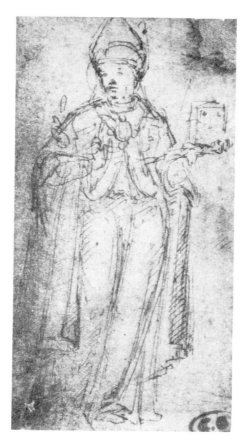

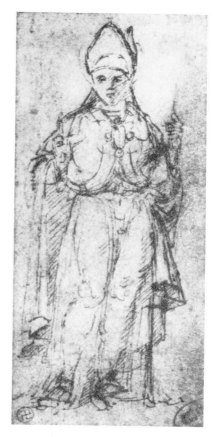

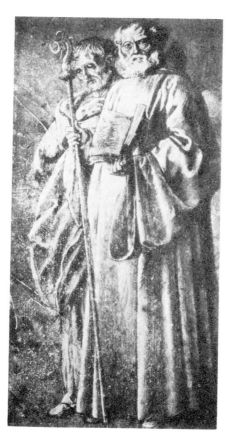

Shop of Giovanni Bellini *1*. No. **350**.—*2*. No. **351**.—*3*. No. **344**.—*4*. No. **336**.

Pl XXXV

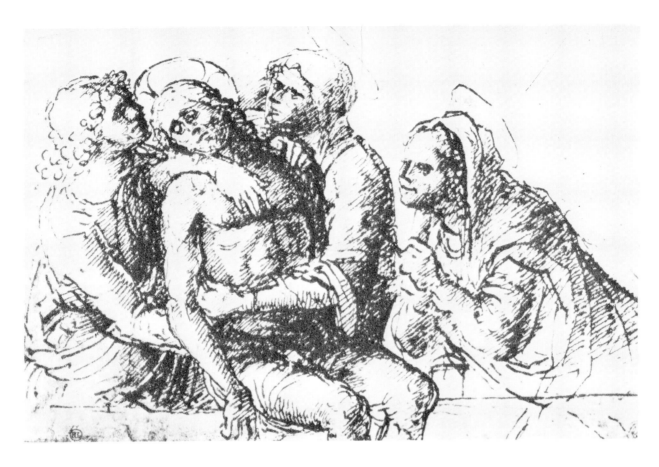

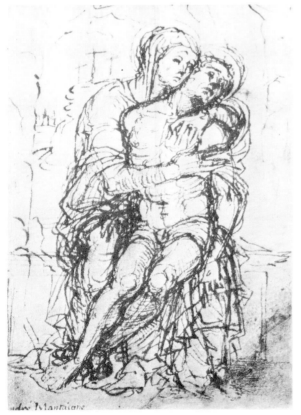

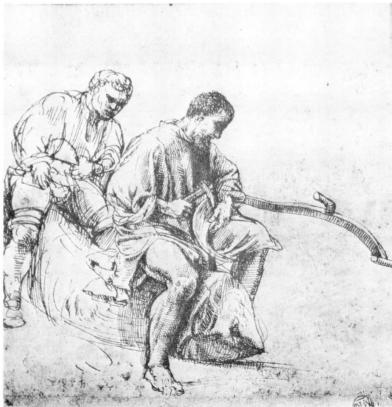

Giovanni Bellini *1–2*. No. **319, 321.**—*3.* No. **1953** Giovanni Bellini?

Pl XXXVI

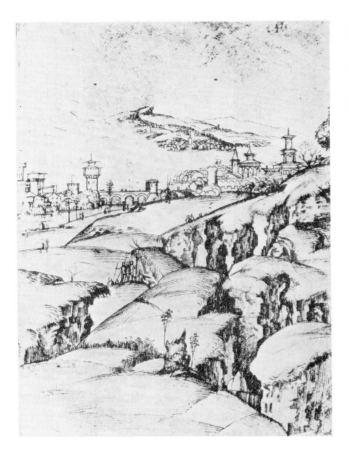

Giovanni Bellini *1*. No. **309**.—*2*. No. **309** *verso*.—*3*. No. **347** (Shop).

Pl XXXVII

1–3. Shop of Giovanni Bellini No. **339, 340, 352.**—*4.* No. **298** Giovanni Bellini.

Pl XXXVIII

1. No. 299 Giovanni Bellini.—*2–4.* Shop of Giovanni Bellini No. **348**, No. **342**, No. **341**.

Pl XXXIX

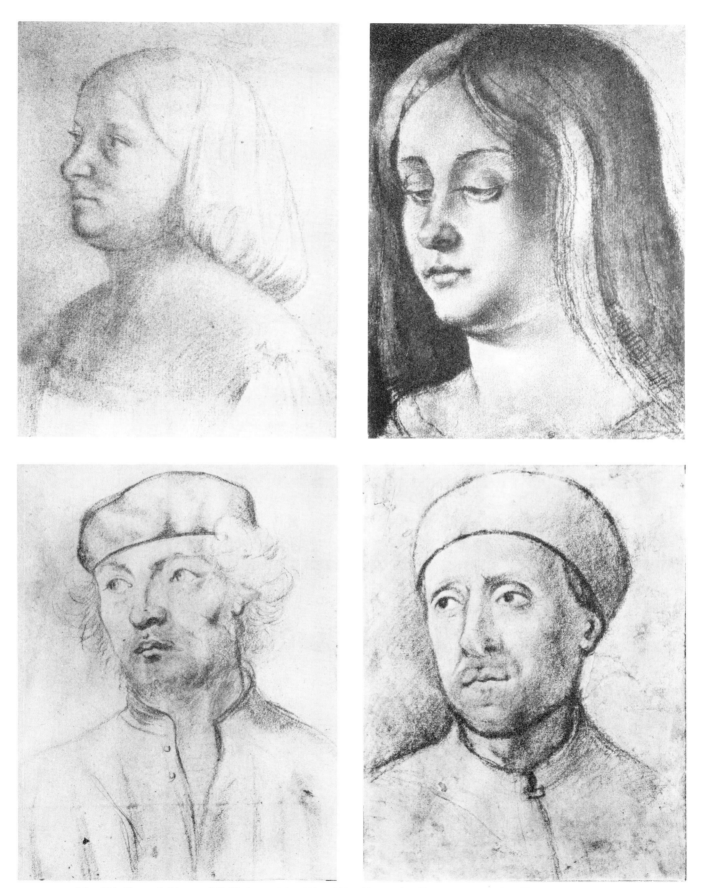

1. No. **331** Shop of Giovanni Bellini —*2*. No. **1375** Niccolò Rondinelli.—*3-4*. Vittore Belliniano No. **372 bis, 371.**

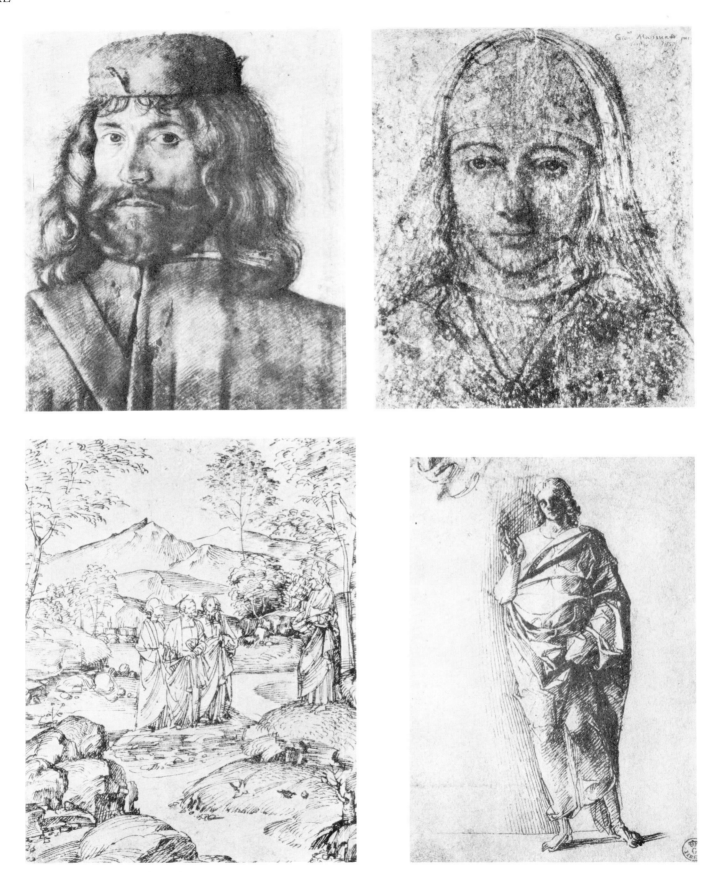

Pl XL

1. No. **802** Marco Marziale.—*2*. No. **799** Giovanni Mansueti.—*3*. No. **353** School of Giovanni Bellini.—*4*. No. **692** Benedetto Diana.

Pl XLI

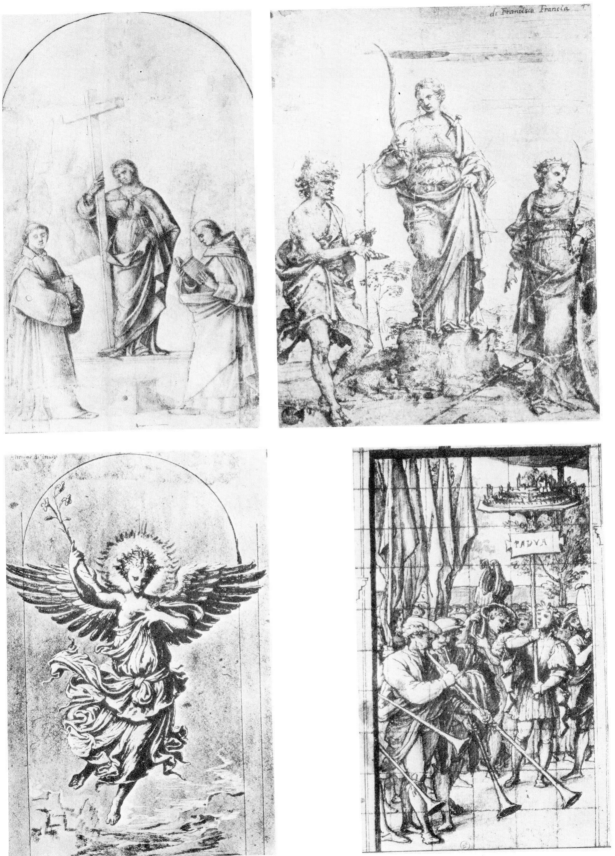

1–2. Francesco Bissolo No. 373, No. 374.—3. No. 745 Girolamo da Treviso.—4. No. 739 Girolamo del Santo.

Pl XLII

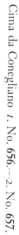

Cima da Coneghano 1. No. 656.—2. No. 657.

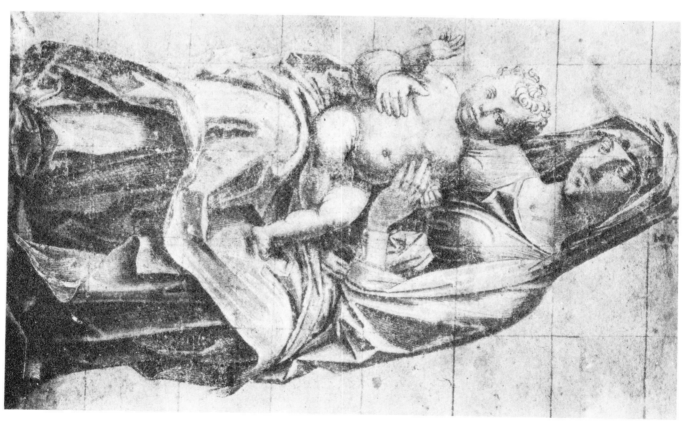

Pl XLIII

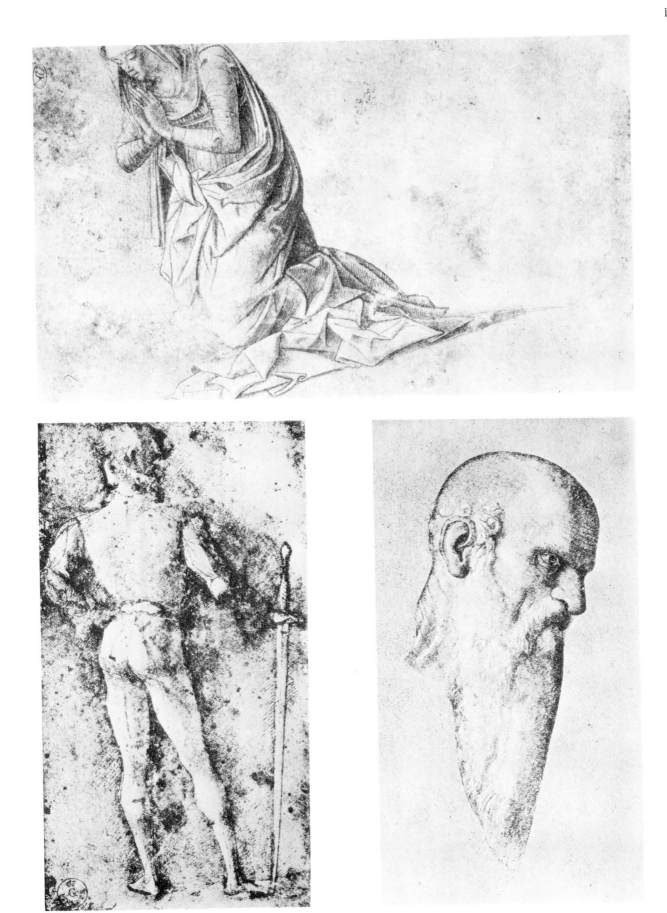

1. No. **658** Cima da Conegliano.—*2.* No. **1372** Andrea Previtali.—*3.* No. **657** *verso* Cima da Conegliano.

Pl XLIV

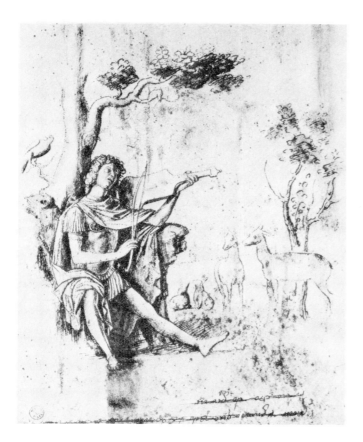

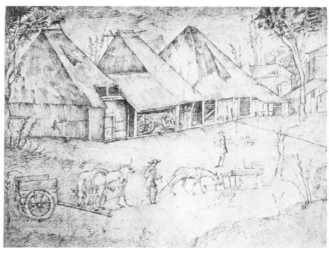

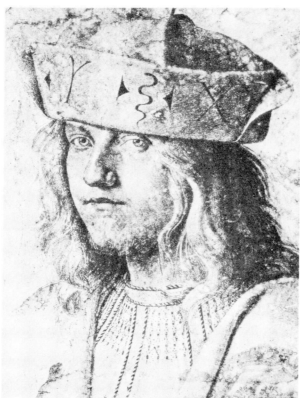

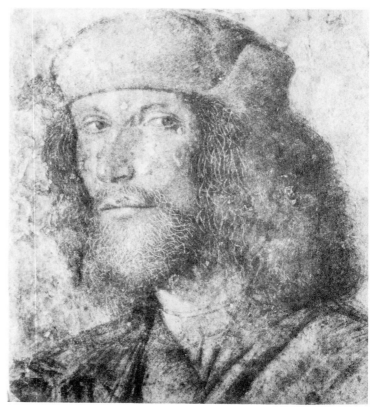

1. No. **655** Cima da Conegliano.—*2*. No. **1370** Andrea Previtali.—*3–4*. Bartolommeo Veneto No. **73, 72**.

Pl XLV

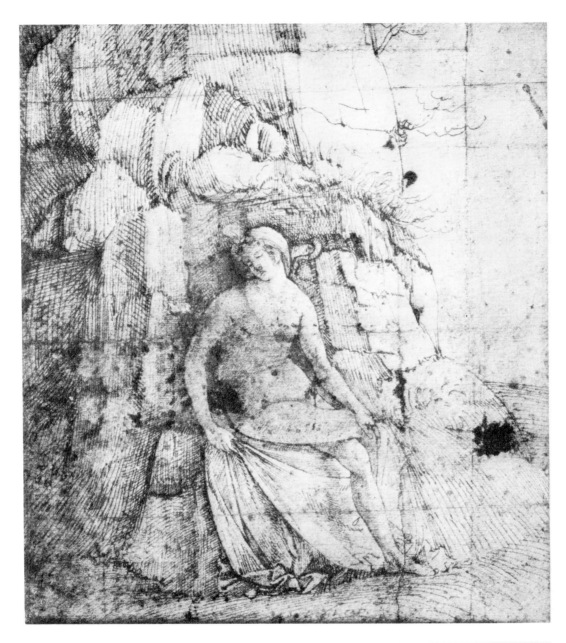

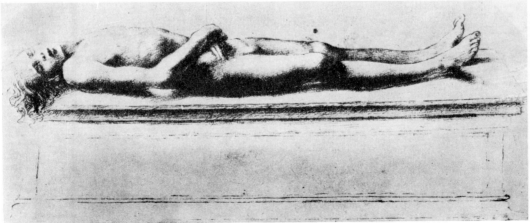

1. No. **62** Jacopo de' Barbari.—*2.* No. **75** Marco Basaiti.

Pl XLVI

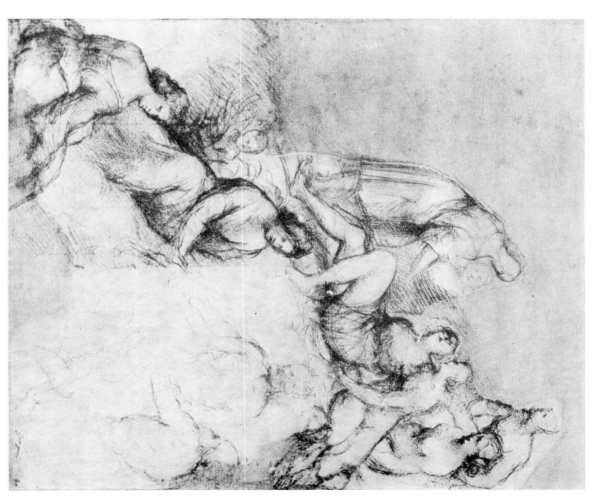

Giorgione 1. No. 710.—2. No. 714.

Pl XLVII

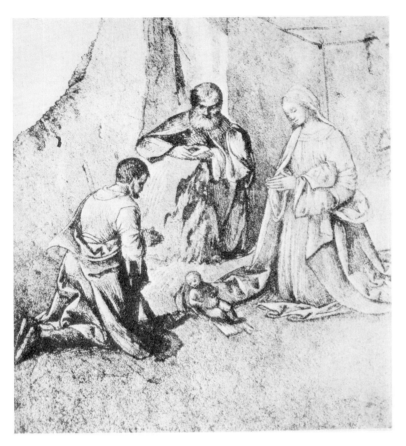
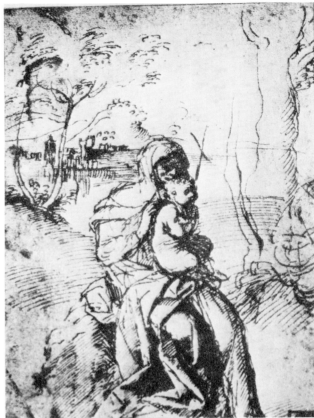

Giorgione *1*. No. **719**.—*2*. No. **703**.—*3*. No. **707**.

Pl XLVIII

Giorgione 1. No. 712.—2. No. 716.—3. No. 706.

Pl XLIX

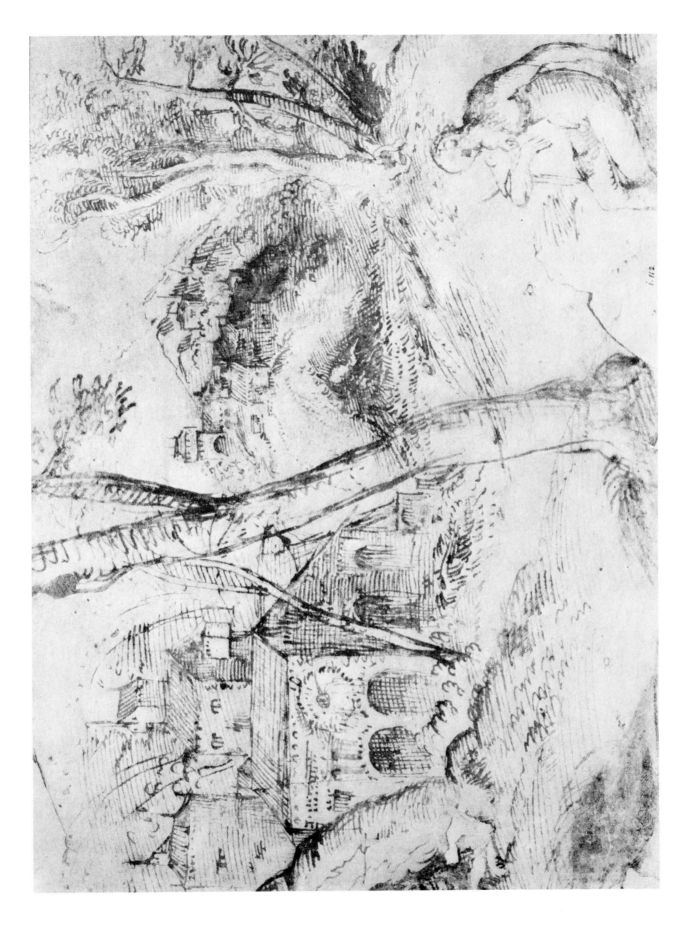

No. 713 Giorgione.

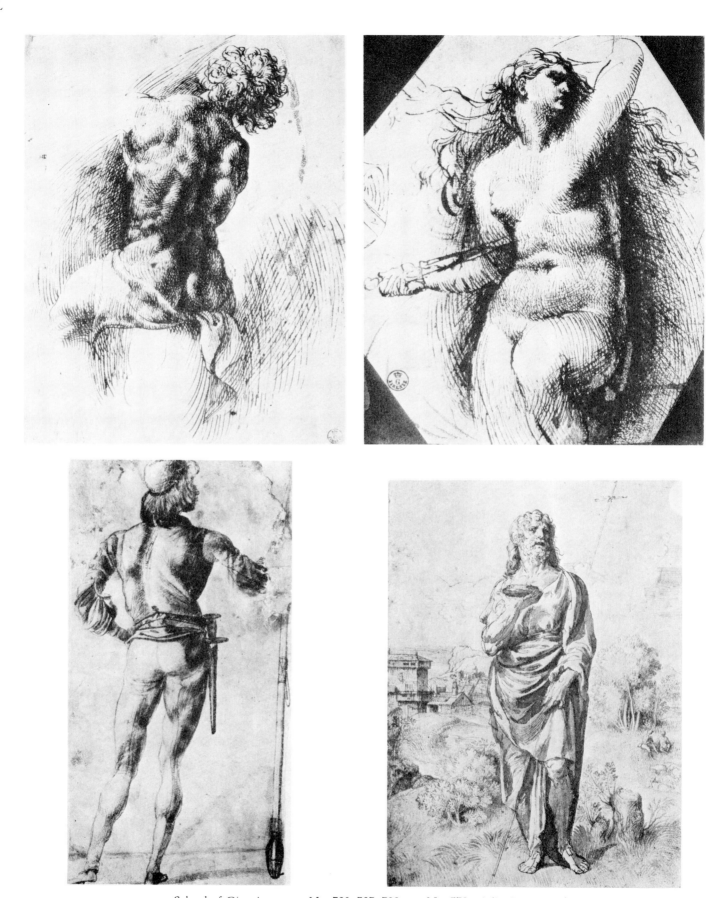

School of Giorgione *1–3*. No. **730, 727, 738.**—*4*. No. **578** Giulio Campagnola.

Pl L

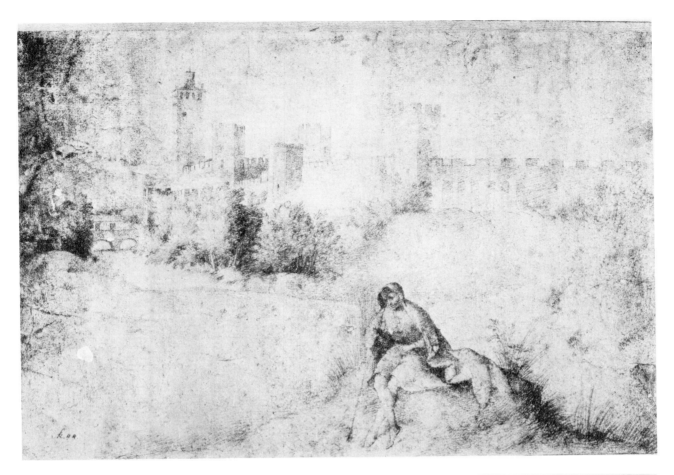

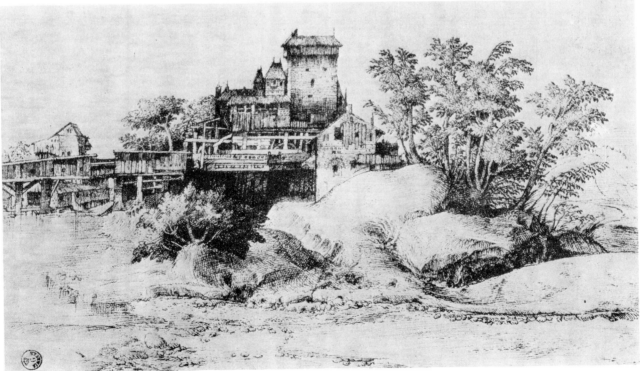

1. No. **709** Giorgione.—*2.* No. **574** Giulio Campagnola.

Pl LI

Pl LII

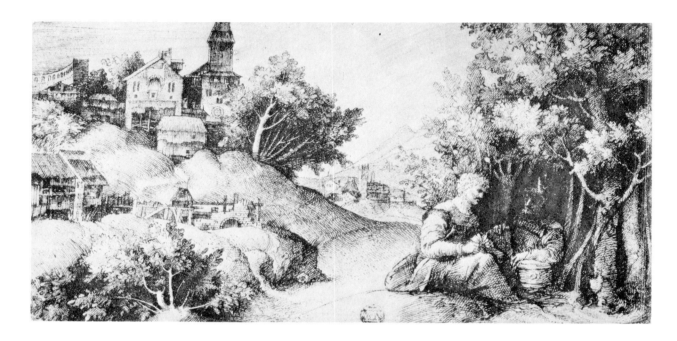

Giulio Campagnola *1.* No. **579.**—*2.* No. **579** *verso.*

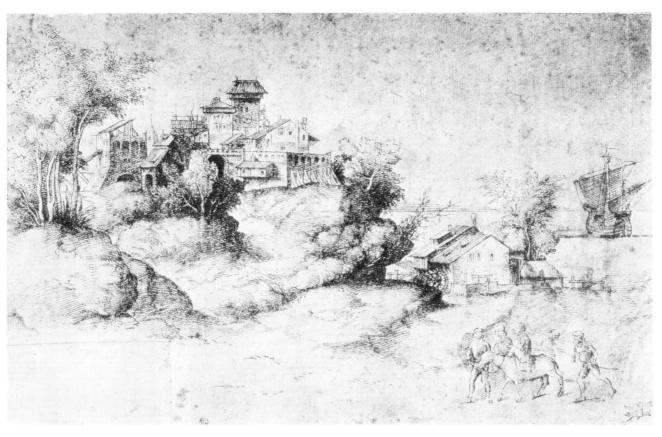

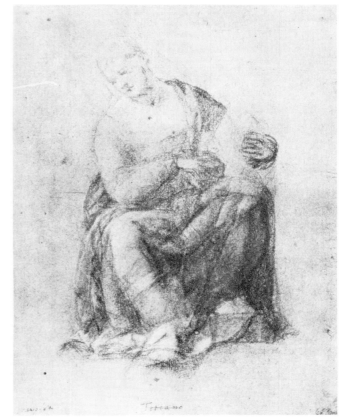

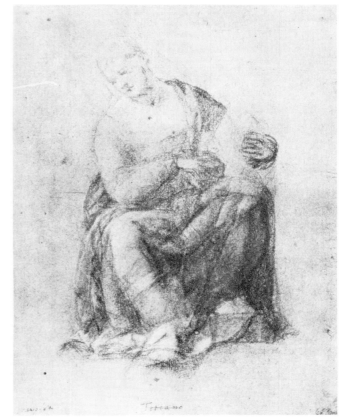

1. No. **577** Giulio Campagnola.—*2.* No. **1266** Palma Vecchio.—*3.* No. **584** Giovanni Cariani.

Pl LIII

Pl LIV

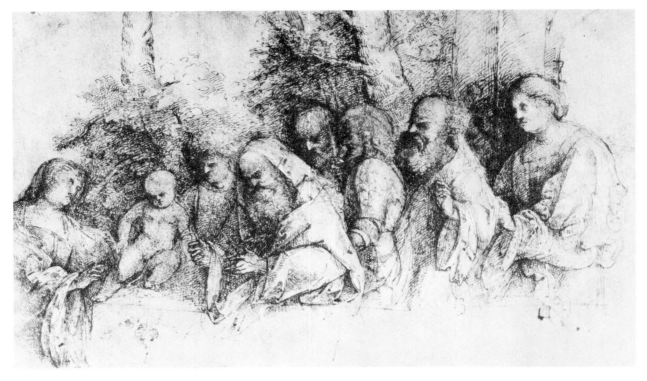

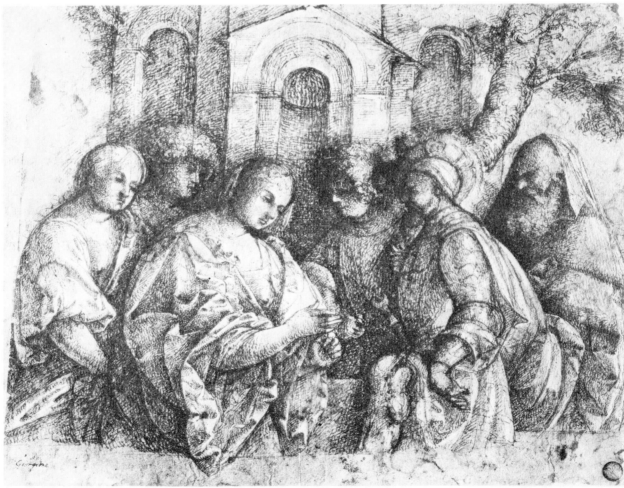

Giovanni Cariani *1.* No. **583.**—*2.* No. **585.**

Pl LV

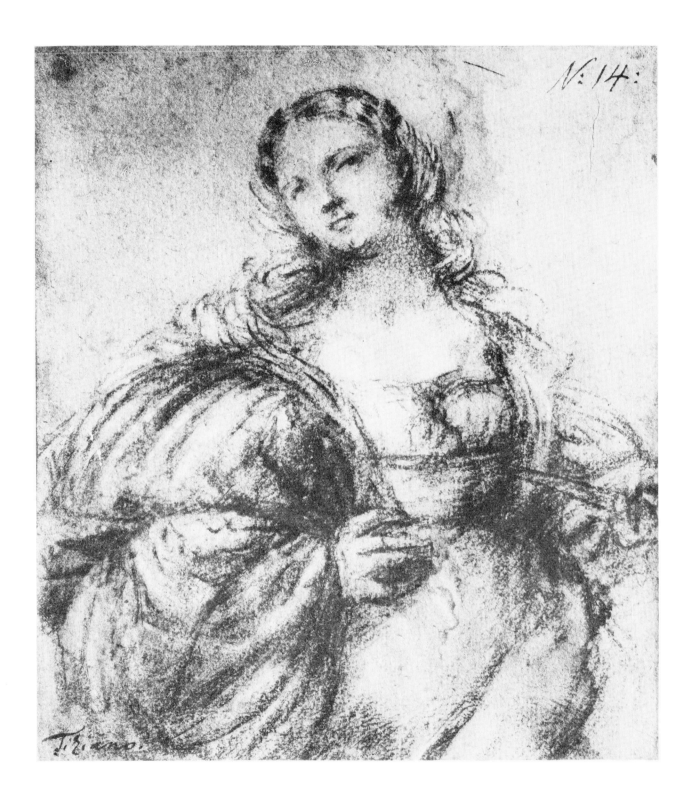

No. **1271** Palma Vecchio.

Pl LVI

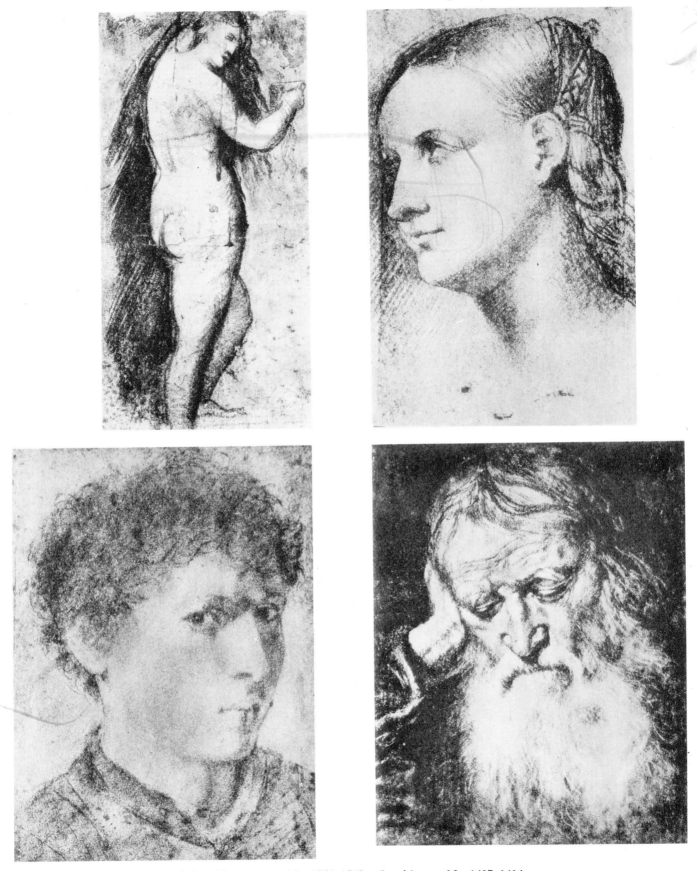

Palma Vecchio *1–2*. No. 1254, 1269.—Savoldo *3–4*. No. 1407, 1414.

Pl LVII

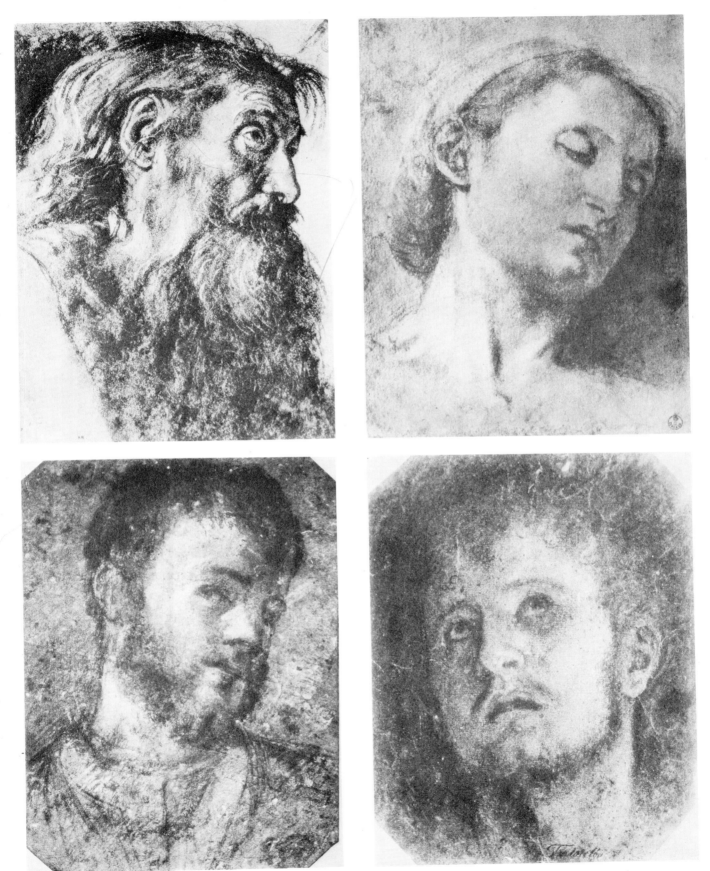

Savoldo *1*. No. 1415.—*2*. No. 1409.—*3*. No. 1412.—*4*. No. 1405.

Pl LVIII

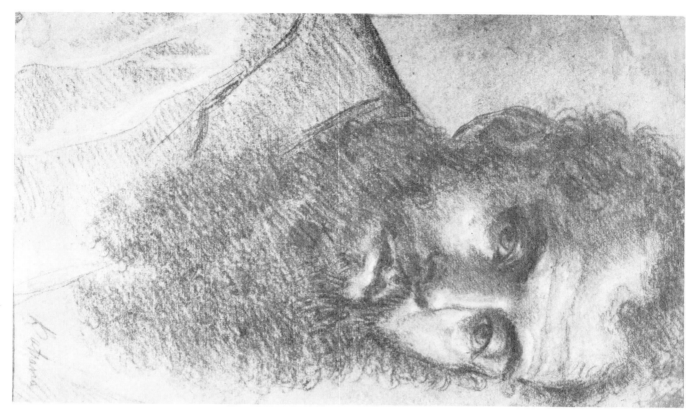

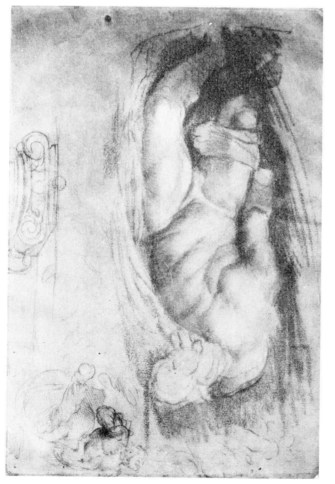

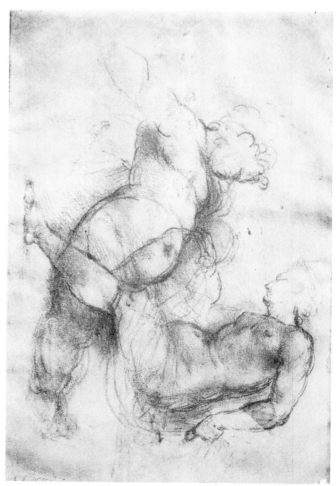

1. No. **1411** Savoldo.—*2–3.* No. **1470, 1470** *verso* Sebastiano del Piombo.

Pl LIX

Pl LX

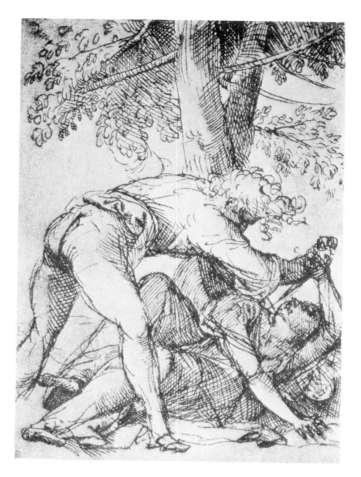

Titian *1.* No. **1961.**—*2.* No. **1932.**

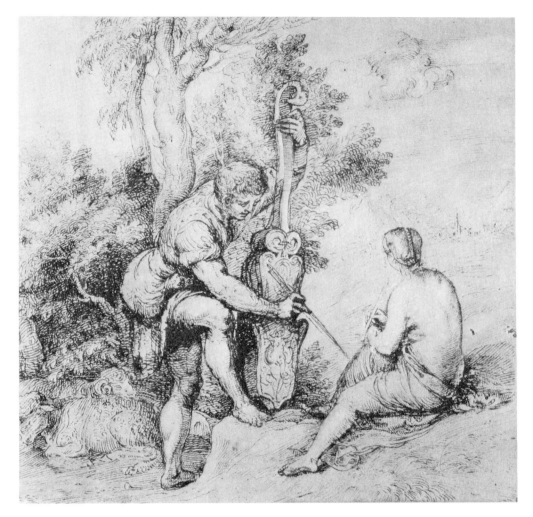

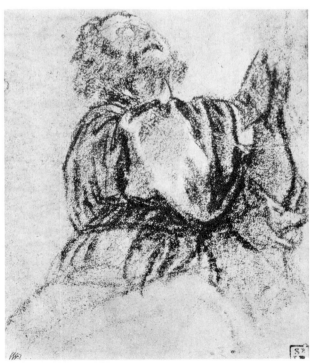

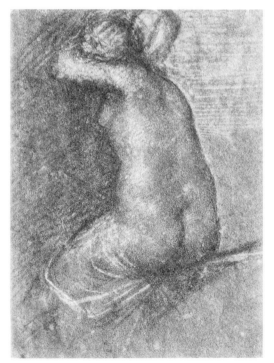

Titian *1*. No. **1928**.—*2*. No. **1929**.—*3*. No. **1920**.

Pl LXI

Pl LXII

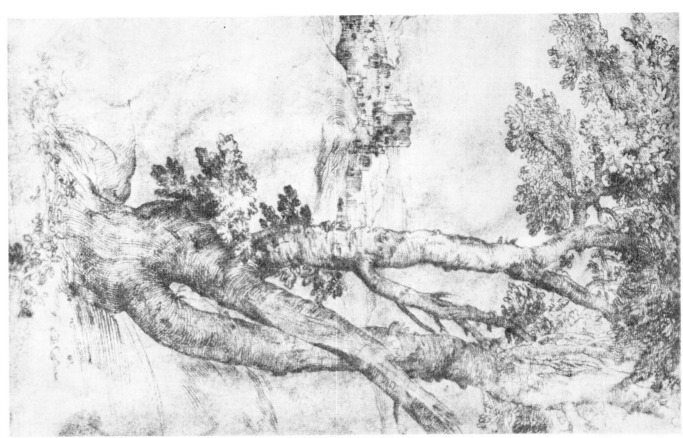

Titian *r*. No. 1912.—2. No. 1915.

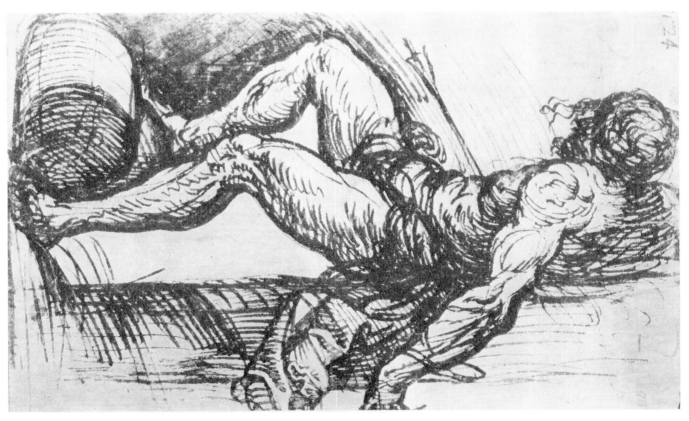

Pl LXIII

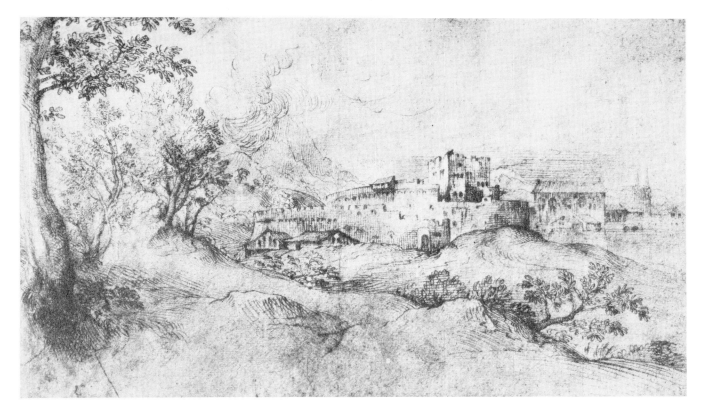

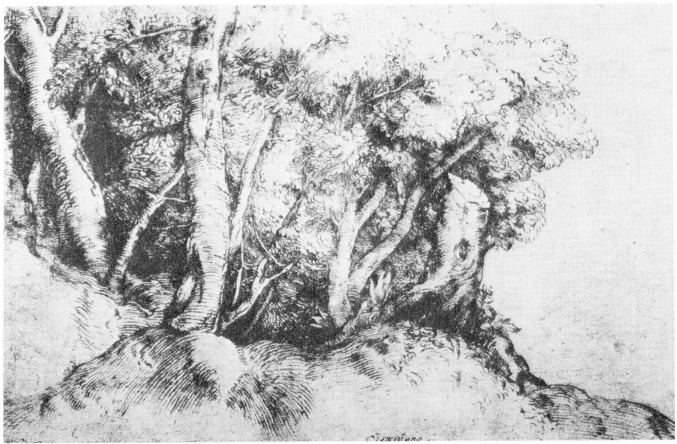

Titian *1*. No. **1875**.—*2*. No. **1943**.

Pl LXIV

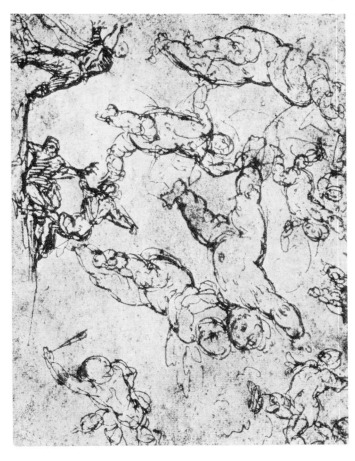

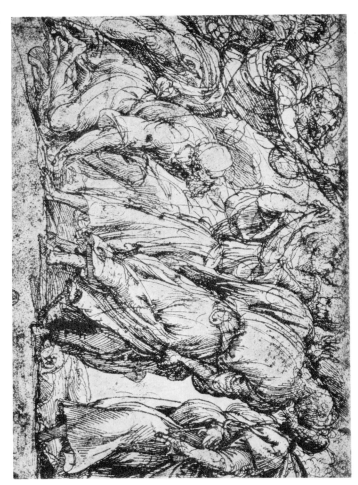

Titian 1. No. 1952.—2. No. 1924.—3. No. 1923.—4. No. 1925.

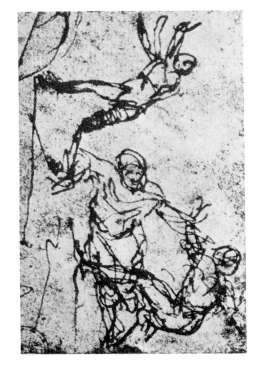

Pl LXV

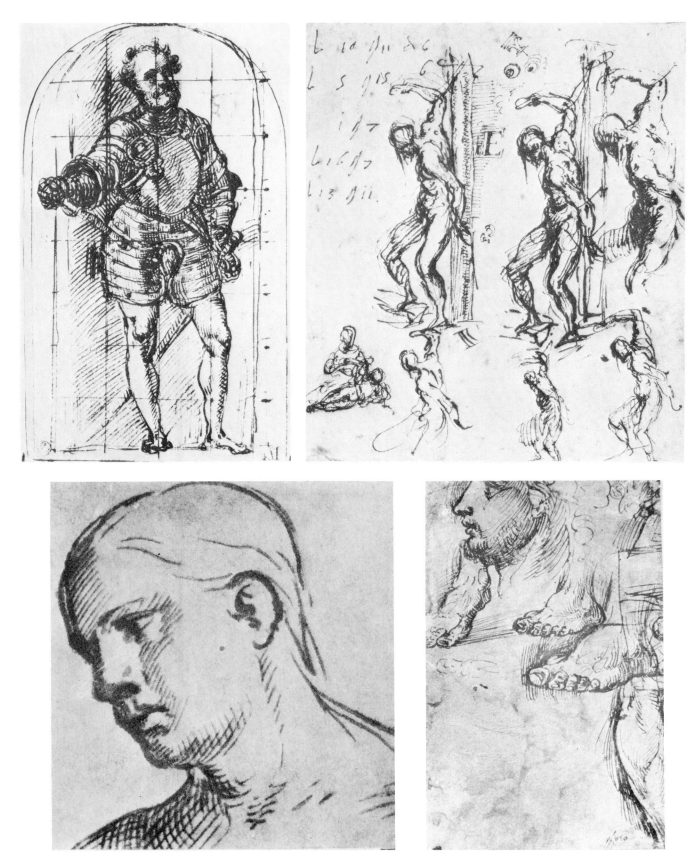

Titian *1*. No. **1911**.—*2*. No. **1880**.—*3*. No. **1894**.—*4*. No. **1915** *verso*.

Pl LXVI

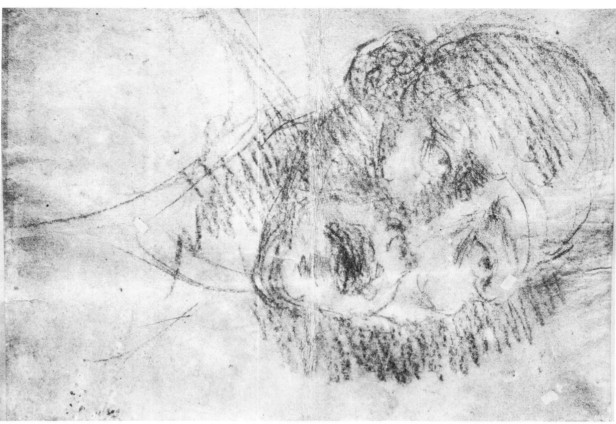

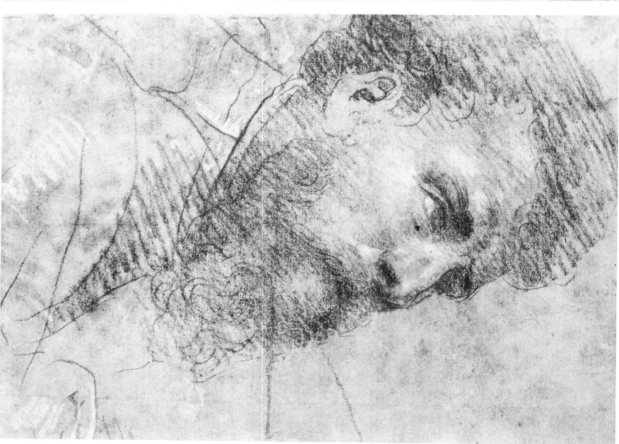

Titian 1. No. 1908 verso.—2. No. 1878.

Pl LXVII

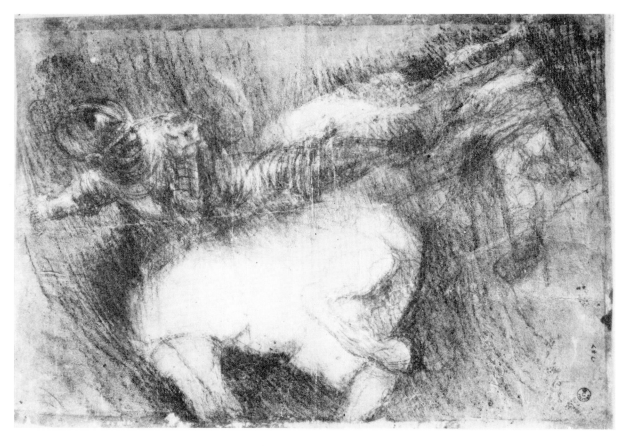

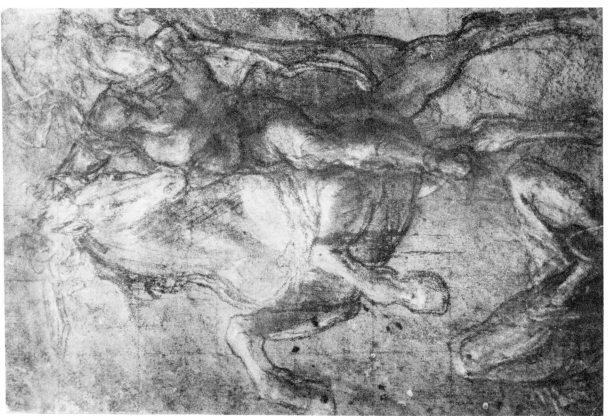

Titian *1.* No. 1941.—*2.* No. 1908.

Pl LXVIII

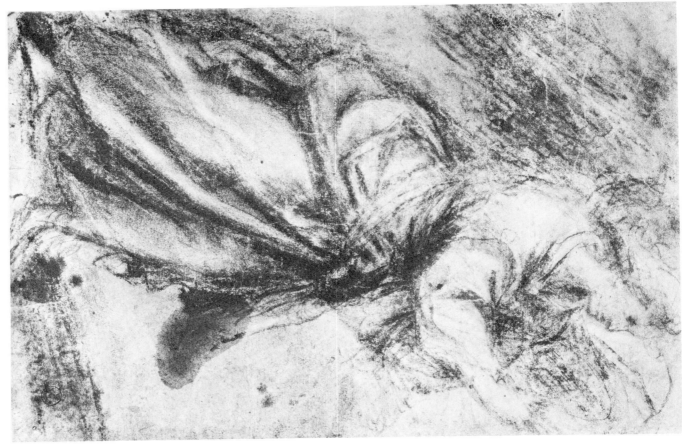

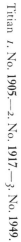

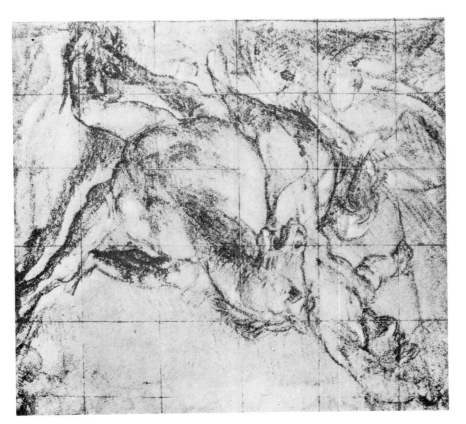

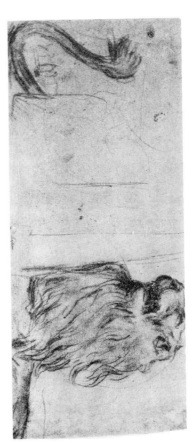

Pl LXIX

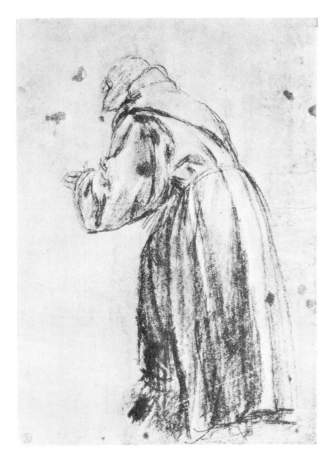 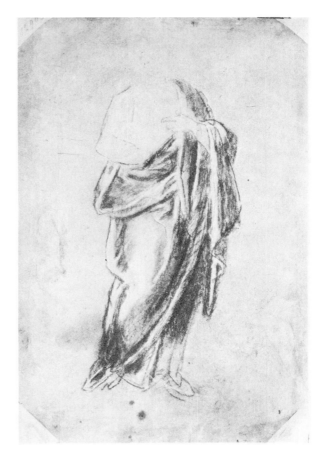

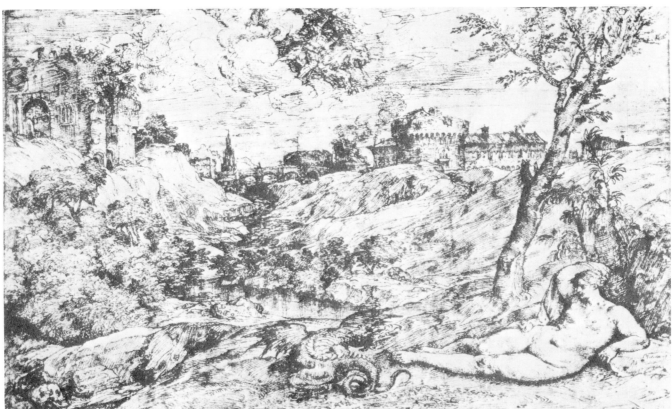

Titian *1.* No. **1904.**—*2.* No. **1905** *verso.*—*3.* No. **1872.**

Pl LXX

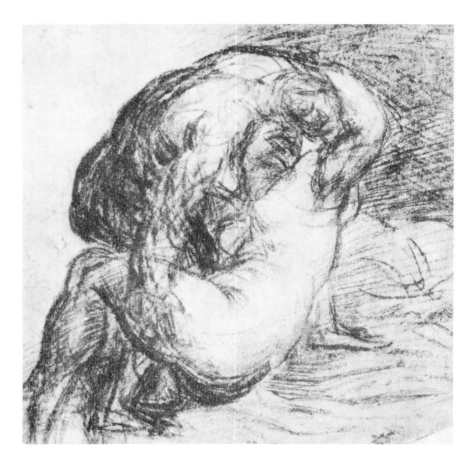

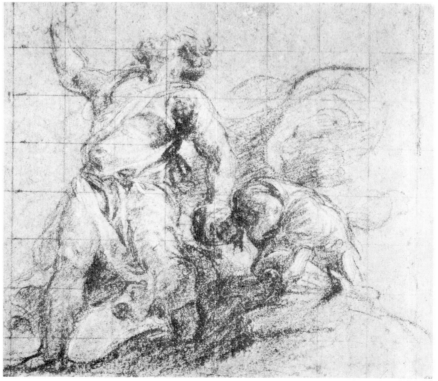

Titian *1*. No. **1886**.—*2*. No. **1962**.

Pl LXXI

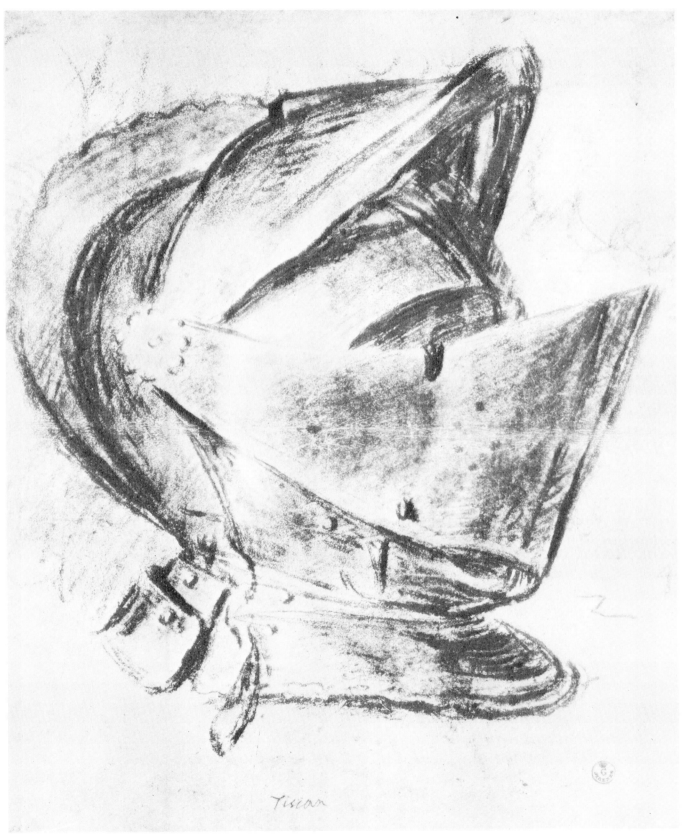

Titian

No. 1897 Titian.

Pl LXXII

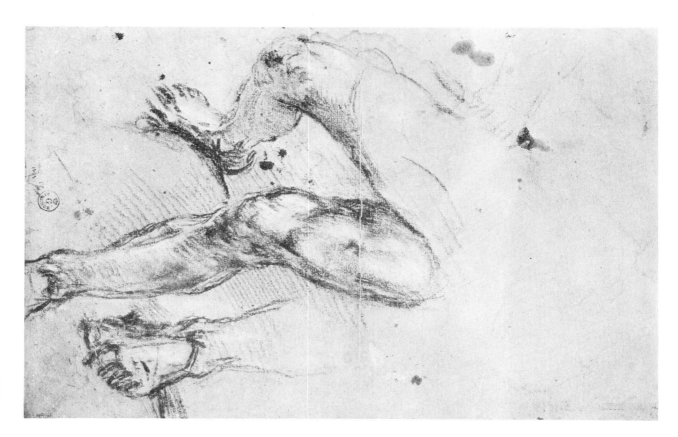

Titian *1*. No. 1906.—2. No. 1935.

Pl LXXIII

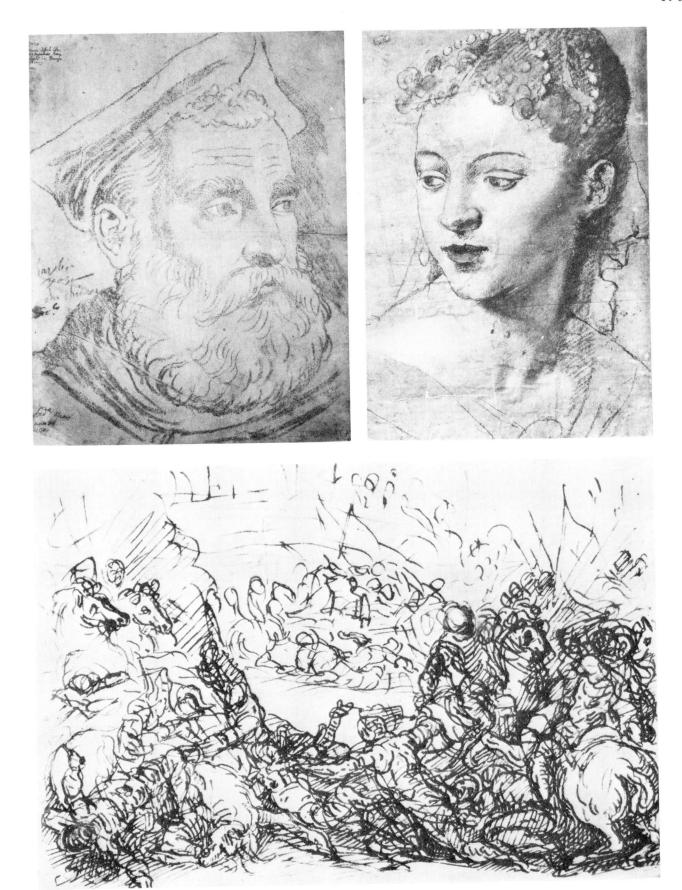

1. No. **1982** Circle of Titian.—*2.* No. **1964** Titian.—*3.* No. **1977** Circle of Titian.

Pl LXXIV

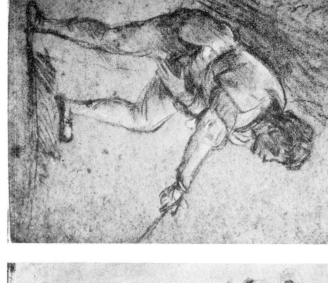

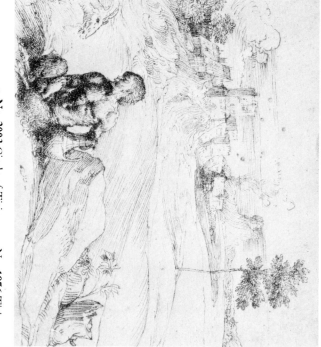

1. No. 2003 Circle of Titian.—2. No. 1956 Titian.—3–5. No. 1989, 1995, 1999 Circle of Titian.

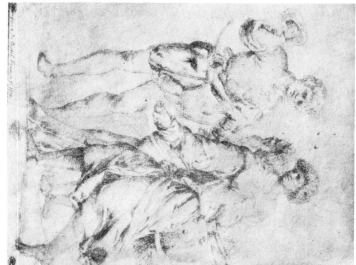

Pl LXXV

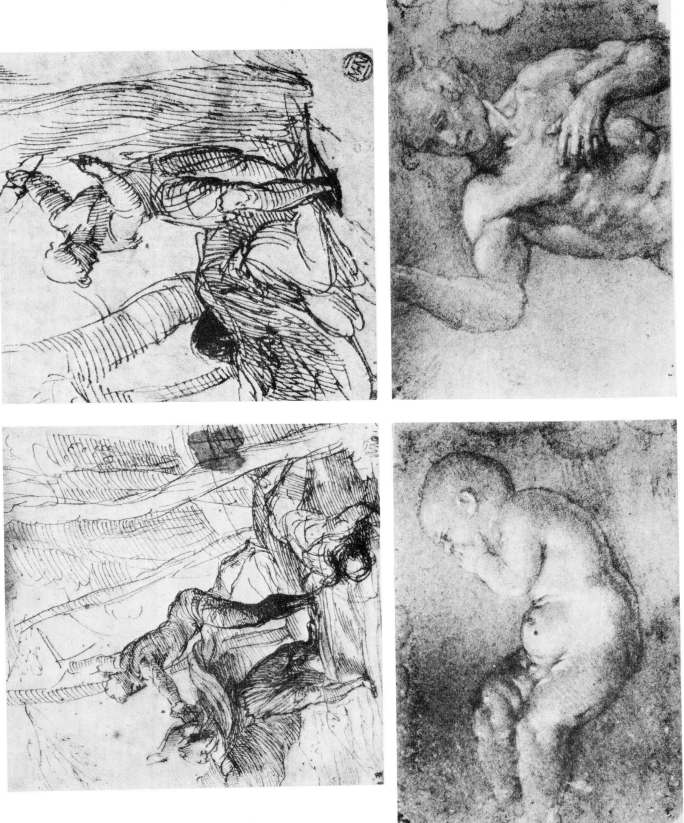

Circle of Titian *1*. No. 1997.—*2*. No. 1998.—*3*. No. 2012.—*4*. No. 2012 *verso.*

Pl LXXVI

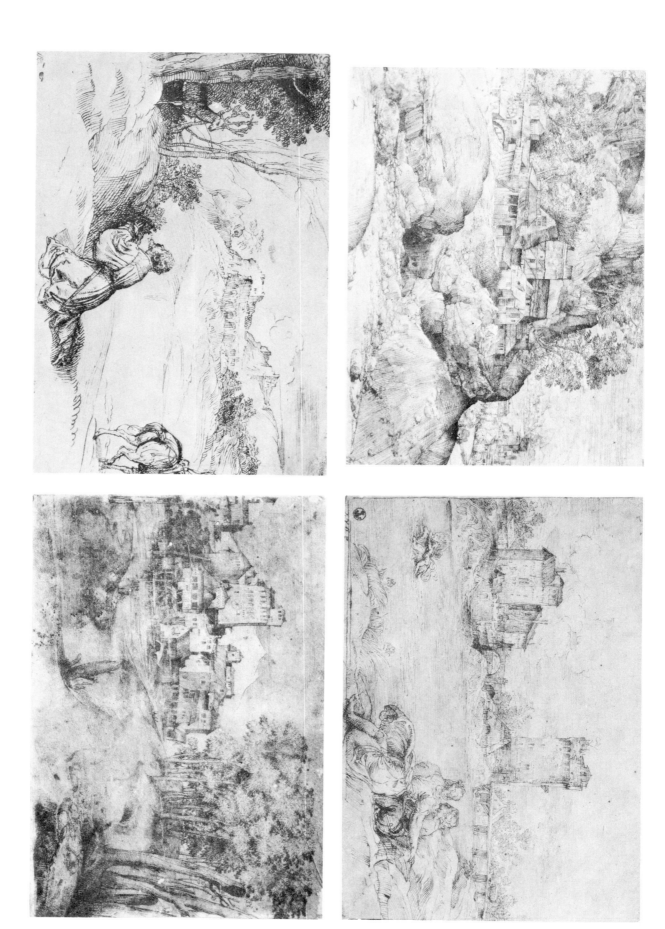

Circle of Titian 1. No. 2000.—2. No. 1986.—3. No 1991.—4. No. 2002.

Pl LXXVII

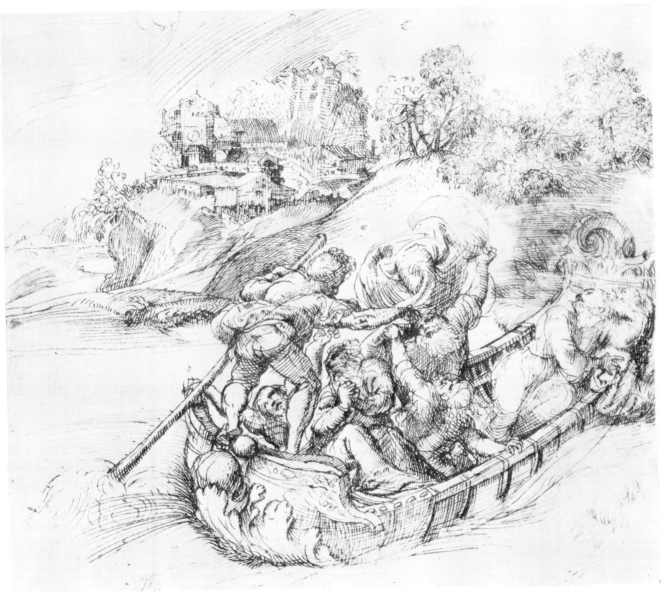

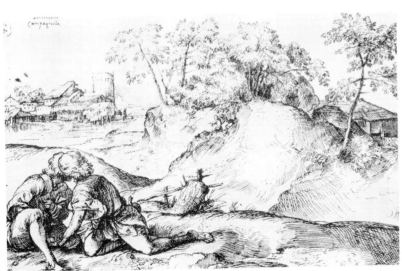

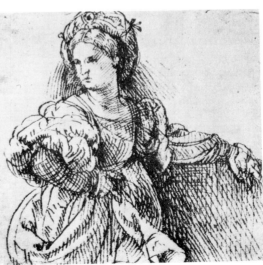

Domenico Campagnola *1.* No. **557.**—*2.* No. **487.**—*3.* No. **478.**

Pl LXXVIII

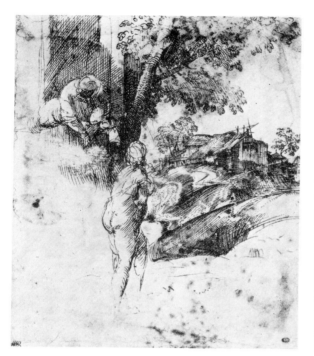
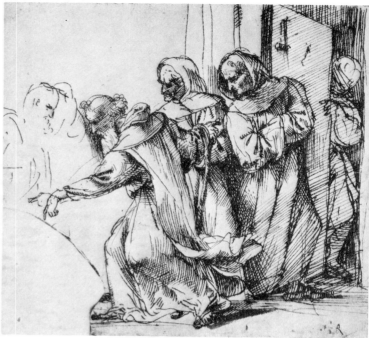
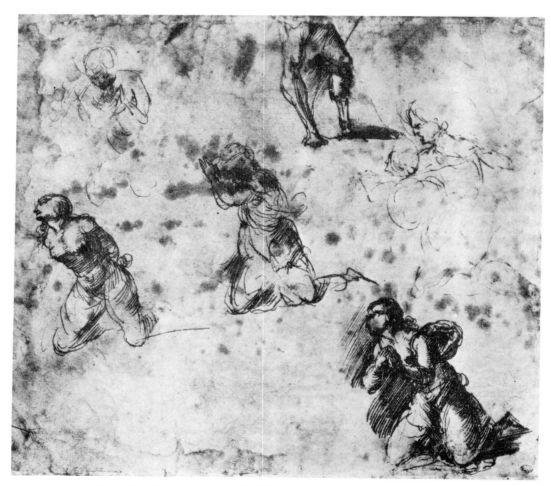

Domenico Campagnola *1*. No. **548**.—*2*. No. **423**.—*3*. No. **548** *verso*.

Pl LXXIX

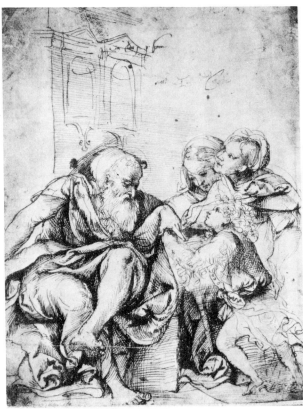

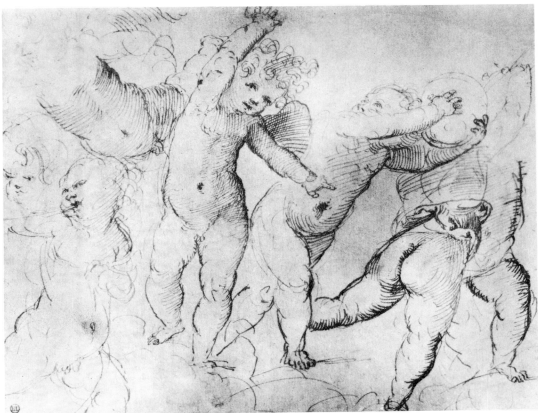

Domenico Campagnola *1.* No. **529** *verso.*—*2.* No. **468.**—*3.* No. **529.**

Pl LXXX

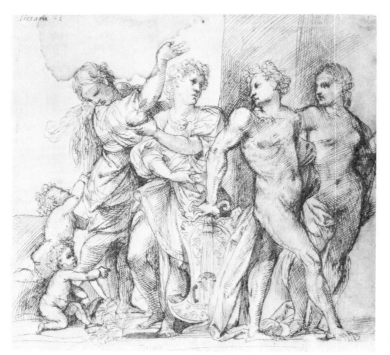

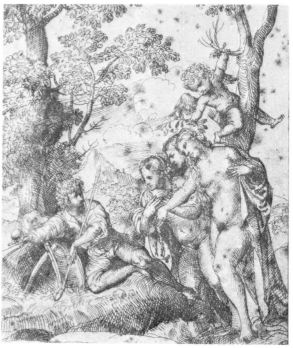

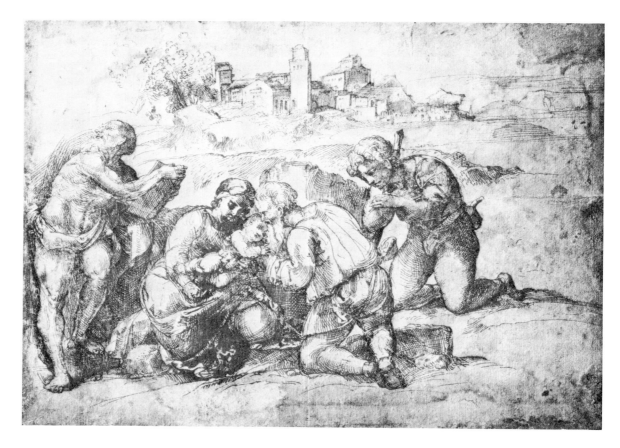

Domenico Campagnola *1.* No. **568.**—*2.* No. **537.**—*3.* No. **558.**

Pl LXXXI

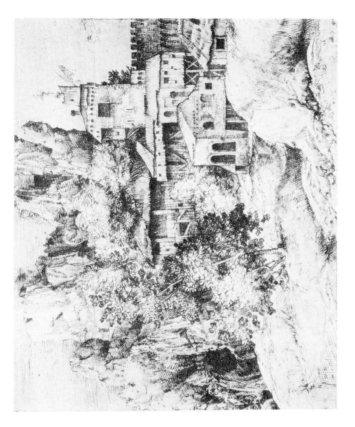

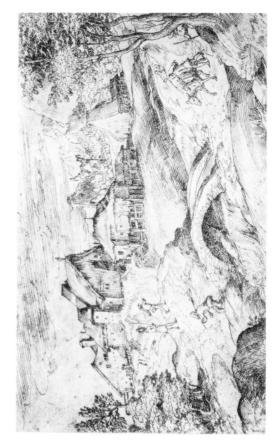

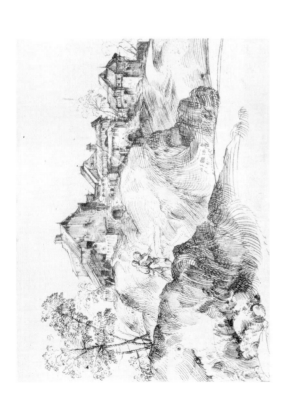

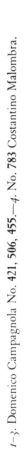

1–3. Domenico Campagnola No. **421, 506, 455.**—*4*. No. **783** Costantino Malombra.

Pl LXXXII

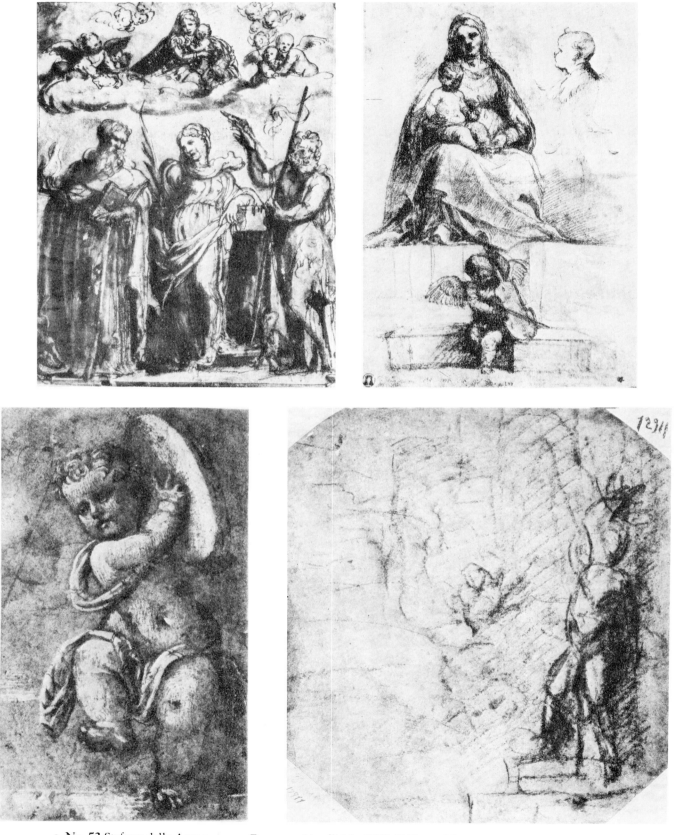

1. No. **52** Stefano dalle Arzere.—*2–3*. Francesco Vecelli No. **2019**, **2017**.—*4*. No. **393** *verso* Paris Bordone.

Pl LXXXIII

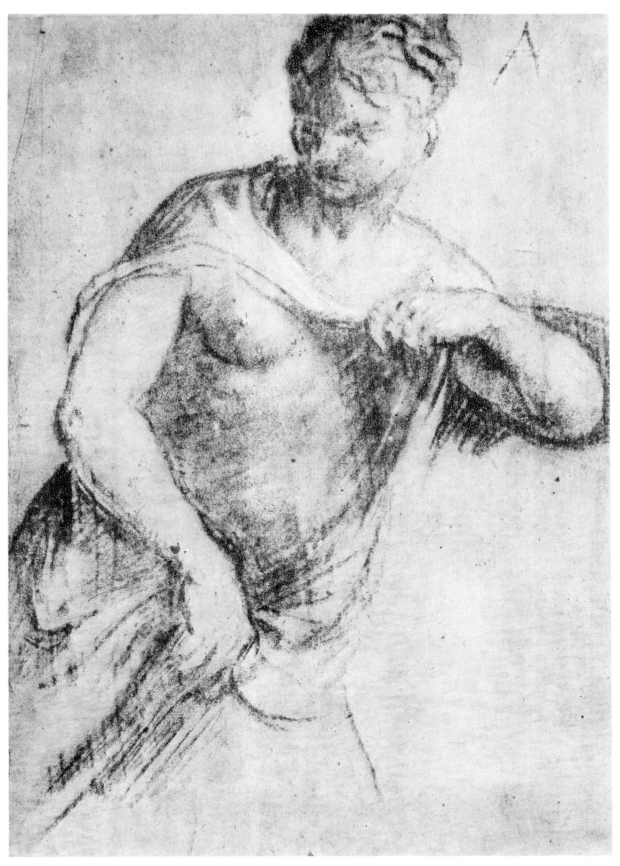

No. 388 Paris Bordone.

Pl LXXXIV

Paris Bordone *1.* No. **404.**—*2.* No. **401.**

Pl LXXXV

Paris Bordone *1*. No. **400**.—*2*. No. **400** *verso*.

Pl LXXXVI

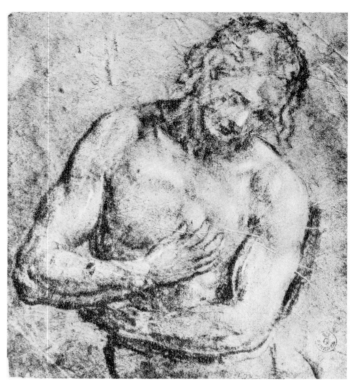

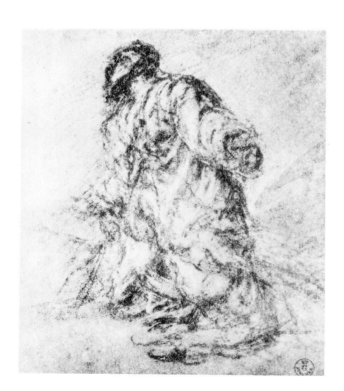

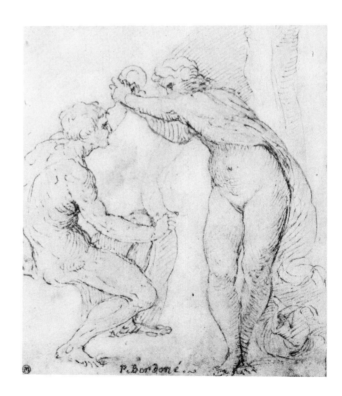

Paris Bordone *1*. No. **391**.—*2*. No. **396**.—*3*. No. **393**.—*4*. No. **398**.

Pl LXXXVII

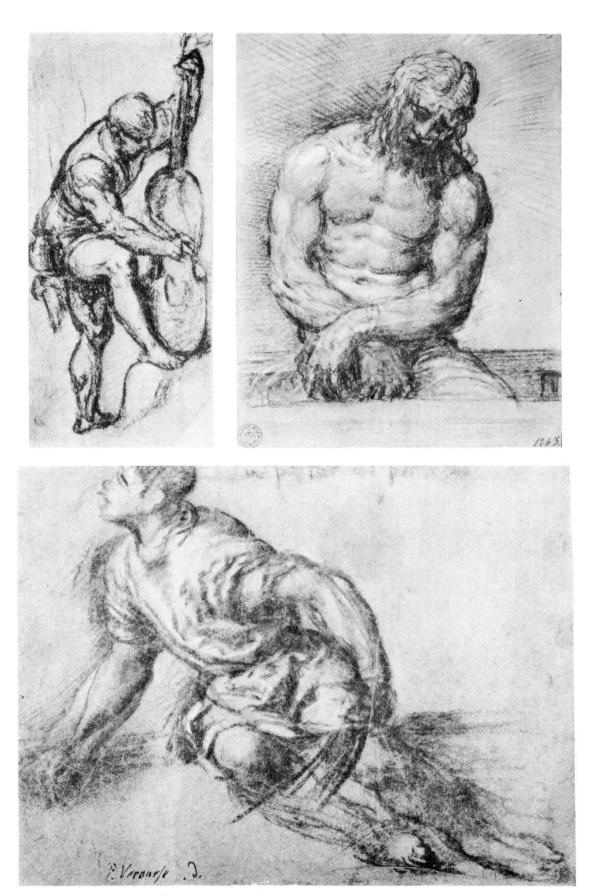

Paris Bordone *1*. No. **403**.—*2*. No. **386**.—*3*. No. **405**.

Pl LXXXVIII

1–2. Paris Bordone No. **389, 407**.—*3–4*. Lorenzo Lotto, No. **755, 756**.

Pl LXXXIX

Lorenzo Lotto 1. No. 779 *verso.*—2. No. 779.

Pl XC

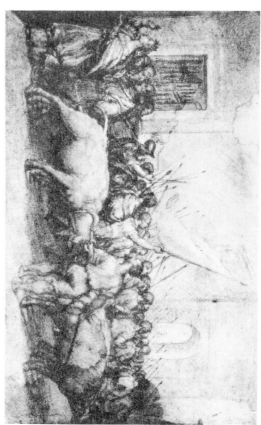

Lorenzo Lotto *1.* No. *767.* — *2.* No. *771.* — *3.* No. *766.*

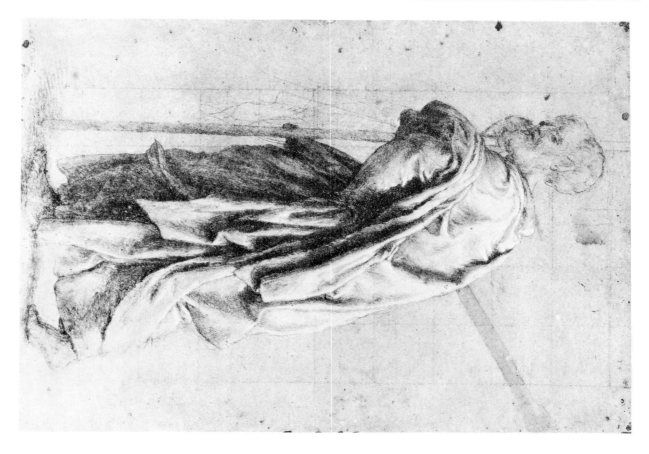

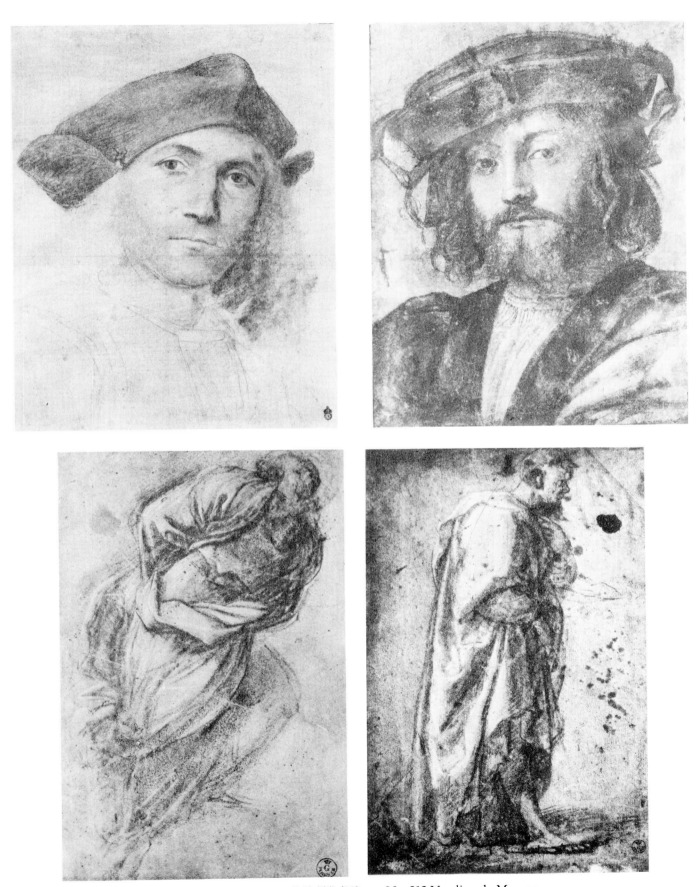

Pl XCI

1–3. Lorenzo Lotto No. **765, 777, 762.**—*4.* No. **813** Natalino da Murano.

Pl XCII

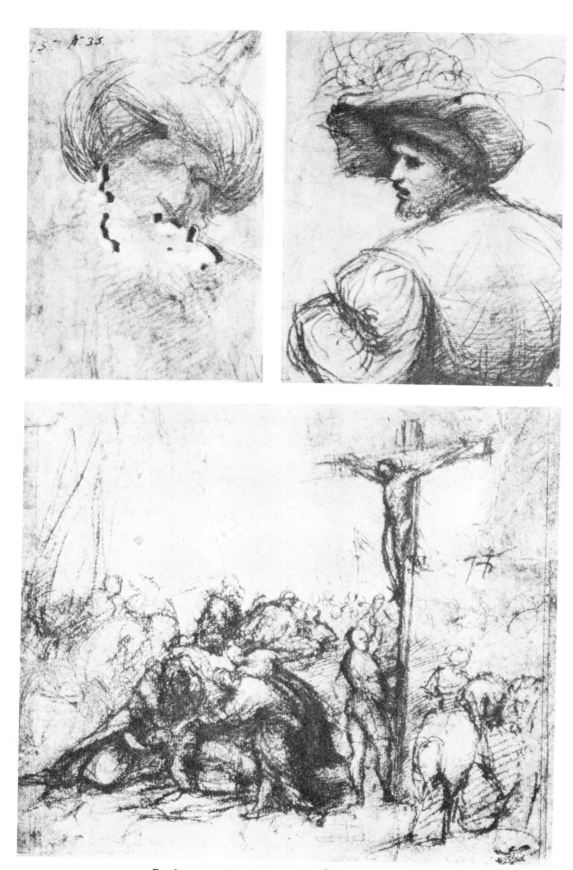

Pordenone *1*. No. 1337.—*2*. No. 1358.—*3*. No. 1340.

Pl XCIII

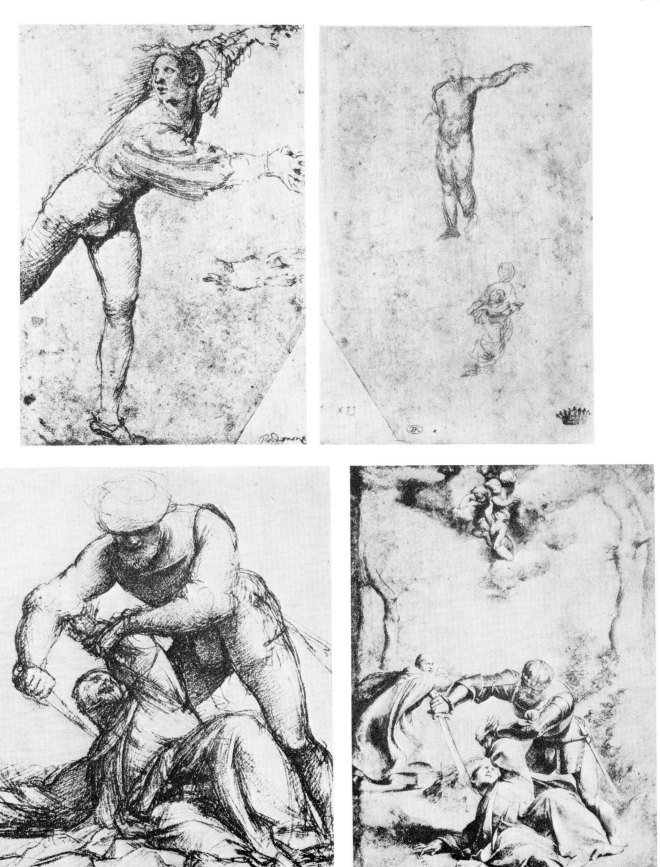

Pordenone *1*. No. **1323**.—*2*. No. **1323** *verso*.—*3*. No. **1301**.—*4*. No. **1311**.

Pl XCIV

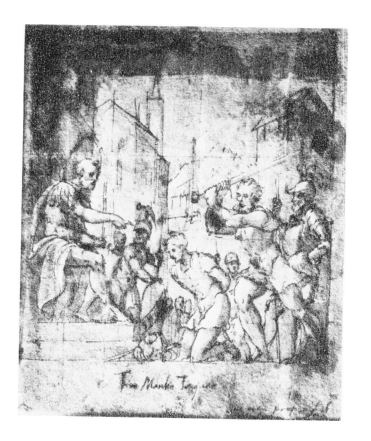
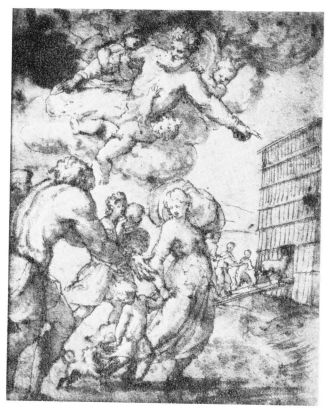
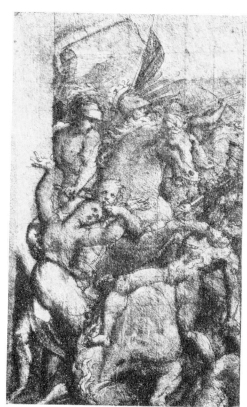

Pordenone *1*. No. **1366** (Shop).—*2*. No. **1343**.—*3*. No. **1344**.—*4*. No. **1334**.

Pl XCV

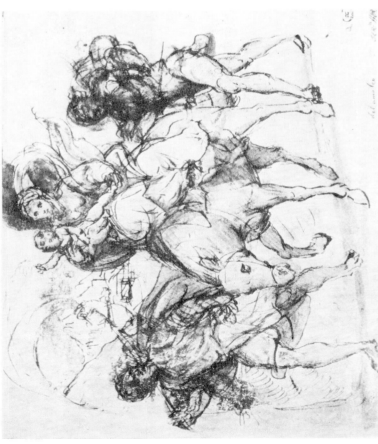

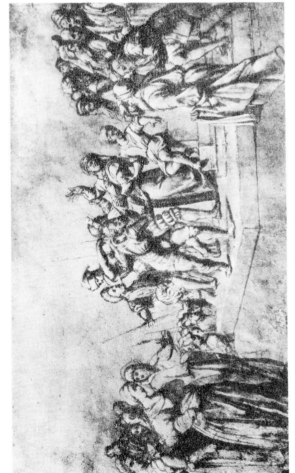

1. No. **23** Pomponio Amalteo.—*2.* No. **1282** Polidoro da Lanzano.—*3.* No. **24** Pomponio Amalteo.—*4.* No. **383** Bonifazio.

Pl XCVI

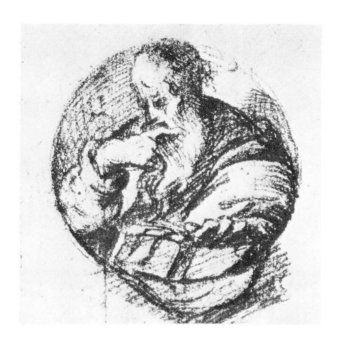

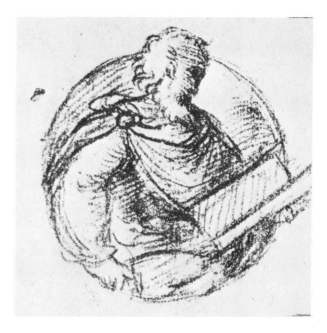

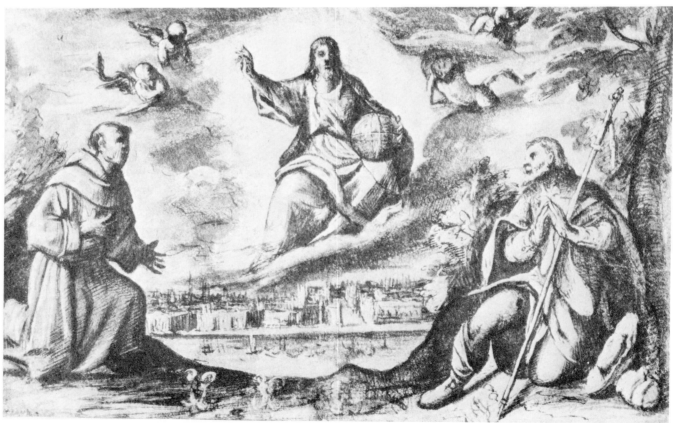

Bonifazio *1–2*. No. **376.**—*3*. No. **384.**

Pl XCVII

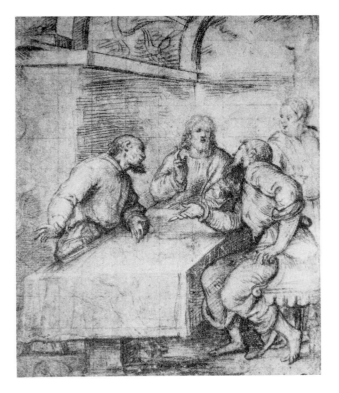

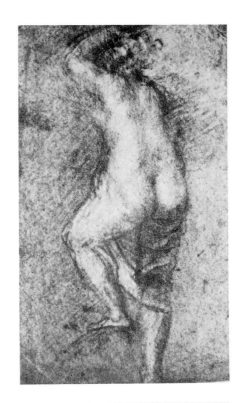

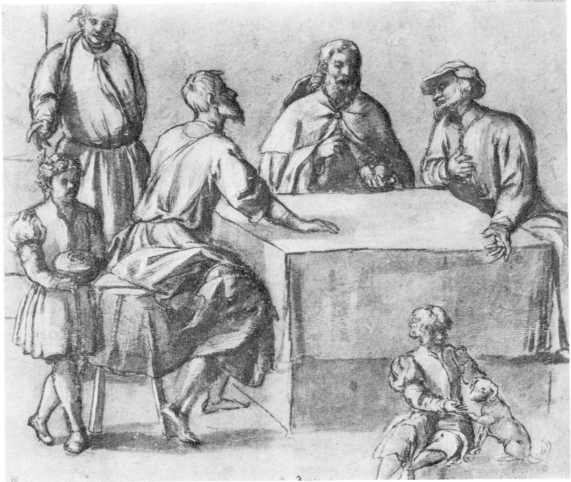

1. No. **378** Bonifazio.—*2*. No. **1285** Polidoro da Lanzano.—*3*. No. **382** Bonifazio.

Pl XCVIII

1–2. Giuseppe Salviati No. 1376, 1383.—3. No. 1287 Battista Ponchino.—4. No. 1393 Giuseppe Salviati.

Pl XCIX

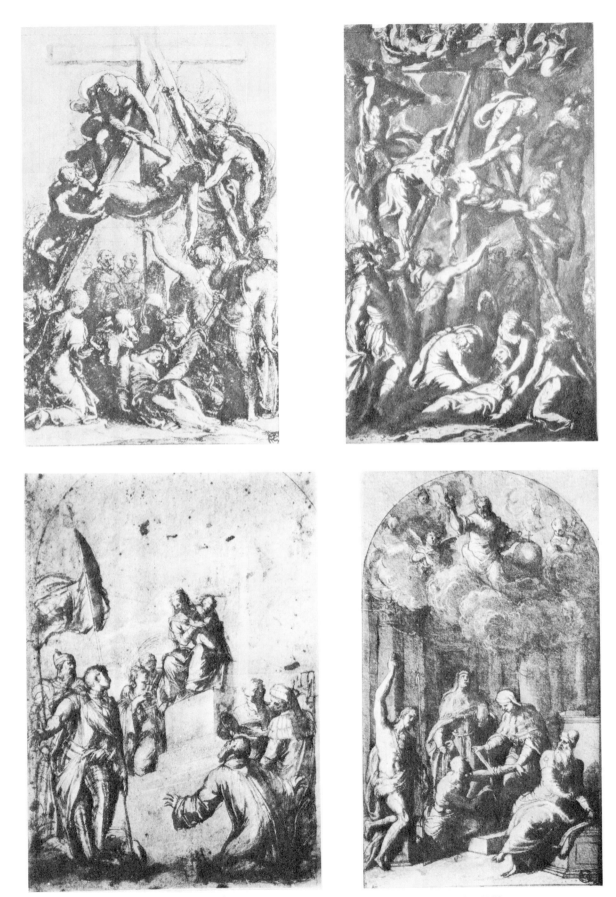

Giuseppe Salviati *1*. No. **1389**.—*2*. No. **1381**.—*3*. No. **1391**.—*4*. No. **1388**.

Pl C

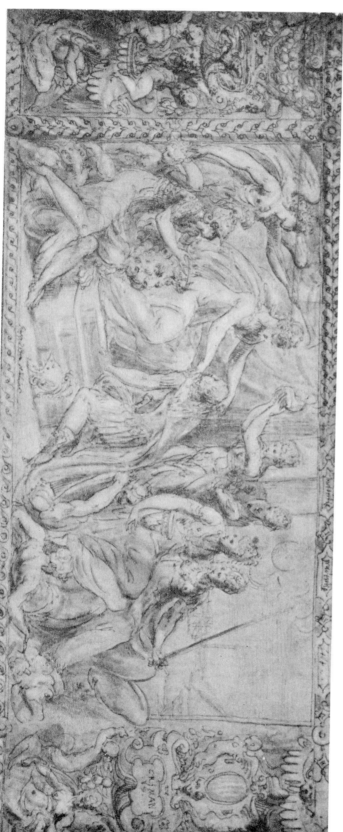

1–2. Giuseppe Salviati No. 1380. 1386. 3. No. 1429 Andrea Schiavone.—4. No. 1382 Giuseppe Salviati.

Pl CI

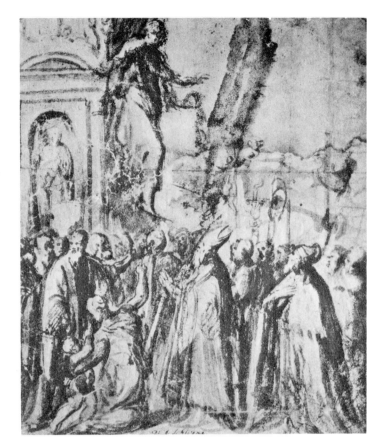
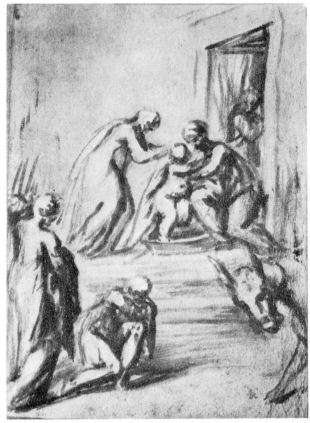
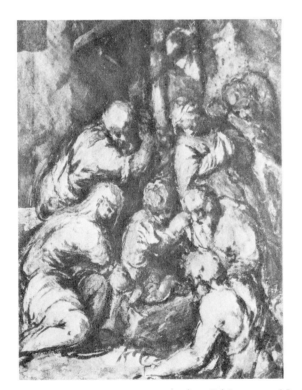
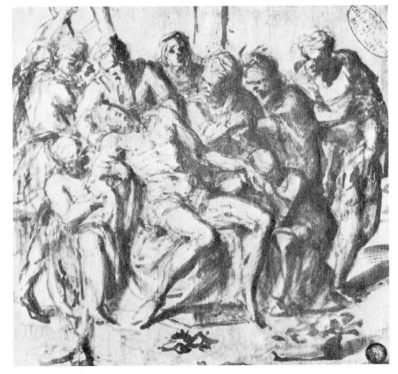

Andrea Schiavone *1.* No. **1469.**—*2.* No. **1436.**—*3.* No. **1450.**—*4.* No. **1453.**

Pl CII

Andrea Schiavone *1*. No. 1440.—*2*. No. 1452.—*3*. No. 1426.—*4*. No. 1438.

Pl CIII

Andrea Schiavone *1.* No. **1451**.—*2.* No. **1449 bis**

Pl CIV

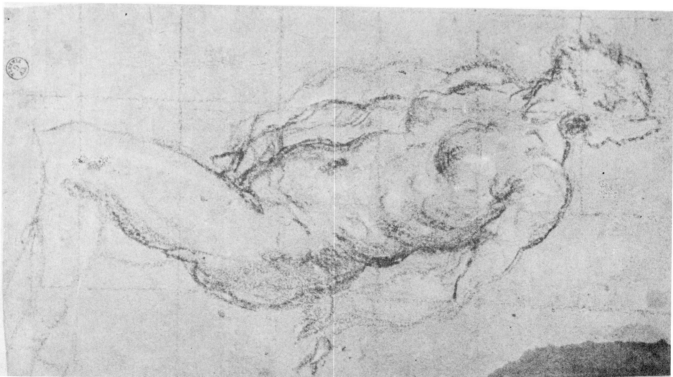

Jacopo Tintoretto *1.* No. **1613.**—*2.* No. **1711.**—*3.* No. **1620.**

Pl. CV

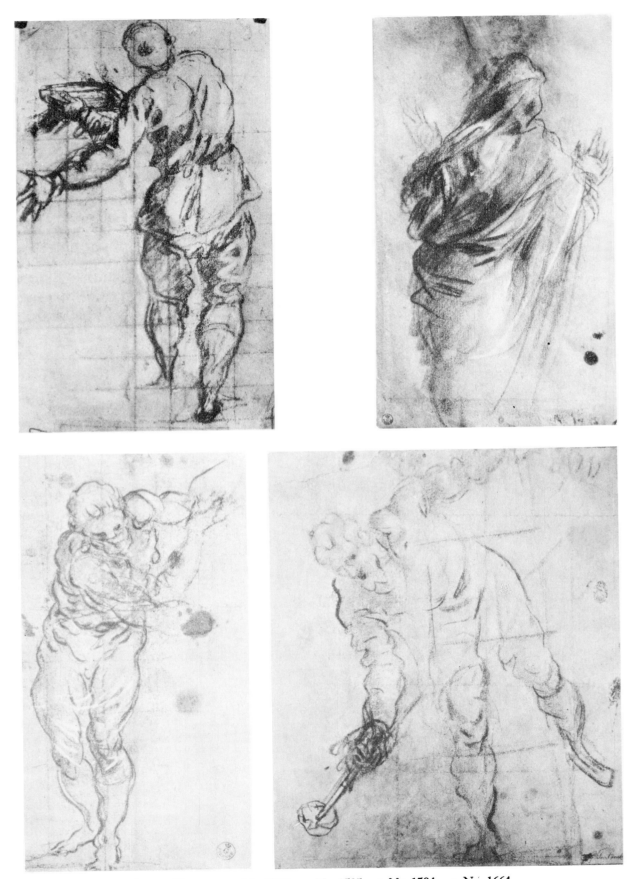

Jacopo Tintoretto *1*. No. 1710.—*2*. No. 1585.—*3*. No. 1594.—*4*. No. 1664.

Pl CVI

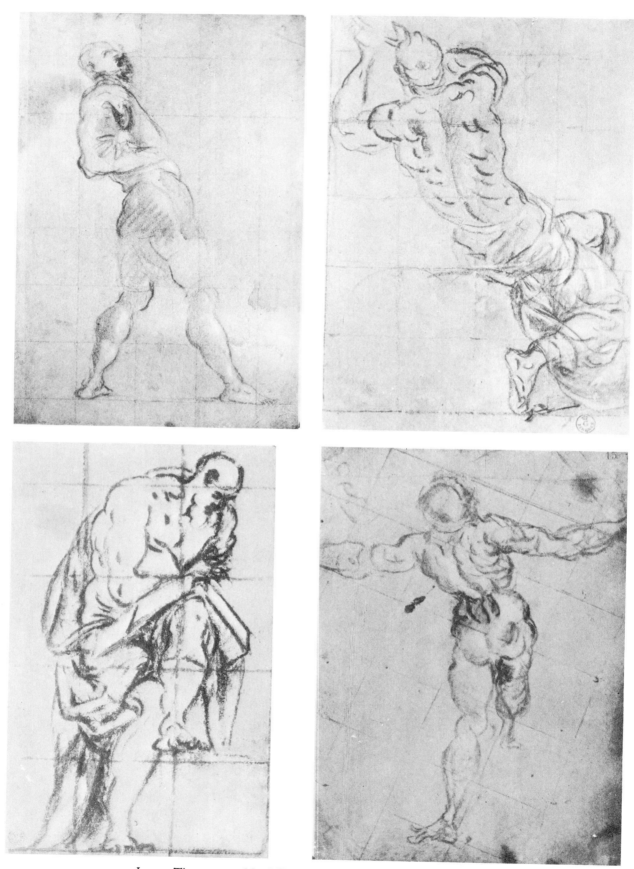

Jacopo Tintoretto *1*. No. **1674**.—*2*. No. **1584**.—*3*. No. **1650**.—*4*. No. **1680**.

Pl CVII

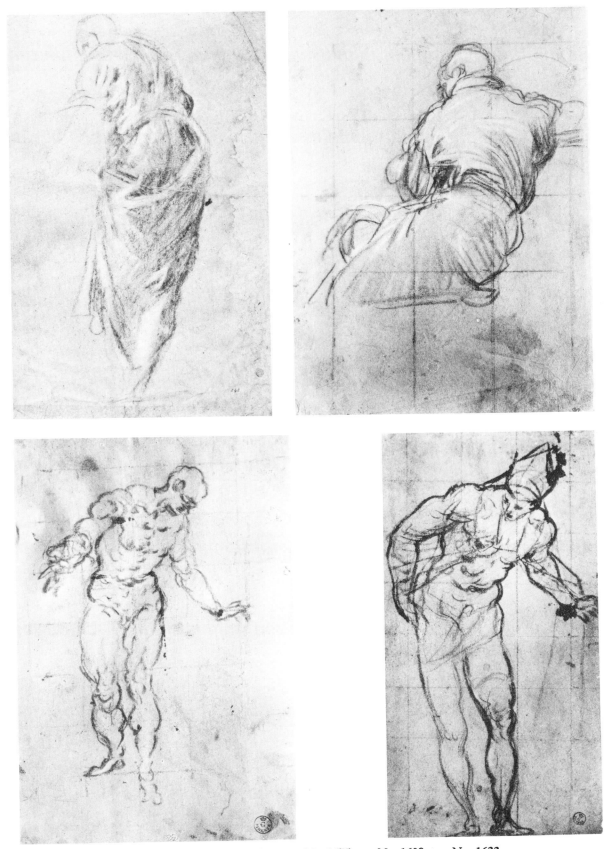

Jacopo Tintoretto *1*. No. **1701**.—*2*. No. **1675**.—*3*. No. **1609**.—*4*. No. **1622**.

Pl CVIII

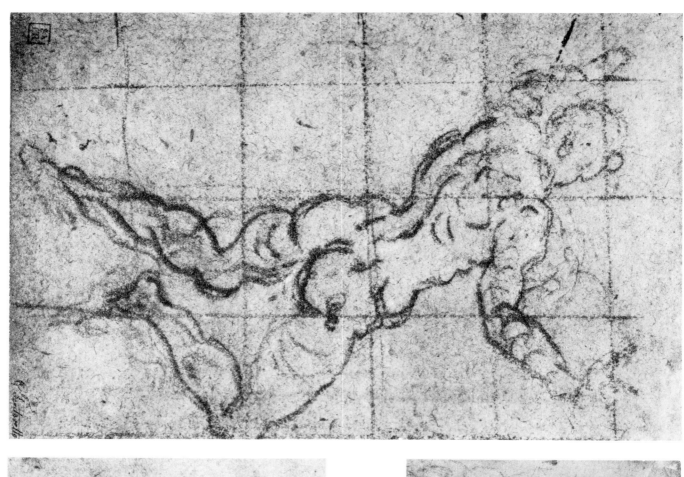

Jacopo Tintoretto *1*. No. 1758—2 No. 1660.—*3*. No. 1571.

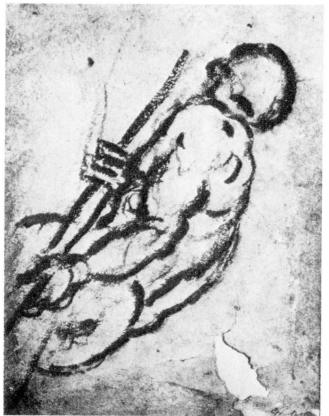

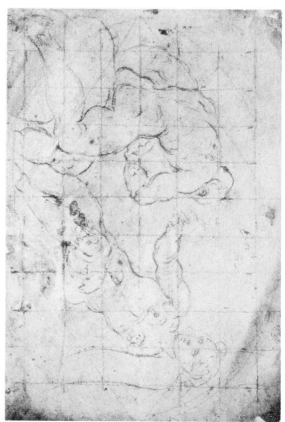

Pl CIX

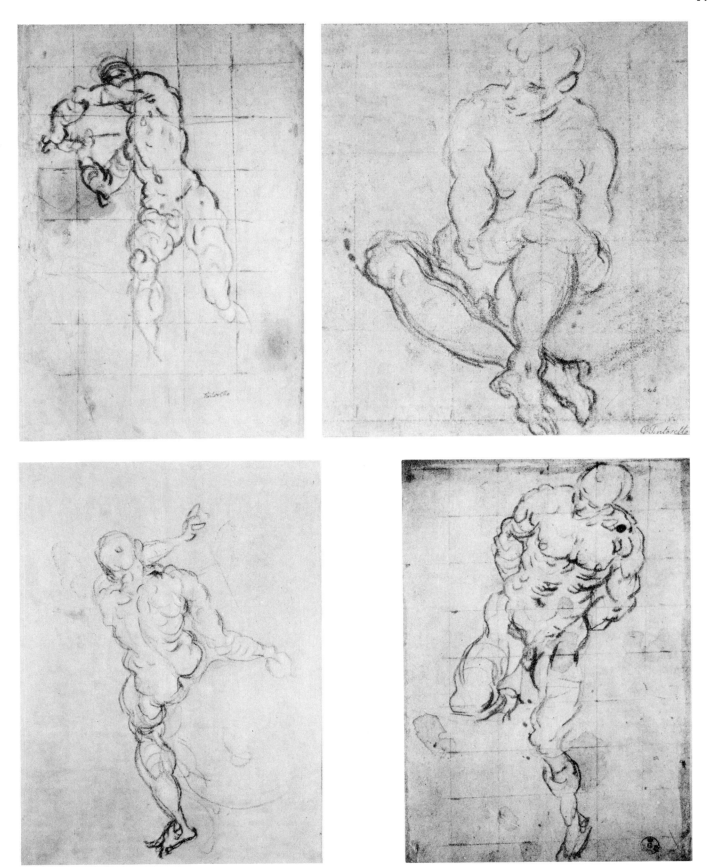

Jacopo Tintoretto. *1*. No. **1657**.—*2*. No. **1704**.—*3*. No. **1661**.—*4*. No. **1603**.

Pl CX

Jacopo Tintoretto *1*. No. 1723.—*2*. No. 1638.—*3*. No. 1725.

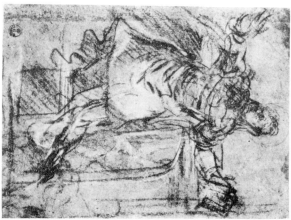

Pl CXI

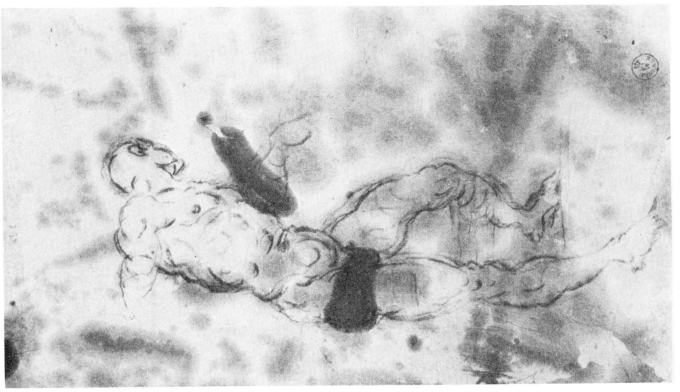

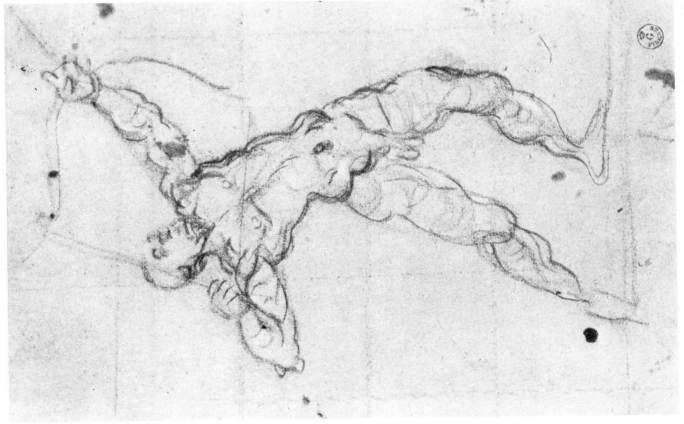

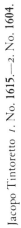

Jacopo Tintoretto 1. No. 1615.—2. No. 1604.

Pl CXII

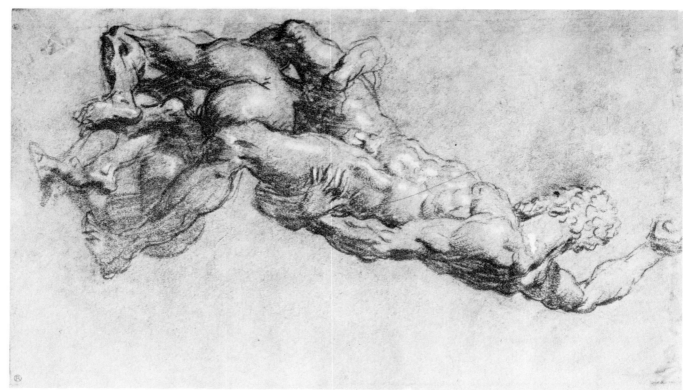

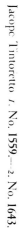

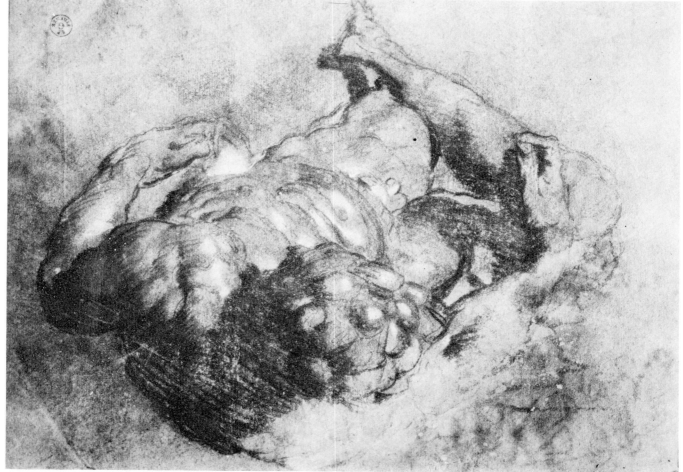

Jacopo Tintoretto 1. No. 1559.—2. No. 1643.

Pl CXIII

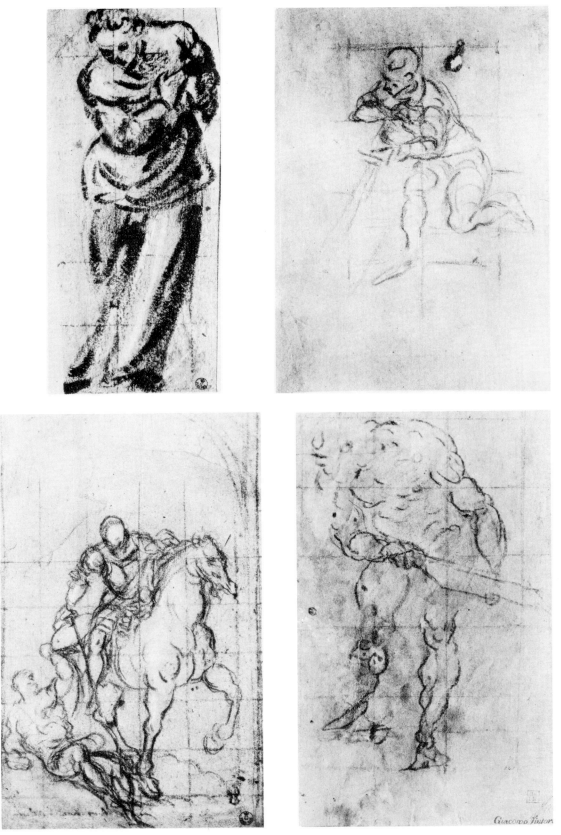

Jacopo Tintoretto ·*1*. No. **1627**.—*2*. No. **1656**.—*3*. No. **1635**.—*4*. No. **1700**.

Pl CXIV

No. 1724 Jacopo Tintoretto.

Pl CXV

1. No. **1561** Jacopo Tintoretto.—*2.* No. **1526**, 2o Domenico Tintoretto.

Pl CXVI

Domenico Tintoretto 1. No. 1529.—2. No. 1545.—3. No. 1510.

Pl CXVII

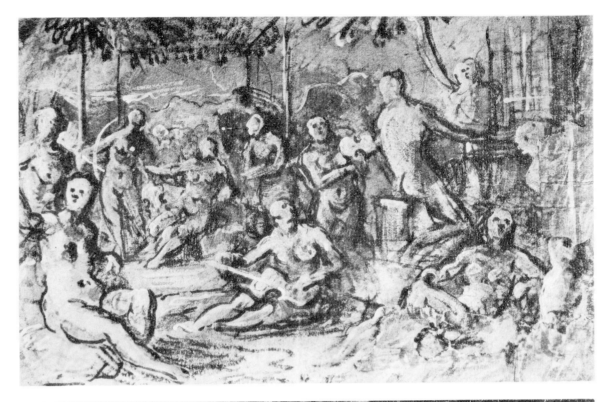

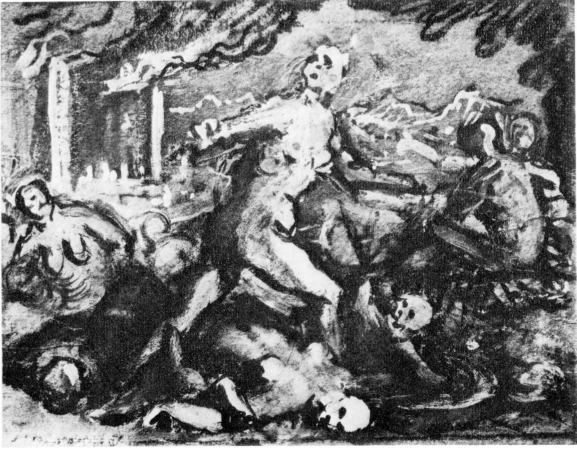

Domenico Tintoretto *1.* No. **1472.**—*2.* No. **1477.**

Pl CXVIII

Domenico Tintoretto *1*. No. 1526, 63.—*2*. No. 1526, 2.—*3*. No. 1518.—*4*. No. 1509

Pl CXIX

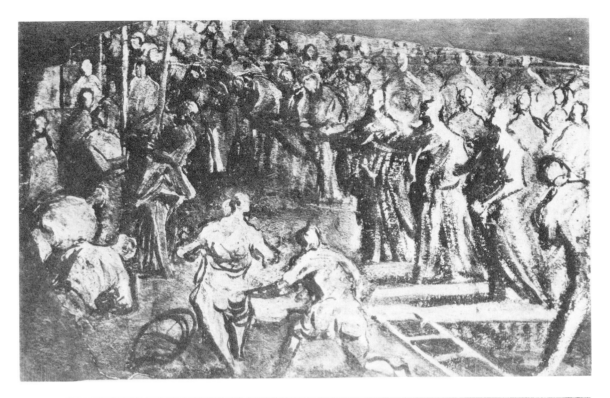

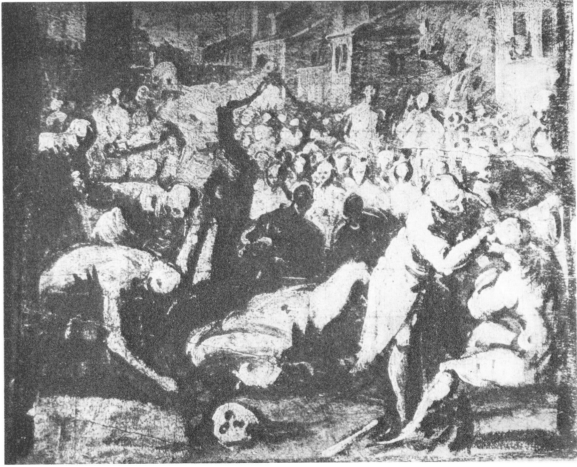

Domenico Tintoretto *1*. No. **1547**.—*2*. No. **1549**.

Pl CXX

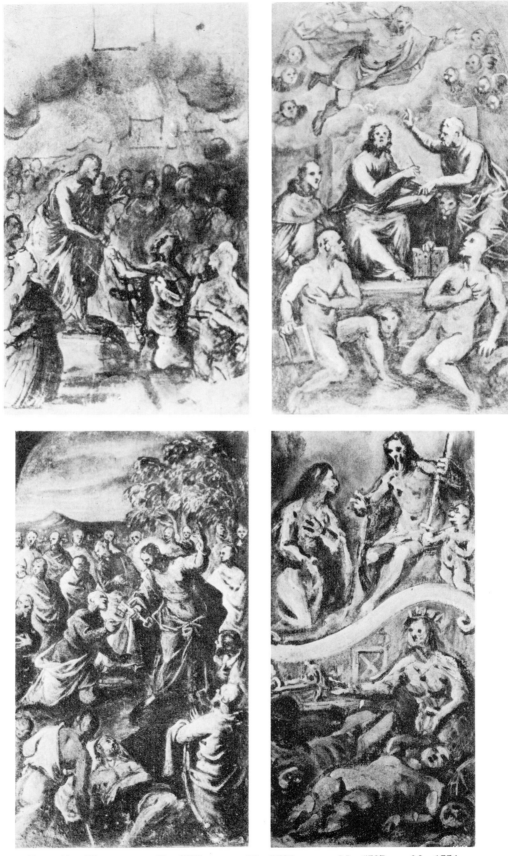

Domenico Tintoretto *1*. No. **1526**, 90.—*2*. No. **1526**, 39.—*3*. No. **1537**.—*4*. No. **1554**.

Pl CXXI

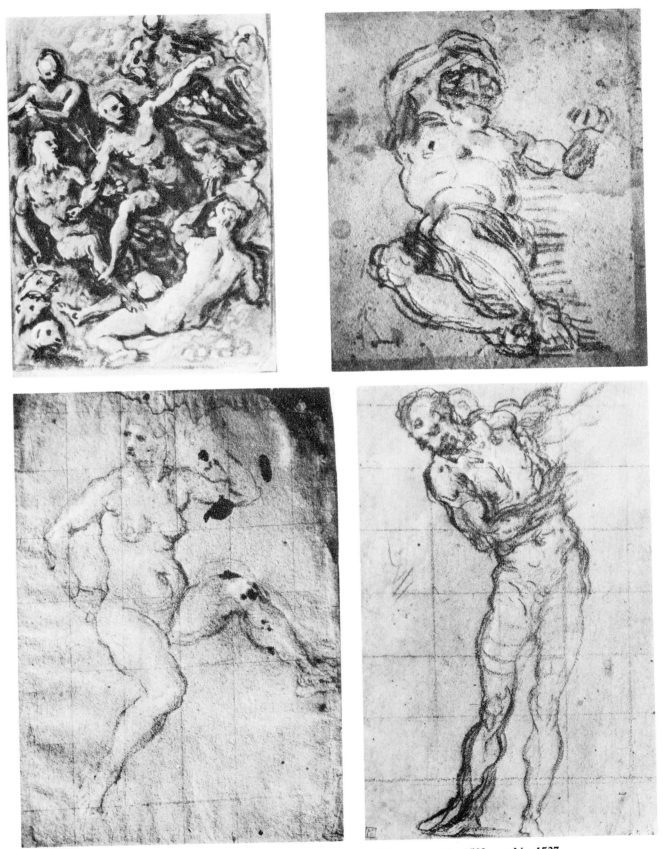

Domenico Tintoretto *1*. No. **1526**, 37.—*2*. No. **1526**, 15.—*3*. No. **1539**.—*4*. No. **1527**.

Pl CXXII

Domenico Tintoretto *1.* No. **1546**.—*2.* No. **1546** *verso.*—*3.* No. **1508**.

Pl CXXIII

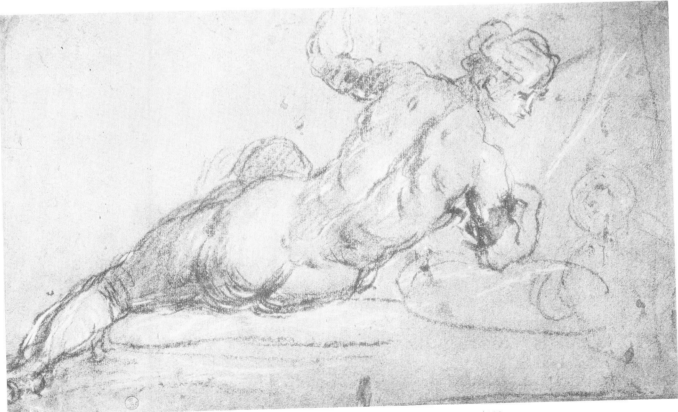

Domenico Tintoretto *1*. No. **1521**.—*2*. No. **1533**.—*3*. No. **1489**.

Pl CXXIV

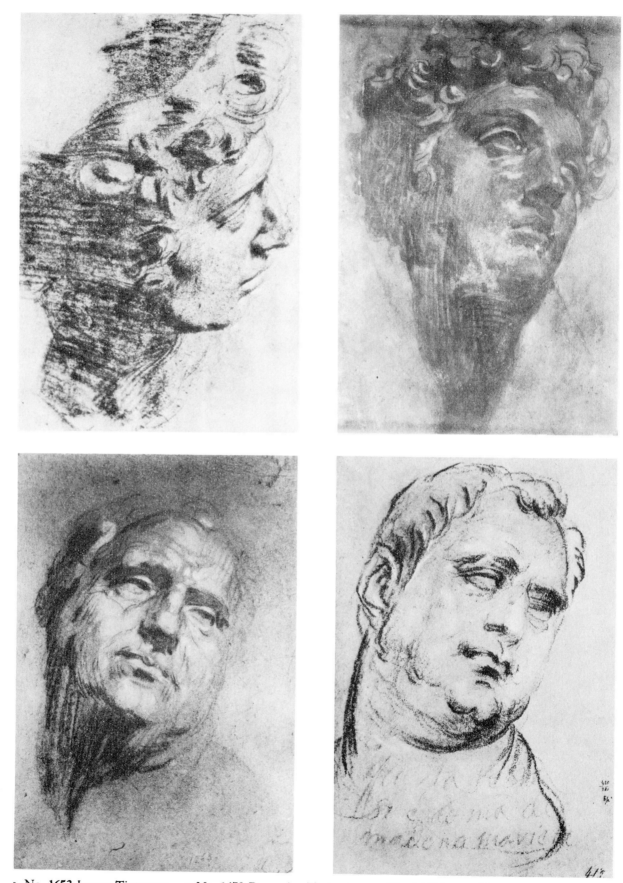

1. No. **1652** Jacopo Tintoretto.—*2.* No. **1478** Domenico Tintoretto.—*3.* No. **1668** Jacopo Tintoretto.—*4.* No. **1762** Marietta Robusti.

Pl CXXV

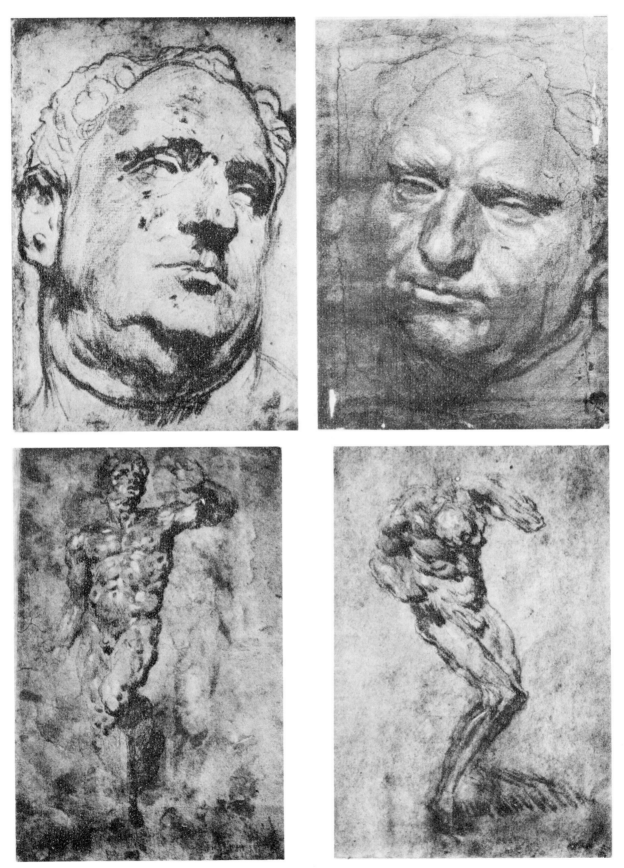

The Tintoretto Shop *1*. No. **1832**.—*2*. No. **1852** —*3*. No. **1825**.—*4*. No. **1858**.

Pl CXXVI

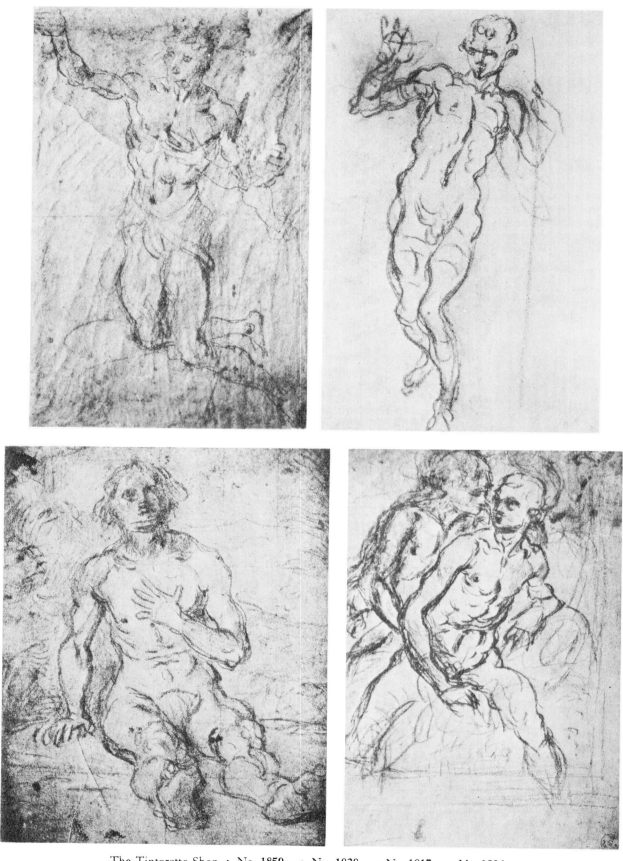

The Tintoretto Shop *1*. No. **1859**.—*2*. No. **1828**.—*3*. No. **1817**.—*4*. No. **1806**.

Pl CXXVII

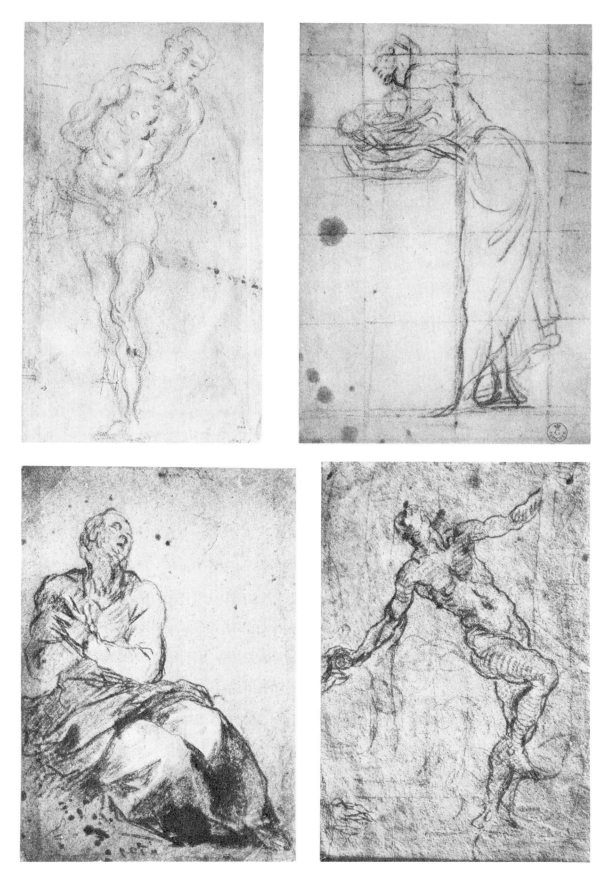

The Tintòretto Shop *1*. No. **1843**.—*2*. No. **1795**.—*3*. No. **1809**.—*4*. No. **1822**.

Pl CXXVIII

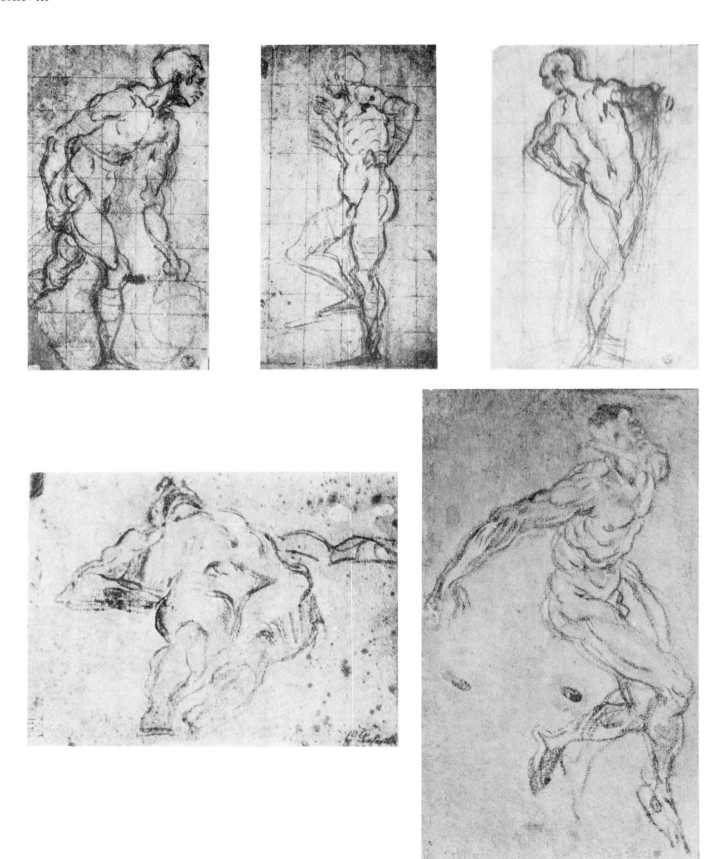

The Tintoretto Shop *1*. No. **1801**.—*2*. No. **1799**.—*3*. No. **1792**.—*4*. No. **1819**.—*5*. No. **1835**.

Pl CXXIX

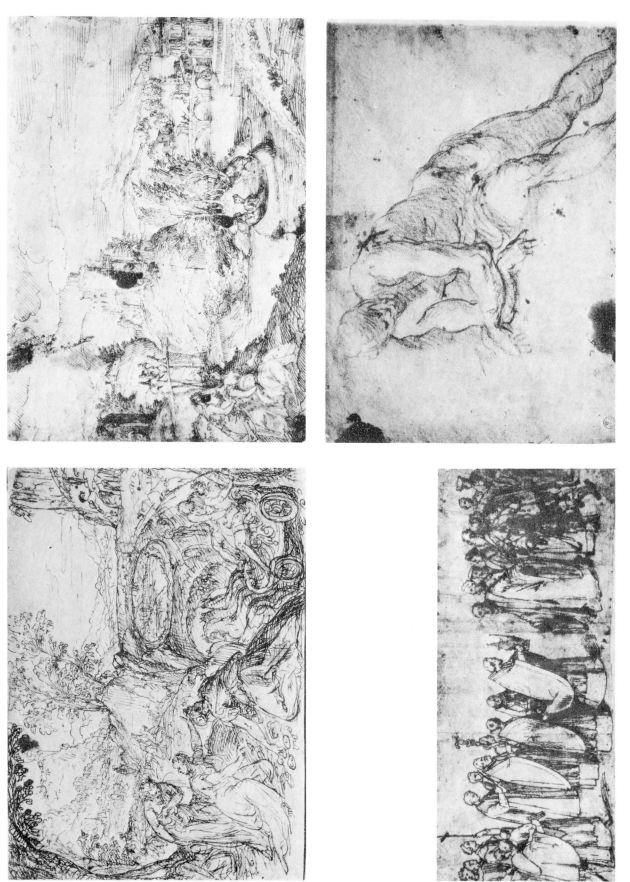

1-2. Paolo de' Franceschi No. 693, 694.—3. No. 1983 Circle of Titian.—4. No. 1788 Tintoretto Shop.

Pl CXXX

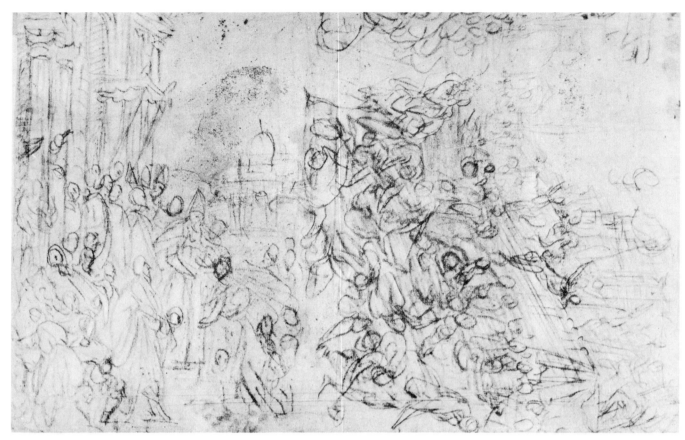

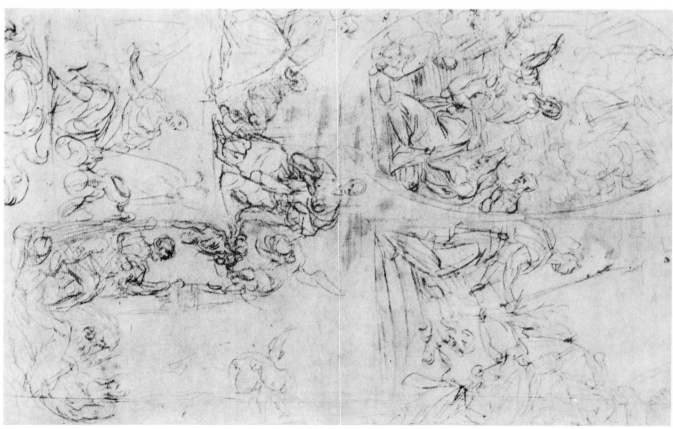

Pl CXXXI

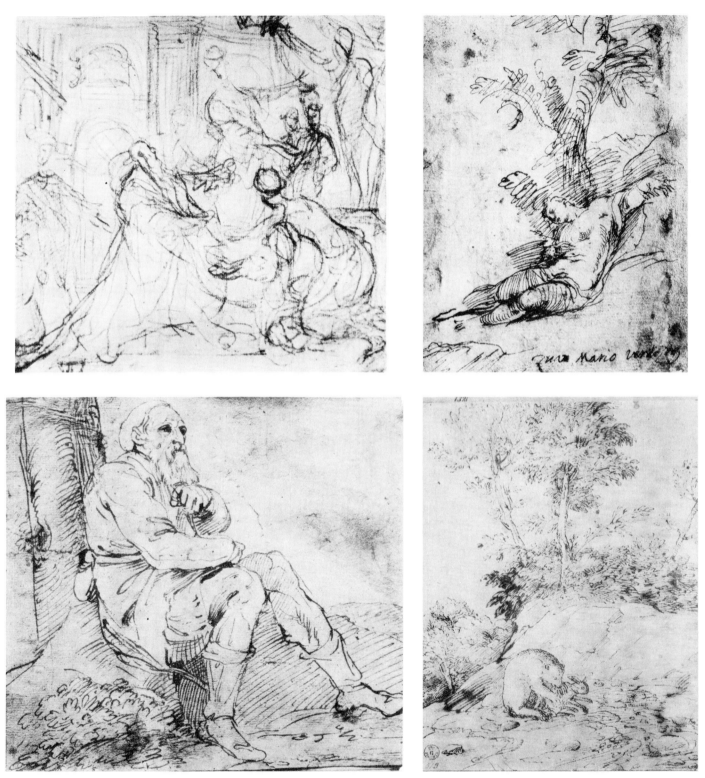

1. No. **202** El Greco?—*2–4*. Verdizotti No. **2021, 2023, 2022.**

Pl CXXXII

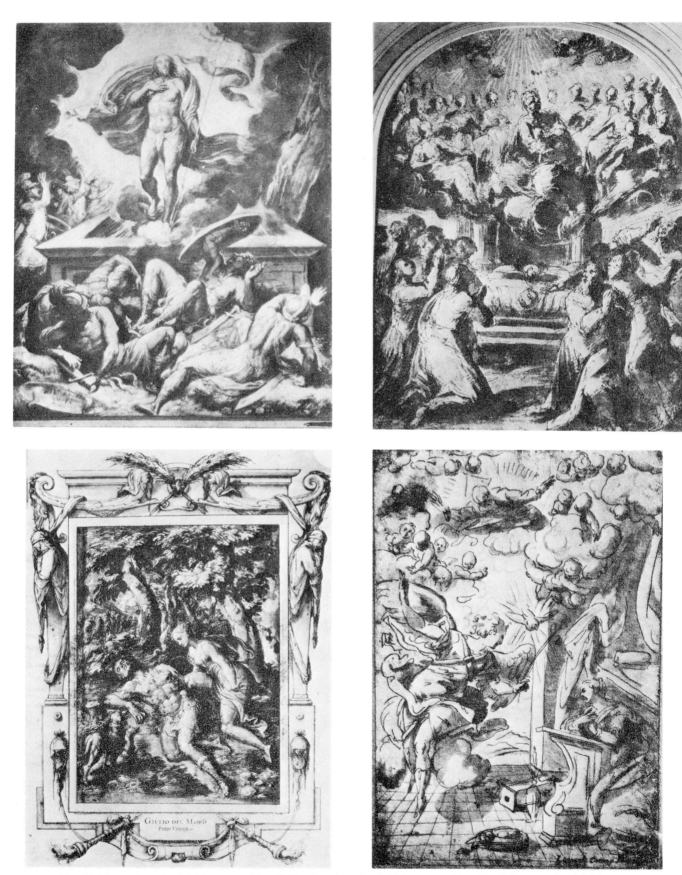

1. No. **42** Marco Angolo dal Moro.—*2*. No. **37** Battista Angolo dal Moro.—*3*. No. **41** Giulio Angolo dal Moro.—*4*. No. **682** Leonardo Corona.

Pl CXXXIII

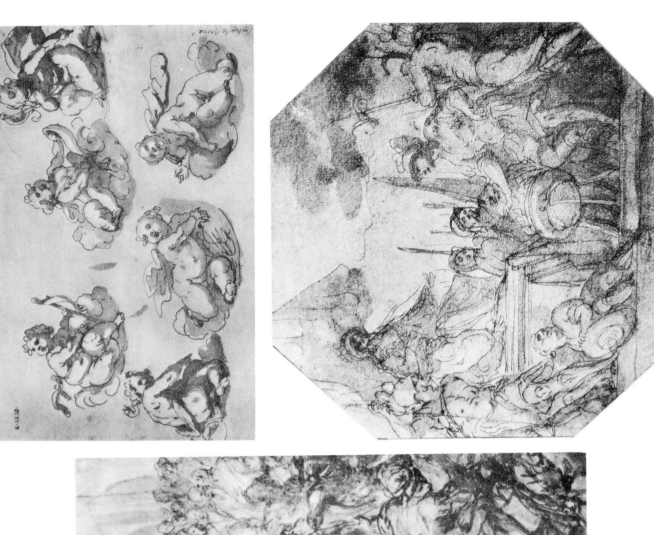

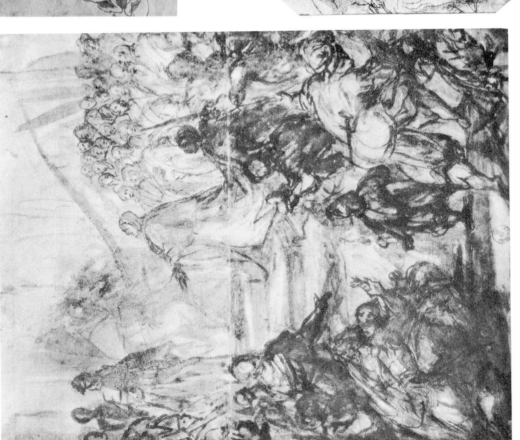

1. No. **40** Guilio Angolo dal Moro.—*2–3.* Leonardo Corona No. **684, 672.**

Pl CXXXIV

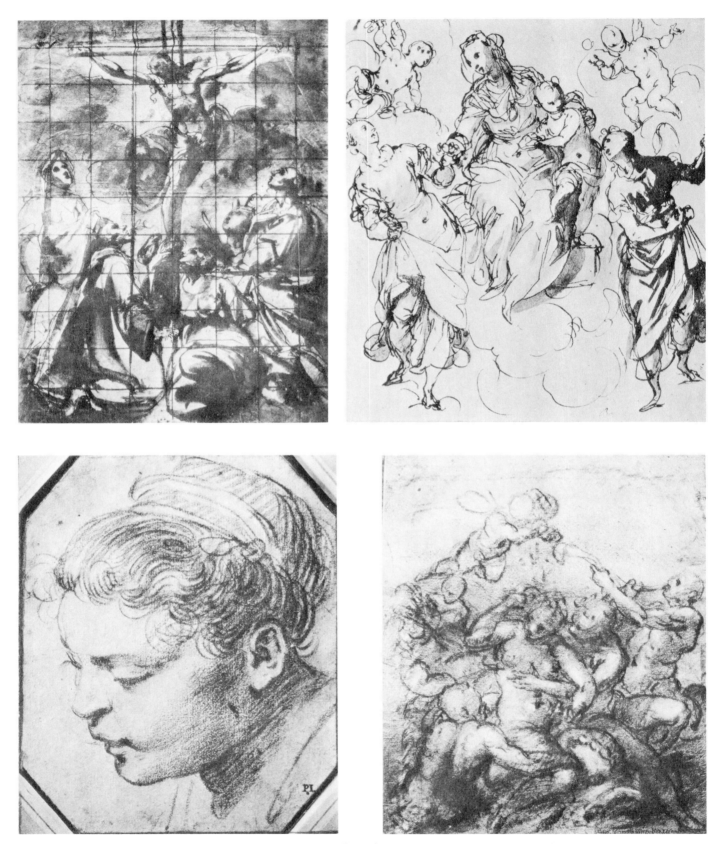

1–3. Leonardo Corona No. **673, 676**, 667.—*4.* No. **664** Giovanni Contarini.

Pl CXXXV

Pietro Malombra *1*. No. **792**.—*2*. No. **796**.—*3*. No. **789**.

Pl CXXXVI

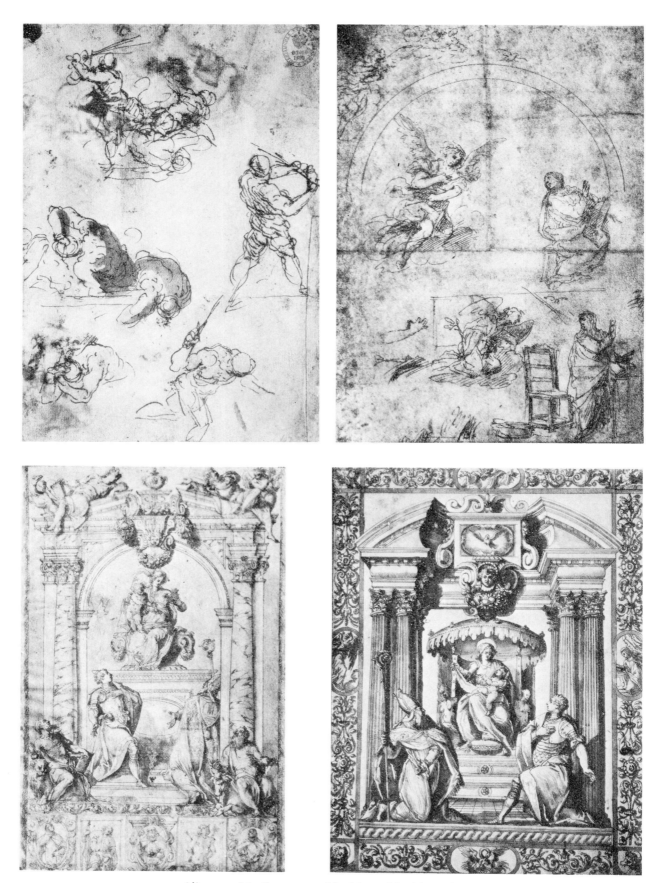

Aliense *1. No. 2 verso.—2. No.* **14.***—3. No.* **16.***—4. No.* **9.**

Pl CXXXVII

Aliense *1.* No. **12.**—*2.* No. **4.**

Pl CXXXVIII

1. No. **10** Aliense.—*2-4.* Andrea Vicentino No. 2136, 2236, 2224.

Pl CXXXIX

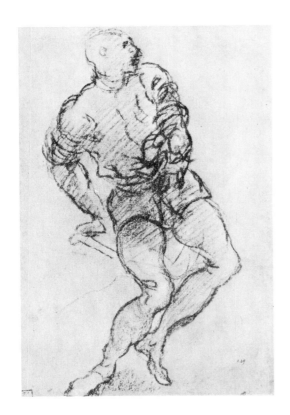

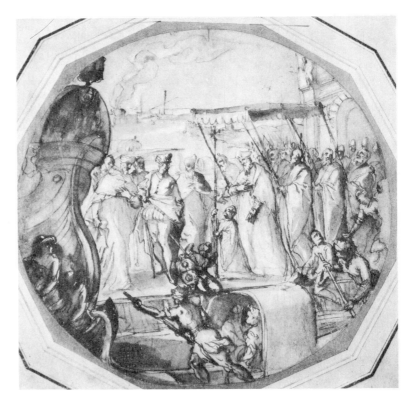

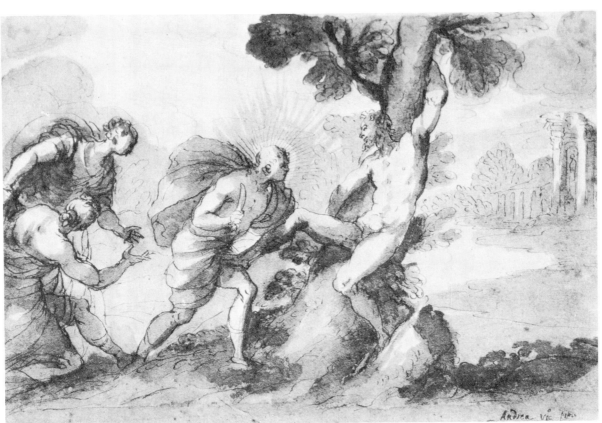

Andrea Vicentino *1*. No. **2225.**—*2.* No. **2216.**—*3.* No. **2229.**

Pl CXL

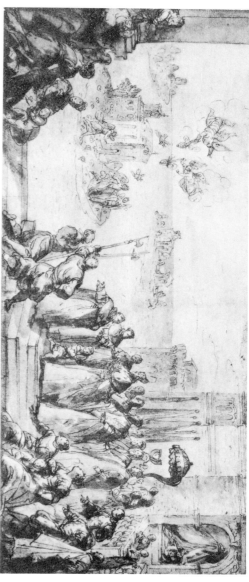

Andrea Vicentino *1*. No. 2219.—*2*. No. 2241.—*3*. No. 2218.—*4*. No. 2240.

Pl CXLI

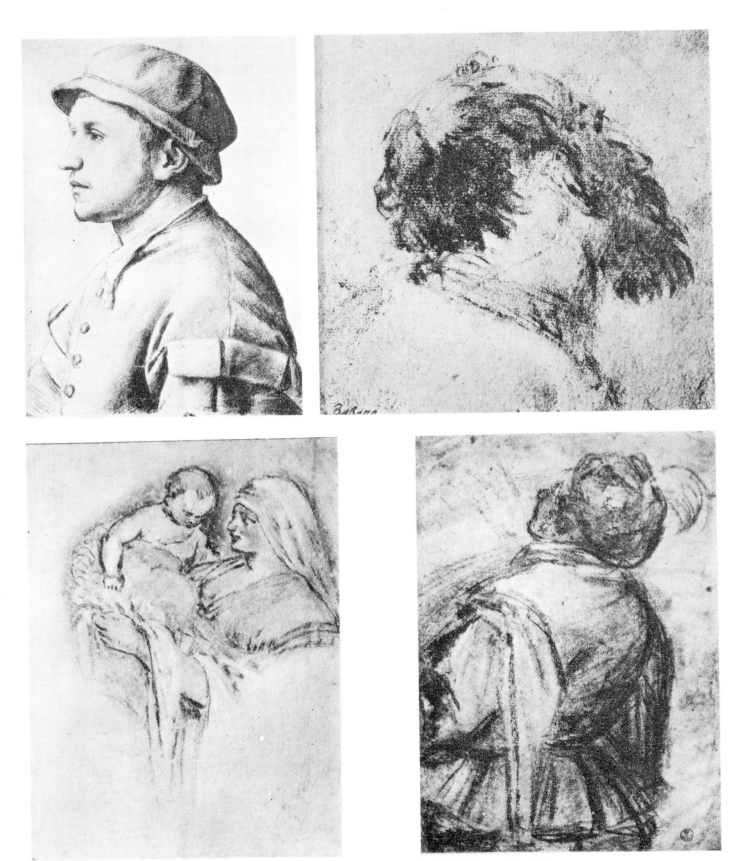

Jacopo Bassano *1*. No. **192**.—*2*. No. **200**.—*3*. No. **186**.—*4*. No. **139**.

Pl CXLII

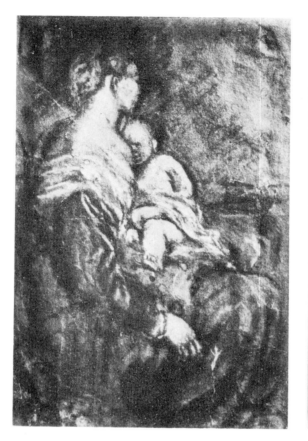

Jacopo Bassano *1*. No. **151**.—*2*. No. **152**.—*3*. No. **120**.—*4*. No. **154**.

Pl CXLIII

No. **177** Jacopo Bassano.

Pl CXLIV

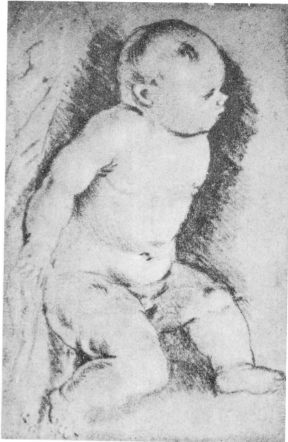

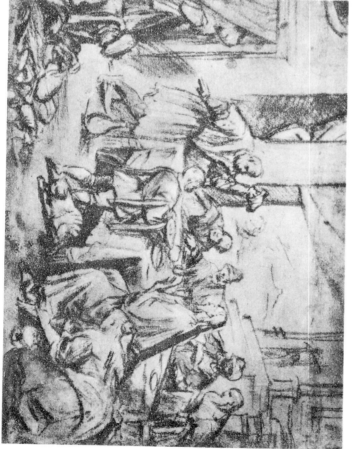

Jacopo Bassano *1*. No. 168.—*2*. No. 155.—*3*. No. 133.—*4*. No. 119.

Pl CXLV

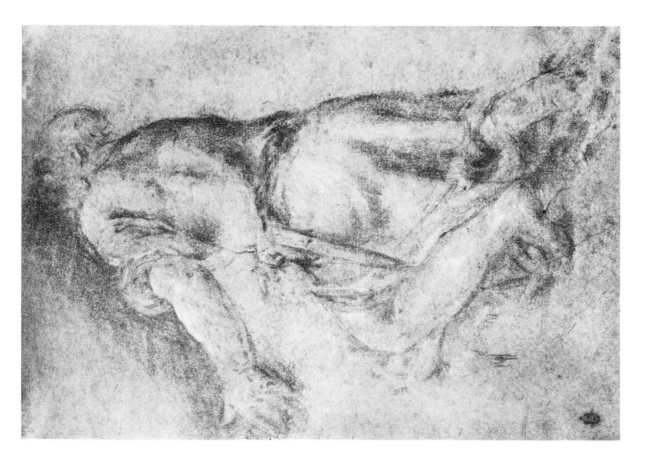

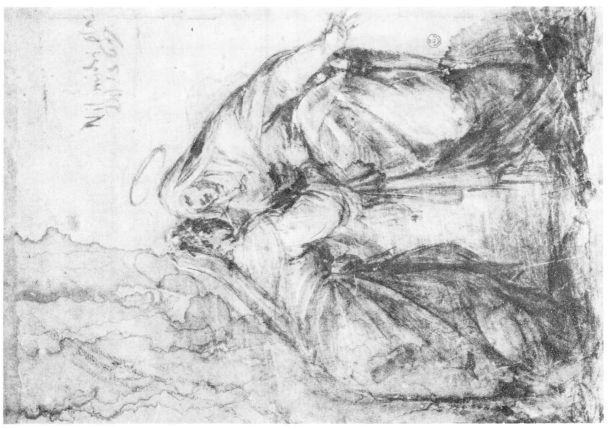

Jacopo Bassano *1*. No. **146**.—*2*. No. 166.

Pl CXLVI

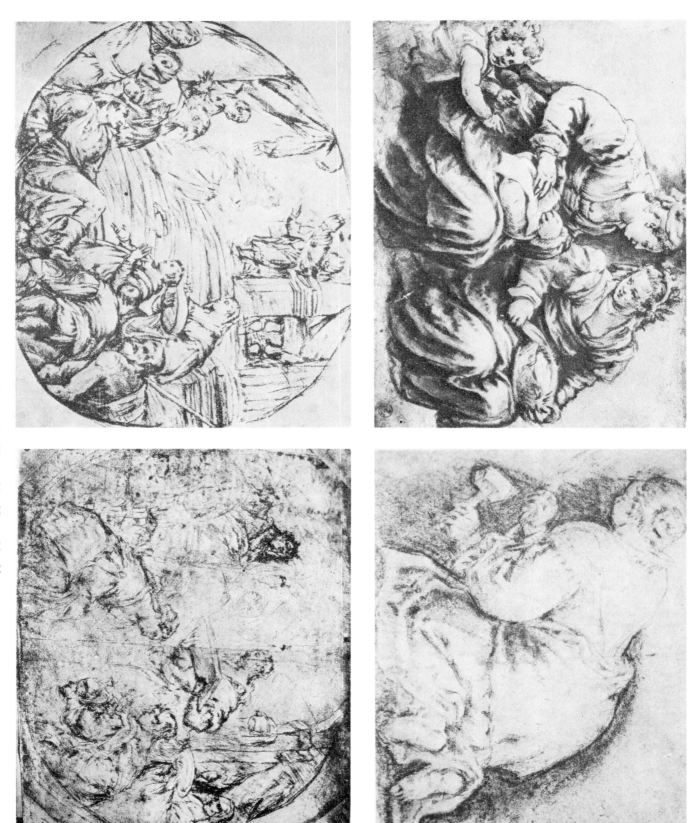

Francesco Bassano 1. No. 84. — 2. No. 98. — 3. No. 82. — 4. No. 82 verso.

Pl CXLVII

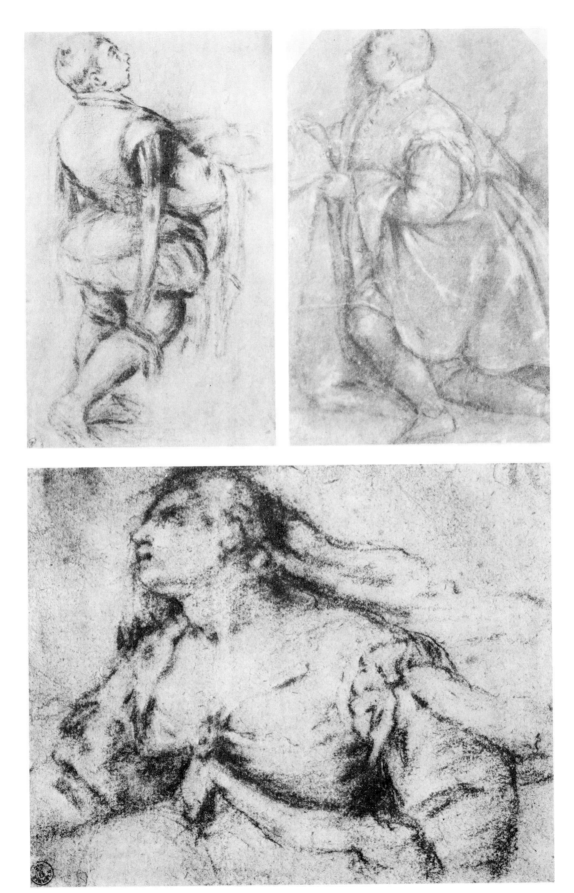

Francesco Bassano *1*. No. **77**.—*2*. No. **94**.—*3*. No. **83**.

Pl CXLVIII

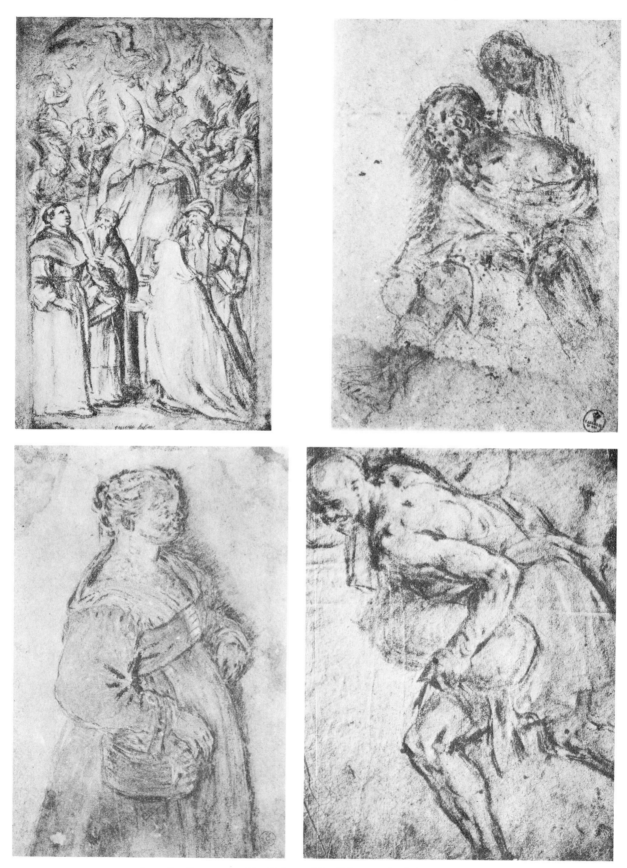

Leandro Bassano *1.* No. 222.—*2.* No. 213.—*3.* No. 214.—*4.* No. 243.

Pl CXLIX

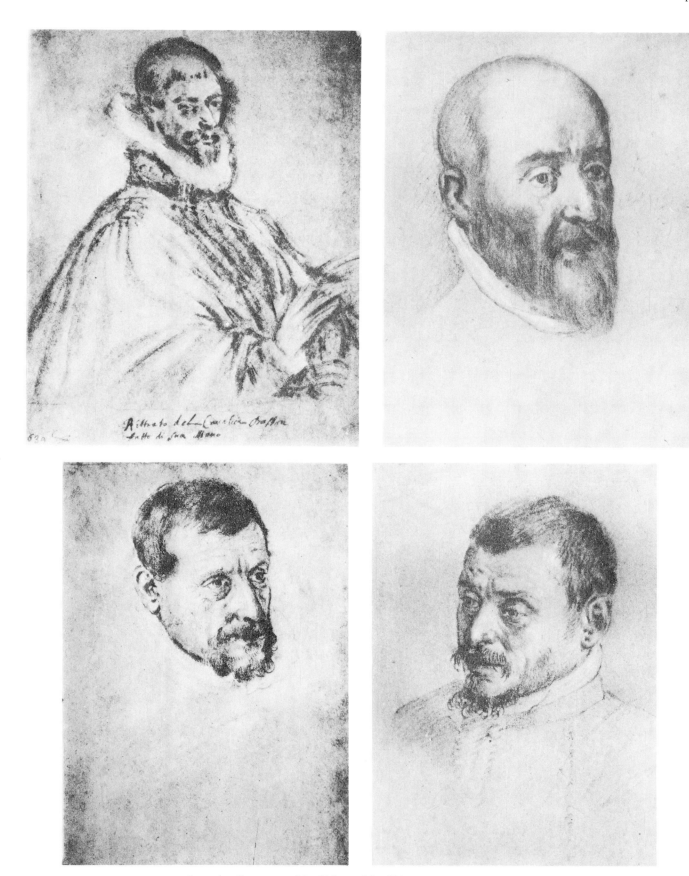

Leandro Bassano *1.* No. **212.**—*2.* No. **238.**—*3.* No. **210.**—*4.* No. **234.**

Pl CL

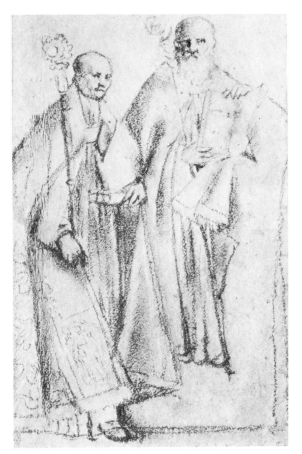

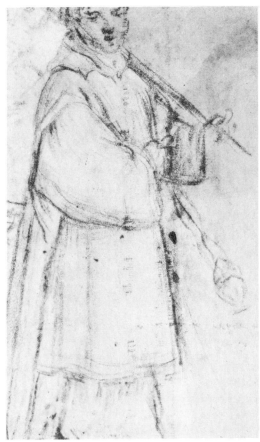

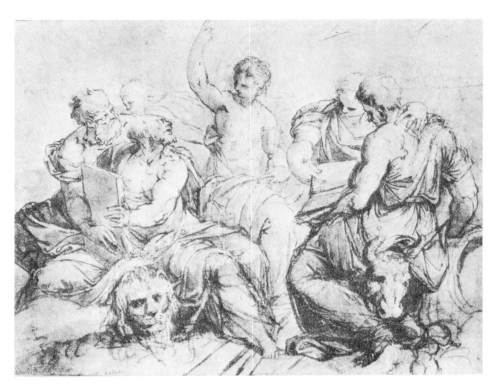

1–2. Girolamo Bassano No. **107, 109 bis**.—*3*. No. **2266** Zelotti.

Pl CLI

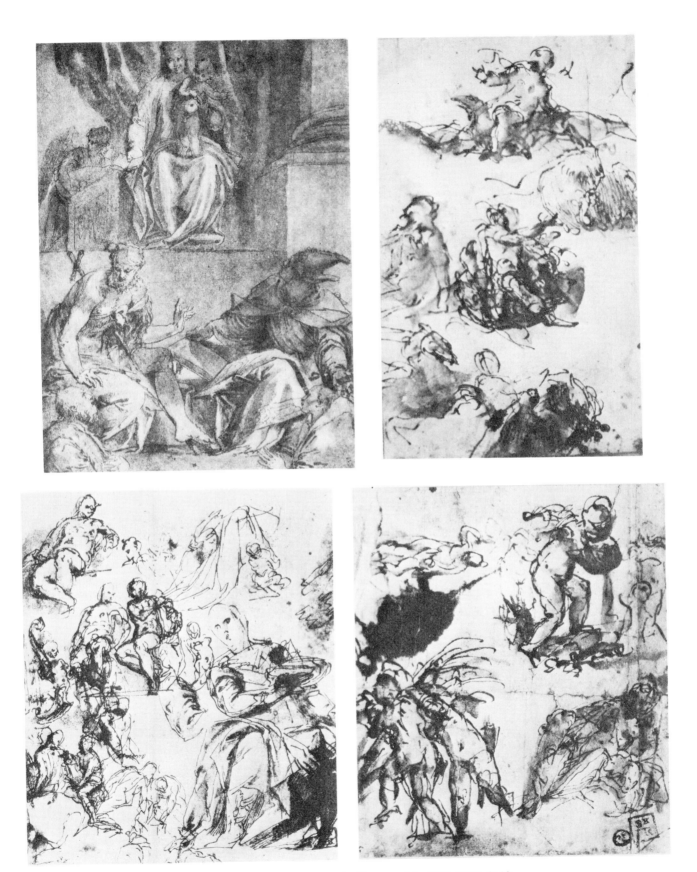

1. No. **2255** Zelotti.—*2–4*. Paolo Veronese No. **2123, 2122, 2110**.

Pl CLII

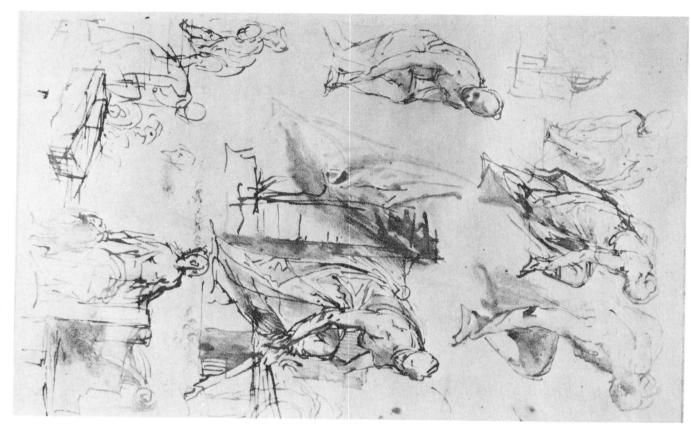

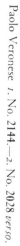

Pl CLIII

No. 2028 Paolo Veronese.

Pl CLIV

Paolo Veronese *1*. No. 2124.—*2*. No. 2049.

Pl CLV

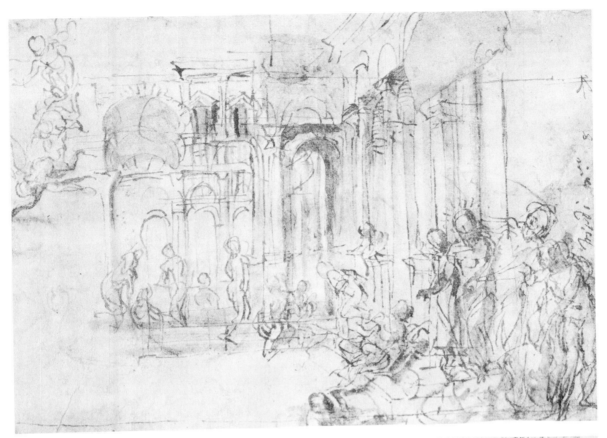

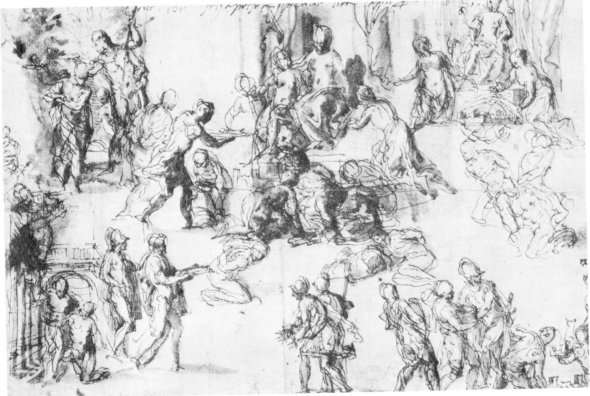

Paolo Veronese *1*. No. **2103**.—*2*. No. **2106**.

Pl CLVI

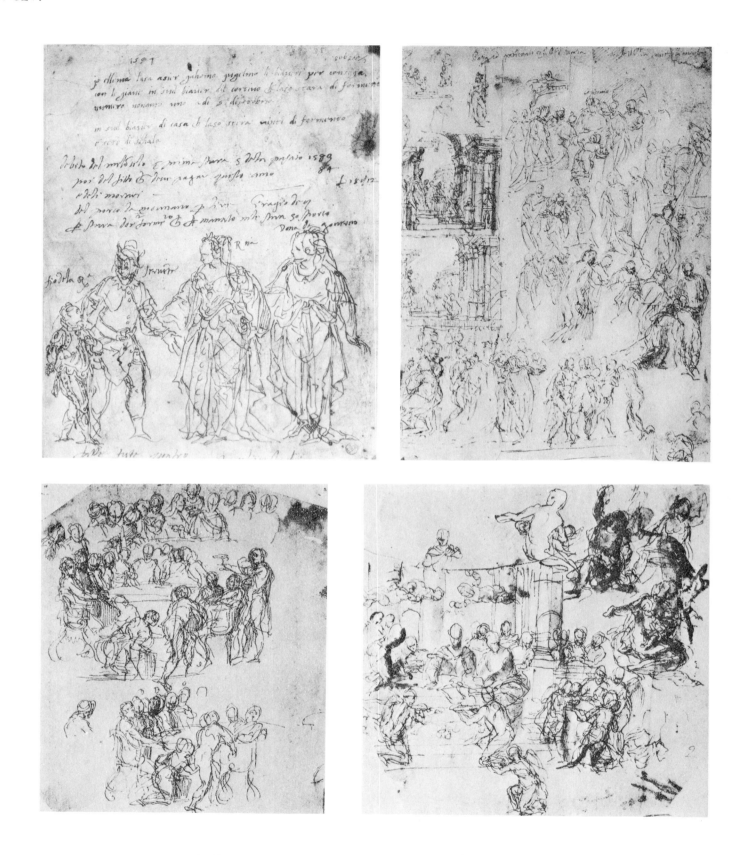

Paolo Veronese *1*. No. **2141** *verso.—2*. No. **2152**.—*3*. No. **2040**.—*4*. No. **2044**.

Pl CLVII

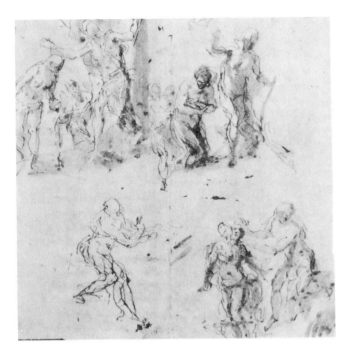

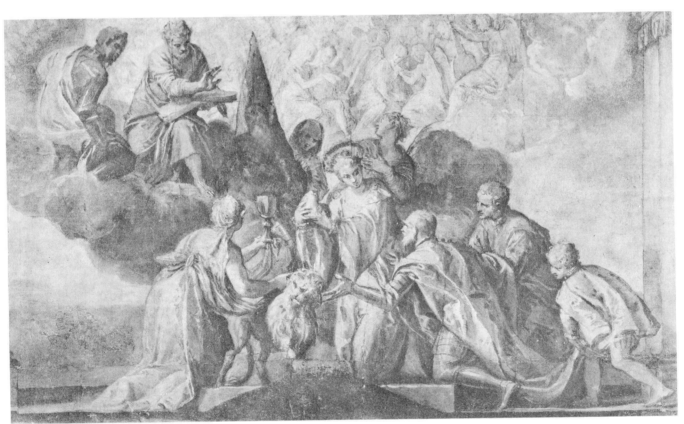

Paolo Veronese *1*. No. **2052**.—*2*. No. **2072**.—*3*. No. **2092**.

Pl CLVIII

Paolo Veronese *1.* No. **2097.**—*2.* No. **2139.**

Pl CLIX

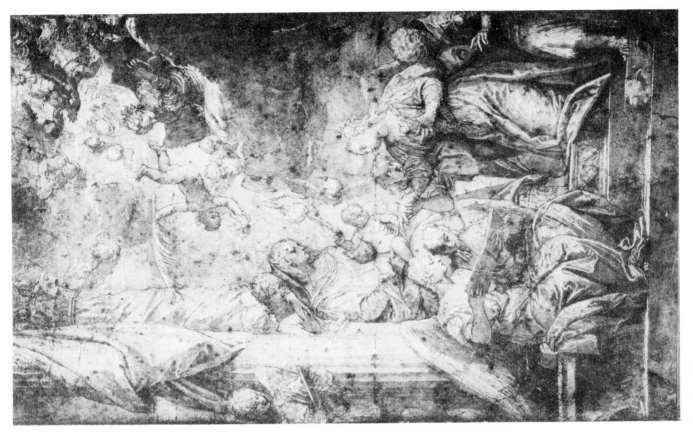

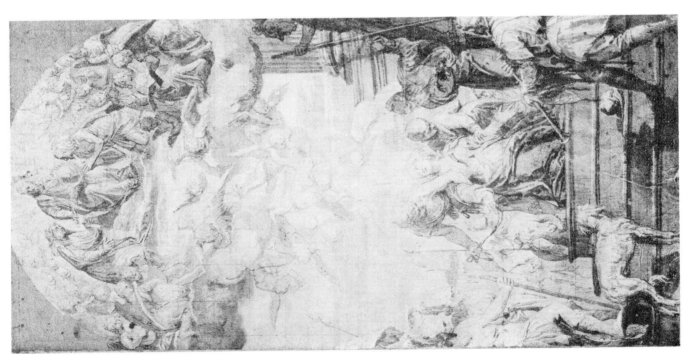

Paolo Veronese *1*. No. 2056.—2. No. 2045.

Pl CLX

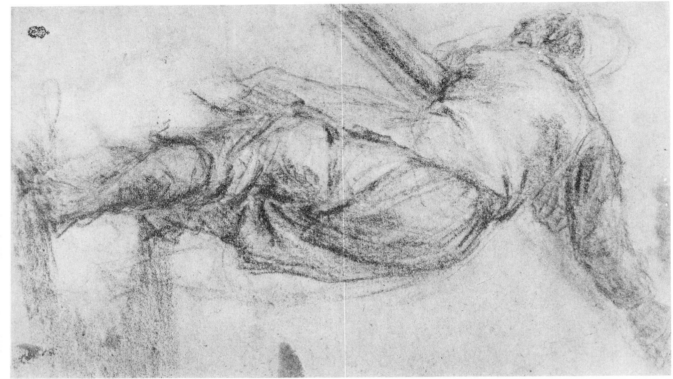

Paolo Veronese *1.* No. 2107. — *2.* No. 2078. — *3.* No. 2084.

Pl CLXI

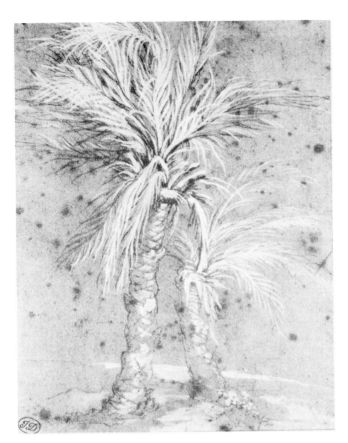

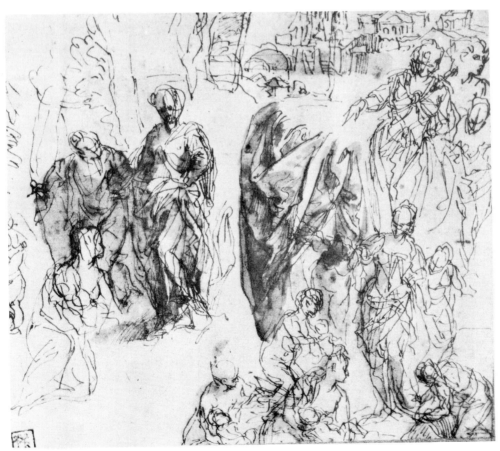

Paolo Veronese *1.* No. **2026.**—*2.* No. **2034.**—*3.* No. **2121.**

Pl CLXII

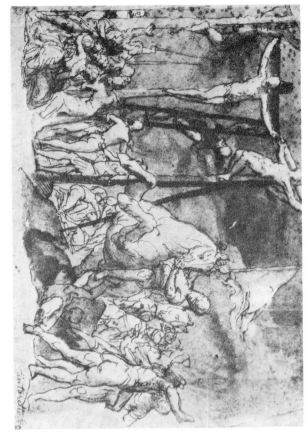

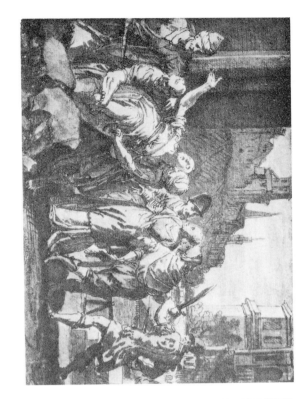

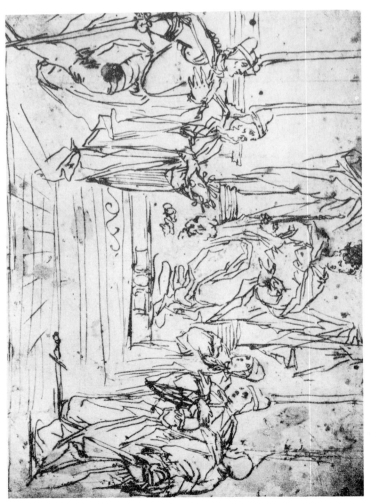

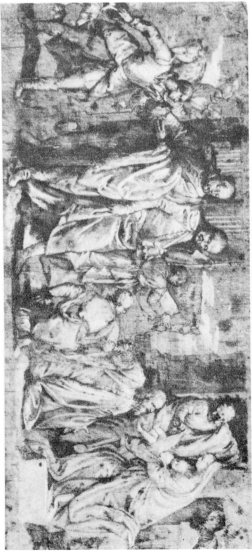

The Veronese Shop 1. No. 2213 (Gabriele Caliari).—2. No. 2160.—3. No. 2161 bis.—4. No. 2189.

Pl CLXIII

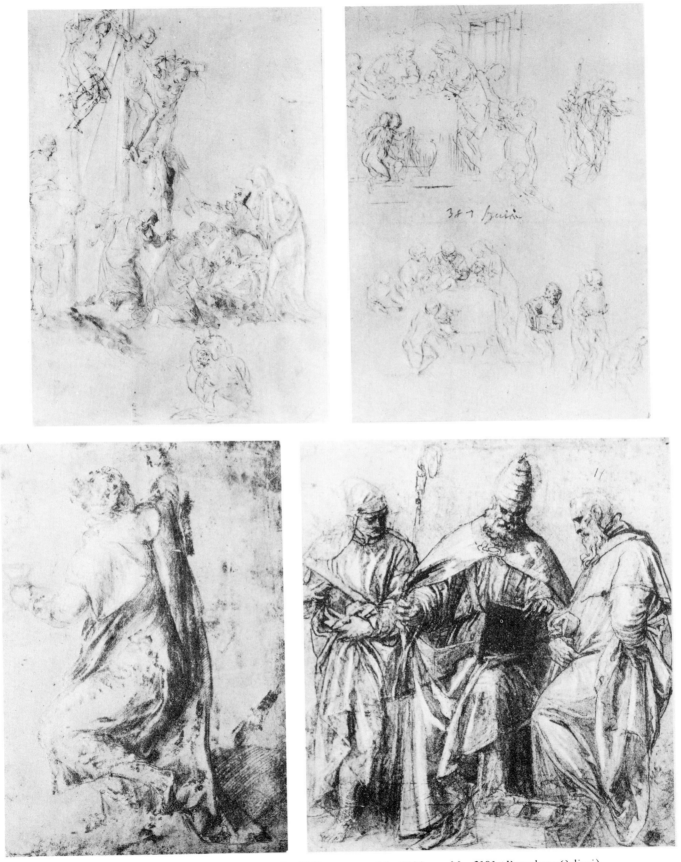

The Veronese Shop *1*. No. **2163**.—*2*. No. **2163** *verso*.—*3*. No. **2184**.—*4*. No. **2191** (Benedetto Caliari).

Pl CLXIV

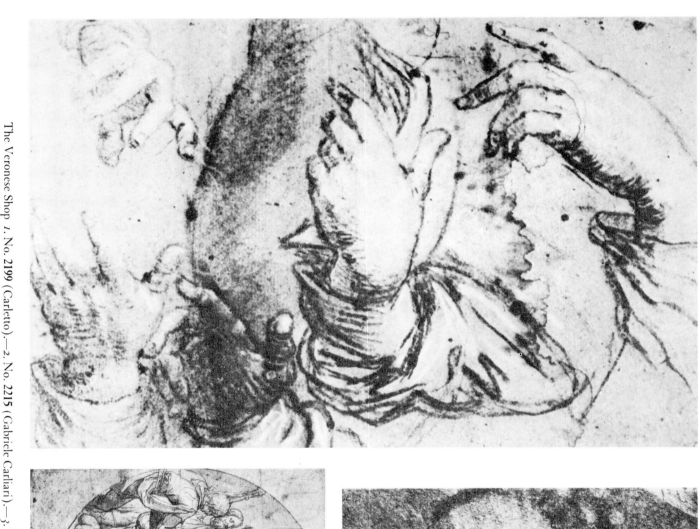

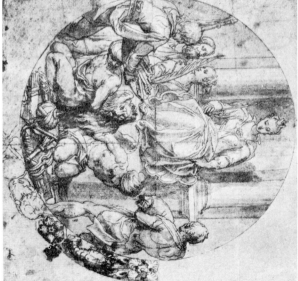

The Veronese Shop *1.* No. 2199 (Carletto).—2. No. 2215 (Gabriele Carliari).—3. No. 2211 (Carletto).

Pl CLXV

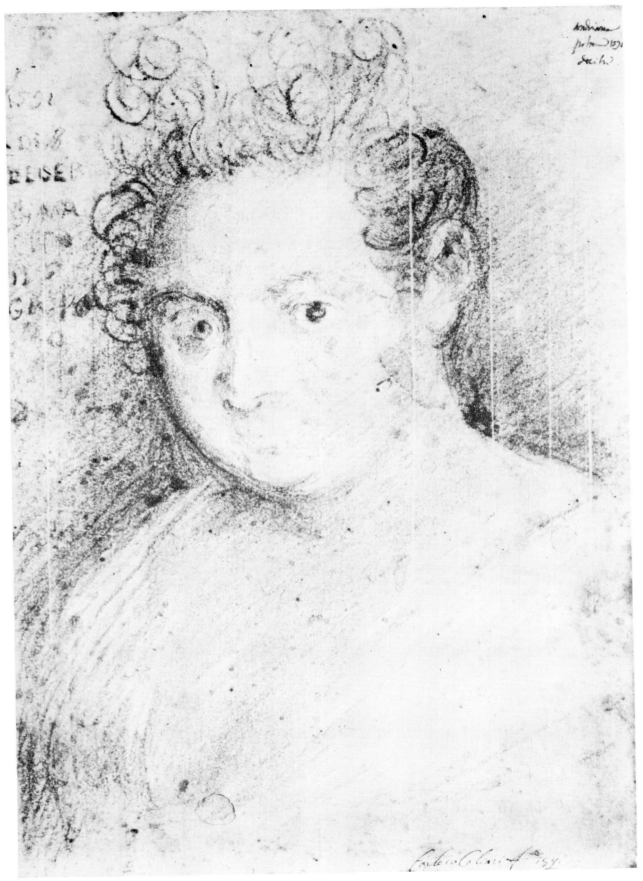

No. **2207**. Carletto Carliari.

Pl CLXVI

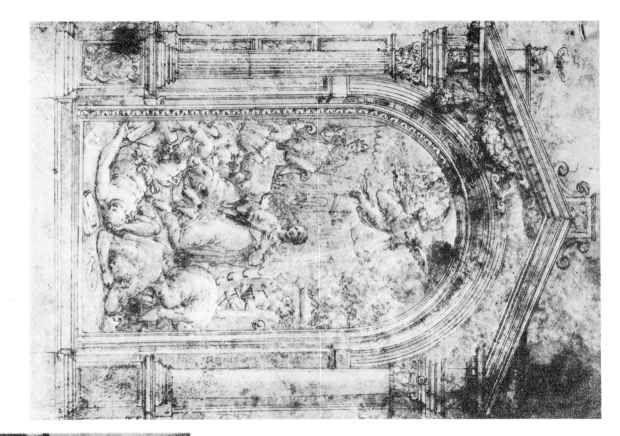

1. No. **805** Montemezzano.— *2.* No. **804** Parrasio Micheli.— *3.* No. **817** Pace Pace.

Pl CLXVII

Carletto *1*. No. **2212**.—*2*. No. **2200**.—*3*. No. **2204**.

Pl CLXVIII

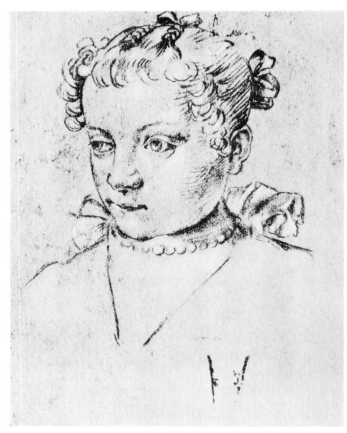

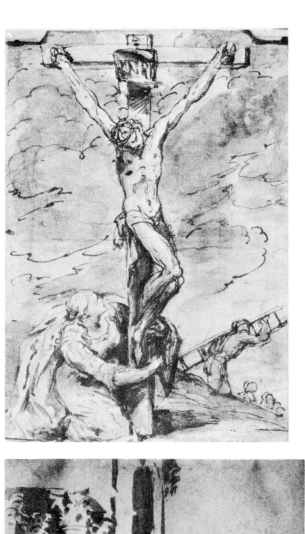

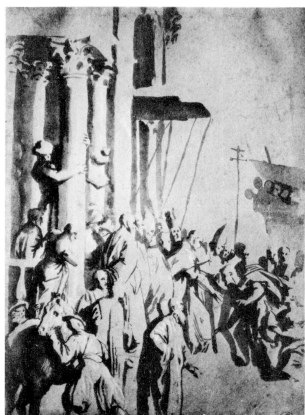

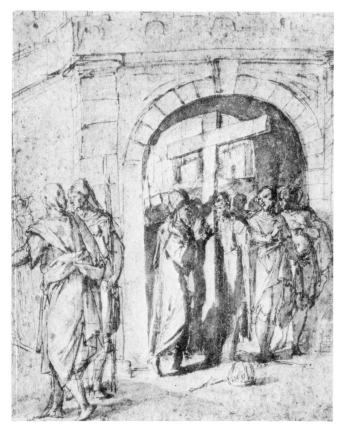

1–2. Montemezzano No. **807, 806.** —*3.* No. **816** Pace Pace. —*4.* No. **696** Friso.

Pl CLXIX

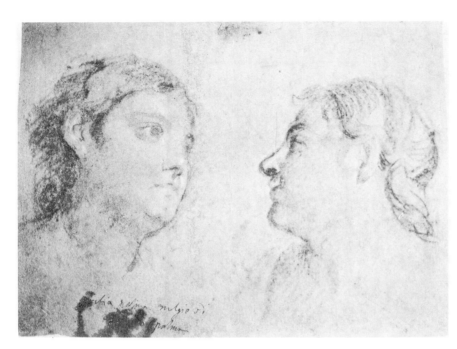
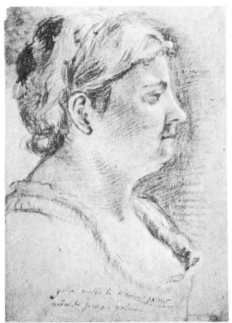
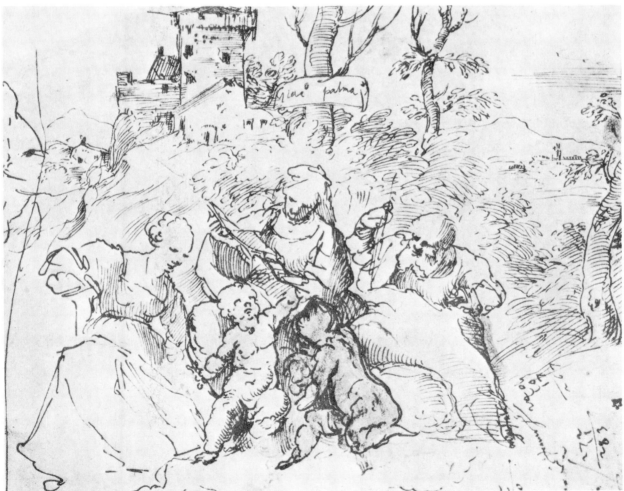

1. No. **820** Antonio Palma.—*2–3*. Palma Giovine No. **1029, 983.**

Pl CLXX

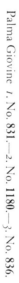

Palma Giovine *1*. No. 831.—*2*. No. 1180.—*3*. No. 836.

Pl CLXXI

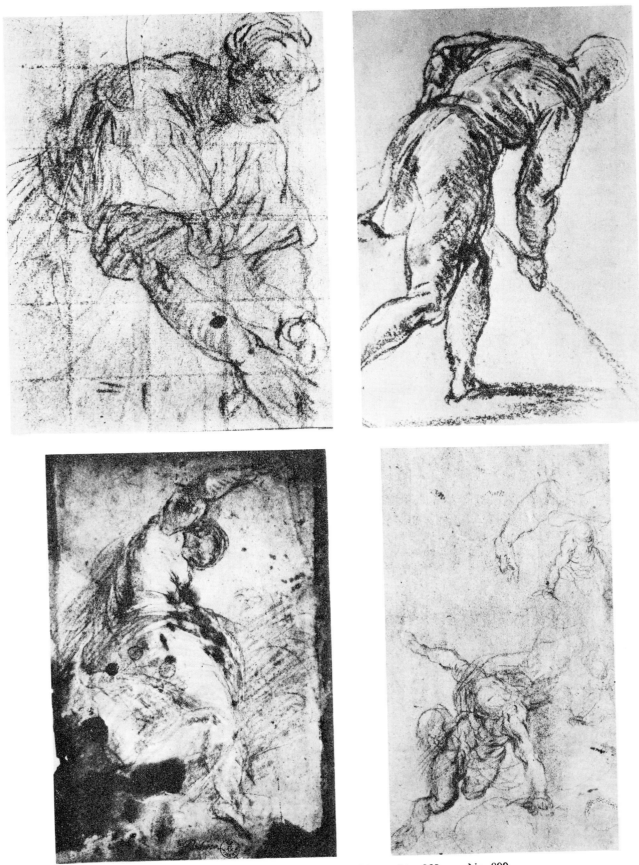

Palma Giovine *1.* No. **1018**.—*2.* No. **883**.—*3.* No. **929**.—*4.* No. **899**.

Pl CLXXII

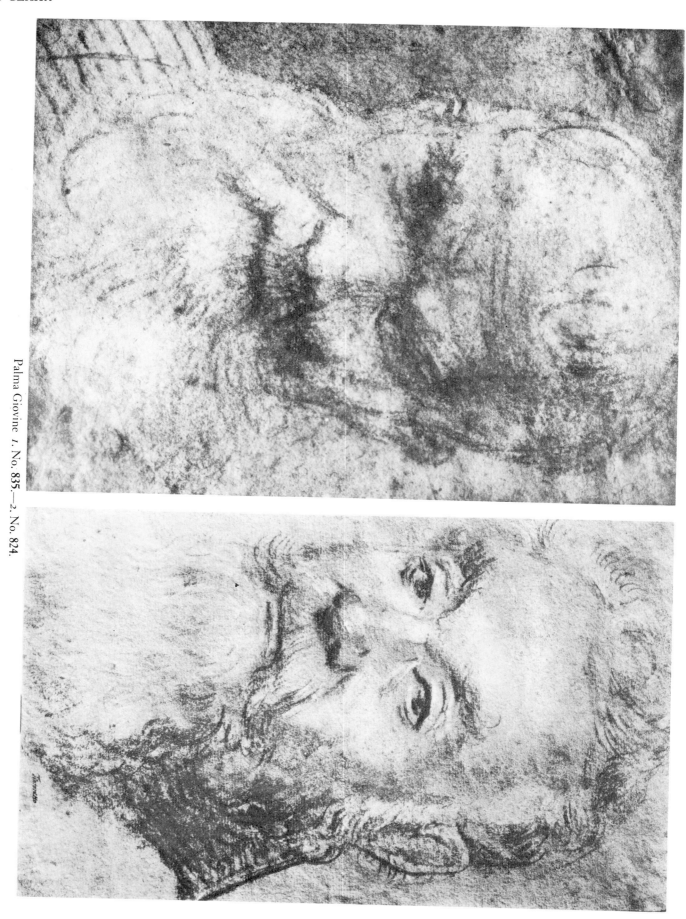

Palma Giovine *1*. No. 835.—*2*. No. 824.

Pl CLXXIII

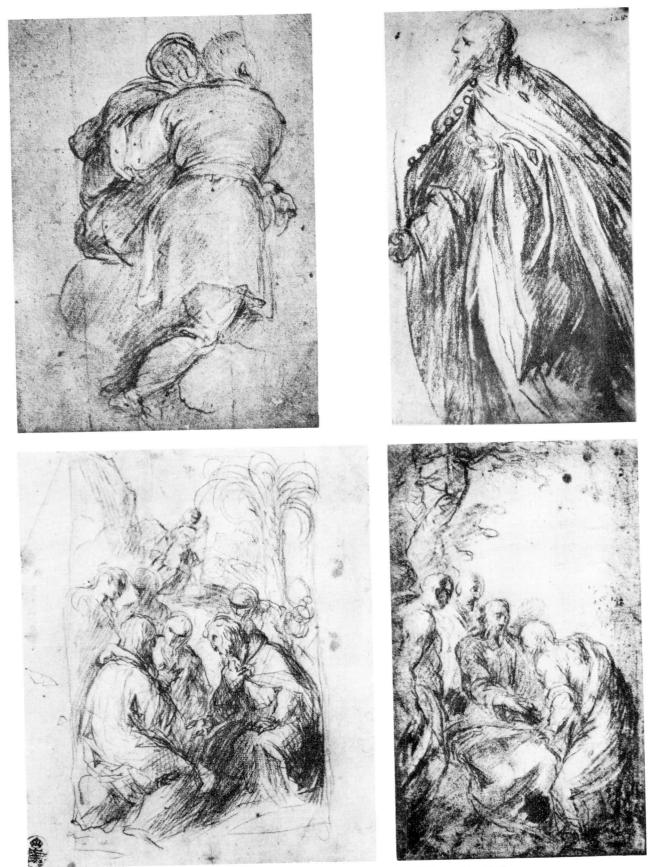

Palma Giovine *1*. No. **1245**.—*2*. No. **917**.—*3*. No. **885**.—*4*. No. **1118**.

Pl CLXXIV

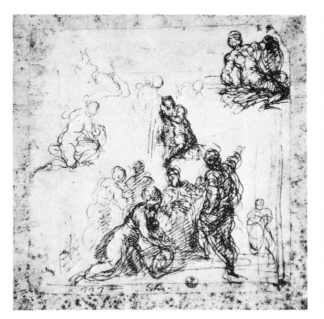

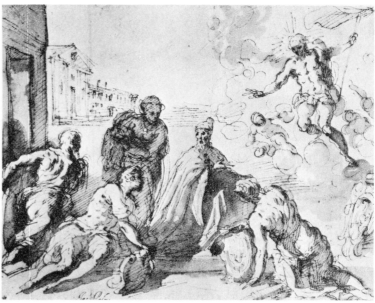

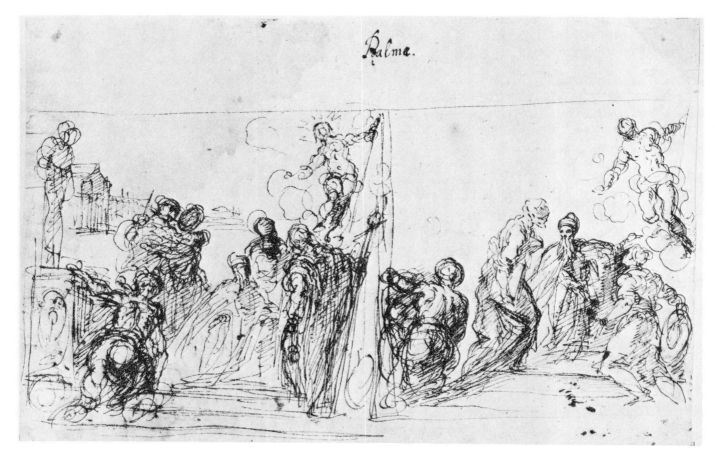

Palma Giovine *1*. No. 922.—*2*. No. 1246.—*3*. No. 881.

Pl CLXXV

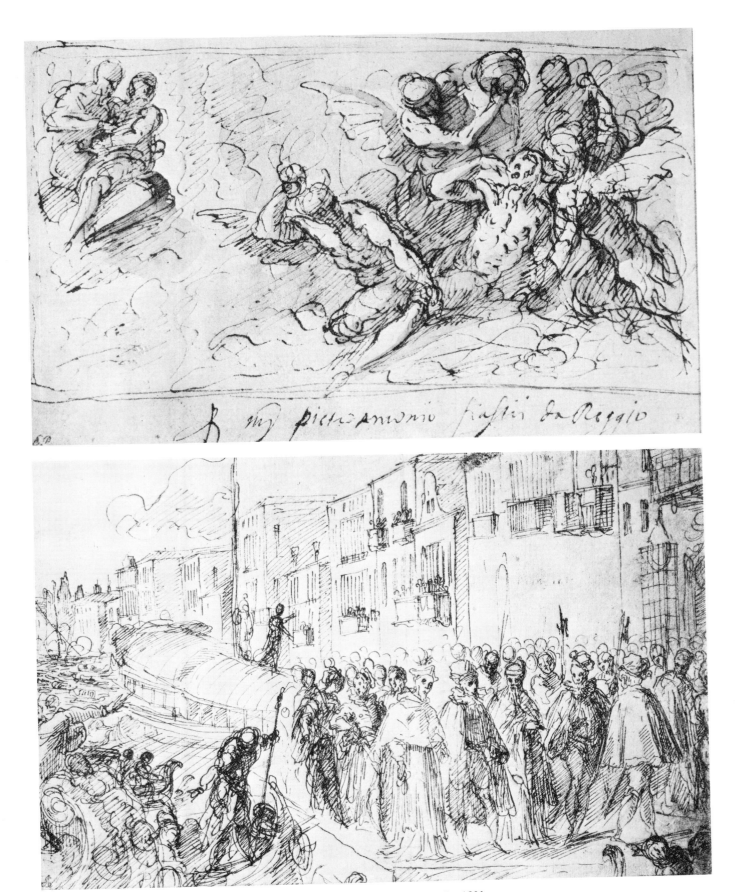

Palma Giovine *1*. No. **998**.—*2*. No. **1201**.

Pl CLXXVI

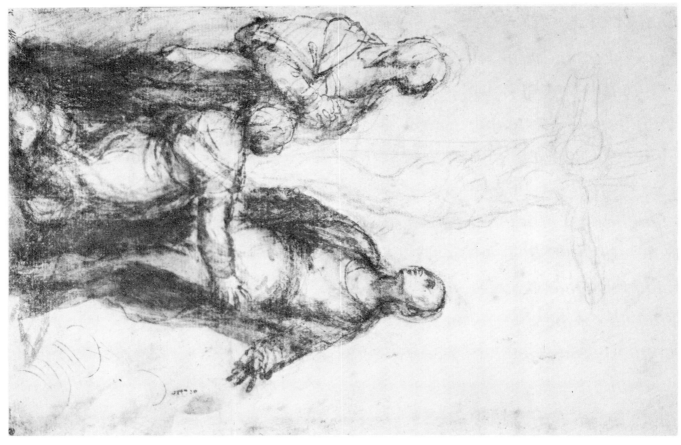

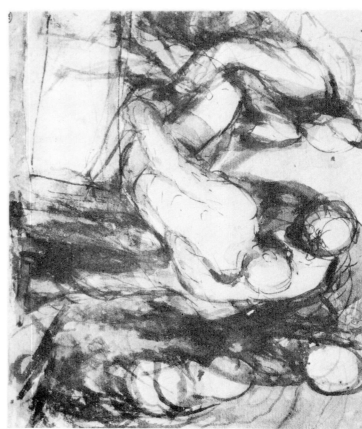

Palma Giovine *1.* No. **861.** — *2.* No. **1095.** — *3.* No. **1126** verso.

Pl CLXXVII

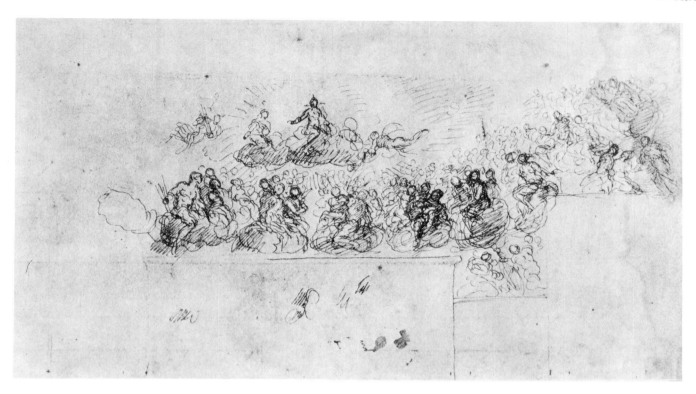

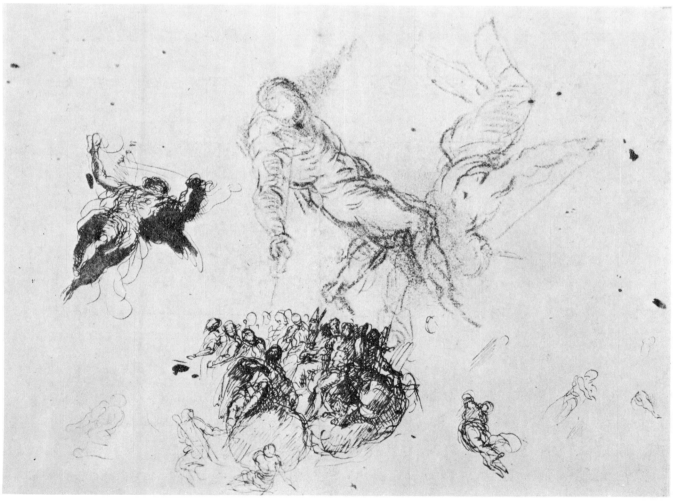

Palma Giovine *1–2*. No. **1143, 1143** *verso*.

Pl CLXXVIII

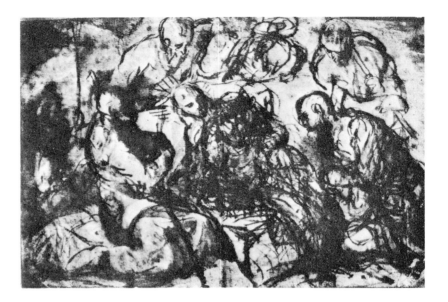

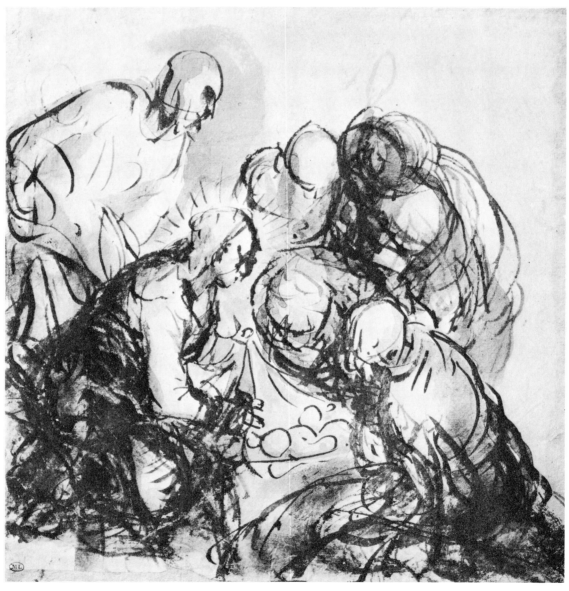

Palma Giovine *1.* No. **1126.**—*2.* No. **1070.**

Pl CLXXIX

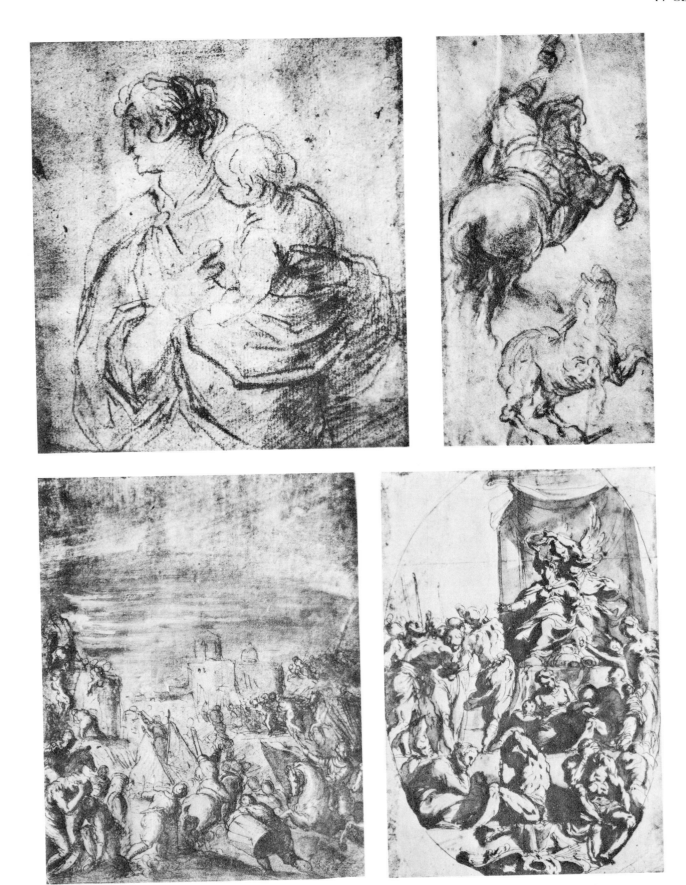

Palma Giovine *1*. No. **1037**, I, *30*.—*2*. No. **1062**.—*3*. No. **1240**.—*4*. No. **1015**.

Pl CLXXX

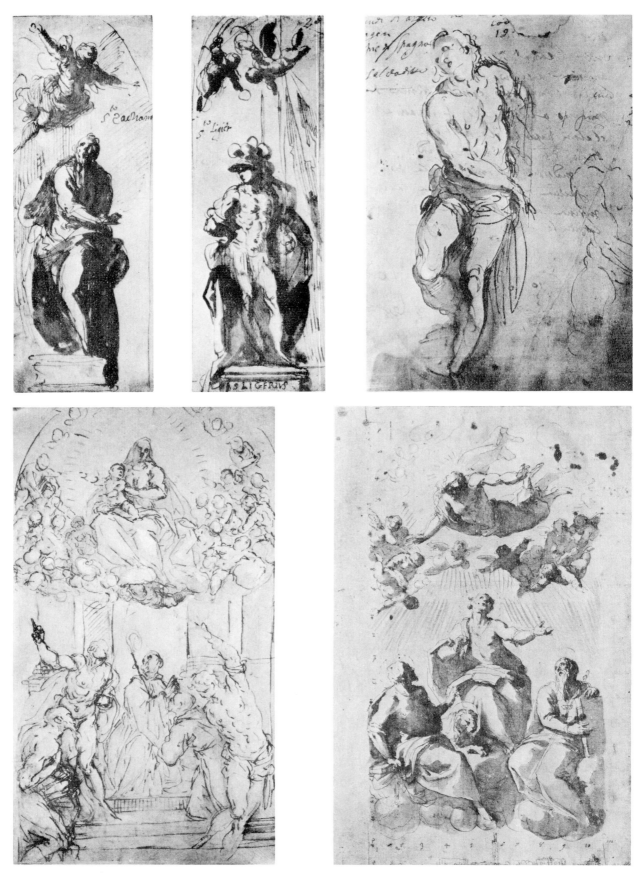

Palma Giovine *1–2*. No. **991**, 103 and 104.—*3*. No. **1037**, II, 12.—*4*. No. **1051**.—*5*. No. **992**.

Pl CLXXXI

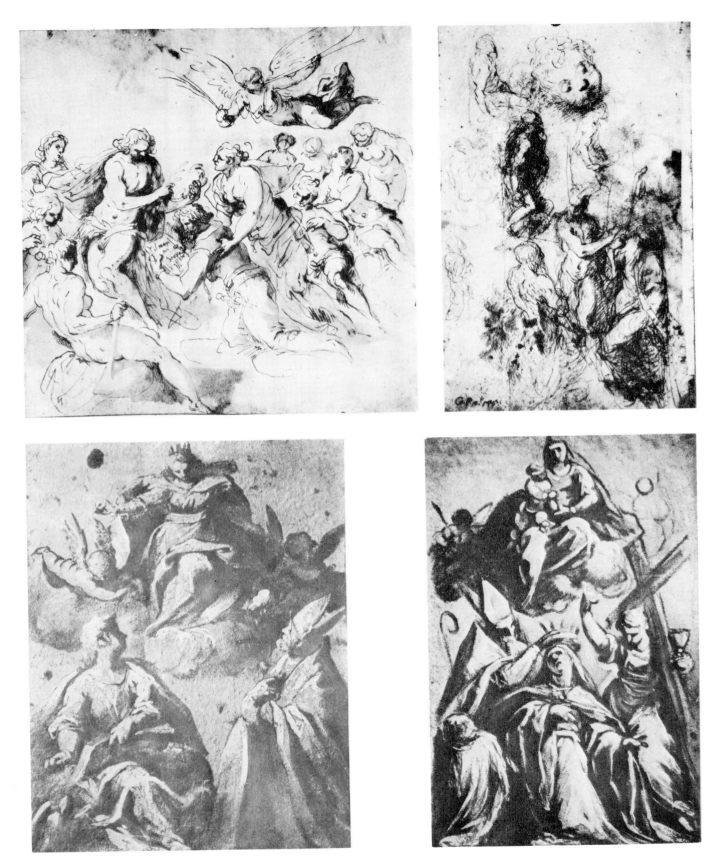

Palma Giovine *1*. No. **991**, 116.—*2*. No. **952**.—*3*. No. **974**.—*4*. No. **1108**.

Pl CLXXXII

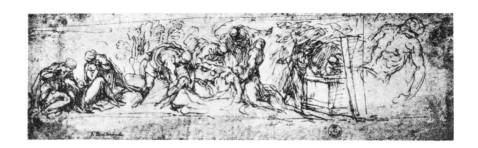

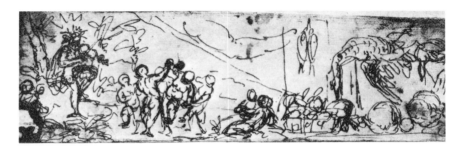

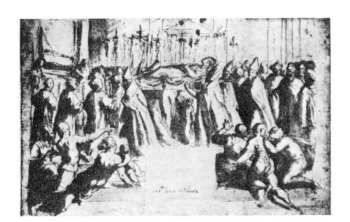

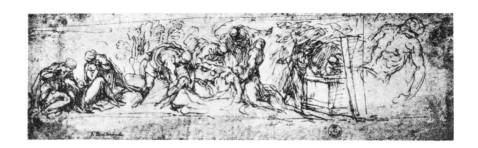

1–4. Palma Giovine No. **914, 1037,** II, 244, **865, 1237.**—*5.* No. **1280** Paolo Piazza.

Pl CLXXXIII

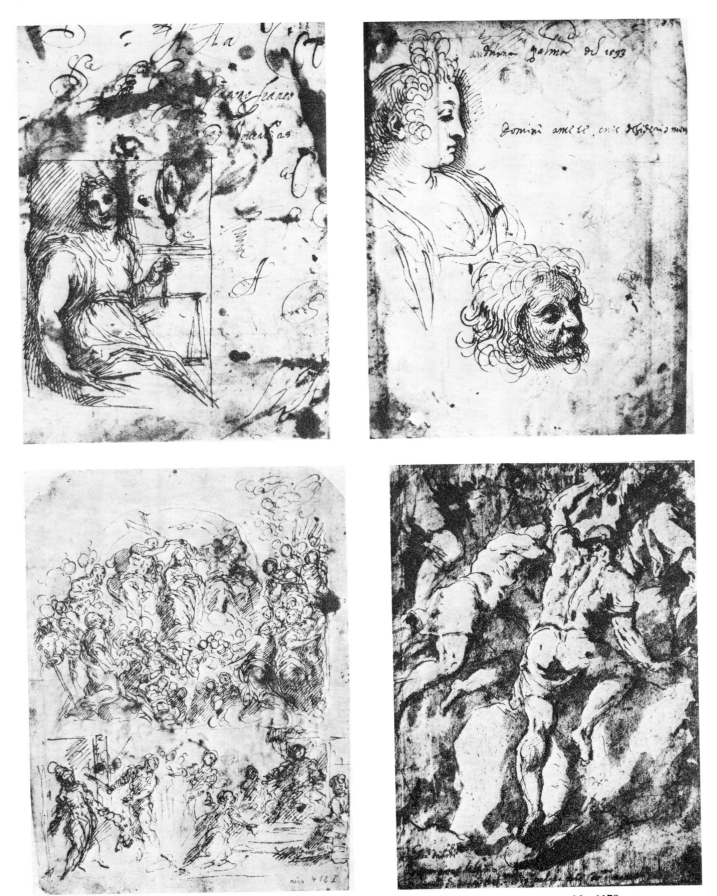

Palma Giovine *1*. No. **1037**, II, 83.—*2*. No. **1037**, I, *219 verso.*—*3*. No. **1037**, I, *23 verso.*—*4*. No. **1178**.

Pl CLXXXIV

1. No. 54 Camillo Ballini.—2. No. 691 Pietro Damini.—3-4. Sante Peranda No. 1276, 1274.

Pl CLXXXV

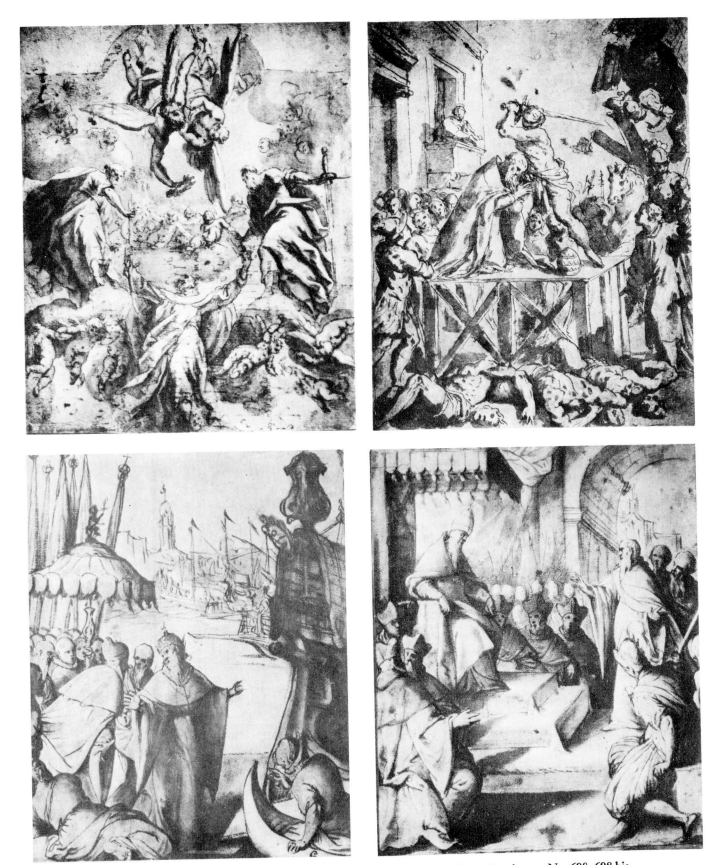

1. No. 1277 Sante Peranda.—*2.* No. 1281 Paolo Piazza.—*3-4.* Girolamo Gambarato No. **698, 698 bis.**

Pl CLXXXVI

1. No. **A 361**.—*2.* No. **A 363 bis**.—*3.* No. **A 304**.—*4.* No. **A 305**.

Pl CLXXXVII

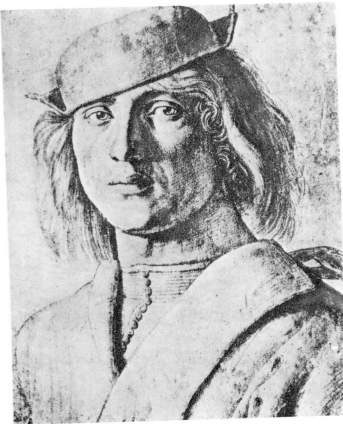

1. No. **A 2253.**—*2.* No. **A 310.**—*3.* No. **A 1267.**—*4.* No. **A 326.**

Pl CLXXXVIII

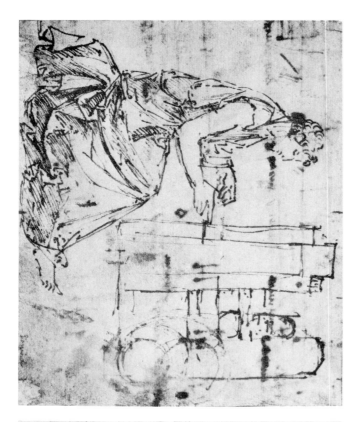

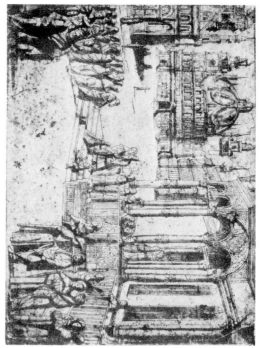

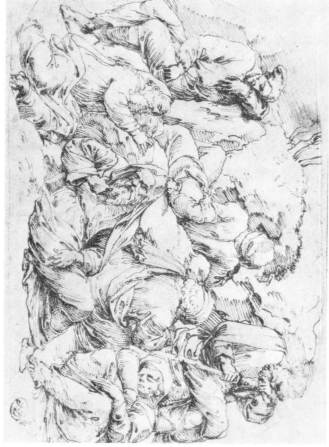

1. No. A 641.— 2 No. A 1582.—3. No. A 609.—No. A 1256.

Pl CLXXXIX

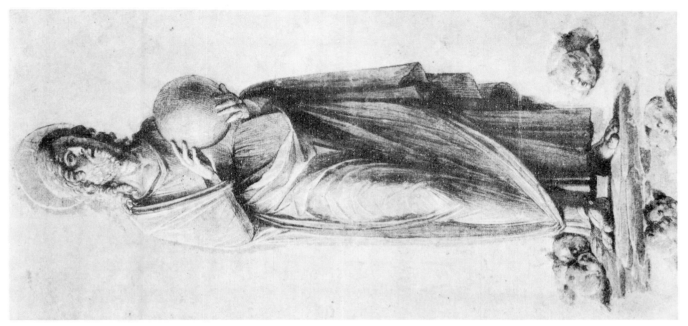

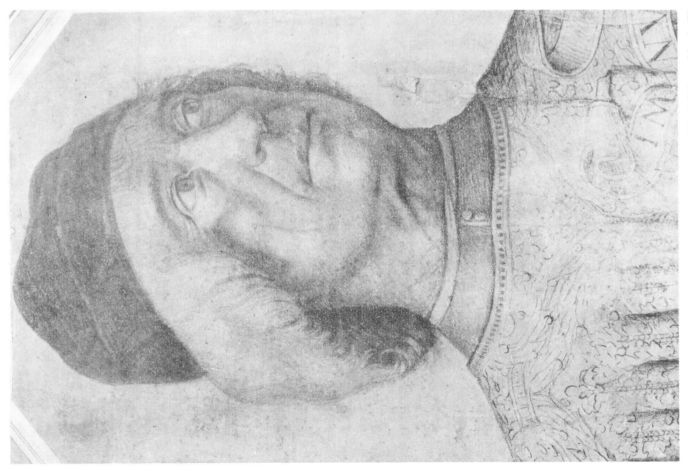

Pl CXC

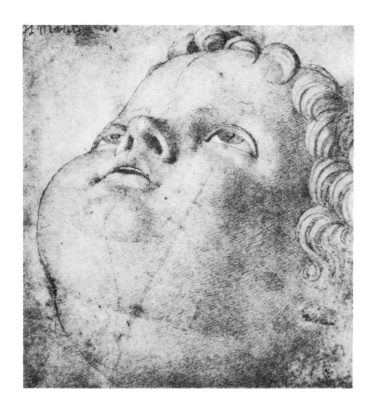

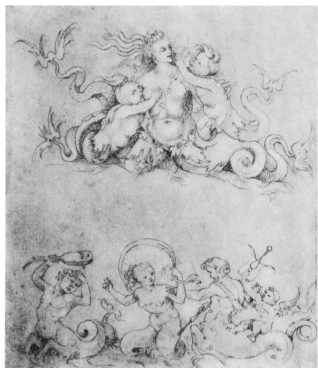

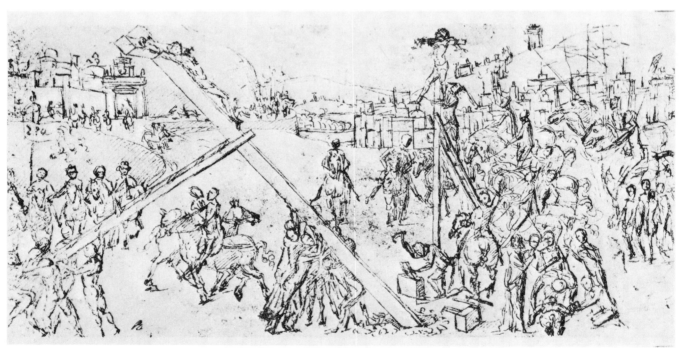

1. No. **A 652.**—*2.* No. **A 654.**—*3.* No. **A 628.**

Pl. CXCI

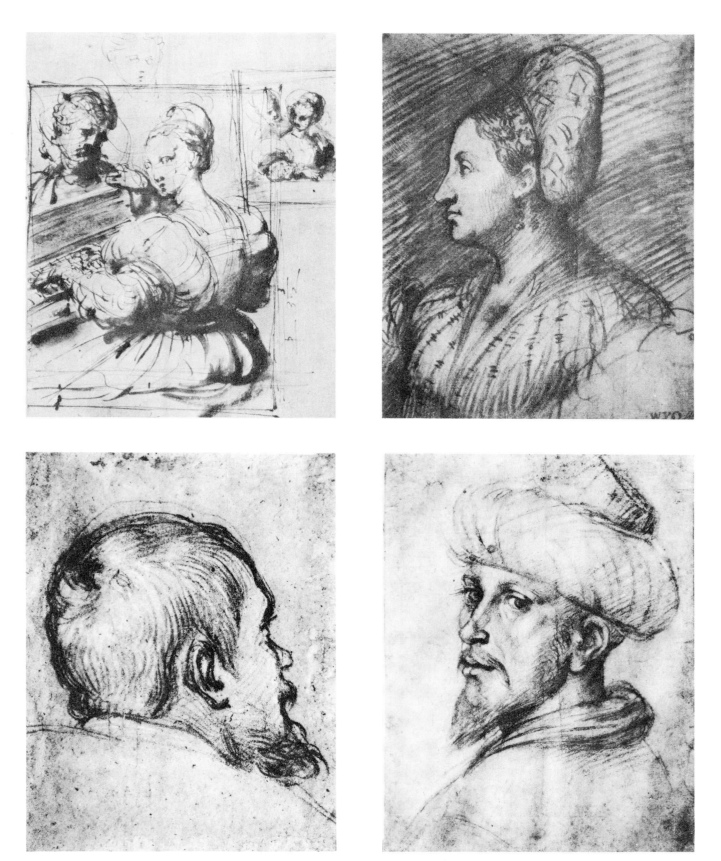

1. No. **A 754.**—*2.* No. **A 752.**—*3.* No. **A 408.**—*4.* No. **A 250.**

Pl CXCII

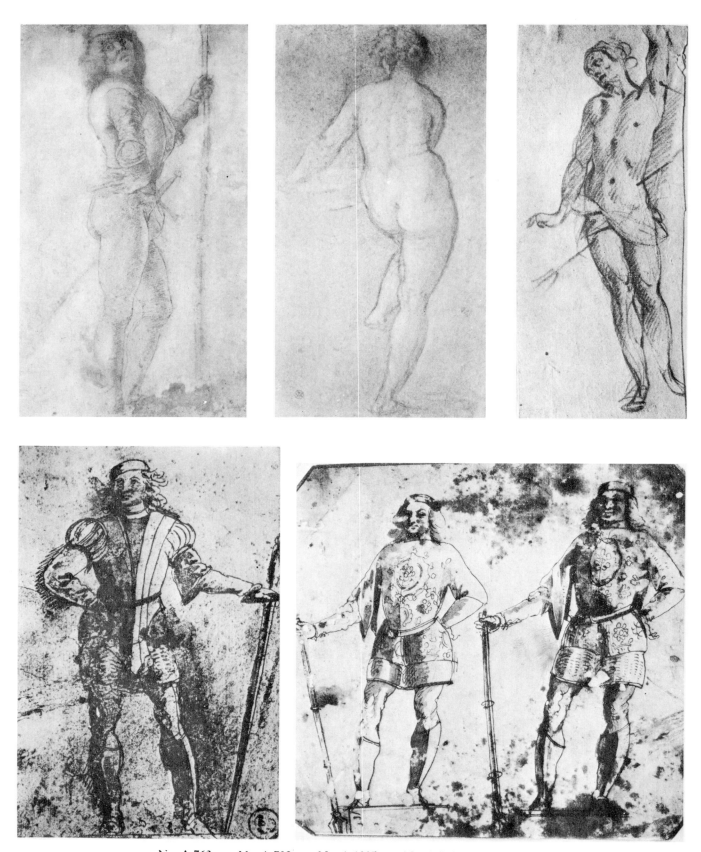

1. No. **A 763.**—*2.* No. **A 708.**—*3.* No. **A 1335.**—*4.* No. **A 769.**—*5.* No. **A 768.**

Pl CXCIII

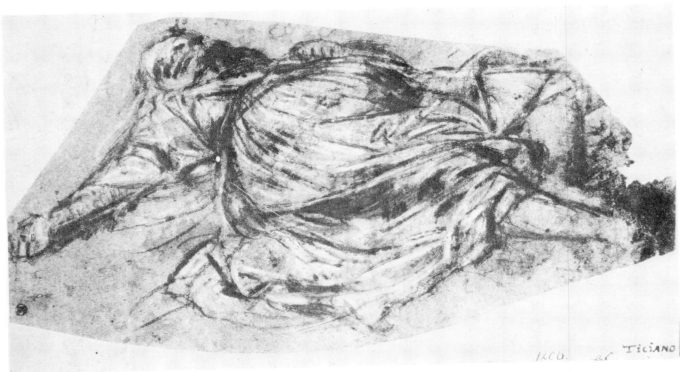

1. No. **A 1985.**—*2.* No. **A 203.**—*3.* No. **A 1967.**

Pl CXCIV

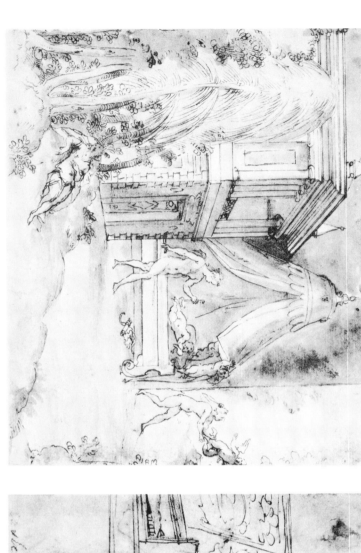

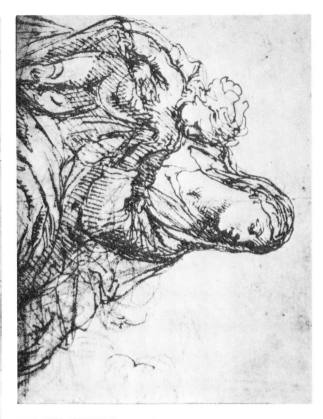

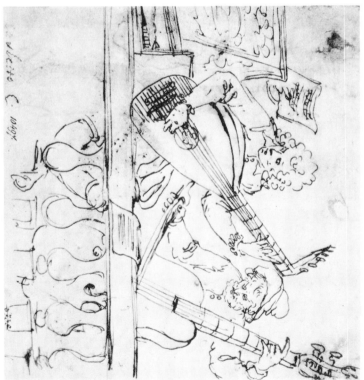

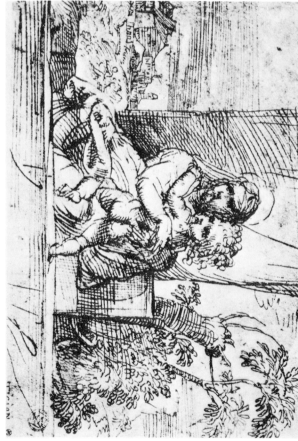

1. No. A 1914.—2. No. A 1951.—3. No. A 2205.—4. No. A 2206.

Pl CXCV

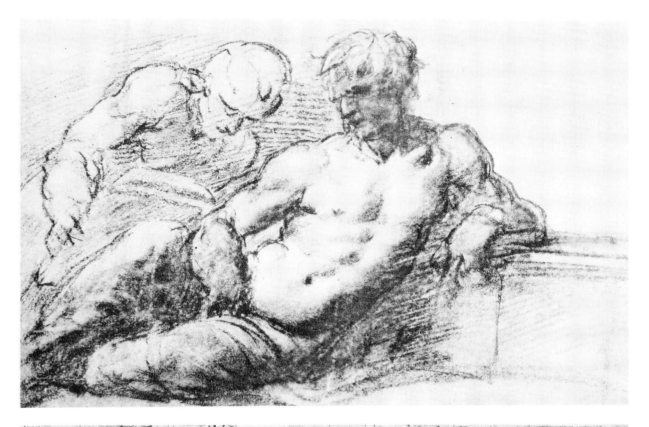

1. No. **A 1898**.—*2*. No. **A 1332**.

Pl CXCVI

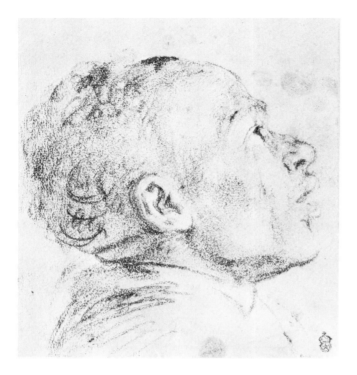

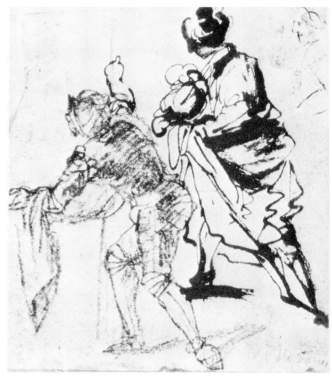

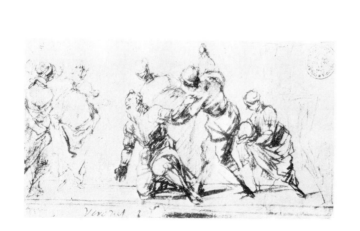

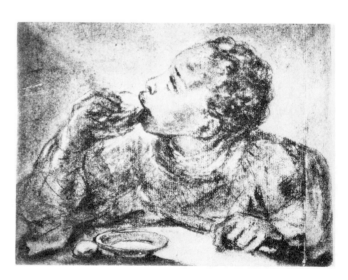

1. No. **A 2108**.—*2*. No. **A 2115**.—*3*. No. **A 2114**.—*4*. No. **A 2109**.

Pl CXCVII

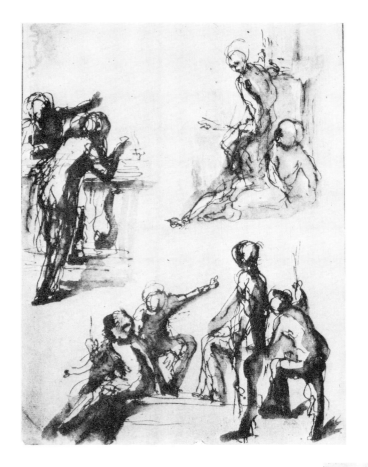

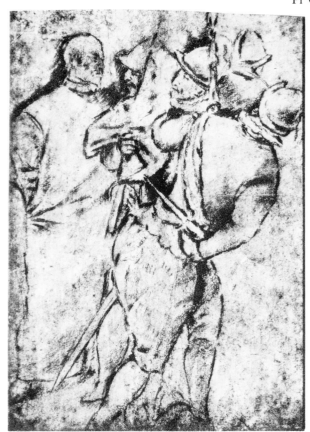

1. No. **A 2086.**—*2*. No. **A 157 bis.**—*3*. No. **A 2143.**—*4*. No. **A 2130.**

Pl CXCVIII

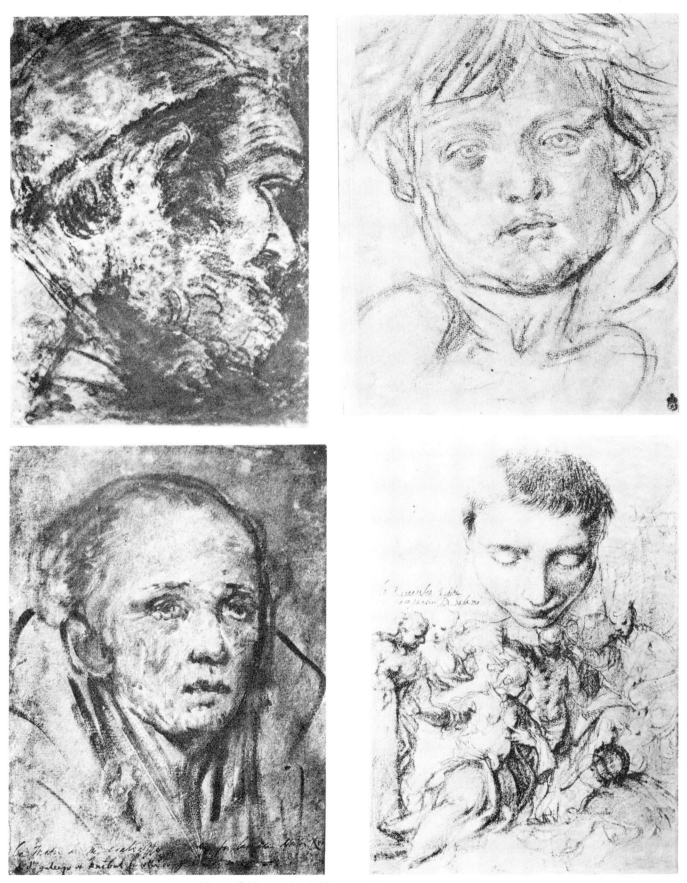

1. No. **A 1718**.—2. No. **A 1940**.—3. No. **A 199**.—4. No. **A 229**.

Pl CXCIX

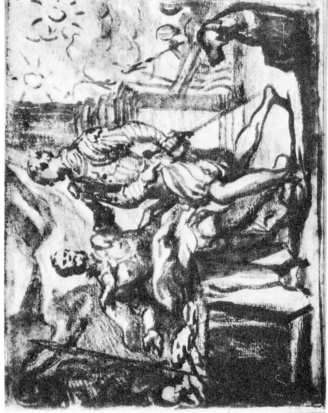

1. No. A 1037, I, 221.—2. No. A 1037, I, 47.—3. No. A 1037, II, 89.—4. No. A 2054.

Pl CC

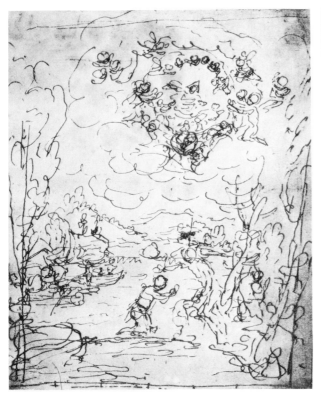

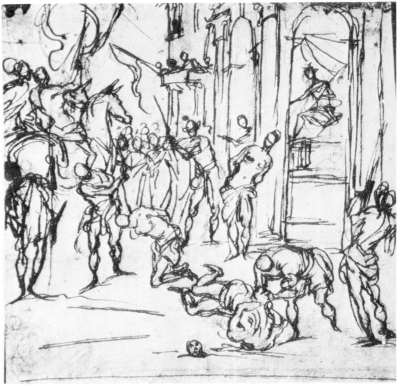

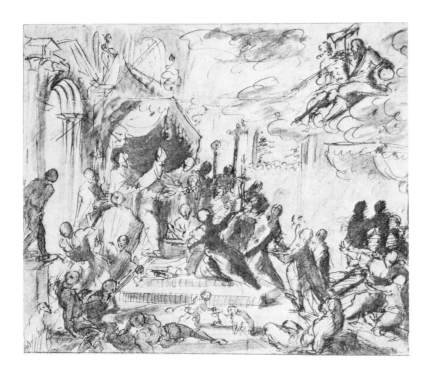

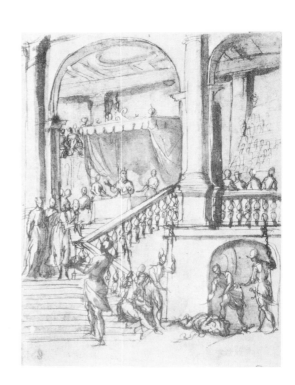

1. No. **A 1037**, II, *36*.—*2*. No. **A 1757**.—*3*. No. **A 2234**.—*4*. No. **A 2221**.